American Silver in the Philadelphia Museum of Art

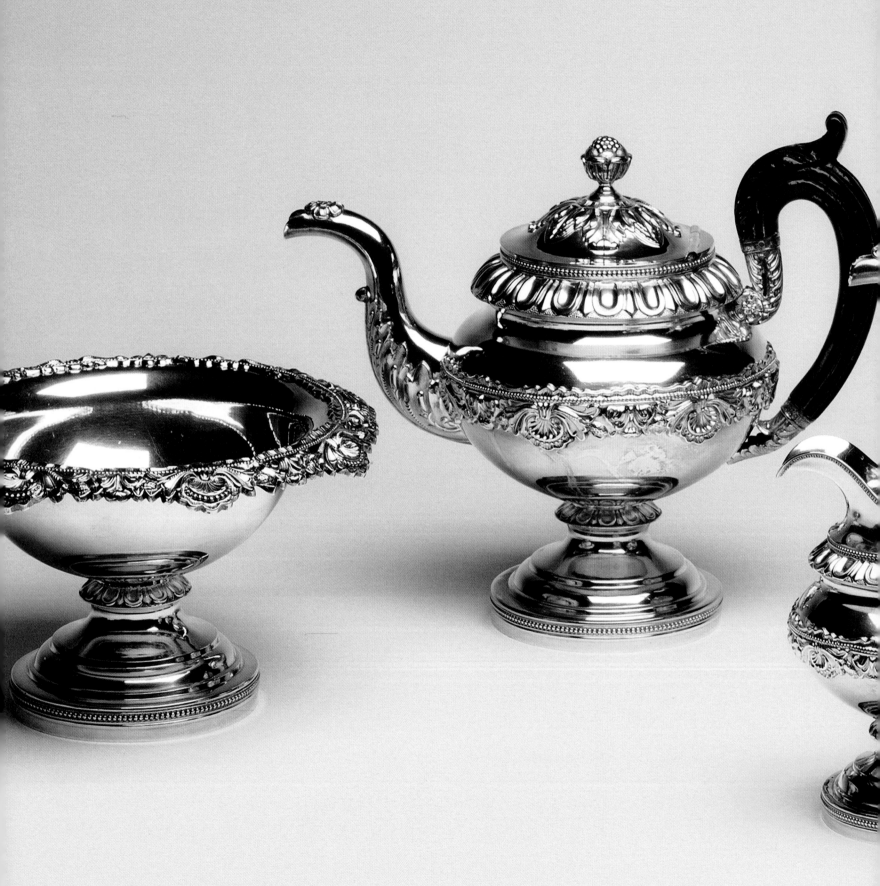

American Silver
in the Philadelphia Museum of Art

Volume 1 · Makers A–F

BEATRICE B. GARVAN AND DAVID L. BARQUIST

WITH ELISABETH R. AGRO

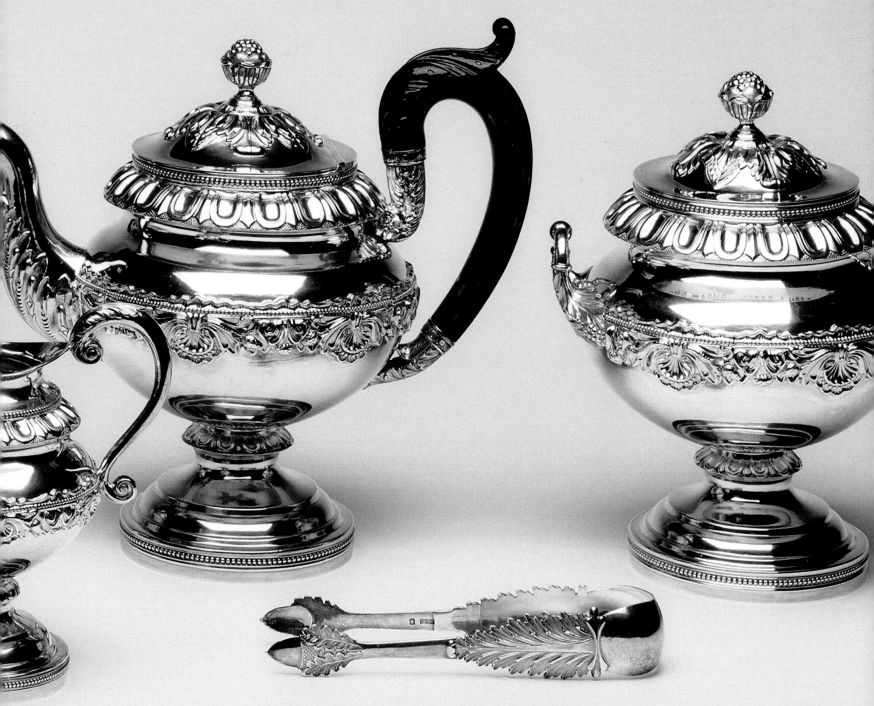

PHILADELPHIA MUSEUM OF ART

IN ASSOCIATION WITH YALE UNIVERSITY PRESS · NEW HAVEN AND LONDON

Dedicated to the memory of
Robert L. McNeil, Jr. (1915–2010)
Museum trustee
Collector of American art
Benefactor of scholarship

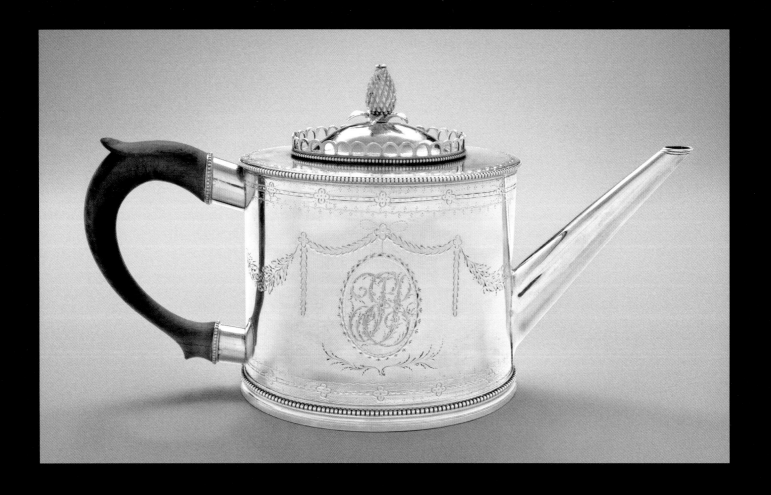

Contents

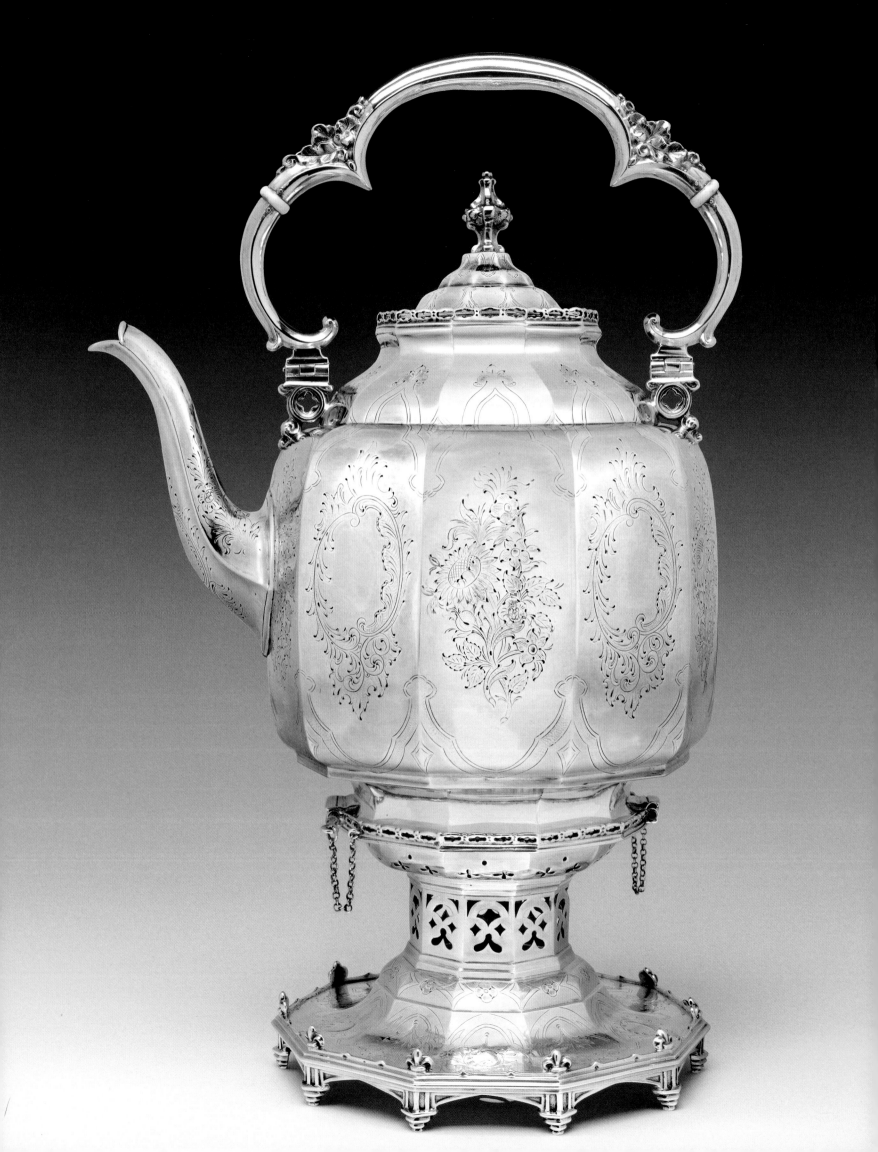

It is widely acknowledged that the Philadelphia Museum of Art's collection of American art is one of the finest of its type in the United States. This should come as no surprise, given the pivotal role that this city played in the development of American art, especially during the eighteenth and nineteenth centuries. The collection is notable not only for its breadth, but also for its depth in several different areas. Among these is American silver. It is a fascinating subject, as anyone who has visited our galleries will surely agree. There is, for one, the indefinable allure of the material, especially the color and gleam of its polished surface. There is also the seductive appeal of eloquent contours and simple yet sophisticated sculptural forms. And then there is the social aspect: the still-brilliant reflection of a time long gone in which finely crafted objects served an important representational function, expressing the taste and the aspirations of those who owned them.

Philadelphia figures prominently in this story, which is central to our understanding of the development of the decorative arts in this country. Beatrice B. Garvan's introductory essay to this publication, the product of diligent research and a discerning eye, traces the history of silversmithing in Philadelphia and examines the role that the Philadelphia Museum of Art has played since its founding in 1876 in collecting and exhibiting American silver. It is a history of which we should be proud, and this is one of the principal reasons why we made a commitment many years ago to publish a comprehensive multivolume catalogue of our collection of American silver.

It is unlikely that anyone then could have imagined how much time and work a project like this would require. Now that the first volume has been completed, it is perhaps fair to say that it represents, to borrow a phrase from Samuel Johnson, the triumph of hope over experience. But a triumph it certainly is, and one that has set a high standard—and an equally high set of expectations—for the three volumes that will follow.

Few museums are capable of remaining focused on a project of such a long duration, and for this reason I would like to express my deepest appreciation to the many members of our staff—curators, conservators, registrars, photographers, installation designers, and editors—who have made invaluable contributions to the stewardship and utilization of our holdings of American silver. I would be remiss if I did not single out among them Mary Cason, the editor of this publication, who has done an exceptional job not only in working collaboratively with our curatorial staff but also for taking on—and solving—a complex logistical task.

Special mention should be made of the several authors of this catalogue and members of the staff of our department of American Art—David L. Barquist, Elisabeth R. Agro, and most especially Bea Garvan—for their unwavering devotion to this project. We are not close to completing it, but with the work done thus far they have clearly marked the way and, in the process, made a significant and lasting contribution to scholarship in the field.

They have also generously recognized all those who have helped them with this project in the acknowledgments that follow. It remains for me to express our continuing gratitude to the late Robert L. McNeil, Jr., who, nearly a decade ago, made a remarkably generous gift to support the development and production of this multivolume catalogue. That he had the foresight to do so and the determination to help us stay the course is a credit to his passion for American art, for the City of Philadelphia, and for the Philadelphia Museum of Art. It is a great honor to dedicate this publication to his memory.

Foreword

Timothy Rub
The George D. Widener
Director and Chief Executive Officer

This has been a long-term project, and there are many friends and colleagues to thank for their input through the years. Many of them shared our interest and enthusiasm in new materials that we found, and many of them probably have forgotten all about their contributions. We hope this will remind them that we are, and have ever been, grateful for the information from near and far that has supported this weighty tome about the Philadelphia Museum of Art's American silver collection, as well as additional volumes still to come.

The support of our colleagues in the American Art department has helped us immensely over the years. Special thanks are due to Kathleen A. Foster, the Robert L. McNeil, Jr., Senior Curator of American Art, for her steadfast support of this project. Jennifer Zwilling, curatorial assistant, provided invaluable research and editorial work and wrote the biography of Virginia Wireman Cute. Debbie Rebuck, curator of the Dietrich American Foundation, assisted with the preparation of entries on the foundation's collection. Curators Alexandra Kirtley, Jessica Smith, and Carol Soltis, and past curators David A. Hanks, Jack L. Lindsey, Mark Mitchell, Darrell Sewell, and Raymond V. Shepherd Jr. made acquisitions, undertook research, and provided thoughtful assistance that enrich this volume. Department assistants Adrienne Gennett, Nan Goff, Carol Ha, Emily Leischner, Rachel Markowitz, and Quillan Rosen helped with innumerable details and computer triage, and special thanks are due Susan Eberhard, Lisa Morra, Lucy Peterson, and Sophia Meyers for their particularly intensive work on the project. For the past four summers, the Center for American Art has supported a Silver Fellow to research and write biographies, and we are grateful to Elyse Gerstenecker, Ann Glasscock, Jennifer Padgett, and Julia Silverman for their contributions to forthcoming volumes; Jennifer also coauthored the entry for the Dominick & Haff porringer and spoon (cat. 194) in the present volume. Research and organization for this project were undertaken by interns Shauna Aaron, Daisy Adams, Rebecca Allen, Thomas Baldwin, Wendy Christie, Jeff Groff, Heather Gibson Moqtaderi, and Erica Warren.

So many colleagues at the Museum have helped with this project over the years that it would be impossible to thank everyone by name. The late Anne d'Harnoncourt, the George D. Widener Executive Director and Chief Executive Officer, initiated this project, and her successor, Timothy Rub, has offered his wholehearted support, as have Alice Beamesderfer and Larry Berger. Our colleagues in Objects Conservation have made the objects look their best and have answered questions about technology: Raina Chao, Kate Cuffari, Adam Jenkins, Amanda Karpowich, Andrew Lins, Sally Malenka, Melissa Meighan, and the late Christopher Wasson. In European Decorative Arts, we have enjoyed many beneficial exchanges of ideas with Donna Corbin and are particularly grateful to Kathryn Hiesinger for French translations. The research for this book would not have been possible without the ready assistance from our colleagues in the Museum's Library and Archives: Susan Anderson, Miriam Cady, Rose Chiango, Alexander Vallejo, Mary Wasserman, and especially Richard Sieber. Registrars Nancy Baxter, Clarisse Carnell, Renee McDade, Irene Taurins, Morgan Webb, and Kara Willig helped answer questions from their records. Past and present colleagues in Development have shepherded donors and grants in support of this project, including Alexa Aldridge, David Blackman, Edward Mills, Kelly O'Brien, Jonathan Peterson, and especially Nico Hartzell.

Mary Cason, our editor, has coped with manuscripts through many changes and additions to texts. She has kept on top of the schedules and tempered our enthusiasms, while kindly accepting yet another endnote. She has sought out obscure illustrations and made timely suggestions, which have given shape to the project. A personal note from Bea: Mary has brought me

Acknowledgments

along, painfully, from DOS to Dropbox. We are grateful to the Museum's Publications department for bringing this book from conception to reality: Sherry Babbitt and Katie Reilly, past and present William T. Ranney Directors of Publishing, editors Kathleen Krattenmaker and Sarah Noreika, and especially Rich Bonk for overseeing the production and printing.

Steven Schoenfelder has created an elegant design despite the challenges of receiving manuscript and images piecemeal. The superb photographs seen in this volume were created by a team of Museum photographers; Lynn Rosenthal took the majority, with others supplied by Will Brown, Graydon Wood, Tim Tiebout, and Joseph Hu. Jared Castaldi was generous to share his photographs of Sharon Church, Steve Ford, and David Forlano. David Fithian kindly supplied the portrait of Elsa Freund. Brent Wahl helped digitize film negatives, and Justyna Badach assisted with and oversaw many of the details.

A research project of this scale would not be possible without the generous help of colleagues in libraries and archives: Kevin Proffitt, The Jacob Rader Marcus Center of the American Jewish Archives, Cincinnati; Charles B. Greifenstein, American Philosophical Society, Philadelphia; Connie S. Houchins, Andalusia (PA) Foundation; Bruce Laverty, Athenaeum of Philadelphia; Jency Williams, Beth Ahabah Museum & Archives, Richmond, VA; Timothy Engels, John Hay Library, Brown University, Providence, RI; Angela Dolsky, Cape Cod Museum of Art, Dennis, MA; Carol W. Smith, Christ Church, Philadelphia; Louis Kessler, Congregation Mikveh Israel, Philadelphia; Joyce Homan, Genealogical Society of Pennsylvania, Philadelphia; Eleni Bide, The Goldsmiths' Company, London; Lynne Anderson, Historic Waynesboro, Wayne, PA; Edward Richi and Bill Robinson, Delaware Historical Society, Wilmington; Lee Arnold, Historical Society of Pennsylvania, Philadelphia; Mary Collins, The Holland Society of New York; Nick McAllister, Laurel Hill Cemetery, Philadelphia; James N. Green and Connie S. King, Library Company of Philadelphia; Francis O'Neill and Damon Talbot, H. Furlong Baldwin Library, Maryland Historical Society, Baltimore; Glenys A. Waldman, Masonic Library and Museum of Pennsylvania, Philadelphia; Jefferson Moak and Gail Farr, National Archives, Philadelphia; Jonathan Stayer, Pennsylvania State Archives, Harrisburg; Jennifer Barr, Presbyterian Historical Society, Philadelphia; David Baugh, Ward J. Childs, and Jill Rawnsley, Philadelphia City Archives; Claudine Catalano-Pipino, Register of Wills, Philadelphia; Susan Bianucci, Swedish American Hall, San Francisco; Bert Denker and especially Jeanne Solensky, Winterthur (DE) Library.

Museum colleagues were equally generous with their time and expertise. Special mention is due Patricia Kane at the Yale University Art Gallery for her analysis of New England makers' marks and for sharing Yale's archival collections of the research Maurice Brix assembled in preparation for his study of Philadelphia silversmiths, as well as the notes Francis Hill Bigelow employed in his *Historic Silver of the Colonies and Its Makers*. Other colleagues have our heartfelt thanks: Elizabeth McGooey and Christopher Monkhouse, The Art Institute of Chicago; Barry R. Harwood and Kevin Stayton, Brooklyn Museum; Rachel Delphia, Carnegie Museum of Art, Pittsburgh; J. Grahame Long, Charleston (SC) Museum; Rosemary Phillips, Chester County Historical Society, West Chester, PA; Amy Dehan and Cecelia Drewing, Cincinnati Art Museum; Alexis Goodin, Sterling and Francine Clark Art Institute, Williamstown, MA; Janine E. Skerry, Colonial Williamsburg Foundation; John Walsh, J. Paul Getty Museum, Los Angeles; Brandy Culp, Historic Charleston (SC) Foundation; Sally VanZant Sondesky, Historical Society of Bensalem (PA) Township; Chad Alligood, Lindsey Hansen and Harold B. Nelson, Huntington Library, Art Collections, and Botanical Gardens, San Marino, CA; Rosemary Carlton, Sheldon Jackson Museum, Sitka, AK; Shelley Selim, Indianapolis Museum of Art; Bobbye Tigerman, Los Angeles County Museum of Art; Jeannine A. Disviscour and Mark B. Letzer, Maryland Historical Society, Baltimore; Ellenor Alcorn, Medill Higgins Harvey, and Beth Carver Wees, The Metropolitan Museum of Art, New York; Jennifer Komar Olivarez, Minneapolis Institute of Art; Anna Tobin D'Ambrosio, Munson-William-Proctor Institute, Utica, NY; Daniel K. Ackermann and Robert Leath, Museum of Early Southern Decorative Arts, Winston-Salem, NC; Jonathan Leo Fairbanks, Eleanor Gadsden, Linda Foss Nichols, and Gerald W. R. Ward, Museum of Fine Arts,

Boston; Margaret K. Hofer and Deborah Schmidt Bach, New-York Historical Society; Karl Kusserow, Princeton University Art Museum; Frank Ricci, Reading (PA) Public Museum; Marcee Craighill and Virginia B. Hart, Diplomatic Reception Rooms, U.S. Department of State, Washington, DC; Sophie Davidson and Alyce Perry Englund, Wadsworth Atheneum, Hartford, CT; Donald L. Fennimore, Anne Verplanck, and Ann Wagner, Winterthur (DE) Museum and Gardens; John Stuart Gordon and Keely Orgeman, Yale University Art Gallery, New Haven, CT. Susan Gray Detweiler supplied invaluable information on the collection of Robert L. McNeil, Jr.

Dealers and auction house experts have been of particular help in supplying us with information on objects and their marks: Jeanne Sloane and Jennifer Pitman, Christie's; Lynda Cain and Whitney Bounty, Freeman's; Robert Mehlman; Gary Niederkorn, Niederkorn Antique Silver; Timothy Martin and James McConnaughy, S. J. Shrubsole; Elle Shushan; Kevin Tierney and John Ward, Sotheby's; Spencer Gordon and Mark McHugh, Spencer Marks; Jonathan Trace; the late Constantine Kollitus; and the late Michael Weller, Argentum.

Our writing has been informed by the research of many independent scholars, conservators, and academic colleagues, including Barbara Almquist, Robert Barker, Edgar Peters Bowron, W. Scott Braznell, Gail Brown, Robert Faber, Jeannine Falino, Jim Gergat, Toni Greenbaum, Linnard R. Hobler, Catherine B. Hollan, William Hood, Christina Keyser, David Maxey, John A. Pinto, Susan L. Shapiro, D. Albert Soeffing, Lita Solis-Cohen (who generously shared her archive of auction catalogues), Ubaldo Vitali, Deborah Dependahl Waters, Terry Royal West, Wynyard Wilkinson, and the late Polly Ullrich.

The splendid collection we have catalogued was created by the tremendous generosity of collectors and donors who have made the Museum a destination for anyone interested in American silver. We are grateful for the opportunity to get to know many of them and share in their enthusiasm for American silver. Foremost among them were Robert L. McNeil, Jr., and H. Richard Dietrich, Jr., whose gifts transformed this collection. Charlene Sussel greatly augmented the Museum's collection of flatware, particularly by lesser-known Philadelphia makers. Robert M. Taylor and Beverly A. Wilson have expanded the holdings for the second half of the nineteenth century. We are also grateful to Helen W. Drutt English Stern, whose devotion to the field and the Museum has enriched the representation of twentieth-century craftsmen in precious metals. Two great friends of the Museum, the late trustee and chair emeritus Gerry Lenfest and his wife, Marguerite, secured important American silver for the Museum as it became available. Frances Richardson endowed an acquisition fund dedicated to American silver, and other purchases were made possible with gifts from the Levitties Family, Friends of the Philadelphia Museum of Art, Young Friends of the Philadelphia Museum of Art, and Norma and Leonard Klorfine.

We are also grateful to those artists who spent time digging through their personal archives and papers in order to provide us with information on the objects in our holdings and personal information to update their biographical statements: Bernard Bernstein, Kathy Buszkiewicz, Chunghi Choo, Sharon Church, Colette, Robert Farrell, Steve Ford, and David Forlano.

The catalogue has had generous financial support beginning with the Henry Luce Foundation, which awarded the grant that launched this project. The Women's Committee of the Philadelphia Museum of Art generously supported the major part of the catalogue photography, with additional photography completed under a grant from the Institute of Museum and Library Services. Publication of this volume and its successors was made possible by a pledge from Robert L. McNeil, Jr., that was completed after his death. For everything that Bob did to support this project, American art at the Museum, and each of us personally, we gratefully dedicate this book to his memory.

BEATRICE B. GARVAN, *Curator Emerita of American Decorative Arts*

DAVID L. BARQUIST, *The H. Richard Dietrich, Jr., Curator of American Decorative Arts*

ELISABETH R. AGRO, *The Nancy M. McNeil Curator of American Modern and Contemporary Crafts and Decorative Arts*

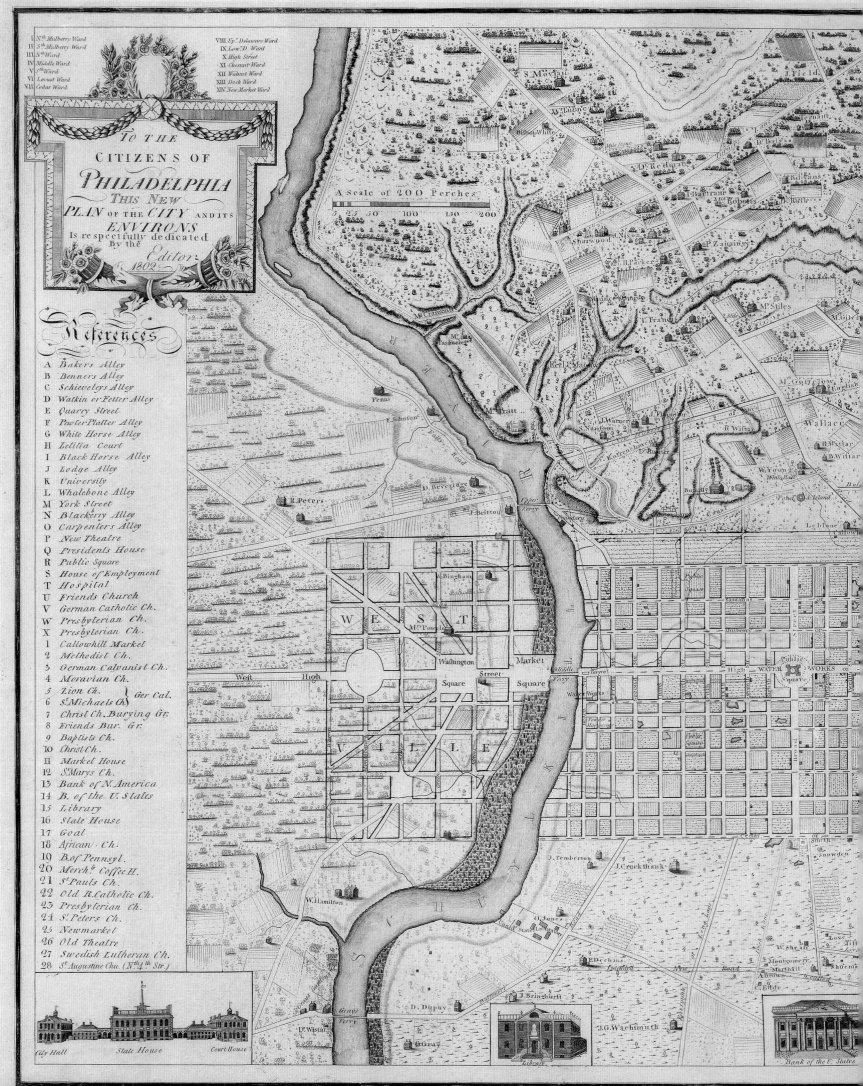

To the
CITIZENS OF
PHILADELPHIA
THIS NEW
PLAN OF THE CITY AND ITS
ENVIRONS
Is respectfully dedicated
By the Editor.
1802.

I Nth Mulberry Ward
II Sth Mulberry Ward
III Nth Ward
IV Middle Ward
V Sth Ward
VI Locust Ward
VII Cedar Ward
VIII Upp. Delaware Ward
IX Low'D. Ward
X High Street
XI Chesnut Ward
XII Walnut Ward
XIII Dock Ward
XIV New Market Ward

References

A Bakers Alley
B Benners Alley
C Schieveleys Alley
D Watkin or Fetter Alley
E Quarry Street
F Pewter Platter Alley
G White Horse Alley
H Letitia Court
I Black Horse Alley
J Lodge Alley
K University
L Whalebone Alley
M York Street
N Blackberry Alley
O Carpenters Alley
P New Theatre
Q Presidents House
R Public Square
S House of Employment
T Hospital
U Friends Church
V German Catholic Ch.
W Presbyterian Ch.
X Presbyterian Ch.
1 Callowhill Market
2 Methodist Ch.
3 German Calvanist Ch.
4 Moravian Ch.
5 Lion Ch. } Ger Cal.
6 St Michaels Ch.
7 Christ Ch. Burying Gr.
8 Friends Bur. Gr.
9 Baptists Ch.
10 Christ Ch.
11 Market House
12 St Marys Ch.
13 Bank of N. America
14 B. of the U. States
15 Library
16 State House
17 Goal
18 African Ch.
19 B. of Pennsyl.
20 Mercht. Coffee H.
21 St Pauls Ch.
22 Old R. Catholic Ch.
23 Presbyterian Ch.
24 St Peters Ch.
25 Newmarket
26 Old Theatre
27 Swedish Lutheran Ch.
28 St Augustine Chu. (No 4th Str.)

A Scale of 200 Perches

City Hall State House Court House

Library

Bank of the U. States

P.C. Varlè Geographer & Engin: Del.

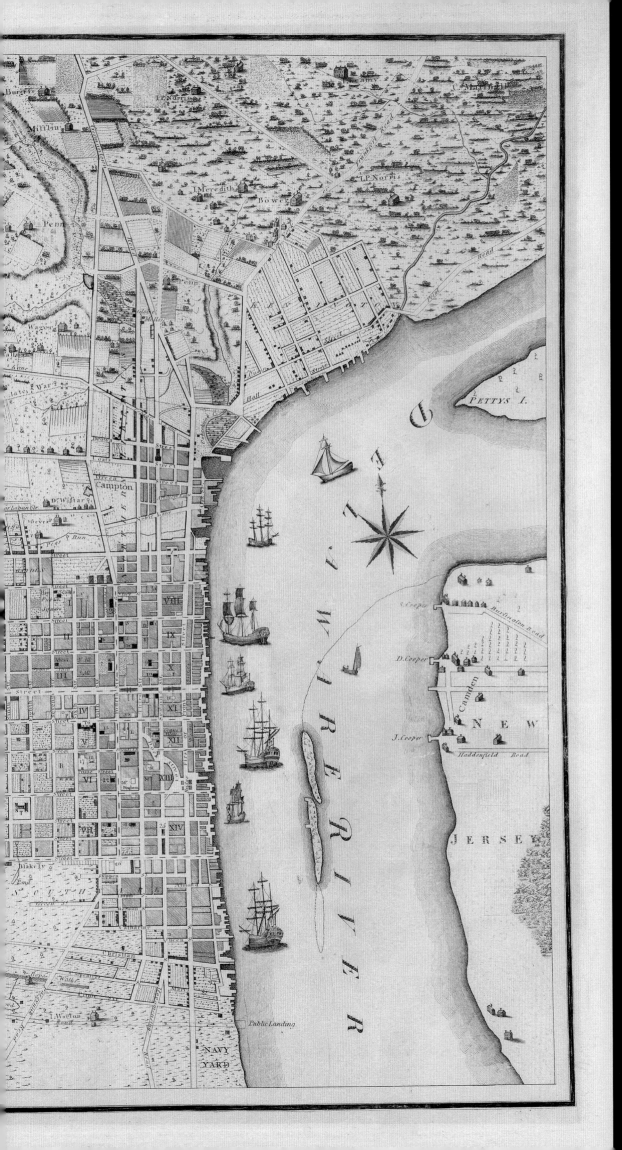

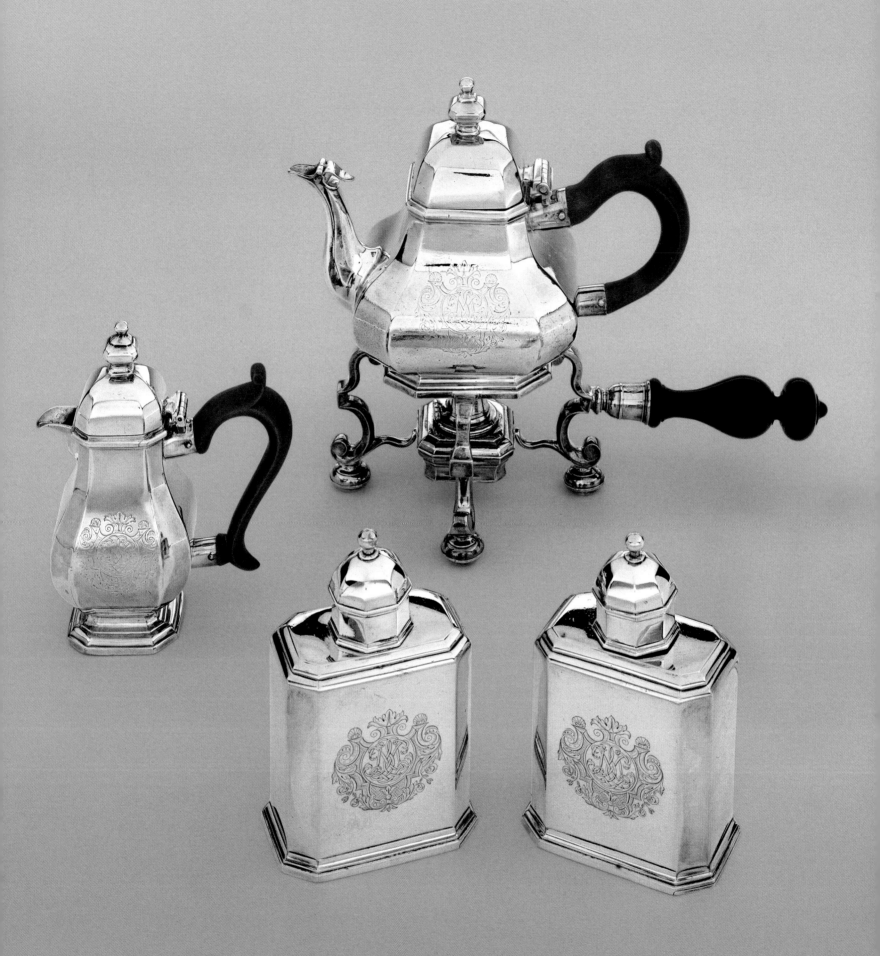

Silver: The Metal and Its Purity

I n the broadest sense, silver is a commodity refined from rocks. A white metal, it is ductile, malleable, and sonorous. It can be raised, spun, cast, and stamped. Due to its versatility, it became a medium of exchange in most cultures and an essential element in trade and wealth from earliest times. One is compelled to take a closer look when silver's highly polished surfaces are embellished with engraving, chasing, or cast ornament.

The primary source of the gold and silver that became the raw material of many a coffeepot and tankard in early America was the specie brought in by world trade—Mexican dollars, English guineas, French pistoles, Spanish pistole pieces, moidores, doubloons, and pieces of eight. The precious metals came into American coastal ports from Spanish and French colonies in the West Indies, Mexico, and South America. Subject to the hazards of dead-reckoning navigation and incomplete coastal charts, overlaid with rampant piracy, wars, and embargoes, a ready supply of gold and silver for silversmiths' shop work was often beyond their control. Moreover, it came into their shops in random amounts, whether as coins or in old silver to be melted down.

The purity of the metal was a key factor in the manufacture and value of silver. In 1753 and the years following, Philadelphia silversmiths petitioned the Pennsylvania Provincial Assembly for "proper regulations as to the Fineness of silver and gold to be wrought," in order to give purchasers confidence and increase their business. They proposed appointment of an assayer to test the metal, to no avail. Each succeeding petition was tabled in the governor's council. John Bayly Sr. (q.v.) advertised in the *Pennsylvania Gazette* on March 18, 1756, "as lately imported from London, setts of gold and silver assay weights in a draw box complete," suggesting that some silversmiths were doing their own assays.[1] Joseph Richardson Sr. (q.v.), however, was sending odd bits of his raw materials and shop sweepings to London for assay. His note to George Ritherton in 1759 recorded: "I have sent thee 52 1/2 oz of Metell Containing Part Silver & Part of other Metels which I desire thee to get Essayed & to Sell it for what it will fetch & Credit me with the Neat Proceeds."[2] It was not until after the Revolution that the assay process was generally available. On October 28, 1786, Philadelphia's *Independent Gazetteer* published "an ordinance for the establishment of the Mint of the United States and for Regulating the Value & Alloy of Coins." From March 3, 1794, until his death in 1803, Charles Gilchrist, "Button and Buckle Maker from Birmingham and Sheffield," at 108 Market Street, offered assay services in Philadelphia's *General Advertiser*: "Ore's [*sic*] assayed with greatest exactness, gold and silversmiths['] sweeps purchased by assay which will enable him to give true value." In 1797 he also operated a refinery on Race Street between Eighth and Ninth. Gilchrist's advertisements, published in French and English, would have accommodated newly arrived French silversmiths such as Claude Amable Brasier or Jean-Simon Chaudron [q.q.v.], who were accustomed to the practice of assay. In 1811 the following standards were established: "Gold coins are to consist of eleven parts of pure gold; and one part alloy. The alloy to be composed of silver and copper, in such proportions not exceeding one half silver, as shall be found convenient; to be regulated by the director of the mint, for the time being, with the approbation of the president of the United States. Silver coins are to consist of 1485 parts of pure silver, to 179 parts copper."[3]

Silversmiths' accounts noted the cost of a finished piece as its weight times the current value per ounce of silver used. Added to the cost of the metal, the "making" was often noted as a separate fee.[4] In cases of loss or theft, newspaper advertisements that included the weight scratched on the bottom of a pot, the silversmith's mark, and the engraved initials of an owner facilitated identification within the community of craftsmen and the piece's return to the owner.[5] A silver teapot was money to a thief; to an owner it was property taxable beyond its utility and was almost as good as ready cash. In August 1743 Daniel Sharpless signed a receipt to William Gorsuch that he had received "a silver half pint cup marked with HA on the handel and 2 Silver Spoons marked on the handels MG for the Security of seven pounds current money of

Introduction

Beatrice B. Garvan

pensilvania [*sic*] and which I have lent to the said William Gorsuch for the term of three months, at the payment of the said interest then due I promise and oblige myself and heirs to return the above said cup and 2 spoons to William Gorsuch."[6] Trust was an important aspect of a silversmith's business, whether dealing with overseas agents and factors or with local patrons. A cupboard of silver made for domestic use was good credit in a trading economy.

Silversmiths in Philadelphia, 1680–1840

Philadelphia was a wilderness when the Massachusetts Bay Colony was settled in 1628. New York was a thriving community by 1660, with New York City and Albany, up the Hudson River. Silversmiths were at work in both locations years before the arrival of Cesar Ghiselin (q.v.) in Philadelphia in 1681. William Penn's plan for his colony of Pennsylvania resulted in a character for the city that differed from that of Boston and New York—socially, economically, politically, and artistically. There was little regular commerce between the cities besides the coastal sea trade until after the Revolutionary War, when roads built by the British for movement of their troops allowed more than horse traffic. While New England ships sailed directly across the Atlantic from their several coastal harbors, Pennsylvania had a single trading port, Philadelphia, which was tucked behind New Jersey, with extensive frontage on the wide, deep Delaware River. The port was protected from Atlantic storms and privateers eager to capture merchant ships, impress their crews, and raid their cargoes. By 1685 Samuel Carpenter had built a 300-square-foot wharf that could accommodate the largest trading ships.

The dynamics for a commercial colony were set up from the beginning. William Penn and his surveyor Thomas Holme drew up a detailed prospectus that included delineated parcels of interior lands, a town plan for Philadelphia, and a governance structure for the colony.[7] A fortuitous aspect of Penn's promotion of his plan was his connections to the Quaker network of English merchants and to Irish investors such as James Logan. Deeds issued by Penn to his purchasers specified that each city plot or country acreage had to be settled and productive within a defined number of years or the deed would be void, thus guaranteeing an active population beyond pure investment. Equally important were his promotional pamphlets distributed during his extensive travels across Europe persuading Mennonite, Huguenot, and Swiss farmers and craftsmen with generations of skills, displaced from years of destructive wars and persecution resulting from repeal of the Edict of Nantes in 1688, to move to his colony. In 1681, the year before Penn himself went to live in Pennsylvania, he set forth the character of the settlement he was promoting: "My Freinds / I wish you all happiness, here & here after. . . . You are now fixt, at the mercy of no Governour that comes to make his fortune great, you shall be govern'd by laws of yr ouwn makeing, and live a free & if you will, a sober & industreous People."[8] The sentiment was carried on through generations of Philadelphia Quakers into the twentieth century, inspiring Nathaniel Burt to write in 1963: "Philadelphia is, for all its slowness, a slowly *fluid* city."[9]

The association of "Quaker" and "plain" seems to have developed in the late nineteenth century, reflecting nostalgia for an earlier era and as a reaction to the penchant for elaborate displays of silver services on sideboards. In 1924 Dr. Samuel Woodhouse, then acting director of the Pennsylvania Museum (as the Philadelphia Museum of Art was then known), offered this perspective: "And all throughout their [silversmiths'] work there is a lack of sophistry and of flamboyance which is particularly pleasing, and inherent expression of the ever-constant Quaker desire for simplicity which has been reflected to a certain degree in all the silver produced in Philadelphia since the earliest days."[10] If Penn's earliest settlers, Quakers and others, brought their silver—plain or not—to Pennsylvania, it was probably as much for its transactional value as for its domestic use.

Quakers did not discourage property ownership; it was the display of it that was discouraged. In 1682 William Penn himself shipped his goods and chattel to Pennsylvania, including

a portion of his silver: one large tankard, one plate, one "pottinger with ears" and a cover, one caudle cup with three legs and a pottinger to cover it, three tumblers, one taster, six spoons, two forks, one pair of "Snuffers," one "handle Cup," and "Two things for Crewett tops."[11] To provide a broader view of early Philadelphians and their silver, a subsequent volume of this catalogue will include important English and European silver objects inherited and donated by Philadelphia families that are now in the collections of the Museum's European Decorative Arts department. A handsome pair of silver canisters (PMA 1975-49-1,2) by London silversmith John Farrell was presented to James Logan by Guglielma Penn in 1723 (see page xiv) They matched a tea service by Huguenot silversmith Peter Archambo acquired previously by the Logans (PMA 1959-151-9–12).

Gabriel Thomas, who sailed from London in 1691, wrote and distributed a pamphlet about Philadelphia in 1698:

> The Industrious (nay Indefatigable) Inhabitants have built a Noble and Beautiful City, and called it Philadelphia, which contains above two thousand Houses, all Inhabited; and most of them Stately, and of Brick, generally three Stories high, after the Mode in London, and as many several Families in each. . . . I must needs say . . . Poor People (both Men and Women) of all kinds, can here get three times the Wages for their Labour they can in England or Wales. . . . And for Silver-Smiths, they have between Half a Crown and Three Shillings an Ounce for working their Silver and for Gold equivalent. . . . [T]hey have constantly good price for their Corn, by reason of the great and quick vent [sale] into Barbadoes and other Islands; through which means Silver is become more plentiful than here in England. . . . [T]he Place is free for all Persuasions, in a Sober and Civil way; for the Church of England and the Quakers bear equal Share in the Government. They live Friendly and Well together.[12]

As Philadelphia's reputation grew, at least two early Huguenot silversmiths, Peter David and Johannis Nys (q.q.v.), relocated to Philadelphia from New York.

The rich, well-watered soil of Pennsylvania, worked by European settlers, produced the wheat, flour, and lumber that were shipped out in the earliest trade in Philadelphia-built ships. They returned with sugar and rum from the West Indies and spices from South America, creating wealth in all forms: silver, gold, and credit, all of which was tallied in the account books of the earliest city merchants, including Thomas Chalkley (1675–1741), whose trading route between Philadelphia, Bristol, England, and the West Indies illustrates what became known as the "triangle trade."[13] Chalkley died in Tortola in 1741, and his wife Martha commissioned Joseph Richardson Sr. to make a cann from silver (probably coins) found on his person (fig. 1). The craftsmen, masters, and so-called mechanics—a term that included apprentices and journeymen—flourished. Letters and hearsay praising Philadelphia as a hospitable city to all comers encouraged further immigration. In the 1790s, when the French owned sugar plantations, and Haiti and Saint-Domingue were raided in native uprisings, trading connections facilitated the escape of French citizens and merchants to Philadelphia, who made a considerable impact on the manners and lifestyle of Philadelphia society.[14]

The Seven Years' War (1757–64), carried on by the French with the Canadian and American Indians in western Pennsylvania, devastated inland farms and diminished the produce available for export, which affected Philadelphia's overseas trade with the West Indies and Europe. However, within the colony of Pennsylvania silversmith-merchants such as William Ball (q.v.) engaged in commerce with the rural centers of Reading and Lancaster. Wagons that carried farm produce to Philadelphia returned with credits and domestic necessities. Ball noted in his account book the dates of regional markets and fairs, and he shipped merchandise to be sold in the outlying counties of Berks and Lancaster.[15] It was a commerce carried out in ledger books in the colony's credit/debit economy.

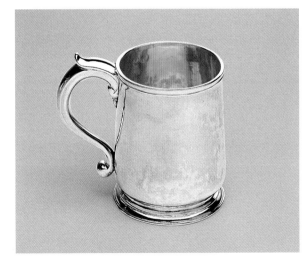

Fig. 1. Joseph Richardson Sr. (American, 1711–1784). Cann, 1741–45. Silver, height 4³⁄₁₆ inches (10.7 cm), width 3¼ inches (8.3 cm). Philadelphia Museum of Art. Gift of Lydia Thompson Morris, 1925-27-340

One trade interruption quickly followed another. The non-importation agreements of 1765 and 1767 impacted all the colonies according to how dependent each was on English sources and how assiduously its merchants adhered to the agreements. An extract from a letter from a gentleman in London (c. 1767) published on October 31, 1770, in the *South Carolina Gazette*, stated: "You Americans are too obstinate. . . . There is no such thing as speaking a word to you on public affairs. . . . I am afraid that it is now too late. To confine your imports to necessities will avail you little here . . . besides while Maryland, Rhode Island and Albany import, your resolutions are fraught with lasting evils to yourselves."[16] Philadelphia followed the non-importation edicts, which were subtly enforced by observation and opinion. Samuel Morris wrote to Samuel Powel in England in 1765:

> I have sold 4 old battered porringers, a pepper box and 8 Silver buttons amtg to 44 oz. 3.12 to I. Richardson a 8/ p. oz—they were country made & not having ye Hall mark would not exceed that price. . . . Household goods may be had here as cheap & as well made from English patterns. In the humour people are in here, a man is in danger of becoming Invidiously distinguished, who buys anything in England which our Tradesmen & others can furnish. I have heard the joiners here object this against Dr Morgan & others who brought their furniture with them.[17]

The years between 1764 and 1774 comprised an important decade in Philadelphia, when artisans in all media flourished with less competition from imports. Silversmiths, singly and in partnerships, advertised and illustrated their wares and shop locations in regional newspapers. Their advertisements were consistent in noting in capital letters that full value would be given for old silver, a source of their metal that was not coming in by sea. This was a period of dramatic growth in Philadelphia's community of craftsmen as the population of Philadelphia expanded with the arrival of the leaders of the Revolutionary movement. By 1774 Philadelphia achieved status as the largest city in British North America, with 30,000 inhabitants. The city became the financial and commercial center of the American colonies. As well as local families, at least two of the "Founding Fathers" commissioned silver in Philadelphia during this period, Jefferson from Samuel Alexander and Anthony Simmons (q.q.v.), and Washington from Joseph Anthony Jr. (q.v.).[18]

Between 1790 and 1801, Philadelphia as the capital of the United States became the most cosmopolitan city in the nation, crowded with French émigrés, artists and writers, and members of the nobility. They enlivened the social scene and brought an intellectual energy into the city that continued until prominent French felt it safe to return to France or the West Indies. While the gentry were partying, the focus of the young citizenry, including silversmiths such as Liberty Browne (q.v.), turned to politics. And when it was announced that the site of the new capital would be Washington, John LeTelier Sr. (q.v.) moved. Others, including George Christopher Dowig (q.v.), relocated to Baltimore. Chaudron moved to Alabama for the patronage of the new cotton barons. The Dumoutets (q.v.) opened a shop in Charleston.[19]

Although patronage of the arts from the "old school" of Philadelphia merchants continued, young civic leaders and newly elected representatives from other states to the new government espoused a new style, which followed London fashion as it had in the pre-Revolutionary era. There were more active silversmiths in Philadelphia during this period than before or after. Silver historians consider that Philadelphia silversmiths achieved their greatest success in this period through their interpretations of the neoclassical style in round and oval flat-bottomed teapots, fluted urn-shaped sugar bowls, and straight-sided tankards and canns with encircling bands— tight and tidy! The grand tea urn (fig. 2) made by Richard Humphreys in 1774, is considered to be the first example of this style made in the colonies.

Versatile engravers, employed by silversmiths and printers, were active from earliest settlement, cutting ciphers and coats of arms. They are listed in city directories and in silversmiths' account books, and they advertised: "Henry Dawkins from London who lately wrought with Mr.

James Turner, having now entered into business for himself, next door to the sign of Admiral Boscawen's head in Arch Street . . . engraves bills, coats of arms for gentlemen's books, on plate, etc."[20] Laurence Herbert, "engraver from London" living with Philip Syng Jr. (q.v.) in 1748, probably engraved the initials "JEC" on a tankard in the Museum's collection (1924-55-1), drawing from *Sympson's Book of Cyphers* (1725) or *New Book of Cyphers* (1726). Another manual used often in Philadelphia was *Bowles's New and Complete Book of Cyphers* by John Lockington (1777) (figs. 3, 4). The engravers rarely signed their silver work, but there are a few examples. James Smithers signed his name "J.Smithers" under his elegant if old-fashioned cartouche on the hot-water urn by Richard Humphreys. The new generation of engravers, like the silversmiths, adapted to the new style and became expert in the light touch of brightwork, creating an endless variety of festoons and floral garlands enclosing initials within leafy wreaths. And Francis Shallus (1773–1821), of this next generation, signed his name plainly on the bottom of a tray by John McMullin (PMA 1944-93-16). A versatile engraver, he worked for Samuel Williamson (q.v.) in the 1790s, and for engraver Robert Scot at the Philadelphia Mint; he also engraved bookplates. Moreover, Shallus's career illustrates the expansion of artisans into the civic arena. He was a Mason, he founded a library in his name, and he served in the militia before the War of 1812.[21] As well as the silversmiths, Philadelphia engravers deserve a separate study.

There were other versatile specialists who had their own addresses and were working independently making chains, spectacle frames, and buckles, turners who made wood handles, jewelers who set stones, and "moulders" like Louis Belin, who created sculptural elements that were applied to some grand objects by Chaudron. The *Pennsylvania Packet* recorded on July 13, 1772, that John Anthony Beau, "a celebrated beater [chaser], in Fourth Street . . . lately arrived from Geneva . . . offers to teach drawing."

When the Embargo of 1807 was enforced, all English imports of manufactured products that had become essential to American consumers ceased again, and American ports were blocked by British ships. It devastated the American economy, especially in Philadelphia, dependent on

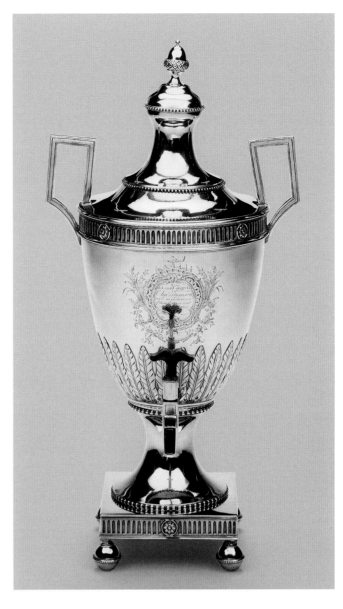

Fig. 2. Richard Humphreys (American [born West Indies], 1750–1832). Hot-Water Urn, 1774. Silver, height 21½ inches (54.6 cm), width 10½ inches (20.3 cm). Philadelphia Museum of Art. Purchased with funds contributed by The Dietrich American Foundation, 1977-88-1

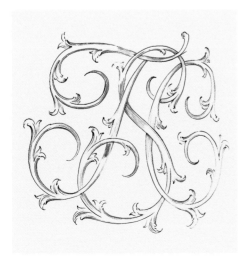 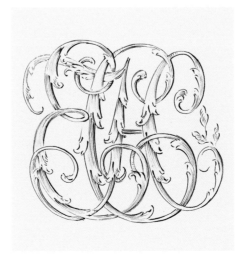

Figs. 3 and 4. These two examples of engraving show the "hands" of two different engravers who drew from from *Bowles's New and Complete Book of Cyphers* (1777). Left: John David Sr. (American, 1736–1794). Tankard, detail, 1770–80 (cat. 171). Right: Samuel Richards Jr. (1767–1827). Cann, detail, 1795–1810. Philadelphia Museum of Art. Gift of Daniel Blain Jr., 1997-67-6

trade with the West Indies and Europe. Silversmith/merchant Abraham Dubois Sr. (q.v.), as did many others, supplemented his own production with imports, turned to investments in newly opened western land—all on credit—and went into debt. Philadelphia silversmiths also began to appear in Delaware and Maryland. Samuel Alexander, for one, went south to Richmond seeking state and federal commissions for swords and arms, which became as important a product for the silversmiths as domestic objects when the United States prepared for war with England in 1812. New England's seaport towns that had been trading directly with England imported workmen from Sheffield and Birmingham with the know-how, if not the actual machinery, and began to manufacture domestic silver. Handwork declined, and although trade rebounded briefly after 1837 and the bank failure, Philadelphia silversmiths did not again achieve the leadership role they carried throughout the Revolutionary and early Federal periods. The later nineteenth-century firms of Bailey & Co., Bennett & Caldwell, and Robert and William Wilson (q.q.v.) illustrate the pressures of competition and mechanization requiring capital for the expansion of shop practices from one or two participants to many hands and specialists. Investors in land and craftsmen chasing their markets headed south and west. When New York began construction of the Erie Canal in 1817, there began another period of rampant speculation and resettlement toward the west, draining the commercial energy of Philadelphia and Baltimore. New York and New England became the centers of silver manufacturing.

Sources of Information

In 1920 Maurice Brix published his prodigious *List of Philadelphia Silversmiths and Allied Artificers, 1682–1850*, which included each craftsman's working dates and his locations carefully transcribed from Philadelphia city directories. He tucked a challenge into his preface: "The data so gathered lay a foundation for a History of Philadelphia Silversmiths, to be illustrated with photographs of their marks and work, which the author has in preparation. Owing to the nature of the proposed book, especially the difficulties attending the collecting and exact engraving of the marks, its completion must be a matter of time; and, having had many inquiries concerning Philadelphia silversmiths, he believes the present list may be helpful, pending the completion of the larger work."[22] Inspired by Brix, and given the long-term focus of the Philadelphia Museum of Art on silver made by Philadelphia silversmiths for their patrons from earliest settlement to the present, a special effort has been made to draw upon Philadelphia's deep archival resources to create sketches if not portraits of these silversmiths, as they navigated within their timelines of regional and national events—such as the pillage of their shops in 1777 during the occupation of the city by British troops, yellow-fever epidemics in late summer, and political riots in which tradesmen were active participants.

Our "sketches" of Philadelphia silversmiths have largely depended upon a subject's appearance in the civic scene beyond his shop. Membership in fire companies was a center of their civic and social participation before 1788. There were stalwarts in other trades upon whom everyone depended, such as the surveyor Gunning Bedford (see cat. 15), but Philadelphians did distinguish, not always subtly, between "gentlemen" and "artisan/tradesman." While there were no absolute class barriers—John Browne (q.v.) was listed as "goldsmith" and "gentleman" in city directories—few moved out of the artisan class. A distinguishing factor of a "gentleman" was the ownership of property and taxable assets beyond the "occupation tax." This became an important political issue during the Constitutional Convention of 1787. After the war, in the 1790s tradesmen in all media became an active force in politics as advocates of the "Liberty of Freemen," seeking to remove the requirement of property ownership for holding office or voting.[23]

A poignant example of social stratification was commented upon by John Watson in his *Annals of Philadelphia and Pennsylvania*, published in the mid-nineteenth century. In 1792/93, Joseph Anthony Jr., his father, Captain Joseph Anthony, and his brother Thomas Powell Anthony all

subscribed to a fund to build a hall for a dancing assembly, an elite social event that had been established by the old families just before the Revolutionary War. Although the hall was never built, after the war the assembly continued and has remained a conspicuous event in the social fabric of Philadelphia. It was held every Thursday evening in the winter from 6:00 p.m. to 12 midnight in a grand space in Oeller's Hotel. The male heads of families managed the event, and the required membership was handed down in the male line. Captain Anthony, although from Newport, was a close friend of the early Pemberton families and a distinguished merchant. He was a member of the Dancing Assembly as was his son Thomas Anthony, also a merchant. Thomas married Sarah Stille, daughter of his father's tailor, John Stille, while Joseph Anthony Jr. married Elizabeth Hillegas, daughter of the treasurer of Pennsylvania

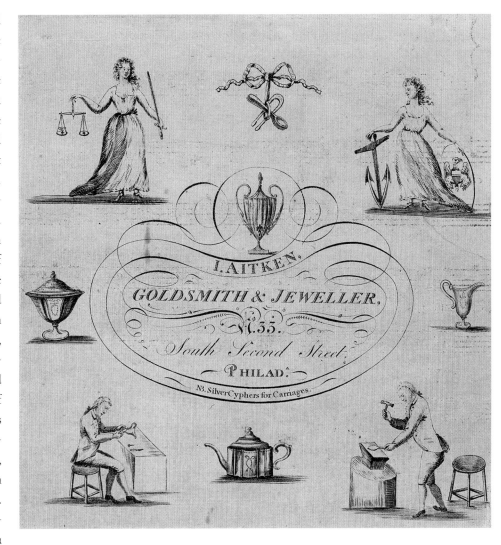

Fig. 5. John Aitken (American [born Scotland], c. 1745–1831). "The Goldsmith's Rant: A New Song" (verso), 1802. The New York Public Library for the Performing Arts. Astor, Lenox, and Tilden Foundations, Music Division (see also fig. 17).

and a "member" family. But Joseph, "silversmith and jeweler," was not eligible for membership![24]

The locations of silversmiths in Philadelphia as determined from addresses in the city directories from 1785 through 1850 are fairly accurate and follow their moves. Information for each edition was gathered during the fall of the previous year. Discrepancies in street numbers emerged due to printing errors or the construction of additional buildings on a block. Where the silversmiths lived has proved to be revealing as to apprenticeships and later partnerships. But a question remains: were the addresses given in the directories the silversmiths' homes or workshops, or both? Daniel Arn's (q.v.) inventory listed a display case in his parlor, suggesting that he had some retail business from his home, whether or not he made the items displayed, whereas Joseph Anthony Jr.'s extensive records show home, workshop, and showroom on one large property. His insurance survey noted built-in showcases in his "front room," and it described his large attached structures. When combined with the extensive inventory, which identified and furnished each room, one is offered a walk into an eighteenth-century establishment much as if the owner had just walked out, which indeed he had, as he died suddenly in Harrisburg.

Another document offered a challenge to unwind what became a tangle of silversmiths occupying a single property over a period of years at 33 South Second Street, on the east side between Market and Chestnut, close to if not at the corner of Chestnut. It was one block west of Front Street and the waterfront shipping trade. This block became a retail center in the city and remained so until the 1790s. In 1765 David Hall (q.v.) insured this property, designated as "his dwelling house," with the Philadelphia Contributionship.[25] The three-story house had 20 feet of frontage on Second Street, insured for £50, and behind it a two-story "brick kitchen," insured for £100, 26 1/2 feet by 16 feet. Between 1765 and 1810 it was occupied or advertised as a location by silversmiths David Hall, Jeremiah Boone (q.v.; with apprentices), Anthony Robinson, John

Dickinson, George Dowig, Christian Wiltberger (q.v.), John Aitken (q.v.; fig. 5), Samuel Alexander, Anthony Simmons (q.v.), Joshua Dorsey (q.v.), John Owen, and James Akin, engraver (see cat. 3 and fig. 73). Besides being a prime retail location in the city, the value of the two-story "brick kitchen" suggests that there was living space, probably for apprentices or journeymen, perhaps a showroom, and, most important, a silversmith's workshop and furnace. (Few records seem to have survived concerning the apprentices and journeymen employed in the largest silver shops beyond numbers and ages as counted in the federal census. The designation "journeyman" has not turned up in the census records or city directories.) Jeremiah Boone eventually built a big house directly opposite at number 30 on the west side of Second Street just below Daniel Dupuy Sr. and Jr. (q.q.v.) at number 4.

Property deeds described precise locations, but as silversmiths generally leased their sites, their names do not appear in deed lists. Owners' tax records sometimes noted to whom a property was leased. An account book or daybook allowed a glimpse of a craftsman's daily encounters with customers not necessarily silversmiths, often mentioning their bartering and

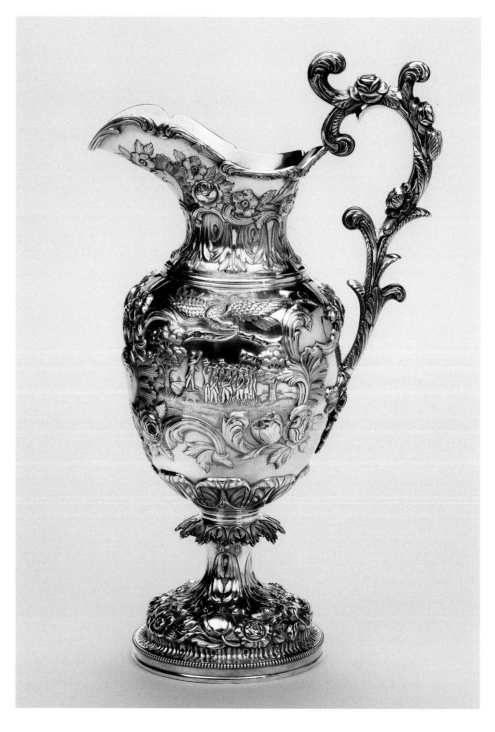

Fig. 6. Osmon Reed (American, active 1833–63). Presentation Ewer, 1843. Silver, height 17 11/16 inches (45 cm), width 11 inches (27.9 cm). Philadelphia Museum of Art. Purchased with the Joseph E. Temple Fund, 1902-6

trading partners. On January 25, 1776, for example, Thomas Shields (q.v.) credited his engraver David Tew £5 2s. for engraving some teaspoons for George Graff, ironworker, who on January 23 had done some soldering for Shields.[26] There are "silversmiths" listed in directories whose marks have not yet been identified and who worked independently for several shops and for retailers like the Birds (Joseph Bird, q.v.), who had a fancy hardware business selling everything from looking glasses to watches, jewelry, and silver, which they purchased locally. Newspapers carried notices of rewards for runaway workmen, noting that they were trained for silver work. Silversmiths' account and receipt books record wages, work, and business transactions within their circle, but the entries rarely noted the recipient's occupation. There were African American silversmiths, journeymen, and slaves entered in tax records.

And there remain occasional fragments that beg for a story, such as the note in Edmund Hogan's *The Prospect of Philadelphia*: "William Grant, silversmith, deaf and dumb but can read and write. He lived with John Gistner, engraver at 115 North Third Street."[27] Scrutiny of the fine print in the "Directory of Coloured Persons" that appeared as an appendix in the 1811 Philadelphia directory revealed Joseph Parie, a jeweler at 114 Vine Street; his name and address were also listed in the general text.

Collecting and Exhibiting Silver at the Philadelphia Museum of Art, 1876–2018

Founded in 1876 on the model of London's South Kensington Museum, the Pennsylvania Museum and School of Industrial Art took over the Centennial Exposition's Memorial Hall and began to form collections of objects to serve as models for designers and craftsmen as well as to elevate public taste. The first pieces of American silver recorded in the collection were otherwise unidentified spoons bequeathed by Mrs. Frederick Graff in 1897.[28] In 1902 an impressive silver ewer by Osmon Reed (fig. 6) was purchased with considerable fanfare by the Museum and publicized as the "Henry Clay cup," although in fact it was commissioned in 1843 by the Philadelphia Whig Party for presentation to James C. Jones upon his successful election as governor of Tennessee. On February 16, 1912, Edwin Atlee Barber, director of the Museum, wrote to trustee John T. Morris: "I have your letter of the 15th inst. in regard to old silver. . . . We have such fine collections of American pottery, porcelain, glass and pewter that I am anxious to build up our silver collection. We already have a case of American silver which attracts attention, but it is not as important as it should be. . . . While, as you state, you have no silver yourself that you would care to place in the Museum, you may hear of examples owned by others which can be obtained, in which event, I hope you will advise me."[29] Barber wrote to Morris again on March 18, 1912:

> I am sending you for examination some pieces of silver which I have located after considerable difficulty. The tea set of three pieces by W. G. Forbes was made in New York about 1775–1790. . . . I presume you are aware that all good pieces of old American silver are now bringing very high prices, and it is only a question of paying these prices or doing without. I would like very much to secure this set (out of the fund which I have collected for the purpose of buying old American silver). . . . I am also sending for your inspection an old silver porringer made by Benjamin Bussy [sic] of Boston. . . . These silver porringers are exceedingly scarce at present and very difficult to obtain. . . . P.S. Mrs. [Sara Yorke] Stevenson thinks these are very desirable for our collection, but is rather staggered by the price.[30]

On March 10, 1917, silver enthusiast Alfred Coxe Prime in Philadelphia wrote to silver scholar Francis H. Bigelow in Cambridge, Massachusetts: "There is an immense amount of work to be done here on old colonial silver and I think that you would find it a far more profitable field than Boston for investigation. Few people here have begun to realize the wonderful work done by early silversmiths not only in shaping the course of the colonies and the early Republic but also in the high grade of craftsmanship shown in their work."[31] Two months later, in May 1917, the Pennsylvania Museum (as the institution was then known)[32] opened the exhibition *Old American and English Silver* (Prime surely knew about it and may have been a consultant). It was organized by Assistant Curator Sara Yorke Stevenson and planned "on an interstate and scientific scale," but was reduced due to "the international situation." Stevenson noted that, "while originally it had been intended to lay the main stress upon makers and their marks, the result of the appeal has been so productive of interesting relics of local history that this feature of the catalogue undoubtedly will forcibly strike all who look through it thoughtfully. . . . There is no doubt as to the principal interest of the collectio n being due, in addition to the silversmiths represented, to local tradition and personal association."[33] That every piece came out of the silver chest of some well-known Pennsylvania family, and that most of the material had belonged to some more or less important personage whose name is preserved in the annals of this Commonwealth, added not a little to the popularity of the exhibition. *Old American and English Silver* was organized in

Fig. 7. Johannis Nys (American, 1671–1734). Tankard, c. 1700. Silver, height 7¹¹⁄₁₆ inches (19.5 cm), width 8¹⁵⁄₁₆ inches (22.7 cm). Philadelphia Museum of Art. Gift of William M. Elkins, 1922-86-17

family units, an approach that became significant in the growth of the Museum's collection. Philadelphians were made aware of their place in history when it became clear to a wider audience that the ancestral silver in their sideboards had importance beyond family association. It also renewed a celebration of Philadelphia's leadership years.

The June 1921 issue of the Museum's *Bulletin* served as the catalogue for the *Loan Exhibition of Colonial Silver*, which included some 439 silver objects loaned primarily by Philadelphia patrons and again presented in family units. Samuel W. Woodhouse Jr. wrote in his introduction: "The collection is further limited to examples of silver made during the Seventeenth and Eighteenth Centuries; though a line of demarcation of this sort cannot be strictly adhered to, yet the styles which typify the Nineteenth century have been kept out of sight."[34] This suggests, if not illustrates, that there was a nostalgic penchant for looking back to Philadelphia's leadership years. Nineteenth-century Philadelphia patrons had continued their silver purchases at Bailey & Co., a firm that adapted and made the important transition from a preindustrial handwork shop to manufacturer to prime retailer, but in the following century silver scholarship and exhibitions focused on the historical early work.

The 1921 exhibition sparked more families' interest, and shortly after the exhibition, in 1922, Cornelius Hartman Kuhn made available for purchase the early silver of the Andrew, James, and William (q.v.) Hamilton families, including the tankard Johannis Nys made for Andrew

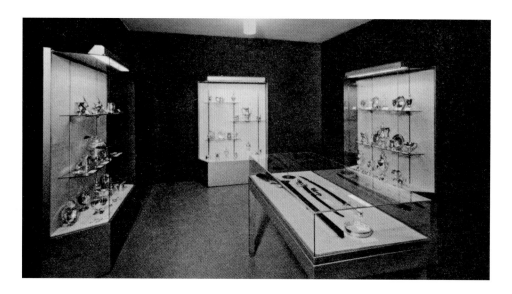

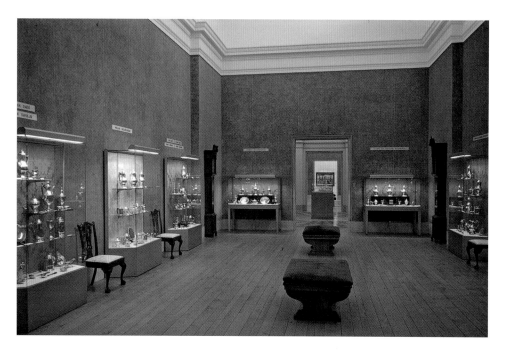

Fig. 8. One of the three galleries showing American silver at the Museum in 1960. "Handbook of the Philadelphia Museum of Art," *Philadelphia Museum Bulletin*, vol. 55, nos. 263/64 (Autumn 1959/Winter 1960), supp., n.p.

Fig. 9. *Philadelphia Silver, 1682–1800*, Philadelphia Museum of Art, April 14–September 9, 1956. Philadelphia Museum of Art Library and Archives.

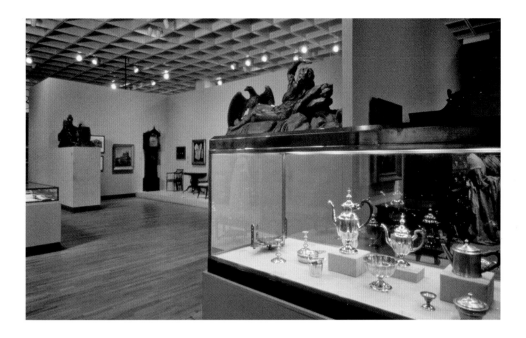

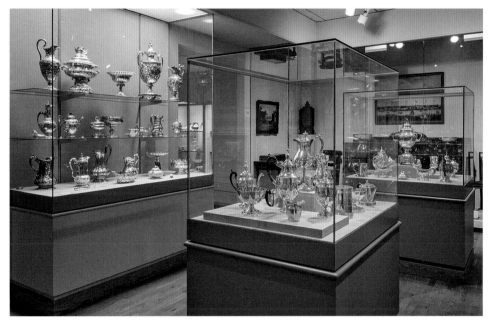

Hamilton, which had been exhibited in 1917 (see fig. 7).[35] Museum trustees individually, and with the Joseph E. Temple Fund, contributed to the purchase of selected pieces for the Museum's collection.[36] John Marshall Phillips of Yale University wrote in his foreword to Mrs. Alfred C. Prime's *Three Centuries of Historic Silver*: "Philadelphians did not become fully aware of their silver heritage until the 1921 exhibition was held at Memorial Hall, in which the emphasis was placed largely on the styles current in the Federal period for which Philadelphia is justly noted. But it was not until the 1929 and 1937 loan exhibitions, sponsored by the Colonial Dames in their rooms that the full development of the craft in the Quaker City could be traced *ab urbe condita* through the lavishness of the rococo into the glorious Federal phase and final decline during the early Victorian period."[37]

When the new Museum building on Fairmount opened in 1928, examples of European and American silver from all periods were installed together there in grand, freestanding glass cases that had originally been used in Memorial Hall. Silver was later installed in three galleries just off the corridor named for Richard Wistar Harvey, who gave important family silver (fig. 8). In 1956 silver was again the subject of a special exhibition curated by Decorative Arts curators Henry P. McIlhenny and Louis C. Madeira IV, *Philadelphia Silver, 1682–1800*, which displayed some 595 pieces

Fig. 10. *Philadelphia: Three Centuries of American Art*, Philadelphia Museum of Art, April 11–October 10, 1976. Philadelphia Museum of Art Library and Archives.

Fig. 11. The installation of the Museum's collection of American silver in Gallery 104, 2018. Philadelphia Museum of Art Library and Archives. Photograph by Joseph Hu

by Philadelphia makers from private and public collections (fig. 9).[38] Among the collectors who participated was Walter Jeffords, who had Philadelphia roots and loaned generously to the exhibition, and who in 1959 gifted to the Museum some 26 pieces of silver by Philadelphia goldsmith Philip Syng Jr.

Looking forward to 1976 and the U.S. Bicentennial celebrations rapidly approaching, the newly formed Committee for American Art, chaired by Robert L. McNeil, Jr., became active; and the Museum's director, Evan Turner, appointed Darrell Sewell as curator of American Art in 1973. In 1976 Sewell, David Hanks, Dorinda Evans, Jane Copeland, and myself, with many hands, created the exhibition *Philadelphia: Three Centuries of American Art* (fig. 10). Silversmiths from Cesar Ghiselin to Olaf Skoogfors (q.v.) shared the stage with the fine arts, architecture, sculpture, and furniture. It was surely patriotic fervor in 1976 that offered the Museum the opportunity to acquire from a direct descendant the grand silver tea urn by Richard Humphreys (see fig. 2). Collector and Museum trustee H. Richard Dietrich, Jr., provided the purchase funds through the Dietrich American Foundation.

In 1977 the permanent American galleries opened (fig. 11), and the silver collection was installed as a central unit. Frances Richardson, a direct descendant of the silversmiths Joseph Richardson Sr. and Jr., established a generous fund for the purchase of American silver in 1983. Keen interest in the history of Philadelphia by Museum trustee Robert L. McNeil, Jr., focused his collecting on objects that expanded our understanding of the versatility of the city's artists. His silver collection, donated in 2005, added a significant number of Philadelphia silversmiths to the Museum's collection and offered further insights into their craft (fig. 12). Bob was a stalwart

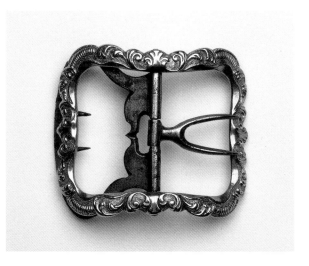

Fig. 12. Joseph Richardson Sr. (American, 1711–1784). Shoe Buckle, 1760–70. Gold, steel, height 1 5/8 inches (4.1 cm), width 2 1/16 (5.2 cm). Philadelphia Museum of Art. Gift of the McNeil Americana Collection, 2005-68-72

Fig. 13. Maker unknown, made in China for export to the Western market. Cruet Stand, c. 1775–1800. Silver, glass, height 10 1/2 inches (26.7 cm), width 7 3/8 inches (19.4 cm). Philadelphia Museum of Art. Gift of Mr. and Mrs. Stanley Eyre Wilson, 1952-86-1

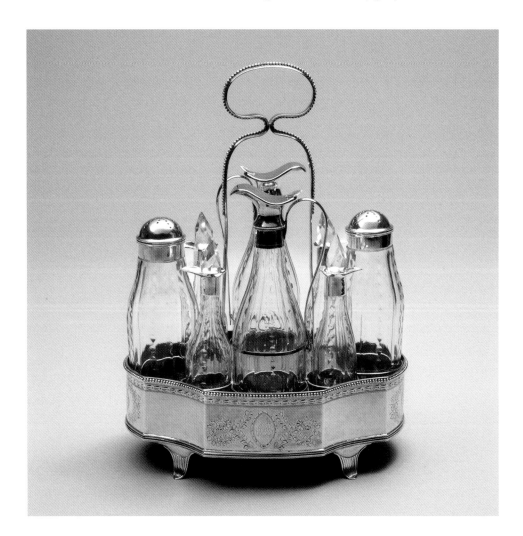

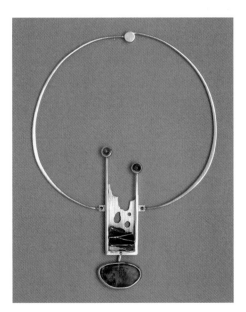

supporter of scholarship in the field of American art and provided generous funding for the publication of this catalogue. The important collection of early silver made in Boston, New York, and Philadelphia of the Dietrich American Foundation, begun by H. Richard Dietrich, Jr., in 1963, was put on permanent deposit at the Museum in 2007, further developing the scope of the collection and offering valuable regional comparisons of style and design.

A catalogue of the Philadelphia Museum of Art's collection of American metals, iron, copper, brass, pewter, and silver was first proposed in 1982, as one volume in a series of handbooks on American art. Thanks to a generous grant awarded in 1983 from the Henry Luce Foundation for Scholarship in American Art, over the next two years all American works in metal that had been accessioned to date were photographed, cataloguing was updated, and the objects were rehoused in new storage. Silver was by far the dominant category in number and distinction. Thus, it was determined by Director Anne d'Harnoncourt to focus on silver made and/or owned in Philadelphia (fig. 13). To stay in stride with current thinking, it was decided that the catalogue should include silver in the Museum's collections of contemporary crafts and industrial design (fig. 14), as well as silver made on the American continents. This led us to consider silver made in Canada, Mexico, and South America, a concept presented by E. Alfred Jones as early as 1928.[39] Come the twenty-first century, craftsmen working with gold and silver collaborating across the world, and others in the industrial complex, have somewhat obliterated national, much less regional styles as artisans draw from global sources (fig. 15).[40] The resulting works—whether or not designed for practical use—produced by the contemporary community of versatile, creative individuals follow no formula, but each

Fig. 14. Designed by Robert Venturi (American, born 1925), made by Alessi S.p.A., Crusinallo, Italy (established 1921). Tray from a Tea and Coffee Service. Silver and gold plating, height 14 inches (35.5 cm), width 16¼ inches (42.5 cm), depth 1 inch (2.5 cm). Philadelphia Museum of Art. Purchased with the Richardson Fund, 1986-15-5

Fig. 15. Olaf Skoogfors (American, born Sweden, 1930–1975). Necklace with Pendant, 1967. Gilded silver, amethyst, tourmaline, sodalite, height 9 inches (22.9 cm), width 6½ inches (16.5 cm). Philadelphia Museum of Art. Gift of the artist, 1970-141-1

maker exhibits a personal style developed from training, the employment of new materials, and the advantage of a world view, perhaps tempered somewhat by market influences.[41] The majority of these objects have been ably catalogued by Elisabeth R. Agro, the Nancy M. McNeil Curator of Modern and Contemporary Crafts and Decorative Arts, who joined the Museum in 2007. Thus the corpus of this catalogue expanded well beyond the 1982 conception of the project. The nut became a tree.[42]

In 1965 Walter Muir Whitehill summarized a conference held at Williamsburg, Virginia, *The Arts in Early American History: Needs and Opportunities for Study*.[43] Joined by specialist scholars, archaeologists, curators, general historians, and librarians, collective discussions suggested that there should be wider boundaries for studies in the field of American art, beyond the familiar, beyond the precedent of eighteenth-century British custom and design, to other national traditions brought to America at first settlement and thereafter. In this catalogue we have responded with what we hope is the broader concept most recently sought and presented, and have addressed the equally important suggestion to explore with vigor the arts of the nineteenth, twentieth, and twenty-first centuries. As seems fitting, our focus has been on Philadelphia. We hope we have duly credited the articles, books, and exhibitions, past and present, by our colleagues, for the biographical material on the silversmiths of other regions. It is also hoped that our volumes, with each object illustrated, document the growth of the Museum's collection and recognize the generosity of our donors, from the first accessioned object in 1902.

It has always been the silversmiths' end products that we have celebrated in exhibitions over the years. As work progressed we realized that partnerships such as that of Samuel Alexander and Christian Wiltberger will be incompletely explored until later volumes, due to our alphabetical arrangement. The "longish" biographies of Philadelphia silversmiths reflect the research that was required to make possible a sense of the community of craftsmen. We hope that the next team of enthusiasts will explore this further, in response to Walter Whitehill's comment in 1965: "Works of art can, and should be studied not only as the achievements of gifted individuals, but as the creations of members of a particular society, whose requirements the artists have had to meet."[44] Reflecting on Brix's preface, we look forward to "completion of the larger work."

To close, it seems appropriate to honor colleague, curator, and friend David L. Barquist, who arrived from the Yale University Art Gallery in 2004 to be the Museum's curator of American Decorative Arts. He had barely a moment to look around before he took hold of this project, which had moved along so slowly that it had almost disappeared—partly because the 1987 exhibition *Federal Philadelphia, 1785–1825: The Athens of the Western World* and reinstallations in the Fairmount Park Houses dropped into the schedule! David has restored the focus of the project and organized the team, and he will be the curator to see it through to the proposed four volumes. I trust he will continue to be "clerk of the works." He has connoisseurship in his fingers and sound reasoning, both of which have been useful in curbing some unrealistic enthusiasms. The production of this first volume will be accomplished because of his expertise.

1. The *Pennsylvania Packet* (Philadelphia) of August 30, 1773, carried a notice by Ludwig Kuhn that "a certain Frederick Ubelin, born in Basil [*sic*], Switzerland by trade a silversmith and refiner of metals, ran away from his bail."

2. Quoted in Fales 1974, p. 224.

3. James Mease, *The Picture of Philadelphia* (Philadelphia: B. & T. Kite, 1811), p. 156. The first and only official U.S. assay with a mark was established in Baltimore from 1814 and in use until 1830.

4. One silversmith recorded the charge for making a link of buttons as 7d.; for two large spoons, 16s.; and for two gold lockets, 16s. Commonplace Book of Joseph Richardson Sr., 1744, in Fales 1974, appendix A, p. 199.

5. William Haverstick advertised in the *Pennsylvania Packet* on May 22, 1781: "A Silver Table Spoon marked with a cypher, was offered for Sale about ten days ago, and stopt on suspicion of its being stolen. Whoever has lost the same by applying to the subscriber, in Second Street, between Arch and Race Streets, Goldsmith and Jeweler, prove property and pay the charge of advertising, may have it again."

6. Stanley B. Ineson MSS Collection, American Art Department, Yale University Art Gallery.

7. "Planning for a New Colony, March–December 1681," in *The Papers of William Penn*, ed. Richard S. Dunn and Mary Maples Dunn (Philadelphia: University of Pennsylvania Press, 1982), vol. 2, pp. 118ff.

8. "To the Inhabitants of Pennsylvania," in ibid., vol. 2, p. 84.

9. Nathaniel Burt, *The Perennial Philadelphians: The Anatomy of an American Aristocracy* (Boston: Little, Brown, 1963), p. ix (original emphasis).

10. Quoted in two undated clippings, "Now My Idea Is This!," *Evening Public Ledger* (Philadelphia), c. 1924, curatorial files, AA, PMA.

11. "Plate Carried to Pennsylvania, January–August 1682," in *Papers of William Penn*, vol. 2, p. 289.

12. Gabriel Thomas, "An Historical and Geographical Account of Pensilvania [*sic*] and of West-New-Jersey," in *Narratives of Early Pennsylvania, West New Jersey and Delaware, 1630–1707*, ed. Albert C. Myers, Original Narratives of Early American History, no. 11 (New York: Barnes & Noble, 1912), pp. 326–29.

13. Thomas Chalkley, Account Book, Library Company of Philadelphia, on deposit at the HSP.

14. Catherine A. Hebert, "The French Element in Pennsylvania in the 1790s: The Francophone Immigrants' Impact," *PMHB*, vol. 108, no. 4 (October 1984), pp. 451–69.

15. William Ball, Account Book, 1759–1762, Philadelphia, Downs Collection, Winterthur Library.

16. Maryland eventually conformed to the nonimportation agreements; see *Pennsylvania Gazette* (Philadelphia), June 14 and July 12, 1770; and July 6, 1774.

17. Notes and Queries, *PMHB*, vol. 19 (1895), pp. 531–32.

18. For the askos by Samuel Alexander and Anthony Simmons, see Thomas Jefferson Memorial Foundation, Monticello (1957-29). For the coffeepot by Joseph Anthony Jr., see Buhler 1956, p. 48, cat. 21.

19. Alfred E. Young, ed., *The American Revolution* (DeKalb: Northern Illinois University Press, 1976), p. 194.

20. In the years following the political and economic distress after the Revolutionary War, not everybody was fully content with young America. In a poignant explanation from a silversmith who may have been one of the many journeymen in a big shop and of whom there does not seem to be another record, he explained why he wanted to go "home." "Henry Crown 'now growing in years' and a true friend to this country but finding business scarce here as to prevent his gaining a subsistence and being a freeman of the Goldsmith's Company in London where is good provision made for the aged and infirm, requests pass to go to New York to get passage to England." After character endorsements by John David Sr. and Thomas Shields (q.q.v.), among others, his pass was granted on May 12, 1781. *Pennsylvania Genealogical Magazine*, vol. 44, no. 3 (Spring/Summer 2006), p. 273.

21. Mary E. Holt, "A Checklist of the Work of Francis Shallus, Philadelphia Engraver," *Winterthur Portfolio*, no. 4 (1968), pp. 143–58.

22. Brix 1920, p. vi.

23. Thomas Willing Balch, *The Philadelphia Assemblies* (Philadelphia: Allen, Lane and Scott, 1916), p. 98.

24. Scharf and Wescott 1884, vol. 2, p. 1688.

25. Survey no. 500991, Philadelphia Contributionship for the Insurance of Houses from Loss by Fire, www.philadelphiabuildings.org/contributionship (accessed April 18, 2018).

26. Thomas Shields, Daybook, Downs Collection, Winterthur Library.

27. Edmund Hogan, *The Prospect of Philadelphia, and Check on the New Directory* (Philadelphia: printed by Francis & Robert Bailey, 1795), p. 37. The biographies in the present volume comprise a linear arrangement of facts drawn from diaries and narratives. Collections of papers from all periods have supplied some personal contemporary chronology. The following texts are recommended: *The Papers of Benjamin Franklin* (New Haven: Yale University Press, 1959); *A Philadelphia Perspective: The Diary of Sidney George Fisher Covering the Years 1834–1871*, ed. Nicholas B. Wainright (Philadelphia: Historical Society of Pennsylvania, 1967); *Philadelphia Merchant: The Diary of Thomas P. Cope, 1800–1851*, ed. Eliza Cope Harrison (South Bend, IN: Gateway, 1978); Dunn and Dunn, eds., *Papers of William Penn*, vols. 1–3.

28. These spoons are no longer in the Museum's collection.

29. Edwin A. Barber to John T. Morris, February 16, 1912, Philadelphia Museum of Art, Library and Archives. Morris supported Barber's purchases of Pennsylvania German pottery. In 1932 his sister Lydia T. Morris bequeathed family silver to the Museum. There are currently sixteen pieces of silver accessioned before 1912 in the American collections.

30. Barber to Morris, March 18, 1912, Philadelphia Museum of Art, Library and Archives. The Forbes tea service was offered at $300, the Benjamin Bussey porringer at $125. Bussey was a nineteenth-century Boston silversmith and silver plater who worked in the styles of the 1760s. Neither the tea service nor the porringer appear to have been purchased for the Museum. Barber's Special Museum Fund made possible the purchase in 1912 of a porringer (PMA 1912-66) by William Nichols of Newport, and a cream pot (cat. 67) by John Bayly Sr. or Jr. In 1913 the Museum accessioned a porringer (cat. 103) by Boston silversmith Benjamin Burt, which was purchased with the Annual Membership Fund. The Joseph E. Temple Fund was established in 1888. Sara Yorke (Mrs. Cornelius) Stevenson was an assistant curator and lecturer at the Museum.

31. Francis H. Bigelow Papers, American Art Department, Yale University.

32. The institution's name was officially changed to the Philadelphia Museum of Art in 1938.

33. S. Y. S. [Sara Yorke Stevenson], *Exhibition of Old American and English Silver* (Philadelphia: Pennsylvania Museum, 1917), p. 3. See also "Exhibition of Old American and English Silver," *Bulletin of the Pennsylvania Museum*, vol. 15, no. 58 (July 1917), p. 23.

34. Woodhouse 1921, pp. 3, 5.

35. The Museum accession numbers 1922-86-1 through 1922-86-51 identify the Kuhn collection.

36. The funders who made possible each purchase are identified in the credit lines.

37. Prime 1938, p. 5.

38. Philadelphia 1956, n.p.

39. "The charming silver wrought in the American Colonies begins with that of Robert Sanderson (1608–93), a London silversmith settled in Boston. Further north on the American continent there were the Canadian silversmiths, while south of the United States some excellent work was executed in Mexico after the Spanish conquest." E. Alfred Jones, *Old Silver of Europe and America from Early Times to the Nineteenth Century* (Philadelphia: J. B. Lippincott, 1928), p. xi.

40. For example, all of the design elements in a tea and coffee service designed by Robert Venturi, and produced by Alessi (1986-15-1-6), make historical references (see fig. 14). The pattern on the tray was drawn from the floor of the Piazza del Campidoglio in Rome, while the swirling lines on the teapot were based on porcelain decoration.

41. Chunghi Choo, who was born in Korea, wrote about her decanter (cat. 141): "I believe that the sweeping movements of the brush in calligraphy have influenced my work and give it a flowing energy." Quoted in Robert Rorex, "The Energy of Qi," *Metalsmith*, vol. 11, no. 1 (Winter 1991), p. 26.

42. To date, makers and retailers number 402; the enlarged collection, as described, numbers about 1,495 objects.

43. Walter Muir Whitehill, Wendell D. Garrett, and Jane N. Garrett, *The Arts in Early American History: An Essay* (Chapel Hill: published for the Institute of Early American History and Culture at Williamsburg, VA, by the University of North Carolina Press, 1965).

44. Ibid., p. 6.

Notes to the Catalogue

This catalogue is the first in a multivolume publication to record the Philadelphia Museum of Art's collection of American works made of precious metals (primarily silver, but also gold and platinum), as well as works fabricated in other metals by craftsmen who primarily worked as silversmiths. This volume is divided alphabetically, as will be subsequent volumes, by names of silversmiths, partnerships, manufacturers, and retailers, with the present volume covering those whose names begin with the letters A through F. Objects are grouped under a retailer's name only if the maker is unknown.

For each maker, a biography precedes the entries on their individual works, which are presented more or less chronologically.

For pairs or sets of identical objects, information on marks, inscriptions, and dimensions are given for one object, usually the largest. If the marks, inscriptions, or dimensions of objects in pairs or sets vary to any significant degree, the information for each object is recorded.

Materials are provided for objects or elements of objects not made of silver; wood handles and finials, ivory handle inserts, and similar elements visible in the photograph are not recorded.

Dates prior to 1752 are given as New Style.

Marks: Unless otherwise indicated, marks are struck once. With a few exceptions, marks are struck with a die on the object by the maker or retailer. All marks are in Roman letters unless otherwise indicated. One illustration is given for each different mark used by a given maker, and reference is made to that illustration in entries on additional objects with the same mark.

Inscriptions: Initials, names, monograms, and texts engraved on objects are in Roman letters unless otherwise indicated. Armorials are described using their achievement. Scratch weights and other shop notations are recorded if they appear to date from the time the object was made.

Measurements: Unless otherwise noted, all dimensions are maximum or "outside" measurements. Dimensions are given in inches (followed by centimeters in parentheses) as height, width, and depth unless otherwise indicated. Weight is given in troy ounces to the nearest grain. Objects with wooden handles or other non-silver elements traditionally are recorded with a "gross" weight, as the historic weights scratched underneath are usually for the silver alone. No weight is given when the precious-metal elements account for less than a quarter of an object's gross weight.

The Museum's credit line and accession number are provided for all objects with the exception of promised gifts.

Provenance: The ownership of an object prior to its acquisition by the Museum is recorded beginning with the earliest known owner. Donors whose names appear in the credit line are not repeated under Provenance if no earlier history is known. The names of dealers through whom collectors acquired objects at auction are given in parentheses after the sale-catalogue information. If a sale catalogue is cited under provenance, this information is not repeated under Published.

Exhibited: Exhibitions that included a given object are cited chronologically by reference to the catalogue; this information is not repeated under Published. If no catalogue was published, exhibitions are cited by title (if relevant), institution, location, and dates.

Published: References or illustrations of a given object in published sources are listed chronologically.

The condition of a given object, including repairs, replacements, or restorations, is described in the entry text when it is not visible in the photograph and/or it is important for an understanding of the object's authenticity, history, or original appearance. Minor repairs or routine wear are not described.

References to objects in this volume of the catalogue are made with the catalogue number. References to objects in forthcoming volumes are made by accession number, preceded by "PMA" if the Museum's ownership is not otherwise clear.

City directories that are frequently cited appear in abbreviated form. Complete bibliographic information appears in the References. It should be noted that names and street numbers are not always consistent in the directories.

Newspapers: In-text citations with the newspaper title and date are provided for references to advertisements or other notices.

U.S. Census: In-text citations with the city and ward, if applicable, are provided for references to the U.S. Census population schedules.

Abbreviations for the Philadelphia Museum of Art (PMA) and its Department of American Art (AA) are used throughout. See also the References for abbreviated and short titles of sources.

The author of each biography and catalogue entry is indicated by the initials that follow the relevant text: Beatrice B. Garvan (BBG), David L. Barquist (DLB), and Elisabeth R. Agro (ERA). The biography of Virginia Wireman Cute (later Curtin) was written by Jennifer A. Zwilling. The entry for cat. 194 was coauthored by Jennifer Padgett.

Adams & Shaw Company

Providence, Rhode Island, 1876
New York City, 1876–1877
Newark, New Jersey, 1877–1880

Caleb Cushing Adams (1833–1893; fig. 16) was born in Newbury, Massachusetts, on March 23, the son of Joseph (1797–1841) and Harriet Adams (1798–1875).[1] Information on his early career primarily comes from an obituary in the *Jewelers' Circular*. After training with the local silversmith Joseph Moulton IV (1814–1903), Adams moved to Brooklyn at age seventeen and worked for about three years as a salesman for Ball, Black & Co. (q.v.) in New York City. He then relocated to Columbus, Georgia, where he established a jewelry store, but left a year later and went to work in about 1855 for the New York office of Rogers and Brother (q.v.), manufacturers in Meriden, Connecticut.[2] At the time of his marriage to Sarah Jewett (1834–1916) in 1856, his residence was given as Brooklyn, New York.[3]

In 1858 Adams began working for Gorham Manufacturing Company (q.v.) as a traveling representative, venturing as far as San Francisco and Cuba.[4] He also continued to serve as the New York agent for Rogers and Brother, at 17 Maiden Lane, his stock in trade listed as "plated ware."[5] At Gorham he advanced to being the "foreman" of their wholesale showroom at 3–7 Maiden Lane.[6] Adams's 1863 draft registration confirmed that he continued to live in Brooklyn and worked at 3 Maiden Lane.[7] When the Gorham Manufacturing Company formally incorporated in January 1865, Adams became an officer and shareholder, with the position of managing agent, in charge of the New York wholesale business.[8] He also traveled to London to explore the feasibility of establishing a retail branch in Britain.[9] The 1870 U.S. census recorded Adams as a "silver ware manufacturer" living in Brooklyn with his wife and four children as well as his younger brother, John Popkin Adams (1837–1895), who was identified as a "silver plater." John P. Adams first appeared in New York in 1868 as an electroplater at the same address as the jeweler Emery Hills Adams (1824–1914), who may have been a relative.[10]

Thomas Shaw (1839–1921) was born in February 1839 in Handsworth, England, now part of the city of Birmingham.[11] He appreciced at Elkington and Mason Company in Birmingham, at that time the leading manufacturer of electroplated goods in Great Britain.[12] In 1861 he was recorded as an "Electro plate worker" in the hamlet of Aston Manor, now also part of the city of Birmingham.[13] The Gorham Manufacturing Company recruited Shaw in March 1865 to help establish an electroplating department, advancing him $46.80 for his passage.[14] By June he had settled in Providence, Rhode Island, with his wife Sarah and three children.[15] Apparently he returned to England at Gorham's behest to hire fifty additional silversmiths for the firm.[16] From 1866 to 1868 Shaw was listed in Providence directories, and although he did not appear between 1869 and 1871, he and his family were recorded in the U.S. census of 1870 as living in Providence.[17] Shaw reappeared as a silversmith in Providence directories beginning in 1872, and the *Jewelers' Circular* later stated that he remained an employee at Gorham until Tiffany & Co. (q.v.) induced him to found his own company in Providence.[18] Located at 33 Beverly Street, Thomas Shaw & Company, electroplaters, first appeared in the 1875 city directory, with Henry W. J. Axelby, Horace Clulee, and Samuel Greaves listed as partners.[19]

It seems likely that Caleb Adams and Thomas Shaw became acquainted when they both were employed by Gorham. Adams's position with Gorham ended in October 1875, when the company requested his resignation as the result of an economic decline following the Panic of 1873 as well as a longstanding "difference of opinion."[20] The *Jewelers' Circular* opined that Gorham's "growth from the business of that day [when Adams began in 1858] to its present magnificent proportions has been, in no small degree, associated with Mr. Adams himself."[21] In 1876 Thomas Shaw & Company became Adams & Shaw Company, electroplaters, at 33 Beverly Street in Providence.[22] Adams, still resident in Brooklyn, was president, whereas Shaw presumably ran the manufacturing operation. In August of that year they opened a "sample office" in the Waltham Building at 1 Bond Street in New York City, and shortly thereafter Adams and Shaw moved to 692–94 Broadway, as wholesale manufacturers of both sterling and electroplated silver objects.[23] The *Jewelers' Circular* reported: "It is not so generally known that Messers. Tiffany &

Company are interested in the manufacturing and wholesale business of the Adams & Shaw Company; Mr. C. L. Tiffany himself being its treasurer."[24] The firm became a significant source, if not the principal supplier, of electroplated wares for retail sale by Tiffany. The partnership acquired the flatware dies of John R. Wendt & Co. (q.v.), which had ceased operations five years earlier. In an 1878 advertisement the Adams & Shaw Company called attention to "our patterns of Spoons and Forks which are regarded as the most successful in the market."[25]

THE LATE CALEB CUSHING ADAMS.

Fig. 16. Caleb Cushing Adams. *Jewelers' Circular*, vol. 27 (December 20, 1893), p. 12. The New York Public Library, Astor, Lenox and Tilden Foundations. Art & Architecture Collection, Miriam and Ira D. Wallace Division of Art, Prints and Photographs

In 1877 Adams and Shaw moved their factory to Newark, New Jersey, at 55 Park Street, although they maintained an office at 694 Broadway until 1879.[26] Shaw was recorded as a resident of Orange, New Jersey, in 1878, whereas Adams remained in Brooklyn.[27] The partnership was dissolved in April 1880, Dominick & Haff (q.v.) acquiring the Wendt flatware dies and the Whiting Manufacturing Company (q.v.) purchasing other materials.[28]

Thomas Shaw continued to work as a manufacturing silversmith at 55 Park Street, and by 1880 he had moved his residence to 395 Sussex Avenue in Newark.[29] At least two of his sons, Francis

(known as Frank, 1863–1886) and Walter (born 1870, died before 1921), worked with their father as designers and chasers and presumably were trained by him. At age twenty-two Frank Shaw completed his "Graduation Piece," an electroplated metal panel with intricate floral repoussé decoration.[30] Beginning in 1883, Tiffany & Co. was listed at 55 Park Street, Newark, and according to Shaw's biography, his firm had been purchased outright by Tiffany, "Mr. Shaw assuming the management for some twenty-five years."[31] In 1893 he was recorded as "sup[erintenden]t Tiffany & Co.," a position he may well have held for the prior decade.[32] In the mid-1880s, Frank Shaw designed a tilt-top table that apparently was intended for Tiffany & Co.'s display at the 1889 Paris Exposition Universelle, but he died before completing its elaborate chased ornament. Made of copper electroplated with silver, the table eventually was finished for Tiffany's exhibit at the World's Columbian Exposition.[33]

Thomas Shaw continued to be listed separately in Newark city directories, albeit at the same address as Tiffany, until 1893, which coincided with the opening of Tiffany & Co.'s new factory in Forest Hill in 1894. By 1892 Shaw and his family had moved to Pompton Plains, a section of Pequannock Township in Morris County, New Jersey, where he remained until his death in 1921.[34] Given the reference to Shaw's managing Tiffany's operations for twenty-five years, he may have continued as superintendent at the new factory, since a quarter century would cover the period from the early 1870s in Providence to the later 1890s in Newark. Shaw was no longer working for Tiffany by June 28, 1898, when he incorporated the Shaw Manufacturing Company, an electroplating factory in Pompton Plains, with $1,000 in capital.[35] Twelve workmen were employed in what was described as Shaw's "new" factory in 1900, and six years later ten people were working there.[36] The firm apparently had ceased production by 1914 or was no longer managed by Shaw, since by that year he was reported as giving "his entire attention to the real estate business, being the owner of a strip of land in Pompton Plains one mile in length, which he intends to cut into building plots and dispose of for residential purposes, and from which he expects to derive a handsome profit."[37]

After his partnership with Shaw dissolved in 1880, Adams led a somewhat peripatetic life. He was recorded in the U.S. census of 1880 at Providence with the profession of "merchant." From 1881 to 1883 he lived in St. Louis, where he held the position of vice president of E. Jaccard Jewelry Company.[38] One obituary stated that Adams was also factory superintendent for L. W. Fairchild in

New York and a buyer for Newell Matson in Chicago, although he was not recorded as a resident in the latter city.[39] In 1887 Adams established the jewelry firm of C. C. Adams & Company at 474 Fulton Street in Brooklyn, where he died suddenly of apoplexy on December 13, 1893.[40] The firm continued for three more years, headed by his sons Caleb Cushing (1869–1938, known as Cushing) and Daniel (born 1871). Cushing Adams had trained as a watchmaker or jeweler and presumably was the watchmaker recorded in the 1889 Boston directory; Daniel first appeared in 1893 as a salesman in his father's store.[41] C. C. Adams & Company went into receivership in 1897, and its stock and fixtures, including "watches, gold and diamond jewelry, solid silver . . . two large safes, ten counter cases, wall cases, two fine chronomotors, regulator, etc.," were dispersed at auction on March 23, 1897.[42] DIB

1. Genealogical information on Adams and his family members is recorded in Andrew N. Adams, comp. and ed., *A Genealogical History of Robert Adams of Newbury, Mass., and His Descendants, 1635–1900* (Rutland, VT: Tuttle, 1900), p. 238; see also the Sherman-McGrath family tree, Ancestry.com (accessed September 23, 2013).

2. "Death of Caleb Cushing Adams," *Jewelers' Circular*, vol. 27 (December 20, 1893), p. 12.

3. Frederic Clark Jewett, *History and Genealogy of the Jewetts of America* (New York: Grafton, 1900), vol. 1, p. 382.

4. Untitled article, *Jewelers' Circular*, vol. 6 (November 1875), p. 232; Carpenter 1982, pp. 61–62; see also Samuel Hough, "Roster of Craftsmen," http://www.owlatthebridge.com (accessed September 26, 2014).

5. Trow's New York directory 1858, p. 24, and advertisement p. 29 of commercial register.

6. "Death of Caleb Cushing Adams," *New York Times*, December 14, 1893. For Gorham's New York showroom, see Venable 1994, p. 44.

7. Records of the Provost Marshal General's Bureau (Civil War), Record Group 110, NARA, Ancestry.com; Trow's New York directory 1868, p. 25.

8. "Death of Caleb Cushing Adams," *Jewelers' Circular*; untitled article, *Jewelers' Circular*, vol. 6 (November 1875), p. 232; Carpenter 1982, p. 62.

9. "American Enterprise in England," *Jewelers' Circular*, vol. 6 (July 1875), p. 132.

10. Trow's New York directory 1868, p. 25.

11. 1861 Census Returns of England and Wales, 1841, Kew, Surrey, England: National Archives of the United Kingdom (TNA), Public Record Office, Ancestry.com.

12. "Shaw" 1914, vol. 2, pp. 197–98.

13. 1861 Census Returns for England and Wales.

14. Hough, "Roster of Craftsmen."

15. 1865 Rhode Island State Census.

16. "Shaw" 1914, p. 197.

17. Providence directory 1866, p. 157; ibid. 1868.

18. Providence directory 1872, p. 240; "The Adams & Shaw Company," *Jewelers' Circular*, vol. 7 (August 1876), p. 99.

19. Providence directory 1875, p. 289.

20. Resolution passed by board of directors, October 15, 1875; see Carpenter 1982, p. 90.

21. Untitled article, *Jewelers' Circular*, vol. 6 (November 1875), p. 232.

22. Providence directory 1876, pp. 26, 308.

23. "Adams & Shaw Company," *Jewelers' Circular*; Trow's New York

directory 1877, p. 23. Perhaps not coincidentally Gorham had established its wholesale and retail showrooms at the Waltham Building in 1871 and 1873, respectively.

24. "Adams & Shaw Company," *Jewelers' Circular*.

25. Advertisement, *Jewelers' Circular*, vol. 9 (February 1878), p. ix, "The Spoon Patterns of American Silversmiths, Part IX," *Jewelers' Circular*, vol. 30 (June 5, 1895), p. 6.

26. Holbrook's Newark directory 1877, pp. 686, 1043; Trow's New York directory 1879, p. 24.

27. Holbrook's Newark directory 1877, p. 686; Brooklyn directory 1878, p. 4.

28. "Trade Gossip," *Jewelers' Circular*, vol. 11 (April 1880), p. 59; "Death of Caleb Cushing Adams," *Jewelers' Circular*; "The Death of Isaac Mills," *Jewelers' Circular*, vol. 30 (March 6, 1895), p. 15.

29. Holbrook's Newark directory 1880, p. 728; 1880 U.S. Census.

30. J. Stewart Johnson, "Silver in Newark: A Newark 300th Anniversary Study," *The Museum*, vol. 18 (Summer–Fall 1966), pp. 28–29, 49. Frank Shaw's "Graduation Piece" is in the collection of the Newark Museum (2006.13a,b).

31. Holbrook's Newark directory 1883, pp. 830, 902; "Shaw" 1914, vol. 2, p. 197.

32. Holbrook's Newark directory 1893, p. 714.

33. Anna Tobin D'Ambrosio, ed., *Masterpieces of American Furniture from the Munson-Williams-Proctor Institute* (Utica, NY: the Institute, 1999), p. 137, cat. 50.

34. Holbrook's Newark directory 1892, p. 628; 1920 U.S. Census.

35. *Corporations of New Jersey: List of Certificates Filed in the Department of State from 1895 to 1899, Inclusive* (Trenton: John L. Murphy, 1900), pp. 46–69.

36. "Eighteenth Annual Report of the Department of Factory and Workshop Inspection of the State of New Jersey," Document no. 10, *Documents of the One Hundred and Twenty-Fifth Legislature of the State of New Jersey* (Trenton: John L. Murphy, 1901), vol. 2, pp. 140–41; Winton C. Garrison, *The Industrial Directory of New Jersey* (Trenton: n.p., 1906), p. 312.

37. "Shaw" 1914, p. 197.

38. *Gould's St. Louis City Directory for 1881* (St. Louis, MO: David B. Gould, 1881), p. 79; ibid., 1883, p. 79; "Death of Caleb Cushing Adams," *New York Times*.

39. "Death of Caleb Cushing Adams," *Jewelers' Circular*. In 1888 Newell Matson was incorporated as Spaulding & Company, a retailer associated with the Gorham Manufacturing Company.

40. "Death of Caleb Cushing Adams," *New York Times*.

41. Boston directory 1889, p. 60; this may be a reference to Cushing's father. Brooklyn directory 1894, p. 5.

42. *Jewelers' Circular*, vol. 34 (March 17, 1897), p. 11.

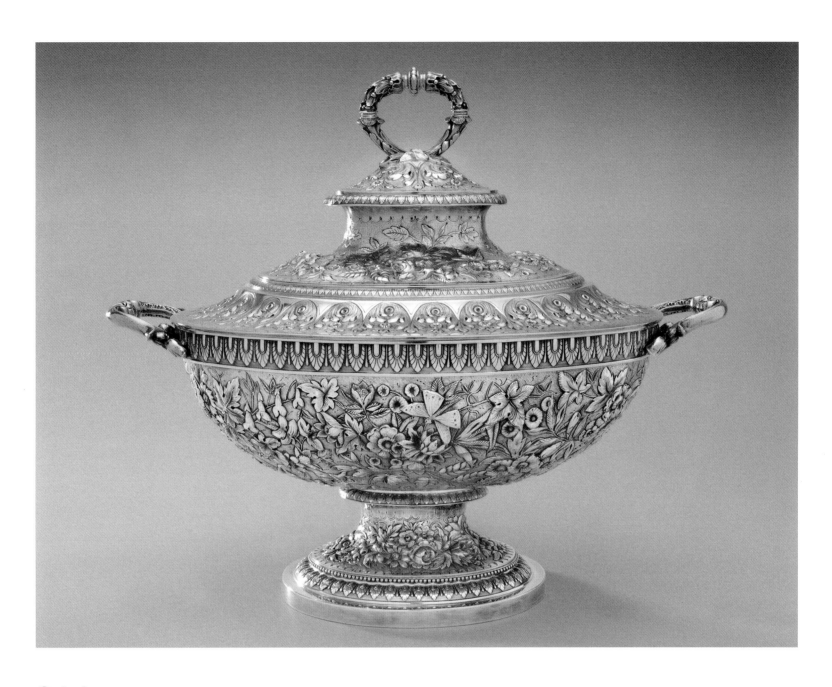

Cat. 1

Adams & Shaw Company
Tureen with Liner

1876–80
Retailed by Tiffany & Co. (q.v.)
Silver electroplated on white metal
MARKS: 3141 / TIFFANY & C⁰ / MAKERS / A Co S
(in scroll) / SILVER-SOLDERED / 51 / E (all incuse, on
underside of bowl; cat. 1-1); MAKERS (twice) TIFFANY &
C⁰ (overstriking MAKERS once; all incuse, on underside of
liner; cat. 1-1); cover unmarked
Height 13⅞ inches (35.2 cm), width 16¹¹⁄₁₆ inches
(42.4 cm), depth 10⅛ inches (25.7 cm)
Promised Gift of Beverly A. Wilson

Cat. 1-1

Electroplated objects offered cost-conscious con-
sumers the ability to acquire large-scale, elabo-
rately decorated pieces that looked like sterling
silver. Both Tiffany & Co. and the Gorham Manufac-
turing Company (q.q.v.) began marketing electro-
plated wares after the Civil War, although Tiffany did
not invest as much capital or interest in this line as
did Gorham. Instead of establishing its own electro-
plate department, Tiffany retailed objects made by
subsidiary firms such as Adams & Shaw.[1]

This tureen is one of the most impressive objects
made by the partnership. According to the *Jewelers'
Circular*, Adams & Shaw used a nickel alloy as the
base metal, "coated with silver of absolute purity to
a thickness practically indestructible."[2] Like contem-
poraneous electroplated wares by Gorham (see PMA
2002-205-1a–c), the tureen exhibits dense, natu-
ralistic foliage that imitates allover repoussé work
popular in sterling wares.[3] The scale and complexity
of the ornament, however, are more sophisticated

than that found on most electroplated objects, with
such details as butterflies and dragonflies influenced
by "Japanese" sterling and mixed-metal objects.[4]
The hand chasing and high degree of finish on this
tureen undoubtedly made it much more expensive
than most electroplate, and it looked very similar to
sterling examples produced contemporaneously by
Tiffany.[5] DLB

1. Charles H. Carpenter Jr., with Mary Grace Carpenter,
Tiffany Silver (New York: Dodd, Mead, 1978), pp. 212–16.
2. "The Adams & Company," *Jewelers' Circular*, vol. 7
(August 1876), p. 99.
3. See the vegetable dish attributed to Peter Krider (PMA
2010-206-31).
4. See the bowl by Gorham (PMA 2008-76-1).
5. Sotheby's, New York, *Important Silver, Vertu and Russian
Works of Art*, October 29, 2013, sale 9068, lot 311; Freeman's,
Philadelphia, *American Furniture, Folk and Decorative Arts*,
May 2, 2014, lot 139.

George Aiken

Philadelphia, born 1765
Baltimore, died 1832

George Bruce Aiken was born in Philadelphia on August 20, 1765, the son of George Aiken and Elizabeth Houston, who married in 1754.[1] The elder Aiken's profession is unknown; his son's apprenticeship would have coincided with the years of the Revolutionary War. Subsequent personal and professional ties suggest that the younger Aiken may have trained with the French immigrant silversmith Peter Leret (born c. 1750, died after 1802).[2] In 1779 Leret was recorded in Philadelphia as a tenant of Martha "Aitkens," a daughter of the clockmaker William Houston (c. 1730–c. 1775); he subsequently married Rebecca Houston. All of these individuals may have been relatives of Aiken's mother.[3] By 1782 Leret had moved to Carlisle, Pennsylvania, and in 1787 both Leret and Aiken established themselves as silversmiths in Baltimore, Aiken at 1 South Calvert Street and Leret around the corner on Market Street.[4] On February 21, 1803, Aiken married Leret's daughter Sarah Leret McConnell (1780–1865) as her second husband.

The substantial amount of surviving silver marked by Aiken indicates that his shop was one of the most productive in Baltimore. Between 1817 and 1820 he presented 1,329 troy ounces of silver for assay at the Baltimore Assay Office.[5] He advertised that he undertook "orders in the silver and jewelry line executed on the most reasonable terms."[6] Nine different initial and surname marks have been attributed to his shop, which moved to 72 Baltimore Street in 1802, to 118 Baltimore Street in 1813, and to 6 South Street in 1822.[7] Among his clients were institutions such as St. Paul's Church in Baltimore, for which he made a covered chalice in 1798, and civic leaders including Governor Charles Ridgely (1760–1829) and Judge John Purviance (1774–1854).[8]

Aiken's first advertisement in Baltimore's *Maryland Gazette* on March 2, 1787, noted that, as both goldsmith and jeweler, he executed "all manner of Devices, worked in Hair for Lockets, Rings, Pins, & c."[9] His subsequent advertisements indicated that a substantial part of his business was as a retail jeweler. In 1800 he announced, "by the last vessels from London, a large and elegant assortment of Fashionable Jewellery and Silver Plate, Silver and Gold Epaulets, and a large assortment of Horseman's Swords," and the following year he advertised "a large and elegant assortment of Jewelry, Silver and Plated Ware, fine Cutlery, and fancy articles, direct from the best manufactories."[10] When he moved his shop in 1802, he placed an advertisement with detailed descriptions of gold, enamel, and gemstone jewelry; watches and their accoutrements; snuff boxes, pocket books, and *nécessaires*; sewing equipment; lamps, candlesticks, and snuffers; and a wide variety of silver and plated tea and tablewares, including "Grecian tea and coffee urns" and "Castors, with from five to eight bottles, rich cut glass."[11]

The U.S. census records from 1790, thirteen years prior to Aiken's marriage, indicate that his household included one free white male under age sixteen; eight individuals have been documented as his apprentices.[12] Aiken presumably also trained his nephew William Aitken (born c. 1780), son of the Baltimore surgeon and apothecary Andrew Aitken (1757–1809) and George's sister Elizabeth (1761–1811). In 1802 a William "Atikens" was listed as a silversmith at 91 Baltimore Street and may be the same silversmith who was working in Philadelphia in 1825.[13] Several authors have speculated that George Aiken briefly formed a partnership with the otherwise obscure "E. Brown," who was listed in Baltimore city directories in 1807 and 1808, although no documentary evidence for such a partnership has been found.[14]

As Jennifer Goldsborough has demonstrated, the Assay Office established in Baltimore in 1814 made local silver more expensive than comparable objects produced elsewhere, by requiring assay fees as well as a higher standard for silver objects than for the legal currency. Numerous Baltimore silversmiths suffered financial difficulties as a result, and Aiken filed for bankruptcy in March 1820.[15] Apparently, he was able to recover financially, although he ceased operating a shop after 1823. In subsequent city directories until his death on April 1, 1832, Aiken was listed as a "gentleman," which indicated a certain degree of financial success. His household had included domestic servants and slaves beginning as early as 1790; he posted a reward for a twenty-six-year-old runaway named Sarah in 1813.[16] George and Sarah Aiken had at least eight children between 1804 and 1820, but none of his four surviving sons appears to have taken up silversmithing as a profession.[17] DLB

1. Life and event dates for the Aiken family are taken from the Witham family tree, Mundia.com (accessed December 13, 2013); and Pleasants and Sill 1930, pp. 84–86.

2. For biographical information on Leret, see Pleasants and Sill 1930, pp. 153–54; Goldsborough 1975, p. 58.

3. Pleasants and Sill 1930, p. 85; 1779 Philadelphia Effective Supply Tax, p. 210, Tax and Exoneration Lists, 1762–92. In the tax documents for 1779, Martha's name is spelled "Aitkens" but in subsequent tax records as "Aitkin."

4. *Maryland Gazette, or The Baltimore Advertiser*, March 2, 1787; *Maryland Journal and Baltimore Advertiser*, April 24, 1787.

5. This total is derived from the chart in Goldsborough 1983, p. 37a.

6. *Federal Gazette and Baltimore Daily Advertiser*, December 16, 1801.

7. Goldsborough 1975, p. 59.

8. Pleasants and Sill 1930, pls. IX, XXII, XXXVIII, XLV.

9. *Maryland Gazette, or The Baltimore Advertiser*, March 2, 1787.

10. *Federal Gazette and Baltimore Daily Advertiser*, May 26, 1800; ibid., December 16, 1801.

11. *Democratic Republican and Commercial Daily Advertiser* (Baltimore), June 17, 1802.

12. 1790 U.S. Census; Catherine B. Hollan, "Baltimore Apprenticeships in Silversmithing and Its Related Branches," in Goldsborough 1983, pp. 44, 46. In 1790, three years after opening his shop and thirteen years before he married, Aiken had one free white male under the age of sixteen living in his household.

13. Pleasants and Sill 1930, p. 87; Goldsborough 1983, p. 238; Hollan 2013, p. 1; Baltimore directory 1802, p. 6; Philadelphia directory 1825, p. 10. For Andrew and Elizabeth Aitken, see *Federal Gazette and Baltimore Daily Advertiser*, April 10, 1809; *Baltimore Weekly Price Current*, November 11, 1811; Witham family tree, Mundia.com.

14. Buhler and Hood (1970, vol. 2, cat. 966, illus. p. 249) were apparently the first to suggest that Aiken and Brown were in partnership, although Pleasants and Sill (1930, p. 105), raised the possibility that the initials "GA" and "EB" found together on a silver breadbasket and at least one spoon represented Aiken and E. Brown. Hollan (2010, pp. 97–98) has demonstrated that the otherwise unidentified Baltimore silversmith E. Brown was not the Edward Brown (c. 1790–1843) active in Richmond and Lynchburg, Virginia, an identification first proposed in George Barton Cutten, *The Silversmiths of Virginia (Together with Watchmakers and Jewelers) from 1694 to 1850* (Richmond: Dietz Press, 1952), p. 60, and reiterated (as Aiken's potential partner) in Goldsborough 1975, p. 59, and Goldsborough 1983, pp. 238, 243. The "GA" mark found on the spoon and basket is not one given traditionally to Aiken, and more recently the basket has been reattributed to the partnership of the New York silversmiths Ephraim Brasher (q.v.) and George Alexander (c. 1772–1801); Yale University Art Gallery, New Haven, 1930.1402; see http://artgalleryyale.edu/collections/objects/bread-basket (accessed December 23, 2013).

15. Goldsborough 1983, pp. 11–12, 66; *Baltimore Patriot, and Mercantile Advertiser*, March 23, 1820.

16. 1790 U.S. Census; *Baltimore Patriot, and Evening Advertiser*, September 18, 1813. In 1830 two free African Americans, male and female, were living in his household; see 1830 U.S. Census.

17. His youngest son, William, may be the William Aiken (also "Aikin") listed as a doctor in Matchett's Baltimore directory of 1837 (p. 45).

Cat. 2

George Aiken
Teapot and Cream Pot

c. 1815

MARKS: G·Aiken (script in irregular rectangle, twice on underside of teapot, on underside of cream pot; cat. 2-1)

INSCRIPTION (on each): F (engraved script, on side)

Teapot: Height 6$\frac{13}{16}$ inches (17.3 cm), width 11$\frac{7}{8}$ inches (30.2 cm), depth 4$\frac{1}{2}$ inches (11.4 cm)

Gross weight 17 oz. 15 dwt. 12 gr.

Cream pot: Height 5$\frac{1}{4}$ inches (13.4 cm), width 4$\frac{13}{16}$ inches (12.2 cm), depth 3 inches (7.6 cm)

Weight 4 oz. 10 dwt. 4 gr.

Gift of Lucinda Brown, 2013-124-1, -2

Cat. 2-1

Made from seamed sheet metal, this teapot and cream pot are characteristic of the fluted forms popular in both Philadelphia and Baltimore in the early nineteenth century.[1] As the largest city on the Chesapeake Bay, Baltimore would have served as a marketplace and style center for places such as Westmoreland County, Virginia, where these objects originally may have been owned.

The objects were owned in the donor's family without a clear record of their history. Her father, George Fulton Brown (1914–1998), was descended from Richard Templeman Brown (1777–1840) and Lucy Redman (born 1782), who were married in 1806 and lived in Westmoreland County, Virginia.[2] However, as none of their immediate forbears, family, or descendants had surnames beginning with "F," the original owner of these two objects remains unidentified. DLB

1. See the pair of teapots by Joseph Lownes in the Museum's collection (PMA 2005-68-48,49).
2. Information on the Brown family genealogy is found in David C. Pratt, "The Union of a Family Heck and a Family Pratt," http://laceypratts.com; and the Pettit family tree, Ancestry.com (both accessed July 1, 2014).

John Aitken

Dalkeith, Scotland, born c. 1745
Philadelphia, died 1831

A versatile metalworker, John Aitken was a silversmith, coppersmith, engraver, printer, and inventor of the use of steel punches to print musical notes, an improvement on the tedious method of engraving.[1] He arrived in Philadelphia in October 1771 on a ship from Rotterdam.[2] On October 14 he signed on as "servant" to the goldsmith William Taylor (q.v.) for a year and a half, with the bond set at £14 4s. 6d.[3] The indenture uses the term *servant* rather than *apprentice*, suggesting that Aitken had completed his training in Scotland and indentured himself to Taylor to pay off his passage to America.

National identities, religious affiliations, and trading connections were important means for establishing oneself in the Philadelphia community. Publications to date have stated that Aitken was born about 1745 in Dalkeith, Scotland, a small town on the outskirts of Edinburgh.[4] Thus he may have been the John Aitken, son of William and Ann Keith Aitken, noted as born in Edinburgh on January 17, 1746, and who was apprenticed to James Oliphant, goldsmith, in Edinburgh on January 17, 1763.[5] It may have been coincidence, but Robert Aitken (1734–1802), also born in Dalkeith, came to Philadelphia in 1769 to assess his prospects for setting up as a bookseller and publisher; he returned in 1771 and located at 12 Market Street.[6] Or it may have been the St. Andrew's Society of Philadelphia that "introduced" John Aitken to William Taylor.[7] (Taylor became a member in 1769, Aitken in 1790 or 1794.)[8] Taylor's regular advertisements in the years from 1771 to 1778 indicate that he was located in the northern part of the Dock Ward, at the southern end of the city near the drawbridge.[9] He was a Loyalist who joined the British army during the occupation of Philadelphia in 1777 and left the city about 1780.[10]

Aitken, who also had Loyalist sentiments, may have moved out of Taylor's shop after his indenture expired in 1773. He was taxed in the Walnut Ward in 1779 or 1778, when Taylor left. His name was included in a list of Loyalists and noncombatants who remained in Philadelphia during the British occupation. By 1779 Aitken had relocated to a more central address in the Walnut Ward, where he leased property on Chestnut Street near Second from a Thomas Doyle. In that year the property was valued at £3,000, and Aitken paid a tax of £45, which included his per-head tax of £15. The notation "Dbl" on this record indicates that he paid double the head tax for his refusal to take the Oath of Allegiance to Pennsylvania. It was noted in 1780 that he again "refused to qualify" (refused to take the oath) and in 1781 that he was "not qualified & non juror."[11] Unlike William Taylor, Aitken remained in Philadelphia and continued to pay his head tax and tax on his lease of Doyle's estate. In 1780 the Effective Supply Tax in the Walnut Ward valued Aitken's estate at £20,400—reflecting the huge rate of inflation following the Revolution—with a tax of £71 8s., and Doyle's estate at £20,000, with a tax of £70.

In February 1782 Aitken took on Tumib(?) Runkin as an apprentice to serve for four years, one month, and seventeen days in his trade of "goldsmith," and in October he took on "Barthelmew" Begonet, son of Lydia Lewis, for eight years.[12] In that year Aitken was assessed £150 for "merchandize," a term that implies he had added a general-merchandise business to his role as silversmith. In that year he paid £6 5s. on his assessment of "merchandize," valued at £150, his occupation at £50, and his lease of Thomas Doyle's building at £700. He enlarged his business, perhaps because of his impending marriage on April 21, 1783, to Elizabeth Swiver (1761–1837) at Swedes' Church, Philadelphia.[13] John Aitken was married and buried according to the rituals of the Anglican Church, his wife's affiliation, but Aitken himself was a devout and supportive communicant at St. Mary's Catholic Church, Philadelphia, where he subscribed to a pew in the "End Gallery," made donations, and baptized two of his children in 1788 and 1791.[14]

In 1785 Aitken was located in the Walnut Ward at 60 South Second Street, between Chestnut and Walnut.[15] In 1786 Alexander Robert Reinable (1756–1809), a fellow Scot with musical talents, arrived in Philadelphia and was probably instrumental in promoting Aitken's invention of the use of steel punches for printing musical scores.[16] The

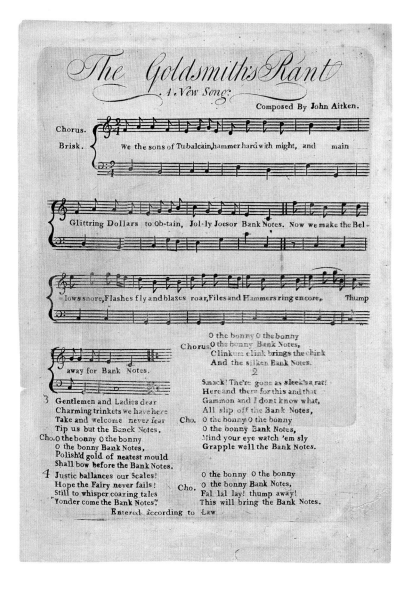

Fig. 17. John Aitken. "The Goldsmith's Rant: A New Song," 1802. The New York Public Library for the Performing Arts, Astor, Lenox, and Tilden Foundations. Music Division

punch was a short metal chisel with a musical device (clef, note, etc.) raised on the tip, which was tapped into the copper engraving plate.[17]

In the Pennsylvania Tax and Exoneration Lists for 1787, Aitken was listed as a "grocer" (that is, wholesaler), with a head tax of £25; a tax of £448 on his residence, leased from Thomas Doyle; and a tax of £2 for ground rent at an additional property, noted in the Philadelphia directory as "Back [of] 60 South Second Street."[18] Aitken's wife Elizabeth, was listed next and separately as "occupant" in what may have been their shop on the Israel Pemberton Jr. property. From this time on, Aitken seems to have applied his skills increasingly to music engraving and publishing, with his wife running the shop.

In 1787 Charles Taws, an organ builder and fortepiano maker, "removed . . . to Mr. Aitken's, jeweler," next door to Taylor's Alley.[19] Their first enterprise together, also in 1787, was an engraved and printed edition of Alexander Reinagle's *Selection of the Most Favorite Scots Tunes*.[20] In 1788 Aitken published *A Compilation of the Litanies and Vespers, Hymns and Anthems as They Are Sung in the Catholic Church* on 136 quarto pages, the first collection of Catholic music published in America.[21]

In 1789 Aitken moved to 48 Chestnut Street (on the south side, just east of Second Street), a property owned by Ann Dawkins.[22] This was next door to the shop of John Aitken, cabinetmaker, at 50 Chestnut Street, at the corner of Second.[23] According to the U.S. census of 1790, the household of John Aitken, silversmith, at this time included eight inhabitants: four males over the age of sixteen (probably including apprentices and journeymen), two males under the age of sixteen, and two females. In 1793 he was still located at 48 Chestnut Street.[24] In 1794 Aitken's address in the city directory was noted as 60 South Second Street.[25]

In 1796 Aitken listed himself as an engraver, copperplate printer, and musical instrument maker at 193 South Second Street.[26] From 1796 through 1798 an Elizabeth Aitken, "widow bh [boarding house]," was listed in city directories as next door at 195 South Second Street. The designation "bh" suggests that the shop may have rented upper rooms. The U.S. Direct Tax of 1798 continued to identify John Aitken as "grocer" at 193 South Second Street.[27]

From this address in 1796 Aitken advertised that he was accepting subscriptions to the *History of France*, "elegantly printed in quarto, and embellished with a superb engraving, representing the first introduction of the Maid of Orleans to Charles VII."[28] A few days later he advertised that the first signature was ready for inspection, with others to be issued weekly until completion.[29]

His next publication, in 1797, was *The Scots Musical Museum*, with a title illustration by the English engraver David Edwin, who had just arrived in Philadelphia and who engraved the silversmith's trade card.[30]

From 1800 until 1809 Aitken was listed at 33 South Second Street.[31] This was surely a silver workshop; it had been used as such by Christian Wiltberger (q.v.) from 1785 until 1796,[32] and from 1800 to 1806 John Aitken's shop was there at the center of the silver trade. In 1802 Anthony Simmons (q.v.), wanting to give up his silver business, moved his shop stock to Aitken's premises for sale.[33]

Aitken may not have been producing much silver after 1805, as he was occupied with the production of sheet copper for his printing business. He moved in 1807 to 76 North Second Street, on the southeast corner, in the Lower Delaware Ward, where his listing in the city directory expanded to "silversmith, goldsmith, jeweller and musical repository."[34] Between 1807 and 1811 Aitken renewed his association with Charles Taws, the fortepiano maker, and during this period Aitken engraved and printed 125 pieces of music (fig. 17; see also fig. 5).[35] The ground floor of the already old building was a music store, with rehearsal rooms in the upper stories. It was known as Jones Folly and considered by some Quakers to be a noisy nuisance. The U.S. census of 1810 listed Aitken and five household members still occupying 76 North Second Street.[36] That year he was the only silversmith listed as a subscriber to the Mechanics National Bank, which had been founded largely by artisans of all trades to serve the interests of those in technology and manufacturing. Aitken remained at 76 North Second Street until 1813. He subsequently needed more space for his business, and in 1814 he moved west on Chestnut Street to a site between Broad (equivalent to Fourteenth) and Schuylkill Eighth streets, where he was listed as "sheet copper maker and founder." His house was at 10 Broad Street. In 1823 and 1824 he was listed at 89 New Street as a "printer," and in 1825 at 53 Wood Street (Palmyra Square), still carrying on the same profession. Listed with him in 1825 was his son William, as "silversmith."[37]

John Aitken died in 1831 and was buried at Christ Church, Philadelphia. His grave marker reads: "Sacred to the Memory of JOHN AITKEN native of Dulheath [*sic*] Scotland who departed this life September 8th A.D. 1831 in the 86th year of his age. Blessed are the dead who die in the Lord for they rest from their labors. Also ELIZABETH, wife of John Aitken who departed this life April 13th 1837 Aged 75 years."[38] BBG

1. Robert R. Grimes, "John Aitkin and Catholic Music in Federal Philadelphia," *American Music* (Champaign, IL), vol. 16, no. 3 (Autumn 1998), pp. 289–310. The name of John Aitken, silversmith, was spelled in some records as "Aitkin."

2. Not to be confused with John Aitken, cabinetmaker, who was active in Philadelphia from 1790 to about 1814, when he retired to Chester County, Pennsylvania.

3. "William Taylor and his assigns" took John "Aitkins" from the port of Rotterdam as a "servant, to be employed at the business of goldsmith" for eighteen months, with the bond set at £14 4s. 6d; "Record of Indentures of Individuals Bound Out as Apprentices, Servants, Etc., . . . Philadelphia, October 3, 1771, to October 5, 1773," *The Pennsylvania German Society Proceedings and Addresses* (1907), vol. 16, pp. 10–11 (repr., Baltimore: Genealogical Publishing, 1973).

4. See Hollan 2013, p. 1.

5. Rodney R. Dietert and Janice M. Dietert, *Edinburgh Goldsmiths II: Biographical Information for Freemen, Apprentices and Journeymen*, pt. 1, Introduction, A–C, p. 14 (https://ecommons.cornell.edu).

6. Ronald Lyndsay Crawford, "Scotland, America and Tom Paine: Ideas of Liberty and the Making of Three Americans—John Witherspoon (1723–1794), Robert Aitken (1735–1802), and Alexander Wilson (1766–1813); A Study in Bibliographical History," PhD diss., University of Strathclyde, Glasgow, 2011. I thank James N. Green at the Library Company of Philadelphia for suggesting this resource.

7. The Scots favored the St. Andrew's Society, whose charter, formally adopted in 1809, stated that "Citizens of the Commonwealth of Pennsylvania . . . have formed themselves into a Charitable association under the name of 'The St. Andrew's Society of Philadelphia'"; *An Historical Catalogue of the St. Andrew's Society of Philadelphia, 1749–1881* (Philadelphia: printed for the Society, 1881), p. 28.

8. The St. Andrew's Society membership list did not include occupations; ibid., p. 58. There were others named Aitken (spelled variously "Aitkin" or "Aitken") in Philadelphia who were contemporary with the silversmith: a cabinetmaker (see note 2 above); and a surgeon: "[I], John Aitken surgeon of the Lady Margaret acknowledge myself a Prisoner of war to the US of A and having permission to go to New York to endeavour to effect an exchange for a person of equal rank . . . in case of failure, I will return to Phila within twenty days from date hereof. Sept. 23, 1780. Jno Aitken"; Bradford Family Papers, Series 3, Thomas Bradford, a. Naval Prisoners, Paroles, vol. 1, 1778–1782, box 16, folder 1, HSP.

9. The Dock Ward extended "within a line from the river Delaware, thence by Walnut Street to Fourth Street, thence by the same to Spruce Street, thence by the same to the river Delaware, and thence by the said river to Chestnut Street"; Philadelphia directory 1805, appendix, p. 67.

10. William Taylor, goldsmith, paid £90 tax in the Dock Ward, northern part, in 1779.

11. Tax and Exoneration Lists, 1762–94: "John Aitkins Est. [£]5400 &pr/h[ead] £20 . . . £130 14s. / Cash £225—[tax] £5 12s. 6d. / refused to qualify / for Thos. Doyles [£]3000 . . . [tax £]61 10s."; ibid. The tax was 7s. per £100. The penalty for refusing to take the oath was double taxation. The Walnut Street extended "within a line from the river Delaware, thence by Chesnut Street to Fourth Street, thence by the same to Walnut Street, thence by the same to the River Delaware, and thence by the said river to Chesnut Street"; Philadelphia directory 1805, appendix, p. 67. For comparison, the estate of John "Bayley" (q.v., as Bailey) was valued at £25,200, with a tax of £88 4s.

12. Stephen Paschall Docket Book, pp. 140, 161, Paschall-Sellers Family Papers, HSP. The "Aitken" signatures on these eighteenth-century documents are not identical but have in common the flourishes associated with copperplate engraving, at which Aitken was proficient. The Begonets were Huguenots who settled in Montgomery County in the Colonial period; see Wayland Fuller Dunaway, "The French Racial Strain in Colonial Pennsylvania," *PMHB*, vol. 53, no. 4 (1929), pp. 322–41.

13. *Pennsylvania Archives*, 2nd ser. (1896), vol. 8, p. 291.

14. He donated £3 to the church and subscribed to a pew in the "End Gallery" in 1781; *Minute Book of St. Mary's Church, Philadelphia, 1782–1811* (Philadelphia: American Catholic Historical Society, 1893), pp. 255, 264. Burial records of St. Mary's Church, Philadelphia, September 20, 1788, and July 9, 1791, HSP.

15. Aitken was listed in Macpherson's city directory of 1785 at 607 South Second Street. A copy of that directory, not to be confused with Francis White's directory of the same year, is at the Library Company of Philadelphia.

16. Grimes, "John Aitkin and Catholic Music in Federal Philadelphia," p. 289. Aitken's book was advertised in 1787 and published in 1788; no copies are known.

17. See Wolfe 1980, p. 213.

18. Israel Pemberton Jr., grantor, to Thomas Doyle, grantee, Philadelphia Deed Book H-5-6. With a tax of 5s. 7d. for every £100, Aitken paid a total of £1 4s. 3d. on the two properties.

19. *Pennsylvania Evening Herald, and The American Monitor* (Philadelphia), May 30, 1787; see also *Pennsylvania Packet* (Philadelphia), May 29, 1787. Taylor's Alley ran east to west from Front Street to Second Street between Chestnut and Walnut.

20. John Bewley, "Philadelphia Music Publishers: John Aitkin (1744 or 45–1831)," Keffer Collection of Sheet Music, c. 1790–1895, Department of Special Collections, University of Pennsylvania Library, www.library.upenn.edu/collections/rbm/keffer /aitken.html. Reinagle also became a member of the St. Andrew's Society. He may have come to Philadelphia when he heard about Aitken's musical enterprise. He was in partnership with Thomas Wignell, and both eventually went bankrupt in Philadelphia; Records of the U.S. District Court for the Eastern District of Pennsylvania, file no. 49, NARA, Philadelphia.

21. Wolfe 1980, p. 112.

22. Tax and Exoneration Lists, 1762–94.

23. John Aitken the silversmith and John Aitken the cabinet-maker were active in their trades during the same period, 1790–1815, and seem to have celebrated the new styles with enthusiasm; see Garvan 1987, pp. 48–49. Both men were Scots, and both were admitted to the St. Andrew's Society, one in 1790, the other in 1794; *Historical Catalogue of the St. Andrew's Society of Philadelphia*, p. 58. John Aitkin, joiner, was located on the east side of Water Street and, by 1793, was at 50 Chestnut Street; Philadelphia directory 1793, pp. 1–2.

24. Philadelphia directory 1793, p. 2.

25. The 1793 and 1794 addresses were within a block of each other. To be included in the 1794 listing, Aitken must have moved by the fall of 1793.

26. Stephen's Philadelphia directory 1796, p. 2. Elizabeth Aitken does not appear in the directories after 1798. No evidence of a divorce was found in the records, but the term *widow* was sometimes used with her name. In 1797 she was listed just as "Mrs. Aitkin" at 195 South Second Street.

27. The Philadelphia directory 1785, p. 2, lists "Aitken and Ribaud," each as "grocer" at the corner of Second and Chestnut streets.

28. *Philadelphia Gazette and Universal Daily Advertiser*, July 20, 1796.

29. *Gazette of the United States* (Philadelphia), July 25, 1796.

30. See Mantle Fielding, "David Edwin, Engraver," *PHMB*, vol. 29, no. 1 (1905), pp. 79–88; H. T. Henry, "Philadelphia Choir Books of 1791 and 1814," *Records of the American Catholic Historical Society*, vol. 26, no. 4 (December 1915), p. 327. It was perhaps also in 1797 that David Edwin engraved Aitken's trade card. For Aitken's and Edwin's work together, see Wolfe 1980, pp. 80, 103–4, 234, 239.

31. Philadelphia directory 1800, p. 12, and continuously thereafter until 1809. The value of the property, with one house, was set at $2,500, which, with a rate of assessment of 4/10 percent, was assessed for $10; see the 1798 U.S. Direct Tax. This property in Chestnut Ward had belonged to the goldsmith David Hall before he died in 1779. (He was listed, perhaps erroneously, on p. 168 of the 1800 *New Trade Directory* for Philadelphia under the heading "Goldsmiths, Silversmiths and Jewellers," at 47 South Second Street.) Among his neighbors on South Second were Joshua Dorsey at no. 33, John Dumoutet at 55, James Musgrave at 44, John Myers at 20, Robert Swan (q.q.v.) at 77, and Lewis Descuret at 75.

32. See the cream pot by Christian Wiltberger (PMA 1918-85).

33. In October 1802 Aitken wrote the following note: "Cashier Bank U. States pleas lett the Bearer have my Silver plate packet in a pine Box / Philada 8 Octr 1802 / John Aitken / markd. J. A." Simon Gratz Autograph Collection, HSP.

34. The Lower Delaware Ward encompassed the area "from the river Delaware, thence by Sassafras Street to Fourth Street, thence by the same to Mulberry Street, thence by the same to the river Delaware, and thence by said river to Sassafras Street"; Philadelphia directory 1805, appendix, p. 67. This address has been located as being near Arch Street, next to Christ Church; 1810 U.S. Census. See also "Mechanics National Bank, Directors and Members," s.v. "John Aitken," http://mechanicsnationalbank .com/members/ (accessed April 7, 2015). According to the city directories, a James Aikin continued in Philadelphia at 37 Pewter Platter Alley from 1801 to 1803 and was listed at 143 Walnut Street in 1805. Philadelphia directory 1801 (p. 129 as Aikin); ibid., 1802 (p. 14 as Aikin); ibid., 1803 (p. 14 as Aikin); ibid., 1805 (p. 143 as Akin).

35. Wolfe 1980, p. 109. On the obverse of the sheet with "The Goldsmith's Rant / A new Song / Composed by John Aitken" is printed his trade card: "I. Aitken / Goldsmith & Jeweller / No. 33 / South Second Street / Philada. / NB. Silver Cyphers for Carriages."

36. The Philadelphia directory of 1807 (n.p.) gave Aitken's address as 96 North Second; the Philadelphia directory of 1810 (p. 15) listed 76 North Second. It is doubtful that Aitken moved. The directories are not consistent, nor are they always accurate in their street numbers.

37. See the Philadelphia directories for these years. Aitken's son John Aitken Jr. married Harriet Schreiner, daughter of Jacob Schreiner, on October 27, 1821; see *Notices of Marriages and Deaths in Poulson's American Daily Advertiser, 1791–1839* (Philadelphia: Genealogical Society of Pennsylvania, 1980).

38. Wolfe 1980, p. 110.

Cat. 3

John Aitken
Cream Pot

1780–90
MARK: I AITKEN (in rectangle, on underside; cat. 3-1) / 19990 / 2 / cuo (scratched, along one edge on underside)
INSCRIPTIONS: M R (engraved script, on front under pouring lip; cat. 3-2)
Height 5 inches (12.7 cm), width 5³⁄₁₆ inches (13.1 cm)
Weight 7 oz. 10 dwt. 8 gr.
Purchased with Museum funds, 1950-12-3

PROVENANCE: Albany Institute of History and Art, Albany, NY

Cat. 3-1

The undulating panels that make up the body of this flat-bottomed cream pot are enhanced by broad bands of engraving that encircle the pot at the shoulder and base in a rhythmic design of circles and quatrefoil leaf motifs punctuated and outlined by double lines of dots. The engraving's overall design has an architectural character, different from the feathery floral swags, shields, and wreaths that embellished the surfaces of smooth, round, urn-shaped pots in the 1780s and 1790s, and distinctly different from the running vine-and-berry borders employed later by James Musgrave (q.v.) and Charles L. Boehme in Baltimore, to name but two.[1] Although speculative, this design seems to have arrived in Philadelphia in 1794 with the engraver James Akin (c. 1773–1846) from South Carolina, who married Eliza Cox at Christ Church on November 30, 1797.[2] Akin worked at 33 South Second Street, where Christian Wiltberger (q.v.) was active from 1785 until 1797, and a fluted cream pot and sugar bowl by Wiltberger clearly illustrates Akin's design.[3] Between 1800 and 1809 James Aitken also worked at 33 South Second Street, and this cream pot has a very similar engraved border design with unusual (unique?) double rows of dots outlining the bands and borders. James Akin worked at engraving and publishing in Philadelphia until 1805, when he removed to the Boston area.[4] The distinctive style of this schematic engraving seems to have removed with him. Ornamental banding with running designs of vines with flowers and fruit became a popular feature of later silver. BBG

1. James Musgrave and Philip Garrett (q.q.v.), who worked in Philadelphia, also employed this style. The fluted melon-shaped pots in the tea service that Musgrave made for John Barry (1745–1811) have encircling bands with a running, scrolling foliage design (PMA D-2007-54–58). The wide engraved band on Philip Garrett's tea caddy of 1817 has a less accomplished design of leafy grasses superimposed over diagonal lines with dots; Buhler and Hood 1970, vol. 2, p. 221, fig. 893. For illustrations of similar forms and engraved decoration by Boehme, see Hammerslough 1958–73, vol. 4, p. 70; Goldsborough 1975, p. 84, cat. 83; and Goldsborough 1983,

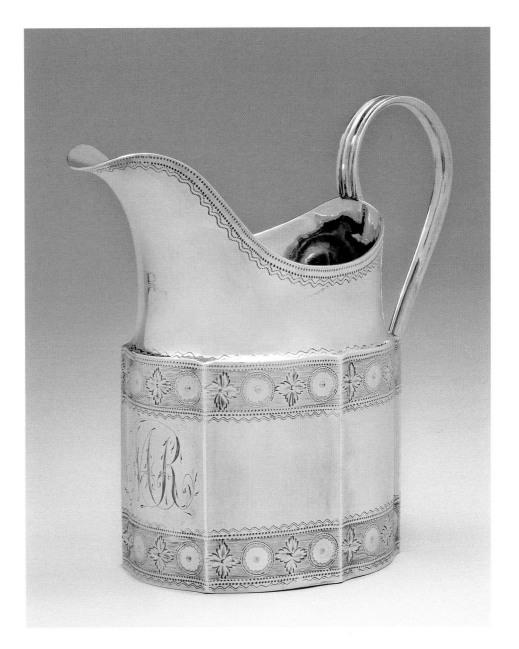

Cat. 3-2

pp. 89–93, cats. 39–47. For George Aiken and E. Brown, see Buhler and Hood 1970, vol. 2, pp. 249–50, cat. 966; and Goldsborough 1975, pp. 59–60, cat. 45.
2. *Pennsylvania Archives,* 2nd ser., vol. 1 (1896), p. 4. Akin was primarily a copperplate and wood engraver, best known for political cartoons, miniatures, and caricatures.
3. For the cream pot by Wiltberger, see PMA 1918-85. For a sugar bowl by Wiltberger in the Winterthur Museum, see Quimby and Johnson 1995, illus. p. 470, cat. 501.
4. According to Philadelphia directories, James Aikin continued in Philadelphia at 37 Pewter Platter Alley from 1801 to 1803, and at 143 Walnut Street until 1805.

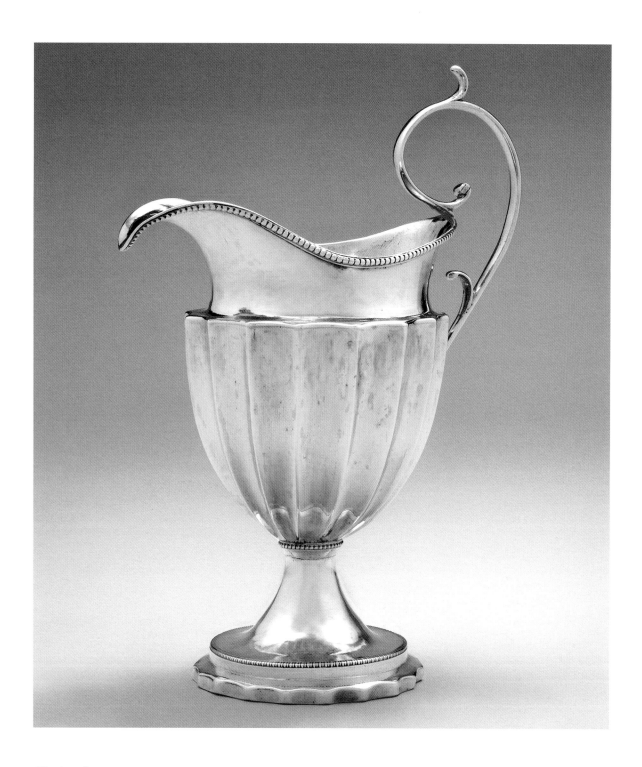

Cat. 4

John Aitken
Cream Pot

1800–1805

MARKS: I AITKEN (in rectangle, at bottom of handle; cat. 3-1); 9110 (scratched, on underside of foot)

INSCRIPTION: A M S (engraved, along edge of foot at back under handle; cat. 4-1)

Height 6⅝ inches (16.8 cm), width 4⅞ inches (12.4 cm), diam. foot 2⅝ inches (6.7 cm)

Weight 5 oz. 5 gr.

Gift of the McNeil Americana Collection, 2005-68-1

PROVENANCE: Sotheby's, New York, *Important Americana*, January 30–February 1, 1986, sale 5429, lot 378; (S. J. Shrubsole, New York).

This cream pot is a handsome and interesting example of "transitions." It seems to be a combination of three somewhat disparate units, which nevertheless appear to have been joined together at the same time. The round, fluted body might have developed into a sugar bowl. The number of "flutes" in the body and the number in the foot do not match. The smooth and plain spout section, which shows a design relationship to Aitken's flat-bottomed cream pot (cat. 3), sits atop the fluted body without any transition, a detail also noted in the composition of the foot. The bead around the foot and that at the top of the stem are different. Finally, the twists and flares of the handle clearly reflect earlier rococo design. There is no obvious surface for engraving,

Cat. 4-1

a feature that developed later with variation in the width of flutes.[1] BBG

1. See the tea and coffee set by John Musgrave (PMA D-2007-54–58).

Edward Akers

England, born 1823
Baltimore, died c. 1895

Born in England, Edward Akers may be the individual recorded in 1841 as a native resident of Castle Eaton, Wiltshire.[1] He immigrated to the United States before 1847, when he married Louisa Ann Passey (or Passcay, born 1828) in Baltimore County, Maryland, on November 23.[2] As a married couple they attended the English Lutheran Church in Baltimore, where Louisa and two of her children were baptized before 1859; the death of another infant child was recorded at the church in 1853.[3]

Edward Akers was first listed as a watchmaker in 1849 at 55 North Exeter Street in Baltimore.[4] From 1850 to 1893 he was listed in Baltimore city directories as a watchmaker and jeweler at a series of addresses: 123 South Paca Street (1851), 74 South Charles Street (1858–59), 65 South Charles Street (possibly a renumbering; 1860–68), 126 Hanover Street (1871–82), and 196 West Pratt Street (subsequently renumbered as 6–8 East Pratt Street; 1885–93). He advertised in 1864 and again in 1885 that he kept "a large assortment of Watches, Jewelry, &c.," without specifically mentioning silver flatware, although the latter advertisement offered "a large assortment of Gold, Silver and Steel Spectacles and Eye Glasses."[5] His business apparently prospered: in the U.S. census of 1860, his personal property was valued at $1,000; ten years later this valuation doubled, and his real estate was valued at $15,000.[6] The last listing for Edward Akers in a Baltimore directory was in 1893; he presumably died in 1894 or 1895.[7] Louisa Ann Akers was not listed as his widow thereafter and may have predeceased her husband.

All but one of Edward Akers's six surviving children entered the watchmaking and jewelry business. Gabriel (born 1849) worked as a watchmaker with his father from 1870 until 1872; he apparently died or moved from Baltimore thereafter.[8] Beginning in 1879, Edward Passey (born 1858) and Albert (born 1862) worked for their father, Edward as a clerk and Albert as a watchmaker; Albert's profession was described as "apprentice to watchmaker" (presumably his father) in the U.S. census of 1880.[9] Their brother Harry (born 1866) joined the firm as a clerk in 1883.[10] In 1894, following the senior Edward's death or retirement, the business was renamed Edward Akers' Son and continued under Albert's ownership at 6–8 East Pratt Street, with his brother Edward continuing to serve as a clerk.[11] In that same year Harry B. Akers apparently left the family firm and worked independently as a watchmaker and jeweler in Baltimore until at least 1906.[12] When Albert died or left Baltimore around 1900, his sister Leonora (born 1864) and subsequently her husband, Edward S. Dawson, managed the firm of Edward Akers' Son until at least 1930.[13] DLB

1. Census Returns of England and Wales, 1841, Kew, Surrey, England: National Archives of the United Kingdom (TNA), Public Record Office.

2. Jordan Dodd, comp., Maryland Marriages, 1655–1850, Ancestry.com, where Louisa's maiden name is spelled "Passcay." In a listing published by her church, the name was spelled "Passey"; *Register of the First English Lutheran Church, Baltimore, from February, 1827, to March, 1859* (Baltimore: Frederick A. Hanzsche, 1859), p. 10.

3. *Register of the First English Lutheran Church*, pp. 10, 60.

4. Matchett's Baltimore directory 1849–50, p. 16.

5. Cross's Baltimore directory 1863–64, advertisements p. 15; Baltimore directory 1885, p. vii.

6. 1860 U.S. Census; 1870 U.S. Census.

7. Polk's Baltimore directory 1893, p. 419.

8. Wood's Baltimore directory 1870, p. 21; ibid., 1871, p. 21; ibid., 1872, p. 21. Birth dates were calculated from the 1870 U.S. census, in which the six surviving Akers children appear. A daughter Estelle (born 1859) was listed in the 1860 U.S. census but did not appear in subsequent ones, indicating that she had died as a child.

9. Woods's Baltimore directory 1880, p. 54; 1880 U.S. Census.

10. Woods's Baltimore directory, 1884, p. 56.

11. Polk's Baltimore directory 1895, p. 58.

12. Ibid., 1906, p. 113.

13. Ibid., 1929, p. 531; 1930 U.S. Census.

Cat. 5

Edward Akers
Salad Set

1880–90
MARK (on each): STERLING E.AKERS
(incuse, on back of handle; cat. 5-1)
INSCRIPTION: L.A.J. (engraved script, on back of handle)
Fork: Length 7 5/16 inches (18.6 cm)
Weight 1 oz. 6 dwt. 17 gr.
Spoon: Length 7 7/8 inches (20 cm)
Weight 1 oz. 12 dwt. 19 gr.
Gift of Beverly A. Wilson, 2010-206-48, -49

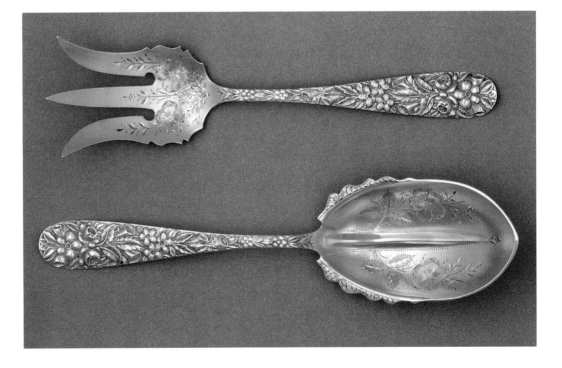

Cat. 5-1

Sets of matching salad servers became popular in the late nineteenth century as salad became a component of formal dinners. Marked by the retailer Edward Akers, this salad set exhibits a variation of a pattern made by several Baltimore silver manufacturers; it was called *Baltimore* by the Stieff Company (q.v.) and *Hand Chased* by the Schofield Company.[1] The bowls of both pieces are ornamented in a sophisticated combination of bright-cut engraving, set off by two colors of gilding. DLB

1. *The Schofield Sterling Silver Book* (Baltimore: Schofield, 1929), p. 20-b.

Thomas F. Albright

Philadelphia, born 1811
Location unrecorded, died after 1883

Born in Philadelphia in 1811, Thomas Albright was the son of Conrad Albright (1769–1850) and Narcissa Davis Albright (1771–1856), who married on December 3, 1796, in Saint George's Methodist Episcopal Church.[1] Conrad Albright was descended from German immigrants, originally named Albrecht, from Hesse.[2] He was listed in city directories as broker, collector, and owner or proprietor of a "shoe warehouse" and apparently was financially successful; Narcissa Albright's funeral arrangements in 1856 included an elaborate coffin, mourning outfits, and the "use of 12 carriages" at the substantial cost of more than $108.[3]

Thomas Albright was recorded consistently in directories and legal records as a watchmaker. Advertisements published between May 1838 and January 1839 showed that Albright's stock in trade was typical for a retail jeweler—"a handsome assortment of Gold and Silver Patent Lever, Lepine, Repeating and Plain Watches; Jewelry of various kinds, consisting of Ear rings, Finger-rings, Breastpins, Lockets, Miniature Cases, Keys, Seals, Chains, &c., Silver Table and Tea Spoons, Sugar Tongs, Soup Ladles, Cups &c; Gold and Silver Pencils, Thimbles and Spectacles"—and noted that he took old gold and silver in exchange.[4] His first directory listing in 1835 would have followed the completion of his apprenticeship, although the identity of his master is not known.[5] In 1844 he moved his shop on Market Street from number 268 to number 246, where he remained until 1848.[6] A watch paper with the latter address advertised that Albright sold "Jewellery & Silver Ware of the Newest Paterns [sic]" in addition to gold and silver watches.[7]

Albright's name was absent from directories for seven years, between 1848 and 1855, possibly because he was an employee of another firm. At the time of the U.S. census of 1850, he was recorded living with his mother and siblings in the Chestnut Ward of Philadelphia. In 1856 he reappeared at a shop at 117 Market Street and with his residence at 398 North Thirteenth Street, but his name was not in directories published between 1857 and 1859.[8] Although his residence was recorded consistently from 1860 to 1881, listings for his workplace beginning in 1862, when his shop was located at 618 Market Street, appeared only sporadically.[9] In 1872 his profession was given as "clerk" at that address, and the U.S. census of 1870 recorded him as a "clerk in store."[10] However, in the 1880 census, taken when Albright was sixty-nine years old, it was noted that he "works in watch fact[or]y."

Albright never married and apparently spent most if not all of his adult life sharing a house with his three siblings, William (born 1801), Eliza Anne (born 1808), and Emeline (born 1816). They were first listed, together with their widowed mother as the head of household, in 1850; William was the head in 1860 and 1870; and Thomas took the place of his eighty-year-old brother in 1880.[11] The Albrights must have had some means; city directories gave William's profession as "merchant" or "gentleman," and every census recorded an Irish-born female servant as part of their household.[12] Following the deaths of his siblings in 1881 and 1882, Thomas Albright relocated to 1025 Market Street, where he was recorded in his final city directory listings in 1883 and 1884. He was not listed in the census of 1890, and his name did not appear in the city death registers for 1884 and the years following. The place and date of his death have not been discovered.[13] DLB

1. Marriage register, Old St. George's Methodist Episcopal Church (December 3, 1796), n.p., Ancestry.com.

2. Celler-Cox family tree, Ancestry.com (accessed March 26, 2013).

3. Philadelphia directory 1819, n.p.; Desilver's Philadelphia directory 1830, p. 2; McElroy's Philadelphia directory 1844, p. 3; Records of Moore Undertaker (December 21, 1856), n.p., Ancestry.com.

4. Public Ledger (Philadelphia), May 16, 1838; January 3, 1839.

5. Desilver's Philadelphia directory 1835, p. 22.

6. McElroy's Philadelphia directory 1844, p. 3; 1847, p. 3.

7. Watch paper of Thomas Albright, undated, Watch Papers Collection, American Antiquarian Society, AmericanAntiquarian.org (accessed January 9, 2018).

8. McElroy's Philadelphia directory 1856, p. 5.

9. Ibid. 1862, p. 6.

10. Gopsill's Philadelphia directory 1872, p. 138.

11. U.S. Census, 1850–80.

12. Ibid.; McElroy's Philadelphia directory 1853, p. 4; 1864, p. 6.; 1870 U.S. Census.

13. Gopsill's Philadelphia directory 1883, p. 91; ibid., 1884, p. 91. At least two apparently indigent white males with the surname Albright were listed in Philadelphia death registers during this period; but without records of their ages or first names, identification with the watchmaker/jeweler is impossible. 1884 Philadelphia Registration of Deaths, p. 76; 1886 Philadelphia Registration of Deaths, p. 276.

Cat. 6

Thomas F. Albright
Teaspoon

1835–50
MARKS: T.F. ALBRIGHT (in serrated rectangle); [eagle] (in surround with rounded corners; all on back of handle; cat. 6-1)
INSCRIPTION: A E (engraved script monogram, on front of handle)
Length 6 1/16 inches (15.4 cm)
Weight 9 dwt. 5 gr.
Gift of Charlene D. Sussel, 2009-155-1

PROVENANCE: From the stock of the Philadelphia antiques dealer Eugene Sussel (1913–1989), the donor's husband.

Cat. 6-1

This teaspoon was marked by Albright as the retailer. Its eagle mark appeared on flatware marked by many silversmiths and retailers in Philadelphia during the second quarter of the nineteenth century; identical or nearly identical eagle marks appear on spoons in the Museum's collection marked by James E. Caldwell (see cat. 112), Nicholas Le Huray Jr. (2000-130-3), and George W. Taylor (2009-155-28). John McGrew suggested that it identified a silversmith working as a wholesale supplier, and Catherine Hollan proposed Robert and William Wilson (q.v.) as a possible candidate.[1] Given its widespread use over a quarter century, this mark may not have belonged to a single maker and possibly may have signified "American made" or "Philadelphia made." DLB

1. McGrew 2004, p. 100; Hollan 2013, pp. 235–36.

Samuel Alexander

Probably Philadelphia, c. 1774
Philadelphia, c. 1819

In 1802 Samuel Alexander described in his own words his travails and predicaments and gave some details and explanations for the stream of events and financial disasters that had overwhelmed him. John Hallowell and Joseph Hopkinson, commissioners of bankruptcy, ordered Alexander to make a full disclosure, on May 7 and 28, and again on June 17, 1802, in a series of interviews conducted in the West Wing of the State House in Philadelphia.[1] As transcribed:

Samuel Alexander the person against whom the commission of bankruptcy now in prosecution is awarded and issued appearing again . . . to finish his examination pursuant to notice in the *Philadelphia Gazette* and *Poulson's*. For that purpose given, upon his oath sayeth he, that in the year one thousand, seven hundred ninety five, this examinant entered the Business as a Goldsmith & Jeweller, having served a regular apprenticeship thereto, & opened his shop in Second Street in the Northern Liberties. The examinant having very little capital to commence business, he was necessarily confined in its objects. He therefore only sold articles manufactured by him self for a considerable time after the commencement—from this period until the spring of 1797 at which time this examinant entered more largely into business, he had accumulated a sum of two thousand dollars or thereabouts in the way of trade. It was then that he purchased the stock of Mr. Anthony Simmons who was then about declining the Silversmith Business, and he leased the house in which he lived in Second Street near Market. Shortly after this a partnership was entered into by the examinant with Christian Wiltberger to carry on in the same line, which however was of very short duration having only continued about six weeks, when each partner took his proportionable share of the stock & debts due. In the month of June of this year this examinant purchased a note drawn by John Swanwick[2] late merchant of this City for the sum of One thousand Dollars & payable in about four months from the time of buying it. In the same month of this year, this examinant purchased four more notes amounting to the farther sum of Four thousand Dollars payable in five months from the date of the purchase. Before these notes became due they

had depreciated to almost nothing, in the short period of four months, they sank in value from 5 [shillings] in the pound to less than one. By this speculation this examinant lost a sum of nearly Two thousand dollars. Shortly after this, this examinant lost by the insolvency of John P Wagner[3] a further sum of Six hundred dollars, being a debt due by the said Wagner for Goods purchased of this examinant. Having sustained these losses in so short a time this examinant found himself pressed by his debts and with great difficulty getting on in his regular business. He once more made an effort to regain some thing and for this purpose borrowed of Messrs John Reid & Co.[4] the sum of Seven hundred & thirty Dollars for which Deposit was made in Plate & Plated ware, watches, etc. to much greater value. Before this note became due Reid & Co. failed, having sold the Goods which were deposited as security to them for money lent and the note was endorsed to Messrs Johnston & King[5] of this City. This note was demanded as a Debt due by this execution and after it had passed into various hands, he discharged nearly the whole of it, rather than to suffer a suit or being harassed by the incessant clamors of the holders. Having sustained the losses above enumerated, this examinant was obliged to make great sacrifices in raising money and found it absolutely impractical to carry on business to any Advantage. Suits were brought against him & Judgments were obtained in the Spring of the year 1798 under which executions were issued against this examinant's property & sold to great sacrifice. Stripped of every thing this examinant for the space of nearly two years from that time was obliged to work as a Journeyman at his business for the support of his family, but having by some good bargaining accumulated something, he found himself able to discharge very considerable debts & did actually pay after his Insolvency a sum of Fourteen or Fifteen hundred Dollars. In the month of March of the present year this examinant found himself able by means of his Credit to deal to some extent and Advantage by purchasing at vendues & by that means as well as by [my] own Labour. But having several creditors, his business did not permit the discharge of their demands as promptly as their wishes urged the payments, and accordingly he was obliged to submit to a surrender of his property under a writ of Bankruptcy.

Samuel Alexander's career, as gleaned from this transcript as well as from short-term addresses in the Philadelphia directories, advertisements, legal notices, and sparse genealogical connections, suggests that he was temperamental, lacked a guiding hand, had little or no financial resources, and from the outset was unable to manage his business through episodes of inflation, shortage of specie, and disruptions in trade, all of which were the norm in the period between the

signing of the Constitution and the War of 1812.[6] He bounced from one enterprise to another in his dealings with the silversmiths Liberty Browne, Anthony Simmons, and Christian Wiltberger (q.q.v.). His name always came second in partnerships and printed notices, as in Wiltberger and Alexander, and Simmons and Alexander.

Documents uncovered to date do not perfectly establish a pedigree for the silversmith. His path intersects with two Presbyterian families occupied in the metals trade, principally Alexander Alexander (1707–1776), a blacksmith in Southwark, and George Goddard (1748–1826), similarly employed in the Northern Liberties.[7] Both blacksmiths were prosperous and had close family ties. Alexander Alexander served the shipbuilders in Southwark. He owned a wharf and storehouse on the waterfront, a large section of Petty's Island in the Delaware, and leases in the Chestnut Ward in 1769 and 1774.[8] George Goddard owned and was the grantor of some ten properties between 1777 and 1820, and the grantee of at least eight. The U.S. Direct Tax of 1798 lists him as the owner of seven brick and three wood structures in the Northern Liberties, with a value of $8,350.[9] His inventory taken in October 1826 included investments (for example, $1,000 in Union Canal), various notes to hand, a loan to the New Market in the Northern Liberties, Samuel Alexander's bond dated 1808 for $588.77, and a bond or mortgage dated 1813 for $5,000 of son-in-law William Heiss, coppersmith.[10] George Goddard's inventory continued with earned rents and ground rents; complete house furnishings, and the tools of his trade. His silver plate included spoons, a tumbler, a sugar dish, a cream jug, a soup ladle, and a strainer valued at $54.17. The total estate was valued at $7,208.96 1/2.[11]

With some prudent management, these family connections in the metalworking community might have carried Samuel Alexander. His grandfather Alexander Alexander had three daughters and a son, William. Alexander Alexander's daughter Margaret married Lewis Grant (1737–1785), a coppersmith, in 1764 at the Second Presbyterian Church.[12] Lewis Grant had apprenticed with William Heiss, whose son W. Heiss Jr. married Rachel Goddard, sister of Samuel's wife Mary Goddard Alexander, in 1812. Lewis Grant was related to the silversmiths William Grant (died 1756) and his son William Grant Jr., who in 1799 was listed in the Philadelphia directory at 387 North Third Street near Coates Street in the Northern Liberties. Alexander Alexander's daughter Ann married Anthony W. Robinson, a jeweler and silversmith located at 36 Chestnut Street in 1799, at the time one block from Samuel

Alexander.[13] In 1801 Robinson was in a property that Jeremiah Boone (q.v.) had occupied at 30 South Second Street, and the other end of that lot was 13 Strawberry Street. Samuel Alexander was at 44 Strawberry Street in 1796.

Alexander Alexander's son William was baptized on March 21, 1745, at Philadelphia's First Presbyterian Church.[14] Archival records at the University of Pennsylvania note that Alexander Alexander, blacksmith, was paying tuition for his son William between 1759 and 1760.[15] He may have worked with his father until he enlisted in the militia.[16] In 1774 William was paying ground rent and tax in Southwark and had married Eleanor Sumner (date and place unknown). His father, Alexander Alexander, died suddenly in 1776 and left all his blacksmith's tools and one-third of his considerable real estate in Southwark to William, then serving in the militia, whose whereabouts were unknown at the time of his father's death.[17] He had been captured in New York by the British in 1777, and was imprisoned there and held in their service until June 1779.

On June 21, 1779, William Alexander was back in Philadelphia and took the Oath of Allegiance to Pennsylvania.[18] He did not become a blacksmith but a mariner. In 1780 he left the city on a trading voyage to the West Indies. His ship was taken and he was imprisoned at Charleston, South Carolina. He had not returned by 1784 when John Robertson and Lewis Grant placed an advertisement for information about his whereabouts, offering a reward of $60 for information.[19] Alexander had returned by 1787 and was paying an occupation tax of £25 in Southwark. The U.S. census of 1790 located him in Bucks County with one male under sixteen (Samuel?), and one male and one female (wife, Eleanor Sumner) over sixteen.[20] In 1797 William and Eleanor moved to Philadelphia, where they lived in Southwark on property that had been owned by his father, the blacksmith. William was listed first as a "bottler," subsequently as a "grocer," and in 1798 was at 284 South Second Street, corner of Shippen Street, where he remained until his death in 1804.[21] On March 10, 1804, the *United States' Gazette*, carried an advertisement for sale by auction of William's buildings: "Sundry brick buildings and lot of ground, situate on the north west corner of Lombard and 5th streets, at present occupied by William Alexander, as a grocery store—the lot is 15 feet front, by 43 deep, the whole of which is covered with new brick buildings, subject to yearly ground rent of £16. 7s. 6d. no other incumbrances, and a good title." In 1829 Eleanor Alexander, widow, was at 29 Shippen Street; her grandson(?) Samuel, oysterman, son of Samuel and Mary Alexander, was

at 165 Shippen Street. A William G. (Goddard?) Alexander took over the grocery at the corner of Second Street and Shippen.[22]

Samuel Alexander, Philadelphia silversmith, seems to have set out on a traditional path. According to his deposition of 1802: "in the year one thousand, seven hundred ninety five, this examinant entered the Business as a Goldsmith & Jeweller, having served a regular apprenticeship thereto." He may have apprenticed with Joseph Lownes (q.v.), who was located in Southwark at the same time as Liberty Browne. On December 5, 1797, Samuel Alexander and Liberty Browne, both with shops in the Northern Liberties, were appointed together to appraise the stock of the shop of the partnership of John Houlton, John Lawrence Otto, and John Folk.[23] Silver made by Joseph Lownes is distinguished by its plain surfaces with fine bead details, and Alexander's work is similar. He surely did some work for Lownes after 1798, probably as a journeyman, because he used his distinctive eagle stamp on silver marked by Lownes.[24] Alexander was a versatile silversmith and seems to have made most forms required for his domestic market.[25] His engraver, not yet identified, used elaborate ermine mantel surrounds for fine, foliate initials, and bands of circles or a vermicelli pattern on fluted forms. The engraving is similar to some on silver by John Aitken (q.v.) and Christian Wiltberger.[26] When Alexander worked with Anthony Simmons and subsequently in Virginia with Johnson & Reat, he made hollowware in a later style similar to some by Samuel Williamson (q.v.), with lobed, melon-shaped bodies with round or scalloped bases.[27]

In the bankruptcy proceedings of 1802, Alexander stated that he had set up shop on North Second Street in the Northern Liberties in 1795; as he is listed there at 213 North Second Street in the Philadelphia directory for that year, he was there or intending to be there in 1794 when the directory information was gathered. The same address was also listed as a location of George Goddard, blacksmith, who owned it and the two adjoining properties at numbers 211 and 212.[28] George Goddard may have set up Alexander after his apprenticeship because he would soon marry his daughter Mary (1781–1831), about 1797.[29] She was one of seven children of George Goddard (1748–1826) and his wife Margaret Switzer, who had married at the Second Presbyterian Church, Philadelphia, on April 10, 1777.[30] A marriage date for Samuel and Mary has not yet emerged in Presbyterian records or in marriage-license lists.[31] She must have been young, sixteen or seventeen, and Samuel was starting out with little or no capital. In 1796 George Goddard arranged and provided security

for Samuel Alexander for the purchase of a small property on Strawberry Alley for $1,570. Running between Second and Third streets and between High (Market) and Chestnut, it was a prime location for a silversmith's workshop.[32]

As Alexander stated in his deposition of 1802, he had done well in two years and saved $2,000, and he hoped to go into business in a bigger way. He moved his residence from his father-in-law's house to 27 Sassafras (Race) Street, next to Liberty Browne's mother and across the street from Nathaniel Browne, blacksmith. In May 1797 he purchased a share of the shop stock of the silversmith Anthony Simmons, who in 1795 had married into the wealthy Coates family of the Northern Liberties and intended to retire from the wholesale silver business to join the judiciary. Alexander's Strawberry Alley location was near Simmons's at 44 High Street, on the south side below Second Street and on the corner of Letitia Court. About the same time, still feeling expansive and about to join in a partnership, Alexander purchased, or more likely leased on ground rent, another very small house of 840 square feet, valued at $500 and located on the south side of Callowhill Street between Kunckle and Delaware Fourth streets, in the Northern Liberties, and measuring 12 by 74 feet: "bounded Eastward by a tenement and lot of Conrad Minniah, southward by a six foot wide alley from Kunckle to Fourth Street, westward by a tenement and lot of Frederick Mangold, and northward by Callowhill-street aforesaid; subject to a yearly rent charge of 22 dollars and 20-90th of a dollar, free of any taxes."[33] It was noted as unoccupied in the U.S. Direct Tax of 1798 and may have been an attempt at investment. When Alexander's profligacy caught up with him in 1799, it was "seized and taken in execution as the property of Samuel Alexander" and sold by Jonathan Penrose, sheriff.[34]

In the meantime, in June 1797 Christian Wiltberger advertised that he had moved from his establishment at 33 South Second Street and joined Samuel Alexander in a partnership as "Wiltberger and Alexander," with a manufactory and warehouse at 13 North Second Street, opposite Christ Church.[35] This was less than a block from Alexander's venture with Simmons at Letitia Court. Alexander seemed to be on a solid course. The partners had their shop mark made up using the full surnames as "WILTBERGER / & ALEXANDER" in a rectangle. Alexander was versatile, while Wiltberger was older and experienced. Alexander's silver products—swords, fluted urn-shaped vessels with fine engraving, and bird-back spoons—owe something to Wiltberger's skills and designs. About this time the partnership received an important commission, a tankard and

tray to be presented to Captain John Hodge by the City of Philadelphia for his role in 1796 saving the lives of 160 soldiers and sailors.[36] The tankard was marked only by Alexander, with his name mark and distinctive eagle stamp. The tray was marked with Wiltberger and Alexander's new partnership mark, and Alexander's eagle stamp. However, Alexander, inexperienced and possibly high-strung, came to believe that Wiltberger was not dealing with him honestly. A specific incident has not emerged in the records, but his cheeky newspaper notice declared that "I am neither dead, insolvent, or run away and as Mr. Wiltberger has authorized himself to settle the business without my knowledge, I have lately removed to the house formerly occupied by Mr. Wiltberger, in South Second Street, No. 33, where I mean to carry on the business in all its branches."[37]

At this time, in 1797 and 1798, Philadelphia newspapers and imported papers from Ireland were reporting the civic turbulence in Ireland, which translated into Philadelphia. Riots ensued caused by the "United Irishmen" protesting or celebrating the politics of their rights as citizens, and they stirred up a large number of the Philadelphia populace. Numbers of rowdy citizens were taken or sent to the Alms or Bettering House. Among those incarcerated: "John Aitken— insane—was here before, apparently restored and discharged, now returned as bad as ever and sent in by Joseph Anthony . . . Discharged June 26." "Insane" in this case meant very disorderly, probably drunk. Another admission entry, on June 19, 1798, recorded "Saml Alexander—insane—(He is one of the United Irishmen) sent in by Edwd Shoemaker . . Discharged June 26." Aitken and Alexander were not members of the United Irishmen but probably participants in the riots. Both discharged on the same day, Aitken and Alexander must have been well-known to Joseph Anthony Jr. (q.v.), an appointed Guardian of the Poor.[38] The Guardians of the Poor were elected by the city and districts and were responsible for keeping social order in their communities. Alexander's troubles began at this moment in his career.

In July 1799 he was forced to sell his ownership of the small house on Kunckle Street in which he had invested in 1796. Short of cash and credit, Alexander must have been suffering losses from his aborted partnership with Wiltberger, as well as carrying his investment in Simmons's shop stock. Simmons removed what was left of his stock at Letitia Court to 33 South Second Street, where Alexander had placed his stock when he broke up with Wiltberger in 1797. Alexander was again listed in the city directory at 213 North Second Street.

The sparse facts about Alexander's family are recorded in the Second Presbyterian Church burial records. Samuel and Mary lost two children (a Samuel and a Charles) as infants. Another son, also Samuel, was born in 1800.[39] In 1800 the silversmith Samuel Alexander was not listed in the city directory at any of his previous addresses. In 1801 he was recorded at 33 South Second Street. Although Simmons continued to be listed at 27 Sassafras Street, he appears to have come out of retirement in an effort to recover some equity in his stock purchased by Alexander. The U.S. Census of 1800 listed Simmons again at his old address, 44 High Street in the Chestnut Ward, with eight people resident.[40] Alexander resumed occupancy of his property at 22 Strawberry Alley in 1801. That same year Simmons and Alexander set about an ambitious business arrangement at Simmons's old location of 44 High Street (Letitia Court), which he still owned. On January 22 they placed an advertisement in the *Philadelphia Gazette*: "Anthony Simmons informs customers and the Public that he has just established a Manufactory OF ALL KINDS OF Silver Ware, Jewellery, etc . . . [w]here may be had any article in that line of the newest fashion and most approved taste. . . . ALSO, An Elegant Assortment of Plated Ware—Cheap." In the same advertisement, under Simmons's notice, the following appeared: "SAMUEL ALEXANDER [r]equests his friends and customers to call at the above Manufactory, where they can always be supplied with work of his manufacture, at the former low prices." The advertisement also noted that Simmons and Alexander required "three or four lads of reputable connections" to be taken as apprentices.[41]

When the Maryland silversmith Thomas Bruff (q.v.) came to Philadelphia, also in 1801, to promote his newly invented spoon-making machine—which he guaranteed would yield a finished product, including maker's mark, in twenty seconds—Alexander and Simmons arranged a public performance of the machine, which they praised as quick and efficient. In spite of being on the tipping edge of bankruptcy, if not insolvent, Alexander proceeded to purchase the rights to the machine from Bruff with an accommodation for sharing some profits. It was not a success for either silversmith.[42]

At that time Simmons and Alexander used separate name marks on their products.[43] In the first year of their joint business venture, they were sought out by Thomas Jefferson's agent to fashion a silver askos based on a wood model that had been owned by Jean-François-Séguier (1703–1784), who had excavated the Maison Carrée at Nîmes. Jefferson had brought the model back from France. An unusual and important commission, it is marked clearly with the names of both Simmons and Alexander, and the latter impressed his special eagle mark twice between the name marks.[44] The commission was probably via John Swanwick, from whom Alexander had borrowed money, and who knew Jefferson and was partial to helping young craftsmen.

This small, distinctive eagle mark, with its head facing right over its left wing, was probably made for Alexander by George Armitage (q.v.), who used a very similar one for himself (see cat. 24). He was a silver-plate manufacturer who was actively producing Indian silver and small brass, copper, and silver-plated insignia, especially winged eagles on cockades for military use on caps and uniforms.[45] If Alexander was inspecting arms for Tench Coxe as has been published,[46] he was in the same business as Armitage. It is possible to track a tentative path for Alexander's career at this point, as the appearance of the device—which has also been found on silver marked by Johnson & Reat of Richmond, Virginia—suggests that he had a hand in the production of an object.[47]

George Goddard remained Alexander's chief creditor. On April 21, 1802, Goddard covered the silversmith's debts to William Carr, jeweler and engraver, for $400 and $250, sums Alexander owed for a two-story frame house and lot on the south side of the Upper Ferry road in Blockley Township; the property had been owned by Samuel Williamson in 1800. The agreement was signed by all parties in May 1802 with a special note: "the said Mary being separate and apart from her husband declared she signed voluntarily."[48]

Goddard must have been maddened by Alexander's continuing profligacy when he brought the case of bankruptcy against his son-in-law in March 1802. The first notice was issued to Alexander by Richard Peters, judge of the U.S. District Court on April 28, 1802, and a schedule was formally presented on May 3. On the following day John E. Hall, "assistant to the messenger," tried to deliver a copy of the bankruptcy notice at Alexander's house but was told by his wife that he was not at home. He was not at home because he had fled the city. The engraver William Carr and the goldsmiths Alexander Stedman and James Smith were called to testify at the first hearing. Smith's testimony on May 4, 1802, is especially poignant:

> In the afternoon of Tuesday or Wednesday, I think the latter, being the 28th day of April last, the said Alexander came to the house of the examinant and asked him if he would go across to Jersey with him, the examinant being busy at last told him that it would be inconvenient for him, but being solicited went over with him. After they had spent the afternoon of that day there, the examinant mentioned that it was time to think of returning, the said Alexander then told thy examinant that "I could not return as the Sheriff was after him, I was afraid of being arrested"—the examinant

then parted with him and came across the River to Philadelphia.[49]

William Carr, who also testified at Alexander's inquiry on May 5, 1802, boarded with and engraved for Samuel Williamson, and it was probably with Williamson that Alexander served as a journeyman. Carr testified that he had known Alexander for two years, during which time he maintained his business as a goldsmith but also dealt extensively in other goods, including hardware, plated ware, and groceries. Transactions with Alexander were entered in Williamson's book as account number 19. He was making small purchases of scissor chains, gold lockets, and so forth, which he paid for intermittently.[50] On May 18, 1803, Alexander paid Williamson $23 for a set of casters. In April 1804 Alexander presented a bill for $55.40 to Jean-Simon Chaudron (q.v.) for one set of casters weighing 22 ounces, which Chaudron then sold to the banker Stephen Girard, providing further evidence that Alexander was "jobbing" as well as manufacturing.[51] The castor stand is unmarked.

Carr's testimony was followed on May 5 by that of George Goddard, who stated that he was owed $1,052.76 by Alexander "for money lent, money paid, and for [b]oarding," as well as $75.00 for money paid on behalf of the silversmith. Goddard had "not received any security or satisfaction whatsoever, save and except a Bond & Warrant of Attorney" for $1,798 for the first sum and a promissory note for the latter, drawn by Samuel Alexander to Batist Lamar [sic] (Benjamin Lamaire, q.v.).[52]

On May 30, 1802, the commissioners of bankruptcy made an assignment of Alexander's estate and effects to Goddard, as he was "the only Creditor of the bankrupt who had proved his debt under the Commission."[53] Alexander's inventory taken at the time consisted of one bureau, nine chairs, two mahogany tables, one walnut table, one timepiece, one looking glass, eight prints, one pair of andirons, a shovel and tongs, five tea caddies, and about six dozen plated teaspoons.

He continued to seek work throughout the bankruptcy proceedings and afterward. In 1802 he was still listed at 22 Strawberry Alley, presumably the Alexanders' residence and probably his workshop.[54] On October 8, 1803, Samuel Alexander plunged into another real estate investment, entering into a deal for an indenture of lease subject to taxes and a yearly rent of $27.37 1/2 for ninety-nine years. The property was owned by an Irishman in Ireland, and the transaction was arranged through John Snyder, a blacksmith on Poplar Lane in Philadelphia. This property was bounded on the east by Old York Road, and on the west by Sixth Street and the estate of John Dickinson, Esq. Alexander paid the fee of $200 on November 8, but on November 20, 1803, he made over the lease to "Thomas Wallis, silversmith," in Philadelphia.[55] On October 22, 1804, Alexander was two years behind in payment of fees and was forced to deed the property to Gabriel and John Kern, tailors.[56] Mary Alexander is not mentioned in this document.

By 1804 Simmons and Alexander had resumed their business together at 17 South Second Street, located at the Second Street end of the Strawberry Alley property,[57] a few doors south of the Dupuys (q.q.v.). At some point between 1800 and 1807, by which time he had built a reputation for making swords, Alexander made a "very handsome saber" for Jonas Simonds, a Revolutionary War veteran.[58]

To satisfy more of George Goddard's claims against him, Samuel and Mary Alexander signed off on their title to the 16-by-80-foot property on Strawberry Alley that had been purchased at auction in 1796, returning it to Goddard in 1805 with the proviso that Alexander promise not to contest the title change. The document was signed by both Samuel and Mary Alexander.[59] The deed also noted, in the usual manner, that Mary had signed voluntarily. After her signature, however, the clerk added "wife-in-law," raising the possibility that by 1805 Mary and Samuel Alexander were estranged, although the designation may have been a means to protect Mary's property from Samuel's debts.[60] In 1807 Samuel Alexander was listed in the city directory at George Goddard's property at 213 North Second Street, where he had started out in 1797. A daughter Caroline was born in 1808.[61] In 1809 Anthony Simmons, listed in the city directory of 1809 as "late goldsmith," finally became a judge in the District Court, but Samuel Alexander dropped out of the directory and does not reappear.

By 1807–8 Philadelphia metalworkers were active in the production of arms, swords, and military paraphernalia for rapidly growing militias sponsored by the U.S. government and individual states and in anticipation of war with the French.[62] Federal armories and private manufacturers were publicly funded. The U.S. Congress had passed legislation and appropriation "for the purpose of providing arms and military equipment for the whole body of the militia of the United States, either by purchase or manufacture."[63] Alexander is said to have been appointed as a U.S. Inspector of Arms in Philadelphia in 1808 by Tench Francis Jr., commissioner of military supplies.[64] That year Alexander rejected ninety-three swords made for the Pennsylvania militia by William Strong because the hilts on iron blades by Diedrick & Co.

were lightweight and inadequate.[65] At the time Strong was listed in the city directory at 22 and 24 Sassafras Street, where Liberty Browne and his mother had been, next door to Anthony Simmons. In the following year, 1809, Mary Alexander would be across the street at number 33. Fletcher & Gardiner, Jacob Kucher, Harvey Lewis (q.q.v.), Liberty Browne, Christian Wiltberger, and General James Wolf, among others, were active in pursuit of military commissions.[66] Alexander probably worked in more than one shop, having previously been associated with Wiltberger, who had purchased sword blades from Lewis Prahl (died 1809), the owner in 1793 of property on Kunckle Street, where Alexander had first purchased property.[67] In June 1808, ever the opportunist, Alexander acquired nine silver gorgets and two mahogany boxes—probably from George Armitage—and sold them to Tench Coxe, who charged the items to the Indian Department.[68]

James Winner was a Philadelphia smith who traveled to Virginia, secured a contract, and returned to set up shop in Philadelphia in 1807.[69] Philip Hartman, listed in the city directory as gold- and silversmith at 27 South Second Street, also traveled to Virginia and returned to Philadelphia in 1813 with commissions.[70] Alexander was not a block away from Hartman, at 17 South Second Street, and he too must have left Philadelphia for Virginia seeking a commission. It may have been Samuel Williamson who provided Alexander's contact in Richmond with the silversmiths Reuben Johnson (1782–1820) and James Reat (1782–1815), as he had commissions from them.[71] To support himself there, Alexander may have served as a journeyman in the firm of Johnson & Reat, where his distinctive eagle stamp has appeared on silver hollowware marked by the firm; the style of some Johnson & Reat ware is similar to sets produced by Simmons and Alexander.[72] After Alexander left for Virginia, his wife and family moved. From 1810 to 1814 Mary was listed as a "shopkeeper" at 33 Sassafras Street (north side). The U.S. Census of 1810 notes her as head of household at the same address, in the Upper Delaware Ward, with three males and one female under age ten, one female ten to fifteen, and herself, twenty-six to forty-four.[73]

In the Virginia records he was identified as "Samuel Alexander of Richmond," suggesting he may have intended to make a permanent move. He was still there in 1815 when James Reat died on February 25 and the firm closed. Alexander saw the opportunity to seek a commission on his own. In March 1816 he received a contract to make seven swords, and in April he was advanced £300 toward the project.[74]

Samuel Alexander must have returned to Philadelphia to fulfill his contract. In January 1817 he was paid an additional $300 for materials.[75] In 1817 Mary moved to 74 North Fourth Street, possibly to accommodate Samuel's return.[76] The location was just off Sassafras Street and very close to Alexander's old property on Kunckle in the South Delaware Ward. He completed one sword, for Colonel George M. Brooks. In a document now in a private collection, Alexander stated that he had been personally involved in the goldsmithing of the "Gaines & Scott" swords.[77] He may have been working with James Winner of Philadelphia, who was contracted to make swords for Scott and Gaines.[78] At his death Alexander had not completed the commission, probably due to his destitute situation and the failure of his "surety."[79] In a letter to Virginia officials, Mary offered the unfinished work, but the offer was rejected and the unfinished work distributed to creditors.[80] Winfield Scott wrote to Thomas Randolph, the governor of Virginia, on July 7, 1821, thanking him for the possibility of a "solid gold sword to be made by Fletcher and Gardiner in Philadelphia."[81] Whether this was originally the Alexander commission is not clear.

The exact date of Samuel Alexander's death is uncertain, but Mary Alexander is noted in the Philadelphia directory of 1820 as "Alexander, widow Mary," at a boarding house at 302 Vine Street. Thus he died in 1819 or before. He does not appear in the U.S. Census of 1820, which shows Mary in the South Mulberry Ward in the boarding house with two males under age ten, one female ten to fifteen, one female sixteen to twenty-five, and two females twenty-six to forty-four engaged in commerce. Mary appeared in the city directories at 74 North Fourth Street until 1822. She was listed as a "widow" in the city directory of 1823 at a boarding house at 202 Vine Street. In the U.S. census of 1830, the household consisted of herself and one male age ten to fourteen. She was listed at that address until her death, which was given full notice in the *Philadelphia Inquirer* on February 26, 1831.[82]

A clause at the end of George Goddard's will, written in 1825, clearly stated his frustration with Alexander and perhaps with his other son-in-law, the coppersmith William Heiss (husband of Margaret Alexander): "for benefit of daughters, rents, income, interest, issues & profits . . . and not withstanding any coverture, without being in the power or control of her husband, or subject to his debts, contracts or engagements."[83] Numbers of items in the full inventory taken at Goddard's death in 1826 reappear in Mary's extensive inventory, taken in March 1831 by Samuel Harvey Jr.

(her son-in-law), William Heiss (her brother-in-law), and Peter Yeager (her son-in-law, husband of daughter Caroline Alexander).[84] Curiously, there is no mention in her will of her son Samuel Alexander Jr. (1800–1831).

George Goddard had protected Mary's inheritance from Alexander's debts.[85] Her household inventory included mahogany furniture, pictures, fancy chairs, ingrain carpet, mantle ornaments, "a l[o]t of boys clothes," and a "lot of books" with a relatively high value at $3.00. Her silver was estimated at thirteen pieces valued at $26.88, and she had nine shares in the Northern Bank at $387.00.[86]

In sad contrast, the report of Harrison Hull, the bankruptcy agent sent to Alexander's home in April 1802 to seize possessions, noted the following: "I have seized and taken into my possession and now have in my possession ready to be delivered to such persons as the Commissioners within shall appoint—one book—that being all the property belonging to the within named Samuel Alexander."[87] BBG

1. Records of the U.S. District Court for the Eastern District of Pennsylvania, Bankruptcy Act of 1800, case no. 80-85, box 18, folder 83, National Archives at Philadelphia, NARA. I am grateful to Jefferson M. Moak, archivist, NARA, Regional Archives, Mid-Atlantic Region, for his assistance in making these and other bankruptcy records available to me. Notices of Alexander's bankruptcy appeared in the *Pennsylvania Gazette* (Philadelphia), May 6, 1802, and the *New-York Herald*, May 22, 1802; the fact of his bankruptcy was established in April 1802.

2. John Swanwick (died 1798) also went bankrupt; Records of the U.S. District Court for the Eastern District of Pennsylvania, Bankruptcy Act of 1800. Swanwick was a Republican against excise taxes in 1797–98 and may have been Samuel Alexander's conduit for information about the American Society of United Irishmen. See *Philadelphia Daily Advertiser and Universal Gazette* (Philadelphia), July 26, 1797.

3. The Philadelphia directories from 1798 to 1803 list John P. Wagner (active 1798–1810), merchant, at 25 South Second Street.

4. John Reid, shopkeeper, Fifth Street between Race and Vine; Philadelphia directory 1785, p. 59 (as John Read).

5. Johnston and King, merchants, 55 South Water Street; ibid. 1798, p. 78.

6. It has long been thought that Samuel Alexander was the first Jewish silversmith in Philadelphia (see "Philadelphia Silversmiths," Brix Files, Yale University Art Gallery), but that turns out not to be the case. He may have been confused with the Samuel Alexander who was a founder of the Congregation Beth Shalome in Richmond, Virginia, in 1791, and who with his brother Solomon was a merchant in Virginia; the two were listed as founders of the Jewish congregation of Mikveh Israel in Philadelphia in 1782. See Henry S. Morais, *Jews in Philadelphia before 1800* (Philadelphia: Levytype, 1894), p. 16; Edwin Wolf and Maxwell Whiteman, *The History of the Jews of Philadelphia from Colonial Times to the Age of Jackson* (Philadelphia: Jewish Publication Society of America, 1957), p. 191; Jacob Rader Marcus, *American Jewry: Documents, Eighteenth Century* (Cincinnati: Hebrew Union College Press, 1959). Not to be confused with Samuel Alexander (1774–1844) of Carlisle, Pennsylvania, who married Isabella Creigh in 1785 at the First Presbyterian Church in Carlisle (Tax and Exoneration Lists, 1762–1794); or Samuel Alexander (died 1828), merchant on Spruce Street (Philadelphia Administration Book N, no. 316, p. 220).

7. George Goddard (died August 23, 1826, age seventy-eight), Margaret Goddard, wife of George (died February 7, 1837, age seventy-eight), and their daughter Sarah Alexander Goddard (died November 4, 1829, age twenty-nine); Pennsylvania,

8. The Eighteen Penny Tax of 1769 noted his dwelling valued at £12, one horse, and money out on interest, and he was paying ground rent to Thomas Wells and John Annis. In 1774 his property and money out on loan were valued at £113 5s. 4d.; Tax and Exoneration Lists, 1762–1794. Whether Alexander Alexander died of natural causes or as a casualty of the Revolutionary War is not mentioned. He wrote his will on August 26, 1776, and it was probated on September 5, 1776; Philadelphia Will Book Q, no. 285, p. 341–43. Following his death Alexander Alexander's estate, including house furnishings, was promptly put up for sale on September 2, 1776, by his executors, Robert Knox and Edward Duffield, leaders in the Third Presbyterian Church; *Pennsylvania Evening Post* (Philadelphia), September 17, 1776.

9. George Goddard's properties are described in insurance surveys of the Mutual Assurance Company (Green Tree) Records, 1784–1995, HSP: survey no. 699, east side of Second Street, a few doors north of Vine; no. 700, east side of Second Street, north of Vine and corner of Goddard's Alley; no. 701, south side of Goddard's Alley.

10. Rachel Goddard married William Heiss on March 3, 1812; *Pennsylvania Archives*, 2nd ser. (1896), vol. 2, p. 570.

11. Mutual Assurance Company (Green Tree) Records, 1784–1995; Philadelphia Will Book 8, no. 136, p. 640. Access courtesy of Claudine Pipino, Department, Register of Wills, City Hall, Philadelphia.

12. "Record of Pennsylvania Marriages Prior to 1810," p. 573.

13. See Second Presbyterian Church (Philadelphia) records, Baptisms, marriages, burials, 1745–1833, HSP (hereafter Second Presbyterian Church records). Alexander Alexander's youngest daughter, Elizabeth, married William Bunn; New England Historical and Genealogical Register, 1868, p. 343, Ancestry.com.

14. *Register of Baptisms, 1701–1746, First Presbyterian Church of Philadelphia* (Philadelphia: Genealogical Society of Pennsylvania, 1954), HSP.

15. Another Alexander Alexander, a contemporary of William, and possibly related to the blacksmith but not mentioned in the will in 1776, was in Philadelphia at the time and then also enlisted in the militia. He was a poet of some local note who graduated from the University of Pennsylvania in 1764 and sought employment as a tutor authorized to collected tuitions; Minutes of the Trustees of the College Academy and Charitable Schools, University of Pennsylvania, vol. 1, 1749 to 1768. He served for three years and was removed for embezzlement, later excused for special circumstances. He married Catherine Campbell, daughter of John Campbell, in Philadelphia in 1764 and died in the Revolutionary War in 1777 (Catherine's name and the marriage date are noted on her petition for support in 1790; Philadelphia Orphans Court Records, 1719–1880, p. 311, file OR, no. 65, November 25, 1790, HSP). William Alexander became a teacher and seems to have moved to Bucks County until he enlisted as a private in Capt. McCalla's Company. Catherine was there in 1780. She returned to Philadelphia and applied for a veteran's pension in 1790. During her widowhood she became a teacher and remained a resident in and close to the blacksmiths' community in the Northern Liberties. The fine script in her signatures on her depositions and Samuel Alexander's on the inventory he signed with Liberty Browne are very alike in the formation of the letters. The possibility remains that Samuel was their son and was sent to Philadelphia for apprenticeship, as Joseph Lownes took on Liberty Browne in similar circumstances.

16. *Pennsylvania Archives*, 6th ser. (1906), vol. 1, p. 409.

17. William M. Clemens, *Alexander Family Records . . .* (New York: printed by the author, 1914), pp. 17, 18; *Pennsylvania Evening Post*, September 17, 1776.

18. Thompson Westcott, *Names of Persons Who Subscribed to the Oath of Allegiance of the State of Pennsylvania between the Years 1777 and 1789* (Philadelphia: John Campbell, 1865), p. 58.

19. *Pennsylvania Gazette*, September 22, 1784.

20. His sister Elizabeth Bunn was also in Bucks County.

21. A William Alexander was recorded in 1805 as dying in the Alms House; Philadelphia Administration Book K, no. 10, p. 196.

22. His wife Mary, two infant children, and son Samuel were buried in the Presbyterian ground; Second Presbyterian Church records. For general information on the genealogy of the Alexander family, see Walter Scott Alexander, *Sketch of Alexander*

Philadelphia Death Certificates, Index, 1803–1915, Ancestry.com.

Alexander, Who Emigrated from County Down, Ireland … (McConnellsburg, PA: Press of Commercial Print Co., 1898); Clemens, *Alexander Family Records*, pp. 17–19. Not to be confused with a Samuel Alexander who settled in Cumberland County, Pennsylvania, enlisted on October 10, 1776, and served as first lieutenant on the *Bull Dog*, an armed row galley; "*Pennsylvania Archives*," 3rd ser. (1897), vol. 23, p. 3; John Adams, diary 24, entry for September 28, 1775, "Adams Family Papers: An Electronic Archive" (Massachusetts Historical Society), www.masshist.org/digitaladams.

23. Copy of inventory courtesy of the Department of American Art, Yale University Art Gallery. It may have been their proximity and previous association as apprentices with Joseph Lownes that brought Alexander and Browne together for this appraisal.

24. Hollan 2010, p. 234.

25. A silver basket with handle and scalloped edge with fine engraving is unusual; Sotheby's, New York, *The Collection of Roy and Ruth Nutt: Highly Important American Silver*, January 24, 2015, sale 9304, lots 510, 511.

26. Some silver by Alexander has distinctive features of fluting and engraving found on Aitken's and Wiltberger's work. See Summer Americana Auction, *Important Collection of American Picture-back Spoons*, no. 1993, August 7, 2007, lots 1991–2002; Donald L. Fennimore, *Flights of Fancy: American Silver Bird-Decorated Spoons* (Winterthur, DE: Winterthur Museum, 2000), p. 29. Similar engraving details are also to be found on James Musgrave's silver. See Sotheby Parke Bernet, New York, *Fine Early American, English and Continental Silver from the Collection of Lansdell K. Christie*, May 17, 1968, sale 2705, lot 175; and the tea set by James Musgrave (PMA D-2007-54-58).

27. A coffeepot in this style bearing Alexander's distinctive eagle stamp is part of a set marked by Johnson & Reat; David B. Warren, *Southern Silver*, exh. cat. (Houston: Museum of Fine Arts, 1968), cat. L-8-D.

28. Philadelphia directory 1797, p. 15 (Alexander). This is a good example of not knowing whether the address is a residence or workshop. Goddard's other son-in-law, the coppersmith William Heiss, was there later.

29. Their marriage is not noted, but at least some of their children are recorded; Second Presbyterian Church records. They had several children, including Caroline (died 1847), who married Peter Yeager (1800–1832) as his second wife in 1829.

30. Ibid., p. 488; 2010 Death Certificates, Index, 1803–1915, Ancestry.com. George and Margaret Goddard named a daughter Sarah Alexander Goddard, born June 7, 1798, baptized December 12, 1802; Second Presbyterian Church records, pt. 2, p. 159, 481. It was unusual to have a surname as a middle name, suggesting a family relationship.

31. Not to be confused with Samuel and Mary Alexander of Somerset County, New Jersey; Calendar of Wills, 1771–1780, Bernardstown, New Jersey, bk. 18, p. 587, Ancestry.com.

32. See the introduction for a discussion of silversmiths' activity at this location.

33. *Pennsylvania Gazette*, July 2, 1799.

34. *Philadelphia Gazette and Daily Advertiser*, July 14, 1799; *Pennsylvania Gazette*, July 2, 1799. Samuel Alexander does not appear as a grantee or grantor in the Philadelphia Deed Index.

35. *Philadelphia Gazette and Daily Advertiser*, May 7, 1797. Wiltberger remained at 13 North Second Street. Coincidentally, silversmith John Aitken and engraver James Atkin, among others, were in and out of 33 South Second Street.

36. Metropolitan Museum of Art, New York, 1971.99.1, .2.

37. Wiltberger published the dissolution of the partnership in the *Philadelphia Gazette and Daily Advertiser*, June 1, 1797. Alexander answered in the same newspaper on June 7.

38. Recorded under Admissions, May 28, 1798, Assessment Ledgers, Alms House Records, Roll no. 211, Philadelphia City Archives.

39. He died in 1838 and was noted as single; Records of Union Cemetery (Sixth and Washington streets), Historic Pennsylvania Church and Town Records, HSP, Ancestry.com.

40. As Simmons was the "owner" of the 44 High Street building, and the new manufacturing project must have been established before the end of 1800, the census would have accounted for the new employees as well as his family household.

41. Alexander took on two apprentices: Aaron Pincus, who did not complete his six-plus years, and Julius Lefevre, who apprenticed for four years; Philadelphia Records of Indentures and Marriages, 1800–1808. John Felix LeFevre (q.v.) was active making swords in 1813 at 45 South Second Street; Hollan 2010, p. 17.

42. Ann Golovin, "A Silver-Spoon Machine, 1801," Clues and Footnotes, *The Magazine Antiques*, vol. 104, no. 2 (August 1973), p. 269.

43. Simmons's name in a rectangle, Alexander's in a wavy rectangle.

44. Thomas Jefferson Memorial Foundation, Monticello (1957-29); see Garvan 1987, p. 79, fig. 48. Susan R. Stein, *The Worlds of Thomas Jefferson at Monticello* (New York: Abrams, 1993), p. 57.

45. J. Duncan Campbell and Edgar M. Howell, "American Military Insignia, 1800–1851," *United States National Museum Bulletin*, no. 235 (Washington, DC: Smithsonian Institution, 1963), pp. x, 15.

46. Peterson 1954, p. 233.

47. I am grateful to Catherine B. Hollan for this information.

48. Philadelphia Deed Book EF-16-104.

49. Records of the U.S. District Court for the Eastern District of Pennsylvania, Bankruptcy Act of 1800, case nos. 80–85, box 18, folder 83.

50. Samuel Williamson, Daybook, Downs Collection, Winterthur Library. There may have been a relationship beyond the limits of this daybook, which terminates in 1811.

51. The bill from Alexander to Chaudron is illustrated in Robert D. Schwartz, *The Stephen Girard Collection* (Philadelphia: Girard College, 1980), cat. 44.

52. Records of the U.S. District Court for the Eastern District of Pennsylvania, Bankruptcy Act of 1800, case nos. 80–85; case nos. 162–166, box 31.

53. Signed John Hallowell, Joseph Hopkinson, and Thomas Cumpston.

54. Strawberry Alley ran between Second and Third streets and High and Chestnut. One end of the property abutted that of Daniel Dupuy Jr. (q.v.).

55. Philadelphia Deed Book EF-11-264. The Philadelphia directories of 1800 (p. 130) and 1804 (p. 244) note a Thomas Wallace, "taylor."

56. Philadelphia Deed Book EF-21-607.

57. The engraved billhead with names and the address is illustrated in Samuel W. Woodhouse Jr., "Two Silversmiths (Anthony Simmons and Samuel Alexander)," *Antiques*, vol. 17, no. 5 (April 1930), p. 327. It bears the date October 12, 1804.

58. Bruce S. Bazelon and William F. McGuinn, *A Directory of American Military Goods, Dealers and Makers, 1785–1915* ([Manassas, VA?]: privately printed, 1990), p. 2.

59. Philadelphia Deed Book EF-23-398, November 12, 1805.

60. A wife-in-law is generally defined as one who has abandoned her husband, or who provides domestic or social support but not love or affection. The Alexanders did not appear in divorce records investigated. In an 1800 deed of Christian Wiltberger, who was not a debtor, his wife was noted as "in law and equity;" Philadelphia Deed Book EF-10-21.

61. Second Presbyterian Church records. He served as Mary G. Alexander's executor in 1831; Philadelphia Administration Book N, no. 55, p. 386, March 7, 1831.

62. James Madison Research Library and Information Center, s.v. "Tench Coxe," www.madisonbrigade.com.

63. Quoted at ibid.

64. Peterson 1954, p. 233; Hollan 2010, p. 859n200.

65. See Peterson 1954, pp. 24–25; Bezdek 1994, pp. 23, 44.

66. Bezdek 1994 and Richard H. Bezdek, *American Swords and Sword Makers, Volume 2* (Boulder, CO: Paladin, 1999), list thirty-two makers.

67. See the biography of John Browne (q.v.); Bezdek 1994, p. 63; Bruce S. Bazelon, *Swords from Public Collections in the Commonwealth of Pennsylvania: With New Information Regarding Swordmakers of the*

Philadelphia Area (Lincoln, RI: Man at Arms Magazine, 1988), pp. 102–4.

68. *Journal of the Purveyor for Public Supplies*, vol. 21 (October 1807–June 1808), p. 97, Coxe Family Papers, 1638–1970, HSP. On Tench Coxe, see Stephen P. Halbrook and David B. Kopel, "Tench Coxe and the Right to Keep and Bear Arms, 1787–1823," www.davekopel.com/2A/LawRev/hk-coxe.htm (accessed December 9, 2016).

69. Bezdek 1994, p. 52.

70. Hollan 2010, p. 18. In July 1809 there was a letter at the Richmond post office addressed to a Samuel Alexander, as reported by the Richmond *Enquirer*, August 4, 1809. I am much indebted to Catherine Hollan for her engaging correspondence and research regarding the Virginia career of Samuel Alexander; see Hollan 2010, pp. 17, 18, 203, 859, 860.

71. Samuel Williamson, Daybook, Downs Collection, Winterthur.

72. The teapot in a service with full, lobed bodies with smooth upper sections marked by Johnson & Reat also bears Alexander's eagle mark; Kathryn Buhler, *Masterpieces of American Silver*, exh. cat. (Richmond: Virginia Museum of Fine Arts, 1960), cat. 330 (Historical Society, Richmond, 1997.156.1A-D). See also a cream pot in a similar shape with the same marks; Warren, *Southern Silver*, cat. L-8-E, n.p.; Hollan 2010, p. 18. A complete and handsome five-piece set made by Alexander, with the full lobed forms that became popular in the early nineteenth century, was offered by Pook & Pook Auctions, Downington, PA, January 15 and 16, 2010, lot 960.

73. These census records list her as head of household in 1810, 1820, and 1830. Presbyterian Church records do not show births or baptisms of children under the name Alexander who can be identified with those in the census.

74. The swords were for Colonel George M. Brooks, Major General P. Gaines, and Major General Winfield Scott, all of the U.S. Army; for relatives of Major Andrew Hunter Holme and Captain John Mitchel, both of the U.S. Army and deceased; and for Robert Henley and Captain Lewis Warrington, both of the U.S. Navy. Virginia General Assembly, House of Delegates, Office of the Speaker, Executive Communications Papers, State Government Records Collection, box 13, folder 27 (February 24, 1822), Library of Virginia, Richmond.

75. Hollan 2010, p. 18.

76. Philadelphia directory 1817, p. 43.

77. Cited in E. Andrew Mowbray, *The American Eagle-Pommel Sword: The Early Years, 1793–1830* (Lincoln, RI: Man at Arms Magazine, 1988), p. 217.

78. "Drawn from a document uncovered by Tharpe Collection researcher Karla Steffen"; ibid.

79. It has been suggested that Alexander may have died in New York in 1821 pursuing other sword work with the Targees; ibid., pp. 217–21. A Samuel Alexander was noted in the *Albany Argus* on January 8, 1821, and in the *New-York Evening Post* on November 3, 1821, as deceased and insolvent with no further identification. (Correspondence and research in New York City Archives was unsuccessful.) Philadelphia papers did not print such a notice in 1821. His name does not appear in an "Insolvent" list from 1821–30 in the Philadelphia City Archives. I am grateful to Jill Crawley at the Philadelphia City Archives for her assistance.

80. Hollan 2010, p. 18.

81. Brunk Auctions, Asheville, North Carolina, *Collection of a Virginia Gentleman*, June 13, 2015, lot 109. The sword commission awarded to Alexander was finished by Harvey Lewis in Philadelphia; Bazelon, *Swords from Public Collections*, p. 97.

82. "DIED./ On Thursday morning, 24th instant, Mrs. Mary Alexander, in the 50th year of her age. Her friends and those of the family are respectfully invited to attend her funeral, from the residence of her brother-in-law, Samuel Harvey, Jr. No. 292 [N]orth Third Street, this afternoon, at 3 o'clock." *Philadelphia Inquirer*, February 26, 1831. Mary died of smallpox; Second Presbyterian Church records.

83. The Goddards had seven daughters, Mary (Alexander), Nancy, Margaret (Heiss), Rachel, Sarah, Julia (the latter two, unmarried at the time of their father's death), and Catherine (deceased at

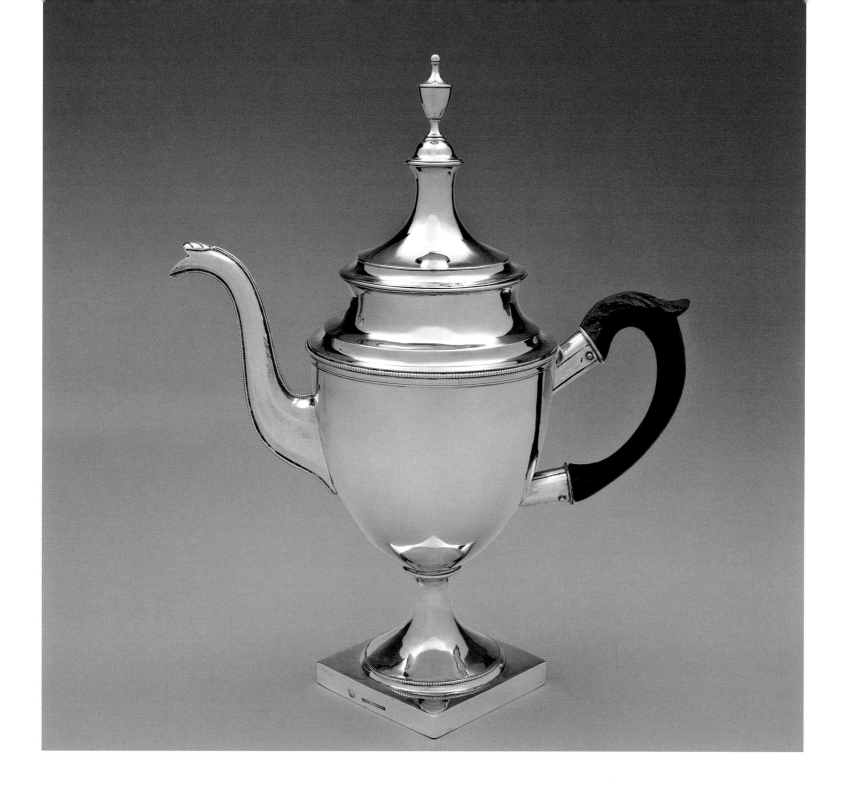

the time of her father's death). *Philadelphia Administration folder*, 1826.

84. *Philadelphia Administration Book N*, no. 55, p. 386, March 7, 1831.

85. George Goddard's inventory value was listed on October 20, 1826, as $7,208.96 1/2; Mary Alexander's on March 7, 1831, as $1,061.92; ibid.

86. A transcription of the complete inventory is in the curatorial files, AA, PMA.

87. See note 1.

Cat. 7

Samuel Alexander

Teapot

1801–5

MARKS: S·ALEXANDER (in rectangle, twice, with impression of winged eagle in conforming shape, twice on base exterior; cat. 7–1); 210.K (scratched, on one corner of underside of base)

Height 13⅛ inches (33.3 cm), width 10⅝ inches (27 cm), diam. 5⅛ inches (13 cm), base on each side 3½ inches (8.9 cm)

Gross weight 25 oz. 5 dwt. 5 gr.

Gift of the McNeil Americana Collection, 2005–68–116a,b

PROVENANCE: C. G. Sloan & Company, Washington, DC, *Public Auction: The Arthur J. Sussel Collection*, February 16–19, 1978, sale 707, lot 1520.

PUBLISHED: J. E. Caldwell & Co., advertisement, *Antiques*, vol. 75, no. 6 (June 1959), p. 511.

Cat. 7-1

This pot bears Alexander's name mark and his distinctive eagle stamp, which he may have acquired during his short partnership with Christian Wiltberger (q.v.). It appears on silver marked by Joseph Lownes and Johnson & Reat of Richmond that does not bear Alexander's name mark, suggesting that it was important to him that his authorship was noted here.

This is a typical late eighteenth-century-style Philadelphia pot with bands of beadwork set between the units of base, body, lid, handle sockets, and the join of the spout. The foot is distinctive in that it is set with a point of the square plinth under the spout. BBG

John Allen and John Edwards

| Boston, c. 1696–c. 1705

The lives and careers of the Boston silversmiths John Allen (1672–1760) and John Edwards (c. 1671–1746) have been thoroughly documented by Barbara McLean Ward.[1] The future partners probably met as apprentices of Jeremiah Dummer, who was Allen's step-uncle. Allen was the son of the Reverend James Allen, the assistant minister of Boston's First Congregational Church, and Edwards was the son of a ship's surgeon. Both silversmiths apparently worked independently for a few years prior to September 1696, when "John Edwards and John Allen Goldsmiths" were recorded as joint tenants of a shop in a building on Broad Street near the Boston Town House. In 1697 Allen married Edwards's sister Elizabeth (died 1749), making them brothers-in-law as well as business partners. At least twenty-one objects have survived bearing both of their marks, with dated examples ranging from the late 1690s to about 1705.

Allen and Edwards followed very different paths once their partnership ended. Allen received a significant bequest of land holdings in and around Boston from his father in 1710 and apparently thereafter lived comfortably as a "grazier," or owner of livestock. No silver has survived that can be dated after this point in his career, although he continued to refer to himself as a goldsmith in some legal documents. In contrast, Edwards was renowned for his diligence as a craftsman and operated a shop that for forty years produced the full range of hollowware and flatware forms for leading clients throughout Massachusetts. He trained two of his sons, Thomas (1702–1755) and Samuel (1705–1762), as silversmiths, and his grandson Joseph Edwards Jr. (1737–1783) was the third generation of the family to enter the trade, presumably trained by one of his uncles. DLB

1. Information in this biography is taken from Barbara McLean Ward, "The Edwards Family and the Silversmithing Trade in Boston, 1692–1762," in *The American Craftsman and the European Tradition, 1620–1820*, by Francis J. Puig and Michael Conforti (Minneapolis: Minneapolis Institute of Arts, 1989), pp. 66–91; and Kane 1998, pp. 141–45, 405–22.

Cat. 8

John Allen and John Edwards
Mug

c. 1696–c. 1705

MARKS: IE (in quatrefoil); IA (in quatrefoil) (both on neck near handle; cat. 8-1)

INSCRIPTIONS: [Southack crest] (dexter arm embowed and cuffed holding a bleeding heart gules)] (engraved, on front of body; cat. 8-2); AS / to / MC (engraved script, on underside; cat. 8-3)

Height 4⅛ inches (10.5 cm), width 5 inches (12.7 cm), diameter 3¹¹⁄₁₆ inches (9.3 cm)

Weight 6 oz. 3 dwt. 22 gr.

Purchased with funds contributed by Mr. and Mrs. Jesse Zanger (Cordelia Dietrich) and the Dietrich American Foundation, 2017-5-1

PROVENANCE: Mr. and Mrs. Ted Samuel, San Francisco (by 1941); sold by the Samuel family, Sotheby's New York, *Important Americana*, June 23–24, 1994, sale 6589, lot 119; Iris Kleban Schwartz (1921–2011), Morristown, NJ; Sotheby's, New York, *The Iris Schwartz Collection of American Silver*, January 20, 2017, sale 9606, lot 3269.

EXHIBITED: On long-term loan to the Los Angeles County Museum of Art, December 29, 1941–March 24, 1944.

PUBLISHED: "The Editor's Attic: First Cousins," *Antiques*, vol. 41, no. 6 (June 1942), p. 378, fig. 2; "Living with Antiques: Mr. and Mrs. Ted Samuel, San Francisco," *Antiques*, vol. 65, no. 1 (January 1954), p. 47; Sotheby's, New York, *Property from a Private West Coast Collection*, December 4, 2003, sale 7954, p. 74 (illus.); Kane 1998, pp. 144, 414.

The form of this mug, with its spherical body, ribbed neck, and strap handle ending in a scroll terminal, was derived from salt-glazed stoneware mugs made in the last quarter of the seventeenth century by Rhenish German potters (fig. 18). Large numbers of these mugs were exported to England and

Fig. 18. Mug with Portrait of Queen Mary II of England. German, 1689–94. Salt-glazed stoneware with cobalt and manganese decoration, height 5⁵⁄₁₆ inches (13.5 cm), diam. 4⁹⁄₁₆ inches (11.6 cm). 125th Anniversary Acquisition. Promised gift of Charles W. Nichols

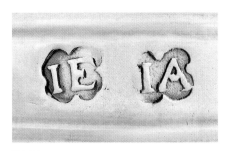

Cat. 8-1

Cat. 8-2

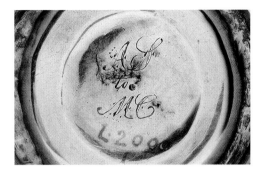

Cat. 8-3

its American colonies; as early as 1630 a German stoneware jug with silver-gilt mounts was brought from Suffolk, England, to Boston by Governor John Winthrop (1588–1649).[1] The German mugs were copied by English potters in both stoneware and delftware, as well as by Chinese potters in porcelain for the European and American export markets.[2] Silver versions of this form were made in London during the 1680s; an example by John Jackson (active 1684–1714) dated 1688–89 was owned in Talbot County, Maryland, and donated to St. Michael's Church in 1728.[3]

American silver mugs of this type are rare survivals, and all are marked by Boston makers who were contemporaries of Allen and Edwards, including John Coney and Edward Winslow (q.q.v.), both of whom also apprenticed with Jeremiah Dummer.[4] Coney's and Winslow's mugs are in the baroque style, featuring cast handles, gadrooned decoration on the bodies, and gadrooned moldings on the necks, whereas Allen and Edwards's mug is in an earlier, more austere style that remained popular among conservative, Puritan New Englanders. Barbara McLean Ward has observed that Allen's and especially Edwards's work adhered to the taste of their master's generation and largely eschewed the baroque taste brought to Boston by immigrant craftsmen.[5] Nevertheless, owning a silver version of a relatively inexpensive ceramic mug would have been an unequivocal statement of the owner's affluence and concomitant social position, reinforced by the heraldic crest engraved on the front.

The mug's history of ownership is undocumented until it was acquired by the antiques dealer Ted Samuel of San Francisco before December 1941, when he lent it to the Los Angeles County Museum of Art. However, the crest engraved on the mug suggests that its original owners may have been the merchant, mariner, and cartographer Cyprian Southack (1662–1745) and his wife, Elizabeth Foy (born 1672), who were married in Boston on February 19, 1690.[6] Elizabeth was the daughter of the mariner John Foy (died 1708) of Boston and his wife Dorothy.[7] Southack's will, written on May 9, 1743, divided his substantial estate between his survivors, children John (born 1692), Mary (born 1704), and Dorothy, and named his son-in-law Edward Tyng (1683–1755) as one of his executors.[8] The "AS" in the later engraved inscription "AS to MC" possibly refers to Ann(a) (Gibbs) Southack (1749–1817), who married Cyprian's grandson and namesake Cyprian Southack (1743–1805) in 1772.[9] DLB

1. Jonathan L. Fairbanks and Robert F. Trent, *New England Begins: The Seventeenth Century* (Boston: Museum of Fine Arts, 1982), vol. 3, cat. 393.
2. For German stoneware mugs made for the Anglo-American trade, see Jack Hinton, *The Art of German Stoneware, 1300–1900, from the Charles W. Nichols Collection and the Philadelphia Museum of Art* (Philadelphia: the Museum, 2012), pls. 19, 23, 29. For English stoneware mugs see Adrian Oswald with R. J. C. Hildyard and R. G. Hughes, *English Brown Stoneware, 1670–1900* (London: Faber and Faber, 1982), p. 29, pl. 3; p. 39, pl. 9; p. 276. For English delftware examples, see Ivor Noël Hume, *Early English Delftware from London and Virginia*, Colonial Williamsburg Occasional Papers in Archaeology, vol. 2 (Williamsburg, VA: Colonial Williamsburg Foundation, 1977), p. 31, pl. 19; p. 33, pl. 23. For Chinese porcelain mugs, see Arlene M. Palmer, *A Winterthur Guide to Chinese Export Porcelain* (New York: Crown, 1976), fig. 13.
3. Bigelow 1941, p. 169, fig. 90. A London example marked by "EG" in 1686–87 is illustrated in Deborah Stratton, *Mugs and Tankards* (London: Souvenir Press, 1975), p. 25; another marked by "TC" and dated 1689–90 is illustrated in Peter B. Brown and Marla H. Schwartz, *Come Drink the Bowl Dry: Alcoholic Liquors and Their Place in 18th Century Society*, exh. cat. (York, UK: York Civic Trust, 1996), p. 66.
4. Buhler 1972, vol. 1, cats. 39, 40; Francis J. Puig et al., *English and American Silver in the Collection of the Minneapolis Institute of Arts* (Minneapolis: the Institute, 1989), cat. 179.
5. Barbara McLean Ward, "The Edwards Family and the Silversmithing Trade in Boston, 1692–1762," in *The American Craftsman and the European Tradition, 1620–1820*, by Francis J. Puig and Michael Conforti (Minneapolis: Minneapolis Institute of Arts, 1989), pp. 68–70.
6. Clara Edli LeGear, "The New England Coasting Pilot of Cyprian Southack," *Imago Mundi* (Berlin), vol. 11 (1954), p. 142; *Dictionary of Canadian Biography*, vol. 3, s.v. "Southack, Cyprian," by Donald F. Chard, University of Toronto/ Université Laval, 2003– , www.biographi.ca/en/bio /southack_cyprian_3E.html (accessed January 30, 2017).
7. James Savage, *A Genealogical Dictionary of the First Settlers of New England*, vol. 2, *Surnames D–J* (n.p.: Jazzybee Verlag, 2016), s.v. "Foy, John."
8. Suffolk County Probate Records, vol. 38, pp. 39–42, Suffolk County Courthouse, Boston.
9. *New England Historical and Genealogical Register*, vol. 82 (1928), p. 287.

Jeronimus Alstyne

| New York City, born 1765
| Location unrecorded, died 1813

The Van Alstyne family came to America from Holland and settled first in the Kinderhook area of Columbia County, New York, from where members of the family migrated to Albany and New York City. Jeronimus Van Alstyne Jr., silversmith, was born in New York City, where he was baptized on April 8, 1765.[1] His parents were Jeronimus (1736–1807) and Edya Beekman (c. 1738–1807) Van Alstyne, who married in 1759. They were initially members of the Dutch Reformed Church in New York. Jeronimus senior was a blacksmith.[2] They took the king's side in the Revolutionary War and joined the English Church in New York.[3] After the Revolution the family dropped "Van" from their name.[4]

With whom the younger Alstyne apprenticed has not yet been discovered. His work is rare, and placing him by method or style has not been productive. He was working in New York in 1787.[5] He married Mary Ann Campbell on April 3, 1790.[6] In the tax records for 1791, he was listed as Jeronimus Alstyne "Junr." below his father, who at the time owned a house and two shops valued at £800, and whose personal estate was valued at £200. Jeronimus junior was noted as "in ditto"— that is, living in his father's property in the East Ward on Crown Street. His personal estate was valued at £50.[7]

The New York City directory for the year 1794 (compiled in 1793) listed Alstyne, "gold and silversmith," at 84 Market Street and his father at 5 Liberty Street.[8] By December 1794 Jeronimus junior had moved to Maiden Lane, where he took on an apprentice, Benjamin Wood (1780–1875), a young man who had departed Rockland County, New York, for the city, seeking an apprenticeship with a silversmith. Wood has left a touching diary of his association with Alstyne:

> After what was thought a remarkable passage, we were in N.Y. the next morning when I immediately inquired after and found a Mr. Dunn [Cary Dunn, q.v.]—a silversmith, a trade I wished to learn, but was sadly disappointed when he told me he was about winding up his business & did not want an apprentice; but he told

me a Mr. Alstyne 76 Maiden Lane might possibly want an apprentice. I immediately called upon him, he said he wanted an apprentice, but was afraid to take one, for he had two & was robbed by both of them, and but for kindly feeling he had for their parents, he would have sent them both to prison. . . . I told him I would strive to earn my victuals & clothes, he told me was much pleased with my confident assurance & that he would take me without further enquiry, that I might come immediately—on the next morning, being the 18th of December 1794, I commenced my apprenticeship, with an understanding that I was to be Bound at the earliest opportunity to serve till I was 21.[9]

From 1794 until 1796 Alstyne's shop was to be found at 76 Maiden Lane, a central location for the silver trade in New York City through the nineteenth century.[10] Initials engraved on the few pieces made by Alstyne suggest that he had prominent clients while in the city.[11] Much to the chagrin of his apprentice, however, work was slow. Wood's analysis of the situation may explain why Alstyne's silver is rare:

> My master and mistress were kind, I do not remember that I ever had an unkind word or look from either of them, but the master lacked energy, his father was wealthy, and his expectations large, he became indolent and neglected his business; his father in 1797 bought a farm in Westchester County and advised him to move with him there, and build a shop & continue his business there. He was not willing to part with me, and being bound I was obliged to go with him. Our workshop, on account of his want of energy, was a year in building, and was not in order for work till late in the season of 1798, the year of the terrible scourge of yellow fever in NY. . . . I also was taken sick and confined to my bed for about two months, and did not recover my strength to work for nearly a whole year. When I asked for my indentures, and obtained them . . . in the month of January 1799, I bid farewell to my master & his family.[12]

The death notice of Alstyne senior in 1807 suggests that he was prominent and perhaps formidable: "He was descended of one of the first families that settled in this city. . . . an honest man, the noblest work of God."[13] His son Jeronimus Alstyne Jr. died in Eastchester, New York, on April 19, 1813, was buried from St. Paul's Church, and was interred in the Alstyne vault.[14] BBG

1. Lester van Alstyne, *Van Alstyn–Van Alstyne Family History* (Provo, UT: J. Grant Stevenson, 1974), vol. 1, p. 30; "Silver by Jeronimus Alstyne," Accessions and Notes, *Bulletin of the Metropolitan Museum of Art*, vol. 16, no. 11, pt. 1 (November 1921), p. 239. See also Waters, McKinsey, and Ward 2000, vol. 2, p. 269.

2. In 1783 a Jeronimus Alstyne Sr., engineer (probably the elder Alstyne, a blacksmith), was appointed as a "freeman" in New York City; Kenneth Scott, *Rivington's New York Newspaper: Excerpts*

from a Loyalist Press, 1773–1783 (New York: New-York Historical Society, 1973), p. 344. "Alstyne, Jeronimus, Sen. Black-smith, 5 Liberty [Street]," is listed in the New York City directory for 1794.

3. Benjamin Wood, autobiographical statement, American Historical Manuscript Collection, New-York Historical Society.

4. "Silver by Jeronimus Alstyne," p. 239.

5. Ensko 1948, p. 15.

6. Information courtesy of Deborah D. Waters.

7. *Tax Lists of the City of New York, December, 1695–July 15th, 1699; Assessment of the Real and Personal Property of the East Ward, City of New York June 24, 1791* (New York: Board of Assessors and New-York Historical Society, 1911–12), vol. 44, p. 373.

8. *The New York Directory and Register, for the Year 1794* (New York: printed by T. and J. Swords, 1794), p. 4.

9. Wood, autobiographical statement.

10. Waters, McKinsey, and Ward 2000, vol. 2, p. 269, cat. 116.

11. "AL," for Aanatje Lansing, is engraved on a teapot in the Clearwater Collection of the Metropolitan Museum of Art (1933.120.523); "AVDB" (perhaps for Ann van den Burgh) on sugar tongs in the collection of the Museum of the City of New York (34.265); see note 10 above.

12. Wood, autobiographical statement.

13. *New York Gazette and General Advertiser*, July 27, 1807.

14. Alstyne, *Van Alstyn–Van Alstyne Family History*.

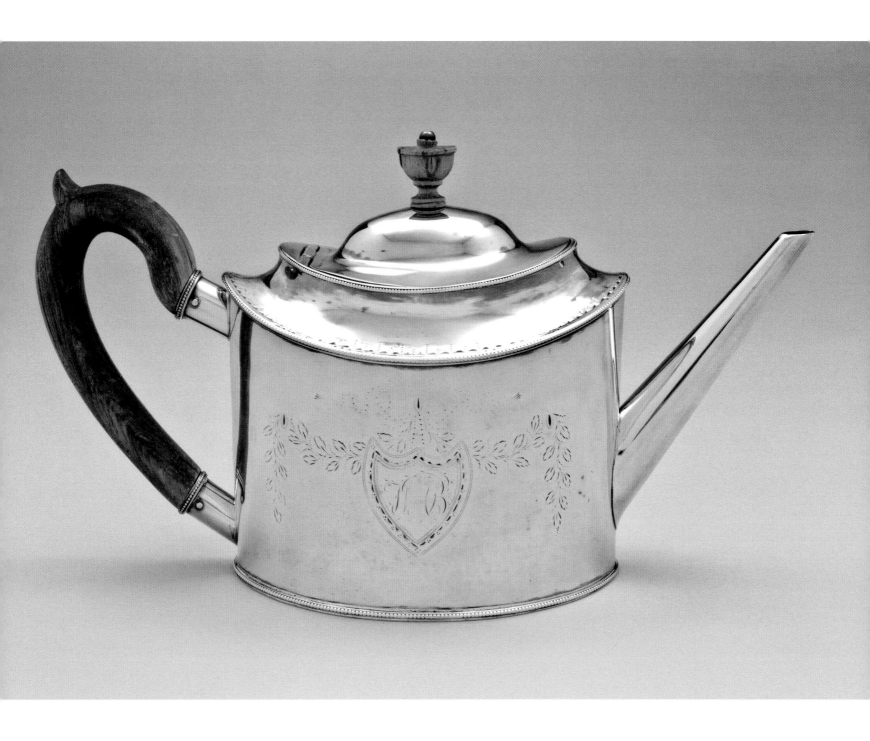

Cat. 9

Jeronimus Alstyne
Teapot

1790–95
MARK: J Alstyne (script on textured ground in conforming rectangle, on underside; cat. 9-1)
INSCRIPTIONS: T N B (engraved and enclosed in shield, on one side); ??B (in shield, on opposite side)
Height 6 11/16 inches (17 cm), width 11 7/8 inches (30.2 cm), depth 4 7/16 inches (11.3 cm)
Gross weight 21 oz. 5 dwt. 7 gr.
Gift of Mrs. John C. Russel, 1976-165-1

EXHIBITED: *Gifts to Mark a Century*, exh. cat. (Philadelphia: Philadelphia Museum of Art, 1976), cat. 99.

Cat. 9-1

The pot is seamed under the handle. The spout is seamed as well. There is a band of chasing and wriggle work around the shoulder and bands of bead around the edge of the base and the edge of the lid. The handle, and perhaps the finial, are replacements. The teapot is about the same size as another that Alstyne made for Aanatje Lansing.[1]

The initials are too worn to be read accurately enough to determine whether they are the same on both sides of the pot. Half the vertical strokes forming the letters and the curved flourishes joining the letters at the top are deep. They do appear to be by the same hand as the engraving on a tea service by the New York silversmith John Vernon (q.v.).[2] The other lines finishing the letters are light and have been polished away. What were fluttering ribbons at the top of the design have been reduced to dots. The shield and the leafy swags were accomplished with chasing tools and stippling. BBG

1. "Silver by Jeronimus Alstyne," Accessions and Notes, *Bulletin of the Metropolitan Museum of Art*, vol. 16, no. 11, pt. 1 (November 1921), p. 239.
2. Waters, McKinsey, and Ward 2000, vol. 2, frontispiece, p. 427, cat. 261.

Loring Andrews
& Company

| Cincinnati, founded 1895

Loring Andrews (c. 1855–1921), the company's namesake, was born in Cincinnati, the son of David B. Andrews (1822–1863) and his wife Maria Zeumar (or Zumer, 1835–1910).[1] His birth date was March 20; legal records offer conflicting information as to the year, ranging from 1853 to 1856.[2] David Andrews was a native of Coleraine, in County Derry, Ireland, where his father was a tanner.[3] Beginning in 1849, David Andrews advertised in Cincinnati newspapers as a watchmaker and jeweler; he was listed in the U.S. census of 1850 as a silversmith.[4] He died when his son was about eight years old, and although Loring may have inherited his father's tools, his subsequent career offers no evidence that he had training as a craftsman.

In 1873 Loring Andrews began working as a clerk for the Cincinnati jeweler William W. McGrew (1833–1893).[5] McGrew's firm went bankrupt in 1875 and was bought out by his employee Everett E. Isbell (1838–1917), a watchmaker who had established himself in Cincinnati as early as 1860, and Thomas Gaff, a distiller.[6] Andrews continued with Isbell's retail jewelry and fancy goods firm for two decades. Although listed in city directories as a clerk or salesman, Andrews apparently had acquired, when still in his twenties, a reputation for a sophisticated understanding of art. He served on the committee for the "Household Art" section of the 1879 Cincinnati Industrial Exposition, which included loans from Tiffany & Co. (q.v.), Sypher & Company, and the Pennsylvania Museum and School of Industrial Art (later known as the Philadelphia Museum of Art); Andrews himself lent a "carved and inlaid Swiss Chair," a sixteenth-century sword, an ebony frame carved by H. L. Fry, and a "shield, Henry IV."[7] In 1888, in an article in the Jewelers' Circular, he was described as an "authority on pottery."[8]

In 1895 E. E. Isbell & Company dissolved, and Andrews took over the firm with backing from the estate of Thomas Gaff and Gaff's relative Willard W. Howe.[9] Loring Andrews & Company, "Jewelers and Silversmiths," retained Isbell's premises at 107–9 East Fourth Street and employed Everett Isbell as a salesman.[10] The firm was listed in the city directory under the category of "Clocks, Bronzes, and Rich Fancy Articles" and became the Duhme & Co.'s (q.v.) rival as retail jeweler to Cincinnati's carriage trade.[11] As Amy Dehan has noted, there is no evidence that the Isbell or Andrews firms ever manufactured silver; after 1915 Loring Andrews became an authorized dealer for Samuel Kirk & Son (q.v.).[12] In 1903 the firm incorporated as the Loring Andrews & Company at 117 East Fourth Street, with Willard Howe as president, Loring Andrews as vice president, William H. Williamson as secretary, and Edward J. Morris as treasurer.[13] When the directors considered closing the firm in 1911, community pressure forced its reorganization; Andrews became the president, and Williamson the secretary and treasurer. The company's capital stock was valued at $120,600.[14]

Loring Andrews, who never married, lived with his widowed mother until her death. He died on August 24, 1921, and was buried at Spring Grove Cemetery in Cincinnati.[15] Loring Andrews & Company continued to operate as a retail jeweler until 1959, when it became Loring Andrews & Ratterman, Inc. Six years later the firm of Newstedt-Loring Andrews was formed after another merger, and it remains in business in Cincinnati.[16]

DLB

1. Dehan 2014, p. 40. David and Maria Andrews were married and living with her parents by 1850; 1850 U.S. Census.

2. Dehan 2014, p. 40, gives Andrews's birth year as 1856, based on Spring Grove Cemetery records; see Spring Grove interment record no. 95025, Spring Grove Cemetery, Cincinnati, www.SpringGrove.org/stats/95025.tif.pdf (accessed December 19, 2014). This year is consistent with information in the 1870 U.S. census, in which his age is recorded as fifteen, and the 1880 U.S. census, in which his age is recorded as twenty-four. However, on a passport application Andrews gave his birth date as March 20, 1854; application no. 15692, March 15, 1880, Passport Applications, 1795–1925, General Records, Department of State, NARA, Ancestry.com. The 1900 U.S. census recorded his birth date as March 1853.

3. William Andrews (1801–1825) was listed as a tanner in The Commercial Directory of Scotland, Ireland, and the Four Most Northern Counties of England, for 1820–21 & 22 (Manchester, U.K.: J. Pigot, 1820), p. 165; see also the Hawkesworth family tree, Ancestry.com (accessed October 5, 2016).

4. Elizabeth D. Beckman, An In-Depth Study of the Cincinnati Silversmiths, Jewelers, Watch and Clock Makers Through 1850 (Cincinnati: B. B. & Company, 1975), p. 5.

5. Dehan 2014, p. 40.

6. Ibid., pp. 180–82, 237; Williams' Cincinnati directory 1874, p. 85. Everett Isbell was listed as a jeweler in the 1860 U.S. census, and as a watchmaker in Williams's 1864 Cincinnati directory, p. 205. Isbell's death on April 19, 1917, was given in his internment record at Spring Grove Cemetery, Cincinnati; see memorial no. 78963311, www.findagrave.com (accessed June 23, 2015).

7. Catalogue of Paintings, Engravings, Sculpture, and Household Art in the Seventh Cincinnati Industrial Exposition (Cincinnati: n.p., 1879), pp. [unnumbered page after title page], 97, 105, 115, 124.

8. "On the Road: Cincinnati, O.," Jewelers' Circular, vol. 19 (July 1888), p. 44.

9. Williams's Cincinnati directory 1900, p. 108. Willard W. Howe was associated with the Sunny Side Distilling Company (ibid., p. 823). During his lifetime Thomas Gaff had been a partner in Perin, Gould & Company, Commission Merchants (ibid. 1864, p. 293); his estate is listed as a partner of E. E. Isbell (ibid. 1864, p. 765).

10. Ibid. 1900, p. 744.

11. Ibid. 1896, pp. 104, 1729, 1976.

12. Dehan 2014, pp. 40–43, 181.

13. Williams's Cincinnati directory 1904, p. 302.

14. Dehan 2014, pp. 42–43; Williams's Cincinnati directory 1915, p. 128.

15. Division of Vital Statistics, "Death Certificates and Index, December 20, 1908–December 31, 1953," Ohio State Archives, Ohio Historical Society, Columbus, Ancestry.com; memorial no. 78884423, www.findagrave.com (accessed July 7, 2015); Spring Grove interment records, Spring Grove Cemetery, Cincinnati, Springgrove.org (accessed December 19 2014).

16. Dehan 2014, p. 43. According to Manta.com, Newstedt-Loring Andrews's date of incorporation was 1969. The Ohio Secretary of State website gives 1996, perhaps a typographical error (both accessed June 3, 2013).

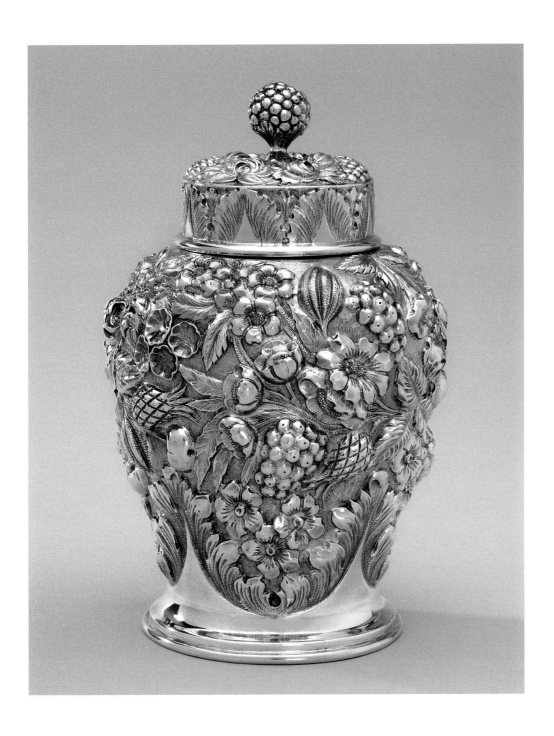

Cat. 10

Loring Andrews & Company
Tea Caddy

1895–1902
MARK: STERLING / LORING ANDREWS & CO.
(all incuse, on underside; cat. 10-1)
INSCRIPTION: J D G; (engraved script monogram,
on underside; cat. 10-1)
Height 6¼ inches (15.9 cm), diam. 4 inches
(10.2 cm)
Weight 8 oz. 3 dwt. 10 gr.
Promised Gift of Beverly A. Wilson

This caddy, an inverted baluster lavishly orna-
mented with chased foliage, fruit, and flowers,
was inspired by silver jars made in London in
the last quarter of the seventeenth century

Cat. 10-1

that in turn imitated Chinese porcelain prototypes.[1]
The plain, triangular shapes at the base appear to be
copied from the center part of the acanthus leaves
that often decorated such vases. Loring Andrews
retailed silver made by many companies in the
northeastern United States, including several manu-
facturers in Baltimore known for their allover chased
decoration.[2] The Stieff Company (q.v.) advertised
similar tea caddies and sugar sifters in 1920.[3] DLB

1. Charles Oman, *Caroline Silver, 1625–1688* (London: Faber
and Faber, 1970), p. 59, pls. 76a, 76b, 77.
2. Dehan 2014, p. 43.
3. *Stieff Handwrought Repoussé Sterling Silver* (1920; repr.,
Baltimore: Michael A. Merrill, 1991), pp. 57, 59.

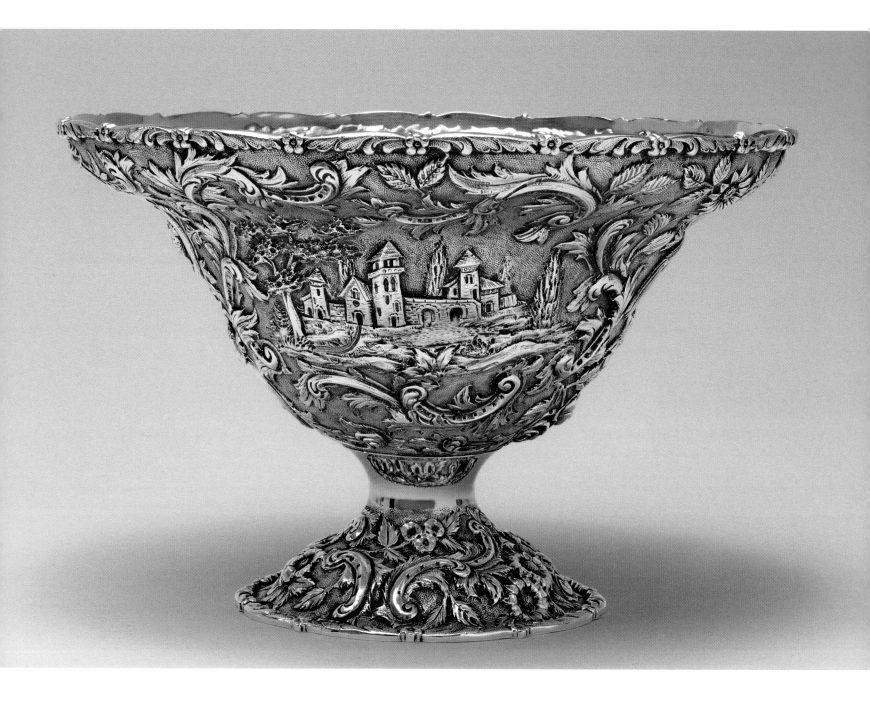

Cat. 11

Loring Andrews & Company
Bowl

1903–30
MARKS: STERLING / THE LORING ANDREWS CO. /
CINCINNATI U.S.A. / 87 (all incuse, on underside
of bowl; cat. 11-1)
INSCRIPTION: Z [triangle] 9 [triangle] (scratched, on
underside of foot near rim)
Height 5⅞ inches (14.9 cm), diam. 9³⁄₁₆ inches
(23.3 cm)
Weight 18 oz. 4 dwt. 14 gr.
Gift of Beverly A. Wilson, 2010-206-23

Cat. 11-1

This early twentieth-century bowl features allover
chased decoration of the type popular in the middle
decades of the nineteenth century. In comparison
with that on earlier objects, such as a pitcher made
around 1860 by Samuel Kirk & Son (PMA 1980-136-1),
the chasing on the bowl is executed in higher relief
but exhibits a decline in the quality of its composi-
tion and execution. DLB

Joseph Anthony Jr.

| Newport, Rhode Island, born 1762
| Harrisburg, Pennsylvania, died 1814

The sea trade brought the silversmith Joseph Anthony Jr. (fig. 19) to Philadelphia.[1] His father, Captain Joseph Anthony (1738–1798), was a socially prominent coastal shipping merchant who lived in Newport, Rhode Island, and traded in and out of Providence, Boston, Philadelphia, and occasionally the West Indies before the Revolution.[2] His sister Elizabeth (born 1728) married Gilbert Stuart Sr., a merchant with premises on Bannister's wharf in Newport.[3] Their son, the portrait painter Gilbert Stuart, painted Captain Anthony's family portraits.[4] It was the captain's reputation and his wife's connections that in large part made possible the success of their son Joseph junior, the silversmith.

On March 11, 1761, Captain Anthony married Elizabeth Sheffield (1739 or 1740–1799), the daughter of John Sheffield, in Portsmouth, Rhode Island.[5] Resettled in Newport, they had six children: Joseph, the silversmith (1762–1814), John (1765–1812), Thomas Powell (1767–1793), Martha (born 1769), Elizabeth (1771–1772), and Josiah Hewes (1774–1800).[6] The Anthonys were Baptists, and in 1773 Captain Anthony, as an elite member, paid fifty-six Spanish silver dollars to the Newport Baptist Meeting House for his subscription and pew number 10, in the "below stairs" section.[7] He kept his Baptist connections when in Philadelphia, as did most of his family.[8] Joseph Anthony Jr., however, held his own family rituals of birth, marriage, and death in Philadelphia at Christ Church, probably in deference to his wife's affiliation.[9]

In his sloop *Peace and Plenty,* Captain Anthony made the trip between Philadelphia and Newport in five or six days on a weekly schedule, carrying passengers, cargo, and money.[10] Samuel Nichols and Benjamin Rawle sailed with him from Philadelphia to Newport in August 1768.[11] "Thomas Mifflin and his Lady" sailed to Newport with Captain Anthony on June 28, 1773, and back on September 6, 1773.[12] John Wharton and his sister, along with William Browne, Thomas Hopkins, Christopher Marshall, the Reverend William Rogers, and their wives also sailed to and from

Fig. 19. Gilbert Stuart (American, 1755–1828). *Joseph Anthony Jr.,* c. 1795–98. Oil on canvas, 30 × 24½ inches (76.2 × 62.2 cm). The Metropolitan Museum of Art. Rogers Fund, 1905 (05.40.1)

Newport with Anthony between 1768 and 1774,[13] an early tradition that has survived the centuries.

Captain Anthony was making friends as well as business partners. The Philadelphia merchants Josiah Hewes and Thomas Powell were among his closest friends, and he named two of his children after them. The captain was also in regular commerce with James Pemberton in Philadelphia and Nicholas Brown in Newport, each a central figure in his city. By 1765 Captain Anthony had a reputation for competence among the merchants of Philadelphia and Newport, a standing that he retained throughout his life and that enhanced the prospects of his children throughout their lives.[14] The silversmith benefited from the associations set up by his father, who remained a principal in all the family enterprises until he died in 1798.

Captain Anthony did not participate in the African slave trade, a mainstay of Newport's early wealth, although he was encouraged by Nicholas Brown Sr. (1729–1791) to do so.[15] Quaker merchants in Philadelphia were inconsistent in their participation in the West Indies slave trade, but by 1765 Captain Anthony was trading regularly with Quaker leaders who were clearly against it.[16] The Pembertons owned the wharf where Captain Anthony docked, and which he eventually purchased, on Water Street at Chestnut.[17] Although not a trader, Captain Anthony did own a slave in Newport, and both he and his son Joseph Anthony Jr. owned one or more negroes in Philadelphia.[18] Given the commercial disruptions in Newport and the talk of boycotts provoked by the Townshend Acts, which had been initiated in 1767,[19]

Captain Anthony's connections and friendships with the Quaker merchants in Philadelphia provided the impetus for his move to Pennsylvania.[20]

As the Baptist church records of 1774 in Philadelphia show the Anthonys' membership, it is reasonable to suppose that the family was in Pennsylvania by 1773 or 1774. Joseph junior was eleven or twelve, the traditional age for beginning an apprenticeship. The possibility remains that he began his education in Newport in the shop of his father's cousin Isaac Anthony (1690–1774), a silversmith, but no record of such an arrangement has turned up. Precise details of an apprenticeship in Philadelphia have not surfaced either. However, in 1779 in Reading, Pennsylvania, Joseph junior, then seventeen, signed a receipt in the usual manner of an apprentice: "Joseph Anthony, Junr. / for Richard Humphreys [q.v.]."[21] The silver that Anthony produced later seems to lend credence to that association. In 1772 Philip Syng Jr. (q.v.), the silversmith and prominent citizen located near the Pemberton wharves, advertised that he was retiring from silver work and was turning over his shop and business to Richard Humphreys. Syng was located less than a block from Captain Anthony's developing import-export business. By August 29 Humphreys had moved to Syng's property on the west side of Front Street between Walnut and Chestnut, a few doors below the Coffee House, the gathering place for news and exchange at Front and Market.[22] Humphreys's first advertisement in the *Pennsylvania Gazette* included Syng's recommendation of his abilities.[23]

In 1776 the citizenry of Philadelphia was polarized by the feverish opposition between Tory and Whig factions. Trade was at best sporadic.[24] An oath of allegiance was mandatory, and many hundreds of Philadelphians left, seeking the relative peace and safety of Germantown or Reading in Berks County. Even the Coffee House had closed, and craftsmen and merchants in the neighborhood moved to Reading, including the silversmiths Daniel Dupuy Jr. and Sr. (q.q.v.) and Richard Humphreys, the printer David Hall, the merchants Samuel Morris, William Redwood from Rhode Island, and the Baptist Reynold Keen.[25] Reading was a substantial town a day's ride from Philadelphia, and it grew rapidly if temporarily into a center for trade. It was also familiar territory for a Baptist.[26]

Captain Anthony and family set up a household near Reading, where he first rented or leased from Isaac Levan, a German farmer, "part of his house and stable."[27] Joseph junior was already in Reading with Humphreys.[28] Subsequently, Captain Anthony and his wife purchased from David Potts Sr. and his wife Mary a house and

"plantation" of 235 acres in Douglas Township on the Schuylkill River and on the Reading–Philadelphia road.[29] The Tax and Exonerations records of 1779 valued his estate in Berks County at £2,799: 109 acres of land at £2,100, 46½ ounces of plate at £79, six horses at £356, and fifteen head of cattle at £104. In 1781 Captain Anthony was noted as "of Pottstown in the County of Philadelphia" and taxed there until he owned property in Philadelphia. The family, at least his wife and younger children, seems to have remained in the Reading area until Captain Anthony's arrangements in 1782 and 1783 in Philadelphia were accomplished.[30] After the British evacuated Philadelphia, Humphreys and presumably his apprentice Joseph Anthony Jr. were back in business there. On December 24, 1782, Captain Anthony and Josiah Hewes formalized their long association and advertised their new enterprise in the *Pennsylvania Gazette*: "Josiah Hewes & Joseph Anthony Having entered into Co-Partnership, are removed from the store lately occupied by Josiah Hewes, in Chestnut street, to the Stores on the north side of Chestnut street wharff, where they have for SALE, lately imported."[31] Captain Anthony leased and finally purchased from Joseph Pemberton the northern section of the large riverfront property that his father, Israel Pemberton, had purchased from the Penns.[32] The property served as the office and storehouse for the Anthony mercantile enterprise through three generations and is clearly labeled "Anthony" on the city plan of 1797.[33]

In 1782 Captain Anthony leased or purchased from Thomas Morris a residence between Walnut and Spruce streets in the Dock Ward.[34] As a property owner in Philadelphia, the captain now paid a tax of £7 15s. 2d. on his estate, valued at the time at £1,400.[35] He was assessed in the U.S. Direct Tax of 1782 for one cow at £5, one negro at £30, 40 ounces of plate at £18, and his occupation at £250. Joseph Anthony Jr. was included under his father's name in the same tax records, but separately as a single male with no property, paying the "head" tax of £1 10s., an indication that he had completed his apprenticeship but was not yet on his own.

Captain Anthony wrote his will in 1782, when he was establishing residency in Philadelphia. In it he included instructions that his two eldest sons, Joseph junior and John, were to "have the use of his wife's annuity when of age, giving security, to go into business, and so the others in rotation."[36] In March 1783 the captain summarized the following in his notebook under "Joseph Anthony, Junr.": "Dr / March 1783 . . . paid £506 carpenters expenses for fixing his shop . . . to cash 20 dollars, to ditto 8 dollars, to 9 for Joseph Jr, 1 oz. 7 dwt silver / £81 6s. 6d., to John Bayard's bill for sundries at Pinchons

vendue £39 17s. 8d."[37] On April 16, 1783, the silversmith William Pinchon (active 1779–1804) had advertised that, "as he proposes leaving this city shortly for Europe, he will expose to PUBLIC SALE . . . GOLD SILVER, and JEWELERY, worked in the newest and best fashions, a great number of TOOLS belonging to every branch of his business, several elegant glass CASES: together with all his Household and Kitchen FURNITURE."[38] John Bayard, merchant, purchased some of this stock, and Captain Anthony repurchased items from Bayard. Judging from the amount paid, it must have been a considerable supply of tools, stock, or display materials for Joseph junior's shop.[39]

In October 1783, in the same notebook in which Joseph junior's shop-building expenses were recorded, Captain Anthony listed the "Expenses paid for repairs to Mr. Keen's house," located in the Middle Ward.[40] The Anthonys must have known Reynold Keen, an important merchant in general trade in Philadelphia, in Reading if not before. In 1785 Captain Anthony's estimated value was £714, and he was leasing Keen's house, valued at £1,000.[41] Probably to furnish it, the captain had a running account with the cabinetmaker Benjamin Randolph, summarized by Randolph in 1786 as "Debtor to shop £203 5s. 10d."[42]

In January 1799, following the captain's death in the yellow fever epidemic of the fall of 1798, his property was advertised for sale. His household goods were described as "a large quantity of very valuable Household and Kitchen furniture consisting of Elegant looking glasses, mahogany chairs, sofas, sideboards, bedsteads . . . cases of knives and forks, girandoles, ornamental china . . . with every other article necessary to housekeeping, of the best kind and in excellent order."[43] His wife Elizabeth died in late February the next year. She signed and dated her will on February 16, 1799.[44] She left $10 dollars to each of her children, Joseph, John, Martha. and Josiah, and to grandson Thomas, son of Thomas deceased, and to her "grandson Joseph Anthony, Jr. [in 1799 this would have been Joseph III] in consequence of his name, the sum of Five hundred dollars . . . to be put out at interest by his said father . . . until he shall arrive at the age of twenty years." She gave to her "granddaughter Elizabeth Anthony, daughter of my said son Joseph (in consequence of her name) my silver Tankard and my cup marked J.E.A. for her to have made of it what she pleases . . . [to her] beloved friend Martha Powell, a dark silk gown . . . to my son Joseph in lieu of the aforesaid ten Dollars, the Bible with explanations. To Sara Simmons, daughter of my nephew Anthony Simmons [q.v.], a suit of lace and thirty dollars to be placed in the hands of her said father until she

should arrive at the age of eighteen years. . . . To my granddaughter Martha Anthony, daughter of my son Josiah, all the rest and residue of my estate of whatsoever kind and wheresoever to be found, to her and heirs." Her inventory taken by Samuel Breck and Joseph Lownes (q.v.) is dated March 5, 1799,[45] and although a considerable amount of their joint property had been sold after the captain died, the value of Elizabeth's inventory must have given the silversmith considerable license to make investments in his business and property. Among her possessions were "General Washington and Family" at £12 and, next on the list, "Do [Ditto] and John Adams" at £6. This line is clearly indented so that "Do" appears under "George Washington." Although the medium of these pictures is not noted, the Washington family was probably the large engraving drawn by Edward Savage (1761–1817), who was living at the time at 70 South Fourth Street in Philadelphia. It is thought to have been engraved by David Edwin, working with Savage in June 1798, in Trenton due to the yellow fever in Philadelphia. On June 3, 1798, Savage wrote to George Washington: "Agreeable to Col. (Clement) Biddle's order, I delivered four of the best impressions of your family print. They are chosen out of the first that was printed."[46] It was immediately popular. Captain Anthony must have procured a print, or possibly received one from Washington himself, before he died of the yellow fever in July 1798. The portrait of John Adams may have been by Philadelphia engraver James Smither (1741–1797) after the painting by John S. Copley (1738–1815) or one published by William Cobbett in Philadelphia in 1797.

In Elizabeth's inventory the print of George Washington had the highest value for a single item with the exception of the following: a gold watch, hook, and chain, at £11 5s.; a plated tea boiler and case, £55; a mahogany bedstead, £30; a coffeepot with handle, 30 ounces, 10 per ounce, £18; a pair of cans, 25.10 ounces, 9/6 per ounce, £12 2s. 9d.; a waiter, 30 ounces, 8.6 per ounce, £12 15s. od.; a tankard, 27.10 ounces, 8 per ounce, £11; and two pairs of large plated candlesticks, £16. Other silver listed in her estate that may have been made by her son included: a cordial cup, 12 ounces, 8 per ounce, £4 16s.; a teapot with handle, 20.5 ounces, 9 per ounce, £9 2s. 3d.; a sugar dish, 13.1 ounces, 8/6 per oz, £5 15s. 9d.; a slop bowl, 13.15 ounces, 8/6 per ounce, £5 16s. 10d.; a pair of porringers, 8/6 per ounce, £16; and a small waiter, 9.15 ounces, 8/6 per ounce (total value not listed). Plated silver not previously listed included: a cake basket, 1s.; a small cake basket, £6; a pair of small candlesticks, £4; a pair of butter boats, £3; a tea canister, £5; and a cream pot, £3. The total value of her estate was

£3,363 17s., including the inventory; "cash in the house at her decease" of £104 25s.; Pennell Beal's paid note, £21; James Smith's paid note, £2,000; and interest on the notes, £21 34s. Although all of the above occurred some sixteen years after Joseph Anthony Jr. set up in business, his family's affluence offered the silversmith good credit and some independence, and set him apart from many of his fellow craftsmen.

On October 3, 1783, Joseph Anthony Jr., just twenty-one, announced, in his first, long descriptive advertisement in the local newspapers, that he "carries on the Gold and Silver Smith Business . . . where he makes all kinds of work in the most elegant manner, viz. SILVER and plated tea urns . . . coffee pots . . . tea pots," and so on "while importing a variety of items from gold snuff boxes" to an "alphabet of ciphers" (a handbook of elaborate designs for letters of the alphabet) to "cases with [a] complete set of teeth instruments."[47] From the outset of his career, Anthony combined an active silver workshop with a merchant's stock. He did not seek partnerships outside the family. The Philadelphia directory of 1785 listed Anthony and Humphreys on Market Street between Second and Third streets. Both were on the south side of Market, at the center of Philadelphia commerce, facing the High Street Market, Humphreys at number 54 and Anthony at number 76, making it tempting to say that they were somehow associated in business. However, their subsequent advertisements located them more precisely, Humphreys "next door to the Friends' Meeting House," at the southwest corner of Market and Second streets, and Anthony "two doors East of the Indian King," between an unmarked alley and the southwest corner of High (Market) Street and Strawberry Alley.[48] From his first setting up shop in 1783, Joseph Anthony's clients were notable merchants and civic leaders. He imported handsome military furnishings and made camp cups for James Pemberton and Winthrop Sergeant, a coffeepot (cat. 12) for Colonel James O'Hara, a fish slice (cat. 22) for William Hamilton of the Woodlands, as well as all manner of hollowware and utensils.[49] The coffeepot that Anthony made in 1783 for General George Washington and engraved with his arms is grand, with fine details of spout and finial that owe much to Humphreys's designs.[50]

In 1784 James Manning, president of the College of Rhode Island (now Brown University), wrote to William Rogers in Philadelphia: "Inclosed you have the device of the College Seal, which you are requested to procure engraved in the best Manner, & at the lowest Price, by the famous Engraver, who executes for the Public their curious Devices . . . as you know the Poverty

Fig. 20. Gilbert Stuart (American, 1755–1828). *Mrs. Joseph Anthony Jr. (Henrietta Hillegas)*, c. 1795–98. Oil on canvas, 30 × 23⅜ inches (76.2 × 59.4 cm). The Metropolitan Museum of Art. Rogers Fund, 1905 (05.40.2)

of the College we rely on you to obtain it on the best Terms." Rogers replied: "The Seal, with suitable Directions, I have got Josey Anthony to procure, he has Intimate Acquaintance with the best Engraver & does the silver Work himself."[51]

On October 8, 1784, Colonel Blaithwaite Jones (c. 1723–1789) purchased a suite of silver from Joseph Anthony for the wedding of his daughter Susannah: two silver teapots, 37 oz. 10 dwt., at £26 5s.; a sugar dish, 15 oz. 5 dwt., £10 13s. 6d.; a slop bowl, 11 oz. 15 dwt., £4 8s.; a cream pot, 4 oz. 5 dwt., £4 18s.3d.; a pair of tea tongs, £1 8s.; and a case of silver handled knives and forks, £4 10s; for the repair of "sundry pieces of plate," £1; engraving for the above, £3 13s., equal to £76 11s. 3d; "[b]y old silver Wgt 55 oz." at 10/6, with a balance due of £47 13s. 9d.[52] At about the same time Anthony made a pair of canns handsomely engraved "MF" (Mary Franklin).[53]

On October 20, 1790, Samuel Meredith, Esq., purchased from Joseph Anthony a plated tea urn at £20; a pair of candlesticks, £10; a dozen dessert spoons, £3; a soup ladle, £11. 1s.; two pairs of salts, £4 10s.; four extra glasses for the above, 15s.; two dozen fruit knives, £1 10s.; four salt ladles, 10s.; a silver soup ladle, £4 10s.; two watch chains, £3 10s.; and credit "by 52 oz. 5 [?] of silver," at "8 [shillings]."[54] On July 10, 1792, Anthony "rec'd from Philemon Dickinson executor of John Cadwalader's estate, a check on the bank of North America for 20 dollars in full for a cream and sugar bucket for Betsy McCall." That receipt was signed by his wife, Henrietta Anthony (fig. 20). A cashier's receipt for $23 was paid to him by Philemon Dickinson in September, and another by General

Dickinson "[f]or Mrs. Ringold, Bot of Joseph Anthony, Jun. a plated tea urn at £2; a teapot, £6; a cake basket, £8 5s.; a tea caddy, £5 12s. 6d.; a cream and sugar "bason," £6; and two mustard tankards, £3.[55] Anthony lent £250 to James Wilson.[56] He sold "new plated patent lamps" to Jonathan Meredith and Jasper Yeates with less success.[57] He continued to advertise and import "elegant objects," "tea urns," and "fancy goods" for his shop and advertised "miniature pictures," "set devices in hair," mourning rings, and lockets as well as "miniature picture and locket cases."[58] It has been noted frequently that he made "settings" for Charles Willson Peale's miniatures,[59] and he commissioned James Peale to paint miniature portraits of his own children, which are set in fine gold frames.[60]

Joseph Anthony Jr. had been in business for two years before he married Henrietta Hillegas (1766–1812), on December 29, 1785, at Christ Church. She was the daughter of Michael (1729–1804) and Henrietta Boude (1731–1792) Hillegas. As prominent and as committed to supporting the Revolutionary cause as was Captain Anthony, Hillegas was a wealthy merchant and a central figure in colonial finance from 1775, when he was appointed treasurer of the Pennsylvania Committee of Safety under Benjamin Franklin. He served as treasurer of the United States from 1777 to 1789. The silversmith's marriage to his daughter Henrietta was a sure step.[61] Although Joseph Anthony Jr. had been a subscriber to the building fund,[62] "[t]he dancing Assembly demonstrated its exclusiveness by refusing admission to its meetings to a daughter of Esquire Hillegas, who had married 'in trade,' that is to say, that she had been wedded to a jeweler."[63]

Joseph and Henrietta Anthony had eleven children, three of whom survived to adulthood: Joseph Anthony III (1786–1804), Michael (1788–1832), and Eliza (1789–1821).[64] When his first child was born, the family moved residence to Chestnut Street in the Middle Ward, leasing from Thomas Shoemaker. The tax account for 1786 notes Joseph Anthony's estate valued as follows: 25 ounces of plate at £10, one negro at £10, his occupation at £280, and his residence at £800 and taxed at £1 19s. The high value placed on his occupation is evidence of his early success as a silversmith. Before his marriage he was living at his shop property, but Chestnut Street was more desirable, as the shop—a block away—faced the busy, often messy Market Street stalls. By 1788 Joseph Anthony was fully enmeshed as a craftsman of note and a participant in Philadelphia's civic scene. The *Pennsylvania Packet* of March 29 and 31, 1788, found Anthony, Jeremiah Boone, and Joseph Cooke (q.q.v.) publicly responding with a challenge to Samuel

Folwell's boast that he was the only hairworker in the city.[65] In January 1788 both Joseph Anthony Jr. and his father joined in a major civic enterprise as subscribers to the bill to erect a permanent bridge over the Schuylkill River.[66]

Both Joseph Anthonys also participated in the Grand Federal Procession, each in their own way, in the celebration of the ratification of the Constitution on July 9, 1788. The *Pennsylvania Gazette* described the scene:

> On the floor of the grand edifice were ten chairs for the accommodation of ten gentlemen, viz. Messrs. Hilary Baker, George Latimer, John Wharton, John Nesbitt, Samuel Morris, John Brown, Tench Francis, Joseph Anthony, John Chaloner, and Benjamin Fuller. These gentlemen sat as representatives of the citizens at large, to whom the federal constitution was committed previous to the ratification. . . . When the grand edifice arrived at Union Green, these gentlemen gave up their seats to the representatives of the states . . . who entered the temple, and fixed their flags to the corinthian columns to which they respectively belonged.[67]

The unit of merchants and traders was escorted by Tench Francis, Charles Petit, John Ross, John Wilcox, and Thomas Willing, Esq., and led by Jonathan Nesbit carrying a staff on which the flag was displayed. The staff terminated in a silver cone on which was a ring suspending a mariner's compass. Joseph Anthony Jr. had made the "silver cone for a standard," for which he billed the committee of merchants £2 5s. Tench Coxe paid for it on August 14, 1788.[68]

Three generations of Anthonys served in the Philadelphia Militia between 1784 and 1813. In 1784 Joseph Anthony Sr. and Jr. were listed on the muster roll of the Third Company, Second Battalion, under Lieutenant James Read. In 1786 Joseph junior and his brothers John and Thomas Powell served in the same battalion. The following year Joseph junior was listed on the muster roll of the Seventh Company, Second Battalion, again under James Read, now a lieutenant colonel.[69]

On December 8, 1789, Joseph Anthony Jr.—in good company with Joseph Lownes, Thomas Shields (q.v.), Richard Humphreys, and Caleb Lownes—signed the act to incorporate "The Pennsylvania Society for Promoting the Abolition of Slavery . . . and for improving the condition of the African race."[70] At this time, the U.S. Census of 1790 recorded that the Anthony household consisted of three males over the age of sixteen, two males under sixteen, four females, and one free person. There were no slaves. While Anthony interacted with other members of the craftsmen's community, as a craftsman he worked independently (see figs. 21, 23). He commissioned Joseph Richardson Jr.

Fig. 21. Billhead of Joseph Anthony Jr., c. 1810. Historical Society of Pennsylvania, Philadelphia. Daniel Parker Papers

(q.v.) to melt down a thousand ounces of gold dust, for which he paid £3 15s.[71]

At the beginning of 1790 the city was celebrating the presence of delegates to the Congress from all the colonies, and Anthony placed an enticing advertisement, headed "A Fresh SUPPLY of Plated Wares & Jewellery" and consisting of a long list of his merchandise.[72] He, like other merchants, touted goods responding to the new climate, advertising on March 15, 1790, that "Joseph Anthony, silversmith, Messrs Rice and Co. booksellers, Market Street, Mr. Carey printer of the Museums, Front Street, the artist in Carter's Alley," would receive subscriptions for "a medal with a striking and approved likeness [of General Washington] . . . of fine white metal, to resemble silver, for one dollar; of a fine gold-coloured metal, for two dollars, of fine silver for four dollars, and of gold in proportion to weight."[73]

While the national government was moving from New York to Philadelphia during the summer and fall of 1790, the state of Pennsylvania ratified its constitution on September 2 and had its first meeting at the State House on September 7.[74] On December 28 the Commonwealth of Pennsylvania purchased some furnishings for its new chambers from Joseph Anthony Jr.: one pair of large oval-feet candlesticks at £5 5s.; three pair of small oval-feet candlesticks at 50s. £7 10s.; and three pair of small, round-feet candlesticks at 45s., £6 15s., for a total £19 10s.[75]

Caught up in the optimism of the military victories, Anthony expanded his business to take advantage of the celebratory climate and "to assist in preserving the memory of the illustrious Events which have marked this period of our Country's Glory, as well as of the Men who have been most important." John Trumbull, or possibly Anthony himself, placed a handsome advertisement in the *Gazette of the United States* on December 22, 1790, for an ambitious project: "PROPOSALS, BY JOHN

TRUMBULL, For PUBLISHING by SUBSCRIPTION, TWO PRINTS, from original Pictures painted by himself; One representing the DEATH of General WARREN, at the *Battle of Bunker's-Hill*. The other, the DEATH of General MONTGOMERY, in the *Attack of Quebec*." Subscriptions were to be received by "*Joseph Anthony*, jun. Goldsmith and Jeweller." On March 17, 1799, George Washington wrote to Joseph Anthony Jr., "I have lately received from John Trumbull Esq. (now in London) four setts of the battle of Bunker's Hill, and Death of General Montgomery, for which I subscribed, & am ready to pay . . . be so good as to inform me, and what I owe on this account, as I have entirely forgot the terms of the Subscription."[76] Joseph Anthony replied from Philadelphia on March 26: "Yours of the 17th inst duly came to hand my being in the Country prevented my returning a immediate answer." Washington wrote again on September 30, 1799, from Mount Vernon, "I now find that on the 4th of April 1790, I paid John Trumbull, Esq. twelve guineas, which is entered in my books as being one half of the Subscription for four copies of two prints to be published by him." Anthony replied to Washington that each print originally cost three guineas. Washington wrote to Anthony that he had sent a check for $56 on the Bank of Pennsylvania to Anthony on March 26 and was awaiting a receipt.[77]

On October 24, 1791, Anthony announced in Philadelphia's *General Advertiser* that he sold and would take subscriptions for an "etching of Mr. COPLEY's celebrated Print of the Death of Lord CHATHAM." In 1792 "Joseph Anthony, junior, No. 76, Market-street, and . . . Zachariah Poulson, junior, at the Philadelphia Library" received the subscriptions for a print by Samuel Jennings after his 1792 painting representing Liberty displaying the Arts and Sciences.[78]

Anthony's standing and his centrally located shop attracted more than local patrons. Benjamin

Henfrey, an ore assayer from England then in "Kensington near Philadelphia," advertised from 1791 to 1792, seeking to purchase "any quantity of lead, copper, or other ores, (iron excepted)" and asked that samples of ore be left "with Anthony, goldsmith in Market Street."[79] Anthony's reputation for performance, like that of his father, extended beyond Philadelphia. In April 1800 "Joseph Anthony of the City of Philadelphia, goldsmith & jeweler," was appointed by Samuel Courtauld of New York City, "his true and lawful attorney," to sell his plantation at Point Breeze, Burlington County, with a piece of marshland and meadow.[80]

Between 1777 and 1809 more than twenty grantor and grantee deeds are listed under the name of "Joseph Anthony," several noted as "Jr," for properties in Philadelphia.[81] In 1792 Joseph Anthony—like many others, including Michael Hillegas—invested in warrants for the unsettled land in western counties. The silversmith also invested in warrants for 397 acres in Luzerne County "on the waters of the Great Mahopenny." His brother Josiah Anthony had purchased four hundred acres in Washington County "on the Wheeling and Ten Mile waters" in 1787.[82] Sales were promoted with enticements such as the claim that "the Turnpike which it is proposed to begin in the next spring, from Nescopeck to Tioga, passes not far Westward of them."[83]

With the arrival of the federal government in 1790, the commercial center of the city, between the Delaware waterfront and Third Street, became crowded; the gentry were moving westward, up Walnut, Chestnut, and Market. The house being built for the president on Ninth Street was half a block south of Market. In July 1792 Captain Anthony purchased for £5,500 in gold and silver, from John Steinmetz and his wife Catherine, a brick messuage and ground, with a courtyard twenty-six feet wide opening into Ninth Street, bounded on the west by open ground granted to Samuel Pleasants.[84] The Pembertons and the Pleasants would again become his neighbors. Captain Anthony's office and warehouse remained at 5 Chestnut Street, but he moved his household to 337 Market Street, at the corner of Ninth.[85] In the U.S. Direct Tax of 1798, his estate was valued at £13,000, more than double the value of others in the neighborhood.

In 1792 Joseph Anthony Jr., following his patrons, moved up Market Street to a property just beyond Third Street that became his permanent location.[86] This was the site of the old jail, which had been abandoned in 1772 as inefficient but was reactivated by the Congress in 1776 so that the new jail on Walnut at Third could be used for

prisoners of war. After the old building was torn down, the property, "whereon the old Gaol and Work House lately stood," was divided into nine lots, offered by an act of the Philadelphia Assembly and "sold and authorized October 20, 1785."[87] On July 24, 1792, Joseph Anthony Jr. purchased for $3,750, from Solomon White and his wife Hannah, a "certain brick messuage or tenement and lot or piece of ground."[88] Solomon White & Co., Dry Goods Importers, had been there in 1790 when they advertised their location at "No. 94, the south-side of Market-street, four doors above Third-street."[89] Subsequent to the sale to Anthony, Solomon White, following his market, announced on July 28, 1792, in the *Mail, or, Claypoole's Daily Advertiser* that he had removed his store to number 34, the south side of Market, between Front and Second streets, that is, closer to his clientele in the commercial center.

Anthony developed his property, converting the narrow street facade to an elegant silversmith's display window, described by Charles Poulson in 1862 as having been "a very handsome double bulk windowed store of plate and jewelry."[90] The panes of glass, measuring 12 by 18 inches, were custom orders and the largest produced in his Pittsburgh factory by Colonel John O'Hara, for whom Anthony had made the coffeepot (cat. 12).

Joseph Anthony's inventory taken after his sudden death, between August 19, 1814, and February 16, 1815, was detailed and divided by room. Even considering the changes that must have occurred in thirty-one years, the inventory offers details about room usage and furnishings as they were when Anthony left it before his trip to Harrisburg. The "Front Parlor," narrow but deep and entered from Market Street, was completely furnished with a suite of cane-bottom chairs and sofa, sideboard, small card tables, pictures and frames, and mahogany cases built in for the display of stock: thirty-three pieces of silver plate; sets of china and glass; two large pier glasses valued at $100 (probably the ones noted in his father's sale); a mantle clock, $100; two "imperfect" sets of dining-table china, $140; a carpet, $60; "1 Portrait of Washington, by Stuart," $30; two small paintings in oil, £5 (perhaps the portraits of Anthony and his wife, also by Stuart; see figs. 19, 20). The total value for furnishings in this showroom was $892.50. The "Front Garret" was at this time a storeroom for fourteen trunks, a plate warmer, old curtains, old red and white bed curtains, and two yellow "marine" curtains with black fringe. In the "Back Garret" were a bedstead with two beds and one mattress, thirty-eight yards of old staircase carpeting, one toilet table, and two benches. In the "Large Front Room up two pair of stairs" were

sixteen mahogany chairs, a mahogany bureau, a looking glass, and four pictures.

The "Small Front room up two pair of stairs" contained a bed, five chairs, a toilet glass, and one "biddy." The "Back Room up two pair of stairs" had a high and low bureau, each valued at $5, two bedsteads, three chairs, thirty-seven volumes of books "of Different Kinds," bed and household linens, two blunderbusses, and one fishing rod. The "North Room over Back Parlor" held a bedstead and bed, a bolster, four chairs, a dressing glass, a table, and a desk. The "South Room over the back Parlor" had a cot and bedding, an open stove, a box stove, an old bureau, five chamber pots, a clothes press, and thirty yards of entry carpeting. The "Back Room over Store" held carpet, a bedstead, a feather bed, an easy chair and two covers, a "night chair" with four covers and a pan, a mahogany wardrobe and stand, a desk and drawers, a trinket box, a bureau, a looking glass, stone mantle jars, window blinds, a washstand with pitcher, basin, and two tumblers, one engraving, and two small chairs.

In the "Back Parlor" were a dining table with two additional ends, a sofa, a breakfast table, a side table, a backgammon table, wineglasses, pitchers, tumblers, a bathing tub and shower bath, an oilcloth entry carpet, andirons, a fender and tongs, and the family silver, listed with weights in ounces: a teapot, 20 ounces; a sugar dish, 13.1 ounces; a pair of sauce tureens, 25.1 ounces; a pair of canns, 26.8 ounces; a slop bowl, 13.15 ounces; a porringer, 9 ounces; a soup ladle, 4.16 ounces; twenty-three tablespoons, 46.13 ounces; eleven dessert spoons, 7.3 ounces; six salt spoons, 2 ounces; nineteen teaspoons, 8.12 ounces; a butter knife, 10 ounces; two pairs of sugar tongs, 1.15 ounces; a marrow spoon, 1.12 ounces; a strainer, 1.17 ounces; and a punch ladle, 0.16 ounces. The total of 183.17 ounces at $1 13/100 had a value of $207.75.

Among the items in the kitchen were eleven pewter plates, two dishes, two basins, two mugs, 36 1/2 pounds at 13/10 for $4.86, two china soup tureens, forty plates, a jack, spits, chain, knuckles and appurtenances, three brass chafing dishes, a copper teakettle, a covered copper fish kettle, eight iron pots, a bread toaster, beef steak tongs, eleven wooden "Trenchards" and one bowl, eight brass candlesticks, tin coolers, two "Spiting Boxes," coffee and pepper mills, ten patty pans, tin stew pans, a griddle and tripod, baskets, brushes, a patent "puffing iron" and two heaters, nine flat irons, a wheelbarrow, tubs, and buckets. At the end of this long kitchen list and continuous with it were a mahogany secretary, one lot of fishing tackle, a family Bible, two volumes of the "History of the Bible," eight fire buckets, a wash kettle,

seven linen shirts, seven night shirts, thirteen cravats, seven waistcoats, eight pairs of pantaloons, twelve pairs of stockings, six silk handkerchiefs, two pairs of leather and one pair of silk boots, two hats, eight pairs of "small clothes" and pantaloons, four coats, a gown, a greatcoat, a pair of suspenders, a pair of spectacles, a pair of sleeve buttons, and one breast pin. The total value of this inventory, taken by William Hulings and James Ash, was $2,316.66.

It was at this house, 94 High Street, that Martha Washington visited Joseph Anthony Jr. General Washington and his wife were familiar with Anthony's stock, having acquired the coffee-pot ten years previously. The Washingtons purchased from both Anthonys, the merchant and the silversmith, distinguishing clearly between the two by designating the latter as junior. Household accounts from 1794 until 1797 note: "p'd Jos. Anthony Jr. in full for sundries furnished per bill & rec't . . . 70.17"; "Jas. Anthony Jr. for sund's. for Mrs. Wn per bill . . . 11.80"; "p'd Jos. Anthony for sund's. for Mrs. Wn. pr bill . . . 107.36"; "p'd Joseph Anthony Jr. for a Coral & Bells for Mrs. Washington pr. Rec't. . . . 25."[91]

In 1793 there were three listings in the Philadelphia directory for the Anthonys: Joseph Anthony, merchant, at 225 High (Ninth) Street; Joseph Anthony Jr., goldsmith, at 94 High Street; and Joseph Anthony & Son at 5 Chestnut Street.[92] Thomas P. Anthony died on September 21, 1793, in the yellow fever epidemic.[93] He was still included in an advertisement in January 1794 that read "Messrs JOSEPH ANTHONY and Sons."[94] The 1795 Philadelphia directory listed Joseph Anthony & Son (the captain and Josiah) at "their counting house" at 5 Chestnut Street.[95] The firm managed the family's general shipping business, including the silversmith's imports.

In November 1795 Joseph Anthony Jr. imported from Liverpool on the ship *Hope* (Swain, master) one case with the merchant's mark "JA" (the crossbar of the "A" like a "V") with a value of $1,658.90, duty at 15 percent, and duty tax of $248.84.[96] There was another shipment directed to Joseph Anthony Jr. with a different merchant's mark, a "P" within a diamond-shaped outline, on the brig *Rebecca* from London (Bazing, master).[97] The timing of these arrivals from England seems to coincide with the silversmith's newspaper advertisements for the latest goods from London.

In 1796 Captain Anthony served on committees of merchants to urge the Congress to put into operation the Jay Treaty of 1794 with England and to finance armed ships to protect Philadelphia commerce by sea. In 1798 the treaty still had not been enforced, and the French

Fig. 22. William Birch (American [born England], 1755–1834), after Thomas Birch (American [born England], 1779–1851). *Devon in Pennsylva. The Seat of Mr. Dallas*, 1808 (1860 restrike). From *The Country Seats of the United States*, published by William Birch, 1808. Etching and engraving (stipple) (restrike), plate: 5¾ × 7⅜ inches (14.6 × 18.7 cm). Philadelphia Museum of Art. Gift of an anonymous donor, 1926-88-203

were attacking shipping. In March of that year a news item appeared in most coastal newspapers, including the *Porcupine's Gazette* in Philadelphia: "The SHIP AMERICA, of this port, armed by Mr. Joseph Anthony and Co. just arrived from Madras, richly laden with spices, &c. She has come all her voyage safe and unmolested, notwithstanding she passed several red-capped ruffian privateers;— but then, she had *twenty guns on board*. This has been her safety."[98]

When Captain Anthony died suddenly in 1798, the family fortunes suffered.[99] The captain's will directed that all real estate be sold. Josiah Anthony and John Maybin (1763–1829), the captain's son-in-law, paid the estate £7,000 for their partnership.[100] Josiah died in November 1800, and Joseph (now no longer junior) sold Josiah's half of the partnership, which was valued at $3,500 and included the property at 5 Chestnut Street, to John Maybin.[101] On December 3, 1801, the *Gazette of the United States* carried the belated notice that "the partnership of Joseph Anthony[,] John Maybin, and Josiah Hewes Anthony, trading under the firm of Joseph Anthony and Co. having expired at the decease of Mr. Joseph Anthony, all persons indebted [*sic*] to that firm are requested to make immediate payment to the subscriber, and all those who have any demands against the same, are desired to bring in accounts for settlement to John Maybin

who has continued business since the dissolution of said partnership on his own account . . . at the same stores occupied by J. A. and Co."

Captain Anthony's grand residence was sold. Joseph Anthony placed an advertisement in the *Gazette of the United States* on December 10, 1800: "WANTED, Genteel Boarding In a private family for TWO LADIES, With the accommodation of two Rooms. APPLY to Mr. Joseph Anthony, No. 94 Market Street, or to John Maybin, No. 5 Chestnut Street." This was for the widows Martha Powell, who had been living with Elizbeth Anthony, and John Maybin's mother.[102]

Soon after his father's death, in 1799 Joseph Anthony purchased ground on the west side of the Delaware River, a location rapidly becoming fashionable as well as removed from the dangerous yellow fever that visited the city each fall. Anthony purchased the property subject to one mortgage held by Stephen Sicard, a developer in the area, and his wife, and another mortgage held by John D. Dorat.[103] This property was the second property south of a farm and estate called Andalusia (now a National Historic Landmark), owned by John Craig in 1794 and enlarged by Nicholas Biddle in 1830 with a handsome Doric porch facing the Delaware. The property between them was called Chelwood, which eventually through marriages became part of the Andalusia property.

Joseph Anthony must have been building in 1799. In 1800 he was assessed in Bensalem Township, Bucks County, as a nonresident. In 1801 his improvements were valued at $700 and his total assessment was $1,406, on which he paid $3.79 in tax. In 1802 his property was valued at $1,463.[104]

Joseph Anthony called his estate Devon, and he built a handsome house with dependencies on a high bank on the west side of the Delaware River (fig. 22). It was important and interesting enough for William Birch (1755–1834) to include the house in his illustrated *Country Seats of the United States*, published in 1808. Between 1798 and 1802 Birch's son Thomas had made the drawings for the engravings in the book. Devon was less formal than the other edifices portrayed, and in the engraving a local sailing craft, with sailors fumbling with a jib, intrudes on the bucolic view of the distant mansion and grounds.[105] The land extended to the low watermark of the river with a gravel shore, from which the bank rose 25 feet, probably the cause of the tragic accident at the property in 1802, when the Anthonys' coachman and their son William, then about seven years old, drowned in the river. Elizabeth Drinker copied into her diary, nearly verbatim, the following notice from *Poulson's American Daily Advertiser* of July 27:

> Melancholy Accident. The coach and horses, together with the coachman, and a son of Mr. Joseph Anthony, of this City, were yesterday unfortunately lost in the river Delaware. This distressing occurrence happened in the following manner, between 8 and 9 o'clock in the morning: The family having rode out to their country seat, situated on the river about 14 miles from the city, the coachman, with Mr. Anthony's son William, a promising lad . . . drove to the edge of the river for the purpose of refreshing his horses and cleaning the carriage. Unfortunately, either from not being well acquainted with the shore, or from not being able to turn the horses in time, they got out of their depth, and in their struggles to swim, it is supposed entangled their feet with the harness or shaft, and immediately sunk. The body of the coachman was found near the carriage.[106]

Whether from painful associations or from continuing economic adversity, on May 2, 1804, Anthony sold the Devon property to Alexander J. Dallas, then treasurer of the United States. Dallas was the owner at the time the Birch drawing was made.[107] Devon burned in 1848.[108] The property is presently the site of the State in Schuylkill Fishing Club.[109]

From 1802 the Anthony shop at 94 High Street included Joseph III until he died "after a short indisposition" on August 26, 1804, at the age of eighteen.[110] Both he and his brother Michael had trained with their father. How active they

were as silversmiths in this period is uncertain, as the marks on their silver seem to be those of their father.[111] The shop continued to advertise.[112] An advertisement in *Poulson's American Daily Advertiser*, on December 16, 1809, included a notice first published November 26, 1809: "J. ANTHONY having taken his son Michael H. Anthony into partnership, the business will in future be conducted under the firm of Joseph Anthony & Son." Joseph's nephew Thomas, son of Thomas Powell Anthony, also joined the business. The 1809 advertisement noted that the firm carried on "the goldsmith and jewelers business in all the various branches."

In 1809 Joseph Anthony went to London, surely to introduce himself to new trading partners and to restock his business. On December 16, 1809, *Poulson's* carried an advertisement announcing his return, and including a long and detailed list of the latest in fashionable goods to be found at his shop. He "has brought with him and is now opening at the old established store, No. 94 HIGH STREET, PHILADELPHIA, A VERY elegant and extensive amount of Goods, selected immediately from the factories of England." About a year later, on November 9, 1810, the Anthonys' advertisement in the *Philadelphia Mercantile Advertiser* carried another extensive list of an elegant assortment of goods imported from the manufactories, and elaborated on their address, listing it as "AT THE GOLDSMITH'S ARMS, No. 94, High street."[113] At the same time they added a flamboyant winged eagle to the shop's billhead (see fig. 21).[114]

The thirteen-page inventory of the Anthonys' shop taken on October 28, 1814, by Philip

Hartmann, Able [*sic*] Brasier (q.v.), James Black (jeweler), and Anthony Rasch (q.v.), four years later than the advertisement, reveals the quantities of military finery and jewelry, and small luxuries for their market, that the Anthonys imported and sold in their shop: 203 pairs of gold, amber, and pearl earrings, 164 breast pins, four diamond brooches, 112 brooches for hair, 162 gold vinagrettes, watch keys, pearl buttons, mourning rings, maltese crosses, tambour needle cases, silver pencil cases, masonic jewels, toothpicks, reticules, scales and weights, sets of billard balls, plated tableware, cigars, backgammon tables, dressing boxes, hairbrushes, slates, paper toys, gold seals, twenty-five papers of "Plate Powder," "real silver" epaulets, silver dirks, silk lace for dirk belts, cords and tassels, sword blades and hooks, and 244 miscellaneous items. The appraised value of the stock in the shop was $14,6540.50.[115] At the very bottom of their long advertisement of 1810, in very small print, it was recorded that, as silversmiths, they continued to make to order all in the "silversmiths' way."

In 1810 and 1811, with the difficulties of trade preceding the War of 1812, the Anthonys reached out to take advantage of the growing interest in textile manufacturing and general stock. Their advertisement placed in *Poulson's*, October 13, 1810, read: "Patent Pruning Shears. JOCELIN's newly invented Patent PRUNING SHEARs for pruning Fruit Trees, gathering selected fruit, cutting away worms nests and taking Mulberry leaves for Silk Worms, above the common reach, and for trimming Gooseberry and other shrubs, just received

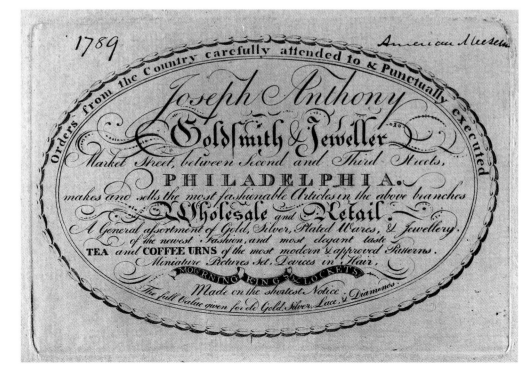

Fig. 23. Trade card of Joseph Anthony Jr., c. 1789. Historical Society of Pennsylvania, Philadelphia

and for sale by JOSEPH ANTHONY and SON, No. 94 High street."[116] In 1812 General Andrew Jackson commissioned them to supply him with, among other things, gilt epaulets and a sword.[117]

An interesting event in the entwined lives of father and son, and not fully explained, occurred in 1812. Joseph Anthony Jr. then had in his possession two seminal historical Pennsylvania documents: the original Charter to the Province of Pennsylvania, and the original Charter to the People of the Province of Pennsylvania, both dated October 28, 1701, and signed by William Penn. Just why the silversmith owned these very early documents is not clear. They may have belonged to Joseph Anthony Sr., who had purchased property from the proprietors via the Pembertons. Alternatively, the Penns may have given the documents to the silversmith in 1788 for safekeeping at the time they commissioned two tankards, one to be presented to their surveyor and land manager, Gunning Bedford, and the other to their lawyer, Charles Jarvis, as a reward for service (see cat. 15). In 1812, in an effort to preserve the historical documents relating to Pennsylvania's early years, a committee of three from the American Philosophical Society—Peter S. DuPonceau, James Gibson, and William Tilghman—called on Anthony to request from him the two documents. Having been informed of the object of their visit, Anthony "very politely & obligingly delivered to them, for the purpose of being preserved among the records of the Society, these original charters, granted by William Penn to the People of the Province of Pennsylvania, & Territory thereunto belonging, bearing the date the 28th day of October in the year of our Lord 1701." The minutes of the Society went on to note that "the thanks of the Society [were] ordered to be presented to Mr. Anthony for the donation."[118]

On August 8, 1814, the Harrisburg *Chronicle* published the announcement of the silversmith's death: "DIED, on Friday evening last, of a stroke of apoplexy, at M. Buehler's stage office in this borough, Mr. JOSEPH ANTHONY, jeweler, of Philadelphia, from whence he had arrived." In Philadelphia, *Poulson's* elaborated on August 12: "He arrived in the stage about 12 o'clock, in apparent good health and spirits. In less than an hour afterwards he was seized with a fit of apoplexy, which put a period to his existence in about five hours. On Saturday evening his remains were interred in the Presbyterian burial ground with every manifestation of respect." He was attended by Dr. Samuel Agnew (1777–1849), who had graduated from the University of Pennsylvania Medical School in 1800. One record notes that Anthony was buried on August 6 by the Reverend W. Charles Schaffer at the Zion Lutheran Church in Harrisburg.[119]

The administration of Joseph Anthony's estate took from August 17, 1814, to March 19, 1816, and concerned property and debt.[120] On August 29, 1814, Michael H. Anthony advertised that the partnership of Joseph Anthony & Son had been dissolved by the death of his father. Henrietta Anthony must have removed to Huntingdon County to live with her daughter. Her estate was processed May 26, 1821, by her executors the attorney William R. Smith of Huntingdon County and Richard Penn Smith of Northern Liberties, Philadelphia.[121]

At some time after 1812 Anthony Rasch, whose partnership with Jean-Simon Chaudron (q.v.) had been dissolved, moved his "manufactory" to 118 Market Street, between Third and Fourth streets and a half block from the Anthonys at number 94. In the Philadelphia directory of 1816, Michael and Thomas Anthony were still listed as having both their business and their residence at 94 High Street, and Rasch was also listed at that address. The Anthonys went into debt to Rasch and on July 9, 1817, they signed a deed to pay their debts:

> Michael and Thomas Anthony indebted to different persons in divers sums of money and at present unable to make full payment in cash to their creditors have agreed to convey and assign over to James Black, jeweler, George Willig, the younger, silversmith, and Allen Armstrong, Merchant all and singular the messuages and lots of ground, household furniture, goods, wares, merchandize, chattels, rights and credits and all the effects and estate real, rights personal and mixed of them the said Michael and Thomas whatsoever upon the Trusts to and for the uses, interests and purposes hereinafter mentioned. . . . Receipt for $1.00. . . . sell anyway possible . . . reimburse themselves and to pay Anthony Rasch in preference to all other creditors $250 part of which is due to him. J. Black, G. Willig, A. Armstrong to receive all money from those in debt to the firm.[122]

The city directory of 1817 listed Thomas Anthony as an "M.D." at 157 North Third Street, and Michael H. Anthony as a conveyancer with an office in the county courthouse. BBG

1. Not to be confused with another family, a Joseph Anthony and Joseph Anthony Jr. who were turners and medical-instrument makers working and living at 25 Brewer's Alley and 227 North Second Street, listed in the U.S. census and the Philadelphia directory from 1791 until 1810.

2. Joseph Anthony Sr., Legal Client Books, 1794–99; Ledger, 1760–82; Receipt Book, 1773–87, Meredith Family Papers, 1759–1964, Series 10a, Miscellaneous, Joseph Anthony, HSP.

3. Account with Gilbert Stuart Sr., 1762–64, 1767–75; Joseph Anthony Sr., Ledger, 1760–82, Meredith Family Papers, 1759–1964, Series 10a.

4. Joseph Wharton, a merchant from Philadelphia, who was visiting in London in 1775 and dining with Benjamin West, met

Gilbert Stuart there. Learning that Stuart was a nephew of his friend Captain Joseph Anthony, Wharton "told Mr. West that he [Stuart] was well connected"; George C. Mason, *The Life and Works of Gilbert Stuart* (New York: Scribner's, 1879), pp. 10–11. The *Portrait of Captain Joseph Anthony* (National Gallery of Art, Washington, DC, 1942.8.11) was begun in Newport and finished about 1794, when Stuart went to Philadelphia to paint President George Washington and several Congressmen. There is another portrait by Stuart, *Captain Joseph Anthony* of 1795, in the Pennsylvania Academy of the Fine Arts, Philadelphia (1909.11) and a miniature of Captain Anthony by Walter Robertson of c. 1794, at the Smithsonian American Art Museum, Washington, DC (1952.12.1). Stuart's oil portraits of Joseph Anthony Jr., silversmith, and his wife Henrietta Hillegas Anthony (see figs. 19, 20), served as the models for a pair of miniatures on ivory at the Walters Art Museum, Baltimore (37.437, 38.437). A portrait of their daughter Eliza was destroyed by the painter: "Stuart's portrait of Joseph Anthony's daughter was said to be 'a striking likeness, but agreeable to his usual custom, [Stuart] could not be persuaded to finish it. The parents frequently importuned him & one day beset him with uncommon earnestness, on which the painter snatched up a brush & with one daub across the face of the likeness destroyed a piece on which he had bestowed much attention & thus put an end to further parley'"; *Philadelphia Merchant: The Diary of Thomas P. Cope, 1800–1851*, ed. Eliza Cope Harrison (South Bend, IN: Gateway, 1978), p. 124 [June 10, 1802]. Stuart's portrait of John Anthony, either Captain Joseph's brother John, who lived in Newport, or the captain's son John, who married Elizabeth Hill and lived in North Carolina, was boxed and dunked into the Roanoke River by a descendant to escape the ravages of the Civil War; Charles L. Anthony, *Genealogy of the Anthony Family from 1498–1904* (Sterling, IL: privately printed, 1904), p. 26.

5. In her will of 1799 Elizabeth mentioned her niece Sarah Simmons, daughter of her nephew Anthony Simmons (q.v.); Philadelphia Will Book Y, p. 145.

6. John was named after Captain Anthony's "beloved brother of Newport." The younger John was probably there acting as a factor for his uncle, who was trading from Newport. In the surviving documents of the Philadelphia family businesses, his name does not appear as a principal. He married Martha Elizabeth Hill, the daughter of Colonel Whitemell Hill and Winifred Blount Hill of Halifax County, North Carolina, c. 1788. They remained in the South. Their son John and his wife, Lucy Tunstall (born c. 1810), inherited the Gilbert Stuart portrait of his father, the silversmith's brother John. Joseph, the silversmith, later named two of his own sons after his brothers, creating some generational confusion (see Anthony, *Genealogy of the Anthony Family*), but did not name a child after John.

Thomas was named after the Philadelphia merchant Thomas Powell (b. 1729). Martha, who was named after her parents' friend Martha Powell, married the New York merchant Hugh Pollock in 1795, in the Philadelphia Baptist Church; *Daily Advertiser* (New York), April 13, 1795. The youngest child was named after Josiah Hewes (1732–1831), Captain Anthony's longtime business partner. In 1778 Hewes's shop in Philadelphia was on Chestnut Street between Second Street and Strawberry Alley; *Pennsylvania Evening Post* (Philadelphia), April 3, 1778.

7. Meredith Family Papers, Series 10a.

8. See ibid. and family birthdays in the records of Philadelphia's First Baptist Church. "Joseph Anthony son of Albro b. December 18, 1738"; Southern Baptist Convention Historical Records, vol. 1, p. 609, HSP. Josiah Hewes Anthony, the youngest child, was entered into the records here at the same time, in 1774.

9. Birth, marriage, and burial records, Christ Church Historical Collections Online, www.philageohistory.org.

10. The cabinetmaker Benjamin Randolph, for one, shipped goods in 1768 with Hewes and Anthony on an account settled in 1774; Benjamin Randolph, Account Book, New York Public Library, p. 138 [October 14, 1786]. In 1775 Dr. Solomon Drowne, visiting from Rhode Island, wrote to a correspondent that he needed money sent "down via Capt Anthony; I shall send my trunk in Anthony's sloop, I expect to return via New York"; contributed by Harrold E. Gillingham, "Dr. Solomon Drowne," *PMHB*, vol. 48, no. 3 (July 1924), pp. 227–50.

11. Carl Bridenbaugh, "List of Philadelphians Visiting at Newport, Rhode Island, 1767–1774," Notes and Queries, *PMHB*, vol. 59, no. 1 (January 1935), p. 94.

12. This trip may have provided John Singleton Copley the opportunity to paint the 1773 double portrait of the Mifflins (PMA EW1999-45-1).

13. Bridenbaugh, "List of Philadelphians Visiting at Newport, Rhode Island, 1767–1774," p. 94.

14. Captain Anthony and his partner, Josiah Hewes, were elected directors of the Bank of the United States when it was chartered in 1791. In 1793 Anthony became a member of the Democratic Society, formed to provide relief to the French colony of Saint-Domingue. In 1798 he acted as inspector of customs, and in June 1798 at a meeting of merchants at the City Tavern, the captain joined others in a subscription for building and equipping two ships, one to be named *The City of Philadelphia* and to be lent to the government of the United States for defense against a possible war with France; Richard G. Miller, "The Federal City, 1783–1800," in *Philadelphia: A Three Hundred Year History*, ed. Russell F. Weigley (New York: Norton, 1982), pp. 193–95.

15. In a partnership with George Gibbs at Newport, Anthony was shipping for Nicholas Brown; see Nicholas Brown & Co. Papers, Subseries A, Joseph Anthony, 1765–1781, box 39, folder 13–14, Rhode Island Archival and Manuscript Collections Online, www.riamco.org.

16. Darold D. Wax, "Quaker Merchants and the Slave Trade," *PMHB*, vol. 86, no. 2 (April 1962), pp. 143–59.

17. The Pemberton wharf is clearly labeled on a 1762 map of Philadelphia prepared by Nicholas Scull and sold by Matthew Clarkson and Mary Biddle; https://commons.wikimedia.org/wiki/File:1762_Clarkson_Biddle_Map_of_Philadelphia.jpg (accessed February 9, 2017). The property was acquired by Anthony in 1782 and is labeled "Anthony" on the *Plan of the City of Philadelphia* 1797. For another city plan, see Martin P. Snyder, *City of Independence: Views of Philadelphia before 1800* (New York: Praeger, 1975), fig. 27, p. 63.

18. "Newport, July 29, 1776 / I have let this day, to John Magee my Negro man named Cato for one year at the rate of eight dollars a month"; notebook, Meredith Family Papers, Series 10a. Tax records reveal the Anthonys' ownership of slaves in Philadelphia; Tax and Exoneration Lists, 1762–94. They were both, however, active members of the Abolition Society in Philadelphia, a clear illustration of ambiguity among non-Quakers.

19. In retaliation merchants in the colonies undertook not to import certain British goods. Initially fairly successful, the movement had petered out by 1771.

20. When they moved they took young Nicholas Brown (1769–1841), also a Baptist, with them to Philadelphia to further his education; receipts, Meredith Family Papers, Series 10a. See also William B. Weedon, *Early Rhode Island: A Social History of the People* (New York: Grafton, 1910), p. 348.

21. "Reading / Received Oct. 21, 1779 of Levi Hollingsworth, two hundred ninety pounds 11 sh in full of balance of an acc't run'd against Mr. John Barnaby / for Richard Humphreys / Joseph Anthony Junr"; Levi Hollingsworth, Receipts, Hollingsworth Family Papers, 1715–1849, HSP.

22. *Pennsylvania Chronicle and Universal Advertiser* (Philadelphia), August 8 and 29, 1772.

23. Richard Humphreys advertised that he had "taken the house in which PHILIP SYNG lately dwelt . . . a few doors below the Coffee House." Immediately below, Syng informed "his friends and former customers" that he recommended Humphreys, "whose fidelity in the above business will engage their future confidence and regard." *Pennsylvania Gazette* (Philadelphia), September 23, 1772.

24. Willard O. Mishoff, "Business in Philadelphia during the British Occupation, 1777–1778," *PMHB*, vol. 61, no. 2 (April 1937), pp. 165–81.

25. See Peter Thompson, *Rum, Punch, and Revolution: Taverngoing and Public Life in Eighteenth-Century Philadelphia* (Philadelphia: University of Pennsylvania Press, 1999). For all the merchants there, see Moon 1898–1909, vol. 2, pp. 335–36.

26. The first Baptists in Pennsylvania came from Newport to Bucks County in 1684. They were in Berks County in 1688. The Episcopal missionary Alexander Murray noted in 1765 that Baptists in his mixed congregation near Reading were numerous enough to set up their own meeting; see Townsend Ward, Granville J. Penn, and George Sharswood, "Second Street and the Second Street Road and Their Associations," *PMHB*, vol. 4, no. 4

(1880), pp. 414–16; and Gregory B. Keen, "The Descendants of Joran Kyn, the Founder of Upland (continued)," *PMHB*, vol. 6, no. 3 (1882), p. 302.

27. Accounts, 1760–1780, Meredith Family Papers, Series 10a.

28. *Pennsylvania Packet, or The General Advertiser* (Lancaster), December 17, 1777: "STOLEN last night. . . . Reward . . . on application to Mr. JOHN JORDAN . . . in Lancaster, or Mr. RICHARD HUMPHREYS, in Reading." The receipt that Anthony had signed for Humphreys (see note 21) was dated and annotated "Reading."

29. It was probably a prearranged lease leading to a purchase, c. 1776; Philadelphia Deed Book D-4-76, recorded January 16, 1782. The recording of deeds took years as a result of the Revolution of 1775–82. The reference to Potts's wife in a purchasing deed is unusual. She must have had a considerable dowry of her own and been a joint owner. David Potts was declared a traitor (that is, a Loyalist) on May 21, 1778. He admitted and was discharged, but he may have sold the property to avoid its confiscation; "Loyalists in the Applications for Passes," *Pennsylvania Genealogical Magazine*, vol. 45 (2007), pp. 251–52.

30. Captain Anthony owned the property at least through 1782, when he was paying Thomas West for work; Meredith Family Papers, Series 10a. By 1780 the captain also owned property in New Hanover Township, Berks County, valued at £5,000, for which he paid a tax of £22 10s., being the rate of 9s. per £100 for two months; Tax and Exoneration Lists, 1762–94.

31. A bachelor all his life, Josiah Hewes (1732–1821), who lived to a great old age, was a close family friend of the Anthonys and the Joseph Lownes (q.v.) family. His obituary in *Poulson's American Daily Advertiser* (Philadelphia), August 21, 1821, noted that he "was a father to many an orphan—a benefactor to the widow and desolate." The partnership continued until at least 1794. Hewes was a director of the Bank of North America in 1785. Captain Joseph Anthony was a stockholder in the bank and became a director in 1791; Burton A. Konkle, *Thomas Willing and the First American Financial System* (Philadelphia: University of Pennsylvania Press, 1937), p. 142; and Pocket Book Receipts, Meredith Family Papers, Series 10a. See also the *Plan of the City of Philadelphia* 1797.

32. The location is clearly marked "Pemberton" on the 1797 city plan (see note 17). In 1791, after Joseph Pemberton died, sections of the original property were put up for public sale as required by law, to pay the inheritance tax, which Joseph's widow Ann could not cover. Charles Jarvis, an agent for the Penns, bought a section for £1,210 and promptly turned it over to Captain Anthony, who paid Ann Galloway Pemberton £1,500. The deed was recorded in February 1791. For Charles Jarvis, see cat. 15. Anthony had been operating from this prime location with a deep wharf, described as "the Southern-most part of the original 57 foot lot with breadth on King [Water] Street 23 feet, extending eastward into the River Delaware 250 feet from the East side of Front Street, bounded eastward with the river, southward by the messuage and lot mentioned to have been devised to John Pemberton, West by King Street and North by a messuage and remaining part of the 57 foot lot, to Mary Pemberton"; Philadelphia Deed Book D-28-132. As the last piece of the estate of Captain Anthony, the property was sold in 1801. The term *messuage* referred to a dwelling house with the adjacent buildings and grounds used in connection with a household.

33. See note 17.

34. Thomas Morris (1745 or 1746–1809), a brewer, owned several rental properties in the city. His residence was recorded in the Philadelphia directory of 1785 (p. 48) as on Second Street between Arch and Race streets.

35. Philadelphia City Direct Estate Tax, 1782.

36. Philadelphia Will Book Y, no. 97, p. 114, written 1782, probated 1798.

37. Cited from a running tally in the notebook in the Meredith Family Papers, Series 10a.

38. *Pennsylvania Packet and General Advertiser* (Philadelphia), April 16, 1783. In 1779 Pinchon was located in the Walnut Ward on Front Street at the corner of Taylor's Alley, which ran east–west between Chestnut and Walnut streets.

39. Captain Anthony, good to his word that he would establish the boys in turn, on March 23, 1791, announced in the *Gazette of the United States* (Philadelphia): "A CO-PARTNERSHIP having commenced between JOSEPH ANTHONY and his son, THOMAS P. ANTHONY, under the firm of JOSEPH ANTHONY

and SON, North side Chestnut-Street Wharf, NEW-ENGLAND Rum, Molasses, Muscovado Sugars, [etc.]." In his will Captain Anthony left £100 extra to Thomas "in consideration of his misfortune losing his hearing"; Philadelphia Will Book Y, no. 97, p. 114.

40. "Poyntell for paper and papering £9 14s. 7d., mason's bill & carpenter bills £14 15s. 0d., upholster bill, painter and glazier £12 12s. 0d"; Meredith Family Papers, Series 10a. From 1785 until 1800 the Middle Ward included the tract that ran east–west above Second Street to the Schuylkill River and north–south between Market and Chestnut.

41. Tax and Exoneration Lists, 1762–94. In 1786 Captain Anthony's personal estate was valued at £20 for 50 ounces of plate, £15 for one horse, £15 for a chair, £60 for one negro, £12 for a servant, £600 for his occupation (merchant), and £1,000 for Reynold Keen's estate.

42. Benjamin Randolph Account Book, New York Public Library, p. 138 [October 14, 1786].

43. *Claypoole's American Daily Advertiser* (Philadelphia), January 11, 1799.

44. Philadelphia Will Book Y, no. 122, p. 145.

45. Ibid.

46. *The Papers of George Washington, Digital Edition*, Retirement Series, vol. 2 (Charlottesville: University of Virginia Press, 2008–17). This reference was kindly supplied by James N. Green, Library Company of Philadelphia.

47. The advertisement appeared throughout October and November in the *Pennsylvania Journal and Weekly Advertiser* and the *Pennsylvania Packet*. Anthony advertised frequently and in different publications, including the *Columbian Magazine* (Philadelphia) in 1787.

48. According to the 1791 city directory, "Michael Kitts, Inn-keeper" was one door from Anthony, at 73 High Street. Kitts's establishment may have been the Indian King, a noted eighteenth-century inn; see Joseph Jackson, *Market Street, Philadelphia: The Most Historic Highway in America, Its Merchants and Its Story* (Philadelphia: privately printed, 1918), p. 31; and Harrold E. Gillingham, "Old Business Cards of Philadelphia," *PMHB*, vol. 53, no. 3 (July 1929), p. 210. John Biddle was for a while the proprietor of the Indian King; Jackson, *Market Street*, p. 31. Biddle was located on the southwest corner of a narrow passageway running south from Market Street to Elbow Lane. The passageway is on the 1797 city plan (see note 17) but not labeled. Anthony's location seems to have been between the unnamed passageway and Strawberry Alley. To the west of the Indian King was Sidney Paul at no. 80 and Hilary Baker, ironmonger, at no. 82.

49. For the camp cups for James Pemberton, see Christie's, New York, *The Collection of May and Howard Joynt, Alexandria, VA*, January 19–20, 1990, sale 7012, lot 233. The camp cups for Winthrop Sargent are marked "J•A" in a tangle; the thick stem of the "J" is not exactly like others in Anthony's small rectangles. See Parke-Bernet Galleries, New York, *The American Heritage Society Auction of Americana*, November 12–13, 1971, sale 3265, lot 338; and Clement E. Conger, Mary K. Itsell, and Alexandra W. Rollins, eds., *Treasures of State: Fine and Decorative Arts in the Diplomatic Reception Rooms of the U.S. Department of State* (New York: Abrams, 1991), p. 333, cat. 207.

50. The bill for the coffeepot was dated December 13, 1783: "By a silvr & engravd arms / The latter 3 Dollrs £37.17.6 / Tea waiter £3.0.0"; Buhler 1956, pp. 45, 48, cat. 21. The coffeepot is in the collection of Mount Vernon; ibid., p. 48, cat. 21. Two of Richard Humphreys's coffeepots are in the collection of the Philadelphia Museum of Art (1977-112-1, 1997-163-1).

51. A copy of the full letter was kindly supplied by Robert Emlen.

52. Autograph Collection, case 19, box 4, HSP.

53. Buhler 1973, cats. 136a,b, illus. p. 66. Inscribed (later), on bottom, "Walter Franklin to Mary Franklin." Walter Franklin (died 1780) and his wife, the former Mary Pearsall, were both Quakers. He was a rich New York merchant who in 1770 built the house on Cherry Street in New York City that George Washington would occupy as president. In 1786 his widow married Samuel Osgood, who was then the owner of the house. Mary inherited property, furnishings, and 5,000 Spanish milled dollars. Each of his daughters, Mary and Sarah, inherited property and 10,000 Spanish milled dollars; *Abstracts of Wills on File in the Surrogate's Office, City of New York*, vol. 9, 1777–83 (New York, 1900), pp. 131, 132.

54. Receipts, Meredith Family Papers, Series 10a.

55. John Cadwalader Estate, Bills and Receipts (August–October 1792), folder 4, Cadwalader Family Papers, Series 2, HSP.

56. James Wilson Papers, 1710–1877, box 6, copies—vol. 9, articles of agreement, bonds and accounts (1710, 1773–1800, undated), pp. 51–60, HSP.

57. Jasper Yeates, Esq., Lancaster, to Edward Burd, Esq., Philadelphia, February 2, 1795: "A few days before I left the City, I bought of Mr. Joseph Anthony's clerk in Market Street a pair of Plated lamps for your sister for 25 dollars. He assured me there were no Complaints made about the pattern. Since my return we have tried the lamps one evening and are mortified to find that they give very indifferent light. It appears to me, that the stem is too small, through which air is communicated from the small holes at the bottom of the lamp to the tube around which the wick is placed and that it is impossible it can burn well. I may be mistaken in the cause but the effect is clear—I rather should have said, very obscured. Be so obliging as to speak to mr. Anthony & know whether he will exchange them for others which will be of use. I would have no objection to give him 15 or 20 dollars for such a pattern as Mrs. Burd would approve of, additional to what I have paid him." Shippen Family Papers, vol. 14, folders 19, 23, HSP.

58. *Pennsylvania Packet* (Philadelphia), January 13, 1790.

59. Lilian B. Miller, ed., *The Selected Papers of Charles Willson Peale and His Family* (New Haven, CT: Yale University Press, 1983), vol. 1, p. 522n145; Gillingham, "Old Business Cards," p. 211. Thanks to Carol Soltis and Elle Sushan for consultations about miniature frames. The frames on the Peale miniatures seen to date are not marked on the exterior, and the miniatures have not been taken out of their frames for examination.

60. James Peale painted miniature portraits of three of the silversmith's children: Thomas Powell Anthony (1791–94; PMA 1954-21-24), Josiah Hewes Anthony (1802–6; Smithsonian American Art Museum, 1952.12.2), and Joseph Anthony III (1786–1821; Pennsylvania Academy of the Fine Arts). I am grateful to Carol Eaton Soltis, author of *The Art of the Peales in the Philadelphia Museum of Art: Adaptations and Innovations* (Philadelphia: the Museum, 2017), for information regarding the miniature portraits.

61. *DAB*, vol. 9, s.v. "Michael Hillegas"; Emma St. Clair Nichols Whitney, *Michael Hillegas and His Descendants* (Pottsville, PA: M. E. Miller, 1891), pp. 37–38.

62. Thomas Willing Balch, *The Philadelphia Assemblies* (Philadelphia: Allen, Lane and Scott, 1916), p. 98.

63. Scharf and Westcott 1884, vol. 2, p. 1688. "The old City Dancing Assembly, which gave a ball on the 21st of February in honor of the birthday of president Washington, was composed chiefly of members of old and aristocratic families, who were disposed to be exclusive; while the new City Dancing Assembly, which gave a similar entertainment on the 22nd, was principally made up of active tradesmen, who had been unable to obtain admission to the older organization"; Scharf and Westcott 1884, vol. 1, p. 469. The Philadelphia Dancing Assembly ball is still held in December.

64. In addition to the three children who survived to adulthood: Thomas Powell (1791–1794), Henrietta H. (1793–1796), William Nicholls (1795–1802), Henrietta H. (1798–1799), Caroline Catbush (1800–1812), Josiah Hewes (1802–1806), and Josephine (1808–1809); Christ Church Historical Collections Online, www.philageohistory.org. Joseph and Henrietta's daughter Eliza married William Rudolph Smith of Huntingdon, Pennsylvania.

65. A hairworker twisted hair into tiny initials and designs for miniatures, mementos, and jewelry such as rings and pins; Benjamin Randolph, Account Book, New York Public Library, p. 138 [October 14, 1786].

66. *Freeman's Journal, or The North-American Intelligencer* (Philadelphia), February 13, 1788. "An Act to Incorporate the subscribers to the plan for erecting a Permanent Bridge over the river Schuylkill, at the western extremity of the High Street of the City of Phila."; Pennsylvania General Assembly, November 14, 1787. The subscription required to become a corporator was 26⅔ Spanish milled dollars, toward a total of 20,000 Spanish milled dollars. A Richard Humphreys and a Samuel Richards also subscribed. If they were the silversmiths, they and Joseph Anthony Jr. were the only ones in that trade listed.

67. Francis Hopkinson, "An Account of the Grand Federal Procession," ed. Whitfield J. Bell Jr., *Old South Leaflets* (Boston), nos. 230–31 (1962). For a detailed description of the procession, see Scharf and Westcott 1884, vol. 1, pp. 447–52, esp. p. 449.

68. Receipt, August 14, 1788 (Aron Anderson), Coxe Family Papers, 1638–1970, HSP.

69. The entries on the muster rolls did record senior or junior in connection with some names. However, three entries in 1787–88, for example, noted a Joseph Anthony without a suffix. In 1787 the roster for the return of the Eighth Company, Second Battalion, commanded by James Read, Esq., included "Joseph Anthony" as well as John Aitken (silversmith [q.v.] or joiner?), Clement Biddle, Joseph Richardson Jr. (q.v.), Nathaniel Richardson (q.v.), and James Trenchard (engraver). In 1788 a Joseph Anthony was listed as a member of the Fifth Company, Second Battalion, under Lieutenant Colonel James Read, and as infantry in the Sixth Company, Second Battalion, also under Read; *Pennsylvania Archives*, 6th ser., vol. 3 (1907), pp. 1006, 1016, 1028, 1041, 1046, 1048. Subsequently, in 1794, the roster for the return of the Seventh Company of the Third Regiment of the Militia of the City of Philadelphia, commanded by Samuel McLean, included "Joseph Anthony," John McAllister Sr. (q.v.), and Nathaniel Richardson, among others; ibid., vol. 5, p. 518. In 1813 Thomas Anthony, son of Thomas Powell Anthony and nephew of Joseph, silversmith (died 1793), served as a private and then as a third lieutenant in a company of infantry commanded by Colonel Lewis Rush; ibid., vol. 7, p. 71; vol. 8, p. 278; vol. 9, p. 42.

70. Statutes at Large, Pennsylvania, vol. 13 (1787–90), p. 424.

71. Fales 1974, pp. 159, 305.

72. *Pennsylvania Packet*, January 13, 1790.

73. Ibid., March 15, 1790.

74. Scharf and Westcott 1884, vol. 1, p. 463.

75. McA MSS 025, John A. McAllister Collection, McAllister Miscellaneous Manuscripts, Library Company of Philadelphia.

76. *The Papers of George Washington, Digital Edition*, Retirement Series.

77. Ibid.

78. The painting by Jennings, *Liberty Displaying the Arts and Sciences, or The Genius of America Encouraging the Emancipation of the Blacks*, is in the collection of the Library Company of Philadelphia.

79. *General Advertiser* (Philadelphia), July 5, 1792, and January 21, 1792. Similar advertisements first appeared in this newspaper on October 28, 1791, and continued at least through March 17, 1792.

80. Samuel Courtauld, land papers, Miscellaneous Collection, case 19, box 33, HSP.

81. Philadelphia City Archives; a large number of them were identified as the deeds of Joseph Anthony Jr.

82. *Freeman's Journal, or The North-American Intelligencer*, September 19, 1787.

83. Public sale of these warrants was advertised for nonpayment in 1811. *Poulson's American Daily Advertiser*, December 17, 1811.

84. Philadelphia Deed Book D-61-189, recorded by Reynold Keen, 1796.

85. *Philadelphia Gazette and Daily Advertiser*, January 9, 1800.

86. Philadelphia Deed Book D-34-336, signed July 24, 1792, recorded November 29, 1792. The location is no. 11 on the *Plan of the City of Philadelphia* 1797 and is also marked on a plan of the city of Philadelphia drawn by Pierre Charles Varlé and published in 1802 (see the map on pp. xii–xiii).

87. Scharff and Westcott 1884, vol. 1, p. 323. Declaring the old jail inefficient, the Assembly had voted to sell it in 1772; ibid., p. 265.

88. Philadelphia Deed Book D-34-256. John Fries, merchant, had purchased the lot at the corner of Third and Market streets; his building was no. 90; Philadelphia Deed Book D-14-518.

89. *General Advertiser, and Political, Commercial, Agricultural and Literary Journal* (Philadelphia), October 11, 1790. The houses were first numbered consecutively from Front Street. Beginning in 1804, house numbers were changed to indicate their location between the numbered streets. In 1804, when White insured his building, no. 94 became no. 304, the fourth house above Third and between Third and Fourth streets. The Anthonys continued to use the old number, 94, until the property was sold in 1817. See Jackson, *Market Street*, p. 206; Philadelphia directories, 1790–1804.

90. C. A. Poulson, "Philadelphia Directory for the Year 1767:

Compiled from Advertisements in Old Newspapers and Other Authentic Documents" (1862), manuscript, n.p., Library Company of Philadelphia.

91. The units for these sums were not included in the manuscript; other bills from 1794 to 1796 are in dollars but many are in pounds. "Washington's Household Account Book, 1793–1797," *PMHB*, vol. 30 (1906), pp. 182; vol. 31 (1907), no. 1, pp. 57, 79, and no. 2, pp. 182–83.

92. Philadelphia directory 1793, p. 3. By 1793 Hewes had retired from Hewes and Anthony (see ibid., where the listing is for Joseph Anthony & Son). In 1794 "Josiah Hughes [sic], gentleman," was at 15 South Third Street; ibid. 1794, p. 74.

93. "DIED . . . At Philadelphia, of the pestilential Disorder prevailing there, Mr. THOMAS P. ANTHONY, Merchant; a Gentleman highly and deservedly esteemed"; *Providence Gazette and Country Journal*, September 21, 1793. Thomas Anthony married Sarah Stille, daughter of John Stille, the tailor from whom Captain Anthony had purchased his clothes. He had a substantial inventory: a four-room, three-story house, furnishings valued at £833 19s. 9d., 100 ounces of silver, shares in the Delaware and Schuylkill Canal and in the Schuylkill and Susquehanna Canal, a share "in the new theater," a share in the Dancing Assembly, the unexpired time of a servant boy, and £3,648 17s. 5d. as his share of the partnership in Joseph Anthony & Son; Philadelphia Administration Book H, no. 288, p. 154.

94. *Philadelphia Gazette and Universal Daily Advertiser*, January 29, 1794. See also Joseph Anthony & Son invoice for rum and oil, signed "M [or W] Holland for Jos Anthony £191 17s.[,] 1794, April 30"; McA MSS 025, McAllister Collection.

95. Josiah Hewes Anthony's residence was then at 79 Arch Street. In 1797 the ship *John*, owned by Benjamin Joy of Boston, held cargo and German redemptioners consigned to Joseph Anthony; *The Diary of Elizabeth Drinker*, ed. Elaine Forman Crane (Boston: Northeastern University Press, 1991), vol. 2, p. 988n154.

96. Impost Book 1, July–September 30, 1795, Philadelphia, Hagley Museum and Library, Wilmington. Richard Humphreys and Joseph Lownes were also importing on these ships.

97. Ibid.

98. *Porcupine's Gazette* (Philadelphia), March 28, 1798 (original emphasis).

99. Two weeks before his death, Captain Anthony had been nominated to run for the Senate. Samuel Hodgdon, in a letter from Philadelphia dated September 29, 1798, to Melancton Smith, noted that, in addition to his concern with supply matters, he considered the death of Captain Anthony a great mercantile loss; Samuel Hodgdon, Letter Book, 1798–99 (Library of Congress), Papers of the War Department, 1784 to 1800, WarDepartmentPapers.org.

100. In February 1799 the executors of Captain Joseph Anthony's estate deeded the wharf property, valued at £7,000, to Josiah Hewes Anthony and his partner John Maybin. Philadelphia Deed Books D-76-537 and D-76-540.

101. John Maybin was listed in the Philadelphia directories of 1800 (p. 85), 1801 (p. 26), and 1802 (p. 167, as Maylain) as a merchant, his residence at 155 North Second Street. In 1803 he was listed (p. 171) at the old business address, 5 Chestnut Street. He was Josiah's executor and the guardian of his own daughter Maria, who married Josiah, and of their daughter Martha; Philadelphia Will Book Y, p. 427. John Maybin had married Ann Peter on July 7, 1790; *Pennsylvania Archives*, 2nd ser. (1895), vol. 9, p. 150. Josiah's will, written in August 1799, included a legacy to "the son of his partner John Maybin, Joseph Anthony Maybin"; Philadelphia Will Book Y, p. 427.

102. Elizabeth S. Anthony wrote her will on February 16, and it was probated on March 1, 1799; Philadelphia Will Book Y, p. 145.

103. For the details of Anthony's property in Bucks County and the associated papers, I am indebted to Sally VanZant Sondesky at the Bensalem Historical Society.

104. Bucks County, Pennsylvania, Tax Records, 1782–1860, Bucks County Historical Society, Doylestown, Ancestry.com.

105. W. W. H. Davis, *The History of Bucks County* (Doylestown, PA: Democrat Book and Job Office Print., 1876); William Russell Birch, *Country Seats of the United States*, ed. Emily T. Cooperman (1808; repr., Philadelphia: University of Pennsylvania Press, 2008), pl. 10. Birch described the property: "An airy and pleasant

situation on the Pennsylvania shore of the Delaware, fourteen miles from Philadelphia. The house was built by Mr. Jos. Anthony" (p. 60). Birch himself owned property on the Delaware. Anthony's Devon and Andreas Everardus Van Hougheest's China Hall were the only estates on the Delaware River to be depicted in the first edition; they were in good company with Lansdowne, Woodlands, Mount Vernon, Hampton, and others. Joseph and Josiah H. Anthony subscribed to the publication in 1798. See Martin P. Snyder, "William Birch: His 'Country Seats of the United States,'" *PMHB*, vol. 81, no. 3 (July 1957), pp. 236–37. See also Joseph Anthony's advertisement for his sale of the estate; *Poulson's American Daily Advertiser*, February 17, 1804; S. F. Hotchkin, *The Bristol Pike* (Philadelphia: George W. Jacobs, 1893), p. 291.

106. At the time of publication, the boy's body had not been found, but Elizabeth noted that it had since been recovered, and that "Josh. Anthony's wife is the daughter of Michel Hillagess [sic] of this City"; *Diary of Elizabeth Drinker*, vol. 2, pp. 153–54. William Nicholls Anthony may have been named after William Nichols (1785–1871), a silversmith in Newport, Rhode Island, who was also a relative of Elizabeth Anthony, the captain's wife.

107. Hotchkin, *The Bristol Pike*, p. 291.

108. Ibid. The date has been variously published as 1848, 1850, and 1858. A stone house replaced Anthony's frame buildings, but the name Devon was retained.

109. A social club that had its beginnings in the eighteenth century on the Schuylkill River and moved to the shores of the Delaware in 1887. Several of Anthony's merchant friends were longtime members, including Josiah Hewes, who was an officer, but neither Anthony senior nor junior was elected to membership. See William Milnor, *A History of the Schuylkill Fishing Company of the State in Schuylkill . . .*, 2 vols. (Philadelphia: members of the State in Schuylkill, 1889).

110. "DIED on Sunday morning, deeply regretted, Mr. Joseph Anthony, jun. of this city"; *Poulson's American Daily Advertiser*, August 31, 1804. "To eulogize departed worth . . . is the last sad tribute of friendship, in exercising this privilege in pourtraying [sic] the merits of Joseph Anthony, jun. lately deceased"; *Gazette of the United States*, August 31, 1804.

111. See cat. 27, with an unattributed mark. The cream pot has characteristics of the Anthony shop in spite of the New York–style handle.

112. At this time the same hand was signing papers of Joseph Anthony and Co. Josiah H. or John Maybin signed a silver receipt for General Dickinson; Autograph Collection, Benjamin Joy, December 25, 1797, and January 22, 1798, HSP. In 1803 John Maybin, "merchant," was listed in the Philadelphia directory (p. 171) at Captain Anthony's old office, 5 Chestnut Street.

113. "J. ANTHONY & SON, beg leave to inform their friends, that they carry on the Gold Smith and Jewellery business, in all its various branches." See also *Philadelphia Mercantile Advertiser*, November 12, 1810.

114. Engraving on the receipt to Zaccheus Collins, who purchased a plated coffee urn in March 1814. Zaccheus Collins Papers, 1760–1847, HSP.

115. Inventory of the Joseph Anthony shop, Downs Collection, Winterthur Library. I thank Ann Wagner and Jeanne Solensky of Winterthur for their assistance.

116. "Made and sold by SIMEON JOCELIN, the patentee, in New Haven, Connecticut, sold also in this city by Messrs. Sayre & Richards, no. 240 Pearl Street . . . also in Philadelphia by Messrs. Joseph Anthony & Son; High Street, No. 94." *New York Spectator*, March 3, 1811.

117. Bezdek 1994, p. 86.

118. Philadelphia, February 7, 1812, Proceedings 22, pt. 3, 432, American Philosophical Society Archives, courtesy of Charles B. Greifenstein. James Mease's *Picture of Philadelphia, Giving an Account of Its Origin, Increase and Improvements* (1811) suggests that there was interest in Philadelphia in establishing the historical record and materials. In 1817 George and Deborah Logan presented to the American Philosophical Society (MSS.B.P38) a cache of letters from Penn to James Logan that they had found in the attic at Stenton.

119. Zion Lutheran Church, Harrisburg, Dauphin County, Genealogical Society of Pennsylvania, Philadelphia, Ancestry.com.

120. The administrators were Michael H. Anthony, jeweler; Henry Kuhl, cashier of the Farmers and Mechanics Bank; and William Moore Smith of Bristol Township, attorney-at-law. "Michael Anthony, debtor to estate of Joseph Anthony, to a balance remaining in my hands as surviving partner of the late firm of Joseph Anthony & Son resulting from the stock of said firm as per partnership accounts: to house-hold furniture [$]2316.66, after paying debts of partnership [$]1530.84." The administration of Joseph Anthony's estate included the expenses of Dr. Samuel Agnew's services for medical attendance and payments to Rose White for making the shroud; to the Reverend W. Charles Shoeffer; to servants at G. Beyhler's Inn; for carriage hire from Philadelphia to Lancaster, Lancaster to Harrisburg, and Harrisburg to Philadelphia; to Charles Still for the coffin; to John Toussaint for a percentage of wages; to Rachel Anderson in full for wages; to William Duane; to Josiah Hewes for interest due him on bonds and mortgage from decedent; to James McClintic; to Virchaux & Co. for counsel fees for defending suits on the estate, to a subpoena for John Maybin in the case of Martha Ewing versus the decedent, and for entering a protest in Orphans Court; to Liberty Browne for taxes for 1812 and 1813; to John Gullin; to John Scotti; to Wayne and Biddle; to Joseph Esherick; to David Kennedy; to "M.M&E." Giberson; to Thomas Tompkins; and for the U.S. Direct Tax on house and estate. The total was $3,852.88. In October 1816, "to cash received, this amount being one fourth of Clarkson & Hillegas's bond to Benjamin Franklin, including interest . . . $3,379.16"; Philadelphia Administration Book L, no. 212, p. 190. On May 17, 1816, the Orphans Court ordered William Britton, Abraham Carlile (q.v.), and John Greiner to audit Michael Anthony's accounts of the estate; Philadelphia Orphans Court Records, 1719–1880, no. 26, pp. 19ff., HSP.

121. Philadelphia Administration Book M, no. 131, p. 271.

122. Philadelphia Deed Book MR-16-55, recorded July 21, 1817.

Cat. 12

Joseph Anthony Jr.
Coffeepot

1783–84

MARK: J Anthony (script in conforming rectangle, twice on underside; cat. 13-1)

INSCRIPTIONS: J M O H (engraved script, on one side); oz / 55 – 15 (engraved, on underside)

Height 15³⁄₁₆ inches (38.6 cm), width 9⁵⁄₁₆ inches (23.6 cm), diam. foot 5¹⁄₁₆ inches (12.9 cm)
Gross weight 53 oz. 15½ dwt.
On permanent deposit from The Dietrich American Foundation at the Philadelphia Museum of Art, D-2007-12

PROVENANCE: James (1752–1819) and Mary (born c. 1749) Carson O'Hara. R. C. Riebel, Louisville, KY; Parke-Bernet Galleries, *Fine Americana*, December 17, 1968, lot 44; (Elinor Gordon, Villanova, PA)

EXHIBITED: Philadelphia 1969, pp. 55, 63, cat. 3; *Brandywine River Museum Antiques Show*, Chadds Ford, PA, May 23–25, 1992, p. 16, fig. 14; on long-term loan to the Diplomatic Reception Rooms, U.S. Department of State, Washington, DC, 1968–92 (Buhler 1973, pp. 1, 66; cat. 137); on long-term loan to the Columbia Museum of Art, SC, 2009–16.

This elegant coffeepot is a grand example of the curvaceous rococo form favored in Philadelphia in the latter part of the eighteenth century. Joseph Anthony produced it from the outset of his career. This example, made in 1783–84, is very like the one he made in 1783 for George Washington,[1] who was known to patronize local craftsmen. Richard Humphreys (q.v.) may have recommended Anthony, or it may have been Clement Biddle who sent the general to Anthony's shop. Biddle was Washington's factor in Philadelphia, sourcing many of his furnishing purchases there, and was also an early factor for Captain Joseph Anthony's trade.

The generous shape and details of the cast spout and handle sockets owe much to the designs of Richard Humphreys.[2] The bands of bead around the raised pedestal foot present a quieter detail than does the chased gadroon on the Washington pot, and show a touch of the neoclassical then coming into style. The finial is different from any other used by Anthony. The discrepancy between the inscribed and the actual weight is probably due to the coffeepot being weighed before the handle was added. The engraved foliate initials sweep across the widest part of the body. The same engraver working for Anthony engraved the tea set for "SRE" (cat. 16).

The initials "JMOH" on this coffeepot belonged to James and Mary Carson (born c. 1749) O'Hara, the daughter of William Carson (died March 1786), an innkeeper in Philadelphia. James (1752–1819) was sent to the Jesuit College of Saint Sulpice in Paris for his early education.[3] In 1770 he returned to England and joined the Cold Stream Guards. In America before the Revolution, O'Hara enlisted and became the captain of a Virginia regiment. He was in Philadelphia in about 1772 and served through the Revolutionary War as an Indian trader in Virginia and western Pennsylvania, including Fort Pitt. His fluency in French came in handy when he was dealing with the French and Indians still active from the war of 1754–57 on the western borders of Pennsylvania. In 1781 he was appointed by General George Washington as the sixth quartermaster general of the U.S. Army, supplying forts along the Ohio River, a post necessitating frequent trips to Philadelphia, and he served in that capacity until 1792.

James and Mary Carson O'Hara married in Philadelphia in 1783. They moved to Pittsburgh in 1784 but retained family and business connections in Philadelphia. He grew into prominence before 1791, trading in and out of Pittsburgh as well as through his father-in-law, William Carson, and Joseph Carson in Philadelphia.[4]

O'Hara continued to serve in a military capacity through the Whiskey Rebellion and Indian uprisings, when as quartermaster general for the Western Counties he supplied General Anthony Wayne in the campaign against the Indians in 1792. O'Hara was known as efficient and reliable, and when he resigned General Wayne wrote that he could not find a suitable person to replace him.[5]

After retiring from the military, James O'Hara invested in businesses in Pittsburgh and purchased a handsome residential property, including some 235 acres bordering the Allegheny River, which he called Guyasuta after a Seneca Indian chief of that name.[6] Combining his military experience and business acumen, O'Hara acquired land in Pennsylvania, Ohio, Kentucky, and Tennessee during the period from 1792 until 1795. He owned some two thousand acres on the north side of the Allegheny River that is now known as O'Hara Township. His investments also included a sawmill, a brewery, and an ironworks. He was president of the Pittsburgh branch of the Bank of Pennsylvania.

James O'Hara established the first glass factory in western Pennsylvania, initially making black and green glass for bottles, and later clear window glass.[7] Men from the Amelung factory in Maryland moved to Pittsburgh to work for him, and he shipped the glass by river on flat boats and by wagon and carriage. His factory made three sizes of window glass, measuring 7 by 9 inches, 8 by 10 inches, and 10 by 12 inches.[8] He had accounts in Philadelphia with J & W Lippincott and with Lippincott and Richards, through an account with John McAllister Sr. and Jr. (q.v.).

A descendant donated tracts of his property (currently known as Schenley Park) to Pittsburgh.[9] A visitor described the O'Hara property:

> In the afternoon Mr. and Mrs. O'Harra [sic] waited on us and insisted on our going to their house [D]'rop'd down the Ohio, and at the distance of a mile and a half had a full view of Capt' O'Hara's Summer house which Stands on the banks of the Alleghany [sic] river, which runs about a hundred yards from the bottom of their garden. It is the finest situation that I ever Saw; they live at the upper end, or rather out of the Town; their house is in the midst of an Orchard of 60 acres, the only one in that place, from the front of which they have a full view of the Monongahela, and the Ohio rivers; it is impossible for the most lively imagination to paint a situation and prospect more delightful.[10]

Celebrated locally for his establishment of business projects in western Pennsylvania, he was recalled with respect as late as 1888: "I remember the funeral procession of General James O'Hara, crossing Wood Street at Fourth, in December, 1819."[11] BBG

1. Buhler 1956, pp. 45, 48, cat. 21. Washington purchased the pot on his way to Mount Vernon from Rocky Point in 1783; Carol Cadou, *The George Washington Collection: Fine and Decorative Arts at Mount Vernon* (Manchester, VT: Hudson Hills, 2006), p. 116.
2. See the coffeepot by Richard Humphreys (PMA 1977-112-1). Anthony would have just completed his apprenticeship in 1783; see Buhler 1956, p. 47, cat. 21.
3. Biographical information drawn from *American National Biography* (New York: Oxford University Press, 1999), s.v., "James O'Hara (1752–1819)."
4. James O'Hara accounts dated June 26, 1786, and February 1787 with Joseph Carson. Joseph Carson, receipts, 1775–1791, HSP.
5. Anthony Wayne to Thomas Pickering, September 19, 1795, Papers of the War Department, 1784 to 1800, WarDepartmentPapers.org.
6. Guyasuta had been a guide for George Washington in 1753. O'Hara purchased land from the U.S. Army in 1793 that had originally belonged to Guyasuta. "Schedule of Titles to the Real Property of James O'Hara, West of the Allegheny," Freeman's, Philadelphia, November 13, 2012, lot 917.
7. "Pittsburgh owed a large proportion of its prosperity and contributed to a princely fortune [that of Gen. O'Hara]"; "Journal of a Tour from Philadelphia thro the Western Counties of Pennsylvania in the Months of September and October, 1809," *PMHB*, vol. 52, no. 1 (January 1928), p. 55. Joseph Anthony used this unusually large-size window glass when rebuilding his shop in 1793.
8. McA MSS 025, John A. McAllister Collection, McAllister Miscellaneous Manuscripts, Library Company of Philadelphia. Among his clients were J. Humes and J & W Lippincott, for hundreds of boxes of glass. There was always breakage, so his accounts read "accounts/commissions/damage."
9. James and Mary had six children, including Thomas (died 1809), who was in the army, William Carson O'Hara, and Richard Butler O'Hara, whose daughter Mary Carson O'Hara married William McCullough Darlington. A handsome tea and coffee service in the collection of the Carnegie Museum of Art in Pittsburgh (26.3.1–5) was made for the Darlingtons by Joseph Lownes (q.v.). One pot also bears the eagle stamp used by Samuel Alexander (q.v.).
10. "Mrs Mary Dewee's Journal from Philadelphia to Kentucky, 1787–1788," *PMHB*, vol. 28, no. 2 (1904), pp. 189, 190–91.
11. Daniel Agnew, "Address to the Allegheny Bar Association, December 1, 1888," *PMHB*, vol. 13, no. 1 (April 1889), p. 55.

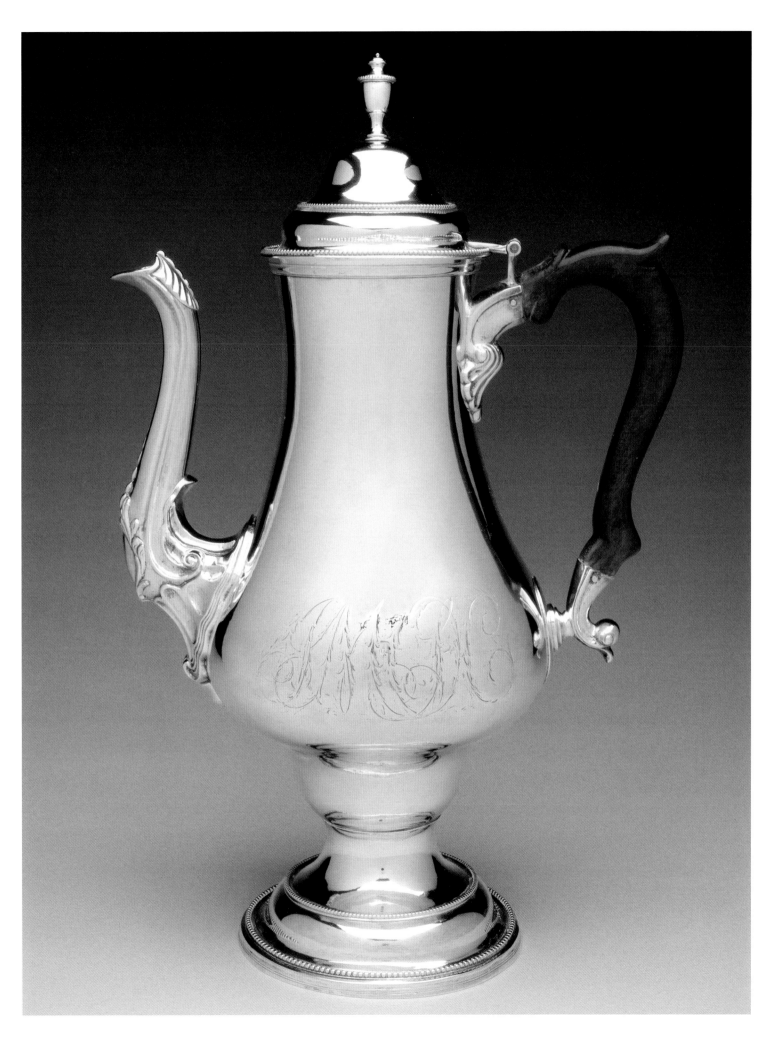

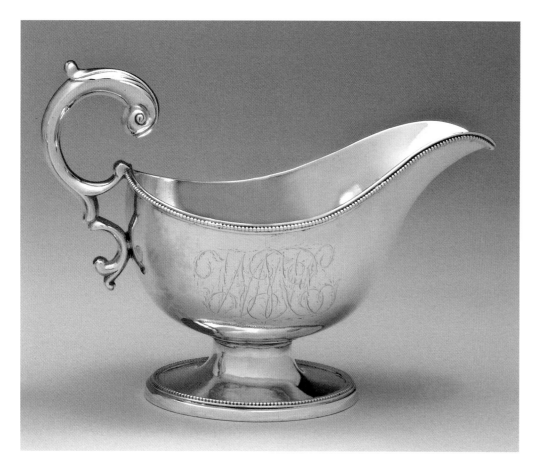

Cat. 13

Joseph Anthony Jr.
Pair of Sauceboats

1783–85

MARKS (on each): J Anthony (script in conforming rectangle, twice on underside; cat. 13-1) / WV 255 (scratched, on underside)

INSCRIPTION (on each): W M H (engraved script, on one side)

Height 5⅝ inches (14.3 cm), length 7¾ inches (19.7 cm), width 3⅞ inches (9.8 cm)

Weight (each) 14 oz. 14 dwt.

Gift of the McNeil Americana Collection, 2005-68-3, -4

PROVENANCE: Christie's, New York, *Important American Silver: The Collection of James H. Halpin*, January 22, 1993, sale 7624, lot 98; (S. J. Shrubsole, New York, NY).

These are truly grand sauceboats in the Philadelphia tradition. Although they are not large, their full shapes are generous and they stand on graceful oval bases. The boldly shaped handles are fully supportive and functional. The surfaces of the sauceboats are plain except for subtle bands of fine bead around the top edge and around the dished foot.[1]

The elaborately engraved monogram on one side is by the same hand that engraved the initials on a coffeepot (cat. 12) for James and Mary O'Hara about 1783. A tall urn-shaped coffeepot by Joseph Lownes (q.v.) bears the same initials, "WMH," in a smaller format, by the same engraver.[2] The initials may have belonged to William and Mary Gilmore Hudson, who married at Swedes' Church, also in 1783, on August 30.[3] BBG

Cat. 13-1

1. A very similar sauceboat by Anthony, with the same features but a slightly more elaborate handle, and with the initials "MP" by the same engraver, is in the collection of the Detroit Institute of Arts. Given the close relationship between the Anthonys and the Pembertons, it is possible that the sauceboat, engraved "MP," may have belonged to one of the Mary Pembertons: Mary Pemberton Pleasants (Mrs. Samuel Pleasants) (1738–1821), the sister of Joseph Pemberton; her daughter Mary Pleasants; or Mary Pemberton Fox (Mrs. George Fox) (1771–1801); Graham Hood, *American Silver: A History of Style, 1650–1900* (New York: Praeger, 1971), p. 188, cat. 209.
2. Published as John Leacock (q.v.), the "IL" in an oval; see Philadelphia 1956, cat. 88; and Sotheby's, New York, *The Collection of Mr. and Mrs. Walter M. Jeffords: Early American Silver*, October 28–29, 2004, sale 8016, lot 184.
3. *Pennsylvania Archives*, 2nd ser., vol. 8 (1896), pt. 3, p. 407.

Cat. 14

Joseph Anthony Jr.
Pair of Shoe Buckles in Fitted Box

1783–90

Paste stones; steel chapes

INSCRIPTION: J. Anthony / Goldsmith & Jeweller / No. 76 Market Street / Philada. (script on engraved paper label, on lid of box)

Buckles: Length 2⅝ inches (6.7 cm), width 1⅞ inches (4.8 cm), rise 1 inch (2.5 cm)

Gross weight (both) 2 oz. 8 dwt. 10 gr.

Box: Length 5½ inches (14 cm), width 2¼ inches (5.7 cm)

Gift of the Misses Margaret G. and Annie A. Cowell, 1928-25-1a-c

PROVENANCE: By descent in the donors' family.

The engraved trade card, glued to the top of the trunk-shaped box, identifies the silversmith Joseph Anthony at least as the retailer, but it does not guarantee that these buckles were made by him. In ornament and construction American and English silver buckles are generally indistinguishable, since London-trained specialists worked in Philadelphia throughout the eighteenth century, and the buckles were imported in great quantity.[1] Marked buckles and other "smalls" are rare, and their documentation is usually obscure unless, like this set, they became family mementos associated with a certain person. The frames of the buckles are parcel gilt on silver and bright cut in a scallop design with a tiny bead on the innermost edge. The imitation or "paste" jewels are secured with silver prongs and set into silver sockets attached at one edge to the frame. Steel chapes were imported in quantities from the factories in Birmingham, England.

Anthony did advertise early in his enterprise, on October 4, 1783, in the *Pennsylvania Packet* that "he makes all kinds of work in the most elegant manner, viz. . . . Ladies elegant paste Shoe Buckles."[2] Other identical sets in labeled boxes are known[3] and also have chapes of this style. The boxes were covered with textured black paper to imitate shagreen and lined in pastel-colored silks. This example is lined with blue silk and fitted for these large buckles.

Family history records that these buckles were owned by Dr. John Cowell (1759–1789). They may have been purchased for his wife, Mary Cash (1754–1831), whom he married on October 10, 1782.[4] Dr. John Cowell served as a surgeon's mate with the prominent Philadelphian Dr. William Shippen (1712–1801) in the Hospital Department of the Continental Army. After the Revolutionary War, he practiced with his brother David Cowell in Trenton.[5] John and Mary Cowell had two children, John V. Cowell and Maria, who married Thomas Mitchell. The donors were the granddaughters of John V. Cowell.[6] BBG

1. "Thomas Beck, Chaser and Bucklemaker . . . carries on the chasing, repairing and cutting, at his shop at Mrs. Yarnall's in Chestnut Street between second and third streets. . . . he has also for sale, an assortment of fashionable Buckles both silver and Pinchbeck"; as transcribed from the *Pennsylvania Gazette* (Philadelphia), December 1, 1778, Brix Files, Yale

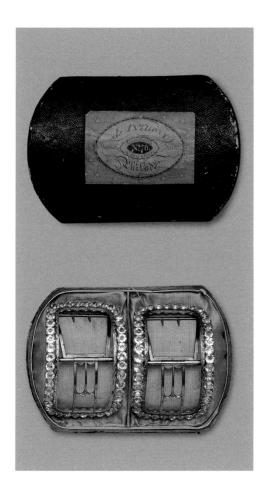

University Art Gallery. See also the *Pennsylvania Evening Post* (Philadelphia), September 8, 1775, and February 22, 1777, for additional advertisements by London silversmiths working in Philadelphia.

2. Seven years later Anthony was clearly importing: "Joseph Anthony, Junr. Has just received by the Brig Lyon, Captain Smith, from London—A Fresh SUPPLY of Plated Wares & Jewellery, Immediately from the Manufactories, . . . A great variety of sett [sic] shoe and knee buckles." *Pennsylvania Packet* (Philadelphia), January 13, 1790.

3. One box is in a private collection and is identical except that it is lined with ivory or yellow satin. Another (also private collection) is lined with pink satin. The buckles have the same chapes and are set with paste stones. Curatorial files, AA, PMA.

4. Mary Cash was the daughter of Abraham Cash.

5. John M. Cowell, "The Family of Deborah Franklin," *PMHB*, vol. 8 (1884), pp. 403–6; and *Notes and Queries*, *PMHB*, vol. 13, no. 1 (April 1889), p. 122.

6. The Museum owns a high chest of drawers (1927-91-1), a pair of tablespoons by John Leacock (1928-25-4a,b), and a gold mourning ring by an unknown maker (1928-25-2) that also descended in the family.

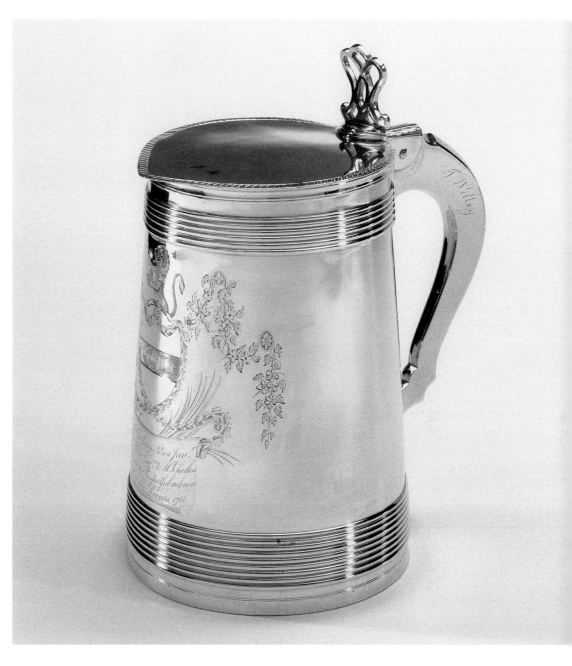

Cat. 15

Joseph Anthony Jr.
Tankard

1788

MARK: J Anthony (script in conforming rectangle, twice on underside of lid; cat. 13-1)

INSCRIPTION: Presented by John Penn Jun. / & John Penn Esq. to M. Charles / Jarvis as a Respectful acknow / ledgement of his Services 1788 (engraved script below engraved coat of arms of Penn family, on front opposite handle; cat. 15-1); T. Willey (engraved script, on one side of handle)

Height 6⅞ inches (17.5 cm), width 7¾ inches (19.7 cm), diam. 5 inches (12.7 cm)

Weight 37 oz. 8 dwt. 12 gr.

Purchased with Museum funds, 1950-53-1

PROVENANCE: Charles Jarvis; Henry Dolfinger; Captain William Lithgow Willey; Samuel T. Freeman & Co., Philadelphia, *Estate of Captain William Lithgow Willey*, April 17–20, 1950, lot. 230.

EXHIBITED: *American Silver: The Work of Seventeenth and Eighteenth Century Silversmiths*, Museum of Fine Arts, Boston, June–November 1906, p. 41, cat. 1; Philadelphia 1956, cat. 15; Philadelphia 1969, cat. 6; Philadelphia 1976, pp. 151–52, cat. 120; Garvan 1987, p. 18, fig. 10, pl. 1.

PUBLISHED: Bigelow 1941, p. 161; Fales 1970, p. 29; Katherine McClinton, *Collecting American 19th Century Silver* (New York: Scribner's Sons, 1968), illus. p. 2; Philadelphia Museum of Art, *Handbook of the Collections* (Philadelphia: the Museum, 1995), p. 266.

The body and the handle of this tankard are seamed. The base was set in and soldered. The ribbed bandings were a design feature that also added strength to the sides and gave the name barrel-hoop to this form, which was popular in Philadelphia. Joseph Anthony made a similar pair for the Sands family (see cat. 20). The form was also made by other silversmiths in other regions, including New York, where Myer Myers (q.v.) made a pair of barrel-hoop

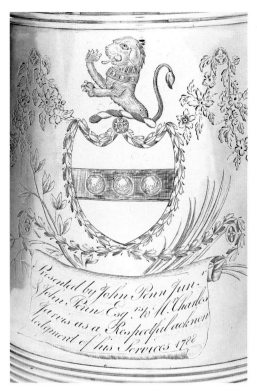

Cat. 15-1

tankards (PMA 1922-86-19a,b) for the Hamilton family. Early in its history this tankard had a spout added and subsequently removed. As a result the engraving at the center, the prancing lion, part of the crest and arms, and the foliage on each side are restorations. The inscription and flower swags were not affected by the repair.

In February 1788 the John Penns senior and junior commissioned two tankards from Anthony that are alike in form, weight, and inscription, one for Charles Jarvis (1731–1806) and one for Gunning Bedford.[1] In an estate record of Governor John Penn, they were noted as follows: "April 1, 1788 Accot Currt [sic] with Anthony Butler. / Feb. 15 to Jos Anthony ¼ of his bill for two Silver tankards . . . 15.10.6 specie. / Feb. 22 to cash pd S. Nichols ¼ of his accot for refreshment to Mess. Jarvis & Bedford . . . 0.6.3."[2] Charles Jarvis (or Jervis) was a Philadelphia lawyer of Irish descent;[3] Gunning Bedford Sr. (1720–1802) was a prominent citizen, carpenter, and surveyor.[4] The presentations were made by John Penn Sr. (1729–1795), grandson of William Penn, and his cousin John Penn Jr. (1760–1834), son of Thomas Penn, for services and petitions in Pennsylvania and London in 1787, in an effort to secure title to land held by the original Penn proprietorship under crown patents.[5] After 1782, with the peace between Great Britain and the newly established United States of America in 1787, and with the adoption of the Constitution in 1788, title to the Penn proprietary lands was not honored. Public sentiment was unfavorable, and the petition to the Pennsylvania legislature was denied. John Penn Sr. remained in Philadelphia until his death, but John Penn Jr. returned to England in 1789.

Two important early documents—the original Charter to the Province of Pennsylvania and the

original Charter to the People of the Province of Pennsylvania—both dated 1701 and signed by William Penn, were in Joseph Anthony Jr.'s possession in 1812. As they had become historical documents rather than legal instruments by 1787, John Penn Sr. or Jr. may have handed them over to Jarvis, who in turn lent or gave them to Anthony as a source for the inscription and Penn arms engraved on the tankards.[6]

Charles Jarvis was a lawyer of some note and performed services for Isaac Norris II and III and the Pemberton family.[7] In 1768 he married Elizabeth Boore (1746–1780). Jarvis was living in the Middle Ward, Philadelphia, in 1772.[8] Considered "dangerous to the state" in 1777, when the English occupied Philadelphia, he was one of the Loyalist Quakers removed to Winchester, Virginia, for confinement.[9] Upon returning, he reestablished himself as a lawyer specializing in real estate. His son Samuel moved to New York.

At some point the tankard became the property of Hetty Green Langdon (1794–1868), who married Captain William Lithgow (1793–1826) on November 16, 1816, in New York.[10] The inscription "T. Willey" identified Tolman Willey (1809–1883), the husband of Phebe Langdon Lithgow (1826–1911). They married in New York in 1844.[11] BBG

1. The Bedford tankard is illustrated in Hammerslough 1958–73, vol. 1, p. 13. Gunning Bedford Sr. left his tankard to his son Judge Gunning Bedford Jr. (1747–1812) of Wilmington; information kindly provided by Lewis D. Cook, Philadelphia.
2. Shippen Family Papers, estate of Gov. John Penn, vol. 32, p. 13, HSP.
3. Francis Olcott Allen, "Earliest Burial Records of the Board of Health, 1802–1860," Publications of the Genealogical Society of Pennsylvania, vol. 1 (July 1897), p. 238. For further genealogical information about Charles Jarvis, see Philadelphia 1976, cat. 120, pp. 151–52.
4. John Penn Accounts, April 1, 1788, Penn Family Papers, HSP; Shippen Family Papers, estate of Gov. John Penn, vol. 32, February 13, September 3, 1788, HSP.
5. Cadwalader Collection, Thomas Cadwalader, Series 3: General Thomas Cadwalader Papers, Anthony Butler Papers, box 60, HSP.
6. Anthony presented the documents to the American Philosophical Society in 1812; see page 55, note 118, in this volume.
7. Norris Family Papers, Family Accounts, vol. 1, p. 13; vol. 3, pp. 88, 90, 91, HSP; Pemberton Family Papers, vol. 54, p. 25, HSP.
8. 1772 Penny Provincial Tax, Tax and Exoneration Lists, 1762–94.
9. Scharf and Westcott, vol. 1, p. 345; Dr. and Mrs. Henry Drinker Collection of Miscellaneous Family Papers, vol. 1, p. 40, HSP.
10. Public Member Trees, Ancestry.com.
11. Ibid.

Cat. 16
Joseph Anthony Jr.
Bowl

1785–88
MARK: J Anthony (script in conforming rectangle, twice on underside; cat. 13-1)
INSCRIPTION: [coat of arms of the Worshipful Company of Pewterers, London] (engraved, on one side; cat. 16-1); S R E (engraved script, on opposite side)
Height 4⅞ inches (12.4 cm), diam. 7⅛ inches (18.1 cm), diam. foot 4⅛ inches (10.5 cm)
Weight 14 oz. 16 dwt. 17 gr.
Gift of the McNeil Americana Collection, 2005-68-5

PROVENANCE: Frances Hopkinson Willing (Mrs. Charles Willing); sale, Freeman's, Philadelphia, Rare Early American Furniture, Modern Period Furnishings, American Silver . . . , October 16, 1951, lot 381-D; in the possession of David Stockwell; Mrs. Arthur J. Sussel; Parke-Bernet Galleries, New York, Arts and Crafts of Pennsylvania and Other Notable Americana, from the Estate of the Late Arthur J. Sussel, October 23, 1958, sale 1847, lot 500; Mr. and Mrs. Hugh B. Cox; Christie's, New York, Highly Important American Furniture: From the Collection of Mr. and Mrs. Hugh B. Cox, June 16, 1984, sale 5596, lot 71; Stanley Paul Sax; Sotheby's, New York, Highly Important Americana from the Collection of Stanley Paul Sax, January 16–17, 1998, sale 7087, lot 65; (S. J. Shrubsole, New York).

EXHIBITED: Philadelphia 1956, cat. 2.

This generous, footed bowl has a bold chased gadroon around the foot and around the top edge. It was the slop bowl in a three-piece tea service. The two other pieces, a cream pot and a drum-shaped teapot are known.[1] The bowl is large enough to have also been used as a small punch bowl. The elegant foliate engraving of the initials "SRE" are in sequence, characteristic of the style of the 1780s and 1790s. The designs of the engraved fronds and roses that frame the initials are slightly different on each piece.

The coat of arms is engraved on one side of the bowl, cream pot, and teapot. The initials are engraved on the opposite side of each. The engraving is not a perfectly correct rendition of the arms of London's Worshipful Company of Pewterers, whose arms are described as: "Azure a Chevron or charged with three Roses Gules barbed and seeded proper slipped and budded vert between three strakes."[2] (Strakes are molds used to test the lead content of molten metal.) Here the three strakes are incomplete. The three roses are drawn as open, flat rosettes with barbs, and the stems are a version of "slipped and budded vert."[3] The engraving lacks the depth and intensity usual in the depiction of coats of arms. The image may have been taken from a line drawing, from a recollection of an illustration, or from a family document. The rendition of the arms does, however, perfectly reflect the period style for the Anthony shop.[4]

The family names Mifflin, Cox, and Hopkinson that recur in the bowl's history offered a clue to the story of this object. The initials "SRE" on the bowl refer to the pewterer Simon Edgell (1687–1742), who

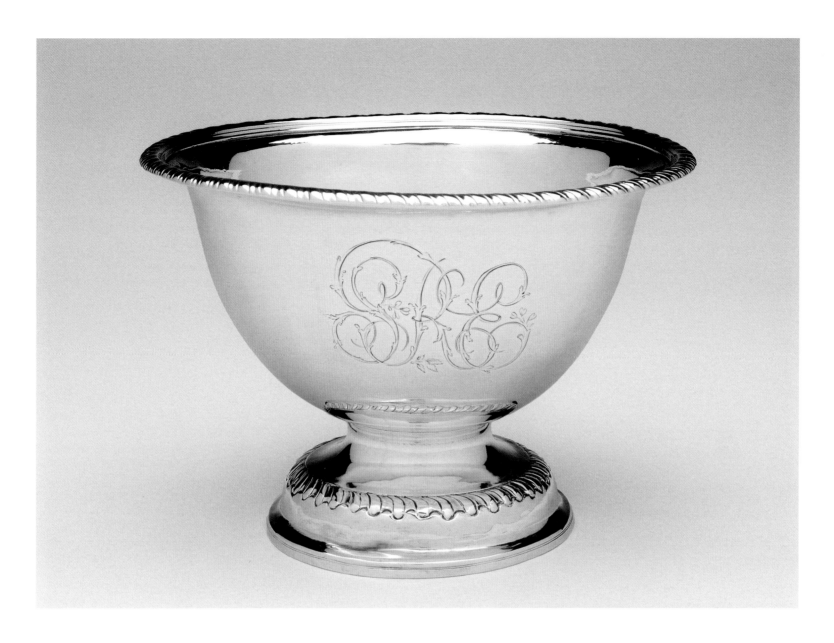

was a member of the Philadelphia Monthly Meeting of Friends, and his wife Rebecca (died 1750).[5] Edgell had been apprenticed to a pewterer in London in 1702,[6] but he was documented in Philadelphia by 1713, when he witnessed the wedding of George Mifflin and Esther Cordrey.[7] He was admitted as a "freeman" in the city of Philadelphia in 1717–18 at the same time as Francis Richardson, goldsmith (q.v.); Edgell paid a fee of 15 shillings 6 pence.[8] He served as an Overseer of the Poor in 1728.[9] The Edgell family was well connected and owned city property and land in Lancaster County and New Jersey.[10] Simon Edgell and his wife Rebecca had two children, William (died 1752) and Rebecca (1727–1788).[11] William Edgell, a merchant, married Sarah E. (whose family name is unknown). At William's death Sarah Edgell married John Cox, as his first wife, by license at Christ Church, Philadelphia.[12]

Simon's daughter Rebecca married Samuel Mifflin (1725–1781) on August 30, 1750, at the Parsonage House of the Oxford Church, Philadelphia.[13] Their daughter Sarah married Turbutt Francis (1740–1780) in 1770, and their children were Samuel Francis (1776–1829) and Rebecca Mifflin Francis.[14] At some

time between 1777 and 1780, Charles Willson Peale painted grand portraits of Rebecca and Samuel Mifflin as elderly, well-to-do Philadelphians in a domestic setting, and Rebecca's portrait includes her granddaughter Rebecca Mifflin Francis.[15] In her will Rebecca Edgell Mifflin stipulated that her grandson Samuel Mifflin Francis, in order to inherit the Mifflin family place of Walnut Grove, change his name to Samuel Francis Mifflin.[16] It seems reasonable to speculate that, with the same intent, she commissioned the tea service for her granddaughter from Joseph Anthony to be engraved with her parents' initials "SRE," together with the arms of the London Pewterers Company in memory of her Edgell family.[17]

There was a close connection between this family and the Anthonys, as revealed in Samuel Mifflin's will of 1781, which included bequests to his friends, among them, Ann, Martha, and Samuel Powell and Josiah Hewes.[18] Martha Powell, a spinster, and Elizabeth Anthony boarded together after Elizabeth's husband, Captain Joseph Anthony, died. Martha Powell was the executor of Henrietta Anthony's will.

BBG

1. The cream pot is in the collection of the de Young Museum, Fine Arts Museums of San Francisco (1996-120-5). For the teapot, see "Pook Kicks Off Antiques Week with Strong Sale," *Maine Antique Digest*, vol. 40, no. 7 (July 2012), illus. p. 15-C.

2. Samuel Kent, *The Grammar of Heraldry with Two Appendices* (London: printed for J. Pemberton by R. Tookey, 1716).

3. Charles Welch, *History of the Worshipful Company of Pewterers of the City of London: Based Upon Their Own Records* (London: Blades, East and Blades, 1902), vol. 2, illus. p. 39.

4. Information kindly supplied by Jim McConnaughy at S. J. Shrubsole, New York.

5. Will of Simon Edgell, written March 9, 1741, probated May 7, 1742, Philadelphia Will Book F, no. 269, p. 298. In his will Edgell mentions his mother Rebecca, as well as his wife, also named Rebecca. His wife's will was written July 10, 1750, probated July 13, 1750; Philadelphia Will Book J, p. 281.

6. For Simon Edgell and his pewter, see Jay Robert Stiefel, "Simon Edgell, Unalloyed," *Antiques and Fine Arts Magazine* (2014), www.antiquesandfineart.com (accessed January 11, 2016).

7. Pennsylvania Vital Records, vol. 1, pp. 23–24.6, Ancestry.com.

8. Minutes of the Common Council of Philadelphia, 1710–1718, p. 130, Ancestry.com; Stiefel, "Simon Edgell, Unalloyed."

9. Josiah Granville Leach, *History of the Bringhurst Family . . .* (Philadelphia: printed for the author, 1901), p. 100,

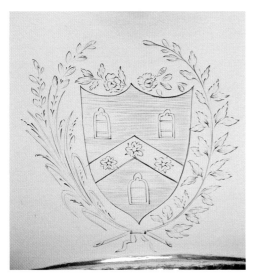

Cat. 16-1

Ancestry.com. Simon Edgell had a nephew also named Simon, son of his brother Cornelius Edgell; will of Simon Edgell, Philadelphia Will Book F, p. 298. He also probably had another brother, William, a pewterer in Boston; Stiefl, "Simon Edgell, Unalloyed," n9.

10. For the division of a Lancaster land patent among the Edgell, Mifflin, and Cox families, see Philadelphia Deed Book H, vol. 20, p. 271.

11. Will of Simon Edgell, p. 297.

12. "Marriage Licenses," *Pennsylvania Genealogical Magazine*, vol. 21 (1958–60), p. 315. He married secondly Esther, with whom he had a son, Cornelius Cox (died 1803).

13. "Rebecca Edgell Mifflin," Partition of Estate of Samuel Edgell, Provincial Commissions, p. 527, Pennsylvania State Archives, Harrisburg.

14. Will of Samuel Mifflin, 1781, Philadelphia Will Book R, p. 422.

15. Peale's portraits are at the Metropolitan Museum of Art, New York (22.153.1, 22.153.2).

16. Will of Rebecca Edgell Mifflin, p. 281.

17. Samuel Mifflin's niece Emily (1774–1850), daughter of Thomas Mifflin, married Joseph Hopkinson in 1794. All the names associated with this silver intermarried. The tea service seems to have descended in various branches of this extended family.

19. See note 15.

Cat. 17

Joseph Anthony Jr.
Six Teaspoons

1791–98

MARK (on each): J Anthony (script in conforming rectangle, on back of handle; cats. 21-1, 22-1)
INSCRIPTION: I M P (engraved script monogram in reserve, on front of handle)
Length 5 7/16 inches (13.8 cm)
Weight 8 dwt. 4 gr.
Gift of Camilla MacKay, 2015-53-1-6

PROVENANCE: Isaac Price (1768–1798) and Mary Fentham Price (born c. 1770); by descent in the donor's family.

The bright-cut engraving on these teaspoons lacks the complexity and finesse seen on a contemporaneous set made in Richard Humphreys's workshop (PMA 1942-47-4–9).

The original owners of this set were the Philadelphia watchmaker Isaac Price (1768–1798) and Mary Fentham (born c. 1770), who married on September 1, 1791.[1] None of their three children had issue; the spoons apparently descended to the donor from Isaac's nephew Philip M. Price (1802–1870), father of Hannah (Price) Barton (see PMA 2011-96-1a-m). DLB

1. Benjamin H. Shoemaker, *Genealogy of the Shoemaker Family of Cheltenham, Pennsylvania* (Philadelphia: J. B. Lippincott, 1903), p. 66; James P. Parke, "Records of Births, Marriages, and Deaths," no. 778, HSP.

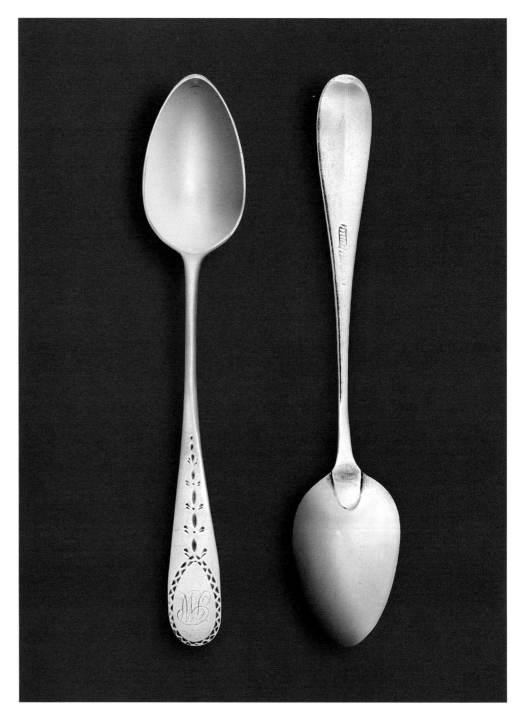

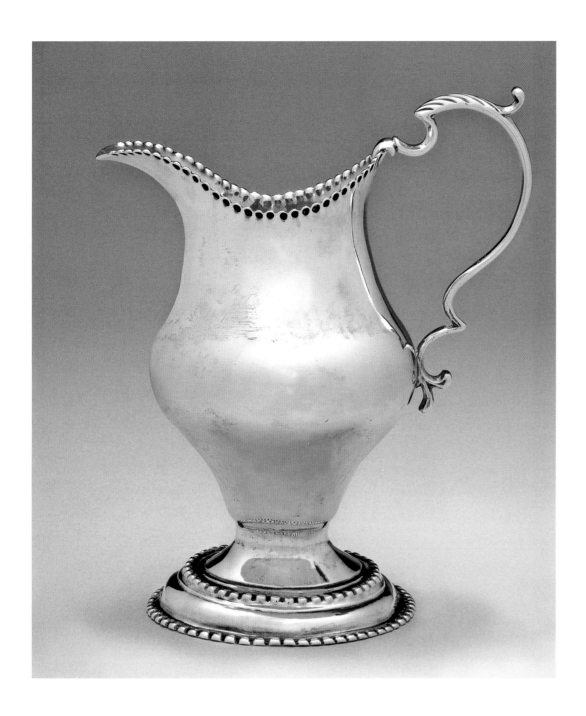

Cat. 18

Joseph Anthony Jr.
Cream Pot

1785–95

MARK: J A (entwined script in rectangle, on underside; cat. 18-1)

Height 5 3/8 inches (13.7 cm), width 4 3/8 inches (11.1 cm), diam. foot 2 13/16 inches (7.1 cm)

Weight 4 oz. 9 dwt. 15 gr.

Gift of the McNeil Americana Collection, 2005-68-2

PROVENANCE: Jonathan Trace, 18th & 19th Century American Silver and Antiques, New Hampshire.

PUBLISHED: Jonathan Trace, advertisement, *Winterthur Magazine*, Fall 2000, p. 23.

This mark, in a short rectangle and in which the scrolled legs of the letters "J" and "A" curl into a bold raised dot, is very similar to the first two letters of one of Joseph Anthony Jr.'s two full-name marks

(cat. 13-1).[1] It appears on the underside of a coffeepot, a teapot, cream pots, a cann, and a sugar bowl,[2] all of which have characteristics similar to hollowware bearing Anthony's full-name mark. Most silversmiths working before 1800 had small marks to use on hollowware where a rectangular mark might not fit.[3]

The raised, molded foot with a double row of flattened tooth-like pearling seems identical to the design and details of the foot of a suave sugar bowl bearing the same script initial mark.[4] The shape of the body and the bands of deeply punched pearl work around the top edge are features of cream pots from the Anthony shop.[5] BBG

Cat. 18-1

coffeepot (Henry Ford Museum, Dearborn, MI; see DAPC 65.1850); cann for the Duncan family, probably James Duncan, a Scot, who married Susannah Lear at the Second Presbyterian Church in 1788 (see Philadelphia 1956, cat. 4); and sugar bowl for a member of the Schuyler family in New York (Hofer and Bach 2011, p. 249, cat. 6.8).

3. For example, John David Sr. and Jr., Daniel Dupuy Sr. and Jr., John Germon, and Richard Humphrey (q.q.v.).

4. New-York Historical Society, 1974.2a,b; Hofer and Bach 2011, p. 249, cat. 6.8.

5. For a similar cream pot with weaker pearling, and with a different "JA" mark (Roman capital letters "conjoined at the bottom," not illustrated), see Quimby and Johnson 1995, p. 330, cat. 311.

1. This mark is a bit longer than a square. For a clear strike of this mark and for a comparison with the mark of James Adam of Virginia, see Hollan 2010, illus. p. 41.

2. Coffeepot, engraved "MM" (Winterthur Museum, 76.276);

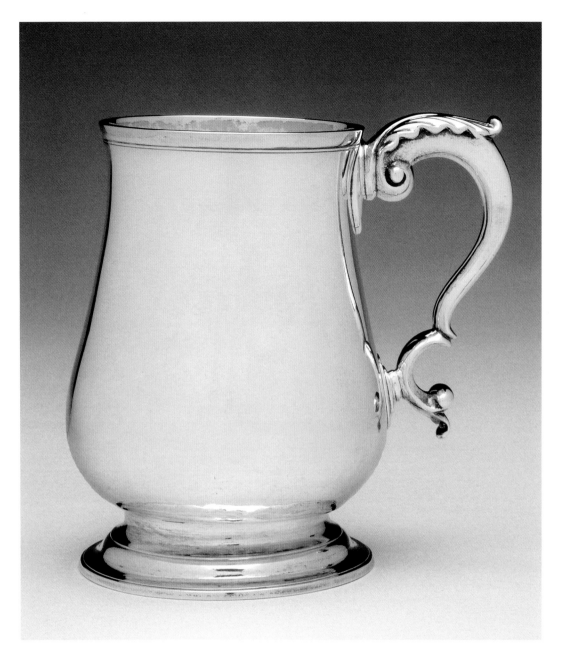

Cat. 19
Joseph Anthony Jr.
Pair of Canns

1795–1800
MARK (on each): J Anthony (script in conforming rectangle, twice on underside; cat. 13–1)
Height (each) 5³⁄₁₆ inches (14.8 cm), width 3¹⁄₂ inches (8.9 cm), diam. foot 3¹⁄₂ inches (8.9 cm)
Weight (each) 12 oz. 16 dwt.
On permanent deposit from The Dietrich American Foundation at the Philadelphia Museum of Art, D-2007-2, -3

PROVENANCE: Captain John Barry (1745–1803); by descent in the family to Mr. and Mrs. Barry Hayes Hepburn; (Elinor Gordon, Villanova, PA).

EXHIBITED: Woodmere Art Gallery, Philadelphia, November 2–30, 1952; Philadelphia 1956, cats. 5, 6; Philadelphia 1969, pp. 55, 64, cats. 1, 2; on long-term loan to the Diplomatic Reception Rooms, U.S. Department of State, Washington, DC, 1968–99 (Buhler 1973, pp. 10, 65, cat. 135); Columbia Museum of Art, SC, 2009–16.

These handsome canns are plain, without engraving, but were designed and made in the best Philadelphia style.

John Barry was born into a farming family in the county of Wexford, Ireland, in 1745. He was apprenticed as a seaman in 1760 and left Ireland to sail in the West Indies trade. Philadelphia was one leg of that trade, and Barry decided to settle there, where his Catholic religion was not a barrier to success in trade. He became a trusted and successful captain of vessels owned by prosperous Philadelphia merchants.[1] Fully espousing the American cause in the Revolutionary War, he spurned monetary inducements from prominent Loyalist-inclined Philadelphians to sail for the British, and served as aide to General John Cadwalader under George Washington at Trenton while his ship the *Effingham* was being built. Barry was captain of the American ship *Lexington*, and he established his fame capturing English ships and sailing in defense of American property

and commerce. From 1797 until 1801 he commanded the frigate *United States* through a short naval war with France, at which time President George Washington appointed him senior officer of the U.S. Navy, a title he held until his death in 1803.[2]

John Barry married first Mary Cleary (1745–1774) at Old St. Joseph's Catholic Church, Philadelphia, in 1767.[3] His second wife was Sarah Keen Austin (1754–1831), daughter of a shipwright, whom he married on July 7, 1777, at Christ Church, Philadelphia, and who later converted to his faith. The Barrys lived at 151 South Third Street in the 1780s but moved three times until 1803, finally settling at 186 Chestnut Street. They also had a fine country estate, Strawberry Hill, where Barry died without issue on September 13, 1803.

These canns descended through Elizabeth Keen (1783–1853), a niece of Sarah Barry, who had been adopted into the Barry household. On April 8, 1795, she married Patrick Hayes (born 1770), himself a sea captain and merchant who was also part of the household and who sailed with Barry after the Revolution in the newly developing China trade. The Hayes family lived with the Barrys until 1801. In 1797 Patrick Hayes was a member of the Society for the Relief of Masters of Ships, and from 1843 until 1849 he was a master warden of the Port of Philadelphia. He succeeded Commodore John Barry in the Pennsylvania chapter of the Society of the Cincinnati.[4]

According to family history, these canns were among the furnishings belonging to Captain Barry on his grand ship the *United States* and then later used as household plate.[5] BBG

1. Among them, Reese Meredith, Robert Morris, and John Nixon. In about 1780 Barry leased property that belonged to Reynold Keen.
2. William Bell Clark, *Gallant John Barry, 1745–1803: The Story of a Naval Hero of the Two Wars* (New York: Macmillan, 1938).
3. *The Catholic Encyclopedia*, vol. 2, s.v. "John Barry" (New York: Robert Appleton, 1907); Bound papers, St. Mary's Graveyard, Fourth and Spruce Streets, Philadelphia, Records and Extracts from Inscriptions on Tombstones, p. 125, HSP. Both his wives are buried in vault 8 in the graveyard of St. Mary's Catholic Church, Philadelphia.
4. Gregory B. Keen, "The Descendants of Jöran Kyn, the Founder of Upland (continued)," *PMHB*, vol. 4, no. 4 (1880), pp. 486–91. See also the tea and coffee service by James Musgrave (PMA D-2007-54, -58), which belonged to Patrick and Elizabeth Keen Hayes, who married April 8, 1795, at Christ Church, Philadelphia.
5. The term *Captain* rather than *Commodore* was used in the navy during Barry's lifetime.

Cat. 20

Joseph Anthony Jr.
Pair of Tankards

1783–1801

MARK (on each): J Anthony (script in conforming rectangle, twice on underside; cat. 13-1)

INSCRIPTIONS (on each): crest (engraved griffin rampant, on lid; cat. 20-1); [draped covered urn with oval reserve (later engraving)] (on front opposite handle)

Each: Height 6⅝ inches (16.8 cm), width 4¹/₁₆ inches (10.3 cm), diam. 4¹/₁₆ inches (10.3 cm)

Weight 22 oz. 3 dwt. (D-2007-4)

Weight 22 oz. 19 dwt. (D-2007-5)

On permanent deposit from The Dietrich American Foundation at the Philadelphia Museum of Art, D-2007-4, -5

PROVENANCE: Firestone and Parson, Boston; Elinor Gordon, Villanova, PA.

EXHIBITED: On long-term loan to the Diplomatic Reception Rooms, U.S. Department of State, Washington, DC, 1968–81 (Buhler 1973, pp. 2, 67, cat. 140a,b); Atwater Kent Museum, Philadelphia, 1981–85; Huntington Library, Art Collections, and Botanical Gardens, San Marino, CA, 1985–present; *Brandywine River Museum Antiques Show*, exh. cat. (Chadd's Ford, PA: Brandywine River Museum, 1992), p. 18, fig. 16.

PUBLISHED: Firestone and Parson, Boston, advertisement, *Antiques*, vol. 42, no. 2 (August 1967), illus. p. 142; Buhler 1973, pp. 2, 67, cat. 140a,b.

This very tight, classical design of the tankard form was introduced in Philadelphia by 1780 and stands in bold contrast to the rotund, curvilinear shapes favored in earlier years. Joseph Anthony made both styles. The bodies of these tankards were constructed of rolled sheet silver and seamed on the back under the handles. The handles, square in section, were also cut from sheet silver and are seamed. The flared, flat, pierced thumb pieces left no impression on the top of the handles. The applied, bold, encircling, convex bands give visual and actual strength to the smooth sides. The edges of the lids are chased and engraved with a running-swag design punctuated with impressed semicircles and deep dots.

The engraved crest is centered on each lid and depicts a griffin rampant, drawn in a lively, free style.[1] There is some pitting on the front in the area of the engraved urns, opposite the handles, suggesting that engraving, probably initials, has been removed.[2] The urns on the front are not by the same engraver, nor are they by a hand recognized as working for the Anthony shop.

The griffin crest belonged to the Sands family of New York, merchants active in Philadelphia in the late eighteenth century, with a wide network of contacts in America and London. In 1780 the brothers Comfort (1748–1834), Richardson (died 1783), and Joshua Sands (1757–1835) were in the business of furnishing equipment and supplies to the patriot troops in the Revolutionary War. Robert Morris, the Philadelphia grandee who is credited with organizing and funding the supply chains supporting the American cause during the war, commissioned their firm to supply West Point in 1782.[3] The Sands

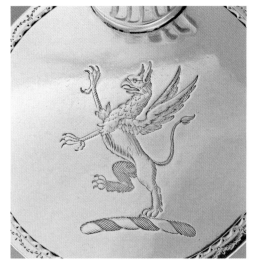

Cat. 20-1

company accounts were kept in Philadelphia by Comfort Sands and his brothers, Richardson and Joshua, between 1781 and 1783.[4]

The tankards may have been purchased by Comfort Sands, although they would have been a very early commission for Anthony.[5] They were more likely commissioned by Comfort's eldest son,

Joseph Sands (1772–1825), whose colorful career became family lore.[6] In 1796, during a spate of political troubles between the United States and France, Joseph—on his way to Europe as supercargo—was aboard an American ship that was captured by the French, and he was imprisoned in the Conciergerie in Paris.[7] At the same time, John Vanderlyn (1775–1852), an American artist in Paris under the patronage of Aaron Burr, exceeded his funds and was incarcerated for debt, also in the Conciergerie.[8] Joseph Sands paid off Vanderlyn's debt, and in return Vanderlyn made a crayon portrait of Sands in 1797, which descended to Sands's daughter Mary Sands Griffin and then to Charles Edwin Sands of Annandale, New York.[9] During Sands's imprisonment he met Maria Theresa Kampfel, daughter of Mathias Kampfel, governor of the prison. On March 26, 1801, after Sands's release, he married Maria Theresa in a ceremony officiated by Charles-Maurice de Talleyrand, then Bishop of Autun.[10] John Vanderlyn, Joseph Sands, and his wife returned to the United States in the summer of 1801 on the ship *Benjamin Franklin* as the only American passengers among French émigrés. Fortunately, they embarked in Portsmouth, New Hampshire, since upon arrival in

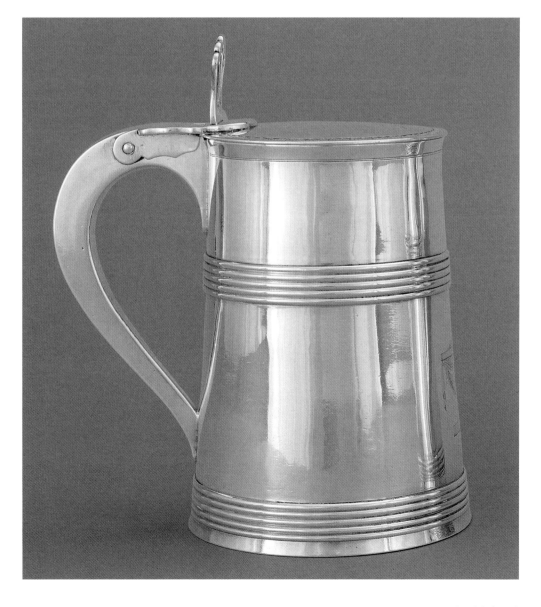

Philadelphia, the ship was impounded by the British, an event that was noted in several newspapers.[11]

Joseph Sands owned spoons made in Philadelphia by the silversmiths Samuel Richards and Samuel Williamson (q.q.v.) to match others made and purchased in France.[12] How long Sands remained in Philadelphia is not clear. Between 1804 and 1810 he served as secretary of the Columbian Insurance Company in New York.[13] Joseph Sands was bankrupt by 1808.[14] BBG

1. John Matthews, *Matthew's American Armoury and Blue Book* (London: printed by the author, 1907), p. 99. The crest illustrated here belonged to James Thomas Sands of St. Louis. His daughter Elizabeth was born in 1781, died young, and was buried in St. Peter's Church Yard on Third Street, Philadelphia.
2. A conservation report noted that the tankards had been highly polished.
3. Their employee Henry Seymour (born 1764), from Connecticut, carried currency to the army encampment at Fishkill, New York, as well as cash and personal property for George Washington's family located there.
4. By 1796 Comfort was listed back in New York at 93 Pine Street; he was bankrupt in 1801. John C. Dann, *The Revolution Remembered: Eyewitness Accounts of the War for Independence* (Chicago: University of Chicago Press, 1980), pp. 376, 377; Comfort Sands & Co., New York, Account Book, 1782–87, New-York Historical Society.
5. Comfort Sands owned a great deal of silver in 1781, as gleaned from an advertisement for a reward placed in the *New York Packet, and American Advertiser*. A partial list included "a three pint tankard in the shape of a cann with a coat of arms on the front, makers name E. Brasher . . . 6 teaspoons marked CS in a cypher . . . one pair gold sleeve buttons, CS in cypher . . . Comfort Sands." Cited in Rita Susswein Gottesman, *The Arts and Crafts in New York, 1726–1776: Advertisements and News Items from New York City Newspapers* (New York: New-York Historical Society, 1936), p. 62.
6. In 1794 Joseph was the firm's representative in London; *Daily Advertiser* (New York), September 10, 1795.
7. Rootsweb.com (accessed October 19, 2015); J. D. Hatch to Anne d'Harnoncourt, curatorial files, AA, PMA.
8. Monographs about Vanderlyn do not mention this incident and lack information about this short time period: "Vanderlyn while thus in Europe at that time devoted himself so exclusively to his studies that very little of any interest can be found to record." Marius Schoonmaker, *John Vanderlyn, Artist, 1775–1852: A Biography* (Kingston, NY: Senate House Association, 1950), p. 10.
9. Information supplied by the donor of the portrait, John D. Hatch. The drawing was destroyed in a fire, but there is a photograph of the work in the Frick Reference Library, New York.
10. John D. Hatch, FamilySearch.org. It may have been Talleyrand who suggested Philadelphia to Sands, as he was resident in the city during the 1790s.
11. Dudley Knox, ed., *Naval Documents Related to the Quasi-War between the United States and France* (Washington, DC: U.S. Government Printing Office, 1935–38); *Boston Gazette*, October 14, 1802; *Middlesex Gazette* (Middletown, CT), October 25, 1802.
12. See the spoons engraved "S" by Richards & Williamson (PMA 1991-85-1–6).
13. Annual Election of Officers of the Columbian Insurance Company, *Daily Advertiser*, April 9, 1804; Notice of Dividend, *American Citizen* (New York), November 21, 1804; *Anne Arundel County* (MD), July 24, 1807: "Sworn before Joseph Sands" (with regard to Aaron Burr's wish to divide the country into east and west.)
14. New York Court of Chancery.

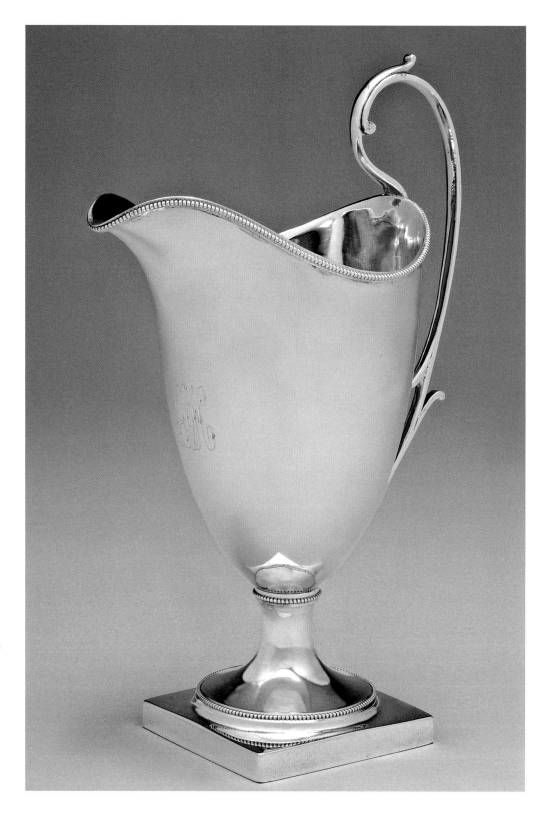

Cat. 21

Joseph Anthony Jr.
Cream Pot

c. 1809

MARK: J Anthony (script in conforming rectangle, twice on opposite corners of base; cats. 21-1, 22-1)
INSCRIPTIONS: A S H (engraved, centered under pouring lip) / one [?] Doll (scratched, on underside of foot)
Height 7 11/16 inches (19.5 cm), width 5 inches (12.7 cm), depth 3 inches (7.6 cm)
Weight 8 oz. 3 dwt.

Bequest of Miss Clarissa Townley Chase, presented by her brother, Samuel Hart Chase, 1945-55-4

PROVENANCE: Abraham Hart (c. 1777–1802) and Sarah Stork (1791–1863); by descent to the donor's family.

PUBLISHED: Prime 1938, p. 15.

The mark on this cream pot is different from the full-name mark that Joseph Anthony used on his silver of the 1780s (cats. 12, 13). The script is more elegant, and the "J" and "A" intertwine, their lines elegantly scrolled with round, dot-shaped terminals. The crossbar of the "A" curves over the left leg in a

Cat. 21-1

loop and curves into the lowercase letter "n." The "J" and "A" break through the top of the horizontal line of the die, which is distinctly rounded on one end, conforming to the sweep of the "J," and on the other to include the leg of the "Y." He used the same mark on a set of teaspoons (cat. 17) and on two fish slices (cats. 22, 23). It is also found on an oval, flat-bottomed cream pot Anthony made in a style that came into fashion in 1800.[1]

The urn shape, with a plain surface alternating with encircling bead bands, was favored in Philadelphia at the end of the eighteenth century. The design of the handle on this pot is especially successful and lively, with two instances of "answering" scrolls and a double swage-molded feature at the bottom, where the handle joins the body.[2] It was not unusual in Philadelphia to assemble sets from different shops.[3]

This cream pot, together with a tea service by Joseph Lownes (q.v.) that it matches closely, descended in a family collection. One piece of the tea service was altered, probably by Joseph or possibly by Edward Lownes (q.v.).[4] The letters "ASH" are engraved in a loose, linear style that matches the engraving on Lownes's pieces in the set.[5] When the set was published in 1938, it was recorded as having "belonged to Hester Stork, great, great maternal grandmother of Miss [Clarissa T.] Chase." [6] However, her mother's handwritten will describes it as "my silver tea service which belonged to my grandmother Hart," and the engraved monogram indicates that the set's original owners were Abraham Hart (c. 1777–1820) and Sarah Stork (1791–1863) of Philadelphia, who married in 1809. The service descended to their son Samuel Hart (1818–1885), and then to his daughter Clarissa (Hart) Chase (1841–1897), the donors' mother.[7] BBG/DLB

1. This flat-bottomed cream pot is a later version of the form recognized from Anthony's shop (see cat. 18) featuring a cylindrical shape and a wide strap handle, probably made after Anthony returned from London in 1809; for an illustration, see American Silversmiths, s.v. "Joseph Anthony," Ancestry.com (accessed June 2, 2015).
2. It is similar to a cream pot by Richard Humphreys (PMA 1976-103-3).
3. Anthony made a cream pot to match a set by Joseph junior and Nathaniel Richardson (q.q.v.); see Quimby and Johnson 1995, p. 330, cat. 311.
4. The surface of this cream pot has the high shine of silver that has been buffed, which might account for the newly cut look of the initials.
5. See the tea service by Joseph Lownes (PMA 1945-55-1a,b–4). The Lowneses and Anthonys were closely connected themselves, particularly by their friendships with Josiah Hewes (died 1821). Both families had a son carrying the name Josiah Hewes.
6. Prime 1938 (p. 56) lists the Lownes set and notes the initials as "ASM," although the final letter is distinctly an "H."

7. Will no. 1704, filed November 9, 1897, Philadelphia City Archives; Malcolm H. Stern, *First American Jewish Families*, 3rd ed. (1960; Baltimore: Ottenheimer Publishers, 1991), p. 99. Stern does not record Samuel Hart as one of the children of Abraham and Sarah Hart; however, the will of Clarissa (Hart) Chase confirms that relationship. Not only does she refer to her "grandmother Hart," she also refers to "my dear Aunt Bluma," and Stern recorded Bluma Hart (1812–1884) as one of Abraham and Sarah Hart's children. For silver by Joseph Richardson Jr. and Philip Syng Jr. owned by the family of Clarissa (Hart) Chase's husband, Frederic Chase (1841–1904), see the teaspoons by Richardson (PMA 1961-106-1–6), and the tongs by Syng (PMA 1961-106-8).

Cat. 22

Joseph Anthony Jr.
Fish Slice

1809–10

MARK: J Anthony (script in conforming rectangle, twice on obverse of blade; cats. 21-1, 22-1)
INSCRIPTIONS: THROUGH ([motto in banner surmounting crest consisting of oak tree fructed with trunk penetrated by frame saw out of ducal coronet]) (engraved, on obverse of blade toward tip); H M K (engraved script, on obverse of blade; cat. 22-2)
Length 13¼ inches (33.7 cm), width 3¼ inches (8.3 cm)
Gross weight 5 oz. 6 dwt.
Gift of Mrs. Hampton L. Carson, 1922-86-1

PROVENANCE: By descent in the family of Cornelius Hartman Kuhn.

EXHIBITED: Philadelphia 1956, cat. 9; Philadelphia 1969, cat. 4.

Before 1780 the fish-slice form was shorter than this one, more like a trowel, with a pointed end.[1] The pierced design at the edges allowed juices to be strained off during serving. There are three engraved designs on the obverse, which appear to be by

different hands. The dominant design of a scaly sea serpent was original to the piece. The crest engraved at the tip belonged to the Hamilton family of Philadelphia. Given the fish slices's subsequent history, either William Hamilton (1745–1813) or his brother Andrew Hamilton III (1743–1784) was probably its original owner. The son of Andrew Hamilton II (died 1747), a lawyer, and Mary Till Hamilton (died 1803), William Hamilton inherited a six-hundred-acre tract west of the Schuylkill, where before 1770 he built a grand house, called the Woodlands, with extensive manicured grounds and gardens.[2] William, like his uncle James Hamilton (1710–1783),[3] who built Bush Hill on the east side of the Schuylkill, lived in style. Both were conspicuous followers of London fashion and used the family arms and crest on their silver.[4] A British sympathizer during the Revolution, William was tried as a Loyalist and banished from Philadelphia in 1780 but acquitted in 1781. He traveled abroad for part of 1782 and returned to Philadelphia in 1784, at which time he furnished the Woodlands and lived there.

William Hamilton died unmarried and without issue, and his possessions descended collaterally to the daughters of his brother Andrew, who married Abigail Franks (1744–1798), at Christ Church in 1768. The fish slice was inherited by their daughter Ann (1769–1798), who married James Lyle on October 17, 1792, also at Christ Church.[5] Their daughter Ellen Lyle (1777–1852) married Hartman Kuhn (1784–1860), son

Cat. 22-1

Cat. 22-2

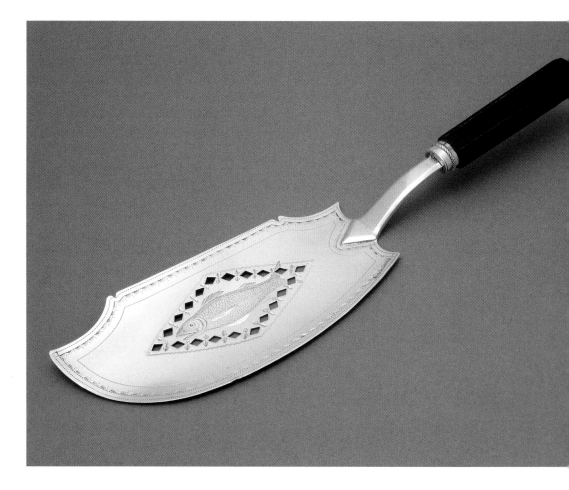

of Elizabeth Hartman Markoe and Adam Kuhn (1741–1817), on December 15, 1818.[6] The elaborate engraved initials "HMK" and the Hamilton arms at the tip were most likely added after the marriage in 1842 of their daughter Mary (1819–1886) to Hartman Kuhn (1812–1892), presumably a relative.[7] The fish slice descended to their son, Cornelius Hartman Kuhn (1854–1948), who sold it to the Museum. BBG/DLB

1. G. Bernard Hughes, "Designs of Silver Fish-Slices," *Country Life* (London), July 19, 1956, pp. 141–42.
2. The house is located on Woodland Avenue on the grounds of the Woodlands Cemetery, Philadelphia.
3. James Hamilton was the son of Andrew Hamilton I (1666–1741) and during his lifetime was considered the most eminent lawyer in colonial America. Andrew is best remembered for his role in the John Peter Zenger case in New York, and in Philadelphia for his plans for the State House (Independence Hall). James, equally prominent as governor of Pennsylvania from 1759 until 1763, was an organizer of the Federalist Party and one of the proposers of a national bank in 1779; he used the seal with this crest on official documents. The same crest, and with the arms, was engraved on two tankards made for the Hamilton family by Myer Myers (PMA 1922-86-19a,b). A seal with the Hamilton crest, as used by James Hamilton, may have provided the design for the engraving on his and his nephew William's silver.
4. Joseph Jackson, Notes and Queries, *PMHB*, vol. 56, no. 3 (January 1932), pp. 275–77. The Hamilton arms are illustrated in Eugene Zieber, *Heraldry in America* (New York: Greenwich House, 1984), pp. 84, 317. Both the American and the English versions of the Hamilton arms are illustrated in John Matthews, *American Armoury and Blue Book* (London: printed by author, 1907), p. 141 and addendum, p. 38.
5. Benjamin West (1738–1820) painted a full-length portrait of William Hamilton with his niece Ann Lyle in about 1785 and altered or finished it in 1810 (HSP, 6.1873).
6. Malcolm H. Stern, *First American Jewish Families*, 3rd ed. (1960; Baltimore: Ottenheimer Publishers, 1991), p. 99; Moon 1898–1909, supp. vol. 5, pp. 212, 213; Patricia Law Hatcher, "When Did Dr. Adam Kuhn of Philadelphia Marry?," editor's note, *Pennsylvania Genealogical Magazine*, vol. 45, no. 2 (2007), pp. 188–89.
7. Stern, *First American Jewish Families*, p. 80.

Cat. 23

Joseph Anthony Jr.
Fish Slice

1800–1812
MARK: J Anthony (script in conforming rectangle, on obverse edge over engraved and chased border; cat. 21-1, 22-1)
INSCRIPTION: J T (engraved script, centered on reverse of blade; cat. 23-1)
Length, 12½ inches (31.8 cm), width 3 inches (7.6 cm)
Gross weight 5 oz. 2 dwt. 10 gr.
Gift of the McNeil Americana Collection, 2005-69-2

This fish-serving implement and the preceding example have similar decorative, triangular piercing with bands of fine chasing. They are marked not on a plain surface but over the decorative border designs. On both fish slices a triangular device is used for the attachment of the handle to the blade.

Cat. 23-1

The initials "JT" are unidentified but may have been for John Travis, who was a warden in the Philadelphia court system at the same time as Captain Joseph Anthony. Travis was buying silver from John David Sr.; see his sauceboat (cat. 26). BBG

George Armitage

England, born 1760–74
Philadelphia, died 1827

George Armitage and his relative Robert Armitage were born in England and worked as silver platers in Sheffield, where they also may have trained.[1] They immigrated to Philadelphia before June 1795, when Robert transferred a lot and building on the south side of Sassafras (Race) Street to George, "of the city of Philadelphia, Silver plater."[2] Robert probably was the individual who married Mary Beveridge on December 2, 1795, at the Second Presbyterian Church, Philadelphia.[3] By August 1797 he had moved to Charleston, South Carolina, where he advertised that "he will make or repair any Work in the Plated Line" and offered plated candlesticks for sale.[4] Remaining in Philadelphia, George Armitage probably was the person who declared his intent to become a naturalized citizen of the United States before the Court of Common Pleas on June 18, 1798, and took the Oath of Allegiance on April 14, 1806.[5]

Armitage was in the vanguard of manufacturers of fused or Sheffield plate in the United States. In Philadelphia the trade was introduced in the mid-1780s and grew considerably in the decade following the protective tariff enacted in 1789.[6] On January 31, 1797, George and Robert had advertised themselves as "from Sheffield in Europe, Manufacturers of Silver and Plated Tea and Table Equipage," offering "double and single plated metal plated to order, and rolled to size wanted."[7] Apparently they had imported the latest equipment from England; on a visit to Sheffield in 1815, Thomas Fletcher (q.v.) described a drop press, "the downwfall block w[eig]hs 1800 lbs fitted like Armitage's w[it]h screws," indicating that Armitage already had a similar piece of equipment in Philadelphia.[8] In addition to tea and table wares, Armitage produced other objects, such as the "silver plated knobs for cabinet ware of the newest fashion and warranted superior to any imported, manufactured and sold on the lowest terms" that he advertised in 1809.[9] From 1800 onward he was listed in Philadelphia city directories as a "silverplate worker" or "silverplater" at 438 Sassafras Street.

Armitage also may have had some training as a silversmith. A teaspoon ornamented with bright-cut engraving was struck with the same surname mark as the Museum's mug (cat. 24), and other pieces of silver flatware and hollowware marked by him have been identified.[10] At least two documents recorded his profession as "silversmith," although it is not clear whether he marked objects as their maker or as a retailer.[11] Between 1801 and 1810 Samuel Williamson (q.v.) supplied Armitage with "sundries, gold, silver, & plated ware," including tablespoons, teaspoons, and a locket and chain made in Williamson's shop. One entry in Williamson's daybook for six teaspoons did not include weights or charges for making and was annotated "wholesale superant," perhaps because Williamson was selling Armitage ready-made stock. He also made cash payments to Armitage, possibly for plated wares that Williamson retailed.[12] A small number of objects marked by Philadelphia silversmiths, including John Black (see cat. 78), James Musgrave, and Abraham Dubois Sr. (q.q.v.) were also struck with a "G•A" mark as well as a spread-eagle mark identical to that on the Museum's mug.[13] The presence of this eagle mark and the fact that Armitage used a similar "GA" mark on his military insignia strongly suggest that Armitage used this mark.[14] Jennifer Goldsborough ascribed this "G•A" mark to George Aiken (q.v.), but his location in Baltimore and the fact that he is not otherwise known to have used a spread-eagle mark make this attribution less likely, particularly as the large production of his shop would have made it unnecessary for him to import objects made by Philadelphia silversmiths.[15] Whether Armitage marked these objects as a maker or retailer is not yet clear. A combination tureen and monteith bowl (private collection) presented to Samuel Mickle Fox (1763–1808) of Philadelphia, marked with the same "G•A" and spread-eagle marks as on cat. 78 together with Abraham Dubois's surname mark, is a monumental, sophisticated object more likely to be a production of Dubois's shop.

From the outset, moreover, Armitage's focus seems to have been on buttons and insignia for official military uniforms, which he produced in brass as well as silver-plated white metal. In March 1799 he advertised "silver eagles, approved by the Secretary of War, for the center of the black cockade," which he offered wholesale to "the shopkeepers in Philadelphia."[16] In June 1799 he announced:

> Volunteer troops and companies who are not provided with the uniform eagles, are informed that their officers or commissioners may be supplied with them in silver, gilt or plated, at the manufactory of George Armitage, in Race Street. . . . likewise the eagle and anchor for the navy, in gold or gilt, with a variety of fancy eagles and ornaments, which are also sold at most shops in the city. . . .
>
> N.B. The uniform eagle is marked G. A. in order it may be known in future; every true American ought to recollect it is adopted by General Washington.[17]

In both of these advertisements, Armitage announced that his eagles were also available wholesale through the clock and watchmaker James Brearley at 79 North Second Street.[18] On July 8, 1803, Samuel Williamson charged Armitage $3.00 for "Gilding three plates," presumably cap or belt plates for a military uniform.[19] Armitage supplied large and small cap plates to the U.S. Marines in August 1804.[20]

In the years leading up to the War of 1812, Armitage became involved in a controversy surrounding Tench Coxe (1755–1824), the Purveyor of Public Supplies, who was responsible for ordering military uniforms. The previous purveyor, the Philadelphia merchant Israel Whelen (1752–1806), had contracted with Armitage to manufacture brass buttons for the U.S. Army. Coxe refused to honor orders placed by his predecessor and ordered what turned out to be English-made buttons from another source, despite Armitage's protests that his were American made and of higher quality and lower price. In 1811, as hostilities with Great Britain loomed and for which the U.S. military was underprepared, William Duane of the *Aurora General Advertiser* attacked Coxe for his poor management, citing as an example "an excellent workman of the name of Armitage in this city, who has frequently offered to make the buttons required for the public service for several years, [but] repeated offers were unavailing; at length he made some that were allowed to be superior to the article of the same description imported."[21] In January 1812 Duane published two letters that Armitage had sent to Coxe claiming that the latter was acting in bad faith.[22] Armitage then took the step of writing to President James Madison to secure his support:

> HONOURED SIR
>
> My name aving apeared several times of late in the Aurora concerning the making of the yallow Metal Buttons—I make bold to state to You—That about 10 Years sinc I was encouraged by Mr. Whelen to cumenc the Manafacture wich I did to the satisfaction of all and to aney number wanted But when Mr. Cox came in that Offic he cumenced his Injustice by refuseing to take the Buttons I ad made by the Order of Mr. Whelen and sufired a person he caled his friend to soply the English Buttons after I showed him the English markes on the back of the Buttons—at the same price and not so good—and after maney entreaty to take mine

all reddy made to Mr. Whelen Order but in vain. And finding his subsequant actes like to his first I was obliged to giv up the work after great expenc and disapointment. But it being now Probabl my servic in that line mite be reciprocal to make what mite be wanted or a serton number for a serton time—but I will ave nothing to do with Mr. Cox. Honoured Sir I remain with sincear Respect Your Obdt. Sert.

GEO. ARMITAGE

NB wat as been said in the Aroura [sic] is been intirely wihout my knolige.[33]

Armitage eventually was successful with his solicitations. Between 1812 and 1821 he served as one of the two principal contractors to the U.S. Army and Navy for gilded and silver-plated insignia and buttons, and numerous examples of the latter have survived.[24] In city directories from the 1820s, Armitage's listing was expanded to "silver-plater and military ornament maker."[25] Dies for some of the buttons and plates manufactured by Armitage were designed and cut by Moritz Fürst (1782–1841), who worked in Philadelphia in 1808 as a diesinker.[26] According to John Fanning Watson, Armitage and another diesinker, Timothy Thomas Bingham (1767–1810), were hired by merchants in the West Indies trade to produce counterfeit coins of alloyed gold.[27] No other evidence for this activity has been found, although Armitage purchased property from Bingham in 1806.[28] Armitage's associations with diesinkers and his patriotic interest in American metal manufactures were reflected in donations he made to the museum that Charles Willson Peale had opened in Philadelphia in 1786. In June 1807 "A medal of Edward Preble Esq. with the reverse pr[esented] by Geo. Armitage" was recorded in the museum accession book.[29] Congress had commissioned this medal three years earlier to honor Commodore Edward Preble (1761–1807) for his successful attack on Tripoli during the Barbary Wars; it was designed by Johann Matthias Reich (1768–1833), Second Engraver at the U.S. Mint in Philadelphia.[30] This donation suggests that George Armitage was the "Mr. Armitage" who in 1813 gave the Peale Museum impressions of the 1756 Kittanning Medal and the 1757 Indian peace medal designed and cut by Edward Duffield (1720–1801), a clockmaker, and struck by Joseph Richardson Sr. (q.v.).[31]

Over time Armitage was involved in numerous real estate transactions.[32] He accumulated several parcels of land on Sassafras Street, and in 1798 his house and manufactory stood on a two-thousand-square-foot lot valued at $250 on the south side of Sassafras and on the west side of Jacobys Alley, between Twelfth and Thirteenth streets.[33] It is not known how many men he employed,

although in the U.S. census of 1800 of the South Mulberry Ward, his household consisted of himself, aged between twenty-six and forty-four, a free white female of the same age, and a free white male aged between ten and fifteen, possibly an apprentice. There is no evidence that Armitage ever married or had children; if the female member of his household was his wife, she must have died relatively young and without surviving issue. In February 1805 Armitage took John Newsham (c. 1793–1870) as an apprentice for a period of seven years and seven months; Newsham subsequently worked in Philadelphia as a "pattern maker."[34]

For much of his career in Philadelphia, Armitage was closely associated with Joseph-Marie-Baptiste Saulnier (c. 1775–c. 1835). Saulnier's earliest record in Philadelphia was his marriage to Rachel Engard (born c. 1770) on December 2, 1794, at the Second Presbyterian Church.[35] Armitage and Saulnier probably became acquainted through Rachel, whose father, the tavern keeper Henry Engard (c. 1737–1818), named "my friend, George Armitage," as an executor of his will in 1816.[36] In August 1801, using his father-in-law's address at 418 North Second Street, Saulnier, as captain of the sloop Cicero, advertised a proposed trip to Havana.[37] Although he was recorded as a sea captain at the same address in the 1802 city directory, the Cicero had been wrecked at sea on December 23, 1801; in the 1803 directory Saulnier was listed as a "grocer" at Armitage's address, 438 Sassafras.[38] From 1803 until at least 1817, Saulnier apparently worked for Armitage at 438 Sassafras as a button maker and silver plater, although his profession occasionally was recorded in directories as "carpenter" and once as "sea captain," suggesting that he was something of a jack-of-all-trades.[39] From 1818 until 1822 he was listed exclusively as a carpenter.[40] In 1807 Joseph (described in the deed as a "carpenter") and Rachel Saulnier purchased a building and lot on Sixth Street in the Northern Liberties from Armitage for only $3.00 and "for divers good causes and considerations."[41] In the U.S. census of 1820 for the South Mulberry Ward, Armitage was the only individual recorded under his name, and the preceding record was for Saulnier's family of six, suggesting that the Saulniers may have functioned as a surrogate family for Armitage. He named Rachel executrix of his will.[42] In turn, the Saulniers named their daughter Penelope Armitage Saulnier (1820–1892).[43]

Armitage also was close to another employee, William Pinchin (1786–1862).[44] At least a decade younger than Armitage and Saulnier, Pinchin may have been Armitage's apprentice, although it is also possible he trained with his father, the silversmith William Pinchin (died 1809), whose

shop was nearby at 326 Sassafras Street.[45] Beginning in 1818 the younger Pinchin was listed in city directories as a "silver plater" on Jacoby Street, presumably working for Armitage.[46] The U.S. census of 1820 recorded William "Pincham" and his family of a wife and three young children in the South Mulberry Ward immediately after Saulnier and Armitage, so the Pinchins may have provided Armitage with another surrogate family.

Armitage died suddenly on January 10, 1827, at the Green Tree Tavern in Deptford, New Jersey. As reported in a newspaper account, he had been in Gloucester County for several days, "attending to the sale of some lands," and after dining with a companion that evening, "while Mr. A. was in the act of raising a glass to his mouth to drink, he was seized with an apoplectic fit, fell over and expired. He had complained of not feeling very well, for a day or two previous."[47] In addition to real estate, he left a personal estate valued at $7,624.11, including equities worth $5,824.75, household goods valued at $135.56, and "tools & contents of glass case" (a showcase in the shop) valued at $420. The account of his estate, filed by his brother-in-law and executor James Salmon together with Rachel Saulnier, listed the hardware merchant Allen Armstrong (see PMA 2009-114-1-6) and Fletcher & Gardiner (q.v.) among the debtors, along with funeral and burial expenses amounting to at least $158.[48]

In his will dated January 23, 1825, and probated January 16, 1827, Armitage bequeathed two brick houses and lots on Race and Jacoby streets to Joseph and Rachel Saulnier for their lifetimes and after their decease to their six children in equal shares; he also left "all the household goods and furniture of every kind and description which may be in my house" to Rachel, his "double barreled Gun and Gunning apparatus" to her son John, and his watch to her son Henry. To William Pinchin he left a brick house and lot on the west side of Jacoby Street and "all my tools, stamps, rollers, presses, materials of work, finished and unfinished, and all metal of every kind and description relating to my business . . . and also the Glass Case in my house with all the finished work then therein." Among the other beneficiaries were his two surviving siblings, Penelope and James, and the children of three deceased siblings, Samuel, Francis, and Anne Salmon.[49] In June 1828 John Saulnier and his wife Margaret sold Pinchin the Race Street properties for $550 "in trust nevertheless for the sole use benefit and behoof of Rachel E. Saulnier . . . for and during all her natural life" as specified in Armitage's will.[50] Between 1827 and his death in 1862, Pinchin operated Armitage's factory on Sassafras as a "manuf[acturer of] military trimmings & ornaments."[51] He continued to supply

buttons, belt plates, and cap buckles and plates to the U.S. Army, and examples with his mark have survived.[52] Joseph Saulnier was not listed in city directories in the years immediately preceding Armitage's death, but from 1828 to 1831 he was recorded as living at 438 Sassafras with no profession; he was listed as a "plater" in 1833, suggesting that he worked for Pinchin in a capacity similar to that he had for Armitage. He was recorded in the U.S. Census of 1830 with a household of thirteen persons, including one woman in her seventies. In 1835–36 Francis H. Saulnier (1807–1839), presumably another son of Joseph and Rachel, appeared at the same address as a "plater," although his career was short-lived, as he died in Houston, Texas, in October 1839.[53] DLB

1. Donald L. Fennimore (2014, pp. 20–21) stated that the Armitages were brothers and speculated that they originally were from Yorkshire and trained at Fenton, Creswick & Company of Sheffield. However, Robert was not among the five siblings named in George's will (see note 49 below), which suggests that Robert was not his brother or predeceased him without issue.

2. Robert Armitage to George Armitage, July 25, 1796, Philadelphia Deed Book EF 4, pp. 196–97.

3. *Pennsylvania Archives*, 2nd ser., vol. 9 (1896), p. 574.

4. *City Gazette, and General Advertiser* (Charleston, SC), August 8, 1797.

5. William Filby, ed., *Philadelphia Naturalization Records* (Detroit: Gale, 1982), p. 10.

6. Diana Cramer, "Philadelphia Silverplaters, 1778–1840, Part I: A Little Known Industry," *Silver Magazine*, vol. 23, no. 3 (May–June 1990), pp. 35–40; Cramer, "Philadelphia Silverplaters, 1778–1840, Part II," *Silver Magazine*, vol. 23, no. 4 (July–August 1990), pp. 17–22; Cramer, "The Plating Industry in 18th and 19th Century Philadelphia: Avoiding the Export Trade Act of 1785," *Silver Magazine*, vol. 24, no. 2 (March–April 1991), pp. 38–41.

7. *Claypoole's American Daily Advertiser* (Philadelphia), January 31, 1797.

8. Thomas Fletcher, Journal, 1815, p. 135, box 11, Fletcher Family Papers, Athenaeum of Philadelphia.

9. *Aurora General Advertiser* (Philadelphia), January 3, 1809. Fennimore (2014, p. 19, fig. 3; p. 20, fig. 4) illustrates a bureau with silverplated knobs that the author attributed to Armitage.

10. Fennimore 2014, p. 19, fig. 1; p. 20, fig. 2; see also Hollan 2013, p. 6.

11. 1800 Septennial Census; George Armitage to Joseph Saulnier and Wife, October 20, 1807, Philadelphia Deed Book EF-30, pp. 44–45; Philadelphia directory 1800, p. 14.

12. Samuel Williamson Papers, Daybook, 1803–1810, pp. 9, 17, 30, 58, 252, 272, 276, 295, 340; Ledger, 1800–1811, p. 12 (a summary of the debits from the daybook); Ledger, 1810–1813, p. 35, Downs Collection, Winterthur Library.

13. A spirit lamp marked by both Armitage and Musgrave is illustrated in Goldsborough 1983, cat. 3.

14. Fennimore (2014, p. 23, fig. 8) illustrates a gilded-brass cockade with the "GA" mark.

15. Goldsborough 1983, pp. 67, 238.

16. *Claypoole's American Daily Advertiser*, March 19, 1799.

17. Ibid., June 17, 1799.

18. Philadelphia directory 1798, p. 27. In 1820, as executor of Henry Engard's estate (see below), Armitage sold Engard's property at 418 North Second Street to Brearley; George Armitage to James Brearley, November 18, 1820, Philadelphia Deed Book GWR 6, pp. 573–74.

19. Samuel Williamson, Daybook, 1803–1810, p. 30.

20. Edwin North McClellan, *Uniforms of the American Marines, 1775 to 1829* (1932; repr., Washington, DC: Marine Corps History and Museums Division, 1982), p. 31.

21. *Aurora General Advertiser*, December 20, 1811.

22. Ibid., January 17 and 18, 1812.

23. George Armitage to James Madison, January 28, 1812, *The Papers of James Madison*, Presidential Series, vol. 4, *5 November 1811– 9 July 1812*, ed. J. C. A. Stagg et al. (Charlottesville: University of Virginia Press, 1999), pp. 151–53.

24. J. Duncan Campbell and Edgar M. Howell, "American Military Insignia, 1800–1851," *United States National Museum Bulletin*, no. 235 (Washington, DC: Smithsonian Institution, 1963), pp. x, 15; Alphaeus H. Albert, *Record of American Uniform and Historical Buttons* (Boyertown, PA: privately printed, 1969), pp. 24, 26–31; Warren K. Tice, *Uniform Buttons of the United States* (Gettysburg, PA: Thomas Publications, 1997), p. 57.

25. Philadelphia directories 1820–22, n.p.; 1825, p. 12.

26. Campbell and Howell, "American Military Insignia," p. 15; Albert, *Record of American Uniform and Historical Buttons*, p. 24.

27. John F. Watson, *Annals of Philadelphia and Pennsylvania, in the Olden Time…* (Philadelphia: printed by the author, 1850), vol. 2, p. 419. Bingham almost certainly is the person baptized in Birmingham, England, on February 20, 1767; he died in Philadelphia on September 24, 1810. Parish Register of St. Philip's Cathedral, Birmingham, Ancestry.com; Philadelphia Death Certificates Index, 1803–1915, Ancestry.com.

28. Timothy T. Bingham to George Armitage, February 21, 1806, Philadelphia Deed Book AM 25, pp. 707–08.

29. Peale Museum accession book, p. 23, Peale Family Papers, HSP. I am indebted to Carol Eaton Soltis for this reference.

30. For the Preble medal see the example donated to the Pennsylvania Academy of the Fine Arts (1807.3) in 1807 by Tench Coxe; see www.pafa.org/collection/commodore-edward-preble -medal.

31. "Late Donations and Additions to the Philadelphia Museum," *Poulson's American Daily Advertiser* (Philadelphia), June 30, 1813. Both medals are illustrated in Fales 1974, fig. 124.

32. In 1825 Armitage sold property on Sassafras Street to the clothier Samuel Martin and on North Second Street to the innkeeper Daniel Miller. George Armitage to Samuel Martin, January 1, 1825, Philadelphia Deed Book GWR 6, pp. 169–70; George Armitage to Daniel Miller, April 25, 1825, Philadelphia Deed Book GWR 6, pp. 576–77.

33. 1798 U.S. Direct Tax.

34. Philadelphia Records of Indentures and Marriages, 1800–1808, vol. 2, p. 209, February 12, 1805; 1850–70 U.S. censuses; Philadelphia Death Certificates Index, 1803–1915, Ancestry.com.

35. Watson, *Annals of Philadelphia and Pennsylvania*, vol. 2, p. 567.

36. Philadelphia Will Book 6, p. 588. As an executor of Engard's will, Armitage advertised the auction of the property at 418 North Second Street in November 1820; *Democratic Press* (Philadelphia), November 1, 1820.

37. *Poulson's American Daily Advertiser*, August 22, 1801.

38. Philadelphia directory 1802, p. 213; *Philadelphia Gazette and Universal Daily Advertiser*, January 12, 1802; Philadelphia directory 1803, p. 220.

39. Philadelphia directory 1806, n.p. (as "button maker" and "sea captain"); 1813, n.p. (as "carpenter & c").

40. Ibid. 1818–22, n.p.

41. George Armitage to Joseph Saulnier and wife, October 20, 1807, Philadelphia Deed Book EF-30, pp. 44–45. Armitage had acquired this property one year previously from the apothecary John Mason and his wife Deborah; John Mason and wife to George Armitage, October 22, 1806, Philadelphia Deed Book EF 30, pp. 115–16.

42. Philadelphia Will Book 9, p. 25.

43. Engard-Burton family tree, Ancestry.com (accessed July 27, 2015).

44. Pinchin's parents were married in St. Michael's and Zion Church, Philadelphia, on August 19, 1785; *Pennsylvania Archives*, 2nd ser., vol. 2 (1880), pp. 12, 391. Pinchin died at the age of seventy-six on May 15, 1862; Parish Register, 1848–1864, p. 658, Church of the Atonement, Philadelphia.

45. 1809 Philadelphia directory, n.p.

46. Ibid., 1818, n.p.

47. "Death Notice," *Salem (MA) Gazette*, January 19, 1827.

48. "Accounts for the estate of the late George Armitage, deceased," March 21, 1828, Records of the Philadelphia Orphans Court Records, 1719–1880, no. 31, p. 303, HSP.

49. Will of George Armitage, Philadelphia Will Book 9, no. 8 (1827), pp. 25–26.

50. John G. Saulnier et ux. to William Pinchin, June 6, 1828, Philadelphia Deed Book GWR 23, pp. 330–32.

51. Philadelphia directory 1828, p. 64.

52. Albert, *Record of American Uniform and Historical Buttons*, p. 18, no. GI 30B.

53. Philadelphia directory 1835–36, p. 158; *North American* (Philadelphia), December 2, 1839. Saulnier's obituary gave his age as thirty-two.

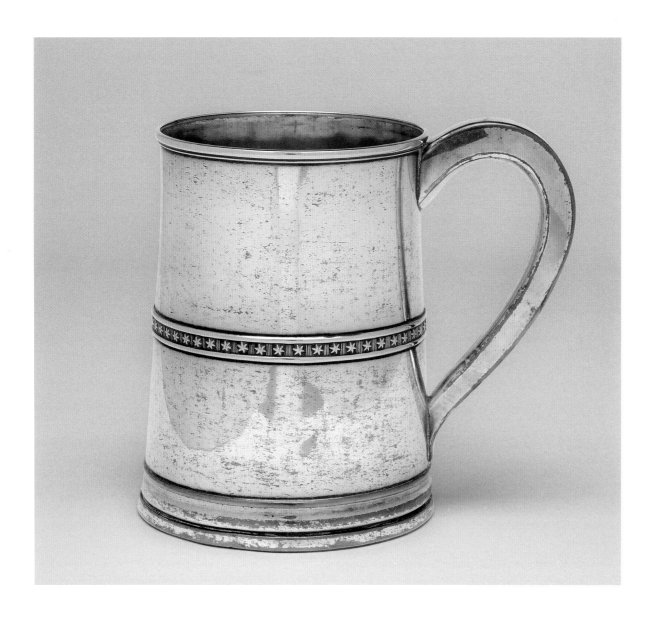

Cat. 24

George Armitage

Mug

1797–1827
Silver-plated copper and brass
MARKS: [G]·ARMITAGE (in rectangle) / [arms of the United
States] (double struck, in conforming surround; all on
underside; cat. 24-1)
Height 4⅝ inches (11.8 cm), width 5½ inches
(14 cm), diam. base 3⅝ inches (9.2 cm)
Gift of Mr. and Mrs. Jonathan Trace, 2007-19-1

This mug is among the earliest surviving hollowware
objects made in the United States using the fused-
plate technique, in which a sheet of copper was
faced on either side with a thin layer of silver. Armit-
age received an honorary mention in October 1826
at the third exhibition of American manufactures at
Philadelphia's Franklin Institute, for silver-plated
mugs "equal in taste of design and workmanship to
the best imported ware of the same description."
A contemporary newspaper account went on to
report, "These are the first articles of the kind made

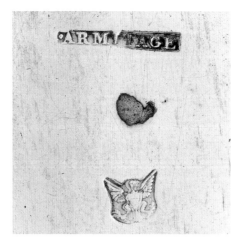

Cat. 24-1

in America that ever came to the knowledge of the
judges."[1] It is possible this mug is from one of the five
pairs Armitage exhibited; an identical example is in a
private collection.[2]

In his first advertisements in Philadelphia, Armit-
age touted his training in Sheffield, the principal cen-
ter of fused-plate production in Britain, but within a

short time he was promoting himself as a manufac-
turer of American wares, urging "every true Ameri-
can" to purchase his military insignia.[3] To underscore
this point, he marked this mug with the arms of the
United States. The die-rolled brass band of stars
around the mug's midsection added another patri-
otic motif to the object, as well as providing support
to the relatively soft sheet copper. Nearly identical
die-rolled silver bands with stars appeared on con-
temporary mugs made of sheet silver, such as a cann
by Edward Lownes (PMA 1991-162-2).

In the 1830s the technique of fused plate was
superseded in England by electroplating, and about
ten years later silverplaters such as Harvey Filley and
J. O. Mead (q.q.v., Mead & Robbins) in Philadelphia
were in the vanguard of American production of
electroplated wares. DLB

1. "Franklin Institute," National Gazette and Literary Register
(Philadelphia), October 19, 1826.
2. Fennimore 2014, p. 22, fig. 5.
3. Claypoole's American Daily Advertiser (Philadelphia),
January 31, 1797, and June 17, 1799.

Daniel Arn

Location unrecorded, born c. 1763
Philadelphia, died 1788

nformation about Daniel Arn's life has been elusive, but he was clearly of Germanic descent.[1] He is first mentioned in Macpherson's Philadelphia directory of 1785. Arn must have attained his majority before 1784, when entries for the city directory were collected, in order to be listed as "silversmith."[2] The address given for Arn in this publication was 718 Second Street.[3]

Daniel Arn's second appearance is in the record of his marriage to Dorothea Streeper at St. Michael's Lutheran Church in Philadelphia on November 16, 1785, when John Switzer stood "Surety" and James Trimble was a witness.[4] Dorothea was a member of the Wilhelm Streeper family, one of thirteen families of weavers who had emigrated in 1683 from Crefeld (Krefeld) in Germany, settled in Germantown, and owned considerable property along the Schuylkill River near Hagy's Mill.[5] Daniel and Dorothea had one daughter, Maria, born on January 23, 1787, and baptized in November 1787 at St. Michael's and Zion Church, the newest and very handsome brick Lutheran church located between Fourth and Fifth streets, and between Cherry and Arch, in the South Mulberry Ward.[6]

The tax record for Arn in 1786 noted that he paid 2s. 3d. on his net worth of £50, and 13s. 6d. for the lease of William Blackwell's property, valued at £300. In the same year records of the tax collector for the western part of Mulberry Ward showed Arn's estate at a net worth of £40 and his tax at 1s. 10d., while he paid £1 3s. 4d. on £400 for the lease of Septimus Coat's property and ground rent of 2s. 4d. on £50 to Samuel P. Moore.[7] The following year, in 1787, he was assessed 3s. 3d. in the North Ward on his net worth of £60. Listed immediately after Arn was Henry Andrews, "grocer," probably a boarder, with a per-head tax of 7s. 6d. Also listed in this tax was George Streepy [sic], Dorothea's brother, a shopkeeper at 390 North Front Street in the Northern Liberties, whose personal estate was valued at £811, and who was paying ground rents to the proprietors (the Penn family) and to Bowyer Brooks, a blacksmith.[8]

Just before or shortly after his marriage, Arn moved from Second Street to the Mulberry Ward, to property on or near Fifth Street between Sassafras (Race) and Vine streets (then the northern border of the city). This was the center of the German settlement in Philadelphia and near property owned by Dorothea's family. It is likely that the Arns moved for reasons of community, as Daniel's previous address on Second Street was closer to a market for the "smalls" that comprised his retail stock, largely jewelry, as listed in his inventory.

Daniel Arn died in August 1788, possibly from yellow fever, or perhaps from the especially virulent strain of measles that caused many fatalities in Philadelphia early in the spring of 1789.[9] Henry Jans(?) and his neighbor John Nicholas Wagner (died 1803), a shopkeeper at 25 South Second Street, produced Arn's inventory at his residence on August 19, 1788.[10] From this document some picture of Daniel Arn might be drawn. The inventory begins with his personal clothing: "one castor hat Raised" valued at $1.00, followed by two coats, two "westcoats," three pairs of breeches, a pair of silk stockings, a pair of cotton stockings, a pair of shoes, and a pair of plated buckles. Last in this category and surely most handy were "a surcoat and a walking cane" by the front door. Furnishings were modest: a feather bed, two pillows, a bolster, a coverlet, a blanket, three sheets, a high-post bedstead, six Windsor chairs, a desk and bookcase, an old walnut table, a looking glass, a wooden clock, and a watch in a wooden case, by far the most valuable item in the list at $15.00. No storage furniture is listed; presumably in a Germanic household a chest or a chest of drawers would have belonged to the wife as part of her dower.

On November 13, 1788, his widow, Dorothea Arn, married Wilhelm Herman at St. Michael's and Zion Church in Philadelphia, and they were listed in the city directory of 1793 as living on North Third Street. She died of yellow fever on November 5, 1793.[11]

Judging by the few known examples of hollowware by Daniel Arn, all of which are well designed and executed, he must have served an apprenticeship in an active shop. His silver has features found in the work of Richard Humphreys and Christian Wiltberger (q.q.v.), as seen in teaspoons with a bird-swage design on the reverse of the bowl, and tongs with pierced arms.[12] Cream pots with deep pearling are very similar to those produced in Joseph Anthony Jr.'s (q.v.) shop. Arn may have served as a journeyman in any of those shops.[13] The fact that Arn had a display case, as listed in his inventory, suggests that he had some business as an independent silversmith, and displayed and sold some items from his home shop. BBG

1. There are no advertisements for Daniel Arn in the *Pennsylvania Gazette* (Philadelphia) in the years 1728–68 and 1784–1800. In his mark his name is spelled "ARN"; in his estate inventory it is spelled "ARND." There were large families with the names Arndt, Arnd, and Arnel living in Northampton County, but no members named Daniel; see John T. Humphrey, *Pennsylvania Births: Northampton County, 1773–1800* (Baltimore: Gateway, 1991). A Daniel Arn (no profession noted) arrived in Philadelphia in 1783 as a mercenary from Anspach-Bayreuth, Germany; P. William Filby and Mary K. Meyer, *Passenger and Immigration Lists Index* (Detroit: Gale, 1981), p. 48. A Daniel Arnd was working in Lancaster with Peter Ranck (active 1794–17), a furniture maker; Cynthia Falk, *Architecture and Artifacts of the Pennsylvania Germans: Constructing Identity in Early America* (University Park: Pennsylvania State University Press, 1992), pp. 191–93; see also Peter Ranck, Account Book, 1794–1817, Downs Collection, Winterthur Library.

2. Macpherson's Philadelphia directory 1785, p. 4.

3. I have found the house numbers in the city directories to be imprecise. As there were no 700 street numbers before 1800, and depending on where John Macpherson began counting (above or below Market Street), this was probably 78 North Second Street, which was between Arch and Vine in 1801. Macpherson had his own way of numbering residences, and he did not use the terms "North" and "South" with street numbers. North Second Street was in the North Ward, which is where the tax record located Arn in 1786; for ward boundaries, see Philadelphia directory 1805, appendix, p. 67.

4. *Pennsylvania Archives*, 2nd ser., vol. 8 (1896), p. 664. Dorothea Streeper was christened on May 18, 1765, at St. Michael's and Zion Church; see "The Streeper Family of Germantown, Philadelphia County, Pa: Descendants of William Streeper (Strieker, Stryker) Who Died About 1717," n.d., HSP.

5. See Charles R. Barker, "The Stony Part of Schuylkill: Its Navigation, Fisheries, Fords, and Ferries," *PMHB*, vol. 50, no. 4 (1926), pp. 355–56.

6. Records of St. Michael's and Zion Church, Philadelphia, corrected version, p. 111, Lutheran Archives, HSP. The church was designed by Robert Smith between 1766 and 1769. For a photograph see William Russell Birch, *Birch's Views of Philadelphia: A Reduced Facsimile of the City of Philadelphia as It Appeared in the Year 1800* (Philadelphia: Free Library of Philadelphia, 1982), pl. 7.

7. Tax and Exoneration Lists, 1762–94. The tax was 4s. 8d. on the hundred.

8. Ibid. Henry Andrews was listed in the Philadelphia directory as a grocer at 139 North Third Street in 1791. In 1776 a Henry Andrews, a German, served in the Revolutionary War and then deserted; *Pennsylvania Gazette*, September 25, 1776. On Bowyer Brooks, see the biography of John Browne (q.v.).

9. Benjamin Rush, "An Account of the Measles as They Appeared in Philadelphia in the Spring of 1789," in *Medical Inquiries and Observations* (Philadelphia, 1793), vol. 2.

10. Daniel Arnd [sic], Philadelphia Will Book I, no. 50, p. 205; Philadelphia Will Book 1A, p. 100. A Hanse family was listed on Race Street between Fourth and Fifth streets in 1785. John Nicholas Wagner (died 1803) was a shopkeeper at 25 South Second Street.

11. Deaths from yellow fever, recorded by Dr. Helmuth, St. Michael's and Zion Church, Philadelphia, Burials, p. 120.

12. Two tablespoons with a bird design on the reverse of the bowl (one is in a private collection; for the other see DAPC 84.3392).

13. As a journeyman using the swage for shaping spoons, his own production would be close to, if not identical with, the production of the shop where he worked. See especially a large ladle and a teaspoon with nice brightwork, both noted in the files of the DAPC 70.3279, 85.2189; I thank Bertram Denker for this information). In the Museum's collection, see a teaspoon by Christian Wiltberger (2004-11-1), spoons by Richard Humphreys (1990-55-4-18), and teaspoons, also by Humphreys, engraved "MS" (1942-47-4-9).

Cat. 25

Daniel Arn
Cream Pot

1785–88
MARK: D·ARN (in rectangle, on underside; cat. 25-1)
INSCRIPTION: MS (engraved script, centered under pouring lip; cat. 25-2)
Height 5⅞ inches (14.9 cm), width 4¹⁵⁄₁₆ inches (12.6 cm), diam. foot 2⁷⁄₁₆ inches (6.2 cm)
Weight 4 oz. 18 dwt. 5 gr.
Gift by exchange of Alice and Frank Osborn, 1988-34-1

PROVENANCE: Barbara Almquist.

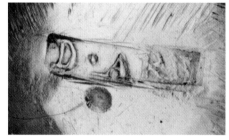

Cat. 25-1

The letters in the maker's mark are crudely cut, and the strike is not pristine. This cream pot is distinguished by its perky stance, its rotund shape, and the deep repoussé pearl work around the upper edge and the pedestal of the foot. Both in shape and in details of manufacture, this cream pot is similar to some by Joseph Anthony Jr. (q.v.).[1] Arn may have worked with or for the Anthonys, who had a busy shop in 1785.

There are approximately seven additional pieces of silver known and marked by this maker, five of which bear the initials "MS," possibly those of a family member of his wife.[2] BBG

1. A pair of cream pots, cats. 18 and 27, have the same characteristics, but only the former has been identified as by Joseph Anthony Jr.
2. These are: a teaspoon with bright-cut engraving and the initials "S / IR" (DAPC 85.2189), a soup ladle (DAPC 70.3279), two tablespoons with a bird design on the reverse of the bowl (one is in a private collection; for the other see DAPC 84.3392), and a pair of pierced-arm tea tongs (private collection). I thank Bertram Decker for this information. Maria Striepy (or Streeper) was Dorothea Arn's sister-in-law, the wife of her brother George (died 1802); Abstracts of Wills, 1790–1802, HSP.

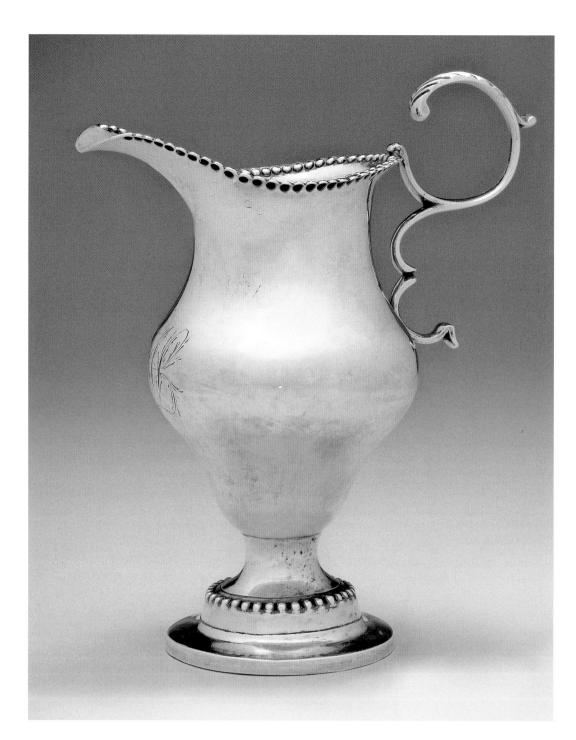

Cat. 25-2

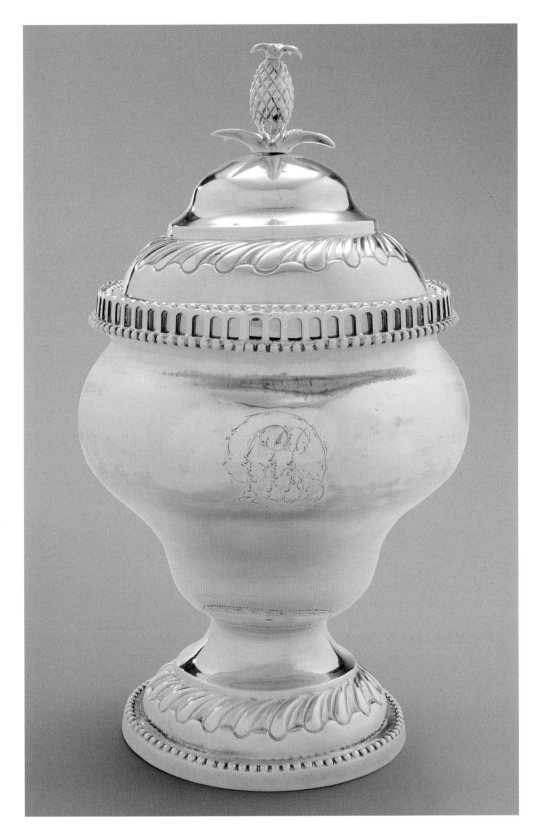

This is a particularly exuberant example of the curvaceous reverse-pear shape with swirling chased-gadroon features on Philadelphia hollowware of the mid-eighteenth century, details of which continued into the early nineteenth century. Here the form is overlaid with the measured classical ornament of three tight, encircling bands of bead, a standing gallery, and a perky pineapple finial on the raised dome lid, features that came into fashion after the Revolutionary War with the resumption of trade with England.

This sugar bowl has long been attributed to the silversmith Joseph Anthony Jr. (q.v.). However, the capital letters "JA" are not in the intertwining script of the first two letters in Anthony's full-name mark.[1] The legs of the letters are thin, the serifs long. The serif on the left leg of the "A" touches the base curve of the "J." There is a pellet between the letters. The mark here is clean and sharp, suggesting a new die; and because it is very like the first two letters of the full name mark of the New York silversmith Jeremiah Andrews, it may be safe to attribute this small mark to him.[2]

Jeremiah Andrews, "jeweler from London," set up shop in New York "on Gold-Hill-Street at the house of Catherine Hubbs, opposite Mr. Scandant's beer and Oyster house."[3] By May 1775 he was located on Hanover Square, advertising that the non-importation regulations lately passed need not be a disadvantage to traders, as he would willingly and cheerfully make "every article as cheap as they could be imported from London, and materials good."[4] In 1776 he served in the Revolutionary War and left New York during the British occupation of the city. He was established in Philadelphia on Second Street between Chestnut and Walnut in December 1778, when he advertised for "two boy apprentices, one to the jewelry business, one to lapidary, to apply at the shop on Second Street between Chestnut and Walnut."[5] In 1779 he was taxed in the Walnut Ward on his estate valued at £400. He paid a per-head (occupation) tax of £21 plus £64 10s. on the £4,300 value of the property he was leasing from the widow Johanna Anthony.[6] He served in the First Company of the First Battalion of the Pennsylvania Militia in August 1780.[7] That year the tax record referred to him as "smith," with his estate valued at £32,000 (reflecting postwar inflation), and his lease valued at £30; the estate tax was £48 10s. and the per-head tax was £25;[8] he continued to lease his residence from the

Cat. 26

J·A [Jeremiah Andrews?]

Philadelphia

Sugar Bowl

1780–84

MARKS: J·A (in rectangle, three times on underside; cat. 26-1); R 1-1 1 8 5
(scratched, on underside of pot)

INSCRIPTION: C L D (engraved script, on one side)

Height 8⅛ inches (20.6 cm), diam. foot 4¾ inches (12.1 cm)
Weight 13 oz. 1 dwt. 19 gr.
Gift of Walter M. Jeffords, 1956-84-1

PUBLISHED: Phoebe Phillips Prime, "Philadelphia in Silver," *Antiques*, vol. 69, no. 5 (May 1956), p. 428, fig. 5 (attributed to Joseph Anthony).

EXHIBITED: Philadelphia 1969, p. 55, cat. 5.

Cat. 26-1

"widow Anthony."[9] In 1782, still in the Walnut Ward, he was taxed as "jeweler," with "merchandize" valued at £150, one horse, one cow, and 60 ounces of plate; his occupation was valued at £69.

He paid £55 15s. and £92 5s. for the property he continued to lease from the widow Anthony. Andrews also owned property beyond Philadelphia: a plantation of fifty acres, including a house and barn, in Ridley Township; a meadow on Tinicum Island "opposite the plantation"; and land in Chester County next to the White Horse Inn.[10] In 1782 he was noted as "jeweller" and taxed on his "merchandize" at £150, on one horse at £30, on one cow at £6, and on 60 ounces of plate at £25, while his occupation tax was £69.[11] Also in 1782 he paid the Effective Supply Tax of £1.11.0 on his estate valuation of £280, and £2.15.5 on the value of his lease from the widow Anthony and an additional £1.7.8 ground rent to George Gray.[12] Jeremiah Andrews moved to Baltimore, advertising his location on Market Street there in 1784. He must have retained his Philadelphia connections, as he married Catherine Lynch on June 2, 1790, at St. Paul's Church, Philadelphia.[13] He eventually moved to Norfolk, Virginia.

Jeremiah Andrews may have been the contact for two of Joseph Anthony's New York commissions, a showy sugar bowl engraved "S" for the New York Schuyler family and a pair of canns for Walter Franklin.[14] BBG

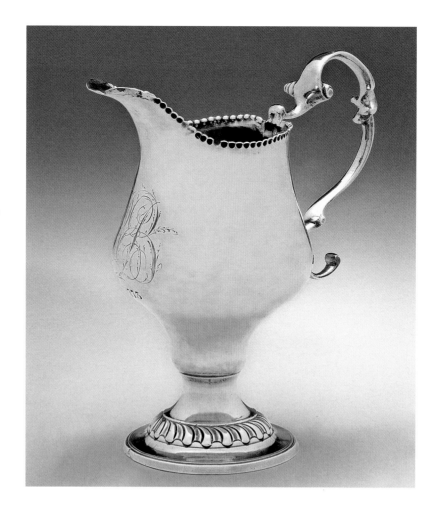

1. See the cream pot by Joseph Anthony Jr. (cat. 17); and the sugar bowl by Anthony in Hofer and Bach 2011, illus. pp. 249–50.
2. Jeremiah Andrews's full name mark is illustrated in Catherine Hollan, *In the Neatest, Most Fashionable Manner: Three Centuries of Alexandria Silver* (Alexandria, VA: Lyceum, 1994), p. 33.
3. *Rivington's New York Gazetteer*, September 15, 1774.
4. Ibid., May 25, 1775.
5. *Pennsylvania Packet, or The General Advertiser* (Philadelphia), December 10, 1778. In 1785 the Walnut Ward was bounded from east to west by Front and Second streets, and north to south from Chestnut to Walnut.
6. John David Sr (q.v.) also leased from the widow Anthony on Second Street. "Joanna Anthony, widow of Stephen, d. 1809"; "Fragments from Old Philadelphia Graveyards," *Pennsylvania Genealogical Magazine*, vol. 11, no. 1 (1930), p. 31. The New York connections shared by John David Sr. and Jeremiah Andrews may have facilitated the latter's relocation to Philadelphia and his location next door to David.
7. August 7, 1780 (Return of the First Company, First Batallion [*sic*], Pennsylvania Militia), but noted as "sick" on September 23; *Pennsylvania Archives*, 6th ser., vol. 1 (1906), p. 86.
8. Ibid., 3rd ser., vol. 15 (1897), p. 814.
9. Tax and Exoneration Lists, 1762–1794.
10. Advertisements for sale of properties, *Pennsylvania Gazette*, January 10, 1797.
11. See note 9.
12. *Pennsylvania Archives*, 3rd ser., vol. 16 (1898), p. 358.
13. Marriage Records of Saint Paul's Church, Philadelphia, 1759–1806, Ancestry.com.
14. The sugar bowl, marked "JA" in script in a rectangle, is illustrated in Hollan, *In the Neatest, Most Fashionable Manner*, p. 33; DAPC 65.1844.

Cat. 27

J•A

Cream Pot

1780–90

MARK: J•A (in rectangle, three times on underside; cat. 27-1)

INSCRIPTIONS: R E B (engraved script in floral cartouche, on front opposite handle; cat. 27-2); 1773 ([later engraving], under initials)

Height 5 inches (12.7 cm), width 2⅞ inches (7.3 cm), diam. base 2⁵⁄₁₆ inches (5.8 cm)

Weight 4 oz. 10 dwt. 10 gr.

On permanent deposit from The Dietrich American Foundation at the Philadelphia Museum of Art, D-2007-8

PROVENANCE: Elinor Gordon, Villanova, PA.

EXHIBITED: On long-term loan to the Diplomatic Reception Rooms, U.S. Department of State, Washington, DC, 1968–2009 (Buhler 1973, p. 67, cat. 138).

This cream pot has a full body tapering into the pedestal base, with a band of gadroon around the foot and deeply punched bead around the top edge, design features of cream pots made in several Philadelphia shops, especially by the Anthonys' shop (q.v.).[1]

The initials in this mark make a broad rectangle. They do not fit the criteria of the first two letters in a known name mark. The "A" is wide with long serifs at the foot, which do not meet the base of the "J." The stem of the "J" and the right leg of the "A" in this mark are thick, while the hook of the "J" and the left leg of the "A" are thin. In another mark with similar Roman letters, the serif of the "A" does meet the bottom of the curved "J."[2] Three of the marks have pellets, which appear in slightly different positions,

Cat. 27-1

Cat. 27-2

possibly as a result of the stamping. Here the mark is stamped precisely three times around the raising dot. It would be tidy to attribute this maker's mark to one of Joseph Anthony's sons, Joseph III or Josiah, who worked in the family shop. The handle has a "twist" at midcurve, familiar on New York products. It is exactly like one used by the New York silversmith Daniel Van Voorhis (q.v.).[3]

This handle was surely a replacement: it has cracked the body at the top edge and through the silver where it attaches to the body. Given the short distance between shops, this New York–style handle may well have been to hand, or possibly supplied by Jeremiah Andrews (q.v.) working nearby (see cat. 26).

The engraved date of 1773 is in a different hand and presumably later than the unidentified initials. BBG

1. For a similar cream pot, see Quimby and Johnson 1995, p. 330, cat. 311; Belden 1980, p. 5. Anthony's small script mark is documented as it appears on camp cups that belong to Winthrop Sargent (1753–1820), who ordered them from Joseph Anthony Jr. in 1783; Falino and Ward 2008, p. 171, cat. 135.
2. The same mark appears on a spoon with the initials "RMA" (DAPC 83.2671).
3. See the cream pot by Van Voorhis advertised by Jonathan Trace, *Antiques*, vol. 142, no. 4 (October 1992), p. 498.

B

Bailey & Kitchen

| Philadelphia, 1832–1846

Bailey & Co.

| Philadelphia, 1846–1878

Bailey, Banks & Biddle

| Philadelphia, 1878–present

Plenty has been written about the Philadelphia firm that began as the partnership of Bailey & Kitchen and that was best known by its last name of Bailey, Banks & Biddle. The careful connoisseurship of the firm's marks, its reputation for having been the first American company to use the English standard silver content, and the role of its suppliers Taylor & Lawrie (q.v.) from 1837 until 1852 and of George B. Sharp (q.v.), the principal designer and manufacturer between 1853 and 1865, have been studied and published.[1] But little notice has been given to the lives of the principals, who, as manufacturers and retailers, survived the "mountains and molehills" of daily commerce, including eras of monetary uncertainty and a rash of counterfeiting,[2] as well as the untimely deaths of its

Fig. 24. "Joseph Trowbridge Bailey at the age of 48 years." From a miniature by J. Henry Brown. From *Ancestry of Joseph Trowbridge Bailey* [2] *of Philadelphia and Catherine Goddard Weaver* [2] *of Newport, Rhode Island* (Philadelphia: n.p., 1892). Historical Society of Pennsylvania, Philadelphia

two founders, Joseph T. Bailey (1806–1854) and Andrew B. Kitchen (1809–1850). Careful management, up-to-date and diverse stock, collaboration with other silversmiths, and connections seem to have been their strengths.

Joseph Trowbridge Bailey (fig. 24) was born on December 16, 1806, to Major (1783–1832) and Lucy Benedict Bailey (1786–1872) in Thompson, Sullivan County, New York. In 1816 the Baileys moved to Poughkeepsie, New York, where family connections surely set up Joseph's apprenticeship with the silversmith Peter Perret Hayes (1788–1842), who was his uncle by marriage.[3] In 1824 Bailey was the oldest apprentice in Hayes's shop at the same time that James E. Caldwell (q.v.) was the youngest apprentice.[4] Exactly where Bailey worked between finishing his apprenticeship in about 1826 or 1827 and his emergence in Philadelphia in 1832 is not known.[5] He may have worked for Samuel Ward Benedict (1798–1880), a relative and watchmaker in New York City, as would Caldwell around 1834.

Andrew Boyd Kitchen was born in Philadelphia in 1809, son of Benjamin Kitchen, a shoemaker who appears in the Philadelphia directory only twice, in 1809 and 1810, and his wife, Mary Boyd (1783–1811).[6] Mary probably died after the birth in 1810 of their second son, Benjamin Jr., and Benjamin Kitchen Sr. must have died prior to 1812, when his father-in-law, Andrew Boyd (1752–1812), wrote his will.[7] Boyd, a Presbyterian shopkeeper whose premises were located at 6 Market Street in Philadelphia,[8] directed "all the estate to my daughter Sarah Boyd and my grandson Andrew Boyd Kitchen."[9] The executors were Sarah and Boyd's "friend John Hall, watchmaker,"[10] and "said Sarah [was] to be guardian of grandson." Andrew was only three years old when he went to live with his Aunt Sarah; the U.S. census of 1820 placed them in Southwark.[11] Beginning about 1820, he may have served an apprenticeship with John Hall, who by 1822 was living and working at 71 Union Street, two blocks from Southwark;[12] or John Hall may have arranged Andrew's apprenticeship with the watchmaker Thomas Boyd (possibly a relative), who was working at 315 North Front Street, Northern Liberties, in 1809. Kitchen's own residences were to be in the Northern Liberties.[13]

Joseph T. Bailey made his first public appearance in Philadelphia on October 30, 1832, when he and Andrew Kitchen advertised in the *Pennsylvania Inquirer and Morning Journal* as Bailey & Kitchen:

> NEW JEWELLERY STORE. The Subscribers respectfully inform their friends and the public, that they have entered into co-partnership for the purpose of manufacturing Jewellery and Silver ware in all their

branches, and will open this day, the 29th inst. at No. 136 Chestnut Street, two doors above the United States Bank, an entire new and choice assortment of superior patent lever and lepine Watches; Jewellery in great variety; Silver Plate, Plated Ware, Fancy Goods &c. of which they at all times intend to keep an assortment of the newest and most fashionable patterns. All orders will be promptly attended to, and particular attention will be paid to the repairing of Watches, Clocks, Jewellery, Music Boxes, &c.

Many of these wares were imported from England; an 1839 invoice for goods that Bailey & Kitchen purchased from the hardware merchants William Chance & Son of Birmingham, England, listed silver flatware, wax holders, "hearts & crosses" (brooches), and silver-gilt "purse snaps," as well as silver-plated baskets, waiters, butter coolers, cruet frames, knife rests, snuffers and trays, and pairs of candlesticks.[14]

Despite their stated intention to manufacture both jewelry and silver, D. Albert Soeffing has speculated that Bailey & Kitchen in fact did not make the silver they retailed.[15] If this is the case, it is not known which craftsmen supplied them during the first four years of the partnership. James Caldwell may have made silver for them after his arrival in Philadelphia in 1836, given his prior association with Bailey in Poughkeepsie and possibly in New York City. After it was formed in 1837, the partnership of Taylor & Lawrie became the primary source of hollowware sold by Bailey & Kitchen.[16] The firm initially was located on Appletree Alley but moved to Bailey and Kitchen's property at 25 Library Street in 1839. The *National Gazette* of December 31, 1839, reported that "the upper part of a three story brick building in Library Street near Fifth was injured by fire on Saturday night. The upper stories were occupied by Bailey & Kitchen, and the lower story by the Fame Hose Company." Taylor & Lawrie manufactured exclusively for Bailey & Kitchen and Bailey & Co. until they moved to 112/114 Arch Street in 1852.[17] Their most spectacular production for Bailey & Co. was the pair of monumental tureens made about 1848–50 for presentation to General George Cadwalader (fig. 25).

It is somewhat ironic that Bailey & Kitchen's advertisements and even their box labels mentioned their proximity to the Bank of the United States, the focal point of a monetary crisis affecting all merchants and craftsmen and causing numbers of them to fail. In 1832 President Andrew Jackson stated that the bank was "[s]cotched, not dead."[18] Controversy raged, especially in Philadelphia, when Jackson vetoed the bill for the recharter of the bank and distributed the government's

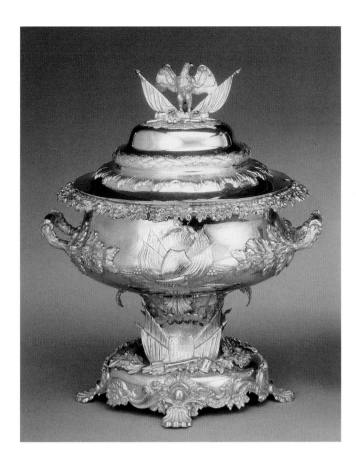

Fig. 25. Tureen, 1848–50. Made by Taylor & Lawrie, Philadelphia. Retailed by Bailey & Co., Philadelphia. Silver, height 17½ inches (44.5 cm), width 16½ inches (41.9 cm). Philadelphia Museum of Art. Gift of John Cadwalader Jr., 1998-157-2a,b

deposits to state banks. Bailey and Kitchen were among the 268 silversmiths and watchmakers, and hundreds of other Philadelphia craftsmen and merchants, who signed a petition to Congress asking for "relief from the present pecuniary distress, by returning the Government deposits to the Bank of the United States."[19] The petition did not sway the government, and other efforts were unsuccessful, resulting in business uncertainty and failures. That Bailey and Kitchen were able to purchase their shop property during the monetary crisis and managed to maintain stock and retain patronage was impressive.

They received notices in the press for the excellence of their silver. On February 26, 1835, the *National Gazette* reported, "On Saturday last, we visited the rich jewelry establishment of Messrs. Bailey & Kitchen, No. 136 Chestnut Street, for the purpose of seeing some splendid pieces of plate, of beautiful workmanship, manufactured by them . . . 2 large Silver Pitchers, with covers, to hold above three quarts each, 2 large Goblets, 1 Silver Waiter for each Pitcher, 1[waiter] for the two Goblets, a rich wreath encircles the body of the Pitchers and the Goblets, and the edges of the Waiters." A review of the annual exhibition at the

Franklin Institute in 1838 praised Bailey & Kitchen for their silver "of handsome workmanship."[20]

In 1833 Bailey and Kitchen were listed only at their business address, 136 Chestnut Street.[21] On June 21, 1834, Bailey married Mary Potter (1811–1841); they had two children, Joseph Trowbridge Jr. (1835–1918) and Emily (1839–1936).[22] Perhaps anticipating the birth of their son, Bailey moved their residence in 1835 to Thirteenth Street just north of Market. Bailey's mother Lucy had moved to Philadelphia after her husband died in 1833, and she remained there until her own death in 1872. In 1836–37 Bailey moved again, to 11 South Thirteenth Street. In 1842 he made his final residential move, to 441 Chestnut Street, "opposite the Mint," an address very near his business establishment.[23] Following his first wife's death in 1841, Bailey married Marie Louise Barry (1820–1882) of New York on August 29, 1843, and had five children: Marie Louise (1846–1881), Lucy (1848–1872), Meredith (1850–1913), Edwin Burr (1851–1854), and Josephine (1854–1896).[24]

Andrew Kitchen married Maria Matilda McCutcheon (1818–1891) in about 1834. They settled at 35 Old York Road in the Northern Liberties.[25] They had seven children and named their fourth Josephine Bailey Kitchen (1841–1842), after Joseph Bailey.[26] In 1836 or 1837 the Kitchens moved to 34 Union Street. In 1840 they were back in the Northern Liberties at 339 North Sixth Street.[27] The U.S. census of 1840 recorded the Kitchen household in the Northern Liberties as consisting of seven free white persons, one free colored person, and one person employed in manufacture and trade. Curiously or just looking ahead, on November 3, 1835, Bailey and Kitchen each had purchased a piece of ground for $40 in the "Philadelphia Cemetery" (Laurel Hill) from James Ronaldson, who was noted in the deed as a "letter founder and cotton spinner."[28]

From the number of deeds executed between Bailey and Kitchen as grantees and then also as grantors or grantees between themselves, it is

clear that their business plan included investments in real estate as an extension of their partnership beyond the jewelry business. It was a traditional way to wealth in Philadelphia and surely a contributing factor to their steady path toward success.[29] In 1836 Bailey and Kitchen purchased the site of their store at 136 Chestnut Street from Joseph and Margaret Coleman Hemphill, for $47,000; it originally had belonged first to the Logan family and then Robert Coleman, a wealthy iron manufacturer from Lancaster. The lot was 27 feet and 10 inches in breadth on the south side of Chestnut between Fourth and Fifth streets and extended 151 feet to what was "commonly called Morris Court." It was bounded on the east by the house and grounds of Dr. Adam Kuhn and on the west partly by grounds of the Library Company of Philadelphia and partly by a house and grounds of John Still. As noted in their company's first advertisement, this location was two doors west from the Bank of the United States. Bailey and Kitchen were specified as "tenants in Common, not joint tenants."[30]

An image of the street from *Rae's Philadelphia Pictorial Directory and Panoramic Advertiser* for 1851 (fig. 26) depicts number 136 as a three-story, three-bay brick structure, with a sculpture of an American eagle over the entrance and a large painted sign for Bailey & Kitchen at the cornice. Either before or after Bailey & Kitchen purchased the building, they outfitted the first floor as their showroom. After they moved to 819 Chestnut

Fig. 26. *Rae's Philadelphia Pictorial Directory and Panoramic Advertiser* (Philadelphia: Julio H. Rae, 1851), pl. 7. Bailey & Kitchen is illustrated on the lower level of 136 Chestnut Street. Philadelphia Museum of Art, Library and Archives

Street in 1859, the firm advertised "the large glass used in the front windows at the old store . . . 7½ by 10 feet, with side and sash lights to correspond," visible in the drawing.[31] The interior was lavishly appointed; in 1849, *Godey's Lady's Book* informed its readers, "Messers. Bailey & Co. of Chestnut street, have opened their splendid jewelry store to the public, and we are told by those who have been abroad that it surpasses in magnificence and real

worth any store in Paris or London."[32] They apparently had no silver manufactory on the premises. The image from Rae's directory records the merchant Ward B. Haseltine on the top floor, and the accountant Stephen Kimball and the merchant George J. Pepper were among the other occupants in the 1835–36 city directory.[33]

In addition to securing their business location, Bailey and Kitchen were investing in the physical expansion of the city westward toward the Schuylkill River, and most of their land transactions were for undeveloped ground. In 1835 Henry Cope, Thomas Evans, Blakey Sharpless, and Thomas Wood of Philadelphia along with Samuel Holgate of the District of Southwark, "surviving Trustees of the Monthly Meeting of the Religious Society of Friends commonly called Quakers of Philadelphia for the Southern District," transferred to Bailey and Kitchen a lot at Third and Federal Streets in Southwark.[34] Between about 1835 and 1838, they purchased from John Inslee in fee, as tenants in common, a lot on the north side of Mulberry (Arch) Street 198 feet west of the west side of Schuylkill Sixth Street (Eighteenth Street).[35] On June 9, 1843, Joseph Bailey transferred his half of this property to Kitchen for $1,500, and on June 12, Kitchen deeded his half of the Southwark property to Bailey for $1,750.[36]

Kitchen also seems to have invested in property independently. On December 18, 1843, he purchased from John Brognard Okie, merchant, and his wife Marianna, for $5,800, a three-story brick house in Franklin Row located on the west side of Delaware Ninth Street between Walnut and Locust. Kitchen and his wife Maria Matilda sold it to Samuel H. Traquair, Esq., on June 11, 1845, for $6,000.[37] Bailey witnessed the transaction. On June 26, 1844, Kitchen purchased from the estate of John Kates (died 1838), for $10,890, "ground on the north side of Chestnut Street at a distance of 230 feet westward from the West side of 12th Street, extending Northward 150 feet to a 27 foot wide Street [Clover Street]." The deed included detailed instructions about what could be built, stipulating that nothing could extend back beyond the neighboring three-story building that Kates had built.[38] This was Kitchen's residence, 407 Chestnut Street.

On November 18, 1846, an advertisement in the North American announced, "The firm of Bailey & Kitchen partnership is this day dissolved by mutual consent, A. B. Kitchen retiring from the concern. . . . The business will be conducted by the subscriber [Joseph Bailey] on his own account, where he will be ever happy to serve the patrons of the establishment as heretofore." Joseph Bailey renamed the firm Bailey & Co.,

although he continued to use printed billheads for the old partnership as late as January 1848, and the cornice sign reading "BAILEY & KITCHEN" remained in place into the 1850s, even when the street-level signage was changed.[39]

In the new company Bailey was joined by his younger brother, Eli Westcott Bailey (1809–1899), who had begun his career in New York City in the 1830s. He married Esther Ann Whitney in New York on June 21, 1834.[40] According to his obituary, Eli Bailey worked first for an auctioneer and subsequently for the hardware merchant Henry Young.[41] In 1835, with the watchmaker Hiram Gilbert and Caleb Draper, Bailey formed the partnership of Gilbert, Bailey & Draper, importers of jewelry, watches, and fancy and military goods at 8 Maiden Lane.[42] The firm did not survive the financial panic of 1837, although Eli Bailey was still in New York in 1840 with a household of seven persons, one employed in commerce.[43] In 1841 Eli began working for Bailey & Kitchen in Philadelphia and was living at 149 Marshall Street.[44] In 1845 his residence was 6 South Thirteenth Street, next to his brother's old residence. In 1847 or 1848 he had moved to 407 Mulberry Street.[45] The U.S. census of 1850 listed his large household of twelve in Philadelphia's Middle Ward: Eli, age forty-one; his wife Esther W., thirty-nine, and her older sister Hannah J. Whitney, both born in Philadelphia; three children who were born in New York and three born in Philadelphia; and three servants. In mid-March 1854 Eli Bailey purchased from William H. Boyer, for $3,333.75, "ground" in Kensington on the northeast side of Hunting Street and on the southwest side of Elizabeth Street and, from the merchant Carleton E. Moore, for $8,216.75, another adjoining piece of "ground" on the west side of Emerald Street and the south side of Adam Street.[46]

Following his retirement, Andrew Kitchen was elected an alderman in Philadelphia in 1845 and in due course, in 1849, was entered on the People's Independent Ticket for the Common Council in Philadelphia when Thomas Fletcher (q.v.) was a vice president.[47] Kitchen's political career was short-lived, however, as he died of consumption on May 15, 1850.[48] His obituary was published in the North American on May 17: "On the 15th inst. Andrew B. Kitchen in the 41st year of his age . . . his male friends and those of his family are invited to attend his funeral from his late residence No. 407 Chestnut Street above twelfth, on Sunday afternoon without further notice." He left an extensive estate, including real estate valued at $19,500 and silver valued at $200, which was still being settled in 1859.[49] In his will, dated September 1, 1848, Kitchen left $200 per year to his Aunt

Sarah for the remainder of her life, his personal property and one-third of his estate to his wife, and the remaining two-thirds of his estate to be divided equally among his children.[50] Two of his sons, William F. Kitchen (1835–1861) and Charles Kitchen (born 1842), were recorded in the U.S. census of 1860 as a jeweler and apprentice jeweler, respectively, living with their mother and her second husband, Joseph Woodward, as well as an Irish gardener, a black coachman, a waiter, and three white female servants.[51]

In the U.S. census of 1850, Joseph Bailey, "jeweler," was listed as head of a household of thirteen people. Other than his five children—one of whom, Meredith Bailey, was an infant—also resident were Bailey's sister Mary, his mother Lucy, three female servants from Ireland and Pennsylvania, and William Ringold, a free black man from New Jersey, later described as a "coachman."[52] Joseph Bailey Jr., age fifteen in the census, had attended Edward Brown's Select School for Boys in 1847 and began work at Bailey & Co. in 1851 as a clerk; he later recalled that he "used to open the door" of the business.[53] He married Catherine Goddard Weaver (1835–1902) of Newport, Rhode Island, on September 1, 1857, and had four children: Emilie (Mrs. Edmund Brandt Aymar, 1858–1938), Joseph Trowbridge III (1860–after 1925), Charles Weaver (1861–1922), and Kathryn Louis (1871–1916).[54]

Joseph Bailey Sr. had been suffering from consumption for some time and became increasingly unable to manage his company. In 1850 Eli Bailey reorganized the firm, taking the watchmaker Jeremiah Robbins (q.v., Clark & Biddle) and the jeweler James Gallagher as new partners.[55] In that same year Eli and possibly his family moved into the house at 441 Chestnut Street to care for his older brother.[56] In 1852 Joseph senior advertised a property available next door to him: "the premises at 431 Chestnut Street above 13th are to be let, a good stand and well suited for a baker's business."[57] In January 1854 Bailey ordered "a superior coffin covered with fine Black cloth, silver mouldings, escutcheons, and engraved breast plate for his son Edwin Burr Bailey."[58]

In February 1854 Bailey took a trip to Cuba in hope of improving his health but died there at Matanzas on March 13, 1854.[59] Joseph junior later related how Cuban authorities had forbidden removal of the body, but during a daring nighttime raid, Bailey's coffin was exhumed and taken to a vessel sailing to Philadelphia.[60] He was buried at Laurel Hill. There is a commemorative inscription on a stone at the cemetery in Connecticut, where other members of the Benedict family were buried. In reporting his death, the Philadelphia Inquirer

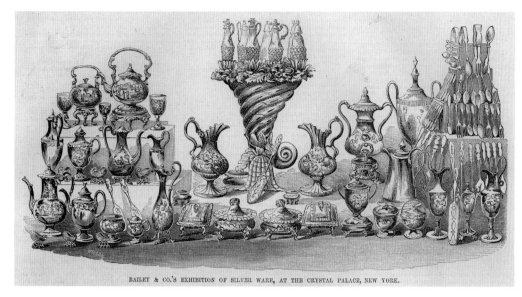

Fig. 27. "Bailey & Co., 136 Chestnut Street, Philadelphia." From *Gleason's Pictorial Drawing-Room Companion*, vol. 5, no. 15 (October 8, 1853), p. 232. Courtesy of the Library Company of Philadelphia

hailed him as "one of the most active and enter-prising citizens of Philadelphia. He was a most estimable man, and in all the relations of life he discharged his whole duty."[61] The *North American and United States Gazette* similarly described Bailey as "long and favorably known as one of our most enterprising and liberal merchants."[62]

In his will written in May 1850 with a codicil in 1853, Joseph Bailey Sr. left all his real and per-sonal property to his second wife, Marie Louise Bailey, naming his brother Eli W. Bailey, Robert M. Stratton of New York, and his brother-in-law Hector Morrison of Brooklyn as trustees.[63] He bequeathed $3,500 annually to his wife "and also such sums as they the Trustees or the majority of them deem necessary for the education and main-tenance of my children while minors." Among the many other beneficiaries were his mother, Lucy Bailey, who received $500 per year; his sisters Mary W. Bailey and Hannah Morrison; his wife's mother, Anna Barry; and his niece Emily Norman, who received $1,000 at the time of her marriage. Although he left no specific bequest to his elder son, Bailey made the stipulation: "It is my desire that my business establishment shall continue after my death and that my son Joseph at the age of twenty one years shall become a partner in the firm[,] My Trustees to make such arrangement with my brother Eli and son Joseph." Following this directive, nineteen-year-old Joseph Bailey Jr. was named president in 1854 and became a part-ner in 1856.

At the same time that Eli Bailey reorganized the partnership, the firm began operating its own silver manufactory instead of using subcontrac-tors. In 1852 Taylor & Lawrie moved out of the Bailey & Kitchen building at 25 Library Street; in that same year, they briefly took a third partner, possibly the jeweler Thomas Wood, and patented a spoon design, further evidence of their separa-tion from Bailey & Co.[64] At their new address of 114 Arch Street, Taylor & Lawrie advertised that they "manufactured for the firm of Bailey & Kitchen 20 years, and owning all the Dies and Patterns from which their work was made, are enabled to match all work finished by them during that time."[65]

William and George B. Sharp (q.v.) became the managers of the new Bailey & Co. factory and were listed at 25 Library Street in the 1853 city directory.[66] In the same year the firm participated in the New York Crystal Palace exhibition. Their elaborate display, illustrated in *Gleason's*, featured a large cornucopia topped by cruet bottles, with flanking pyramids of flatware and tea and coffee services and an artful arrangement of other table-wares (fig. 27). The accompanying article stated, "The style and beauty of their product speaks [*sic*] for themselves," although another writer criticized one of their covered vegetable dishes as "solid, massy and well wrought in a mechani-cal point of view, but we cannot call it beautiful in all respects."[67] In 1857 Edwin Freedley claimed that Bailey & Co.'s reputation, "at the present time, throughout the Union, is unsurpassed by any other similar establishment" and reported, "All the processes—the designing and drawing of the patterns, the melting and refining of the metal, to the last finishing touch of the graver, are exe-cuted upon their own premises, and under their personal inspection."[68]

As D. Albert Soeffing has demonstrated, during the 1850s Bailey & Co. began using quality

marks to denote the different alloys they used: an "S" mark with a lion statant denoted the ster-ling (i.e., British) standard of 92.5 percent silver, whereas a "U" mark with a spread eagle denoted the lower, U.S. standard of 90 percent silver, as illustrated by one of the firm's billheads (fig. 28).[69] The firm's invoices for silver objects from this period occasionally specify that a given object is of sterling standard, as in the "Sterling Silver Sugar Bowl" sold in 1859 to Edward Ingersoll (1817–1893) of Philadelphia, but most simply list objects as made of silver without specifying the standard.[70] Although earlier Philadelphia silversmiths such as Chaudron & Rasch (q.v.) had marked their sil-ver as sterling (for example, see cat. 134), Bailey & Co. repeatedly claimed that they were the first American firm to adopt it, perhaps because they were unaware of these earlier instances. Bailey & Co. began marking silver with these quality marks at about the same time that Sharp took over

Fig. 28. From a bill to Edward Ingersoll, May 15, 1856, Edward Ingersoll Records. Historical Society of Penn-sylvania, Philadelphia

Fig. 29. Mark of Bailey & Co. From a hot-water urn, c. 1853. National Museum of American History, Smith-sonian Institution. Division of Home and Community Life, DL.276317.0001

management of their factory, and a tea and coffee service that may have been the one exhibited in New York in 1853 is marked with the "U" mark for American standard silver, together with an ele-phant statant mark that appears to have been the American standard counterpart to the lion pas-sant guardant that accompanied the British ster-ling standard marks (fig. 29).[71]

Because the introduction of these marks coincided with Sharp's arrival, the "S" mark has

Fig. 30. The Bailey & Co. storefront as illustrated on the back cover of *An historical account of the ancient Greek city of Paestum, the magnificent ruins of which are the subject of the Large Mosaic Picture, imported and exhibited by Bailey & Co., No. 819 Chestnut Street, Philadelphia* (Philadelphia, 1864). Courtesy of the Winterthur Library, Delaware. Joseph Downs Collection of Manuscripts and Printed Ephemera, coll. 214

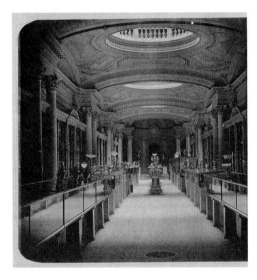

Fig. 31. Interior of Bailey & Co. store, 819 Chestnut Street, 1859–68, c. 1860. Photograph by W. & F. Langenheim. Albumen on stereograph mount, 3¼ × 6¾ inches (9 × 17 cm). Library Company of Philadelphia, 1322-F-31g

generated considerable confusion among subsequent scholars and collectors, many of whom mistakenly identified the letter as Sharp's initial. Examples of the "U" mark are comparatively rare, perhaps because, as Freedley reported in 1857, "Messrs. Bailey & Co. . . . claim the distinction of having first introduced the use of Silver of the full British standard, say from 925–1000 to 930; the American standard being but 900. They now work in no other, a test being made monthly by J. C. Booth, 'Esq., Chief Assayer of the Mint.'"[72] This statement suggests that the "U" mark was only in use for about three years. An 1864 promotional pamphlet listed "British standard silver ware, Sheffield and American plated wares" among the firm's offerings, with no mention of American standard silver.[73] It is unclear whether objects (such as cats. 29, 31) without quality marks predate the introduction of such marks or are not of sterling standard.

In 1859 the retail shop and factory moved to 819 Chestnut Street. This new establishment was described as an "elegant white marble fireproof building . . . one of the most valuable on Chestnut Street" (fig. 30).[74] The first floor featured a vaulted ceiling, with the walls lined with mirrors and showcases (fig. 31). A subsequent description noted that it was "fitted up in magnificent style at an expense of probably fifteen or twenty thousand dollars."[75] The factory, located at the rear, was "supplied with large manufacturing conveniences—steam power, elevator, &c."; a subsequent real estate advertisement noted that it had "steam power suitable for any kind of manufacturing purposes."[76] In the 1861 city directory, George B. Sharp's work address changed to 819 Jayne (now Ranstead) Street, the address at the rear of the Chestnut Street store. Sharp remained the factory supervisor until 1865, when he established his own business at 414 Prune Street. During his tenure at Bailey & Co., the factory produced many impressive objects in the Rococo and Renaissance Revival styles, such as the dinner service presented in 1865 to Samuel Felton (cat. 45).

From the partnership's earliest years, a significant part of its sales had been devoted to jewelry. The jewelry-making part of the business may have been separate from the silver manufactory operated by Taylor & Lawrie, as Bailey & Kitchen advertised for jewelers in 1845, noting that "permanent situations will be given to two or three first-rate workmen."[77] The quality of the jewelry offered by Bailey & Kitchen was indicated by the "Single Stone Brilliant Diamond Finger Ring, weighing about 1 carat, set in a square setting of silver, with plain gold border—chased ring" that was lost or stolen from their shop in October 1833.[78] The jewelry manufactured by Bailey & Co. repeatedly was singled out for praise; in 1854 one British survey of American manufactures commended their original designs and workmanship: "At Philadelphia, Messrs. Bailey produce excellent articles in silver, many of which are in good taste.

The gold filigree and pearl work manufactured in this establishment is, when the French taste is not followed, both superior in design and workmanship."[79] Jewelry and diamonds in particular assumed even greater importance for Bailey & Co. in the 1860s, perhaps because of Eli Bailey's role. The firm's trade card gave its specialties as "manufacturing jewelers and silversmiths," in that order, and an advertising token of 1855 put "diamonds" in larger type than the "watches, pearls, silver & plated wares" that it also listed.[80] Newspaper advertisements from these years headed the list of Bailey & Co.'s wares with the word "diamonds" and in some instances repeated it twenty or more times.[81] Lucy Hamilton Hooper, a correspondent for the *Philadelphia Inquirer*, reported in 1879 that while visiting Paris she was shown "some unusually fine matched stones, and also a yellow diamond of wonderful beauty. . . . That small box, whose contents were worth more thousands than I am willing to state, represent[ed] this season's purchases of Mr. Joseph Bailey."[82]

Eli Bailey also seems to have been responsible for the firm's expansion into selling paintings and other works of art, perhaps due to his previous experience as an auctioneer. In 1864 Bailey & Co. published a pamphlet to accompany their display of an Italian mosaic picture of the Greek temples at Paestum (fig. 30), "composed of upwards of 750,000 pieces of small cubes of enamel . . . the most splendid specimen ever brought to this country."[83] The firm organized an exhibition of paintings at the Pennsylvania Academy of the Fine Arts in October 1865 to benefit the Soldiers' Home.[84] Two years later Bailey & Co. announced the auction of 155 oil paintings described as "importations"; one of the featured works was *Christ in the House at Emmaus* by the Austrian artist Leopold Carl Müller.[85] Eli Bailey's obituary noted his important role in selecting and importing paintings by European artists: "Two of the collections of painting made by him then were probably among the finest that had been imported for sale in America up to that time."[86]

Eli Bailey retired in 1867 as the firm's senior partner, and the firm reorganized as a limited partnership between Joseph Bailey Jr. and his cousin Westcott Bailey (1846–1917), with the latter's father Eli remaining a special partner by virtue of the $150,000 capital he contributed; this arrangement was renewed in 1873 and 1877.[87] After the Civil War what was called "the fashionable retail trade" in Philadelphia was moving closer to Broad Street, and in October 1868 the new management moved the retail operation to a new building at the southeast corner of Twelfth and Chestnut streets that had been built for the S. S.

Fig. 32. S. S. White Building, 1899. From *Philadelphia, Pa.: The Book of Its Bourse and Co-operating Public Bodies* (Philadelphia?: Lippincott, [1899]), p. 280. Bailey & Co. moved its retail operation to this building when the structure was completed in 1868.

Fig. 33. "Messrs. Bailey, Banks & Biddle's New Art Room." From John V. Wood, "An Art Room," *The Connoisseur: Bailey, Banks & Biddle's Illustrated Quarterly of Art and Decoration*, vol. 2, no. 2 (December 1887), p. 81. Thomas J. Watson Library, The Metropolitan Museum of Art, New York

White Dental Company, which occupied most of the upper floors (fig. 32).[88] Bailey & Co. apparently retained ownership of 819 Chestnut until about 1880 and leased the space at Twelfth and Chestnut for the entirety of their occupancy.[89] As with the firm's previous store, the Chestnut Street facade of the S. S. White building was white marble, with the fronts on Twelfth and Sansom streets of brick and the doors and windows framed in marble. The Baileys clearly spared no expense on outfitting the interior, which the *Philadelphia Inquirer* hailed as "Bailey's New Jewelry Palace. . . . One is wholly amazed on entering the doorway at the magnificent scene which meets the bewildered view. A vista is presented which makes one think of an enchanted ground." The first floor was 44 feet wide and 235 feet deep; the 21-foot-high ceiling had fresco decorations by the firm of Konstantin Kaiser & Brother. At the Chestnut Street entrance were a pair of 18-foot-high mirrors that reflected a pair of marble statues, *Echo* and *Narcissus*, by the Philadelphia sculptor Joseph A. Bailly. The jewelry counters were white marble, while the cabinets displaying silver were walnut with "heavy cornices and elaborate carvings." At the rear of the store were an art room (fig. 33) for furniture, ceramics, bronzes, and oil paintings and a ladies' reception room with "carpet, furniture, wall hangings and everything else, designed for the comfort of the fair sex."[90]

In addition to selling art objects, Bailey & Co. mounted short-term displays of art and pieces of historical interest in the store's front windows, which functioned as a quasi-museum and garnered significant publicity. In 1872 the firm displayed John Quincy Adams Ward's life-size bronze figure of Major General John F. Reynolds, cast in Philadelphia and intended for the National Cemetery in Gettysburg.[91] In succeeding years paintings by Philadelphia artists including George Cochran Lambdin (1830–1896), Daniel Ridgway Knight (1839–1924), and Edward Lamson Henry (1841–1919) were exhibited in the show windows. On one occasion in May 1873, a still life of water lilies by Lambdin was shown in Bailey & Co.'s window, and simultaneously his still life of roses and azaleas was exhibited in the east window of Robbins, Clark & Biddle's (q.v., Clark & Biddle) neighboring store.[92] Bailey & Co. also featured antiques, such as "a cup and saucer of genuine chinaware, once the property of Deborah, wife of Benjamin Franklin," as well as contemporary items such as the elaborately embroidered banner that the Americus Club took to the Democratic National Convention of 1880 in Cincinnati.[93]

Business practices in this period showed the influence on the luxury trades of John Wanamaker's "Oak Hall" clothing store at Sixth and Market streets, which had introduced fixed prices at its opening in 1861. In the aftermath of the Panic

of 1873, Bailey & Co. announced, "We have marked our whole stock, Diamonds, Watches & Jewelry included, at prices to meet the present reductions in values. We do not, therefore, make any discounts, but mark each article in plain figures. Prices fixed!"[94] Advertising became a major and important means of attracting customers, and the firm ran extensive advertising for holidays such as Easter and Christmas, with extended opening hours in the weeks leading up to Christmas Day.[95] Bailey & Co.'s advertisement for "Holiday Presents" in December 1865 described a stock similar to those advertised by Bailey & Kitchen thirty-three years earlier: "Imported and domestic jewelry of the choicest kinds. Fine and elegant silverware and silver plated goods, European fancy goods, selected from the Factories of Europe by [a] member of the firm. Vienna fancy goods in great variety. Paris fancy goods, select and beautiful. A large stock of fine watches and jewelry, imported directly from the most celebrated factories of Geneva, Hanau, Naples, and London."[96]

An effusive visitor to the new store in 1868 described watch repair, jewelry, and engraving departments located on an upper floor, but significantly did not mention any silver manufacturing.[97] Most secondary sources agree that Bailey & Co. discontinued manufacturing silver in the years prior to their move in 1868, and Soeffing has speculated that Bailey & Co. sold its silver

manufactory to George B. Sharp when he set up independently in 1865.[98] These conclusions are supported by the fact that most of the flatware and all of the hollowware in the Museum's collection marked by Bailey & Co. or the successor firm of Bailey, Banks & Biddle after the mid-1860s is also marked by another silver manufacturer; also supporting Soeffing's theory is a serving spoon marked by Sharp formed with the same die as a presumably earlier spoon marked by Bailey & Co. (cat. 35). The spectacular, 40-inch-tall "Union Vase" that Bailey & Co. donated to Philadelphia's Great Central Fair in 1864 was in fact made by the Gorham Manufacturing Company (q.v.).[99] After about 1865 Bailey & Co. advertised as retailers of silver made by other makers. In 1868 notices placed in several newspapers announced that the company was "the authorized agents in this city for the sterling solid silver wares, of the Gorham Manufacturing Company."[100] A ladle made by John R. Wendt (q.v.) of New York in the "Medallion" pattern that he patented in 1862 (see PMA 2011-15-2) was also struck with Bailey & Co.'s mark.[101] In 1873 the firm announced that it was "now receiving new and choice styles [of] silverware."[102] After the company reorganized as Bailey, Banks & Biddle, it is clear that it was primarily a retailer of silver made by other American companies, including William B. Durgin (cat. 226), Gorham (PMA 2001-197-1-6), Graff, Washbourne & Dunn (PMA 1968-79-5-6), Whiting Manufacturing Company (PMA 1995-69-16-18), and Richard M. Woods & Company (PMA 1975-89-1a,b).[103] An 1896 advertisement of "exclusive" flatware patterns included *Monarque* by the Howard Sterling Co. (q.v.) and *Marguerite* by Gorham.[104] In addition, Bailey, Banks & Biddle sold silver imported from France, Russia, England, Germany, and the Netherlands. A separate department was established for silver-plated wares made by Gorham.[105]

Nevertheless, other newspaper articles and some of Bailey & Co.'s own catalogues and advertisements stated that the firm maintained a workshop for custom silver orders. One article from 1868 reported, "The firm deals largely in silver ware; they are agents for the Gorham Solid Silver Ware Co., and make to order services of plate in their own laboratory."[106] In 1871 a Bailey & Co. catalogue stated, "The advent of Messers. BAILEY AND COMPANY in the year 1832, with new and improved machinery, created quite a revolution in the art of manufacturing silverware. They immediately took the lead in this department of industry, which they have steadily maintained."[107] Bailey & Co. mounted what was described as a "large and beautiful exhibit" at the 1876 Centennial Exposition in Philadelphia, including a tea and

Fig. 34. "Service, Repoussé Silver: Messrs. Bailey & Company, Philadelphia." From *Masterpieces of the Centennial International Exhibition*, vol. 2. Philadelphia Museum of Art, Library and Archives

coffee service singled out by one critic as an "elegant" example of their work (fig. 34), which suggested that the exhibited objects had been made by the company.[108] Ten years later, in 1886, the *Pennsylvania Historical Review* reported: "The firm manufactures very largely, both of jewelry and sterling silverware for their heavy and desirable retail trade. Articles of silverware, whether for table use or ornaments, are manufactured by them to meet the requirements of a cultivated and refined taste, combining elegance of design and ornamentation, good workmanship and purity of material. Their long experience in the manufacture of sterling silver, with the facilities at their disposal, together with their own personal supervision, justify them in submitting their productions as the best, most elaborate and desirable, which in the present advanced stage of the art have been produced."[109]

Hints that the company manufactured some silver continued into the early twentieth century. A review of silver displayed in the firm's art rooms in 1895 distinguished objects made by Bailey from those of other companies, noting, "The Bailey, Banks & Biddle Co.'s chrysanthemum sterling 925–1000 silver exhibits attracted much attention, while the products of the Whiting Mfg. Co.[q.v.], Gorham Mfg. Co., Dominick & Haff [q.v.], Goodnow & Jenks [q.v.], Wm. B. Durgin, Ludwig, Redlich & Co., [q.v.] and other famous silverware houses created genuine admiration."[110] In 1906 the firm displayed in its show windows the forty-six-piece service created for the U.S. Navy battleship

Virginia and stated that it was "designed and made by the Bailey, Banks & Biddle Company, in competition with the leading silversmiths of the country," implying that it was made in-house.[111] Early in October 1908 the *Philadelphia Record* reported on the first-place trophy for the Fairmount Park Motor Race that was being supplied by Bailey, Banks & Biddle: "As the cup must be specially constructed throughout, it will require two forces of artisans, working day and night, to complete it in this remarkably short time."[112] The company's ability to work within this short time frame suggests that the cup was being made under their supervision instead of by an outside workshop.

On March 2, 1878, after ten years at Twelfth and Chestnut, Bailey & Co. merged with their competitors Robbins, Biddle & Co. (q.v., Clark & Biddle) to form Bailey, Banks & Biddle. The general partners were Joseph T. Bailey Jr. and Samuel Biddle (1844–1919), joined by George W. Banks (1837–1924), formerly a partner at another competitor, J. E. Caldwell & Co. (q.v.). Eli Bailey and Clayton French (1824–1890), who was Banks's father-in-law, were listed as special partners, presumably for their financial backing.[113] The son of a farmer, George Washington Banks was born in Redding, Connecticut, but by age twenty-three had moved to Philadelphia, where he was working as a clerk. He was listed as a jeweler in the 1862 city directory, and the following year he was working for J. E. Caldwell & Co. at 822 Chestnut Street. In 1866 he became a partner in the firm.

On January 15, 1868, Banks married Mary French (born 1850), whose father made a fortune as a wholesale druggist and real estate investor; the value of Clayton French's real and personal estate was estimated at $600,000 in the U.S. census of 1870 and had risen to $225,000,000 at the time of his death in 1890.[114]

The new partnership offered advantages over the competition; as one source noted, "They bring to bear the highest order of culture and the widest range of experience. Their facilities and connections are of a character unequalled, while their immense and valuable stock represents the judicious outlay of large capital, and well-directed to secure the finest and rarest of the Old World *objects d'art*, while as manufacturing jewelers and diamond mounters no house in the United States has achieved a higher reputation."[115] An article in the Harrisburg *Patriot* in November 1878 observed, "Since the consolidation of two great jewelry houses of Philadelphia, with the addition of a leading member of another one, there has been a gratifying increase of business in the new house. Bailey, Banks & Biddle may safely be said to stand at the head of this branch of business in Philadelphia."[116] This was not mere hype. Within eight years a reporter noted, "The constant increase of Messrs. Bailey, Banks & Biddle's business in all departments during the last few years has rendered insufficient the factory accommodations which not long since seemed ample."[117] A new brick and iron, five-story factory building, designed by the architectural firm Furness and Evans, was erected in 1886 directly across Sansom Street from the store's south entrance, connected by telephones and a pneumatic tube system.[118] A newspaper article described the store and factory as "furnished throughout with all business conveniences adapted to the requirements of their large force engaged in the mounting of precious stones and the manufacture of fine gold jewelry, including watch makers, clockmakers, silversmiths, stampers, illuminators, die sinkers, medalists, makers of civic and military insignia, artists, designers, and others employed in the preparation of their goods."[119] This somewhat passing mention of silversmiths again suggests that Bailey, Banks & Biddle was engaged primarily in the production of watch cases and other jewelry and not in manufacturing flatware or hollowware.

Eli Bailey remained a special partner until 1889, when he and his son formed the firm Westcott Bailey to import diamonds and precious stones, at 1020 Chestnut Street.[120] Following the retirement of Samuel Biddle in 1894, the firm was incorporated on March 2, 1894, as Bailey, Banks & Biddle Co., "the character and object of which

is the manufacture of iron or steel, or both, or of any other metal or of any article of commerce from metal or wood or both, and the manufacture and production of silverware, plated ware, jewelry, works of ornament and art, and pictures, and the buying and selling of such articles." Joseph Bailey Jr. became president, his son Charles first vice president and treasurer, and his brother-in-law Clement Weaver (1848–1913) second vice president and secretary, with George Banks and Harry N. Robison as partners.[121] Charles Weaver Bailey had trained as jeweler under Edward S. Lawyer (c. 1825–1895), who was described as "a pioneer in the manufacture of jewelry" at 925 Chestnut Street.[122] In 1885 they formed the partnership of Bailey & Lawyer, which continued until 1889, when Bailey joined the family company.[123] His obituary noted, "His activities in the concern of Bailey, Banks & Biddle were confined chiefly to the manufacturing end."[124] George Banks retired from the firm in April 1895.[125]

However humble his father's origins, by virtue of his personal wealth and the prestige of his business, Joseph Bailey Jr. had risen to the same social circles as his wealthy clientele. He further cemented this position with his daughter Kathryn's marriage on December 15, 1890, to Jean-Théodule-Francisque-Louis, comte de Sibour, of Paris and Carpentras, France. "Philadelphia has added another of its prominent society leaders to the European nobility in the person of Miss Kathryn Bailey," the *Philadelphia Inquirer* reported. "The wedding was as quiet as the important social positions of both bride and groom and their families would permit."[126] Joseph Bailey Jr.'s brother-in-law Clement Weaver and his wife and daughter similarly moved in exalted circles; reviewing the "prominent figures in the upper strata of society" vacationing in Atlantic City, the *Inquirer* noted, "Miss Weaver wears some exquisite toilettes and is always in demand at the social functions."[127]

By the 1890s the company's retail business was organized into twelve separate departments: gems, gold jewelry, sterling silver, Gorham silverplate, cut glass, porcelain, clocks, leather goods, insignia, heraldry, stationery, and "bric-a-brac," the last defined as "thousands of dainty objects from the Art centres of the World."[128] Divided between the store and the factory, Bailey, Banks & Biddle's workforce in the late nineteenth and early twentieth centuries was large; annual employee banquets held in the 1910s included between 200 and 300 people.[129] At the top of the hierarchy were specialists such as Eugene Zieber, who headed what was touted as the only heraldry department in the country, "fully equipped to

trace Arms and execute all work to which Heraldry is applicable," with "absolute correctness guaranteed."[130] In 1895 the firm published Zieber's *Heraldry in America*, the first full-length study of the subject, and Zieber served as a consulting specialist at the Pennsylvania Museum's School of Industrial Art.[131] Experienced retail salesmen included Edmund J. Stager, a buyer in the bric-a-brac department, who "was known not only in this country, but in the art centres of Europe, to which he made annual trips."[132] In 1900 the factory alone employed 210 people, including eleven women, thirty-one men and women under twenty-one years of age, and five boys ages thirteen to sixteen.[133] At the top of the factory hierarchy were specialists such as L. K. Siggins, who had worked as head of the engraving department at Matthews & Company before joining Bailey, Banks & Biddle's stationery department.[134] Bailey, Banks & Biddle placed help-wanted notices for experienced craftsmen, such as the "one first-class script and two general engravers on gold and silver jewelry" the company sought to hire in 1912.[135] It also advertised for unskilled labor, usually boys around age sixteen, "to learn the jewelry and silverware polishing trade," as well as girls "for enameling on jewelry, exp[erience] not necessary."[136] Significantly, most of these help-wanted notices related to jewelry fabrication. As before, the factory soon proved inadequate to the company's needs, and in 1919 an auxiliary twelve-story factory building was erected on the south side of Sansom Street, directly across from the Bailey Building's factory component.[137]

In addition to manufacturing, Joseph Bailey Jr. had maintained the partnership's promotion of paintings and other imported artwork, making his own annual trips to Europe to acquire stock. As reported in a newspaper article on the improvement in public taste since the Centennial, Bailey was "frequently consulted by the leading fabricants abroad upon what it is advisable to produce."[138] Objects of "special designs" were made by such leading European porcelain manufacturers as Royal Worcester and Mintons, and specifically marked for the firm (fig. 35). In 1883 Bailey, Banks & Biddle offered 122 cases of "choice novelties" that had been acquired at the International Export and Colonial Exhibition of 1883 in Amsterdam.[139] Five years later, the firm offered a pair of monumental vases made by the Royal Berlin Porcelain Factory that Joseph Bailey Jr. had seen and acquired at the German National Exhibition in Munich.[140] The firm also dealt in American-made ceramics; in 1885 it exhibited Belleek porcelain made in Trenton, New Jersey, with the observation: "As marking the opening of a rich field of

Fig. 35. Vase entitled *Folie* or *Jester*, 1894. Decoration designed and executed by Marc-Louis-Emmanuel Solon, also executed by Alboine Birks. Made by Mintons, Ltd., Stoke-on-Trent, England. Parian ware with pâte-sur-pâte and gilt decoration, height 23⅞ inches (60.7 cm). Philadelphia Museum of Art. Purchased with the Joseph E. Temple Fund, 1898-95

native artistic manufacture, American Belleek is invested with more than the ordinary interest attending the advent of a new ware."[141] From 1886 to 1889 Bailey, Banks & Biddle published *The Connoisseur*, a quarterly magazine with articles on historical and contemporary art as well as poetry and artistic illustrations. Art objects became such a significant part of the business that one of the independently occupied storefronts on the first floor was taken "in response to a demand from certain quarters for a department for the sale of such household ornaments as porcelains, clocks, and fancy goods."[142] A house on South Twenty-first Street was acquired to store them; in 1905 the *Philadelphia Inquirer* reported, "Besides the bric-a-brac and paintings in the house there are many other valuables and curios collected from all over the world, some of which are almost priceless. The house is stocked from cellar to garret, and the contents are said to be worth many thousands of dollars."[143]

In 1903 the partners announced they had acquired a fifty-year lease on property at 1218–1222 Chestnut Street for constructing a new building that would consolidate their retail and manufacturing operations. Designed by the Thompson-Starrett Company of New York and completed in February 1904, the Bailey Building was a ten-story office tower with an eight-story factory building "nearly as large as the store" behind; the Chestnut Street facade was granite with terra-cotta and copper elements.[144] As in the previous location, the first-floor interior was lavishly appointed in Gilded Age style and was described as "a triumph." Each department had a different decor; the rooms for selling diamonds were finished in ebony and large mirrors. Technological features included a pneumatic tube system as well as electric lighting throughout the store. The building's upper floors were rental offices occupied in 1904 by lawyers, architects, bankers, brokers, and other professionals.[145]

Reflecting the nativist and isolationist sentiments of many early twentieth-century Americans, Bailey, Banks & Biddle put increasing emphasis on their insignia and heraldry departments, describing themselves as "jewelers, silversmiths, makers of insignia, heraldic stationers."[146] During the Civil War, they had made many presentation swords and sold other military equipment, and medals and die cutting remained a specialty of Bailey, Banks & Biddle throughout the later nineteenth and early twentieth centuries.[147] In 1903 the U.S. Department of State commissioned Bailey, Banks & Biddle to supply new dies for the Great Seal of the United States, replacing the third set of dies made in 1885 by Tiffany & Co. (q.v.). The new dies were cut by engraver Max Zeitler and first used on June 27, 1904.[148] The following year Bailey, Banks & Biddle received the contract from the U.S. Army to manufacture the Medal of Honor as redesigned by Brigadier General George Lewis Gillespie Jr.[149] In 1917 the firm published *American Orders and Societies and Their Decorations*, written by Jennings Hood, manager of the insignia department, and Charles J. Young, who headed the heraldry department. The company would go on to make the Distinguished Flying Cross in 1926 and the Silver Star, Bronze Star, and Purple Heart Medal in 1932.[150]

On September 11, 1917, Joseph Bailey Jr. married Isabelle (Bradley) Wildermuth (1877–1927) as his second wife; originally from Titusville, Pennsylvania, she was on the faculty of the Pennsylvania School of Industrial Art.[151] Their marriage was short-lived, as Bailey died of pneumonia at age eighty-three on February 2, 1918.[152] Presidency of the company passed to his son Charles Weaver Bailey, the last family member to serve in that office. He died of a heart attack four years later, on December 9, 1922. [153] He left his majority interest in the company in trust for his only surviving child, Emilie (Bailey) Knowles (born 1887), naming three trustees to oversee the business "as long as it remains profitable."[154] His deceased daughter, Beatrice (1892–1921), like her aunt Kathryn, had married into European aristocracy and become the Baroness Bernhard von Wullerstorff-Urbair of Austria.[155] After Charles Bailey's death, David Hilsee, who had been serving as the firm's vice president and treasurer, was elected president, Andrew Alexander Jr. was elected vice president and treasurer, and Jennings Hood of the insignia department was elected secretary; it was reported that these three "have grown up with the firm and in their years of service with Bailey, Banks & Biddle absorbed the ideas of the early owners of the business."[156]

Bailey, Banks & Biddle continued as Philadelphia's premier luxury-goods purveyor into the third quarter of the twentieth century, but like other merchants of expensive, traditional goods, they faced an increasing number of changes and challenges as the years progressed, including less formal lifestyles, fewer servants, the rising cost of skilled labor, and shortages of metals during both world wars. In 1953, when their lease on 1218–1222 Chestnut Street expired, Bailey, Banks & Biddle moved their flagship retail store to 1530 Chestnut, a limestone and granite office buildiing erected about 1902 for Perry & Company.[157] They were at this address in 1961 when the company was bought out by the Zales Corporation of Dallas.[158] Beginning in 1962, Zales opened a chain of retail stores under the storied name.[159] Zales made the Liberty Medal in 1988 and the gold calling cards for the *Mercury* astronauts using the Bailey, Banks & Biddle trademark. In 2005 over a hundred Bailey, Banks & Biddle retail stores operated across the United States, but two years later the Zales Corporation sold the company for $200 million to Finlay Enterprises of New York, which operated Bailey, Banks & Biddle stores until Finlay went into bankruptcy in 2009, when the remaining sixty-seven stores were liquidated.[160] The trade name of Bailey, Banks & Biddle was acquired by Gordon Brothers Retail Partners with the remainder of Finlay's assets in 2010, and in 2017 six retail stores were in operation under the Bailey, Banks & Biddle name in Pennsylvania and Texas.[161]

For over a century the firm that was founded as Bailey & Kitchen supplied silver, silverplate, jewelry, and other goods. During the years that their factories were operated by Taylor & Lawrie and George B. Sharp, the firm produced some of the most exceptional silver objects made in antebellum Philadelphia. Although the company apparently decided after the Civil War not to

manufacture silver on any great scale, if at all, it continued as the purveyor of objects made by America's leading silver manufacturers. The survival of the Bailey, Banks & Biddle name for a greatly diminished retail jewelry enterprise demonstrates the lasting reputation that the firm achieved in its heyday. BBG/DLB

1. The authors gratefully acknowledge D. Albert Soeffing for his article "Some Bailey & Co. Marks and Their Significance," *Silver Magazine*, vol. 27, no. 6 (November–December 1995), pp. 12–15; Rainwater and Redfield 1998, pp. 33–34; Historical Note, Bailey, Banks & Biddle records (2453), Hagley Museum and Library, Wilmington, DE; Bailey & Co., *History of Silver: Ancient and Modern* (Philadelphia: Bailey & Co. and Rowley & Chew, 1871).

2. On counterfeiting, see "Counterfeit Detector," *North American* (Philadelphia), March 10, 1840. The Baileys senior and junior were bank officers during their careers. The 1840 article included examples of bills confiscated at banks: "Bank of Delaware, Wilmington. 2's [bills] . . . Jos. Bailey, President; payable to J. T. Bailey; engraving bad"; and "3's dated Sept. 9th, 1837, well executed; others of various dates, Wm. Paxon, cashier; Joseph Bailey, President."

3. Trade card of Bailey & Co., Silver Salon Forums, posted January 7, 2012, www.smpub.com/ubb/Forum12/HTML/000312.html (accessed December 20, 2014); Silversmiths and Related Craftsmen, s.v. "Joseph Trowbridge Bailey," Ancestry.com. Peter Hayes used a small die stamp with his name mark, a circle enclosing a star. Perhaps Joseph Bailey recalled it as the same star motif that often accompanied the Bailey mark. See the spoons and tongs by Bailey & Co. (cats. 41, 43). Hayes married Betty Benedict (1793–1851) July 1, 1813, in Danbury; Joseph T. Bailey's mother, Lucy Benedict Bailey (1786–1872), was Betty's sister. All the family names come together in the genealogy of Benjamin Bailey (died 1807) of Danbury; Joseph Trowbridge, born in Danbury May 19, 1780, died in New York City in 1808. He married Hannah Benedict (born 1781, Danbury) on May 19, 1800, in Danbury. She was the daughter of Joshua (1753–1825) and Ruth Westcott Benedict (died 1838). Trowbridge Benedict (1784–1869) was a watchmaker working for Benedict & Scudder (1828–36) in New York. Francis Bacon Trowbridge, *Trowbridge Genealogy* (New Haven, CT: privately printed, 1908), p. 169; freepages.genealogy.rootsweb.ancestry.com; William R. Cutter, ed., *New England Families: Genealogical and Memorial* (New York: Lewis Historical Publishing Company, 1914), vol. 4, p. 1926; Silversmith Directory, s.v. "Trowbridge Benedict," SterlingFlatwareFashions.com.

4. After finishing his apprenticeship, Caldwell went to work for Samuel Ward Benedict, watchmaker, in New York; Rainwater and Redfield 1998, pp. 33–34.

5. In 1830 a Samuel W. Bailey was listed in the Philadelphia directory as a watchmaker at 80 High Street. Joseph's great-great-grandfather was named Samuel (born 1728).

6. Murphy family tree, s.v. "Andrew B. Kitchen," Ancestry.com (accessed December 22, 2014); Philadelphia directory 1810, p. 160.

7. Benjamin Kitchen was baptized September 8, 1810, at the First Universalist Church; Register, Universalist Church (Philadelphia), Commencing 1801, Historic Pennsylvania Church and Town Records, HSP, Ancestry.com.

8. "His friends are requested to attend his funeral from his late residence, No. 6 Market Street at 3 o'clock"; *Poulson's American Daily Advertiser* (Philadelphia), March 9, 1812.

9. Will of Andrew Boyd, Philadelphia Will Book, no. 4, p. 105; Obituary of Andrew Boyd Kitchen (1809–1850), *Poulson's American Daily Advertiser*, March 9, 1812.

10. Philadelphia directory 1809, n.p.; 1813, n.p. From 1809 to 1813 John Hall, clock and watchmaker, was located at the southeast corner of Front and Chestnut streets, barely a block from Boyd's location at 6 Market Street.

11. The household reported as consisting of one male under ten, one female between sixteen and twenty-five, and one female forty-five and over.

12. Philadelphia directory 1822, n.p. Union Street ran between Spruce and Pine streets from 165 South Front Street to 79 South Fourth.

13. Joseph T. Bailey, in a deed to Andrew B. Kitchen dated June 9, 1843, noted "Andrew B. Kitchen N.L. jeweler"; Philadelphia Deed Book RLL-5-315.

14. D. Albert Soeffing, "Taylor & Lawrie, Philadelphia Silversmiths," *Silver Magazine*, vol. 21, no. 5 (September–October 1988), pp. 18–19.

15. Ibid.; Diana Kramer, "Bailey & the Mysterious Philadelphia Marks," *Silver Magazine*, vol. 21, no. 4 (July–August 1988), pp. 12–15; Venable 1994, p. 315.

16. Although Taylor or Lawrie (q.v.) manufactured flatware after 1852, they seem to have made more hollowware than flatware for retail sale by Bailey & Kitchen or Bailey & Co.

17. Soeffing 1995, pp. 13, 14.

18. Jackson, in an address to Congress, quoted in Robert V. Remini, *Andrew Jackson and the Course of American Democracy, 1833–1845* (New York: Harper & Row, 1984), p. 52.

19. H.R. doc. no. 206, 23rd Cong., 1st sess. (1834).

20. *Public Ledger and Daily Transcript* (Philadelphia), November 16, 1838.

21. Shortly after they had opened, they placed two advertisements in the *Philadelphia Inquirer*, December 7, 1832. Curiously, one was signed "BAILY KITCHEN'S," the other as "Manufacturers of Silverware / BAILEY & KITCHEN."

22. Bailey 1892, pp. 5–6. Mary Potter was the daughter of Sheldon Potter (1789–1834) and Sarah Betsy Raymond (1792–1872). See Cutter, *New England Families*, vol. 4, p. 1926. Emily (Bailey) Harrison Duggin was buried at Laurel Hill Cemetery, Philadelphia, on May 6, 1936; Pennsylvania and New Jersey Church and Town Records, Ancestry.com.

23. Philadelphia directory 1839, p. 10; 1842, p. 10.

24. Bailey 1892, p. 49; marriage announcement, *New-York Evening Post*, August 30, 1843; genealogical information from the PEB 2014-02-08 family tree, Ancestry.com (accessed April 24, 2017).

25. Murphy family tree, s.v. "Andrew B. Kitchen," Ancestry.com (accessed December 22, 2014).

26. Ibid.

27. Kitchen's various addresses suggest that he belonged to the large Kitchen family who lived in the Northern Liberties. Perhaps all the moving about caused the Philadelphia directories of 1835 and 1836 to list Bailey & Kitchen alphabetically under "K."

28. Cemetery plot, "6 west, 21 South, containing in breadth East and West 8 feet and in length the North end, South 2 feet"; Philadelphia Deed Book AM-71-325, and AM-71-326. Ronaldson appears in grantor lists with other grantees, suggesting that he was the business manager of the cemetery. In 1843 Joseph Bailey deeded this cemetery plot to Andrew Kitchen; Philadelphia Deed Book RLL-5-318.

29. More than twenty deeds are recorded from 1830 through 1857, including deeds made out to Eli Westcott Bailey.

30. Deed of Sale from Joseph and Margaret Coleman Hemphill to Joseph T. Bailey and Andrew B. Kitchen, filed May 3, 1836, Philadelphia Deed Book SHF-2-328.

31. Advertisement, *Philadelphia Inquirer*, November 8, 1860.

32. *Godey's Magazine and Lady's Book*, vol. 39 (December 1849), p. 469.

33. Philadelphia directory 1835–36, pp. 87, 142, 154.

34. Philadelphia Deed Book AM-62-462 and AM-62-463. In 1837 Federal Street ran from South Front Street to the Schuylkill River, between Prime and Wharton streets.

35. Today Schuylkill Sixth Street would be well above Broad Street at Eighteenth.

36. Philadelphia Deed Books AM-62-202; RLL-5-316; and RLL-5-315.

37. Philadelphia Deed Books RLL-13-524 and RLL-49-33-35.

38. Philadelphia Deed Book RLL-23-463.

39. Bailey & Co.'s first listing in the Philadelphia directory as "Bailey & Co." appeared in 1848 (p. 12). Bailey & Kitchen, invoice to J. J. Skerrett, January 1848, Loudoun Papers, HSP. The lithograph "Chestnut Street, East of Fifth" of c. 1856 from Collins & Autenrieth's *Panorama of Philadelphia* shows an image similar to the 1851 Rae drawing but updated in certain details. In this image the "BAILEY & KITCHEN" sign is still in place, but the sign board above the front door reads "Bailey & Compy." Library Company of Philadelphia, P.2007.21.18.

40. "Death of Eli Westcott Bailey," *Jeweler's Circular*, vol. 38 (April 5, 1899), p. 18.

41. Ibid. In this source Henry Young was identified as a jeweler, but he was consistently listed as a hardware merchant in city directories.

42. Longworth's New York City directory 1836, pp. 70, 222, 274–75. Draper's profession is not identified in New York directories.

43. 1840 U.S. Census.

44. Philadelphia directory 1842, p. 10 (as E. J. Westcott Bailey). In 1842 Marshall Street ran north from Vine west of North Sixth and west from South Fourth above Wharton.

45. Philadelphia directory 1845, p. 13 (as E. Wescott Bailey); 1848, p. 13 (as E. Wescott).

46. Deed of sale from William Boyer to Eli Westcott Bailey, March 14 and 19, 1854, Philadelphia Deed Book TH-15-38,40.

47. *Philadelphia Inquirer*, September 27, 1849.

48. Philadelphia Death Certificates Index, 1803–1915, Ancestry.com.

49. There was some controversy surrounding the guardian, resulting in a decision handed down by the Orphans Court that "the very duties imposed upon the trustees appointed by the orphan's court could not be performed by guardians"; Andrew B. Kitchen Estate, in Henry Edward Wallace, "Estate of Andrew B. Kitchen from The Legal Intelligencer, 1857, vol. 14, p. 196," in *Philadelphia Reports: Containing the Decisions Published in the Legal Intelligencer* (Philadelphia: J. B. Wallace, 1871), vol. 2, p. 292.

50. Andrew B. Kitchen, no. 128, September 1, 1848, Probate Records, Philadelphia City Archives.

51. Maria Matilda Kitchen, 1814–July 1, 1891, Philadelphia, buried Laurel Hill Cemetery; memorial no. 96405007, www.findagrave.com (accessed July 7, 2015); William F. Kitchen, Philadelphia Death Certificates Index, 1803–1915, Ancestry.com. William moved in 1860 to Roxborough and died the next year; Charles resided at 1223 Chestnut Street in 1862 and 1863; Philadelphia directory 1860, p. 335; *National Gazette* (Philadelphia), December 31, 1839.

52. 1850 U.S. Census. Edwin was the youngest son of Joseph senior, as noted in the codicil to his will in 1853; Philadelphia Will Book 31, no. 84, p. 356. Thomas Fletcher (q.v.) was the assistant marshal who took the census on August 23. Joseph's residential address in 1850 was "opposite the Mint"; Philadelphia directory 1850, p. 15.

53. "Edward Brown's Select School for Boys," advertisement, *North American*, August 30, 1847. "J. T. Bailey Dies, Pneumonia Victim," *Philadelphia Inquirer*, February 4, 1918.

54. Bailey 1892, pp. 6–7.

55. This partnership was renewed at periodic intervals, with additional copartners; see *Philadelphia Inquirer*, April 1, 1865.

56. Philadelphia directory 1851, p. 14 (as E. Wescott).

57. This was adjoining, or one building from, his own on Chestnut Street; *Public Ledger* (Philadelphia), September 9, 1852.

58. Laurel Hill Cemetery Records, Genealogical Society of Pennsylvania, Philadelphia, Ancestry.com.

59. Deaths, *Philadelphia Inquirer*, March 21, 1854.

60. Bailey 1892, p. 11.

61. "The Death of Mr. Joseph T. Bailey," *Philadelphia Inquirer*, March 21, 1854.

62. Obituary of Joseph Bailey Sr., *North American and United States Gazette* (Philadelphia), March 21, 1854.

63. Philadelphia Will Book 31, no. 84, p. 356.

64. 1852 Philadelphia directory, p. 435; 1853, pp. 408, 454; advertisement, *Public Ledger*, July 22, 1853; Soeffing, "Taylor & Lawrie, Philadelphia Silversmiths," pp. 18–19.

65. Soeffing, "Taylor & Lawrie, Philadelphia Silversmiths," p. 18.

66. Philadelphia directory 1852, p. 395; 1853, p. 370.

67. "Bailey & Co.'s Contribution to the Palace," *Gleason's Pictorial Drawing-Room Companion*, vol. 5, no. 15 (October 8, 1853), p. 232. Benjamin Silliman Jr. and C. R. Goodrich, eds., *The World of Science, Art, and Industry Illustrated from Examples in the New-York Exhibition,*

1853–54 (New York: G. P. Putnam, 1854), pp. 61, 65. A tea and coffee service that may be the one exhibited in 1853 is in the collection of the National Museum of American History, Smithsonian Institution (Philadelphia 1976, cat. 291).

68. Edwin T. Freedley, *Philadelphia and Its Manufactures: A Hand-Book Exhibiting the Development, Variety, and Statistics of the Manufacturing Industry of Philadelphia in 1857* (Philadelphia: Edward Young, 1859), p. 349.

69. Soeffing 1995, pp. 12–15.

70. Bailey & Co., invoice to Edward Ingersoll, March 5, 1859, Edward Ingersoll Records, box 3, HSP.

71. Soeffing 1995 (p. 14) notes the elephant mark as a "complete puzzlement."

72. Freedley, *Philadelphia and Its Manufacturers*, p. 348.

73. *An Historical Account of the Ancient Greek City of Paestum* (Philadelphia: Bailey & Co., 1864), inside front cover.

74. Philadelphia directory 1860, p. 30; advertisement, *North American and United States Gazette*, March 16, 1868.

75. "The Security Company," *North American and United States Gazette*, July 30, 1874.

76. Advertisement, ibid., March 16, 1868; advertisement, *Public Ledger*, October 13, 1870.

77. *Public Ledger and Daily Transcript*, August 18, 1845.

78. *Pennsylvania Inquirer and Morning Journal* (Philadelphia), October 24, 1833.

79. Joseph Whitworth and George Wallis, *The Industry of the United States in Machinery, Manufactures, and Useful and Ornamental Arts* (London: George Routledge & Co., 1854), p. 136.

80. Illustrated in Soeffing 1995, p. 13, figs. 4–5.

81. Advertisement, *Philadelphia Inquirer*, December 19, 1879.

82. "The Diamond Trade—A Philadelphia House that Enjoys a Reputation in That Line," *Philadelphia Inquirer*, October 2, 1879.

83. *An Historical Account of the Ancient Greek City of Paestum*, p. 1.

84. Advertisement, *Philadelphia North American and United States Gazette*, October 26, 1865.

85. Notice, *The Age* (Philadelphia), March 26, 1867; advertisement, *Philadelphia Inquirer*, November 27, 1867.

86. "Death of Eli Westcott Bailey" (1899), p. 18.

87. *North American and United States Gazette*, May 20, 1873; *North American*, April 3, 1877. For Westcott Bailey, see Bailey 1892, p. 49; "Death of Eli Westcott Bailey" (1899), p. 18; obituary of Eli Westcott Bailey, *Philadelphia Inquirer*, August 27, 1917.

88. Advertisement, *Philadelphia Inquirer*, October 22, 1868. This building is still standing with all but the first floor of the facade intact.

89. "S. S. White's New Building," *Philadelphia Inquirer*, October 20, 1868; "Gas Causes an Explosion," ibid., November 26, 1892.

90. "Bailey's New Jewelry Palace," ibid., October 20, 1868.

91. "Our Dead Heroes," ibid., September 2, 1872.

92. "Two Pictures of Remarkable Merit," ibid., May 15, 1873; "Mr. Knight's Last Picture," ibid., December 9, 1873; "Pleasant Pictures," ibid., March 2, 1878.

93. "Philadelphia and Suburbs," ibid., December 2, 1873; "Philadelphia Pickings," *The Patriot* (Harrisburg), June 12, 1880.

94. Advertisement, *Philadelphia Inquirer*, December 4, 1873.

95. Advertisements, ibid., December 1, 1868; December 17, 1870.

96. Advertisement, ibid., December 9, 1865.

97. "Bailey's New Jewelry Palace," ibid., October 20, 1868.

98. Soeffing 1995, p. 14.

99. Rainwater and Redfield 1998, p. 33; Soeffing 1995, pp. 13, 14. For the "Union Vase," see Charles J. Stillé, *Memorial of the Great Central Fair for the U.S. Sanitary Commission* (Philadelphia: the Commission, 1864), pp. 119–20. The vase is documented in an album of production photographs taken at the Gorham Factory ("Photographs of Silver Ware Mfg. by the Gorham Mfg. Co.," 1872, Gorham Manufacturing Company Archives, John Hay Library, Brown University, Providence, RI); the identical photograph was illustrated in Stillé's publication, facing p. 119.

100. Advertisements, *Philadelphia Inquirer*, October 29, 1868; *North American and United States Gazette*, October 29, 1868.

101. Diana Cramer, "Rare & Interesting," *Silver Magazine*, vol. 19, no. 6 (November–December 1985), p. 39.

102. Advertisement, *Philadelphia Inquirer*, September 22, 1873.

103. "Bailey, Banks & Biddle Co.'s Display of Silverware," *Jewelers' Circular*, vol. 30 (March 27, 1895), p. 16.

104. Advertisement, *Philadelphia Inquirer*, November 16, 1896.

105. Advertisement, ibid., December 16, 1894.

106. "City Affairs: A Museum of Wonders," *North American and United States Gazette*, December 16, 1868.

107. Quoted in V. Stephen Vaughan, "James Watts, Silversmith of Philadelphia," *Silver Magazine*, vol. 21, no. 3 (May–June 1988), p. 10.

108. Walter Smith, *The Masterpieces of the Centennial International Exhibition Illustrated*, vol. 2, *The Industrial Art of the International Exhibition* (Philadelphia: Gebbie & Barrie, 1876), pp. 85–86.

109. *Pennsylvania Historical Review: Gazetteer, Post-office, Express, and Telegraph Guide; City of Philadelphia; Leading Merchants and Manufacturers* (New York: Historical Publishing Company, 1886), p. 80.

110. "Bailey, Banks & Biddle Co.'s Display of Silverware," p. 16. The reference to Bailey, Banks & Biddle's "chrysanthemum" silver is unclear; no flatware or hollowware pattern by that name has been credited to the firm.

111. Advertisement, *Philadelphia Inquirer*, October 22, 1906; see also "Silver Service for Battleship," *Times-Dispatch* (Richmond, VA), October 26, 1906; "Philadelphia," *Jewelers' Circular*, vol. 53 (October 31, 1906), p. 69.

112. "Ready for the Big Park Race," *Philadelphia Record*, October 4, 1908; see also Michael J. Seneca, *The Fairmount Park Motor Races, 1908–1911* (Jefferson, NC: McFarland & Company, 2003), pp. 28–29.

113. Clayton French's life dates were recorded in his funeral record; W. W. Bringhurst & Co., Record Cards, HSP.

114. "Clayton French Dead," *Philadelphia Inquirer*, July 27, 1890; "A Millionaire's Will: How the Late Clayton French Disposes of His Vast Estate," ibid., July 31, 1890.

115. *Pennsylvania Historical Review*, p. 80.

116. *The Patriot* (Harrisburg), November 13, 1878.

117. "A New Factory," *Philadelphia Inquirer*, June 14, 1886.

118. George E. Thomas, Michael J. Lewis, and Jeffrey A. Cohen, *Frank Furness: The Complete Works* (New York: Princeton Architectural Press, 1991), cat. 325; legal notice, *Philadelphia Inquirer*, December 15, 1886.

119. "A New Factory," *Philadelphia Inquirer*, June 14, 1886.

120. "Death of Eli Westcott Bailey" (1899).

121. Legal notice, *Philadelphia Inquirer*, February 9, 1894; "Philadelphia," *Jewelers' Circular*, vol. 28 (April 11, 1894), p. 15. For Clement Weaver, see PEB 2014-02-08 family tree, Ancestry.com; "Clement Weaver Falls Dead as Golf Game Ends," *Philadelphia Inquirer*, June 15, 1913.

122. "Major C. W. Bailey, Jeweler, Is Dead," *Philadelphia Inquirer*, December 11, 1922; Philadelphia directory 1882, pp. 124, 905; 1885, pp. 129, 1027; death notice of Edward S. Lawyer, *Philadelphia Inquirer*, April 12, 1895.

123. Philadelphia directory 1886, pp. 127, 995; 1890, p. 130.

124. "Major C. W. Bailey, Jeweler, Is Dead" (1922).

125. "Philadelphia," *Jewelers' Circular*, vol. 30 (May 1, 1895), p. 13.

126. "An American Comtesse," *Philadelphia Inquirer*, December 17, 1890.

127. "Atlantic City's Day Broke All Records," ibid., August 9, 1897.

128. Advertisement, *Philadelphia Inquirer*, December 16, 1894.

129. "Employees to Hold Dinner," ibid., November 5, 1915; "Honor Heads of Concern: Bailey, Banks & Biddle Employes [sic] Attend Banquet," ibid., November 28, 1916.

130. Advertisements, ibid., December 16, 1894; December 9, 1896.

131. "Gashed His Throat with a Razor," ibid., June 6, 1897; H. M. M. Richards, "In Memoriam: Eugene Zieber," *The Pennsylvania-German Society: Proceedings and Addresses at Philadelphia, October 25, 1896*, vol. 7 (1897), pp. 424–25.

132. "Borne to the Grave," *Philadelphia Inquirer*, August 14, 1898.

133. *Eleventh Annual Report of the Factory Inspector of the Commonwealth of Pennsylvania for the Year 1900* (Harrisburg, 1901), pp. 242–43.

134. Advertisement, *Philadelphia Inquirer*, November 19, 1881.

135. Help-wanted notice, ibid., January 14, 1912.

136. Help-wanted notices, ibid., March 1 and October 10, 1918.

137. "Big Jewelry Company to Build New Factory," ibid., May 22, 1919.

138. "Works of Art," ibid., December 14, 1885.

139. Advertisement, ibid., October 11, 1883.

140. Advertisement, ibid., March 24, 1885; *Catalogue of Paintings by Mr. Herman [sic] Herzog* (Philadelphia: Bailey, Banks & Biddle, 1885). One of the vases is now in the collection of the Museum (2012-83-1).

141. Advertisement, *Philadelphia Inquirer*, October 3, 1885.

142. "Bailey, Banks & Biddle's New Store," ibid., November 7, 1891.

143. "Grappled with Negro Robber in Dark Room," ibid., March 5, 1905.

144. "New Chestnut St. Office," ibid., February 28, 1903; "Philadelphia," *Jewelers' Circular*, vol. 46 (March 4, 1903), p. 39. The Bailey Building is still extant, although the street level of the facade has been altered.

145. Advertisement, *Philadelphia Inquirer*, September 22, 1904.

146. Jennings Hood and Charles J. Young, comps., *American Orders and Societies and Their Decorations* (Philadelphia: Bailey, Banks & Biddle, 1917), title page.

147. Advertisement, *Philadelphia Inquirer*, January 13, 1862.

148. Gaillard Hunt, *The History of the Seal of the United States* (Washington, DC: U.S. Department of State, 1909), pp. 63–64.

149. *The Medal of Honor of the United States Army* (Washington, DC: Department of the Army, 1948), p. 8; *Above and Beyond: A History of the Medal of Honor from the Civil War to Vietnam* (Boston: Boston Publishing Company, 1985), pp. 124–25.

150. National Clock Repair, www.nationalclockrepair.com/Bailey_Banks_Biddle_Clock_History.php (accessed April 24, 2017).

151. Marriage notice, *Philadelphia Inquirer*, September 12, 1917; "School Notes," *Bulletin of the Pennsylvania Museum*, vol. 16, no. 63 (October 1918), p. 59. Life dates for Isabelle Bailey are taken from MyHeritage.com (accessed April 24, 2017); and Martin family tree, Ancestry.com (accessed April 25, 2017).

152. "J. T. Bailey Dies, Pneumonia Victim," *Philadelphia Inquirer*, February 4, 1918.

153. "Major C. W. Bailey, Jeweler, Is Dead" (1922); "Death of Major C. W. Bailey," *Jewelers' Circular*, vol. 85 (December 13, 1922), p. 75.

154. "Bailey Estate Goes to Only Daughter," *Philadelphia Inquirer*, December 16, 1922; "Philadelphia," *Jewelers' Circular*, vol. 85 (December 27, 1922), p. 65. His daughters' life dates are from Bailey 1892, p. 7.

155. "Phila. Baroness Dies," *Philadelphia Inquirer*, September 30, 1921.

156. "Philadelphia," *Jewelers' Circular*, vol. 85 (December 27, 1922), p. 65.

157. Rainwater and Redfield 1998, pp. 33–34; Venable 1994, p. 315; "Zales to Close Up to 35 Bailey Banks & Biddle Stores; Local Impact Unclear," *St. Louis (MO) Business Journal*, August 31, 2005; "Dealbook: Zale to Sell Bailey Banks & Biddle," *New York Times*, September 27, 2007; Barton Eckert, "Bailey, Banks & Biddle to Liquidate," *Washington (DC) Business Journal*, September 25, 2009.

158. "Baileys to Move to 16th, Chestnut," *Philadelphia Inquirer*, October 25, 1951; advertisement, ibid., September 22, 1953.

159. "Bailey, Banks & Biddle Studies Purchase Bid," ibid., September 15, 1961.

160. "Bailey Banks & Biddle Expanding," ibid., October 14, 1962; advertisement, ibid., March 31, 1967.

161. BaileyBanksandBiddle.com (accessed April 24, 2017).

Cat. 28

Bailey & Kitchen
Pitcher

c. 1846
Mark: BAILEY & KITCHEN (incuse, on underside; cat. 28-1)
Inscription: Mrs. Eliza Y. McAllister / as a testimonial of esteem / from / W.Y. McAllister, / W.B. Dick, / Jas W. Queen, / Dec. 25, 1847 (engraved script in cartouche, on front)
Height 13 5/16 inches (33.8 cm), width 9 inches (22.9 cm), depth 6 15/16 inches (17.6 cm)
Weight 40 oz. 13 dwt.
Gift of the McAllister Family, 2007-64-2

PROVENANCE: This pitcher was a Christmas gift in 1847 to Eliza Melville Young McAllister (1790–1853), wife of the Philadelphia eyeglass and instrument maker John McAllister Jr. (q.v.), who also received a second pitcher marked by Taylor & Lawrie (fig. 36). The gifts were presented by the three partners in the McAllister firm: their eldest son, William Young McAllister (1812–1896), Walter B. Dick (1803–1869), and James W. Queen (1815–1890).[1] The two pitchers descended from William Y. McAllister to his great-grandson, John McAllister Jr. (1918–1992), the donors' father.[2]

BAILEY & KITCHEN

Cat. 28-1

Presented together in a fitted walnut box, the two pitchers given to John and Eliza McAllister offer insights into the choice of different designs for a husband and wife in the middle of the nineteenth century. John McAllister's pitcher (fig. 36) is a pyriform shape raised on a foot, with vertical ribs that contain the relatively restrained chased decoration.

Fig. 36. Made by Taylor & Lawrie, Philadelphia, retailed by Bailey & Kitchen, Philadelphia, c. 1846. Pitcher. Silver, height 14 15/16 inches (36.4 cm), width 9 7/16 inches (24 cm), diam. 7 5/8 inches (19.4 cm). Philadelphia Museum of Art. Gift of the McAllister Family, 2007-64-1.

In contrast, Eliza McAllister's pitcher (cat. 28) is an inverted pyriform shape on a flat base, decorated with asymmetrical flat- and repoussé-chased rococo ornament. The contrast between its shorter, more irregular design and the taller, more disciplined design of its companion could be interpreted as a reference to the genders of their intended owners. Pitchers of this design apparently were a stock item sold by Bailey & Kitchen, as a number of nearly identical examples have survived.[3] Together with its companion, marked by Taylor & Lawrie, this pitcher was made and marked prior to Bailey & Kitchen's dissolution in 1846 and presumably remained in Bailey & Co.'s inventory until it was selected for presentation in December 1847. DLB

1. Dick's life dates are recorded in the Philadelphia Death Certificates Index, 1803–1915, Ancestry.com; Queen's life dates are recorded in his obituary, *The Druggists Circular and Chemical Gazette*, vol. 34 (September 1890), p. 215. The partners in the McAllister firm are recorded in "McAllister Family Business Timeline," John A. McAllister Collection, Library Company of Philadelphia, www.librarycompany.org (accessed July 16, 2014).
2. Genealogical information on the McAllister family was found in the McCarthy/Flynn family tree, Ancestry.com (accessed July 16, 2014). Francis Wardale McAllister (1856–1945?), to his son Dr. John Wardale McAllister (1882–1963?), to his nephew.
3. Another example marked by Bailey & Kitchen was sold at auction in 1984; Sotheby's, New York, *Important American Furniture, Decorations, Silver and Chinese Export Porcelain*, January 26 and 28, 1984, sale no. 5142, lot 315. An unmarked example is in the collection of the Baltimore Museum of Art (1975.49.1).

Cat. 30
Bailey & Co.
Dessert Spoons

1846–60

MARK (on each): BAILEY & CO. (in rectangle, on reverse; cat. 29–1)

INSCRIPTION (on each): Ann Brown (engraved script, lengthwise, on obverse of handle)

Length 7⅛ inches (18.1 cm)

1996-81-48: Weight 1 oz. 4 dwt. 12 gr.

1996-81-49: Weight 1 oz. 2 dwt. 15 gr.

Gift of Patricia A. Steffan in memory of Mr. and Mrs. Thomas Hollingsworth Andrews III, 1996-81-48, -49

PROVENANCE: These spoons descended in the family of the donor.[1]

Similar handles with the *Tipped* pattern were made by some silversmiths as late as the 1870s. A full-name inscription was unusual; "Ann Brown" is unidentified. BBG

1. For other silver owned by this family and in the collection of the Museum, see: Conrad Bard, dinner forks (cat. 62); John Fries, tablespoon and teaspoons (cat. 264); Thomas J. Megear, dessert spoon (1996-81-17); Joseph Shoemaker, ladle (1996-81-4); John Tanguy, miniature flatware including serving spoon, teaspoons, tablespoons, and tongs (1996-81-18–34); Robert and William Wilson, serving spoons, teaspoons, tablespoons, and tongs (1996-81-50–64); and Thomas Wriggins, pap dish (1996-81-3).

Cat. 29
Bailey & Co.
Cup and Saucer

1846–60

MARKS (on each): BAILEY & CO. (in rectangle) / PHILAD. (in rectangle, on underside; cat. 29-1)

INSCRIPTIONS: L A (engraved gothic letters, on saucer near rim and on front of cup near rim); cup: K.C./–/–/0-1-/Cup $9–tiko (scratched on cup, on underside); saucer: S–C./–/–/o [reversed "c"] u–B/Saucer $UI (scratched on saucer, on underside)

Cup: Height 3⁵⁄₁₆ inches (8.4 cm), width 5 inches (12.7 cm), diam. 3¹³⁄₁₆ inches (9.7 cm)

Weight 5 oz. 2 dwt.

Saucer: Height 1⁵⁄₁₆ inches (3.3 cm), diam. 6¾ inches (17.2 cm)

Weight 6 oz. 2 dwt.

Gift of Beverly A. Wilson, 2010-206-2a,b

Impractical for tea or other hot beverages, silver cups and saucers probably served as decorative objects or commemorated special occasions. A contemporaneous cup and saucer by John C. Moore for Tiffany, Young & Ellis were given as a christening gift to a child born in 1852.[1] The pristine condition of the chased decoration on the Museum's cup and saucer indicates that they probably saw little use. The imagery of a rustic village with thatched-roof houses and a Gothic-style church, framed by flowers and rococo scrolls, was derived from transfer-printed ceramics made from 1810 until 1830 by Staffordshire potteries.[2]

Cat. 29-1

The relief marks struck on this cup and saucer may be the earliest marks used by the partnership of Bailey & Co.; it seems likely that the "PHILAD." mark was superseded by the incuse mark giving the firm's address on Chestnut Street as well as the city (see cat. 33 and PMA 1998-157-2a,b–3a,b). If this is true, these marks were in use when Taylor & Lawrie were manufacturing silver for the firm, and objects such as this cup and saucer that lack Taylor & Lawrie's marks raise the question of whether Bailey & Co. retailed silver made by others during these years. DLB

1. Hofer and Bach 2011, cat. 4.5.
2. For examples, see A. W. Coysh, *Blue and White Transfer Ware, 1780–1840* (Newton Abbott, UK: David & Charles, 1970), figs. 33, 61, 88, 131.

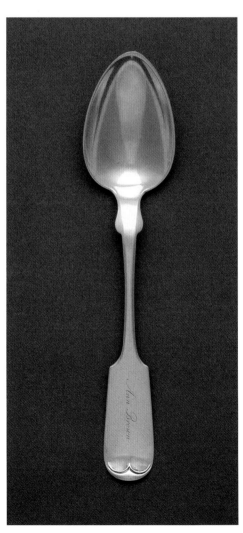

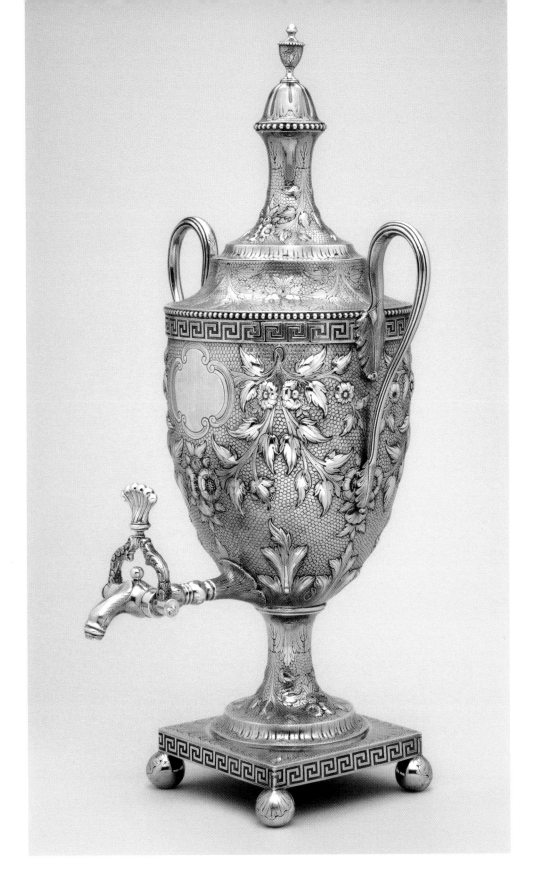

Cat. 31
Bailey & Co.
Hot-Water Urn

1846–60
MARKS: BAILEY & CO. (in rectangle) / PHILAD. (in rectangle) (on underside of urn; cat. 29–1); cover and sleeve for heating element unmarked
Height 20 3/16 inches (51.3 cm), width 10 9/16 inches (26.8 cm), depth 10 1/16 inches (25.6 cm)
Weight 80 oz. 2 dwt. 9 gr.
Gift of Beverly A. Wilson, 2010-206-30a–c

Hot-water urns became popular in the late eighteenth century with the advent of the neoclassical style (see fig. 2), and this urn may have been made to accompany an earlier tea service with urn-shape bodies. A hot-water urn of similar design was included in Bailey & Co.'s display at the 1853 New York Crystal Palace (see fig. 27). DLB

Cat. 32
Bailey & Co.
Skewer

1850–65
MARKS: BAILEY & CO. (in rectangle; cat. 29–1); [lion statant] (facing left in rounded rectangle); S (in horizontal oval); [shield with plain chief and vertical stripes] (in conforming surround); [lion passant guardant] (facing left in rectangle with chamfered corners; all on reverse of blade; cat. 34–1)
Length 9 1/16 inches (23 cm)
Weight 1 oz. 3 dwt. 15 gr.
Alan Dewees Wood Collection, 1969-224-119

Skewers were originally used for serving and eating meat.[1] This is a Colonial Revival–style example of the form, with traditional plain surfaces and a serrated band around the ring handle. The form of the engraved shield on the obverse is similar to others made by Bailey & Co. (see cat. 44). BBG

1. For an earlier example, see cat. 169.

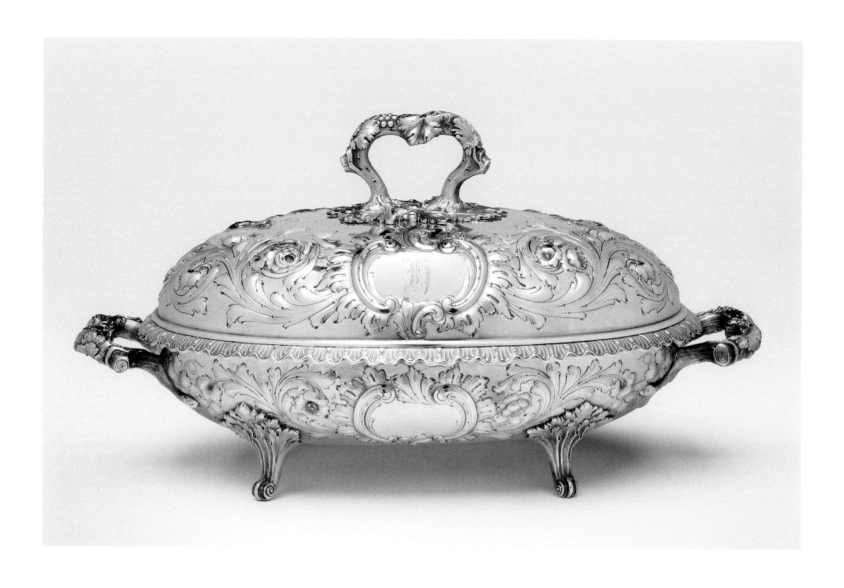

Cat. 33

Bailey & Co.

Tureen

c. 1854

MARKS: BAILEY & Cº (in arc) / 136 / CHESTNUT Sᵗ PHILᴬ (in arc, all incuse); [lion passant guardant] (facing left in rectangle with chamfered corners, twice); [lion statant] (facing left in rounded rectangle); S (in horizontal oval) [shield with plain chief and vertical stripes] (in conforming surround; all on underside of dish; cat. 34-1); cover and handle unmarked

INSCRIPTION: H (engraved gothic letter in reserve, on cover)

Height 8¼ inches (21 cm), width 15½ inches (39.4 cm), depth 8⅞ inches (22.5 cm)

Weight 62 oz. 10 dwt. 12 gr.

Gift of Christina Sidey, 2013-122-1a,b

PROVENANCE: The tureen's original owner, Sophia Brown Swain (1827–1905) of Philadelphia, probably acquired it around 1854, when she married her second husband,

William Jordan Howard II (1826–1898), the first attorney for the Pennsylvania Railroad.[1] It descended to their daughter, Henrietta Nimick Howard (1859–1935), who in 1883 married Charles Delany (1857–1937); and to their daughter, Ada Howard Delany (1886–1993), who around 1990 gave the tureen to her niece, the donor.[2]

The crisp cast and chased ornament on this tureen elevated a relatively simple form into a superb example of the Rococo Revival style. The striking effect of the textured foliage and flowers against the otherwise mirror-bright surface was very different from the denser, allover chasing on Bailey & Co.'s hot-water urn (cat. 31). A smaller but otherwise identical covered dish by Bailey & Co. was presented in 1857 to President Franklin Pierce by members of the Democratic Party in Savannah, Georgia.[3] DLB

1. Genealogical information from the Martin/Fry family tree, Ancestry.com (accessed July 3, 2014); Baptisms, 1814–1829, Tabernacle Methodist Episcopal Church, Philadelphia; Philadelphia Death Certificates Index, 1803–1915, Ancestry.com.
2. Genealogical information from the Lara Guest family tree, Ancestry.com (accessed July 3, 2014).
3. Tania June Sammons. *The Story of Silver in Savannah: Creating and Collecting Silver Since the 18th Century* (Savannah, GA: Telfair, 2010), p. 90.

Cat. 34
Bailey & Co.
Ewer

1856
MARKS: BAILEY & C^o (in arc) / 136 / CHESTNUT S^T PHIL^A
(in arc, all incuse); [lion passant guardant] (facing left in
rectangle with chamfered corners, twice on either side of
raising dot); [lion statant] (facing left in rounded rectan-
gle); S (in horizontal oval); [shield with plain chief and ver-
tical stripes] (in conforming surround; all on underside;
cat. 34-1)
INSCRIPTION: To John W. Forney / From / Personal friends /
who appreciate / his untiring exertions / in the cause of /
the Constitution / Philadelphia. November 4, 1856.
(engraved script in free-form oval, on front under pouring
spout; cat. 34-2)
Height 16⅝ inches (42.2 cm), width 9 inches (22.9 cm),
diam. 6⅜ inches (16.2 cm)
Weight 36 oz. 5 gr.
Gift of Mr. and Mrs. Peter Winokur, 1961-105-1

Cat. 34-1

This presentation ewer is quite grand in profile. The
smooth, elegant shapes of the sections of the vessel
are defined and enhanced by the decorative bands
around the base and the flaring collar at the top of
the base, around the shoulder, and at the top, where
they define the curvaceous shape of the upper edge.
The ewer is distinguished by the subtle and unusual
design on the identical bands, which are composed
of a pattern of graduated scales overlaid with pearl-
like swags. The leafy design of the cast and chased
handle has a rare terminal, a leaf that is a repeat of
the larger leaf at the top of the handle where it joins
the upper edge.

The ewer was presented to John Wien Forney,
who was born in Lancaster, Pennsylvania, Sep-
tember 30, 1817. He apprenticed at the *Lancaster*

Cat. 34-2

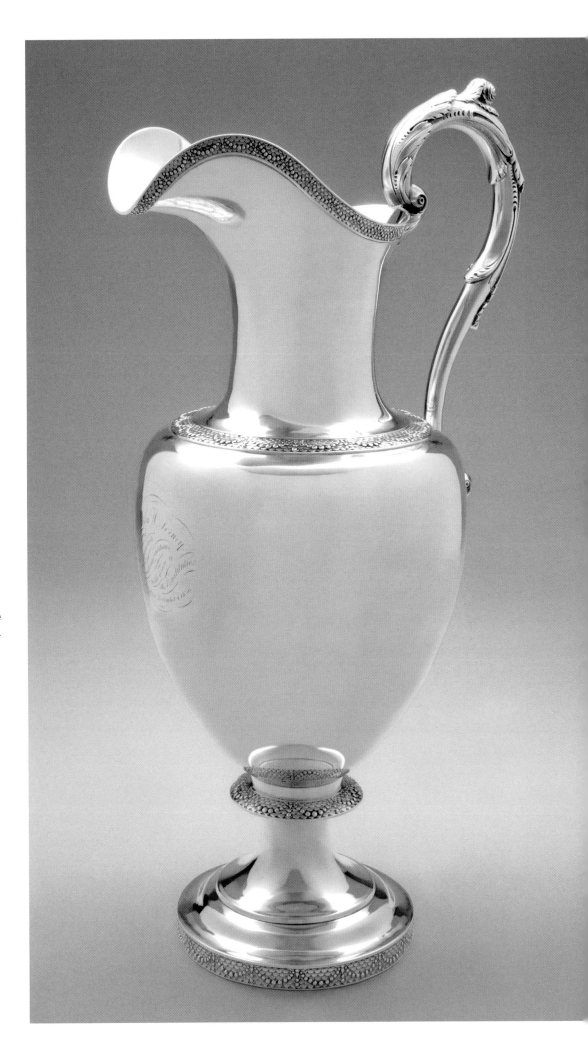

Journal and became the editor before age twenty-one. He moved to Philadelphia in 1845 to become a surveyor of the port and the editor of the *Pennsylvanian*. He was elected to the U.S. House of Representatives, where he served as clerk from 1851 until 1855 and for two months as acting speaker. Forney was described as a Democrat and a leader who was "bold, dashing, and aggressive" in advancing the interests of James Buchanan. As chairman of the Pennsylvania State Central Committee for the campaign of 1856, Forney was credited as being the key figure in Buchanan's election as president of the United States.[1] Forney continued to be a political leader, establishing *The Press* in Philadelphia in 1857, where he decried the Democrats' policies regarding slavery and, after Buchanan wavered on his pledge to keep Kansas a free state, espoused the cause of Stephen A. Douglas in the election of 1860.[2] Forney lived in Washington from 1859 until 1870. From 1861 until 1868 he served as the secretary of the U.S. Senate.

Forney died May 8, 1893, leaving a widow and five children. He was buried in West Laurel Hill Cemetery, where his portrait was carved in relief on the headstone.[3] BBG

1. Scharf and Westcott 1884, vol. 3, pp. 2054–56; *DAB*, s.v. "Forney, John W."; Frank H. Norton, "A Brief History of the Accomplishments of the Honourable John W. Forney," in *Illustrated Historical Register of the Centennial Exposition at Philadelphia* (New York: American News Co., 1879), p. 301.
2. Scharf and Westcott 1884, vol. 3, pp. 2026–27.
3. Memorial no. 36017515, www.findagrave.com (accessed June 28, 2015).

Cat. 35
Bailey & Co.
Serving Spoon

1855–65

MARKS: [lion passant guardant] (facing left in rectangle with chamfered corners, on underside of bowl); [lion statant] (in rounded rectangle); S (in horizontal oval); [shield with plain chief and vertical stripes] (in conforming surround; cat. 34-1), [five-pointed star (incuse); BAILEY & Co (incuse; cat. 35-1; all on underside of handle)
INSCRIPTION: RULON (engraved sideways in banner, on front of handle)
Length 9½ inches (24.2 cm), width 2¹⁵⁄₁₆ (7.5 cm), weight 3 oz. 5 dwt.
Gift of Stewart G. Rosenblum in honor of Linda L. Dennery, 2011-14-2

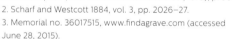

Cat. 35-1

George B. Sharp's (q.v.) role as the manager of Bailey & Co.'s factory is demonstrated by this spoon in the *King's* pattern, with its scalloped bowl formed by the same die as the bowl of another serving spoon (PMA 2011-14-1), marked by Sharp after he left Bailey's employ in 1865 and made for the New York retailer Ball, Black & Co. (q.v.).

Although no provenance for this spoon is recorded, the surname engraved on the handle suggests that the original owner may have been the wealthy Philadelphia China trade merchant John West Rulon (1799–1872) or a member of his extended family. Between 1857 and 1865 his second cousin the watchmaker and jeweler Nathaniel Rulon (1833–1879) had a shop at 802 Chestnut Street, across the street from Bailey & Co.'s showroom.[1] DLB

1. Information on the Rulon family is taken from John C. Rulon, *The Rulon Family and Their Descendants* (Philadelphia: Lineaweaver & Wallace, 1870), p. 9; Burnham family tree—revised, Ancestry.com; Wetherill family tree, Ancestry.com. Nathaniel Rulon's shop listings are in the Philadelphia directories.

Cat. 36
Bailey & Co.
Pair of Salt Dishes

1855–65

MARKS (on each): BAILEY & CO. (incuse; cat. 36-1) / [lion statant] (facing left in rounded rectangle) S (in horizontal oval) [shield with plain chief and vertical stripes] (in conforming surround) / [lion passant guardant] (facing left in rectangle with chamfered corners, twice; at four cardinal points on underside; cat. 34-1)
INSCRIPTION (on each): A W M (gothic letters) / 1863. (engraved script, on one side)
Each: Height 1½ inches (3.8 cm), length 3⅛ inches (7.9 cm), width 2⁵⁄₁₆ inches (5.9 cm)
Weight 2 oz. 7 dwt. 10 gr. (1991-98-7); 2 oz. 5 dwt. 17 gr. (1991-98-8)
Gift in Memory of Eugene Sussel by his wife Charlene Sussel, 1991-98-7, -8

PROVENANCE: From the stock of the Philadelphia antiques dealer Eugene Sussel (1913–1989), the donor's

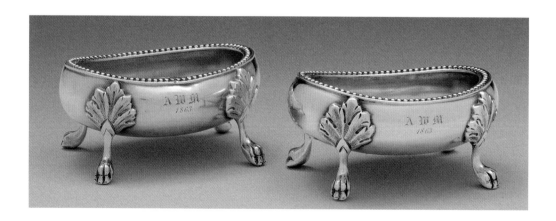

husband.

These salts with oval bodies have a wide top edge. The bead banding was set into the edge. The hairy paw feet and naturalistic leafy knees are handsomely chased. The bowls are sturdy nineteenth-century examples of the lingering Colonial Revival style in

Cat. 36-1

Philadelphia. There are traces of gilding on the inside of each bowl. BBG

Cat. 37

Bailey & Co.
Pitcher

c. 1859

MARKS: BAILEY & Cº (in arc) / 136 / CHESTNUT Sᵀ PHILᴬ
(in arc, all incuse); [lion statant] (facing left in rectangle)
S (in horizontal oval) [shield with plain chief and vertical
stripes] (in conforming surround); [lion passant guardant]
(facing left in rectangle with chamfered corners, twice; all
on underside; cat. 34-1)

INSCRIPTIONS: Cutler Downer / from / J.B. & Co. / January 1,
1859.(engraved script, on front opposite handle; cat. 37-1);
19 5 (scratched script, on underside under Bailey & Co. mark)
Height 8¾ inches (22.2 cm), width 5¼ inches (13.3 cm),
diam. 4 inches (10.2 cm)
Weight 22 oz. 13 dwt. 15 gr.
Gift (by exchange) of Richard V. Mattison and George
McCall, 1988-36-1

PROVENANCE: Peter L. L. Strickland, Philadelphia.

The rotund shape of the pitcher is enhanced by the
allover naturalistic, curvilinear vine-and-berry design
that swirls around the body. Perched at the top of
the cast handle is the mask of a bearded elder wear-
ing a turban.[1] The numerals "19 5" scratched on the
underside do not seem to designate weight unless
they specify a measurement before the handle
was applied.

The pitcher was presented to Cutler Downer
(1818–1884), son of Samuel and Sarah Reed Downer
of Weathersfield, Vermont, where he was born. He
married Elizabeth Tyler of Newburyport, Massachu-
setts. They had no children. He married his second
wife, Emily Chandler Martin (died 1880) of Chester,
Vermont, and New York City, about 1848; they had
three children and moved to Somerville, Massachu-
setts, in 1852. He was a founding partner in Downer
& Company, bankers and brokers. His third wife was
Chloe Helen Adams, whom he married in 1881.[2] BBG

1. Possibly a coincidence, possibly with a design source
in common, a pitcher of the same shape with a repoussé
design of entwining vine and berries (grapes) and a handle
with the same bearded mask, appeared with false Scottish
marks for 1809. Information courtesy of Rachel Layton and
Rachel Delphia, Carnegie Museum of Art, Pittsburgh; corre-
spondence, curatorial files, AA, PMA.
2. David R. Downer, *The Downers of America* (Newark, NJ:
Baker, 1900), pp. 124–25.

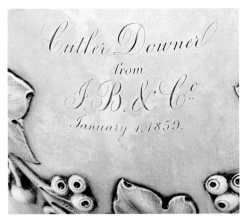

Cat. 37-1

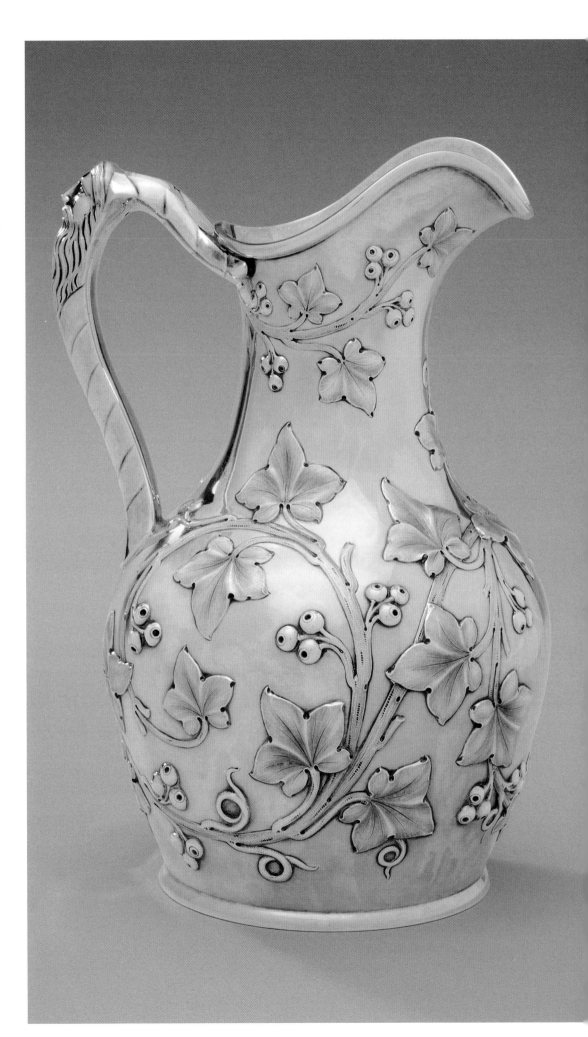

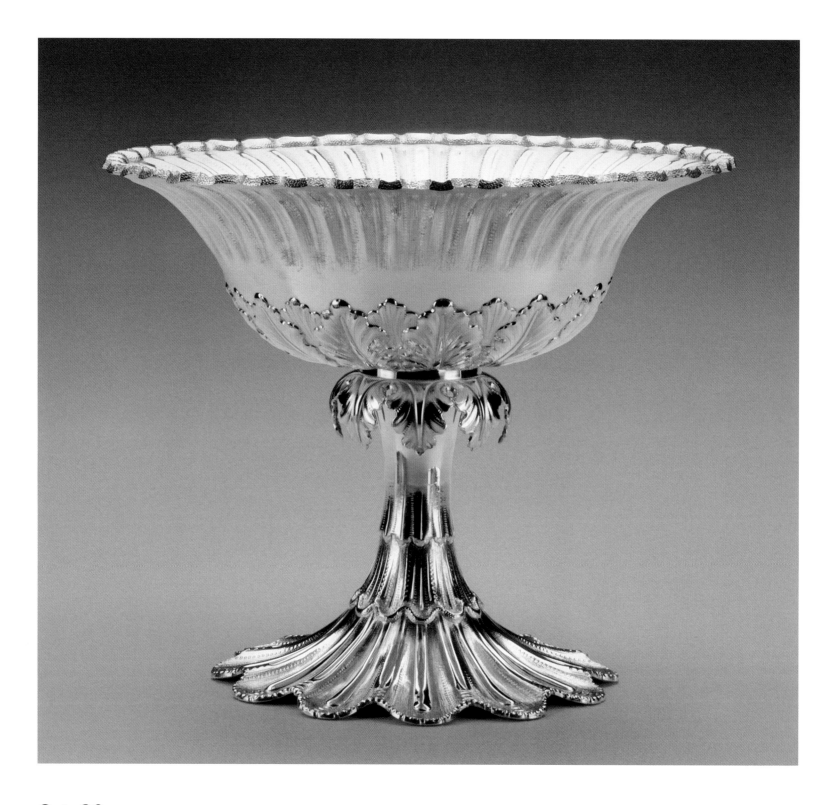

Cat. 38

Bailey & Co.
Centerpiece Bowl

c. 1860

MARKS: BAILEY & C° (in arc, incuse) / [lion passant guardant] (facing left in rectangle with chamfered corners) / CHESTNUT S⸆ PHIL᠕ (in arc, incuse) [lion passant guardant] (facing left in rectangle with chamfered corners, twice); [lion statant] (in rounded rectangle); S (in horizontal oval); [shield with plain chief and vertical stripes] (in conforming surround; all on underside of bowl; cat. 34-1)

INSCRIPTION: 956371 / 15114 / P1116 (scratched, on underside of three lobes of foot)
Height 9½ inches (24.1 cm), diam. 11¾ inches (29.9 cm), diam. base 7¾ inches (19.7 cm)
Weight 51 oz. 11 dwt.
Gift in memory of Eugene Sussel by his wife Charlene Sussel, 1991-98-1

PROVENANCE: From the stock of the Philadelphia antiques dealer Eugene Sussel (1913–1989), the donor's husband.

The pedestal of this centerpiece is a lively, elaborate, and elegant design of sweeping, curvaceous leafy forms, which support the tighter design of the flaring, fluted bowl. The more abstract pattern of overlapping leaves on the underside of the bowl was also used on other forms.[1] BBG

1. For another bowl and a basket with monogram, see Sotheby's, New York, *Important Americana*, January 24–27, 1990, sale 5968, lot 145.

Cat. 39
Bailey & Co.
Sugar Bowl

1859–70

MARKS: BAILEY & Cᵒ " (incuse, in arc) / [lion passant guardant] (facing left in rectangle with chamfered corners) / "CHESTNUT Sᵗ PHILᴬ (incuse in arc) / [lion statant] (facing left in rounded rectangle) S (in horizontal oval) [shield with plain chief and vertical stripes] (in conforming surround; all on underside of dish); [lion passant guardant] (facing left, in rectangle with chamfered corners; on cover; cat. 34–1)
INSCRIPTIONS: M C W (gothic letters) / to (script) / A C M J (gothic letters; engraved in cartouche on side of bowl)
Height 4⁵⁄₁₆ inches (11 cm), diam. 4⁵⁄₁₆ inches (11 cm)
Weight 10 oz.
Gift of Beatrice B. Garvan in honor of David L. Barquist, 2013–59–1a,b

PROVENANCE: Jonathan Trace, Portsmouth, NH, 2013.

Like most nineteenth-century American silver manufacturers, Bailey & Co. made relatively free interpretations of eighteenth-century models and frequently adapted the style to nineteenth-century forms (see fig. 25). In contrast, this sugar bowl closely imitates prototypes from a century earlier. The inverted pyriform shape with a ring handle on the cover was made in colonial Philadelphia, although this form was much more popular in New York.[1] The spiral fluting and chased decoration also resembles eighteenth-century examples by makers such as Thomas Shields (see PMA 2011-18-1) and Edmund Milne (see 1956-84-32). Bailey & Co. may have made this sugar bowl to match earlier tea wares, or possibly as a duplicate of a prized eighteenth-century object when heirlooms were divided among family members.

This sugar bowl probably was made after Bailey & Co.'s move in 1859 to 819 Chestnut Street, as indicated by the placement of the lion passant guardant where the address number "136" previously had been positioned in the marks on the underside. DLB

1. See sugar bowls PMA 1991-91-1 and 2008-126-1a, both by Myer Myers, and 2005-68-74a,b, by Joseph Richardson Sr.

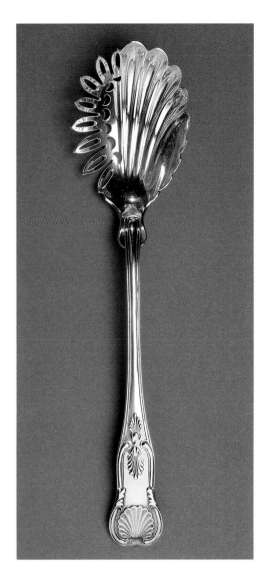

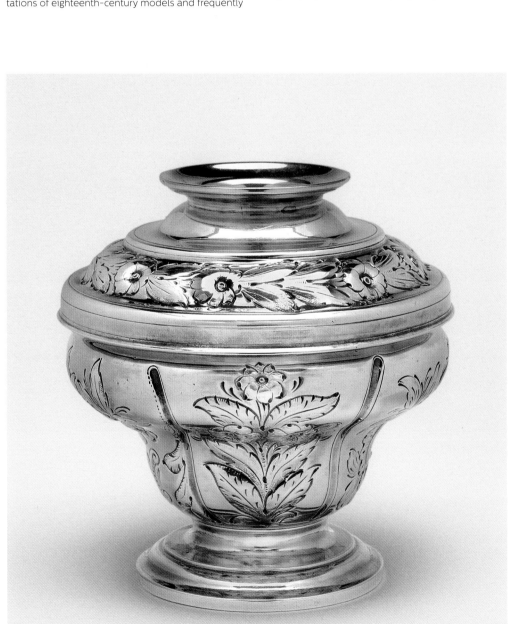

Cat. 40
Bailey & Co.
Pasta Server

1860–75

MARKS: [lion passant guardant] (facing left in rectangle with chamfered corners); [lion statant] (facing left in rounded rectangle); S (in horizontal oval); [shield with plain chief and vertical stripes] (in conforming surround; cat. 34–1); BAILEY & Co (incuse; cat. 35–1; all on reverse of handle)
Length 10¾ inches (27.3 cm), width 2½ inches (6.4 cm)
Weight 3 oz. 12 dwt. 16 gr.
Gift of Charlene Sussel, 2006–94–4

PROVENANCE: From the stock of the Philadelphia antiques dealer Eugene Sussel (1913–1989), the donor's husband.

This serving utensil has a handsome handle with a flared shell enclosed in a rolled-leaf edge. At the bottom, palmetto-shaped leaves and a long plain stem with molded edges overlap the tongue extending from the fluted, scalloped-edge spoon. One edge has eight pointed, pierced spikes with fine pierced half-moons at their base. The pattern is very close to *Kings II* (1860–70), used by Gorham.[1] BBG

1. Larry Freeman, *Victorian Silver: Plated & Sterling, Hollow & Flatware* (Watkins Glen, NY: Century House, 1967), p. 301.

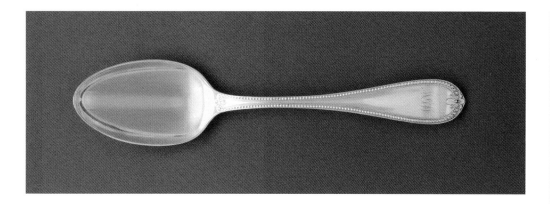

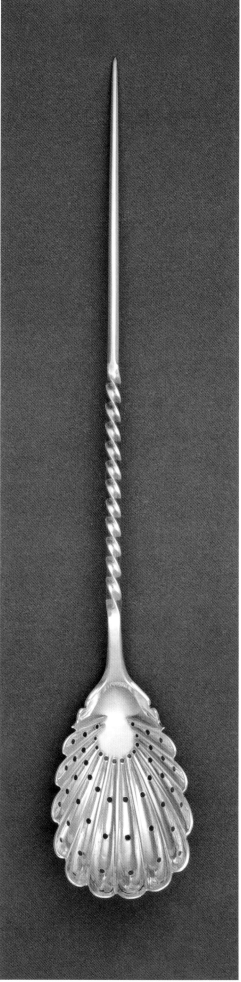

Cat. 41
Bailey & Co.
Pair of Tablespoons

1855–65

MARKS (on each): BAILEY & Co (incuse; cat. 35–1); [lion passant guardant] (facing left, in rectangle with chamfered corners); [lion statant] (facing left, in rounded rectangle); S (in horizontal oval); [shield with plain chief and pointed stripes] (in conforming surround; cat 34–1); [five-pointed star] (all on reverse of handle)

INSCRIPTION: A G W (engraved script on front, at top of handle)

Length 8⅞ inches (22.5 cm)

Weight 3 oz. 2 dwt. 10 gr. (1990-55-38); 3 oz. 5 dwt. 12 gr. (1990-55-39)

Bequest of Mrs. James Alan Montgomery, 1990-55-38,-39

PROVENANCE: The initials "AGW" on these handsome spoons belonged to Alida Gouverneur Wharton, daughter of Francis Rawle Wharton and Juliana Matilda Gouverneur Wharton, daughter of Isaac Gouverneur of New York.[1] Alida Wharton married John Teakle Montgomery in 1856.

These spoons in the *Beaded*, or *Italian*, pattern have beaded edges on the obverse and reverse of the handles. The symmetrical leaf motifs also appear on the obverse and reverse at the top of the handles. BBG

1. For another piece that descended in the same family, with the same initials, see the salver by Myer Myers (PMA 1990-55-3).

Cat. 42
Bailey & Co.
Olive Spoon

1855–65

MARKS: BAILEY & Co (incuse, on back of handle above twist; cat. 35–1); [lion passant guardant] (facing left in rectangle with chamfered corners); [lion statant] (in rounded rectangle); S (in horizontal oval); [shield with plain chief and vertical stripes] (in conforming surround; all on back of handle where it joins bowl; cat. 34–1)

INSCRIPTION: J T M (engraved foliate script, on reverse of base of bowl)

Length 8¾ inches (22.2 cm)

Weight 15 dwt.

Bequest of Mrs. James Alan Montgomery, 1990-55-40

PROVENANCE: The initials "JTM" belonged to John Teakle Montgomery (born 1817), who married Alida Gouverneur Wharton in 1856. The spoon descended in the family to the donor.[1]

Olive spoons, with pointed ends for spearing the fruit and pierced bowls for draining the liquid in which it was served, became popular during the second half of the nineteenth century, when olives frequently were served as a side dish at formal dinners. Tiffany, Young & Ellis (q.v. Tiffany & Co.) advertised olive spoons for sale as early as 1846.[2] The twist design used at the middle of the tapering handle appears on other Bailey & Co. pieces. It may have been introduced to the factory by George B. Sharp (q.v.), but it could have been copied from other manufacturers that also used the design.[3] BBG/DLB

1. For information provided by the donors, see curatorial files, AA. PMA.
2. William P. Hood Jr., Roslyn Berlin, and Edward Wawrynek, *Tiffany Silver Flatware, 1845–1905: When Dining Was an Art* (Woodbridge, UK: Antique Collectors' Club, 1999), pp. 23, 126.
3. A pair of serving spatulas with twist stems and the same Bailey & Co. marks is illustrated in Diana Cramer, "George Sharp: The Products," *Silver Magazine*, vol. 24, no. 5 (September–October 1991), p. 29. For a spoon with a twist stem made by Duhme & Co., see cat. 208.

Cat. 43

Bailey & Co.
Ice Tongs

1860–75

MARKS: BAILEY & Co (incuse, flanked by incuse five-pointed stars, inside each arm; cat. 35-1}; [lion statant] (facing left in rounded rectangle); S (in horizontal oval); [shield with plain chief and vertical stripes] (in conforming surround); [lion passant guardant] (facing left in rectangle with chamfered corners; all flanked by incuse five-pointed stars, inside bow; cat. 34-1)

Length 11 inches (27.9 cm), width handle 1⅛ inches (2.9 cm)

Weight 6 oz. 6 dwt. 12 gr.

Gift of Charlene Sussel, 2006-94-10

PROVENANCE: From the stock of the Philadelphia antiques dealer Eugene Sussel (1913–1989), the donor's husband.

The arms of these spring-action tongs were made using the dies for a spoon or fork handle in the *Shell and Thread* pattern. One terminal is in the form of a realistically detailed bird's claw, the other is an oval spoon shape with rectangular perforations for draining the ice and semicircular cutouts around the edge. BBG

Cat. 44

Bailey & Co.
Serving Spoon

1850–65

MARKS: BAILEY &CO. (in rectangle; cat. 29-1); [lion statant] (facing left in rounded rectangle); S (in horizontal oval); [shield with plain chief and vertical stripes; cat. 34-1]; [lion passant guardant] (facing left in rectangle with chamfered corners; all on reverse of handle)

INSCRIPTION: Lillie (engraved script in shield-shaped reserve, on obverse of handle)

Length 9¼ inches (23.5 cm), width handle 1¹¹⁄₁₆ inches (4.3 cm), length bowl 3⅛ inches (7.9 cm)

Weight 1 oz. 12 dwt. 5 gr.

Gift in memory of Eugene Sussel by his wife Charlene Sussel, 1991-98-30

PROVENANCE: from the stock of the Philadelphia antiques dealer Eugene Sussel (1913–1989), the donor's husband.

The concave, fluted surface of the melon-shaped bowl of this serving spoon is parcel gilt and chased with double dash-like marks that accentuate the flutes. The handle is continuous with the bowl. There is no drop. The obverse surface of the handle is engine chased with a leafy pattern. There is a light, flat gadroon edge on the handle. The design of this spoon, including the engine chasing and the shield shape enclosing the inscription, is similar to the work on a pie server by J. E. Caldwell & Co. (cat. 116) made about 1863. BBG

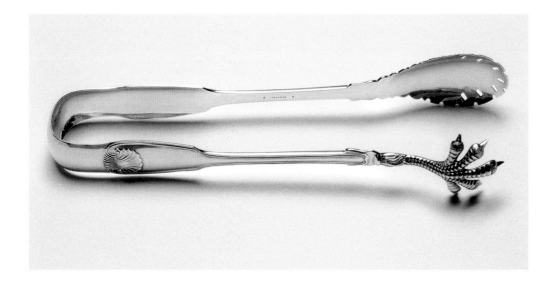

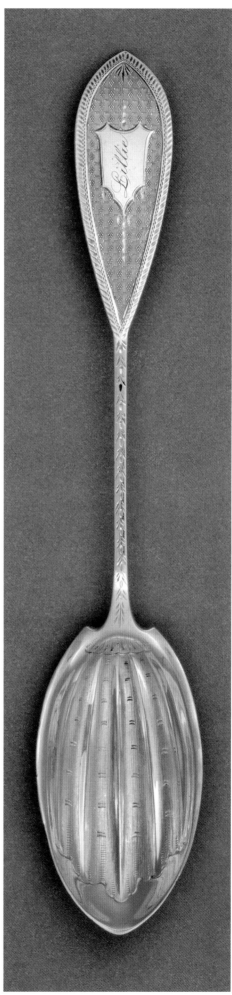

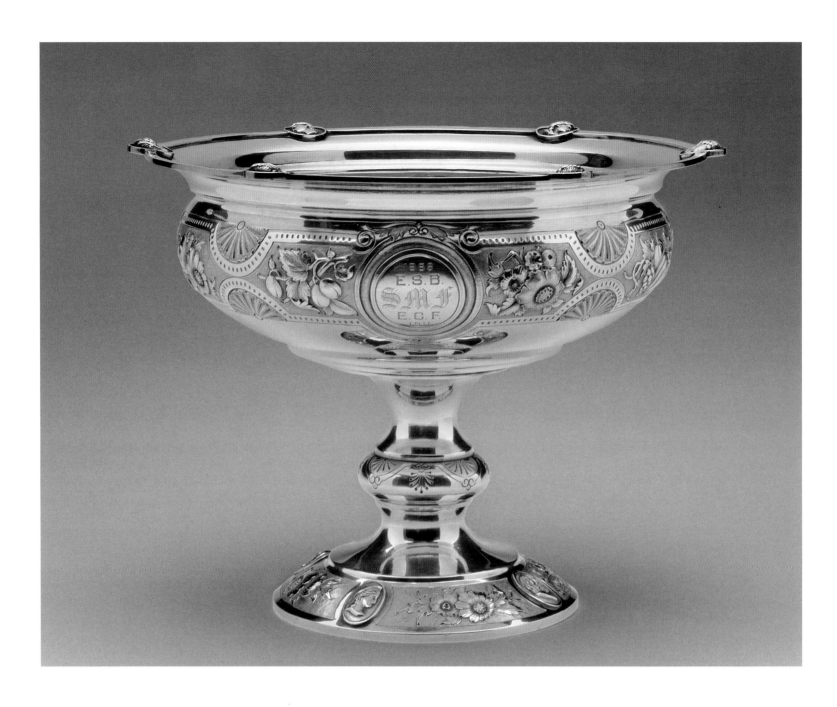

Cat. 45

Bailey & Co.

Four pieces from the Felton Service: Compote, Cake Basket, Entrée Dish, Butter Dish

1865

Compote

MARKS: BAILEY & C̥ (incuse, in arc) / CHESTNUT S.ͭ PHIL.ᴬ (incuse, in arc); [lion passant guardant] (facing left in rectangle with chamfered corners, twice); [lion statant] (facing left in rounded rectangle); S (in horizontal oval); [shield with plain chief and vertical stripes] (in conforming surround; all on underside of bowl; cat. 34–1)

INSCRIPTIONS: Presented to / Samuel M. Felton / by his Friends / of the City of / Philadelphia / and its vicinity. / 1865. (engraved script in roundel, on outside of bowl; cat. 45–1); 1889 / E.S.B. / S M F (gothic letters) / E.C.F. / 1911 (engraved in roundel, on opposite side)

Height 8⁵⁄₁₆ inches (21.1 cm), diam. 10⅞ inches (27.6 cm), diam. base 8¼ inches (21 cm)

Weight 36 oz. 5 dwt. 5 gr.

Cat. 45-1

Cake Basket

MARKS: BAILEY & C̥ (incuse in arc) / CHESTNUT S.ͭ PHIL.ᴬ (incuse in arc) / [lion passant guardant] (facing left in rectangle with chamfered corners) / [lion statant] (facing left in rounded rectangle); S (in horizontal oval) [shield with plain chief and vertical stripes] (in conforming surround; all on underside; cat. 34–1)

INSCRIPTION: S M F (engraved gothic letters, on interior)

Height 10 inches (25.4 cm), width 12¹⁵⁄₁₆ inches (32.9 cm), depth 10⁹⁄₁₆ inches (26.8 cm)

Weight 38 oz. 7 dwt. 10 gr.

Entrée Dish

MARKS: BAILEY & C̥ (incuse in arc) / CHESTNUT S.ͭ PHIL.ᴬ (incuse, in arc); [lion passant guardant] (facing left in rectangle with chamfered corners, twice); [lion statant] (facing left in rounded rectangle); S (in horizontal oval); [shield with plain chief and vertical stripes] (in conforming surround; all on underside of dish; cat. 34–1); 2 (incuse, on interior bezel of dish, under rim, on handle socket of cover, and on underside of handle)

INSCRIPTIONS: Presented to / Samuel M. Felton / by his Friends / of the City of / Philadelphia, / and its vicinity. / 1865. (engraved script in roundel, on outside of cover; cat. 45–1); S M F (engraved gothic letters in roundel, on opposite side of cover); A.M. Felton / 1889 (engraved in roundel, on one side of dish); Felton Bent / 1906 (engraved in roundel, on opposite side of dish); A M Felton (scratched, on underside); Feb 1865 / Kn C / maki[ing?] /150 + + / Preis oct (scratched, on underside)

Height 6⅛ inches (15.6 cm), width 13¾ inches (34.9 cm), depth 10¹⁄₁₆ inches (25.6 cm)

Weight 58 oz. 15 dwt. 9 gr.

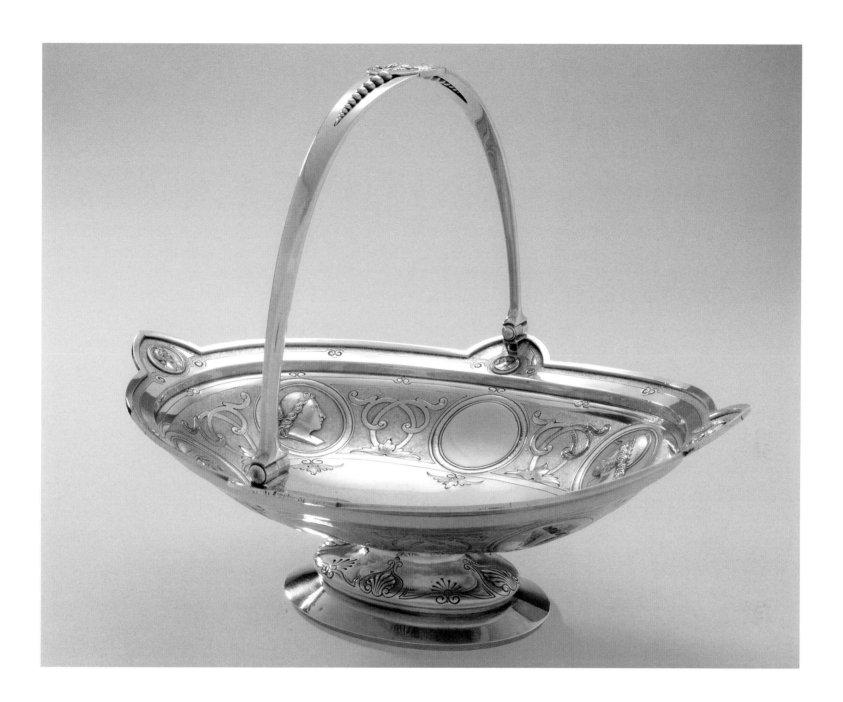

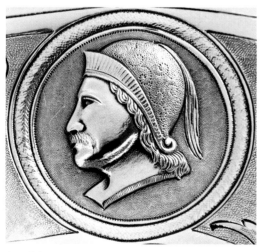

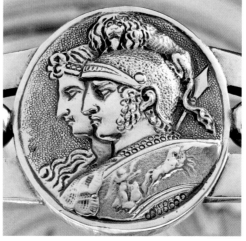

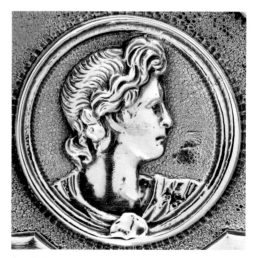

Cat. 45-2

Cat. 45-3

Cat. 45-4

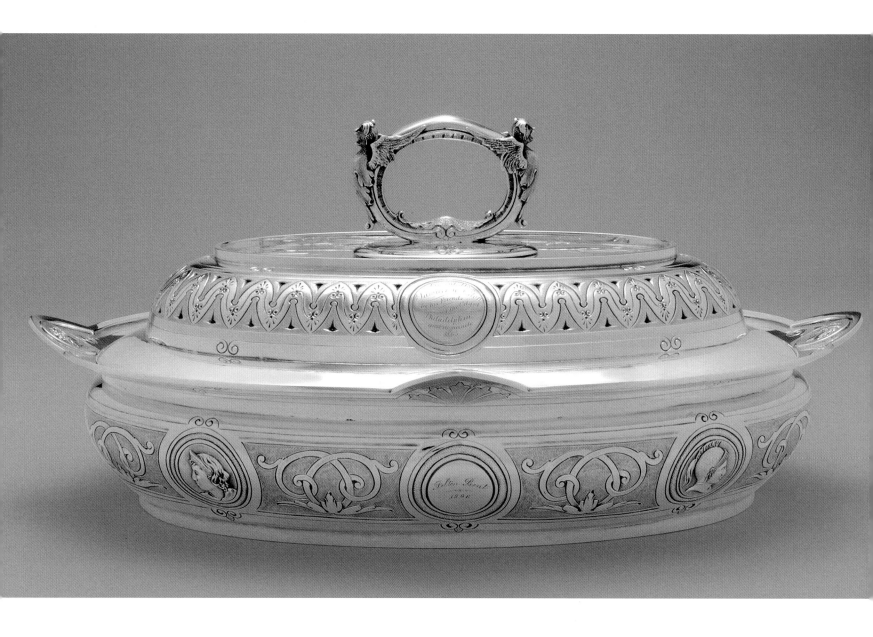

Cat. 45-5

Cat. 45-6

Cat. 45-7

Butter Dish

MARKS: BAILEY & Cº (incuse in arc) / CHESTNUT Sᵀ PHILᴬ: (incuse in arc) / [lion statant] (facing left in rounded rect-angle) S (in horizontal oval) [shield with plain chief and vertical stripes] (in conforming surround) / [lion passant guardant] (in rectangle with chamfered corners; all on underside of bowl; cat. 34-1); cover and liner unmarked

INSCRIPTION: S M F (engraved gothic letters in roundel, on exterior of bowl); engraving erased from roundel on opposite side

Height 8¹⁄₁₆ inches (20.5 cm), width 7⅛ (8.1 cm), depth 7 inches (17.8 cm)

Weight 30 oz. 12 dwt. 10 gr.

Purchased with the Richardson Fund and a gift from the Levitties Foundation, 2009-84-1–4a,b

PROVENANCE: These four objects were part of a dinner service presented in 1865 to Samuel Morse Felton Sr. (1809–1889), of Chester, Pennsylvania. As inscriptions on two objects indicate, the service was divided up after Felton's death. The entrée dish was given to his unmarried daughter Anna Morse Felton (1839–1923), who in 1906 gave it to her nephew, Felton Bent (1872–1939), son of Luther (1829–1914) and Mary Stearns (Felton) Bent (1842–1918).[1] The compote was given in 1889 to Samuel Felton's daughter Eleanor Stetson (Felton) Barker (1837–1913), who had no children and left it to her

younger half-brother, Edgar Conway Felton (1858–1937), and his wife, Alice Bent (1862–1957), who was also Eleanor and Mary's niece by marriage.[2] The Museum acquired these four objects from the dealer Spencer Marks of Northampton, Massachusetts, who had brought them together from different sources.

PUBLISHED: Spencer Marks, advertisement, *Silver Magazine*, vol. 34, no. 6 (November–December 2002), p. 9; *Silver Magazine*, vol. 36, no. 1 (January–February 2004), p. 1; *Antiques*, vol. 175, no. 1 (January 2009), p. 119.

These four objects were part of a large silver din-ner service presented to Samuel M. Felton on June 9, 1865, when he retired as president of the Phila-delphia, Wilmington and Baltimore Railroad. As originally constituted the service was substantial, including at least four entrée dishes.[3] One Philadel-phia newspaper reported that the service was valued at $6,000.[4] The grand scale and opulent ornament of these objects reflects the fashion after 1860 for lavish displays of silver on the dining table, a trend fueled both by American industrial prosperity and by the discovery of vast silver deposits in the west-ern United States. The service also represents one of the last groups of hollowware produced in the Bailey

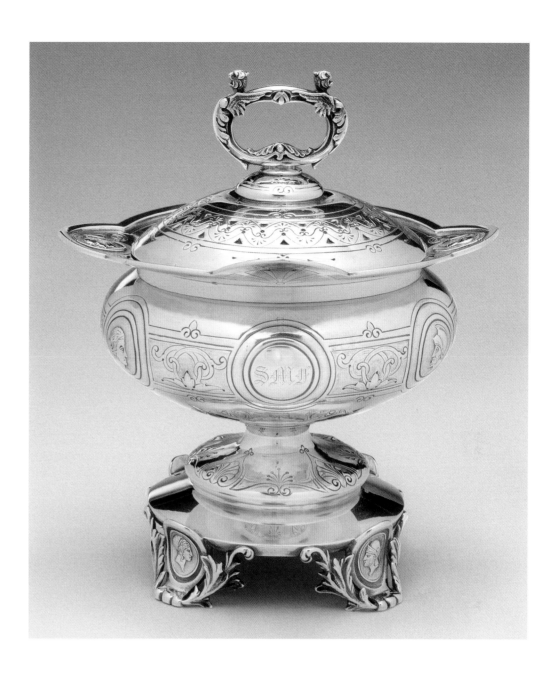

& Co. factory prior to the firm's discontinuing large-scale silver production after 1865.

As president of the Philadelphia, Wilmington and Baltimore Railroad, Felton had played an important role during the Civil War, transporting Union troops and supplies and operating the "Annapolis Route," the only active rail link between the Union states and Washington, D.C. Moreover, Felton was credited with helping prevent an assassination attempt on President–elect Abraham Lincoln when he took one of the company's trains through Baltimore to his inauguration in 1861.[5] On April 17, 1865, a committee of twenty-six prominent Philadelphians met to recognize that "to Mr. Felton, more than to any other man, is due the credit of successfully opening the Annapolis Route to Washington in April, 1861, a measure which contributed so essentially to the preservation of our National Capital . . . [and] mainly owing to the vigilance, energy, and skill of Mr. Felton that the plot to assassinate President Lincoln . . . was discovered and frustrated." The committee unanimously resolved "to prepare and present to Mr. Felton a

suitable service of silver plate as a testimonial of our admiration and regard."[6]

As Philadelphia's largest jewelry and silverware firm at that time, Bailey & Co. was a logical choice for this commission. With less than eight weeks to complete the order, Bailey & Co. acquired some of the pieces from other makers, including the Gorham Manufacturing Company (q.v.), which supplied a water pitcher and matching goblet with unornamented areas complemented by relatively narrow bands of chased foliage and applied medallions.[7] The compote apparently was a preexisting piece from Bailey & Co.'s stock that was repurposed for the Felton service, as its chased decoration of repoussé fruit and foliage within panels framed by dotted borders and fluted shells is unlike the other pieces of the service from Bailey & Co.'s workshop.

Like the compote, the basket, entrée dish, and butter dish were stock forms, as indicated by an unrelated tureen of the same form as the butter dish but decorated with allover floral chasing.[8] Their chased decoration, however, was exceptional: large

Cat. 45-8

Fig. 37. Cameo of the Egyptian ruler Ptolemy II and his wife, third century BCE. Hermitage Museum, St. Petersburg. Photo: HIP / Art Resource, NY

medallions of classical heads separated by panels of interlaced strapwork on a textured background. Influenced by contemporary French and English silver that was in turn inspired by Renaissance and Baroque prototypes, this ornament may have been specifically designed for the Felton service.[9] Medallions with profile heads of classical figures were popular ornaments in American silver during the 1860s; four design patents for medallion flatware patterns were granted between 1862 and 1867.[10] On the Felton service most of the female heads are generic, but many of the male heads can be interpreted as having a specific resonance on pieces of presentation silver connected to the Civil War. These heads were well-known types representing Alexander the Great (cat. 45-7), Ajax (cat. 45-5), Paris, Heracles, and Apollo (cat. 45-4) and based on renowned works of art; for example, the medallion on the basket's handle (cat. 45-3) was derived from the third-century-BCE "Gonzaga Cameo" of an imperial couple (fig. 37).[11] It seems doubtful that the silversmiths or Felton himself were aware of all these specific identities; more likely they viewed the heads as images of Greek or Roman warriors who embodied the virtues of bravery, loyalty, and military service.

On most American hollowware that was decorated with medallions, the decorations were die struck, or cast separately and applied,[12] or engraved, and some of the smaller medallions on the Felton service were executed in this fashion (cat. 45-4). The Bailey & Co. pieces were exceptional for large-scale medallions that were chased. The quality of the chasing varies considerably from object to object, indicating that more than one chaser was employed on this commission. A comparison of the same warrior's profile from the basket (cat. 45-2), entrée dish (cat. 45-6), and butter dish (cat. 45-8) reveals not only differences in various ornamental details, but also in the direction of the head and the degree of finish. The somewhat random placement

of the medallions and the fact that some heads are repeated on the Museum entrée dish but not used at all on the one offered at auction[13] suggests that chasers were given designs to follow but considerable latitude in their execution. DLB

1. Genealogical information on the Felton and Bent families comes from William Reid Felton, *A Genealogical History of the Felton Family* (Rutland, VT: Tuttle, 1935), pp. 284–87; and Prouty/Sawyer family tree, "Just for FUN" family tree, and Bent family tree, Ancestry.com (all accessed July 23, 2014). The life dates for Anna Felton, Mary Felton Bent, and Felton Bent are recorded on their death certificates; Philadelphia Death Certificates Index, 1803–1915, Ancestry.com.
2. Eleanor Barker's life dates are recorded in Philadelphia Death Certificates (see note 1). Edgar Conway Felton's life dates are recorded on his gravestone, www.findagrave.com (memorial no. 102318948, accessed July 23, 2014).
3. A second, nearly identical entrée dish, stamped "4" on the dish, cover, and handle, was offered at auction by Samuel T. Freeman & Company, Philadelphia, *The Pennsylvania Sale*, November 14, 2013, lot 545. As noted, the Museum's entrée dish is stamped "2."
4. "A Testimonial to Mr. S. M. Felton," *North American and United States Gazette* (Philadelphia), June 9, 1865. The amount of $6,000 in 1865 is equivalent in 2017 to around $150,000.
5. "Extract from an Autobiography Written by Samuel Morse Felton for His Children in 1866," in Felton, *Genealogical History of the Felton Family*, pp. 389–96; Norma B. Cuthbert, ed., *Lincoln and the Baltimore Plot, 1861: From Pinkerton Records and Related Papers* (San Marino, CA: Huntington Library, 1949), pp. 8–10.
6. "City Intelligence: The Felton Testimonial," *Philadelphia Inquirer*, June 13, 1865.
7. The Gorham pitcher and goblet were previously illustrated on the Spencer Marks website, www.spencermarks.com (accessed July 24, 2014). Another object from the service made by Bailey & Co., a covered milk jug, was also illustrated on the same website (accessed July 24, 2014).
8. Sotheby Parke Bernet, New York, *Fine American Furniture, Silver, Folk Art, and Related Decorative Arts*, June 30–July 1, 1983, sale 5056, lot 73.
9. A silvered-bronze casket with repoussé medallion decoration made by Louis-Constant Sévin, Désiré Attarge, and Ferdinand Barbedienne was exhibited at the 1867 Paris Exposition Universelle; see Sotheby's, London, *The Polo Collection*, February 24, 2016, lot 109. A pair of German stacking beakers of c. 1555–60 is engraved with ancient and modern medallion heads; Timothy Schroder, *British and Continental Gold and Silver in the Ashmolean Museum* (Oxford: Ashmolean Museum of Art and Archaeology, 2009), vol. 3, cat. 431. Examples of French Baroque silver with this vocabulary include a 1727–29 ewer and basin by Léopold Antoine of Paris, a 1705–6 box from a toilet service by Robert Turpin of Paris, and a 1709–10 silver stand by Elie Pacot of Lille; Faith Dennis, *Three Centuries of French Domestic Silver: Its Makers and Marks* (New York: Metropolitan Museum of Art, 1960), vol. 1, cats. 6, 328, 450. An English example is a 1728–29 salver by Paul de Lamerie of London; James McConnaughy and Tim Martin, eds., *Shrubsole* (New York: S. J. Shrubsole, 2013), vol. 19, p. 15.
10. D. Albert Soeffing, *Silver Medallion Flatware* (New York: New Books, 1988), pp. 12–14. See PMA 2011-15-4 by Gorham Manufacturing Company and 2010-206-29 by John R. Wendt & Co.
11. For example, the head of Ajax is modeled on the so-called *Pasquino* group that now is thought to represent Menelaus and Patroclus; see Francis Haskell and Nicholas Penny, *Taste and the Antique: The Lure of Classical Sculpture, 1500–1900* (New Haven, CT: Yale University Press, 1981), cat. 72.
12. See PMA 2002-107-1–4 by Wood & Hughes.
13. See note 3.

Cat. 46

Bailey, Banks & Biddle
Sugar Sifter

1880–85

MARK: STERLING BAILEY BANKS & BIDDLE (incuse, on reverse of handle; cat. 46-1)

INSCRIPTION: IN MEM. OF MY SISTER / Catherine Browning / Dec.17, 1869 / A Browning (engraved script, at top of reverse of handle; cat. 46-2)

Length 7¼ inches (18.4 cm)

Weight 1 oz. 11 dwt. 6 gr.

Gift of Charlene Sussel, 2006-94-6

PROVENANCE: From the stock of the Philadelphia antiques dealer Eugene Sussel (1913–1989, the donor's husband.

The handle of this strainer spoon, chased in swirling foliage in the rococo style, is enlivened near the top with an asymmetrical design in the Japanesque style. Plain surfaces are divided into straight and curved bands lightly punctuated with dotted chasing. The parcel gilt bowl has seventeen flutes with four circular piercings in each; the round bottom has eight holes and one in the center.

Catherine Browning (1805–1869) was the daughter of Abraham and Beulah Browning of New Jersey. Catherine's younger brother, Abraham Browning (1808–1884), was a prominent attorney general of New Jersey and is often credited with coining New Jersey's nickname, the Garden State.[1] BBG

1. "Catherine Browning, Burial Date, 12-18-1869," Death Notices for 1869, Death Notice Index for the Philadelphia Inquirer, HSP, Ancestry.com.

Cat. 46-1

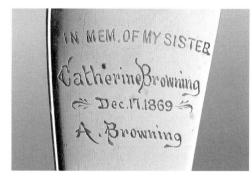

Cat. 46-2

Cat. 47

Bailey, Banks & Biddle
Pair of Teaspoons

c. 1881

MARK (on each): B. B. & B. STERLING (incuse, on reverse of handle; cat. 47-1)

INSCRIPTION (on each): H.S. (shaded letters, at top of handle)

Length 4³⁄₁₆ inches (10.7 cm)

Weight 5 dwt. 15 gr. (1988-25-13); 5 dwt. 20 gr. (1988-25-14)

Gift of Dorothy Kirkbride Hulme Flavell, 1988-25-13, -14

PROVENANCE: The initials "H S" belonged to Hannah Story (1858–1910), daughter of Samuel and Margaret Pownall Story of Jenkintown, Montgomery County, Pennsylvania. She married Robert Richardson Hulme on January 15, 1881. They were Quakers who attended the Newton and Langhorne Friends meetings. The spoons descended in the family to the donor.[1]

Cat. 47-1

The upturned, rounded-end handles of these plain spoons and the style of engraving were typical of the Colonial Revival style, modeled on forms made by most eighteenth-century silversmiths.[2] BBG

1. For other silver in the Museum's collection that descended in this family, see cats. 59, 61; spoons (1988-25-1–3,10,11,12,17,18) and cream pot by Philip Garrett (1988-25-30); tongs by the Gorham Manufacturing Company (1988-25-19); spoon by James Hansell (1988-25-16); ladle by Hildeburn & Brothers (1988-25-42); mustard spoon by Joseph Howell (1988-25-28); spoons by Isaac Reed & Son (1988-25-5-7,26); teaspoons by Joseph junior and Nathaniel Richardson (1988-25-20,21); spoon by John Tanguy (1988-25-8); teaspoon by R. & W. Wilson (1988-25-25); sugar box by an unknown maker (1988-25-31); and teaspoon by an unknown maker (1988-25-4).

2. For examples in the Museum's collection, see teaspoons by Joseph Richardson Sr. (1957-93-52), Philip Syng Jr. (1959-2-31), and William Young (1950-29-6).

Cat. 48

Bailey, Banks & Biddle

Salt Spoon

1885–95
MARK: __DLE (incuse, on reverse of handle; cat. 46-1)
INSCRIPTION: S E (engraved script, at top of obverse of handle)
Length 4 inches (10.2 cm)
Weight 4 dwt. 5 gr.
Gift of Marjorie Wentworth Pitts Graves, 1994-14-5

The full name "Bailey Banks & Biddle" has been worn off. This salt spoon was made in the early twentieth century to match one by the London silversmiths Peter and Ann Bateman; the initials "SE" referred to that spoon's original owner, Sarah Fishbourne Emlen (Mrs. George Emlen IV, 1741–1812), who was married in 1775. The two spoons and two salt dishes made by Richard Humphreys descended in the family to the donor.[1] BBG

1. See the salt spoon by Peter and Ann Bateman (PMA 1994-14-6) and the salt dishes by Richard Humphreys (1994-14-3, 4).

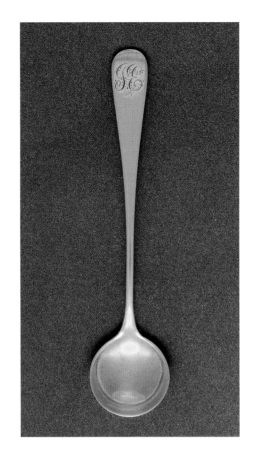

Cat. 49

Bailey, Banks & Biddle

Medal

1918–20
Gold electroplated on silver and base metal, enamel, silk
MARKS: BBB CO. SILVER (incuse, on reverse of bar supporting ribbon; cats. 49-1, 49-2); 1084 (incuse, on link joining ribbon and wreath); 713498 (scratched, on reverse of clasp joining ribbon and wreath)
INSCRIPTIONS: WAR WITH GERMANY (relief letters in rectangle on silver bar across ribbon, on obverse); DEUS ET LIBERTAS (gilt letters on blue enamel ground in circle around motif of crossed swords and anchor on red enamel ground, on reverse of medal)
Diam. 1½ inches (3.8 cm), length overall including ribbon 3⅝ inches (9.2 cm)
Gift of Mrs. John H. Easby, 1926-64-1

PROVENANCE: This medal was presented to William Yorke Stevenson (1878–1922) for service in the Ambulance Corps in World War I. In 1918 he published a detailed account of his experience.[1] The donor was his paternal aunt.

This decoration is the Military Order of Foreign Wars. The medal is suspended from the red-, blue-, and yellow-striped silk repp ribbon by a small, gilded flat loop in which the incuse numbers are inscribed. There is a deep honeycomb pattern in the field of the dark-red enamel stars. BBG

1. William Yorke Stevenson, *From "Poilu" to "Yank"* (Boston: Houghton Mifflin, 1918).

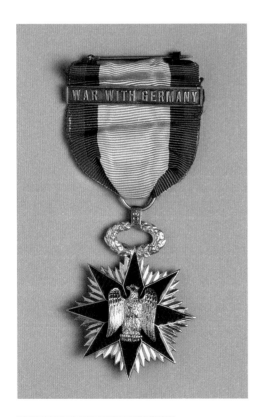

Cat. 49-1

Cat. 49-2

James Bailey

Utica, New York, born 1822
San Francisco, died 1898

The village of Utica, New York, was incorporated in 1798; in 1802 it had about ninety houses. When the Erie Canal opened between Albany and Utica in 1823,[1] a general westward movement began, and Utica rapidly grew from a rural community to a small city. As Utica developed it became a stop on the westward route; its economy flourished; and silversmiths and the manufacturing of silver, especially flatware, thrived there until 1900.[2] The Baileys, like so many of the silversmiths in Utica before 1850, had moved from an eastern town, probably Albany.[3] By 1832 there were about twenty-eight active silversmiths and jewelers in Utica, but no Baileys until 1846. From 1846 to 1852 the firm of Bailey & Brothers advertised,[4] and it was listed in the Utica directory until 1852.

The Bailey brothers were the sons of Irish immigrants, John and Elizabeth Bailey. William (1818–1892), James (1822–1898), Thomas (born 1825), and Hugh (1830–1887) were born in Utica.[5] An elder son, Robert, had set up in business in Cleveland, where William worked with him until 1846, when he returned to Utica. James Bailey graduated from Hamilton College in Clinton, New York, in 1845. The following year he joined his brothers Thomas and William in the silver and jewelry business in Utica, and the firm became known as Bailey & Brothers.[6] They advertised in Utica's *Oneida Morning Herald* on September 1, 1849: "BAILEY & BROTHERS, Manufacturers of Silver Ware, and wholesale and Retail Dealers in Watches, Jewelry and Fancy Goods, No. 122 Genesee street (opposite the National Hotel.) Watches and Clocks carefully repaired and warranted, also Jobbing done in the best manner."

After the locks on the Erie Canal were widened in 1848, the same newspaper carried long advertisements about the ease of travel between New York, Albany, and Utica—by passage on the steamer *Rip Van Winkle* for fifty cents; from Utica to Chicago and Buffalo on packet boats along Lake Michigan; and to multiple points via the developing train service. Sometime in 1848 or 1849, James Bailey left the family firm in Utica and set out for California. Details documenting his subsequent peregrinations are lacking, but it is likely that he was enticed to follow the stream of entrepreneurs seeking their fortunes after the discovery of gold in the Sacramento Valley at Sutter's Mill on the American River in 1848.

Buildings in the town of Sacramento, erected in a hurry, were constructed of wood, and in September 1849 a huge fire destroyed the town. Three years later, on November 4, 1852, another fire started at a millinery shop near Fourth and J streets and burned down fifty-five city blocks.[7] James Bailey was established in Sacramento by 1850, but just where is not known, although his later address was in the area that burned in 1852. After the fire it was determined that new city buildings would be constructed of brick, and in 1852 Sacramento became California's temporary capital.

In 1851 William, who was then the senior partner of Bailey & Co. in Utica, retired. Two years later, in 1853, the firm of Hawley & Leach advertised that it had purchased the large jewelry stock of the remaining Bailey brother, Thomas, "who has been carried off by the gold fever to California."[8] It seems that William, too, headed out to California that year, cutting short his retirement.[9] It may have been simply gold that motivated the brothers' move. They may also have wanted to partner with James or to help him rebuild his business if it had indeed fallen victim to the fire. Almost immediately after the Baileys arrived in 1853, another fire and a flood caused the capital to be moved to Benicia until 1854, when Sacramento became the state's permanent capital. William purchased an interest in James's jewelry enterprise in 1854, and their shop, located in the newly built brick section between Fourth and Fifth streets on J Street in Sacramento, was in a prime location near the Dawson Hotel (later known as the St. George Hotel), situated at the corner of Fourth and J streets.[10] James and William, and possibly Thomas as well, flourished in business together in Sacramento, where they were known as Bailey Brothers.

Having made a success of their new venture, William and Thomas returned to Utica in 1857.[11] William retired to a country life, and Thomas reappeared in the Utica directory from 1858 through 1860 at 123 Genesee Street, boarding with a silversmith, Thomas Midlam, at 15 Broad Street.

Soon after his brothers returned to Utica, James Bailey, an early retiree like his brother William, sold his jewelry business. An advertisement at the front of the Sacramento directory for the period 1859–60 reveals the purchaser: "J. P. Floberg & Co., (*Successors to Bailey Brothers.*) Manufacturers and Importers of Watches, Jewelry, Silver Ware, Fancy Goods, etc. No. 188 J Street, between 4th and 5th, Sacramento."[12]

James's jewelry business in Sacramento must have been prosperous from the start, whether from his own success as a gold prospector, as a result of the plethora of newly rich miners eager to purchase jewelry and "fancy goods," or from prudent investments in property and real estate. He had clearly made a name for himself in Sacramento, and in the 1860s became involved in a major civic project. At some point James's path crossed that of Theodore D. Judah (1827–1863), a railroad engineer from Troy, New York, who had been employed on the Erie Canal and with the Buffalo and New York railroads, and who became the engineer of the Sacramento Valley Railroad.[13] Theodore's brother Charles Judah, like James Bailey, had also headed for California from upper New York State in 1849, which may have been the connection between them. But it was Theodore Judah's ambition and vision for a project on a national scale, a transcontinental railroad, that captured Bailey's interest and support. In 1860 he was among the first of Judah's friends to subscribe to and promote what would become the Central Pacific Railroad, and he was at the first meeting of the men in Sacramento who would become the main investors: "Upon his return to Sacramento in March 1861 Judah called for a meeting of Sacramento's most influential business men, as well as his friend Dr. Strong. About 30 men attended the presentation he gave at the St. Charles Hotel. The 'Big Four': Stanford, Huntington, Crocker and Hopkins, had been introduced to Judah through one of Judah's enthusiasts, Sacramento Jeweler James Bailey. . . . Also in attendance that evening were Lucius A. Booth, James Bailey, Cornelius Cole [a Sacramento lawyer who later served as both a congressman and senator], one of Judah's surveyors, B. F. Lette, and several others."[14] Bailey knew the "Big Four," who would become known as the Associates. They were all of an age, from the East Coast, and had gone west in 1848 or 1849 to seek their fortunes. Leland Stanford (1824–1893) was born in Henderson, New York, and had attended Cazenovia Seminary in Cazenovia, New York, as had James's brother William; Collis P. Huntington (1821–1900) was born in Connecticut; Charles Crocker (1822–1888) was born in Troy, New York; and Mark Hopkins (1813–1857) was also born in Henderson. Work on the Central Pacific Railroad commenced in January 1863 and, when completed in 1869, made coast-to-coast travel possible in just eight days.

James Bailey remained in Sacramento until after the Civil War, when he returned to Utica. The U.S. census of 1870 records a James Bailey,

age forty-three, born in New York, and listed as "no occupation" but with real estate valued at $40,000. His wife Lucy (born 1832) is listed as "keeping house," tending four children age three to thirteen; two domestic servants and one other person, of an age to vote, were also in residence. James Bailey owned real estate in San Francisco and at some point took up residence there, returning to Utica on occasion. He died in San Francisco in August 1898, survived by his wife and three sons, Alfred, James, and John.[15] BBG

1. The canal was completed in 1825.

2. Barbara Franco, *Utica Silver*, exh. cat (Utica, NY: Munson-Williams-Proctor Institute, 1972), pp. 4–10; additional information kindly supplied by Anna Tobin D'Ambrosio, director of the Munson-Williams-Proctor Arts Institute, Utica. Further biographical information came from searches of the family at Ancestry.com; U.S. censuses; Old Trinity Episcopal Church (Utica) Baptisms, 1806–18, http://oneida.nygenweb.net (accessed April 2013); and *The Utica City Directory* ([Utica, NY]: G. Tracy, 1855–59).

3. In 1817 there were six silver- and/or goldsmiths listed in the Utica directory: Joseph Barton, W. B. Clark, Charles J. J. DeBernard, Joseph S. Porter, Shubael Storrs, and N. N. Weaver; oneida .nygenweb.net/towns/utica/1817cen.htm (accessed February 26, 2018).

4. George Barton Cutten, *The Silversmiths, Watchmakers and Jewelers of the State of New York Outside of New York City* (Hamilton, NY: printed by the author, 1939), p. 34.

5. In 1851 Hugh Bailey rented "upstairs" at 17 John Street and, later, with his brother Thomas and another silversmith, Thomas Midlam, he was a boarder at Midlam's Temperance House. See Utica directory 1851; Old Trinity Episcopal Church (Utica) Baptisms, 1806–18.

6. Thomas Bailey was listed as a watchmaker from 1843 until 1846 and as a partner in Bailey Brothers from 1846 until 1852, and had his own jewelry store at 123 Genesee Street from 1852 until 1854. See the Utica directories for these years; Henry J. Cookinham, *History of Oneida County, New York, from 1700 to the Present Time, Illustrated* (Chicago: S. J. Clarke, 1912), vol. 2, pp. 210–13.

7. Steven M. Avella, *Sacramento: Indomitable City* (Charleston, SC: Arcadia, 2003), pp. 39–41.

8. Thomas is not listed again in the Utica directories until 1857. This information was generously supplied by Anna Tobin D'Ambrosio of the Munson-Williams-Proctor Arts Institute.

9. Cookinham, *History of Oneida County*, vol. 2, pp. 210–13.

10. *Sacramento City Directory for the Year A.D. 1860* (Sacramento: H. S. Crocker & Co., 1859), front matter and pp. 15, 39. This may also have been the site of Bailey's original shop, which would have burned, or it may be that he took advantage of this burned-out location to enlarge his own enterprise.

11. J. David Rogers, "Theodore Judah and the Blazing of the First Transcontinental Railroad over the Sierra Nevadas," p. 16, http:// web.mst.edu/-rogersda/american%26"&military_history (accessed April 11, 2017).

12. *Sacramento City Directory* (Sacramento: D. S. Cutter & Co., 1859), front matter and pp. 15, 39. The entry for Floberg (p. 39) lists him as "Floberg, J. P., of F. & Co., 118 J street; s.; Germany." Preceding the title page an advertisement lists his partner as C. P. Brostrom, from Sweden (see also p. 15).

13. John Debo Galloway, *The First Transcontinental Railroad: Central Pacific, Union Pacific* (1950; New York: Dorset, 1989), pp. 52–93.

14. Rogers, "Theodore Judah and the Blazing of the First Transcontinental Railroad," p. 16.

15. "Death of James Bailey," *The Jewelers' Circular*, vol. 37 (August 24, 1898), p. 14; Necrology, *Hamilton Literary Magazine* (Clinton, NY), n.s., vol. 3, no. 3 (December 1898), p. 185; Railway Miscellany: Obituary, *The Railway Surgeon* (Chicago), vol. 5, no. 8 (September 6, 1898), p. 191.

Cat. 50

James Bailey
Teaspoon

1846–59
MARK: J·Bailey (in rectangle with incurvate corners, on reverse of handle; cat. 50–1)
INSCRIPTION: E.H.T. (engraved, on obverse of handle)
Length 5^{15}/$_{16}$ inches (15.1 cm)
Weight 10 dwt. 10 gr.
Gift of Dr. and Mrs. Anthony N. B. Garvan, 1988–67–1
PROVENANCE: Purchased by the donor in the Utica area in 1988.

Cat. 50-1

This spoon has an unrecorded mark, but it is a full name mark, the use of which seems to have been general in Utica. It is unclear, however, whether Bailey would have used his own mark when he was in partnership in Utica with his brothers, or whether this full-name mark dates to his time in Sacramento. Marks on a ladle made in Utica by James's brother Thomas employ capital letters in a rectangle with curved ends and pseudo-hallmarks.[1] This spoon is thin and flat, with the suggestion of a midrib on the obverse of the fiddle-style handle, also typical of Utica spoons.[2] Rounded "fins" at the base of the handle are a practical detail that strengthened the join to the bowl. BBG

1. For example, "T. BAILEY" in a rectangle; Barbara Franco, *Utica Silver*, exh. cat (Utica, NY: Munson-Williams-Proctor Institute, 1972), illus. p. 8.
2. Ibid., p. 5.

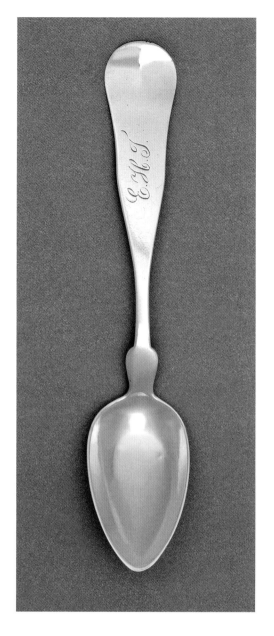

John Bailey

Yorkshire, England, born c. 1736
New York City, died 1815

John Bailey, born in Yorkshire, England, around 1736, was one of the enterprising and skilled craftsmen who set out to seek opportunity in America.[1] He had apprenticed in Sheffield to learn the art of cutlery and came to New York with his brother William (died 1832) at about age twenty. William subsequently settled in New Brunswick, Canada, in 1782, along with other Loyalists who left New York after the British vacated the city.

John Bailey joined with James Youle, also from Sheffield, in the metals trade at their shop in New York City's Battery from about 1755 to 1772, when, as Youle noted, the copartnership had been dissolved.[2] Having set themselves up in a building that Bailey constructed at the corner of Wall and Water streets, they advertised themselves as cutlers who made "all sorts of surgeon instruments, trusses, steel collars for children, irons for lame legs, and silversmiths tools. . . . They likewise have for sale Silk stockings, silver hafted knives, and forks, . . . taylors shears and thimbles . . . shoemakers knives of all sorts . . . carving gouges and chisels. . . . N. B. They give the greatest price for old gold, and silver lace, and old gold and silver."[3] Besides doing general metalwork, both of them made swords. In the course of his lifetime, Bailey worked in most metals, including brass, iron, and silver, in response to market demands.

In May 1772 Bailey married Anne Brickstock. They had at least three children, Harriott (Mrs. Peter Mabie), Charlotte (Mrs. James Dobbin), and James S. Bailey, who succeeded his father in business. Bailey's New York shop was damaged when the British fired on the city in August 1775, after which he, like many others, moved his household, including his wife, their first child, and two black servants to Fishkill, New York, one of the largest villages in Dutchess County.[4] Having settled his family in a house in the village, he returned to New York to close his shop and carry furnishings to Fishkill, only to discover that in his absence his clerk had sold the property and goods and absconded. When he returned to Fishkill he purchased a two-hundred-acre farm, which he managed until the war escalated.[5]

In 1776 the Committee of Safety and the New York Treasury moved to Fishkill, where the American army under General George Washington was stationed, necessitating the establishment of an armory.[6] Bailey was active at the armory at Fishkill and had his own workshop in nearby Fredericksburg.[7] In 1778 he advertised in New York for metalworkers of all types at his Fishkill location.[8]

Bailey was fully occupied in his craft as a cutler and sword maker at Fishkill. It has been estimated that he made between four hundred and a thousand swords during his tenure there. He tanned his own leather for the scabbards, and his wife sewed them. Around 1780 Bailey made a handsome silver-mounted sword for Isaac Roosevelt (1726–1794) that had a lion-head pommel and a steel blade etched with "Dutch"-style flowers.[9] Also in Fishkill he made George Washington's hunting sword, worn in one of his portraits by Charles Willson Peale and carried by Washington throughout the Revolutionary War.[10]

Bailey moved back to New York with his family in 1785 and purchased property on Dock Street.[11] He rejoined his former partner James Youle, who remained active in 1794 and specialized in making dog-head sword handles. Bailey was a member of the General Society of Mechanics and Tradesmen in New York in 1786, but not of the Gold and Silversmiths Society, of which Myer Myers (q.v.) was chairman. The New York City directory for 1787 lists him at 22 Queen Street as a cutler and brass founder. By 1790 Bailey was casting bells in his established brass foundry at 20 Little Dock Street, working with George Hedderly from England.[12] His foundry produced tall, stylish andirons, some of which he engraved with patriotic symbols, and tools to match.[13] Bailey wrote to George Washington in April 1790 offering his services over those of Matthew Boulton in England for producing copper coinage for the new American government: "I am acquainted with the whole mystery of Coining in gold in silver in Copper or in Billon . . . and I have at this moment in my possession as complete an apparatus for coining as was as yet ever used in any part of Europe that I am acquainted with."[14] A handsome, engraved billhead of Bailey's, in which he identified himself as "Brass Founder, Copper, Smith and Ironmonger," is dated by his hand November 5, 1792, where he corrects 20 Little Dock Street to 60 Water Street (fig. 38).[15]

At this juncture Bailey seems to have been retailing silver. In 1797 he bought dozens of spoons, soup ladles, and tongs from the silversmith Teunis DuBois, located at 90 John Street.[16] Bailey was also importing silver and other merchandise. He advertised in New York's *Commercial Advertiser* on November 19, 1798—still listing his address as 60 Water Street: "He also imported by the latest arrivals an elegant assortment of the most fashionable patterns in the plated line viz. Tea and Coffee Urns, Pots, Cram Juggs, Cruet Frames, Tea and Table Candlesticks, Bread Baskets, etc., together with every other article in the Ironmongery and Hardware Line as usual."[17] Sometime after 1798 Bailey must have moved to Maiden Lane. In 1801 "John Baly Maden Lane" purchased from Teunis Du Bois "45 dozen spoons, tea, table and

Fig. 38. Invoice of John Bailey for andirons, November 5, 1792. Courtesy of the Winterthur Library, Delaware. Joseph Downs Collection of Manuscripts and Printed Ephemera, col. 774, 65x668

dessert," and in 1804 "John Baly, 27 Maden Lane" bought "tea spoons, 2 caddy ladels, and tongs."[18]

John Bailey died in New York on January 22, 1815. His obituary noted that he had "grown venerable in the esteem of his friends, neighbors, and acquaintances, after a long and well spent life."[19]

BBG

1. The primary source for Bailey's biography is Isaac J. Greenwood, "Memoirs of John Bailey and the War-Sword of George Washington," paper presented to the New-York Historical Society, May 3, 1864 (unpublished manuscript); later published in brief as Greenwood 1887. Greenwood had met with Charlotte, one of Bailey's daughters, from whom he gathered biographical facts. Further sources of biographical information, unless otherwise noted, are Kauffman and Bowers 1974, pp. 122–30; and Harold L. Peterson, *American Silver Mounted Swords, 1700–1815: A Catalog of an Exhibition Held at the Corcoran Gallery of Art* (Washington, DC: privately printed, 1955), pp. 23, 55.

2. *New York Gazette and Weekly Mercury*, May 25, 1772.

3. Ibid., May 25, 1772; see also Kauffman and Bowers 1974, p. 122.

4. "Historical Sketch of Fishkill Village," in Henry D. B. Bailey, *Local Tales and Historical Sketches* (Fishkill Landing, NY: John W. Spaight, 1874), pp. 357–58; Greenwood 1887, pp. 2, 6.

5. Greenwood 1887, p. 3; Hartzler 2000, pp. 137–38.

6. Hartzler 2000, p. 238.

7. Kauffmann and Bowers 1974, pp. 124–25. John Bailey, metalworker, is not to be confused with another John N. Bailey (born 1704), a miller-farmer in Fishkill; Bailey, *Local Tales and Historical Sketches*, pp. 349–57. There are John Bailys in the Rombout/Fishkill tax lists from 1730 through 1779 for the periods 1765–75 and 1777–79; "Eighteenth Century Records of the portion of Dutchess County, New York, That Was Included in the Rombout Precinct and the Original Town of Fishkill," collected by William Willis Reese and ed. Helen Wilkerson Reynolds, from *Collections of the Dutchess County Historical Society*, vol. 6, 1938, www.relativelyconnected.com/drake/research-notes/Rombout-Tax-Records.pdf (accessed April 12, 2017). Coincidentally, Philadelphia also had a prominent John Bailey, a whitesmith, who was contemporary with New York's John Bailey and active at 250 South Front Street, Philadelphia, from 1761 to about 1800; he died in 1813.

8. Kauffman and Bowers 1974, pp. 124–25.

9. Fred J. Peters, *Isaac Roosevelt, 1726–1794: Soldier, Statesman, Citizen of New York: A Short Genealogical Record of the Roosevelts from 1649 to 1934 and Notes in Reference to John Bailey Sword Maker* (New York: privately printed, 1934).

10. Washington's sword is in the collections of the Smithsonian Institution, Washington, DC; Peterson 1954, pp. 213–15, cat. 174 .

11. New York City directory 1786, pp. 69, 77.

12. Kauffmann and Bowers 1974, p. 127. In 1789 the New York City directory lists him at 20 Little Dock Street.

13. See, for example, the pair of andirons in Clement E. Conger, Mary K. Itsell, and Alexandra W. Rollins, eds., *Treasures of State: Fine and Decorative Arts in the Diplomatic Reception Rooms of the U.S. Department of State* (New York: Abrams, 1991), pp. 368–69, cat. 236 (text by Beatrice B. Garvan). For Bailey's career as a founder and the change of his shop's street number and then name, see Kauffman and Bowers 1974, pp. 126–28.

14. John Bailey to George Washington, April 17, 1790, Founders Online, s.v. "George Washington," www.founders.archives.gov.

15. See Kauffman and Bowers 1974, illus. p. 126 (where it is dated 1790).

16. DuBois, Daybook, 1797–1823, Schanck Family Papers, 1741–1906, Monmouth County Historical Association, Freehold, NJ.

17. Quoted in Kauffman and Bowers 1974, p. 128.

18. DuBois, Daybook, 1797–1823. DuBois's account with John Bailey continued over thirteen years; Christine Wallace Laidlaw, "Silver by the Dozen: The Wholesale Business of Teunis D. DuBois," *Winterthur Portfolio*, vol. 23, no. 1 (Spring 1988), pp. 35, 36, 39.

19. Greenwood 1887, p. 6.

Cat. 51

John Bailey

Hunting Sword and Scabbard with Silver Mounts

1778

MARKS: 7 (at lower edge of silver midband of scabbard); [profile head] A N [profile head] D R [profile head] E A [profile head] (on obverse of steel blade); [profile head] F A [profile head] R A [profile head] R A [profile head] (on reverse of steel blade)

INSCRIPTIONS: J, Bailey, Fecit / Fredericksburgh (engraved script, on one side of silver band at top of scabbard; cat. 51 - 1); J, De Lamater (engraved script, on obverse of silver band at top of scabbard; cat. 51 - 2)

Length 31⅛ inches (79.1 cm), length blade 24¾ inches (62.9 cm), width guard 2⅛ inches (5.4 cm)

Gift of Walter M. Jeffords, 1958 - 115 - 4a–c

PROVENANCE: Made for Jacob De La Mater (1762–1828), a young lieutenant in the Fourth Regiment of the Ulster County Militia during the Revolutionary War.

In July 1776 British troops and a fleet under the command of General Sir William Howe and Admiral Richard Howe occupied Staten Island and New York City, headquartering there in 1777. The Americans believed that the British would next turn their attention toward New England, so General George Washington moved his army, establishing headquarters at Fredericksburgh (now Patterson) and Fishkill, New York, to protect the upper Hudson River passage and prevent the British from reaching New England.[1] John Bailey, by then actively manufacturing arms for the colonial troops, left his shop in New York City to set up in Fredericksburgh and later Fishkill.[2]

Bailey made similar silver-handled swords with lion-head pommels and ivory grips, some tinted green, for Isaac Roosevelt (in 1775–77), Captain John I. Roosevelt, Francis Dana (in 1777), Henry O'Hara of the Delaware Militia, and George Washington (in 1778), the latter with a cushion-shaped pommel inscribed "Fishkill."[3] The present sword is most like the one he made for Dana.[4] The lion-head pommel with a green-dyed, twisted ivory grip was used by other silversmiths in New York and New England and was derived from a traditional British design (cat. 51-3). Despite the political implications of the royal lion, this form of dress sword was made and used before, during, and after the Revolutionary War.[5]

A hunting sword that Bailey made for a Lieutenant John Finch has a scabbard almost identical to this one, employing the same black-dyed leather with a silver "throat" inscribed "J. Bailey" in script above "Verplanck's Point" in upper- and lowercase Roman letters. The midband with scalloped outline is also from the same pattern.[6]

The details of Bailey's scabbards are traditionally thought to have been made by his wife. The details of the metalwork on his swords vary. The shaped edges of the silver bands differ, as does the modeling of the lions' heads, guards, and handles, suggesting that these parts were made in Bailey's own shop by silversmiths he employed for the purpose. On

Cat. 51-1

Cat. 51-2

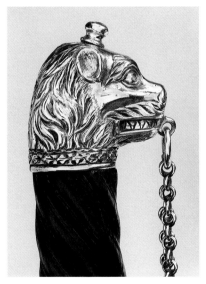

Cat. 51-3

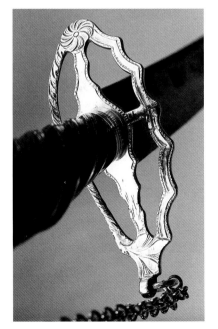

Cat. 51-4

this pommel the hair of the lion's mane has a pattern that is more swirling and a collar with a cross-hatched design that is more deeply engraved than those on some other examples by Bailey. The green-tinted ivory grip has an especially lively design of twisting spirals and a "floating" guard that is pierced and chased (cat. 51-4). The edge of the guard on the side worn away from the leg is scalloped, while that worn next to the leg is smooth. The silver mount at the top of the scabbard has a decorative drop below the finely engraved owner's name. The silver double chain attached to the pommel and the guard, whose fine links intersect at right angles, is exactly like those on other swords by Bailey and was certainly made by him. But the steel belt hook and hanging rings were probably pre–Revolutionary War imports from an English factory at Birmingham or Sheffield and may not be original to this sword.

The steel blade is marked "ANDREA FARARA." Stamped between each of the letters is a king's head in profile with long hair under a soft-crowned, fur-brimmed hat, facing left. The blade appears to be original to this hilt, although the fit is not precise. It is slightly longer than the scabbard, which has been repaired and is missing its silver tip. Bailey used at least one other "FERARA" blade for a sword with a scabbard inscribed "J. Bailey / N·YORK."[7] Blades marked "ANDREA FERARA" (with spelling variations) and stamped marks of quarter-moons, stars, and king's heads are attached to hilts of seventeenth-century European, English, and Scottish swords, many of which must have come to America in the earliest period of settlement.[8] It is likely that in making this sword Bailey remounted an old blade, as steel of this quality and strength was not produced in America until the 1830s.[9]

Jacob De La Mater was born in Amenia, Dutchess County, New York, son of Johannes and Maria Kipp De La Mater and twin brother of Benjamin. The sword may have been made for him in February 1778, when the Fourth Regiment of the Ulster County Militia was reorganized and he became a major; or perhaps just before October 13, 1778, when Washington and his troops, still at Fredericksburgh, celebrated the anniversary of the surrender of General John Burgoyne to the Americans under General Horatio Gates. It was an occasion demanding dress uniform, which included swords such as this one. In 1786 Jacob De La Mater married Elizabeth Dorr at Lynn, Massachusetts. He was a wealthy farmer in Duanesburgh, Schenectady County, New York, before moving to Florida, Montgomery County, New York. His widow died in Lockport, New York, in 1850.[10] BBG

1. "Historical Notes of Dr. Benjamin Rush, 1777," *PMHB*, vol. 27, no. 2 (1903), p. 146.
2. On May 14, 1778, Bailey placed advertisements in the *New York Packet, and The American Advertiser* stating that he was moving from Fredericksburgh to Fishkill and was looking for skilled metalworkers, silversmiths, and cutlers at that location; Kauffman and Bowers 1974, pp. 124–25.
3. The Roosevelt sword is undated, but its elaborately engraved blade with scrolling foliage and tulips suggests it was made by Bailey when he was still working at his shop in New York, before the British occupation. The guard is stamped with the maker's mark, "BAILEY" in script, and the lip is engraved with the owner's name, the maker's signature, and "N.YORK." Roosevelt was a member of the New York Committee of Safety in 1775. The sword is illustrated in Sotheby's, New York, *Important American Furniture, Folk Art, Folk Paintings, and Silver*, October 22, 1988, sale 5755, lot 85. Another sword with an elaborate hanger and inscribed "J. Bailey. Fecit / N. York" is illustrated in E. Andrew Mowbray, *The American Eagle-Pommel Sword: The Early Years, 1793–1830* (Lincoln, RI: Man at Arms Magazine, 1988), p. 44, fig. 24. For Washington's sword, see Edgar P. Richardson, Brooke Hindle, and Lillian B. Miller, *Charles Willson Peale and His World* (New York: Abrams, 1983), pp. 44–45, cat. 11, and pp. 56–57, cat. 26. Peale updated military insignia and accoutrements in his many portraits of Washington. The swords in earlier and later portraits of Washington have different pommels and hand guards. For O'Hara's sword, see Hartzler 2000, p. 19, fig. 27.
4. This sword is in the collections of the Massachusetts Historical Society, Boston. The Dana pommel is illustrated in Fales 1970, cat. 193. For another Ferara blade on a Bailey sword, see Hartzler 2000, p. 149, fig. 250.
5. For illustrations of similar chains and hooks, see A. Hyatt Mayor, "Mail Orders in the Eighteenth Century," *Antiques*, vol. 108, no. 4 (October 1975), pp. 756–63.
6. This hunting sword of Lieutenant Finch is on exhibit at Washington's Headquarters State Historic Site, Newburgh, NY.
7. This sword measures 33½ inches in overall length; the blade measures 28½ inches. The pommel is a dog's head rather than a lion's, but the grip is spiral and tinted green, like that of the present example by Bailey. See *Edge Weapons and Firearms in the Collection of Eugene S. Jones* ([s.l.]: privately printed, 1986), p. 15, no. 33, pls. 27, 27A.
8. Leonid Tarassuk, "The Collection of Arms and Armour in the State Hermitage, Leningrad," *Journal of the Arms and Armour Society* (London), vol. 3, no. 1 (March 1959), pp. 1–39; Lloyd Cabot Briggs, "European Blades in Tuareg Swords and Daggers," *Journal of the Arms and Armour Society*, vol. 5, no. 2 (June 1965), pp. 40, 41, 78–79. The latter includes a discussion of Andrea Ferrara and various markings used on blades stamped with this name. Who he was and where he worked are still unknown; "Ferrara" may also designate a region of production, Solingen or northern Italy. See also Edward Perry, "Notes on the 1966 Northern Branch Exhibition," *Journal of the Arms and Armour Society*, vol. 5, no. 8 (December 1966), p. 331, pl. 79; pl. 79A illustrates a blade stamped "ANDREA FARARA" and impressed with a design of "four kings' heads" in profile facing left on an eighteenth-century Scottish basket-hilted broadsword.
9. Daniel D. Hartzler, *Arms Makers of Maryland* (York, PA: George K. Shumway, 1977), pp. 79–82.
10. Genealogical notes by Stephen Ensko, New York City, 1958, curatorial files, AA, PMA.

Thomas W. Baily

| Philadelphia, born 1821
| Philadelphia, died 1893

Thomas W. Baily was born in Philadelphia in 1821, son of William Baily (1792–1857), a clock and watchmaker, and his wife Catherine (1791–1875).[1] Thomas may have trained with his father, although his subsequent career indicates that he worked as a retail jeweler rather than as a craftsman. In his first directory listing, in 1848, he was described as a merchant at his father's shop at 216 High (Market) Street.[2] Between 1852 and 1857 the business was named "W. Baily & Son, jewellers," with William identified as a watchmaker and Thomas as a merchant.[3] In 1857 Thomas, still listed as a merchant, established an independent shop at 622 Market Street.[4] His father died that same year, leaving a substantial estate; according to the U.S. census of 1860, Catherine Baily owned real estate and personal property valued at $50,000; she was subsequently listed in city directories as "gentlewoman."[5]

In 1851 Bailey married Hannah Foulke (1829–1884) at the Episcopal Church of the Advent on York Avenue (now North Fifth Street) at Buttonwood Street.[6] She was the daughter of the physician Antrim Foulke (1793–1861) and Letitia Lancaster (1799–1877) of Philadelphia.[7] The marriage provided Baily with additional financial security, as in 1860 Foulke owned real estate valued at $20,000 and personal property worth $5,000.[8] In the first years of their marriage, Bailey and his wife lived at lived 358 Green Street; in 1856 they moved to 291 North Eleventh Street.[9] The U.S. census of 1860 listed the Baileys as living with her parents at 541 North Seventh Street. Antrim Foulke died the following year, and the Bailys remained in the house on North Seventh for the rest of their lives. In 1860 the household also included Baily's thirteen-year-old nephew and namesake, Thomas Baily Goodall (1846–1870), for whom Baily apparently served as guardian. At the time Goodall's older brother, William Baily Goodall (1845–1906), was living with Baily's widowed mother.[10]

Beginning in 1861, Baily was listed as a jeweler in city directories, although in 1864, when he posted surety bond for an ordnance contract between the War Department and the iron founders Savery &

Company, he described himself as a merchant.[11] In this same document he affirmed that "the value of his property, over and above all debts and liabilities . . . is over thirty-one hundred dollars." Between 1863 and 1869 his shop was located first at 914 Chestnut Street and subsequently at number 922, adjacent to the city's "Jewelers' Row." In September 1870 Baily advertised the return of his "old-established WATCH AND JEWELRY STORE" to its original location at 622 Market, with a stock of "American and Imported Watches, Diamonds, and fine Gold Jewelry and Silver Ware."[12] Baily's subsequent advertisements touted his reasonable prices, calling his jewelry a "good investment if purchased at the low prices offered."[13]

Thomas and William Goodall may have apprenticed with their uncle or worked in his shop. In 1870, when he died, Thomas was described as a clerk and William as a salesman at Baily's shop.[14] William was first listed as a jeweler in 1871 and took over the firm, given as "W. Baily Goodall, watches," at 620 Market Street, in 1877 when Baily retired.[15] City directories from 1878 onward list Baily's name with no profession, and he was recorded as "retired jeweler" in the U.S. census of 1880. Hannah Foulke Baily died in 1884, and four years later Thomas Baily married Emma A. Glascoe, who in 1880 had been living at 839 North Seventh Street.[16] He died at the age of seventy-two on December 29, 1893, and was buried in Laurel Hill Cemetery in Philadelphia.[17] Baily's substantial estate, consisting primarily of real estate, mortgages, stock shares, and bonds, was valued at $33,631.40; his will divided the income from these holdings between his widow and his sister Ellen Baily Barrows (died 1910), who were named executrices.[18] DLB

1. Howard M. Jenkins, *Historical Collections Relating to Gwynedd*, 2nd ed. (Philadelphia: privately printed, 1897), p. 273. William Baily's burial record of April 1857 gave his age as sixty-five, and Catherine Baily's burial record of December 27, 1875, gave her age as eighty-four years and four months; Philadelphia Death Certificates Index, 1803–1915, Ancestry.com.

2. Philadelphia directory 1848, p. 13.

3. Ibid. 1852, p. 16; 1853, p. 15; 1854, p. 18; 1855, p. 19; 1856, p. 21.

4. Ibid. 1858, p. 23.

5. Ibid. 1863, p. 54.

6. Church of the Advent, Philadelphia, "Vol. 1, Births, Marriages, and Burials, 1841–1876," p. 225, HSP.

7. Jenkins, *Historical Collections*, pp. 272–73.

8. 1860 U.S. Census.

9. Philadelphia directory 1853, p. 14; 1857, p. 23.

10. 1860 U.S. Census. Birth dates for Thomas and William Goodall were recorded by the Church of the Advent (see note 1).

11. Philadelphia directory 1861, p. 31; *Executive Documents Printed by Order of the House of Representatives during the Second Session of the Fortieth Congress, 1867–'68* (Washington, DC: Government Printing Office, 1868), vol. 12, p. 586.

12. Philadelphia directory 1864, p. 24; 1870, p. 172. *Daily Evening Telegraph* (Philadelphia), September 7, 1870. The advertisement continued in this newspaper every few days until October 1.

13. *Public Ledger* (Philadelphia), November 4, 1871.

14. Thomas B. Goodall, January 19, 1870, Philadelphia Death Certificates Index, 1803–1915; Philadelphia directory 1870, p. 632.

15. Philadelphia directory 1871, p. 609; 1878, p. 615. William Goodall either moved next door to the old shop or the street was renumbered, as occurred multiple times in Philadelphia in the nineteenth century. He continued working as a jeweler until about 1902.

16. Marriage license 21564, Clerk of the Orphans Court, Philadelphia; Philadelphia Marriage Index, 1885–1951, Ancestry.com.

17. Thomas W. Baily, January 1, 1894, Philadelphia Death Certificates Index, 1803–1915; Burial Register, Laurel Hill Cemetery, Philadelphia, Ancestry.com.

18. Philadelphia Will Book 170, no. 116 (1894).

Cat. 52
Thomas W. Baily
Tablespoon

1857–63 or 1870–77
MARKS: T.W.BAILY 622 MARKET ST.PHILA. (incuse, on back of handle; cat. 52-1)
INSCRIPTION: H M R (engraved script monogram, lengthwise on front of handle)
Length 8 13/16 inches (22.4 cm)
Weight 1 oz. 15 dwt. 3 gr.
Gift of Charlene D. Sussel, 2009-155-32

PROVENANCE: From the stock of the Philadelphia antiques dealer Eugene Sussel (1913–1989), the donor's husband.

Cat. 52-1

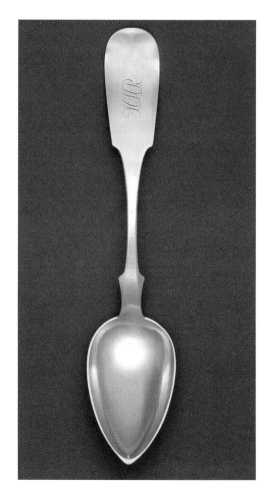

Ball, Black & Co.

| New York, 1851–74

This well-known, sophisticated New York City firm, founded by Henry Ball (1811–c. 1884) and William Black (active 1839–52), was active from 1851 until 1874. It had a huge business in silver, gold, and jewelry in New York[1] and retailed products from the independent jewelers Garrett Eoff and William Gale (q.q.v.) and from John R. Wendt (q.v.), the latter becoming the principal supplier after 1861. Originating in 1819, the firm traced its development through a series of partnerships from Erastus Barton & Co. to Marquand & Co. in 1830, to Ball, Tompkins & Black, at 247 Broadway in 1839 and at 181 Broadway in 1842.[2] When Erastus Osborne Tompkins (born 1811) died in 1851, the firm's name was changed to Ball, Black & Co.[3] In 1874 Henry Ball left the company, and Black was joined by Cortlandt Starr (c. 1832–1888) and the jeweler Aaron Vail Frost (born 1830),[4] creating the firm Black, Starr & Frost, which remained in business until 1908.[5]

Ball, Black & Co. made a significant competitive move about 1858, when it changed the formula of the silver it used from the British sterling standard of 925/1000 to 950/1000, then popular in France.[6] In 1860, when the firm moved to 565–567 Broadway, at the corner of Prince Street, John R. Wendt occupied the top floors, where he operated his silver manufactory, while the proprietors of Ball, Black & Co. placed their emphasis on presentation. The Prince of Wales visited in 1860, and the building was featured in guidebooks as a marble palace with the largest French plate-glass windows in the city.[7] BBG

1. For a full account of this firm, see D. Albert Soeffing, "Ball, Black & Co. Silverware Merchants," *Silver Magazine*, vol. 30, no. 6 (November/December 1998), pp. 44–49; Waters, McKinsey, and Ward 2000, pp. 450–52.

2. Doggett's New York City directory 1842–1843, p. 22 ("Ball Henry, jeweller, 181 Broadway, h. 93 Prince"); p. 35 ("Black William, jeweller, 180 Broadway, h. 190 Madison Ave"); p. 318 ("Tompkins, Erastus O., jeweller, 181 B'dway, h. Bklyn.").

3. Erastus Osborne Tompkins was born in Southbury, Connecticut, and married Mary P. M. Marquand on July 7, 1836; Connecticut Deaths and Burials, 1772–1934, Index (Salt Lake City: Family Search, 2009, 2010), Ancestry.com.

4. Obituary of Cortlandt W. Starr, *New York Times*, October 2, 1888;

1900 U.S. Census (Aaron Vail Frost).

5. Rainwater and Redfield 1998, p. 49.

6. Soeffing, "Ball, Black & Co. Silverware Merchants," pp. 46–47.

7. William L. Stone, *History of New York City from the Discovery to the Present Day* (New York: E. Cleave, 1868), quoted in ibid., p. 47n1.

Cat. 53
Ball, Black & Co.
Egg Coddler

c. 1853

MARKS: BALL.BLACK & CO (incuse, on underside of boiler; cat. 53-1); ET (in rectangle, on exterior of boiler near rim, on undersides of both cover flaps, on handle, on base, and on one ring of egg holder)

INSCRIPTIONS: J T K / 1853 (engraved script monogram, on one side); W E or E W / 1929 (engraved, on opposite side); 257 (scratched, on underside); 476 (scratched, on underside)

Height 11⅜ inches (28.9 cm), width 6⅝ inches (16.8 cm), diam. 4½ inches (11.4 cm)

Gross weight 28 oz. 13 dwt. 5 gr.

Purchased with funds contributed by Boyd Lee Spahr III and C. Stewart W. Spahr, 2002-169-1a,b

PROVENANCE: North Hill Antiques, Suffern, New York.

This showy device, designed to boil eggs at table, may have been designed by George Wilkinson, an English-trained designer familiar with English fashion, or possibly by John R. Wendt (q.v.). Both were working for Ball, Black & Co.[1] Originally the egg coddler probably had a matching stand with a burner to keep the water at boiling point. The cover of the boiler opens with two flaps, allowing the frame, which holds six eggs, and its tall handle to be inserted or removed. The ribbonlike top handle twists to form a frame for the glass timer filled with fine sand. One flip of the timer equals four and a half minutes.

The engraved dates appear to be original with each set of unidentified initials. At some point this egg coddler was imported into France, as it was struck multiple times with the "ET" mark for silver of foreign origin. BBG

1. D. Albert Soeffing, "Ball, Black & Co. Silverware Merchants," *Silver Magazine*, vol. 30, no. 6 (November/December 1998), pp. 44–49.

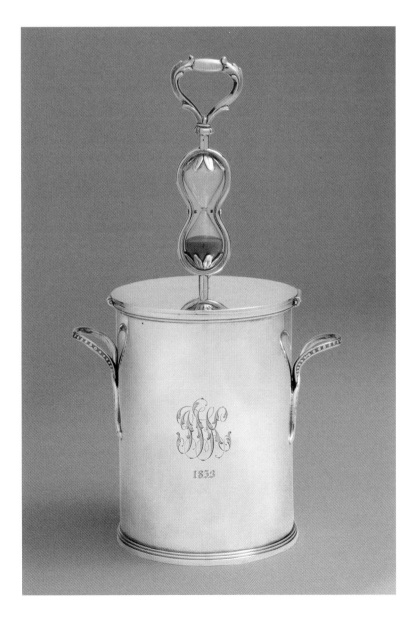

John Ball

Concord, Massachusetts, 1724
Location unrecorded, after 1781

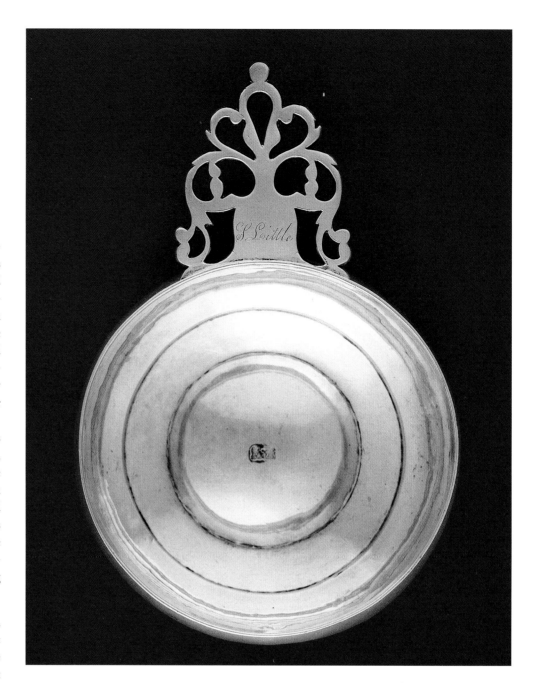

John Ball was born in Concord, Massachusetts, on February 8, 1724.[1] He was the son of Jonathan Ball (born 1691) and Hannah Clarke (born 1691), who married in 1713. John Ball probably apprenticed with Jacob Hurd (q.v.) in Boston from 1737 to 1745. He was working in Boston in 1746, when he married Sarah Brooks (1724–1780) of Concord. Two children were born to them in Boston. By 1752 they had moved back to his hometown, where their daughter Elizabeth was born.

In 1761 John Ball Jr. purchased six-plus acres of land with buildings, including a brick shop, from his father, who in 1759 had mortgaged the property to the Boston silversmith William Homes Sr., who does not seem to have occupied the property himself. In a series of transactions from 1763 to 1773, John Ball Jr. sold parcels of the land, and mortgaged whole and parts of the buildings, probably to carry his debts. The following notice, for example, was dated April 14, 1767:

> To be sold at Public Vendue, / By John Ball of Concord, Goldsmith, on Wednesday the 6th day of May next, at 3 o'clock in the afternoon, at said Ball's dwelling-house in said town, for cash or good security—About six acres of land situate in said town, in two pieces, opposite each other, both fronting the country road, within about 20 rods of the meeting-house, with the one half of a large dwelling-house, a very good cellar, and a back kitchen, a brick shop, good barn, corn barn, and other buildings standing thereon, with a very good well. Said land consists of orcharding, tillage and a good garden; a superior situation for a gentleman of almost any kind of trade, or trading business.[2]

He may have relinquished full title in 1773. Nothing is known of John Ball after 1781. BBG

1. The facts here have been drawn from Kane 1998, pp. 166–69, 580.
2. *Boston Gazette*, supp., April 27, 1767.

Cat. 54
John Ball
Porringer

1761–65

MARK: JOHN / BALL. (in shaped cartouche, on underside of bowl; cat. 54-1)[1]

INSCRIPTIONS: S Little (engraved script, on obverse of handle); oz d gs / 8 – 18 = 12 (scratched script, on underside of bowl)

Length 7^{15}/16 inches (20.2 cm),
diam. 5½ inches (14 cm)

Weight 8 oz. 4 dwt. 7 gr.

Gift of Sol M. Flock, 1969-200-2

PUBLISHED: Kane 1998, p. 168.

This is one of two porringers known to have been made by John Ball. The pattern of the pierced handle, the cartouche shape of the maker's mark, and the tradition of the weight scratched on the

Cat. 54-1

underside are very similar to what is found on a porringer by Benjamin Burt (q.v.) of Boston.[2]

The engraved "S Little" appears to be in a script later than the accepted date for the porringer. There were several generations of the name Little in Massachusetts at the time John Ball was active. BBG

1. See Buhler and Hood 1970, vol. 1, p. 167, pl. 214. The mark on this porringer is illustrated in Kane 1998, p. 166, as mark "B."
2. Ibid.

William Ball

England, born 1763
Baltimore, died 1815

The silversmith William Ball of Baltimore was born in England in 1763 to William and Rebecca Ball.[1] He has long been confused with the silversmith William Ball of Philadelphia (q.v.) because of the similarity of their marks, but there does not seem to have been a family relationship between the two.

A record of apprenticeship has not yet turned up for Baltimore's William Ball, but his later association with George Dowig (q.v.), who moved to Baltimore in 1784 after working in Philadelphia for many years, suggests a possibility. Ball was then twenty-one, an age when he would have just finished an apprenticeship, perhaps with Dowig, whom he may have followed to Baltimore. In 1785 Ball joined Israel H. Johnson as a junior partner in Johnson & Ball in Baltimore, where he remained until the partnership was dissolved in 1790.[2]

On October 8, 1790, Ball placed an advertisement in the *Maryland Journal and Baltimore Advertiser* that he had "removed his Shop to the House formerly occupied by Messrs. Abraham Usher and Co. opposite Mr. William Wilson's Boot and Shoe Manufactory on the North Side of Market-Street, a few Doors below Calvert-Street." Shortly thereafter, on October 21, he married Elizabeth Dukehart (1771–1833), daughter of Henry and Margaret Dukehart of Baltimore.[3]

The U.S. census of 1790 for the city of Baltimore lists William Ball's household as consisting of four males over the age of sixteen, two under sixteen, one free female, and no other persons or slaves. Ball was then twenty-seven and had moved to larger quarters, as was customary. These premises were at 60 Market Street, which became his permanent location until his death in 1815. He must have had journeymen and possibly two apprentices residing with him. In May 1793 he advertised:

> BALL, WILLIAM.—Gold and Silversmith, At the Sign of the Golden Urn . . . has Removed from his shop in Market-street, between South and Calvert Streets, to the house lately occupied by Mr. George Dowig, in Market-street, seven doors above the Branch Bank, and nearly opposite Tripolet's Alley, where he carries on his business in all its various branches, with neatness and dispatch, and has now on hand, an extensive assortment of Gold and Silver Ware, which he is determined to sell on the most reasonable terms. He returns his most grateful thanks to his friends, and customers for the generous encouragement he has experienced since his commencement in business. . . . He has Also For Sale, An assortment of Shoe and Knee Buckle Chapes, and Crucibles.[4]

In 1796 Ball added to this property, annexing the shop of a watchmaker next door at 62 Market Street.[5] His business had expanded, and the U.S. census of 1800 reveals a large household of fifteen people. The two males and two females under age ten were probably his own children. Also listed were four males between the ages of ten and fifteen, one male between sixteen and twenty-six, one male between twenty-six and forty-four (himself), one female between sixteen and twenty-five, one female between twenty-six and forty-four (his wife), one female age forty-five and over, two other free persons, and no slaves. The 1810 census reveals a change, William Ball having acquired three slaves. The total number of people in the household was still fifteen: four children under the age of ten, four males between sixteen and forty-four, one male age forty-five and over (himself), two females between ten and fifteen, one female between twenty-six and forty-four (his wife), and three slaves.

William Ball was a prolific silversmith, and there are many examples of his silver extant. These were fashioned largely in the neoclassical style of the late eighteenth century, and some have particularly fine engraving.[6] He was in a partnership with John S. Heald in Baltimore from 1811 to 1814 at Heald's shop at 60–63 Baltimore Street, at which time Ball was making a number of eagle-head pommels for swords.[7]

Ball and Heald advertised that they were manufacturers and dealers in silver plate.[8] In 1814 Baltimore instituted an assay office, with the result that Baltimore silver became more expensive than silver from Pennsylvania or Virginia, and Baltimore silversmiths subsequently suffered from competition with silversmiths in these neighboring states.[9] Added to this was the devastation caused by the British attack on Baltimore in the War of 1812.

William Ball died on June 2, 1815, and was buried in the Asquith Street Quaker burial ground.[10] BBG

1. Ball 1993, p. 21.

2. Ball had submitted a notice on September 25, 1790, to the *Maryland Journal and Baltimore Advertiser* that appeared on October 8, 1790, announcing the dissolution of the partnership with Israel Johnson and urging anyone "indebted to the said Partnership . . . to make speedy Payment to the Subscriber." Goldsborough 1975, p. 67.

3. Silversmiths and Related Craftsmen, s.v. "William Ball," Ancestry.com; Goldsborough 1975, p. 67.

4. *Baltimore Daily Repository*, May 13, 1793. George Dowig had announced his retirement in 1789 but was still selling out his stock and tools in 1790.

5. Goldsborough 1983, p. 72.

6. Ibid., pp. 72–74, cats. 11–16.

7. Silversmiths and Related Craftsmen, s.v. "William Ball"; E. Andrew Mowbray, *The American Eagle-Pommel Sword: The Early Years, 1793–1830* (Lincoln, RI: Man at Arms Magazine, 1988), pp. 146–47.

8. Heald seems to have moved his business to Pittsburgh at this time; Belden 1980, p. 47.

9. Jennifer Goldsborough, "Silver in Maryland," *Antiques*, vol. 29, no. 1 (January 1984), p. 266.

10. Goldsborough 1975, p. 67, cat. 59.

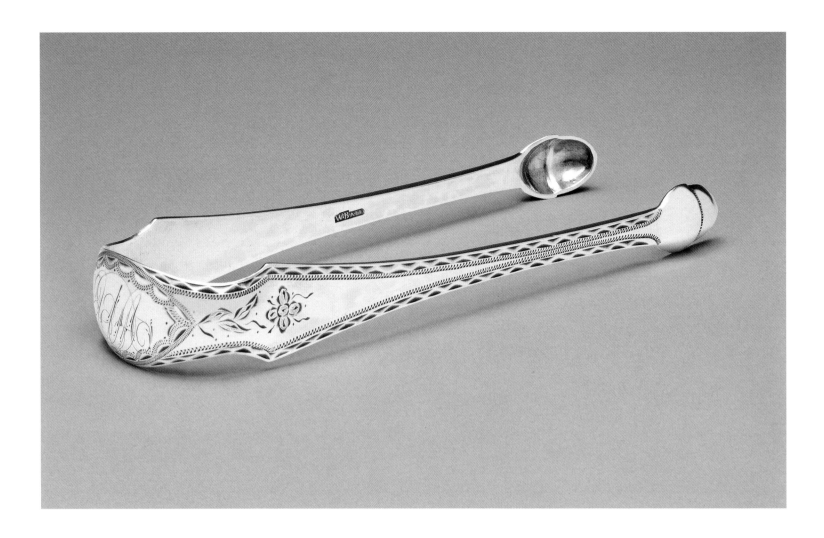

Cat. 55

William Ball
Sugar Tongs

1790–1810
MARK: W·BALL (in conforming rectangle, on inside of each arm; cat. 55-1)
INSCRIPTION: U D A (engraved script, at top of handle; cat. 55-2)
Length 6¾ inches (17.2 cm), top width 1⅞ inch (4.8 cm)
Weight 1 oz. 16 dwt. 11 gr.
Gift of Fenton L. B. Brown, 1991-143-11

Cat. 55-1

The attribution of these tongs to William Ball of Baltimore rather than to William Ball (q.v.) of Philadelphia, whose mark was similar, is based on details of the Baltimore maker's mark. The stems of the letters are thick, and there are distinct left- and right-foot serifs on the "A." There are serifs at the head and on the left and extended right foot of each "L." The pellet is lower in the Baltimore mark. This is the same mark illustrated by Jennifer Goldsborough but is slightly different than those illustrated by A. William Ball and by Louise Belden as that of William Ball of Baltimore.[1]

The edges of the tapering arms of these spring-action tongs are decorated with wriggle work and chasing, and are engraved with a bright-cut flower design at the top of each arm. The nippers, realistically modeled to resemble acorns, have a deeply chased, zigzag band on the obverse delineating the husk from the nut.

The intials "UDA," which are unidentified, were engraved after the bands of zigzag brightwork were done. They are in a freehand, linear style that appears often on Baltimore silver from 1780 to 1800.[2] BBG

1. Goldsborough 1975, illus. p. 67, mark B; Ball 1993, illus. p. 6; Belden 1980, illus. p. 47. The marks of the two silversmiths named William Ball, one in Philadelphia and the other in Baltimore, are compared and illustrated in Ball 1993, pp. 6, 18.
2. The order of the initials and thus the surname are difficult to determine. The largest letter "D" is centered and intertwined with the "U" and the "A." For other examples of the Baltimore freehand style, see Goldsborough 1975, pp. 37, 45, 53, 54, 59, 64.

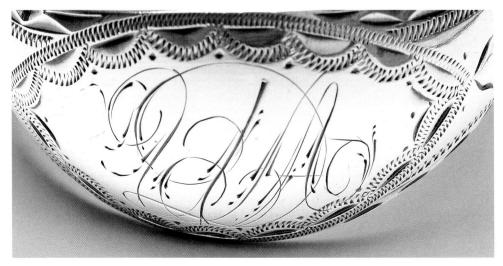

Cat. 55-2

William Ball

Philadelphia, born 1729
Philadelphia, died 1810

William Ball was a merchant and silversmith in Philadelphia, practicing both occupations simultaneously with great success throughout his life. His grandfather and his father, both also named William, gave him a running start. William Ball's grandfather left Devonshire, England, with his family and settled near Philadelphia about 1692, when the city was only ten years old. His enterprise was farming. In 1728 his son William senior (1686–1740) bought a house and an 840-acre property he named Hope Farm, a property bounded by Gunner's Run and the Delaware River, just north of the city in what was then Northern Liberties Township.[1] The land was rich, with deep-water access on the Delaware. It was an important property in the early settlement period and sustained the family's fortunes into the late nineteenth century. An advertisement that the silversmith William Ball Jr. placed in a Philadelphia newspaper in May 1770 offered a full description:

> To Be Sold or Let, On ground-rent forever, with Liberty to purchase off, One hundred lots of fine building ground, well situated on the river Delaware, near the city of Philadelphia, and adjoining Kensington. The nearness of these lots to said river and city, will always provide industrious people for any number of houses that may be built. The water is deep and convenient for large ships; the ground a fine garden mould, dry and healthy, and commands as fine a prospect as any in America. Several people having already engaged lots, with intent to build on, others that intend to have any, are desired to be speedy in their applications, as those that apply first will have the first choice of the situation. The title is good and indisputable.[2]

Toward the end of his life, William senior combined farming with running a city shop located on the east side of Front Street between Market and Chestnut, another property handed down to William junior. Neighboring landowners in the country, the Foxes, Norrises, Warners, and others, also owned property in the city and were among the leaders of social and political life there, along with Ball, who was an original member of the elite Schuylkill Fishing Company, founded in 1732.[3] He and his wife, Mary White Ball, who was from Newport, Rhode Island, had six children; William junior was the oldest.[4] In 1738 Mary's sister Elizabeth and her husband Thomas Byles, a pewterer, moved from New England to Philadelphia and settled on Market Street. From the time of their arrival, they were closely associated with William senior's silver shop.[5]

Before 1744 Mary Ball had moved to Arch Street in the city proper. She advertised Hope Farm for let and planned a public sale of all the livestock.[6] But the family retained ownership, and the land on the Delaware remained a tax obligation for the family through the eighteenth century. In 1767 William junior lived in the city in the Chestnut Ward, when he was taxed as "single / two negros / 200 acres, dwelling and plantation at one hundred pounds / 5 horses, 16 cattle, 2 servants, 3 negros."[7] In 1780 the harvests of the field and meadow on the property in the Northern Liberties, although these were not in constant use, were valued at $552,000 with a tax of $1,242, only outdone by the assets of Abel James, which were valued at $640,000 but with a lesser tax of $1,200—evidence of inflation after the Revolutionary War but also of the quality of Ball's productive land.[8] When George Washington was in residence in Philadelphia between 1795 and 1797, William junior supplied his establishment with more than twenty tons of hay and straw, valued at over $700.[9]

William junior kept a residence on the farm and continued to use the income from the property, as evidenced by a notice about a robbery in 1782 at "the House of the subscriber [William Ball], about a mile above Kensington." The thieves had stolen a silver pint mug with a "Hall and Tower stamp," a silver tablespoon "stamped W. Gilbert, New York," six silver teaspoons, and "several pair of buckels." They were caught in 1783 and hanged.[10]

In his shop William senior apparently employed a silversmith, possibly as an indentured servant; when he died in 1740, his inventory included farm equipment and some silversmith's tools.[11] William junior was only eleven years old, and who carried on the shop before he took over around 1750 is not known. Pewter was often mentioned in advertisements for the shop during this time, and Thomas and Elizabeth Byles would have been obvious candidates, although no formal document has yet come to light. Byles may have trained William's younger brother Samuel (born 1739), who apprenticed with a brazier and appears regularly in Ball's merchandise book as a purchaser of metalworking supplies in his brother's enterprise.[12] During this ten-year interlude,

William junior would have had plenty of time for a thorough apprenticeship with a local silversmith, possibly someone working in his father's shop, or he may have gone abroad himself, as suggested in Masonic records that stated, "Bro. Ball learned the goldsmith trade and was a member of that Guild at London."[13] No records exist, however, to corroborate the claims that Ball was a member of the Goldsmith's Company or was apprenticed to a London goldsmith.

William Ball had just reached his majority when he was made a Mason in Lodge Number 2 of the "Moderns" in March 1751. He joined the "Ancients" in 1760 but remained a regular member of the "Moderns" until 1763.[14] He served as grand master from 1761 until 1781, and again in 1795,[15] and remained active as a Mason throughout his life. His surviving account book reveals that he also served the Baptist congregation of Philadelphia during those years.[16] The extant Ball accounts illustrate the activities entailed in a thriving commercial wholesale and retail business, showing debit and credit accounts sometimes carried over for years. Additional information on William junior's undertakings comes from his regular appearance in assessments for the collection of personal, poor, estate, and per-head taxes, usually in more than one city ward.[17] From these records it would seem that he and his family escaped the scourge of yellow fever that regularly struck at the end of each summer—it is possible that they moved to their property upriver, at the northern limit of the city and away from the commercial docks.

In May 1752, listing himself as goldsmith—the first mention found noting his occupation—William Ball placed a notice that a black horse of his had strayed.[18] He was at his father's shop, on Front Street between Black Horse Alley and Chestnut Street.[19] In October, together with his mother, he was selling land: "several lots of upland and meadow a little above Kensington . . . likewise a small new cart and geers for one horse."[20] In 1754 he was listed in city assessments as "taxable" without an occupation; in his assessment for 1756, he was listed simply as "smith."[21] On February 24, 1757, he was noted in the *Pennsylvania Gazette* as a goldsmith acting as an executor for the estate of his cousin Daniel Byles of Merion, son of Thomas Byles. In 1760 he advertised as a silver- and goldsmith located on Front Street opposite John Rhea.[22]

As a silversmith William Ball used two marks, one with his full surname, "W•BALL," in capitals with a pellet, in a rectangle, the other a very small mark with the initials "WB" in a rectangle that is almost square. Besides the different outlines of the dies used by the Baltimore and Philadelphia silversmiths, the "W" is distinctive

in both surname marks of the Philadelphia Ball. The oblique legs of the "W" meet below the apex, and the pellet is in the middle. The very small initial mark can confidently be assigned to William Ball himself because it is the same mark he used on the fully documented two-handled covered cup he made for the First Baptist Church in Philadelphia in 1762 (cat. 56). Silver bearing this mark has in the past been attributed to William Bartram.[23] This attribution was probably prompted by an an advertisement in the *Pennsylvania Chronicle and Universal Advertiser* on June 19, 1769, stating that "William Bartram goldsmith and jeweler, hath set up shop at the sign of the golden cup and crown."[24] To date, Bartram's mark has not been documented.

William Ball's name mark "W·BALL" in a conforming rectangle, the distinctive "W" and the first "L" without a serif at the top, has appeared not only on silver, but also on pewter, whereas his initial mark "WB" has thus far appeared only on silver. Examples of the full-name mark definitely assignable to Philadelphia's William Ball are on an officer's silver pillow-pommel sword hilt, with a clear strike of the mark on the cross guard; a lidded pewter pitcher with a clear strike of the same mark on the underside; a silver inverted-pear-shaped teapot stamped twice with the mark; and a silver strainer that descended in the Ball family.[25] Although any conclusions must be speculative, it is possible that the full-name mark was Ball's shop mark, used on objects made by his journeymen, who were working with various metals. In 1775 he advertised for "a journeyman Silversmith that is a neat hammerman; also a Pewterer, if a good workman."[26]

The number of accounts and the density of entries in Ball's surviving merchandise book, which begins in 1758, along with the rarity of his marked silver, suggest that his business was focused on his retail enterprise. Entries show that his shop on the east side of Front Street between Market and Chestnut was selling imported and custom-made silver as well as all kinds of general merchandise. Ball's trading was conducted by any means of conveyance—on seagoing ships, overland, and by small boats on the Delaware.[27] He traded by sea and overland with William Waters in Annapolis, Spaight and Ellis in North Carolina, and James Riley in Augusta, Virginia. He also lent cash and advanced credit to local silversmiths and traded actively with them.[28] Among his customers were the clockmakers Joseph Hollingshead of Burlington, New Jersey, and Benjamin Chandlee, Joseph Ellicott, and William Huston, all of Philadelphia, whom he supplied with imported parts. Ball then sold the finished clocks and watches in his shop.[29] Total debts owed to Ball as revealed

in his accounts in September 1760 amounted to £5,400 8s. 8d.[30]

He also advertised repairs and silverware made to order and sold jewelry, watches, clocks, iron crucibles, scales and weights, blowpipes, wire, borax and gunpowder, hundreds of buckle chapes, and "a neat assortment of goods."[31] Ball placed a number of advertisements in which he offered indentured servants and slaves for sale or in which he gave notice of runaways.[32] In 1752 he had "a likely negro man" for sale, and in 1772, advertising in two papers, a "likely young Negro Woman" for sale.[33] On September 23, 1760, Ball made a summary of his shop's silver production: for William Bingham, one silver-chased "hightop," sugar dish, 11 oz., £8 16s.; for Samuel Morris, sheriff, one silver sugar dish, 10.1 oz., £7 19s.; and for John Gibson, one coffeepot, 39 oz., 13 dwt, £14 8s., and the handle for 6s. 6d., partially paying with a 25-ounce silver basin, for a balance of £10 12s. 6d.[34] On October 17 Alexander Murray bought a pint can weighing 11 oz. 17 dwt. for £7 2s. 6d. On November 10 Captain Hardin paid £1 1s. for "putting Silver on a Scabard." Other customers, in 1761, were Joseph Wood, a Mrs. Howel, and Richard Cole, who bought, among many other things, shoe buckles and teaspoons. At the end of 1761 William Ball had "Sundry Goods on hand" amounting to £1,005 16s. 8d. and a farthing. On January 2, 1762, the Ball shop billed John Heaton for silver made to order:

> 1 pr Silver salts wt 5 oz. 12 dwt. fashions of [i.e., charge for the making of] [£]5
> 1 Silver tankard wt 38 oz [fashion of] 13s. [£]24 14s.
> 1 Silver Waiter 11 oz. 1 dwt. [fashion of] 15s. [£]8 5s. 6d.
> 6 Large Spoons 13 oz. 8. [dwt.] fashion 30s. [£]7 10s. 9d.
> Cleaning old plate 5s. [£]5s.[35]

On the same day Ball paid or credited "Edmond" Milne (q.v.) for "1 Water [illegible] / 11 oz. 1 dwt. @ 15/pr:oz. [£]3 5s. 9d. / abatement 1 pr oz − 11 −," for a balance of £7 14s. 2d. Entries in 1761 and 1762 record that Alexander Bartram bought a dozen teaspoons; Samuel Cowden, tea tongs and teaspoons; John Doyle, a silver cream jug; and Stephen Shewel, a pint cann, six tablespoons, six teaspoons, a soup spoon, a pair of "best tea tongs," a "silver tea pott," and "handle for do [ditto]."[36]

In the *Pennsylvania Gazette* of May 28, 1761, Ball advertised that he was "Intending for England next Fall," but that his goldsmith business would continue unabated in Philadelphia. This was a period when his shop made quantities of Indian trade silver for use as the appeasement of Indians during the French and Indian War of 1754–63. Captain William Patterson commissioned some in 1760 that was shipped to western

Pennsylvania by the firm of Baynton and Wharton, and in 1762 George Ross purchased more.[37] There is no specific notice of Ball's departure for England in his account book, and more than one hand was entering transactions throughout the period that it covers. Ball did, however, have running accounts with William Barber and Richard Neave in London; Bentley and Knipe as well as Halliday and Dunbar in Liverpool; Freeman and Oseland in Bristol; John Grume of Halifax in Yorkshire; and Thomas Gorson in Manchester—shipping to them a variety of commodities, from flour, bread, and pork to "best summer deer skins." He imported clock parts from Thomas Wagstaffe of London, whom he paid on July 16, 1761, by sending a "Wedge of gold / weighing 38 ounces & 12 grains" and worth £228 3s.[38] If Ball did in fact go to England, he was back before July 3, 1762, when he received the important commission to make the grand two-handled silver covered cup for the First Baptist Church, of which he was a leading member and served as clerk.[39] In February 1763 Ball purchased rotten stone and saltpeter for 15 sh. 7 1/2 d. from the sale of the estate of silversmith Philip Hulbeart (q.v.).[40]

In November 1765 the Stamp Act and tax made British imports unpopular. Ball, together with many of the merchants in Philadelphia, signed a non-importation agreement, a compact not to take merchandise from England. This controversial agreement was openly circumvented by merchants in New York, putting merchants in Philadelphia at a disadvantage. A year later, in an appeal to Philadelphians who were patriotic but still desired their imports, Ball announced that he had "removed to Front-street, the very next Door to the London Coffee-House, where he continues his business of Manufacturing Gold and Silver in all its branches, as in London, with good allowance for chapmen to sell again; and has for sale, a general Assortment of Plate and Jewellery; a great part thereof was lately imported in the last ships from London."[41] All the while he was diverting some of his trading ventures in commodities, flour, wheat, and pork to Jamaica, Guadeloupe, and Lisbon. After 1770 the non-importation agreements were generally ignored. Ball continued to advertise his wares and import goods from England. On May 2, 1771, he announced in the *Pennsylvania Journal* that he had "just imported in the brig Bridge, Captain Towers, from Liverpool . . . Irish linens . . . sail cloth . . . rose blankets . . . watch-seals. . . . He also has for sale, choice Madeira wine . . . and has a quantity of ready made plate and jewelry, which he sells at the very lowest rates, as he employs London workmen, in the several branches."[42] He also satisfied the intent of the agreements and

the popular climate of enterprise by employing workmen trained in England, as did others. Ships brought many immigrant laborers, leading the *Pennsylvania Journal* to remark: "Such are the fruits of the agreement, that, instead of dry-goods, which drained the colonists of their cash and kept them as poor as beggars, they are now receiving from England what may well be termed the nerves and sinews of any country."[43]

Ball was at work in Philadelphia throughout the Revolutionary period, when Philadelphia was occupied by the British. Like many of the merchants who had signed the non-importation agreements in the late 1760s, Ball may have been ambivalent about restrictions on trade. During the war overseas trade almost ceased, and Ball proceeded again to invest in real estate. He was a British sympathizer if not outright Loyalist, as was his close associate Alexander Bartram, whose estate was confiscated in 1777.[44] In a lawsuit Timothy Canby was "charged upon the oath of William Ball of calling him a Rebel and threatening him with the pruve."[45] In 1778 Ball lost three "negro" men to the British army. One of them, Tom, was a silversmith.[46]

General merchants Alexander Bartram and George Bartram Sr. (1734–1777), who ran a general retail business, carried the largest debits in Ball's accounts, possible evidence of a partnership arrangement between them.[47] All three were Loyalists and added to their association by investing in land together when, in November 1768, Nathan Shepherd of Philadelphia conveyed to Alexander Bartram and William Ball "et al." two hundred acres of land with some buildings in Philadelphia Township on St. John's Island, Nova Scotia (now Prince Edward Island).[48]

Although his fellow silversmiths Peter David, Francis Richardson, and the Syngs (q.q.v.) were neighbors of Ball's, they do not appear in his daily records. However, Edmund Milne had regular entries in both the debit and credit accounts. He is listed for chapes for all kinds of buckles, and he was credited with making hollowware for Ball. Further records for silversmiths include the following: April 10, 1762, Michael Brothers (q.v.), £86 16s. 2d. for "work Done to this Day"; and December 1761, Henry Dawkins, £7 19s. 11d., for engraving work. Dawkins also bought "15 Engravers plat" from Ball on April 20, 1762. Other silversmiths noted as debtors to stock were John Strangeways Hutton (September 1, 1760) and David Hall (q.q.v.); the latter bought shoe chapes and "stone rings" and was a debtor for 29 ounces 7 pennyweights of silver to make a tankard at a charge of 9s. (October 12 and 17, and November 10, 1761). Simon Soumain bought dozens of shoe chapes in

1760 and 1761. New Jersey clockmaker Joseph Hollinshead ("Hollandshead"), Bancroft Woodcock (q.v.), and William Young (q.v.) bought silver seals and shoe buckles. The Ball shop made seven gold rings for Young, who made Indian silver for Ball. John Bayly Sr. (q.v., as "Bayley"), was a debtor for "Cash in Jersey money £42 12s. – / @ 2¼ Johanes [a type of coin] @ £5. 15s. . . . [£]12 18s. 9d.," for an account balance of £55 10s. 9d. (July 16, 1761).[49] Ball's continuing account with Bayly shows purchases of dozens of knee and shoe chapes. He was also a debtor for 4 ounces of gold lent to him on October 16, 1761; he repaid the debt on January 1 of the following year. Daniel Dupuy Sr. and Jeremiah Elfreth Jr. (q.q.v.) both bought knee chapes (December 2, 1760; January 28, 1761); William Faris ("Fairis"), silversmith, of Annapolis bought shoe and knee chapes, six nests of crucibles, and eight black melting pots for £5 5s. (November 21, 1760). John Gemmill, a watchmaker in Carlisle, bought gold rings, a gross of watch-crystal swivel scales, and brass watch keys. William "Ghisling" (Ghiselin?; q.v.) was entered for cash (March 24, 1761); John Jones, silversmith, a piece of bed ticking (June 5, 1761); John Leacock (q.v.), chapes (December 2, 1760); Peter Lorin "in New York Jeweller," "1 doz Christials" and "1 doz Gold Ciphers" (May 20, 1761); and Theodorus Carbine, ciphers, amethysts, and gold buttons (October 6, 1762). Richard Humphrey—a merchant, not the silversmith—was a debtor to stock in September 1760.

William Ball's uncle Thomas Byles died on June 11, 1771, and William married Thomas's daughter Elizabeth Byles (born 1722), his first cousin, on the same day. Elizabeth's inheritance from her father was handsome, and when added to the Ball enterprise, it made the couple wealthy. In November 1771 Ball moved his business and his city domicile to 41 Market Street, "three doors below Messieurs Hall & Sellers's Printing-Office and exactly opposite Letitia Court,"[50] formerly the location of Thomas Byles's pewter shop. Before he expanded this shop, located in the High Street Ward, "William Ball, goldsmith," was assessed for "one Negro," a long list of debts owed to him, totaling £195.14, and several ground rents.[51] In May 1775 he called the shop "his New Ware house of Gold, Silver, Pewter, Copper and Brass Wares, the north side of Market-street" and noted that it included "all the Stock in Trade of the late Thomas Boyles [sic]."[52] On January 2, 1776, Thomas Nevil, carpenter, noted in his daybook "to measuring and valuing William Ball's house £5 19s. 1d."[53] Ball was located at this address throughout the remainder of his business life and until his death in 1810.[54]

On May 9, 1782, William Ball retired and advertised the sale of his shop and his working

tools, of which he provided a detailed list.[55] Published immediately after the shop was shut down, this advertisement may be the most complete account of the tools present in a Philadelphia shop active in general metalwork as well as silver:

> Planishing Teasts, Forging Anvils, Raising Anvils, Belly-pot Anvils, Round and flat bottomed Stakes, Beek-Irons, Heads and Stakes, Hammers of most sorts, a large number, Large and small Bench-Vizes, Bench and hand Shears, Forging nealing and melting Tongs, and Bellows, Founders Tongs, Flasks and Screws, Silversmiths Flasks and Screws, Thimble Stamps, ring and other Swages, Button Stamps, Collars and Dies, Cutting and dapping Punches, Smooth and bastard Files of various sorts and sizes, Best Turkey Oil-Stones, Seventeen and 45 ounce Skillets, Ingots, A variety of Patterns, Two turning Lath[e]s, A variety of turning Tools and Burnishers, A very large assortment of brass Moulds for pewter dishes, plates, basons, tankards, mugs, porringers, &c. A number of Scale-beams, from 12 inches to 4 feet long, Money Scales and Weights, penny-weights and grains, Hessian Crucibles, Iron Melting Pots, Borax, Sanders, Pomice and Rotten Stone, Putty, Blow-pipes, Chapes and Tongues, Button, buckle and ring Stones, Foil, Clockhead and dolphins Hands, Variety of watch Seals and Keys, &c. &c.

Ball bought property in western Pennsylvania and in Delaware and Virginia, and at least one rental property in Philadelphia.[56] A three-story house on the south side of Spruce Street between Front and Second streets, it measured eighteen feet along the front and sixteen feet deep, with chimney breasts, wood mantels, a surbase (molding), and washboards with cased windows. The second story was "finished in like Manner." Ball insured the property with the Mutual Assurance Company for £250 in October 1792.[57] The assessment list of the U.S. Direct Tax of 1798 taken by John Keen in the district of Northern Liberties records John Browne (q.v.) and William Ball as the joint occupant-owners of a property in the city proper, on the west side of Front Street at High (Market) Street, assessed at £1,500. Ball and John Browne probably worked together at this location. Browne was sole owner of an adjoining property, noted as unoccupied in 1798 and valued at £500.[58] Both men were Baptists and property owners in the Northern Liberties. Childless, Ball sold a large tract of his patrimonial lands to John Hewson for a textile printing factory.[59] The community that grew up around Hewson's calico works was known then, and into the nineteenth century, as "Balltown." On October 29, 1801, Hewson's eldest daughter, Esther (1779–1863), married William's nephew Joseph Ball, son of William's brother Samuel. Joseph eventually inherited

William's properties.[60] He called the estate Richmond Manor because it was located in what had become Richmond and is now Port Richmond on the Delaware.

If Ball was a sympathizer during the non-importation era of the 1760s, or when British troops were occupying Philadelphia in 1777 and 1778, no prejudice appears to have followed him later in life. In the Grand Federal Procession in 1788 celebrating Pennsylvania's ratification of the Constitution, William Ball, as the senior member of the delegation of goldsmiths, silversmiths, and jewelers, was chosen to carry the symbolic urn on one of the floats.[61]

William Ball died on May 30, 1810, and was "interred in Masonic Form in the Burial Ground of the Baptist Congregation on the next day."[62] There are at least two colorful descriptions of this unusually elaborate funeral; one in *Poulson's American Daily Advertiser* and the other written by a Moravian Sister visiting Philadelphia, who reported: "First came the Philadelphia Grand Lodge—its most exalted rulers leading, according to their office and rank; then its members in full regalia, walking two abreast and carrying various symbols of their order—such as swords, silver trowels, chisels, carpenter's squares, etc.; all presenting a magnificent spectacle. . . . But what pleased me above all else was the sweet music of the band—so soft, so soothing was the dirge they played."[63] BBG

1. Gerard Vandergucht, Nicholas Scull, and George Heap, *An East Prospect of the City of Philadelphia; Taken by George Heap from the Jersey Shore, under the Direction of Nicholas Scull Surveyor General of the Province of Pennsylvania* ([London]: published according to an Act of Parliament, 1754); see also the Ball Families Papers, 1676–1879, HSP; A. William Ball, *William Ball, Philadelphia Silversmith* (Philadelphia: printed by the author, 1993). The survival of numerous documents, inventories, executor's estate manuscripts, a daybook, an account book, rent-receipt books, a genealogy chart, property maps, and so on, in this collection presents a rich trove of rare material for the study of early Philadelphia, and this short biography of just one of the characters, silversmith William Ball, does not do justice to the source.

2. *Pennsylvania Chronicle and Universal Advertiser* (Philadelphia), May 7, 1770. In 1890, 281 acres of the original Ball land on the Delaware were still vacant; Emmett William Gans, *A Pennsylvania Pioneer: Biographical Sketch with Report of the Executive Committee of the Ball Estate Association* (Mansfield, OH: R. J. Kuhl, 1900), pp. 27–28, 528–29.

3. Ball 1993, p. 1; William Milnor, *A History of the Schuylkill Fishing Company of the State in Schuylkill . . .* (Philadelphia: members of the State in Schuylkill, 1889), vol. 1, p. 359. A William Ball is listed as one of the original members. This must have been William Ball Sr., although the entry in this official club history gives the life dates of his son, the silversmith.

4. The Newport connection suggests that the immigrant William Ball may have been a Baptist and a member of the Baptist Congregation in Pennsylvania, founded in 1688. Pennsylvania was a destination for Newport Baptists, who were more comfortable with the Quakers than with the Puritans. The first Baptists in Pennsylvania came from Newport, Rhode Island, to Pennepek (now Pennypack) in Bucks County in 1684. See also the biography of Joseph Anthony Jr. (q.v.).

5. Thomas Byles, son of Josias and Sarah Davis Byles, was probably born in England around 1684. He was apprenticed to "Mr. Man, Brazier" and was in Newport in 1711 or 1712. See Arthur Wentworth Hamilton Eaton, "Old Boston Families, IV: The Byles Family," *New England Historical and Genealogical Register* (Boston), vol. 69 (April 1915), pp. 101–3.

6. *Pennsylvania Gazette* (Philadelphia), February 2, 1744.

7. Taxables in Chestnut, Walnut, and Lower Delaware Wards, Philadelphia, 1767, MSS Mic.6, Penn Libraries, University of Pennsylvania, Philadelphia.

8. *Pennsylvania Archives*, 3rd ser. (1897), vol. 15, pp. 347–48.

9. "Washington's Household Account Book, 1793–1797," *PMHB*, vol. 31, nos. 1–3 (1907), pp. 58, 184, 343.

10. *Pennsylvania Packet, or The General Advertiser* (Philadelphia), November 21, 1782; "Extracts from the Diary of Jacob Hiltzheimer, 1768–1798," *PMHB*, vol. 16, no. 2 (1892), p. 164.

11. In his inventory William Ball Sr. had 40 ounces of "old plate" valued at 6s. an ounce (for a total of £12). The tools probably belonged to the shop. Ball Families Papers, box 5, folder 5.

12. Ball's shop was debited for supplies for his brother Samuel of "crucibles, melting pots, borase, blow pipes, binding wire, scales and weights"; there were additional entries about joint commercial adventures in trade, and a regular "£3 Dr to cash" entry, indicating that Samuel was part of the family enterprise. Ball Families Papers, box 5, folder 5.

13. "Grand Lodge of Pennsylvania," Brix Files, p. 750, Yale University Art Gallery.

14. Brix Files, Yale University Art Gallery.

15. Norris S. Barratt and Julius F. Sachse, *Freemasonry in Pennsylvania, 1727–1907* (Philadelphia, 1909), vol. 1, pp. 65–68; vol. 2, pp. 112–13.

16. For example, the entry for June 1761 records: "Baptist meeting Dr to Cash pd John Holme 1 year ground rent at 120/F 8% for which he is to account with the meeting or their Deputy . . . [£]10"; for July 16, 1761: "Baptist Meeting Dr. to Cash paid Henry Woodrow . . . [£]100." See William Ball, Account Book, 1759–1762, Philadelphia, pp. 107, 110, Downs Collection, Winterthur Library. The "title page" of this account book or daybook reads: "William Balls Journal / Merchandize Began May 16 1758."

17. Ball was listed in the "taxables" of the Chestnut, Middle, and South wards; see William Savery, "List of the Taxables of Chestnut, Middle, and South Wards, Philadelphia, 1754," *PMHB*, vol. 14, no. 4 (1890), p. 415.

18. *Pennsylvania Gazette*, May 28, 1752.

19. Ball was sharing a part of this property with James Wagstaff, who also had an account with him. On March 2, 1761, he made a note in his "Merchandize Journal" (p. 69, bottom): "from This Day I take the whole Rent of the Stable in Blackhorse Alley at 7% pr year formally in Company with James Wagstaff [£]1 4s."; William Ball, Account Book, 1759–1762.

20. *Pennsylvania Gazette*, December 19, 1754.

21. Tax and Exoneration Lists, 1762–1794.

22. *Pennsylvania Journal and Weekly Advertiser* (Philadelphia), June 19, 1760. John Rhea's store was midway between Market and Chestnut streets on Front.

23. Buhler 1956, p. 89. In Philadelphia 1956 (cats. 26–30), a cann, nippers, a pair of salts, and a tray (all from private collections) with initial mark were listed as by William Bartram.

24. Quoted in Prime 1929, p. 46. It had been thought that this William Bartram was the son of the botanist John Bartram, as Benjamin Franklin had suggested to the elder Bartram that engraving "would suit Billy well"; Ernest Earnest, *John and William Bartram: Botanists and Explorers, 1699–1777, 1739–1823* (Philadelphia: University of Pennsylvania Press, 1940), p. 93. However, in 1771, in an entry in one of his ledgers and in his own hand, Dr. Benjamin Rush makes a correction when he records that he attended the death of "William Bartram, silversmith from New Jersey and NOT [sic] the son of the botanist"; Hannah Benner Roach, "Genealogical Gleanings from Dr. Rush's Ledger A," in *Colonial Philadelphians*, Genealogical Society of Pennsylvania Monograph Series, no. 3 (Philadelphia: Genealogical Society of Pennsylvania, 1999), p. 187. The silversmith William Bartram married Mary Fisher in 1767 at Christ Church, Philadelphia, where he would also be buried; *Pennsylvania Archives*, 2nd ser. (1896), vol. 8, p. 24. In 1769 he was living on Chestnut Street near Philip Syng Jr. (q.v.); 1769 Effective Supply Tax.

25. For the sword hilt, see Clegg Donald Furr, *American Swords and Maker's Marks: A Photographic Guide for Collectors* (Orange, CA: Paragon, 1999), p. 15, nos. 11, 11a (collection of a Ball descendant). For the pitcher, see J. O. Reese, "A Rare Pewter Discovery with the Mark of William Ball, Philadelphia, 1729–1810," *Pewter Collectors' Club of America Bulletin*, vol. 9, no. 8 (December 1988), pp. 179–82. For the teapot and strainer, see Philadelphia 1956, cats. 24, 25.

26. *Pennsylvania Packet, or The General Advertiser* (Lancaster), May 29, 1775. Evidence that Ball employed journeymen comes mostly from such advertisements.

27. He purchased a shallop to ferry meadow grass to Burlington, New Jersey. Other customers at his shop, as revealed in his account book, were the Misses Sarah and Polly King of Lancaster, Pennsylvania, who ordered small jewelry, buckles, watches, and seals from him on a regular basis. Henry Pinkerton worked on consignment, carrying small articles to sell at regional fairs. Throughout, the day-to-day accounts reveal that Ball did a huge business in chapes and buckles, selling imported ones and making and repairing other examples regularly.

28. "Mr. Johnson, Silversmith, Dr [debtor] to Inv," for a silver watch costing £7 (March 11, 1762); and Stephen Reeves, owing £2 (October 25, 1759); William Ball, Account Book, 1759–1762.

29. Ball sold sets of "heads and Dolphins," "faces and circles," watch mainsprings, piercing files, watch glasses, clock hands, clock bells, etc. He paid John Gemmill for engraving a clock plate. Ibid.

30. Among the accounts carried forward were those of John Bayly Sr. for £14 19s. 10d. (folio 56); William Gisling [sic, Ghiselin], £2 14s. (folio 18); Bancroft Woodcock, £5 7s. od. (folio 10); William Young, £7 5s. 10d. (folio 4); Michael Brothers (q.q.v.), £10 15s. 1d. (folio 214); and Henry Dawkins, £7 0s. od. (folio 120). Ibid.

31. *Pennsylvania Journal* (Philadelphia), November 13, 1760.

32. In the *Pennsylvania Gazette* on February 19, 1761, he posted notice that an English servant named William Davy, "bought by William Ball," had run away, and in the *Pennsylvania Packet and General Advertiser* on May 6, 1776, that George Norris "an English servant, by trade a silver-smith who came last November from London, ran away in the night."

33. *Pennsylvania Gazette*, July 18, 1752; ibid., September 23, 1772; *Pennsylvania Packet, or The General Advertiser*, October 12, 1772.

34. William Ball, Account Book, 1759–62.

35. John Heaton was apprenticed to David Cane in August 1746 to become a joiner and learn the trade of chair maker; George W. Neible, "Account of Servants Bound and Assigned before James Hamilton, Mayor of Philadelphia [cont'd]," *PMHB*, vol. 32, no. 2 (1908), p. 239.

36. June 5, 1761 (Bartram); May 19, 1762 (Doyle); July 26 and August 21, 1762 (Shewel); July 6, 1762 (Cowden). William Ball, Account Book, 1759–1762.

37. Entries (in ibid.) for Indian trade silver include:

October 28, 1760, purchased by "Capt. Wm. Paterson": "9 Doz Broaches & Rings wt 5 oz 14 dwt. £2 11s. 6d. / 6 Large arm plates wt 14 [oz.] 16 [dwt.] £6 13s. 3d. / fashion 9 Doz Rings & Broaches 7s. [£]3 3s. od. / fashion 6 Large arm plates & engra / ving 11s. [£]3 6s.," for a total of £15 13s. 9d.

December 30, 1760, purchased by "Wm Paterson Trader": "24 Large Crosses wt 2 oz 17 dwt £3 13s. 9d. / 36 Small Crosses 1 [oz.] 13 [dwt.] 12 [gr.] [£]2 11s. od. / 6 Scollop'd wrist plates 4 [oz.] 6 [dwt.] [£]2 15s. od. / 6 Swaged Do 5 [oz.] 3 [dwt.] 12 [gr.] [£]3 7s. 6d. / 4 hair plates Engraved 6 [oz.] 16 [dwt.] [£]5 5s. od. / 4 hair plates Sorted 4 [oz.] 17 [dwt.] [£]4 2s. od.," for a total of £21 14s. 3d.

June 12, 1762, purchased by George Ross: "12 Broad arm plates 34 oz 8 [dwt.] 9s. £15 9s. 7d. / fashion of Do 10/ [£]6 / 12 Wrist Bands 5 [oz.] 15 [dwt.] 6 [gr.] 9s. [£]2 11s. 11d. / fashion of Do 3s. 9d. pr 3s. [£]2 [os.] 6d. / 14 doz Broaches 8 [oz.] 11 dwt 9s. £3 18s. 4d. / fashion of Do 6/ [£]4 4s.," for a total of £34 4s. 4d.

38. William Ball, Account Book, 1759–62.

39. July 1762, Minutes, 1760–1850, First Baptist Church, Philadelphia, HSP. Ball was paid for the cup on December 4, 1762.

40. Account of Goods Sold of Phil Hulberts [Hulbeart], p. 4. Downs Collection, Winterthur Library.

41. *Pennsylvania Journal and Weekly Advertiser*, November 13, 1766.

Ball moved up High [Market] Street but remained below Second Street, and another contemporary silversmith moved into his shop: "Theodore Carben, Jeweler, informs the gentlemen and ladies that he has removed into Front Street in this city, in the shop lately occupied by Mr. Wm. Ball, next door to Mr. John Ord, where he carries on his Business as usual"; ibid., May 1, 1766.

42. Quoted in Scharf and Westcott 1884, vol. 1, p. 284.

43. Ibid.

44. W. A. Newman Dorland, "The Second Troop Philadelphia City Cavalry," *PMHB*, vol. 50, no. 1 (1926), p. 86. See the biography of Michael Brothers (q.v.).

45. William Ball was "held in £100 to prosecute"; *Commonwealth versus Timothy Canby, City of Philadelphia*, August 15, 1778, Stephen Paschall Docket Book, Paschall-Sellers Family Papers, 1734–1875, HSP.

46. As quoted in the Brix Files, Yale University Art Gallery.

47. This association with the Bartrams suggests that an unmarked silver salver and sugar tongs made for John Bartram (PMA 1950-29-3, -4) may have been products of Ball's shop.

48. Dupuy Papers, Ball Estate, folder 16, HSP; *Pennsylvania Chronicle and Universal Advertiser* (Philadelphia), January 28, 1768; William Otis Sawtelle, "Acadia: The Pre-Loyalist Migration and the Philadelphia Plantation," *PMHB*, vol. 51, no. 3 (1927), p. 281. Bartram sold out his one-quarter share in this colonizing venture in 1769; "Philadelphians in Nova Scotia," Notes and Queries, *PMHB*, vol. 22, no. 2 (1898), p. 250. William Ball continued his investment, building a grist mill there. The property was sold after his death.

49. John Bayly was also recorded in Ball's account book on March 11 and 16, 1761. Phonetic spelling was a general practice at the time, and since the entries for "Bailey" and "Bayley" are in the same hand, they probably refer to the same man.

50. Advertisement, *Pennsylvania Gazette*, November 21, 1771.

51. *A Transcript of the Fifteenth Eighteen Penny Provincial Tax, Assessed the 13th Day of March 1772, for the City and County of Philadelphia* (Salt Lake City: Genealogical Society of Utah, 1948), p. 82.

52. *Pennsylvania Packet, or The General Advertiser*, May 29, 1775.

53. This entry is listed as account no. 109 in a section titled "To measuring and valuing" in Thomas Nevil's daybook, p. 198, Rare Book and Manuscript Library, University of Pennsylvania. As Nevil did the valuation, he probably was not the contractor on the project.

54. The Effective Supply Tax of 1780 listed Ball's property value at this location at £196,400, and his tax at £454 4od. His property in the eastern part of the Northern Liberties was valued at £552,000, with a tax of 6 s. on the hundred pounds, at £1,242. Joseph Ball's value was £160,000, and his tax, £360.

55. *Pennsylvania Packet, or The General Advertiser*, May 2, 1782.

56. 1798 U.S. Direct Tax.

57. See Anthony N. B. Garvan et al., *The Architectural Surveys, 1784–1794* (Philadelphia: Mutual Assurance Co., 1976), vol. 1, pp. 225–26.

58. Ibid., policy no. 345.

59. See the entry by Elsie McGarvey for a printed coverlet in Philadelphia 1976, pp. 155–56.

60. This Joseph Ball is not to be confused with Joseph Ball (1748–1821), son of John and Mary Richards Ball of Berks County, Pennsylvania, who became an important merchant in Philadelphia after having run the ironworks in Batsto, New Jersey, during the Revolutionary War. See Louis Richards, "A Sketch of Some of the Descendants of Owen Richards, Who Emigrated to Pennsylvania Previous to 1718," *PMHB*, vol. 6, no. 1 (1882), p. 76.

61. See Francis Hopkinson, "An Account of the Grand Federal Procession: Performed at Philadelphia on Friday the 4th of July 1788," ed. Whitfield Bell Jr., *Old South Leaflets* (Boston), nos. 230–31 (1962), pp. 24–25.

62. *True American* (Philadelphia), June 1, 1810, p. 228. William Ball wrote his will on September 4, 1809. It was probated June 2, 1810. Philadelphia Will Book 3, no. 193.

63. *Poulson's American Daily Advertiser* (Philadelphia), June 1, 1810; A. R. Beck, "Notes of a Visit to Philadelphia, Made by a Moravian Sister [Catherine Fritsch] in 1810," *PMHB*, vol. 36, no. 3 (1912), p. 356.

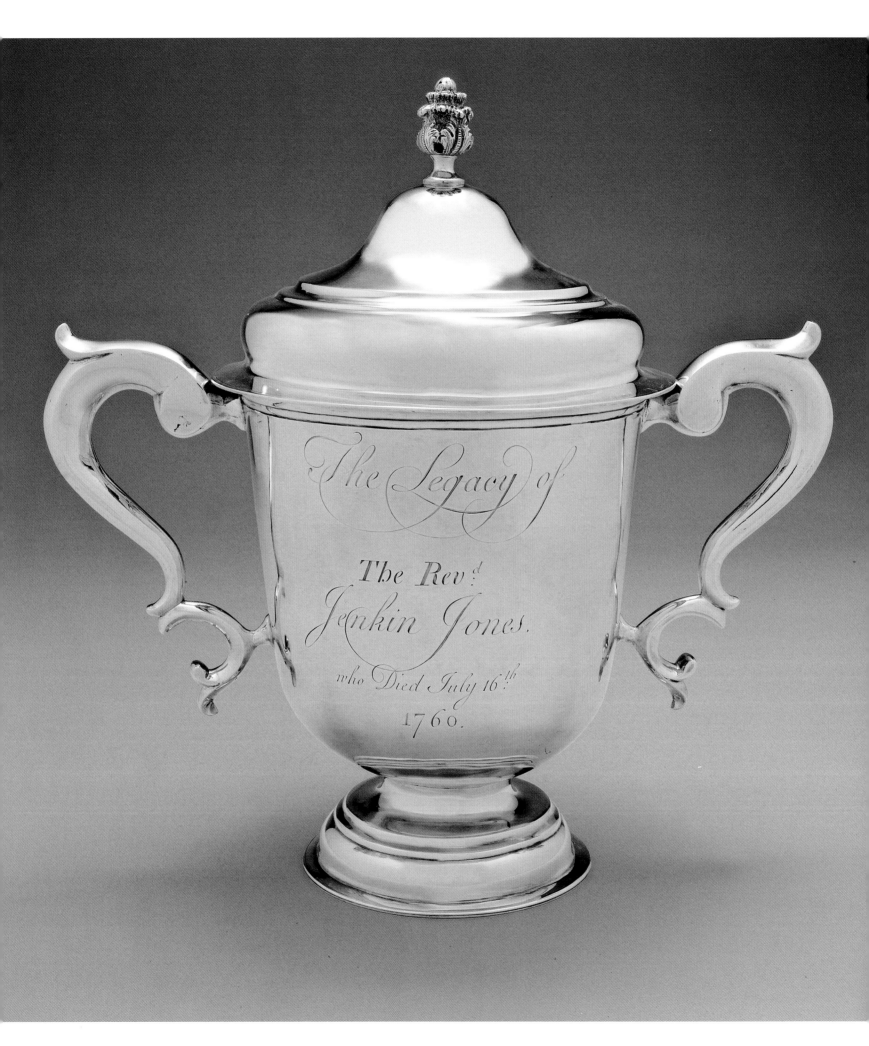

The Legacy of

The Rev.d
Jenkin Jones.

who Died July 16.th
1766.

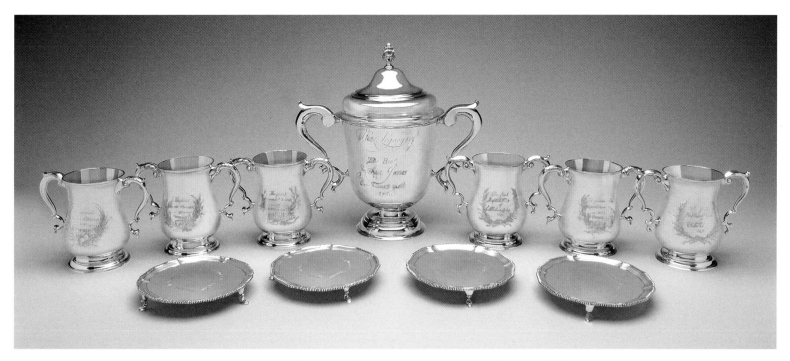

Cat. 56 (center) with cups and salvers by John Browne (cat. 95), cups by M. F. Hamilton & Son (PMA 2005-40-8,9) and Thomas Shields (PMA 2005-40-1,2), and salvers by Richard Rugg (PMA 2005-40-6,7)

Cat. 56

William Ball
Covered Cup

1762
MARK: WB (in rectangle, on lid and at top of vessel on either side of one handle; cat. 56-1)
INSCRIPTIONS: The Legacy of / The Rev^d / Jenkin Jones. / Who Died July 16^th / 1760 (engraved script, on front); 61 oz 4 dwt (scratched, on underside)
Height 12¼ inches (31.1 cm), diam. foot 4¾ inches (12.1 cm), diam. lid 7¹/₁₆ inches (17.9 cm)
Weight 58 oz. 5 dwt. 18 gr.
Purchased with contributions from Robert L. McNeil, Jr., and H. Richard Dietrich, Jr., and with the Richardson Fund, 2005-40-3a,b

Cat. 56-1

PROVENANCE: First Baptist Church, Philadelphia; sale, Christie's, New York, *Important American Furniture, Silver, Folk Art and Decorative Arts*, June 16, 1999, sale 9072, lot 73.

EXHIBITED: On long-term loan to the Philadelphia Museum of Art, 1912–99; Philadelphia 1956, cat. 23; Philadelphia 1969, pp. 54–55, cat. 7; *Antiques Show: A Benefit for the Hospital of the University of Pennsylvania*, Philadelphia, April 10–15, 1984, p. 62, cat. 41; David B. Warren, Katherine S. Howe, and Michael K. Brown, *Marks of Achievement: Four Centuries of American Presentation Silver*, exh. cat. (Houston: Museum of Fine Arts, 1987), pp. 40–42, cat. 30.

PUBLISHED: William M. Keen, *The Bi-Centennial Celebration of the Founding of the First Baptist Church of the City of Philadelphia, 1698–1898* (Philadelphia: American Baptist Publication Society, 1899), illus. p. 163; Jones 1913, pp. 368–69; Prime 1929, illus. opp. p. 44; William D.

Thompson, *Philadelphia's First Baptists: A Brief History of the First Baptist Church of Philadelphia, Founded 1698* (Philadelphia: First Baptist Church of Philadelphia, 1989), illus. p. 10; *Philadelphia Museum of Art Handbook* (Philadelphia: the Museum, 2014), pp. 264–65.

Although a familiar presentation form in early Boston, this two-handled covered cup is most like presentation cups made in the mid-eighteenth century in New York. All are between 10 and 14 inches in height and have double-scrolled handles and domed lids with finials.[1] This grand vessel may be a unique example of the form in eighteenth-century Philadelphia. It was commissioned by the First Baptist Church of Philadelphia to honor the memory of the Reverend Jenkin Jones, who had served as pastor in the Baptist church for about fifty years.

Born in Wales, Jenkin Jones (1690–1760) came to Pennsylvania around 1710. He served Baptist parishes in the Welch Tract until he went to serve the early church in Philadelphia in 1724,[2] and from 1731 until 1740 he also administered to Baptists in surrounding areas, including Pennypack, where he oversaw the building of a new meeting house.[3] The Philadelphia church was enlarged and incorporated in 1746, having fifty-six members, Jones as minister, and Ebenezer Kinnersley his assistant.[4] Jones remained as pastor of Philadelphia's First Baptist Church until his death in 1760. In his will he left £25 to the church to be applied to the building of a parsonage.[5] At the meeting of the church's vestry on July 3, 1762, the clerk B. Barnes recorded that "the church will appoint somebody to receive the legacy of the Rev J Jones to the church, which he has in his hands. Isaac Jones, Esqr. was appointed to receive the legacy which was £25 and to give a receipt for

the same."[6] Rather than applying the legacy to the building project, which "was at a stand," the vestry "agreed that Rev. M. Edwards and Isaac Jones Esqr. do buy a two-handle silver cup or chalice for the wine in the Lord's-supper, with the above said legacy; and in case the chalice should cost more than £25 that the old silver cup (now belonging to the meeting) should be sold to help paying for the new. And that the Rev. Jenkin Jones' name be engraved on the front of the new chalice."[7] The vestry commissioned William Ball to make this cup and did not stint on the commission to honor Jenkin Jones's service.[8] The silversmith was a regular member, which surely secured him this commission.[9]

As an object this cup has impressive stature. The lid rises from a flat, broad rim to a full cushion shape, ending at a gentle dome at the top. The lid has a deep flange that fits tightly into the top of the cup. The leafy, bud-shaped, cast finial is a larger version of a design used in varying sizes on Philadelphia coffeepots.[10] The hollow handles are especially large, lack the usual detailing of leafage at the top, and swing out horizontally with more than usual exuberance. The wide flange of the lid required that the plain tubular terminals at the top of the handles be especially long, and they are attached directly to the body without the transition of a collar. The position of the deep pouring spout ruled out a midband, which was a usual feature on standing cups of this size.[11]

Surviving examples of silver marked by William Ball are smaller pieces for domestic use.[12] The Ball shop employed journeymen trained in London, who also may have had a hand in the design and manufacture of this cup. Ball advertised that he was going to England in May 1761, before he received this commission,[13] and presumably he made the trip.

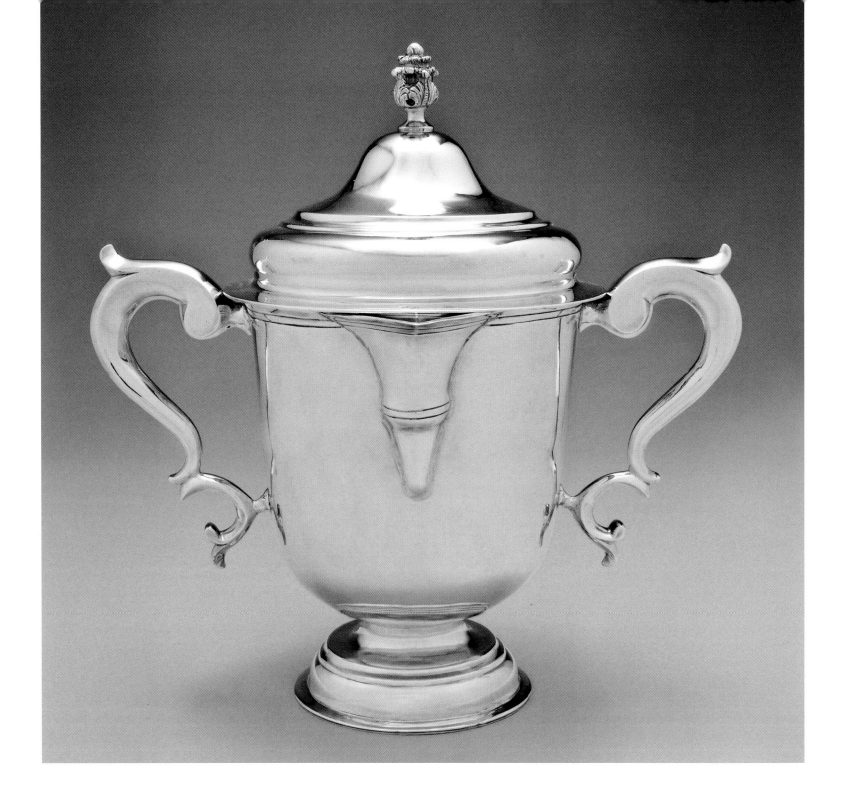

His advertisements resumed in March 1762.[14] His import business possibly was the source for the purchase by the Baptist church of two communion cups and trays by Richard Rugg in 1773–74 (PMA 2005-40-6,7).[15] BBG

1. See the cup by Jacob Hurd of Boston, 1747, in Buhler and Hood 1970, vol. 1, cat. 159, illus. p. 134; and the cups by Elias Pelletreau and Myer Myers of New York, in Louise C. Belden, "The Verplanck Cup," *Antiques*, vol. 92, no. 6 (December 1967), pp. 840–42, figs. 2, 3.
2. Richard B. Cook, *The Early and Later Delaware Baptists* (Philadelphia: American Baptist Publication Society, 1880), p. 52.
3. Jenkin Jones witnessed the will of Nicholas Dowdney of Philadelphia in 1726; Philadelphia Will Book D, p. 459. In 1731 or 1732 Jones served as trustee to the will of Dorothy Newberry (widow of Richard Newberry), who left a bequest

for the "New Meeting House for Baptists"; Philadelphia Will Book E, p. 163.
4. Rev. David Spencer, *The Early Baptists of Philadelphia* (Philadelphia: W. Syckelmoore, 1877), pp. 68–69.
5. Will of Jenkin Jones, written September 14, 1759, probated July 18, 1760, Philadelphia Will Book L, p. 480.
6. From the minutes of the vestry, July 3, 1762; personal communications by the Rev. William D. Thompson, to the author, December 9–10, 1986.
7. Ibid.
8. "Agreed that B. Barnes, clerk, draw an order on Th. Loxley in favor of William Ball for 12-17-8 being the sum which the chalice amounted to besides J. Jones' legacy and the old silver cup"; First Baptist Church Archives, courtesy of the Rev. William D. Thompson.
9. First Baptist Church of Philadelphia, Minutes (July 2, 1762), 1760–1850, HSP. William Ball's mother, Mary, his uncle Thomas Byles, and his wife Elizabeth were also original members of the First Baptist Church.

10. This finial appears in variations in other colonial centers as well as in Philadelphia. See Philip Syng Jr.'s coffeepot (PMA 1966-20-1); and Myer Myers's coffeepot in the collection of Columbia University, New York (David L. Barquist, *Myer Myers: Jewish Silversmith in Colonial New York*, exh. cat. [New Haven, CT: Yale University Press, 2001], cat. 20, p. 102).
11. See, for example, Belden, "The Verplanck Cup."
12. Silver marked by William Ball is rare. There is a handsome sauceboat by him marked "WB" in the Bayou Bend Collection, Museum of Fine Arts, Houston (B.2001.28).
13. *Pennsylvania Gazette* (Philadelphia), May 28, 1761.
14. *Pennsylvania Journal* (Philadelphia), March 25, 1762.
15. For other pieces of silver made for the First Baptist Church in Philadelphia, see cat. 95 (John Browne); PMA 2005-40-8, -9 (M. F. Hamilton & Son), 2005-40-1, -2 (Thomas Shields), and 2005-40-6,7 (Richard Rugg).

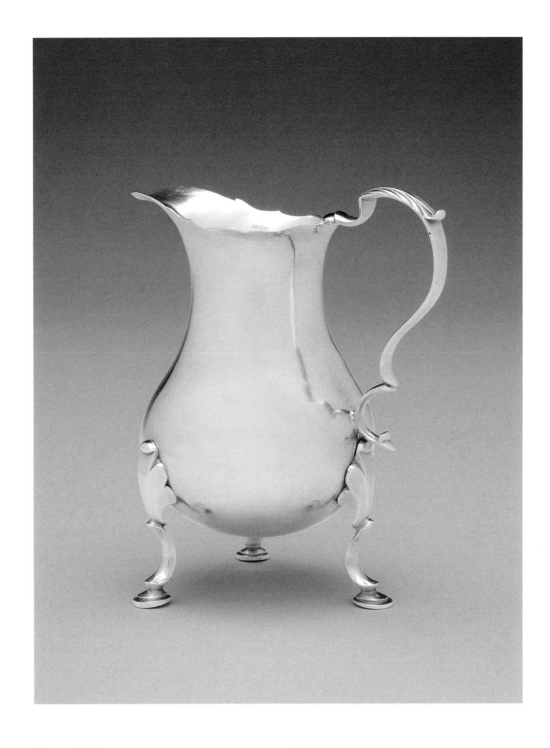

Cat. 57

William Ball
Cream Pot

1765–75
MARK: WB (in rectangle, on underside; cat. 57-1)
INSCRIPTION: E / A·S (engraved, on underside)
Height 3⅞ inches (9.8 cm), width 3⅝ inches (9.2 cm)
Weight 2 oz. 16 dwt.
Gift of the McNeil Americana Collection, 2005-68-121

PROVENANCE: Sotheby's, New York, *Important Americana*,
January 24, 26, 27, and 30, 1995, sale 6660, lot 1444;
(S. J. Shrubsole, New York).

The "W" in the mark on this object has the distinctive character identified as Ball's initial mark. The cream pot has a nice full shape, with generous lobed-leaf forms at the top of the legs where they

Cat. 57-1

join the body. The plain pad feet sit on round discs. The handle, which appears to be original, seems a bit too big.

The initials "E/A·S" may have belonged to Abraham and Sarah Price Evans, who married at St. Paul's Church, Philadelphia, on May 30, 1771.[1] BBG

1. Historic Pennsylvania Church and Town Records, HSP, Ancestry.com.

Conrad Bard

Philadelphia, born 1801
Philadelphia, died 1854

Conrad Bard and Frederick Hoffman

Philadelphia, 1837–38

Conrad Bard and Robert Lamont

Philadelphia, 1840–45

Edwin Milford Bard

Philadelphia, born 1826
Philadelphia, died 1865

Conrad Bard was eleven when his father, Valentine Bard, died in the War of 1812. Valentine Bard enlisted in Captain Van Deusen's Fifteenth U.S. Infantry as a private on June 5, 1812, for five years but died in service a few months later, on December 24, 1812.[1] From 1805 to 1811 Philadelphia directories listed Valentine Bard (Bardon) as a laborer at 12 Gilles Alley in the Cedar Ward.[2] In the U.S. census of 1810, Valentine Bard's household in the Cedar Ward was noted with twelve persons, two of whom were over forty-five (Valentine and his wife Margaret), one male under ten (Conrad), three females under twenty-five, four members over twenty-five, and four other free persons. In 1813 Margaret Bard, widow and "tailoress," presumably along with Conrad, was at 144 Spruce Street. In 1817 and 1818 "M. Bard widow" was listed in the city directory at "back, 154 Spruce Street," near their previous location.

On July 3, 1818, Conrad and his mother, Margaret Bard, petitioned the Philadelphia Orphans Court:

the only son and heir at law of Valentine Bard deceased. . . . Humbly sheweth That your petitioner's father was entitled by the laws of the United States to a certain tract of Military Bounty land which land descended to your petitioner. But by the rules of the War office your petitioner is obliged to produce a certificate that he is the legitimate heir at law of the said Valentine . . . from

some Court of competent jurisdiction . . . further that your petitioner is now of the age of seventeen years and has not had a guardian appointed for him . . . permit him to make choice of guardian.[3]

On the same date Jacob Baker, a relative and an alderman of the city of Philadelphia, appeared before Felix Queen, also a city alderman, to state that he was "well acquainted with Valentine Bard an enlisted soldier for five years previous to his death, that he was related to said Valentine and his wife and has frequented their home upon very intimate terms."[4] On March 17, 1820, Conrad Bard again appeared in Orphans Court "as a minor but above age fourteen" to request appointment of a guardian, as his mother had died, and a Samuel Benson was appointed.[5] Conrad Bard was nineteen and must have been almost through an apprenticeship, although with whom is still unknown.

The first notice of Conrad Bard, silversmith, or John (Conrad) Bard as he was listed in the 1830 census, was at 80 Locust Street in 1825, about the same time that he married Annie Foley (born 1804).[6] On March 30, 1826, he was listed as depositor number 6572 at the Philadelphia Savings Fund Society.[7] About 1829 the Bards moved to 107 Lombard Street.[8] They were not listed in the 1830 city directory. The U.S. census of 1830 located the Bard family in the North Mulberry Ward between Sassafras (Race) and Vine streets, at the north end of the city, with a household of ten persons, four of whom were their children, as well as four boys over fifteen and under twenty, who must have been apprentices. This census suggests that Conrad Bard had already made arrangements to purchase a residence. For $2,700 he acquired from Joseph Johns, bricklayer, and Rebecca, his wife, a three-story brick house and lot of ground on the east side of Chester Street between Sassafras and Vine and between Eighth and Ninth streets. The deed was written and signed on August 31, 1831.[9] The address for this property was 211 Chester Street although the number varied in city directories, as 216 in 1825, for example.[10]

In 1830 Conrad Bard had made a real estate purchase in the same Northern Liberties area, which was still largely undeveloped. He entered in a long and complicated deed dated March 26, 1830, with Caleb Iddings as trustee for a property on Wissahickon Road near Pegg's Run, in the district of Spring Garden in Penn Township, which had been owned by David Evans, carpenter, and was inherited by his son Charles. Bard was to pay the yearly rent of $15.76 and all taxes and to build on the granted lot "sufficient brick buildings

to secure the yearly rent."[11] This must have been investment property, since promptly on August 21, 1830, Conrad Bard and his wife Ann sold to George H. Beamer, a druggist in Kensington, a piece of the lot on the northeast corner of Buttonwood and Twelfth streets.[12]

Business in all categories suffered hardship in Philadelphia in the 1830s. The federal government had removed its deposits from the Bank of the United States, making credit transactions difficult and specie scarce. In 1834 Conrad Bard, silversmith and jeweler, was one of several hundred who signed a petition for the restoration of those deposits.[13] Perhaps to solve the monetary crunch, in 1836 Bard, resident on Chester Street, joined with Frederick Hoffman (q.v.) in a short-lived partnership that they must have formed at the end of 1836.[14] They are listed as silversmiths at 297 Arch Street in the city directory (as "Bard & Hoffmann [sic]") of 1837 and in Harris's Commercial Directory of 1838.[15] But the city directory of 1839 places Hoffman on Catherine Street above Lebanon, at the other end of the city, and Bard at 21 Chester Street. Several years later, in 1843, Hoffman was listed at 20 Chester Street, across the street from Conrad Bard.

In 1839 Conrad Bard established his silver manufacturing business at 205 Mulberry (Arch) Street, between Fifth and Sixth streets; his silver mark often included that address (see cat. 58). In 1840 he entered into partnership at the Arch Street location with Robert Lamont, with whom he worked until early in 1845.[16] Lamont was a Scot with some financial resources. From 1842 until 1845 his only address was with Bard at 205 Arch Street. He died in Philadelphia in January 1851 without a will. The value of his estate, which was administered by appointees, was $6,501.91. His inventory was spare; the administrator paid the British consul $2.35 for a certificate of burial; $2.50 was paid to John Hughes "as per receipt"; $15.00 was paid to Richard Joyce for ground internment; the undertaker, J. B. McCormick, was paid $75.00, and "general expenses" totaled $75.00. No Bard names were mentioned in his estate papers.[17] However, there must have been a close association, as Conrad and Ann Bard named their second son, born in 1841, Robert Lamont Bard. He died at the age of three in 1844. They named their third son Winfield Scott Bard (born 1845) after the general who was a hero of the War of 1812.

According to the city directories, in 1842 the Bards were living at 159 North Seventh Street. In 1843 or 1844 they moved to Ninth and Morgan streets, and in 1845 Conrad Bard was listed at 211 North Sixth. In 1846 his listing was 267 Callowhill Street.

The decade of the 1840s was an era of heroes, especially local ones, who were being recognized for a variety of reasons and commemorated with prizes and presentations. Silver was the requisite material, and large shops were commissioned to make appropriate items that enhanced the reputations of the firms. A commemorative pitcher (private collection) marked "BARD & LAMONT" was presented to Robert M. Huston in January 1840 in appreciation of his services as president of the trustees of the Philadelphia Gas Works. In January 1841 a pair of ewers by Bard, specially engraved with the scene of a slave in bonds adapted from a painting by John Sartain (1808–1897), was presented to David Paul Brown (1795–1892) for his legal work in advocating the rights of the oppressed.[18] Conrad Bard's silver manufactory began appearing in newspapers in the editorial columns as well as in his own paid advertisements. On October 21, 1846, for instance, Bard was recognized by the Franklin Institute for his exhibition of "Rich specimens of Silver ware, in Vases, Pitchers, Cups, Spoons, etc,"[19] and for several years he continued to be noted and awarded medals for his silver.[20]

On March 18, 1846, the *North American* carried a notice:

Presentation of a Fireman's Horn—A massive and magnificent firemen's [*sic*] horn will be presented this evening at the Moyamensing Hall by the Moyamensing Assembly, to the Moyamensing Hose company. The instrument is from the manufactory of Conrad Bard, in Arch street, and is the most splendid horn of the kind ever made by that artisan. It is of pure silver, exquisitely chased; the devices are admirably executed, and the whole workmanship of the first order. As if to make beauty and splendor fairly dazzling, the horn is studded in several places with rich topazes and other stones of various colors, while the mouth piece is inlaid with gold. Its weight is 37 ounces, and its cost was 120 dollars.

On January 13, 1847, in preparation for the "Grand Fireman's Concert at the Musical Fund Hall," it was announced that there would be "by far the most splendid and costly present made to three companies . . . [the objects] being manufactured by the celebrated Conrad Bard expressly for this occasion, and at whose establishment, No. 205 Arch Street, they will be exhibited in a short time, of which due notice will be given."[21] Two weeks later, on January 27, a reporter who happened to be on Arch Street filed a newspaper notice flagged with a bold pointing hand: "COMMUNICATION. As we were passing the Store of Conrad Bard in ARCH, below Sixth Street we observed in the window a splendid HORN, TORCH and GOBLET,

Fig. 39. Advertisement for Conrad Bard & Son, 1852–63. Courtesy of the Winterthur Library, Delaware. Joseph Downs Collection of Manuscripts and Printed Ephemera, col. 9, 74x144

all of silver, which are considered the most elegant and rare articles ever manufactured."[22]

On April 2, 1853, under the headline "An Interesting Ceremony," the following appeared in the *Philadelphia Inquirer*: "The gentlemen connected with the Philadelphia Post Office, assembled at the Board of Trade Room, in the Merchant's Exchange . . . for the purpose of presenting . . . a magnificently wrought service of silver, consisting of six pieces . . . manufactured by Messrs. Conrad Bard & Sons . . . [inscribed] Presented to Mrs. Emma B. Latta, as a testimonial of esteem and regard for her husband, John E. Latta, Chief Clerk, from his official companions in the Philadelphia Post Office."

While Bard was producing these conspicuous, newsworthy pieces of silver, his strictly commercial advertisements appeared daily in the city's newspapers, especially in the *Philadelphia Inquirer* and the *Public Ledger*. They offered all the usual guarantees of "warranted," "sterling," and "highest prices for old silver" and appeared under the headings "Manufacturing Silversmiths," "Silver Table and Tea Spoons Cheap, Warranted Equal to Dollars," and "Bard's Silver Plate, Spoon & Fork Manufactory." He also began a series of advertisements at holidays that were emulated by other firms.[23]

Bard's eldest son, Edwin Milford Bard, who would become a principal in the firm, had been serving in a New Jersey battalion and was headed for Vera Cruz in the transport ship *Senator* in 1847 when his gallantry saved the crew of a foundered

schooner, the *Thomas P. Hunt* out of New Orleans: "Adjutant Bard is the son of Conrad Bard of this city. Though not more than nineteen years of age, he joined the company raised by Captain Reynolds under the requisition upon the State of New Jersey, and possessing considerable knowledge of military tactics from his former connection with one of our volunteer corps, he was appointed Adjutant of the battalion. The gallant act warranted above, proves that when occasion offers he will not fail to distinguish himself upon the field of battle."[24]

The hero returned, and "Conrad Bard & Son" first appeared in advertisements in August 1849 (fig. 39).[25] The U.S. census of 1850 lists Conrad Bard, silversmith, as age forty-nine in the First Ward, Spring Garden; his wife, Ann Bard, forty-five; Ellen F. Bard, eighteen; Ann M. Bard, eleven; Winfield J. Bard, six; James Fletcher, silversmith, twenty-one; and Sally Brady (born Ireland), sixteen. In the same census Edwin was recorded as age twenty-three and married to Catherine, twenty-one, with their residence in the Northern Liberties, Sixth Ward. They had a son Conrad born in 1852, who died at the age of nine in 1861, when they were living at 811 Wood Street in the Thirteenth Ward.[26] Edwin was listed as a "silverplater" in the Pennsylvania Septennial Census of 1863. He held a patent dated March 14, 1854, for "Improvements in Mould Boards for plows."[27]

Conrad Bard Sr. lived to see the firm move to its final location in 1852, to 116 Arch Street on the south side, exactly opposite its old shop. He died on May 12, 1854, of a "lumbar abscess," at the age, according to Dr. G. Duhring, of fifty-five. At the elaborate funeral, carried out by Moore Undertakers, his walnut coffin was covered with fine black cloth, had silver escutcheons, and was lined and padded. White and black silk gloves were provided, and thirty carriages were provided for the procession. He was buried May 20 from St. Philips Protestant Episcopal Church in the Spring Garden section of Philadelphia[28] and interred in Ronaldson's Cemetery. After Conrad died Mrs. Ann Bard, his widow, moved to Edwin's residence at 480 Vine Street. She died September 8, 1862, at the age of fifty-eight, and was buried in Philadelphia at Ronaldson's Cemetery.[29]

Conrad Bard's will, written on December 17, 1753, was probated May 30, 1854, and directed:

To my son Winfield Scott Bard, my gold watch now worn and carried by me. To my son Edwin Milford Bard, his Executor, assigns all my right title and interest in the Business now carried on by me in conjunction with my said son under the name Conrad Bard & Son, Silversmiths at No. 116 Arch Street below Sixth

St., silversmiths, he my son paying unto his mother for and during all the term of her natural life, six percent per annum the amount of the capital invested by me in said business. After the death of my wife, divide the estate into five equal parts: 1/5 to my son Edwin Milford Bard his heirs, etc; 1/5 to my son Winfield Scott Bard, his heirs etc.; 3/5 to Edwin M. Bard in trust for my daughters Ann, and Frances Burnett wife of A. S. Burnett, and Ellen F. Tower wife of William.[30]

Conrad Bard's estate papers, detailed in some eighteen pages, offer an unusually complete list of stock on hand, as well as tools with a total value of $15,366.44. The appraisers were William W. Supplee, acting as a clerk at Bard & Sons from 1854 until 1856, and David Merritt, MD. The inventory was listed by category of objects rather than by location in the building. Watches and jewelry carried the highest wholesale value, $4,322.31. Some of the watches—hunting lever, silver face, engraved, and the like—were imported from Joseph Johnson in Liverpool and two from M. J. Tobias & Co., at a cost to Bard of $106.00 each. All categories of jewelry are listed: mourning earrings, enamel, hoop, cluster, and garnet; studs and clasps in French gold; coral; and so forth. His silver production is not totaled, but the list included, in part: six oyster ladles; ten dozen teaspoons; a six-piece "Cottage" tea service; a six-piece "Daily" tea service; a "Plain" tea service; a six-piece "Grape" tea service; and coffeepots in sets with an "acorn top" or "flower top"; and a "grapevine" pitcher.

The inventory of tools is also unusually complete, suggesting that Bard's clerk and appraiser William Supplee and Edwin Bard made the list: six raising anvils, six vises, one draw bench and plates, one stoning tub, two border mills, four rolling mills (three damaged), three spoon mills, one lathe, thirty-seven hammers, two flat anvils, one forging anvil, four pairs of bellows, one soldering kettle, one molding apparatus, one lot of dies, one lead pickle tub, one copper pickle tub, one bench table, one pan and tub, ten stools, two stoves, one grind stone, one stoning tub, five spoon stakes, fifty punches, one shaft and pulleys, one stamping stake and sledge, and one stove and pipe; an unspecified number of tongs, skillets, ingot molds, lead pans, pyramids, fixtures, bench tools, chucks and blocks, mallets, gas fixtures, plate tools, crucibles, benches, lamps, drop dies, and sundries; and an unspecified quantity of scotch stone, German silver, and lead.

Conrad Bard & Son suffered from the urban hazards of robbery and fire. In February 1852, before Conrad died, an attempted robbery was foiled by a worker in a drugstore next door. In 1855 there was a fire on the fourth floor of 116 Arch Street, below Sixth Street, occupied by a dental college and White & McCurdy, manufacturers of teeth; the first floor of the building was occupied by Conrad Bard & Son (the name was retained by Edwin Bard after his father died), and the firm suffered damage to its stock.[31] Edwin continued the business until 1863, when he was listed in the Philadelphia directory as "gentleman" at 1520 State Street.[32]

The firm's versatility and civic presence is captured in a recollection by L. Stern published in the monthly publication of the English-Speaking Union in 1919: "In the July number of *The Landmark* I notice an illustration of the 'liberty bell' which tolled the celebration of the Independence of the United States. It may interest my fellow members to know that in 1849, at the age of fourteen, I was employed by Conrad Bard & Son, silversmiths in Arch Street, Philadelphia, and my first work for this firm was to file out the crack shown in your illustrations, as it was intended to ring the bell again at Independence Hall in 1850."[33] BBG

1. The 1810 U.S. census recorded that he was under ten; his petition to Orphans Court in 1818 said he was seventeen; and his death certificate in 1854 listsed his age as fifty-five; *Records of Officers and Men of New Jersey in Wars, 1791–1815* (Trenton: State Gazette Publishing, 1909); "Records of Men Enlisted in the United States Army Prior to Peace Established May 17, 1815," p. 280, Interactive.Ancestry.com.

2. Gilles Alley ran from 136 Lombard Street to 119 Cedar Street.

3. Philadelphia Orphans Court Records, books 27–29, 1818–1824, p. 105, HSP.

4. Ibid.

5. Ibid., p. 364. A Samuel Benson was listed in the 1819 Philadelphia directory as an exchange broker at 2 South Third Street.

6. Stephen G. C. Ensko (1927, p. 18) indicated that Bard was listed in 1825 on Chestnut Street. The family belonged to the Lutheran and Episcopal churches. Conrad Bard was a member of St. Philip's Protestant Episcopal Church, located on the north side of Spring Garden Street below Broad Street, where he was buried. Others—Samuel Bard in 1735, John son of Peter in 1742, Andrew son of Thomas in 1748, and William son of Peter in 1751—were members of Christ Church, Philadelphia; "Records of Christ Church, Philadelphia: Burials, 1709–1760," *PMHB*, vol. 1, no. 3 (1877), p. 351. John George Bard and Catherine Glantz married in 1764 at the Lutheran Church in New Hanover Township, Pennsylvania. Elizabeth Bard (1801), Sarah Bard (1791), and Catherine Bard (1799) all married in the German Reformed Church; *Pennsylvania Archives*, 2nd ser. (1896), vol. 8, p. 653.

7. Philadelphia Saving Fund Society, account no. 65723, Ancestry.com.

8. The directories of 1829 and 1830 list him as Conrad Bird. In the directory of 1833 he was listed as "Connard Bardeer," silversmith, 28 Chester Street (p. 10). The 1830 census listed him twice in the North Mulberry Ward, once as John (Conrad) Bard and once as Conrad Bard, and in both cases ten persons were listed. There are also two records for him in the 1850 U.S. census in the Spring Garden Ward, but the notations of his age differ.

9. Philadelphia Deed Book AM-16-521.

10. Chester Street ran north from Race to Vine between Eighth and Ninth; John A. Paxton, *New Plan of the City [Philadelphia] and Its Environs* (1810), Historical Society of Frankford, www.philageohistory.org. The Philadelphia directory for 1835–36 (p. 28) lists his address as no. 211. It was later noted as his residence. Torr's Court ran east from Ridge Road above Wood Street, and from 190 Second Street to Schuylkill Street in Kensington, from Gunner's Run to West Street.

11. Philadelphia Deed Book AM-43-169.

12. Ibid.

13. H.R. doc. no. 206, 23rd Cong., 1st sess. (1834).

14. Frederick Hoffman, a long-lived Prussian-born metalsmith and silversmith, was in Philadelphia by 1816, located at Torr's Court, which ran east from the Ridge Road above Wood Street, also in the Northern Liberties.

15. *Harris's Commercial Directory and Merchants' Guide for Philadelphia, 1838* (Philadelphia: printed by Rackliff & King, 1838). The information for the publication was gathered in 1837. For their rare mark, see Hollan 2013, p. 12.

16. An advertisement in the *Pennsylvania Ledger* (Philadelphia) of April 21, 1845, was signed "Conrad Bard, Late Bard and Lamont."

17. Philadelphia Administration Book Q, no. 9, p. 65. Benjamin Rush served as the attorney for the administrator, Robert Buist. Rush signed off on the administration on June 21, 1851; transcription, curatorial files, AA, PMA.

18. David B. Warren, Katherine S. Howe, and Michael K. Brown, *Marks of Achievement: Four Centuries of American Presentation Silver*, exh. cat. (Houston: Museum of Fine Arts, 1987), cat. 89, pp. 113, 137, 138.

19. *Philadelphia Inquirer*, October 21, 1846.

20. "We learn with pleasure that our worthy fellow citizens, Messrs. Conrad Bard & Son . . . were awarded a medal at the recent Pennsylvania State Agricultural Society for the best exhibition of silverware"; ibid., October 8, 1856.

21. *Public Ledger* (Philadelphia), January 13, 1847.

22. Ibid., January 27, 1847.

23. Some examples of advertisements can be found in the *Public Ledger*, August 3, 1846, and November 12, 1849; and the *Philadelphia Inquirer*, July 30, 1852, and December 6, 1853.

24. *Public Ledger*, December 2, 1847.

25. Ibid., August 31, 1849.

26. Philadelphia Death Certificates Index, 1803–1915, Ancestry.com.

27. United States Patent Office, *Report of the Commissioner of Patents for the Year 1854: Art and Manufactures*, vol. 1, *Text* (Washington, DC: printed by Beverly Tucker, 1855), p. 274 (patent no. 10,629).

28. Historic Pennsylvania Church and Town Records, HSP, Ancestry.com; Moore Undertaker Records (829 Vine Street, Philadelphia), 1854–1857, HSP.

29. Philadelphia Death Certificates Index, 1803–1915.

30. Philadelphia Wills and Probate Records, 1683–1993, Wills, nos. 158–199, 1854, Ancestry.com.

31. *Philadelphia Inquirer*, February 12, 1855.

32. Philadelphia directory 1863, p. 60.

33. *The Landmark* (New York), vol. 1, no. 7 (July 1919), p. 753.

Cat. 58

Conrad Bard
Tablespoon

c. 1840–50
MARK: C.BARD 205 ARCH ST. (in rectangle, on back of handle; cat. 58-1)
INSCRIPTION: C B T C / T A (engraved script, on front of handle)
Length 8 11/16 inches (22.1 cm)
Weight 1 oz. 19 dwt.
Gift of Mary Tatnall, 2008-132-1

PROVENANCE: This tablespoon originally was part of a set acquired by Catherine Brigit Taylor Clark (1815–1884) of Philadelphia, who in 1831 or 1832 married Dr. Theodore Ashmead (1800–1853). The spoons were inherited by their youngest daughter, Theodosia Ashmead (born 1854), who had her own initials engraved on them. She was the maternal grandmother of the donor's first husband.[1]

Although these spoons were engraved with Catherine Clark Ashmead's maiden initials, the address that appears on the mark indicates that Bard made them no earlier than eight years after her marriage. The spoons may have been purchased with a gift

Cat. 58-1

or legacy from her parents or another member of the Clark family. DLB

1. Thomas Allen Glenn, *Some Colonial Mansions and Those Who Lived in Them* (Philadelphia: Henry T. Coates, 1900), p. 393; "My Family Tree," www.ancestry.com/family-tree /person/tree/4139784/person/220000799813/facts (accessed March 29, 2017). Theodosia Ashmead and her first husband, Guyer Troutman Jones (1844–1887), were married in 1886 and had one daughter, Dora Ashmead Jones (born 1887), who married Sydney Bullen Dunn Sr. (born 1889). Their son, Sydney Bullen Dunn Jr. (born 1916), was the donor's first husband.

Cat. 59

Conrad Bard and Robert Lamont
Pair of Teaspoons

1841–45
MARK (on each): BARD & LAMONT (in rectangle, on reverse of handle; cat. 59-1)

INSCRIPTION: M C P (engraved script, on obverse of handle at top)
Length 6 1/4 inches (15.9 cm)
Weight 16 dwt. 12 gr. (1988-25-22); 18 dwt. (1988-25-23)
Gift of Dorothy Kirkbride Hulme Flavell, 1988-25-22, -23

PROVENANCE: The initials "MCP" belonged to Mary Coleman Pennock (1816–1887), who married David Sellers at Upper Darby Friends' Meeting on April 25,1844.[1]

Cat. 59-1

These spoons were engraved by the same hand as the spoon marked only by Conrad Bard (cat. 60). Bard's estate inventory included an entry for a "moulding apparatus," valued at $6.00.[2] BBG

1. U.S. Quaker Meeting Records, Ancestry.com. Not to be confused with Mary Cadwalader Sellers (1813–1842), who married Samuel Sellers, a member of the same family, on February 5, 1835.
2. Philadelphia Wills and Probate Records, 1683–1993, Wills, nos. 158–199, 1854, Interactive.Ancestry.com.

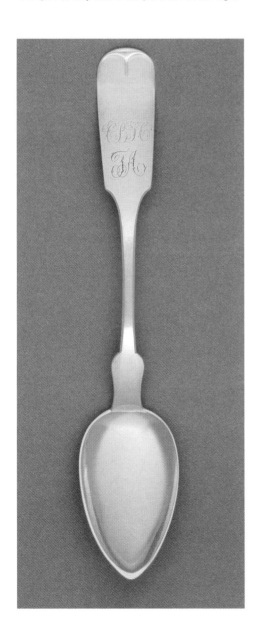

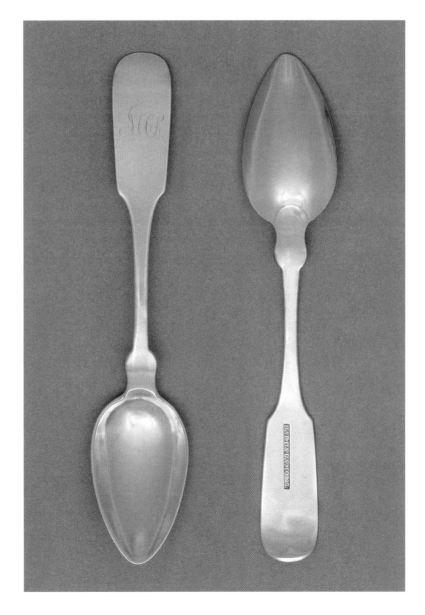

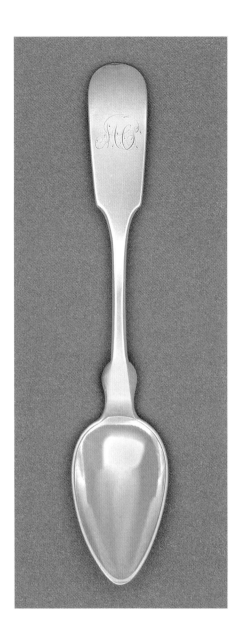

Cat. 60

Conrad Bard

Teaspoon

c. 1844

MARK: C.BARD 205 ARCH ST (incuse, on reverse; cat. 60-1)

INSCRIPTION: M C P (engraved script, on obverse of handle)

Length 6¼ inches (15.9 cm)

Weight 19 dwt. 11 gr.

Gift of Dorothy Kirkbride Hulme Flavell, 1988-25-9

PROVENANCE: This spoon was engraved for Mary Coleman Pennock (see cat. 59), who presumably purchased it to augment the set made by Bard & Lamont.

C.BARD 205 ARCH ST

Cat. 60-1

A news item in the *North American* on June 4, 1846, under the heading "Silver Spoons," noted: "A friend exhibited to us a full set of silver spoons, intended as a present to a young married couple, which for exquisite workmanship we have never seen excelled.

In pattern and style, also, the set is perfect, and the engraving of the initials admirably executed. The spoons are from the manufactory of Conrad Bard, No. 205 Arch Street, whose celebrity as a silverworker is well known."

She may have purchased her silver after the Bard & Lamont partnership had ended, although it is possible that the spoon manufactory may not have used the partnership mark. BBG

Cat. 61

Conrad Bard

Teaspoon

1846–49

MARK: C.BARD 205 ARCH ST (incuse, on reverse; cat. 60-1)

INSCRIPTION: A B (engraved script, at top of obverse of handle)

Length 6⅛ inches (15.6 cm)

Weight 13 dwt. 22 gr.

Gift of Dorothy Kirkbride Hulme Flavell, 1988-25-24

PROVENANCE: Family history stated that the initials "AB" belonged to Abigail Biddle.[1]

This is surely an example of a spoon produced by Conrad Bard at his spoon and fork manufactory. The flatness of the spoon suggests that it was produced in one of Bard's rolling mills. The inventory of his estate notes three spoon mills and four rolling mills.[2] These were probably the mills invented by Bard that facilitated his production of thinner spoons that could be made in molds.[3] BBG

1. The name Abigail was used across the generations and in several Biddle lines; see Henry D. Biddle, *Notes on the Genealogy of the Biddle Family* (Philadelphia: privately printed, 1895).
2. Philadelphia Wills and Probate Records, 1683–1993, Wills, nos. 158–199, 1854, Interactive.Ancestry.com.
3. Hollan 2013, p. 13.

Cat. 62

Conrad Bard
Twelve Dinner Forks

1848–49

MARK (on each): C.BARD 205 ARCH Sᵀ (incuse, on reverse; cat. 60-1)

INSCRIPTION (on each): M A T (engraved script, on obverse of handle)

Length 7¾ inches (19.7 cm)

Weight 2 oz. 4 dwt. 10 gr. to 2 oz. 7 dwt. 3 gr.

Gift of Patricia A. Steffan in memory of Mr. and Mrs. Thomas Hollingsworth Andrews III, 1996-81-5-16

PROVENANCE: The engraved initials are for Martha Archer Thomas (1820–1855), who married Joseph E. Dixon on March 29, 1849.[1] The donor was their great-great-granddaughter.

These twelve forks are handsome, heavy pieces in the *Fiddle Thread* pattern. BBG

1. See curatorial files, AA, PMA. For other silver owned in this family, see PMA 1996-81-1, -2 by Christian Wiltberger.

Cat. 63

Conrad Bard & Son
Ewer and Tray

1851

MARK (on each): C.BARD & SON (incuse, on underside; cat. 63-1)

INSCRIPTION: A Testimonial of Esteem / to / John M. Whitall / from his / Mercantile Friends / in / Acknowledgement / of his / Moral Worth / and / Commercial Integrity (engraved script, in center of tray and on front of ewer under spout) / 6 Mo 2, 1851 (scratched, on underside of foot of ewer)

Ewer

Height 18 inches (45.6 cm), width 9 inches (22.8 cm), diam. base 5½ inches (13.8 cm)

Weight 45 oz. 16 dwt.

Tray

Length 18³⁄₁₆ inches (46.2 cm), width 14⁷⁄₁₆ inches (36.7 cm)

Weight 52 oz. 10 dwt.

Cat. 63-1

Gift of Mr. and Mrs. W. Brinton Whitall, 1986-101-1, -2

PROVENANCE: By inheritance in the family of the donor.

This handsome ensemble was presented to John Mickle Whitall, who was born on November 4, 1800, in Woodbury, New Jersey, to James (1757–1843) and Sarah Mickle Whitall (1766–1826), a Quaker family who farmed in New Jersey. In 1816 John Whitall shipped out as apprentice on the *William Savery* to Calcutta, and in 1818 and 1819 traveled to Charleston, Savannah, Liverpool, and Canton. By 1822 he had been promoted to first mate and received high marks from various captains with whom he sailed. In 1824 he was appointed to the command of a new

ship, the *New Jersey*, the largest ship in Philadelphia, which he sailed successfully until he retired from the sea in 1829.[1] A renowned and respected sea captain, Whitall became a "sincere Quaker" during his voyages: "While at home, after my fifth voyage, I believed it right to adopt the plain dress and language of Friends," and he exerted this influence on his crews.[2]

John Whitall's sisters Hannah and Sarah M. Whitall established a boarding school at 244 Sassafras Street in 1824. The first notice of John is in the city directory of 1830, where he is listed as resident with his sisters; his business, a dry goods store, is listed at 245 High Street with George Haverstick, a carpenter. On November 5, 1830, he married Mary Tatum at the Friends Meeting in Woodbury, New Jersey. He belonged to the Newton Monthly Meeting in New Jersey until his death.[3] Haverstick and his wife resided with his sisters at the southeast corner of Race and Seventh streets until 1832, when they moved to Ninth Street, north of Race, and John Whitall partnered with John C. Capp as dry goods merchants at 79 High Street.[4]

John Whitall's grocery business failed in 1837. The 1838 city directory lists his residence as 62 Lawrence Street and his business at 68 North Third Street. In 1836 or 1837 his former partner George Haverstick had joined with William Scattergood and Thomas Booth at 68 North Third Street in the glass-bottle business. The next year that partnership moved to Millville, New Jersey; Haverstick & Booth were not listed in the Philadelphia directory of 1838. Whitall became the Philadelphia agent for and eventually a partner of Scattergood & Haverstick & Co., druggists and glass manufacturers. In 1849 the Philadelphia branch was listed as Whitall and Booth, glass manufacturers at 138 Sassafras Street. By 1854 it was Whitall Brothers, manufacturers of glass, at 138 Race, and the family had moved to 1317 Filbert. In 1859 the firm had become Whitall, Tatum & Co. at 410 Race Street.[5] John Whitall retired in 1865.[6] From 1867 to 1873 he served on the Board of Guardians of the Poor, which he chaired until he retired from the board in 1872. He was also a manager of the Friends Asylum for the Insane at Frankford, of Haverford College, and of the Pennsylvania hospital.[7]

Whitall earned a local reputation as "The Honest Quaker Merchant." When his business had failed in the financial panic of 1837, his creditors accepted payment of seventy-five cents on the dollar. However, Whitall's "high sense of honor would not permit him to feel satisfied until he had paid the remaining twenty-five cents," and in 1850 he settled the final "twenty-five per cent. of my old debts with the interest, amounting altogether to over $50,000, to the great satisfaction of my late creditors, who sent me a costly pitcher and salver, suitably inscribed."[8] BBG

1. Hannah Whitall Smith, *John M. Whitall: The Story of His Life* (Philadelphia: privately printed, 1879), pp. 39, 98, 112, 167. The Whitall name appears first in New Jersey records c. 1688, when members of the family settled in the Red Bank area; ibid., pp. 1–2.
2. Ibid., p. 121.
3. Philadelphia Death Certificates Index, 1803–1915, Ancestry.com.
4. Smith, *John M. Whitall*, pp. 167–68, 175.
5. The city directory lists the partners as John M. Whitall, Edward Tatum, Joseph Whitall, and Henry Lawrence.
6. Obituary of John M. Whitall, *Philadelphia Inquirer*, June 13, 1877.
7. Ibid.
8. Smith, *John M. Whitall*, pp. 194–96. This source contains a poignant summary in Whitall's own words about his business failure and his method of recovery. See also John F. Watson, *Annals of Philadelphia and Pennsylvania, in the Olden Time* (Philadelphia: J. B. Lippincott, 1870), p. 570.

Cat. 64

Conrad Bard & Son
Bowl

1852–53
MARK: C.BARD & SON (incuse, on underside of bowl;
cat. 63-1)
INSCRIPTION: To Hon. Neal Dow (engraved script in car-
touche, on obverse of bowl) / By his friends / In Penn.ª
(engraved script in cartouche, on reverse)
Height 5⅜ inches (13.7 cm), diam. 6⅜ inches (16.2 cm)
Weight 15 oz.
Gift of Mr. and Mrs. I. Wistar Morris III, 1988-89-3

In this example, what would traditionally have been
a slop bowl became a presentation piece. The
highly decorative design of flowers and scrolls, in
deep chasing and repoussé work, are set against a

stippled ground. The rolled band of Greek fretwork,
Bard's "Roman Border,"[1] is chased; the bead banding
is applied.

Born a Quaker in Portland, Maine, Neal Dow
(1804–1897) was nationally known as the "Napoleon
of Temperance." He married Maria C. D. Maynard on
January 30, 1830, in Portland.[2] Active in politics, with
the cause of temperance always in mind, he regu-
larly attended the sessions of Maine Constitutional
Conventions. He was an active volunteer fireman for
twenty-five years, and served as the mayor of Port-
land in 1850 and 1851 and again in 1855 and 1856.
He served in the Thirteenth Regiment of Maine vol-
unteers after the fall of Fort Sumter and became a
brigadier general. In 1880 he ran for president of the
United States as the Prohibition Party's candidate.[3]

This bowl, although not dated, was probably
presented to Dow in about 1852, when he traveled
across the United States in the cause of prohibition.[4]
BBG

1. See the inventory of Bard's estate; Philadelphia Wills
and Probate Records, 1683–1993, Wills, nos. 158–199, 1854,
Ancestry.com.
2. Frank L. Byrne, *Prophet of Prohibition: Neal Dow and His
Crusade* (Madison: State Historical Society of Wisconsin for
the Department of History, University of Wisconsin, 1961).
3. *Portland City Guide* (Portland, ME: Forest City Printing,
1940), p. 270.
4. Ibid.

John Bayly Sr.

Philadelphia, born c. 1725
Philadelphia, died 1789

John Bayly Sr. made some of the most impressive examples of Philadelphia silver from the third quarter of the eighteenth century, although like his contemporary and neighbor William Ball (q.v.), he also was actively involved in mercantile and real estate dealings. In his life and career he has been difficult to distinguish from other individuals in Philadelphia with the same name, including his own father, his son, and his nephew. Moreover, his surname was variously spelled Baily, Bailey, Baley, Bayley, and even Buly, although for his own signature and touchmarks he consistently used Bayly, as did his son. Not surprisingly, until relatively recently most books on American silver conflated father and son into a single individual. In 1967 Ruthanna Hindes was the first scholar to suggest that the John Bayly active in Delaware in the 1790s was a different person from the silversmith working in Philadelphia in the 1760s.[1] The subsequent research of Barbara Almquist has expanded greatly on Hindes's supposition to establish separate identities for father and son.[2]

John Bayly Sr. was born about 1725 and possibly was the child baptized at the First Presbyterian Church of Philadelphia on May 21, 1727.[3] He was the son of the cordwainer or shoemaker John Bayly (died 1752), who was living in Philadelphia and purchasing land as early as May 1723 and had married Hannah Warner (life dates unknown) no later than December of the same year, when they were involved in land transactions with two of her brothers in Gloucester County, New Jersey.[4] Over the next three decades, the shoemaker acquired considerable real estate holdings that augmented his work as a tradesman with rental income and subsequently became important assets for his son and grandson.[5] The elder Bayly may have been a stern master, for he advertised for runaway indentured servants in 1728 and 1731.[6] Almquist suggested that his son trained as a silversmith with Philip Syng Jr. (q.v.), noting various documentary connections between these families; for example, Syng sold the elder John Bayly two properties on Front Street in August 1726.[7] The two families

were in fact closely related by marriage, as Syng's wife, Elizabeth Warner (1715–1786), was Hannah Bayly's niece, the daughter of her brother, Swen Warner (1688–1761), who also was a cordwainer.

John Bayly Sr. probably completed his apprenticeship as a silversmith in about 1745 or 1746 and presumably was fully trained by the time of his marriage to Jane Watkins at Christ Church on February 1, 1750.[8] She was the eldest child of the carpenter Joseph Watkins (died 1776) and his wife Ellenor, and her family would figure prominently in the Baylys' lives.[9] John and Jane Bayly had two children who survived to adulthood, John junior (q.v.), and Elizabeth (c. 1754–1814).[10] The first record to describe Bayly senior as a goldsmith was a deed of August 21, 1751, in which his father transferred to him the use of a property "in his actual possession now being" on Almond (now Kenilworth) Street near the city's southern boundary.[11] It seems likely that Bayly had spent the first years of his career working as a journeyman, possibly in Syng's large shop.

Bayly's father died intestate in the first months of 1752, and in a partition deed of May 1 of that year, he and his elder brother Richard (died 1758) divided their father's considerable property according to the provincial law that gave the elder son a two-thirds share and the younger a one-third share. John Bayly received three houses and lots, including his Almond Street residence, and two annual rents.[12] By the time his earliest newspaper advertisement appeared on September 5, 1754, he had moved his residence and workshop to another of these inherited properties "at the sign of the Tea-pot, at the lower end of Front Street, near the Draw-bridge."[13]

The legacy from his father gave Bayly significant financial advantages at the outset of his career. In 1756 tax assessors rated Bayly's estate at £60, far above that of most of the residents in the Dock Ward.[14] These resources enabled Bayly to sell goods from Britain to supplement the products of his shop. In addition to "all sorts of gold and silver work made and sold as usual," Bayly's earliest newspaper advertisement in the *Pennsylvania Gazette* in September 1754 listed an extensive range of jewelry and tools imported from London:

> Steel chapes and tongues, round and square ditto for knee buckles, chrystal stone buttons, steel topped thimbles, corals for whistles, silver watches, with enamelled and silver faces, silver jockey spurs, lined with steel, watch glasses, chrystal waist-coat buttons, set in silver, money scales and weights, in boxes, silk watch strings, broad and narrow sorted colours, watch keys, fine pierced Pinchbeck shoe and knee buckles, in setts, silver pendants for watches, sundry sorts of

files, viz. half round, flat, round, rough, bastard and smooth, spring dividers, compasses, cutting nippers, hand shears, clock and watch plyers, blow pipes, fine binding wire, and fine drawing plates, hand vizes, rotten stone, allom, salt petre, &c. &c.[15]

These wares, usually imported from Great Britain, were typical of those offered by retail jewelers of the period. Beginning in the same issue of the *Pennsylvania Gazette* and continuing until November, Bayly advertised his intention to travel to London "in a short time," suggesting that he had connections in England.[16] He had regular shipments from England, advertising an almost identical list of goods "lately imported from London" in December 1755.[17] It is possible that Bayly was related to one or more contemporary London silversmiths with the Bayley surname, such as Richard Bayley (active 1706–48).[18]

Records from the early 1750s document Bayly's participation in Philadelphia organizations that included several of his professional compatriots. He became a member of Masonic Lodge Number 2 in June 1752 and served as treasurer from 1756 to 1762. William Ball had joined in 1750, and Bayly was succeeded as treasurer by the silversmith William Ghiselin (q.v.).[19] On March 30, 1751, a John "Bayley" was among the charter members of the Union Library Company. It is not certain whether this was the silversmith or possibly his father; there were, however, other silversmiths among the Union Library members, including William Ball, Jeremiah Elfreth Jr. (q.v.), and Philip Syng Jr.[20] The identity of the John "Baily" recorded in 1763 as a member of the Fort S. David's Fishing Company is also uncertain; the group was composed primarily of colonists of Welsh descent and appears to have included few silversmiths.[21] Similarly, the John Bayly who contributed to the Pennsylvania Hospital in 1762 may or may not have been the silversmith.[22]

After Bayly's older brother Richard died in November 1758, the silversmith became embroiled in legal battles over family real estate as well as custody of his nephew.[23] John Bayly claimed title to three of the properties that Richard Bayly had inherited from their father and initiated an ejectment against Richard's widow, Elizabeth Bayly, who died early in 1760 before any action was taken. When Richard's executor, John Fraser, put the properties up for auction in March 1760, the silversmith advertised his claim "to prevent . . . honest purchasers from being imposed upon in the Sale."[24] At the same time, Bayly challenged Fraser for guardianship of his minor nephew, Richard and Elizabeth's son John Bayly (born c. 1750, died before 1785), offering to pay to "Cloathe, Educate,

Maintain & Put [him] to Apprentice."[25] They compromised on two independent guardians appointed by the Orphans Court, although Fraser delayed giving up custody.[26]

In April 1757 Bayly moved to another of his properties at the corner of Front and Chestnut streets, across Front Street from William Ball.[27] He put his previous home at Front and Dock streets on the market one year later with the incentive that "the title is very clear and good."[28] Bayly remained at the Front and Chestnut location for about twelve years, although for approximately two years between 1761 and 1763 he apparently moved elsewhere and rented the premises to a succession of tradesmen, including the grocers Denormandie & Pierce and Reed & Petit and the tailors Fitzrandolph & Stille, all of whom advertised their address as "the House where John Bayly formerly lived."[29] In August 1763 Bayly announced that he "hath removed to his late Dwelling house . . . where he carried on his Business as usual."[30]

Little evidence survives about the size of Bayly's shop over the years. His only recorded apprentice was Thomas Shields (q.v.) of Newlin Township, Chester County, whose father apprenticed him at age seventeen on September 15, 1760, "in the Sum of Fifty Pounds . . . for the term of four Years and Six Months."[31] Bayly's son and namesake, John Bayly Jr., presumably apprenticed with his father about the same time or a few years later. Almquist speculated that Shields's younger brother, Caleb (c. 1745–1793), and Stephen Reeves (1754–1776) may also have been Bayly's apprentices.[32] In 1763 Bayly advertised for sale "three healthy Negroe Lads, that have had the Small pox, two of which can work at the Goldsmith Trade," which suggests that they had worked in his shop and possibly received some training from him.[33] Bayly's advertisement of December 1755 lists tools that he offered for sale, which gives some indication of what was being used in his shop:

> Sundry sorts of rough, bastard and smooth files, spring dividers, carpenters compasses, clock and watch plyars, cutting nippers, hand shears, fine round drawing plates, fine and coarse binding wire, hand vizes, spur rowels, brass blow pipes, borax, sandiver, salt petre, allom, rotten stone, pumice stone and sand paper, best blue melting pots, and crucibles, a pair of best fine steel assay ballance fixed with silver pans and skirts, and skirts in a neat mahogany square glass lanthorn, with setts of gold and silver assay weights in a draw box compleat.[34]

Bayly oversaw production of the full range of hollowware, including coffeepots, teapots, cream pots, tankards, and canns, as well as waiters, punch strainers, porringers, and a variety of flatware. An impressive array of tableware was in his shop when its contents were put up for auction in December 1769: "A very genteel silver tea kettle and stand, chased coffee pot and stand, tea pot and stand, chased and plain sugar dishes, bowls, waiters, castors, salts, soup and punch ladles, wine cocks, table and tea spoons, snuff boxes, graters, tweezers, mason medals, buckles, watch chains, &c."[35] Most of the surviving hollowware marked by Bayly is relatively simple, with the plain, bellied forms popular from the 1730s to the 1770s (see cats. 67, 68). One anomaly is a sugar bowl with a flaring rim and ornamented with repoussé chasing not found on any other surviving object attributable to him.[36]

Not all of the silver he sold was made in his shop. He acquired finished pieces made by other silversmiths, such as the thirteen cream pots and six watch chains he purchased in 1763 when the estate of Philip Hulbeart (q.v.) was liquidated.[37] He also imported objects from England. In August 1763 he advertised "a neat assortment of London and Philadelphia made plate."[38] His account with the merchant David Franks (1720–1794) in September 1760 detailed the costs for "making" spoons and camp cups, charging nine shillings per ounce for the silver, twelve shillings for making each camp cup, and twenty-four shillings for making each set of spoons. In the same account, a cann, salts with spoons and glass liners, a cream pot, and a soup ladle were described as "London make," with no charges for the silver or their manufacture:

> 6 silver spoons w[eight] 12 oz. 9 dwt. @ 9/ [shillings per ounce] & making 24/ [£]6.16.[0].
>
> 6 camp cups 8 [oz.] 1 [dwt.] 9/ p oz [& making] Each 12/ 7.10.3
>
> 2 larger do 3 [oz.] 19 [dwt.] 12 [gr.] 9/ p oz [& making] Each 12/ 2 19.9.
>
> 6 spoons marked TM 12 [oz.] 3[dwt.] 9/ p oz making 24/ 6. 13.4.[0]
>
> 1 London Make 1/2 pint can 4 18.3.
>
> do 1 p[air] Salts Ladles & Glasses 5.6.7.
>
> do 1 Cream pot 2.15.9.
>
> do 1 Soup Ladle 4.12.[0]
>
> [Total £]41.11.11.[39]

A significant part of Bayly's business was in jewelry and flatware, some of it made in his shop and some of it acquired for retail. Between 1760 and 1762 he purchased from his neighbor William Ball large quantities of thimbles, stay hooks, and chapes for knee and shoe buckles, as well as gold, the thimbles and stay hooks presumably for retail sale, and the gold presumably for incorporation into gold and silver buckles.[40] Bayly charged David Franks for two pairs of tea tongs in 1760 and for "making" twelve dozen heart-shaped brooches for the Indian trade in 1761.[41] In November 1768 Bayly advertised "a Very neat and beautiful assortment of Jewellery, consisting of curious set combs for ladies hair, shoe buckles, diamond and other rings, buttons, and a variety of other articles—all executed in an elegant and masterly manner, after the newest taste, and most approved fashions."[42] As he had in 1754, Bayly advertised that he intended to travel to England in 1761, perhaps to purchase more stock of this kind.[43] However, his ability to retail London-made silver was curtailed after October 25, 1765, when he signed the Philadelphia non-importation agreement.[44]

Over the course of his career, Bayly served a wide range of clients. Almquist identified his earliest surviving object as a tablespoon from a set of six listed in the 1756 will of Nathan Smart (died 1757), a farmer in Elsinboro, New Jersey.[45] In 1778 the coppersmith Lewis Grant advertised for a stolen cream pot "market [sic] L M G, maker John Buly."[46] More prominent patrons included the brewer Anthony Morris (1705–1780), who similarly advertised for "a Silver Spoon, almost as good as new, supposed to be taken out of his House, no Mark except the Silver Smith Stamp, J. Bayly."[47] General John Cadwalader (1742–1786) purchased a gold hat buckle and a silver buckle from Bayly in 1768 and 1769, and in the latter year Mary (Parker) Norris (died 1799) acquired a watch chain and two pairs of buckles.[48] In 1765 Bayly was paid £15 for a teapot presented by the Province of Pennsylvania to Harriet Tew (born c. 1736), in gratitude for her husband Edward's role in constructing piers on Reedy Island in the Delaware River.[49] Some clients lived outside Pennsylvania. The miller Isaac Dushane (died 1790) and his wife, Mary Dushane (died 1792) of Red Lion Hundred, New Castle County, Delaware, acquired a tankard and cann; and Edward Tonkin (1706–1768) of Burlington County, New Jersey, had Bayly make matching tankards for his daughters (cat. 65).[50]

In common with that of every silversmith, Bayly's work encompassed a variety of tasks besides making and selling silver objects. At least three gold Portuguese coins have survived with plugs marked by Bayly, indicating that he had been asked to bring their weight up to their current face value.[51] In 1754 and again in 1758, he advertised spoons that he had held on suspicion of their being stolen after being offered them for sale, noting in one instance, "A lad offered one of them for sale, and said he found it in a stump, in

Daniel Bryan field, in Kent county, Maryland."[52] In December 1760 Bayly weighed and valued 62 ounces of "old plate" belonging to Abigail (Powel) Griffitts (1735–1797) that had been deposited with the merchant Charles Norris (1712–1766).[53] He repaired a porringer, strainer, and spoon for Norris in 1765.[54] Bayly also had dealings with no connection to silver. In 1754 he advertised "two good saddle or chair horses to dispose of, and will give twelve months credit, if required, for the same."[55]

At some point between May 1763 and September 1764, Bayly acquired a plantation of 150 acres that included an inn at the site of mineral waters known as the Yellow Springs in West Pikeland Township, Chester County.[56] According to one nineteenth-century source, he replaced the existing inn with a larger and more commodious structure.[57] On the township tax lists between 1764 and 1768, Bayly was recorded as an "innkeeper" and assessed for 120 acres with buildings and 30 acres of woodland, a saw mill, four horses, three cows, and three sheep.[58] He advertised the property for lease in 1764 and again in 1765, noting that "none need apply except one that understands Farming, and will keep a genteel orderly House of Entertainment, being a noted licensed House, and much resorted to in the Summer Season, for the Benefit of the Mineral Waters, greatly to the Advantage of any Tenant who shall incline to entertain such Resorters."[59] Unfortunately, one man who leased the property, George Maxon, proved less than satisfactory; the Uwchlan Friends Meeting remonstrated against Maxon as the keeper of a "place of promiscuous resort."[60]

By the second half of the 1760s, Bayly owned substantial property that yielded a significant income. In 1767 his annual rents totaled more than £122, and he paid a proprietary tax of £104 8s. 10d. on these as well as the house, horse, cow, and slave that he owned.[61] In that same year, the Overseers of the Poor assessed Bayly for a poor tax of £1, significantly more than was paid by most residents of the Chestnut Ward, other than merchants.[62] He was among the investors in the Philadelphia Land Company, which in 1766 had taken control of 200,000 acres of land in Nova Scotia and attempted to attract settlers from Pennsylvania. An advertisement in April 1768 listed Bayly and the clockmaker Edward Duffield (1720–1801) as two of the agents "who will make known the terms of settlement, enter into articles, and give all reasonable encouragement."[63]

Despite or perhaps because of his real estate dealings, Bayly accumulated significant debts during these years. By 1769 he no longer owned a cow or slave, and his tax was reduced to £97 2s. 2d.[64] By the end of that same year, Bayly was

bankrupt, and management of his financial affairs was assigned to six creditors, one of whom, Charles Meredith (c. 1720–1783), had been a long-term tenant of both Bayly and his father.[65] In a deed dated November 31 [sic], 1769, Bayly and his wife transferred to these trustees ownership of ten lots or tracts of land with their buildings, the Baylys' "share of Lands in Nova Scotia," one annual ground rent, and "all and singular the household goods & all other the goods chattels negroes servants wares merchandizes Plate effects and moveables."[66] The trustees acted quickly, placing a notice in the Pennsylvania Gazette on December 7 to request that "all persons who have any demands against the Estate of John Baily, Goldsmith, are desired to send in their Accounts to the Subscribers; and all those indebted to the said Estate are requested to pay their Accounts immediately." On December 18 they held an auction of "all the shop goods belonging to the estate of JOHN BAILY, Goldsmith, consisting of a valuable collection of the most fashionable plate and jewellery. . . . At the same time will be disposed of, a variety of household furniture, belonging to the said estate."[67]

This sale was followed by at least two auctions of Bayly's real estate in Philadelphia. One on February 14, 1770, included his residence and shop at Front and Chestnut as well as three other properties; the second, on July 12, featured additional houses and lots.[68] The Yellow Springs plantation was offered in March 1771.[69] Some of the properties that were offered did not sell immediately, and it took several years to settle Bayly's debts. The trustees were still soliciting accounts from Bayly's creditors in May 1771 for the "first Dividend" to be made on July 1 from what funds they had realized.[70] A second dividend was paid almost two years later, in February 1773, and a third in March 1775.[71]

The deed that Bayly had signed in November 1769 included the note that he was "willing and desirous to pay the same [debts] as far as in him lies," and he continued working. In December 1769 he placed advertisements in the Pennsylvania Gazette, the Pennsylvania Journal, and the Pennsylvania Chronicle and Universal Advertiser to announce that

THE subscriber takes this method of informing the public in general, and his customers in particular, that he still continues to carry on the Goldsmith and Jeweller business as usual, at the corner of Front and Chestnut streets.

As it always has been his constant endeavour to oblige his customers, so every one may depend upon it, that he will exert himself, as much as lies in his power, to perform his work with all the care, dispatch and nicety, that can be required. And all orders shall be

executed, at the most reasonable rates, to the full satisfaction of his employers, who he hopes will continue their former favours, which will greatly oblige their humble servant, John Bayly.[72]

The same advertisement continued to appear until the end of May 1770.[73] Bayly's efforts to settle his debts apparently earned him the nickname "honest John Bailey," as recorded in a mid-nineteenth-century history.[74]

At some point after the sales of his property, Bayly apparently moved from Philadelphia to Yellow Springs while he worked his way out of his financial difficulties. When the Yellow Springs plantation was offered for sale in 1771, a whole or partial interest was purchased by Samuel Kennedy (1730–1778), a physician in Philadelphia.[75] That Bayly resided there is indicated by an advertisement placed in February 1772 offering the tenancy of one of the houses on the property and including the instruction that interested parties should apply either to Kennedy in Philadelphia or to "Mr. JOHN BAYLY, at the Springs." The same notice also sought to purchase "a NEGROE Man, acquainted with Farming," an indication that Bayly himself was not farming, although it is unclear whether he continued working as a silversmith in Chester County.[76] In August of the same year, Bayly petitioned for a tavern license because he "has removed to reside at the Yellow Springs."[77] Bayly's last recorded association with the plantation was in November 1773, when he placed an advertisement for a stray horse found on the property.[78]

By the outbreak of the War of Independence, Bayly had returned to Philadelphia. The "John Bailey Sen'" who paid for a private substitute for military service on August 12, 1777, almost certainly was not the silversmith, as the act creating a Pennsylvania militia conscripted white males between the ages of eighteen and fifty-three, and Bayly was about fifty-seven at the time.[79] For the first few years after he returned, the location of his residence and shop is unknown, and his name was not recorded in the 1774 Provincial Tax lists.[80] He may have been living in the Mulberry Ward with his father-in-law, Joseph Watkins Sr., who paid a substantial tax of £111 0s. 11d. in that same year. Watkins's death early in March 1776 apparently gave Bayly his own residence as well as some welcome financial assistance, since his wife Jane inherited interests in Philadelphia properties to which his creditors had no claim. These were identified in a trust document as "the proper Inheritance of her the said Jane left to her by the last Will and Testament of her Father Joseph Watkins deceased, [and] should be conveyed settled and assigned

to the sole and separate benefit of the said Jane during her coveture and after her decease to their children . . . that she and her assigns might receive the Rents Issues and Profits thereof to her sole and separate use exclusive of her said Husband . . . notwithstanding her coveture or the Bankruptcy of her said Husband."[81]

By 1779 both the Pennsylvania state tax and Philadelphia Effective Supply Tax lists recorded Bayly living in the east part of Mulberry Ward, immediately adjacent to his brothers-in-law the cabinetmaker Joseph Watkins Jr. and the hatter Samuel Davis, all presumably at properties that had belonged to Joseph Watkins Sr.[82] Bayly's address was on Fetter Lane, otherwise known as Watkin[s] Lane, one of the properties Jane Bayly had inherited.[83] The 1785 city directory recorded this address as "Cherry alley b[etween]. Third and Race-streets."[84] Tax records show that the value of Bayly's property slowly declined, perhaps as his career wound down. The 1782 Effective Supply Tax assessed his dwelling in the Mulberry Ward at £200, but this declined each subsequent year until it was valued at £135 in 1788; his taxes declined over the same period from £1 5s. to 9s.[85]

Bayly resumed his activity as a silversmith almost immediately upon his return to Philadelphia. As before, he purchased both parts and finished wares from other silversmiths. Between 1776 and 1781 Bayly acquired silver shoe buckles as well as buckle chapes and "Spur Rowells" from his former apprentice, Thomas Shields.[86] He apparently also was supplied with raw materials. In January 1777 Bayly offered a 15s. reward for "a small white metal barr about 12 or 13 inches long, stamped J.BAYLY" that had been lost north of the city.[87] In November 1777 he was one of eight silversmiths, including William Ball and John David Sr. (q.v.), who signed a statement fixing the value of various coins and paper currency.[88] A cann marked by Bayly bears an inscription dated 1778, after the evacuation of the British army from Philadelphia, although this engraving may be commemorative rather than an indication of the cann's date of manufacture.[89]

Bayly did not advertise again in newspapers until September 1783, after the war had concluded. In a subsequent listing he reminded potential clients of his previous experience: "[He] carries on his Business in its different Branches, and makes all Sorts of Gold and Silver Work in the newest Fashion. He formerly carried on Business at the Corner of Front and Chesnut [sic] streets, and will be much obliged to his old Customers for the Continuance of their Favours."[90] Among the new items he offered were "Spectacle glasses, mounted or unmounted."[91]

Bayly's last newspaper advertisement was placed in November 1783, and he was listed as a goldsmith in the 1785 city directory.[92] Almquist dated the chalice and paten that Bayly made for Shrewsbury Parish Church, Kent County, Maryland, to around 1785.[93] No evidence has come to light of his activity as a craftsman after that year. He apparently died in 1789; Almquist identified him with the John "Baley" interred in the burial ground of Christ Church, Philadelphia, on October 13, 1789.[94] Evidence supporting this identification is found in the Effective Supply Tax lists for the South Mulberry Ward. In 1788 Bayly was recorded with a dwelling valued at £135; the following year "Widow Bailey" appeared in the same position on the list with the same valuation.[95] Jane (Watkins) Bayly was still alive in March 1797 but was recorded as deceased in April 1802.[96]

At least five marks are firmly attributable to John Bayly Sr., three of them represented in the Museum's collection: "I•BAYLY" incuse (cat. 65) "IB" incuse (cat. 66), and "I•BAYLY" in a rectangle (cat. 67).[97] Bayly also used a pseudo-hallmark of a pair of lovebirds.[98] It is not known whether John Bayly Jr. also used any of them. As noted above, most of the surviving objects with Bayly marks are in styles popular in decades before 1775, when Bayly junior began working, but it is possible that some of them were made by him. No Bayly hollowware in the neoclassical style has been identified. Stylistically the latest object with a Bayly mark is a tablespoon with a downturned, rounded-end handle, roulette-work engraving, and die-struck decoration of a dove that resembles examples from the 1780s by other Philadelphia makers such as Edmund Milne (q.v.).[99] The spoon is marked with the "I•B" in a rectangle mark that appears on the Tonkin family tankards of about 1765–70, so it is possible that the spoon was made by the elder Bayly toward the end of his career. DLB

1. Hindes 1967, pp. 255–56.

2. Almquist 1996, pp. 20–21.

3. "Register of Baptisms 1701–1746, First Presbyterian Church of Philadelphia," *The Pennsylvania Genealogical Magazine*, vol. 19, no. 3 (September 1954), p. 291.

4. Mrs. William M. Mervine, "Abstracts of General Loan Office Mortgages," *Publications of the Genealogical Society of Pennsylvania*, vol. 6, no. 3 (March 1917), p. 273; Jordan 1911, vol. 1, p. 239. Hannah (Warner) Bayly presumably died before her husband did, as his estate was divided between his two sons, with no mention of a widow (see note 5 below).

5. At the time of his death in 1752, the elder John Bayly owned nine lots, eight houses, and three annual rents; Deed of Partition, Richard Bayly and John Bayly, May 1, 1752, Philadelphia Deed Book H, vol. 3, pp. 367–73.

6. Kenneth Scott, comp., *Genealogical Abstracts from the American Weekly Mercury, 1719–1746* (Baltimore: Genealogical Publishing, 1974), pp. 39, 51.

7. Almquist 1996, p. 20. See Philip Syng to John Bayley, August 15, 1726, Philadelphia Deed Book F, vol. 3, pp. 449–51.

8. *Pennsylvania Archives*, 2nd ser. (1896), vol. 8, p. 13.

9. Joseph Watkins's will, written January 10, 1766, probated March 12, 1776, named the following children: Jane (wife of John Bayly), James, Esther (wife of Samuel Davis), Joseph, John, Mary (wife of Evan Morgan), and Hannah (wife of Leeson Symonds); Philadelphia Will Book Q, p. 266.

10. Almquist (1996, pp. 20–21) identifies the silversmith's daughter with the Elizabeth Bailey, age sixty, who was interred in Christ Church Burial Ground on January 25, 1814; "Burial Register, 1785–1800," no. 3707, Archives, Christ Church, Philadelphia. See also Philadelphia Death Certificates Index, 1803–1915, Ancestry.com.

11. John Bayley Sr. to John Bayley Jr., August 21, 1751, Philadelphia Deed Book D, vol. 57, pp. 317–18.

12. See note 5.

13. *Pennsylvania Gazette* (Philadelphia), September 5, 1754.

14. Hannah Benner Roach, *Colonial Philadelphians*, Genealogical Society of Pennsylvania Monograph Series, no. 3 (Philadelphia: Genealogical Society of Pennsylvania, 1999), p. 112.

15. *Pennsylvania Gazette*, September 5, 1754.

16. Ibid.

17. Ibid., December 11, 1755.

18. Arthur G. Grimwade, *London Goldsmiths, 1697–1837: Their Marks and Lives* (London: Faber and Faber, 1976), pp. 434–35.

19. Julius F. Sachse, *Old Masonic Lodges of Pennsylvania: "Moderns" and "Ancients," 1730–1800* (Philadelphia: Grand Lodge of Pennsylvania, 1912), vol. 1, pp. 63–64, 70.

20. E. V. Lamberton, "Colonial Libraries of Pennsylvania," *PMHB*, vol. 42 (July 1918), pp. 195–96.

21. *A History of the Schuylkill Fishing Company of the State in Schuylkill, 1732–1888* (Philadelphia: the members of the State in Schuylkill, 1889), p. 401.

22. *Pennsylvania Gazette*, July 15, 1762.

23. Richard Bayly's will was written on November 5, 1758, and probated on November 20; Philadelphia Will Book L, p. 194.

24. *Pennsylvania Gazette*, April 3, 1760.

25. Philadelphia Orphans Court Records, book 5, 1757–61, pp. 154–55.

26. Ibid., pp. 167, 204–6.

27. *Pennsylvania Gazette*, April 21, 1757. John Ord advertised imported broadcloth at his shop on Front Street "opposite Mr. John Baily's, Goldsmith, and next Door to Mr. William Ball's"; ibid., June 10, 1762.

28. Ibid., March 16, 1758.

29. Ibid., December 24, 1761; October 21, 1762; August 4, 1763.

30. Ibid., August 11, 1763.

31. Almquist 1996, p. 24.

32. Ibid., p. 21.

33. *Pennsylvania Gazette*, March 10, 1763.

34. Ibid., December 11, 1755.

35. Ibid., December 14, 1769.

36. Wees and Harvey 2013, cat. 81, which records how Almquist determined that this mark, "IB" in an oval, could be securely attributed to Bayly; it appears on a tankard together with Bayly's relief surname mark (Quimby and Johnson 1995, cat. 319; see cat. 67 for an example of the latter mark). Additionally, it was struck on another tankard together with Bayly's incuse surname mark; Sotheby's, New York, *The Collection of Roy and Ruth Nutt: Highly Important American Silver*, January 24, 2015, sale 9304, lot 563.

37. Fales 1974, p. 204.

38. *Pennsylvania Gazette*, August 11, 1763.

39. David Franks, Account Book, 1760–1766, p. 5 (left), September 10, 1760, HSP.

40. William Ball, Account Book, 1759–1762, Downs Collection, Winterthur Library.

41. David Franks, Account Book, p. 6 (left), October 23, 1760; p. 11 (left), March 26, 1761. The latter account reads: "9 doz silver heart broaches / 3 do stronger d[itt]o / Wt 5oz 18dwt 6gr @ 9 / [£]2.13.5. / making the above 12 doz broaches @ 5/ [£]3 0.0. / [£]5.13.5."

42. *Pennsylvania Chronicle and Universal Advertiser* (Philadelphia), November 7, 1768.

43. *Pennsylvania Gazette*, July 2, 1761.

44. Scharf and Westcott 1884, vol. 1, p. 273. The original document is in the HSP collection.

45. Almquist 1996, p. 37. For Smart's will, see A. Van Doren Honeyman, ed., *Calendar of New Jersey Wills, Administrations, Etc.*, vol. 3, 1751–1760, Documents Relating to the Colonial History of the State of New Jersey, 1st ser., vol. 32 (Somerville, NJ: Unionist-Gazette Association, 1924), p. 296.

46. *Pennsylvania Ledger, or The Philadelphia Market-Day Advertiser*, April 29, 1778.

47. *Pennsylvania Gazette*, August 16, 1764.

48. Mr. Cadwallader to Jnᵒ Bayly, invoice, December 15, 1768 and January 12, 1769, Cadwalader Family Papers, Series II, folder Ba, box 7, Incoming Correspondence, HSP; Mrs. Norris, invoice, June 2, 1769, Norris Family Papers, Family Accounts, 1740–73, folder 68, box 6, HSP.

49. *Pennsylvania Archives*, 8th ser. (1935), vol. 7, p. 5893. Edward Tew married Harriet Mullan (or Mullens) in Philadelphia at Christ Church on February 15, 1752; ibid., 2nd ser. (1896), vol. 8, p. 185. See also the Lacy family tree, Ancestry.com (accessed June 30, 2015).

50. For the Dushane silver, see Donald L. Fennimore, "A John Bayly Tankard and Cann," *Silver Magazine*, vol. 19, no. 3 (May–June 1986), pp. 18–19; and Quimby and Johnson 1995, cats. 319, 320. For Edward Tonkin's will, see Honeyman, *Calendar of New Jersey Wills*, 1st ser., vol. 33, p. 435.

51. Gregory G. Brunk, *Merchant and Privately Countermarked Coins: Advertising on the World's Smallest Billboards* (Rockford, IL: World Exonumia Press, 2003), p. 110.

52. *Pennsylvania Gazette*, November 7, 1754.

53. "Invoyce & Weight of Plate d[eposite]ᵈ Chaˢ Norris"; December 29, 1760, Norris Family Papers, Griffitts Estate, box 13, folder 18, HSP. I am grateful to James Gergat for discovering this source. Abigail Griffitts's husband, William Griffitts, was the nephew of Charles Norris's brother-in-law; Jordan 1911, vol. 1, p. 112. Bayly valued the Griffitts silver at 8s. per ounce for a total of £24.16.0.

54. Estate of Mr. Charles Norris due in Account with James Johnson, September 24, 1765–September 11, 1766, and September 12, 1765–September 11, 1766, Norris Family Papers, Family Accounts, 1740–73, box 6, folders 47 and 53.

55. *Pennsylvania Gazette*, September 5, 1754.

56. Estelle Cremers, *30,000 Acres: Vincent and Pikeland Townships, 1686 to 1850* (Pottstown, PA: privately printed, 1989), pp. 66–67.

57. J. Smith Furthey and Gilbert Cope, *History of Chester County, Pennsylvania, with Genealogical and Biographical Sketches* (Philadelphia: Louis H. Everts, 1881), p. 202.

58. Cremers, *30,000 Acres*, p. 67.

59. *Pennsylvania Gazette*, September 6, 1764; May 23 and August 8, 1765.

60. Cremers, *30,000 Acres*, p. 67.

61. 1767 Proprietary Tax List, p. 184; Tax and Exoneration Lists, 1762–1794.

62. Roach, *Colonial Philadelphians*, p. 158.

63. *Pennsylvania Gazette*, April 14, 1768. Moncton, now in New Brunswick, was the company's only successful settlement.

64. 1769 Philadelphia Proprietary Tax List, p. 233v, Tax and Exoneration Lists, 1762–1794. See also *Pennsylvania Archives*, 3rd ser. (1897), vol. 14, p. 218.

65. Insurance survey no. 110, October 14, 1752, Philadelphia Contributionship for the Insurance of Houses from Loss by Fire. The other creditors were merchants Samuel Cadwalader Morris (1734–1812), William Craig (life dates unknown), George Meade (1741–1808), John Rhea (1730–1773), and John Wilcox (1728–1793).

66. John Bayly and uxor to Charles Meredith & c., November 31 [sic], 1769, Philadelphia Deed Book I, vol. 7, pp. 138–42.

67. *Pennsylvania Gazette*, December 14, 1769.

68. Ibid., December 28, 1769; May 31, 1770.

69. Ibid., March 14, 1771.

70. Ibid., May 23, 1771.

71. Ibid., February 3, 1773; *Pennsylvania Journal and Weekly Advertiser* (Philadelphia), March 8, 1775.

72. *Pennsylvania Gazette*, December 28, 1769; *Pennsylvania Journal and Weekly Advertiser*, December 28, 1769; *Pennsylvania Chronicle and Universal Advertiser*, January 1, 1770.

73. *Pennsylvania Gazette*, May 31, 1770.

74. Sherman Day, *Historical Collections of the State of Pennsylvania* (Philadelphia: George W. Gorton, 1843), p. 224.

75. *Pennsylvania Gazette*, March 14, 1771.

76. Ibid., February 27, 1772.

77. Cremers, *30,000 Acres*, p. 68.

78. *Pennsylvania Gazette*, November 4, 1773.

79. *Pennsylvania Archives*, 6th ser. (1906), vol. 1, p. 193.

80. Ibid., 3rd ser., vol. 14 (Harrisburg, 1897).

81. Philadelphia Will Book Q, p. 266; John Bailey and uxor to Samuel Davis, March 9, 1776, Philadelphia Deed Book I, vol. 15, pp. 345–47.

82. 1779 Philadelphia Effective Supply Tax list, p. 87; 1779 Pennsylvania State Tax list, p. 168, Tax and Exoneration Lists, 1762–1794. See also *Pennsylvania Archives*, 3rd ser. (1897), vol. 14, pp. 536, 813.

83. Fetter or Watkin[s] or Cherry Lane (or Alley) was located in the block framed by North Third, Quarry, Arch, and Race streets; it was officially renamed Cherry Street in 1900.

84. White's Philadelphia directory 1785, p. 10.

85. 1782 Philadelphia Supply Tax list, pp. 156, 272, and 1788 Philadelphia Supply Tax List, p. 66, Tax and Exoneration Lists, 1762–1794.

86. Thomas Shields, Daybook, pp. 66, 82, 94, 96, Downs Collection, Winterthur Library.

87. *Pennsylvania Evening Post* (Philadelphia), January 21, 1777.

88. *Pennsylvania Ledger, or The Philadelphia Market-Day Advertiser*, November 12, 1777.

89. McGoey 2016, cat. 27.

90. *Pennsylvania Gazette*, September 24 and October 1, 1783.

91. *Pennsylvania Packet, or The General Advertiser* (Philadelphia), October 11, 1783.

92. *Pennsylvania Gazette*, November 5, 1783.

93. Almquist 1996, pp. 37, 39.

94. Burial Register, p. 148, Christ Church and St. Peter's, Archives of Christ Church, Philadelphia. I am grateful to the church's former archivist Carol Smith for supplying this reference.

95. 1788 Philadelphia Supply Tax List, p. 66, 1789; Philadelphia Supply Tax List, p. 83, Tax and Exoneration Lists, 1762–1794.

96. John Bayly and Jane and Elizabeth Bayly to Leeson and Joseph Simmons, March 4, 1797, Philadelphia Deed Book D, vol. 66, pp. 32–33. Leeson Simmons and others to John Bayly, April 3, 1802, Philadelphia Deed Book EF, vol. 9, pp. 120–22, p. 121, stated: "Whereas the said Jane Bayly the Mother is since dead."

97. The other two marks are "IB" in an oval (Buhler and Hood 1970, vol. 2, p. 277, cats. 994, 995) and "I•B" in a rectangle (Belden 1980, p. 52).

98. David B. Warren, *Bayou Bend: American Furniture, Paintings and Silver from the Bayou Bend Collection* (Houston: Museum of Fine Arts, Houston, 1975), cat. 312; see also Almquist 1996, p. 18 (incorrectly captioned).

99. Donald L. Fennimore, with contributions by Louisa D. Bartlett, *Delaware Silver: The Col. Kenneth P. and Regina I. Brown Collection* (Dover, DE: Biggs Museum of American Art, 2008), p. 35; see also Hollan 2013, p. 272. Hindes (1967, illus. no. 1), showed a tablespoon with a pointed handle with a down-turned end, decorated with bright-cut engraving characteristic of the 1780s as a very tentative attribution to John Bayly Jr., but the "IB" in a rectangle mark on this spoon is not one presently attributed to him or his father.

Cat. 65

John Bayly Sr.

Tankard

1765–70

MARK: I•BAYLY (incuse, on underside; cat. 65-1)

INSCRIPTIONS: M T (engraved script monogram, on front; cat. 65-2); E•Tonkin (engraved script, on underside); oz dᵗ / 35 " 12 (engraved, on underside)

Height 8½ inches (21.6 cm), width 7¼ inches (18.4 cm), diam. foot 4⅝ inches (11.7 cm)

Weight 35 oz. 4 dwt. 5 gr.

Gift of Coizie Ferguson Bettinger, 2016-66-1

PROVENANCE: The tankard's original owner, Mary Tonkin (1748–1822) of Springfield Township, Burlington County, New Jersey, married Thomas Carpenter (1752–1847) of Salem, New Jersey, in 1774. It descended from their son Edward (1777–1813) and his wife Sarah Stratton (1781–1852) to their great-great-grandson James Stratton Carpenter III (1887–1969), who was the donor's maternal grandfather.[1]

PUBLISHED: Almquist 1996, p. 41.

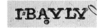

Cat. 65-1

This impressive tankard is a classic example of the form made in Philadelphia during the third quarter of the eighteenth century; contemporary tankards by John David Sr. (cat. 171) and Richard Humphreys (PMA 1997-164-1) feature the same "bellied" shape, openwork thumbpieces, and large, foliate monograms on the front. Bayly's tankard is distinctive for its taller proportions and the cover's scalloped front edge, a holdover from earlier, straight-sided tankards (see PMA 1959-2-20 by Philip Syng Jr.).

The precise date of the tankard's manufacture is uncertain. As the name engraved on its underside indicates, Bayly made it and a second, nearly identical example for the wealthy New Jersey landowner Edward Tonkin (1706–1768).[2] The close similarity of the two tankards indicates that they were made at the same time. The Museum's tankard is ornamented with the monogram of his daughter Mary Tonkin; the second tankard is engraved with the monogram "DBC" for her elder sister, Bathsheba (1737–1822), and her husband, David Clayton (1734–1772), of Gloucester County. Similar large, foliate monograms appear on other objects from Bayly's shop.[3] Moreover, the Tonkin/Clayton monograms appear to have been executed by the same hand, which makes it likely that they were part of the original commission and not later additions. Tonkin presumably ordered

these tankards to present to his daughters at some point after the Claytons' marriage in 1760 and prior to his death on April 5, 1768, although Mary was only twenty years old in the latter year. It is possible that these tankards were ordered after Tonkin's decease as part of the monetary bequests he left to these two daughters, although his will stated that Mary's legacy of £500 was to be made "at day of marriage," which did not occur until 1774, two years after David Clayton's death—when Bathsheba presumably would not have included his initial in her monogram.[4] DLB

1. Edward Carpenter and General Louis Henry Carpenter, comp., *Samuel Carpenter and His Descendants* (Philadelphia: J. B. Lippincott, 1912), pp. 57–60, 67–68, 97, 124, 148–49.
2. David and Bathsheba (Tonkin) Clayton's tankard is in the Burrows Collection at the Sterling and Francine Clark Art Institute, Williamstown, Massachusetts (2003.4.146); illus. in Almquist 1996, p. 42. Information on the Claytons is taken from the Adams family tree, Ancestry.com (accessed March 4, 2016).
3. Bayly made a similar tankard and matching cann with the foliate monogram "CSM" for Christopher Marshall (1709–1797) and his second wife, Sarah Thomson (1702–1771), who were married in 1735. For the tankard and cann, see Sotheby's, New York, *The Collection of Roy and Ruth Nutt: Highly Important American Silver*, January 24, 2015, pp. 200–201, lot 563; Almquist 1996, p. 30. Information on the Marshalls is taken from the Carl Hartsfield family tree, Ancestry.com (accessed March 4, 2016).
4. A. Van Doren Honeyman, ed., *Calendar of New Jersey Wills, Administrations, etc.*, vol. 4, 1761–1770, Archives of the State of New Jersey, 1st ser. (Somerville, NJ: Unionist-Gazette Assocation, 1928), vol. 33, p. 435.

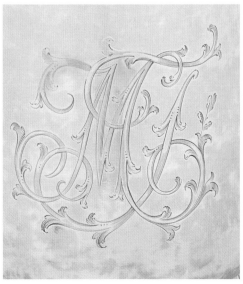

Cat. 65-2

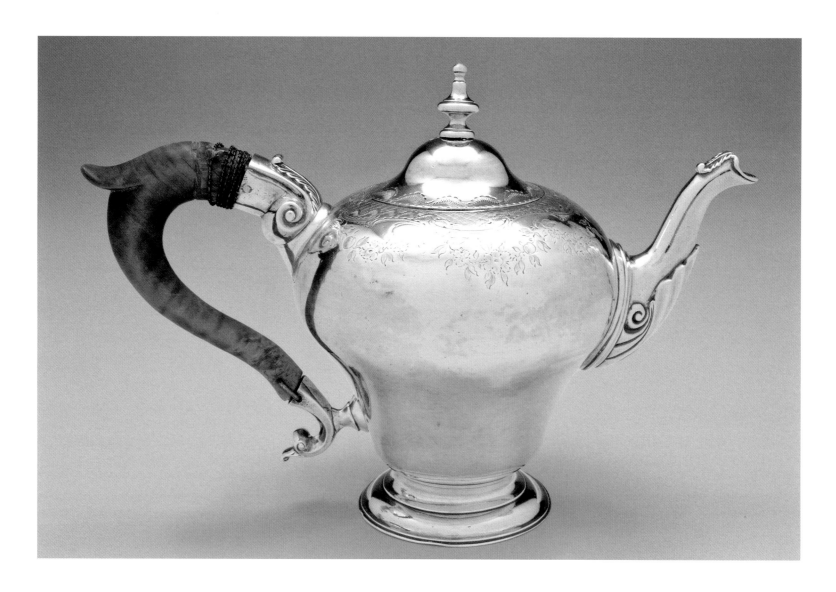

Cat. 66

John Bayly Sr.

Teapot

1755–75

MARKS: IB (incuse, twice on underside; cat. 66-1)
INSCRIPTIONS: H / I·M (engraved, partially cut off, on under-side of foot); oz dt / 19 " 15 (scratched, on underside)
Height 6⅜ inches (16.2 cm), width 9⁷/₁₆ inches (23.9 cm), depth 4½ inches (11.4 cm)
Gross weight 20 oz. 3 dwt. 5 gr.
Gift of the McNeil Americana Collection, 2005-68-6

PROVENANCE: The donor purchased this teapot at auction in New York in 2003.[1] The teapot and a small bowl, also by Bayly, were consigned by heirs of Dan Hughes Dupree (1918–1988) of Athens, Georgia, with a history of descent from his paternal great-great-grandparents Thomas Stockton (1781–1846) and Fidelia Johns (1785–1871) of New Castle, Delaware. Bayly presumably made these objects for a previous generation, and the ini-tials engraved on both indicate that the original owners had a surname beginning with "H." None of Thomas or Fidelia Stockton's immediate forebears had names that matched this combination of initials. It is possible that the silver was acquired secondhand by the Stocktons or their descendants via gift or purchase.

Teapots of this inverted pear shape, known as "double bellied," first appeared in America in the mid-1750s, following their introduction in England about a decade earlier.[2] Bayly's teapot shares several features with other Philadelphia examples from the third quarter of the eighteenth century. The shells, floral garlands, and diaper patterns engraved on and around the cover were executed by an engraver who created the almost identical design on a teapot (PMA 1992-17-1a,b) by Joseph Richardson Sr. that apparently belonged to Joseph Arthur (1715–1766) of Philadelphia and his wife, Jane Chevalier (1723–1778), who married in about 1755.[3] The Bayly tea-pot's upper handle socket is identical to the casting used on another teapot by Richardson senior (PMA 1969-277-1). The lower handle socket and the dis-tinctive spout, with a shell and scroll at its base, are similar to those on a teapot by Philip Syng Jr. (q.v.).[4] At present this is the only teapot marked by Bayly senior known to survive, although he was paid £15 by the Province of Pennsylvania in 1765 for "a Silver Tea-pot given Edward Tew's Wife" in gratitude for her husband Edward's role in constructing piers at the mouth of the Delaware River.[5] The base of the teapot was damaged in the past; the foot has been reduced in size and reattached to the bottom, which has been reshaped. DLB

Cat. 66-1

1. Christies, New York, *Important American Furniture, Silver, Prints, Scrimshaw and Folk Art*, January 16–17, 2003, sale 1189, lot 120, p. 75.
2. Inverted-pear-shape teapots made in London around the same time as Bayly's include an example by Louisa Cour-tauld of 1765–66; Helen Braham, *A Century of Silver: The Courtauld Family of Silversmiths, 1710–1780* (London: Cour-tauld Institute Gallery, 2003), p. 43, cat. S12. Another was made by William Grundy in 1765 or 1766; Ellenor Alcorn, *English Silver in the Museum of Fine Arts, Boston*, vol. 2, *Silver from 1697 Including English and Irish Silver* (Boston: the Museum, 2000), cat. 124.
3. Information on Joseph and Jane Arthur is taken from the Hazard family tree, Ancestry.com (accessed January 8, 2016).
4. Clement E. Conger, Mary K. Itsell, and Alexandra W. Rol-lins, eds., *Treasures of State: Fine and Decorative Arts in the Diplomatic Reception Rooms of the U.S. Department of State* (New York: Abrams, 1991), cat. 194.
5. *Pennsylvania Archives*, 8th ser. (1935), vol. 7, p. 5893.

John Bayly Jr.

Philadelphia, born c. 1751
New Castle County, Delaware, died 1806

John Bayly Jr. led a less well-documented life than did his father, John Bayly Sr. (q.v.). His name presents the same difficulty of identification in public records, further complicated by his near-contemporary first cousin John Bayly (born c. 1750, died before 1785), son of Bayly senior's brother Richard, as well as a second John Bayly Jr., mentioned in the 1795 will of a Robert Baily, both apparently unrelated to the silversmiths.[1] In addition, the younger Bayly apparently never advertised in newspapers and had fewer real estate or other documented transactions. As noted under the biography of John Bayly Sr., previous scholarship conflated the two men's careers into one until Ruthanna Hindes and Barbara Almquist began the research that established their separate identities.[2]

John Bayly Jr. apparently was born within a year or two of his father's marriage to Jane Watkins in 1750. He presumably apprenticed with his father and would have trained together with Thomas Shields (q.v.). The earliest evidence for the younger Bayly working as a craftsman is his invoice to Mary (Parker) Norris (died 1799) dated April 8, 1775, and receipted on April 11 by "John Bayly Jun[r]."

To one pair of silver knee buckles £0.9.0.
To one pair D[itt]o 0.8.3.
To one pair of silver shoe buckles 0.19.0.
To two pair of buttons wt. 11 dw. 8 gr. at 6/ 6 pr pennyweight and 20 making 4.13.8.
[subtotal] 6.9.11.
By 11 dw. 6 gr. of gold at 6/ pr pennyweight 3.7.6.
By 2 oz 5 dw of old silver at 3/ 6 pr ounce 0.19.1.
[subtotal] 4.6.7. Ballance [sic] £2.3.4[3]

Both Norris and her husband, the merchant Charles Norris (1712–1766), had been clients of Bayly's father, and it is possible that Bayly junior was working with his father at this time. However, between October 1775 and June 1777, Bayly had numerous dealings with Thomas Shields that were recorded under the name "John Bayly Ju[r]," with separate accounts for "John Bayly Sen[r]," presumably after both younger men had left the older man's employ.[4]

Numerous records for individuals named John Bayly Jr. exist in Philadelphia for the decade between 1776 and 1786, but the silversmith can be definitely identified in only one deed. On August 12, 1777, a John "Bayley Jun[r]" paid for a private substitute for military service, although the John "Bailey Sen[r]" on the same list almost certainly was not his father.[5] However, he probably was the "John Bayley J'r" reported "sick at Philadelphia" when his artillery company was mustered on August 10, 1780, as the commander was his maternal uncle, Joseph Watkins, and another uncle, Leeson Simmons, was a gunner.[6]

In 1776 and 1779 a John Bayly was recorded as a resident of Philadelphia's Dock Ward and paid a head tax, indicating that he was a single man who owned no real estate or other taxable property.[7] In 1780 this individual was first denominated "Jun[r]" and continued to be listed as such through 1783.[8] Because he was not paying an occupation tax, none of the tax lists record this individual's profession, but circumstantial evidence indicates that he probably was the silversmith. The 1782 tax list listed him together with Joseph Lownes (q.v.) as the "Inmates" of the cordwainer Samuel Richards, which suggests the possibility that the two were fellow journeymen rooming together.[9] This Bayly remained a tenant of various homeowners on the same block of Front Street between Walnut and Spruce: in 1780 he was recorded with the hatter William Lawrence, and he was listed with the innkeeper John Spence in 1783.[10] As a tenant, Bayly would not have had his own forge or shop, but Thomas Shields as well as John David Sr. (q.v.) had their shops on the same block of Front Street, and it is possible the silversmith Bayly chose this location because he was working in association with one or both of them.[11] Lownes apparently worked for the elder David and in 1798 would acquire the shop from John David Jr. (q.v.), his son. The only other record of a John Bayly Jr. in the Dock Ward was in the will of the tavern keeper Thomas Newark, a neighbor on Water Street, which he witnessed on December 12, 1786.[12]

Bayly's absence from the Dock Ward tax records after 1783 may be explained if the silversmith was the John "Bayley" who married Jane Faithfull on September 9, 1784, at Christ Church, Philadelphia, the church in which his parents were married and where his father and sister were buried.[13] The timing of the marriage seems to coincide with a deed recorded on December 6, 1785, by which John Bayly Jr. received by transfer from his father title to properties belonging to his namesake grandfather that had passed through his uncle Richard and subsequently his cousin John, who was recorded in the deed as deceased and without issue.[14]

At some point between December 1785 and December 1790, the silversmith John Bayly Jr. moved from Philadelphia to White Clay Creek Hundred, New Castle County, Delaware. Almquist identified him as the John Bayly Jr. who declared his intention to marry Jean Simpson of New Castle County on January 25, 1787.[15] However, the marriage bond recorded this man as a resident of New Castle County and his profession as "yeoman," which would indicate this is not the same individual consistently recorded in other legal documents as a gold- or silversmith.[16] Moreover, a deed made in Philadelphia on December 24, 1790, described him as "John Bayley late of the City of Philadelphia silversmith now of Nework [sic] in the County of New Castle," suggesting that his move to Delaware was more recent.[17]

The younger Bayly continued to work as a silversmith after moving to Delaware, as attested by a bill he submitted in May 1795 for six teaspoons made for Captain David Nivin (1764–1823) of White Clay Creek Hundred, presumably a neighbor.[18] He was described as a silversmith of New Castle County in at least six deeds recorded in Philadelphia between 1790 and 1804, most of them disposing of property inherited from his maternal grandfather, Joseph Watkins (died 1766).[19] No John Bailey was recorded as a head of household in the U.S. census of 1800 for New Castle County, and it is possible he and his family were part of another household.[20]

John Bayly Jr. died intestate in Delaware in March 1806, when he was approximately fifty-five years old. The account of his estate recorded payments on March 24, 1806, of $37.83 to George Russell for funeral expenses and in April to James Anderson for a coffin.[21] Four years later the U.S. census of 1810 recorded a Jane "Baily" as the head of a household in Wilmington Hundred with one female age forty-five or older, five females under twenty-five, and one male sixteen to twenty-five. On February 20, 1810, an "Inventory of Goods in Possession of John Baylay at the time of his Death and now in the care of his Widdow Jane Baylay" was taken by John Simpson and Israel Stalcup. The inventory includes no real estate or silver, which again suggests that John and Jane Bayly may have been living as part of another household. Appended to the inventory were detailed lists of previous vendue sales totaling $261.71 1/2 made by the estate, presumably to pay debts.[22] Farm animals and equipment comprised the largest portion of these sales, including a horse (at $47.00 the single most expensive item sold), a young bull, three cows, ten sheep, four turkeys, and a "Yoke of Oxen," indicating that Bayly was engaged in some kind of farming. His estate contained no

silver or silver objects, but the sales included a significant number of silversmith's tools, mostly grouped together. In addition to a grindstone, saws, pans, and ladles that may have been farm or kitchen equipment, the estate sold several small and large hammers, small and large anvils, vises, shears, pincers, files, punches, chisels, a box of scales and weights (see PMA 1999-56-1a–d), a "Lot of Old Buckles," and a "Rolling Machine." This list of tools is similar to those offered for sale by his father half a century earlier (see p. 135).

Based on the surviving evidence, John Bayly Jr. seems to have worked primarily as a retail jeweler who made at least some of the flatware or jewelry that he sold. The bill presented to Norris in 1775 included 20s. for "making" the buttons but not the buckles. Thomas Shields sold Bayly brass chapes and tongues, presumably to be used in making buckles, but also charged him for "sundry work." In one entry Shields noted, "The above Chapes left for Sale to be Returned if not Sold," although the same entry also credited Bayly with a "Ball[anc]e sleeve buttons" of 6s., indicating that Bayly's relationship with Shields was as both retailer and supplier.[23] Twenty years later the bill Bayly presented to David Nivin in 1795 included 12s. for "making" six teaspoons, as well as 2s. 4d. for the silver.[24] Bayly had both farming and silversmith's tools in his estate, so it is possible that he took up farming after he moved to Delaware but, like many craftsmen living in more rural locations, continued to work at his profession in the winter.

Assessing Bayly's career as a craftsman is difficult, as there are no surviving objects that definitely can be attributed to him instead of his father. If Bayly were employed in Philadelphia by John David Sr. or Thomas Shields, it is possible that he never had his own mark, since the wares sold in their shops presumably would have been struck with their initials or names. There appears to be no documentary evidence that the younger Bayly, unlike his father, made or sold hollowware. However, the anvils and hammers ranging in size from large to small in his estate indicate that he had the means to make larger objects, as does the "Rolling Machine," possibly a mill either for producing sheet silver or die-rolled borders, although no surviving piece with a Bayly mark was made using sheet metal or die-rolled ornament. Several surviving objects with Bayly marks have histories of ownership in Delaware, possibly including cats. 66 and 69, and it is possible that some of them were made by the younger Bayly after he moved to New Castle County.

A miniature portrait drawn in 1798 in Harrisburg, Pennsylvania, by the Swiss émigré artist David Boudon (1748–c. 1816), was identified

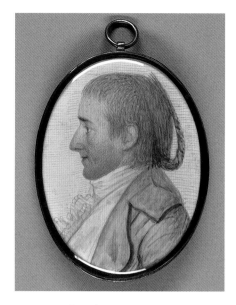

Fig. 40. David Boudon (Swiss, active United States, 1748–c. 1816). *John Bayly Jr.*, September 1798. Watercolor and silverpoint on card, 2 1/8 × 1 3/4 inches (5.4 × 4.4 cm). Yale University Art Gallery. Gift of Walter M. Jeffords, B.A. 1905, 1949.240

as an image of the Philadelphia silversmith John Bayly (conflating father and son) at the time of its acquisition by the Yale University Art Gallery, New Haven, in 1949 (fig. 40).[25] Based on the miniature's date of execution, the sitter would have to be John Bayly Jr., but in the absence of a history of ownership in his family, this identification seems worth reconsideration. In 1798 Bayly was living in New Castle County, over a hundred miles from Harrisburg. The hotel keeper and coal merchant John Bailey (1750–1837) of Pottstown and Port Carbon, Schuylkill County, northeast of Harrisburg, seems equally plausible as the subject.[26] However, the miniature's gold case is signed "S. Ford / 1798," for the Philadelphia goldsmith Samuel Ford (active 1796–1803), whom John Bayly Jr. was more likely to have known and patronized.[27] DLB

1. Philadelphia Will Book X, p. 381. The inconsistent spellings of the surnames are those in the will.

2. Hindes 1967, pp. 255–56; Almquist 1996, pp. 20–21.

3. Mrs. Norris, invoice, April 8, 1775, Norris Family Papers, Family Accounts, 1774–81, box 7, folder 28, HSP.

4. Thomas Shields, Daybook, 1775–1791, pp. 13, 15–16, 23, 25, 31, 70, 72, 74, 81, Downs Collection, Winterthur Library.

5. *Pennsylvania Archives*, 6th ser. (1906), vol. 1, p. 193.

6. Ibid., vol. 1, pp. 557–58.

7. 1776 Philadelphia Effective Supply Tax, p. 2; 1779 Philadelphia Effective Supply Tax, p. 31, Tax and Exoneration Lists, 1762–1794; see also *Pennsylvania Archives*, 3rd ser. (1897), vol. 14, p. 483.

8. 1780 Philadelphia Effective Supply Tax, p. 101, Tax and Exoneration Lists, 1762–1794; see also *Pennsylvania Archives*, 3rd ser. (1897), vol. 15, p. 230.

9. 1782 Philadelphia Effective Supply Tax, p. 57, Tax and Exoneration Lists, 1762–1794.

10. 1783 Philadelphia Effective Supply Tax, Tax and Exoneration Lists, 1762–1794.

11. White's Philadelphia directory 1785, p. 19.

12. Philadelphia Will Book T, p. 424; White's Philadelphia directory 1785, p. 52.

13. Marriage register, 1709–1800, no. 4457, Archives, Christ Church, Philadelphia; see also *Pennsylvania Archives*, 2nd ser. (1896), vol. 8, p. 16.

14. Philadelphia Deed Book EF-IS, p. 9.

15. Almquist 1996, p. 20.

16. Marriage bond, January 25, 1787, Marriage Records, 1744–1912, vol. 1, p. 150, Delaware Public Archives, Dover, Ancestry.com. This John Bayly could have been the namesake son mentioned in the 1781 will of John "Bayley" of Appoquinimink Hundred, New Castle County; Historical Research Committee of the Colonial Dames of Delaware, *Calendar of Delaware Wills: New Castle County, 1682–1800* (New York: Frederick H. Hitchcock, 1911), p. 95. It should be noted the silversmith's wife was recorded consistently as "Jane" in deeds and estate papers.

17. John Bayley and uxor to Thomas Hough, December 24, 1790, Philadelphia Deed Book D, vol. 27, pp. 212–15.

18. Historical Society of Delaware, transcribed in Septimus E. Nivin, *Genealogy of Evans, Nivin and Allied Families*, 2nd. ed. (Philadelphia: International Printing Company, 1930), p. 124.

19. John Bayley and uxor to Thomas Hough, December 24, 1790, Philadelphia Deed Book D, vol. 27, pp. 212–15; John Bayly et ux. to John Clement Stocker, April 10, 1793, Philadelphia Deed Book D, vol. 40, pp. 1–3; Samuel Davis et al. to Leeson and Joseph Simmons, March 4, 1797, Philadelphia Deed Book D, vol. 60, pp. 260–64; John Bayly, Jane and Eliz^h Bayly to Leeson Simmons and Joseph Simmons, March 4, 1797, Philadelphia Deed Book D, vol. 64, pp. 32–33; Leeson Simmons et al. to John Bayly, April 3, 1802, Philadelphia Deed Book EF, vol. 9, pp. 120–22; John Bayly to Edward C. Gardner, November 13, 1804, Philadelphia Deed Book EF, vol. 18, pp. 189–91.

20. The John "Bail" listed as a head of household in Christiana Hundred in the 1800 U.S. census apparently is not the silversmith, as no male over age forty-five is recorded as a member of this household. The Delaware records for the 1790 U.S. census have not survived.

21. "Settlement, John Baily, March 12th 1810," John Bailey estate papers, Delaware Public Archives, Dover.

22. "Inventory and Lists of Sales, John Bailey, March 7th 1810," John Bailey estate papers, Delaware Public Archives, Dover.

23. Shields, Daybook, December 15, 1775, p. 23.

24. Septimus E. Nivin, *Genealogy of Evans, Nivin and Allied Families* (Philadelphia: Philadelphia International Print Co., 1930), p. 124.

25. Nancy E. Richards, "A Most Perfect Resemblance at Moderate Prices: The Miniatures of David Boudon," *Winterthur Portfolio*, vol. 9 (1974), pp. 82–83, fig. 9.

26. *Schuylkill County, Pennsylvania: Genealogy, Family History, Biography* (Chicago: J. H. Beers, 1916), vol. 1, pp. 383–84. This John Bailey was born in Chester County, Pennsylvania, and moved to Schuylkill County after the War of Independence. Port Carbon is approximately 65 miles from Harrisburg; New Castle, Delaware, is 100 miles. Another possible, albeit less likely, sitter is the farmer John Bailey, age forty-eight, who was recorded in the 1800 septennial census in Mifflin Township, Lycoming County, northwest of Harrisburg. Present-day Mifflintown is approximately 100 miles from Harrisburg.

27. Ford was listed as a goldsmith at 39 Arch Street in the 1797 Philadelphia directory (p. 70) and has been identified as the same individual who appeared as a silversmith and jeweler in Baltimore directories between 1800 and 1803; Goldsborough 1983, p. 252. See *The New Baltimore Directory and Annual Register for 1800 and 1801* (Baltimore: Warner & Hanna, 1800), p. 39; Baltimore directory 1802, p. 38; Cornelius William Stafford; Baltimore directory 1803, p. 50. For the signature scratched on the case, see Peter J. Bohan, *American Gold, 1700–1860*, exh. cat. (New Haven, CT: Yale University Art Gallery, 1963), p. 41, cat. 89.

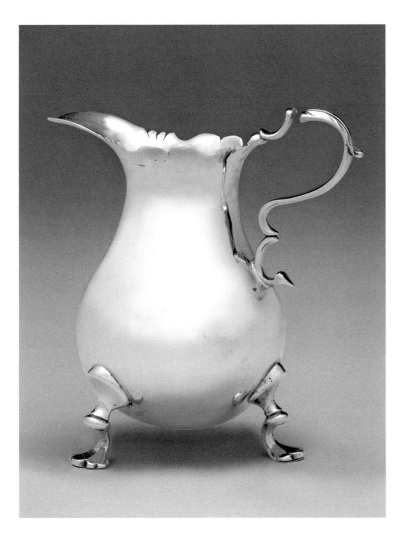
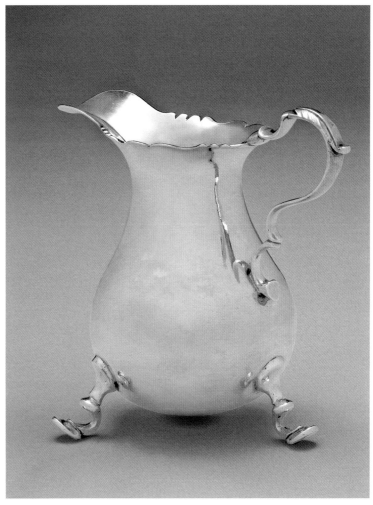

Cats. 67, 68

**John Bayly Sr. or
John Bayly Jr.**

Cream Pot

1750–1800

MARK: I•BAYLY (in rectangle, on underside; cat. 67–1)

INSCRIPTION: T [two triangles] / 9 S (scratched, on underside)

Height 4 1/16 inches (10.3 cm), width 3 13/16 inches (9.7 cm), depth 2 11/16 inches (6.8 cm)

Weight 3 oz. 16 dwt. 5 gr.

Purchased with Special Museum Funds, 1912–217

EXHIBITED: Philadelphia 1956, cat. 33.

PUBLISHED: Edward Wenham, "The Silversmiths of Early Philadelphia," *The Antiquarian*, vol. 13 (September 1929), p. 49.

Cat. 67-1

Cream Pot

1750–1800

MARK: IB (incuse, on underside; cat. 66–1)

INSCRIPTION: B / I•C (engraved, on underside); oz / 3 = 12 = 12 / £ 3 2 8 (scratched, on underside)

Height 4 inches (10.2 cm), width 4 1/8 inches (10.5 cm), depth 3 3/8 inches (8.6 cm)

Weight 3 oz. 11 dwt. 21 gr.

Purchased with the Elizabeth Wandell Smith Fund, 1929–140–1

PROVENANCE: The Museum purchased this cream pot from an otherwise unidentified Miss Ella Smith of Germantown, who was not related to the donor of the acquisition funds.

Small cream pots with three feet were the least expensive form of silver hollowware available to eighteenth-century Americans, among them crafts-men such as the coppersmith Lewis Grant (died 1786) of Philadelphia, who advertised in 1778 for a lost or stolen "silver cream pot, three feet, marked L M G, maker's name John Bailey."[1] At least a dozen virtually identical examples marked by John Bayly

Sr. or Jr. have survived, an indication of this form's popularity over time. A cream pot marked by Bayly and engraved with the maiden initials of Phoebe (Coates) Lane (1754–1807) probably was made around the time of her marriage in 1780 but stylis-tically resembles pots made forty years earlier (see cat. 92).[2]

The legs of cat. 68 were forced into their splayed posture after the piece was made. DLB

1. *Pennsylvania Evening Post* (Philadelphia), April 27, 1778. An immigrant from Londonderry, Ireland, Grant died before January 21, 1786, when his estate was advertised; *Indepen-dent Gazetteer* (Philadelphia), January 21, 1786; see also *Pennsylvania Journal and Weekly Advertiser* (Philadelphia), February 12, 1761.

2. David B. Warren, Michael K. Brown, Elizabeth Ann Cole-man, and Emily Ballew Neff, *American Decorative Arts and Paintings in the Bayou Bend Collection* (Princeton: Prince-ton University Press for the Museum of Fine Arts, Houston, 1998), cat. M50. For Phoebe (Coates) Lane, see the Utzinger family tree, Ancestry.com (accessed January 8, 2016).

Cat. 69

John Bayly Sr. or
John Bayly Jr.
Caster

1750–1800

MARKS: IB (incuse, twice on underside; cat. 66–1)

INSCRIPTIONS: W / W+A; 1732 (engraved, on underside of foot)

Height 5¾ inches (14.6 cm), diam. 2³⁄₁₆ inches (5.6 cm), diam. foot 2¼ inches (5.7 cm)

Weight 3 oz. 15 dwt. 1 gr.

Gift of Mrs. G. Colesberry Purves in memory of her husband, Guillermo Colesberry Purves, 1928-4-1a,b

PUBLISHED: Almquist 1996, p. 32.

PROVENANCE: The caster was given to the Museum by Elizabeth (Gilkison) Purves (1864–1931), who subsequently bequeathed examples of eighteenth- and early nineteenth-century furniture that were heirlooms from her own and her husband's families. Although her ancestors lived in New England and New York, Guillermo Colesberry Purves (1843–1923) was the great-great-grandson of the merchant William White (died 1778) of Duck Creek Hundred (now Smyrna), Delaware, whose estate was valued at £1,800, by far the highest valuation in Kent County at that time.[1] His means and the engraved initials suggest that White could have been the caster's original owner, although this cannot at present be confirmed as his wife's first name has not been verified. If this provenance is correct, the caster descended from White's only surviving heir, his daughter Jane (White) Darrach (born c. 1750), to her granddaughter, Anna (Kennedy) Purves (1811–1889), Guillermo Purves's mother.[2] Beatrice Garvan has proposed another possibility for the caster's original owners: William West (c. 1710–1782) and Abigail Carwithen (born 1710), who married at Christ Church, Philadelphia, on January 16, 1732, the year subsequently engraved on the underside of the caster's foot.[3] A prominent merchant in Philadelphia, West was among the founding members of the Union Library Company in 1751, as was a John "Bayley" who may have been Bayly senior or his father.[4] If this provenance is correct, the Purveses or their forebears presumably acquired the caster as an antique.

Like the majority of surviving objects with Bayly marks, this baluster-shape caster's form was popular during the second half of the eighteenth century and could have been made by either the younger or the elder Bayly. DLB

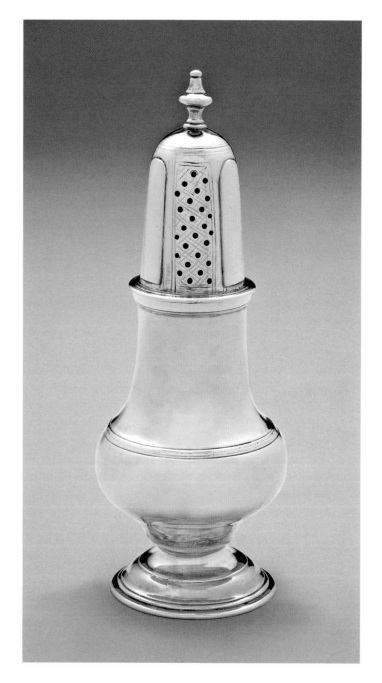

Delaware: People, Contexts, and the Culture of Agriculture (Knoxville: University of Tennessee Press, 2004), pp. 23–24.

2. Jordan 1911, vol. 3, pp. 1328–30; Frost-Olmsted family tree, Ancestry.com (accessed November 19, 2014).

3. *Pennsylvania Archives*, 2nd ser. (1896), vol. 8, p. 271. West's death was recorded in the *Pennsylvania Gazette* (Philadelphia) on November 13, 1782.

4. E. V. Lamberton, "Colonial Libraries of Pennsylvania," *PMHB*, vol. 42, no. 3 (1918), p. 196.

1. Leon deValinger Jr., *Calendar of Kent County Delaware Probate Records, 1680–1800* (Dover, DE: Public Archives Commission, 1944), p. 316. The administration of White's estate was granted to his son-in-law, which suggests that White's wife had predeceased her husband. For William White, see Lu Anne De Cunzo, *A Historical Archaeology of*

T. L. Bear Company

| Camden, New Jersey, 1879–c. 1950

Theophilus L. Bear (1858–1940) was born in Camden, New Jersey, son of Joseph Bear (1819–1897), a house carpenter, and his wife, Christiana (born 1830).[1] In 1879 Theophilus began working at his parents' home address of 34 South Fourth Street as a "watchmaker and jeweler," which suggests that he may have trained as a watchmaker.[2] By the time of the U.S. census of 1880, he had moved to 204 Market Street in Camden, where he continued to live and work until his death. In 1885 Bear married Adelaide (surname unknown, born 1857 or 1858); the couple had one daughter, Adelaide Estella Bear (1886–1951).[3] They were members of St. Paul's Episcopal Church in Camden.

T. L. Bear Company apparently was a retail jeweler and not a manufacturer; in 1930 Bear himself was described as "retail manager."[4] He advertised gemstones, jewelry, and watch repair in Philadelphia and Camden publications, and employed a number of individuals, including the watchmaker F. Kille in 1921.[5] Nevertheless, the firm seems to have been relatively small. Not only did the family live at the same address, but also Bear's daughter, Adelaide Estella, was a "saleslady" in her father's shop in 1920, despite her avocation as an author and historian.[6] Bear himself thwarted an attempted theft of diamonds in 1908.[7] The firm appears to have provided Bear with professional and personal success: in 1893 he was elected a member of the Jewelers' Security Alliance, a national organization, and in 1918 he was a founding partner in the Swift Aircraft Manufacturing Company in Camden.[8] From 1910 until 1914 Theophilus and Adelaide Bear owned a riparian lease from the state of New Jersey worth $3,311, presumably for a dock or some other waterfront property.[9]

Theophilus Bear died in Camden on February 12, 1940, and was buried in Evergreen Cemetery.[10] In the U.S. census of that year, his widow and daughter were recorded as the company's owners. In 1943 Adelaide E. Bear was listed in the city directory as the "manager" of T. L. Bear.[11] The company apparently continued until at least 1947; Adelaide Estella Bear died in 1951.[12] DLB

1. 1860 U.S. Census; "Philadelphia," *Jewelers' Circular*, vol. 34 (April 14, 1897), p. 15.

2. *Chew's Camden Directory for 1879–80* (Camden: S. Chew, 1879), p. 73.

3. Adelaide Y. Bear's maiden name and date of death have not been discovered. She is not listed in the 1943 Camden directory, which may indicate that she died shortly after her husband, but her death is not recorded in the burial register for St. Paul's Church, as are those of her husband and daughter. See *Polk's Camden City Directory* (Pittsburgh: R. L. Polk , 1943).

4. 1930 U.S. Census.

5. *Boyd's Philadelphia Blue Book* (Philadelphia: C. E. Howe, 1906), pp. 10, 994; *Jewelers' Circular*, vol. 82 (May 11, 1921), p. 115.

6. 1920 U.S. Census.

7. *Jewelers' Circular*, vol. 56 (May 6, 1908), p. 57.

8. "The Jewelers' Security Alliance," *Jewelers' Circular*, vol. 27 (August 16, 1893), p. 10; "New Incorporations: New Jersey Charters," *New York Times*, May 24, 1918.

9. *Report of the Joint Committee on Treasurer's Accounts and of the State Treasurer to the Legislature of New Jersey, with the Treasurer's Report to the Governor on the Finances of the State for the Fiscal Year Ending October 31st, 1911* (Trenton: State Gazette Publishing, 1911), p. 940; *Annual Report of the Comptroller of the Treasury of the State of New Jersey for the Year Ending October 31st, 1911* (Camden, NJ: Sinnickson Chew & Sons, 1914), p. 127.

10. Burials 1922–1987, St. Paul's Episcopal Church, Camden, NJ.

11. Polk's Camden directory 1943, p. 130.

12. The firm was listed as being in business in 1947 at the following website, www.dvrbs.com/camden-streets/Camden NJ-Streets-MarketStreet.htm (accessed August 31, 2011); it has thus far not been possible to verify this independently. Burials 1922–1987, St. Paul's Episcopal Church, Camden, New Jersey.

Cat. 70
T. L. Bear Company
Ring in Original Box

1880-90
Ring
Unmarked
Height 1 inch (2.5 cm), diam. ⁹⁄₁₆ inch (1.5 cm)
Weight 18 gr.
Box
Cardboard
MARK: T L BEAR / JEWELER / 204 MARKET ST / CAMDEN, N.J. (printed, on cover)
Height 1 inch (2.5 cm), width 1¼ inches (3.2 cm), depth ¹⁵⁄₁₆ inch (2.4 cm)
Gift of the family of John R. Shinn in his memory and in memory of his New Jersey Shinn ancestors, 1999-8-39a,b

PROVENANCE: In the late nineteenth century, this ring and its box were among a group of family possessions assembled in an eighteenth-century spice cabinet by Phoebe (1817–1893) and Willit (1825–1911) Shinn. The cabinet and its contents, which were kept intact, descended to their brother Elwood (1822–1901) and then to Shinn's great-grandson, John Robert Shinn (1926–1988), whose widow and children donated it to the Museum.

This simple, inexpensive ring was characteristic of objects owned by the Shinn family and probably was representative of wares retailed by the T. L. Bear Company. DLB

Peter Bentzon

St. Thomas, Danish West Indies,
born c. 1786
Philadelphia (?), died after 1852

n 1816, in a Census of Free Coloreds taken in St. Croix, Peter Bentzon was listed as "thirty years old, born in St. Thomas but no christening certificate—he has been here for eight years," making his birth date 1786.[1] The St. Croix census of October 1, 1841, records that "Bentzon, jeweler says that he is sixty years old and his wife forty-two," putting his birth in 1781.[2] In 1844, in his testimony in a court case against him in Christiansted in the Danish West Indies, Bentzon stated that he was born in St. Thomas in 1783.[3] In 1846, in "A Register of Free Inhabitants in Christiansted, St. Croix," Peter Bentzon, "goldsmith," is listed as age sixty, putting his birth in 1786. Finally, the U.S. census of 1850 gave his age as fifty-eight, putting his birth about 1792.

According to H. F. Garde, Bentzon was probably the son of Jacob Bentzon (1754–1816), a Norwegian lawyer and royal judge advocate active in St. Thomas, and an as yet unidentified free mulatto woman.[4] Thus Peter Bentzon would have been a "mustice," a free citizen in the Danish West Indies of one-quarter African ancestry. Given his status as a royal judge, Jacob Bentzon must have had personal and business connections with merchants and agents active in the sea trade, all of which would have facilitated an apprenticeship arrangement for his son Peter in Philadelphia. Peter Bentzon himself stated in 1845 that he went to Philadelphia at the age of eight and learned to be a silversmith there.[5] Depending upon which date is accepted for his birth, Bentzon set out very young for Philadelphia, then the capital of the United States. Who sponsored him is not yet known. His later connection with the Quaker Dawson and Coates families, some of whom were active abolitionists, suggests that Bentzon may have been sponsored in Philadelphia through that society.

His apprenticeship completed, and probably having reached his majority in 1806, he settled in Christiansted, where for a time he boarded with the lawyer and landowner John Daly, also a mustice.[6] He purchased a residence and shop at 53A Company Street, where he worked for about ten years. Bentzon paid a head tax and owned a slave named Pedro.[7] A census document taken at Christiansted and dated November 26, 1811, names Peter, Rachel (de la Motta, c. 1799–after 1870), and Mary Bentzon and a Francis Usher living at 53A Company Street. Francis Usher was a seaman, born about 1793 in St. Croix and baptized a Catholic; in the baptismal document he was attested to as freeborn by a member of the de la Motta family.[8] It is thought that Bentzon, baptized in the Lutheran Church, and Rachel de la Motta, a free person of color and a Catholic, married in about 1813, when she was fourteen. Members of her family belonged to Lutheran, Jewish, Anglican, and Catholic congregations on St. Thomas. By February 1815 Bentzon had sold his Company Street property to a Mr. Rigallon and placed a newspaper advertisement stating that "the subscriber intends leaving the island for the benefit of his health."[9] He authorized John Daly, with whom he had boarded, to handle his affairs in St. Croix, and he must have departed for Philadelphia, where he had connections from his apprenticeship, in March or April 1816.

The activities of the Bentzon family as gleaned from official records, the frequency of Peter's appearances in St. Thomas and St. Croix, and the rarity of silver made by him all suggest that his mercantile travels may have occupied him as much as or more than his silver work. On October 1, 1816, a bill of lading from the sloop *Mary* owned by Joseph Sims, a Philadelphia merchant, arrived in Philadelphia from St. Croix carrying as its passenger "Mr. Peter Bentzon of Philadelphia with his baggage," which comprised "One old Looking Glass for repair / A quantity of old plate, American manufactured, for repairs / One Box of Sweetmeats / One Dozen Coconuts / One bundel of Skins." He had his own merchant's mark, "PB," which was noted on the report and manifest of cargo, suggesting he traded and shipped often.[10] On June 28, 1817, Bentzon arrived again in Philadelphia from St. Croix on the same sloop.[11] On August 16, 1819, *Grotjan's Philadelphia Public Sale Report* noted that he was importing sugar on the schooner *Columbia*. In September 1824 he was a passenger, noted as a "merchant" from Rum Key (St. Croix is crossed out), on the brig *Forrest*, owned by David Lewis and others, and bound for Philadelphia.[12] In July and August 1829 Bentzon made a round-trip from Philadelphia to Havana on a ship named the *Olive Branch*.[13] Further evidence that he traveled frequently as a trader is given by the birthplaces of his children.[14] The two eldest were born or baptized in St. Croix, the next three in Philadelphia, and the two youngest in St. Croix. Moreover, there are no listings for him in the Philadelphia directories in 1822, 1835, 1843, or 1845.

In the Philadelphia directories Peter Bentzon was listed variously as "goldsmith" and "jeweler"; none of these listings marked him as a person of color, as was customary, suggesting that his racial identity was not widely known in Philadelphia. He was first recorded in Philadelphia in 1817, when the directory listed Peter Bentzon, silversmith, at 6 North Sixth Street.[15] He was there until 1819, when he moved and was renting a property from Robert Dawson at 19 North Third Street in the High Street Ward, for which he paid ground rent of $6.00.[16] The U.S. census of 1820 listed the "Benson" family at 19 North Third Street, and as in the city directories, Bentzon was identified as white. The household included one white male between the ages of sixteen and twenty-five, perhaps an apprentice, one white male between twenty-six and forty-four (Bentzon), five white females under ten, one white female between sixteen and twenty-five (his wife), and one free "colored" female whose age was given as forty-five or over (possibly his mother or mother-in-law), for a total of nine, with two people engaged in commerce.[17] From 1824 until 1828 he was at 85 North Second Street, and from 1829 until 1833 on Walnut Street north of Third.

Three of the Bentzons' daughters, Almira, Emma, and Caroline, were born in Philadelphia and baptized in the Catholic faith. Their next two children, Francis Adrian (born 1833) and Victoria Augusta (born 1838), were baptized in the Lutheran Church in St. Croix.[18] The St. Croix census of 1841 listed the family in Christiansted at his old location at 52A Company Street. In 1844 he was caught up in a lawsuit that charged him with receiving stolen jewelry from a slave; he was acquitted in 1845.[19] In the Free Colored Census for 1846, Peter "Bentzen" was described as a "goldsmith" who "served in Militia: Brand Corps, 1st Unit, 3rd Class, Woolen cockade."[20] Before the slave revolt of 1848 in St. Croix, the Bentzon family left again for Philadelphia, and in 1849 was listed in the city directory as a "jeweler" on Coates Street above Tenth, in the Spring Garden section of the city. The U.S. census of 1850 placed the Bentzon family at that address in the South Mulberry Ward, listing the family as: Peter, jeweler, age fifty-eight; Rachel, forty-six; Mary, twenty-eight; Hannah, twenty-seven; Almira Strubel (or Stabel, née Bentzon), twenty-five; Emma, twenty-three; Caroline, twenty; Victoria, ten; Francis, eighteen; and Albert Strubel (or Stabel), Almira's husband, twenty-seven.[21] The Stabel family was also from St. Croix.[22] In 1851 Francis Bentzon and Albert Strubel were box makers working at 297 High Street.

In 1852 Peter Bentzon, jeweler, was located on Wallace Street below Ninth. He was not listed

in Philadelphia directories after 1852, nor in the U.S. census of 1860. His death was not noted in death or cemetery records in Philadelphia. In the U.S. census of 1870, "F. A. Benson, Merchant," was recorded as the head of a household in Baltimore that included his wife Ida, their two children, his mother Rachel, his sister "Elmira" Stabel and her husband Albert, whose profession was recorded as "Clerk," and at least one servant. Under the category of race, each family member again was recorded as white. BBG

1. Free Colored Census, 1815–1832, Virgin Islands Historical Social History Associates, Frederiksted, U.S. Virgin Islands, Ancestry.com. Throughout the records the name is variously spelled as Bentzon, Bentzen, and Benson. The silversmith is not to be confused with two Bensons in Pennsylvania, a farmer and a dentist recorded in 1850, and a Peter Benson native of Hamburg but for his last forty years residing in Baltimore. Another Peter Benson was listed in the 1820 U.S. census in Baltimore, and supposedly born the same day as the silversmith and living in a household with the same number of inhabitants. Could this have been a mistake in the records? Much of this brief biography of Peter Bentzon has been drawn from Rachel Layton Elwes's research and publications on the life and work of this interesting silversmith, especially "Race, Authenticity and Colonialism: A Mustice Silversmith in Philadelphia and St. Croix, 1783–1850," in *Colonialism and the Object: Empire, Material Culture, and the Museum*, ed. Tim Barringer and Tom Flynn (London: Routledge, 1998), pp. 82–94; and H. F. Garde's transcription of the court case against Bentzon that took place in Christiansted in 1844 and 1845 (Garde 1993; translation courtesy of Rachel L. Elwes). See also Rachel Layton, "Peter Bentzon, Silversmith," *Antiques*, vol. 147, no. 2 (February 1995), pp. 308–15; Rachel Layton Elwes, "A New Addition to African American Silver," *The Silver Society Journal*, no. 13 (2001), pp. 14–17.

2. Free Colored Census for St. Croix, U.S. Virgin Islands Census, 1841, St. Croix (Danish Period, 1835–1911), Virgin Islands Historical Social History Associates, Frederiksted, Ancestry.com. For family dates from the 1841 census, see Svend E. Holsoe, "Virgin Island Families," www.vifamilies.org. Family ages here are based on the 1841 Census Register of Free Inhabitants, which Bentzon signed.

3. "After the court had been trying to find documentation of Bentzon's age"; Garde 1993. The genealogical data in dated official documents pertaining to the Bentzon family do not match up. Rachel L. Elwes settled on Bentzon's statement in the 1844 trial that he was born in 1783; Elwes, "Leaving His Mark," *American Legacy: The Magazine of African American History and Culture*, Spring 2004, illus. p. 31.

4. Garde 1993.

5. Ibid. The statement did not name the person with whom he studied.

6. Layton, "Peter Bentzon, Silversmith," p. 310.

7. St. Croix Slave Plantation and Head Tax Lists, 1772–1821, U.S. Virgin Islands Census (Danish Period, 1835–1911). Peter and Rachel owned three slaves, the aforementioned Pedro, Elizabeth, and another not named. Pedro, status "enslaved," owner "Bentzen, Peter," document dated January 23, 1810, Selected Records of the Danish West Indies, 92–1917, Essential Records Concerning Slavery and Emancipation, Records of the Government of the Virgin Islands, Record Group 55, NARA, Washington, DC, Ancestry.com; Holsoe, "Virgin Island Families."

8. Holsoe, "Virgin Island Families."

9. Quoted in Rachel Layton, "Career Choices and Racism: A Black Silversmith in Philadelphia and St. Croix, 1805–1850," draft typescript, [1994], p. 10, curatorial files, AA, PMA. The death of Peter Bentzon's father, Jacob Bentzon, in 1816 may have prompted Peter to move, but more likely he was influenced by the Danish takeover of the islands previously held by the British.

10. Passenger Lists of Vessels Arriving at Philadelphia, Pennsylvania, 1800–1882, Washington, DC, NARA, Ancestry.com.

Layton ("Career Choices and Racism," pp. 10–11) notes that Bentzon may have specified that the goods were made in America to avoid import duties on manufactures made outside the United States.

11. Passenger Lists of Vessels Arriving at Philadelphia, Pennsylvania, 1800–1882.

12. Bentzon was noted as age thirty-eight; Report or Manifest, Passenger Lists of Vessels Arriving at Philadelphia, Pennsylvania, 1800–1882.

13. Shipping News, *Grotjan's Philadelphia Public Sale Report*, August 16, 1819.

14. On October 2, 1841, the family was enumerated as baptized in a "Register of Free Inhabitants in Christiansted, St. Croix," as follows: "For the House No. 52a in Company Street belonging to Peter Bentzon / Peter Bentzon [born] St. Thomas, [age] 60, [religion] Lutheran [by whom baptized] unknown , married, Jeweller, [Burgerbrief] lost by Fire in America, [military service] Exempt, by Age / Francis Adrian Bentzon, St. Croix, 8, Lutheran, child, emp[loyed] by Parents / Rachel Bentzon St. Croix, 42, Catholic, married, emp. By Husband / Mary Cath[erine?] Bentzon, St. Croix, 26, Catholic, Unmarried, emp. by Parents / / Almira Louisa Bentzon, Philadelphia, 18, Catholic, unmarried / Emma Marinda Bentzon, Philadelphia, 16, Catholic, unmarried / Caroline Amanda Bentzon, Philadelphia, 12, Catholic, unmarried / Victoria Augusta Bentzon, St. Croix, 3, Lutheran, child." A subsequent Register in 1846 omitted Caroline but added Hannah "Bentzen," age twenty-six, born in St. Croix. See also Passenger Lists of Vessels Arriving at Philadelphia, Pennsylvania, 1800–1882.

15. If the head of a household was absent when data were collected, the family would probably not have been identified in the city directory. According to information from the Philadelphia City Archives, information for the directories was gathered between October and December and published in about April of the following year.

16. Robert Dawson, shopkeeper, lived in the Lower Delaware Ward in 1800 and 1810; 1800 U.S. Census. There is no evidence that Bentzon was living there. Josiah Dawson was an active member of the Pennsylvania Abolition Society; on Dawson, see Elwes, "A New Addition to African American Silver," p. 16.

17. Ancestry.com has records for the same family in Philadelphia and in Baltimore, but Rachel Elwes notes Peter Bentzon at 19 North Third Street through 1820; Elwes, "A New Addition to African American Silver," p. 16n15.

18. His residence in 1831 and 1832 was given as St. Croix in the Free Colored Census for those years.

19. See Garde 1993, which includes transcripts of the court proceedings.

20. Wearing the "cockade" was required for all freemen to distinguish them from slaves. Bentzen was noted as being "exempt" from military service due to age; Free Colored Census, 1841.

21. In the 1846 census of St. Croix, U.S. Virgin Islands (Danish Period, 1835–1911), an Albert Strubell was listed as born in St. Croix in 1820, baptized in 1822, "free," clerk, Lutheran Danish, resident at 15 Queen Street; Christiansted History Associates (VISHA), Ancestry.com. The surviving population schedule from the 1850 U.S. census that listed the Bensons did not record individuals' race.

22. Holsoe, "Virgin Island Families."

Cat. 71

Peter Bentzon (attributed)

Teaspoon

1816–50
MARK: PB (in rectangle, on back of handle; cat. 71–1)
INSCRIPTION: T C E (engraved script monogram, on front
of handle)
Length 5¹³/₁₆ inches (14.7 cm)
Weight 7 dwt. 4 gr.
Gift of Robert M. Taylor in memory of Robert L. McNeil, Jr.,
2016-200-1

PROVENANCE: The donor acquired this teaspoon and its
mate from the silversmith Ruth Rhoten of Richmond, Cali-
fornia; the mate remains in the donor's collection.

This teaspoon, with its long, straight-sided "fiddle"
handle and pointed oval bowl, possibly was made
when Bentzon was living in Philadelphia. It is nearly
identical to spoons made in the city by a variety of
makers from the 1810s to the 1840s, such as John
Tanguy (PMA 1996-81-36) and Edward Lownes
(1940-16-705). A set of very similar teaspoons with
shorter fiddle handles and round drops is struck with
Bentzon's surname mark (see cat. 72-1).[1] The mark
on cat. 71 is similar to the initials mark Bentzon used
after his return to St. Croix in 1829 (see cat. 72-2),
but it is not the different initials mark he struck on
objects made in St. Croix between 1806 and 1816,
including a pair of tablespoons with down-turned,
rounded handles and rounded bowls.[2] It is tempting
to speculate that Bentzon may have used this initials
mark during his residence in Philadelphia between
1816 and 1829, although as yet no documented
objects with this mark have been identified.[3] DLB

1. Two of the six teaspoons are in the collection of Colonial
Williamsburg (2017-2, 1&2). The set of set of six was sold at
auction by Skinner Boston, *American Furniture and Decora-
tive Arts*, February 27, 2016, sale 2880B, lot 78. I am grateful
to Janine E. Skerry for bringing these spoons to my attention.
2. Rachel E. C. Layton, "Peter Bentzon, Silversmith,"
Antiques, vol. 147, no. 2 (February 1995), p. 311, pl. V, fig. 4.
3. What appears to be a very similar "PB" in a rectangle mark
was reproduced in Ernest M Currier, *Marks of Early Amer-
ican Silversmiths* (Portland, ME: Southworth-Anthoensen,
1938), p. 18, and in Peter Bohan and Philip Hammerslough,
Early Connecticut Silver, 1700–1840 (Middletown, CT: Wes-
leyan University Press, 1970), p. 273, as the mark of the New
Haven, Connecticut, silversmith Phineas Bradley (1745–1797).
Bradley, however, ceased working about a decade before
fiddle-handle flatware of this design was introduced. It is
possible the mark on the Museum's spoon was used by
Phineas Bushnell (1741–1836) of Guilford, Connecticut,
although no object with this mark has been documented
as his work.

Cat. 71-1

Cat. 72

Peter Bentzon

Cup

1841
MARKS: P.BENTZON (in rectangle, three times inside rim of
foot; cat. 72–1); PB (small letters in rectangle, four times
on underside of cup; cat. 72–2)
INSCRIPTION: Presented / To / THE REV. B. LUCKOK / By
The / Superintendant, and Teachers / of / St John's Church
Sunday School / In Christianstad StCroix / as a token of
their / Esteem & Respect April^th 1841 (engraved script,
on front opposite handle; cat. 72–3)
Height 6⅞ inches (17.5 cm), width 5⅜ inches (13.7 cm),
diam. 4 inches (10.2 cm)
Weight 15 oz. 17 dwt. 17 gr.
Purchased with the Thomas Skelton Harrison Fund and
with the partial gift of Wynyard R. T. Wilkinson,
1994-56-1

PROVENANCE: By inheritance in the family of the donor.

EXHIBITED: Gwendolyn DuBois Shaw and Richard J. Powell,
*Represent: 200 Years of African American Art in the Phila-
delphia Museum of Art* (Philadelphia: Philadelphia
Museum of Art, 2015), p. 39, cat. 11.

PUBLISHED: Garde 1993, p. 314, pl. IX; Rachel E. C. Layton,
"Peter Bentzon, Silversmith," *Antiques*, vol. 147, no. 2
(February 1995), illus. p. 314, pl. IX and fig. 6; "Curator's
Choice," *Pennsylvania Heritage* (Summer 1995), illus.
p. 38; Rachel E. C. Layton, "Peter Bentzon, A Mustice Sil-
versmith in Philadelphia and St. Croix," *The International
Review of African American Art*, vol. 12, no. 2 (1995),
illus. p. 30; Rachel Layton Elwes, "Leaving His Mark,"
*American Legacy: The Magazine of African American His-
tory and Culture*, Spring 2004, illus. p. 27; Rachel Layton
Elwes, "Peter Bentzon, African American Silversmith,"
Chester County (PA) Antique Show 2007, illus. p. 23.

This cup on a pedestal is well made and heavy. The
upper section and the foot are seamed. The lower,
rounded unit of the body was raised. There is a
molded band soldered at the join of the bowl and
the stem. The cup has a gilt wash on the inside. The
engraving is in script and uppercase Roman letters
and was probably accomplished by Bentzon. This
cup is one of three pieces of hollowware known by
him thus far.[1]

The cup was made for presentation to the Rever-
end Benjamin Lucock (1792–1846), an Englishman
from Staffordshire who moved to St. Croix in 1832 as
minister to the Sunday school in the Episcopal par-
ish of St. John's Church in Christiansted. The church
had a racially mixed congregation, of which Bentzon,
a free colored person, was a member. Lucock was an
Anglican who had converted from the Quaker faith.
In 1822 he received an honorary master's degree

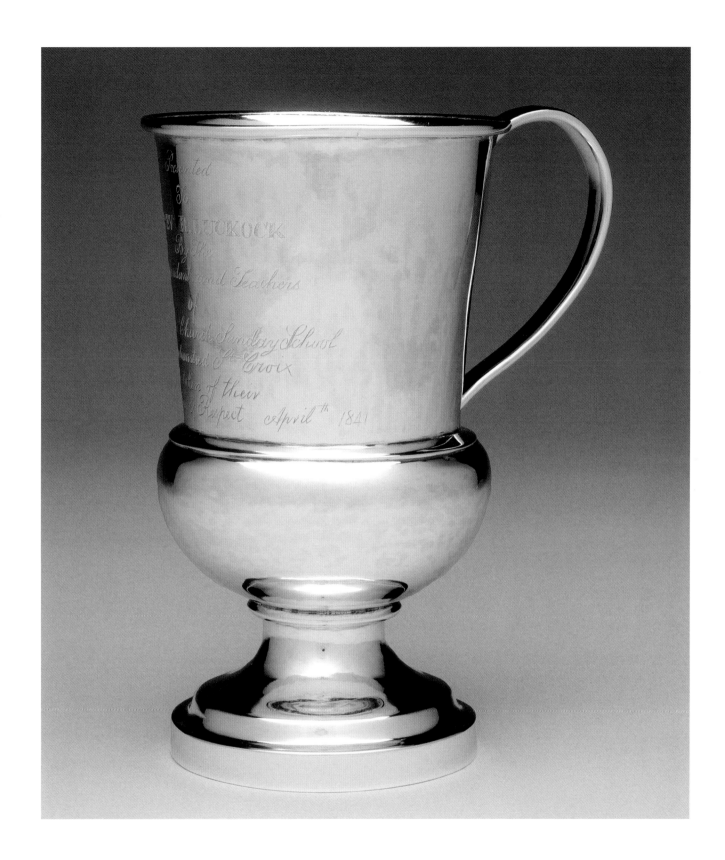

Cat. 72-1

Cat. 72-2

from Columbia University in New York. He married Louisa Augusta von Krause in 1834 and returned to England in 1841.[2] The cup descended in the family until purchased by the Museum. BBG

1. The others are a pair of teapots. One is in the collection of the Saint Louis Art Museum (41-2001). The other is in the National Museum of African American History and Culture, Smithsonian Institution, Washington, DC (2010.14).

2. Rachel E. C. Layton, "Peter Bentzon, Silversmith," *Antiques*, vol. 147, no. 2 (February 1995), pp. 308–15; Garde 1993, pp. 68–77 (translation courtesy of Rachel Layton).

Cat. 72-3

Bernard Bernstein

| Bronx, New York, born 1928

Bernard Bernstein (fig. 41) was raised by parents who valued reading, engaged in great storytelling, and had a strong work ethic imbued with self-reliance. His parents were Galician Jews who immigrated to the United States after World War I. Their sense of terror as a result of traumatic experiences at the hands of both German and Russian soldiers led them to closely protect their son during his childhood and adolescence.[1] He excelled in school and showed aptitude in drawing at an early age. Bernstein attended the High School of Music and Art in New York City for three years, but was forced by illness to drop out. He later graduated from Evander Childs High School in the Bronx and was then hired to run errands for a pawnbroker in New York's jewelry district, where he watched setters, polishers, casters, platers, and others at work.[2] This formative experience shaped his knowledge of jewelry and metalwork. Through happenstance, he heard about the Industrial Arts Program at the City College of the City University of New York (CCNY) and enrolled in the winter of 1953. He continued to work for the pawnshop on weekends but began making jewelry from his home to sell at the college's cafeteria during the week. Graduating in 1957 with a bachelor's degree in education, he taught woodworking for a year in the elementary schools of Ridgefield Park, New Jersey, and from 1958 to 1962 in the elementary schools of New Rochelle, New York. Throughout this time he continued taking graduate courses at CCNY, and earned his master's degree in education in 1960. In the summer of 1959 Bernstein also began his pursuit of a master's degree in fine arts, focusing on silversmithing and jewelry, at the School for American Craftsmen (now known as the School for American Crafts) at the Rochester Institute of Technology.

During this industrious period of his life, Bernstein learned about Ludwig Yehuda Wolpert (Israeli-American, born Germany, 1900–1981), a master and innovator of contemporary Jewish ceremonial art who headed the Tobe Pascher Workshop (1956–89) at the Jewish Museum in New York

City. Wanting to use the time between summer sessions in Rochester to practice his metalsmithing skills, Bernstein took classes with Wolpert at the workshop. At the time, he told Wolpert that he had no interest in or knowledge of Jewish objects, saying, "I have no Jewish education, no Bar Mitzvah, no background, no nothing."[3] In spite of his new student's lack of interest in Judaica, Wolpert instructed Bernstein to study his designs for Hanukkah lamps and menorahs with the assignment of creating a design of his own. The Hanukkah lamp that Bernstein designed in response was his first Jewish liturgical object.

Bernstein began to write his master's thesis and make a journeyman's piece for Hans Christensen (1924–1983), the famed Danish silversmith and metals professor at the School for American Craftsman. The unlikely subject of Jewish ritual silver felt fitting as Bernstein had not only taken classes with Wolpert for several years, but had also conducted his own research on Jewish history, culture, and Torah crowns, shields, and finials at the Jewish Division of the New York Public Library. Taking into consideration the practical implications of life as a silversmith, Bernstein recalls his epiphany that "making teapots and coffeepots and sugar bowls was not very exciting,"[4] and he decided instead to create Jewish liturgical objects. He proposed and completed a Torah crown as his thesis, which focused on the origin, uses, significance, and symbolism of Torah ornaments. According to the artist, it is likely that this Torah crown was the first Jewish liturgical object created as a journeyman's piece for the School for American Craftsman.[5]

Fig. 41. Bernard Bernstein at the Haystack Mountain School of Crafts, Deer Isle, Maine, c. 1970s. Photo: Jonathan Thomas

In 1962 Bernstein joined the faculty of the Department of Industrial Education at CCNY, where for twenty-three years he taught courses in design, woodworking, technical drawing, jewelry, and metalworking; he retired in 1985 as a full professor but continued to teach until 1988. While teaching, he pursued his doctorate in education through the Creative Arts Program at New York University, receiving his degree in 1971. To fulfill the requirements, he fashioned ten ceremonial works of art in silver, comprising several Torah crowns, shields, finials, and pointers, and wrote his dissertation on the ornamentation of the Torah. For Bernstein his study of Torah ornaments was intentional, because it was "deeply woven in with the kind of work I wanted to do anyway."[6] Following in Wolpert's footsteps, Bernstein focused his entire career on the study, teaching, and creation of one-of-a-kind contemporary Jewish liturgical metalwork. In 1988 he became an instructor in Judaica silversmithing at the 92nd Street YM-YWHA in New York. He is particularly gratified that it remains the only course in the United States to focus on Jewish ritual silversmithing. Bernstein, who retired from teaching in 2015, sees himself as "the spiritual descendant of Paul Revere or maybe I should say Myer Myers, [q.q.v.] the first Jewish silversmith in New York."[7]

Early in his career, Bernstein's work was exhibited widely in shows celebrating craft, metalwork, and contemporary Judaica, most notably *Young Americans* (Museum of Contemporary Crafts, New York, 1958), *Contemporary Jewish Ceremonial Art* (Jewish Museum, New York, 1961), *The Goldsmith* (Renwick Gallery, Smithsonian American Art Museum, Washington, D.C., 1974), and *Ceremonial Art in the Judaic Tradition* (North Carolina Museum of Art, Raleigh, 1975).[8] He was the guest curator for the exhibition *Sanctification and the Art of Silversmithing* (Derfner Judaica Museum, Riverdale, New York, 1994), which was accompanied by a catalogue that he authored. This critical text interweaves rituals, processes, and techniques, and serves as a handbook for museums that hold collections of Jewish ritual metalwork. Bernstein's Judaica is found in many private and public collections, including the Brooklyn Museum; Museum of Fine Arts, Boston; Derfner Judaica Museum, Riverdale, New York; Skirball Museum at Hebrew Union College, Cincinnati; Herbert and Eileen Bernard Museum of Judaica, Temple Emanu-El, New York; Museum of Arts and Design, New York; New-York Historical Society; Yeshiva University Museum, New York; and Smithsonian Museum of American Art, Washington, D.C. ERA

1. Biographical information was obtained from Bernstein's oral

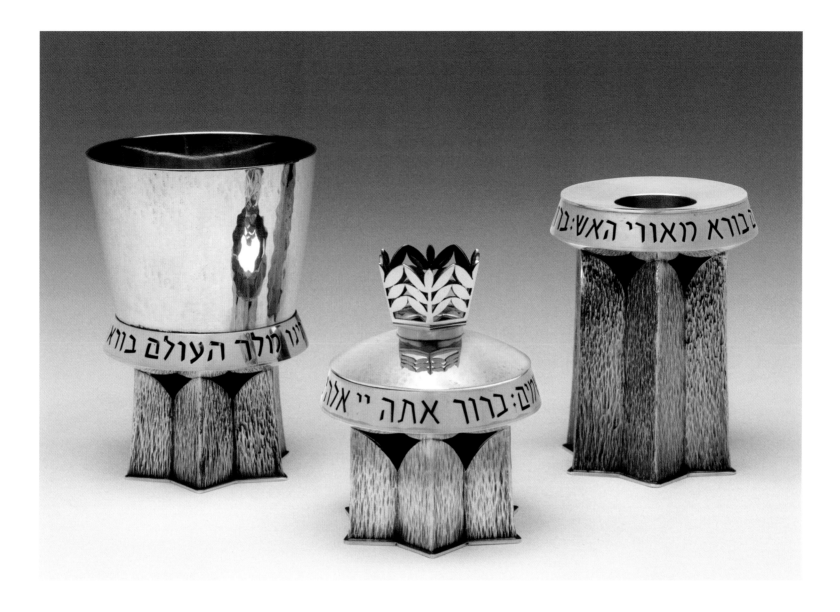

history manuscript, April 21, 1995, archived at the Oral History Project, UJA-Federation of Jewish Philanthropies of New York (hereafter Oral History Project); and from communications with the artist in 2017 that clarified some passages in his oral history.

2. "A New York Hanukkah," New-York Historical Society Museum & Library, www.NYHistory.org (accessed January 10, 2017); "Biography: Bernard Bernstein," Academic Metals Directory, Tyler School of Art, Temple University, www.temple.edu /crafts/metalsdirectorypage/p12.html (accessed April 14, 2017).

3. Oral History Project, pp. 13–16, 18–22. The greatest sources of *Yiddishkeit*, or Jewishness, that held the artist's attention as a child were the daily use of Yiddish spoken by his family, through many colorful stories of their old life in Europe and his Aunt Rivka's tales from the Bible.

4. Ibid., p. 23.

5. Ibid, pp. 23–24.

6. Ibid, p. 30.

7. Bernstein quoted in "Chanukah Celebrations Highlight Silversmith Bernard Bernstein's Craft," posted December 15, 2014, http://newyork.CBSlocal.com/2014/12/15/hanukkah-celebrations-highlight-silversmith-bernard-bernsteins-craft/ (accessed April 14, 2017).

8. *Contemporary Jewish Ceremonial Art* was circulated in the United States for two years by the American Federation of Arts. *The Goldsmith* also toured nationally for two years. *Sanctification and the Art of Silversmithing* was additionally on view at the Rabbi Ario S. & Tess Hyams Judaica Museum of Temple Beth Sholom, Roslyn Heights, New York.

Cat. 73

Bernard Bernstein
Havdalah Set

Kiddush Cup
1993
Candle Holder
1997
Spice Box
1998

MARKS: (Kiddush cup: 2015-117-3) STERLING BERN-STEIN © 1993 (incuse, on underside of foot); (candle holder: 2015-117-2) © BERNSTEIN 1997 STERLING (incuse, twice on underside); (spice box: 2015-117-1a,b) [diamond on top of a diamond] / © BERNSTEIN / 1998 / STERLING (incuse, on underside of lid); © BERN-STEIN 1998 STERLING (incuse, on underside of foot; cat. 73-1)

Kiddush Cup
Height 4⅛ inches (10.4 cm), width 3 inches (7.6 cm)
Weight 9½ oz.

Candle Holder
Height 3⁷⁄₁₆ inches (8.8 cm), width 2¾ inches (7 cm)
Weight 10 oz., 17 dwt.

Spice Box
Height 3⁵⁄₁₆ inches (8.4 cm), width 2¹¹⁄₁₆ inches (6.8 cm)
Weight 6 oz.

Purchased with the Leonard and Norma Klorfine Foundation Endowed Fund for Modern and Contemporary Craft, 2015-117-1a,b-3

EXHIBITED: *Living in the Moment: Contemporary Artists Celebrate Jewish Time*, Hebrew Union College, New York, and Hebrew Union College, Cincinnati, 2000–2001; *Contemporary Judaica*, Aaron Faber Gallery, New York, 2001. Kiddush cup (2015-117-3): *Sanctification and the Art of Silversmithing*, Derfner Judaica Museum, Riverdale, NY, and Judaica Museum of Temple Beth Sholom, Roslyn Heights, NY, 1993; *Artisans in Silver: Judaica Today*, National Ornamental Metal Museum, Memphis, TN, Hebrew Union College Skirball Museum, Cincinnati, and Yeshiva University Museum, New York, 1997; Carnegie Museum of Art, Pittsburgh, Minneapolis Institute of Art, and Mitchell Museum, Mount Vernon, IL, 1998. Candle holder (2015-117-2): *Artisans in Silver: Precious Illumination*, Eskenazi Museum of Art, Indiana University, Bloomington, 1997.

PUBLISHED: "Exhibition in Print," *Metalsmith*, vol. 21, no. 4 (Summer 2001), p. 19.

These three objects are designed to be employed in the Havdalah ritual, which is held after nightfall on Saturday to celebrate the distinction between the holy Sabbath and the secular week. Havdalah, which means "separation," is composed of a

Cat. 73-1

blessing over wine, light from a multiwick braided candle, and spices, and thus requires a *kiddush* (literally, "sanctification") cup, a candle holder, and a spice box—objects that are often made of precious metal to mark the disjunction between the Sabbath and day-to-day life. Symbolizing the spiritual riches of the Sabbath, the sweetness of the spices anticipates "that a new week should be fragrant in deeds."[1] Bernstein conceived this assemblage of unique objects over a five-year period.

Although ritual use governs Judaic design, the ethnic diversity of Jewish communities worldwide produces many national and regional designs, usually employing historical styles. Contemporary artists such as Bernstein combine modern design concepts and materials with traditional religious precepts. Following in the footsteps of Ludwig Yehuda Wolpert (1900–1981), his former instructor, Bernstein makes only contemporary Jewish ritual objects. He reflects upon the spirit of Judaism today, inspired by the stylistic freedom that contemporary Judaica invites, and manifesting that spirit in precious silver, as exemplified in this Havdalah set. Bernstein's aesthetic centers on form rather than decoration, "the balance of masses, the proportion of the height of an object to its width," and what he calls "variety in unity," which strives for an object to have similarities yet differences "in terms of size or texture or color or proportion or volume."[2]

Bernstein admits that he adopted Wolpert's aesthetic, composed of simple, geometric forms that have integrity and a uniformity of style.[3] Wolpert is also recognized for his use of the Hebrew alphabet as a precise and explicit graphic element that itself becomes the surface ornament.[4] Focusing on the strength of the individual object, Bernstein likes "to follow that style" but has his "own feeling . . . I like to be able to make a single aesthetic statement, possibly with some little stuff as accents; but not to load the thing up so that it overpowers you."[5] He incorporates Hebrew lettering as a stylistic detail but also as a practical one. Each of the Hebrew prayers that is commanded for this observance is pierced on a collar that encircles the respective object.[6] The finial on the spice box is a pierced hexagonal form of stylized myrtle leaves, which are traditionally associated with the ritual of Havdalah, and is a superb example of the decorative details that adorn Bernstein's work.[7]

Although Wolpert's stylistic genetic code can be detected in this Havdalah set, these three objects definitively speak to Bernstein's own stylistic concerns regarding unity, proportion, and beauty. Ritual objects found in homes or synagogues are highly treasured since they are integral to religious observances, celebrations, and holidays throughout the Jewish calendar. Like many artists who strive to create sacred objects that will enrich a participant's

ritual practices, Bernstein's Havdalah set reflects the Talmudic idea of *hiddur mitzvah*, "observance in beauty." ERA

1. Louis Jacobs, *The Book of Jewish Belief* (New York: Behrman House, 1984), p. 102.
2. Quoted in Bernstein's oral history manuscript, April 21, 1995, archived at the Oral History Project, UJA-Federation of Jewish Philanthropies of New York, pp. 51, 53.
3. Ibid., pp. 58, 60.
4. Ibid., p. 58.
5. Ibid.
6. *Barukh atah Adonai, Eloheinu, melekh ha'olam borei p'ri hagafen (Amein)* (Blessed are you, Lord, our God, sovereign of the universe who creates the fruit of the vine [Amen]). *Barukh atah Adonai, Eloheinu, melekh ha'olam borei minei v'samim (Amein)* (Blessed are you, Lord, our God, sovereign of the universe, who creates varieties of spices [Amen]). *Barukh atah Adonai, Eloheinu, melekh ha'olam borei m'orei ha'eish (Amein)* (Blessed are you, Lord, our God, sovereign of the universe, who creates the light of the fire [Amen]).
7. According to the artist, myrtle was the traditional spice used in spice boxes until the sixteenth century. The Hebrew name for myrtle is *hadassah*, which explains the spice box's alternate name of *hadas*. Artist's undated business records, curatorial files, AA, PMA.

Harry Bertoia

San Lorenzo, Italy, born 1915
Bally, Pennsylvania, died 1978

Harry Bertoia was born Arri Bertoia in San Lorenzo, Italy, near Udine. At an early age he was inclined toward drawing and art,[1] and when he was ten an encounter with gypsies selling their hammered copper wares and utensils left an indelible impression on him about metal and its malleability.[2] He emigrated with his father first to Canada and then to the United States in 1930 at the age of fifteen, settling in Detroit.[3] Having shown artistic aptitude in school, Bertoia entered an art program for gifted students at Cass Technical High School in Detroit, where he studied drawing, painting, and metalsmithing. In 1936 he was granted a one-year scholarship to the Detroit Society of Arts and Crafts (now the College for Creative Studies). On the strength of the metalwork he had created while still in high school, Bertoia received a scholarship in 1937 to attend Cranbrook Academy of Art in Bloomfield Hills, Michigan.[4]

One of the conditions of Bertoia's acceptance into the academy was to reinstate the metalworking studio, which he accomplished by 1939.[5] While at school he studied painting, drawing, woodcuts, and metalwork concurrently, a practice encouraged by the Academy, which created a laboratory environment so that students would become creative in their artistic endeavors.[6] The artist's interest in contemporary abstraction blossomed in school and can be traced to his interaction with the artists Wallace Mitchell (1911–1977) and Zoltan Sepeshy (1898–1974), as well as with William Valentiner (1880–1958), a collector of the work of Vassily Kandinsky (1866–1944) and Paul Klee (1878–1940) and at the time director of the Detroit Institute of Arts.[7] It is speculated that, owing to the friendship between Bertoia and Mitchell, whose paintings of the 1940s (fig. 42) share similar geometric elements with Bertoia's work, each may have had an influence on the work of the other.[8]

In 1938 he began teaching metalwork full-time at Cranbrook (fig. 43).[9] When World War II broke out in 1941, metal programs such as Cranbrook's were suspended. In 1943 Bertoia married Brigitta Valentiner, daughter of William

Valentiner. That same year, he and Brigitta moved to Venice, California, to work for the designer Charles Eames. Over the course of the next seven years, he designed furniture for Eames, undertook war contract work at Evans Products Company, obtained his American citizenship, did graphic work at Point Loma Naval Electronics Laboratory, and continued to make jewelry.[10] Bertoia and his wife moved to La Jolla, California, in 1947.[11] At that time his jewelry was exhibited and sold through the Nierendorf Gallery, New York; Alexander

Fig. 42. Wallace Mitchell (American, 1911–1977). Untitled, 1947. Casein, gesso, and graphite on paper, 14 1/16 × 22 7/8 inches (35.7 × 58.1 cm). Solomon R. Guggenheim Founding Collection, 48.1185. Photo: The Solomon R. Guggenheim Foundation/Art Resource, NY

Girard Gallery, Grosse Pointe, Michigan; Rapson, Inc., Boston; Outlines Gallery, Pittsburgh; Armin Richter, San Diego; and Open Circle Gallery, San Francisco.[12] He was also represented in the exhibition *Modern Jewelry Design* at the Museum of Modern Art, New York, in 1946, and the Walker Art

Fig. 43. Harry Bertoia with a student at the Cranbrook Academy of Art, March 1939. Photographer: Richard G. Askew. © Cranbrook Archives, 4879-9

Center's seminal surveys *Modern Jewelry under Fifty Dollars* in Minneapolis in 1948 and 1955.[13]

At the invitation of Florence Knoll, Bertoia moved to Bally, Pennsylvania, in 1950 to design for Knoll Associates, working in the factory in nearby East Greenville.[14] His jewelry continued to sell and be exhibited well into the 1950s and is now represented in several notable collections, including the Museum of Fine Arts, Boston, the Montreal Museum of Fine Arts, and Cranbrook Art Museum.

After he moved to Pennsylvania, Bertoia occasionally made jewelry as gifts. In the 1950s he continued exploring spatial constructions and the effect of light in his sculpture and the architectural commissions for which he is widely recognized. Just as in the 1930s and 1940s his jewelry evoked his drawings and sculpture, in the latter part of his career, when Bertoia returned to jewelry making, he produced a series of pendants closely related to his *Gongs* and *Sonambients*, tall wire sculptures of the 1960s and 1970s that included elements of sound and motion.[15] ERA

1. *The Bertoia Legacy: Sound and Motion*, exh. cat. (Bethlehem, PA: Payne Gallery, Moravian College, 1990), p. 2.

2. Selim 2015, p. 11. To make the cooking utensils the gypsies would beat the metal out with small implements, creating a variety of sounds. The memory of these sounds would stay with Bertoia to be realized at the end of his life in his *Tonal* and *Sonambient* sculptures of the 1960s and 1970s. Marter 1983, p. 256.

3. Oreste, Bertoia's brother, had settled in Detroit before he and his father arrived in the United States; Susan J. Montgomery, "The Sound and the Surface: The Metalwork and Jewelry of Harry Bertoia," *Metalsmith*, vol. 7, no. 3 (Summer 1987), p. 23.

Biographical details presented here are drawn primarily from the chronology in Beverly H. Twitchell, *Harry Bertoia: An Exhibition of His Sculpture and Graphics*, exh. cat. (Allentown, PA: Allentown Art Museum, 1975), p. 53.

4. Montgomery, "The Sound and the Surface," p. 23.

5. Selim 2015, p. 13.

6. Ibid., p. 12.

7. Marter 1983, pp. 253–54.

8. Ibid., p. 261.

9. J. David Farmer, "Metalwork and Bookbinding," in *Design in America: The Cranbrook Vision, 1925–1950*, ed. Robert Judson Clark and Andrea P. A. Belloli (New York: Abrams, in association with the Detroit Institute of Arts and the Metropolitan Museum of Art, 1983), pp. 163–64.

10. Twitchell, *Harry Bertoia*, p. 53; Selim 2015, p. 22.

11. Selim 2015, p. 22.

12. At the Nierendorf Gallery and the Alexander Girard Gallery in the 1940s, his jewelry was exhibited with the work of Alexander Calder (q.v.); ibid.

13. Ibid., p. 23.

14. Ibid.

15. Ibid., p. 23.

Cat. 74

Cats. 74, 75

Harry Bertoia
Two Brooches

c. 1947
Silver electroplated with gold

Cat. 74: Height 3½ inches (8.9 cm), width 4 inches (10.2 cm)
Weight 6 dwt. 3 gr.
Cat. 75: Height 3 inches (7.6 cm), width 3½ inches (8.9 cm)
Weight 8 dwt.
Gift of Frances Elliot Storey and Gay Elliot Scott, 2014-10-2, -3

PROVENANCE: Helen Pauling Donnelley (1892–1984), Chicago.

EXHIBITED: Shelley Selim and Celia Bertoia, *Bent, Cast, and Forged: The Jewelry of Harry Bertoia* (Cranbrook, MI: Cranbrook Art Museum, 2015), pp. 50, 52, pls. 20, 22; Museum of Arts and Design, New York, May 3–September 25, 2016.

These two brooches by Harry Bertoia are significant examples of his jewelry from the end of the 1940s. Like many metalsmiths and sculptors affected by the increased difficulty of obtaining metals during World War II, Bertoia turned to jewelry by using scraps found around the metals shop at Cranbrook Academy of Art in Bloomfield Hills, Michigan, where he taught from 1938 until 1943.

Cat. 74 is a geometric composition with repeated units positioned at irregular intervals to form a spatial construction. This work is evocative of reductive plant life. A single silver wire, like the trunk of a tree, serves as the central element from which four wires or limbs are attached. Multiple wires or branches of various lengths are connected to these limbs and terminate in flattened petal-like forms.

Bertoia's interest in biomorphism, a movement in the 1940s that was part of the prevailing taste for

abstract Surrealism in avant-garde jewelry, and that was sustained by the art establishment well into the 1950s, is clearly reflected in cat. 75.[1] The design is reminiscent of a single-celled microorganism, with a silver wire forming the undulating outer membrane of the brooch. Two thinner silver wires, attached at two separate points by cold connection (without the use of heat), suggest the different functioning parts of a cellular structure, further implying movement. Likened to Constructivist sculpture, Bertoia's work—large and small—emphasizes structure through repetition, spatial play, and dynamism.[2]

Both brooches exemplify the artist's ability to create one-off, hand-hammered wire compositions, showcasing his direct connection to the metal. They also reveal his skill and craftsmanship, which carried

Fig. 44. Harry Bertoia. *Untitled Monotype (Non-Objective Polychrome Block Print)*, c. 1940s. 16⅝ x 12¼ inches (42.2 x 31.1 cm). Cranbrook Art Museum, Bloomfield Hills, MI. Gift of Brigitta Valentiner Bertoia, CAM 1988.2. Photo: courtesy of Cranbook Art Museum. Photo: R. H. Hensleigh

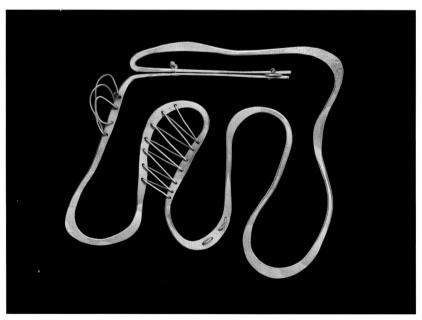

Cat. 75

over into his larger work.[3] Light falling on the pieces casts shadows and reflections on the stippled gold surface, effects that Bertoia also employed in later sculptural work. Although the brooches are inanimate, the reflection provides a constant state of kinesis.

Bertoia's *Multiplane Constructions* of the 1950s and 1960s have been described as three-dimensional translations of the spatial interaction found in his monoprints of the late 1930s and 1940s (see fig. 44).[4] His spatial experiments in painting from the same period are also connected to his later sculptural work. These two examples of Bertoia's jewelry, like many others, are further three-dimensional manifestations of his graphic work and are strongly aligned with his paintings of the late 1930s and 1940s.[5] Bertoia's intention at this time was to make jewelry, but in the realization of small-scale wearable constructions, he was able to experiment with form and material, working out formal ideas spatially. Significantly, his jewelry foretells the large-scale constructions he would create from the 1950s through the 1970s.

These superb brooches were donated to the Museum by Frances Elliot Storey and Gay Elliot Scott, nieces of Helen Pauling Donnelley.[6] While living in Chicago, Donnelley was a painter and a dancer well-known in art-world social circles. Following her divorce from Thorne Donnelley in 1931, she studied painting with Hans Hofmann in Provincetown, Massachusetts, some time between 1933 and 1945.[7] Although it is certain she was the original owner of these brooches, it is not known where she acquired them.[8] ERA

1. While many painters and sculptors abandoned Surrealism in the 1950s, applied artists continued to design in this style; Toni Greenbaum, "Bizarre Bijoux: Surrealism in Jewelry," *Journal of Decorative and Propaganda Arts*, vol. 20 (1994), p. 201.
2. Beverly H. Twitchell, *Harry Bertoia: An Exhibition of His Sculpture and Graphics*, exh. cat. (Allentown, PA: Allentown Art Museum, 1975), pp. 7–8.
3. Ibid., p. 8.
4. Ibid., pp. 10, 14.
5. While at Cranbrook, Bertoia made paintings that he considered space experiments, which informed his cloudlike "floating" sculptures created in the early 1950s; Marter 1983, p. 256.
6. Helen Pauling Donnelley was born in 1892 in Chicago and died in Marin County, California, in 1984; 1900 U.S. Census.
7. *Chicago Tribune*, August 2, 1944, p. 11. From 1933 through 1945 Donnelley is listed as an art student of Hans Hofman at the Hans Hofmann School of Fine Arts Summer School in Provincetown, Massachusetts; "Color Creates Light: Studies with Hans Hofmann, Partial List of Hofmann Students per Era," www.colorcreateslight.com/studentsccl.html (accessed April 14, 2017).
8. Bertoia's jewelry was exhibited both in Chicago and at Ralph Rapson's retail store in Boston, where Donnelley may have acquired them.

Joseph Bird Jr.

| Philadelphia, born 1808
| Philadelphia, died 1854

I n 1823 there were six "importers of fancy hardware & cutlery" dealers on Market Street between numbers 78 and 198, illustrating the emergence of a retail trade becoming important after the War of 1812.[1] The collection of the Charles Bird Papers at the Library Company of Philadelphia, which includes correspondence with vendors and legal papers concerning the "fancy hardware" business of Charles Bird (1778–1849) and family, reveals the extent of this business. When sea commerce was uncertain, they patronized local craftsmen such as silversmith Peter Bumm on Queen Street, and the silver manufactory of Bumm & Shapper on South Fourth Street. They supplied Philadelphia jewelers and silversmiths including James Black, in 1801, Samuel Richards (q.v.) in 1808, and Watson & Umster in 1803. They renewed their patronage of Philadelphia craftsmen in 1827 when James Watson (q.v.) supplied the Birds' "hardware" store with some $600 worth of gold, pearl, and diamond jewelry, watches, seals, and a silver-mounted dirk.[2] At the same time their business extended well beyond the local scene, offering the products of the world to Philadelphia patrons. The Birds were investors, exploring new sources and commodities, with a far-reaching vendor list from Venezuela to Sheffield and Liverpool, England, as well as to most American cities from Savannah and New Orleans to Pittsburgh and New York. The Bird family hardware business was active from 1802 to 1849.

As well as retailing fancy hardware, Charles Bird invested heavily in real estate, long considered by Philadelphians as a hedge against fluctuating market conditions. The number of deeds, eighteen or more as grantor and grantee, entered into by Joseph senior and Charles between 1785 and 1848 illustrate their activity in that market. Charles Bird's success was evident when at his death he left $30,000 to each of his children, a bequest of such national interest that notice of his death was published in New York and New England newspapers.[3]

The Birds were originally a New Jersey family. In 1791 Joseph Bird Sr. (1758–1825) was the only entry for a Bird listed in the Philadelphia directory, where he was identified as a wood corder and carter, which had also been his father William's profession in New Jersey, an occupation identified with and essential to metal manufacturing. He married Mary Phipps in Philadelphia on March 10, 1788.[4] By 1818 he was on the Board of Commissioners for Southwark District, and in 1819 "Joseph Bird, Esq., was unanimously elected Philadelphia County Treasurer with his office on the second floor of the State house on 5th Street." His listing as "gentleman" in the city directory just before his death in 1825 recognized his status.[5]

Joseph's younger brother Charles Bird, moved from Basking Ridge, New Jersey, to Philadelphia, sometime before March 2, 1799, when he married Jennet P. North (died 1819) of Southwark.[6] His arrival and first location in Southwark suggest that Joseph senior had made important contacts for him. In 1801 Charles was listed in the Philadelphia directory as a clerk at the Bank of Pennsylvania at 236 South Second Street. He played a limited role in Philadelphia politics but served on committees and in societies dedicated to fundraising for public improvements, from gas lighting to the Girard College for orphans, where he was a trustee. In 1819 he was a stockholder in the Mechanics Bank at 9 South Third Street,[7] and in 1833 served as clerk of the Common Council.[8] His lifetime pursuit was the stylish end of the hardware trade. In 1802 he established a hardware store at 225 South Second Street, two blocks south of the several silversmiths' shops on Second Street between Chestnut and Market. In 1807 he joined briefly with the Earp Brothers, merchants, as Bird & Earp at the 225 South Second Street address. The firm continually advertised looking glasses, cutlery, and "fancy hardware."[9] In 1809 Charles Bird moved his principal hardware business to 82 High Street. With additional building on High (Market) Street, number 82 became number 98 and the Bird's permanent location at the southwest corner of High and Fifth streets.[10]

Charles and Jennet Bird had one daughter and three sons. Caroline married John R. Neff, a bank director and prominent auctioneer in Philadelphia, in 1817. Eldest son Henry established a branch of the Philadelphia hardware store in Baltimore as Bird & Neff. Charles's younger sons, John and Joseph junior (born 1808), the latter named after his uncle Joseph senior (and thus the clarifying "junior"), were in the family business.[11] Considering the suggested dating (1832–45) of the silver spoons bearing the mark "JOSEPH BIRD" (cat. 76), it must have been Joseph junior who was the retailer. Charles Bird retired in 1828/29. The 1829 city directory noted a Thomas Bird (relationship not determined)

with a "hardware" at 98 High Street.[12] Henry Bird returned from Baltimore to Philadelphia in 1833 to run the business on High Street. The firm's name became Bird & Brothers (1833–37) and was active with various partners until 1849.

The Birds and others were not immune from the losses incurred from the War of 1812, followed by the bank failure in the 1830s, which caused a shortage of hard currency and credit. In 1819 Joseph senior borrowed $3,000 from his brother Charles, $1,500 of which was specified to be in "silver money."[13] Joseph senior died intestate six years later, in debt but not bankrupt since he owned real estate in the city, which his wife Mary was putting up for sale as late as 1847 to cover debts.[14] His administration included a simple inventory: cash in the Philadelphia Bank, $25.81; clothing, $158.00; one silver watch, $5.00; and a horse, $40.00; it also listed "silver spoons," valued at $10.00.[15] When Mary Bird died in 1849, her modest inventory included household goods valued at $79.20, some kitchen accoutrements, and "fourteen silver spoons appraised at $5." Although it is tempting to suggest that these spoons were the ones under consideration in cat. 76, Joseph senior's death date of 1825 seems too early for a *Queen*-pattern spoon to have been imported into Philadelphia.

Few genealogical details have emerged about Joseph Bird Jr. He was born in Philadelphia. He and his brother John attended a Quaker school in Burlington, New Jersey, where the headmaster was John Gummere (1784–1845), after which they attended William Brownlee's Academy.[16] Joseph junior married Elizabeth M. Hyde, daughter of Francis Hyde, Esq., of Baltimore on Saturday May 7, 1831, in Baltimore.[17] On August 17, 1837, Joseph and his wife lost a daughter, Caroline Neff Bird, named after his sister, Caroline, and brother-in-law John R. Neff.[18] In 1833 and 1837, Joseph was listed in the Philadelphia directory at the family hardware business at 98 Market Street, with his residence at 119 South Fifth, the house that had belonged to Joseph senior. In 1839 the firm was listed as Henry Bird & Co. at 98 Market Street. In 1843 Joseph was at 28 St. John Street in the Northern Liberties.[19] In this location he was a neighbor of the silversmith John Curry (q.v.), who marked a set of silver spoons in the *Queen* pattern that was found with the spoons marked by Bird. In the U.S. census of 1850, Joseph Bird, age fifty, was resident in Ward 4 of the Northern Liberties, in a boardinghouse with twenty-two residents. He was not listed in the city directories from 1850 onward. His death was noted in the *North American and United States Gazette* on June 26, 1854, and in the *Public Ledger* on June 28, 1854. He was buried in Laurel Hill Cemetery with other family members. BBG

1. Earps & McMain, no. 78; Charles M. Stokes, no. 82; Samuel Knight, no. 91; Bird & Co., no. 98; Earps & Co., no. 170; John Carrell & Son, no. 198. *Commercial Directory* (Philadelphia: J. C. Kayser, 1823), p. 170.

2. McA MSS 010, Charles Bird Papers, box 3, folders 246, 265, 264, John A. McAllister Collection, McAllister Miscellaneous Manuscripts, Library Company of Philadelphia.

3. Charles Bird Papers, Finding Aid.

4. Certificate of Marriage, Society Miscellaneous Collection, HSP.

5. *Poulson's American Daily Advertiser* (Philadelphia), July 20, 1825: "July 19, 1825, Joseph Bird Esq. late of Penn Township in the County of Philadelphia, Late County Treasurer, in the 67th year of his age."

6. Charles Bird Papers, descriptive summary; Bird family, Laurel Hill Cemetery, Pennsylvania and New Jersey Church and Town Records, Ancestry.com. There was an extended North family in Southwark, three members of whom were listed as carpenters. Charles and Joseph Bird served as executor and witness, respectively, to the will of Samuel Davis of Southwark in 1801.

7. *Franklin Gazette* (Philadelphia), August 5, 1819.

8. *Philadelphia Inquirer*, February 6, 1833.

9. *Poulson's American Daily Advertiser*, October 27, 1807.

10. From 1785 to 1791 this property had been the residence of the Dutch consul, leased from "Mrs. House."

11. *Poulson's American Daily Advertiser*, July 20, 1825.

12. A "Thomas Bird Hardware" was listed in the 1825 city directory at 58 North Seventh Street.

13. This was the year Joseph senior was made treasurer of Philadelphia County; Charles Bird Papers, box 4, folder 305. The $3,000 was related to a mortgage on Joseph senior's Fifth Street house.

14. *Public Ledger* (Philadelphia), October 27, 1847.

15. Philadelphia Administration Book N, no. 232, p. 57. Books and a carriage each had the same $10 value. Mary Bird's administration papers were signed by James W. Hone and Stephen Phipps in 1847; Philadelphia Administration Book P, no. 242, p. 410.

16. Charles Bird Papers, Series I, Correspondence (1803–1830).

17. *Philadelphia Album and Ladies' Literary Portfolio*, May 7, 1831.

18. *Public Ledger*, August 19, 1837; Laurel Hill Cemetery, Pennsylvania and New Jersey Church and Town Records, Ancestry.com.

19. St. John Street ran between Vine Street and Germantown Avenue, west of Second Street. It later became American Street.

Cat. 76
Joseph Bird Jr.
Pair of Stuffing Spoons

1832–45
MARK (on each): JOSEPH BIRD (in rectangle); (small die stamp of bird in lobed, conforming shape, on reverse of handle; cat. 76-1)
1976-249-1: Length 12 11/16 inches (32.2 cm)
1976-249-2: Length 12 5/8 inches (32 cm)
Each: Length bowl 2½ inches (6.3 cm)
Weight (1976-249-1) 7 oz. 18 dwt. 5 gr.;
(1976-249-2) 8 oz. 4 gr.
Purchased with the Richardson Fund, 1976-249-1, -2
PROVENANCE: Anthony Stuempfig, Philadelphia.

Cat. 76-1

These spoons are grand and heavy, and show no signs of use. They may have been specialized stuffing spoons, as their length was the norm for an English model. The spoons were two from a set marked by Joseph Bird, purchased for the Museum from a family with connections to the Curry family in Haddonfield, New Jersey. They were found en suite with two dozen smaller spoons in the same pattern marked by John Curry (q.v.) and by the partnership of Curry and Preston.[1]

The spoons are in the *Queen* pattern, which is more ornate than the *King* and would have demanded a high level of expertise and machinery to produce it. The convex shells at the top of the handles are larger on the obverse than the reverse. The upper anthemion pattern on the obverse is taller than the lower set. There are two pairs of "C" scrolls, one at the top of the handle, the other just below the incurved section; and the crisp "oyster shell" design on the reverse of the bowls is a feature that distinguishes the *Queen* from the *King* pattern.[2] The stamen-like threads between the lobes of the shells evident on this pair are lacking on other versions of the pattern by later Philadelphia makers.[3] The stylized leaf shapes, on the obverse and reverse of the fins on these spoons, seem identical to those on a caddy spoon advertised as in the *Queen* style about 1828 by London silversmith Jonathan Hayne.[4] In Philadelphia these spoons would probably have been described as finest-quality *King* pattern, which was advertised in the city at least by November 23, 1835, when John Curry at 76 Chestnut Street advertised in the *Pennsylvania Inquirer*: "Also an order of Spoons and Forks . . . King pattern." On January 30, 1840, Robert and William Wilson advertised in the *North American*: "Plated ware . . . King pattern Table and dessert Forks plated on steel." On December 15, 1841, Thomas Fletcher (q.v.) on Chestnut Street advertised, also in the *North American*, as a "Manufacturer of Silver plate & Jewelry . . . King pattern."

Perhaps these grand spoons, as well as a fork marked by Thomas Fletcher, were made in England

for export and thus have no English marks. They possibly were part of a batch of silver advertised on March 29, 1841, in the *North American*: "on Thursday morning at the Auction store . . . Sterling Silver Plate on Thursday morning, April 1 . . . to be sold without reserve several hundred ounces sterling silver comprising forks, spoons, ladles, knives etc. King pattern, made in London to order and of the finest quality." As the Birds and Thomas Fletcher are known to have ordered from abroad, the possibility remains that one of them put the batch up for sale. Curry was in business at his spoon-and-fork manufactory at 76 Chestnut Street, but was "selling off at reduced prices" in 1837. He went bankrupt in June 1842. Fletcher sold out in the same year.

As well as the name mark "JOSEPH BIRD" on these spoons, there is the very small mark of an eagle with its head tilting to the left over its right shoulder, its left wing extended, stamped in a conforming shape at the top of the reverse of the handle below the ornament.[5] Thomas Fletcher stamped his mark on the fork in the same pattern, but it does not have the eagle mark.[6] John Curry evidently marked the set of spoons found with Bird's spoons, but there was no mention of an eagle mark on Curry's spoons.[7]

This winged-eagle mark has been generally recognized as a characteristic motif on silver made in Philadelphia, but it has not yet been attributed to a specific silversmith or manufacturer. The eagle mark may have been the retail mark of the Bird hardware enterprise. In 1803 John Bird had an extensive account for watches, jewelry repairs, gilt bracelets, gold chains, silver thimbles, and so forth, with Watson & Umsted, and from April to November 1827, and again in 1833, with James Watson at 72 High (Market) Street.[8] The mark appears on other tableware with the marks of the Philadelphia silversmiths George G. Dowell (active 1843–46), and Watson and Hildeburn (q.v.).[9] BBG

1. Information provided by the dealer Anthony Stuempfig at the time of purchase; curatorial files, AA, PMA.
2. Ian Pickford, *Silver Flatware: English, Irish and Scottish, 1660–1980* (Woodbridge, Suffolk, UK: Baron, 1983), pp. 124–25.
3. E.g., Peter L. Krider and James E. Caldwell (q.q.v); see Hollan 2013, p. 250.
4. Image in curatorial files, AA, PMA.
5. The same mark, "JOSEPH BIRD" with an eagle stamp, also from the handle of a spoon, was published in *New York State Silversmiths* (Eggertsville, NY: Darling Foundation, 1964), p. 31, as "Location Unknown."
6. Hollan 2013, p. 250.
7. A search through sale catalogues has not produced one of Curry's *King* pattern spoons.
8. Charles Bird Papers, 1800–1837, Series II; Financial Documents, box 3, folders 264, 265, Library Company of Philadelphia.
9. Hollan 2013, p. 235; McGrew 2004, p. 102. In 1843 Dowell was listed in the city directory as a silversmith at 120½ High (Market) Street, with his residence at 13 East North Street, which ran between Fifth and Sixth streets. In 1846–47 he was still listed as a silversmith at 112 Chestnut Street with John C. Farr, merchant. Silversmith Directory, s.v. "George G. Dowell," http://sterlingflatwarefashions.com (accessed May 20, 2015); Philadelphia directory 1843, p. 74; 1846, pp. 92, 108; 1847, pp. 90, 106. Dowell was not listed as a "manufacturer" in primary sources consulted. George G. Dowell was a member of the First Universalist Church; Burial Records, First Universalist Church, Historic Pennsylvania Church and Town Records, Philadelphia, HSP, Ancestry.com. He was a "past Grand, of Olive Branch Lodge, No. 115 of the Odd Fellows . . . he died on the 18th of September, on board of the steamboat J Q Adams, on the passage from St. Louis to Cincinnati. His remains were brought on under the superintendent of the Olive Branch Encampment and the above lodge. The funeral was numerously attended by the order." "Odd Fellows Funeral," Local Affairs, *Public Ledger*, October 16, 1848.

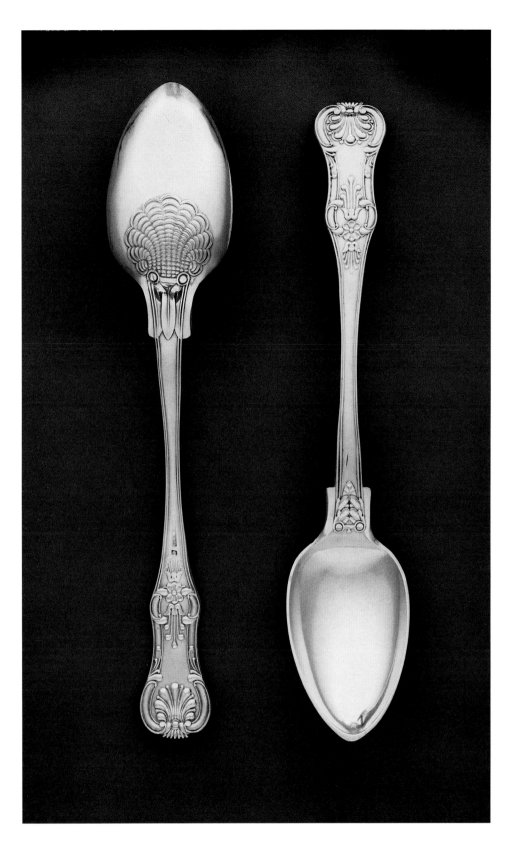

John Black

Philadelphia, born 1787
Philadelphia, died 1819

The search for biographical details about John Black (fig. 45), a Philadelphia silversmith who has often been confused with James Black (active c. 1796–1821), a jeweler, began with the will of a Mary Vallance, widow of Captain Nicholas Vallance. She was a resident in an unknown capacity in the household of the silversmith John McMullin (q.v.) when she wrote her will on October 1, 1810.[1] The witnesses to it were Samuel Hildeburn (q.v.) and a John Black. It was probated in Philadelphia on October 27, 1825, with the following note: "John Black one of the subscribing witnesses to the above Will of Mary Vallance, being deceased, whereupon John McMullin silver-smith and jeweler then personally appeared and on his solemn affirmation did declare and say that he was well acquainted with the said John Black in his lifetime and is well acquainted with his handwriting having frequently seen him write his name as well as other matters that he has viewed the signature 'JOHN BLACK,' subscribed to the Will and that he verily believes the signature to be of the proper handwriting of the aforesaid John Black." Letters of administration were granted to James McMullin (son of John), the sole executor. John Black was not listed at any address before 1810, although he was probably nearby, if not residing with, McMullin in order to have witnessed Mary Vallance's will. The McMullins, the Vallances, and the Blacks were all Presbyterians, surely a tie if not the only reason they became associated.

In 1798 and thereafter until 1810, John McMullin was listed at 120 South Front Street. John Black is recorded as having had a household of four in 1810.[2] In 1811 John McMullin was listed at 114 South Front, and John Black, "silversmith," appears in the city directory for the first time at McMullin's old location, 120 South Front, where he lived and worked throughout his short career.[3] This was an area in the Dock Ward populated by silversmiths with large families and shops. From 1803 to 1810 Liberty Browne (q.v.) was at 70 South Front Street, and by 1811 Samuel Richards (q.v.) was at number 136. The U.S. census of 1810 lists John McMullin with a household of fourteen; Joseph Lownes (q.v.) at number 130 with a household of eleven; and Samuel Williamson (q.v.) at number 118, where he resided from 1809 to 1813, with a household of twenty by 1811.[4]

There surely were working associations among these neighbors. John Black may have worked as an apprentice or journeyman with McMullin or Liberty Browne until the latter moved in 1810.[5] After his partnership with Liberty Browne ended in 1811, William Seal (q.v.) was not separately listed in the Philadelphia city directory for several years, but the 1810 census placed his household of eight in Blockley, and in 1817 he was at 118 South Front Street, where Williamson had been located, at premises between the shops of Black and McMullin.[6] A small teaspoon with sharp spurs, usually a feature that may be dated between 1815 and 1820, bears Black's mark and another bears a small eagle head in an octagon—a distinctive mark found on silver by William Seal—suggesting early on that the "I•BLACK" mark belonged to John.[7] Other silver with John Black's mark also carried the stamp of various silversmiths acting as retailers, including George Armitage (q.v.) and Thomas Harper (active 1813–17). A tablespoon in the Museum's collection (1996-8-8) has a subtly different "I•BLACK" mark overstriking the mark of Robert Wilson (q.v.); the pellet is higher, and the "L" and "A" have exaggerated serifs.[8]

The partnership of John McMullin and John Black was published in the city directory of 1813 and was listed as being at 120 South Front Street.[9] After John Black's death in September 1819, John McMullin may have sold that property. McMullin remained at 114 South Front Street through 1837.[10]

The partnership mark of McMullin and Black had its own distinctive die, consisting of a rectangle enclosing both names and an ampersand. The letters are all Roman, as are those in Black's own mark; in McMullin's own mark the letters are in script. Extant silver bearing the partnership mark is quite rare. The grand tankard commissioned and made for Aaron Levy in 1813 is notable (Rosenbach Museum and Library, Philadelphia). It is an unusual design, very tall, straight sided, with two units of encircling molded bands, a long handle, and a rather small acorn finial. A partial tea service with the full mark and engraved initials "HP" is in the style popular in Philadelphia from 1810 until 1820, having rectangular rather than round bodies with multiple undulating surfaces and straplike handles.[11] It is similar to McMullin's work. The matching tongs bear only Black's mark.

While the partnership continued, both silversmiths also worked individually. The variety of styles that John Black employed suggests that he was a competent silversmith and worked with and for several shops. Some of his silver shows an uncanny similarity to silver by Liberty Browne, suggesting an apprenticeship or full journeyman status in that shop. Two tea services, one of three pieces and another of four, have the same full, curved bodies in a rectangular shape on rectangular pedestals with round ball feet. A wide band in the Greek-key pattern is inset at the top of the bodies exactly like the set made by Browne in the collection of the Philadelphia Museum of Art (cat. 101).[12] The lids rise in two tiers, one set has an acorn finial, and the other has a cast bud-shape finial like those on the Museum's set. The spouts are curved but flat sided, the handles to match. One was made for Abigail Cary (1777–1809), who married Thomas Redman (1773–1820) at the First Church of Boston on February 12, 1797.[13] The slop bowl (cat. 77) in the round, fluted shape is in an earlier style similar to the silver made by Black's neighbors Samuel Richards and Samuel Williamson. Black made an elaborate six-piece tea and coffee service that featured cast lion finials, claw and ball feet, and handles in a linear design, with burners under two of the pots, for Aaron Burr (1756–1836), who was in Philadelphia from 1801 until 1805, serving as vice president under Thomas Jefferson.[14] The tea caddy (cat. 78) by John Black offers the most obvious evidence of a workshop exchange: the grinning lion masks seem to have been cast from the same mold as those on a monumental urn by McMullin.[15]

Little is known about Black's family life. South Front Street on the Delaware, near shipping, was an area subject to devastating, seasonal epidemics of yellow fever. The records of the Third and Fourth Presbyterian churches suggest

Fig. 45. Watchpaper of John Black, undated. Courtesy of the Winterthur Library, Delaware. Joseph Downs Collection of Manuscripts and Printed Ephemera, Scrapbook, doc. 499

that John Black and other members of the family succumbed to it in 1819: Dorcas Black (age thirty-one, February 3), John Black (thirty-two, September 8), Isabella Black (eight months, September 1), Jane Black (nineteen months, September 18), and Mary Ann Black (twenty-two, September 22).[16]

Black's heirs seem to have continued their association with the McMullins through two further generations, although not in the silver business. His son John Black, who may have moved back in with the McMullins, later partnered with John S. McMullin in the grocery and chocolate business.[17] He died in 1847 without a will. John's wife, Charlotte C. Black, Margaret M. Gouge, and Adeliza M. McMullin renounced their right to the administration of his estate, to which Joseph Black (of 176 Coates Street) was appointed administrator.[18] The bond was set at $4,000, cash on hand and the amount of his mortgage, on September 13, 1847. An appraisal was accomplished on October 16, 1847, by John Robinson (tinsmith at Northwest St. John and Poplar streets), George Billger (237 North Third), and Henry Robinson (morocco finisher at St. John above Poplar). The total value of possessions was $432.50. On May 6, 1848, Joseph M. Black presented his accounting, which included a "note from Mr. McMullin for $400." Among the claims were $47.31 for Charlotte Black and $8 for carriage hire for "Mr. and Mrs. McMullin."[19] BBG

1. Will of Mary Vallance, October 1, 1810, Philadelphia Will Book 8, no. 122, p. 480. Mary Williamson married a Nicholas Vallance at the First Presbyterian Church on November 9, 1766. Their son Nicholas married Mary Evans at the Third Presbyterian Church, October 16, 1785. *Pennsylvania Archives*, 2nd ser. (1896), vol. 9, pp. 102, 548. The will quoted here probably belonged to Mary Evans Vallance. She left to James McMullin "my chiming clock and one half part of my cash" and "to Mary McMullin, sister of James, my chest of drawers."

2. 1810 U.S. Census. Dock Ward included three city blocks from Front to Fourth streets and between Chestnut and Walnut.

3. McMullin and Black, silversmiths, are listed at 120 South Front Street in the Philadelphia directory of 1813 (n.p.). John Black is listed at the same address in the Philadelphia directories of 1811, 1813, 1817, 1818, and 1819.

4. For Liberty Browne, see Philadelphia directory 1803, p. 38; 1804, p. 38; 1805, p. 39; 1806, p. 57; 1807, p. 63, 1809, p. 53; 1810, p. 48. For Samuel Richards, see Philadelphia directory 1811, p. 268. For John McMullen and Joseph Lownes, see 1810 U.S. Census. For Joseph Lownes, see Philadelphia directory 1810, p. 175. For Samuel Williamson, see Philadelphia directory 1809, p. 315; 1810, p. 306; 1811, p. 352; 1813, p. 456.

5. Philadelphia directory 1810, p. 185.

6. Ibid. 1817, p. 386. Williamson was there previously.

7. DAPC 78.3100. Both Belden (1980, p. 62) and Hollan (2013, p. 20) attribute this mark to the jeweler James Black, who had a long jewelry account with Charles Bird; Charles Bird Papers, McA MSS 010, Series II, Financial Documents, Library Company of Philadelphia. Samuel Williamson's ledger book for 1808–9 is precise in showing James Black to have been purchasing silver tumblers, teapots, hoop tumblers, teaspoons, and so forth from Williamson, and paying with old silver and/or cash; Samuel Williamson, Ledger Book, p. 136, Chester County Historical Society, West Chester, PA.

8. Hollan (2013, pp. 20–21), attributes this mark to the jeweler James Black, but it is so similar to John Black's other mark that it seems likely to have been his. See also the spoon with "I·BLACK" and "TH" (Thomas Harper) in a rectangle (DAPC 70.3424); and the tea caddy (cat. 78) with "I·BLACK" and a "G·A" mark confirmed, in conversation with Donald Fennimore in 2014, as belonging to George Armitage. There may have been a familial relationship between the Blacks and the Armitages. A Dr. Samuel Henry Black (1782–1827) married Dorcas Armitage Middleton (1789–after 1860) in 1807 in New Castle County, Delaware. They were Presbyterians. Historic Glasgow Park, Ancestry.com.

9. Philadelphia directory 1813, p. 275. The dates cited are from Philadelphia directory entries and are probably accurate within a year, depending upon the month the surveys were taken. A formal statement of the dissolution of the silver partnership has not yet entered the record. It naturally ceased when John Black died. However, it may have been carried on by the same families in the grocery business (see note 17 below).

10. Philadelphia directory, 1819–37.

11. See Gebelein Silversmiths, Boston, advertisement, *Antiques*, vol. 86, no. 3 (September 1964), p. 243; John McMullin (q.v.) made other examples.

12. See also another set with the same design features, attributed to "Black Philadelphia" and probably made by John Black; Walter H. Willson, advertisement, *Antiques*, vol. 18, no. 5 (November 1930), p. 441.

13. Documents of the City of Boston, vol. 4, Marriages, no. 101, p. 148. See curatorial files, AA, PMA, for photographs of the three-piece set (private collection) inscribed to Abigail Cary Redman, from the New England branch of the Philadelphia Redman family.

14. DAPC 68.3949.

15. Wees and Harvey 2013, cat. 88.

16. Dorcas, who died in February, was buried in the Blockley Cemetery; the others were buried at the Third and Fourth Presbyterian churches; Philadelphia Death Certificates Index, 1803–1915, Ancestry.com.

17. "Dissolution—The partnership heretofore existing between the subscribers under the firm of McMullin, Black & Co. is this day dissolved by mutual consent. The business of the late firm will be settled by either of the subscribers. John McMullin,

Samuel Pulny. NOTICE:—The subscriber will continue the business of manufacturing Chocolate, Mustard, Ginger, and Spices of all kinds, as heretofore, at the old stand No 64 1/2 North Front Street. John S. McMullin." *Public Ledger* (Philadelphia), September 13, 1839.

18. In the 1847 Philadelphia directory (p. 27), Joseph Black was listed as "dealer" at 84 Swanson Street.

19. Philadelphia Administration Book P, no. 275. John Black was buried at the Third Presbyterian Church; Records of Old Pine St. Church, Philadelphia; Philadelphia Death Certificates Index, 1803–1915.

Cat. 77
John Black
Slop Bowl

1800–1810
MARK: I·BLACK (in rectangle, on front and back edges of pedestal; cat. 78–1)
INSCRIPTION: T S B (engraved script in bright-cut shield, on one side)
Height 5⅝ inches (14.3 cm), diam. 6⅜ inches (16.2 cm)
Weight 14 oz. 19 dwt. 20 gr.
Gift of the McNeil Americana Collection, 2005-69-58

This is a fine, heavy, footed bowl, articulated with encircling bands of bead. The engraved loop of ribbon ends abruptly at the top molding, but the bowl does not seem to have been cut down. In style this bowl resembles silver being made by the partnership of Richards & Williamson (q.v.), located near John Black on South Front Street. BBG

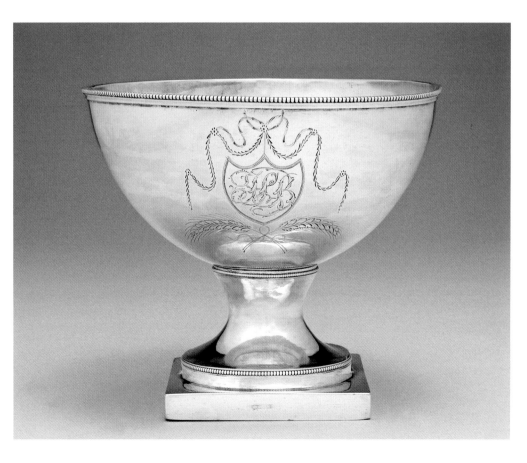

Cat. 78

John Black
Tea Caddy

1810–15
Retailed by George Armitage (q.v.)
MARK: [Winged eagle with shield holding arrows and olive branch] (in conforming cartouche); I·BLACK (in rectangle); G·A (in rectangle; all on underside; cat. 78-1)
INSCRIPTION: J G K (engraved script, on one side)
Height 6¼ inches (15.9 cm), width 6½ inches (16.5 cm), depth 3¾ inches (9.5 cm)
Weight 21 oz. 9 dwt. 19 gr.
Gift of Charlene Sussel, 2006-94-1a,b

PROVENANCE: Sotheby Parke Bernet, New York, *Important American Silver*, October 17, 1972, sale 3416, lot 48 (illus.); subsequently in the stock of the Philadelphia antiques dealer Eugene Sussel (1913–1989), the donor's husband.

The marks on this tea caddy are pristine, with an eagle stamp that has been identified as belonging to George Armitage (see cat. 24). This is a somewhat eclectic design, probably later than another caddy made by John Black in a pumpkin-shaped fluted body embellished with fine engraving.[1] The flutes divide the oval shape of this body into concave panels, giving the design an architectural character. Decoration is limited to the handles and the finial. Smiling lion's masks are applied just below the ring handles, which are hinged to the top edge of the box. It is the same cast lion's mask that John McMullin (q.v.) used on the grand tea urn presented in 1799 to Dr. Philip Syng Physick for his service in the 1798 epidemic of yellow fever.[2] There is hammering evident on the inside of the body and on the underside of the lid. The bottom is set in and soldered.

The initials "JGK" probably belonged to Jacob Gerard Koch (1761–1830) and/or his second wife, Jane Griffith Koch (1772–1848), whom he married in Philadelphia in 1801.[3] In the same year he purchased a country place, "Fountain Green" at the Falls of Schuylkill.

Jacob Koch came to Philadelphia about 1778, and by 1796 he was an extremely successful merchant, importing German linens at his store at the corner of Lombard Alley and Little Water Street.[4] He played a prominent, patriotic role during the War of 1812, offering $5,000 to build a ship to defend commerce; and in February 1815 during celebration of the signing of peace with England, when Philadelphians installed elaborate decorations throughout the city, the Koch house on the northwest corner of Ninth and Market was noted for its splendor.[5] The corpulence and opulence of Jacob Gerard Koch is illustrated in his portrait painted by Rembrandt Peale from around 1817 (Los Angeles County Museum of Art, 1978.5.1). He and his wife lived in high style, and this small, somewhat eclectic caddy offers a hint about their worldly goods. The Kochs moved to Paris about 1820. BBG

1. Sotheby's, New York, *The Collection of Mr. and Mrs. Walter M. Jeffords*, October 28–29, 2004, sale 8016, vol. 3, no. 624. The band of engraving is very like the designs found on sugar bowls by John Aitken, James Musgrave, and Christian Wiltberger (q.q.v.). The engraved arms, three annulets or, may have belonged to a member of the Philadelphia Barton family.
2. Wees and Harvey 2013, cat. 88.
3. John Black also marked a spoon with the engraved initials "SPK" that is attributed to James Black in Belden 1980, p. 62.
4. "Biographical Note," Koch-Messchert Family Papers, 1784–1914, University of Delaware, Special Collections, www.lib.udel.edu/ud/spec/findaids/koch.htm.
5. Scharf and Westcott 1884, vol. 1, pp. 554, 579.

Cat. 78-1

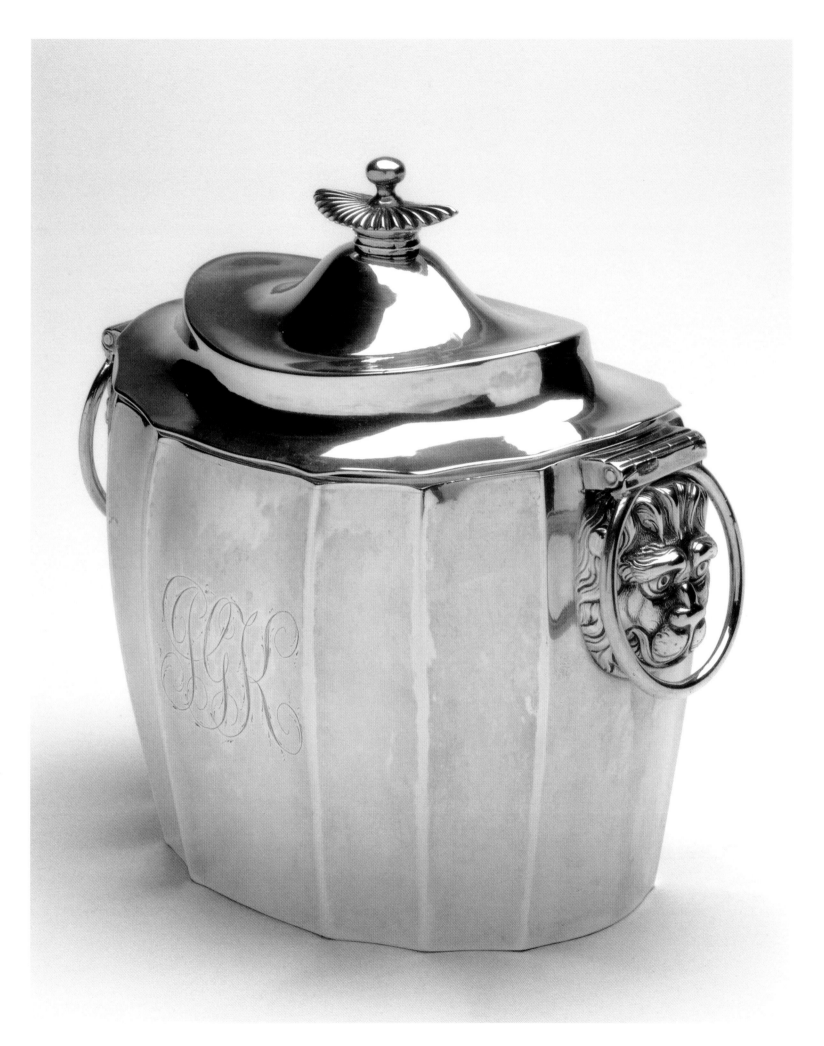

R. Blackinton & Co.

North Attleboro, Massachusetts,
1861–1966

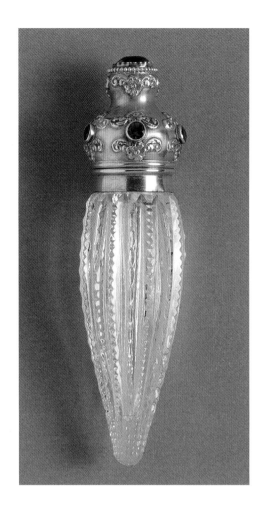

Roswell Sweet Blackinton (1831–1906) founded R. Blackinton & Co. with Walter Ballou (born 1835) and T. S. Mann (1830–1882) in 1861 in North Attleboro, Massachusetts.[1] A trade card notes "Established 1861" and illustrates the trademark—a capital letter "B" with a sword and arrow, in a rectangle with canted corners—and indicates the location of the factory in North Attleboro.[2] The company was successful as a family enterprise. In the 1890s R. Blackinton & Co. employed traveling salesmen; J. T. Metcalf was one who traveled to Cincinnati, Indianapolis, and cities in the Midwest to expand the business.[3] The firm specialized in high-quality leather, hollowware, and small sterling accessories, especially dresser sets. After the Depression in 1929 the company specialized in gold and silver work as well as repairs for retailers.[4]

R. Blackinton & Co. continued in operation until 1966, when it was sold by the Blackinton family to Wells Inc., also of North Attleboro.[5] The New England Sterling Company's promotion at one time suggested that it continued the tradition of R. Blackinton & Co. Ross Blackinton, great-great-grandson of the founder, who had apprenticed in the company in 1962, went out on his own and established the New England Sterling Co.[6] BBG

1. Rainwater and Redfield 1998, p. 49; *Representative Men and Old Families of Southeastern Massachusetts* (Chicago: J. H. Beers, 1912), vol. 1, pp. 456–57. The partners' life dates are found at American Silversmiths, s.vv. "Roswell Sweet Blackinton," "Walter Ballou," and "Thomas Stanley Mann," http://freepages.genealogy.rootsweb.ancestry.com (accessed April 17, 2017).

2. Illus. at Silversmith Directory, s.v. "R. Blackinton Co.," www.sterlingflatwarefashions.com (accessed June 3, 2015).

3. *Jewelers' Circular*, vol. 34 (April 7, 1897), p. 28.

4. New England Copperworks, necopperworks.com (accessed May 16, 2016).

5. American Silver Marks, www.925-1000.com/americansilver (accessed May 16, 2016).

6. New England Copperworks, necopperworks.com (accessed May 16, 2016).

Cat. 79
R. Blackinton & Co.
Cologne Bottle

1885–1910
Silver-gilt; cut colorless lead glass; blue glass "jewels"
MARKS: STERLING B (crossed horizontally with sword; cat. 82-1); 8185 (all incuse, on collar)
Height 4³⁄₁₆ inches (10.6 cm), diam. 1⅛ inches (2.9 cm)
Gift of Beverly A. Wilson, 2010-206-59

Cologne bottles, also called perfume, scent, or smelling bottles, were carried or worn by women in the event that they encountered unpleasant odors. The form existed in the Renaissance and even earlier but reached its peak during the late nineteenth century, when even the smallest personal accessory could be transformed into an opulent statement of its owner's wealth. Elite retailers such as Tiffany & Co. (q.v.) offered this form in a dazzling variety of styles and sumptuous materials, with bottles made of rock crystal or lapis lazuli, mounted in gold and platinum and ornamented with enamel, diamonds, and other precious stones. At the turn of the twentieth century, Louis Comfort Tiffany and Paulding

Farnham collaborated on designs for spectacular gold-mounted favrile glass and rock-crystal cologne bottles shown at international expositions.[1]

Alternatives to such productions were made for the middle-class market; some, such as an example made by the Gorham Manufacturing Company (PMA 2015-120-1), were simple glass bottles with small silver caps; others were all silver, inexpensively formed by die stamping (1991-52-5a,b). Blackinton's cologne bottle used less costly materials but consciously imitated the style of some high-end models. Its tapered, vaguely organic shape and gilded silver mounts set with glass "jewels" resembles several lavish productions by Tiffany & Co., and cologne bottles of very similar design are also recorded in the Whiting Manufacturing Company (q.v.) ledger in 1884.[2] DLB

1. Clare Phillips, ed., *Bejeweled by Tiffany, 1837–1987* (New Haven, CT: Yale University Press, 2006), cats. 21, 30, 62–65, 98–99; John Loring, *Paulding Farnham: Tiffany's Lost Genius* (New York: Abrams, 2000), p. 127.
2. Ledger "Numbers / A / W. Mfg. Co.," 1883(?)–1924, n.p., design nos. 1254, 1292; Section XII, Acquired Companies, Whiting C. 2, The Gorham Manufacturing Company Archives, John Hay Library, Brown University, Providence, RI.

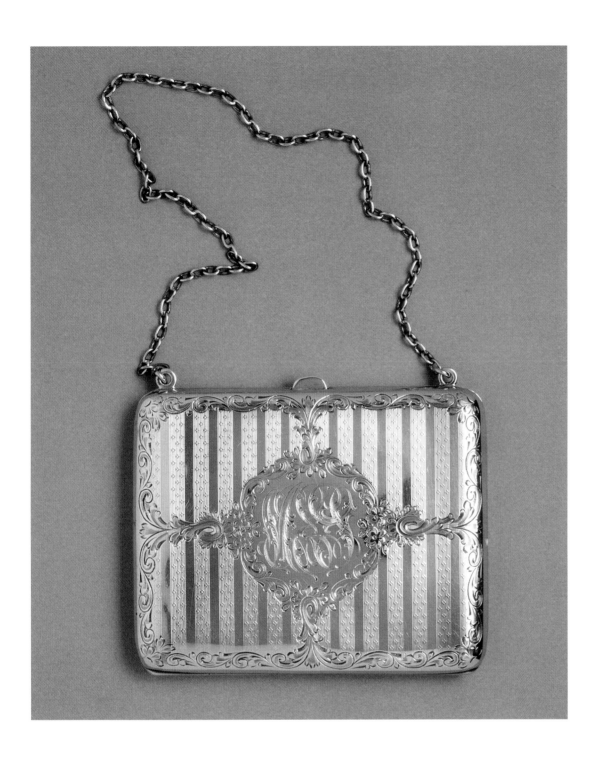

Cat. 80

R. Blackinton & Co.

Purse

1900–1920

MARKS: STERLING B (crossed horizontally with sword, cat. 82-1); 1508 (all incuse, on inside edge); 571/41 (scratched, on inside edge)

INSCRIPTION: M E S (engraved script in chased floral cartouche, on one side)

Height 3¼ inches (8.3 cm), width 4 inches (10.2 cm), depth ⅜ inch (1 cm)

Gross weight 4 oz. 6 dwt. 5 gr.

Gift of Barbara Sweeney, 1965-165-7

PROVENANCE: By inheritance in the family of the donor.

The surface of this purse, with carrying chain, is machine engraved with a design of fine wavy stripes alternating with plain surfaces. The two sides close with a snap clasp. The inside is lined with pink moiré taffeta and is divided into four compartments with narrow silver bands across their tops. The smallest compartment in the center has its own clasp and was fitted for calling cards. BBG

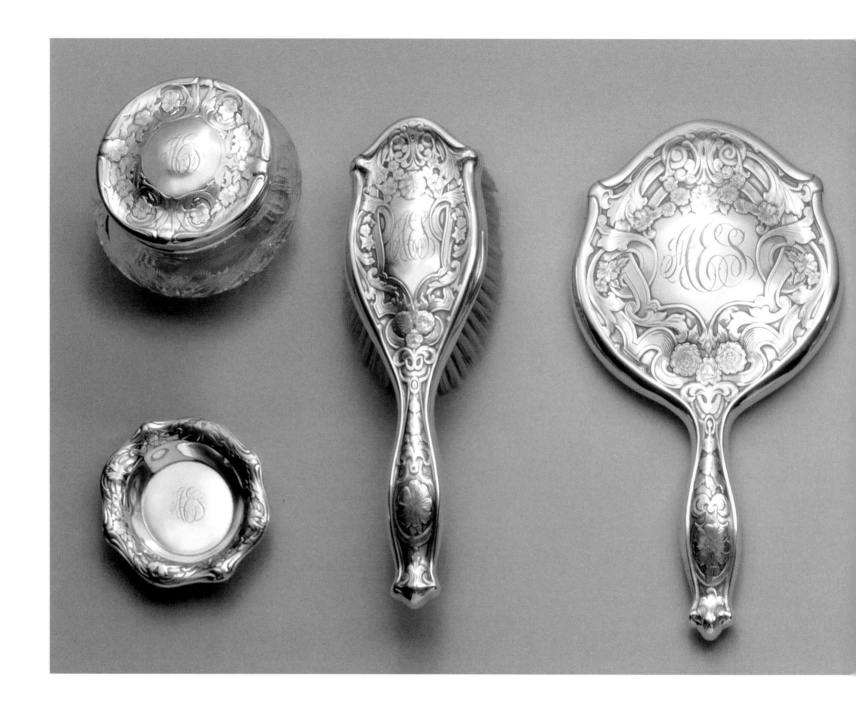

Cat. 81

R. Blackinton & Co.
Dressing-Table Set

1900–1917

MARKS: (2001-99-1-4, 6,7,10) STERLING B (crossed horizontally with sword, cat. 82-1; all incuse); (2001-99-5a,b, 8, 9) STERLING R (in square with chamfered corners); B (crossed horizontally with sword, in rectangle with chamfered corners); C° (in rectangle with chamfered corners, cat. 81-1; all incuse); (2001-99-1) 1898 (incuse); (2001-99-2) 2028 (incuse); (2001-99-5a,b) 1908 (incuse, cat. 81-1); (2001-99-6) 1900 (incuse); (2001-99-7) 1902 (incuse); (2001-99-8) 1901 (incuse); (2001-99-9) 1897 (incuse)

INSCRIPTION (on each): A E S (engraved script; cat. 81-2)

Hand Mirror: Length 10¼ inches (26 cm), width 5⅞ inches (14.9 cm)

Clothes Brushes: (2001-99-7) Length 7⅜ inches (18.7 cm), width 2¼ inches (5.7 cm). (2001-99-8) length 5½ inches (14 cm), width 1⅞ inches (4.8 cm)

Hairbrush: Length 9½ inches (24.1 cm), width 3³⁄₁₆ inches (8.1 cm)

Comb: Length 9 inches (22.9 cm), width 2¼ inches (5.7 cm)

Cotton–Ball Jar: Height 2⅝ inches (6.7 cm), diam. 4⅜ inches (11.1 cm), diam. rim 3¾ inches (9.5 cm) Weight (cover) 1 oz. 12 dwt.

Buttonhook: Length 7¾ inches (19.7 cm), width handle ⅞ inches (2.3 cm)

Nail File: Length 7⅛ inches (18.1 cm), width handle ⅞ inches (2.3 cm)

Shoehorn: Length 8¼ inches (21 cm), width ⅞ inches (2.3 cm)

Pin Tray: Height ½ inch (1.3 cm), width 3¼ inches (8.3 cm), diam. base 1¾ inches (4.4 cm) Weight 18 dwt. 10 gr.

Gift of Douglas P. and Jeanne S. Chaloult in memory of Lewis and Anna Segrest, 2001-99-1–10

PROVENANCE: The initials engraved identify Anna E. Sommer (1893–1987), who married Lewis F. Segrest Jr. (1892–1957) in Philadelphia at the Catholic Church of the Most Precious Blood, Twenty–Eighth and Diamond streets, on June 16, 1917.[1] This silver was inherited by her daughter, Jeanne S. Chaloult, the donor.

Cat. 81-1

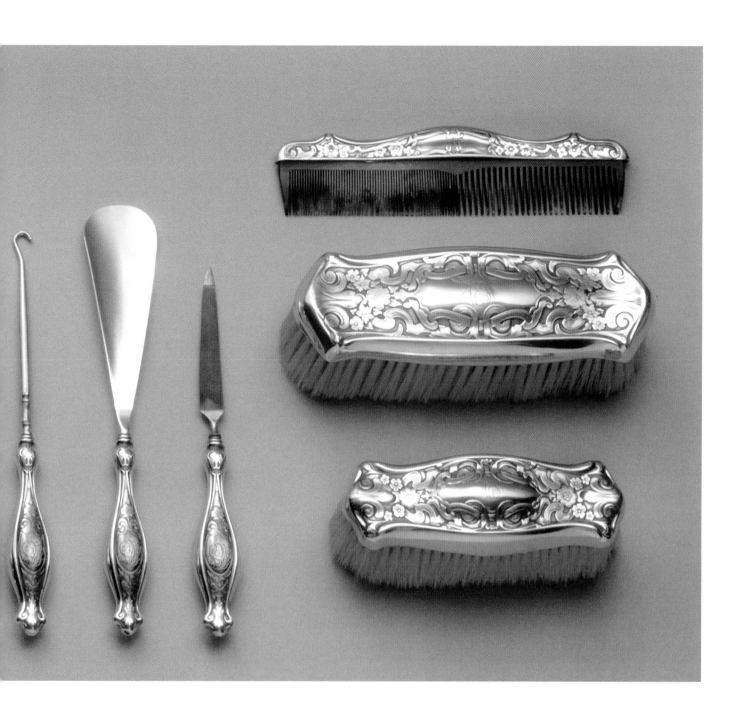

This is one of the elaborate and complete dress-ing-table sets for which R. Blackinton & Co. was known. The frames of the hand mirror, hairbrush, and clothes brushes, and the lids of the boxes, are acid etched in bands of scrolls enclosing foliage and flower designs that frame the plain reserves where the script initials are engraved. The bowl for the cot-ton balls is made of cut glass in an alternating pat-tern of three flower forms and diamond shapes. The bristles of the brushes are set into ivory sockets. The comb is tortoiseshell. The buttonhook, nail file, and shoehorn have steel fittings. Each object is engraved with foliate initials and has a four-digit number that identifies the form. BBG

Cat. 81-2

1. *Philadelphia Evening Bulletin*, June 16, 1917; *Public Led-ger* (Philadelphia), June 17, 1917. Information from the donor suggested that the set was purchased from Franz Zirnkilton (q.v.), a silversmith in Philadelphia who was a friend of the bride's father; for objects by Zirnkilton in the Museum's col-lection, see 1969-283-1–5 and 2002-125-1–3.

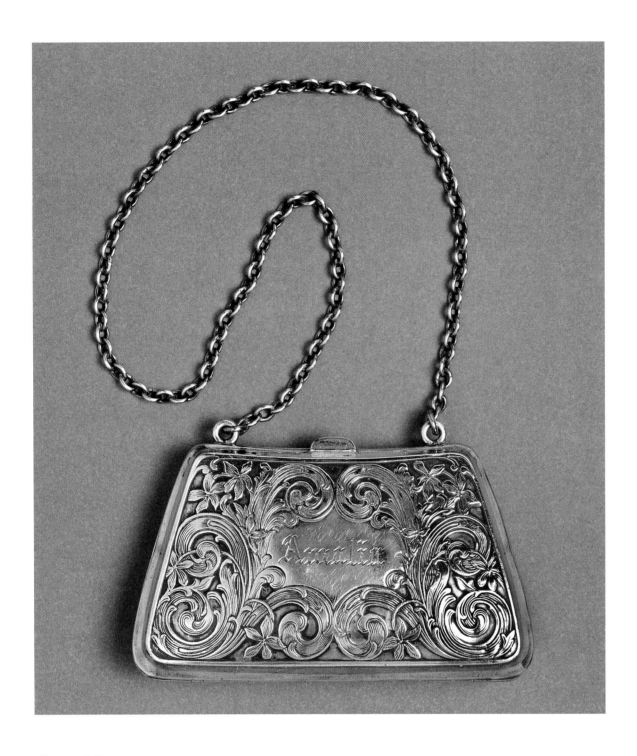

Cat. 82

R. Blackinton & Co.

Purse

1920–25
MARKS: STERLING B (crossed horizontally with sword; cat. 82-1); 2478 (all incuse, on inside at top of frame)
INSCRIPTION: Amalia (engraved gothic script in reserve, on one side)
Height 2 inches (5.1 cm), width top 3⅜ inches (8.6 cm), width bottom 7 inches (17.8 cm), depth ¹³⁄₁₆ inch (2.1 cm)
Gross weight 2 oz. 7 dwt.
Gift of Mrs. Edwin H. Weil, 1958-65-13

This small silver reticule, purse, or card carrier has a cardboard inner lining fitted with green silk. It snaps shut and opens into three compartments. BBG

Cat. 82-1

Henricus Boelen

New York City, baptized 1697
New York City, 1755

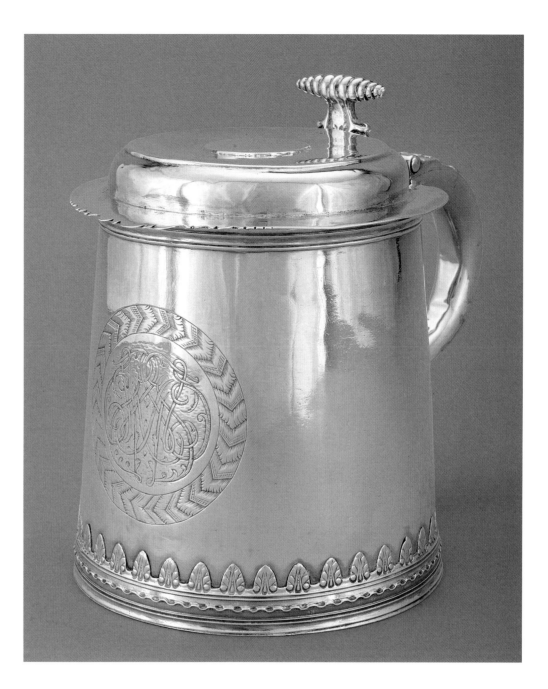

enricus Boelen was the youngest of eight children of the silversmith Jacob Boelen I (1657–1729 or 1730) and Catherina Klock Boelen, who came to New York before 1660.[1] He was baptized May 5, 1697, in New York. Henricus probably apprenticed with his father Jacob. On June 19, 1718, he married Jannetje Waldron (1698–1776) at the Dutch Reformed Church in New York.[2] She was a member of the church, which he joined in 1725. When the Moravians formed a congregation in New York in 1741, there were several silversmiths among their number, and Jannetje Boelen became an active member.[3] Henricus Boelen joined the Moravians just before he died and was buried in the Moravian cemetery.

Boelen was not active in New York's civic life. He inherited a house and lot close to Hanover Square on the waterfront from his father in 1729.[4] His son Jacob II (1733–1786) apprenticed with him and became a silversmith. BBG

1. Avery 1930, p. 159; Waters, McKinsey, and Ward 2000, pp. 115–21.

2. Rootsweb.ancestry.com (accessed October 4, 2014).

3. Waters, McKinsey, and Ward 2000, p. 116. See also the biography of Simeon Coley (q.v.).

4. Deborah Waters, *Elegant Plate: Three Centuries of Precious Metals in New York City* (New York: Museum of the City of New York, 2000), vol. 1, pp. 115–21.

Cat. 83

Henricus Boelen
Tankard

1737–40

MARK: HB (conjoined letters in trilobed shield, struck on body on either side of handle, once on lid in front of thumb piece, once on underside; cat. 83-1)
INSCRIPTIONS: C V D (engraved script in reverse cipher, on front in circular reserve; cat. 83-2); W TD(?) (conjoined) / C·I (engraved script, worn, on handle below "W TD"; cat. 83-3). Silver coin inset in lid: (obverse) LVD. XIIII.D.G.FR.ET.NAV.REX (raised letters encircling portrait bust of bewigged king in profile, facing right); (reverse) I·NOMEN·DOMINI·BENEDICTUM· (raised letters encircling three crowns with fleur-de-lis between each crown); T (in center)
Height 7⅝ inches (19.4 cm), diam. 5⅞ inches (14.9 cm), width 9¼ inches (23.5 cm)
Weight 38 oz. 19 dwt.
On permanent deposit from The Dietrich American Foundation Collection to the Philadelphia Museum of Art, D-2007-33

Cat. 83-1

PROVENANCE: Anita O'Keefe Young; Robert R. Young Foundation; sale, Sotheby's, New York, *Important Americana*, January 30–February 1, 1986, sale 5429, lot 401.

EXHIBITED: *Brandywine River Museum Antique Show*, Chadds Ford, PA, May 23–25, 1992, p. 8, fig. 4; on long-term loan to the Huntington Library, Art Collections, and Botanical Gardens, San Marino, CA, 1986–present.

This tankard exhibits the distinctive characteristics of early New York tankards with the decorative features used by the Boelens, Jacob I and Henricus, and earlier by other New York silversmiths such as Jacobus van der Spiegel (q.v.) and Cornelius Kierstede (1675–1757). The tankard has straight, flared sides, a flat, stepped lid with a scalloped front edge, and a coin

Cat. 83-2

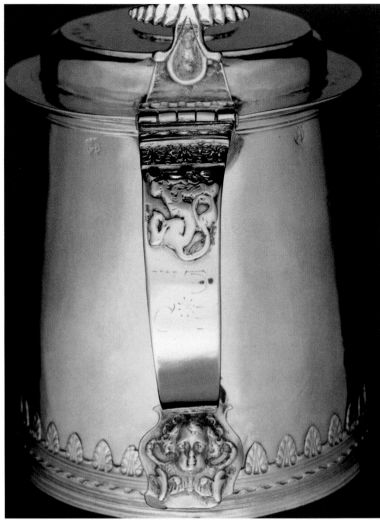

Cat. 83-3

inserted in the center. Encircling the base are two molded bands with a line of wriggle work between them. The cut-card band in a leaf design is prim and precise. The cast hinge is ornamented with the same wriggle work and leaf pattern. The lion couchant in relief applied to the handle below the hinge attachment has lost its crisp outline (cat. 83-3), as has the cupid head on the tailpiece; Jacob Boelen I used similar designs on a tankard of about 1690–1710.[1] On the reverse of the coin inserted in the lid is the Roman letter "T," which was the mark of Nantes, France, before 1775.[2]

The engraved initials in the cipher together with those on the handle offered a special challenge. The initials "CVD" are engraved in a handsome double-reverse cipher form, with each "V" also forming the single, large, centered "W," suggesting that it represented a surname.[3]

The initials may have belonged to Catherine van Dorn Wyckoff (born 1707) of Freehold, Monmouth County, New Jersey. She was the seventh child of Jacob van Dorn (c. 1668–1720) and Maria Adriaanse Bennet (c. 1672–1735), who married about 1690–92 and were early residents of Brooklyn, New York. By 1705 the family had moved to Freehold, where Jacob van Dorn was well-known as a wealthy farmer and

mill owner.[4] They had ten children. His inventory listed ownership of "Plat," valued at £4.[5] His will written in 1719 and probated in 1720 directed that either after the death of his wife, or when his two eldest sons, Adrian and Jacob, reached their majority they would inherit the farm and mills. He further specified that both sons, after succeeding to their shares, were responsible for the administration of the cash inheritances of £75 each to their eight siblings until they reached responsible ages.[6] In November 1737 Catherine signed a receipt for her £75 with interest, as received from her brother Jacob II.[7] She had married Cornelius Wyckoff (1711–1793), son of John Wyckoff (died 1746) of Middlebush, Somerset County, New Jersey. The ciphered initials "CVD," which can also be read with a large centered "W," offer the possibility that she purchased this tankard with her van Dorn inheritance and acknowledged her married estate with the "W." Weighing thirty-eight ounces, the tankard is larger than most known to date, which are closer to twenty-eight ounces.

The plain, engraved initials on the handle below the lion ornament presumably represent descendants who inherited. The suggested initials "WTD" are worn and not perfectly complete. The initials "C·I" are in a different hand. Cornelius and Catherine

had at least one child, Abraham, whose daughter was also named Catherine (born c. 1770).[8] BBG

1. Waters, McKinsey, and Ward 2000, vol. 2, illus. p. 68.
2. In the French silversmith trade during the reign of Louis XIV, a capital letter at the center of the reverse of a coin identified an atelier and mint in the town at the center of the administrative jurisdiction in which an object was made; the mark indicated that the silver standard in the piece was equal to that used in Paris. Wilfred J. Cripps, *Old French Plate: Its Makers and Marks*, 2nd ed. (London: J. Murray, 1893), pp. 54–56.
3. After testing many combinations presented by the initials "VD" in the vast resources of the internet, one family survived the tests, offering a possibility for identification with this tankard.
4. A. Van Doren Honeyman, *The Van Doorn Family (Van Doorn, Van Dorn, Van Doren, etc.) in Holland and America, 1088–1908* (Plainfield, NJ: Honeyman's, 1909), vol. 2, pp. 53–59.
5. Ibid., p. 55; *plat* meaning "plate," i.e., silver.
6. George Crawford Beekman, *Early Dutch Settlers of Monmouth County, New Jersey* (Freehold, NJ: Moreau, 1901), p. 43.
7. Honeyman, *Van Doorn Family*, p. 77.
8. Francis Bazley Lee, ed., *Genealogical and Personal Memorial of Mercer County, New Jersey* (New York: Lewis Publishing, 1907), vol. 2, p. 469.

Jeremiah Boone

Philadelphia, born 1765
Philadelphia, died 1833

Jeremiah Boone was a jeweler and hair-worker. Silver bearing his mark is rare; he was primarily a retailer and plied his silversmith skills for a relatively short time, selling out in 1796 when he turned to mercantile trading by land and sea. Jeremiah's father, William, died when the boy was five years old. His uncle Jeremiah (1729–1787), noted as "the elder" in family records, was a prosperous Quaker merchant in Philadelphia who died unmarried and seems to have taken an interest in his nephew. The younger Jeremiah may have boarded with him during an apprenticeship, and his uncle left him generous bequests at his death in 1787.[1]

It was probably because of his uncle's tutelage and support that Jeremiah Boone had a relatively short career as a jeweler and silversmith. Retailing became an important focus of his business, and in 1796 he turned to general merchandise. In spite of the obvious advantages of family support that Boone enjoyed, he was subject to shifts in the import and export markets that followed the Revolutionary War, shifts that were closely followed by the uncertainties of commerce leading up to the War of 1812. He and his peers combined general retail sales of imports with the manufacture of silver wares. When Boone was in serious financial difficulty, there was general empathy for his losses, and his creditors showed considerable restraint in collecting their debts. He seems to have been a well-liked and responsible person during and after becoming indebted. The term "insolvent" was not applied to him. Because he had retained some of the property acquired by his forebears, which would serve as final security for his creditors, he did not suffer bankruptcy as did others such as Samuel Alexander (q.v.).[2]

George Boone III (1666–1744), the silversmith's great-grandfather, and his wife, Mary Maugridge Boone (born 1669), who married in Devonshire, England, emigrated to Pennsylvania in 1717. They settled north of Philadelphia, in the vicinity of Exeter Township, Berks County.[3] The family was predominantly Quaker, although its records reveal many family members who chafed under the Friends' restrictions and "married out," joined the Baptist Church, or moved away to Virginia, Kentucky, and Maryland.[4]

George Boone IV (died 1753), the silversmith's grandfather, owned large properties in Berks County, including mills and waterworks.[5] In his will he left to his oldest surviving son, William Boone (1724–1769), the silversmith's father, "all that part of my lands and livings lying and being on the south side of the Tullpahocen [Tulpehocken] wagon road belonging to and appertaining to the old plantation in Exeter and also one half part of all the mills and waterworks . . . to son Hezekiah all of said old plantation lying and being on the North side of said wagon road and the other half part of all the mills and water works . . . to beloved son Jeremiah [the silversmith's uncle], all that plantation and land called Andrew Sanduskies situate in Amity Township."[6]

William was a prominent member of his community, holding the offices of coroner and sheriff.[7] He married Sarah Lincoln (1727–1810) at the Quaker Meeting in Exeter Township on May 26, 1748. They had seven children; Jeremiah was the youngest. He was two years old in 1767 when William, Sarah, and other members of their extended family, vexed by the doctrines of the strict Quakers in Berks, moved to Frederick County, Maryland. William died there in 1770. The eldest son, Mordecai, remained on the Maryland property until he died in 1774. Sarah and the other children returned to Berks County.[8] William's will, written in 1767 and probated on December 6, 1771, shows bequests in pounds. No land is listed except a bequest to his wife, who inherited their homestead in Berks County and £100. Other bequests were to his daughter Abigail, wife of Adin Pancoast, £70; his daughter Mary, £100 to be held in trust until she attained the age of twenty-one; Mordecai, £50; £10 to be divided among his five other sons; and £10 to the Exeter Meeting of Friends. In a note to his executors at the end of his will, William Boone directed that they "put the children's money to use until arriving at proper ages and the interest to my loving wife until they arrive to the age of fifteen years to defray the expense of their education and maintenance and that then my said sons be put to trades of their own liking until they arrive to the age of twenty-one years."[9]

At the age of sixteen Jeremiah left the family homestead and their farming community and set out for Philadelphia with a certificate of removal, dated July 24, 1781, from the Exeter Meeting of Friends at Maiden Creek in Berks County to the Philadelphia Meeting.[10] Had he begun to serve an apprenticeship before 1781 in the Reading area of Berks County, it is possible that he apprenticed with Richard Humphreys or Daniel Dupuy Sr. and Jr. (q.q.v.), who had moved their silver shops to Reading in 1776 or 1777, during the British occupation of the city. Humphreys did in fact advertise for two apprentices when he moved back to Philadelphia in 1781. If Jeremiah's apprenticeship began in 1781, it was brief, since he was listed in the city directory as a jeweler in 1785.

Jeremiah's uncle Jeremiah lived in Philadelphia and managed a prosperous mercantile trading business. In 1785 he was listed in the city directory as "Jeremiah Boone, merchant, at 90 South Wharves, home at 100 Spruce Street."[11] In his estate he was described as "Jeremiah Boone the elder, late of Oley, Berks County, carpenter." He left bequests to his sister-in-law Sarah, the silversmith's mother, and to Jeremiah he left a plantation called "The Trap," a "tract of land in Northumberland County, of 344 acres."[12] Although not mentioned in his will or in recorded deeds, the elder Jeremiah must have transferred Philadelphia properties to his nephew. According to the city directory, in 1805 the silversmith was located at 100 Spruce Street and was operating his shipping business from his uncle's South Wharves address.

The Webb family, several of whom were jewelers, was related to the Boones. Mary Boone (1699–1774), Jeremiah's great-aunt, married John Webb (1694–1774) at Gwynedd Meeting in 1720.[13] The Philadelphia directory for 1785 listed the partnership of "Webb and Boone, jewelers, South Second Street b.[between] Walnut and Chestnut."[14] Robert Webb, jeweler (active 1791–1817)—probably a family member and like Boone a Quaker—may have been the senior partner.[15] Because Jeremiah was listed second, he was probably the junior partner. In the same directory neither Robert Webb nor Jeremiah Boone had dwellings listed separately from the partnership. The family connection continued. In 1798 Boone insured a property at 57 Shippen Street as "a new house and jewelry shop."[16] In 1801 it was listed as occupied by William Webb, jeweler, and in 1802 by Robert Webb, also a jeweler.[17]

In March and through the summer months of 1788, Boone, Joseph Anthony Jr., and Joseph Cooke (q.q.v.) were engaged in a front-page stream of protests in Philadelphia newspapers that went back and forth challenging Samuel Folwell, who had claimed he was the only real "hair worker" in Philadelphia. His claim was countered with the following: "Mr. Folwell is not the only real hair worker in this city as the master who taught him, and afterwards employed him at 7sh 6[d.] per day, is now here, and with several others who are capital workmen in that branch, and far superior to Mr. Folwell."[18] Boone and his colleagues were

perhaps referring to William Donovan, goldsmith and jeweler, on Second Street between Walnut and Chestnut, a neighbor who advertised his jewelry and plated-silverware factory: "Hair curiously wrought into any device on ivory, and set in gold . . . and every branch of the above profession executed with taste and elegance: as Donovan has, at a considerable expence, brought experienced artists from the manufacturing towns in Europe . . . An apprentice wanted."[19]

The U.S. census of 1790 noted Jeremiah Boone as "silversmith" in the Middle District on the east side of South Second Street between Market and Chestnut. The number of inhabitants suggests that the survey included shop workers. There were four males over the age of sixteen, none under sixteen; two females over sixteen, none under sixteen; one other free person; and no slaves. At the time he had at least two apprentices, Jonathan Dickinson and Anthony Robeson (Robinson).

In 1790 Jeremiah Boone noted himself as "Jeweller and Hairworker" when he advertised in the *Pennsylvania Packet* that he had moved from 33 to 30 South Second Street, "directly opposite his former residence where he will execute any article in his line with neatness and dispatch."[20]

The Quaker records of the New Jersey and Philadelphia Friends meetings clearly note that in 1792 Jeremiah Boone was courting Rebecca Ridgway from New Jersey.[21] Following Quaker custom, he was granted a certificate to the Meeting at Burlington, New Jersey, from the Philadelphia Meeting on May 25, 1792, for first approval and on June 29, 1792, a second certificate "on account of marriage."[22] Thus on July 19, 1792, "Jeremiah Boone of Philadelphia, a jeweler, son of William Boone late of Exeter Township, Berks County, deceased, and Sarah Boone, and Rebecca Ridgway, daughter of John and Beulah Ridgway of Springfield, New Jersey, were married."[23] On September 3 "Rebecca Boone wife of Jeremiah was granted a certificate to the Philadelphia Monthly Meeting." They had four children, Mary Ridgway Boone (born 1793), one child stillborn in 1794, Sarah Lincoln Boone (born 1795), William Ridgway Boone (born 1796), and Rebecca Boone (1802–1832).[24]

In 1793 Jeremiah Boone was advertising, and was listed in the city directory, as a jeweler and hairworker.[25] His trade card noted his address as 30 South Second Street (fig. 46).[26] Boone was a member of an elite, young professional group, all Quakers, in Philadelphia, called the Society for the Attainment of Useful Knowledge, founded between 1790 and 1793. Members were all merchants pursuing intellectual interests and included Joseph Bringhurst, Charles Brockden Brown, Thomas P. Cope, Walter Franklin, Timothy Paxon, and Zachariah Poulson.

Fig. 46. Trade card of Jeremiah Boone, by James Thackara and John Vallance, c. 1790–97. Trade Cards Collection, Historical Society of Pennsylvania, Philadelphia

Most of them had attended the Friend's Latin School in the mid-1780s. The organization was an outgrowth of their earlier Belle Letters Society.[27] Boone resigned from the Society sometime before February 1794, when Walter Franklin wrote to him: "I have it in charge from the 'Society for the Attainment of Useful Knowledge' to assure you of the regret with which they received your letter of resignation . . . tho the particular circumstances of your situation will not permit you to continue."[28] The events that precipitated Jeremiah's "situation" are not clear, but in September 1794 Jeremiah entered into a "bail bond" with his apprentice Jonathan Dickinson "of the city, silver and gold worker for £50. . . . to be repaid by Dickinson, September fifteenth."[29] Then, in December 1794, Jeremiah Boone sold the 344 acres of land called The Trap that had been willed to him by his uncle, with its provisions, the full amount to be paid to Jeremiah in installments over four years.[30] With some capital and probably experience gained from his uncle, Boone purchased a half-interest from Edward Russell in the sloop *Nabby*, built in New York in 1793, and the two men joined in a partnership for trading ventures to Trinidad and the West Indies. They began trading in commodities, such as sugar, beef, and flour, shipping goods between Philadelphia and Trinidad and the West Indies.

Boone retained some interest in his silver retailing business. In November 1795 the frame building on Strawberry Alley in the tenure of Jeremiah Boone was "seized and taken" by the sheriff John Baker for sale.[31] On May 27, 1797, Jonathan Dickinson and Anthony W. Robinson, "Jewellers, Hair-Workers, Enamellers, &c.," advertised in *Porcupine's Gazette* "that they continue to carry on . . . as successors to Mr. J. Boone, at No. 30, south Second-street, under the tenure of Mr. John Smith, merchant." When Dickinson died later that year, he named "my trusty friends Jeremiah Boone and Joshua Dorsey [q.v.] my executors, [to] take the inventory, pay debts, residue to my brother Isaac Dickinson."[32]

On July 27, 1798, Jeremiah Boone, his wife Rebecca, and their three children were granted a certificate from the Philadelphia Meeting to the Southern District Monthly Meeting. The family had relocated to 168 South Front Street in the New Market District, where Jeremiah Boone was listed as a merchant and "gentleman."[33] In 1799 the Boones removed to 19 Pine Street.[34] In 1798, 1801, and 1802 Jeremiah Boone, "merchant," also owned property at 1 Union Street, on the north side at the corner of Front Street. He advertised for sale another three-story brick messuage and lot on the south side of Almond Street between Front and Second in the district of Southwark.[35] In 1804 he moved to 100 Spruce Street, another property inherited from his uncle, which the nephew had owned and rented out since 1787, and where the family remained until 1811.[36] On May 8, 1804, "due to falling trade," both partners, Boone and Edward Russell, were "summoned" for debt.[37] Together they owed £2,666, payable over five years. Well-known as an honest Quaker, Boone was not summoned to Bankruptcy Court but was able to remain in business to try to satisfy his creditors.[38] In 1805 he and Russell were still listed in the Philadelphia directory as merchants at 88 South Wharves.

The swings in his business fortunes and misfortunes notwithstanding, Boone's services were valued in various civic roles. In March 1795, together with John Myers (q.v.), he appraised the estate, tools, and products of Joseph Lord, a buckle and smalls maker.[39] In August 1795 Boone was witness to the will of Joseph Russell, merchant.[40] He was appointed by his uncles to collect old debts due their father's estate: "Josiah Boone of Culpepper County, Virginia and Hezekiah Boone of the County of Washington in territory South West of river Ohio, ironmaster but at present being in Philadelphia the only surviving executors named in the Will of George Boone late of Exeter Township in the County of Berks, esq. deceased . . . we have nominated and appointed and authorize Jeremiah Boone of the City of Philadelphia, merchant, to be our attorney to receive all debts due and payment from the estate of William Peters [1702–1789] dec'd and Richard Peters Esq. [1744–1828] of Philadelphia."[41] Boone also served as a Guardian of the Poor from January until August 1798.[42] In September 1800 he was elected to the city's Common Council.[43] In 1803 he was appointed a "collector" for the New Market Ward to raise money for the relief of citizens burned out of their homes on Sansom Street.[44] In September 1813 he was appointed assessor for the Republicans of Cedar Ward, and the following month he was elected as a member of the Common Council for the Friends of Peace.[45] In 1820

Jeremiah Boone, with an address of 90 South Wharves, was elected a delegate to the Fire Association of Philadelphia.[46]

He was importing sugar in 1812,[47] and his correspondence reflects the slow markets during and after the War of 1812. A notice in *Poulson's American Daily Advertiser* on April 28, 1814, stated:

> Whereas Jeremiah Boone, merchant, of the city of Philadelphia, hath made an assignment of all his property to the subscribers in trust for the benefit of such creditors as are therein specified, who shall within three months from the date hereof come forward and claim the benefit of this assignment, and sign a release or discharge for all claims they may have against the said Jeremiah Boone: and all persons indebted to the said Jeremiah Boone, are requested to come forward and pay their respective debts to either of the subscribers to whom all those having demands are desired to present their accounts legally authenticated. / Clayton Earl, / Joseph R. Jenks. / N.B. The release will be left at the Counting House of Joseph R. Jenks, No. 54, South Wharves.

In 1815 his cousin Arnold Boone wrote from Georgetown, "the segars thee sent on come safe to hand but to a dull market" and again, from Martinique, about "glutted markets."[48] Jeremiah and his son William, who joined his father, were active, well-known traders and were sought out by merchants from other towns. They had developed a thriving trade, importing sugar, molasses, leather, and other commodities from the West Indies (or at least those islands that were not held by the British) and supplying the islands with food products from southern New Jersey.[49] Samuel Davenport, "formerly of Boston, now of Charleston," solicited business with Jeremiah in salt, cotton, and rice, among other things.[50] Trading prospects must have improved because at some time before June 1815 Jeremiah bought a house at 163 Pine Street and hired Anthony Humphreys to paint and hang wallpaper with borders for his entry and parlor.[51]

In 1819 father and son invested further and built the schooner *Hebe*.[52] William traveled and made connections; he wrote from Boonsboro of the "difficulty in all trade due to scarcity of money."[53] They were listed in the Philadelphia directory of 1823 as "Provision merchants." Jeremiah Boone had been an original subscriber to the Chesapeake and Delaware Canal Company, but in 1824 he, and a number of others from Pennsylvania and Maryland, were obliged to forfeit their shares for nonpayment. Boone owed $200 for one share.[54] Although Jeremiah Boone's business troubles continued, his credit remained good. A letter in 1827 from Elias Davis of Washington City, Maryland, noted: "I was authorized to settle a claim as agent

but my intentions of agitating the matter were frustrated by seeing the deep affliction under which you and your family still labored from the loss you had recently sustained."[55] This may well have been a reference to the death of his son William Boone in 1827.

Eventually, however, in 1832 tax collectors authorized the sale of all his "goods, land tenements etc. to pay to U.S. Custom's House at Philadelphia an account for eleven boxes of sugar, then to all creditors originated since May 1806."[56] On August 4, 1832, his daughter Rebecca died, and her funeral was held from the Boone house at 163 Pine Street.[57] Less than a year later, on "Saturday, April 14, 1833, Died after a short illness, Jeremiah Boone in the 68th year of his age.... Funeral from his late residence, 163 Pine Street."[58]

Jeremiah Boone died without a will. His inventory was taken by J. W. Brown and J. Glendaniel.[59] It encompassed goods on hand in his store and on the wharf, and fixtures belonging to the same: his stock, including barrels of beef and pork, hogsheads of rum "part full," a patent balance and frame, a desk and drawers, small scales and weights, a coal stove and pipe, a barrel of vinegar, and a lot of copper and iron. This was followed by a long list of debts due to the estate from John Y. Beyant, Robert Cooper, J. Fernandes, Joseph Franklin, Havens & Smith, Aaron B. Hollingsworth, Joseph B. Hughes, a Captain Hughes, Benjamin Jones Jr., Isaac Lloyd and son, Robert Maquire, Barnet Quinn, Daniel Smith Sr., James A. Thompson, Thomas Wickersham; a note from Glendaniel; jury fees related to District Court for city and county; and commissions. The total amount due was $656.45. Jeremiah Boone was survived by his wife Rebecca and his daughter Mary, "a single woman," who served as administrator of the estate. Rebecca died in 1861 without a will. Her administration papers stated that there was "no personal property whatever belonging to her estate."[60] BBG

1. Spraker 1922, p. 31.

2. For a description and bibliography of the Boone family, see ibid.; Rupert F. Thompson, comp., *Boone Genealogy, 1984* (Studio City, CA: privately printed, 1984); Jeremiah Boone Papers, 1782–1833, no. 66, HSP. For information about debt and bankruptcy at the time, see Bruce H. Mann, *The Republic of Debtors: Bankruptcy in the Age of American Independence* (Cambridge, MA: Harvard University Press, 2002), p. 45.

3. Spraker 1922, pp. 19–25; *Pennsylvania Gazette* (Philadelphia), January 22, 1754.

4. Spraker 1922, pp. 23–24.

5. Jeremiah Boone's grandfather George Boone had dealings with Joseph Richardson Sr. (q.v.) in 1730, and the Quaker connection was important; *PMHB*, vol. 11, no. 2 (1887), p. 221; vol. 14, no. 3 (1890), p. 314; vol. 29, no. 1 (1905), p. 122.

6. Spraker 1922, pp. 29–31.

7. Ibid., p. 54. He owned a fifty-acre tract in Berks County in July

1752; Index of Early Pennsylvania Land Warrants, 1733–1987, from the Pennsylvania State Archives (Stevens, PA: Ken McCrea, 2010), Ancestry.com.

8. Abigail (1749–1808), William (1750–1774), Mary (1755–1782), George (1759–1824), Thomas (1761–1823), Hezekiah (1764–1827), and Jeremiah (the silversmith), not to be confused with another Jeremiah (1760–1832) also from Berks County, son of Josiah and Hannah Boone.

9. Spraker 1922, p. 54. He owned a fifty-acre tract in Berks County in July 1752; Index of Early Pennsylvania Land Warrants, 1733–1987.

10. Spraker 1922, pp. 104–5. Quakers kept careful records of their communicants. "Through the certificate system, meetings of origin recommended their moving members to new meetings, indicating where the Quaker previously worshipped, and assessed the character of prospective members. The certificates symbolized the values that the Society cherished." Neva Jean Specht, "Removing to a Remote Place: Quaker Certificates of Removal and Their Significance in Trans-Appalachian Migration," *Quaker History*, vol. 91, no. 1 (2002), pp. 47–48. The records maintained the discipline and exclusiveness of the Society.

11. Both properties must have been included in the elder Jeremiah's transfer to his nephew since the silversmith and his wife Rebecca were listed as owning them in 1805.

12. "I give and devise unto Jeremiah Boone (son of my brother William), all my plantation in Northumberland County which I purchased of John Murray, called 'the trap' 344+ acres ... subject to payment of £50 for Abner Williams (son of my sister Dinah).... Now know ye ... the sum of £50 to me in hand paid by the said Jeremiah Boone of the City of Philadelphia, jeweler and goldsmith." Will of Jeremiah Boone, February 20, 1787, Philadelphia Administration Book O, no. 126, p. 78; will of Jeremiah Boone, Boone Papers, folder "The Trap.

13. Spraker 1922, p. 39; "Boone Genealogy," *PMHB*, vol. 21, no. 1 (1897), p. 113. Was their grandson Robert Webb (1791–1817), the jeweler, Jeremiah's first partner? See also the Philadelphia directory 1785, Charles Webb (1738–1850), merchant (p. 78); 1791, Robert Webb, jeweler, 24 Carter's Alley (p. 138); 1801, William Webb, jeweler, 57 Shippen Street (p. 181); and Thomas Webb (active 1818–19), hat manufacturer (p. 136). Jeremiah Boone is listed alone in 1793 at 30 South Second Street (p. 13).

14. The address was 33 South Second Street, between High (Market) and Chestnut on the west side of Second Street. This was an important location for other silversmiths before and after Webb and Boone. Among the silversmiths who occupied some part of this property were George Christopher Dowig, John Aitken, Christian Wiltberger, Samuel Alexander (q.q.v.), Joshua Dorsey, Anthony Simmons, and John Owen. Jeremiah Boone remained there until 1790, when he moved across the street, to no. 30; Philadelphia directory 1785, p. 79.

15. Brix Files, Yale University Art Gallery; Elizabeth Allen, grantor, to Robert Webb, grantee, Philadelphia Deed Book D-43-242.

16. Mutual Assurance Company, policy no. 1078, August 1800, Mutual Assurance Company (Green Tree) Records, 1784–1995, HSP.

17. Philadelphia directory 1801, p. 181; 1802, p. 256. Shippen (now Bainbridge) Street was in the Southern District, where Boone would locate his mercantile business. The location was known in its day for the Black Bear Tavern, a center for meetings and political discourse, at 62 Shippen Street, a two-story brick building with adjoining billiard room and dining capacity of sixty to eighty persons; *General Advertiser* (Philadelphia), June 18, 1793. See also Michael Schreiber, "The Black Bear Tavern and Ball Alley," www.southwarkhistory.org, posted May 5, 2014 (accessed April 27, 2015).

18. *Pennsylvania Packet* (Philadelphia), March 29 and April 1, 1788.

19. *Pennsylvania Evening Herald* (Philadelphia), June 15, 1785.

20. He continued this advertisement with the same location location through 1792; *General Advertiser*, January 30, 1792. See also note 14 above.

21. Southern District (Philadelphia) Monthly Meeting Records, 1789–1801, Minutes, p. 73, HSP.

22. Not to be confused with a Jeremiah Boor [*sic*] who married Rachel Weatherby [*sic*] at the First Baptist Church in Philadelphia in September 1790; U.S. and International Marriage Records, 1560–1900, Ancestry.com.

23. Charlotte D. Meldrum, *Early Church Records of Burlington County, New Jersey* (Westminster, MD: Family Line Publications, 1994), vol. 1, p. 64.

24. "Some Records of Philadelphia Monthly Meeting and the Pine St. and Orange St. Meetings, Philadelphia, Pa.," births, marriages, deaths, 1682–1870, pt. 1, p. 670, HSP.

25. *General Advertiser* (Philadelphia), January 31, 1792. See also *Dunlap's American Daily Advertiser* (Philadelphia), February 2, 1792, where his front-page advertisement was the only advertisement placed by a craftsman, except that by Robert Leslie, watchmaker, between January 31 and March 28, 1792; Philadelphia directory 1793, p. 13.

26. A photocopy is included with a family typescript in the Boone Papers. The engravers were located at 72 Spruce Street from 1791 until 1797.

27. Philip Barnard, Elizabeth R. Hewitt, and Mark L. Kamrath, eds., *Collected Writings of Charles Brockden Brown* (Lewisburg: PA: Bucknell University Press, 2013), vol. 1, p. 824.

28. Walter Franklin, secretary, to Jeremiah Boone, Letters to Jeremiah Boone, February 10, 1794–August 15, 1829, Boone Papers.

29. Boone Papers, Correspondence, HSP.

30. Ibid. This property had been owned in partnership with his grandfather George Boone and Richard and William Peters. He sold it to Bowman Runyan. The first payment of £100 was due in 1795, and the total due over four years was £300, with possession upon first payment. Sale of Tract of Land in Northumberland County, ibid.

31. *Aurora General Advertiser* (Philadelphia), November 14, 1795.

32. Jonathan Dickinson's will and full inventory of his remaining wares and tools, written November 2, 1797, probated December 29, 1797, Boone Papers.

33. Some financial relief must have come from his wife Rebecca. When Sarah Lincoln Boone died in 1810, she left bequests to "daughter Rebecca Boon [sic?] wife of Jeremiah, £200, and the children of Rebecca Boone £0 to be divided between them"; New Jersey Historical Society, Calendar of New Jersey Wills and Administrations (Newark, 1901), vol. 40, p. 281, Ancestry.com. As Philadelphia developed, 166 South Front Street may have become no. 168, or there was a mistake in printing the directory. The Philadelphia directory of 1798 lists "Boone, Jeremiah, gentleman, 168 South Fourth St" (p. 25).

34. Philadelphia directory 1797, p. 29.

35. *Philadelphia Inquirer*, November 18, 1839. As a delegate from one of the fire companies to the Fire Association in 1820, his address was noted as 90 South Wharves; *Franklin Gazette* (Philadelphia), December 21, 1820.

36. See the Philadelphia directory 1804, pp. 32 ("Boone, Jeremiah, 100 Spruce") and 200 ("Russell & Boone, merchants, 88 south wharves").

37. Their creditors were all noted Philadelphia merchants: Francis Gurney; Jehu, John, and Levi Hollingsworth; Philip Latimer; Daniel Smith; James Steel Jr. and William Steel; and John Wall. Insurance papers, Boone Papers.

38. It would appear that Jeremiah Boone was insolvent rather than bankrupt. He was not subject to legal action, and he had sufficient equity in property and real estate to afford some assurances to creditors. For a discussion of Philadelphia merchants and their markets, see Thomas M. Doerflinger, "Enterprise and Adversity," in *A Vigorous Spirit of Enterprise: Merchants and Economic Development in Revolutionary Philadelphia* (Chapel Hill: University of North Carolina Press, 1986). With thanks to David Maxey for bringing this source to my attention.

39. Document Box, American Art, Yale University Art Gallery, New Haven.

40. Probably the brother of his partner Edward Russell. Joseph Russell died in 1801; will of Joseph Russell, 1801, Philadelphia Will Book Y, p. 488.

41. Letter of Attorney, Estate of George Boone, Nov. 9, 1795–March 13, 1798, Boone Papers. Richard Peters was a judge.

42. *Gazette of the United States, and Philadelphia Daily Advertiser*, September 21, 1798. The almshouse records note the following, dated February 7 and 10, 1798: "Ann Roach pregnant, sent in by Jere [sic] Boone, city"; and on the reverse, "Jeremiah Boone holds himself accountable for all Expenses that may accrue, he having

sworn the child to be his." List of Admissions commencing June 24, 1797–October 13, 1798, Guardians of the Poor, Almshouse Admissions and Discharges, 1785–1805, Philadelphia City Archives.

43. *Gazette of the United States, and Philadelphia Daily Advertiser*, August 7, 1800.

44. He and Joseph Lownes (q.v.), for the Dock Ward, were the only silversmiths chosen; *General Advertiser* (Philadelphia), December 24, 1803.

45. *Poulson's American Daily Advertiser* (Philadelphia), September 30, 1813; October 12, 1813.

46. *Grotjan's Philadelphia Public Sale Report*, June 15, 1812.

47. Boone Papers, Correspondence.

48. Ibid.

49. Various entries recording goods bought and sold can be found in *Grotjan's Philadelphia Public Sale Report*, June 15, 1812; April 10, 22, and 29, 1815; March 9 and August 24, 1818.

50. Boone Papers, Correspondence.

51. "17 2/3 pieces of parlour paper [$]8.83, 14 1/2 d[itt]o entry [$]2.43, 1 2/3 border [$]2.50. hanging do 22 pieces of paper [$]5.50, Do 1 2/3 do border [$]0.42, painting, repairing." Miscellaneous Receipts, 1823–32, Jeremiah Boone and George Ashbridge, Boone Papers.

52. Extensive accounts regarding the building of the *Hebe* and lists of sailors, workmen, and cargo reveal the extent to which the Boones were accumulating debt; Boone Papers, Correspondence (1815, 1816, 1819, 1820–23).

53. Ibid.

54. "Office of the Chesapeake and Delaware Canal Company," *Republican Star, or Eastern Shore Political Luminary* (Easton, MD), March 2, 1824.

55. Boone Papers, Correspondence.

56. Boone Papers.

57. "Died. . . . On the morning of the 1st inst. Rebecca, daughter of Jeremiah Boone, in the 30th year of her age"; *National Gazette* (Philadelphia) and *Poulson's Daily Advertiser*, August 2, 1832.

58. *Poulson's Daily Advertiser*, April 19, 1833.

59. Administration of the estate of Jeremiah Boone, 1833, Philadelphia Administration Book O, no. 126, p. 78.

60. Administration of the estate of Rebecca Boone, 1861, Philadelphia Administration Book R, no. 462, p. 591.

Cat. 84
Jeremiah Boone
Pair of Tablespoons

1790–1800
MARK (on each): J. BOONE (in rectangle, on reverse; cat. 84-1)
INSCRIPTION (on each): T M M (engraved script, at top of handle)
Length 9 inches (22.9 cm)
Weight 1 oz. 15 dwt. 1 gr.; 1 oz. 17 dwt. 1 gr.
Purchased with the Director's Discretionary Fund, 1968-243-1, -2

PROVENANCE: Frank S. Schwarz, Schwarz Gallery, Philadelphia.

Cat. 84-1

A zigzag, bright-cut banding follows the edges of these spoons and outlines an oval at the top of the handles. This design was the most popular pattern in Philadelphia from the late eighteenth century until 1825. BBG

Elias Boudinot

New York City, born 1706
Elizabethtown, New Jersey, died 1770

The Boudinot family were Huguenots from Marans, France. Elias Boudinot (1642–1702), caught in the social unrest after the revocation of the Edict of Nantes, emigrated to England and then to New York in 1686. His son Elias (1674–1720) was a merchant who married Marie Catherine Carré in New York in 1699. Their son Elias, born July 14, 1706, and baptized at the French Huguenot Church in New York City, became the silversmith. His father died in 1719 or 1720. His older sister Susannah (1704–1777) married the silversmith Peter Vergereau (q.v.) of New York in 1737. Vergereau was a contemporary of Simeon Soumaine (c. 1695–1750), with whom Elias Boudinot was apprenticed for the customary seven years, from June 6, 1722, until 1729.[1] Directly after completing his apprenticeship, he sailed for Antigua to follow up on family business and interests in Jamaica that he had inherited from his grandfather. He married Susannah Leroux there in 1729 or 1730; she died in Antigua in 1733.[2] He married, secondly, Catherine Williams (1714–1765) in Antigua. Their first child, John, was born in 1734. General uncertainty provoked by civil unrest and threats of an uprising led the Boudinots to leave Antigua and move to Philadelphia that same year.[3] Their daughter Annis was born in 1737, Mary Catherine in 1738, and Elias in 1740; all three were christened at Christ Church in Philadelphia.[4]

By 1742 Elias was actively at work in Philadelphia when he made a tankard for George and Anna Clarke O'Kill, who married at Christ Church in that year.[5] The years from 1745 until 1758 were the most productive for Boudinot, and he made silver for prominent patrons in Philadelphia and New Jersey.[6] In 1747 he advertised that he "is removed from the house next door to the Post office, in Market Street, to the house were Mr. Joseph Noble lately dwelt in Second Street, four doors above Black Horse Alley; where also clocks are made after the best manner, and watches are repaired by Emanuel Rouse."[7] Rouse was replaced by Alexander Leith, a Scottish merchant who advertised in 1747 that he had a large assortment of goods, including "scotch checks [woven textiles] . . . for sale at Mr Boudinot's in Second Street."[8] Boudinot was a neighbor of Benjamin Franklin. They were great friends, and the silversmith made a tankard for Franklin and his wife Deborah.

It may have been through Franklin that Boudinot was appointed postmaster at Princeton, New Jersey, and in 1752 or 1753 the Boudinots moved there, where he was listed as a postmaster, merchant, and tavern keeper.[9] Boudinot owned shares in copper mines (as had his grandfather) in New Brunswick, New Jersey, and in Simsbury, Connecticut, and in 1761 he advertised his shares for sale as well as his house and grounds in Princeton.[10] Boudinot was still in Princeton in March 1762, but he had been in poor health for most of his adult life, and by May of that year he was living with his son Elias and family in Elizabethtown. By this time he was quite ill and suffering with "dead Palsy." Franklin wrote to Elias's son on December 11, 1762: "I hope your good father's indisposition will be of no long continuance."[11] Franklin commented in a letter to his wife Deborah: "I am glad to hear Mr. Budenot [sic] has so seasonable a supply; and hope he will not go mining again."[12]

A few pieces of silver may be dated to this late period of his life, such as a mug, probably for his granddaughter Suzanne (born 1764), daughter of

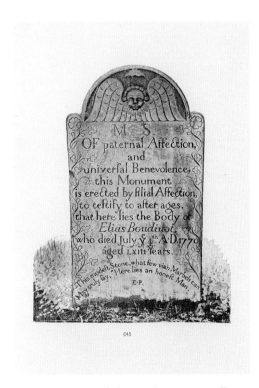

Fig. 47. Gravestone of Elias Boudinot. From William Ogden Wheeler, *Inscriptions on Tombstones and Monuments in the Burying Grounds of the First Presbyterian Church and St. Johns Church at Elizabeth, New Jersey, 1664–1892* (New Haven, CT: Tuttle, Morehouse & Taylor, 1892), p. 95. The New York Public Library, Astor, Lenox and Tilden Foundations. Milstein Division of United States History, Local History & Genealogy

his son Elias and his wife, Hannah Stockton. The mug was commissioned and purchased by the girl's father, as recorded in a receipt: "To cash paid by my father for making a silver mug / £3 light. £2 11s 6p."[13]

On November 1, 1765, Boudinot's wife Catherine died. On July 4, 1770, Boudinot, silversmith, was buried in the ground of the First Presbyterian Church in Elizabethtown (fig. 47). His son provided the inscription on his father's tombstone: "M S / Of paternal Affection, / and universal Benevolence, / this Monument / is erected by filial Affection / to testify to after ages / that here lies the Body of Elias Boudinot, / who died July ye 4th A D 1770 aged LXIII Years / This modest Stone, what few vain Marbels can / May truly say, 'Here lies an honest man.'"[14] BBG

1. Perhaps the family connection secured the apprenticeship: "Indenture of Elias Boudinot son of Mary Catherine Boudinot, widow, to Simon Semine [sic] silversmith for seven years from June 4, 1721"; signed by Elias Boudinot and witnessed by Louis Carré and Louis Carré Jr. Albert F. Koehler, *The Huguenots or Early French in New Jersey* (Bloomfield, NJ: Huguenot Society of New Jersey, 1955), p. 19; David H. Conradsen, *Useful Beauty: Early American Decorative Arts from St. Louis Collections*, exh. cat. (St. Louis: Saint Louis Art Museum, 1999), p. 89.

2. *Proceedings of the New Jersey Historical Society*, 3rd ser. (Newark: the Society, 1899), vol. 3, p. 124; Cheryl Robertson, "Elias Boudinot: A Case Study in Ethnic Identity and Assimilation, 1979" (master's thesis, University of Delaware, 1980); Conradsen, *Useful Beauty*, p. 89.

3. Hedy Backlin-Landman, "Boudinot Family Portraits at the Art Museum of Princeton University," *Antiques*, vol. 93, no. 6 (June 1968), p. 770.

4. Charles R. Hildeburn, "Records of Christ Church, Philadelphia, Baptisms, 1709–1760 (continued)," *PMHB*, vol. 14, no. 4 (January 1891), p. 428.

5. Conradsen, *Useful Beauty*, illus. pp. 88–89; Christie's, New York, *Important American Furniture, Folk Art, Silver and Chinese Export*, January 21, 22, and 25, 2010, sale 2287, lot 79.

6. A teapot for John and Abigail Stockton, c. 1750 (New Jersey Historical Society, Newark, 1953.22); a salver engraved with Van Rensselaer arms (private collection); a tankard for Benjamin and Deborah Franklin, 1745–52 (Franklin Institute, Philadelphia, 1946-08-22; see Prime 1938, p. 128, cat. 7); a tray for Henry and Mary Aspen Harrison (McGoey 2016, cat. 26); a tray for Joshua and Mary Maddox (cat. 86); a dozen tablespoons and a soup ladle at £20 5 s. for Lynford Lardner (see Jack Lindsey, "Lynford Lardner's Silver: Early Rococo in Philadelphia," *Antiques*, vol. 143, no. 4 [April 1993], p. 614).

7. *Pennsylvania Gazette* (Philadelphia), September 10, 1747. In 1748 Samuel Rouse announced his move from Elias Boudinot's on Second Street to Michael Koyl's on Front Street, near the drawbridge. Ibid., August 4, 1748; Brix Files, Yale University Art Gallery.

8. Brix Files, Yale University Art Gallery, p. 41. Boudinot witnessed Alexander Leith's will in May 1748. Like many craftsmen, Boudinot supplemented his silver work and took on general merchandise. He advertised "lately imported from London, and to be sold at the house of the said Boudinot, in Second Street: a quantity of men's Wearing Apparel, some whole suits, and many single Coats, and warm clothing for the Winter-Season. There is also a Bermudas [sic] Two-mast Boat, with a good Suit of Sails, to be sold by Boudinot"; *Pennsylvania Journal* (Philadelphia), December 8 and 13, 1748. In March 1749 Boudinot, Joseph Hall (q.v.), Andrew Reed, and John Redman, merchants, acted in a Declaration of Trust for a piece of land on Mulberry at Third Street in Philadelphia, for the benefit of the Presbyterian Church and the Reverend Gilbert, tenant; Philadelphia Deed Book H-3-362, recorded July 13, 1752.

9. G. A. Boyd, *Elias Boudinot: Patriot and Statesman, 1740–1821* (Princeton, NJ: Princeton University Press, 1952), pp. 6–16.

10. Ibid., pp. 5, 9–10. See also Corlette 1973, p. 91; *Proceedings of the New Jersey Historical Society*, 3rd ser. (Newark: New Jersey Historical Society, 1899), vol. 61, pp. 153–54. For the advertisement of land, see *The Papers of Benjamin Franklin* (New Haven, CT: Yale University Press, 1959), vol. 7, p. 275.

11. *The Papers of Benjamin Franklin*, vol. 10, p. 174.

12. Ibid., vol. 7, p. 275. At the time there was some concern about a relationship between mining and illness.

13. Walter Hamilton Van Hoesen, *Crafts and Craftsmen of New Jersey* (Rutherford, NJ: Fairleigh Dickinson University Press, 1973), p. 111. See also "Elias Boudinot," *New York Sun*, June 15, 1940, in Helen Burr Smith, ed., *Early American Silversmiths: A Collection of Clippings from the New York Sun, 1938–1941* ([New York], 1938).

14. William Ogden Wheeler, *Inscriptions on Tombstones and Monuments in the Burying Grounds of the First Presbyterian Church and St. Johns Church at Elizabeth, New Jersey, 1664–1892* (New Haven, CT: Tuttle, Morehouse & Taylor, 1892), p. 94.

Cat. 85

Elias Boudinot
Sauceboat

1735–40

MARK: EB (in rectangle, at upper rim; cat. 85-1)
INSCRIPTION: S·P (engraved with "P" shaded, on underside; cat. 85-2)
Height 4⅜ inches (11.1 cm), length 7⁹⁄₁₆ inches (19.2 cm)
Weight 10 oz. 12 dwt.
Purchased with the John T. McIlhenny Fund, 1956-69-1

PROVENANCE: The sauceboat probably belonged originally to Samuel Powel (1704–1759) and his wife, Mary Morris Powel (1713–1759), who married in 1732. Powel, a leading merchant in Philadelphia, was purchasing silver from Joseph Richardson Sr. (q.v.) about the same time, as recorded in Richardson's daybook dated 1733–40.[1] The initials may have been his, or they may have been added for his daughter, Sarah Powel (1747–1773), who married Joseph Potts as his second wife in 1768.[2] Their daughter Mary Powel Potts married Jonathan Jones in 1786. Sarah's brother, Samuel Jr. (1739–1793), nicknamed the "Patriot Mayor" of Philadelphia, was a close friend of George Roberts (1737–1821), and the two men carried on a long correspondence while Powel was in Europe.[3]

Cat. 85-1 Cat. 85-2

This sauceboat was purchased by the Museum from George B. Roberts Jr., a direct descendant of the above mentioned George Roberts.

EXHIBITED: Philadelphia 1956, cat. 39; Philadelphia 1969, pp. 55, 63, cat. 9; Corlette 1973, p. 93, cat. 63.

PUBLISHED: Carl M. Williams, *Silversmiths of New Jersey, 1700–1825* (Philadelphia: George S. McManus, 1949), p. 107; Louis C. Madeira IV, "The Quest for Philadelphia Silver," *Philadelphia Museum Bulletin*, vol. 53, no. 255 (Autumn 1957), p. 11, fig. 7; "Current and Coming," *Antiques*, vol. 114, no. 7 (July 1978), p. 26.

The sweep of the cast bird's-head handle set at a wide angle to the body and the extended pouring lip are notable features of this sauceboat, which is one of a pair.[4] The shells attaching the legs to the body have especially nice corner scrolls. BBG

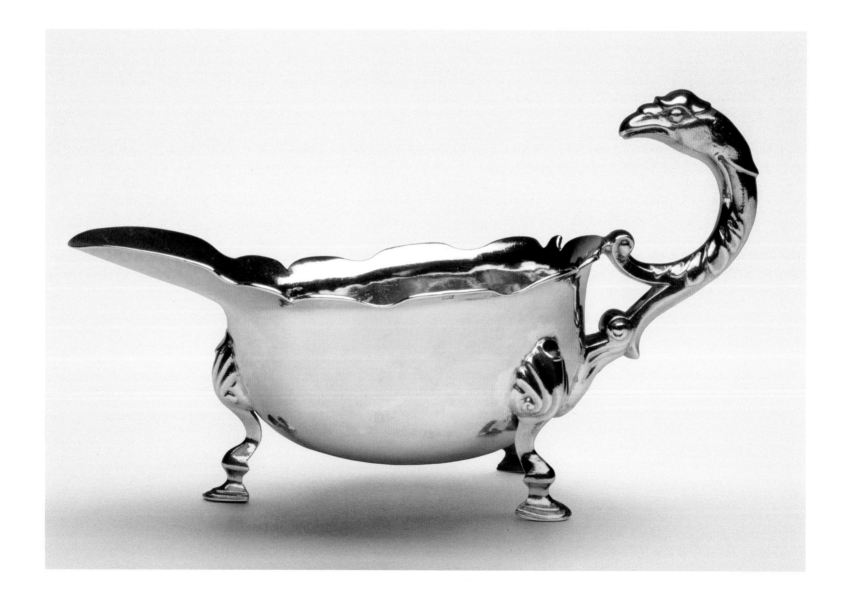

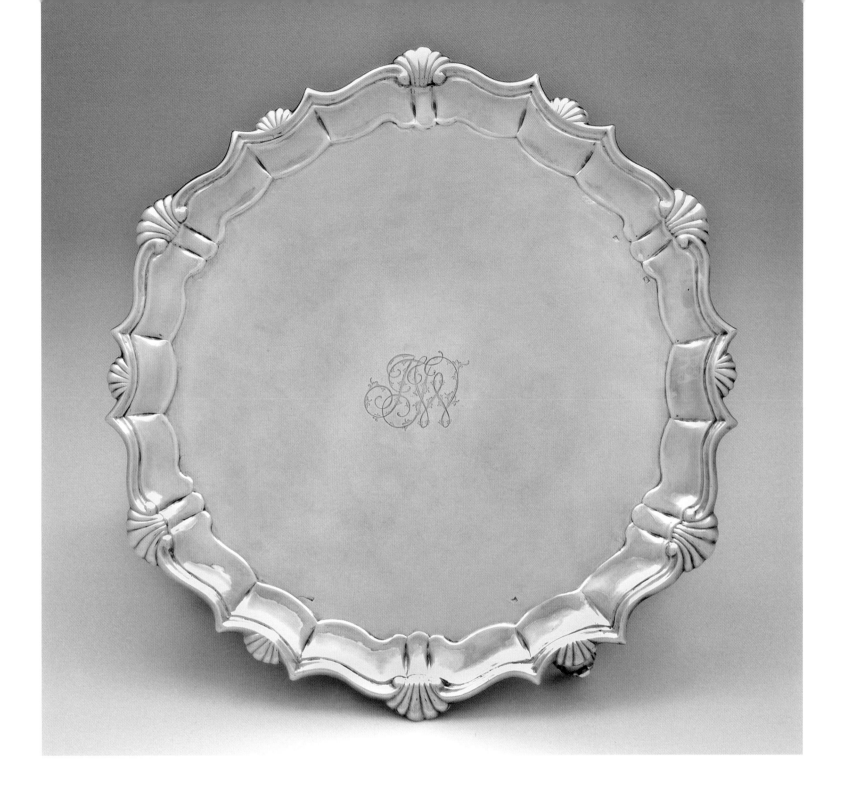

1. "Samuel Powel, Jnr. Gold Locket; Pepper and Mustard Castor, 1 Pair Salts." "Excerpt from the Day Book of Joseph Richardson, Silversmith, of Philadelphia, 1733–1740," *PMHB*, vol. 29, no. 1 (1905), p. 122.

2. In 1759 and 1760 Deborah Morris was Sarah Powel's guardian and kept her accounts, which included clothing and payments "for education to Mary Goswell for quarter schooling, silk for her work at ye above school . . . birds for shellwork . . . for necessary, silver thimble, silver garter & buckles"; Morris, Account Book, 1759–86, HSP. Deborah Morris also made an inventory of possessions stashed away during the occupation of Philadelphia by the British, November 10, 1778: "Belonging to Joseph Potts daughter, Mary Powel Potts: 1 gold locket and double chain, 6 small silver tea spoons 'SP,' silver wissells & bells & coral broke, 1 set Delph [*sic*] dishes 12 blue and white, 1 large china dish, 1 ditto enameled, 2 mahogany tea trays, one broke, 1 japan ditto . . . 1 set enameled & [*illegible*] containing: 1 coffee pot & stand & 5 cups, 2 teapots, 1 stand, spoon tray, 1 plate, cream pot,

sugar, slop bowl, canister, 11 saucers, 12 tea cups, 1 smaller japan tray & a set of enameled china . . . 2 glass plaits for his son John, molds for wax fruit, child bed linen."

3. "Powel-Roberts Correspondence, 1761–1765," *PMHB*, vol. 18, no. 1 (1894), pp. 35–42. It was long customary to leave bequests to friends. Other Roberts family silver marked "S·P" in the Museum's collection clearly descended in the Potts-Powell-Jones-Roberts-Vaux line; see the dessert spoons (1932-45-3a,b) and porringer (1991-96-1) by Joseph Richardson Sr.

4. The mate, marked similarly, is in the collection of the Metropolitan Museum of Art, New York (1986.312); see Wees and Harvey 2013, p. 292.

Cat. 86

Elias Boudinot

Salver

1742–45

MARK: EB (in rectangle, four times on obverse; cat. 85-1)
INSCRIPTIONS: J T W (engraved script, on obverse);
Collet (scratched script, on underside near one foot)
Height 1½ inches (3.8 cm), diam. 13 inches (33 cm)
Weight 31 oz. 8 dwt.
Gift of the McNeil Americana Collection, 2005-68-7

PROVENANCE: The salver was made for Joshua Maddox (1687–1759) and Mary Gateau Maddox (1681–1783), who married at Christ Church, Philadelphia, on February 20, 1728, and who had a grand house on Second Street opposite the Friends Great Meeting House.[1] Some of their surviving silver is boldly engraved with the Maddox coat of arms and/or initials.[2] In her will Mary G. Maddox left all her

furniture and plate to her daughter Mary (1732–1784), who had married John Wallace (1718–1783),[3] a Scot who emigrated first to Rhode Island. He and his mother-in-law died within a month of each other, and Mary Maddox Wallace died the next year. Mary G. Maddox had excepted from her bequest to her daughter a two-quart silver tankard, this silver salver, a one-quart silver tankard, a saucepan, and a set of casters, all of which were to go directly to her grandson Joshua Maddox Wallace Jr. (1752–1819) at age twenty-one.[4] He was born in Philadelphia and attended the College of Philadelphia before joining the business enterprise of Archibald McCall in the same city. A close friend of Elias Boudinot Jr. and the son of the silversmith Joshua Wallace Jr., the grandson inherited a handsome estate and owned a property on the Raritan River called "Ellerslie," which he sold when he moved to Burlington at the time of his marriage to Tace Bradford at Philadelphia's Christ Church, August 4, 1773.[5] He retired, and the surviving family continued to live at Hope Farm in Somerset County, New Jersey. The three Maddox estates took years to settle.

The light, foliate style of the centered initials "JTW," the initials of Joshua Maddox Wallace Jr. and his wife, were added. The name "Collet" scratched on the underside suggests that the salver was inherited by Susan Bradford Wallace, who married Mark Wilks Collet,[6] and then by their daughter Laura Susan Collet (1829–1896). Mr. and Mrs. Louis C. Ohland.[7] Christie's, New York, *Important American Furniture, Silver, Prints, Folk Art and Decorative Arts*, January 18, 1997, sale 8578, lot 69; (S. J. Shrubsole, New York).

EXHIBITED: Philadelphia 1956, cat. 41.

PUBLISHED: McGoey 2016, p. 85.

This is an especially large, heavy salver exhibiting the earliest form of the rococo style as it appeared in Philadelphia and is most like contemporary English models. It has three handsome scrolled feet and a fine rococo edge with an alternating pattern of shells and scrolls. It is exactly like another salver also by Boudinot, of the same dimensions and weight.[8] BBG

1. Joshua Maddox and Mary Gative [*sic*]; *Pennsylvania Archives*, 2nd ser. (1895), vol. 8, p. 170; Edward L. Clark, *A Record of the Inscriptions in the Tablets and Grave-stones in the Burial-Grounds of Christ Church, Philadelphia* (Philadelphia: Collins, 1864), p. 62. At the time the house was valued at £150, and in 1754 was taxed at £1 5s., a tax of 2d. on the pound and 6s. per head. John Wallace was the occupant. The tax was collected for paving and regulating streets. Hannah Benner Roach, "Taxables in Chestnut, Middle and South Wards," in *Colonial Philadelphians* (Philadelphia: Genealogical Society of Pennsylvania, 1999), p. 74.

2. Tankard, Yale University Art Gallery, New Haven, 1930.1194; a tazza, cann, and salver are in a private collection. See Philadelphia 1956, cats. 317, 578; Buhler 1956, p. 97, cat. 333. The tazza, by Henry Pratt, bears the full Maddox coat of arms with the initials "EBW" in a later hand below. Those initials belonged to Elizabeth Binney Wallace, sister of Horace Binney and wife of John Bradford Wallace (1778–1837), son of Joshua and Tace Wallace; see Henry Flanders, "A Commemorative Address Delivered at the Hall of the Historical Society of Pennsylvania, November 10, 1884, on John William Wallace, LL.D.," *PMHB*, vol. 8, no. 4 (December 1884), appendix, p. xliv; Christie's, New York, *Highly Important American Furniture, Silver, Paintings, Prints, Folk Art, and Decorative Arts*, January 16, 1998, sale 8840, lot 85, illus. p. 69. The salver bears the same initials "M / I·M" on the underside as does the tazza; Lindsey et al. 1999, p. 192, cat. 235.

3. Mary G. Maddox, widow of Philadelphia merchant Joshua Maddox, died in 1783 at Hope Farm in New Jersey at the residence of her daughter Mary M. Wallace; will of Mary Gateau Maddox, written March 9, 1781, probated September 6, 1783, Philadelphia Will Book S, no. 238, p. 288; will of Mary G. Maddox, 1783, Wallace Papers, vol. 5, p. 36, HSP.

4. "To her grandson Joshua Wallace my books and my gold watch"; to Mary Wallace "all my plate and household furniture" with the caveat that "after the decease of Mary Wallace, one half of her plate to be given to Joseph Stamper [died 1785] husband of Sarah Maddox, daughter of Joshua junior, and to William Bingham Sr. who married Mary Stamper, her trusty friends"; ibid. Also quoted in *Freeman's Journal, or The North-American Intelligencer* (Philadelphia), August 27, 1783.

5. "American County Histories," chap. 40, pp. 5–6, AccessibleArchives.com (2009). Tace Bradford was the daughter of Colonel William Bradford, the patriot printer. The Wallaces inherited a fortune from her family, and they retired in about 1784 from Philadelphia to a social and intellectual life at Hope Farm in Somerset County, New Jersey. He was a member of the Convention of New Jersey that ratified the Constitution in 1787, a trustee of Princeton College, and a judge of the Court of Common Pleas of Burlington County. See Flanders, "A Commemorative Address."

8. Will of Mary G. Maddox, 1783, Wallace Papers, vol. 5, p. 36, HSP; will of Judge Joshua M. Wallace Jr., son of Joshua and Tace Wallace, signed November 25, 1806, probated March 10, 1821, friend Horace Binney, witnesses E. Boudinot Stockton and M. W. Collet, Philadelphia Will Book 7, p. 277.

7. Philadelphia 1956, cat. 41.

8. A salver with closely similar weight (31 oz. 7 dwt.) made in about 1748 for the marriage of Henry Harrison (1714–1766) and Mary Aspen Harrison (1719–1813) of Philadelphia; McGoey 2016, cat. 26.

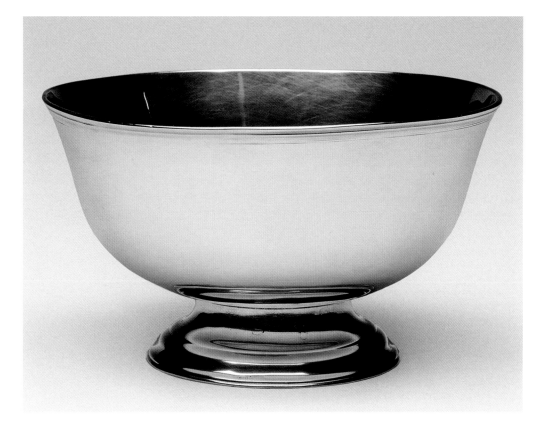

Cat. 87
Elias Boudinot
Bowl

1750–56

MARKS: EB (in rectangle, on underside above and below raising dot; cat. 85-1); 8101 (1018?) (tiny scratched numbers, on underside of foot)
INSCRIPTION: M / M·E (engraved, on underside)
Height 3½ inches (8.9 cm), diam. 5¾ inches (14.6 cm), diam. foot 3¼ inches (8.3 cm)
Weight 9 oz. 14 dwt. 15 gr.
Gift of the McNeil Americana Collection, 2005-68-8

PROVENANCE: Sotheby's, New York, *Important Americana*, January 24, 26, 27, and 30, 1995, sale 6660, lot 1442; (S. J. Shrubsole, New York).

This small, heavy, elegant bowl may have been a slop bowl or a small punch bowl, sometimes referred to as a tea bowl. The surface is plain and finished only with a molded, stepped foot and a rolled top rim. BBG

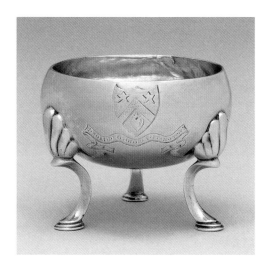

Cat. 88
Elias Boudinot
Cream Pot (fragment)

1758–62

MARK: EB (in rectangle, twice on underside; cat. 88-1)
INSCRIPTION: [Boudinot arms (Azure a chevron between two mullets in chief and a flaming heart in base or)] (engraved, on front opposite handle)

Motto: SOLI DEO·GLORIA·ET·HONORUM (in banner, below arms)
Height 1⅞ inches (4.8 cm), diam. 2⅜ inches (6 cm)
Weight 1 oz. 17 dwt. 13 gr.
Purchased with Museum Funds, 1960-53-1

PROVENANCE: Owned by the collector and museum curator Vincent Dyckman Andrus (1915–1962); purchased on behalf of the Museum by Walter M. Jeffords.

EXHIBITED: Buhler 1956, cat. 273, fig. 98; Corlette 1973, p. 92, cat. 62.

Cat. 88-1

This small item has long been labeled and published as "a salt," but it surely started out as a cream pot with a distinctly New York shape and legs. The upper edge has no finishing detail or molding—it was simply cut off—and the position of the coat of arms, correct on a taller cream-pot form, is too close to the top edge. Although curvaceous legs and feet might have been cast for use on more than one form, the legs on this vessel are the same height and design as those on a complete cream pot by Boudinot and appear extraordinarily tall for this little bowl.[1]

Annis Boudinot (the silversmith's eldest daughter) married Richard Stockton in 1758, and Elias Boudinot Jr. (the silversmith's youngest son) married Hannah Stockton in 1762.[2] The two mullets over the chevron in the Boudinot arms are derived from those of the Stockton family, which had another mullet under a chevron *vairé*.[3] Instead there is a Huguenot motif of a flaming heart.[4] BBG

1. The full, rounded shapes of the shell lobes, the sharp knees, and the graduated design of the hoof feet are exactly the same; DAPC 81.3720. See also Sotheby Parke Bernet, New York, *Property from the Collection of the Late Helen Janssen Wetzel*, pt. 1, September 30–October 1, 1980, sale H-3, lot 485.
2. The coat of arms and motto of the Stockton family were engraved on a teapot, also by Elias Boudinot, made for Richard Stockton, in the collection of the New Jersey Historical Society; Corlette 1973, p. 90, cat. 61.
3. John Matthews, *American Armoury and Blue Book* (London: privately printed, 1907), p. 227; addenda, p. 71.
4. The flaming heart was an important Huguenot motif, and here made reference to the French Huguenot origins of the Boudinots.

W. J. Braitsch & Company

| Providence, Rhode Island, 1893–1915

The company's founder, William James Braitsch (1863–1951), was born in New York City on August 18, 1863, the son of German immigrant parents.[1] He graduated from the Cooper Union and subsequently was trained as a chaser at Tiffany & Co. (q.v.), where he worked for several years and received two medals for silver design.[2]

Braitsch had relocated to Providence by 1887, when he formed the partnership of Hearn & Braitsch with John Hearn, a fellow New Yorker.[3] The firm specialized in "gold-headed canes, umbrella mountings, and novelties in gold and silver" and within five years was described as "the largest and leading manufacturers in the United States, in the[se] lines."[4] The company was primarily a wholesale supplier to retailer jewelers and maintained a sales office in New York. Initially located at 121 Broad Street in Providence, Hearn & Braitsch was, by 1892, operating in a factory at 2–12 Melrose Street that was powered by a Corliss steam engine and housed a workforce of 135 individuals in twelve different departments.[5] The company's real estate was valued at $38,880 in 1891, when Braitsch's personal property was valued at $1,000.[6]

In 1893 Hearn sold his interest to George H. Grant (1850–1921), and the firm was renamed W. J. Braitsch & Company.[7] In 1901 Grant left the partnership, and Braitsch became the sole proprietor. Continuing as a wholesale manufacturer, he built a new factory at 472 Potter Avenue that employed an average of seventy-five people per year.[8] The factory and its land apparently belonged to Braitsch himself, as the company's assets were valued at $12,000 in 1911, whereas his personal real estate holdings were valued at $33,200 and his personal property at $3,000.[9] In 1909 the company was the plaintiff in an unsuccessful suit to recover losses from an order placed by Kiel & Arthe Company, a New Jersey umbrella manufacturer, which refused to accept or pay for umbrella handles that had been delivered later than promised.[10]

W. J. Braitsch & Company appears to have closed in 1915, the last year in which it was listed in city directories.[11] In the 1915 Rhode Island State census, Braitsch himself was listed as a "mfg. Jeweler" with the status of employer, but in the 1916 Providence directory as well as the U.S. censuses of 1920 and 1930, he was recorded as having no occupation.[12] He apparently lived off other business investments, including the Crane Automobile & Garage Company, a partnership he formed with Harold C. Crane. In 1907, on the lot next to the Braitsch Company factory, Crane Automobile constructed what it heralded as the state's first fireproof garage building.[13] William Braitsch died in Providence on July 18, 1951.[14] DLB

1. 1900 U.S. Census; 1935 Rhode Island State Census, New England Historic Genealogical Society, Boston, Ancestry.com.

2. Joseph D. Hall Jr., ed., *Biographical History of the Manufacturers and Business Men of Rhode Island at the Opening of the Twentieth Century* (Providence: J. D. Hall, 1901), p. 107; obituary of William J. Braitsch, *New York Times*, July 20, 1951.

3. Hearn and Braitsch were identified as "natives of New York" in the directory *Industries and Wealth of the Principal Points in Rhode Island* (New York: A. F. Parsons, 1892), p. 85. Thus far it has not been possible to identify this John Hearn with any certainty in New York City or Providence records.

4. Ibid.

5. Providence directory 1889, pp. 265, 1120; *Industries and Wealth*, p. 85. The factory building is still standing; see "Providence Preservation Society Industrial Sites and Commercial Buildings Survey, 2001–2002," http://local.provplan.org (accessed July 6, 2015).

6. *Tax Book: City of Providence* (Providence: O. A. Carleton, 1891), pp. 47, 165.

7. "Death of George H. Grant," *Jewelers' Circular*, vol. 83 (November 16, 1921), p. 93; William Harrison Taylor, *Legislative History and Souvenir of Rhode Island, 1899 and 1900* (Providence: E. L Freeman, 1900), p. 106.

8. Hall, *Biographical History*, p. 107.

9. *1911 Tax Book: City of Providence* (Providence: What Cheer, 1911), p. 68. The 1910 U.S. census recorded that he rented his home on Adelaide Avenue, so this valuation presumably refers to the factory property.

10. *The New York Supplement (Annotated)*, vol. 114 (*New York State Reporter*, vol. 148) (St. Paul, MN: West, 1909), pp. 872–75. For the Keil & Arthe Company, see *The Trow (formerly Wilson's) Copartnership and Corporation Directory of the Boroughs of Manhattan and the Bronx* (New York: Trow Directory, Printing, and Bookbinding Company, 1909), p. 411.

11. *The Providence House Directory and Family Address Book 1915* (Providence: Sampson & Murdock Company, 1914), p. 636. By 1916 the company was no longer listed at 472 Potter Avenue; ibid. 1917, p. 738.

12. 1915 Rhode Island State Census, New England Historic Genealogical Society, Boston, Ancestry.com; Providence directory 1915, p. 161.

13. This building is still standing at 450 Potters Avenue; "Providence Preservation Society Industrial Sites and Commercial Buildings Survey, 2001–2002" (see note 5 above).

14. Polk's Providence directory 1952, p. 89; obituary of William J. Braitsch, *New York Times*, July 20, 1951.

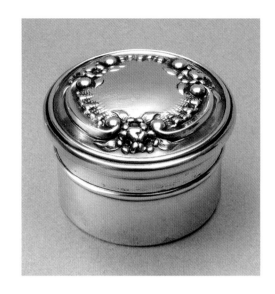

Cat. 89

W. J. Braitsch & Company
Pill Box

1893–1915
MARKS: W J B & CO (each in shield with striped background) / STERLING / 925/1000 / 73 (all incuse, on underside; cat. 89-1)
Height ⁵⁄₁₆ inch (2.4 cm); diam. 1⁵⁄₁₆ inches (3.3 cm)
Weight 6 dwt.
Museum collection, 2014-156-1a,b

Cat. 89-1

Made of thin-gauge metal with die-stamped decoration, this box is characteristic of "novelties" mass-produced by many silver manufacturers in Providence, Rhode Island, at the turn of the twentieth century. Such objects were intended to make silver affordable to a much larger number of consumers than had been possible earlier in the nineteenth century. Although Braitsch specialized in such wares, at least one water pitcher marked by the company exists with hand-chased ornament similar to the Gorham Manufacturing Company's *Martelé* line (see PMA 1976-160-1, 1984-43-1) that may have been made at Gorham for Braitsch to retail, or perhaps a chaser from Gorham was employed at Braitsch to create such luxury-market wares.[1] DLB

1. Sold by the dealers Spencer Marks, Southampton, MA; www.spencermarks.com/items/h73.html (accessed June 26, 2013); L. J. Pristo, "'Unmarked' Martelé," *Silver Magazine*, vol. 34, no. 6 (November–December 2002), pp. 30–31.

Ephraim Brasher

New York City, born 1744
New York City, died 1810

Ephraim Brasher was born in New York City on April 18, 1744, to Ephraim and Catharina Van Keuren Brasher, and he was baptized in the Collegiate Dutch Church in New York in 1744.[1] He was probably at work as a silversmith in New York City by 1765.

Craftsmen in the mid-1760s were especially affected by the political and economic consequences of the non-importation agreements, and feelings ran high on both sides.[2] Brasher was on-the-spot for one incident. On August 25, 1766, the *New York Mercury*—quoting from several formal depositions by the carpenter Theophilus Hardenbrook, John and Cornelius Berrian, Philip Will, Joseph Dwight, and Ephraim Brasher, all "of full age, being duly sworn"—described an encounter between British regulars and a small group of young men, including Brasher, gathered in the Commons to erect a notice that had been taken down the night before:

> that during there [*sic*] being there, some Person appeared in the Crowd in the Dress of a Drummer; that upon his coming up to them, several Words passed; that the first expression he understood from the said Drummer was, do you resent it, or Words to that Effect; that one Berrian replied, I do resent it; and thereupon the said drummer drew his Weapon, when some Persons who stood by, took hold of him and shoved him from the Crowd, some of which said carry him to the Mayor, others said let him go; . . . that accordingly they let him go; that soon after a Number of soldiers appeared, which he the Deponent, thought came from the Barracks, being about 50 in Number, with their Bayonets in their Hands, some drawn, and others drew them as they came up; that as soon as they came up to the Deponent and others they the said Soldiers fell foul of them by cutting and slashing everyone that fell in their Way; that the Deponent and those with him were obliged to retire for Safety; the said Soldiers pursued them as far as Chappel-Street; that several Persons were cut and wounded by the said soldiers, particularly Captain Sears and John Berrien. . . . Sworn August 12, 1766.

Soon after this event, on November 10, 1766, Ephraim Brasher married Adriaantje (Ann) Gilbert (1742–1797), sister of the New York silversmith William Gilbert (1746–1832; q.v.), with whom he would continue association throughout his life.

With whom Brasher apprenticed is not yet known, but his swords for the Revolutionary soldiers Ethan Allen and Petrus Wynkoop, and one other, "a silver mounted hanger, with a Dog's head, and green ivory grip," advertised as stolen in February 1776, as well as some domestic silver in a mid-eighteenth-century style, suggest he had an active and versatile master, possibly Charles Oliver Bruff (1735–1817).[3] Brasher does not seem to have advertised independently in New York newspapers in the 1760s and early 1770s, and his marked silver that can surely be dated before the Revolution is rare.

In 1776 the Brashers and the Gilberts removed their households to Red Hook in Dutchess County, where the Brashers' son Ephraim was baptized in 1777. In March of that year Brasher and his brother-in-law were serving in the same unit of the Revolutionary army. Brasher was a third lieutenant in Captain Abraham Van Dyck's Company of Grenadiers, belonging to Colonel Lasher's First Battalion of Independent Companies in the City of New York.[4] The Company was ordered by the New York Provincial Congress to be stationed at the house of Governor Nicholas Bayard to guard the Records of the Province removed there by the order of Congress. Brasher was recompensed £5 6s. for his service.[5]

By 1783 the Brashers were back in New York, listed at 1 Cherry Street, and almost immediately he began his service in various capacities in city politics and government. On November 18, 1783, Brasher and his brother-in-law William Gilbert were appointed to a "Committee of Exiles" to make arrangements for Evacuation Day, when the British would leave the city. The business of the committee was to design a "badge of distinction," to be worn on the day of evacuation in a procession and that would recognize those who had served in some capacity in the Revolutionary conflict: "Resolved, That, if it appears eligible, his excellency Gen. Washington (should he accompany the gov.) shall be received by the citizens drawn up in the form of a square, and in that manner conducted to his quarters." Brasher and Gilbert were among the few who were appointed to conduct the procession.[6]

In 1784 Brasher was appointed a commissioner for Montgomerie [*sic*] Ward in New York, "for the speedy & effectual cleansing of the City."[7] In August 1785 he petitioned the Common Council for permission to convert a firehouse into a place of business.[8] On October 5, 1785, the minutes of the Common Council noted:

> The Committee to whom was referred the Petition of Ephraim Brasher reported (*verbally*) that in their Opinion the granting of the Prayer thereof would not be injurious to the public or any Individual. Thereupon it was determined that the Board would grant to Ephraim Brasher the fire Engine House in St. George's Square [at the intersection of Pearl and Cherry streets] with the Ground it occupies . . . on his conveying to this Corporation an equal quantity of Ground (parcel of the Lot adjoin[ing] the said fire Engine House) and erecting thereon an Engine House equal to the present and that one of the City Surveyors survey it & make Return thereof.[9]

In 1787 there was a great deal of interest in establishing a United States coinage. Brasher, known as an assayer, had been stamping copper coins, probably with John Bailey (q.v.), a cutler and sword maker. On February 12, 1787, Bailey and Brasher petitioned the State of New York regarding their desire to set up a mint for copper coinage. On February 16, Daniel Van Voorhis (q.v.) and William Coley also petitioned a Mr. Brooks, Mr. Gallatin, and Mr. Dunlap for a grant to set up a mint.[10] New York decided not to mint copper coinage, and it is thought that Brasher, possibly with Bailey, turned again to the design and production of gold doubloons, for which he is best known.[11] The New York City directory located Brasher at 1 Cherry Street in 1786, then briefly at 77 Queen Street in 1787, at Cherry Street (various numbers) from 1789 until 1802, and finally at the end of his life, in 1809, at 350 Pearl Street.

Ephraim Brasher was identified as a member of the "Gold and Silver Smiths's [*sic*] Society" in 1786. He was a versatile silversmith producing tea ware in the style of the 1790s, tankards, and an elaborate hot-water urn in the rococo style of the 1770s.[12] He was a proficient sword maker from the outset of his career. He made one for "PETRUS·WYNKOOP·JUNR" that he marked in script "Ephm Brasher / Makr: N.York."[13] An advertisement in the *New York Journal* for February 22, 1776, described a sword "STOLEN . . . out of Mr. John Tuttle's, near Powles Hook Ferry, New York, A Silver mounted HANGER, with a Dog's Head, and green ivory grip, the grip rather small, the swell of which designed for the underside, is above. . . . On one side of the Plate of the Scabbard, is engraved in script, E·m Brasier, New-York, Maker; on the other side *Isaac Morrison*." In 1790, when his temporary residence was nearby Brasher's address at 1 Cherry Street, George Washington purchased four silver skewers for £16 and two tea trays weighing 84 and 86 ounces, respectively, for £118 16s. 6d., with a note that the payment was made in Pennsylvania currency.[14]

The U.S. census of 1790 listed Ephraim Brasher in New York City's Montgomery Ward, with a household of seven, one male age sixteen and over, two females, and four slaves. In 1790 he was elected a Sachem (leader) in the Columbian order of the Society of St. Tammany, established in 1789.[15] In 1792 Brasher became chairman of the non-subscribers to the Tammaniel Tontine Association, and in February 1792 he was appointed a commissioner of the mayor's court regarding a partition of private land.[16] In 1794 he served as an assistant justice of the peace with his brother-in-law William Gilbert. Brasher's wife Ann Gilbert Brasher died in 1797, and in December of the same year, he married the widow Mary Austin in New York.[17] While a partnership with George Alexander, formed in 1800, lasted less than a year, Brasher became a person of note in the civic life of New York.[18]

In April 1802 he was appointed by the Common Council of New York City to be an inspector of elections for the Fifth Ward, and in November 1802 he was noted as "Esq.," serving as chairman of the Republican electors of the Fifth Ward.[19] In 1803, "at a numerous and respectable meeting of the mechanics and tradesmen of the city of New York held at Adam's Hotel. . . . *Resolved*, That the petitions lately presented to the legislature for the establishment of a penitentiary, or work shop, be read." Brasher and six others signed for the Fifth Ward.[20] In May 1803 he was appointed by the Common Council as an assessor "to cause a Bulkhead to be built at the New Ship to be fitted in on a line on the South side of Water Street."[21] In 1806 he was appointed an inspector of elections in the Seventh Ward.[22] In the U.S. census of 1810 he was located in the Tenth Ward, with a household of three: he and his wife Mary, both forty-five years of age or over, and one female between sixteen and twenty-five.

A short notice of his death appeared in the *New York Spectator* of November 21, 1810: "DIED, last evening, in the 66th year of his age, EPHRAIM BRASHER, Esq."[23] BBG

1. Hofer and Bach 2011, pp. 261–62; Waters, McKinsey, and Ward 2000, vol. 2, pp. 289–90; Quimby and Johnson 1995, p. 207.

2. See the biography of Simeon Coley (q.v.).

3. Hartzler 2000, p. 170; Buhler and Hood 1970, vol. 2, p. 121, cat. 693; *New York Journal, or General Advertiser*, February 22, 1776. See the coffee urn by Brasher in John Webster Keefe, *The Antiquarian Society of the Art Institute of Chicago: The First One Hundred Years* (Chicago: the Institute, 1977), p. 157, cat. 193; and his pear-shaped tankard in Spencer 2001, p. 99, cat. 152.

4. U.S., Revolutionary War Rolls, 1775–1783, War Department Collection of Revolutionary War Records, Record Group 93, NARA, Ancestry.com.

5. Ibid.

6. *Pennsylvania Evening Post and Public Advertiser* (Philadelphia), November 28, 1783.

7. Minutes of the Common Council of the City of New York,

1784–1831, vol. 1, p. 16 (March 23, 1784), Ancestry.com.

8. Ibid., p. 166 (August 31, 1785).

9. Ibid., p. 173 (October 5, 1785).

10. *The Colonial Newsletter* (Huntsville, AL), no. 81 (April 1989), p. 1087. For William Coley, see the biography of Simeon Coley (q.v.).

11. How many he made is not known; seven doubloons survive. See Heritage Auctions, Signature Sale no. 360, January 12–15, 2005, lot 30016.

12. For a tea service, see Gebelein Silversmiths, Boston, advertisement, *Antiques*, vol. 76, no. 1 (July 1959), p. 21; tankard, Gregor N. Wilcox, "American Silver, 1690–1810," *California Collects*, January 1954, pp. 48–51; sugar urn, Buhler and Hood 1970, vol. 2, p. 118, cat. 689.

13. Buhler and Hood 1970, vol. 2, pp. 121–22, cat. 693.

14. Kathryn C. Buhler, *Mount Vernon Silver* (Mount Vernon, VA: Mount Vernon Ladies' Association of the Union, 1957), pp. 56–57.

15. *New York Weekly Museum*, May 22, 1790; Frank von A. Cabeen, "The Society of the Sons of Saint Tammany of Philadelphia (concluded)," *PMHB*, vol. 27, no. 1 (1903), pp. 41–42.

16. *New-York Journal and Patriotic Register*, February 1 and 12, 1792.

17. *New York Weekly Museum*, in U.S., Newspaper Extractions from the Northeast, 1704–1930 [database online] (Provo, UT: Ancestry.com Operations, Inc., 2014).

18. *American Citizen and General Advertiser* (New York), February 21, 1801.

19. Ibid., November 15, 1802.

20. *Chronicle Express* (New York), March 24, 1803.

21. Minutes of the Common Council of the City of New York, 1784–1831, vol. 3, pp. 276–77 (May 9, 1803), Ancestry.com.

22. *New-York Evening Post*, April 9, 1806.

23. Ephraim Brasher's will is recorded in New York, Wills and Probate Records, 1659–1999, Will Book 49, p. 119, probated December 11, 1810.

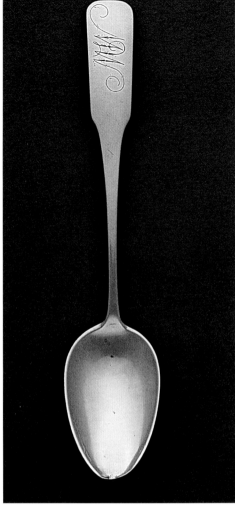

Cat. 90

Ephraim Brasher

Teaspoon

1800–1810
MARK: E B (in rectangle, on reverse of handle; cat. 90-1)
INSCRIPTION: M W (engraved script, on obverse of handle)
Length 5½ inches (14 cm)
Weight 8 dwt.
Gift of Mrs. Hampton L. Carson, 1917-134

Cat. 90-1

The mark "E B" is not a perfect strike; the base line of the "E" is not defined.[1] The capital letters have the same serifs as those in Brasher's oval mark on a 1787 doubloon.[2]

The character of this spoon, made in a single piece with a fiddle-shaped handle, is surely the product of one of the nineteenth-century spoon manufactories, probably that of Teunis DuBois, who set up a silver manufacturing enterprise in Freehold, New Jersey, and had a thriving business supplying New York silversmiths. Among his tools were a rolling mill and two spoon stamps.[3] The unusual orientation

of the initials "MW" at the top of the obverse of the handle on this spoon was typical of the Dubois manufactory.[4] Dubois and Brasher were both working in New York until 1799, when Dubois left the city. This spoon does not bear Dubois's marks. It may represent a working association between the shops in New York, or perhaps the spoon machine was at first a joint venture.

The script letters "MW," engraved inexpertly and slightly offcenter, match in calligraphic style those on a teapot and sugar bowl that Brasher made for Colonel Marinus Willett (1740–1830) in about 1797.[5] BBG

1. The spoon has been in the Museum's collection since 1917 and has previously been attributed to Elias Boudinot (q.v.), who died in 1770, much too early for him to have made a spoon in this style. The mark was published as Ephraim Brasher's in Buhler and Hood 1970, vol. 2, cat. 692, p. 277. For a clean strike of this mark, see Belden 1980, p. 73. For other "E B" marks, see Ensko 1948, p. 171.

2. "PGCS Coin Facts," www.pcgscoinfacts.com/Coin/Detail/489?redir=t (accessed February 27, 2015).

3. See Joseph W. Hammond, "John Schuyler Walter: Silversmith of Matawan, New Jersey," *Silver Magazine*, vol. 20, no. 2 (March–April 1987), p. 11; Sarah B. Heald, "'With Elegance and Dispatch:' Monmouth County Silversmiths, 1775–1864," *Silver Magazine*, vol. 20, no. 1 (January–February 1987), p. 13.

4. See Heald, "'With Elegance and Dispatch.'" Ibid.

5. Brasher's mark on the sugar bowl is "E·B" in a rectangle; Waters, McKinsey, and Ward 2000, vol. 2, pp. 291–92, cat. 136.

Claude Amable Brasier

France, born 1764[1]
Philadelphia, died 1842

Claude Amable Brasier (fig. 48) was born in France and emigrated to Saint-Domingue, where he may have served his apprenticeship as a watchmaker and jeweler. Whom he worked with or for is not yet known. Brasier's obituary published in the *Philadelphia Inquirer* on July 14, 1842, described his life as a successful craftsman and citizen:

An excellent father, a valued citizen and a faithful friend, who departed this life on Tuesday last, in the 78th year of his age. Those who knew him best esteemed him most. . . . Engaged in successful business, until induced by old age to retire, he always possessed an unblemished reputation. He never had an enemy; and all who knew him aspired to be deemed his friend. He was not only distinguished by his high sense of honor and integrity as a merchant, but also by his remarkable mildness of disposition. His home was the abode of comfort and peace. He died as he had lived, a Christian.[2]

Although his name does not appear in lists of the Société Française de Bienfaisance (French Beneficial Society) or the Société des Grivois (Society of Merry Fellows), the notice of his death placed in the *Philadelphia Inquirer* on July 7, 1842, is clear evidence that Brasier retained close connections with the French citizenry in Philadelphia: "Mort le 12, du Court, Claude Amable Brasier, age de 78 ans. Les membres de la Societe Francaise de Bien faisance sont invites a assistes a l'enterrement lequel aura hier Samedi, le 16 a 8 heures du matin, dvendu residence S 3rd Street No. 117 [Died the 12th, Claude Amable Brasier, age 78. Members of the Société Française de Bienfaisance are invited to assist at the interment on July 16 at 8 A.M. from the residence at 117 South Third Street]."[3]

Cap-Français was the main town in French Saint-Domingue and was known to be a cosmopolitan and commercially successful city. Jean-Simon Chaudron (q.v.), six years older than Brasier and a trained watchmaker, was working there in 1784. The two men may well have crossed paths before they met later in Philadelphia. Brasier took the Oath of Allegiance to the United States in

Philadelphia in 1795, vouched for by Leopold Nottingel, a merchant whose shop was at 64 North Front Street. The document was finally signed by Edward Burd on February 13, 1798.[4]

Brasier was one of roughly ten thousand French-speaking immigrants who descended, some temporarily, upon Philadelphia in the aftermath of the French Revolution and the slave revolts of 1791–93 in Saint-Domingue. Charles Maurice de Talleyrand-Périgord, Médéric-Louis-Élie Moreau de Saint-Mery, Bon Albert Brios de

Fig. 48. Charles Balthazar Julien Févret de Saint-Mémin (French, 1770–1852). *Claude Amable Brasier*, 1800. Engraving on paper, image: 2⅛ × 2³⁄₁₆ inches (5.6 × 5.6 cm), sheet: 21⅝ × 15¾ inches (55 × 40 cm). National Portrait Gallery, Smithsonian Institution, Washington, DC. Gift of Mr. and Mrs. Paul Mellon, S/NPG.74.39.6.4. Photo: National Portrait Gallery, Smithsonian Institution/Art Resource, NY

Beaumetz, Lucretius Blacon (the former marquis de Blacon), and Louis-Philippe, duc d'Orléans, were prominent émigrés who arrived about the same time as Brasier. In the years between 1785 and 1795, one out of every ten Philadelphia residents was French, and they settled in contiguous neighborhoods along Second, Third, and Fourth streets.[5] While Brasier may not have been in the social circle of the French gentry and intellectuals,[6] he was an accomplished craftsman in the jewelry line, he was one of those who established themselves in the French community, described in 1816 in a letter from William Lee to Thomas Jefferson as "sober, amiable and industrious . . . there is a degree of civilization and good manners in their social intercourse . . . and, when contrasted with their neighbors, highly honorable to them."[7] Jewelry was in fashion, and refugees from Cap-Français and France, such as Talleyrand, fled their revolutions carrying only their jewels to support themselves in America. Repairing watches and altering and selling jewelry were the basis of

Brasier's early success. His first business listing as a clock- and watchmaker appeared in the Philadelphia directory of 1794, and he was established by then and well-known as a jeweler in the French community.[8] A bill and receipt running from 1807 until 1819 for an account from Brasier to John Soullier, a French merchant at 132 Pine Street, is annotated entirely with jewelry purchases and repairs.[9]

Brasier leased part of a three-story house on the east side of North Third Street at number 7, in the High Street Ward, from Mary Warder Emlen.[10] Brasier leased the shop in the front building, and Wesley Eames, "gentleman," and Ann Eames, midwife, boarded in the back building. In 1796 Brasier moved from number 7 to number 23 North Third Street, still on the east side, in the North Ward, in an area that Talleyrand noted as "the fashionable quarter of Third Street North."[11] In 1795 John Germon (q.v.) was at number 3, the French goldsmith François Poissonier at 53, and John "Dmoute" (Dumoutet Jr.) (q.v.) at number 75.[12]

Sometime before 1799 Brasier married Elizabeth Peyrusse la Fleur, who had been born in France; the wedding was probably at St. Mary's Catholic Church on Fourth Street, north of Spruce.[13] The baptism of their son Emile Frances Brasier, born April 18, 1799, and baptized October 8, 1801, took place at St. Augustine's, the new Catholic church on North Fourth Street, and was the first baptism recorded there.[14] His sponsors were Francis Philippon and Anna Maux Peyrusse la Fleur by their proxies Joseph Louis Gaschet Delisle and Mary Peyrusse la Fleur.[15]

The U.S. census of 1800 listed Brasier still on North Third Street in the High Street Ward[16] with five people in his household: one male under the age of ten, one male between twenty-six and forty-four, one female under ten, one female between sixteen and twenty-five, and one female between twenty-six and forty-four. Their daughter Maria Charlotte Athenais Brasier was born on October 8, 1801, and was baptized on the same day as her brother Emile; and in 1804 another daughter, Amelia Emeline Margaret Brasier, was baptized at St. Augustine's on February 23.[17] Their son Amable Joseph Brasier was born in 1808. The census of 1810 shows Brasier's household at eleven persons, including; six children under sixteen and three adults over twenty-five. Brasier did have at least one apprentice, Stephen Delisle, from 1801 to 1803, until Delisle moved to Baltimore to finish his term with Lewis Poncet.[18]

Hollowware marked by Brasier is rare. The designs of his hollowware pieces are round and full. The slop bowls have wide flaring rims, and the sugar bowls have important, horizontally extended cast handles. The bodies have extra height above

the bowl.[19] His mark is on a full tea service made in about 1805 with these distinctive shapes, with added ornament in encircling bands of classical motifs and elaborate ram's-head details on the handle sockets.[20] His hollowware often bore other marks, suggesting that Brasier commissioned or retailed silver for one supplier. At least some silver tableware was made for him by John Ward Gethen (q.v.), possibly through Brasier's extensive account between 1809 and 1812 with Samuel Williamson (q.v.), from whom he purchased hollowware and paid with cash and old silver.[21] Brasier remained on North Third Street for eighteen productive years as a jeweler. In 1810 the silversmith George Walker was next door at number 19, and John Tanguy (q.v.) was next but one at number 33.[22]

In 1813 or 1814 the Brasiers moved to 12 South Third Street in the other predominantly French neighborhood, where Talleyrand had first rented in 1794, where in December 1799 Charles de Saint-Mémin lived, and where Chaudron had his silver shop.[23] Saint-Mémin engraved Brasier's portrait there in 1800 (fig. 48).[24] On November 7, 1818, Brasier and his wife Elizabeth witnessed the marriage of Antoine Joseph Chauveau, an accountant at 26 Powel Street, and Jeanne Cecile Lauzan.[25]

As a jeweler Brasier was commissioned by the English population as well as the French, which allowed him to survive the financial pressures before and after the War of 1812. La Roche-foucauld-Liancourt's phrase described the scene: "it did not matter . . . if you were a philosopher, priest, man of letters, prince, or prime tooth puller . . . all doors were open to the immigrant and hostesses vied for their company."[26] Brasier had a running account with William Meredith and his wife from 1813 through 1815 repairing jewelry, earrings, combs, a medallion with a gold cipher "ETM," an amber necklace, a topaz and pearl breast pin, a hair necklace, carnelian earrings, and more.[27] In January 1813 Benjamin Rush patronized him.[28] In 1816 John Hamilton paid him $5 for "sundries."[29] Although usually identified as a jeweler or clock- and watch-maker, Brasier was called "goldsmith" in 1813 when acting as a trustee for Chaudron.[30] In November 1819 he was listed as a director of the Mechanics Bank, in which he owned stock at his death.[31]

In 1820 Brasier was living on the south side of Spruce Street between Third and Fourth streets, noted as 117 South Third, still in a French community. He purchased a large, handsome house built in 1796 by William Marshall (1739–1802), pastor of the Scot's Presbyterian Church.[32] The U.S. census of 1840 noted six people in Brasier's household, which included two free colored persons. Brasier remained there until his death in 1842. The city directory notes that his widow was there in 1843.[33]

In the 1820s Brasier began to diversify his business, investing in real estate and acting as an agent for others. In 1822 Charles Bird, hardware merchant, sold to Brasier for $1,000 a piece of ground in an important location between High (Market) and Chestnut streets, and Delaware Third and Fourth streets, bounded on the north by other ground belonging to Charles Bird and on the east by ground already belonging to Brasier.[34] In 1828 he purchased 108 South Fourth Street, and in 1829 he purchased property on the west side of the Schuylkill River at 3112 Market Street. He insured that property, a two-story brick house and two-story kitchen with a store in front, with the Franklin Insurance Company. In 1830 his son Amable Joseph advertised it "To Let," as "a large building, suitable for a factory, with stone Dwelling and a garden attached; one mile West of the city on Market Street. . . . There is at present a steam engine on the premises. Apply to Amable J. Brasier." In J. D. Scott's *Atlas* of 1868, this property is still labeled "Mrs. Brasier."[35]

In 1833 and 1834, in the interests of his father, Amable Joseph was traveling and acting as a real estate agent on behalf of Colonel James Thomas, then in Bangor, Maine, and a General D. Parker of Philadelphia, who were interested in land with a partially worked lead mine. Amable Joseph was to ascertain whether this land, which had belonged to the Spanish government and then to a Moses Austin, had clear title. He recommended not pursuing the purchase and then returned to St. Louis "by the first steam boat."[36] When he returned from "western lands," he became a wine merchant and was listed in Philadelphia directories from 1833 through 1836 as a "Distiller" at 32 Chestnut Street and, in 1835 and 1836, as "Dist Wine" at 63 South Front Street. At the same time Claude Amable Brasier was adding to his real estate interests and expanding into general imports. Renting his earlier location, "the house and store, No. 12 South Third Street," the elder Brasier established an office at 32 Chestnut Street and advertised "Prime New Orleans Sugar and Fresh Prunes."[37] In 1833 he purchased from Ann White, widow of Robert White, a large piece of ground on South Bedford Street in Moyamensing Township.[38] By 1842 it had eight brick houses on it.

Claude Amable Brasier wrote his will on May 18, 1842, and left to his widow Elizabeth all his property and household goods; his house at number 117, "East side of the Delaware Third Street"; a vacant lot between Spruce and Walnut streets; and the ground rent from the Mechanics Bank on the west side of Delaware Third Street between High and Chestnut. In a series of deeds involving his wife and children—his two daughters, Maria

Charlotte Athenais and Mary Elizabeth (both single), and four sons, Emile, Francis, Amable Joseph, and John Felix—the estate was eventually divided into five parts.[39] Frederick Thibault (q.v.) did the inventory of the estate.

Amable Joseph Brasier served as executor for his father.[40] In 1845 he was listed as a "gentleman," living with his mother and two sisters at their house at 117 ½ South Third Street.[41] He was elected captain of the Irish Volunteers of the Patterson Guards attached to the First Regiment Volunteer Infantry, First Brigade, First Division, on August 20, 1849. The company held regular drills on a parade ground. The flag-staff finial long attributed to Claude Amable Brasier was made and inscribed for his son Amable Joseph by an as yet unidentified silversmith (PMA 1972-48-1). By 1858 the Brasiers had moved to Market Street near Till, in West Philadelphia, at the property his father had purchased in 1829.[42] Amable Joseph moved back to 271 South Third Street before he died, unmarried, on June 9, 1877.[43] He was buried two days later at St. Mary's Roman Catholic Church in a vault in the South Yard.[44] Mrs. Elizabeth Brasier resided with her two unmarried daughters, Maria Charlotte Athenais and Mary Elizabeth, at "Market Street below 41st Street," where Elizabeth paid federal income tax in 1862 and the daughters in 1865.[45] Elizabeth Brasier died on November 5, 1864, in West Philadelphia. By 1866 Maria Charlotte and Mary Elizabeth had moved to Exton in West Whiteland Township, Chester County, where together they were taxed in 1866 on their income and a carriage, and Mary Elizabeth was taxed for a gold watch.[46] In 1873 Mary Elizabeth was noted as owning property there near the Lancaster turnpike.[47] An unnamed descendant made a contribution to St. Joseph's Hospital, on January 4, 1907, in the names of Mr. Claude Amable Brasier and Mrs. Elizabeth Peyrusse Brasier, each for $5,000.[48] BBG

1. Brasier was seventy-eight in 1842 when he died; *North American* (Philadelphia). July 14, 1842; hence the birth date here of 1764, instead of the previously published date of 1766. A birth date of 1764 is also listed on his death certificate; Philadelphia Death Certificates Index, 1803–1915, Ancestry.com. In records of the L'Amenité Lodge of French Masons in Philadelphia, he was noted to be thirty-eight in 1803; Ellen G. Miles, *St. Mémin and the Neoclassical Profile Portrait in America* (Washington, DC: National Portrait Gallery, 1994), p. 252, cat. 81.

2. The obituary, signed "N," was probably written by a member of the L'Amenité Lodge or the Société Française de Bienfaisance; Brasier belonged to both.

3. "The French in Philadelphia," Francis James Dallett Papers, 1853–1997, HSP.

4. The petition stated: "That your petitioner is a native of France and that your petitioner resided within the limits and under the jurisdiction of the United States . . . that he hath resided two Years at least within [left blank]." No age or date of arrival was given in Brasier's petition, but it is noted that he entered the United States at Philadelphia. Supreme Court Naturalization Papers, 1794–1908, no. 9291, Pennsylvania Historical and Museum Commission, Harrisburg, Ancestry.com.

5. See Earl 1967; Frances S. Childs, *French Refugee Life in the United States, 1790–1800* (Baltimore: Johns Hopkins Press, 1940), pp. 103ff.

6. Earl 1967, p. 291; "The French in Philadelphia," Dallett Papers.

7. Kent Gardien, "The Splendid Fools: Philadelphia Origin of Alabama's Vine and Olive Colony," *PMHB*, vol. 104, no. 4 (October 1980), p. 491.

8. "Brasier Amable, watchmaker, 7, No. Third St"; Philadelphia directory 1794, p. 16. Thus, Brasier was working by 1793 when the information for the directory was collected.

9. Stanley B. Ineson Collection, Department of American Art, Yale University Art Gallery, New Haven. John M. Soullier, merchant, was established at 132 Pine Street from 1816 to 1822 and retired to 132 South Fifth Street in 1828; Philadelphia directories, 1817–24.

10. Copy of original survey from the unpublished second volume of surveys of the Mutual Assurance Company, policy nos. 1020, 1021 (curatorial files, AA, PMA); and Anthony N. B. Garvan, *The Architectural Surveys, 1784–1794* (Philadelphia: Mutual Assurance, 1976), pp. xiv–xv.

11. *Philadelphia Gazette*, April 21, 1796. Talleyrand moved there after his visit to New York. The descriptions ended with "but it has at the end of it a wretched blind alley"; Earl 1967, p. 291.

12. Philadelphia directory 1795, p. 145.

13. The only Peyrusse in the Philadelphia directories was a tailor, Arnoud Peyrusse, listed from 1813 through 1824 at 156 South Fourth Street, at the corner of Fourth and Spruce, and 57 Union Street. Old St. Mary's Catholic Church and St. Joseph's were one congregation until 1820, on Fourth Street just north of Spruce; Scharf and Westcott 1884, vol. 2, p. 1372.

14. The cornerstone of St. Augustine's was laid in 1796, and the church began serving its parish in 1801; ibid., vol. 2, pp. 1376–77.

15. "De Lisle L. G [sic]. merchant 179 S Fifth"; Philadelphia directory 1804, p. 57.

16. The censuses of 1800 and 1810 placed him at this address.

17. *Records of the American Catholic Historical Society of Philadelphia*, vol. 13 (1902), pp. 361, 370; St. Augustine's Church, Sacramental Registers of Marriages and Baptisms: Marriages, 1810–1830; Baptisms, 1801–1810, p. 83, HSP. Amelia died in 1837, and the funeral departed from her father's residence at 117 South Third Street; death notice of Amelia Brasier, *Poulson's American Daily Advertiser* (Philadelphia), February 9, 1837.

18. Philadelphia Records of Indentures and Marriages, 1800–1808; Goldsborough 1983, p. 43. Brasier's friend Joseph Louis Gaschet Delisle was listed in the Philadelphia directory of 1804 (p. 57) as a merchant at 179 South Fifth Street.

19. These pieces also bore an eagle head used by William Seal (q.v.); Gebelein Silversmiths, Boston, advertisement, *Antiques*, vol. 84, no. 6 (December 1963), p. 646. For a plainer set but with the same design for handles and flaring bowls, see Christie's, New York, *Highly Important American Furniture, Silver, Paintings, Prints, Folk Art, and Decorative Arts*, January 16, 1998, sale 8840, lot 106.

20. The initials engraved are "EPC." Pierre Chouteau was born in New Orleans. The family moved to St. Louis, where Chouteau became hugely wealthy in the fur trade with the Indians. The tea service may have been ordered about 1804 at the time President Jefferson appointed Chouteau an agent for Indian affairs. Images and information courtesy of Anne Woodhouse, senior curator, Missouri Historical Society, St. Louis.

21. Samuel Williamson Papers, Daybook, January 1, 1803–July 28, 1810, p. 344, Downs Collection, Winterthur Library.

22. Philadelphia directory 1813, n.p.; Chaudron and Saint-Mémin were listed at 16 South Second, at the corner of Spruce; Earl 1967, p. 291. In 1811 Chaudron and Rasch opened their new store at 9 South Third; *Democratic Press* (Philadelphia), January 4, 1811.

23. Miles, *Saint-Mémin and the Neoclassical Profile Portrait in America*, p. xv.

24. Ibid., p. 252, cat. 81.

25. "Marriage Register 1818," *Records of the American Catholic Historical Society of Philadelphia*, vol. 20 (1909), p. 158.

26. Earl 1967, p. 289.

27. Brix Files, Yale University Art Gallery.

28. Benjamin Rush, Receipts, Benjamin Rush Papers, 1807–13, Library Company of Philadelphia.

29. John Hamilton, Receipts, 1814–33, HSP. Also in 1816 Brasier was called with Charles Villar to "affirm" the will of Seraphin Merdier of Pottsgrove; Philadelphia Will Book 6, no. 36.

30. As one of the trustees for Simon Chaudron and his wife Jeanne Genevieve, December 4, 1813; Philadelphia Deed Book IC-26-624.

31. *Franklin Gazette* (Philadelphia), November 15, 1819.

32. Mutual Assurance Co. Papers, insurance policies nos. 591, 592, February 1820, HSP. Brasier used this address when operating as an agent for the estate of Robert Peter Branu, "late of the City of Philadelphia deceased"; *Philadelphia Inquirer*, November 27, 1830. Brasier had a resurvey in 1820 of "a new two story Brick kitchen adjoining & communicating with his three story brick house No. 118 on the South side of Spruce . . . dimensions 12 feet by 16 feet . . . an ash hole with a two story brick kitchen, North a two story Brick Back Building, Water plenty."

33. See also Philadelphia directory 1843, p. 29: "Brasier, Elizabeth, 117 S 3d."

34. The property was bounded on the south by Samuel Bettle's land and on the west by ground "formerly of Benjamin Loxley & wife Gina"; Philadelphia Deed Book, I-H-6. For Charles Bird, see the biography of Joseph Bird Jr. (q.v.).

35. This may originally have been purchased as investment property, but his wife was resident there in 1858; Franklin Fire Insurance Company of Philadelphia Surveys, HSP. The building was later occupied as a flour, feed, and hay store. In 1878 the area was called the Bridgehead Commercial Corridor; illus. in *1878 Atlas of 24th and 27th Wards, West Philadelphia* (Philadelphia: J. D. Scott, 1878).

36. Daniel Parker Papers, c. 1792–1848, box 11, Incoming Correspondence, January–February 1833, HSP. He corresponded with his father and friends from St. Louis. It was perhaps Pierre Chouteau (see note 20 above) who had commissioned a full silver service from Claude Amable Brasier about 1810.

37. *Philadelphia Inquirer*, June 19 and December 6, 1830; December 16, 1831.

38. Sale by Amable Brasier et al. to Marie Elizabeth Brasier, Philadelphia Deed Book, RLL-19-466.

39. The whole was valued at $4,620 when recorded in April 1844; Philadelphia Mortgage Records Deed Book (1842–45); Philadelphia Deed Books RLL 19-466 and RLL-21-106.

40. Will of C. A. Brasier, written May 18, 1842, probated July 20, 1842, Philadelphia Will Book 15, no. 184, p. 643; Philadelphia directories 1860–64. The estate was summarized by his widow Marie in November and December 1843; Philadelphia Orphans Court Records, book 38, 1842–43, no. 37, p. 590.

41. Philadelphia directory 1845, p. 37; 1851, p. 42.

42. Till Street was in West Philadelphia; "Plan of the Western Portion Hamilton Village," as laid out March 1851, surveyed by James Miller, engraved by P. S. Duval, Philadelphia, courtesy of Philadelphia City Archives, West Philadelphia Community History Center, www.archives.upenn.edu/histy/features/wphila (accessed June 3, 2015). The ages in the 1860 census do not correspond with the birth dates in church records: Elizabeth Brasier, age seventy; Athena, forty; Amable J., forty; Elizabeth, thirty; Joanna Kelley, twenty; Nora Dougherty, thirty.

43. Philadelphia Death Certificates Index, 1803–1915, Ancestry.com.

44. St. Mary's Roman Catholic Church (Manayunk, Philadelphia) Records, 1849–1976, HSP, Ancestry.com; *Philadelphia Inquirer*, November 7, 1864.

45. Records of the Internal Revenue Service, Pennsylvania, 1862 and 1865, Record Group 58, NARA, Washington, DC, Ancestry.com.

46. Ibid.

47. Probably the property shown in the 1878 atlas (see note 35). See also Various Publishers of County Land-Ownership Atlases, Library of Congress, Washington, DC, map no. 17, Ancestry.com.

48. Robert B. Cruice, "List of Endowed Beds," *Annual Report of St. Joseph's Hospital . . . for the Year Ending December 31st, 1911* (Philadelphia, 1912), p. 78.

Cat. 91

Claude Amable Brasier
Sugar Tongs

1812–20

MARK: A·BRASIER (in rectangle with rounded ends, on reverse of one arm; cat. 91-1)

INSCRIPTION: C L (engraved script, at top of handle)
Length 6 inches (15.2 cm); top width 7/8 inch (2.2 cm)
Weight 1 oz. 5 dwt. 16 gr.
Gift in memory of Eugene Sussel by his wife Charlene Sussel, 1991-98-25

PROVENANCE: From the stock of Philadelphia antiques dealer Eugene Sussel (1913–1989), the donor's husband.

Cat. 91-1

These plain spring tongs with especially deep, round, fluted nippers may have been made by Brasier or by one of the silversmiths from whom he purchased items, perhaps John Ward Gethen, whose marks sometimes accompany Brasier's, or Samuel Williamson, with whom he had an account (q.q.v.).[1] BBG

1. For other objects with Brasier's and Gethen's marks, see the description of a mustard spoon with a *Fiddle*-pattern handle, marked "A·Brasier" in a rectangle and incuse "IWG," offered c. 1980 by T & R Yonge, Cambridge, Massachusetts; and an image of *Fiddle*-pattern tongs marked "A·Brasier IWG," offered by Imperial Half Bushel, Baltimore, April 28, 2009, inv. no. 1479-62.

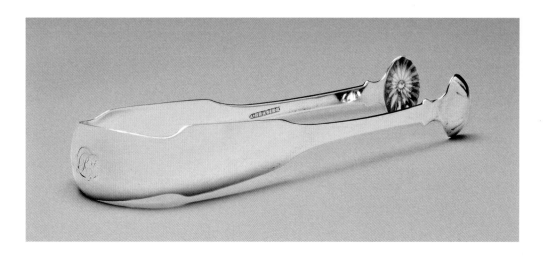

Anthony Bright

Chester, Pennsylvania,
or London (?), c. 1710
Philadelphia, died 1749

Anthony Bright placed rare public notices about his work or civic life, and facts about him are rare. He was active by 1733, when he owed Cesar Ghiselin (q.v.) £2 15s.[1] In September 1739 he placed an advertisement for a reward for the return of Stephen Draper, his servant who had run away.[2] He witnessed the will of Edward Fretwell in January 1741.[3] His interactions with the Ghiselins, Joseph Richardson Sr., and Philip Syng Sr. (q.q.v.), and the few pieces of silver known and marked by him suggest he had a full apprenticeship.

Anthony Bright may have been the son of Thomas Bright, a prominent landowner in Chester, Delaware Township, who was active there in 1715 and named his oldest son Thomas. Anthony Bright married three times, first to Mary Todd about 1732, second to Mary Emmet (Hemmet) on June 23, 1739, and finally to Jane Hobart (Hobard) on February 5, 1743, all at Christ Church.[4] Mary Todd Bright died about 1738, and Mary Bright was buried at Christ Church July 31, 1742.[5] Anthony Bright had several children: Thomas (1734–1751), James (died 1768), Katherine (died 1741), Anthony (1738–1742), and Jane (baptized July 21, 1742–1751).[6]

By 1739 Anthony Bright, silversmith, had established his residence and shop on Second Street, "a little below the Church [Christ Church]," at the center of commercial Philadelphia.[7] He does not seem to have advertised his skills although he did work independently. He had a running account with Joseph Richardson Sr., with whom he exchanged the materials of their craft, such as iron crucibles, as well as finished products throughout the 1730s.[8] From linen to cash, pieces of coral, bushels of coal, spurs, salvers, and buckles, Richardson's accounts record the debit and credit exchanges between the two men. In 1734 Bright made a snuff box and a salver for Richardson, purchased coral, and borrowed cash. In 1736 Richardson gave Bright a pepper box, spurs, linen, and cash in exchange for stay hooks, stock buckles, and cash. In 1739 Bright "borrowed" the skills of Richardson's journeyman silversmith Randall Yeaton for four days, which cost Bright 10s.[9]

Yeaton became part of the Bright family when he married Anthony Bright's sister Jane (died 1744). They too were members of Christ Church, where their two children were baptized, both at the age of one, Elizabeth on April 10, 1737, and James on February 24, 1741.[10] After Anthony's death his third wife, Jane Hobard Bright, employed Yeaton, as noted in her will (see below). The Yeaton family names suggest that the silversmith Randall Yeaton was somehow related to a Yeaton family in New Hampshire and Maine who were early settlers, seafarers, fishermen, and merchants. John Yeaton (1682–before 1757) married Elizabeth Randall (c. 1682–after 1765), daughter of James Randall of New Castle, Rockingham County, New Hampshire. A Katherine Randall (born c. 1700), Elizabeth Randall Yeaton's first cousin, married Samuel Yeaton.[11] Randall Yeaton's wife Jane died in 1744.

When Anthony Bright wrote his will on October 1, 1749, he was survived only by his third wife, Jane, and two young sons, Thomas and James, both by his first wife, Mary Todd Bright. Anthony Bright died in August 1749. His executors were his wife Jane and "Joseph Richardson, silversmith, my trusty friend."[12] The will specified that if his wife was dead, his estate should be handled by his brother-in-law Henry Lurman, a lapidary in London. At the time of his death in August 1749, Anthony Bright "silversmith" specified that all plate, bills, bonds, book debts, goods, chattel, and estate (he owned four acres and ten perches of ground in the Northern Liberties) be left "to beloved wife Jane and two children, Thomas and James to be divided between them." At this date both his children were underage. On October 26, 1749, the "widow Bright" and "Mr. Joseph Richardson, silversmith," placed an advertisement in the *Pennsylvania Gazette* for Bright's Northern Liberties land: "To be let for a term of years . . . 4 acres and ten perches one half grubb'd and clear'd. There is a run of water goes through it; it is fenced with good cedar post and rails, and has a good gate." A manuscript note entered in the margin of Bright's will indicates that Joseph Richardson Sr. took up the executorship in 1752 after Jane's death.

On June 29, 1751, Thomas Bright, Anthony Bright's son by his first wife, Mary Todd, was buried at Christ Church. Thus, when Anthony's wife Jane wrote her will on October 1, 1751, her stepson James was the only descendant mentioned.[13] The will was probated on October 15, and she specified as executors Philip Syng Jr. (q.v.) and William Lawrence, shopkeeper. She left the family silver to James:

one silver tankard and one silver cann, a silver tea pot, two silver porringers and one cream pot, one silver stand for a tea pot, the large silver spoons, six silver tea spoons, one pair of silver tea tongs, a silver salt and a silver pepper box, and all the tools belonging to the silversmith trade. If he do learn, but if he declines the said trade when of age fit to go apprentice, my will is that my sd [said] executors do sell tools and that they be deposited in their care . . . and I give unto Randall Yeaton all and whatever he is indebted unto me and as for the residue of my plate, goods, chattel & effects, sell for the benefit of my son-in-law for his education. . . . If son in law [James] dies, all unto Philip Syng and William Lawrence, house to William Gisling, silversmith, I now live in, to rent as long as my lease runs on the condition that he employ said Randall Yeaton in the same manner he is now employed by me.

She lists as friends Randall Yeaton (Yetton) and William Gisling (Ghiselin; q.v.); as witnesses, Benjamin Hooten, Joseph Johnson, and Randall Yeaton. On November 14, 1751, William Ghiselin advertised in the *Pennsylvania Gazette* that he had moved into the premises formerly occupied by Anthony Bright on Second Street.

James Bright, son of Anthony and Mary, did not become a silversmith. A Quaker, he was listed as a "hatmaker" with his shop on Strawberry Alley.[14] His will included a long list of beneficiaries, civic and personal—among them, the Monthly Meeting of Friends in trust for clothing of poor apprentice boys, the Pennsylvania Hospital, the Overseers of the Poor, poor prisoners of the Philadelphia jail—but no members of the Bright family. His bequests included silver that had been bequeathed to him by his stepmother Jane: a tankard, a teapot and stand, spoons, porringers, a cream pot, tongs, and a pepper box, some of which he bequeathed in turn: "To Mary Dorsey, daughter of Benedict Dorsey, my 2 silver porringers & to her sister Abigail, my two silver salts."[15] BBG

1. Harrold E. Gillingham and Wm. Ghiselin, "Cesar Ghiselin, Philadelphia's First Gold and Silversmith, 1693–1733," *PMHB*, vol. 57, no. 3 (1933), p. 249.

2. "Run away on the 16th instant from Anthony Bright of this City, Silversmith, a Servant Man named Stephen Draper, about 27 Years of Age, middle Stature, well set, long Visage, long Nose, and long Chin, has a Scar on right side of his Cheek: Had on a dark brown Drugget Coat lin'd with brown shalloon and with mohair Buttons, brown Holland Jacket and Breeches, new grey worsted Stockings, good shoes, Felt Hat, and white Cap. Whoever takes up and secures the said Servant so that he may be had again, shall have Three Pounds Reward, and reasonable Charges paid by Anthony Bright, Philad. Sept. 20, 1739." *Pennsylvania Gazette* (Philadelphia), September 13–20, 1739.

3. Will of Edward Fretwell, January 1741, Philadelphia Will Book, F.277, no. 284.

4. *Pennsylvania Archives*, 2nd ser. (1896), vol. 8, p. 29.

5. Charles R. Hildeburn, comp., "Records of Christ Church, Philadelphia. Burials, 1709–1769 (Concluded)," *PMHB*, vol. 7, no. 3 (1883), p. 345. The will of Sarah Todd probated November 3, 1743, includes the following note: "cousin Thomas Bright son of Anthony Bright by his former wife not late Aunt [with reference to Mary Emmett Bright]"; Philadelphia Will Book P, p. 75.

6. Charles R. Hildeburn, comp., "Records of Christ Church,

Philadelphia. Baptisms," *PMHB*, vol. 14, no. 4 (1891), p. 429; Hildeburn, comp., "Records of Christ Church, Philadelphia. Burials," *PMHB*, vol. 1, no. 4 (1877), p. 464. The dates in these sources suggested the life dates for the silversmith.

7. Gillingham and Ghiselin, "Cesar Ghiselin," p. 255.

8. Fales 1974, p. 288.

9. Ibid., p. 66. Although sometimes spelled Yetton, it is Yeaton in family and Philadelphia tax records; 1754 Tax on Inhabitants, Historic Pennsylvania Church and Town Records, HSP. Randall Yeaton was listed as a freeholder and inhabitant of the North Ward in 1754, and noted as having paid 10d. for the paving tax of 2d. on the pound and 6s. per head. Yeaton's occupation was not noted in this tax list, although it was for most other residents, e.g., John Winter, painter, 20d. Later, in 1756, still in the North Ward at the Bright's residence, Yeaton was probably working with William Ghiselin (q.v.), who had inherited the house. His estate was valued at £10; Hannah Benner Roach, *Taxables in the City of Philadelphia, 1756* (Philadelphia: Genealogical Society of Pennsylvania, 1990), p. 37. Until 1785 the boundaries of the North Ward were Second Street on the east, High (Market) Street on the south, Seventh Street on the west, and Mulberry (Arch) Street on the north.

10. Charles R. Hildeburn, comp., *Baptisms and Burials from the Records of Christ Church, Philadelphia, 1709–1760* (1982; Baltimore: Clearfield, 1995), p. 108.

11. There were Yeatons in Philadelphia church records midcentury, but the family history does not include a Randall Yeaton in Philadelphia; kristinhall.org/fambly/yeaton/ YeatonRegister Report.pdf (accessed April 4, 2016).

12. Will of Anthony Bright, October 1–15, 1751, written July 14, 1749, probated August 3, 1749, Philadelphia Will Book J.433, no. 94, p. 156.

13. Will of Jane Bright, Philadelphia Will Book J, no. 277, p. 433.

14. Kenneth Scott, *Genealogical Data from Colonial New York Newspapers: A Consolidation of Articles from the New York Genealogical and Biographical Record* (Baltimore: Genealogical Publishing, 1977), p. 41.

15. Will of James Bright, Philadelphia Will Book O, no. 345, written December 12, 1768, probated March 11, 1769.

Cat. 92

Anthony Bright
Cream Pot

1740

MARK: AB (in rectangle, on underside; cat. 92-1)
INSCRIPTION: H·O (engraved, on underside)
Height 4¼ inches (10.8 cm), width 4⁵⁄₁₆ inches (11 cm)
Weight 5 oz. 11 dwt. 3 gr.
Bequest of R. Wistar Harvey, 1940-16-707

PROVENANCE: The first leg of the first engraved letter ("H") is almost erased. In any case, the initials note the ownership by Hannah Owen (1720–1791), who married John Ogden (died 1742) in 1740. They had one son, William (1742–1818), to whom Hannah left "my silver tankard."[1] After John Ogden died Hannah remarried, to Joseph Wharton (1707–1776), in 1752. Their daughter Rachel Wharton (1762–1836) married William Lewis (1748–1801) on December 13, 1781; their daughter Hannah Owen Lewis (1795–1857) married Richard Wistar (1790–1863) in 1824. The cream pot descended to their daughter Rachel Lewis Wistar (1828–1893), who married Alexander Elmslie Harvey on May 24, 1865, and it descended to their son R. Wistar Harvey (1868–1939), the donor.[2]

Cat. 92-1

The mark on this cream pot is distinguished by the V-shaped serif joining the legs of the "A," and it is attributed to Anthony Bright, who advertised that he was opening shop in 1739.[3] This pot looks exactly like others by Philadelphia silversmiths of the period that have segmented splayed legs with trifid feet and an especially round, low belly. The edge of the deep pouring spout has a shaped, curved, and notched upper edge.[4] BBG

1. Thomas Allen Glenn, "Owen of Merion," *PMHB*, vol. 13, no. 2 (July 1889), pp. 168–83.
2. For other silver in the Museum's collection that descended in this family, see William Hollingshead, tray (1940-16-698) and cann (1940-16-695); Edward Lownes, spoon (1940-16-705); Joseph Lownes, canns (1940-16-696,697), fish slice (1940-16-703), ladle (1940-16-706), and spoons (1940-16-708a–f); Johannis Nys, brazier (1940-16-700); Joseph Richardson Sr., cann (1940-16-694); and Joseph junior and Nathaniel Richardson, cream pot (1940-16-701).
3. In his manuscript notes Maurice Brix attributed this mark and this cream pot to Anthony Bright; Brix Files, Yale University Art Gallery.
4. It is very similar to cream pots by John Bayly Sr. or Jr. (cat. 67), John Leacock (PMA F1902-2-46), and Philip Syng Jr. (PMA 1959-2-2). It also resembles a cream pot made by the New York City silversmith Adrian Bancker; Buhler and Hood 1970, vol. 2, cat. 632.

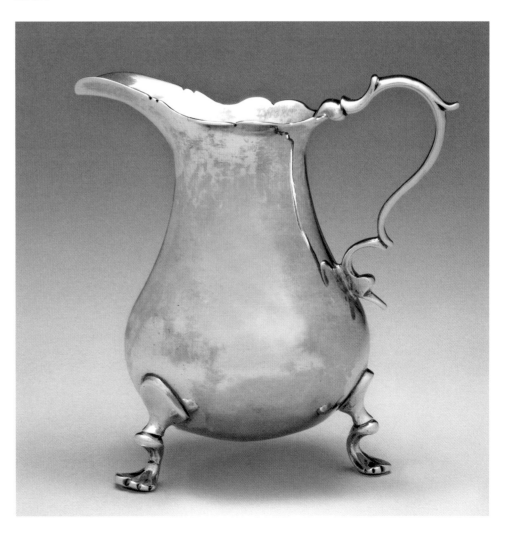

Michael Brothers

| Philadelphia, active c. 1758–79

Michael Brothers must have reached his majority no later than the mid-1750s. In the surviving volume of his account book, William Ball (q.v.) kept a day-to-day account of his commercial transactions; Michael Brothers was noted as having account number 151, carried over from an earlier journal.[1] In March 1759 Brothers was entered as "Dr to 1 pr shoe chapes . . . £0.1.0." Further entries show him purchasing from Ball regularly from 1759 as "Dr to stock" and for a variety of materials, including coral beads, a gown pattern, a pair of blankets, a spotted rug, checkered handkerchiefs, and 3 dwt. of gold.[2]

Brothers's purchase from William Ball in 1759 of a gown pattern and textiles—"3 1/2 yards claret colored cloth, 1 1/4 yards Blue [ditto]"—suggests that the Michael Bruder (Brother) who married Ilse (Alice) Finck at the Dutch church of St. Michael and Zion on September 30, 1759, was the silversmith.[3] Alice was Dutch, and Germanic spellings were used throughout the early marriage registers of St. Michael's. This is the only instance where Michael Brothers's name appears in a Germanic version.[4] He was a contributor to St. Paul's Anglican Church in Philadelphia. Silversmith William Young (q.v.), who also had an account with William Ball and who married Michael Brothers's sister, was an active member of St. Paul's in 1761 and 1762.[5]

William Ball was paying Michael Brothers regularly: September 18, 1760, £7; February 17, 1761, £8; March 1761, £3 and 1s. 16d. Then on April 10, 1762, Brothers presented his account to Ball "for work done to this day," amounting to £86 16s. 2d. On the same day Ball's entry noted, "Michael Brothers Dr. to cash paid him in full £42.18.4." That is the last entry in this journal for Michael Brothers.[6] The large amount for "work done" and the finality of "paid him in full," suggests that Brothers had been a regular supplier if not full journeyman for Ball, and that one or the other may have terminated the account.

In 1763 Michael Brothers was located at the upper end of South Second Street close to Market Street in the Chestnut Ward. In August 1763 Brothers purchased from the sale of the estate of Philip Hulbeart (q.v.) a parcel of punches for 10s., a pair of seals and a set of weights in a box for £3 10s., and in September a pair of large seals and two sets of weights for £3.[7] The estate sale was administered by Joseph Richardson Sr. and Philip Syng Jr. (q.q.v.).[8] From this time Brothers may have begun to work as an independent silversmith or in some capacity for Philip Syng, who lived in the Chestnut Ward. In the tax of 1769 Syng's assessment noted he "had £32 of Michael Brothers NW [North Ward]."[9] Syng owned on ground rent (£1 10s.) one of two properties in the North Ward owned by Samuel Shoemaker, who was then living in Southwark.[10] Whether the taxable amount Syng had from Brothers was an annual lease for the above property, a credit for work done, or both is not specified. However, from then on Michael Brothers began to advertise with a notice that he had moved "next door to Mr. Benjamin Hooten's, hatter," on Second Street between Market and Arch, in the North Ward.[11] In the proprietary tax of 1769, Brothers was listed as a "goldsmith" in the North Ward, without estate value or a per-head tax.[12] By March 13, 1772, he had a servant, probably an indentured journeyman, and was taxed on this "property" at £1.[13] Brothers advertised then that he would be willing to take an apprentice.[14] He took on two: The first, on January 26, 1773, was James Black with the consent of his father Daniel to be taught the silversmith's trade, and to read, write and cypher, for thirteen years, eight months, and twenty-one days. On March 6 of the same year, Brothers took on John Wagg with the consent of his father, who was also a silversmith and clockmaker, to be taught the silversmith's trade for four years, two months, and twenty-four days, to have three-quarters' night schooling, and to have £5 6s. in lieu of Freedom dues.[15]

Syng had retired in 1774 and moved out of town to Merion and must have sold his interest in the North Ward property, as Michael Brothers was now leasing it from Jonathan Dilworth, grocer. Described by Brothers in his advertisement of 1772 as "next door" to Benjamin Hooten, there was another small property next to him, also owned and leased from Shoemaker by a John Andrew Messersmith on ground rent of £3 8s. 9d. Brothers was listed through 1774 in the North Ward without any estate value or occupation tax.[16] In the 1774 tax in the same location, Michael Brothers and Thomas Bennet were listed with no taxes. Listed next was Edmund Milne (q.v.), with "two servants" at £46 19s. 6d., suggesting that Brothers and Bennet may have been working in Milne's shop.[17]

Between 1776 and 1779 Philadelphia was the center of the Revolutionary War tumult, especially regarding the resident Loyalists. Michael Brothers did not sign the non-importation agreement in 1765,[18] nor did he sign the Petition of Citizens presented to the occupying British in 1777–78 that would permit the circulation of colonial currency.[19] His name does not appear in deed records as grantor or grantee between 1760 and 1800. There is no mention of *non juror* in records relating to Michael Brothers to suggest that he was a Loyalist.[20] An investigation into military records came up empty. His landlords and neighbors Samuel Shoemaker and Benjamin Hooten, and his friend William Young, silversmith, were Loyalists subject to confiscation of their estates.[21] If Michael Brothers was a British sympathizer, and wanted to avoid the double tax assigned to *non jurors*, he would have left Philadelphia in 1778 along with the British troops and hundreds of Loyalists from Pennsylvania and New Jersey, their destination New York or Canada.[22] Brothers was thought to have accompanied his sister to New York for her marriage to his friend William Young. On November 20, 1781, a Catherine Brothers married a William Young in New York.[23] Young is recorded as arriving at St. John in Nova Scotia in 1783. Past histories have stated that Michael Brothers also took up the offer of land in St. John, but the histories are not consistent, and no clear documentation has surfaced to confirm the fact.[24]

Michael Brothers's name is listed at the end of the Philadelphia proprietary tax record of 1779 for the North Ward.[25] The inscription looks almost like an afterthought, with no occupation, value, or tax. It was followed by "Widow Brothers," noted as debtor for a tax of £40 10s.[26] In 1780 "Alice Brothers, widow," was noted as paying tax of £2 5s. per £100 on Jonathan Dilworth's estate.[27] Later, in 1780, Alice Brothers, "widow," paid a tax of £36 on William West's estate in the Upper Delaware Ward.[28] Thus, unless the term "widow" carried a meaning of desertion, Michael Brothers must have died in Philadelphia in 1779, or possibly on the trip to New York. In 1781 Alice Brothers, "widow," applied to the Supreme Executive Council of Pennsylvania for permission to remove to New York. She stated that she was Dutch and had a brother in New York who would secure her passage with her three children back to Holland. She was granted a pass with the stipulation that she not return.[29] Alice Brothers was noted as being in New York in 1783.[30]

1. William Ball, Account Book, 1759–1762, Philadelphia, Downs Collection, Winterthur Library. There are no entries for 1758, and only a few for 1759; the bulk of the accounts concern Ball's business from 1760 to 1762.

2. Ibid. An entry on September 29, 1761, notes, "Michael Brothers Dr. to shop 3 dwt. Gold £0.18.0. Rec'd in past £0.4.0."

3. *Pennsylvania Archives*, 2nd ser. (1895), vol. 9, p. 309. There were no further entries in the records of St. Michael's and Zion Church for the Brothers family.

4. Not to be confused with Private Michael Brode from Upper Salford Township, Montgomery County, who served in the Pennsylvania Militia in a troop under Captain Philip Gobbs in 1785, as a volunteer in the War of 1812, and until 1820; *Pennsylvania Archives*, 6th ser. (1907), vol. 3, p. 1336; vol. 7, p. 845; vol. 8, p. 345.

5. In 1760 Michael Brothers was one of the original ninety-four people who signed Articles of Agreement for raising money to purchase the ground for St. Paul's Church; Norris S. Barratt, *Outline of the History of Old St. Paul's Church, Philadelphia* (Philadelphia: Colonial Society of Pennsylvania, 1917), p. 34. Records investigated do not suggest a relationship to a William Brothers who married Eleanor Quin at Christ Church in Philadelphia in October 1769; *Pennsylvania Archives*, 2nd ser. (1895), vol. 8, p. 31.

6. William Ball, Account Book, 1759–62, p. 181.

7. Account of Goods Sold of Phil Hulberts [Hulbeart], pp. 15, 17, Downs Collection, Winterthur Library, 53.165, 58x31.

8. Fales 1974, appendix B, pp. 202–6.

9. Syng, then listed as a resident of Merion Township, was taxed £19 4s. on the £32 from Brothers; Tax and Exoneration Lists, 1762–1794.

10. "Samuel Shoemaker," Southwark, 1769, Record for Philip Syng, Fifteenth 18 Penny Provincial Head and Estate Tax, Tax and Exoneration Lists, 1762–1794.

11. *Pennsylvania Packet, or The General Advertiser* (Lancaster), December 7, 1772; Prime 1929, p. 49. Brothers had moved from South Second Street near the corner of Market Street, two blocks north; Fifteenth 18 Provincial Penny Tax. Benjamin Hooten (1718–1792) was valued at £70 and was paying ground rent of £2 10s. to Mary Leech; Pennsylvania Tax and Exoneration Lists, 1762–1794. Brothers was listed in the tax simply by name with no tax. Hooten married Hannah Head in 1742, and thus was a generation older than Brothers. The Hootens were a New Jersey family, and members of a Brothers family were also located in New Jersey; there may have been a connection.

12. *Pennsylvania Archives*, 3rd ser. (Harrisburg, 1897), vol. 14, pp. 196, 273.

13. Fifteenth 18 Penny Provincial Head and Estate Tax.

14. *Pennsylvania Packet* (Philadelphia), December 7, 1772; Prime 1929, pp. 49–50. Hooten was located on Second between Market and Arch streets in 1785; Philadelphia directory 1785.

15. John Wagg's apprenticeship may have been completed; James Black must have finished with another craftsman. "Record of Indentures of Individuals Bound out as Apprentices, Servants, etc., . . . Philadelphia, October 3, 1771, to October 5, 1773," *The Pennsylvania-German Society Proceedings and Addresses* (repr., Baltimore: Genealogical Publishing, 1973), vol. 16, pp. 178–79, 202–3. Michael Brothers does not appear in Philadelphia City Archives in the Grantor Index in 1769, or from 1780 to 1781, nor is he listed in the Grantee Index from 1755 to 1769.

16. Tax and Exoneration Lists, 1762–1794.

17. *Pennsylvania Archives*, 3rd ser. (Harrisburg, 1897), vol. 14, p. 273.

18. Scharf and Westcott 1884, vol. 1, p. 273.

19. The petition was intended to relieve stress, shortages, and high prices. For a full list of all who stayed in Philadelphia during the occupation, see ibid., vol. 1, pp. 365–67.

20. Tax records note *non juror* (i.e., refused the Oath of Allegiance), a designation that levied a double tax. Brothers's name does not appear in Clifford Neal Smith, *Whereabouts of Some American Refugees, 1784–1800: The Nova Scotia Land Grants*, British-American Genealogical Research, no. 12, pt. 1: *Surnames Aarons–Clapper* (McNeal, AZ: Westland, 1992–95); nor in James Hannay, *History of New Brunswick* (Campbellville, Ont.: Global Heritage, 2006).

21. Hooten actually served in 1785 in the Seventh Corp of the Fifth Battalion of the Philadelphia Militia, and thus was later pardoned; *Pennsylvania Archives*, 6th ser. (1907), vol. 3, p. 1150.

22. Michael Brothers was not on the published list of Loyalists in 1782, nor is he listed in forfeited estates: Lewis Sabine, *Biographical Sketches of Loyalists of the American Revolution* (Boston: Little, Brown,

1864), vol. 1, pp. 512–13, 597; Robert Dallison, *Hope Restored: The American Revolution and the Founding of New Brunswick* (Fredericton, N.B.: Goose Lane Editions and the New Brunswick Military Heritage Project, 2003); Hannay, *History of New Brunswick*, pp. 130–34; Smith, *Whereabouts of Some American Refugees, 1784–1800*. According to various records there were some 35,000 Loyalists in and around New York, many of them from Philadelphia, attempting to traverse or sail to Nova Scotia and settle on lands reserved for them. "The evacuation is going on as fast as the number of transports here will admit. There are still between 16 and 18 hundred loyalists to be provided with passages to Nova Scotia. A general influenza seems to have seized the inhabitants of this city." *Pennsylvania Gazette* (Philadelphia), August 27, 1783. "Influenza" here perhaps refers to yellow fever or cholera.

23. *New York Marriages Previous to 1784* (Baltimore: Genealogical Publishing, 1968), pp. xxxiv, 49.

24. "A Silversmith in Philadelphia in 1772 . . . is said to have come to St. John as a Loyalist in 1783, no record of land grants nor other records have been found to verify this, despite research extending over the past quarter century"; Donald C. Mackay, *Silversmiths and Related Craftsmen of the Atlantic Provinces* (Halifax, N.S.: Petheric, 1973), p. 93. "Michael Brothers of Philadelphia was the first silversmith in New Brunswick, Canada"; Berthold Fernow, comp. and ed., *Calendar of Wills on File and Recorded in the Offices of the Clerk of the Court of Appeals, of the County Clerk at Albany, . . . 1626–1836* (New York: Knickerbocker, 1896). See also Berthold Fernow, comp., *Calendar of Wills on File and Recorded with Offices of the Clerk of the Court of Appeals at Albany, and Secretary of State, 1626–1836* (1896; Baltimore: Genealogical Publishing, 1967).

25 *Pennsylvania Archives*, 3rd ser. (1897), vol. 14.

26. This large amount may represent a tax on Michael Brothers's estate.

27. Tax and Exoneration Lists, 1762–1794.

28. Ibid.

29. *Minutes of the Supreme Executive Council of Pennsylvania* (Harrisburg: Theo. Fenn, 1858), vol. 12, p. 670 (March 22, 1781). This phrase was often used in passes issued to Loyalists or suspected Loyalists, for travel outside Philadelphia boundaries.

30. New York Genealogical Records, 1675–1920, Ancestry.com.

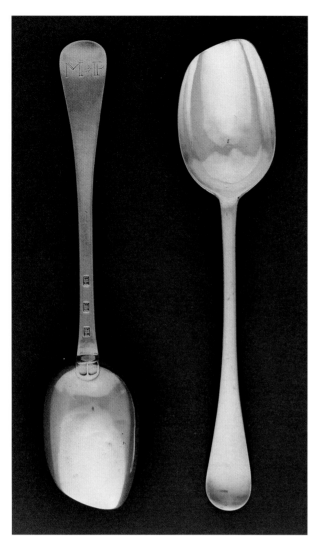
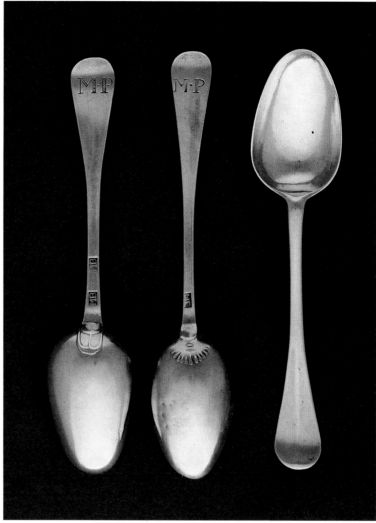

Cat. 93

Michael Brothers
Six Tablespoons and Eight Teaspoons

1765–70

MARK: MB (conjoined in rectangle, three times on reverse of each tablespoon, twice on reverse of three teaspoons, on reverse of five teaspoons; cat. 93-1)

INSCRIPTIONS: M·P; M P; M-P (engraved and shaded letters in three different styles, on reverse of each spoon at end of handle)

Tablespoons (1957-93-3–8)
Maximum length 8¹⁄₁₆ inches (20.4 cm)
Maximum weight 1 oz. 14 dwt. 14 gr.
Teaspoons (1957-93-9–16)
Maximum length 4¾ inches (12.1 cm)
Maximum weight 7 dwt. 13 gr.
Gift of Mrs. W. Logan MacCoy, 1957-93-3–16

PROVENANCE: By descent in the donor's family.

The early style and Philadelphia provenance of these spoons suggested a Philadelphia maker. The mark "MB" has not been identified, and the attribution here to Michael Brothers is genealogical and documentary.[1] All the other silver from this family and in the Museum's collection was made by Philadelphia craftsmen.[2]

The handles with turned-up ends and midrib, with initials on the reverse, represent a general mid-eighteenth-century style.[3] On the heels of the tablespoons and three teaspoons, just above the "drop," is a swaged decoration known as a "buckle." On the heel of five teaspoons, above a plain "drop," there is a design of eleven, radiating, daisy-like petals in a semicircle. This variation in details of manufacture within the set, together with the different hands revealed in the engraving techniques used to "shade" the initials "MP," seems to correspond to the number of maker's marks—three, two, or one—on the reverse of the handles.

All the spoons descended in the family to the donor, Marguerite Paschall Wood McCoy. She was named for Martha Humphreys Paschall (Mrs. Stephen Paschall, died 1774), who married in the First Presbyterian Church in Philadelphia in 1738. Their daughter Margaret Paschall I (1748–1771) married John Hughes in 1766. Their children, Martha (1768–1796) and Rebecca Hughes (1770–1792), died unmarried. Hannah Paschall Hollingsworth (Mrs. Levi Paschall, born 1744/45) served as the executor for her niece Martha Hughes and distributed the estate to family. Her daughter Mary Hollingsworth married Israel Wistar Morris in 1799. The donor Marguerite Paschall Wood MacCoy was their great-granddaughter.[4] BBG

Cat. 93-1

1. The Philadelphia provenance is clear. The silversmith Michael Brothers was active in Philadelphia at midcentury and is the only silversmith with the initials "MB" on record thus far. These spoons were formerly attributed to Miles Beach of Hartford, Connecticut. For his mark see Henry N. Flynt and Martha Gandy Fales, *The Heritage Foundation Collection of Silver: With Biographical Sketches of New England Silversmiths, 1625–1825* (Old Deerfield, MA: the Foundation,1968), p. 155. A similar mark (unattributed) on a tablespoon of c. 1760 is described as "Handle, with forward bent, rounded end and short midrib, tapered to oval bowl with molded double-drop"; Buhler and Hood 1970, pp. 265, 277.
2. For other silver in the Museum's collection that descended in this family, see: cats. 164 and 185); and Cesar Ghiselin, porringer (1957-93-1); John Jenkins, spoon (1957-93-56); Joseph Lownes, tablespoons (1957-93-20–31, 32–43); Henry J. Pepper, salt spoon (1957-93-57); Samuel Richards Jr., spoons (1957-93-44–47); Joseph Richardson Jr., spoons (1957-93-48–51); Joseph Richardson Sr., teaspoon (1957-93-52); Philip Syng Jr., porringer (1957-93-2); R. & W. Wilson, spoons (1957-93-53–55).
3. The tips of the bowls of the tablespoons have been trimmed to even the wear, or they have been damaged.
4. Moon 1898–1909, vol. 2, pp. 550–55.

Thomas G. Brown & Sons

New York City, 1881–1917
Newark, New Jersey, 1881–90

According to his marriage record, Thomas Gibbins Brown was born in New York in about 1815, son of Thomas and Mary Brown, both natives of England.[1] The younger Brown's subsequent career suggests that he had some training as a silversmith or jeweler. His father may have been the silversmith Thomas S. Brown born in England about 1795, who was recorded in New York City directories between 1850 and 1854, as well as in the U.S. census of 1850.[2] According to Janet Zapata, Thomas G. Brown's first employment in New York was as a precious metals refiner before he went to work in the 1830s for the silversmiths George Wood Platt (1798–1881) and his brothers Nathan and David Platt.[3]

With James A. Dwight Jr., a fellow employee of Platt's, in 1850 Brown formed the partnership of Brown & Dwight, watchmakers, at 10 Cortlandt Street.[4] The jeweler Stephen H. Palmer joined the firm in 1852, when it was renamed Brown, Palmer, & Dwight, "importers of watches and jewelry," and moved to 172 Broadway.[5] In that same year Brown was described as a "merchant" when he married Lovira Chapin (1830–1915), daughter of Briant and Lucinda Jones Chapin of Springfield, Massachusetts.[6] Thomas and Lovira Brown had four sons: William A. (born about 1854), Thomas Bryant (born about 1855), Albert D. (born about 1861), and Austin G. (born about 1867).[7] Brown left the partnership in 1854, with Palmer and Dwight continuing together at the Broadway address. Brown returned to 10 Cortlandt Street, where he worked independently as a jeweler.[8] He moved to 170 Broadway in 1857, to 182 Broadway in 1862, and to 192 Broadway in 1866. Between 1857 and 1874 his residence was recorded on West Forty-Eighth Street.[9] During the 1860s Brown also acquired an interest in Baldwin & Company, manufacturers of "rich jewelry & watches," in Newark, New Jersey, a firm with origins in the partnership of Taylor & Hinsdale (q.v.).[10] In 1869 Brown bought out the remaining partners and renamed the firm Thomas G. Brown.[11] The Newark factory was moved from Franklin Street to Marshall Street in 1872.[12] By 1874

Brown himself had moved to 115 Clinton Avenue in Newark, and the following year his business address in New York changed to 1 Bond Street.[13]

In the U.S. census of 1880 Brown was recorded as a jewelry manufacturer, with his two elder sons working as clerks in the firm. The following year Thomas and William Brown joined their father to form the partnership Thomas G. Brown & Sons.[14] Austin Brown also worked for the family business as a traveling salesman and by 1889 was listed as another partner.[15] They maintained the shop on Bond Street in Manhattan, where Thomas B. Brown lived. The Newark and New York City establishments may have manufactured different wares: hollowware may have been made in New York, whereas the Newark factory was known for making silver jewelry, including necklaces, earrings, charms, shawl pins, and reproductions of the "Campanello Margherita," an ancient Roman bell excavated in 1875.[16] The Newark factory apparently closed in 1890, and the firm's operations were consolidated at 860 Broadway and 21 Bethune Street in Manhattan.[17]

In 1897 the firm had fifty-seven employees, including fifteen adult women and seven minors.[18] They manufactured sterling-silver hollowware as well as copper objects with silver mounts, many of them marked with retailers' names, including Gorham Manufacturing Co., Marcus & Company (q.q.v.), and Shreve & Company (see PMA 2010-206-46).[19] In 1905 the company received what was probably its largest and most high-profile commission, a twenty-three-piece silver service for the U.S.S. *Nebraska*, comprising a centerpiece, loving cup, and punch bowl with tray, ladle, and eighteen cups. The order was placed by J. E. Caldwell & Co. (q.v.), who designed the service for the Omaha retail jeweler Reichenberg-Smith & Company.[20]

Thomas G. Brown moved to East Orange, New Jersey, in 1891 and retired from business the following year.[21] He died on December 2, 1903; his widow died in Sandwich, Massachusetts, on May 14, 1915, and was buried with her husband in Green-Wood Cemetery, Brooklyn.[22] For health reasons Austin Brown left the firm in the 1890s and took up poultry farming.[23] William left in 1896 to form the partnership of Brown & Ward, manufacturers of "high class novelties in sterling silver" in New York.[24] Thomas B. Brown continued to operate the company in New York City as Thomas G. Brown & Sons, claiming in 1900 to be the oldest jeweler in the country, a result of the firm's connection with Taylor & Hinsdale.[25] Thomas G. Brown & Sons' final listing in the New York City directory was in 1917.[26] DLB

1. Marriage register for South Hadley, Massachusetts, Massachusetts Vital Records, 1840–1911, New England Historic Genealogical Society, Boston, Ancestry.com. Brown's age was recorded as sixty-two in the 1880 U.S. census, which indicated a birth year of 1817 or 1818, whereas Dietz et al. (1997, p. 164), give 1813 as his birth year without citing a source.

2. New York City directory 1850–51, p. 76; 1854, p. 102. It is not certain whether the Thomas S. Brown listed as a "smith" in the 1857 city directory (p. 112) was the same individual.

3. Dietz et al. 1997, p. 164.

4. New York City directory 1850–51, pp. 76, 158.

5. Ibid. 1852–53, pp. 79, 398.

6. Marriage register for South Hadley, Massachusetts, Massachusetts Vital Records, 1840–1911; Orange Chapin, *The Chapin Genealogy* (Northampton, MA: Metcalf, 1862), p. 126.

7. 1880 U.S. Census.

8. New York City directory 1854, p. 102.

9. Ibid. 1857, p. 112; 1862, p. 115; 1866, p. 134; 1873, p. 161.

10. Dietz et al. 1997, pp. 164–65.

11. Ibid., p. 156n6; Holbrook's Newark directory 1869, p. 126; New York City directory 1869, p. 142.

12. Holbrook's Newark directory 1869, p. 143.

13. Ibid., p. 149; Trow's New York City directory 1876, p. 161.

14. Holbrook's Newark directory 1881, pp. 165–66.

15. Ibid. 1889, p. 222; "Huge Poultry Raising Establishment near Lakewood Where There Are Incubating Facilities for Hatching More than 30,000 Chicks at One Time," *American Poultry Journal*, vol. 40 (February 1909), p. 149.

16. Dietz et al. 1997, p. 165.

17. Trow's New York City directory 1891, p. 162. Beginning in 1891, the firm is not listed in Newark city directories.

18. *Eleventh Annual Report of the Factory Inspector of the State of New York*, Documents of the Assembly of the State of New York, vol. 18 (Albany: Wynkoop Hallenbeck Crawford, 1897), p. 176.

19. Skinner, Boston, *20th Century Furniture and Decorative Arts*, May 10, 2003, sale 2202, lot 229; Skinner, Boston, *European Furniture and Decorative Arts*, April 6, 2013, sale 2645B, lot 192; Argentum, advertisement, *Antiques*, vol. 172, no. 4 (October 2007), p. 60. Examples of sterling hollowware marked by Thomas G. Brown & Sons include a coffee service at the Portland Art Museum, Oregon (2002.91.37), and a bowl and underplate at the Charles Hosmer Morse Museum of Art, Winter Park, Florida (MET-027-82).

20. Gail DeBuse Potter, "The Silver Service for the USS *Nebraska*," *Nebraska History*, vol. 69 (1998), pp. 115–19.

21. *Baldwin's Directory of the Oranges and Townships of Essex County* (Orange, NJ: Orange Journal, 1891), p. 41; Dietz et al. 1997, p. 165.

22. Dietz et al. 1997, p. 165; Death certificate no. 1557, Massachusetts Vital Records, 1911–1915, New England Historical Genealogical Society, Boston, Ancestry.com. At Green-Wood the Browns were interred in section 40, lot 870; Green-Wood Cemetery Burial Database, www.green-wood.com/burial_search.

23. "Huge Poultry Raising Establishment," p. 149.

24. "New York Notes," *Jewelers' Circular*, vol. 32 (March 25, 1896), p. 24; *Eleventh Annual Report of the Factory Inspector*, p. 176.

25. *Jewelers' Circular*, vol. 40 (May 16, 1900), p. 52, as cited by Rainwater and Redfield 1998, p. 61.

26. Polk & Co.'s Trow New York City directory 1917, p. 436.

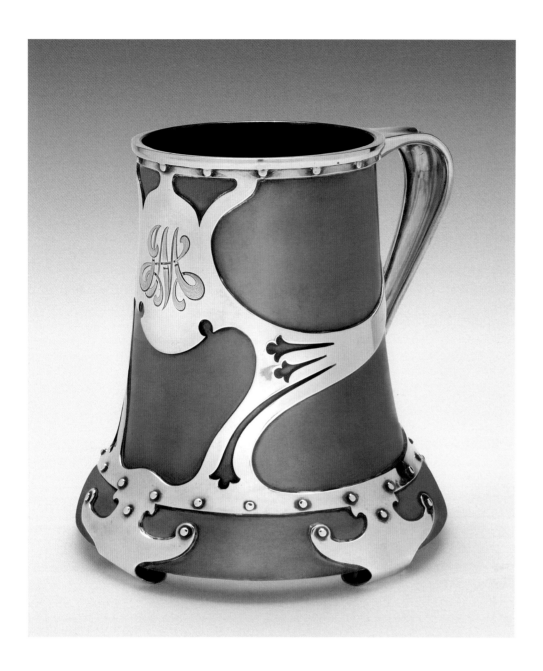

Cat. 94

Thomas G. Brown & Sons (attributed)
Mug

1900–1915
Copper body with silver mounts; interior with gold wash
and glass bottom
MARK: STERLING AND / OTHER METALS (incuse, on
inside of base)
INSCRIPTION: J M (engraved script monogram, on front)
Height 5⅜ inches (13.7 cm), width 6 inches (15.2 cm),
diam. 5¼ inches (13.3 cm)
Gift of Jay A. and Emma Lewis, 2008-133-1

PROVENANCE: This mug was one of a set of six acquired by
the donors from a dealer. Mugs from this set are now in
the collections of the Brooklyn Museum (86.242.2) and
the Metropolitan Museum of Art, New York (1992.95);
another was sold at auction in 2012.[1]

Although this mug and the others from its set do not
bear a maker's mark, an identical mug sold at auc-
tion in 1990 was recorded as marked by Thomas G.

Brown & Sons.[2] The silver strap-and-rivet ornament
on this mug also appears on solid silver objects
made by the firm, including a mug dated 1911 and
a three-piece coffee service.[3] Inspired by medie-
val iron hardware, this ornament was embraced by
Arts and Crafts–era metalworkers; on this mug it was
adapted to the sinuous curves of the European Art
Nouveau style.[4] DLB

1. Christie's, New York, *Important American Furniture,
Folk Art, Silver and Chinese Export*, January 19, 20, and 23,
2012, sale 2532, lot 27.
2. Skinner, Boston, *Arts and Crafts*, November 3, 1990, sale
1348, lot 281.
3. The mug was offered for sale by the dealer Anna Marcel,
www.trocadero.com/stores/annamarcel/items/949855
/item949855.html; the coffee service is in the collection of
the Portland Museum of Art, Oregon (2002.91.37).
4. Wendy Kaplan, *"The Art That Is Life": The Arts & Crafts
Movement in America, 1875–1920*, exh. cat. (Boston:
Museum of Fine Arts, 1987), p. 283.

John Browne

Philadelphia, born 1739
Philadelphia, died 1825

The Brownes, Coates (Coats), Fishers, Parrocks, and Smiths were early residents of Philadelphia who intermarried, becoming an extended family of merchants, shipwrights, blacksmiths, brickmakers, riggers, and three silversmiths.[1] Their primary residences were located on properties bounded by Front and Second, and Sassafras (Race) and Vine streets in the Northern Liberties.[2] Their brick manufactory, ironworks, shipyards, rope walks, and wharves were located on large tracts, some bordering the Delaware River. The silversmiths in the family listed themselves on properties in the commercial city and in the Northern Liberties that were held and leased through several generations, providing income during stressful economic periods. Their occupations guaranteed that family members became active participants in, and beneficiaries of, Philadelphia's thriving mercantile trade—along the coast and abroad—before the Revolution and into the nineteenth century.

John Browne's will, family notes, and property deeds offer a timeline of the life of this elusive silversmith, whose marked work is rare. He may have been reclusive, but he used the designation "goldsmith" or "silversmith" in the Philadelphia directory throughout his mature years. He invariably signed his name on documents with "NL" following his signature, a notation that also appears in his directory listings. It was an abbreviation of Northern Liberties, the section of Philadelphia where he resided during his entire life. As he belonged to a large, land-rich family, Browne probably did not need to depend entirely on a craftsman's income. He lived to old age (eighty-six), long enough to have conversations about "the old days" with John Fanning Watson, the venerable transcriber of lore.[3]

John Browne advertised only twice. He may have been working in or supplying another shop. His name does not appear in silversmiths' journals known to date, although he had some association with William Ball of Philadelphia and Thomas Shields (q.q.v.), both active members of the Baptist congregations of which Browne was a member. The details of his life might explain why his mark is so rare and possibly his role in the production of the Baptist silver in the collection of the Philadelphia Museum of Art (cat. 95).

The information that has emerged from a variety of records is sufficient to separate this John Browne, "silversmith and goldsmith," from the other contemporary John Brown(e)s who lived or worked in Philadelphia.[4] His will specified that he and his family be interred in the Coats burying ground at Third and Coats streets, between Brown Street and Fairmount Avenue.[5] The inscription provided his life dates.[6] A quit-claim deed dated March 14, 1768, for a water lot in the Northern Liberties, between John Browne, "goldsmith et ux," and Thomas Cuthbert, mast maker, not only identified him as a goldsmith but also clarified various family connections: "John Brown [sic] and Mary his wife, the said John Brown being the son of Peter Browne late of the City shipwright by Priscilla his wife, the said Priscilla being the daughter of William Coates late of the Northern Liberties, yeoman (dec'd) of the one part and Thomas Cuthbert, mast maker of the other part."[7] Military records, including those filed by descendants who applied for membership in the Society of the Sons of the American Revolution, confirm other family names[8] and the fact that Browne served in the Revolutionary War.[9]

Members of these families were Quakers and Baptists. John Browne was not listed in Philadelphia records of the Baptist Church after 1784; he probably joined the Northern Liberties congregation, which in 1772 was located on a lot behind 42 North Second Street.[10] He was the son of Peter Browne (1690–1749), a shipwright who had three wives. Peter's first wife was Sarah Fisher Browne (1695–1738); their son William (1734–1777) was the father of silversmith Liberty Browne (q.v.). Peter Browne married his second wife, Priscilla Coates Parrock (c. 1702–1745), widow of James Parrock Jr., in 1738.[11] She was the daughter of William and Sarah Smith Coates, both Quakers; he was a joiner and an important landowner of more than a hundred acres north of Vine Street in the greater Northern Liberties.[12] Peter and Priscilla Browne had five children, two of whom survived to adulthood: John, the goldsmith, and Mary Brown Brooks (died 1767), who married their neighbor the blacksmith Bowyer Brooke (Brooks; died 1764). In 1746, following Priscilla Browne's death, Peter married as his third wife Sarah Lane Fisher, widow of his brother-in-law Samuel Fisher.[13] Shortly after this marriage William Coates, father of the late Priscilla Browne, conveyed to Peter Browne and Sarah a large property on the south side of Phillips' Rope Walk in the Northern

Liberties, probably to provide an inheritance for Priscilla's two children.[14] All of Peter Browne's children had the advantages of family and property; his will devised a piece of the Coates property to his son John, the goldsmith. Thus, John inherited, through his mother and father, legacies from his grandfather William Coats and from his great-grandfather Thomas Smith.[15]

Jeremiah Elfreth Sr. signed Peter and Sarah Fisher Browne's Quaker marriage certificate, and Peter and Sarah's eldest son, Nathaniel Browne (1726–1800), married as his second wife Mary Elfreth, daughter of Caleb Elfreth, at the Friends Monthly Meeting in 1759.[16] These early Quaker family connections may have set up the apprenticeship for John Browne with the goldsmith Jeremiah Elfreth Jr. (q.v.). A list of members of the Philadelphia Arch Street Friends Meeting bearing the inclusive dates 1759–72 is annotated: "John Browne at Jeremiah Elfreth's Jun."[17] He would have been close to finishing or have just finished an apprenticeship in 1759. John Browne does not appear in further Quaker records investigated to date. Depending on when the Arch Street Friends Meeting list of members was made, he may have been working with Jeremiah Elfreth Jr. until the latter's death in April 1765. Browne appraised Elfreth's house, shop, and family silver for the estate.[18]

On August 7, 1760, at the age of twenty-one, John married Mary Arrell (1742–1822) by license, a family event seemingly not recorded in extant Quaker or Baptist marriage records. She was the daughter of William and Mary Maston (Matson) Arrell[19]; the Arrell family also was located in the Northern Liberties. John and Mary Browne had seven children: Anna Browne, "a young lady distinguished for her amiableness and virtue,"[20] who died of yellow fever in 1803, Priscilla B. Hulings (1763–1793), Aquilla Arrell Browne (1770–1850), Polly Brown (1774–1803),[21] Colonel Peter Arrell Browne (1782–1850),[22] Adelissa B. Harned (1793–1855), and Melissa B. Warwick.

John Browne was continually occupied with the management of his inherited real estate. In the 1769 tax list for the East Part of the Northern Liberties, he was assessed £19 5s. 6d. on forty-two ground rents from his properties valued at £199 6s. 3d.[23] In March 1763 "John Browne, NL goldsmith," purchased a property on Hudson's Square on the east side of Sixth Street from the tobacconist Jacob Cox and, on September 1, 1764, sold it to another tobacconist, Abraham Wilt. In November 1763 "John Browne NL, goldsmith," and his wife Mary wrote a deed to Peter Hawn, "labourer," for £2 rent and "performance of a covenant," to build a house on the property worth £100; with a payment of £80 to John Browne, Hawn was allowed to

occupy the property rent free.[24] Browne collected ground rents from twenty-nine leases on his properties, amounting to more than £200, and paid £12 6s. ground rent to his elder half-brother, Nathaniel Browne. The 1769 tax records for the Northern Liberties and the North Ward show that he was leasing a dwelling to the "goldfinder" Peter Stout on ground rents to Ludwig Cress, and land to his brother-in-law Bowyer Brooke for £2 10s. ground rent.[25] A great deal of Browne's real estate activity was carried on within his extended family and related to the properties he had inherited as a young man. In 1769 his estate was valued as follows: a dwelling at £12, two negroes at £7 4s., and one horse and one cow at £1, and he had thirty-six properties leased on ground rents—"£40 of John Poor—for brickyard" was the most important. His only debt was an annuity to Rachael Coates.[26]

Along with several silversmiths in the Chestnut Ward, Browne was listed as paying the Poor Tax in 1767.[27] Few additional references to Browne can be found in the public record with the exception of his civic commitments.[28] He had opened his shop at the height of the controversy provoked by the non-importation agreements and the subsequent difficulties of trade between 1765 and 1768. It is possible that Browne abandoned his own shop then and was employed by another silversmith, in which case his work probably would have been marked by the master or shop owner. The most likely shop would have been that of William Ball. In 1771 Ball moved his shop from Front Street to the north side of Market Street, three doors below Hall and Sellers's printing office, and he advertised for a journeyman.[29] Ball's shop was across Market Street less than a block from Browne's stated location. Much later, in 1798, the U.S. Direct Tax shows Ball and Browne owning adjoining property on Front Street.

By 1772 Browne was a member of the First Baptist Church. A rare notice of him is recorded when the ministry requested that a John Brown and John Jarmon (Germon; q.v.) visit a Mrs. Church to determine whether she was married to Thomas Dungan.[30] The Baptist records have a few mentions of a John Brown(e) in their tallies of membership. Browne may have worked for Thomas Shields, who was a trustee and prominent member of the Baptist Church and, like William Ball, often kept its accounts. Shields's daybook notes in its index "John Brown, wheat merch.," the only occupation recorded in the book with the exception of "Thomas Shields, carpenter," suggesting a need for clarification regarding those names.[31]

Members of the Browne family, Quakers and Baptists, participated in the Revolutionary War as soldiers, shipbuilders, and blacksmiths.[32] Peter

Browne and his sons William and John, our silversmith, served in companies of the Philadelphia Militia. John Browne served under Captain Jehu (John) Eyre (1739–1781), first as a city guard stationed at the statehouse in August 1775, and then at the powder house and jail in September and October of that year. In January 1777 he served at the Battle of Princeton, and in October of that year at the Battle of Germantown and Chestnut Hill.

Also in 1777 he served with troops building the fort at Billingsport on the Delaware, and in June he was listed as a private in Captain Charles Syng's company of the militia, which served at Fort Billingsport in October of that year.

On June 5, 1777, some thirty men in Eyre's company took the Oath of Allegiance: "We, whose names are hereunto subscribed do Pledge our Faith to each other that we will continue to associate for the Defence of American Liberty, and to stand forth for the same when called on, as witness our hands this 5th day of June 1777, in a company of artillery." The oath was signed by Captain Eyre, First Lieutenant John Browne, and Sergeant William McMichael. It is also recorded that he served in 1777 as major in Captain Bingham's company in Colonel Joseph Cowperthwait's regiment.

Browne was wounded, a fact confirmed by the inclusion of his name and location in the Northern Liberties on a list of pensioners issued in 1794 of those awarded "invalid" (disability) pensions.[33] Browne retired from active duty in 1779 but continued to serve as quartermaster from August to October 1780 in Captain Elijah Weed's company and from October 10, 1780, to August 20, 1781, in the same capacity in Lieutenant Benjamin Eyre's Second Battalion of the Philadelphia Militia. Browne's war injuries may have prevented his reentry into the silver business; or, because property interests were affected by the establishment of the United States government after 1782, his property may have demanded attention.

In the Pennsylvania Tax and Exoneration records for 1779 in the Northern Liberties, John Browne's tax notation—that he was allowed half of the single, per-head tax and paid £37 10s. against his occupation tax of £150—suggests recognition of some incapacity. In 1781 his estate was valued at £1,906 with a tax of £24 15s. 7d. The only larger amount in this list was that of his grandfather William Coats at £364, taxed at £88 10s. Although John Browne had interest in the family brickyard and shipbuilding enterprise, his own property escaped the worst of the British destruction, as experienced by his relatives. In 1782 John Browne owned two acres on Poplar Lane, two acres on Hickory Lane, and forty feet on Brown Street in the Northern Liberties, valued at £800, as well as

other improved properties that he leased out on ground rents. Then, in 1786, he was paying ground rent of £31 to Peter Stout, "gentleman," who had been occupied earlier as a goldfinder.

In the U.S. census of 1790, John Browne's household included four males under sixteen, three males sixteen and over, and one female. In 1793 he was still listed in the city directory as a goldsmith at 368 North Front Street. That same year the Pennsylvania Septennial Census noted John Browne, "gentleman," in the South Mulberry Ward. Thereafter he was listed as a "gentleman" at 368 or 376 North Front Street, sometimes with just "NL" (Northern Liberties) after his name. The assessment list in the U.S. Direct Tax of 1798, taken by John Keen in the District of Northern Liberties, shows John Browne as the occupant of a property on the west side of Front Street, which he owned jointly with William Ball. It was assessed at £1,500, and another adjoining property, owned solely by Browne and noted as unoccupied, was valued at £500. Both men had supposedly retired. William Ball, "Esq," was listed at 41 Market Street from 1791.[34] The retention of these properties by both Ball and Browne at least to 1798 suggests that it may have been the location of a jointly operated silver workshop, which might explain the gaps in John Browne's career notices.

In 1797 and 1798 Browne served as a county commissioner. George Nice assessed Browne's property on Hickory Lane in the West Northern Liberties at £716 for the U.S. Direct Tax of 1798; his land in the East Northern Liberties (a total of 7,000 square feet) was valued at £400, with the tax at 76s. In May 1799 "John Browne NL Principal Assessor for the first Division of the Third District" validated the report for the 1798 assessments of the West Northern Liberties.[35]

The U.S. census of 1800 listed John Browne and his wife as over forty-five, with two other free persons under twenty-five, in the Upper Delaware Ward. In 1800 he was appointed surveyor of the revenue for the Northern Liberties District, with his office at 368 North Front Street, which was also his home. On July 2 of that year, the *Philadelphia Gazette* published the following notice: "In conformity to the 6th Section of the act aforesaid a full and correct copy of the tax list remains in the office of John Browne, No. 368, north Front Street, Northern Liberties, the surveyor of the revenue for the said assessment district, open to the inspection of all persons inclined to inspect the same." In 1806 and 1807 "John Browne N. L." and Thomas Cope served as auditors for the Board of Managers of the Alms House and House of Employment.[36] In 1800 Browne was executor of his half-brother Nathaniel's estate, which included "a large 3 story

HOUSE, in Race Street, in good order, No. 32."[37] The census of 1820 for the Northern Liberties lists John Browne's household as one male and one female, both over forty-five.

John Browne wrote his will on March 9, 1821. His wife Mary was to be the executor but she died in 1822. He died on June 20, 1825.[38] The will noted his son Aquilla and his daughter Anna Smith Browne; his son Colonel Peter A. Browne, Esq.; his daughter Melissa Warwick; the children of his daughter Adelissa Harned, wife of John; Abraham, Priscilla, and Hester Levering, the children of his deceased daughter Priscilla Hulings; and his daughter Mary Browne, widow. The will described various parcels of real estate, including "part of my brick yard lot estate on Hickory lane, etc. . . . all to be divided into six parts." BBG

1. The silversmiths were John Browne, Liberty Browne (q.v.), and Jesse Browne (active 1810–28), nephew of Liberty Browne. In 1817 Jesse Browne was at 47 Lombard Street. He may have been the Jesse Browne active in New York at 4 Greene Street, with his residence at 85 Liberty Street in 1827 and 1828; New York City directory 1827–28, p. 106. To date no silver has been recognized as having been made by Jesse Browne. John Browne, silversmith, is not to be confused with a John Brown, "plater," listed in Philadelphia directories, in 1805 at 1 Elbow Lane, from 1813 through 1817 at 22 South Third Street, and in 1824 at 15 North Third Street. That they were clearly different people is made clear in the 1796 city directory (pp. 22, 23), which listed John Brown, silverplater, at 32 South Front Street, and John Browne, silversmith, at 368 North Front Street.

A close-knit family, the Brownes carried the same given names through and across several generations; for example, two generations of Nathaniel Brownes married three Sarahs. For extensive genealogies, see Hill and Hill 1982, pp. 571–75. See also First Baptist Church of Philadelphia, membership records, 1775–1894; church letters, 1775–78; letter book, 1826–36; list of names, 1746–1824; deeds, 1691–1852, HSP.

2. In 1799 the addresses of this extended Browne family—a cabinetmaker, a blacksmith, a distiller, a shipwright, a lumber company, and the silversmith—on Front Street alone extended from numbers 148 to 395; Philadelphia directory 1799, pp. 26–27.

3. John F. Watson, *Annals of Philadelphia, and Pennsylvania, in the Olden Time . . .* (Philadelphia: printed for the author, 1843), vol. 1, pp. 228, 477–82.

4. In the family's documents signed by its members, the last name is spelled using the final "e." In official records in which another person wrote the name and in some editions of the Philadelphia directory, the "e" is omitted. Two John Browns are listed in the Tax and Exoneration Lists, 1762–1794: John Brown, a relative and distiller, who as of 1769 was a wealthy property owner with extensive holdings; and John Brown, a cabinetmaker working with William Wayne in the Northern Liberties. John Brown, a wheat dealer, was identified in the index of the daybook kept by Thomas Shields (q.v.) between 1775 and 1791 (Downs Collection, Winterthur Library); see also John Browne's own account books, 1774–1777 and 1783–1787, HSP.

5. Will of John Brown, 1825, Philadelphia Will Book 8, no. 10, p. 431. The tombstone was originally in the Coats burying ground. John Browne's remains, along with those of his wife and children, were removed to the Moore family plot in Monument Cemetery.

6. Hill and Hill 1982, p. 567.

7. Philadelphia Deed Book I-13-89. In a deed dated 1800 between John Browne and Lewis Prahl, blacksmith, Browne was still noted as a goldsmith. The deed concerned a strip of land adjoining Prahl's property that Browne had sold in 1763 to someone who had neglected to pay ground rent; Prahl took over the debt. It has been suggested that Prahl bought Browne's shop in 1800, but this deed did not include a building.

8. Parkin Scott Browne (1913); Thomas H. Bowyer Browne (1914, Maryland); Peter Arrell Browne Hoblitzell (1920, Baltimore); Charles Lloyd Riley (1944), probably through Hannah Lloyd, who married John C. Browne; Schuyler Dill Browne (1926, Iowa). Sons of the American Revolution membership applications, 1889–1970, National Society of the Sons of the American Revolution, Louisville, KY, Ancestry.com.

9. Revolutionary War Battalions and Militia Index Cards, vol. 1, p. 562, HSP, Ancestry.com.

10. The two-story building was 60 feet by 55 feet, with pews and galleries; Philadelphia directory 1795, p. 31. Surviving records of the church, including membership roll books, minute books, and baptismal records, are incomplete.

11. "Marriage Records, 1665–1800," *Archives of the State of New Jersey,* 1st ser. (Trenton: John L. Murphy, 1909), vol. 22, p. 175. She was the widow of James Parrock Jr., whom she had married at the Philadelphia Monthly Meeting on July 20, 1731. He died four months later. Quaker Meeting Records, Friends Historical Library.

12. Henry D. Biddle, ed., *Extracts from the Journal of Elizabeth Drinker* (Philadelphia: Lippincott, 1889), p. 371 (April 28, 1802). See also Elaine Forman Crane, ed., *The Diary of Elizabeth Drinker* (Boston: Northeastern University Press, 1991), vol. 2, p. 1512 (April 28, 1802): "William Coats [sic] of the Northern [L]iberties died yesterday, he has latterly been called Collonel [sic] Coates."

13. There were no children from Peter's third marriage, to Sarah Lane Fisher; William Wade Hinshaw, *Index to Quaker Meeting Records* (Swarthmore, PA: Friends Historical Library, Swarthmore College, 1953), p. 341.

14. Philadelphia Deed Book H-20-146, July 11, 1746.

15. Hill and Hill 1982, p. 567.

16. Ibid., p. 579.

17. Quaker Meeting Records, Friends Historical Library.

18. Monthly Meeting of Friends of Philadelphia, Pa., Minutes, 1759–1772, Ancestry.com.

19. *Pennsylvania Archives,* 2nd ser. (1896), vol. 2, pt. 2, p. 38 (as John Brown and Mary Arcle).

20. *Philadelphia Repository and Weekly Register,* October 8, 1803.

21. Mary, also known as Polly, married "Captain John Brown [sic]" of New York on March 9, 1795; *Philadelphia Gazette and Universal Daily Advertiser,* March 10, 1795. She died in 1803 of yellow fever at the same time as her sister Anna Browne; *Dunlap and Claypoole's American Daily Advertiser* (Philadelphia), March 10, 1795.

22. Peter A. Browne was an original member of the State Fencibles, serving in the War of 1812, and in 1818 he was colonel of the Eighty-First Regiment of the Pennsylvania Militia; Thomas S. Lanard, *One Hundred Years with the State Fencibles . . . 1813–1913* (Philadelphia: Nields, 1913). In 1825 he served as corresponding secretary for the Franklin Institute of the State of Pennsylvania for the Promotion of the Mechanic Arts.

23. In 1761 John Browne advertised "a convenient wharf, fit for a Boat yard, formerly occupied by Richard Arrell. For Title and terms apply to John Browne in the Northern Liberties near the premises." *Pennsylvania Gazette* (Philadelphia), December 31, 1761.

24. Philadelphia Deed Books EF-5-20, EF-5-23, EF-5-24, EF-1-489; Church and Town Records, Pennsylvania and New Jersey, 1708–1785, Ancestry.com. Hawn's payment was recorded April 3, 1800. In the same year Browne leased to Joseph Higginson, bricklayer.

25. Others owing ground rents to Browne included Lawrence Bamberger, George Bartle, William Cleward, Michael Cripps, Henry Faunce, Jacob Greager (mason), (another?) Peter Hawn (stocking weaver), William Small, Christian Straley, Dewalt Strouse, and George Warner; Tax and Exoneration Lists, 1762–1794. In 1700 a goldfinder, as used in this context, was defined as a gold seeker; *New Standard Dictionary of the English Language* (New York: Funk & Wagnalls, 1939).

26. Tax and Exoneration Lists, 1762–1794. In the same list a John Brown [sic], distiller, was recorded as leasing to many of the same people.

27. The silversmiths John Browne, John Bayly Sr., William Ball, Philip Syng Jr. (q.q.v.), and Stephen Reeves all paid a Poor Tax of nine shillings on February 21, 1767, in the Chestnut Ward; Tax and Exoneration Lists, 1762–1794. The Poor Tax, the first of two taxes for the year, was an assessment collected by the Overseers of the Poor from everyone with a ratable estate, to be applied toward the maintenance of the poor of the city for the ensuing year.

28. From 1767 until 1769 he was identified as John Browne, goldsmith, in a list of those serving on a traverse jury; "Courts of Oyer and Terminer: Juries and Appointments, Philadelphia County," *Pennsylvania Genealogical Magazine,* vol. 46, no. 2 (2009), p. 83; Courts of Oyer and Terminer, ser. 126, Supreme Court, Record Group 33, Pennsylvania State Archives, Harrisburg, Ancestry.com. In 1806 and 1807 he and Thomas Cope were auditors of the accounts (receipts and expenditures) of the Guardians of the Poor for the Township of Northern Liberties and Southwark; *Aurora General Advertiser* (Philadelphia), September 1, 1807.

29. *Pennsylvania Gazette* (Philadelphia), November 21, 1771.

30. First Baptist Church of Philadelphia, membership records, July 5, 1772, HSP. John Brown, John Browne, John Jarmon (or Germon; q.v.), and William Coates were all listed as members of the church in 1772. John Browne moved in and out of Baptist records under the headings "Increase" and "Decrease," e.g., "John Browne has forsaken our assembly"; First Baptist Church of Philadelphia, Minutes, 1760–1850, June 1, 1783, pp. 72–73, HSP.

31. Thomas Shields, Daybook, 1775–1791, Downs Collection, Winterthur Library.

32. *Pennsylvania Archives,* 6th ser. (1906), vol. 1, pt. 1, pp. 152, 171, 484, 581, 586; Bigwood-Browne-Mitchell family tree, Ancestry.com. According to family records, Browne missed the Battle of Trenton because his was one of many companies unable to maneuver its artillery pieces across the river; Bigwood-Browne-Mitchell family tree.

33. *Dunlap's American Daily Advertiser* (Philadelphia), July 21, 1794: "John Browne, Lieutenant of marines, placed on pension list"; the list was signed by Henry Knox, Secretary of War. Applications noted as "evidence imperfect" or "no evidence of the continuance of his disability for two years after leaving the service" were denied. In 1821 John Browne, "major of the regiment," wrote an affidavit for Frederick Burkhart, age seventeen, regarding his service "in the company of Captain Bingham during the Revolutionary War, which company marched from Philadelphia in the year 1777 attached to Colonel Joseph Cowperthwait's regiment, of which Regt. he was a Major, and that he allways [sic] volunteered his services on shooting parties when among others [who] depended on their chance in a draft for that duty and that he was with me at the attack of the enemy piquet guard on Chestnut Hill where he performed the duty of a Volunteer with faithfulness as becoming a young solider." The affidavit was signed "John Browne of NL / Major of the Regiment"; Bigwood-Browne-Mitchell family tree.

34. Philadelphia directory 1791, p. 6.

35. "Orders were drawn on the Treasurer in favor of the following persons, to wit—No. 104 John Browne and Samuel Church, for the sum of One hundred and sixty one dollars thirty eight cents, for 34 days attendance as auditors at settling the Commissioners Accounts for the year 1798"; Tax and Exoneration Lists, 1762–1794.

36. *Aurora General Advertiser* (Philadelphia), September 1, 1807.

37. *Poulson's American Daily Advertiser* (Philadelphia), October 11, 1800.

38. See note 5.

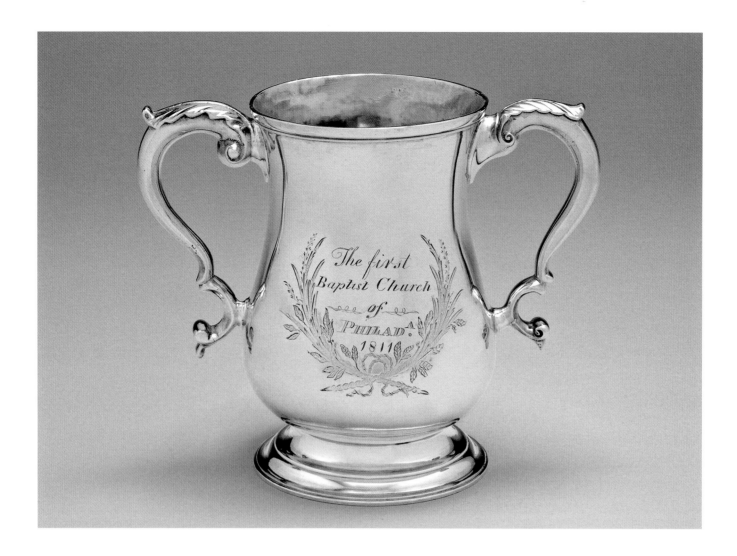

Cat. 95

John Browne
Pairs of Communion Cups and Salvers

1794–1811

MARK: J·B (in rectangle, twice on underside of each cup, once on underside of each salver; cat. 95-1)

INSCRIPTION (on each): The first / Baptist Church / of / PHILAD[A] / 1811 (cups: engraved within design of crossed leafy fronds, on one side of each); (salvers: Roman and gothic scripts in circular design)

Cups: Height 5⅜ inches (13.7 cm), width 6⅜ inches (16.2 cm), diam. rim 3⅜ inches (8.6 cm)
Weight 16 oz. 2 dwt. 13 gr.; 16 oz. 13 dwt. 5 gr.
Salvers: Height 1 inch (2.5 cm), diam. 6 inches (15.2 cm)
Weight 7 oz. 10 dwt. 15 gr.; 7 oz. 13 dwt. 8 gr.
Purchased with contributions from Robert L. McNeil, Jr., and H. Richard Dietrich, Jr., and with the Richardson Fund, 2005-40-4, -5 (salvers); Gift of the McNeil Americana Collection, 2005-50-1, -2 (cups)

PROVENANCE: First Baptist Church of Philadelphia; Christie's, New York, *Important American Furniture, Silver, Folk Art and Decorative Arts*, June 16, 1999, sale 9072, lots 75, 79.

EXHIBITED: On long-term loan to the Philadelphia Museum of Art, 1912–99.

PUBLISHED: Jones 1913, pp. 368–69.

Cat. 95-1

One compelling reason for attributing these objects to John Browne is precedent, and another is his membership in the Baptist congregation. The earlier silver for the Baptist Church in Philadelphia was commissioned from William Ball (cat. 56) and Thomas Shields (PMA 2005-40-1,2), also members of Baptist congregations. Although his parents were Quakers, John Browne and a few other people in his family became members of Baptist congregations. In 1913 Alfred E. Jones attributed these cups and salvers to "John Browne or John Black [q.v.]" without any further information, although he noted the date and cost of the matching silver, including cups, by Thomas Shields.[1] If there had been any information in church records regarding "J.B," presumably Jones would have included it in his exhaustive volume. The maker's marks are pristine, with a clear strike of the die and crisp edges. The mark is distinguished by the neat fit and precise spacing of the letters within the edges of the die, with a low placement of the pellet. There are few examples of this mark, and it may have been made especially for this commission.[2]

Browne's cups are close in size and weight to those by Shields, but they differ in one unusual aspect. The handles on the left side of Browne's cups were cast from a slightly different mold from those on the right, which are identical to both the left and right handles on Shields's cups. (Shields used the term "mugs" in his daybook.) Browne's handles on the left are also a bit bigger, the leafage on the top of the handles has more flutter, and the handles are attached to the body of the cup in a closer join.[3] The joins of the edges of the salvers, although not quite clean, are exactly like those on the salvers made by Shields. The cast feet on all the salvers are so alike that they may have been cast from a mold, possibly one made from the earliest set by Richard Rugg.[4] Two of the feet on one of the English salvers by Rugg seem to have been reset.

These cups with their salvers, and the set by Thomas Shields, may not have been engraved when they were first made.[5] Along with those by Rugg, ordered with the first expansion of the Baptist church in Philadelphia, the ensemble served the community's rapidly growing First Baptist congregation. Under the leadership of its popular ministers Dr. Thomas Ustick and Dr. William Staughton, expansion by dismissal began in earnest in 1789: "Those who witnessed the sudden transition from empty pews to crowded meetings foresaw that a house so small and so in every way inconvenient, could never accommodate the audience which the preacher at

all times commanded, and accordingly the church resolved on the enlargement of the place of worship. Dr. Staughton who was having some difficulty in securing his compensation nevertheless expressed his enthusiasm, 'I have embarked with you, dear bretheren [sic], as a fellow member, hoping that our little one may become a thousand.'"[6] According to the minutes of the association, the church in October 1807 consisted of 367 members, and in 1808 of 394. Assisted by his deacons and other members of the church, Dr. Staughton initiated a public subscription to defray the cost of purchasing land.[7] Before the church was built, the overflow congregation met in the courthouse next to the statehouse. The round church built at Ninth and Sansom streets was exceptional in its time and the first Baptist church to have an indoor baptistery: "The design of the building was furnished by Mr. Mills, a pupil of Mr. [Benjamin Henry] Latrobe . . . [and] when finished, will do credit to his talents and prove an ornament of our city."[8]

The engraved foliate design that surrounds the inscriptions on the cups by Browne and Shields have similar dimensions and a similar pattern, but they were probably not engraved by the same hand and possibly not by Browne or Shields. The engraving on Browne's cups and salvers is less accomplished. The engraved dates on both sets of cups are not quite centered and seem tipped into the designs. That engraving may have been done when the Fourth Baptist Church, on Sansom Street, was finally constituted on January 24, 1811.[9] As a practical matter the communion silver was divided, and the dates were added to commemorate and distinguish the new congregation from the original, so-called Particular Baptist Church.[10] Browne's silver went with the new congregation to Sansom Street.

The U.S. Direct Tax of 1798 lists William Ball and John Browne as co-owners of a property on the west side of Front Street in the Northern Liberties, with Browne as the occupant. Although both men had apparently retired and listed themselves as "gentleman" in the directories, Ball's shop may have still been active. These cups and salvers attributed to John Browne were probably made by him in Ball's shop. BBG

1. According to Alfred E. Jones (1913), the set of cups by Thomas Shields was recorded as paid for in 1794. This suggests that these cups by Browne were not recorded in detail in church records. More recently these cups have been attributed to James Black, a jeweler and a Presbyterian.
2. There is one possible example in the DAPC collection at Winterthur (74-2560).
3. If the handle of a cup or cann marked by Ball or Shields were to match those on the cups by Browne, it might be

possible to determine where Browne spent his silver-working time.
4. See Richard Rugg, pair of salvers (PMA 2005-40-6,7).
5. The date of a payment, often a year or two after the fact, may not precisely date the silver.
6. Rev. S. W. Lloyd, *Memoir of Dr. Reverend William Staughton* (Boston: Lincoln, Edmands, 1834), pp. 81–82.
7. *Philadelphia Inquirer*, December 19, 1929; William D. Thompson, *Philadelphia's First Baptists: A Brief History of the First Baptist Church of Philadelphia, Founded 1698* (Philadelphia: the Church, 1989), p. 17.
8. James Mease, *The Picture of Philadelphia, Giving an Account of Its Origin, Increase and Improvements . . .* (Philadelphia: B. & T. Kite, 1811), p. 328.
9. "Dr. William Staughton and ninety two members of the First Baptist Church were 'dismissed' during a period of growth and were sent off with well wishes for the further expansion of their congregation"; American Baptist Historical Society Manuscript Collection, Calendar of Archives, chap. 3, p. 78, abhsarchives.org. In this case, the term "dismissed" is not pejorative.
10. The Particular Baptists, founded in 1707 and expanded in 1774, were differentiated from the General Baptists by their inclusion of Calvinist ideas spread through the sermons of George Whitfield. The cups by Shields engraved for the Particular Baptist Church made clear the separation of the congregations. They established the Philadelphia Baptist Association, which encouraged the formation of new churches nationally.

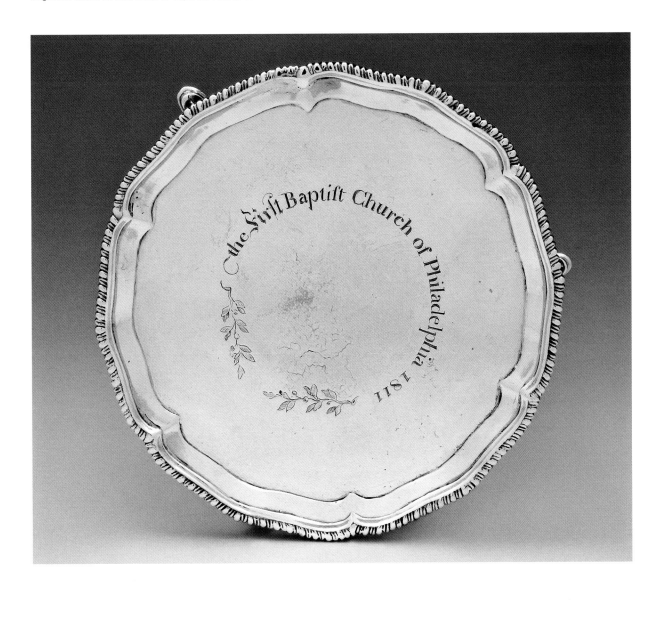

Liberty Browne

Philadelphia, born 1776
Philadelphia, died 1831

One family story is that William and Elizabeth Borradaille Browne had a son early in the day of July 4, 1776, and when they heard the cheering in the streets of Philadelphia following the signing of the Declaration of Independence, they celebrated and named their son Liberty.[1] They were members of a large family with the surname Browne, whose given names—among them Peter, William, Nathaniel, and John—ran across and down through the generations. Liberty was unique, and as his life unfolded it may have been a name to live up to or live down.[2] Perhaps the name, combined with his membership in a large, wealthy, landowning clan, gave him his personal self-confidence. Liberty's activities suggest that he was an independent, gregarious, perhaps precocious individual, eager to play a role on the public stage, different from his uncle John Browne (q.v.), also a silversmith. The civic roles played by a few of the prosperous and well-connected eighteenth-century Brownes, and their husbandry of family real estate, must have facilitated the conspicuous role that Liberty Browne played on the political scene in Philadelphia during and after the War of 1812. The world of public office and politics beckoned. He signed his name clearly and with flourishes. He named his dogs Peace and Plenty.

Liberty's grandfather Peter Browne (1690–1749), shipwright, married his first wife, Sarah Fisher (c. 1695–1737/38), daughter of William Fisher (died 1728), a joiner, in about 1725.[3] Their second son, William (1734–1777), was Liberty's father. On May 1, 1748, William Browne was bound to a local shipwright for seven years, probably to James Parrock Sr. (died 1755), shipwright and landowner, from whom in 1727 Peter had purchased three properties for £140, which remained in family ownership into the nineteenth century.[4] The properties were not contiguous but were both on the south side of Sassafras (Race) Street between Front and Second streets; one lot was located at the southeast corner of Second and Race; another 211 feet east of the first lot; and a third on Race "down toward Front Street, 46 feet

West of that corner."[5] Peter built his own house there, probably on the lot with a 30-foot frontage on Sassafras. Occupied by three generations, 16 Sassafras Street became known as the Brownes' old family homestead.[6]

At his death in 1749 Peter Browne left silver to his three sons.[7] To Nathaniel he left a silver tankard, his watch, and silver spoons, along with the house he had built on Sassafras Street, with the provisos that Nathaniel pay off the mortgage on the house that Peter then lived in and, "after ages, devise the house and the lot of ground to William." To John, the silversmith, he left two silver spoons, surely symbolic as John would receive important real estate from his grandfather Smith. Peter left to William a suit of clothes, two silver spoons, and the residual interest in the house and property on Sassafras Street then devised to Nathaniel. William eventually owned the house, and his son Liberty grew up in it.

William Browne's parents, Peter and Sarah Fisher Browne, were Quakers, and he too was a Quaker.[8] William married Elizabeth Borradaille (1740–1802), daughter of Arthur and Margery Moore Borradaille, in October 1760 and, according to Friends' records, "out of the discipline of marriage." One record notes that they were married in New Jersey.[9] In 1764 they were living in a brick house on the east side of Second Street between Brown Street and south of the Rope Walk. This was part of a property that had belonged to Peter, who left it to his children as tenants in common. His children, Nathaniel (born 1764), William (1771–1793), and their sister, Mary B. (Mrs. Thomas) Say, partitioned it in 1768. In 1769 William leased out this Second Street house and moved closer to the city proper, to the south side of Sassafras Street between the residences of John Parrock and his brother Nathaniel, then resident at number 16, the family homestead.[10] In 1774 William moved his household back to the Northern Liberties and leased a house from William Masters for £30 per year. It was located well to the north of Sassafras, west of Second Street, and north of the Cohocksink Creek, not far from his Second Street property in an area known then as Point Pleasant. William wrote his will there in 1776. As a shipwright and landowner, he owned a number of properties for which he was collecting ground rents.[11]

In 1776 Pennsylvania was arming for a British attack and invasion. In spite of their Quaker tenets of nonparticipation, William Browne and other members of his family responded to the call to arms in the Revolutionary War. The shipyards and blacksmith shops belonging to members of the extended Browne family provided vital services

to the navy. In April 1777 an order was placed "on William Webb to William Brown, Ship Builder, for Three Hundred & Thirty-one pounds Eighteen Shillings and Eight pence."[12] William Browne himself served in the Revolution as a member of the Ninth Pennsylvania Rifle Regiment, which he formed and trained. He relinquished that militia commission when he became first lieutenant in the Company of Foot, Fourth Battalion of Associators of the City of Philadelphia, and thus a member of General George Washington's staff.[13] William's half-brother, the silversmith John Browne, also served, as lieutenant in Colonel Jehu (John) Eyres's company of the Philadelphia Militia and in 1777 with Washington.[14] William's death on September 9, 1777—two days before the Battle at Brandywine—was attributed to sunstroke.[15] In June 1778 the British evacuated Philadelphia, destroying properties on their way north. William's widow Elizabeth applied for reimbursement "due his estate for a boat valued at £30 specie which was taken by Colonel John Eyres in the year 1777 and entered in the service of the state at the Fort on Mud-Island and never returned."[16]

When William Browne died he was "possessed of divers messuages, landings and tenements in the City," which were out on leases, as well as his residence in the Point Pleasant District, Northern Liberties, where his family was living.[17] He left one-third of his estate, including the Second Street house, to his wife during her life and the remainder of his properties to his four sons, three of whom were shipwrights in the Northern Liberties: Samuel (died 1798); Nathaniel, who married Catherine Williamson at the First Baptist Church in 1787; William, who died of yellow fever without issue; and Liberty, the silversmith. Nathaniel's son Jesse (active 1808–28) is noted intermittently in records as a silversmith.[18] In 1777 after her husband died, Elizabeth Borradaille (Burdell) Browne and her children moved from the leased property at Point Pleasant back to the house on the east side of Second Street south of the Rope Walk. Nathaniel was then living at the house his father Peter had built at 16 Sassafras Street. In 1790 Elizabeth and three of her children, Samuel, William, and Liberty, moved "to town" to the Browne homestead at 16 Sassafras.[19] Nathaniel had moved in favor of William, as his father had specified, to another property nearby, at number 24.

In 1791 or 1792, when Liberty was fifteen, his mother or possibly Nathaniel arranged for Liberty's apprenticeship for five years and nine months, probably with Joseph Lownes (q.v.), who was noted in Elizabeth's will as a "close family friend."[20] On August 10, 1792, the *General Advertiser* published

a notice of "Dr. Franklin's Legacy," regarding a stipend specifically dedicated to encourage young artificers:

> The Committee appointed by the Corporation to manage the legacy of One Thousand Pounds Sterling, from the late Dr. BENJAMIN FRANKLIN, to the inhabitants of this City, and for Loaning the same to such married Artificers as are under 25 years of age, who have faithfully served an Apprenticeship in the City, and can give two respectable Citizens as their Sureties, to repay One-tenth Part of the Principal Annually, with an Interest of Five per Cent—Do hereby give Public Notice that a small Part of that Sum is still on hand, ready to be loaned to such as are entitled, and desirous to participate in the advantage which may result therefrom, so as not to exceed Sixty Pounds Sterling, nor less than Fifteen Pounds, to one Person. Such as inclined to apply, will produce to George Roberts, Joseph Ball, Michael Hillegas, James C. Fisher, or Joseph P. Norris, who are the present Committee, such Credentials as will establish their Applications, before the 15th Day of August next.

> The Application should be accompanied with these Credentials and Documents, proving the Age, Apprenticeship in this City, good Moral Character, Marriage, Occupation or Trade, and Place of Residence of the Applicant (as none but Persons living in this City, appear to be entitled to any Part of the Loan) with the Names of the two Persons who are willing to become their Sureties.

In a 1789 codicil Franklin specified that the money was to be invested, lent to artisans, and paid back at 5 percent interest in ten years. He wrote, "I have considered that, among artizans, good apprentices are most likely to make good citizens."[21] Before the above notice, on July 21, 1792, sixteen-year-old Liberty Browne had applied for this stipend from the Franklin Fund. Peter Browne and Joseph Lownes signed his application with a $175 surety. Later, in 1803, Liberty Browne made a payment on the loan of $35.[22] The amount was slightly under the median of the amounts due from craftsmen, the lowest being $11, the highest $100.[23]

The next year, in November 1793, Liberty Browne took another step toward his independence, and while still an apprentice and underage, he petitioned the Orphans Court to have a guardian appointed for himself because he wanted to own the real estate left to him by his father. On March 10, 1794, his petition was heard: "That your petitioner is between seventeen & eighteen years of age—That he is intitled [sic] to a share of the real estate in the City & County of Philadelphia under the Will of his late Father William Brown late of the Northern Liberties of Philadelphia deceased. Your petitioner not being

of sufficient legal discretion to manage his said estate prays the Court to nominate him a Guardian. Your petitioner having a personal knowledge of the Character of Joseph Lownes of the City of Philadelphia goldsmith, prays the Court to act."[24] Then, promptly on April 11, 1794, his brothers "Samuel and Nathaniel Browne [William had died in 1793] of the one part, and Liberty Browne of the Northern Liberties of the second part, by his guardian Joseph Lownes of the third part, conveyed to Liberty the brick house and ground on the east side of Delaware Second Street that William had acquired in a partition agreement with his siblings in 1768, inherited by Elizabeth in 1777."[25] With the security of the Franklin Fund and income from the property described above, which he rented out, Liberty Browne may have been in business well before he was twenty-one.

The appraisal of shares in the partnership Houlton, Otto & Folk, Goldsmiths, in Philadelphia, was taken December 5, 1797, by Liberty Browne and Samuel Alexander (q.v.), suggesting that Browne and Alexander may have been together as apprentices with Joseph Lownes. The Philadelphia directory of 1793 listed a David Houlton, shopkeeper, at 52 Sassafras Street, indicating that he was there by the fall of 1792 to be listed. In 1795 he was described as a "rag merchant" at number 39 on the north side of Sassafras. In 1797 David Houlton moved to North Second Street, and John Houlton, silversmith, moved from Chancery Lane, where he had been in 1793 and 1794, to David Houlton's location at 39 Sassafras. John Houlton had been in a partnership in Philadelphia with John Lawrence Otto and John Folk as Houlton, Otto & Folk, Goldsmiths, a partnership that ceased with the deaths of Folk and Otto in 1797.

Liberty Browne was then twenty-one, and his Quaker congregation was hoping to "gather him in." On July 31, 1798, the Philadelphia Quaker Meeting of the North District entered into their minutes: "From the preparation Meeting was introduced the case of Liberty Brown (son of Wm Brown ship wright decd); having been treated with an account of his neglecting to attend our religious Meetings, which he endeavors to justify, alleging also that he is not united with friends in their Testimony respecting the unlawfulness of war—Mr. Garrigues & Danl Trotter are appointed to give the needful Attention thereto."[26] Sometime between this reminder and a further Quaker Meeting record in 1799, Liberty Browne married Hannah Knox (1778–1827). She may have been the daughter of Charles Knox, a bricklayer on St. John Street in 1816 and a very close neighbor of the Brownes.[27] In 1799 the Quaker Meeting further recorded:

The Friends who have treated with Liberty Brown having prepared a testimony against his conduct, it was now considered & agreed to as follows,

Liberty Brown who had a birthright amongst us the people called Quakers for want of attending the Dictates of Truth in his own mind has neglected the Divine worship and acknowledges that he is not one with us in our peaceable testimony, hath been tenderly dealt with in order to convince him of the impropriety of his conduct without the desired effect, and having further disregarded our Christian order by accomplishing his marriage with a person not professing with us—we testify that he hath disunited himself from religious membership amongst us until thro divine Favor he seeks to be restored, which we desire for him.

They are desired to deliver him a copy thereof and inform him that he hath a right to appeal.[28]

In 1798 Liberty Browne and family were not separately listed in the city directory. They were living with his mother Elizabeth at 16 Race Street through 1802, when she died. Christian Wiltberger (q.v.) was nearby from 1797 until 1800. John Houlton, silversmith, had two listings in the 1798 directory, at 39 Race Street and 102 North Front Street. Liberty Browne and John Houlton must have contemplated some working association if not a partnership when they had a mark made up with their surnames, "HOULTON & BROWNE" in a rectangle, and Liberty Browne moved to Baltimore, to 122 Baltimore Street.[29] It was a short-lived association, as the Brownes were back in Philadelphia in 1801 and 1802.[30] Liberty Browne, goldsmith and jeweler, was then listed at 102 North Front Street with his residence at 16 Sassafras. The U.S. census of 1800 described their household as comprising five persons, one male between the ages of ten and fifteen (perhaps Jesse Browne, silversmith, Liberty's cousin), one male between sixteen and twenty-five (Liberty), one female under ten (Elizabeth [1799–1808], Liberty's daughter, named after her grandmother), one female between sixteen and twenty-five (Hannah), and one female over forty-five (Elizabeth, Liberty's mother). Liberty and Hannah's first child, Charles Knox Browne, was born in Philadelphia in 1801.[31]

Elizabeth Browne wrote her will on July 8, 1799. When she died in late December 1802, she left £30 to her son Nathaniel and forgave any debts to her. She also left dresses to her two daughters-in-law. To Liberty Browne she bequeathed all ground rents and the residue of her estate, both real and personal; he was to be her executor with her "esteemed friend Joseph Lownes."[32]

On May 20, 1801, with some inheritance in hand, Liberty Browne purchased from Elizabeth

Armitt a property between Chestnut and Walnut streets and between Front and Second, well south of his Northern Liberty–based clan.[33] This was part of what became his 70 South Front Street property, well located for his trade and the commencement of his political career. By 1803 he was acting as a Guardian of the Poor, ordering a grave to be dug for a James McElween.[34] The established silversmiths John Black, Joseph Lownes, John McMullin, and Samuel Williamson (q.q.v.) were a block down Front Street.

On November 2, 1803, the Office of Indian Trade (OIT) ordered a quantity of trade silver marked "L•Browne," in capital and lowercase letters in a conforming rectangle, with the right leg of the "n" forming the left leg of the "e," along with another, smaller mark, "L•B" in a tight rectangle. These marks have not been firmly attributed to Liberty Browne but may be early examples. The order specified six armbands, sixteen and a half moon gorgets, twelve wristbands, seventy-three dozen ring brooches, and six earbobs.[35] The order was possibly on the recommendation of Browne's neighboring silversmiths, McMullin and Williamson, along with William Carr, Williamson's engraver and with whom Browne was doing a real estate deal; McMullin, Williamson, and Carr were making trade silver for the OIT in 1804. Martha Wilson Hamilton names Liberty Browne but suggests the mark may have belonged to a Levi Brown working in Detroit from about 1819 to 1844,[36] although that seems unlikely as those dates record him some fifteen years later than this order. In November 1804 OIT again ordered from "LB" thirty-six pairs of wristbands.

On November 19, 1803, Liberty Browne entered into a tripartite indenture between himself and his wife Hannah of the first part; William Carr, engraver, of the second part; and John Draper, engraver, of the third part, for $633.33 to Liberty Browne and $666.67 to William Carr, paid by and sold to John Draper.[37] This was the Second Street property that had been subject to his mother's estate and that he had previously mortgaged for £100 to Sarah Worrall when he was living on Sassafras Street.

In May 1806 he added to this property by purchasing from Caleb Carmalt, an officer of the Hand in Hand insurance company, and Joseph Cruikshank, stationer, "a messuage . . . on the west side of Front Street at the corner of Morris's Alley between Chestnut and Walnut Streets, . . . bordering the ground formerly of Charles Norris."[38] This became Browne's primary residence, 70 South Front Street.

His name marks "L.BROWNE" and "LIBERTY BROWNE" in a rectangle appear on silver probably made during this period, before his partnership with William Seal Jr. (q.v.), which began sometime before 1808. The full-name mark is stamped four times around the central dot on the underside of a spectacular, tall, heavy tankard made in a mid-eighteenth-century style.[39] The prominent placement of the marks suggests that Liberty considered it an important commission. At 10 inches in height, it is taller than most tankards, which stand between 7 and 9 inches and hold about a quart. At 51.7 troy ounces, it is also heavier than tankards made by John David Sr. and Jr., Joseph Richardson Jr., and Philip Syng Jr. (q.q.v.), which vary between 31 and 33 ounces. Handsomely engraved in foliate script with the initials "JCB," it was possibly a commission from John Coats Browne (1774–1832), Liberty Browne's cousin and eldest son of Peter (1751–1810) and Sarah Dutton Browne.[40]

Even before he moved to "center city," Liberty Brown began to participate in civic and political activities, first as an elections inspector. From the outset he seems to have been a conspicuous personage, taken to task in news items and official records. In 1801 "an important and interesting trial was . . . concluded in the Supreme Court, between the Commonwealth and Mr. Benjamin Gibbs," concerning interruption in an election hearing caused by "a sudden quarrel, excited by the Judge and an Inspector, one Liberty Browne."[41] In 1803 Browne was appointed secretary pro tem of the Board of the Guardians of the Poor.[42] By 1805, as an enthusiastic new Democrat, he was an active member of political committees. Gathering recognition, he applied for and was awarded the post of tax collector for the Middle Ward, which he held from 1806 until 1816.[43] In 1806 he collected monies for the city, county, poor, and health taxes in the Chestnut Ward.[44] Guardians of the Poor were important appointments; other members of the family, including his grandfather Peter Browne and his cousin John Coates Browne, held the posts at various times in the Northern Liberties.[45] From March 1806 Liberty Browne was acting as paymaster to collect militia fines of the Twenty-Fifth Regiment.[46] In 1807 he was on the electoral ticket for the directors of the Farmers' and Mechanics' Bank.[47] Busy with politics and his work, he advertised in 1807 for final settlement of all duplicate fines as well as "an active industrious person . . . to collect the fines for non-attendance in the militia on the days of training."[48] In October 1807 he was elected assistant to the "Friends of the Constitution" in the Walnut Ward.[49]

With these political appointments Liberty Browne achieved some notoriety as he went from meeting to meeting to carry out his official duties. Whether the notices increased the patronage of his silver business is not clear, but sometime before July 24, 1808, he and William Seal Jr. established a partnership.[50] Liberty Browne's name came first in the banner-shaped partnership mark, probably indicating that he was the senior or primary partner. The center of retail commerce was gradually moving westward, and Browne and Seal moved their business to 119 Chestnut Street, three or four blocks west of the Delaware waterfront. It was advantageous for the shop and for Browne's public persona and his role as tax collector for the Middle Ward. Browne and Seal are listed together in the city directory as a partnership at 119 Chestnut only in 1810 and 1811.[51] Together they marked a tea service for Benjamin Chew Jr. in 1811.[52] At that time Browne was listed at his old address, 70 South Front Street, where his household numbered eleven.[53] During the short partnership of Browne and Seal, Allen Armstrong (active 1808–17), gold- and silversmith, was listed at their address and either worked or retailed for them.[54] Meanwhile, Liberty Browne continued in the political fray as treasurer of the Democratic Society.[55] In 1810 he was elected vice president, with Joseph Snowden president, of the Master Mechanics Benevolent Society. On January 22, 1812, the Philadelphia *Tickler* posted the following comment: "At the late election for officers of the Master Mechanics Society, LIBERTY BROWNE, *ass*-squire, had an ardent longing to be elected president, but without effect—he was foiled by a large majority. Liberty, though ambitious, was not one of those who resolve to be *aut Caesar, aut nullus*, and cowered in his wing to be one of the vice presidents—here again did Liberty's evil genius predominate, and is now neither more nor less than *Liberty Browne*, in *statu quo*."

On May 29, 1811, Browne gave up or was not reappointed to one of his tax-collecting positions, and the *Tickler* could not resist:

That wonderful bird of wisdom, Liberty Browne, *ass*-squire, ex-common-council man, and now—heaven save the mark!—a Guardian of the poor, has been recently removed from his lazy place of collector of taxes, so that Libby may now attend to the manufacture of silver urinals with very little or no interruption on the score of public business.

This removal from the place of collector of taxes of one who has frequently rendered his situation subservient to political views, claims and will ensure for our country commissioner the grateful acknowledgments of their fellow citizens. Libby made silver jugs and tankards, before he felt too lazy to work at his trade; and when he succeeded in getting into a lazy berth he bestowed his favors as he was wont to fix the handles of his tankards, *all on one side*.

Let the good work of reformation progress.

While Browne was listed as both a silversmith and a collector of taxes through 1818, he kept right on with politics.[56] In 1811 he was chairman of a committee to elect a Democratic governor and was charged to meet with other ward leaders on the subject.[57] On February 2, 1811, as committee chairman, he was selected to confer with other wards about the issues before Congress relative to renewal of the charter of the Bank of the United States.[58] Also in 1811, as one of the Guardians of the Poor, he was made president of the Provident Society and handled the detailed work of the society in connection with allowances to the sick of $3 weekly, awarded to widows and children for education and clothing.[59] Research in Philadelphia newspapers did not turn up any advertisements for silver by Browne and Seal during this period.

The War of 1812 brought new challenges and a new line of business developed, the manufacture of swords and small armaments. In December 1812, on Browne's motion, the Philadelphia Common Council passed a resolution celebrating the gallantry of Commodore Stephen Decatur of the ship *United States* for his capture of the British ship of the line *Macedonian*, and voted to present him with a sword made by Browne.[60] In 1817 Governor Snyder honored Charles Stewart with a sword, also made by Browne, presented on October 14, 1817.[61]

Browne was elected president of Philadelphia's Select Council in 1813. It may have been the last straw for his business partner William Seal. On January 1, 1813, the *Democratic Press* announced that the Browne and Seal partnership had "expired" that day, and either partner would receive payments due. The announcement noted that the business would be carried on by Liberty Browne.[62] On January 19, using large capital letters, he advertised: "LIBERTY BROWNE, GOLD AND SILVERSMITH . . . RETURNS his thanks to his friends and former customers and begs leave to inform them that he continues to manufacture and sell every article in his line in stile [*sic*] of workmanship and quality of metal equal to any manufactured in this country. . . .WHOLESALE OR RETAIL."[63] On May 31, 1813, he took on James Bresling as apprentice for nine years, eleven months, and thirteen days to learn the art and mystery of the silversmith.[64] In 1814 Browne was on a committee to prepare for defense of the city against the British, and in that year became president of the Common Council, attending its frequent meetings between August and October.[65]

The press began to comment frequently on Browne's expanding political role: "After having been the most virulent abusers of Governor Simon Snyder, every one of those men suddenly became his most abject flatterers, because every one of them got his price, except Liberty Browne, and that poor gentleman has been literally *enceinte* of all the offices in this city, but unhappily he has as yet been out in his reckoning—he may be an alderman if he behaves himself well at the present election—and any of the incumbents should *die off*."[66] The issues of the day in which Browne was immersed were all about the reform of government, Governor Snyder's hopeful first term, and his failure to achieve reform in his second.[67] The tug-of-war between the old and new school of Democrats made lively press. Browne and his wealthy compatriot and council member Thomas Leiper (1745–1825) were frequently featured in the press. The *Tickler* of November 2, 1808, was especially hard on Browne: "We wish to be informed, whether or not, persons holding offices under our city corporation, are excluded from a seat in the councils? If they are ineligible, (and that they are we are fully convinced) by what right does that dunder-head, Liberty Browne occupy a seat in the Common Council to the exclusion of a better man? Liberty is a two penny half penny per cent collector of city taxes, and consequently a subordinate officer to the corporation. Let our city Solomon's [*sic*] look to it."[68]

Council meetings in 1808 were described thus in the *Tickler*, under the heading "Theatrical":

On Thursday evening last, precisely at 7 o'clock, the curtain was drawn at the City-hall, to a crowded auditory, and discovered among others, the following characters:

Presidentulum Jackassum,	Tom Leiper
Malvolio,	Billy Dalzell
Sir Stupid Silence,	Joseph Morris
Don Tunbelly Foolco,	T. F. Gordon
Liberty Softskull, *the clown*,	L. Browne
Light, *the Tallow Chandler*,	Alek Cook
Anthony Littlewit,	A. Taylor
Gill, *the tippling shop-keeper*,	Mosey Stewart
O' Blather, *an orator*,	John Steel

The performance had progressed considerably, when we entered the room, to see our City Solomon's [*sic*] metamorphosed into Merry Andrews. . . . They were divided into several whispering circles, in which each shook his cap and bell coronet at his fellow. In fact this pantomime way of disposing of business appears to be a great favorite with our councils.[69]

And subsequently:

Solomons in Council.
Thursday evening last the Common Council again exhibited themselves to the infinite gratification of a crowded gallery.

The great Tom-ass Leiper being chosen one of the presidential electors, had not yet returned from Lancaster; and consequently our Solomons were left to *fill up* the chair temporarily.

We have often remarked, that in public assemblages, or deliberative bodies, that the fellow who bellows out most stoutly for a particular person as chairman, generally wishes himself to be greeted with that honor. So it was with Liberty Browne, for he ardently vociferated for Mr. Dalzell to take the chair, when doubtless he would have felt himself immensely gratified to hear reciprocated "Mr. B. on the stool."[70]

The Tax Fund accounts published in *Poulson's American Daily Advertiser* showed Browne and others in the years of his tax collecting, 1804 through 1820, as owing "on account" to the Corporation of the City of Philadelphia various amounts between $1,074 and $7,457. The procedures for the collection and deposit of taxes that had been published in 1782 by the Office of Finance seem to have been treated casually.[71] Liberty was chided in the press for this. On July 14, 1817, it was reported in the *Aurora General Advertiser*: "Liberty Browne has found out a new interpretation of the president's motto, he says it means 'collect taxes but keep the money.'" The *Berks and Schuylkill Journal* weighed in as well:

No Harm at all.

When Mr. Matthew Carey began to talk of "*analogous cases,*" and argue that there was *no harm at all* in giving the *good money* of the people for the bad money to a *political leader*, how delighted the partisans of *Findlay* must have been!

It is *no harm at all*, said *Hugh Ferguson*, treasurer of the board of health, for I too blended my *private money* transactions with those of the *Board of health*.

"*Not the least criminality in the business,*" said *John Thompson*, "I have *money of the people* to this moment in my hands, and what is more I never will pay them a cent of it."

"Right" said *Liberty Browne*, "have not I collected thousands of *publick money*, and do you think I believe it *any harm at all* to keep it as long as I can." "Bravo" said *Binns*, "have I not had the *medal money* for years, and *where is the harm of it.*"

"Huzza for *analogous cases,*" said all the Lazaroni, and [a] fig for the *moralists!*"—*Aurora*.[72]

Official duties continued, but business faltered after the War of 1812, as specie payments were rare and notes substituted.[73] Browne witnessed wills and deeds.[74] In 1816 and 1817 he combined his role as tax collector with operation of a dry goods store at 119 Chestnut Street. He was still listed as a gold- and silversmith at the same address, but in

that year he made an unusual move well out of the city, to the village of the Falls of the Schuylkill.[75] He is listed there in the Philadelphia directories of 1819 and 1820 although he retained a "business" address as a "conveyor" at 393 North Front Street, just a few houses north of his uncle John Browne, at number 376. Perhaps Liberty's tax-collecting irregularities as well as Philadelphia's financial depression had caught up with him, and he retreated beyond city limits. But more likely he was responding to notices "From the Democratic Press" in the *Berks and Schuylkill Journal* of August 1, 1818, about the Schuylkill Navigation Company's stock offering and the grand scheme to connect the Schuylkill and Susquehanna Rivers. The company's plan included building canals on the Schuylkill to facilitate navigation upriver while damming it to create water power for Philadelphia's mills and manufacturing: "Few situations in the United States it is believed, present as great advantages as those now offered for sale."[76]

From 1821 to 1824 Browne was back in the city proper dealing in real estate as a "conveyancer" at 18 South Sixth Street, perhaps working with his cousin Aquilla A. Browne, "attorney and conveyancer" and son of John Browne, goldsmith, nearby at 38 South Sixth Street. However, Liberty's domicile remained in Browne territory in the Northern Liberties, at 59 Tammany Street.[77] Then, in 1825, he moved to 4 Noble Street, at the corner of Front Street.[78] In 1826 John Andrew Schultz, Governor of Pennsylvania, appointed Browne to the office of justice of the peace for District 4 of the Northern Liberties and Penn Township in Philadelphia County, a patronage position.[79]

Liberty and Hannah's son William B. died in February 1830, at the age of twenty-five. Their son Liberty Browne Jr. (1811–1889), a coach maker, served in the Civil War under Phillip Sheridan in the Sixteenth Pennsylvania Cavalry, and in 1865 was a sheriff in Downingtown, Pennsylvania. Liberty Junior had five sons, two of whom were killed in the war and two captured and imprisoned in the south.[80] Nathaniel Borradaille Browne (1819–1875), the elder Liberty's youngest son, became a lawyer in Philadelphia, served in state and federal government, was the first president of the Fidelity Trust Company, and served on the first Board of the Commissioners of Fairmount Park. A Democrat, he was appointed postmaster of the City of Philadelphia by President Buchanan in 1859.[81]

Browne's wife Hannah died on December 16, 1827, at the age of forty-nine. Liberty himself died on November 20, 1831, at the age of fifty-five.[82] In a headline that he might have hoped for, the *Philadelphia Inquirer* reported, "LIBERTY BROWNE, PATRIOT, DEAD." BBG

1. Browne and Spencer 1987, n.p. Facts and dates in the family typescript vary from some official records. Where there is a conflict the least likely option is in a footnote. In official documents the family signed "Browne" with an "e." In some documents transcribed by an official, the "e" was not always present.

2. A close inspection of the Philadelphia directory between 1791 and 1830 has not turned up another "Liberty." A Freedom Brown has been confused with Liberty and was once listed as "silversmith" at the Falls of Schuylkill; Philadelphia directory 1819, n.p; again as "Brown, Liberty, labourer, 26 Passyunk [sic]"; ibid. 1818, n.p; and "Brown, Liberty, conveyancer, 393 N 2d and Falls of Sch"; ibid. 1821, n.p.

3. Jeremiah Elfreth Jr. (q.v.) signed Peter and Sarah Fisher Browne's marriage certificate.

4. Philadelphia Deed Book G-1-231, February 28, 1727.

5. Hill and Hill 1982, pp. 564–65; Philadelphia Deed Book G-1-231, February 28, 1727.

6. Peter Browne purchased the properties in 1727; Hill and Hill 1982, p. 565; Philadelphia Deed Book G-1-231, February 28, 1727. William's mother would, at this time, have been his stepmother, Sarah Lane Fisher Browne, Peter's third wife; see Hill and Hill 1982.

7. Will of Peter Browne, written February 1749, probated April 24, 1749, Philadelphia Will Book J, p. 107; will of Nathaniel Browne, 1800, Will Book Y, p. 396; will of William Browne, written Point Pleasant, July 12, 1776, probated August 28, 1778, Will Book R, no. 95, p. 97; will of John Browne, 1825, Will Book 8, no. 78, p. 431.

8. "William Browne, ship carpenter in Race Street & child"; List of Members of Philadelphia Monthly Meeting, Arch Street, 1759–72, Quaker Meeting Records, Friends Historical Library.

9. If they were married in New Jersey without the succession of announcements at the Womens' Meetings, or if either were of another faith at the time of their marriage, the description "married out of discipline" would have applied. Elizabeth was the daughter of Arthur (died 1760) and Margery Moore Borradaille of Chester, Burlington County, New Jersey; *Calendar of New Jersey Wills, Administrations, Etc.*, vol. 3, *1751–60* (Somerville, NJ: printed by the Unionist Gazbeth Association, 1924). Arthur Borradaille ran an inn or a pub in Moorestown, New Jersey, called "The Cable;" "The Taverns of Moorestown," *From the Front Porch: The Newsletter of the Historical Society of Moorestown*, June 2010. Elizabeth wrote her will July 8, 1799, and it was probated January 5, 1803; Philadelphia Will Book I, no. 1, p. 63. She left bequests to her sons Nathaniel and Liberty and legacies to their wives and to her sister Esther Venables.

10. John Parrock owned twenty-one properties around Sassafras Street between Front and Second streets, as well as a wharf and a house; since he was a Loyalist his estate was confiscated and put up for sale in 1782. Anne M. Ousterhout, "Opponents of the Revolution Whose Pennsylvania Estates Were Confiscated," *Pennsylvania Genealogical Magazine*, vol. 30, no. 4 (1978), p. 247.

11. Hill and Hill 1982, pp. 565, 586.

12. *Pennsylvania Archives*, 2nd ser. (1879), p. 125 (April 14, 1777).

13. Browne and Spencer 1987, n.p.; William Garretson Browne, descendant of William Browne, Sons of the American Revolution membership applications, 1889–1970, National Society of the Sons of the American Revolution, Louisville, KY, Ancestry.com. Not to be confused with a Captain William Brown of the Marines on the ship *Montgomery* on the Delaware River in September 1776; *Pennsylvania Archives*, 2nd ser. (1879), vol. 1, p. 489; CG (Coast Guard) Grand Account CXCIV, ledger C, p. 33, ledger B, p. 514, Arias, Pennsylvania's Digital State Archive, www.digitalarchives.state.pa.us.

14. See John Browne (q.v.), p. 192.

15. The date was also noted in Friends' records. Hill and Hill 1982, 586; Browne and Spencer 1987, n.p.

16. CG (Coast Guard) Grand Account CXCIV.

17. Philadelphia Deed Books H-21-26 and D-66, pp. 178–82; the deeds record Samuel Browne and others to Liberty Browne, April 11, 1794. William Browne's will, which included Liberty, noted that he was from Point Pleasant, Northern Liberties (see note 7).

18. No silver or mark has yet been identified as by Jesse Browne. He was a member of the First Baptist Church. In 1811 he subscribed to *The Picture of Philadelphia, 1811* (Philadelphia: B. & T. Kite, 1811), by James Mease, MD. A Jesse Browne, "silversmith," was listed in the Philadelphia directory from 1813 through 1817. See also John Browne (q.v.), p. 193, note 1.

19. From 1797 until 1800 and in 1817–18, Christian Wiltberger was at this address and Abraham Carlile (q.q.v.) next door at no. 18. The latter two were not listed in the Philadelphia directory. From 1795 through 1801 Carlile, now an ironmonger, was also located at 102 North Front Street.

20. As Lownes took on Liberty Browne, whose father was killed in the Revolutionary War, he may have taken on Samuel Alexander (q.v.) for the same reason.

21. Quoted in Mease, *The Picture of Philadelphia*, p. 339.

22. "State of the Account," *Aurora General Advertiser* (Philadelphia), June 11, 1804.

23. Liberty Browne was the only silversmith in the list this year; Philadelphia City Records of Franklin Legacy Funds and Loans Accounts, January 1–December 31, 1803, American Philosophical Society, Philadelphia.

24. Philadelphia Orphans Court Records, book 17, 1793–98, p. 33, file 68.

25. Philadelphia Deed Book EF-14-627.

26. Minutes, 1795–1804, Records of Philadelphia Monthly Meeting for the Northern District, p. 204, Friends Historical Library.

27. There does not seem to be a record of Browne's marriage in Philadelphia church or meeting archives or of Charles and Ann Knox in Philadelphia or Baltimore during this time. There is a reference to Charles and Ann Knox as having been "received by certificate" on June 16, 1844, at the Kensington Methodist Episcopal Church, Montgomery Square, Philadelphia, and, according to another source, an indication that they were from Scotland; however, in the 1850 U.S. census, Liberty Browne Jr. noted that his mother was born in Ireland. There were Knox families in Kensington who were listed in the Philadelphia directory: William Knox, ship carpenter, 395 North Front Street, close to the Brownes' shipyard in 1803; and Hannah Knox, widow, listed, from 1796 until 1816, on North Seventh Street. Hannah K. Browne's life dates are given in "Notices of Marriages and Deaths," *Poulson's American Daily Advertiser, 1791–1839* (Philadelphia: Genealogical Society of Pennsylvania, 1980), p. 273; Browne and Spencer 1987, n.p.

28. Minutes, 1795–1804, Records of Philadelphia Monthly Meeting for the Northern District, Philadelphia, p. 222, Friends Historical Library.

29. Hollan 2013, illus. p. 100.

30. Philadelphia directory 1801, p. 21.

31. Not to be confused with Charles Cresap Browne, who was born in Maryland, son of Aquilla Arrel Browne, grandson of John Browne, silversmith.

32. As Liberty Browne died intestate, this piece of ground was subsequently owned by his children, Ellet, James M., John V., Francis K., Ann B. Helms, and Liberty II. In 1844 they sold it to George D. Hauck of the Northern Liberties. Philadelphia Deed Book D-66-178-182.

33. Philadelphia Deed Book AM-75-609, May 20, 1801. In 1791 seven members of the Browne family were located on North Front Street or on Sassafras (Race) just off Front. John the goldsmith was at 366 North Front for most of his life.

34. Frances Alcott Allen, "Earliest Burial Records of the Board of Health, 1807," *Pennsylvania Genealogical Magazine*, vol. 1 (1895), p. 227.

35. Martha Wilson Hamilton, *Silver in the Fur Trade, 1680–1820* (Chelmsford, MA: printed by the author, 1995), pp. 202–3.

36. Ibid.

37. Philadelphia Deed Book EF-14-627.

38. Philadelphia Deed Books AM-75-606 and AM-75-609.

39. Aspire Auctions, Pittsburgh, *Fine Arts and Antiques*, September 15, 2006, lot 388.

40. Peter and Sarah married in 1773; *Pennsylvania Archives*, 2nd ser. (1896), vol. 2, p. 38. Just as grand as the tankard is the full-length portrait of John Coats Browne as a boy by Joseph Wright, painted in Philadelphia about 1784 (Fine Arts Museums of San Francisco, M. H. de Young Memorial Museum, 1979.7.107). John

Coats Browne was a Quaker. He died of cholera on September 19 (?), 1832; Darby Monthly Meeting, Quaker Meeting Records, Friends Historical Library.

41. "Philadelphia, Dec. 9," *Poulson's American Daily Advertiser* (Philadelphia), December 11, 1802. The article was republished in the *Farmer's Cabinet* in Amherst, Massachusetts.

42. "Board of Guardians," *Poulson's American Daily Advertiser*, June 18, 1803.

43. John Stock, Receipts, July 1806–December 1815, HSP; Society Miscellaneous Collection, Bills and Accounts, HSP; Edward Shippen Burd, Receipts, HSP.

44. McA MSS 025, John A. McAllister Collection, McAllister Miscellaneous Manuscripts, Library Company of Philadelphia; Edward Shippen Burd, Receipts, 1805–1831, Edward Shippen Burd Papers, HSP; John Stock, Receipt Books, 1784–1841, HSP; Receipt, August 29, 1806, "Received of S W Condy, seven dollars 33/100 in full for City, County, Poor, and Health taxes on his person in Chestnut Ward for 1805, [signed] Liberty Browne Coll," David McNeely Stauffer Collection on Westcott's *History of Philadelphia, 1644–1844*, folder 1009, HSP; "John Morrells Dr. to Liberty Browne, Collector, No. 119 Chestnut Street for taxes, Chestnut Ward, 1813," Bills and Receipts, Miscellaneous Collections, Bills/Accounts, HSP.

45. *Gazette of the United States* (Philadelphia), May 18, 1803.

46. *Aurora General Advertiser*, March 17, 1806.

47. "Directors of the Farmers' and Mechanics' Bank," *Poulson's American Daily Advertiser*, February 12, 1807.

48. "Militia Fines," *Aurora General Advertiser*, March 3, 1806; "A Collector Wanted," ibid., December 2, 1807.

49. "Friends of the Constitution," *Gazette of the United States*, October 3, 1807.

50. "July 24, 1808, John Hamilton To Browne & Seal / to 6 silver teaspoons, 1 pair silver sugar tongs / $10.40"; "January 13, 1810, John Hamilton $50.00 to Browne and Seal"; John Hamilton, Receipts, Collection of Hamilton and Hood Records, 1803–1863, HSP. Liberty Browne collected Hamilton's taxes on July 12, 1808, and for his estate in 1814. Neither Liberty Browne nor William Seal Jr. were listed together or separately in the 1809 Philadelphia directory.

51. The only William Seal in Philadelphia directories or recorded in the 1810 U.S. census was a "mate" at 60 Shippen Street, Blockley Township.

52. Hope Coppage Hendrickson, "Cliveden," *Antiques*, vol. 124, no. 2 (August 1983), p. 263.

53. 1810 U.S. Census.

54. Armstrong worked with them using his own mark. He was at 4 North Second Street in 1806, 12 North Second in 1809 and 1810, and 225 Arch from 1814 through 1816. He was listed as "hardware merchant" from 1818 through 1821 at 56 High (Market) Street; Sotheby's, New York, *Important Americana*, January 28, 29, and 31, 1987, sale 5551, lot 227; Hollan 2013, p. 6.

55. *Poulson's American Daily Advertiser*, March 9 and May 3, 1810.

56. In the Philadelphia directory of 1813 (n.p.), for example, he was listed as "silversmith & collector of taxes 119 Chestnut Street." The Auditors Account for the County of Philadelphia published in the *Franklin Gazette*, February 18, 1820, listed Liberty Browne, tax collector, as in arrears for depositing the taxes he had collected!

57. "Resolved—Chairman Liberty Browne," *Democratic Press* (Philadelphia), January 22, 1811.

58. "Democratic Committee," ibid., February 2, 1811.

59. Philadelphia directory 1811, p. 428.

60. Yale University Art Gallery, New Haven, 1994.34.1.

61. *Niles' National Register* (Baltimore), vol. 13 (August 30, 1817–February 21, 1818), p. 93.

62. *Democratic Press*, January 1, 1813. Seal did not reappear in the Philadelphia directory until 1816 (n.p.), at 118 South Front Street.

63. *Democratic Press*, January 19, 1813.

64. In 1817 the apprenticeship was canceled, and Bresling was rebound to John Harwood; Philadelphia Records of Indentures and Marriages, p. 62.

65. This was an important and distinguished group of men: John Barker, Charles Biddle, Thomas Cadwalader, John Connelly, John Geyer (mayor), Henry Hawkins, George Latimer, Thomas Leiper, William McFadden, Condy Raguet, Joseph Reed, John Sergeant, and General John Steel; *Minutes of the Committee of Defence of Philadelphia, 1814–1815*, Memoirs of the Historical Society of Pennsylvania, vol. 8 (Philadelphia: J. B. Lippincott, 1867), pp. 7–8.

66. *Weekly Aurora* (Philadelphia), October 17, 1815 (original emphasis).

67. Ibid., January 17, 1815; "Hints to Honest Democrats," *Voice of the Nation* (Philadelphia), April 4, 1814.

68. In 1896 the *Philadelphia Inquirer* published, as a reflection on old times, "SOME PERSONAL THRUSTS" about the *Tickler* style of journalism.

69. *The Tickler* (Philadelphia), November 30, 1808.

70. Ibid., December 14, 1808.

71. "Reprint of Office of Finance, February 12, 1782," Notes and Queries, *PMHB*, vol. 39 (1915), pp. 224–25.

72. *Berks and Schuylkill Journal* (Reading, PA), October 4, 1817.

73. Scharf and Westcott 1884, vol. 1, pp. 577, 581, 585.

74. Witness, will of Margaret Maney, widow, Northern Liberties, 1819, Philadelphia Will Book 7, p. 472; witness, deed between Daniel Barndollar (cedar cooper) of Northern Liberties and Charles Stout, Philadelphia Deed Book IW-7-631; executor, will of Louis Bodin, Northern Liberties, 1822, Philadelphia Will Book 8, p. 42.

75. Philadelphia directory 1818, n.p. In 1819 two Liberty Browns were listed: the silversmith at the Falls of Schuylkill, and Liberty Brown, laborer, at 26 Passyunk. The latter was the only appearance of this "Liberty," noted as African American in the directory; he may have been a member of the family of Lunar Brown in Passyunk, one of whom was named Freedom Brown.

76. *Berks and Schuylkill Journal*, August 1, 1818, and July 24, 1819.

77. Tammany Street ran between Second and Third streets and between Green and Noble.

78. Noble Street ran from 330 North Front to North Seventh Street, in the Northern Liberties.

79. *National Gazette and Literary Register* (Philadelphia), February 25, 1830.

80. *Philadelphia Inquirer*, April 20, 1889

81. Biographical note, MSS 424, N. B. Browne Papers, 1845–1873, Special Collections, University of Delaware Library, Newark.

82. Dr. Samuel Wister Butler Records, Wister and Butler Families Papers, 1700–2004, HSP; "Elfreth Necrology," *Pennsylvania Genealogical Magazine*, vol. 2, no. 2 (May 1902), p. 177.

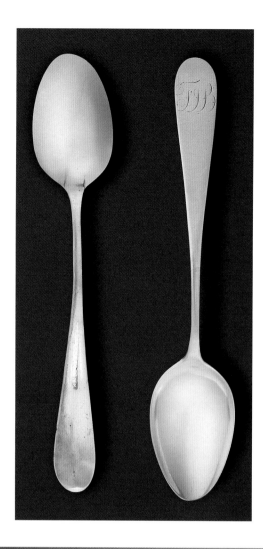

Cat. 96

Liberty Browne

Pair of Teaspoons

1800–1805

MARK (on each): LIBERTY.BROWNE (in rectangle, on reverse of handle; cat. 96-1)

INSCRIPTION (on each): T J B (engraved script, at top of obverse of handle)

Length 5⅝ inches (14.3 cm)

Weight 8 dwt 14 gr.

On permanent deposit from The Dietrich American Foundation Collection to the Philadelphia Museum of Art, D-2007-42, -43

PROVENANCE: Dr. George Barton Cutten; James Graham and Sons, Inc., New York.

EXHIBITED: On long-term loan to the William Penn Memorial Museum, Harrisburg, PA, 1972–78; Springfield Museum of Art, Springfield, MA, 1978–86.

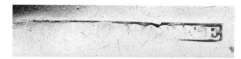

Cat. 96-1

These spoons have a slightly turned-back handle, with plain surfaces that are worn.

The initials "TJB" may have belonged to Thomas (died 1820)[1] and Jane Baker, as they are similar to the "MJB" (for Michael Baker, a lumber merchant, and his wife Jane) engraved on the reverse of the handle of a tablespoon marked by Browne and Seal.[2]

The Bakers were located in Liberty Browne's neighborhood, on Brown and North Second streets in the Northern Liberties. BBG

1. Thomas Baker, Philadelphia Administration Book M, no. 148, p. 223.
2. The spoon (Colonial Williamsburg, VA., B.82.18) bears their marriage date of September 23, 1784.

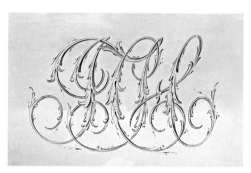

Cat. 97-1

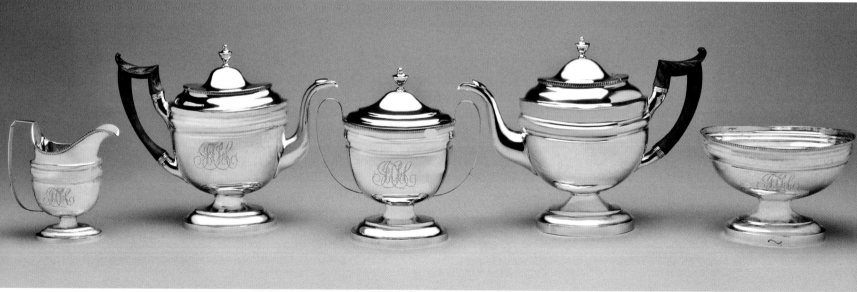

Cat. 97

Browne and Seal

Tea Service

c. 1811

MARK (on each): BROWNE & SEAL (in banner, on underside of foot; cat. 100-1)

INSCRIPTION: J C H (engraved script, on one side of each; cat. 97-1); 64216 (scratched, on underside of both teapots and sugar bowl)

Teapot[1]: Height 9⅜ inches (23.8 cm), width 11½ inches (29.2 cm), depth 4¼ inches (10.8 cm)
Gross weight 20 oz. 14 dwt.

Sugar Bowl: Height 8⅝ inches (21.9 cm), width 8 inches (20.3 cm), depth 3⅞ inches (9.8 cm)
Weight 14 oz. 14 dwt.

Slop Bowl: Height 5 inches (12.7 cm), width 7¼ inches (18.4 cm), depth 5⅝ inches (14.3 cm)
Weight 12 oz. 6 dwt.

Cream Pot: Height 5⅝ inches (14.3 cm), width 5½ inches (14 cm), depth 2½ inches (6.4 cm)

Weight 5 oz. 12 dwt. 15 gr.

Gift of Charlotte Calwell Stokes, 2001-106-1–4

PROVENANCE: According to family tradition, the service was first owned by John Cunningham Hardy, a baker who lived at 78 Spruce Street and died September 7, 1839, without heirs. The service descended in the family of his sister Catherine Hardy, who married Joseph Hanley, and then descended to their daughter Anna Pringle Hanley (died 1891), who married William C. Edwards on July 14, 1839. It went to their daughter Sarah Ann Edwards (1841–1928); to the great-grandson of John Hardy's sister

Marion; to her son, Edward J. Moore, who married Emily Wynn; to their cousin, Cora Eleanor Parker Calwell (Mrs. Charles Sheridan Calwell); to her daughter, the donor, Charlotte Calwell, who married Francis Joseph Stokes Jr. in Philadelphia in 1936.[1]

All the forms are raised. The carved wood handles on the teapots match and are probably original. BBG

1. For the second, larger teapot, see PMA 2001-106-5, by Thomas Whartenby. It matches the service but is not engraved. It may have been added by the Edwards. Another, probably larger, pot for hot water, which would have been typical of a service at this period, was presented to the donor's older sister; see curatorial files, AA, PMA. Hardy is listed at this address from 1811 until 1820 in the Philadelphia directory. The initials also match those of his sister Catherine and her husband Joseph Hanley.

Cat. 98

Browne and Seal
Bread or Cake Basket

1808–13
MARK: BROWNE & SEAL (in banner, on underside of foot; cat. 100–1)
INSCRIPTION: A. M.cCausland (engraved script, on one side); Nº 2 oz/25 Dwt/15 (scratched, on underside)
Height 4⅝ inches (11.8 cm), length 12¾ inches (32.4 cm), width 9½ inches (24.1 cm)
Weight 25 oz. 11 dwt. 5 gr.
Gift of the McNeil Americana Collection, 2005-68-9

PROVENANCE: Christie's, New York, *Fine American Furniture, Silver, Folk Art and Historical Prints*, January 26, 1991, sale 7214, lot 43; (S. J. Shrubsole, New York).

The oak leaves decorating the inside ends of the basket are in deep repoussé. John McMullin (q.v.) used a similar leaf design, cast and applied on a similarly shaped basket.[1] When lowered the handle conforms to the contours of the ends of the basket. The inscription "Nº 2" suggests that this basket was one of a pair.

The inscription "A. M.cCausland" may have been added in about 1864, when Anna McCausland (1836–1908) married Arthur Kyle in Philadelphia.[2] BBG

1. Martha Gandy Fales, *American Silver in the Henry Francis Dupont Winterthur Museum* (Winterthur, DE: the Museum, 1958), cat. 140.
2. U.S. and International Marriage Records, 1560–1900, Ancestry.com.

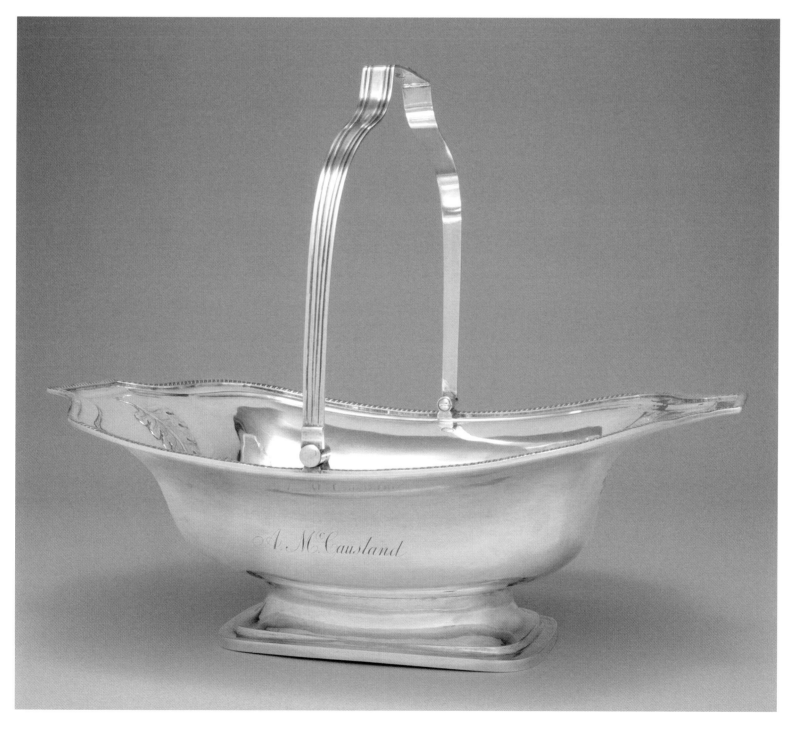

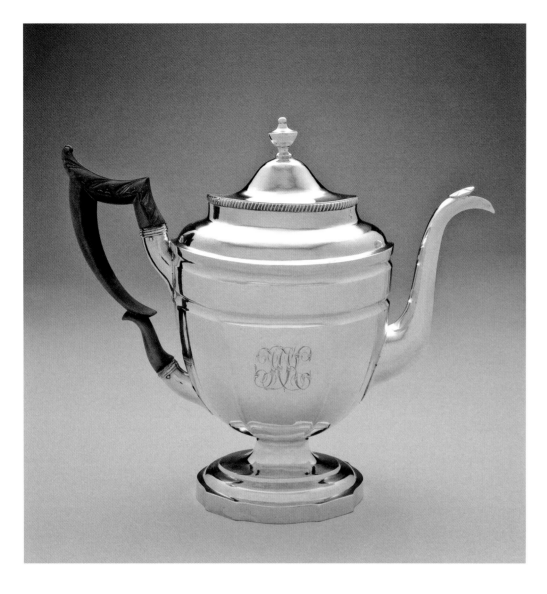

Cat. 99

Browne and Seal

Coffeepot

1808–12

MARK: BROWNE & SEAL (in banner, on underside of foot; cat. 100-1)

INSCRIPTIONS: H K (engraved script, on one side); 31 oz.-18 (scratched, on underside of foot)

Height 10⅜ inches (26.4 cm), width 12½ inches (31.8 cm), depth 4¼ inches (10.8 cm)
Gross weight 31 oz. 13 dwt. 5 gr.

Gift of the McNeil Americana Collection, 2005-68-10

PROVENANCE: Sotheby's, New York, *Important Americana, Including Furniture, Folk Art and Folk Paintings, Prints, Silver, and Chinese Export Porcelain*, January 30–February 1, 1986, sale 5429, lot 374; (S. J. Shrubsole, New York).

This coffeepot is distinctive for its smooth, undulating, convex, and concave surfaces embellished only by a single chased band at the top and handsome engraved initials on one side. The foot and the knop are made in cyma curves. The lid is hinged. The handle, carved in a leaf design at the top with a "break" where contrasting curves meet, is an unusual design and may be the original. BBG

Cat. 100

Browne and Seal

Tablespoon

1810–13

MARK: BROWNE & SEAL (in banner, on reverse of handle; cat. 100-1)

INSCRIPTION: J K (engraved script, lengthwise on handle)
Length 7 inches (17.8 cm)
Weight 18 dwt. 7 gr.

Gift of Mrs. F. Joseph Stokes, 1989-19-1

PROVENANCE: Purchased by the donor, Charlotte Calwell Stokes, at Freeman's, Philadelphia, to match a tea service that had descended in her family (see cat. 97).

Cat. 100-1

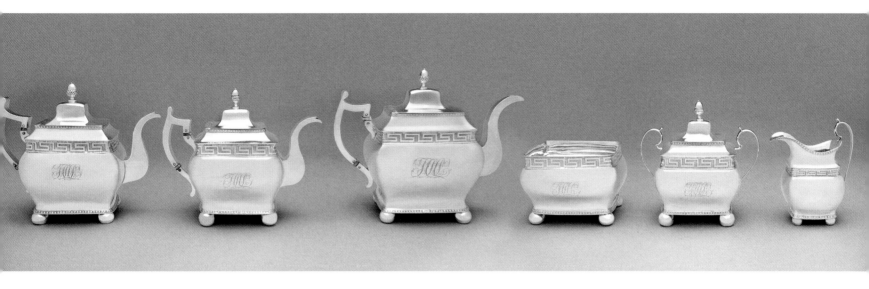

Cat. 101

Liberty Browne
Tea and Coffee Service

1814

MARK (on each): BROWNE & (in wavy rectangle, on underside); PHILADᴬ (in conforming rectangle with hexagonal ends and period under final small "A," on underside; cat. 101-1)

INSCRIPTIONS: H H L (engraved script, on one side of each; cat. 101-2); Helen Hamilton Leiper / married April 20" 1814 / Robert Maskell Patterson / Helen Hamilton Patterson / married June 17" 1856 / James Wiltbank Robins / Given to her daughter Helen Hamilton Robins / June 17" 1906 / Helen Wood Davis / married February 14" 1924 / James Hamilton Robins / Given to her daughter Helen Louise Hendrix / June 17, 1973 (engraved script on underside of hot-water pot); 46708 8" (scratched, on underside of teapot)

Coffeepot: Height 8⁹⁄₁₆ inches (21.8 cm), width 10⁷⁄₁₆ inches (26.5 cm), depth 5⁹⁄₁₆ inches (14.1 cm) Weight 30 oz. 18 dwt. 2 gr.

Hot-Water Pot: Height 9½ inches (24.1 cm), width 12⅛ inches (30.8 cm), depth 6⁵⁄₁₆ inches (16 cm) Weight 39 oz. 4 dwt. 5 gr.

Teapot: Height 8⁵⁄₁₆ inches (21.1 cm), width 10⁵⁄₁₆ inches (26.2 cm), depth 5⁹⁄₁₆ inches (14.1 cm) Weight 29 oz. 2 dwt. 2 gr.

Sugar Bowl: Height 7⁷⁄₁₆ inches (18.9 cm), width 5⅜ inches (13.7 cm), depth 4¹⁵⁄₁₆ inches (12.5 cm) Weight 20 oz. 17 dwt. 19 gr.

Cream Pot: Height 6⅜ inches (16.2 cm), width 5⅜ inches (13.7 cm), depth 5¹³⁄₁₆ inches (14.8 cm) Weight 8 oz. 7 dwt. 19 gr

Slop Bowl: Height 4⅜ inches (11.1 cm), width 6⅝ inches (16.8 cm), depth 5¹³⁄₁₆ inches (14.8 cm) Weight 15 oz. 16 dwt. 12 gr.

Gift of Helen Louise Robins Hendrix, 1976-105-1-6

PROVENANCE: The service was made for Helen Hamilton Leiper and given to her at the time of her marriage on April 20, 1814, to Robert Maskell Patterson Jr. (1787–1854), son of Robert Patterson Sr. (1743–1824) and Amy Hunter Ewing Patterson.[1] Helen, who was named for her grandmother Helen Hamilton of Kipe, Scotland (who had married Thomas Leiper Sr.),[2] was the daughter of Thomas Leiper Jr. (Scotland 1745–1825 Avondale, Delware) and Elizabeth Coultas Gray Leiper (died 1829). Robert M. Patterson Jr. graduated from the University of Pennsylvania in 1804 and obtained a medical degree in 1808. He was vice provost of the university from 1836 until 1854 and president of the American Philosophical Society in 1849.[3]

EXHIBITED: *Gifts to Mark a Century*, exh. cat. (Philadelphia: Philadelphia Museum of Art, 1976), cat. 126

Cat. 101-1

The maker's mark "BROWNE" was made from the first section and part of the ampersand of the "BROWNE & SEAL" die, which was broken apart after that partnership dissolved in 1813.

This is an especially handsome set. From the acorn finials to the star bandings at top and bottom, to the round, cannonball-shaped feet, to the wide, three-quarter-inch bands of the Greek-key design—which became stylish for its association with the idealism of a republic—this is an "all American" silver service. Made during the middle of the War of 1812, in its detail this set exhibits the patriotic fervor of the time in Philadelphia.[4] The forms are generous, the bodies of the pots curvaceous and full at the shoulders. The pots are seamed up the back under the handle. The Greek-key band, the design that moves to the left, is a separately applied piece.[5] The teapot has piercing inside at the entrance to the spout. The pots have hollow handles that are rectilinear in cross section, with ivory insulators, and their shapes are repeated in the spouts. The bands around the bases and the tops of the vessels have stars alternating with horizontal lines.

Cat. 101-2

Thomas Leiper Jr., who presumably commis-
sioned this service for his daughter, was an organizer
of the First City Troop in 1774 and among the earli-
est to advocate independence. A prominent leader
of the Democratic Party in Philadelphia, he became
closely associated with Liberty Browne in the civic
world of politics. As members of the Philadelphia
City Council, Liberty Browne, Thomas Leiper, John
Steel, and John Thompson made up the commit-
tee to organize the defense of Philadelphia in 1814.[6]
Browne was president of the Common Council
when Leiper was authorized to collect and disburse
money for families of soldiers and their families.[7] The
connection between Leiper and Browne probably
secured the commission for this set and inspired its
distinction. BBG

1. There is a beautiful miniature of Robert Maskell Patterson,
MD, by Benjamin Trott in the collection of the Philadelphia
Museum of Art (2008-26-1). See Carol Eaton Soltis, "Patriots
and Presidents: Philadelphia Portrait Miniatures, 1760–1860,"
The 48th Annual Philadelphia Antiques Show (Philadelphia,
2009), p. 88, fig. 16.
2. Thomas Leiper Jr. emigrated from Scotland to Philadelphia
via Virginia in 1764. In 1799 he was captain of the new Fourth
City Troop, leading George Washington's funeral cortege.
Known as a man of great wealth and generosity, he built the
first railroad in America in 1809 and was a director of the
Bank of Pennsylvania and the Bank of the United States. He
was president of the Philadelphia Common Council inter-
mittently from 1801 until 1814. Liberty Browne succeeded him
as president in 1814. W. A. Newman Dorland, "The Second
Troop Philadelphia Calvary," *PMHB*, vol. 48, no. 3 (July 1924),
p. 281n406.
3. Scharf and Westcott 1884, vol. 1, p. 571
4. "The year 1814 was one of the most exciting periods in the
history of Philadelphia. . . . A new spirit inspired the national
government and united the people for an aggressive war";
Scharf and Westcott 1884, vol. 1, p. 569. This set was acces-
sioned by the Museum in honor of the two-hundredth anni-
versary of the silversmith's birth.
5. The Greek-key design was used by other silversmiths; cf.
the tea service by Harvey Lewis (PMA 1953-112-1–6). A set
attributed to the Connecticut silversmith John Ward (q.v.) is
almost identical to the Browne set. It may have been made
by the Philadelphia silversmith Jehu Ward (q.v.); see Ham-
merslough 1958–73, vol. 4, p. 27.
6. Information from the donor; *DAB*, vol. 14, s.v. "Robert
Patterson."
7. Dorland, "The Second Troop," p. 281.

Thomas Bruff

Chestertown, Maryland, born c. 1760
New York City, died 1816

Thomas Jefferson wrote of Thomas Bruff that he was a "mighty good, and a very ingenious man." Bruff established himself as a dentist in Georgetown (D.C.) in 1799, and he moved to Washington in 1802. He served as Jefferson's dentist three times between 1803 and 1808. They had a conversation in 1800 about Bruff's plan and program to invent a time and perpetual-motion machine, and Jefferson seems to have been his target for sponsorship.

In a long letter to Jefferson written on December 16, 1801, Bruff woefully describes his family of nine, of whom five were ill, three had died, and his wife was in extremis. All the while he had been hard at work demonstrating and trying to sell his spoon machine so that he could make the time machine. In the letter Bruff noted about himself:

> Nature has me designed for inventing, such things are almost as easy to me, as to eat or sleep; and if I could live by it, I would devote my life in that way, to the service of my country. . . . I have brought to perfection the patent tooth instruments, and a coffee mill that grinds a pound in 4 1/2 minutes, the spoon machine that turns a flat bar of silver to a spoon in 12 seconds, a machine for treading wheat, a grist mill, a cider mill . . . these are not all, but sufficient to shew that nature has formed me for such employment. I ought to have assistance. . . . I now stand in the need of public patronage . . . hoping my promise respecting the time piece will be constituted as my apology for calling your attention to the subject. . . . your humble servant.[1]

Discussions continued about various inventions. Bruff had title to six patents registered between 1797 and 1813. In 1811 Jefferson forwarded to President James Madison "Dr." Bruff's proposal to set up and sell shares in a manufactory to produce compressed bullets and shot.[2] This included building a two-hundred-foot shot tower near Washington. In a letter to Bruff of June 7, 1812, Jefferson said, "I have duly received your letter of May 30 and am very happy to learn that your manufactory of solid shot is likely to get into operation."[3]

Thomas Bruff, silversmith and inventor, was the third of the name in a long line of Maryland silversmiths. The first of the line was Thomas Bruff I (c. 1645–c. 1702), son of a goldsmith, who emigrated to Maryland from London in about 1665.[4] He had two sons, Richard and Thomas II (c. 1700–c. 1772). The latter married Mary Turbutt and inherited the fifty-acre Bruff's Island, owned and named for Thomas Bruff I, where he was the proprietor of a regular ferry over the Miles River. His allowance from the state of Maryland for this service was six thousand pounds of tobacco per year.[5] As a silversmith he was the keeper of weights and measures in Talbot, Maryland, between 1732 and 1735. In about 1743 Thomas II's son Joseph Bruff (1730–1784) became his apprentice. It has been presumed that Joseph inherited his father's tools when the senior Thomas's inventory was taken on February 24, 1772. Joseph, in turn, practiced in Maryland while advertising broadly. On January 1, 1767, his advertisement in the *Pennsylvania Gazette* stated that "JOSEPH BRUFF, Goldsmith, At Talbot Court-House, Having procured a Hand from Glasgow, that has been regularly bred a Watch-finisher, takes this method to inform the Public that he undertakes to repair either Repeating or plain Clocks and Watches."[6] Joseph himself had two sons, Thomas III, our silversmith (c. 1760–1816), and Joseph (died 1803), both of whom apprenticed with their father.[7]

Thomas Bruff III finished his apprenticeship in about 1783 and set up shop in Easton until November 1791, when he moved to Chestertown, Maryland, and referred to himself as "Thomas Bruff of Kent County, goldsmith, eldest son of Joseph Bruff."[8] He advertised that he made "in the neatest manner and on the shortest notice for Philadelphia prices, all kinds of gold and silver work."[9] From 1792 until 1803 he was in Chestertown "nearly opposite the printing office."[10] His advertisement of May 7, 1793, in the *Apollo, or Chestertown Spy* described his versatility: he "executes devices with the Graver on Gold, Silver, Copper and Type metal, mends and rivets Silver and broken Chinaware. N.B. Guns buffed with gold after the London method; and cash given for old gold and silver." Before 1797 he moved to the northwest corner of Pennsylvania Avenue and Twenty-First Street in Washington, D.C., where his inventions of tooth-extracting instruments must have helped establish his dentistry practice.

In 1801 the *Museum and George-Town Advertiser* published under the headline "News to Silversmiths:"

> Thomas Bruff, Dentist, the inventor of patent Tooth Extracting instruments has constructed and patented a machine for making silver spoons, which with one impression and one hand to work it, will turn out from a flat bar, a spoon a minute, ready for the punch, with the heel and name impressed upon it. This machine is capable of receiving 3 impressions to advantage, requiring then two hands to work it. . . . The trial was made at the shop of Messrs Burnett and Rigdon. . . . CERTIFICATE I certify that I have tried Mr. Bruff's spoon machine, and have proved by the watch, that the advantage gained by the machine, in working spoons from the bar to the punch, is 25 to one faster than with the hammer, the machine turning out in a minute, with the name and heel impressed; that the bars are sooner prepared, and that the whole difference, smithing included, is nearly 3 to one . . . JOHN ADAM. Applications post paid, for the machines or tooth instruments, will be attended to by the inventor at Chestertown, Maryland.[11]

Bruff demonstrated the device in Philadelphia for Anthony Simmons and Samuel Alexander (q.q.v.), and the latter purchased the rights to sell the machine in that city.[12] He died in New York on March 20, 1816. His daughter Susan Maria wrote to Thomas Jefferson on March 31: "Oh sir, picture to yourself our agony—our—distraction—deprived of our staff—my mama left in a state of ill health, with 5 children to support and educate, without the means, honored sir. You will excuse a young female . . . from infancy taught to believe that she should one day be independent of the unfeeling world." Jefferson replied on March 31 with condolences.[13] BBG

1. Thomas Bruff to Thomas Jefferson, December 16, 1801, *The Papers of Thomas Jefferson*, vol. 36, ed. Barbara B. Oberg (Princeton, NJ: Princeton University Press, 2009), pp. 123–25, http://founders.archives.gov.

2. Thomas Jefferson to James Madison, June 6, 1812, *The Papers of Thomas Jefferson*, Retirement Series, vol. 5, ed. J. Jefferson Looney (Princeton, NJ: Princeton University Press, 2008), pp. 107–8, http://founders.archives.gov.

3. Thomas Jefferson to Thomas Bruff, June 7, 1812, ibid., p. 108. This letter may refer to a notice in *Poulson's American Daily Advertiser* (Philadelphia), August 7, 1811: "SHOT MAKING—Thomas Bruff has invented a machine for making shot by pressure, and a company is forming in Baltimore for the purpose of carrying on the manufacture of that article in a new way. The product of a single machine is said to be at the rate of eight pounds per minute; and the whole process being by pressure, the shot will be perfectly solid, round and equal in size."

4. Oswald Tilghman and S. A. Harrison, *History of Talbot County, Maryland* (Baltimore: Williams & Wilkins, 1915), vol. 2, pp. 54–41; Marion Robertson, *King's Bounty: A History of Early Shelburne, Nova Scotia* (Halifax: Nova Scotia Museum, 1983), pp. 33, 141, 206, 217.

5. Ibid., p. 11.

6. Quoted in Prime 1929, p. 50.

7. Pleasants and Sill 1930, pp. 211–14. Thomas III married Mary Bruff (1765–1821), daughter of New York silversmith Charles Oliver Bruff and his wife Mary Letellier Bruff; "American Silversmiths," s.v. "Thomas Bruff," Ancestry.com. Pleasants and Sill (1930, p. 213) suggest that Thomas Bruff married Mary Valliant in 1801.

8. Pleasants and Sill 1930, pp. 211–14.

9. *Maryland Herald and Eastern Shore Intelligencer* (Easton), April 26, 1791, quoted in "American Silversmiths," s.v. "Thomas Bruff."

10. Advertisement, *Apollo, or Chestertown (MD) Spy*, May 7, 1793.

11. Advertisement, *Museum and Washington and George-Town Advertiser*, September 14, 1801, quoted in Anne C. Golovin, "Clues and Footnotes: A Silver-Spoon Machine, 1801," *Antiques*, vol. 104, no. 2 (August 1973), p. 269.

12. See the biography of Samuel Alexander (q.v.).

13. Quoted in Andrew Burstein, *Jefferson's Secrets: Death and Desire at Monticello* (New York: Basic Books, 2005), p. 310.

Benjamin Burt

Boston, born 1729
Boston, died 1805

Cat. 102

Thomas Bruff

Six Teaspoons

1800–1810

MARK (on each): TBRUFF (in stepped rectangle, on reverse; one mark double struck; cat. 102-1)

INSCRIPTION (on each): E D F (engraved script, at top of handle)

Maximum length 4 inches (10.2 cm)

Maximum weight 3 dwt. 9 1/2 gr.

Gift of Evelyn Eyre Willing in memory of Mary Eyre Howell and Evelyn Virginia Willing, 1944-93-4a–f

PROVENANCE: Descended in the Maryland Eyre family to the donor.[1]

Cat. 102-1

These spoons show a very slight variation in size, but otherwise they are identical, with an inscribed V-shaped drop on the back of the bowl. The letters in the die and the shape of the die, with a rise over the "T" and "B," seem to be the same on all these spoons, as well as on other spoons of a similar shape but not part of this set.[2] Another double-struck mark like the one on cat. 102 is sharper but has exactly the same so-called error over the "T" and "B," and has been attributed to this Thomas Bruff.[3] Although details of the overstrikes vary, the consistency of the location of the error in the strike,

as well as the simplicity and inscribed drop of the mark, suggest that these spoons may have been the product of the spoon machine that Bruff invented in 1800 or 1801. The machine as demonstrated could impress, shape, and mark three spoons at a time in a single minute.[4] It is possible that the mark, if inserted in the press, slipped on occasion, or that the thickness of the silver blank was slightly uneven.

The initials on the obverse of these spoons are sketchy. The engraver seems not to have followed his first attempt. Other examples of engraving on some Bruff silver show the same hand at work, perhaps his own.[5]

These small spoons would have been in proper scale with the smallest teacups without handles. BBG

1. For other silver in the Museum's collection that was owned and/or collected by this family, see cats. 128, 227, and 265, and ewer and plates by Samuel Kirk & Son (1944-93-18, 1944-93-19, 1944-93-20, 1944-93-31a-l); porringer by John LeRoux (1944-93-2); tray by John McMullin (1944-93-16); and an unmarked nutmeg grater (1944-93-13) and cream pot (1944-93-23).

2. See Goldsborough 1975, p. 53, cat. 31 (teaspoon engraved "JGA").

3. For an illustration of this mark, see *Silversmiths and Related Craftsmen*, s.v. "Thomas Bruff," Ancestry.com. The object on which this mark appears is not identified.

4. *New Jersey Journal* (Elizabeth), September 29, 1801; Anne C. Golovin, "Clues and Footnotes: A Silver-Spoon Machine, 1801," *Antiques*, vol. 104, no. 2 (August 1973), p. 269.

5. "New to Silversmiths," advertisement, *Museum and George-Town Advertiser* (DC), September 14, 1801, quoted in Golovin, "Clues and Footnotes," p. 269.

orn in Boston to goldsmith John Burt (1693–1746) and Abigail Cheever Burt (1691–1778), Benjamin Burt apprenticed first with his father and, following his father's death, with his older brothers, Samuel (q.v.) and William. He married Joan Hooton (1731–1785) in 1754. They had one boy, John, who died in 1798.[1]

In the 1760s Benjamin Burt had a number of real estate transactions involving ownership, investment, and possibly speculation, which his apprentices (at least eight of whom have been identified) witnessed for him. He had business exchanges with local silversmiths including Paul Revere (q.v.), who did some engraving for him. He served on town committees and, in 1777, served on the Boston Committee of Correspondence, Inspection, and Safety. In 1789, when George Washington visited Boston, Burt led the goldsmiths and jewelers' unit in the celebratory procession. Numerous pieces of silver by Burt survive.[2] He made

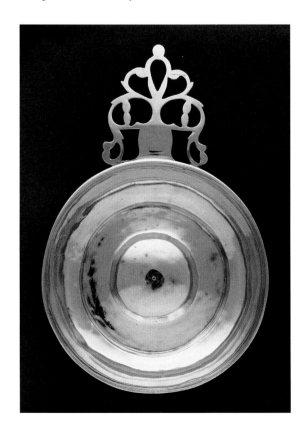

most forms in demand and also accomplished the engraving.

Burt lived on Ship Street in a property he purchased in 1760, and after his mother died in 1778, he bought his father's house and ground on Fish Street from the other heirs for more than £500. He died on October 9, 1805. Having no direct heirs he left his property and possessions to his sister's children and grandchildren, and special silver pieces to the silversmiths Caleb Swan and his son Benjamin Burt Swan and to Caleb's wife Sarah Swan, who was Benjamin Burt's niece. His inventory included the Fish Street property, valued at $4,500, 207 ounces 15 pennyweight of silver valued at $228.52, and certificates of stock. BBG

1. This biographical portrait is drawn from the in-depth essay in Kane 1998, pp. 224–28.

2. A full list of surviving silver by Burt is included in ibid., pp. 228–44.

Cat. 103
Benjamin Burt
Porringer

1755–65
MARK: B·BURT (in rectangle, on reverse of handle; cat. 103-1)
Height 1 15/16 inches (4.9 cm), length 8¼ inches (21 cm), diam. 5⅜ inches (13.7 cm)
Weight 6 oz. 12 dwt. 19 1/2 gr.
Purchased with the Annual Membership Fund, 1913-32

Cat. 103-1

Although the mark on this porringer is partly defaced, it seems to be the same mark as that illustrated by Patricia Kane as mark B, in which the top serifs of the "U" meet and the head serif on the "T" tips to the right.[1] The polished surface of the "keyhole" handle where it is attached to the bowl suggests there has been erasure of engraving. The date assigned here is based on the shape and handle pattern of a very similar porringer made for George and Experience Leonard in about 1759.[2]

This handle pattern was used by Benjamin's father, John Burt, and by his brothers Samuel (q.v.) and, probably, William.[3] BBG

1. Kane 1998, p. 224.
2. Kathryn C. Buhler, *American Silver: From the Colonial Period through the Early Republic in the Worcester Art Museum* (Worcester, MA: the Museum, 1979), p. 33, cat. 35.
3. David B. Warren, *Bayou Bend: American Furniture, Paintings and Silver from the Bayou Bend Collection* (Houston: Museum of Fine Arts, Houston, 1975) pp. 157, 158, cats. 295, 297.

Samuel Burt

| Boston, born 1724
| Boston, died 1754

Samuel Burt was born in Boston in 1724 to the silversmith John Burt (1693–1746) and Abigail Cheever Burt (1691–1778).[1] It seems likely that he apprenticed with his father, as he probably took over the shop after his father's death and may have trained his younger brother Benjamin (q.v.). Samuel married Elizabeth White (1728–1748) in 1747 at the New Brick Church in Boston. They purchased part of a brick house on Ship Street in 1748. His second wife was Elizabeth Kent (1726–1804) of Newbury, Massachusetts, whom he married in 1749. Samuel Burt is buried in Boston at Copp's Hill Burying Ground.

A list of Burt's known works reveals that he made a full range of hollowware and the usual small items, such as strainers and spoons.[2] BBG

1. For a full biography, see Kane 1998, p. 260. See also an unmarked patch box that belonged to Abigail Cheever in 1700 (cat. 159).

2. See ibid., pp. 261–63.

Cat. 104
Samuel Burt
Caster

1745–50
MARK: SAMUEL / BURT. (in cartouche, at top of straight body just under encircling molding; cat. 104-1)
Height 5 7/16 inches (13.8 cm), diam. foot 2 1/16 inches (5.2 cm)
Weight 3 oz. 16 dwt.
Gift of Fenton L. B. Brown, 1991-143-12

PROVENANCE: Jonathan Trace, Putnam Valley, NY, by 1987; purchased by the donor prior to 1991.

PUBLISHED: Advertisement, *Antiques*, vol. 131 (January 1987), p. 139; Kane 1998, p. 261.

Cat. 104-1

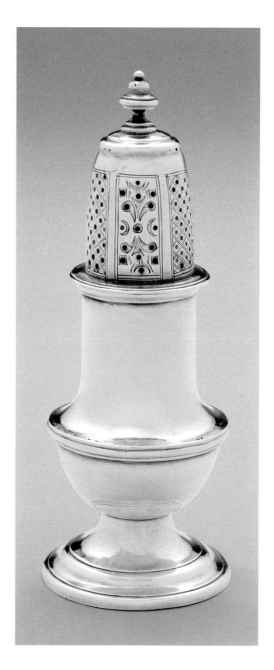

The cover of this caster is not pierced all the way through the material, suggesting its use as a dry-mustard container. The cover is decorated with alternating panels of engraved diagonal lines with centered chased dots and panels of engraved feather-like patterns with crescent moons, dots, and squares. It is slightly larger but otherwise almost exactly like another made by Samuel Burt for the unidentified owner "L A."[1] The scribed lines dividing the panels in the top are similarly engraved, and the abstract arabesque patterns on the covers are alike. In addition, the bell-shaped finials appear to be from the same mold. The flaring molded foot on this caster shows hammer and planishing tool marks with stress cracks on the underside. The bowl-shaped body was raised and the seamed upper section joined to it with three raised bands. The cover, from the flaring collar to the base of the finial, was seamed. BBG

1. Buhler 1972, vol. 1, p. 287, cat. 240. The maker's mark is the same as that shown in Kane 1998, p. 260, fig. B.

Kathy Buszkiewicz

| South Bend, Indiana, born 1953

Kathy Buszkiewicz was born in South Bend, Indiana, in 1953, daughter of Helen Kruk and Casimer Buszkiewicz. Her father, a carpenter and toolmaker, and inherently skilled with his hands, was employed by the Studebaker Corporation in South Bend.[1] She was naturally affected by watching him at work.[2] Buszkiewicz spent two years at Indiana University in South Bend (1971–72), then pursued independent art study at the University of London, and traveled throughout Europe in 1974. She received a BA degree in 1975 from Ball State University, Muncie, Indiana, where she studied jewelry and metalsmithing with Leslie Leupp (1944–2011). At Indiana University she studied under the renowned metalsmith Alma Eikerman (1908–1995) and obtained an MFA degree in jewelry and metalsmithing in 1980. Buszkiewicz first taught as an instructor of metals, jewelry and crafts, and design from 1977 through 1980 at Indiana University. From 1981 until 1983 she worked at Smith Diamond Brokers, the Shane Company, in Indianapolis as a diamond setter and jeweler. In 1983 Buszkiewicz joined the Cleveland Institute of Art as professor in the jewelry and metals department; she served as chairperson of both the metals and the enamels departments from 1987 until 1997, and became head of the jewelry and metals department in 2007. She has received four grants from the Ohio Arts Council and in 2005 received the Viktor Schreckengost Teaching Award from the Cleveland Institute of Art. In 2016 Buszkiewicz was awarded the Creative Workforce Fellowship, a program of the Community Partnership for Arts and Culture in Cleveland.

Her work has been exhibited at several contemporary galleries, including the Susan Cummins Gallery in Mill Valley, California; Facèrè Gallery in Seattle; Mobilia Gallery in Cambridge, Massachusetts; and Velvet da Vinci Gallery in San Francisco. She has also been included in a number of exhibitions, among them, *Sculptural Concerns: Contemporary American Metalworking*, Contemporary Arts Center, Cincinnati, 1993; *Signals: Late Twentieth-Century American Jewelry*, Cranbrook Museum of Art, Bloomfield Hills, Michigan, 1996; *The Art of Gold*, which traveled to three museums; *The Edges of Grace: Provocative Uncommon Craft*, Fuller Craft Museum, Brockton, Massachusetts, 2006; and *Adornment and Excess: Jewelry in the 21st Century*, Miami University Art Museum, Oxford, Ohio, in 2010. Buszkiewicz's jewelry is found in notable collections such as the Museum of Fine Arts, Boston; the Alice and Louis Koch Collection of Historic and Contemporary Rings, Swiss National Museum, Zurich; and the Dorothy Mackenzie Collection of Jewelry and Metalwork, Bowling Green State University, Ohio. ERA

1. Biographical details were provided by the artist in 2009 and 2014.
2. Kathy Buszkiewicz, email message to the author, September 20, 2017.

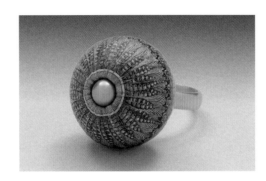

Cat. 105-1

Cat. 105

Kathy Buszkiewicz
Omnia Vanitas X

2004
Gold, U.S. currency, pearl
MARK: K.BUSZIEWICZ 18K (incuse, on inside loop; cat. 105-1)
Height 1½ inches (3.8 cm), width 1 inch (2.5 cm), depth 1 inch (2.5 cm)
Gross weight 7 dwt. 5 gr.
Gift of Gail M. Brown, 2013-119-2

PROVENANCE: Gallery M, Columbus, OH, purchased by the donor, 2005.

This ring is the tenth in a series of twelve works of art titled *Omnia Vanitas* (Everything Is Vanity), consisting of rings, a brooch, and pendants. Kathy Buszkiewicz began this series in 2001 with a brooch and concluded it in 2006 with a pendant.[1] Each object was made with natural materials such as gold, gemstones, and pearls that are traditional for jewelry, combined with U.S. currency. The artist's intention was to juxtapose the natural materials with shredded currency,[2] with its intimations of "cold hard cash," to express a point about value and commodity.

Working with banknotes since 1994, she was drawn to the "visual activity" of graphic patterns found on older examples.[3] Having sorted through shredded currency for particular imagery such as scrolls, guilloche, acanthus leaves, cartouches, garlands, and crests, Buszkiewicz pairs a form with a selected pattern to create each work of art. This series also plays upon the former relationship between U.S. currency and the gold standard, which was established in 1834 by the federal government to insure the face value of currency but abandoned in 1973. In the instance of *Omnia Vanitas X*, acanthus leaves and a pearl are used as a deceptive element to lure the viewer. Upon closer inspection, the ornament reveals itself as "elements of money—that which infiltrates every aspect of our culture and nature."[4] According to the artist, this body of work is as much about process as it is about value. ERA

1. Kathy Buszkiewicz, telephone conversation with the author, June 30, 2014.
2. "Omnia Vanitas," *Value and Meaning*, www.valueandmeaning.com/ov.html.
3. Buszkiewicz obtained the shredded currency from the federal government.
4. Artist's statement (2009), curatorial files, AA, PMA.

Butler & McCarty

| Philadelphia 1851–68

O riginally from New London, Connecticut, Franklin Butler (1816–1876) and Edward McCarty (1818–1879) were first cousins. Butler was the son of the shoemaker William (1788–1870) and Emelia Harris (born 1798) Butler, who married in 1810.[1] Edward McCarty was the son of William and Betsey Harris McCarty, who married in 1812.[2]

According to a history of the firm published in 1919, Butler and McCarty moved together to Philadelphia in the early 1830s at the instigation of the silversmith James Peters (q.v.), who in 1815 had married their maternal aunt, Frances Harris.[3] McCarty was apprenticed with Peters to learn the silversmith's trade; Butler was apprenticed to the clock- and watchmaker Daniel Solliday (1798–1883).[4] Butler presumably had completed his apprenticeship by September 16, 1841, when he filed his intention to marry Elizabeth S. Smith of Kent County, Delaware.[5] He was first recorded in the 1842 Philadelphia directory at Peters's address, 105 North Second Street, but without a profession.[6] McCarty was first listed in the 1845 directory as a silversmith at the same address.[7] Sometime between 1850 and 1853, he married Mary Elizabeth Hause (1828–1924).[8]

Peters gave Butler and McCarty, as employees, a "financial interest" in his business, which became "a jobbing house," or wholesale supplier, to retail jewelers and silversmiths.[9] An advertisement for James Peters & Company placed in 1842 had offered articles that the company made itself—"gold and silver thimbles, spectacles, spoons, forks &c."—and those that it acquired—"clocks, watches, watch materials, jewelry, and fancy goods."[10] The firm apparently specialized in silver flatware and other small objects rather than in hollowware. The cousins played distinct roles within the company: Butler was recorded in directories variously as merchant, jeweler, and watchmaker, whereas McCarty was consistently described as a silversmith.[11]

When Peters retired in 1850, Butler and McCarty took over the firm, establishing the partnership of Butler & McCarty in 1851.[12] The

U.S. census of the previous year provides at least a partial picture of the company's employees at the outset of the new partnership. McCarty was described as a "watchmaker," heading a family consisting of his wife and two-year-old son and owning real estate valued at $7,000. The as-yet-unmarried McCarty, recorded as a "silversmith," was living with them and owned no property. Butler's household also included five additional silversmiths, presumably all affiliated with the firm. T. H. Stephen, a thirty-five-year-old immigrant from the Isle of Man, probably was employed as a journeyman. Four younger men, all born in Washington, D.C., presumably were apprentices: John Galt (1828–1852), son of the silversmith James Galt and uncle of Charles Ernest Galt, a partner in Davis & Galt (q.v.); Isaac Martin, age nineteen; Lawrence Perdriaux (1832–1869), apparently the younger brother of Peter G. Perdriaux (q.v.); and William Hoag, age seventeen.[13]

As the workforce listed in the 1850 census indicated, Butler & McCarty were manufacturing silversmiths and continued to be listed as such throughout the 1850s. The 1850 Census of Manufactures recorded that the firm consumed 9,000 ounces of silver, produced tableware worth $13,500, and pencil cases and other articles worth $4,500. By 1860, however, the firm had begun to phase out silverware, and its consumption and production of silver fell by half from a decade earlier.[14] Butler and McCarty shifted their focus to watches and jewelry, both made in-house and imported. The 1864 city directory listed them as "manufacturers & importers [of] watches & jewelry."[15] McCarty was called a jeweler in his draft registration record in 1863 as well as in the U.S. census of 1870.[16] In 1868 the firm became "Butler, McCarty & Co., jewellers," and was listed as jewelers thereafter.[17] The company marked and sold flatware made by other silversmiths, such as a teaspoon struck with a device that has been attributed to either James Watts (q.v.) or James P. Butler (1822–1891), a relative of Franklin Butler's,[18] and continued to operate at its Second Street premises, which in 1858 had been renumbered as 131 North Second Street.[19]

The name change in 1868 also signaled the arrival of a new partner, Henry O. Hurlburt (1834–1900), possibly a relative by marriage.[20] First recorded in the 1860 city directory as a "clerk," Hurlburt had been a salesman for the gold-pen manufacturers Bard & Wilson prior to beginning work for Butler & McCarty in 1864.[21] Also working for the firm at this time was Butler's son William F. Butler (born 1846), who was recorded as a jeweler in the U.S. census but as a clerk in the city directory.[22] At the time of his retirement

in 1870, Franklin Butler was a wealthy man: the U.S. census valued his real estate at $20,000 and his personal property at $43,000.[23] He died in 1876 and was buried with his wife's family in the Old Presbyterian Cemetery in Dover, Delaware.[24] McCarty's financial success was more modest: his real estate in 1870 was valued at $9,000 and personal property at $500.[25] He died on September 15, 1879, and was buried in Laurel Hill Cemetery.[26]

Following Butler's death in 1876, the firm was renamed McCarty & Hurlburt.[27] After McCarty's death three years later, Hurlburt became the outright owner but continued to operate under the name McCarty & Hurlburt until 1888, when his sons William (born 1864), Frederick (1866–1925), and George (born 1873) joined the firm and it was renamed H. O. Hurlburt & Sons.[28] They moved in the same year to a new store at 938 Market Street, with a large sign advertising watches.[29] Following Hurlburt's death the company moved in 1902 to 14 South Tenth Street, Philadelphia's "Jewelers' Row" neighborhood and in 1912 to a nearby location at 813 Chestnut.[30] H. O. Hurlburt & Sons was still in business as wholesale jewelers in 1954, when the company issued a catalogue.[31] DLB

1. Lorraine Cook White, ed., *The Barbour Collection of Connecticut Town Vital Records* (Baltimore: Genealogical Publishing, 1994–2002), vol. 3, p. 173.

2. Ibid., p. 59.

3. Ibid., p. 165.

4. "Philadelphia and Its Old Jewelers," *Jewelers' Circular*, vol. 78 (February 5, 1919), p. 311.

5. Marriage Records, 1744–1912, vol. 17, p. 399, Delaware Public Archives, Dover.

6. Philadelphia directory 1842, pp. 36, 208. Peters was listed as a "spectacle maker."

7. Ibid. 1845, p. 219.

8. Laurel Hill Cemetery (Philadelphia) Archives, www.webcemeteries.com/thelaurelhillcemetery (accessed May 30, 2014). Hause's maiden name comes from the Bowen family tree, Ancestry.com (accessed June 3, 2014).

9. "Philadelphia and Its Old Jewelers," p. 311.

10. Advertisement, *Public Ledger and Daily Transcript* (Philadelphia), September 28, 1842.

11. Philadelphia directory 1848, pp. 47 ("jeweller"), 218; 1849, pp. 50 ("watchmaker"), 229.

12. Ibid. 1852, p. 59.

13. For John Galt, see his obituary and grave at www.findagrave.com (memorial no. 70030579; accessed June 28, 2018). Perdriaux was recorded as a silversmith in the 1863 Pennsylvania Septennial Census.

14. Hollan 2013, p. 31.

15. Philadelphia directory 1864, p. 97.

16. Records of the Provost Marshal General's Bureau (Civil War), Record Group 110, NARA, Washington, DC, Ancestry.com.

17. Philadelphia directory 1868–69, p. 316.

18. DAPC no. 76.2733; the same combination of marks is illustrated in Hollan 2013, p. 31. McGrew (2004, p. 115, die 3), attributes the maker's mark on this flatware to James Watts, whereas Hollan (2013, p. 239) has suggested that this device was used by James P. Butler, who worked in partnership with Watts in 1867. See also Hollan 2013, p. 32.

19. Philadelphia directory 1859, p. 93.

20. Hurlburt's life dates are provided in the Grigson family tree, Ancestry.com (accessed June 3, 2014). The suggestion that Hurlburt was a relative was made by Hollan (2013, p. 31).

21. Philadelphia directory 1860, p. 469; "Philadelphia and Its Old Jewelers," p. 311; Philadelphia directory 1865, p. 339.

22. 1870 U.S. Census; Philadelphia directory 1871, p. 303.

23. 1870 U.S. Census.

24. Memorial no. 7525132, www.findagrave.com (accessed May 30, 2014).

25. 1870 U.S. Census.

26. Memorial no. 25740690, www.findagrave.com (accessed May 30, 2014).

27. Philadelphia directory 1877, p. 910.

28. Ibid. 1889, p. 888. "Philadelphia and Its Old Jewelers" (p. 311), gives 1887 as the year of the renaming and move, a date that is not corroborated by listings in the city directories. The Hurlburt brothers' life dates are provided in the Grigson family tree, Ancestry.com.

29. Photograph no. pdct00019, Print and Picture Collection, Free Library of Philadelphia.

30. "Philadelphia and Its Old Jewelers," p. 311.

31. H. O. Hurlburt & Sons: Wholesale Jewelers—Diamonds, Watches, Clocks, Jewelry, Silverware, Appliances (Philadelphia, 1954); see www.princetonantiques.com (accessed June 3, 2015).

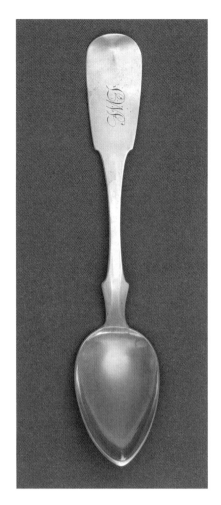

Cat. 106
Butler & McCarty
Sugar Tongs

1851–68

MARK: BUTLER & M'CARTY (in rectangle, inside one arm; cat. 106-1)

INSCRIPTION: M E P (engraved script monogram, on outside of bow)

Length 6⅛ inches (15.6 cm), width 2¹¹⁄₁₆ inches (6.8 cm)

Weight 1 oz. 6 dwt. 2 gr.

Gift of Charlene D. Sussel, 2009-155-3

PROVENANCE: From the stock of the Philadelphia antiques dealer Eugene Sussel (1913–1989), the donor's husband.

Cat. 106-1

Cat. 107
Butler & McCarty
Teaspoon

1851–68

MARK: BUTLER & M'CARTY (in rectangle, on back of handle; cat. 107-1)

INSCRIPTION: T M T (engraved script monogram, lengthwise, on front of handle)

Length 5¾ inches (14.6 cm)

Weight 11 dwt. 19 gr.

Gift of Charlene D. Sussel, 2009-155-4

PROVENANCE: From the stock of the Philadelphia antiques dealer Eugene Sussel (1913–1989, the donor's husband).

Cat. 107-1

Thomas Byrnes

Wilmington, Delaware, born 1766
Wilmington, Delaware, died 1798

Thomas Byrnes, born February 1, 1766, was the seventh child of Joshua Byrnes (c. 1718–1777) and Ruth Woodcock Byrnes (1727–1815), who were Quakers.[1] When his father died, Thomas was eleven. He was apprenticed to his uncle Bancroft Woodcock (1732–1813; q.v.) in Wilmington until the age of twenty. Before he set up his own silver shop in Wilmington, Byrnes traveled, perhaps looking for a new market, to Joppa on the Gun Powder River in Maryland, where the deep harbor facilitated an active trade in the export of iron and tobacco by wealthy landowners to their English factors.[2]

Back in Wilmington by 1790 Thomas Byrnes went to work with his master Bancroft Woodcock as Woodcock & Byrnes from 1790 until 1793.[3] He also had his own shop on the west side of Market Street in Wilmington. In 1793 he advertised for two apprentice lads and listed items for sale including tea and coffee urns, tea services, ladles, gold and silver buckles and lockets, rings, and miniature frames as well as imported plated pieces such as boilers, bread baskets, and candlesticks, all of which were also priced for trade and resale.[4]

He married Sarah Pancoast (born 1769), a Quaker and daughter of Joshua and Hannah Lownes Pancoast, in Philadelphia on October 7, 1795.[5] They had two children, Hannah Pancoast Byrnes, born July 29, 1796, and Thomas Byrnes, born October 11, 1798, after his father's death.[6]

Thomas Byrnes was a successful silversmith, making some investments in the Wilmington and Lancaster Turnpike Company and in land in Bedford County, Pennsylvania. He, like so many silversmiths, must have been caught in the period of shortage of currency. It slowed the silver business, and Byrnes expanded his retail business to include more general items such as seeds and iron and brass implements. Byrnes had a very short career, dying suddenly on August 7, 1798, probably from yellow fever. BBG

1. Not to be confused with Thomas Byrnes (born 1756), an Irish-born doctor who joined Captain Craig's Company of Marines in Philadelphia in December 1775; "Muster Rolls of Marines and Artillery Commanded by Capt. Isaac Craig, of

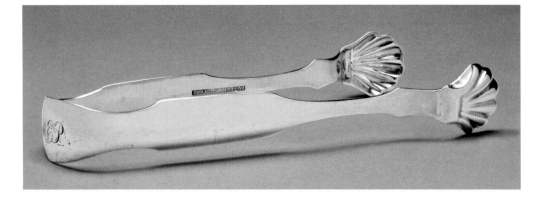

Pennsylvania, in 1775 and 1778," *PMHB*, vol. 12, no. 3 (October, 1888), p. 351. There was also a Dublin-born goldsmith Thomas Byrnes active in 1776; Sir Charles James Jackson, *English Goldsmiths and Their Marks* (New York: Dover, 1964), p. 604. Thomas Byrnes of Wilmington does not seem to have been related to James Byrnes, goldsmith and jeweler in Philadelphia, active from 1784 through 1786 on Front Street above Chestnut; "James Byrne [*sic*]," *Pennsylvania Packet and General Advertiser* (Philadelphia), October 18, 1784. There were other Woodcock and Byrnes connections; William Woodcock (born 1719), the brother of Ruth (Thomas Byrnes's mother), married Elizabeth Byrnes about 1750; Ann Byrnes Alleman, "Byrnes Family History," www.halebyrnes.org /history/byrnesfamily.pdf (accessed April 4, 2016).

2. Noted as "Gunpowder, Maryland" in Fennimore and Wagner 2007, p. 38. Also see the chocolate pot made for the Lloyd family by Whipham & Wright (PMA 365-1996-1).

3. Advertisement, *Pennsylvania Gazette* (Philadelphia), July 4, 1754, reproduced in Roland H. Woodward, "Bancroft Woodcock Silver in the Collections of the Historical Society of Delaware," in *Bancroft Woodcock, Silversmith*, exh. cat. (Wilmington: Historical Society of Delaware, 1976).

4. *Delaware Gazette* (Wilmington), September 28, 1793; see also David B. Warren, "Bancroft Woodcock: Silversmith, Friend, and Landholder," in *Bancroft Woodcock*; Hindes 1967, pp. 258–59. *Delaware Register*, September 20, 1793, reproduced in Hindes 1967, pp. 258–59.

5. They made their first declaration of intent at a Friends Meeting on July 10, 1795; Quaker Meeting Records, Friends Historical Library.

6. Herbert Standing, comp., "Delaware Quaker Records: Early Members of Wilmington Meeting," p. 52, https://archive.org /details/delawarequakerreoostan. Son Thomas died in 1803; Quaker Monthly Meeting Records, Philadelphia, Southern District, Friends Historical Library.

Cat. 108

Thomas Byrnes
Sugar Bowl

1794

MARK: T·BYRNES (in rectangle, double struck, on underside of foot; cat. 108-1)

INSCRIPTION: A S (engraved script in bright-cut oval, on front); E T to A SIPPEL (engraved script, on inside of lid; cat. 108-2); 13 " 0 " 0 " (scratched on underside of foot)
Height 10 inches (25.4 cm), diam. rim 4⅞ inches (12.4 cm), diam. foot 3½ inches (8.9 cm)
Weight 13 oz. 7 gr.
Gift of Mrs. Benjamin West Frazier Jr. in memory of her parents, Mr. and Mrs. William Marriott Canby, 1984-120-1

PROVENANCE: The initials "ET" inscribed on the inside of the lid belonged to Elizabeth Lea (1744–1805), who married Joseph Tatnall (1740–1813) at the Wilmington Friends' Monthly Meeting in 1765.[1] The initials "AS" on the front of the bowl belonged to their daughter Ann Tatnall (1775–1816), who married the Honorable Thomas Sipple (1765–1798) on September 25, 1794, at the Friends Meeting in Wilmington.[2] They lived in St. Jones Hundred, Kent County, Delaware. The sugar bowl descended to their daughter Eliza Tatnall Sipple (1795–1865), who married Marriott Canby (1787–1866), and in the family to the donor.

Cat. 108-1

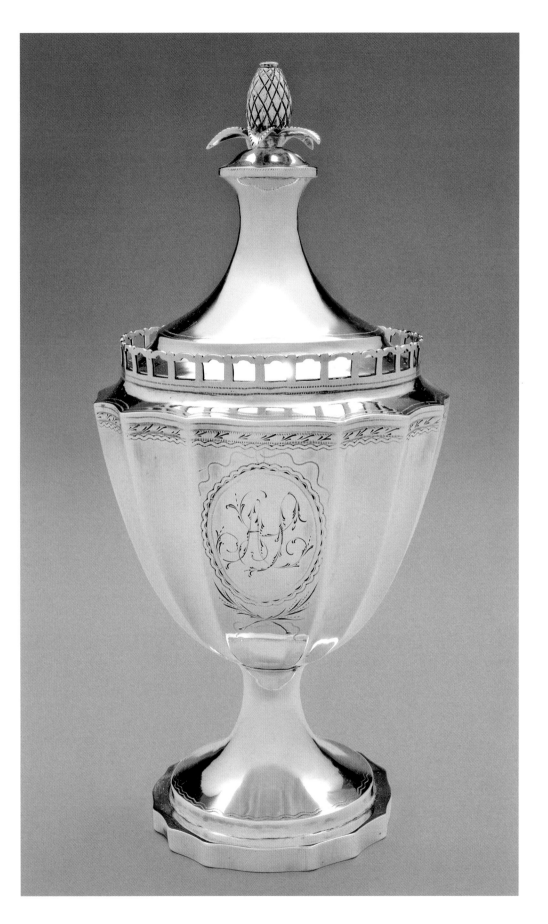

This is an accomplished design of the sugar-bowl form. Thomas Byrnes had just set up his own shop at this date, and the fluted shape, as well as the gallery around the top of the bowl, are evidence that he was aware of work in Philadelphia by Samuel Williamson and the Richardsons (q.q.v.).[3] The alternating convex and concave curves of the fluted body are repeated in the plinth of the base. The engraved initials fit into the wider convex panel at the front, and the stippling and wriggle-work techniques used to frame the initials are repeated on the foot, shoulder, and lid. The style and hand of the engraved initials is similar to

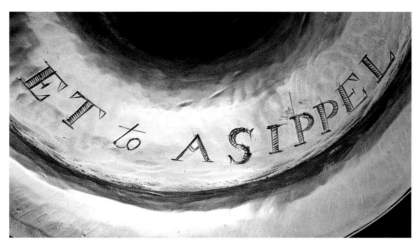

Cat. 108-2

those by the hand that was also engraving for Ban-
croft Woodcock from 1785 until 1790.[4]

The screw attaching the pineapple finial is excep-
tionally long, which may account for the slight dis-
crepancy between the scratched and actual weights.
The inside of the lid has been buffed, probably at
the same time that the inscription was added to the
obverse of the lid. BBG

1. Herbert Standing, comp., "Delaware Quaker Records:
Early Members of Wilmington Meeting," pp. 189, 325,
https://archive.org/details/delawarequakerre00stan.
2. Ibid., p. 323.
3. Plain cream pots and one handsome but plain teapot are
known; David B. Warren, "Bancroft Woodcock: Silversmith,
Friend, and Landholder," in *Bancroft Woodcock: Silversmith*
exh. cat. (Wilmington: Historical Society of Delaware, 1976),
cats. 53–57.
4. Ibid., cats. 7, 8, 18, 19.

Alexander Calder

Lawnton, Pennsylvania, born 1898
New York City, died 1976

Alexander Calder (fig. 49) was the third of the name. His grandfather Alexander Milne Calder (1846–1923), a Scot who came to Philadelphia in about 1868, was a sculptor who created more than two hundred figural works, including the giant bronze sculpture of William Penn atop Philadelphia's City Hall. His son Alexander Stirling Calder (1870–1945) created the Swann Memorial Fountain on the Benjamin Franklin Parkway. Grandson Alexander Calder was born in Lawnton, Pennsylvania, outside Harrisburg, in 1898.[1]

The family moved in 1906 to Pasadena, California, where Calder was given his first tools and provided a workshop in the cellar of their Euclid Avenue home. His predilection for repurposing found materials to make jewelry as gifts for family and friends began at an early age. Using fine copper wire that he found discarded on the street by workmen who had spliced electric cables, Calder created his first pieces of jewelry to adorn his sister Peggy's dolls. He graduated from Lowell High School in San Francisco in 1915,[2] and in response to an interest in engineering he attended Stevens Institute of Technology in Hoboken, New Jersey, graduating in 1919 with a degree in mechanical engineering. By 1923 Calder had taken up painting and began studying at the Art Students League of New York.[3] With his genial nature and a deft hand for painting, sculpture, and illustration, as well as his witty approach to daily affairs, he soon found his niche doing line drawings of sporting events, New York City scenes, zoo animals, and the Ringling Bros. and Barnum & Bailey Circus.[4] In 1926 Calder's interest in working with wire was revived, leading to the creation and first performances in New York of *Cirque Calder* in 1927 and the exhibition *Wire Sculpture by Alexander Calder* at the Weyhe Gallery in 1928.

Calder married Louisa Cushing James in Concord, Massachusetts, in 1931. They peregrinated between New York and Paris, moving back to the United States in 1933. From the beginning of their courtship and throughout the rest of his life, Calder created jewelry—using silver, gold, and brass wire, and sometimes incorporating found objects—for Louisa and their family and friends. His jewelry was often exhibited alongside his mobiles and stabiles.[5] Of the 1937 exhibition *Calder: Mobile and Stabiles* at the Mayor Gallery, London, the artist noted, "The show is going quite well. . . . Sold three objects and a lot of jewelry."[6] In 1940 *Calder Jewelry* was organized by the Willard Gallery in New York.[7] His work was also included in the notable large-group exhibition *Modern Handmade Jewelry* at the Museum of Modern Art in 1946. Bringing wide exposure and mass appeal to the studio-jewelry movement, this show traveled to fifteen different cities over a two-year period and placed Calder's jewelry in context with that of his peers at midcentury. Considered one of the most important sculptors of the twentieth century, Calder continued to create major sculptural works and to be celebrated with international exhibitions. His imagination showed no limits, and virtuosic ability to fashion distinctive

jewelry set him apart from most metalsmiths of his time.

The jewelry of Alexander Calder is found in several collections, including those of the Metropolitan Museum of Art and the Museum of Modern Art in New York; National Museum of American Art, Smithsonian Institution, Washington, D.C.; and Museum of Fine Arts, Boston. ERA/BBG

1. Unless otherwise indicated, biographical details are culled from the chronology in Rower and Rower 2007, pp. 252–59.

2. Seymour I. Toll, "My Way: Calder in Paris," *Sewanee Review*, vol. 18, no. 4 (Fall 2010), p. 592.

3. Calder studied at the Art Students League of New York for a year and a half.

4. He became a freelance illustrator in 1924 for the *National Police Gazette*. In 1925 Calder spent two weeks illustrating the Ringling Bros. and Barnum & Bailey Circus for that publication; Toll, "My Way," p. 592.

5. The first documented exhibition of his jewelry was *Alexander Calder: Paintings, Wood Sculptures, Toys, Wire Sculptures, Jewelry, Textiles* at the Fifty-Sixth Street Galleries, New York, in December 1929. Twenty-two pieces of jewelry were included in the retrospective exhibition *Alexander Calder: Sculptures and Constructions* at the Museum of Modern Art, New York, in 1943.

6. Rower and Rower 2007, p. 256.

7. It seems that a flurry of interest in his jewelry followed this exhibit, as inquiries came from galleries, art clubs, and museums in Washington, DC, Rochester, NY, and Pittsburgh, with requests to exhibit and sell Calder's jewelry exclusively.

Fig. 49. Arnold Newman (American, 1918–2006), Alexander Calder, 1943. Gelatin silver print, image and sheet: 9⁷⁄₁₆ × 7¹⁵⁄₁₆ inches (23.9 × 18.5 cm). Philadelphia Museum of Art. Gift of R. Sturgis and Marion B. F. Ingersoll, 1945-72-10

Cats. 109, 110

Alexander Calder
Cone Bracelet

c. 1940
Height 1½ inches (3.8 cm), length (when opened)
7½ inches (19.1 cm), depth 3⁹⁄₁₆ inches (9.1 cm)
Weight 5 oz. 5 dwt. 13 gr.
Gift of Jane Goldstone Hilles in memory of
her parents, John Lewis and Jeanette Kilham Goldstone,
2011-94-1 (Calder inv. no. A 25491)

Bracelet

c. 1940
Height 3⁹⁄₁₆ inches (9.1 cm), depth 2⅝ inches (6.7 cm)
Weight 2 oz. 7 dwt. 4 gr.
Gift of Jane Goldstone Hilles in memory of
her parents, John Lewis and Jeanette Kilham Goldstone,
2011-94-3 (Calder inv. no. A 25492)

PROVENANCE: Descended in the family of the donor.

Alexander Calder redefined sculpture through his iconic mobiles and stabiles, and his metal jewelry was equally innovative. These wearable artworks were an important extension of his larger sculptural projects. Beginning in the late 1920s, the artist made jewelry by shaping wire or sheet metal, creating hundreds of ingeniously designed, one-of-a-kind handmade objects, and reinventing ancient decorative motifs. The bold, simple shapes evoked prehistoric and non-Western design sources. Their aggressively hammered and sawn surfaces, together with the use of simple and found materials, underscored their direct quality.

These bracelets are characteristic examples of the designs that Calder produced for sale through trunk shows and gallery exhibits.[1] The gilded silver cone bracelet (cat. 109) is similar to bracelets and necklaces for which he used the spiral as the main decorative device during the mid- to late 1930s. Calder introduced the spiral, a universal symbol for eternity, as a leitmotif in his early wire figures and continued to employ it throughout his oeuvre.[2] The broad, cuff-style bracelet (cat. 110) appeared in his personal design book of 1938 and remained in his

repertoire for several years.[3] This bracelet is flexible and formed from a single silver wire. Both bracelets have the tool marks—made by the use of pliers to manipulate the wire—that are common for Calder's jewelry. When producing bracelets, brooches, and rings, it was always Calder rather than his shop or assistants who worked directly with the metal, and his inventiveness and playfulness had no boundaries. Each of his pieces is a unique work of art.

Given to the Museum by Jane Goldstone Hilles of Bryn Mawr, Pennsylvania, these two bracelets descended through her family, whose introduction to Calder may have occurred through Jane Houston Kilham (1870–1930), Hilles's maternal grandmother, an artist and a founder of the Boston Society of Independent Artists (1927–61). Kilham exhibited two works by Calder, the wire sculptures *Polo Player* and *Woman on a Beach*, in the fourth annual show she organized for the Independent Artists in February 1930.[4] *Polo Player* had previously been exhibited in the Harvard Society of Contemporary Art's inaugural exhibition in February 1929, where Kilham first encountered Calder's work and from which she subsequently borrowed the piece for her exhibition in

1930. She relinquished management of the exhibit as the Independent Artists show neared and died ten days after it opened to the public.

Hilles's family became more enmeshed with Calder through John and Jeanette Kilham Goldstone. John Goldstone was a New York attorney who represented Fernand Léger.[5] Found within the family papers was correspondence between Calder and John Goldstone, and Goldstone and Calder, dating from June 24 through August 2, 1948. The tone of this correspondence is familiar rather than formal and supports the idea of a personal relationship between John and Jeannette Goldstone and Alexander and Louisa Calder. Jeannette Goldstone (1897–1992) may have had her own affiliation with Calder, having studied art in Paris in the mid- to late 1920s and subsequently with Léger and Hans Hofmann in New York in the 1940s and 1950s. The Goldstones had homes in Manhattan and Connecticut (Wilton, Westport, and then West Redding in 1952 and 1953), all within twenty-five miles of Calder's home and studio in Roxbury, Connecticut.[6] According to Hilles, her parents were close personal friends of Alexander "Sandy" and Louisa Calder. She recalls many social occasions, dinners, and visits at

their Roxbury home that included, to her childhood delight, performances by Sandy Calder.

According to family history, the cone bracelet descended in the family from Jeannette Kilham Goldstone, which seems likely given that Jane Houston Kilham died in February 1930, at the very beginning of Calder's interest in jewelry as an art form, and given the relationship between the Goldstones and the Calders in the 1940s. Jane Hilles recalls being told by her mother that, to support Calder as an artist, she had purchased the silver-wire bracelet directly from him for $25 as a gift for Aline Lewis Goldstone, her mother-in-law. It is the importance the family placed on these artworks that has stayed with Jane Hilles since she was a child, for her parents treasured their relationship with the Calders and cherished the jewelry as valued symbols of the relationship between the two families. ERA

1. Calder's jewelry was first exhibited in 1929 at the Fifty-Sixth Street Galleries, New York. The dealer Marian Willard was the first to promote his jewelry exclusively, in her gallery in 1940. Jane Adlin, "Calder and Adornment," in Rower and Rower 2007, pp. 177–81.
2. It appears as design no. 9, annotated as "Bracelets Silver beaten flat (20.00 each)," in the drawings from Calder's

jewelry inventory book, c. 1938, and as design no. 4 in an inventory drawing for Calder's exhibition in 1946 at the Galerie Louis Carré, Paris; see Rower and Rower 2007, endpapers and p. 258, fig. 43.
3. Adlin, "Calder and Adornment," p. 149.
4. Theresa Dickason Cederholm, The Battle to Bring Modernism to New England: The History and Exhibition Record of the Boston Society of Independent Artists, 1927–1961 (Madison, CT: Falk Art Reference; Boston: Boston Public Library, 2005), pp. 33–34, 135.
5. An archive of business and personal correspondence, receipts, financial exchanges, immigration papers, and matters pertaining to storage of paintings accompanied the donor's gift of Calder jewelry.
6. Jane Goldstone Hilles to the author, August 19, 2011, curatorial files, AA, PMA.

Cat. 111

Alexander Calder
Figa Brooch

1948–50
Height 4¾ inches (12.1 cm), width bottom 2⅝ inches
(6.7 cm), width top 1⅞ inches (4.8 cm)
Weight 1 oz. 12 dwt. 13 gr.
Gift of Anne d'Harnoncourt in honor of the artist's
centenary, 1998-164-2

PROVENANCE: This brooch belonged to Sara Carr d'Harnon-
court (1903–2001) and was probably made by Calder for
her. The donor was her daughter, Anne d'Harnoncourt
(1943–2008), curator, director, and chief executive offi-
cer (1982–2008) of the Philadelphia Museum of Art.

EXHIBITED: *Calder Jewelry*, Philadelphia Museum of Art,
July 12–November 2, 2008; *Wrought and Crafted: Jew-
elry and Metalwork, 1900–Present*, Philadelphia Museum
of Art, May 8, 2009–February 7, 2010.

This brooch in the shape of a hand, with the thumb
placed between the index and middle fingers, and
rising from a sleeve cuff, is made of silver and steel
wire, hammered and cut square in cross section.
The lively, playful design is a modern rendition of
an ancient "cross your fingers" amulet called a *figa*,
which came to the New World with the African slave
trade. Based upon an African symbol for protec-
tion against the evil eye, the *figa* "remains a symbol
of good luck and fertility, worn today by Brazilian
men and women."[1] It was during his first visit to Brazil
in 1948 that Calder became familiar with this sym-
bol, and he subsequently created many examples
informed by it.[2] Alexander Rower has noted, "Never
satisfied with superfluous decoration, Calder used
jewelry as an alternative way of communicating his
artistic ideals. He developed a direct process using
honest industrial materials such as brass and steel
wire that he bent, twisted, hammered, and riveted in
an immediate way. At once primitive and refined, the
resulting works show the eccentricities of his hand
expressing subtly tactile qualities."[3] Calder once told
his sister: "I think best in wire."[4] When working in
Paris in 1926, he was known there as "le roi du fil de
fer" (the king of wire).[5]

Although designed as a flattish pin, this brooch
has a three-dimensional quality, extending from the
flat scrolls at the bottom through the convex curve of
the "sleeve" into the flat fingers. The focal point is the
impossible curve of the thumb. Calder made several
variations on this theme, none exactly alike.[6] BBG/ERA

1. Christopher Fennell, "Multivalent Symbols of an Enclosing
Hand," *African Diaspora Archaeology Network Newsletter*,
December 2007, www.diaspora.illinois.edu/news1207
/news1207-2.html (accessed January 21, 2015); Jane Adlin,
"Calder and Ornament," in Rower and Rower 2007, p. 153.
2. Adlin, "Calder and Ornament," p. 153.
3. Alexander S. C. Rower in Rower and Rower 2007, p. 13.
4. Seymour I. Toll, "My Way: Calder in Paris," *Sewanee
Review*, vol. 18, no. 4 (Fall 2010), p. 594.
5. Ibid.
6. "I'd rather not mass-produce objects. Sometimes I am
asked to, but I turn down such offers. Mass production
makes me think of paintings of Martha Washington on the
inside of candy boxes." Calder quoted in Adlin, "Calder and
Ornament," p. 185. For other examples of the *Figa* brooch,
see Rower and Rower 2007, p. 270, cats. 106, 107, and p. 274,
cat. 156.

James E. Caldwell

| Philadelphia, 1839–1842

Bennett & Caldwell

| Philadelphia, 1843–48

J. E. Caldwell & Co.

| Philadelphia, 1848–2003

The "life" dates of the J. E. Caldwell & Co. are clear, but less so are the dates of its founder (fig. 50). In 1965 J. Morton Caldwell, great-grandson of J. E. Caldwell (1813–1881), introduced Joseph Hugh Green, then president of J. E. Caldwell & Co., to address the American Newcomen Society.[1] Green stated that James E. Caldwell was born in Poughkeepsie, New York, on May 29, 1805.[2] Although James Emmot Caldwell was born in Poughkeepsie, the correct date is in fact August 15, 1813; he died on September 24, 1881, in Philadelphia.[3] In 1824 he was the youngest apprentice in the shop of Peter Perret Hayes (1788–1842), a silversmith and watchmaker in Poughkeepsie at the same time that Joseph T. Bailey (q.v.) was there as the eldest apprentice. Hayes's wife was Betty Benedict (1793–1851), and Bailey's mother was Lucy Benedict (1786–1841).

Fig. 50. Portrait of James E. Caldwell, from *Philadelphia and Popular Philadelphians* (Philadelphia: The North American, 1891), p. 125

When Caldwell left Poughkeepsie about 1834 and went to work in New York City, it was with Samuel Ward Benedict (1798–1880).[4] These early personal and familial relationships of the Caldwells and the Baileys later facilitated a close friendship between James E. Caldwell and Joseph T. Bailey in Philadelphia.

Headed south, James E. Caldwell arrived in Philadelphia about 1836 and may have worked for a short time for Samuel Hildeburn (q.v.), an active watch wholesaler, probably with a recommendation from Bailey, who was already in Philadelphia.[5] In 1837 Hildeburn was at 72 High Street.[6] A notice in the *Pennsylvania Gazette* in 1839 under "Watches and Jewelry" announced the opening of James E. Caldwell's first shop (fig. 51): "The subscriber respectively makes known to his friends and the public that he has taken the store No. 163 Chestnut Street, four doors above the United States Hotel where will be found an assortment of fine watches, of the most approved makers and fashionable jewelry of the newest patterns, a variety of English and French fancy goods; Silverware constantly on hand and manufactured to order. Watches of every description carefully repaired and warranted." This early advertisement suggests that Caldwell was primarily a retailer with wide contacts and stable credit for importing, and with watchmaking and -repairing skills and services. He offered Duplex lever watches manufactured by T. F. Cooper in London and M. J. Tobias in Liverpool.[7]

If Caldwell had been working with Hildebrand, he must have become acquainted with James M. Bennett (1808–1849) soon after his arrival in Philadelphia. From 1837 until 1839 the Philadelphia directory lists Bennett as "merchant" next door to Hildebrand, at 74 High Street.[8] In 1839 a James Bennett, silversmith, was listed at James M. Bennett's residence at 185 South Seventh Street. In 1841 James M. Bennett, merchant, moved his business location to 112 Chestnut Street.[9]

In 1840 Bennett's household was in the Pine Ward with a total of five persons, including one male between the ages of twenty and twenty-nine who was employed in manufacture and trade, one person under five, and three females between twenty and twenty-nine.[10] Early that same year Bennett sailed to Liverpool on the packet ship *Susquehanna* to purchase stock for his shop.[11] Soon after his return in 1841, and possibly prompted by the ill health for which he was known, the

partnership between Bennett and Caldwell developed quickly. They had three listings in the 1843 Philadelphia directory, compiled in the fall of 1842, "Bennett & Caldwell, watchmrs," "Jas. M. Bennett, mer.," and "James E. Caldwell, watchmaker," all at what became the business address, 163 Chestnut Street.[12] Bennett's name preceded Caldwell's in the listing, suggesting that he was the primary or financial partner.

Caldwell married Sarah Caroline Butler (1824–1904) on September 1, 1842, and moved his residence out of 163 Chestnut to 139 Walnut Street.[13] In about 1843 or 1844 "Bennett & Caldwell" moved from 163 Chestnut, where the firm was listed as watchmakers, to 140 Chestnut, where it was listed from 1845 to 1848 as "watchmakers & jewellers." In 1847 or 1848 Caldwell moved his residence

The Caldwell store of 1839, between 4th and 5th on Chestnut Street, Philadelphia, in "the shadow of Independence Hall."

Jewelers • Silversmiths • Stationers • Antiquarians
CHESTNUT & JUNIPER STREETS
PHILADELPHIA 7, PA.
Haverford, Pa. Wilmington, Del.

Fig. 51. The Caldwell store in 1839, between Fourth and Fifth streets on Chestnut, "in the shadow of Independence Hall," illustrated in an advertisement for J. E. Caldwell & Co., *Antiques*, vol. 75, no. 6 (June 1959), p. 511

again, to 18 Clinton Street, and Bennett moved to 8 South Penn Square.[14] On May 18, 1848, the *North American* carried this notice: "The COPRTNERSHIP heretofore existing between the subscribers, under the firm of BENNETT & CALDWELL, is hereby dissolved, JAMES M. BENNETT retiring from the concern. Signed, JAMES M. BENNETT / JAMES E. CALDWELL. / Philadelphia, May 16, 1848. / JAMES E. CALDWELL has associated with him JOHN C. FARR and will continue the business at the old stand, 140 Chestnut Street, under the firm of JAMES E. CALDWELL & CO. . . . the hope . . . to retain the patronage. . . . An assortment of Fine Watches, Rich Jewelry, mantle Clocks, Silver Ware, English, Chinese and French Fancey goods."

On November 21, 1849, the *North American* of Philadelphia carried a notice that James M. Bennett, "late of the firm of Bennett & Caldwell," had died in Kingston, Jamaica, on October 3, 1849, following his return from a business trip to San Francisco: "He was a native of Vermont, and developed in an unusual degree the energy, enterprise, self-control and high-toned morality which distinguish the New England character. . . . [H]is disease was of long standing. . . . For the sake of his health, and in the hope of leaving a competence to his family, he braved in his weakness, the hardships of San Francisco and the perils of a voyage half round the globe."

Before his partnership with Bennett was dissolved in 1848, Caldwell had made a business arrangement with John C. Farr (1809–1888). By 1830 Farr was well-known and well connected in the craft community. In March 1834, at a meeting of citizens engaged as silversmiths, jewelers, and watchmakers from the city and county of Philadelphia, he was appointed a vice president, along with John McAllister Jr., George K. Childs (q.q.v.) as secretary, and William Warner, to sign and present a petition to the U.S. Twenty-third Congress to plead for the restoration of government deposits in the Bank of the United States.[15] In 1844 Farr had purchased the building at 112 Chestnut Street, where his business had been located since 1840.[16] Bennett's business address was located there in 1841 and 1842.[17] Farr would have been an important connection for Caldwell.

Farr was listed as "merchant" and "manufacturing chemist." His early advertisements show a varied inventory, including olachita oilstone (for use by engravers and machinists), an electromagnetic apparatus sold in small portable boxes, gold pens, a clock with an ingenious mechanism, and daguerreotype plates, as well as lost jewelry.[18] He dealt often in real estate. Nine grantor deeds and eight grantee deeds dated between 1842 and 1851 are recorded in Farr's name.[19] His shop at 112 Chestnut Street was located in a handsome, three-story stone building between Third and Fourth streets, with a grand showroom on the first floor.[20] In 1847 and 1848, when he joined with Caldwell, his advertisements became more frequent and visual, with a different message, featuring gold jewelry, silver, silver-plated wares, diamond-pointed gold pens, and watchmakers' tools. On December 21, 1848, Farr advertised: "Gold scales and weights—Very desirable for those about embarking for California."[21] He extended his advertising with large print notices in Philadelphia's *Public Ledger* and in the outlying *Washington (PA) Reporter*, for jewelry, gold pens, and so forth. He advertised further afield than Caldwell had, using exclusively Philadelphia newspapers. In 1844 Farr, along with Henry McKeen and Osmon Reed (q.q.v.) and other wholesalers, advertised to dealers in other regions: "We the undersigned Houses of this city, beg leave to inform the Western and Southern merchants that the assortment of Goods in our respective departments are now complete."[22] While Farr advertised regularly, Caldwell used newspapers sparingly but did advertise in the newest magazines, including *Godey's Lady's Book* and the *Saturday Evening Post*.[23] Farr's advertisements always referred to his own address at 112 Chestnut Street, never to Caldwell's at 140 Chestnut, suggesting that their interaction was on the wholesale level, each retaining his retail patrons. Sales may have been handled with referrals from both locations.[24]

On January 1, 1850, Farr advertised: "We now have in store, a fine assortment of watches of our own importation. . . . J. C. Farr & Co., Importers of watches, 112 Chestnut street," further evidence that Farr and Caldwell were separate if equal (see fig. 52).[25] Farr had his own partnership with Charles E. Thompson and William M. Farr.[26] In 1853 he retired from his enterprise, turning it over to William M. Farr and Charles E. Thompson, who advertised themselves as Farr & Thompson, "watchmakers and jewelers," at 112 Chestnut.[27] In 1856 the firm moved to 120 Chestnut Street.[28] In 1854 Farr was listed as a merchant with Caldwell at 140 Chestnut, with his residence on Spruce at Eighteenth Street. Farr had completely retired by 1859.[29]

In 1855 Caldwell, intending to expand his business (fig. 53), hired two salesmen, Edwin Langton and Richard A. Lewis, and the firm prepared to move to larger quarters.[30] In 1857 or 1858 the company moved to 822 Chestnut Street. Caldwell held a ten-year lease on that property, a handsome stone and marble building just below Ninth Street that served while their new store was being built at 902 Chestnut. The *Public Ledger* on June 18, 1857, under "Chestnut Street Improvements," noted that "Messrs James E. Caldwell & Co. will soon commence the alterations and improvement of their new store, on Chestnut Street, and will fit it up in a style heretofore unequalled in the world, Mr. John McArthur Jr. is the architect, Mr. Otton superintending the carving."[31] In the meantime the 1863 Philadelphia directory listed "Caldwell, J. E. (James E. Caldwell, Edwin Langton & Richard A. Lewis), jewelers, 822 Chestnut Street"; the salesmen had become full partners.[32] In 1865 the Caldwell family moved from the city to Green and Manheim streets in Germantown.[33]

The company made its final move, to 902 Chestnut Street, on March 2, 1867. The premises were described in *Godey's Lady's Book* as a profusion of riches and delicacy of taste that reigned everywhere within. . . . The first level was dedicated to displays and sales, a counting room, a private office, a wardrobe, and accessories; the second story, in two large rooms accommodated the picture gallery, duplicate stock, and a dressing room for two clerks who slept at the store; the third story for engravers, watchmakers and repairers; the fourth story was the jeweler's work shop, for melters, modelers, diamond setters and polishers . . . this vast apartment was lighted from the roof; sunbeams seemed to fall in masses upon the magnificence within, bringing out with each change of standpoint new beauties and harmonies of color.[34]

Fig. 52. *John C. Farr & Co./Importers of Watches.* . . . Color lithograph printed by P. S. Duval, c. 1850, 16 × 14 inches (40.6 × 35.6 cm). Library Company of Philadelphia. Print Department, *W202[P.2122]

Fig. 53. Trade card for J. E. Caldwell & Co., 1845–58. Lithograph, plate: 2¼ × 1¾ inches (5.7 × 4.5 cm). Philadelphia Museum of Art. Gift of Mrs. William R. Cabot, PDP-527

On October 17, 1868, the *Philadelphia Inquirer* noted that "James E. Caldwell, Esq. of Messrs J. E. Caldwell & Co. jewelers, has just returned from Europe, after making selections for their fall and winter sales." Then, on the night of January 14, 1869, the heating boilers in the basement of the new store exploded and destroyed the three newly built adjoining buildings, Howell & Brothers paper hangers, J. F. and B. Orne carpet dealers, and J. E. Caldwell & Co. jewelers. The April 1869 issue of *Godey's Lady's Book* began its dramatic story of Caldwell's fire by quoting Longfellow: "In the world's broad field of battle, In the bivouac of Life, Be not like dumb cattle, Be a hero in the strife!" It went on: "HEROISM is not confined to times of national trial and revolution. It is displayed as well in the tests that show the temper of man in daily life. There has lately occurred in Philadelphia a disaster so gigantic and crushing as to enlist the sympathy of all our citizens. The jewelry store of Messrs. Caldwell & Company is now a blackened mass of ruins." Two clerks perished, and the first and second floors burned. The loss was thought to be $1,300,000, with insurance covering $600,000. In his diary Sidney George Fisher wrote: "This morning at 1 o'clock, Caldwell's magnificent jewelry store at 902 Chestnut Street was destroyed by fire and the adjoining stores, Howell's paper hangings at 900, Orne's carpet establishment, at 904, were greatly injured. They were all three costly and very handsome buildings of white marble, erected where the house of Mr. Edward Burd stood some years ago and by his estate, and were filled with valuable goods."[35]

When Caldwell returned from New York the morning after the fire, he told an associate, "I care nothing for the property destroyed, we earned it once, we can earn it again but the lives of these faithful young men, we can never restore."[36] Promptly in February, in a characteristically generous gesture, Caldwell wrote to the Marvin Safe Company of 721 Chestnut Street: "gentleman— the two large safes you manufactured for me, and which were in the front part of our store during the fire were opened on Saturday last. Everything in them was found in perfect condition . . . they contained a large stock of our best and finest goods."[37]

Undaunted, in 1871 James E. and his son J. Albert Caldwell, "the most prominent of our Chestnut Street jewelers, sailed for Europe . . . in the *Scotia*," one of their twice yearly trips.[38] James Caldwell had immediately set about rebuilding and received public acclaim and praise for his enterprise and for the results. The new building had a 30-foot frontage on Chestnut Street and extended 235 feet to Sansom Street. It had four floors and a full basement. The first floor was for

diamonds, watches, jewelry, and silver; the second housed picture galleries and bronze art objects; the third, engravers and watchmakers; and the fourth a jewelry-making shop with goldsmiths and diamond setters.[39] "The company advertised: "While the main business of the Caldwell firm is importations, with the exception of their silverware, this house has been quick to appreciate and ready to advance American goods of pre-eminence. American cut glass, for instance, was struggling for recognition when this firm gave the infant industry the publicity it deserved."[40]

In March 1875 the company was reorganized: "The partnership heretofore existing between James E. Caldwell, Richard A. Lewis, Joseph H. Brazier, George W. Banks, J. Albert Caldwell and Hugh B. Houston under the name of J. E. Caldwell & Co. expired February 1, 1875 by limitation." A "Notice of Limited Partnership" was published immediately below: "The only general partners are James E. Caldwell residing in Manheim Street, Germantown, Joseph H. Brazier No. 25 North 19th Street, George W. Banks, La-Pierre house, Broad Street below Chestnut, J. Albert Caldwell No. 1513 Pine Street and Hugh B. Houston, No. 206 North Eighteenth Street, all in the City of Philadelphia; and the only Special Partner is Richard A. Lewis No. 1909 Green Street, in said city. . . . The amount of capital contributed by said Special Partner is One hundred thousand ($100,000) dollars in cash. . . . Begins February 1, 1875 . . . will terminate January 31, 1877."[41]

J. E. Caldwell & Co. exhibited at the Centennial International Exposition of 1876. The *Philadelphia Inquirer* noted with regard to Waltham gold and silver watches, used by "nearly every railway conductor in the country, . . . that the entire lot, numbering more than 2000, has been purchased by James E. Caldwell & Co., the well known jewelers, No. 902 Chestnut Street. The timepieces are now being offered for sale, with immediate delivery, from the Company's stand in Machinery Hall."[42]

James E. Caldwell held a number of civic offices and made frequent charitable bequests, including contributions in 1851 to the Moyamensing Soup Society and in 1880 to the Irish Relief Fund. In 1869 Caldwell served as a reference for the Hill Boarding School for the classical education of young boys. In 1879 he was appointed to the "Committee of the Month" by the Board of Trade Executive Council to investigate levels of piracy at sea. He served as accounting warden for Calvary Episcopal Church in Germantown and was a member and director of the Union League and a director of the Farmer's and Mechanics Bank.[43] At his death in 1881 he was survived by his wife and all of his children except one:

THE LAST RITES—Obsequies of the Late James E. Caldwell. The funeral of James E. Caldwell, late senior partner in the well-known jewelry firm, took place yesterday morning from the mansion which the family have so long occupied, on Manheim Street, Germantown. The attendance was very large. In the parlor where the remains lay in a casket covered with rich black cloth, with its silver plate bearing the usual inscription, there were a large number of floral designs, many of them the gifts of sorrowing friends; the most beautiful of all, perhaps, being a broken column, the tribute of the gentlemen associated with the firm in business at the Chestnut street store.[44] Rev. James De Wolfe Perry D.D. Rector of Calvary Church, Germantown, officiated, assisted by Rev. Charles A. Maison, Rector of St. James Church, Kingsessing. After the services at the house, the long funeral cortege took up its line of march for Central Laurel Hill Cemetery, where the remains were committed to the earth according to the solemn forms of the Protestant Episcopal ritual. Many citizens of prominence were in the funeral train, the pallbearers being Messrs. James L. Claghorn, Joseph Patterson, Richard Lewis, Benjamin Homer and Edward Langton, a former partner of the deceased.[45]

The company carried on under the direction of J. Albert Caldwell (died 1914). His younger brother, Richard N. Caldwell (died 1899), joined the firm, and J. Albert was followed by his son J. Emott Caldwell (died 1919) as president. The company moved to Chestnut and Juniper streets in 1916, the site of the old Philadelphia Mint. The Widener estate owned the building, which was leased to the firm under the direction of William R. Eisenhower. The renovations were overseen by the architect Horace Trumbauer, and the premises were decorated in the French Regency style with abundant gold embellishment.[46]

J. E. Caldwell & Co. maintained Philadelphia's social calendar beginning in the early years of the twentieth century and through the years of World War II. Called "The Book," it was consulted before any important social dates were set for weddings, charity balls, or debuts, sometimes years ahead.[47] The company had a difficult time during the depression years but recovered by 1936 and changed its stock to suit the times: the diamonds were smaller, and customers who expected high-quality goods purchased freely but were buying smaller items. It made the necessary adjustments in its inventory and survived. The firm operated its own jewelry manufactory on-site and had a factory for fine stationery on North Sixteenth Street. After 1914 the Keystone Silver Company was J. E. Caldwell & Co.'s main supplier of silverware. Two workmen were employed to do hand engraving on silver.[48] Branch stores were opened in 1953 in Wilmington, Delaware, and in 1954 in Haverford, Pennsylvania.[49]

J. E. Caldwell & Co. and its branch stores were purchased by a Minneapolis-based merchandising firm in 1968, and that firm was in turn acquired in 1992 by Carlyle & Co. of North Carolina. In 2009 Adamas Partners Ltd. purchased the chain (one of the partners in Carlyle was a partner in Adamas). Finley Enterprises, Inc., of New York eventually owned the whole.[50] In 2003 J. E. Caldwell & Co. closed its doors at 1339 Chestnut Street, the store's final location in Philadelphia.[51]

BBG

1. Green 1965, pp. 5-7.

2. Ibid., p. 7. His birth date in other sources has been given variously as 1812, 1814, and 1817.

3. Memorial no. 80561145, www.findagrave.com (accessed June 15, 2015).

4. Samuel W. Benedict, born in Danbury, Connecticut, was surely related to Peter Hayes's wife. Andrew C. Benedict (1802–1862), jeweler and watchmaker, was another member of the extended family active in New York City from 1828 until 1846; Silversmiths and Related Craftsmen, s.v. "Andrew Comstock Benedict," Ancestry.com; see also the biography of Joseph T. Bailey (q.v.).

5. Philadelphia Inquirer, September 26, 1881; Rainwater and Redfield 1998, p. 64; William Richard Cutter, ed., New England Families, Genealogical and Memorial (New York: Lewis Historical Publishing, 1913), vol. 4, pp. 1926–27.

6. Samuel Hildeburn was listed as a merchant at 72 High Street; Philadelphia directory 1837, p. 99.

7. Public Ledger (Philadelphia), November 8, 1841.

8. His residence was at 185 South Seventh Street in 1839; there were a number of James Bennetts in directories and genealogical sources. This James Bennett always used the middle initial "M"; Philadelphia directory 1837, p. 15; 1839, p. 18. Not to be confused with a James M. Bennett who was born in New York City c. 1806; 1850 U.S. Census.

9. This precise listing does not occur again. A Jacob Bennett, silversmith, was listed in 1837, 1841, and 1842 with his residence at 53 South Fifth Street; Philadelphia directory 1837, p. 15; 1841, p. 19; 1842, p. 18.

10. 1840 U.S. Census. In 1841 Pine Ward was defined as between Spruce and Pine streets and Front and Seventh streets. James M. Bennett was born in Vermont.

11. National Gazette (Philadelphia), June 9, 1840.

12. Neither listing included a residential address; Philadelphia directory 1843, pp. 19, 39.

13. Sarah Caroline Butler was born in Northampton, Massachusetts, daughter of Edward and Caroline Hyde Butler Laing (1804–1892); memorial no. 100261811, www.findagrave.com (accessed June 3, 2015). They had several children. Their oldest, James Albert Caldwell (1846–1914), succeeded his father in the company; Lennox Caldwell died in 1888; Richard N. Caldwell (died 1899) also joined the family firm; and another, unnamed child died in 1895; Green 1965, p. 13.

14. Philadelphia directory 1844, p. 21; 1848, pp. 23, 49.

15. H.R. doc. no. 206, 23rd Cong., 1st sess. (1834).

16. Eli Kirk Price to John C. Farr et al., Philadelphia Deed Book RLL-18-689, April 25, 1844.

17. Ibid.; Philadelphia directory 1842, p. 18.

18. Public Ledger, January 15, 1839; May 6, 1843; March 13, 1844; June 24 and November 28, 1845. Farr was described as a "Dealer in Watches, Jewellery and Silverware"; Philadelphia Inquirer, February 29, 1844.

19. For details of the deeds see the curatorial files, AA, PMA.

20. Nicholas Wainwright, Philadelphia in the Romantic Age of Lithography, 1828–1878 (Philadelphia: HSP, 1958), p. 224, cat. 421.

21. Public Ledger, December 21, 1848; Washington (PA) Reporter, July 31 and August 14, 1847.

22. Philadelphia Inquirer, February 29, 1844.

23. Green 1965, p. 10.

24. Philadelphia and Popular Philadelphians: The North American, s.v. "J. E. Caldwell & Co." (Philadelphia: American Printing House, 1891).

25. Public Ledger, January 1, 1850.

26. Ibid., January 3, 1853.

27. Philadelphia Inquirer, February 28, 1853; Philadelphia directory 1853, pp. 125, 411.

28. The listing in the Philadelphia directory of 1859 (p. 192) gave his address as 1810 Spruce Street but made no mention of an occupation.

29. Philadelphia directory 1854, p. 213. Farr died August 12, 1888. He was buried at the Presbyterian Church at Fourth and Pine. He had requested of Bringhurst Funeral Company that there be no advertising and no flowers; genealogical records, Accessible-Archives.com (accessed December 9, 2014).

30. Sara Josepha Hale, ed., "Jewelry and Its Lessons," Godey's Lady's Book, April 1869.

31. John McArthur Jr., "architect 16 Mercantile Library Building 5th and Library Streets h. 186 South 15th Street"; Philadelphia directory 1857, p. 248. J. Hare Otton, "carver 82 South 5th Street"; ibid., p. 316.

32. Both were listed in 1855 as "salesman" at 140 Chestnut Street. Langton lived on South Third, Lewis at 138 Pine. In about 1865 Lewis moved to the junction of North Seventh and North Fifteenth streets; Philadelphia directory 1863, pp. 306, 317; 1865, p. 425.

33. Ibid. 1865, p. 119.

34. Quoted in Hale, "Jewelry and Its Lessons."

35. Nicholas B. Wainwright, ed., A Philadelphia Perspective: Diary of Sidney George Fisher (Philadelphia: Historical Society of Pennsylvania, 1967), p. 548; Harrisburg Weekly Patriot, January 15, 1869; also quoted in Hale, "Jewelry and Its Lessons."

36. Green 1965, p. 12. Apocryphal or not, this declaration seems characteristic of the man.

37. Harrisburg Weekly Patriot, February 11, 1869. This letter appeared immediately under an advertisement for Marvin Safes. Caldwell's customers kept their jewelry and legal documents in Caldwell's safes.

38. Philadelphia Inquirer, May 4, 1871.

39. Green 1965, p. 11.

40. "Advertisement—J. E. Caldwell & Co.," in Philadelphia: Its Founding and Development, 1683–1908, ed. William W. Matos (Philadelphia: Founders Week Celebration Executive Committee, 1908), p. 487, cited at Silver Salon Forums, www.smpub.com/ubb/Forum12/HTML/000042.html, posted April 4, 2010 (accessed June 3, 2015).

41. North American (Philadelphia), March 31, 1875. The large contribution by Richard Lewis was probably made right after the fire.

42. Philadelphia Inquirer, October 4, 1876.

43. Ibid., February 8, 1851; November 18, 1879; January 28, 1880; Harrisburg Weekly Patriot, August 12, 1869.

44. The broken-column motif, also used at Lincoln's funeral, was a symbol of a life cut short.

45. Philadelphia Inquirer, September 29, 1881. On September 27, 1881, the Philadelphia Inquirer carried a notice that on the following day thirty carriages would meet the 9:55 A.M. train from Ninth and Green Depot at Wayne Junction for the convenience of mourners.

46. Green 1965, pp. 14–15.

47. Ibid., pp. 15–18.

48. Ibid., p. 22. Initials on the small cosmetic boxes attest to their style and expertise; see cats. 118, 119.

49. Green 1965, p. 19.

50. Philadelphia Inquirer, March 30, 1988, and August 25, 1992; Triad Business Journal, December 10, 2009, www.bizjournals.com (accessed November 24, 2014).

51. Philadelphia Inquirer, March 27, 2003.

Cat. 112

James E. Caldwell
Teaspoon

c. 1839–42

MARKS: J.E.CALDWELL (in rectangle); [eagle] (in rounded square; all on back of handle) (cat. 112-1)

INSCRIPTION: H [. . .] R (engraved script monogram, on front of handle)

Length 5 13/16 inches (14.8 cm)

Weight 8 dwt. 12 gr.

Gift of Charlene D. Sussel, 2009-155-5

PROVENANCE: From the stock of the Philadelphia antiques dealer Eugene Sussel (1913–1989), the donor's husband.

Cat. 112-1

The mark on this spoon presumably was the earliest used by Caldwell, before and possibly during his partnership with Bennett. The eagle mark, also found on flatware marked by other Philadelphia makers and retailers (see cats. 6, 163), indicates that the spoon was made after Caldwell moved from New York to Philadelphia. DLB

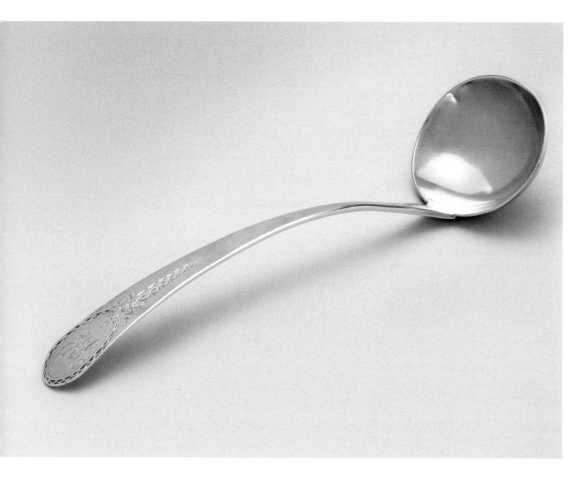

Cat. 114

Bennett & Caldwell
Covered Pitcher

1845
MARK: BENNETT & CALDWELL (incuse, on underside; cat. 114-1)
INSCRIPTIONS: Presented to / John M. Scott Esqʳ. / LATE MAYOR / of the / City of Philadelphia / BY HIS OFFICERS / As a testimonial of their / high respect & regard, / for his / Urbanity as a Man, / and Uprightness / as a Magistrate. / January 1845. (engraved script, on side of body); 49=1 (scratched, on underside near edge)
Height 12 inches (30.5 cm), width 8¼ inches (21 cm), depth 5⅝ inches (14.3 cm)
Weight 49 oz. 1 dwt.
Gift of the Levitties Family, 1994-8-2
PROVENANCE: Learning Montgomery; Margaret B. Caldwell, New York.

PUBLISHED: Maria Scott Beale Chance and Mary Allen Evans Smith, eds., *Scott Family Letters: The Letters of John Morin Scott and His Wife, Mary Emlen Scott* (Philadelphia: privately printed, 1930), facing p. 286; Christie's, New York, *Important American Furniture, Silver, Folk Art and Decorative Arts*, June 17, 1992, sale 7492, lot 31.

Cat. 114-1

The baluster form is divided into six panels ornamented with plain and repoussé surfaces typical of pre-Victorian design. Stylistically, the acorn finial may be the earliest detail and the serpentine handle the latest.

John Morin Scott (1789–1858) was born in New York on October 25, 1789, son of Lewis Allaire (1755–1798) and Julianna Sitgreaves Scott (1755–1842).[1] John graduated from Princeton University at the age of fifteen and studied law in the office of William Rawle in Philadelphia. He was a member of the First Troop Philadelphia City Cavalry in 1808, resigned in 1812, and was made an honorary member in 1813.[2] He served as first lieutenant of the Second Troop Philadelphia City Cavalry in 1814, near the end of the War of 1812.[3] In 1815 he was elected to the Pennsylvania House of Representatives.

Scott married Mary Emlen (1795–1881), daughter of George and Sarah Fishbourne Emlen, in 1817. He was a member of the Philadelphia Common Council for several terms and in 1836 a member of the convention to propose amendments to the constitution of Pennsylvania. He was elected mayor of Philadelphia in 1841 and served for three terms. Scott was shot in his office during one term and, during the last, in

Cat. 113

James E. Caldwell
Ladle

1839–42
MARK: CALDWELL (in rectangle, on reverse of stem; cat. 113-1)
INSCRIPTION: W (engraved script, at top of obverse of handle; cat. 113-2)
Length 8¼ inches (21 cm), width 2¾ inches (7 cm)
Weight 1 oz. 19 dwt. 5 gr.
Gift of Mr. and Mrs. Lawrence Campbell, 2001-190-2
PROVENANCE: Originally owned by Anne Waln Ryerss (1813–1886);[1] to her stepson Robert Waln Ryerss and his wife Mary A. Reed Ryerss; to their niece Alice J. Reed Vallee (died before 1984); to her daughter Mary S. Vallee; presented as a gift to the donor, Mary Louise (Mrs. Lawrence) Campbell.[2]

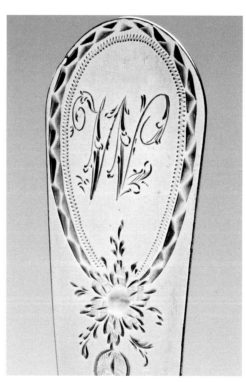

Cat. 113-2

This ladle has an early Caldwell mark, used before his partnership with Bennett. BBG

1. Anne Waln was the seventh child of Robert Waln Jr. (1765–1836) and his wife Phebe Lewis Waln, who married in 1787. She was the second wife of her cousin Joseph Waln Ryerss (1803–1868). Joseph Waln Ryerss was the second child of Judge John Ryerss and his wife Hannah. His first wife was Susan (born 1806), Anne's sister. Her son was Robert Waln Ryerss, who settled his stepmother's estate and in her name established the Ryerss Farm for Aged Equines in Pottstown,

Pennsylvania, in 1888.
2. Additional genealogical information was kindly provided by Joe Donahue, president of the Ryerss Farm. For other silver that descended in this family, see the the serving spoons by John R. Wendt (PMA 2001-190-3) and Thomas Whartenby (PMA 2001-190-1).

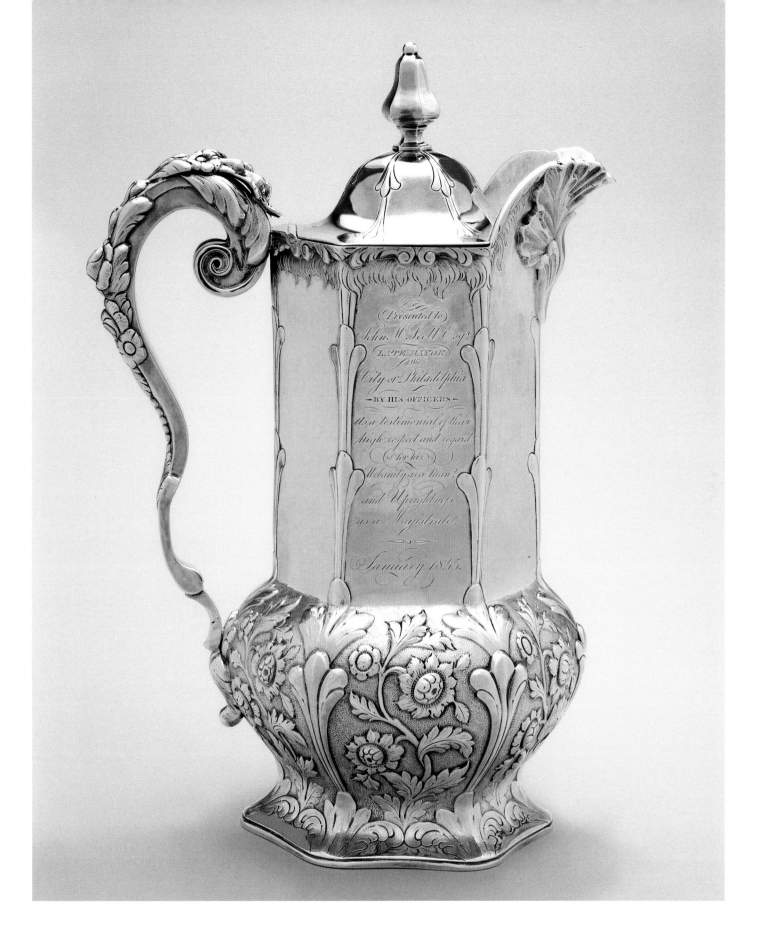

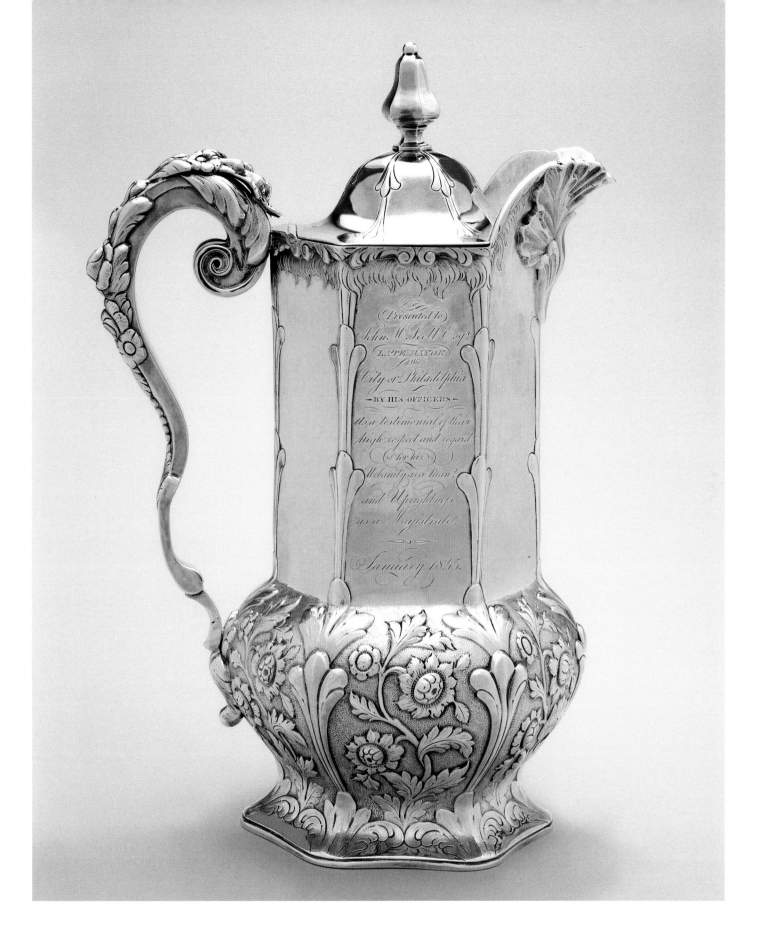Presented to
John M. Scott Esqr.
LATE MAYOR
of the
City of Philadelphia
— BY HIS OFFICERS —
As a testimonial of their
high respect and regard
for his
Urbanity as a Man,
and Uprightness
as a Magistrate.
January 1845.

1844, was "at the front" in Kensington, charged with subduing intense riots centering on a developing conflict between Catholic citizens, new immigrants, and the newly formed Native American Party.[4] The inscription on this pitcher recognized Scott's central role in one of Philadelphia's most volatile periods. He served again on the Common Council from 1850 until 1852 and died on April 3, 1858.[5] BBG

1. For biographical information on Scott, see Henry Simpson, *Lives of Eminent Philadelphians* (Philadelphia, 1859), s.v. "John M. Scott"; John W. Jordan, *Colonial Families of Philadelphia* (Philadelphia: Lewis, 1911), vol. 2, pp. 1434–36.
2. "Pennsylvania National Guard, First Troop of Philadelphia Cavalry," in *History of the First Troop Philadelphia City Cavalry . . .* (Trenton, 1895), p. 183.
3. "Military Order of Foreign Wars of the United States," in *Register of the Military Order of Foreign Wars of the United States, National Commandery* (New York, 1900), p. 222.
4. Catholic churches, the rare book library of the Order of the Hermit Friars of Saint Augustine, and numerous private and public buildings were burned; see Scharf and Westcott 1884, vol. 1, pp. 663–68. The Native American Party was formed in 1837.
5. See also the tankard made by Jacobus van der Spiegel (q.v.) for the Morin family and inherited by John Morin Scott (PMA 1996-176-1).

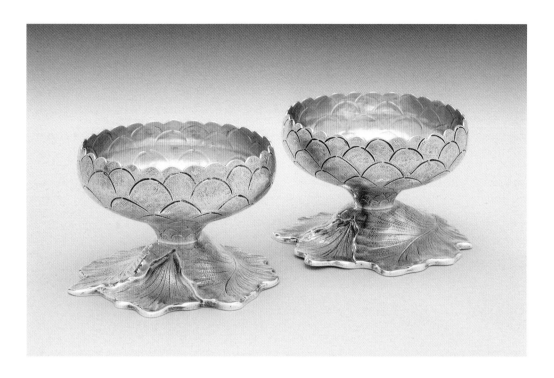

Cat. 115

J. E. Caldwell & Co.
Pair of Salt Dishes

1850–60
Retailed by J. E. Caldwell & Co. (q.v.)
MARKS (on each): J.E.CALDWELL &Cº / 925 (encircled; all incuse, on underside; cat. 115-1)
INSCRIPTION (on each): C J M (engraved script monogram, on underside; cat. 115-1)
2010-206-8: Height 1⅞ inches (4.8 cm), width 2¹⁵⁄₁₆ inches (7.5 cm), depth 2⁹⁄₁₆ inches (6.5 cm)
Weight 3 oz. 10 dwt. 11 gr.
2010-206-9: Height 1¹⁵⁄₁₆ inches (4.9 cm), width 3 inches (7.6 cm), depth 2⅝ inches (6.7 cm)
Weight 3 oz. 7 dwt. 17 gr.
Gift of Beverly A. Wilson, 2010-206-8, -9

Cat. 115-1

Charters, Cann & Dunn of New York made a nearly identical pair of salt dishes (cat. 131). It is possible that the same firm also made these salts retailed by J. E. Caldwell & Co., although the popularity of acorn-and-oak designs, as well as differences in the castings and chasing, make a definitive attribution difficult. DLB

Cat. 116

J. E. Caldwell & Co.
Pie Server

c. 1863
MARK: J.E.CALDWELL & CO (incuse, on reverse of handle; cat. 116-1)
INSCRIPTIONS: Marshall (diagonally engraved script in shield-shaped reserve, on front of handle); Christmas 1863. (engraved script, on reverse of handle)
Length 8¾ inches (22.2 cm), width 2½ inches (6.4 cm)
Weight 2 oz. 2 dwt.
Bequest of Marian Marshall, 1981-71-1

PROVENANCE: Descended in the family of the donor.

Cat. 116-1

The design on this handle of a shield on a striated, machine-engraved ground is similar to examples marked by Peter G. Perdriaux (q.v.) and other silversmiths working in Philadelphia between 1850 and 1865.[1] The twisted, stemlike shaft is similar to a design by George B. Sharp for Bailey & Co. (q.q.v.), and was made in other locales as well.[2] BBG

1. D. Albert Soeffing, "A Mark Attribution: Peter G. Perdieux [sic]," *Silver Magazine*, vol. 24, no. 2 (March–April 1991), p. 13.
2. Diana Cramer, "George Sharp: The Products," *Silver Magazine*, vol. 24, no. 5 (September–October 1991), p. 29; R. David Ives, "F. A. B. & Company," *Silver Magazine*, vol. 23, no. 2 (March–April 1990), p. 20.

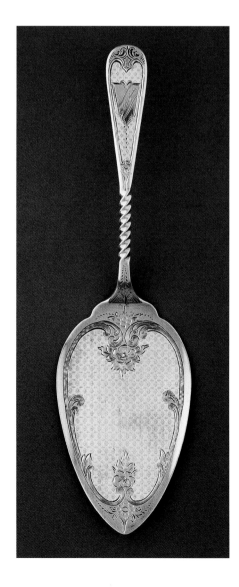

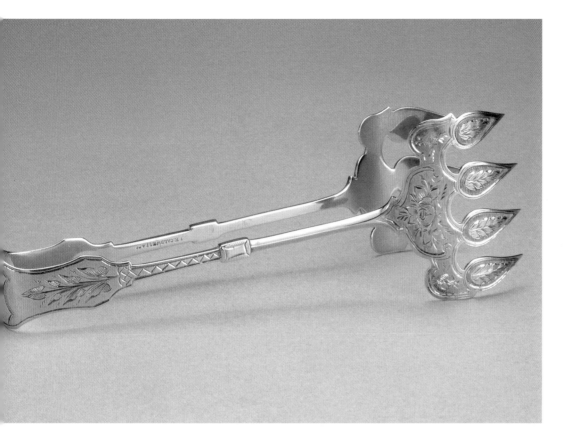

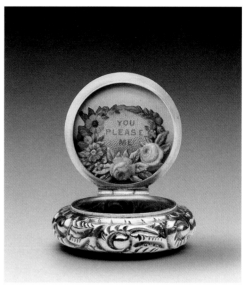

J. E. Caldwell & Co. (attributed)
Pill Box

1890–1904
MARK: STERLING (incuse, on interior of bottom)
INSCRIPTION: B A C (engraved superimposed script,
on top; cat. 119-1)
Height ⅜ inch (1 cm), diam. 1¹/₁₆ inches (2.7 cm)
Weight 4 dwt. 6 gr.
Gift of Joan Root, 2005-87-2a,b (pill box), 2005-87-6
(powder box)

PROVENANCE: According to the donor, the initials on both
boxes belonged to Blanche Chambers, an unmarried
woman who lived in Overbrook, Pennsylvania, and left her
estate to the donor's family.

Cat. 119-1

Cat. 117
J. E. Caldwell & Co.
Asparagus Tongs

1865–70
MARK: J.E.CALDWELL &Cᵒ (incuse, on inside of one arm;
cat. 115-1)
INSCRIPTION: A C V R (engraved script, "V" and "R" con-
joined, at top of obverse of handle)
Length 5¾ inches (14.6 cm), width 2¹/₁₆ inches (5.2 cm)
Weight 1 oz. 7 dwt. 5 gr.
Gift in memory of Eugene Sussel by his wife Charlene
Sussel, 1991-98-27

PROVENANCE: From the stock of the Philadelphia antiques
dealer Eugene Sussel (1913–1989), the donor's
husband.

These spring-action asparagus tongs are engraved
and chased with Persian motifs. One arm ends in
a three-pronged fork, the other in four prongs. The
forks were parcel gilt. These tongs are a fine example
of the specialization of serving implements, which
became de rigueur for the well-set table.[1]

The engraved initials possibly belonged to Alice
Cogswell Van Renssalaer (1846-1878) of Burling-
ton County, New Jersey, who married the Reverend
Edward Blanchard Hodge (1841-1906) in 1868.[2] BBG

1. Diana Cramer, "Asparagus Anyone?," *Silver Magazine*,
vol. 19, no. 6 (November–December 1986), pp. 38–41.
2. Daggs and Rodney—18th and 19th Century America family
tree, Ancestry.com.

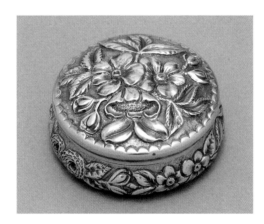

Cats. 118, 119
J. E. Caldwell & Co.
Powder Box

1890–1904
MARKS: STERLING 16 J.E.CALDWELL&Co. (incuse, on rim
of bottom section; cat. 118-1)
INSCRIPTIONS: B A C (engraved script, on underside); 8776
(scratched, on rim; cat. 118-2)
Height ⅞ inch (2 cm), diam. 2¼ inches (5.7 cm)
Weight 1 oz. 7 dwt. 5 gr.

Cat. 118-1

Cat. 118-2

Although the pill box does not have the "J.E.
CALDWELL&Co." imprint found on the powder box,
the chased patterns of dots in semicircles around
the top of the powder box and the interior rim of the
pill box are identical. The large capital incuse letters
"STERLING" on the interior of the pill box are like
those on the powder box, which is fully marked and
from the same donor. The lids on both objects are
hinged. The interior of the powder box is parcel gilt.

Caldwell's advertised that the firm provided
exceptional engraving. Both boxes are distinguished
for the artistic style of their engraved initials. A small
paper "favor" found inside the pill box reads, "You
please me." BBG

Abraham Carlile

Philadelphia, born 1764
Philadelphia, died 1837

The Carliles were a Quaker family who lived and owned property on Front Street in Mulberry Ward, in the Northern Liberties section of Philadelphia. The silversmith's father, Abraham Carlile Sr. (1720–1778), was a carpenter active in the Friends meetings. In 1756 he was a subscriber to the capital stock of the "Friendly Association for Regaining and Preserving Peace with the Indians by Pacific Measures," established by a group of Quakers.[1] He married Ann Brookes (1723–1787) at the Philadelphia Monthly Meeting on February 19, 1747.[2] In 1774 he was paying tax of 2s. on £35, the value of his carpentry shop in Mulberry Ward. He paid ground rent of £4 10s. to Elizabeth Norris on his property.[3]

The British occupation of Philadelphia in 1777–78 caused major rifts in the fabric of Philadelphia between Quakers and the general population and Loyalists. Abraham senior was appointed by the British General William Howe to guard the gate and issue passports at the northern end of the city. A professed Quaker, he understood the commission to be a civil appointment, not a military one, but he was accused by non-Quakers of serving the British. He was tried, convicted, and sentenced to be hanged. In 1778 he was hanged at Center Square, in spite of a petition signed by seven thousand Pennsylvanians and a plea for mercy by the petit jury that had convicted him.[4] He was interred in the Friends burying ground, attended by more than four thousand people in procession.[5] The story and opinions regarding such an event were frequently aired in the press, and it was a topic of conversation in Philadelphia for years.[6] On May 8, 1793, the *National Gazette* of Philadelphia published a note by an anonymous "X" concerning the 1778 trial of John Roberts and Abraham Carlile, refuting an English translation of Brissot de Warville's published observations of the situation: "When the English had evacuated the town, and the Presbyterian party was rendered master, persecutions raged with renewed violence against the Quakers—two of them were condemned to be hung under pretence of high

treason. . . . The English translator of the Travels of Mr. Chatelleux has exceedingly disguised and misrepresented this fact and has made use of it, in order to prove that the Quakers had betrayed the cause of the Americans."[7] Abraham senior's notoriety must have affected his young son, age fourteen at the time of his father's death, through most of his life.

Carlile Sr.'s property, his house and lot at 19 Front Street, were forfeit and sold for £20,000 on June 6, 1780, to William Rush.[8] His carpentry shop in the Mulberry Ward, valued at £20, was described as "[a] frame building, late his office, in the Liberties aforesaid standing on the ground of Jacob Weaver."[9] His wife, Ann Carlile, paid a tax of £5 before the property was sold quickly in August 1779 for £365 to Benjamin George Eyre.[10] The house where she and her son Abraham lived was described as "[a] three story brick messuage and lot of ground, situate on the west side of Front Street, between Sassafras and Mulberry Streets, containing in breadth about fifteen feet, and in depth about 135 feet, subject to a ground rent of £4 10s. Pennsylvania currency per annum."[11] In 1779 she paid a tax of £34 10s. on this property, then valued at £2,300; the following year the property was valued at £2,400, and she paid tax of £48 13s.[12] It too was forfeit as part of Abraham Carlile's estate. On May 24, 1780, the brick house and ground was advertised for sale in the *Pennsylvania Gazette*, and on June 26, 1780, it was sold for £20,000 to Robert Bethel, a ship chandler who lived nearby and resold it to George A. Baker.[13] On the remainder of the estate, £1,000, Ann Carlile paid tax of £2 15s. in the Mulberry Ward. Later, in the U.S. Direct Tax of 1798, Bethel was partner/resident with Carlile junior at 102 North Front Street.

Abraham Carlile and his mother must have had some means in spite of the forfeitures. Ann's family owned important commercial property on Front Street, and the Carliles lived on Brookes Court, owned by her family.[14] With the death of his mother in 1787, Abraham may have inherited from her some or all of the £1,000 that she had paid tax on in 1779.[15] In the Tax and Exoneration records for Mulberry Ward in 1788, Bowyer Brookes's property was valued at £326, which included a dwelling, 20 ounces of plate, and his occupation value of £60. Still listed next to him in 1788 was the "widow" Carlile, for Bowyer Brookes's estate, with no tax or rent on the £110, the value of the dwelling. As Ann Carlile was deceased, this may have been an accommodation by Bowyer Brookes to Carlile junior, who would pay his first per-head or occupation tax of £30 in 1788 and 20s. in 1789. Listed next to the widow Carlile was Edward Brookes, merchant, paying a

per-head tax of 30s., followed by Abraham Carlile, silversmith, paying £30 occupation tax. Bowyer Brookes owned two more dwellings adjoining these properties on Brookes Court.[16] In 1789 Carlile was still on Brookes Court. The following year he occupied another Brookes property, on the east side of Water Street at the head of Brooke's [*sic*] Wharf. The U.S. census of 1790 for the Mulberry Ward shows Carlile's household there with three persons, one male sixteen and over and two females. Bowyer Brookes, with a household of ten, was listed next door in the census. In the Philadelphia directory of 1791, Abraham Carlile, silversmith, was at 5 Brookes Court; Bowyer Brookes, boat builder, was at number 7.[17]

Abraham Carlile would have begun an apprenticeship between 1775 and 1779, probably with the Richardsons, who also were located on Front Street, and he would have finished between 1785 and 1787. His father, prominent in his local Quaker Meeting, had been appointed to represent it at the Quarterly Meeting, as was the silversmith Joseph Richardson Sr. (q.v.). The marriages of Carlile senior and Richardson took place five days apart in February 1747, at the Friends Meeting in Philadelphia. It seems probable that the Richardsons took on Abraham Carlile at the age of eleven or twelve in some capacity in their silver shop, and that he was there during the Carlile family distress.[18] In 1785 he was witness to the will of Joseph Richardson's wife Mary, which was written January 21, 1785.[19] In 1786 Abraham Carlile made parts of a tea service (see cat. 120) with Joseph junior and Nathaniel Richardson (q.q.v.) for the marriage of Margaret Rawle and Isaac Wharton, and he continued to do some work with or for the Richardsons.[20]

Before her death Ann and her son Abraham, with Henry Drinker as one of their sponsors, had applied to the Royal Commission for compensation of their losses from the forfeitures.[21] They were granted their claim of £600 in 1787, but it was not awarded until 1792, after Ann had died.[22] Then, in April 1792, William Bingham and Samuel Powell, Speakers of the Pennsylvania House and Senate, respectively, ordered that the Commonwealth of Pennsylvania restore to Abraham Carlile, "only son of said Abraham Carlile, deceased . . . all right, title, and interest in property remaining, that has not been seized."[23]

He had a bit of money and some prospects, and on October 18, 1792, Abraham Carlile married Mercy Jenks (1769–1836) at the Middletown Monthly Meeting in Bucks County.[24] She was the daughter of Thomas Jenks (1738–1799), a wealthy Quaker, and Rebecca Richardson Jenks (1742–1808).[25] Thomas Jenks was a member of the

Provincial Assembly in 1775 and of the Constitutional Convention in 1790, and a state senator.[26] After the wedding Abraham and Mercy moved to 102 North Front Street, across Arch Street, where they lived until 1807. Their son Thomas Jenks Carlile was born October 15, 1793. Four children followed: Ann, born December 11, 1795; Rebecca, born March 3, 1798; Abraham junior, born August 30, 1805; and Joseph J., born February 19, 1812.[27]

Abraham Carlile pursued the silversmith's craft for a relatively short time.[28] By 1795 he was listed as an ironmonger.[29] Was he following the path of Nathaniel Richardson, who gave up work as a goldsmith in 1790 and joined Isaac Paxton in the ironmongery and hardware business?[30] In 1795 Carlile joined with John Lohra as "Lohra and Carlile" at 41 North Third Street.[31] In time for their 1800 listing in the city directory, the firm relocated to 139 High (Market) Street, between Third and Fourth streets, where it remained until 1824 or 1825, when Carlile retired. Lohra and Carlile handled general wares, cutlery, brass fittings, chisels, files, rasps, earthenware in casks, bundles, and baskets, all of which they imported in bulk from Liverpool.[32] In 1800 Charles Bird, a merchant, purchased from them lockets, toothbrushes, nutmeg graters, snuffers, pen knives, Buck knives, forks, and other items.[33]

In 1808 Mercy Carlile's mother, Rebecca Jenks, died and left specific bequests to her daughters as well as "all the rest and money not previously bequeathed, to my five daughters. The total value $2,574.09. . . . To Mercy Carlile, the sum of forty five pounds and six enamel china plates."[34] The size of Abraham Carlile's estate and inventory taken in 1837 suggests that Mercy's inheritance must have been significant. In 1809 the Carliles moved their large household (nine people) to Sassafras (Race) Street at the corner of Water Street in the Lower Delaware Ward.[35] The hardware business remained at 139 High Street. In the U.S. census of 1810, Carlisle and a household of nine people were next door to Christian Wiltberger (q.v.) and his household of eleven people.[36]

In 1812 Abraham and Mercy deeded a house and ground on the west side of Delaware Front Street between Vine and Callowhill, in the Northern Liberties, to Sarah Cowperthwait, mother of Joseph Cowperthwait, who would marry their daughter Rebecca Carlile in 1818.[37] On March 28, 1816, they deeded half a piece of ground (8 feet by 68 feet) on Catherine Street to Robert McMullin, lumber merchant, for $56. The whole had belonged to Abraham senior, who purchased it from Joseph and Rebecca Cox in 1763 for the yearly rent charge of £3. It was divided after his death into two lots each 18 feet by 68 feet, with each owner to pay £1

10s. The rent was vested in his heir at law, Abraham junior.[38] In 1817 Carlile was administrator of the will of James Cooper, "late of the Northern Liberties," which entailed selling a three-story brick house on the west side of Delaware Front Street between Market and Arch for $5,000 to Sarah Gaskill.[39]

On July 1, 1819, Abraham Carlile, "merchant," and Mercy his wife purchased for $5,200 from Thomas Brown and Jacob Kenderdine, house carpenters, a three-story brick messuage and kitchen and lot of ground, measuring 18 feet 2 inches on the east side of Fourth Street and 106 feet in length, bounded on the east by the back end of Kunckle Street, in the Northern Liberties. It was subject to $81.75 annual ground rent.[40] In 1820 Carlile's large household included ten people, Abraham and his wife, four younger males, and four females under the age of twenty-five.[41] In 1822 the Carliles were listed in the city directory at their new address, 219 North Fourth Street.[42] In 1825 he retired as "gentleman," as listed in the city directory.[43] In 1827 Abraham and Mercy had left the Northern District Monthly Meeting and joined the Green Street Meeting. He was a member of the Philadelphia Bible Society in Ward 4 in 1828 and was selected to distribute Bibles and collect donations.[44] The U.S. census of 1830 lists his son Abraham III in the same Ward 4 of the Northern Liberties with a household of four; the household of Abraham, silversmith, consisted of seven people at the time.

Mercy Carlile died in October 1836 and was the first person interred in the Laurel Hill Cemetery.[45] Abraham Carlile died February 3, 1837, at his home at 218 North Fourth Street, the result, according to Dr. T. T. Kirkbride, of "a congestion of the brain."[46] He was buried next to Mercy in Laurel Hill. Joseph J. Carlile, son of the deceased, whose address was given as North Fourth Street, was the administrator of the estate. His son Abraham and Joseph Cowperthwait of 211 Fourth Street were witnesses.

The inventory was taken by Joseph Trotter, cashier of the Bank of Pennsylvania, and George M. Justice, hardware merchant, on February 22, 1837.[47] It was carefully done, complete, and as accomplished room by room revealed a well-appointed house furnished throughout, including the back building, with mahogany, walnut, and maple furniture. The total value of the inventory was $7,065.18. The main room of the first floor included a mahogany dining table, a pair of card tables, a breakfast table, a sofa, a "Venetian" carpet, a walnut desk and bookcase, a variety of rush-seated chairs, glassware, wine, goblets, decanters, a plated caster, and a pair of plated candlesticks.

The second floor held mahogany chairs, maple bedsteads, a large clock, a walnut tea chest, and walnut and mahogany furniture. On the third story were bedsteads and walnut and mahogany furniture. The garret held bedsteads, bedding, window cornices, and clothes. The loft in the back building stored rags, flowerpots, and baskets. The second story of the back building held bedsteads, coverlets, china plates and bowls, a teapot, beeswax, eight chairs, a large blue pitcher, a small yellow pitcher, a pewter basin, and a mahogany dining table. In the kitchen were a dresser, tablecloths, andirons, a shovel, four chairs, and a set of tinware. Carlile's tools were in the cellar: a vice, a bench, tools valued at $10, a workbench and tools ($3), tools ($1), four barrels of vinegar ($10), a Dutch oven, a cabbage cutter, a quilting frame, shovels, and a spade. No silver plate was noted. Carlile did own a share of stock in the Philadelphia Library (the Library Company of Philadelphia), eight shares in the United States Bank, valued at $928, and a Lehigh Loan of $4,850 redeemable in 1838. BBG

1. Coates and Reynell Family Papers, 1677–1930, Series 1a, John Reynell, Incoming Correspondence, box 7, folder 17, HSP.

2. Ann Brookes was the daughter of Edward Brookes and Elizabeth Snead Brookes; William Wade Hinshaw, *Encyclopedia of American Quaker Genealogy* (Baltimore: Genealogical Publishing Company, 1994), vol. 2, pp. 473, 481; vol. 7, p. 57.

3. Tax and Exoneration Lists, 1762–94.

4. For a thorough discussion of this case condemning Abraham Carlile and John Roberts, see David W. Maxey, *Treason on Trial in Revolutionary Pennsylvania: The Case of John Roberts, Miller* (Philadelphia: American Philosophical Society, 2011).

5. Scharf and Westcott 1884, vol. 1, p. 394; *Independent Gazetteer* (Philadelphia), September 4, 1784.

6. Elaine Forman Crane, ed., *The Diary of Elizabeth Drinker* (Boston: Northeastern University Press, 1991), pp. 91–92.

7. *National Gazette* (Philadelphia), May 8, 1793. For the effect of the Revolutionary War on Quakers, see Fales 1974, pp. 45–47; Scharf and Westcott 1884, vol. 1, p. 394.

8. He was one of many who forfeited property and paid an extra tax because they did not sign the Oath to Pennsylvania; *Pennsylvania Archives*, 6th ser. (Harrisburg, 1907), vol. 12, pp. 349, 503, 852. In these entries he is sometimes called Abraham Alexander Carlile.

9. *Pennsylvania Gazette* (Philadelphia), August 4, 1779.

10. Anne M. Ousterhout, "Opponents of the Revolution Whose Pennsylvania Estates Were Confiscated," *Pennsylvania Genealogical Magazine*, vol. 30, no. 4 (1978), p. 242; Tax and Exoneration Lists, 1762–94.

11. *Pennsylvania Gazette*, May 24, 1780.

12. Tax and Exoneration Lists, 1762–94.

13. Ousterhout, "Opponents of the Revolution," p. 242.

14. Bowyer Brooks Sr. (1737–1815); Bowyer Brooks Jr. (1769–1838). The 1779 tax lists put them in Brookes properties.

15. Ann Carlile died intestate.

16. Brookes Court was on the west side of Front Street between Sassafras (Race) and Vine.

17. This was the listing for single men. They were both resident on Bowyer Brookes's property; Tax and Exoneration Lists, 1762–94.

18. Carlile does not appear in the early Richardson accounts as an apprentice; Joseph Richardson Papers, HSP.

19. Will of Mary Richardson, probated December 31, 1787, Philadelphia Will Book U, p. 33. As noted above, his mother Ann had died in September of that year.

20. In 1787 Joseph junior and Nathaniel Richardson paid Abraham Carlile £24 17s. 10d. for work done for them; Fales 1974, p. 303.

21. Maxey, *Treason on Trial in Revolutionary Pennsylvania*, p. 133.

22. Ibid., pp. 128, 203.

23. *Dunlap's American Daily Advertiser* (Philadelphia), April 6, 1792. No accounting followed.

24. Friends Historical Library. Joseph Richardson Sr. and Jr. signed the Carlisles' wedding certificate.

25. She was not in the direct line of the Richardson silversmiths.

26. His estate was valued at £3,542 11d.; Bucks County Will no. 2892, Bucks County, Pennsylvania, Archives.

27. Friends Historical Library.

28. Carlile may not have given up his silver work entirely. Christian Wiltberger (q.v.) lived next door to Carlile in the Northern Liberties in 1810 and 1811. Liberty Browne (q.v.) was at Carlile's address in 1802.

29. Philadelphia directory 1796, p. 29.

30. Fales 1974, p. 155.

31. Philadelphia directory 1796, p. 79. The city directory of 1797 gives the firm's address as 42 North Third Street (p. 114), and Carlile's residence as 102 North Front Street (p. 39). John Lohra lived nearby at 41 Cherry Street (p. 114). In 1793 John Lohra had been listed as a clerk at 26 South Alley (p. 86).

32. *Claypoole's American Daily Advertiser* (Philadelphia), April 30, 1800; *Poulson's American Daily Advertiser* (Philadelphia), March 21, 1808, and April 19, 1819; *Grotjan's Philadelphia Public Sale Report*, October 12, 1812, and July 17, 1815; *Franklin Gazette* (Philadelphia), March 31, 1818.

33. Charles Bird Papers, 1800–1837, Lohra and Carlile, box 3, folder 231, Library Company, Philadelphia.

34. There were some furnishings of value: a silver tea service, a pap spoon, a knitting-bag hook, and teaspoons; her sons inherited cash. Will of Rebecca Jenks, signed May 8, 1807, probated April 1808, Bucks County Will no. 3548, Bucks County, Pennsylvania, Archives.

35. In 1800 the Lower Delaware Ward was located between Arch and Race, and between Front and Fourth streets. Christian Wiltberger owned adjoining property at 16 Water Street until 1813, when he moved to 13 North Second.

36. There were business and family connections among the Carliles, Brookeses, and Wiltbergers. Peter Wiltberger operated a hardware business at 101 High Street in 1798, also renting property from Bowyer Brookes.

37. Philadelphia Deed Book IW-6-697.

38. Philadelphia Deed Book MR-8-568-573. On June 26, 1816, Robert McMullin, lumber merchant in Southwark, administrator of the estate of William McMullin, Esq., divided the property into two pieces. On June 26, 1816, John McMullin (q.v.), Philadelphia silversmith, purchased one piece with a house on the north side of Catherine Street for $430 and the yearly rent charge of £1.10. Then, on June 29, John McMullin and wife Maria sold it to John C. Kelsey of Philadelphia, collector, for $430.

39. Philadelphia Deed Book MR-13-34.

40. Philadelphia Deed Book SHF-29-15-17. The deed was recorded when Ann Carlile's children sold the property to John Gamble on October 2, 1838.

41. 1820 U.S. Census.

42. Philadelphia directory 1825, p. 28.

43. He is listed at the new address in the "Corrections and Removal" section of the Philadelphia directory of 1823 (n.p.).

44. *National Gazette and Literary Register* (Philadelphia), January 3, 1828.

45. Conger Sherman, *Guide to Laurel Hill Cemetery, near Philadelphia* (Philadelphia: C. Sherman, 1847), p. 15.

46. Death and Cemetery Records, March 5, 1837, p. 140, HSP.

47. Will of Abraham Carlile, dated February 22, 1837, Philadelphia Administration Book O, no. 60, p. 338.

Cat. 120

Abraham Carlile
Tea Caddy

1786

MARK: A Carlile (script in rectangle, on underside; cat. 123-1)

INSCRIPTION: M R (engraved script enclosed in partial wreath with garlands, on front under keyhole)

Height 5½ inches (14 cm), width 5⅜ inches (13.7 cm), depth 3½ inches (8.9 cm)

Weight 10 oz. 6 dwt. 15 gr.

Gift of Mr. and Mrs. Peter S. Elek, 1987-43-1

PROVENANCE: The initials "MR" belonged to Margaret Rawle (1760–1881), who married Isaac Wharton (1745–1808) on November 14, 1786, at the Philadelphia Friends Meeting.[1] This caddy descended from Margaret Rawle Wharton to her granddaughter Frances Brinley Wharton. It then passed to her niece Mary Frances Drinker, and to her daughter Mary Elwyn Drinker Elek, the donor.

EXHIBITED: Woodhouse 1921, cat. 17; Philadelphia 1956, cat. 42; Garvan 1987, cat. 172.

PUBLISHED: Thorn 1949, p. 214.

This tea caddy was made en suite with a coffeepot and a teapot by Joseph junior and Nathaniel Richardson (q.q.v.).[2] The oval, flat-bottomed shape was new, as was the drum shape of the teapot.[3] The body is seamed, the beading is applied in bands, and the lid is hinged. Although it appears that different engravers were used, the source of their design was the same, giving some unity to the effect of the service arranged on a tea table. The engraving on the caddy seems somewhat less accomplished than that on the other pieces. The extension of the tied ribbon appears unfinished when compared to the engraving on the coffeepot.[4] BBG

1. Ann H. Wharton, *Genealogy of the Wharton Family of Philadelphia* (Philadelphia: Collins, 1880), p. 17. For a history of the Rawle family, see John W. Jordan, *Colonial and Revolutionary Families of Philadelphia* (New York: Lewis, 1911), vol. 1, pp. 147–60; vol. 2, p. 535.

2. The teapot (private collection) is illustrated in Woodhouse 1921, pl. VII. For the coffeepot see PMA 1986-105-1.

3. See Joseph junior and Nathaniel Richardson's teapot for Mary Pemberton (long-term loan to PMA). For examples by the New York silversmiths John Sayre (1771–1852) and George Stephens (advertised 1787), see Hammerslough 1958–73, vol. 4, pp. 34, 35. For an example by Daniel Van Voorhis, who

worked in Philadelphia and New York, see Graham Hood, *American Silver: A History of Style, 1650–1900* (New York: Praeger, 1971), p. 181, cat. 198.

4. A comparison of silver made by Abraham Carlile and the Richardsons and engraved "AW," for Anthony Wayne of Waynesboro, Pennsylvania, makes the same point; see Sotheby's, New York, *Important Americana*, January 28–29, 31, 1987, sale 5551, lots 290, 291.

Cats. 121, 122

Abraham Carlile

Cann

1790–95

MARK: A Carlile (script in rectangle, on underside; cat. 123-1)
INSCRIPTIONS: T R (engraved script monogram, on front opposite handle); I R / to / T R (engraved, on underside); T R / 13 " 14 / Nº 1 (scratched on underside)
Height 5⁵⁄₁₆ inches (13.5 cm), width 5⁵⁄₈ inches (14.3 cm), diam. base 3⁹⁄₁₆ inches (9.1 cm)
Weight 13 oz. 12 dwt. 5 gr.
Gift of the McNeil Americana Collection, 2005-69-3

PROVENANCE: Christie's, New York, *American Furniture, Silver, Folk Art and Decorative Arts*, June 25, 1991, sale 7294, lot 32.

Cann

1790–95

MARK: A Carlile (script in rectangle, double struck, on underside; cat. 123-1)
INSCRIPTIONS: M R (engraved script monogram, on front opposite handle); I R / to / M R (engraved, on underside); M R / 13 " 16 / N 5" (scratched, on underside)
Height 5³⁄₈ inches (13.6 cm), width 5⁹⁄₁₆ inches (14.1 cm), diam. 3⁷⁄₈ inches (9.8 cm)

Weight 13 oz. 14 dwt. 4 gr.
Gift of the family of Winfield Scott Wilson Jr. and Cynthia Carpenter Wilson, 2017-11-1

PROVENANCE: Elizabeth Dawson (Tyson) Wilson (1894–1980); to Winfield Scott Wilson Jr. (1920–2006) and Cynthia (Carpenter) Wilson (1925–2013); by inheritance to the donors.

The nearly identical monograms and inscriptions engraved on these two canns suggest that they were made for the same client as gifts for different relatives. To date it has not been possible to identify the "IR" who gave the canns, or the "TR" and "MR" who received them. The donors of cat. 122 inherited this cann from their maternal grandmother, Elizabeth Dawson (Tyson) Wilson. On her father's side, she was descended from several Philadelphia and Haddonfield, New Jersey, families, none of whom had surnames beginning with the letter "R"; her mother's family was from Shepherdstown, Virginia (later West Virginia).

The scratched initials "TR" and "MR" on the undersides may have been an inheritance notation or instructions for the engraver. BBG/DLB

Cat. 123

Abraham Carlile

Saucepan

1787–95

MARK: A Carlile (script in rectangle, twice on underside; cat. 123-1)
INSCRIPTION: oz. dwt. / 11 " 7 (scratched, on underside)
Height 5⅛ inches (13 cm), diam. 4¼ inches (10.8 cm), length handle 5¼ inches (13.3 cm)
Gross weight 12 oz. 5 dwt.
Gift of the McNeil Americana Collection, 2005-68-11a,b

PROVENANCE: The catalogue for the 1955 Brix sale stated that this saucepan had belonged to Florence Earle Coates (1850–1927), a Philadelphia-born writer, poet, and philanthropist.[1] Maurice Brix presumably acquired it from her. Parke-Bernet Galleries, Inc., *The Unique Collection of Early Philadelphia and Other American Silver Formed by the Late Maurice Brix*, October 19–20, 1955, sale 1617, lot 245; James H. Halpin; Christie's, New York, *Important American Silver: The James H. Halpin Collection*, January 22, 1993, sale 7624, lot 82.

The original nomenclature for this type of object is uncertain; it may have been called a sauceboat rather than a saucepan. There is a wide band or flange soldered on the edge of the inside of the cover, which fits snugly inside the body. The handsome, turned handle socket is secured with a heart-shaped piece soldered to the body. The turned, urn-shaped knop on the lid is secured with a silver screw and nut. The knop is made of the same wood as the handle and apparently has been reset with a new finial, as the photograph of this object in the auction catalogue for the Maurice Brix collection shows the same knop upside down with a flat silver cap.[2] The bottom is slightly concave in the center, creating a narrow foot. There are no signs of extensive wear. BBG

1. She lived in the Germantown neighborhood of Philadelphia, wrote for the *Mentor* and *Lippincott's Magazine*, and in 1912 was the subject of a portrait by Violet Oakley entitled *Tragic Muse*. See Edward T. James and Janet Wilson James, eds., *Notable American Women, 1607–1950: A Biographical Dictionary* (Cambridge, MA: Radcliffe College, 1971), s.v., "Florence Earle Coates." The portrait of Coates is in the collection of the Pennsylvania Academy of the Fine Arts, Philadelphia (1923.9.4).
2. Admittedly, this comparison is based on a photograph; see Parke-Bernet Galleries, *The Unique Collection of Early Philadelphia and Other American Silver Formed by the Late Maurice Brix*, October 19–20, 1955, sale 1617, lot 245.

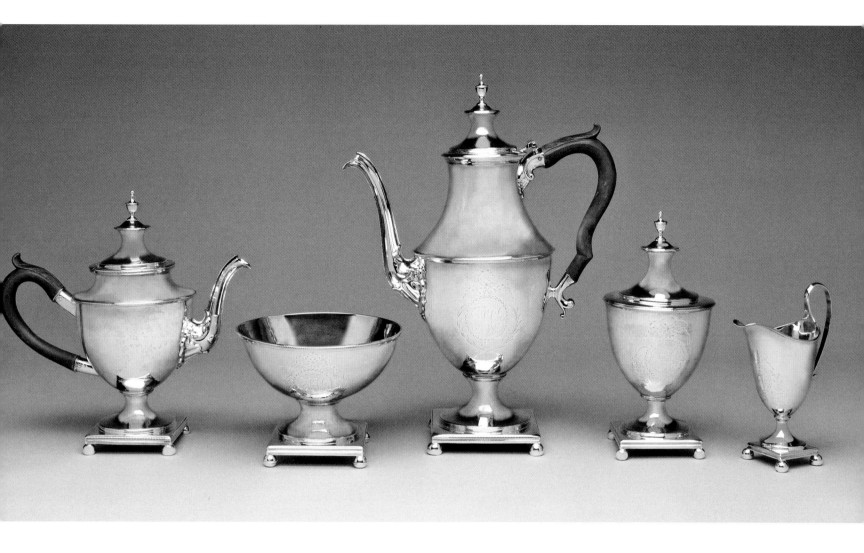

Cat. 124

Abraham Carlile
Tea and Coffee Service

1790

MARKS: A Carlile (script in rectangle, on base of each piece; cat. 123-1); A·C (in rectangle, on exterior of cream pot below rim; cat. 124-1)

INSCRIPTION: E H F (engraved script, on one side of each piece and on front under pouring spout of cream pot)

Coffeepot

INSCRIPTIONS: 19/2178; x 17436/Norris (scratched script, on underside of foot)

Height 14^{15}/$_{16}$ inches (38 cm), width 11 inches (27.9 cm), depth 5^{7}/$_{8}$ inches (14.9 cm)

Gross weight 40 oz. 7 dwt.

Teapot

INSCRIPTIONS: 787; 4341; 1532/766; J17436/Norris (scratched script, on underside of foot)

Height 10^{3}/$_{8}$ inches (26.4 cm), width 10^{3}/$_{8}$ inches (26.4 cm), depth 5 inches (12.7 cm)

Gross weight 24 oz.

Sugar Bowl

INSCRIPTION: x 17436 Norris (scratched script, on underside of foot)

Height 9^{9}/$_{16}$ inches (24.3 cm), width 4^{1}/$_{2}$ inches (11.4 cm)

Weight 14 oz. 10 dwt. 17 gr.

Cream Pot

INSCRIPTION: x 17436 (scratched script, on underside of foot)

Height 6^{7}/$_{8}$ inches (17.5 cm), width 4^{7}/$_{8}$ inches (12.4 cm)

Weight 4 oz. 17 dwt. 7 gr.

Slop Bowl

INSCRIPTION: x17436 (scratched script, on underside of foot)

Height 5^{1}/$_{8}$ inches (13 cm), diam. 6^{9}/$_{16}$ inches (16.7 cm)

Weight 15 oz. 2 dwt. 20 gr.

Gift of John S. Newberry, 1961-1-1-4 (coffeepot, teapot, sugar bowl, cream pot)

Purchased with funds contributed by H. Richard Dietrich, Jr., 1972-51-1 (slop bowl)

PROVENANCE: The initials "EHF" belonged to Elizabeth Hill Fox, daughter of Joseph and Elizabeth Mickle Fox. On May 20, 1790, at the Market Street Friends Meeting House in Philadelphia, she married Joseph Parker Norris (1763–1841), son of Charles and Mary Parker Norris.[1] Joseph Norris was a prominent banker and with his wife had seventeen children. They lived at 140 Chestnut Street, Philadelphia, and at the Norris country house, Fair Hill, north of the city, built by Isaac Norris between 1717 and 1719.[2] (1972-51-1): Carl L. Kossack.

EXHIBITED: *Early American Silver from the Newberry Collection* (Detroit: Detroit Institute of Arts, 1959), cover and pp. 17–19, cat. 36; Garvan 1987, cat. 168.

PUBLISHED: Henry P. McIlhenny, [Report of the] Department of Decorative Arts, *Philadelphia Museum of Art Bulletin*, vol. 56, no. 270 (Summer 1961), pp. 102, 116; "In the Museums," *Antiques*, vol. 83, no. 1 (January 1963), p. 119.

The full-name maker's marks are particularly sharp and cleanly struck. The initial mark on the upper edge of the cream pot is almost erased from polishing. This is a typical late eighteenth-century Philadelphia tea and coffee service.[3] The crisp line between the urn shapes of the bodies and the alternating convex and concave surfaces of the upper parts are articulated with encircling bands of beading. Beading also outlines the round pedestals and the square plinths. The addition of ball feet under the plinths gives added stature to each piece of the set except perhaps the coffeepot, on which the plinth seems too small for the height of the pot. The slop bowl had become separated from the set before its acquisition by the Museum. BBG

1. See the set by Christian Wiltberger (PMA 1980-62-1–3).
2. For an example of Mary Parker Norris's silver, see the slop bowl by John Leacock (PMA 1991-158-3).
3. Townsend Ward, "The Germantown Road and Its Associations," *PMHB*, vol. 5, no. 1 (1992), pp. 4–15.

Cat. 124-1

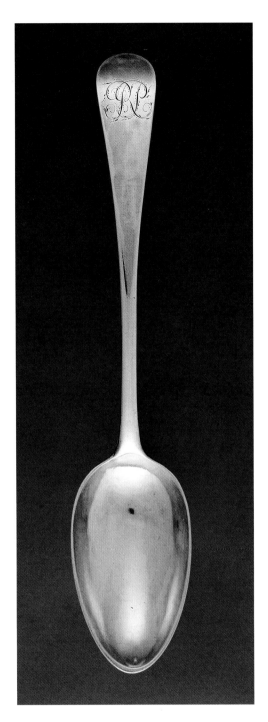

Cat. 126

Abraham Carlile

Cann

1790–94
MARK: A Carlile (script in rectangle, twice on underside; cat. 123-1)
INSCRIPTION: C H H (engraved script, on front opposite handle; cat. 126-1)
Height 5½ inches (14 cm), width 5½ inches (14 cm), diam. 3¹⁵⁄₁₆ inches (10 cm)
Weight 13 oz. 1 dwt. 20 gr.
Purchased with the Richardson Fund, 1974-147-1
PROVENANCE: The initials "CHH" belonged to Catherine Haines Hartshorne (1767–1808), sister of Caspar Wistar Haines I (1762–1801). She married Richard Hartshorne in 1798.[1] The cann was sold to the Museum by a descendant of the Haines family.

This is a typical, well-constructed, Philadelphia-style cann. The engraved initials appear slightly later than the cann. The engraver's hand is different from the that of the person who engraved Carlile's tea and coffee service (see cat. 124). BBG

1. For genealogical information I am grateful to Jeff Groff, curator, Wyck House, Germantown, Pennsylvania.

Cat. 126-1

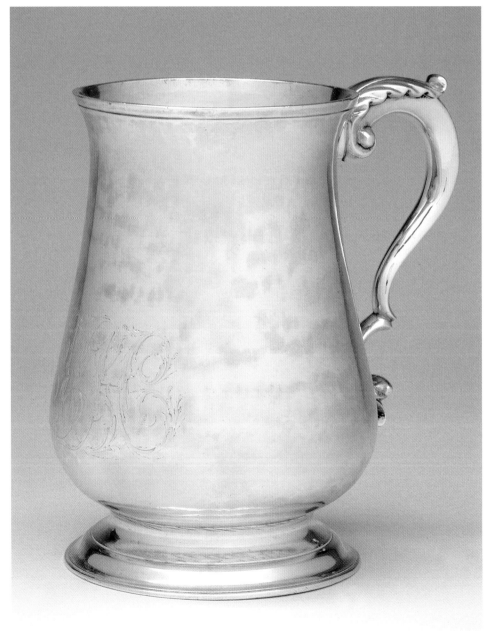

Cat. 125

Abraham Carlile

Tablespoon

1787–95
MARK: A Carlile (script in rectangle, on reverse of handle; cat. 123-1)
INSCRIPTION: R P (engraved script, on obverse of handle)
Length 8¹¹⁄₁₆ inches (22 cm)
Weight 1 oz. 19 dwt. 2 gr.
Gift of Daniel Blain Jr., 1991-158-10

PROVENANCE: The initials "RP" belonged to a member of the Portsmouth family. Sarah Portsmouth married William Logan II in 1797. They had no surviving issue, and the spoon descended to their nephew William Logan Fisher (1781–1862), to his daughter Sarah Logan Wistar Starr, and to the donor. BBG

Daniel Carrell

Philadelphia, born 1761
Philadelphia, died 1818

Daniel Carrell was born in Philadelphia on January 28, 1761, son of the merchant Timothy (1723–1786) and Elizabeth Mary (Clater) Carrell (1731–1809), who were descendants of Roman Catholic settlers in Pennsylvania.[1] Daniel apparently trained as a silversmith, although the identity of his master is unknown. At age twenty-three he witnessed the will of John Baxter on September 22, 1784, in which his father was named executor.[2] In that same year he formed a partnership with his older brother John (1758–1830), who evidently trained as a watchmaker; he was identified as a watchmaker when he stood surety for the marriage bond of John Reily, also a watchmaker, and Sarah Leib on December 30, 1784.[3] The brothers placed their first advertisement in December 1784 as "Clock and Watch-makers, goldsmiths and jewelers work done in the best and neatest manner" on Market Street.[4] In May 1785 they moved their shop to Front Street, "to the house formerly occupied by Mr. Philip Syng [Jr.; q.v.]."[5] They were recorded at that location in the 1785 city directory as "goldsmiths."[6] Indicating that they were as much retail jewelers as working craftsmen, the Carrells offered for sale a wide range of imported goods: "Gold and silver watches, eight-day clocks, repeating spring clocks, gold, silver, gilt and steel watch chains, seals, keys, and trinkets, watch-glasses, main-springs, pendants, &c. all kinds of gold and silver works, plated ware and jewelry, japan'd trays, waiters, &c. neat fowling pieces, pictures and looking-glasses, spy glasses of different kinds."[7]

The Carrells' partnership ended in October 1786, and John Carrell continued to work in Philadelphia as a "Clock and Watch Maker."[8] Although he offered "all kinds of work in gold, silver and jewellery, done in the neatest manner," his focus clearly was on watchmaking: "Any person wanting a Watch of any quality or description, may be furnished at as low a price as he could purchase it in England."[9] In April 1790 he advertised "Japanne'd clock dials, Watch dials and glasses, Mainsprings and fuze chains, Watch hands, pendants and verges" that had just been imported from Liverpool on the ship *Grange*.[10] Carrell announced his intention to move to 32 High Street in March 1791, signaling a change in his profession. In addition to clock- and watchmaking, he advertised that he had "an Assortment of Ironmongery, Sadlery and Cutlery" imported from Liverpool and Bristol.[11] In the city directories of 1791 and 1793, he was listed with the combined professions of "clock and watch maker and ironmonger" at 32 High Street.[12] By December 1794 he announced that he planned to "decline the Watch and Clock Business, and will dispose of his Stock either wholesale or retail."[13] Beginning in that same year he was listed in directories only as an ironmonger at the same address.[14] Carrell continued to offer watches for sale after this date, but his subsequent advertisements did not mention gold, silver, or other jeweler's goods. Carrell relocated to 107 High Street in 1810, when he first was described as "hardware merchant."[15] He moved the business to 198 High Street in 1818, when he formed a partnership with his son John junior (born 1791) as John Carrell and Son.[16] The last directory listing for John Carrell and Son appeared in 1825.[17]

After the brothers ended their partnership, Daniel Carrell moved to Charleston, South Carolina, although his relocation apparently did not go smoothly. Carrell advertised in Charleston in April 1787 that he was "intending shortly to go to the Northward" while the silversmith John Bering (active 1787–1807) "continues to carry on the business, as usual," which suggests that Carrell initially had set up shop with Bering.[18] A Daniel "Carroll" who had subscribed for a pew in St. Mary's Church in Philadelphia beginning in 1782 continued to rent the pew until at least 1790, which may indicate that the silversmith spent as much time during those years in Philadelphia as he did in Charleston.[19] Carrell next advertised in Charleston in April 1789, offering groceries, wines, "Philadelphia keg biscuit and flour," and other goods for sale at 125 Broad Street, with no mention of silver or jewelry, perhaps because of some conflict or competition with local artisans.[20] In December of the same year, however, he "informs his friends and the public that he has got his business again into his own hands" at his "Silversmith, Jewellery, Plated, and Hardware Store" at 129 Broad Street.[21]

After December 1789 Daniel Carrell appears to have succeeded in establishing his silversmith's shop in Charleston; his advertisements in the 1790s indicated he was primarily producing small work, flatware, and jewelry rather than hollow-ware. He advertised in 1791 that he "manufactures all kinds of silver, gold, and jewellery work, viz: silver Indian work, plate work, all kinds of spoons, buckles, small work, gold lockets, buttons, rings, &c., paintings, hairwork, engraving, gilding, &c. The workmen he employs and his experience in the business, enables him to do most of the above work equal in every respect and cheaper than those imported."[22] The U.S. census of 1790 recorded Carrell as head of a household with no women or slaves, one male over the age of sixteen, and another under sixteen, presumably a journeyman and an apprentice. He had moved his shop to "the Sign of the Coffee Pot" at 124 Broad Street by January 1793.[23] After a major fire in the city in June 1796, Daniel Carrell sought to recover silversmith's tools that had been lost, such as hammers, spoon- and soup-ladle punches, and "small cutting and carving punches."[24] He offered a reward of $50 for items "FELONEOUSLY taken" from his shop during a fire in 1798, including "six silver Table Spoons, stamped with the initials of my name as maker, D.C."[25]

In addition to manufacturing silver and gold objects, Carrell's shop also offered a stock of retail jeweler's goods similar to those that he and his brother had sold in Philadelphia. One particularly detailed advertisement in September 1791 listed, in addition to silver and gold wares, "plated spurs, a variety of penknives and steel watch chains on cards, tortoiseshell combs, camel hair pencils, billiard balls, dice, a number of watch chains, seal, keys, and trinkets, silver mounted, common and green glass spectacles, mourning buckles, a quantity of cypher seals, stationary [sic], steel clasps and buckles, agate pistol flints, smelling bottles, a number of gilt picture frames of different sizes, mathematical instruments, glaziers diamonds, &c."[26] Much of this was imported: he announced merchandise "just received" from London in 1790 and the following year from Liverpool.[27] Other European-made wares included the "Argand's and Mile's Patent Lamps" that Carrell offered in 1795.[28] Some of this merchandise may have come by way of Philadelphia, as Carrell maintained ties to his native city. His advertisements frequently mentioned whips with silver mounts that on one occasion he described as "M'Allester's [sic] Philadelphia Whips," made by John McAllister Sr. (q.v.).[29]

Daniel Carrell apparently achieved some measure of stature in his adopted city. He served as an appraiser for the estate of Joseph Parker, a fellow silversmith (died 1790).[30] Like his older brother in Philadelphia, Carrell was active in the local Roman Catholic Church. In August 1789 he was one of the trustees who purchased property for the church on Hasell Street.[31] He was among the petitioners to the South Carolina House of

Representatives for the incorporation of Charleston's Roman Catholic congregation in 1791.[32] The following year he was listed among the stewards of Charleston's St. Tammany Society, a quasi-political organization that was friendly to Irish Catholics.[33] At some point after 1790 Carrell married Elizabeth Cullen (died 1810) and had three children.[34]

Despite his community involvement, Daniel Carrell could be somewhat litigious. He sued his debtors Thomas Haughton in August 1791 and James Hickey in November 1799.[35] William Hasell Gibbes of the Charleston Chancery Court conveyed three lots on Tradd Street to Carrell in February 1795 "to satisfy creditors of the estate of Thomas Ferguson."[36] In March 1790 Carrell published a notice warning readers not to accept a note for £15 that had been fraudulently obtained from him by the silversmith Joseph Sayre Cart (1767–1822), who five days later asked his fellow citizens "please to suspend their opinion until the next court; when if they will give their attendance, they will find how capable Mr. Carrell is of asserting a falsehood."[37] In 1798 Carrell offered a reward of 20s. for a runaway female slave named Lid, who "formerly lived with Mr. Thomas Warson, carpenter," but Polly Warson published a notice in response that "the said Negro Girl Lid, is my property, and I forwarn [sic] the said Daniel Carroll, or any other person, from daring to secrete, harbour, or lay hands on said Lid."[38]

Perhaps in response to the second fire at his shop, in September 1798 Carrell announced his intention to leave Charleston and "decline the Silversmith and Jewellery Business next month." He offered his remaining stock for sale, assured that "any person wishing to contract for the Business, shall have reasonable terms," and warned his debtors that any accounts left unsettled "must then be left in the hands of a person that will use no discrimination."[39] As with his arrival Carrell's departure from Charleston did not go according to plan, and he remained in the city for at least four more years. He occasionally offered gold jewelry for sale, but with one exception his advertisements after 1798 did not mention silver hollowware or flatware, although he continued to be listed as "goldsmith" in the city directory.[40] On April 14, 1800, Carrell announced that he "intends to go to Philadelphia by the first of June" and again requested all debtors to settle their accounts.[41] He sold his three lots on Tradd Street to Robert Limehouse in May.[42] One year later, on April 10, 1801, he placed another notice that "he intends closing his business by the 1st of May next."[43] On May 20 the Charleston silversmith Nathaniel Vernon (1777–1843) announced that he had taken over Daniel

Carrell's business, which had been located a few doors down on Broad Street from Vernon's shop.[44]

Carrell was not recorded in the U.S. census of 1800 in either Charleston or Philadelphia. He may have returned to Philadelphia by 1801, but he did not advertise or appear in a city directory until 1806, when he was listed as a jeweler at 14 Filbert Street.[45] Between 1807 and 1812 Carrell was listed in Philadelphia directories at the Filbert Street address without a profession; in 1813 he was listed as "gentleman."[46] By December 1813 he had moved to land he owned in southern New Jersey and was recorded as resident at Bricksboro in 1815.[47] He died in Philadelphia on April 25, 1818, and was interred in St. Mary's burying ground at Fourth and Spruce streets, where his parents and brother were also buried, although the marker for his grave has not survived.[48] The will of "Daniel Carrell, gentleman" was filed on March 4, 1818, and probated on April 27. He directed that his properties in Philadelphia and Roxborough be sold to provide support for his three minor children: Charles, Caroline (1807–1875), and Thomas.[49] In September, auctioneer Tristram Bampfylde Freeman advertised the sale of "All the Household Goods, consisting of, beds and bedding, mahogany and other bedsteads, bureaus, tables, chairs, &c. &c. and the kitchen furniture, together with sundry farming utensils" from Carrell's estate, as well as the 24-acre, 114-perch Roxborough plantation.[50] DLB

1. Sister M. Virginia Geiger, *Daniel Carroll II: One Man and His Descendants, 1730–1978* (Baltimore: College of Notre Dame of Maryland, 1979), pp. 290–91; John J. Maitland, "St. Mary's Graveyard, Fourth and Spruce Streets, Philadelphia: Records and Extracts from Inscriptions on Tombstones," in *Records of the American Catholic Historical Society of Philadelphia*, vol. 3 (1888–91), p. 270; see also the Meeth family tree, Ancestry.com (accessed April 1, 2014). Timothy Carrell was identified as "shopkeeper" in the 1769 tax list for Southwark and as "merchant of Phila." in 1775 as an executor of the will of William Shey; Provincial Tax List, Philadelphia, 1769, p. 155, Division of Public Records, Pennsylvania Historical and Museum Commission, Harrisburg; Philadelphia Will Book Q, 1774–1784, p. 229. The surname is spelled "Carroll" in many sources.

2. Philadelphia Will Book Q, 1774–1784, p. 530.

3. Mrs. Harry Rogers, transcriber, "Marriage Bonds in the State Library, Harrisburg, Pennsylvania," *PMHB*, vol. 55, no. 3 (1931), p. 272.

4. *Independent Gazetteer* (Philadelphia), December 24, 1784.

5. *Carey's Pennsylvania Evening Herald* (Philadelphia), May 11, 1785.

6. White's Philadelphia directory 1785, p. 12.

7. *Independent Gazetteer*, December 24, 1784.

8. *Pennsylvania Packet, and Daily Advertiser* (Philadelphia), October 3, 1786.

9. Ibid., September 29, 1787.

10. Ibid., April 21, 1790.

11. *Dunlap's American Daily Advertiser* (Philadelphia), March 31, 1791.

12. Philadelphia directory 1791, p. 20; 1793, p. 21.

13. *Dunlap and Claypoole's American Daily Advertiser* (Philadelphia), December 29, 1794.

14. Philadelphia directory 1794, p. 23; 1802, p. 48.

15. Philadelphia directory 1810, p. 56.

16. Ibid. 1818, n.p.

17. Ibid. 1825, p. 29.

18. *Charleston Morning Post, and The Daily Advertiser*, April 2, 1787.

19. Quimby and Johnson 1995, p. 338; Rev. Thomas C. Middleton, "Pew Register of St. Mary's Church, Philadelphia, from 1787–1791," *Records of the American Catholic Historical Society of Philadelphia*, vol. 5 (1894), pp. 362, 366, 371, 375, 379, 383.

20. *City Gazette, or The Daily Advertiser* (Charleston), April 1, 1789.

21. Ibid., December 9, 1789.

22. *City Gazette, or The Daily Advertiser*, July 25, 1791.

23. Ibid., January 19, 1793.

24. *South-Carolina State-Gazette, and Timothy and Mason's Daily Advertiser* (Charleston), July 21, 1796.

25. Ibid., January 17, 1798.

26. *City Gazette, or The Daily Advertiser*, September 30, 1791.

27. Ibid., November 2, 1790, and September 30, 1791.

28. *South-Carolina State-Gazette, and Timothy and Mason's Daily Advertiser*, October 29, 1795.

29. *City Gazette, or The Daily Advertiser*, April 20, 1790.

30. Inventories, vol. B, 1787–1793, p. 281, Charleston County Probate Court, Charleston, SC.

31. Charleston County Land Records, Miscellaneous, pt. 81, book H6, 1791–1793, pp. 472–73, Register of Mesne Conveyance, Charleston, SC.

32. Richard C. Madden, *Catholics in South Carolina: A Record* (Lanham, MD: University Press of America, 1984), pp. 21–23.

33. *City Gazette, or The Daily Advertiser*, April 28, 1792; for further information on the St. Tammany Society, see Edwin Patrick Kilroe, *Saint Tammany and the Origin of the Society of Tammany or Columbian Order in the City of New York* (New York: E. P. Kilroe, 1913).

34. "St. Mary's Graveyard," p. 270; Meeth family tree (see note 1); Jim Holt family tree, Ancestry.com (accessed April 2, 2014).

35. *State-Gazette of South-Carolina* (Charleston), August 8, 1791; *City Gazette and Daily Advertiser*, November 23, 1799.

36. Charleston Land Records, Miscellaneous, pt. 85, book 6, 1795, pp. 181–87.

37. *City Gazette, or The Daily Advertiser*, March 10 and March 15, 1790.

38. *City Gazette, and The Daily Advertiser*, November 23 and November 26, 1798.

39. Ibid., September 8, 1798.

40. Ibid., February 8, 1800; Carrell's advertisement in the same newspaper on April 14, 1800, included "silver Cream Pots, Sugar Dishes, Spoons, Ladles, silver and plated Bottle Labels" in addition to the gold jewelry enumerated. *Nelson's Charleston Directory, and Stranger's Guide* (Charleston: John Dixon Nelson, 1801), n.p.

41. *City Gazette, and The Daily Advertiser*, April 14, 1800.

42. Charleston Land Records, Miscellaneous, pt. 91, book C7, 1800, pp. 176–79.

43. *City Gazette, and The Daily Advertiser*, April 10, 1801.

44. Ibid., May 20, 1801.

45. Philadelphia directory 1806, n.p.

46. Ibid. 1813, n.p.

47. *Poulson's American Daily Advertiser* (Philadelphia), December 29, 1813; ibid., July 21, 1815.

48. Philadelphia Death Certificates Index, 1803–1915, Ancestry.com.

49. Philadelphia Will Book 6, p. 575; "Abstracts of Philadelphia County Wills," vols. 5–7, 1815–1819, HSP.

50. *Poulson's American Daily Advertiser*, September 10, 1818.

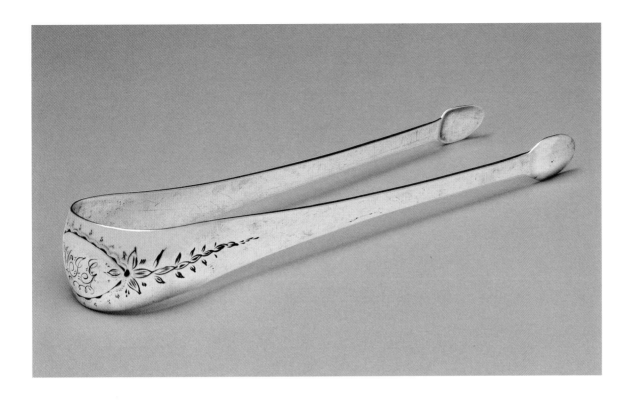

Cat. 127

Daniel Carrell
Sugar Tongs

c. 1785–1810

MARK: CARREL (in rectangle, inside one arm; cat. 127-1)
INSCRIPTION: W J G (engraved script, on outside of bow)
Length 5¹³⁄₁₆ inches (14.8 cm), width 1⁵⁄₁₆ inches
(3.1 cm)
Weight 1 oz. 7 gr.
Gift of Charlene D. Sussel, 2009-155-6

PROVENANCE: From the stock of the Philadelphia antiques
dealer Eugene Sussel (1913–1989), the donor's
husband.

Cat. 127-1

The few surviving objects marked with "CARREL" in a rectangle include this pair of sugar tongs, two snuffers with matching trays, a chatelaine hook, and a half-dozen spoons, all in the neoclassical style with similar engraved decoration.[1] The spoons were recorded in the 1930s with family histories in South Carolina; one originally belonged to the Charleston merchant Nathaniel Heyward (1766–1841).[2] The other objects mentioned above have twentieth-century histories in the Philadelphia area. These provenances suggest that Daniel Carrell used this mark in both Philadelphia and Charleston. It seems odd that he would have chosen a different spelling from his signature, which was written "Carrell," although his surname had various spellings in contemporary documents.[3] Carrell apparently also used an initials

mark; in 1798 he described a set of spoons "stamped with the initials of my name as maker, 'D.C.'"[4] The inscription "Danl Carroll / Charleston / Maker" has been recorded as engraved on the silver-gilt mount on a now-unlocated scabbard.[5] DLB

1. One snuffer and tray is at Winterthur (Quimby and Johnson 1995, cat. 324a,b); a matching set is at the National Museum of American History, Smithsonian Institution, Washington, DC (44,828a,b). The chatelaine hook was recorded in the DAPC as no. 73.2793. I am most grateful to Catherine Hollan for information on the spoons marked by Carrell, which were recorded in notes made by E. Milby Burton from exhibitions at the Charleston Museum in 1935 and 1937. I am also indebted to Grahame Long of the Charleston Museum, Brandy Culp of Historic Charleston Foundation, and Daniel Ackerman of the Museum of Early Southern Decorative Arts for searching their institutions and other collections for additional examples with South Carolina histories.
2. Jennie Haskell Rose, "Some Charleston Silversmiths and Their Work," *Antiques*, vol. 13, no. 4 (April 1928), pp. 303, 305.
3. Daniel Carrell's signature on the 1791 petition to the South Carolina House of Representatives is transcribed as "Danl Carrell" in a letter from Mary Alma Parker to Warren Ripley, October 20, 1995, Ripley family collection. I am grateful to Grahame Long and Brandy Culp (see also note 1) for this reference.
4. *South-Carolina State Gazette, and Timothy's Daily Advertiser* (Charleston), January 17, 1798.
5. E. Milby Burton, *South Carolina Silversmiths, 1690–1860*, Contributions from the Charleston Museum, no. 10 (Charleston: the Museum, 1942), p. 35. Burton and Ripley p. 24 reported that the scabbard was unlocated by that date; E. Milby Burton and Warren Ripley, *South Carolina Silversmiths, 1690–1860*, Contributions from the Charleston Museum, no. 10, 3rd rev. ed. (Charleston: the Museum, 1991), p. 24. Via email in February 2014, Grahame Long confirmed that its location remains unknown.

Samuel Casey

Newport, Rhode Island, born 1723
Location unknown, died after 1779

Samuel Casey's career as a silversmith was fraught with adventure and considerable illegal activity. Born in Newport, Rhode Island, to Samuel and Dorcas Ellis Casey, he apprenticed with Jacob Hurd (q.v.) in Boston, and in 1750 set up in business in Exeter, Rhode Island.[1] His silver production, which included hollowware with plain as well as elaborate engraved and repoussé decoration, is rare because of his life story but reveals a competent, well-trained hand.[2]

As was the custom with most silversmiths, Casey operated also as a retailer and a goldsmith. Sometime after 1750 he moved to Little Rest, South Kingston, Rhode Island, where he took on two apprentices, John Athan White in 1755 and Joseph Perkins in 1762. In 1764 his business suffered from a fire, which began in his own forge and destroyed his house and an estimated £2,000 worth of his stock. With the non-importation agreements in full force, he could not recover and went into debt. It is likely that Casey found himself in desperate straits, and he and his brother Gideon were alleged to have counterfeited dollars. They were convicted and Samuel was sentenced to death.[3] Within the week an angry mob, convinced that Casey was not guilty, broke into the jail and released all the prisoners.[4] Casey escaped and left Rhode Island. He may have served in the ensuing Revolutionary War, and in 1779 his wife Martha petitioned the Rhode Island General Assembly for his amnesty and pardon, which was granted. Whether he returned or when he died is not yet known. BBG

Cat. 128

Samuel Casey
Porringer

1750–60
MARK: S:CASEY (in rectangle, on reverse of handle; cat. 128–1)
Length 7 11/16 inches (19.5 cm), diam. 5 5/16 inches (13.5 cm), depth 2 inches (5.1 cm)
Weight 7 oz. 14 dwt. 20 gr.
Gift of Evelyn Eyre Willing in memory of Mary Eyre Howell and Evelyn Virginia Willing, 1944-93-3

Cat. 128-1

Samuel Casey made at least two other porringers in this exact design and size, and in roughly the same weight, for Robert and Elizabeth Whitehouse of South Kingston, Rhode Island, in 1757.[1] BBG

1. Hammerslough 1958–73, vol. 1, p. 32.

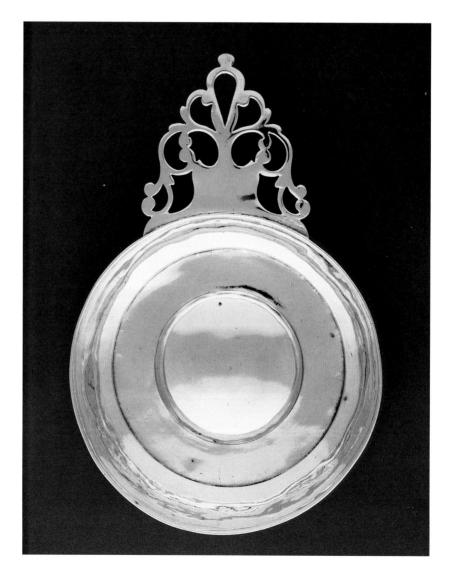

1. For more information about Samuel Casey, see "The Rhode Island Furniture Archive at the Yale University Art Gallery," s.v. "Samuel Casey," http://rifa.art.yale.edu (accessed May 4, 2015); Henry N. Flynt and Martha Gandy Fales, *The Heritage Foundation Collection of Silver, with Biographical Sketches of New England Silversmiths, 1625–1825* (Old Deerfield, MA: the Foundation, 1968), pp. 178–79.

2. Examples include teapots in the reverse-pear shape of the early rococo; full-bodied cream pots, plain and engraved; a straight-bodied coffeepot with a somewhat provincial interpretation of rococo repoussé decoration; and handsome pieces with plain surfaces. Casey's engraving patterns were derived from pre-rococo sources. For examples, see Spencer 2001, pp. 218–21, cats. 352–55; Buhler and Hood 1970, vol. 1, pp. 287–94, cats. 481–84;

Buhler 1972, vol. 1, pp. 562–63, cat. 492.

3. The first verdict from the court was not guilty. Forced by the court to reconsider, the jury issued a second, "special verdict," which was acted upon. "The Trial of Samuel Casey," *New-London (CT) Gazette*, October 19, 1770.

4. "Saturday Last a Considerable Number of People Riotously Assembled in King's County," *Essex (MA) Gazette*, November 13–20, 1770.

Los Castillo

| Taxco, Mexico, founded 1939

Born in the state of Veracruz, the Castillo de Terán brothers Antonio (1917–2000; fig. 54), Jorge (known as "Chato"; fig. 55), and Justo (known as "Coco") moved to Taxco as teenagers in 1932 and began training at the Taller de las Delicias, founded by the American expatriate William Spratling (q.v.).[1] Between about 1934 and 1936, Antonio and Jorge Castillo worked for the Taller Matl in Toluca with designer Matilde Poulat (q.v.) before returning to Las Delicias; at that time, Spratling named Antonio a *maestro*, or master, responsible for training apprentices. Following a strike at Spratling's workshop in 1939, the three Castillo brothers left to form the firm of Los Castillo in Taxco, together with their cousin Salvador Terán (1920–1974) and Antonio's wife, Margot van Voorhies Carr (1915–1985), an artist and photographer who designed jewelry.[2] Spratling reportedly told them, "The one thing I ask is that you not copy me."[3]

Spratling's enterprise had established Taxco as a destination for tourists from the United States, and during World War II the market for Mexican silver grew exponentially with the demand from American retailers unable to get luxury goods from Europe. Together with other Taxco firms Los Castillo expanded to meet this demand, introducing innovative strategies such as inventory numbers that facilitated reorders for popular models.[4] This prosperity continued into the postwar period, and at its peak in the early 1950s, Los Castillo employed over 350 craftsmen with a weekly production of 200 kilos of worked silver and operated satellite shops in Mexico City and Puebla.[5] Many designers and craftsmen who worked with Los Castillo went on to independent careers, including Elias Alvarado, Enrique Ledesma, Sigfrido ("Sigi") Pineda, and Estela Popowski.[6] In addition to silver jewelry and hollowware, the firm produced large-scale architectural metalwork and became renowned for their combinations of materials, including *metales casados* (married metals), *onix negro* (black onyx inlay), *mosaico azteca* (stone inlay), and *pluma azteca* (colored feathers in resin). Chato Castillo served as

Fig. 54. Antonio Castillo doing repoussage, c. 1940–50s. Spratling Taxco Collection 148, Manuscripts Collections, Latin American Library, Tulane University, New Orleans

master craftsman and designer, whereas Antonio Castillo acted as the firm's chief executive and also operated the Hotel Los Arcos in Taxco.

In the late 1950s Taxco's popularity declined as a tourist destination, and in 1958 the Mexican government began requiring large silver workshops like Los Castillo to pay social security for their workers. In response, Los Castillo laid off half its workforce and reduced the workweek to three days, resulting in a strike that closed the firm for a year. Antonio Castillo attempted to reorganize the firm in the early 1960s with a workers' cooperative being given control of the machinery and tools as well as the rights to produce many of the firm's designs. When the cooperative failed, these assets were sold at auction by the government, and Los Castillo resumed business as a private company with about thirty craftsmen.[7] This iteration of the enterprise closed in 1995, although the second and third generations of the Castillo family continue to operate a silver workshop in Taxco under the Los Castillo name. DLB

1. Unless otherwise noted biographical information is taken from Penny C. Morrill and Carole A. Berk, *Mexican Silver: Modern Handwrought Jewelry and Metalwork*, rev. 4th ed. (Atglen, PA: Schiffer, 2007), esp. pp. 82–95.

2. After Antoino and Margot Castillo divorced in 1948, she established herself independently as "Margot de Taxco" and operated a workshop for thirty years, closing it in 1978; Penny C. Morrill, *Margot Van Voorhies: The Art of Mexican Enamelwork* (Atglen, PA: Schiffer, 2010).

3. Quoted in Joan Mark, *Silver Gringo: William Spratling and Taxco* (Albuquerque: University of New Mexico Press, 2000), p. 66.

4. Morrill, *Margot Van Voorhies*, p. 99.

5. Joanne Stuhr, ed., *Reflections: Precolumbian Inspiration in Mexican Silver Design, 1930–1970*, exh. cat. (Tucson, AZ: Tucson Museum of Art, 1999), p. 9; Gobi Stromberg, *El juego del coyote: Platería y arte en Taxco* (Mexico City: Fondo de Cultura Económica, 1985), p. 52.

6. Penny C. Morrill et al., *William Spratling and the Mexican Silver Renaissance*, exh. cat. (San Antonio, TX: San Antonio Museum of Art, 2002), pp. 43–45.

7. Stromberg, *El juego del coyote*, pp. 54–57; Gobi Stromberg and Ana Elena Mallet, *Silver Seduction: The Art of Mexican Modernist Antonio Pineda from the Collection of Cindy Tietze and Stuart Hodosh*, exh. cat. (Los Angeles: Fowler Museum at UCLA, 2008), pp. 54–55; Stuhr, *Reflections*, pp. 9–10; Morrill, *Margot Van Voorhies*, pp. 154–55.

Fig. 55. Chato Castillo (left), with Felipe Zamora, c. 1950. Zamora Carbajal Family Collection

Cat. 129

Los Castillo
Bracelet

1948–60

MARKS: LOS CASTILLO TAXCO (forming a circle); 468;
STERLING MADE IN MEXICO (forming a circle; all incuse,
on back of one link; cat. 129-1)
Height 1 15/16 inches (5 cm), length 7 1/16 inches (18 cm)
Weight 3 oz. 2 dwt. 13 gr.
Gift of Ofelia Garcia, 2016-131-4

PROVENANCE: Purchased by the donor at an Atlanta,
Georgia, flea market between 1985 and 1991.

In addition to the pre-Hispanic motifs and geometric
forms created by Taxco silversmiths Antonio Pineda
and William Spratling (q.q.v.), Los Castillo produced
organic designs in the style of Georg Jensen, such as

the motif of three curvilinear leaves framing a circular
bud. This bracelet is composed of opposing pairs of
this motif, linked together side to side; some exam-
ples had buds set with amethysts.[1] Another bracelet
design by Los Castillo used the same leaf-and-bud
element linked end to end.[2] DLB

1. Gobi Stromberg and Ana Elena Mallet, *Silver Seduction:
The Art of Mexican Modernist Antonio Pineda from the
Collection of Cindy Tietze and Stuart Hodosh*, exh. cat.
(Los Angeles: Fowler Museum at UCLA, 2008), cat. 92.
2. Karen Davidov, Elaine Mathas, and Meredyth Smith, *Mex-
ican Silver Jewelry: The American School, 1930–1960* (New
York: Muriel Karasik Gallery, 1985), p. 20, cat. 4.

Rebecca Cauman

Poland, born 1882
New York, died 1964

Rebecca Cauman was born in a part of the Russian Empire now located in eastern Poland.[1] She was one of at least eleven children of Kelman (1852–1918) and Hannah Sarah Cauman (1855–1912), who were married in 1874.[2] Although there is significant disparity in primary documents and published biographies about Cauman's birth year, three early records confirm the date as 1882. The 1891 census of Canada recorded her age as eight years, and her enrollment card, dated October 1898, for the Massachusetts Normal Art School in Boston recorded her age as sixteen.[3] In 1900 the U.S. census recorded her birth date as April 1882. In subsequent documents Cauman probably adjusted her birth year to appear younger than she really was.[4]

In 1889, undoubtedly motivated by pogroms of the early 1880s, the Cauman family emigrated from Russia to Canada, where they settled in Hamilton, Ontario.[5] Kelman became a resident of the United States that same year, working in the Boston area as a salesman in the iron business.[6] Hannah and her children continued to live in Ontario, however, and three more daughters were born there between 1889 and 1893. In 1896 the entire family settled in Chelsea, Massachusetts, where the youngest child, Josephine (1897–1958), was born. Rebecca, her mother, and her foreign-born siblings all became naturalized U.S. citizens in that year.[7] In October 1898 Cauman enrolled as a student at the Massachusetts Normal Art School (now Massachusetts College of Art and Design), but remained for only a few months. She re-enrolled for the academic year 1903–4, when she presumably studied silversmithing and enameling with Laurin Hovey Martin (1875–1939), who had joined the faculty in 1901.[8] Cauman is also reported to have studied at the Rhode Island School of Design in Providence.[9]

Between 1904 and 1908 she was listed in the Chelsea city directory as a saleslady for I. Wolper & Company, "Ladies,' Gents' and Childrens' [sic] Clothing and Jewelry," at 234 Broadway, living with her parents at 8 Warren Avenue.[10] In the U.S. census of 1910, she was still living at home, working at an unspecified factory as a "designer—children's designs." Over the ensuing decade she appeared in Boston directories at various addresses in Roxbury and Brookline without any profession.[11] In January 1920 she enrolled for a third time at the Massachusetts Normal Art School, but it is not recorded how long she remained there.[12]

In the 1920s Cauman became active as an independent craftsman. The Boston directory of 1922 listed Cauman as a "designer and enameller" in a shop at 516 Atlantic Avenue, where she remained until she left the city in 1929.[13] Her residence, however, changed from 1680 Commonwealth Avenue in Brookline in 1921 to 8 Glendale Avenue in Allston in 1922, and to 447 Washington Avenue in Brookline in 1925.[14] She shared this last address with three of her sisters: Leah (1882–1966), Ethel (1893–1980), and Josephine. She was first elected a master craftsman of the Society of Arts and Crafts in 1924.[15] In 1927 she participated in two significant exhibitions: the *Tricennial Exhibition of Boston's Society of Arts and Crafts* (see cat. 130) and the *Exposition of Arts-in-Trade* at Macy's in New York.[16] Perhaps because she perceived New York as offering greater opportunities for craftsmen, Cauman relocated to Manhattan in 1929 with her sister Josephine.[17] In the autumn of that year, the sisters advertised pewter-covered boxes and bowls from their shop, "Cauman," at 645 Madison Avenue, where they also lived.[18]

Rebecca Cauman enjoyed a successful career in New York during the 1930s and early 1940s. A member of the New York Society of Craftsmen (NYSC), she participated in their annual exhibitions and in due course was elected a life member.[19] The silver she exhibited at the society's exhibition in 1938 was praised by *New York Times* critic Walter Rendell Story as representing "the originality of this craftsman."[20] In 1937 her work was included in an exhibition of handicrafts organized by the American Federation of Arts to represent the United States at the Paris *Exposition Internationale des Arts et Techniques dans la Vie Moderne*, where she was awarded a bronze medal.[21] Silver by Cauman was included in the *Contemporary Industrial and Handwrought Silver* exhibition at the Brooklyn Museum in 1937 and the *Contemporary American Industrial Art* exhibition at the Metropolitan Museum of Art in 1940.[22] In that same year she designed pewter covers for ceramic objects produced under the auspices of Russel and Mary Wright's short-lived "American-Way" program; Mary Wright hailed Cauman as a "pioneer of American crafts."[23]

Cauman's productivity appears to have slackened after the early 1940s; anecdotal information related that she developed arthritic hands in middle age and was unable to continue working as a metalsmith.[24] A register of NYSC members published in 1957 listed "textiles" in addition to metal as Cauman's specialty; if correct, this may indicate that she took up fiber as an alternative.[25] Between 1942 and 1947 Cauman and her sister lived at and operated "Cauman Gifts" at 14 East Fiftieth Street.[26] The sisters' residence changed to 1737 York Avenue in 1949 and subsequently to 308 East Seventy-Ninth Street in 1953.[27] In 1948 the shop was moved to 151 Lexington Avenue, where it remained for a decade. The business apparently closed thereafter, perhaps due to Josephine's unexpected death on November 13, 1958.[28] Rebecca Cauman died in New York on August 3, 1964, and was buried next to her parents and some siblings in Adath Jeshurun Cemetery in West Roxbury, Massachusetts.[29] DLB

1. 1900 U.S. Census.

2. Memorial no. 58263742, www.findagrave.com (accessed June 3, 2015); information on Kelman Cauman provided in the Bernstein/Telschitz family tree, Ancestry.com (accessed June 21, 2013).

3. 1891 Census of Canada, Library and Archives Canada, Ottawa, Ontario, Ancestry.com (accessed June 11, 2013); enrollment card no. 2519, Archives and Library, Massachusetts College of Art and Design, Boston.

4. The 1910 U.S. census recorded Cauman's age as twenty-five, i.e., born in 1884 or 1885. When she was buried in 1964, the cemetery recorded that she was eighty years old, i.e., born in 1883 or 1884; JewishGen Online Worldwide Burial Registry, Ancestry.com. The Social Security Administration listed her birth date as March 30, 1890, which, although it presumably came from Cauman herself, cannot be correct, given that she first attended the Massachusetts Normal Art School in 1898; Social Security Death Index, Social Security Administration, Washington, DC, Ancestry.com.

5. 1891 Census of Canada.

6. 1900 U.S. Census.

7. Ibid.

8. Enrollment card, Massachusetts College of Art and Design (see note 3); Marilee Boyd Meyer, ed., *Inspiring Reform: Boston's Arts and Crafts Movement* (New York: Abrams, 1997), pp. 81–82, 223.

9. The assertion that Cauman "studied" at the Rhode Island School of Design was made by Dianne O. Pierce, "Design, Craft, and American Identity: Russel Wright's 'American-Way' Project, 1940" (master's thesis, Cooper-Hewitt, National Design Museum, Smithsonian Institution, and Parsons The New School for Design, 2010), p. 66; however, no records survive at the Rhode Island School of Design to document Cauman's enrollment or attendance.

10. *The Chelsea, Revere and Winthrop Directory* (Methuen, MA: Union, 1904), pp. 7, 134; 1908, pp. 7, 112.

11. Boston directory 1912, p. 383; 1920, p. 378.

12. Enrollment card, Massachusetts College of Art and Design (see note 3).

13. Boston directory 1922, p. 404; 1928, p. 916.

14. Ibid. 1922, p. 404; 1923, p. 293;

15. Karen Evans Ulehla, *The Society of Arts and Crafts, Boston: Exhibition Record, 1897–1927* (Boston: Boston Public Library, 1981), p. 48.

16. *Tricennial Exhibition of the Society of Arts and Crafts in Celebration of the Thirtieth Anniversary of Its Organization* (Boston: Merrymount, 1927), p. 7, cat. 77.

17. The Boston directory of 1930 listed her as "rem[oved] to NY city" (p. 926).

18. *Scribner's*, October 1929, supp., p. 12; December 1929, supp.,

p. 13; I am grateful to W. Scott Braznell for these references. See also Polk's Trow's New York City directory 1933–34, vol. 1, p. 744.

19. Sandra Giles Jenkins, "The National Society of Craftsmen, New York, New York (1906–1920) and the New York Society of Craftsmen (1920–1957): A Craft Continuum from the Arts and Crafts Movement to the Studio Craft Movement" (master's thesis, Smithsonian Associates and Corcoran College of Art and Design, 2009), p. 76.

20. Walter Rendell Story, "Decorative Wares of the Nation's Craftsmen," New York Times, November 20, 1938.

21. Janet Kardon, ed., Craft in the Machine Age, 1920–1945, exh. cat. (New York: Abrams for the American Craft Museum, 1995), p. 231. For the exhibition of American craftsmen at the 1937 Paris Exposition, see "Field Notes: American Crafts at Paris," Magazine of Art, vol. 30, no. 5 (May 1937), p. 324; "Events Here and There," New York Times, June 20, 1937; "Craftsmen of U.S. to Exhibit in Paris," New York Times, July 3, 1937.

22. Contemporary Industrial and Handwrought Silver, exh. cat. (New York: Brooklyn Museum, 1937), [p. 14]; Contemporary American Industrial Art, exh. cat. (New York: Metropolitan Museum of Art, 1940), p. 13.

23. Quoted in Pierce, "Design, Craft, and American Identity," p. 67.

24. "Focus: Rebecca Cauman," Fine Early 20th Century American Craftsman Silver, Jewelry and Metal, sales cat. no. 92-1 (New Haven, CT: Ark Antiques, 1992), p. 8.

25. New York Society of Ceramic Arts and New York Society of Craftsmen, Studios and Workshops Today (New York: Cooper Union Museum for the Arts of Decoration, 1957), n.p.

26. Manhattan New York City directory 1942, p. 175; 1948, p. 237.

27. Ibid. 1949, p. 253; 1953–54, p. 284; 1957–58, p. 285.

28. Obituary of Josephine Cauman, New York Times, November 16, 1958.

29. Obituary of Rebecca Cauman, New York Times, August 4, 1964; memorial no. 58263618, www.findagrave.com (accessed June 3, 2015).

Cat. 130

Rebecca Cauman
Candy Dish

1927
Yellow enamel decoration, Swiss rock-crystal knob
MARK: STERLING / CAUMAN ("C" underscoring other letters, all incuse, on underside of dish; cat. 130-1); cover unmarked
Height 3⅝ inches (9.2 cm); diam. 5⁹⁄₁₆ inches (14.1 cm)
Gross weight 22 oz. 5 dwt. 8 gr.
Purchased with the Richardson Fund, 2007-32-1a,b

PROVENANCE: The dish was purchased from the artist by a member of the Society of Arts and Crafts in 1927, for $190.[1] It descended in the buyer's family and was consigned in 2006 to Skinner Auction, Boston.[2] The dealers Spencer Marks of Northampton, Massachusetts, purchased the dish at the auction and subsequently sold it to the Museum.

EXHIBITED: Tricennial Exhibition of the Society of Arts and Crafts in Celebration of the Thirtieth Anniversary of Its Organization (Boston: Merrymount, 1927), p. 7, cat. 77.

Cat. 130-1

Throughout her career Rebecca Cauman made covered dishes in silver, pewter, and copper. She clearly intended this example as one of her most spectacular statements of the form, embellishing it with yellow enamel, a rock-crystal finial, and saw piercing on its cover and foot. The foot piercings reflect onto the dish's underside, adding a design to the otherwise unornamented form. According to a statement she provided for the Tricennial Exhibition, the foliate and floral piercings represent the Tree of Life, a perennial Arts and Crafts motif:

The cover has twelve branches from the Tree of Life and in each branch is worked in the leaf, the flower

and the fruit. The fine tracery of design filling the spaces between the branches is the shadow cast by the branches. The rock crystal ball topping the whole is meant to symbolize Light, as is also the color of golden yellow which lines the bowl. Somewhere in an ancient book is the statement "Light is Life" and that has always appealed to me. When the crystal ball was brought to me from Switzerland, it seemed like a bit of Light and so it got worked in. It is rather fun to work a definite meaning into a piece of work even though it is only a little candy box. By the way, the base holds the small offshoots from the branches—I couldn't work in twelve offshoots because the base wouldn't hold twelve and remain good design.[3]

Cauman sent ten objects to the exhibition, more than any other silversmith except Arthur Stone (q.v.).[4] It proved to be a turning point in her career. After her move to New York City in 1929, Cauman's style shifted from the hammered surfaces and enamel decoration favored by Boston Arts and Crafts metalsmiths to a modernist idiom, exemplified by a group of circular pewter boxes with glass-disc finials on their covers.[5]

DLB

1. Memorandum of sale, The Society of Arts and Crafts, Boston, March 22, 1927, private collection; photocopy in curatorial files, AA, PMA.
2. Skinner, Boston, *Twentieth Century Furniture and Decorative Arts*, December 9, 2006, sale 2342, lot 279.
3. Rebecca Cauman, "Box with Crystal Knob," typescript, 1927, private collection; photocopy, curatorial files, AA, PMA.
4. *Tricennial Exhibition of the Society of Arts and Crafts in Celebration of the Thirtieth Anniversary of Its Organization* (Boston: Merrymount, 1927), pp. 6–7.
5. Janet Kardon, ed., *Craft in the Machine Age, 1920–1945: The History of Twentieth-Century American Craft* (New York: Abrams for the American Craft Museum, 1995), p. 184.

Charters, Cann & Dunn

| 1848–54
| New York City

Cann & Dunn

| 1855–60
| New York City and Brooklyn, New York

The partnership of Thomas Charters Jr. (1820–1910), John Cann (1812–1867), and David Dunn (1814/15–1885) was one in a series formed by Cann and Dunn over a twenty-five-year period. This extended association suggests that they were apprenticed to the same master or had some other close connection. John Cann was born in New York City on December 6, 1812.[1] It is not known with whom he trained as a silversmith; his first independent listing in the city directory was in 1835, at 2 Bayard Street.[2] According to U.S. census records, David Dunn was born in Scotland in 1814 or 1815.[3] The date of his arrival in New York and the identity of his master are unknown; he first appeared in the 1834 New York City directory at 750 Greenwich Street.[4] Thomas Charters Jr. was born in New York in September 1820, the son and namesake of the coach maker Thomas Charters Sr.[5] In 1846 Charters was listed in the city directory at 250 Pearl Street with "hats" as his profession, although subsequent listings gave his profession as "silversmith."[6] The identity of his master is likewise unknown.

Cann and Dunn formed their first partnership in 1836, with a shop at 107 Hammond Street.[7] After the partnership ended in 1838, they began working independently, Dunn at 60 Ninth Avenue in 1838 and Cann at 179 Church Street in 1839.[8] In 1841 David Dunn established himself as a jeweler at the rear of 4 Cortlandt Street, initially as the partner of Thomas G. Bridgwood in the firm of Dunn & Bridgewood.[9] This partnership dissolved within a year, and Dunn continued to operate a jewelry manufacturing or retail firm on Cortlandt Street until 1848.[10] Cann possibly was also part of this enterprise, as he was not listed in directories between 1840 and 1844. During these years Dunn occasionally was listed separately as a silversmith, in 1842 at 771 Washington Street and in 1847–48 at 750 Greenwich Street.[11] Dunn was held in high

esteem by his fellow craftsmen. In 1842 he signed a petition to the U.S. Senate advocating an increase in the tariffs on imported silverware and in 1845 was one of the six-person committee representing "the gold and silver artisans of New York, employers and journeymen" who presented a silver vase to Senator Henry Clay in gratitude for raising the tariffs.[12]

As noted above, John Cann was only sporadically listed in directories between 1837 and 1847. In the latter year he formed a partnership with Thomas Charters at 7 Leonard Street.[13] One year later Dunn joined them as a third partner in Charters, Cann & Dunn at 53 Mercer Street, where they remained for five years.[14] In 1853 they moved to 89 Mercer and opened a second workshop or retail store at 487 Broadway.[15] During the partnership's final year, in 1854, they worked at 22–24 Frankfort Street.[16]

Charters, Cann & Dunn apparently operated as a wholesaler manufacturer to retail jewelers such as Ball, Tompkins & Black (see cat. 258) and John Cox & Company (see cats. 131, 132) of New York City, as well as Hood and Tobey of Albany.[17] Observing the absence of surviving flatware with their marks, D. Albert Soeffing suggested that they specialized in hollowware.[18] Further evidence is offered by the advertisement Cann and Dunn placed in the New York city directory of 1855, announcing their new partnership's move to Brooklyn and listing hollowware forms but no flatware: "Cann & Dunn, Manufacturers of Silverware, 144 & 146 Jay Street, Between High and Nassau, Brooklyn. Vases, pitchers, tea services, cups, etc."[19]

Cann and Dunn continued as partners until 1860, moving the workshop to Manhattan at 64 Duane Street, "Sign of the Golden Pitcher," in 1858 and to 112 Greene Street the following year.[20] After the partnership dissolved Cann continued working at 112 Greene Street until 1863, when he formed the partnership of Kidney, Cann & Johnson, at the "Sign of the Golden Pitcher," 38 White Street, with two younger silversmiths, Edmund Kidney (1821–1875) and Samuel H. Johnson (1819–1892). Their display advertisement in the city directory of 1863 listed "Vases, Pitchers, Waiters, Dishes, Urns, Tea Sets, Cups, Forks, and Spoons," the first time Cann's name was connected with the production of flatware.[21] Cann continued as a partner in this firm until his death on October 17, 1867; he was buried in Green-Wood Cemetery in Brooklyn.[22] John Cann's son, Baldwin Cann (1837–1920), became a silversmith and apparently trained with his father, as in 1855 he was living at home with the profession of "silver chaser."[23] In the U.S. census of 1860, Cann's daughter Mary Jane (born 1840) was likewise recorded living at home

with the profession of "burnisher," presumably for her father.

After dissolving the partnership with Cann in 1860, Dunn worked as a silversmith first in Manhattan and subsequently in Brooklyn, where he took up residence on Lafayette Avenue beginning in 1862.[24] His last listing as a silversmith in the Brooklyn city directory was in 1880, the same year that he was recorded as "clerk in store" in the U.S. census.[25] Dunn died in September 1885, and he too was buried in Green-Wood Cemetery.[26]

When he left the partnership with Cann and Dunn in 1854, Thomas Charters went into business in 1856 with his brother William as Charters & Brother, manufacturing and retailing electroplated wares at three different locations in Manhattan.[27] Their final listing in the New York City directory was in 1859.[28] Charters was recorded in the U.S. census of 1860 as living in Brooklyn with the profession of "Silverplater," but in 1862 he was listed in the Brooklyn city directory as a "broker" working in Manhattan.[29] In 1863 and 1864 Charters served in the U.S. Army during the Civil War, and in 1865 he was listed as an agent for the United States Christian Commission, which supplied religious texts and some medical services to Union troops.[30] By 1866 the directories recorded his profession as "missionary."[31] The U.S. census of 1870 as well as subsequent Brooklyn city directories described him as a "Lecturer."[32] He died in Brooklyn on June 6, 1910.[33] DLB

1. Memorial no. 74337245, www.findagrave.com (accessed May 14, 2015).

2. Longworth's New York City directory 1835, p. 143.

3. 1860 U.S. Census. Dunn's birthplace was recorded as Scotland in the 1850 and 1860 U.S. censuses, but as New York in the 1870 and 1880 U.S. censuses.

4. Longworth's New York City directory 1834, p. 261.

5. 1900 U.S. Census.

6. Doggett's New York City directory 1846–47, p. 77; 1847–48, p. 85.

7. Longworth's New York City directory 1836, p. 227.

8. Ibid. 1838, p. 223; 1839, p. 145.

9. Ibid. 1841, pp. 123, 247. Thomas Bridgewood's surname was spelled with an "e" in the partnership listing but without one in his individual listing.

10. Ibid. 1842, p. 216; Doggett's New York City directory 1847–48, p. 132; 1848–49, p. 134.

11. Doggett's New York City directory 1842–43, p. 105; 1847–48, p. 132.

12. D. Albert Soeffing, "The New York City Gold and Silver Manufacturers' Petition of 1842, " Silver Magazine, vol. 24, no. 3 (May–June 1991), p. 11; Calvin Colton, ed., The Works of Henry Clay, Comprising His Life, Correspondence, and Speeches, vol. 3 (New York: G. P. Putnam's Sons, 1904), pp. 41–42. The vase is now owned by the Henry Clay Memorial Foundation, Lexington, Kentucky; Voorsanger and Howat 2000, cat. 206.

13. Doggett's New York City directory 1847–48, pp. 78, 85.

14. Ibid. 1848–49, pp. 81, 88, 138; Trow's New York City directory 1852–53, pp. 106, 116, 188.

15. Rode's New York City directory 1853–54, pp. 119, 129, 202.

16. Trow's New York City directory 1854, pp. 122, 134, 222.

17. McGrew 2004, p. 7; Falino and Ward 2008, cat. 185; Christie's, New York, Silver, October 29, 1991, sale 7243, lot 343.

18. Venable 1994, p. 317. The same observation was made in McGrew 2004, p. 7.

19. Trow's New York City directory 1855, advertising section preceding text, n.p.

20. Ibid. 1858, pp. 132, 236.

21. Ibid. 1863, pp. 140, 441, 468.

22. Green-Wood, burial search, www.green-wood.com (accessed May 14, 2015).

23. Biographical information on Baldwin Cann was found under memorial no. 72706076, www.findagrave.com (accessed May 14, 2015).

24. Brooklyn directory 1863, p. 121.

25. Ibid. 1881, p. 295.

26. Green-Wood Cemetery, Section 82, lot 2462, www.green-wood.com.

27. Trow's New York City directory 1856, p. 147. "Charters & Brother, plated goods," was located at 66 William Street, 39 Cedar Street, and 392 Greenwich Street.

28. Trow's New York City directory 1859, p. 153 .

29. Brooklyn directory 1863, p. 70.

30. Ibid. 1864, p. 76; 1865, p. 70; 1866, p. 84.

31. Ibid. 1867, p. 90.

32. Brooklyn city and business directory 1868, p. 100; 1873, p. 119.

33. Certificate no. 11810, New York City Death Records, New York City Department of Records, Municipal Archives, New York.

Cat. 131
Charters, Cann & Dunn
Pair of Salt Dishes

c. 1854
Retailed by John Cox & Company (1854–63)
New York
MARKS (on each): JOHN COX &CO (incuse) / C.C & D (in rectangle) / N·Y (in rectangle; all on underside; cat. 131-1)
INSCRIPTION (on each): J K (engraved gothic script, on underside)
2010-206-65: Height 1 7/8 inches (4.7 cm), width 3 inches (7.6 cm), depth 2 3/4 inches (7 cm)
Weight 3 oz. 8 dwt.
2010-206-66: Height 1 13/16 inches (4.6 cm), width 2 15/16 inches (7.5 cm), depth 2 11/16 inches (6.8 cm)
Weight 3 oz. 8 dwt. 14 gr.
Gift of Beverly A. Wilson, 2010-206-65, -66

Cat. 131-1

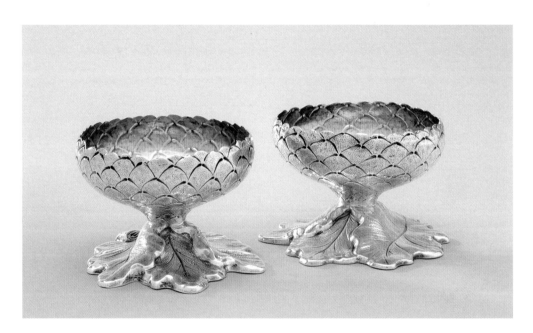

Reflecting the mid-nineteenth-century interest in naturalistic motifs, silver mimicking acorns and oak leaves became popular in the United States. Charles Venable has associated these designs with the nascent Colonial Revival and specifically with Connecticut's historic Charter Oak, although this tree did not attain iconic status until it was felled in 1856, two years after the silversmiths' partnership ended.[1] In addition to these salts designed as acorn caps, Charters, Cann & Dunn made an acorn-pattern tea and coffee service, including a hot-water kettle.[2] The popularity of these designs is demonstrated by a nearly identical pair of salt dishes that were retailed contemporaneously in Philadelphia by J. E. Caldwell & Co. (cat. 115).

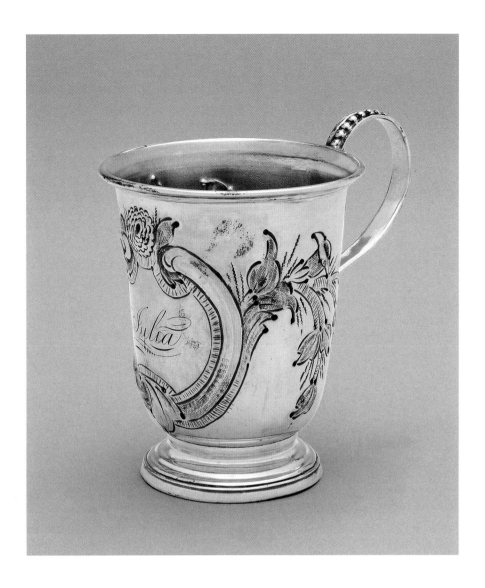

This pair of salts was retailed in New York by John Cox & Company, which advertised in city directories as "importers of gas fixtures, clocks, bronzes, plated ware &c.," a typical stock for retail jewelers.[3] The firm sold silver hollowware made by Charters, Cann & Dunn and the successor firm of Cann & Dunn, although as Deborah Waters noted, Cox & Company was also described as "manufacturers of silver ware" and exhibited silver under its own name.[4] Cox & Company and Charters, Cann & Dunn were in business at the same time only in 1854, although the retailer could have acquired an earlier pair of salt dishes for resale after the makers had dissolved their partnership. DLB

1. Venable 1994, p. 268.
2. Ibid., fig. 9.20.
3. Trow's New York City directory 1862, p. 191. John Cox & Company was the successor firm to J. & I. Cox, listed in New York directories from 1817 until 1853; Paul von Khrum, *Silversmiths of New York City, 1684–1850* (New York: printed by the author, 1978), p. 33; Waters, McKinsey, and Ward 2000, vol. 2, pp. 302–3. In 1864 the partnership of Cox Brothers was the successor to John Cox & Company and likewise was listed as "manufacturers of silver ware"; Trow's New York City directory 1864, p. 195.
4. Voorsanger and Howat 2000, pp. 362–63.

Cat. 132

Cann & Dunn
Cup

1855–60
Retailed by John Cox & Company (1854–63)
New York
MARKS: [beehive] (in oval); C&D (partial strike, in lozenge); JOHN COX &CO (incuse; all on underside; cat. 132-1)
INSCRIPTION: Julia (engraved script in cartouche, on front)
Height 3¼ inches (8.3 cm), diam. rim 2½ inches (6.4 cm), diam. base 1¾ inches (4.5 cm),
Weight 2 oz. 18 gr.
Gift in memory of Eugene Sussel by his wife Charlene Sussel, 1991-98-2

PROVENANCE: From the stock of the Philadelphia antiques dealer Eugene Sussel (1913–1989), the donor's husband.

Cat. 132-1

Repoussé decoration of swirling foliage with a cartouche surrounding the inscription clearly places this cup in the Rococo Revival style of the 1850s, and in 1859 Cann & Dunn advertised cups as one of its specialties.[1] After Charters, Cann & Dunn was dissolved in 1854, the successor firm Cann & Dunn continued to use the earlier partnership's lozenge-shaped mark by partially clipping the first "C" from the die, as seen here. This mark usually was struck with two pseudo-hallmarks, a beehive and an arm and hammer; the latter does not appear on this cup.[2] BBG/DLB

1. New York City directory 1859, commercial register, p. 26.
2. McGrew 2004, p. 7.

Jean-Simon Chaudron

Vignory, France, born 1758
Mobile, Alabama, died 1846

Three life portraits of Jean-Simon Chaudron are known: one shows the young man in Paris (fig. 56); the others (see fig. 57) the more mature silversmith in Philadelphia.¹ Recent studies of French settlements in the West Indies and America have filled in some of the gaps in his biography, including his birth in Vignory, France, his moves to Paris, Switzerland, and Saint-Domingue (now Haiti) in the West Indies, his relocation to Philadelphia in 1793, and his final home in Alabama.²

Chaudron was born in 1758 in a village situated in a lush agricultural area in northeastern France. He was the son of François and Marguerite Geoffrin Guilles Chaudron,³ highly respected vintners whose families had lived in the region for generations.⁴ His great-great-grandparents were Simon Chaudron and Sebastienne Geoffrin. Family history relates that Jean-Simon was sent at a young age to Paris to the household of an aunt and uncle, Marie-Thérèse Rodet Geoffrin (1699–1777) and François Geoffrin (born 1664). Marie-Thérèse was the eldest child of the "bourgeois" Pierre Rodet, a valet de chamber for the Duchess of Burgundy, and Angelique-Thérèse Chemineau, daughter of a Parisian banker.⁵ At the age of seventeen Marie-Thérèse had married the forty-nine-year-old François Geoffrin, lieutenant colonel in the National Guard, cashier of the Saint-Gobain Venetian mirror manufactory, and a widower who had inherited wealth from his first wife. None of the family was of the nobility. Although she had little education, Marie-Thérèse nevertheless became the hostess of one of the most celebrated salons in Paris during the Enlightenment period.⁶ Prominent artists and writers met at her home on Mondays and Wednesdays, respectively. Dena Goodman describes her salon during the period when Chaudron would have been resident: "In using the social gathering and transforming it to meet their own needs, Mme Geoffrin and salonnières like her created a certain kind of social and intellectual space that could be exploited by the expanding group of intellectuals who were beginning to call themselves 'philosophes.'"⁷ This informal style of conversation and intellectual debate manifested itself later in Philadelphia in the convivial assemblages hosted by Médéric-Louis-Élie Moreau de Saint-Méry in his bookstore at Front and Walnut streets.

The oval miniature portrait of Chaudron, by an unknown artist and dated to sometime between 1770 and the early 1780s, set into a pendant and in a later, pearl-encrusted gold frame, shows him to be about twenty years of age, with a full head of reddish hair and dressed in a somewhat arty, urban costume, a silk repp jacket with large covered buttons worn over a white collared shirt with a ruffle.⁸ His expression seems alert, bordering on a smile, and his informal dress is illustrative of the style and manners of a young intellectual participating in the freedoms offered at this time in Paris. If Chaudron had been sent as a very young person to Mme. Geoffrin's sophisticated household, one focused entirely on adult intellectual pursuits, he might well have found it difficult to fit in. Some accounts say he was disgruntled because he did not inherit from his uncle, and he ran away. However, as Chaudron's later career makes clear, exposure to the conversations and ideas flourishing during the Parisian Enlightenment made a lasting impression.

The preface to the publication of his poems in 1841 celebrates aspects of Chaudron's life, among them his "qualités du coeur" (qualities of the heart) and mentions the fact that he apprenticed with a watchmaker in Switzerland.⁹ He must not have returned to Paris upon completion of his term and before his aunt died in 1777. Whether he pursued that relatively genteel trade in Paris is not known, but he participated in the city's life and took an interest in the American Revolution. His associations in Paris with the Masonic movement and especially contemporary oratory must have inspired the grandiloquent writing style evident in his odes, seen particularly in his celebrated funeral oration honoring George Washington:

> When the mother country threw her armies on the shores of America, to support her pretensions, all eyes, all hearts were turned towards the peaceable Farmer of *Mount Vernon*. . . . All the friends of glory and liberty flocked to his standard, and the proud aggressors of *Bunker's Hill* soon found, that, a nation armed by justice and led by a great man, was not the conquest of a day. . . . Plains of *Trenton*! your name is as immortal as the Hero whom I celebrate. The feeling traveller, will stop, in every age, to contemplate the fields, w[h]ere victory wove a wreath for valour and justice.¹⁰

Chaudron had a lifelong association with the Society of Masons. He is thought to have been a member of the exclusive and venerable Masonic

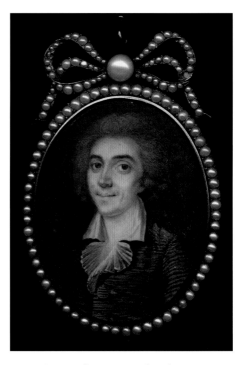

Lodge "Neuf-Soeurs" (Nine Sisters) in Paris, founded in 1776, of which Benjamin Franklin was a member and master.¹¹ Chaudron was praised later for not boasting about his membership in this group, which was limited to a hundred people.¹² He admired Franklin and wrote that the "humble printer" was more than an equal of British royalty.¹³ Chaudron was probably present in 1778 when Franklin attended the Neuf-Soeurs' memorial to Voltaire.¹⁴ Franklin served as the American minister to France from 1774 to 1785 and was in Paris in February 1778 to sign the Treaty of Alliance. His activities at court brought the politics of the moment, including contemporary problems in the wealthy West Indian colony of Saint-Domingue, into daily Parisian conversation. While French merchants in the sugar trade were then suffering from the English blockade of the British West Indies, those same circumstances offered opportunities for French commerce with America.¹⁵

According to family history, Chaudron returned to Switzerland in about 1780, perhaps to work with his brother-in-law Pierre Martin, a watchmaker, with whom he may also have served an apprenticeship. In 1784 he left for Saint-Domingue, where his family may have had some interest in the sugar trade.¹⁶ Family history relates that Chaudron's father had connections there and that the young man served as secretary to the colonial general assembly in Saint-Domingue until he left for Philadelphia in 1793.

During the 1780s Saint-Domingue was the world's richest and most productive colony, and with eighteen thousand residents Cap-Français was its most populated city. Many of the young men immigrating there from France, including Moreau de Saint-Méry, were committed Masons and became members of the Cercle des Philadelphes,[17] a learned society founded in Cap-Français in 1785. Chaudron joined the company of the French Stollenwerck family, whose considerable wealth had its source in exports from their sugar plantations and their manufacture and export of jewelry and watches.[18] Peter (Pierre) Hubert Stollenwerck (1740–1817) was a silversmith, and Chaudron may have added that skill to his credentials as a watchmaker when he joined the Stollenwercks' mercantile business. Whether immediately successful or whether endowed by his Parisian aunt, by 1789 Chaudron had whole or part ownership in, or perhaps simply chartered, a craft for trading. In the brig *Commerce*, sailed by Captain James Munroe and others between New York, New England, Philadelphia, and Saint-Domingue, Chaudron exported—both as a member of the Stollenwercks' firm and on his own account—locally made jewelry, watches, silverware, and general commodities.[19] He also sailed as a factor on the same ship, on voyages of four to five months' duration.

In this role he likely learned of Stephen Girard, a wealthy French-born merchant in Philadelphia who had sailed his own ship, *La Jeune Bébé*, ,in and out of Saint-Domingue and other French ports to Charleston and New Orleans. Girard settled in Philadelphia in 1777 and, after the American Revolution, continued to trade in his own ships with his brother Jean, a commission merchant and trader.[20] Chaudron, while on a trading trip to the United States to celebrate Bastille Day, prescient of the civil unrest developing in Saint-Domingue, and, moreover, having experienced the uncertainties inherent in the sea trade, deposited $10,000 with Girard.[21] In April 1790 Chaudron was in New York, where he attended the presidential inauguration of George Washington.[22] He was in Philadelphia on July 7 of that year and visited his great friend Dr. Seraphin Merdier in Pottsgrove, Pennsylvania; later Merdier taught Chaudron's son Jules.[23] Back in Saint-Domingue in 1791, Chaudron married Jeanne-Genevieve Melanie Stollenwerck (1774–1859), the eighteen-year-old daughter and sister of his partners.[24]

If Chaudron was still employed as secretary to the colonial general assembly at this time, he would have been aware of the urgent appeal sent in 1791 by the commissioners to the National Assembly of France for "the sums necessary for

re-establishing the agriculture of the Island, as well as a large supply of provisions which are become absolutely necessary, by the depredations of the insurgents. . . . St. Domingo is at this instant a prey to the devastations of fire and sword . . . [and] probably in a very short time [will] be considered the grave of its inhabitants, and covered with the ashes of its buildings and plantations."[25] The last notice of Chaudron's *Commerce*, then sailed by a Captain Eliot, was a report of the ship's arrival at Philadelphia from Cap-Français in the *Federal Gazette and Philadelphia Daily Advertiser* of October 27, 1792. Shortly thereafter, in 1793, the devastating slave rebellion led by François-Dominique Toussaint Louverture broke out in Saint-Domingue, and Chaudron, his wife, and their two children departed with hundreds of others for various ports on the east coast of the United States. The Chaudrons, the Stollenwercks, and the family of Pierre Martin made their way to Philadelphia.[26]

Chaudron had previously deposited funds in Philadelphia, but his decision to move there suggests that he knew of the Cercle des Philadelphes, whose membership, including the foreign members Benjamin Franklin and Benjamin Rush, had close connections to the city. Claude Amable Brasier (q.v.), a Swiss watchmaker and an early member, had used the connection to immigrate to Philadelphia. As Chaudron too was a watchmaker, he may have known Brasier before he immigrated.[27] The two men were certainly well acquainted later, as both were members of L'Amenité, Lodge Number 73, the French Lodge of Ancient York Masons in Philadelphia, which existed under a grant from the Grand Lodge of Pennsylvania.[28]

Chaudron was in Philadelphia by March 22, 1793, when he signed on as a subscriber to the stock of a company whose purpose was to promote the cultivation of vines.[29] However, he may not have been independently settled in the city by then. Stollenwerck family history suggests that the Chaudrons first resided with Peter Stollenwerck (1740–1817),[30] who was listed as a silversmith in the Philadelphia directory of 1794 at 1 Drinker's Alley. Chaudron does not appear on the list of subscribers present at the founding of the Société Française de Bienfaisance, established for the relief of distressed citizens of France then in Philadelphia.[31] When the organization was revived in 1805 and renamed the French Benevolent Society (still in existence), Brasier and Chaudron were on the board of directors.[32]

Charles Pierre Billon (1766–1822), a Swiss watchmaker, immigrated from Paris to London, where he remained long enough to learn English, and then set off for Philadelphia via New York, arriving in 1795.[33] On April 4, 1796, he was in

Philadelphia, where he placed a long advertisement in the *Aurora General Advertiser* announcing that "Charles Billon & Co. at No. 12, Third-Street, South, Have just received from FRANCE, by the last arrivals . . . Watches, and Clocks." Billon, who had the most recent mercantile contacts in France, had moved in briefly with Chaudron and seems to have been the primary partner and bookkeeper in the enterprise. On October 5, 1796, Chaudron selected Billon as sponsor at the baptism of his son Peter Paul Emile, suggesting that they were also friends and had worked together previously in France or Switzerland.[34]

Chaudron's address was 12 South Third Street from 1795, shortly before Billon arrived, until about 1810. Chaudron may have been producing silver for their partnership in addition to importing, but the firm's advertisements did not note anything to that effect. In the *Aurora General Advertiser* of April 29, 1796, he announced: "Have just received from FRANCE . . . MATERIALS of the best choice, an[d] such as were never before imported into America . . . Gold enamell'd cap'd REPEATING WATCHES . . . Marble and Gilt CLOCKS . . . ENGRAVING by the best Artists of Paris and London." The partners had a distinguished clientele from the outset, though the partnership was short-lived. On March 8, 1797, Thomas Jefferson paid Chaudron "for J. Randolph's watch."[35] In 1800 Jefferson wrote to Chaudron, "I am informed by a gentleman who called on you in Philadelphia that the watch is arrived, which you imported for me. The question is how to procure a safe conveyance of it to this place, which can only be in a gentleman's pocket."[36] Then, on February 8, 1801, Jefferson wrote that he had "safely received the watch by mr. [*sic*] Richards, and in good order."[37] On February 6, 1808, he "drew . . . in favr. Henry Voight for 85.D. for a watch."[38]

On March 16, 1797, the *Aurora General Advertiser* carried the following notice: "The Partnership between C. BILLON and S. CHAUDRON, trading under the firm of CHARLES BILLON & CO being dissolved . . . make payment to Chaudron. . . . S. CHAUDRON has on hand a General Assortment of CLOCKS and WATCHES in the most elegant style." Billon's own advertisement on the first page of the *Philadelphia Gazette* followed on March 17: "CHARLES BILLON informs his numerous customers, and the public in general, that he has removed from No. 12 to No. 45, South Third Street." On May 12 Billon married Jeanne-Charlotte Stollenwerck (1780–1880), sister of Chaudron's wife Jeanne-Genevieve, and established himself on Third Street.[39] On November 27, 1799, Chaudron advertised "a quantity of French Silver Plate."[40]

The U.S. Direct Tax of 1798 records Chaudron as the "possessor" of 12 South Third Street but Ephraim Olden as the "owner." The property included one house and two outbuildings, for a total of 1,188 square feet, a valuation of $3,600, and a tax of $18. This was a high value; the property was capacious and in a central location in the Middle Ward.[41] Chaudron is recorded there in newspaper notices[42]: In January 1799 Charles B. J. Févret de Saint-Mémin advertised in the *Aurora General Advertiser* that his portrait of Washington, mounted on mourning rings, was available, as were portraits of eminent citizens, and that these objects could be seen at Chaudron's, 12 South Third Street. On December 18 Saint-Mémin announced in the same newspaper that he had "removed" to the same address. On October 27, 1799, Chaudron published "An Ode on the Assassination of French Deputies," and on December 6, 1799, his ode on the conquest of Italy.[43]

On October 30, 1800, a daughter was born to the Chaudrons.[44] Her baptism at Philadelphia's Holy Trinity Roman Catholic Church in 1804 affirmed Chaudron's French family connections: "Chaudron, Rose Victoria Lainee . . . of Simon, negotiant of this city Philadelphia and Genevieve Jeanne Stollenwerck Chaudron, sponsor Pierre Gosselin de Meurant, a Bordeaux, grand uncle to the infant, represented by Louis Martin, negociant of this city and Rose Gosselin maternal grandaunt of the infant represented by Victoria George of this city."[45] Chaudron's younger daughter, Victorie Chaudron, born in 1803, was baptized at the same time; her sponsors were Pierre Edward Chaudron, "son frère aîné" (his elder brother), and Victoria George. The U.S. census of 1800 shows Chaudron's household in the Chestnut Ward as consisting of ten persons, including four males and one female under age ten, one male and one female each between twenty-six and forty-four, one male over forty-five, and two other free persons.

By this time Chaudron had been appointed orator of the L'Amenité Masonic lodge in Philadelphia, and he was selected to give the oration to its members on the death of George Washington.[46] Chaudron was accomplished in English and French, and the speech was long, effusive, and much praised. John Adams, president of the United States, declared: "This exquisite morcell of eloquence, does honor to Mr. Chaudron."[47] Thomas Jefferson stated: "The tender expressions of grief which flow from the eloquent pen of M. Chaudron, find their unison in our hearts; we

feel, & at the same time admire, the touches of the masterly hand which renew, while they paint, the effusions of our sorrow."[48] Mourning rings with Washington's likeness by Saint-Mémin and others were made and sold by many firms, including Chaudron's.[49]

In 1801 Saint-Mémin drew a portrait of Chaudron (fig. 57), the only goldsmith in that series besides the jeweler and watchmaker Peter Perpignan (active 1809–25).[50] Newspaper notices placed by Chaudron between 1802 and 1808 do not suggest, however, that he was still active as a silversmith. Samuel Alexander (q.v.) billed him on April

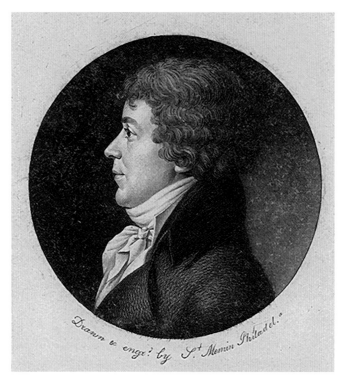

Fig. 57. Charles B. J. Févret de Saint-Mémin, *Jean-Simon Chaudron*, 1801. Engraving, 2⅜ × 2 ½ inches (6 × 6.4 cm) (unframed). National Gallery of Art, Washington, D.C. Corcoran Collection (Gift of William Wilson Corcoran), 2015.19.1843

28, 1804, for a set of casters, which Chaudron then sold to Stephen Girard.[51] Chaudron also advertised in *Relf's Philadelphia Gazette* and the *Aurora General Advertiser* that he sold prints, including *The Apotheosis of Washington* by John James Barralet (1747–1815) and a *View of New Orleans* by John L. Bosquet de Woiseri, as well as a variety of French imports, such as gilt and marble timepieces, French china (which Elizabeth Willing Powell, a prominent saloniste in Philadelphia and a confidante of Washington, purchased in 1804), silver plate, and a collection of European paintings.[52] At the end of this advertisement Chaudron noted: "The subscriber having been taken in to partnership

with Mr. Lewis Martin, the business will be carried on under the firm of S. Chaudron and Co." The silversmith Lewis Martin was a close family connection from Saint-Domingue and an investor who may also have run the shop. Chaudron, however, was the one who kept it open during the yellow-fever episodes.[53]

The location on Third Street was at the center of the lively French émigré community. One Philadelphia institution, the fire company, became part of the French citizens' scene. Founded in 1804 the Resolution Fire Company, on Third Street just south of Market Street, was a social center patronized by French inhabitants and known as the French Company. Its members met on the second floor for entertainments. Chaudron's name does not appear on the company's list of members, but he was then serving as secretary of the Société Française de Bienfaisance and probably attended the balls sponsored at Oeller's Hotel. On June 21, 1805, Chaudron petitioned to become a citizen of the United States.[54] From December 1806 to December 1808, he was a member of the L'Amenité lodge, which met on Taylor's Alley between Front and Second streets below Chestnut, and he was a member of the social club known as the Société de Grivois (The Merry Fellows). He served as executor to wills and as godparent to the children of other French Catholic families.

On November 19, 1805, Chaudron purchased from the painter William Stubbs a "two story frame messuage or tenement and one story frame messuage and lot of ground thereto belonging, situate on the North side of Plum Street between Third and Ninth Streets in the District of Southwark."[55] There is no indication that Chaudron lived there; it may have been part of his mercantile operation, or it may have become the first site of his silver-making enterprise.[56] He sold it to the carpenter Jesse Vodges in September 1808 for $1,350, after he had purchased land in Hamilton Village for his manufactory and in anticipation of his partnership with Anthony Rasch (q.v.).[57] One conspicuous notice of his new partnership with Rasch was an announcement in the press on February 2, 1809, in German, in handsome gothic type.[58]

On October 9, 1809, Chaudron began purchasing property in Hamilton Village in Blockley Township. The land, which lay across the Schuylkill from the city proper, had been owned by Andrew Hamilton (1676–1741). His son William Hamilton (1745–1813) inherited a portion and devised a strategy for development. He laid

a gridlike plan over 356 acres and advertised it for sale in numbered parcels. In 1808 and 1809 Lewis Martin, who was still in partnership with Chaudron, purchased several lots.[59] In 1809 Chaudron purchased some twenty numbered lots or parcels of the ground in three units, for $2,677.75.[60] On May 18, 1810, "William Hamilton of the Woodlands" sold to the "jeweler" Simon Chaudron two more parcels contiguous with his earlier purchase, for $220.00.[61] Chaudron built his manufactory on parcels 46, 48, 50, and 52, "containing in front on Andrew Street, two hundred feet, and in length or depth one hundred seventy five feet, bounded eastward and southward with other ground of Simon Chaudron, westward by William street and northward by Andrew street aforesaid."[62] The buildings were described as a "two story stone dwelling house, messuage and tenement and two story stone and frame messuage or tenement heretofore used for a Silver Smith's manufactory, with all the outhouses and appurtenances thereto belonging."[63] On parcels 45 and 47 Chaudron built another two-story stone house, possibly as a residence, since the South Second Street property had been converted into his "new store," where in 1810 Edward Burd purchased spoons, forks, a wedding ring, chain, and ladles, and ordered engraving on pots, a slop bowl, a jug, and a medallion in a box, among other items.[64] Daniel Dupuy Jr. (q.v.) paid Chaudron $14 on account in 1811.[65] In 1812 Dr. William Biddle, Esq., ordered and paid for three silver coffeepots (or pitchers).[66] The successful merchant Thomas Newbold placed a large order for goblets and tableware sometime between 1812 and 1815, the year of his death.[67]

Business was going well, and Chaudron pursued his civic and literary ventures. He was elected master of L'Amenité lodge in 1808. In April 1809 he was moved to produce an ode to Duncan McIntosh, a wealthy trader from Saint-Domingue who had saved some twenty-four hundred people from a shipwreck.[68] In 1809 Chaudron joined William Seal Jr. and Christian Wiltberger (q.q.v.) in opposing the assay proposal by Baltimore, protesting that the word of a silversmith regarding quality sufficed in Philadelphia.[69] In September 1811, at a meeting of the Democratic citizens of the Chestnut Ward, Liberty Browne (q.v.) appointed Chaudron to a committee of vigilance.[70] In 1812 he became treasurer of the French Benevolent Society.

In 1811 Chaudron & Co. advertised the new store at 9 South Third Street, boasting that "the success of the SILVER PLATE MANUFACTORY of Simon Chaudron and Rasch having attracted the attention of a judicious public, they pledge themselves to concur with their fellow Manufacturers in this city, in the improvement of that branch of the national industry. They have on Hand . . . Two Hundred Pieces of Sterling Silver Plate."[71] It was a brave proclamation since Chaudron was already in some financial trouble, partially the result of his land purchases but also because in 1810 the charter of the Bank of the United States was denied. He was not alone. As the trade of silversmith was integrally tied to specie and the credit system that had grown up around it, Chaudron and others suffered catastrophic losses as well as interruptions. Foreign trade was at a standstill due to embargoes imposed before and after the War of 1812.[72] In 1811 Chaudron and his wife began to sell some of their Hamilton Village properties. On January 30, 1811, he mortgaged the factory property, with a total of twenty lots and improvements, to the merchant Anthelme Francis Fournier Rostain for $2,677.75. On February 2, 1811, Chaudron mortgaged more units of his original purchase to the merchant Joseph Chaveau for $1,080.[73]

The partnership between Chaudron and Rasch ended in 1812 with an announcement in the July 17 issue of *Relf's Philadelphia Gazette*: "The manufactory of all kinds of silver plate will be continued under the immediate direction of S. Chaudron at the old establishment in Hamilton Village."[74] The monumental tureen and pitcher presented to Captain James Lawrence was made about 1813, as was another tureen made for presentation to Captain Jacob Jones and signed on the underside, "Designed by Belin / Directed by Chaudron."[75] Chaudron had plenty of sources for the ornament wrought and applied on the grand shape of these tureens. Louis Belin was a French craftsman in Philadelphia, listed as Lewis Belin in the city directory at 141 South Second Street, in 1817 as a sculptor, in 1818 as a silversmith, and in his will as a silversmith and chaser.[76] As a craftsman who probably wanted to ply his trade upon arrival, Belin, like George Bridport, Benjamin Latrobe's painter and designer, probably brought with him the modeling tools, measuring devices, calipers, molds, and drawings needed for his trade. Research on the volumes that Bridport owned in Philadelphia at this time might reveal the source for the relief panels and distinctive classical ornaments on the grand tureens and the accompanying pitcher made in Chaudron's shop and now in the collection of the New-York Historical Society.[77]

By 1813 Chaudron's affairs were in receivership. On November 13, with regard to "Simon Chaudron, watchmaker and silversmith and his wife J. Genevieve S. Chaudron of the first part and Jean Laval merchant, Amable Brasier, watchmaker and goldsmith, and Andrew Prevost merchant of the second part," it was recorded that

whereas Simon Chaudron in having a series of misfortunes, became unable to pay and satisfy his debts which he had partly contracted in partnership with Lewis Martin under the firm Simon Chaudron and Company, did in the month of February in the year 1811, call together the creditors of said firm and lay before them a correct statement of his affairs and requested their advice and direction as to what should be done for their greatest benefit and advantage . . . also several individuals indebted to the said firm to a large amount . . . had failed and they took advantage of insolvency laws and so far again diminished the means of the said Simon Chaudron to comply with the said engagements.[78]

Subsequently, on December 4, it was recorded that "the said Simon Chaudron having since discovered considerable difficulties in the way of effecting a compromise with the generality of his creditors has thought it best on restive consideration to abandon his property to his creditors without condition or restrictions . . . for $1.00 to Simon and Jeanne Chaudron . . . In trust nevertheless and upon special confidence that they the said trustees . . . sell as soon as convenient and pay all debts originally contracted . . . subsequent to 12 February 1811 . . . if any should remain to apportion the residue among all others."[79]

A sheriff's sale of Chaudron's properties took place at the Merchant's Coffee House on April 7, 1813, with the first offering a "two story stone dwelling house, messuage and tenement and two story stone and frame messuage or tenement heretofore used for a Silver Smith's manufactory . . . marked in the general plan of said village, Nos. 46, 48, 50 and 52."[80] The property sold for $5,000.[81] Second in the sale was a "two story stone dwelling house and two contiguous lots or pieces of ground at the north-east corner of Locust and William streets" in Hamilton Village, numbers 45 and 47; the three following items in the sale were open lots of ground.[82] In August 1815 the second house was still owned under a mortgage by Chaudron, but it was again seized, to be sold by Sheriff Jacob Fitler.[83]

Chaudron operated the shop on Third Street until 1815, when his son Edward took it over. He continued to advertise Washington memorial rings, and customers dropped in for jewelry purchases. Harriet Manigault, a member of a prominent Philadelphia family, wrote in her diary, "Directly after dinner Joseph came & asked us to go with him to Chandrous [*sic*] & bespeak a pearl cross like Charlotte's for his sister Susan, which we did and it is to be finished by Wednesday."[84] Although Edward was running the business, Jean-Simon still had a hand in it: in 1816 he, William Seal Jr., and Christian

Wiltberger dispatched a note to Philip Stadtler in Baltimore, concurring with Baltimore silversmiths that an assay office was still not necessary since their stamps and marks were sufficient guarantee of quality.[85]

Publishing continued to be an important and successful occupation in Philadelphia when other businesses were failing. On April 17, 1815, Chaudron placed his proposal in the New York *Commercial Advertiser* for *L'Abeille Américaine* (The American Bee), a journal to be published in French that would carry independent political opinions, memoirs, and imaginative compositions for the benefit of artists and connoisseurs. He subsequently placed an advertisement for subscriptions at $5 a year in Wilmington's *American Watchman* on June 5, 1816. The French community in Philadelphia was thinning out by 1817 and 1818. Edward Chaudron, "merchant," and Jean-Simon Chaudron, "Editor of The French Journal," moved to 168 Spruce Street, where they were based from 1818 until 1822.[86] Those years brought a severe economic depression to the city. Billon moved to St. Louis and Rasch to New Orleans. Chaudron's publication, concerned with all things French, promoted the new colony for French émigrés established in Tombigbee County, Alabama.

The Chaudrons and their extended family in Philadelphia had purchased some eight hundred acres of ground in what became the Vine and Olive Colony in Demopolis, Alabama. Chaudron had served as a commissioner for subscriptions to the colony when he first came to Philadelphia in 1793.[87] By 1819 he was suffering from impaired eyesight, and when he died in 1846, he had cataracts and was quite blind. His diminished vision may have been a reason for his move and pursuit of another line of work. He tried farming in Alabama but was not suited to the occupation, nor were most of the other white settlers. It was wilderness to them, and property irregularities discouraged ownership and development. In 1818 the colony numbered only sixty-nine settlers; many other Philadelphians had sold their shares and did not move to the South. When the farming enterprise failed, the family moved to Mobile, where Chaudron advertised as a watchmaker and may have retailed some silver[88]; he may also have established a wine-importing business. The U.S. census of 1830 notes his household in Mobile at eight persons, four of whom were white and four slaves. He delivered a public funeral elegy honoring Gilbert du Motier, marquis de Lafayette, in 1835.[89] Chaudron continued to write, and a collection of his poems was published in France in 1841.[90] In 1850 his widow, Jeanne Genevieve, was living with Edward in Mobile with some of Edward's siblings

and his own family.[91] Descendants of Jean-Simon Chaudron live in the area to this day.

Before he left Philadelphia Simon received several letters of appreciation, including one from Thomas Jefferson dated March 3, 1819: "I have recently received thro' mr Girardin your favor of Feb. 7 informing me of your intention to remov [*sic*] with your family to the Tombigee [*sic*] . . . I congratulate . . . the new society to which you will carry the high order of understanding, the talents, and correctness of character and conduct which have rendered you so estimable to those who, like myself, have had the pleasure of your acquaintance and society here."[92] Another letter, from Peter DuPonceau, was written in October 1819:

> I received the letter you had the kindness to write to me and I saw with sorrow that you have decided to leave us forever. Your absence is going to leave an empty space that I don't believe will soon be filled. Those who are born to light the way for others rarely enrich themselves; nature believes always in having done so in giving them talent and genius and the glory their profession brings. There is the real key to the puzzle that your commercial life has presented to those who dwell on the superficial. For myself, I have always seen you with trepidation follow a path taken by those who ordinarily come off best. Console yourself with the effects that have been similarly produced. But we who are losing you cannot be so consoled so easily . . . receive my sincere and cordial greetings and please keep me always among those whom you value.[93]

BBG

1. The miniature descended in the family; I am indebted to Ellie Sushan for consultation and her expertise. An oil portrait of 1806 by Rembrandt Peale (1778–1860) is in a private collection; illus. on the cover of Robin Fabel, *The French Connection: Jean-Simon Chaudron Returns to Mobile* (Mobile, AL: Mobile Museum of Art and Alabama Humanities Foundation, 1996).

2. Estelle M. Chaudron (1879–after 1935) to S. W. Woodhouse Jr., February 11, 1935, photocopy, curatorial files, AA, PMA; Rafe Blaufarb, *Bonapartists in the Borderlands: French Exiles and Refugees on the Gulf Coast, 1815–1835* (Tuscaloosa: University of Alabama Press, 2006); James R. Cormany, "Jean Simon Chaudron: Silversmith, Poet and American Pioneer," *Silver Magazine*, vol. 25, no. 4 (July–August 1992), pp. 8–11; Fabel, *The French Connection*, n.p.; Harriet Smith, "Jean Simon Chaudron: The Blind Poet of the Canebrakes, 1758–1846," *Bulletin de l'Institut français de Washington*, vol. 4 (1954), pp. 111–19.

3. See the entry for Felix Chaudron (1808–1873) in the public information subject files, card index of personal and corporate names and of subjects, c. 1920–60, Alabama Department of Archives and History, Montgomery, Ancestry.com.

4. Chaudron to Woodhouse, February 11, 1935.

5. Pierre Rodet was also from Vignory. At age seven Marie-Thérèse was sent with her brother to live with their maternal grandmother, Mme. Chemineau, on the fashionable rue de Faubourg in Paris. Simon Rodet (born 1738) was also a vintner in Vignory; Cercle Généalogique de Saône-et-Loire, comp., *Base de données indexée à partir de registres de mariage* (Mâcon, France: Cercle Généalogique de Saône-et-Loire, 2009), Ancestry.com.

6. Dena Goodman, "Enlightenment Salons: The Convergence of Female and Philosophic Ambitions," *Eighteenth-Century Studies*, vol. 22, no. 3 (1989), pp. 329–50. When Diderot ran out of money

for the final volumes of his encyclopedia, Mme. Geoffrin funded the project; Benedetta Craveri, *The Age of Conversation*, trans. Teresa Waugh (New York: New York Review of Books, 2006), p. 302. Mme. Geoffrin's salon is illustrated in a painting of 1812 by Anicet Charles Gabriel Lemonnier (French, 1743–1824) at the Château de Malmaison, Paris.

7. Goodman, "Enlightenment Salons," p. 337.

8. The especially large eyes in this miniature are also evident in Peale's portrait but partially obscured in Saint-Mémin's profile (see note 1 above).

9. "Envoyé très-jeune en Suisse pour se perfectionner dans l'horlogerie, il n'eut de maîtres que ses lumières naturelles, son amour du travail et son grand besoin d'apprendre"; *Poésies choisies de Jean-Simon Chaudron: Suivies de l'oraison funèbre de Washington* (Paris: E.-B. Delandry, 1841), p. vi.

10. Jean-Simon Chaudron, *Funeral Oration of Brother George Washington* (1800; Philadelphia: printed by A. J. Blocquerst, 1811), pp. 15, 21.

11. A passage by J. H. M. DeLandry published in the 1841 French edition of Chaudron's *Poésies choisies* (see note 9 above) seems to confirm his membership rather than simply association: "C'est de cette paisible retrait qu'il a fait l'hommage de ses oeuvres à la loge maçonnique des *Neuf-Soeurs* de Paris, à laquelle il appartient, comme lui appartinrent [*sic*] autrefois Voltaire, Helvétius, Franklin, Lalande, de Parny, Dalayrac, et tant d'autres illustrations du siècle dernier" (p. vii).

12. "Cette Loge aurait cru se render coupable d'un blamable égoïsme si elle eût gardé ce noble présent pour elle seule. En le publiant, elle pense se montrer juste envers l'auteur et rendue un service aux belle-lettres." *Poésies choisies*, p. vii.

13. Fabel, *The French Connection*, n.p.

14. Martha Langford, "Une architecture murmurante: An Expression of Free Masonry in Claude-Nicolas Ledoux's Propylaea for Paris?" (master's thesis, McGill University, 1991). Because of Voltaire's atheistic views, there was public controversy about this service as well as Franklin's attendance.

15. Stacy Schiff, "Franklin in Paris," *The American Scholar* (blog), posted March 1, 2009, theamericanscholar.org (accessed May 4, 2015).

16. Chaudron is reported to have stayed with a friend of his father; Chaudron to Woodhouse, February 11, 1935.

17. See James E. McClellan III, *Colonialism and Science: Saint Domingue in the Old Regime* (Baltimore: Johns Hopkins University Press, 1992), pp. 183–206. The Cercle des Philadelphes was also called the Société Royale des Sciences et des Arts du Cap François. It was the third learned society to be established in the western hemisphere, after the American Philosophical Society in Philadelphia and the Academy of Arts and Sciences in Boston. Ibid., p. 250.

18. See Frank and Dixie Orum Stollenwerck, *Stollenwerck, Chaudron and Billon Families in America: A Narrative with Lineage Listing, 1740 (circa)–1947* (Baltimore: printed by the authors, 1947–48).

19. According to family history, the brig was called the *James Munroe*, an easy mistake by one not familiar with shipping reports; Chaudron to Woodhouse, February 11, 1935. See also "Arrivals at Providence, Nov. 12 [1790] . . . Brig Commerce, Munroe Cape-Francois [*sic*]," *Federal Gazette and Philadelphia Daily Advertiser*, November 24, 1790; "Arrived at Philadelphia . . . Commerce, Eliot, Cape Francois [*sic*]," ibid., October 27, 1792.

20. *Stephen Girard: The Man, His College and Estate*, chap. 1, www.girardweb.com (accessed May 4, 2015).

21. The large sum may have been his wife's dower; Catherine Hebert, "Demise of the American Dream: The French Experience of American Life in the Age of the French Revolution," *Social History*, vol. 23, no. 46 (November 1990), p. 230. Girard's reputation at the time was as good as that of a bank.

22. Chaudron made reference to his attendance in his funeral oration of 1800 (see note 10).

23. In 1788 he was known as Brother Seraphin de Merdier, superintendent of the Franciscan Brothers of Charity at Cap-Français; Stollenwerck and Stollenwerck, *Stollenwerck, Chaudron and Billon Families*, p. 20. Chaudron served as executor to Seraphin Merdier's estate, probated in March 1816 (Philadelphia Will Book 6, p. 245), and John Baptiste Merdier's estate in 1808 (Philadelphia Will Book 2, no. 63, p. 311). He also served as

godfather to Lydia Merdier, daughter of John.

24. Index to List of Baptisms and Marriages Registered at St. Joseph's Church, HSP.

25. "Particulars Relative to the Disturbances in French Hispanoia [sic]," *Connecticut Courant* (Hartford), November 14, 1791.

26. Mrs. Stollenwerck died of yellow fever soon after their arrival. Her daughter Jeanne-Charlotte Stollenwerck and son Peter, the silversmith, arrived in 1794. Peter Hubert Stollenwerck (1740–1817) was listed as a silversmith in the Philadelphia directory of 1794 (p. 148, as "Stollenworth"). He used a name mark with a pseudo-hallmark in an oval.

27. Brasier was one of Chaudron's executors in 1819; Philadelphia Deed Book IC-26, p. 624, December 4, 1813.

28. Scharf and Westcott 1884, vol. 1, p. 504.

29. Commonwealth of Pennsylvania to the Vine Company, Philadelphia Deed Book EF-13-108, recorded May 5, 1803. The initial petition for a stock company was presented to Governor Thomas McKean and subject to the following requirements: 500 or more subscribers to the stock of the company, with a perfect list of the same and the number of shares of each to be submitted to the governor. Among the commissioners in 1801 authorized to receive subscriptions were Jean-Simon Chaudron, Samuel Coates, Stephen Girard, Benjamin Latrobe, Samuel Wetherill, and Caspar Wistar Jr. There was a total of 383 subscribers to 553 shares. *Poulson's American Daily Advertiser* (Philadelphia), April 2, 1801.

30. Stollenwerck and Stollenwerck, *Stollenwerck, Chaudron, and Billon Families*, p. 15.

31. Not to be confused with Anthony Chardon, a "paper stainer," who was also on the list; "The French Society," Accessible Archives.com (accessed January 30, 2015). Chaudron is clearly identified as a customer in the daybook of Samuel Williamson (q.v.). Chester County Historical Society, West Chester, Pennsylvania.

32. "The French Society."

33. Norman Mack, *Missouri's Silver Age: Silversmiths of the 1800s* (Carbondale: Southern Illinois University Press, 2005), pp. 20.

34. List of Baptisms Registered at St. Joseph's Church, Philadelphia (Philadelphia: American Catholic Historical Society of Philadelphia, 1887), p. 490, HSP.

35. James A. Bear Jr. and Lucia C. Stanton, eds., *Jefferson's Memorandum Books: Accounts, with Legal Records and Miscellany, 1767–1826* (Princeton, NJ: Princeton University Press, 1997), vol. 2, p. 955.

36. Thomas Jefferson to Jean-Simon Chaudron, December 18, 1800, in *The Papers of Thomas Jefferson*, vol. 32, *1 June 1800–16 February 1801*, ed. Barbara B. Oberg (Princeton, NJ: Princeton University Press, 2005), pp. 560–61, http://founders.archives.gov.

37. Jefferson to Chaudron, February 8, 1801, in ibid, pp. 560–61.

38. Bear and Stanton, *Jefferson's Memorandum Books*, vol. 2, p. 1218. The editors note that this was purchased as a gift for one of Jefferson's granddaughters and cite an invoice from Chaudron & Co. to Jefferson dated December 18, 1807; ibid., p. 1218n52. Voight was Jefferson's agent, and it was he who handled the order to Anthony Simmons and Samuel Alexander (q.q.v.) for a silver askos; Thomas Jefferson Memorial Foundation, Monticello (1957–29); Garvan 1987, p. 79, fig. 48.

39. Records of Holy Trinity Roman Catholic Church, Philadelphia, Baptisms and Marriages, 1790–1806, p. 223, HSP; from 1809 to 1813 the Billons were on South Second Street. Charles Billon advertised a new process of "Malleable Platinum" in bars, as well as rolled plates in smaller sizes available at his store; *Democratic Press* (Philadelphia), March 21, 1813.

40. *Federal Gazette and Philadelphia Daily Advertiser*, November 27, 1799.

41. 1800 Septennial Census.

42. *Federal Gazette and Philadelphia Daily Advertiser*, November 27, 1799, and January 4, 1800; *Claypoole's American Daily Advertiser* (Philadelphia), February 17, 1800.

43. Jean-Simon Chaudron, *Ode sur la conquête de l'Italie [Ode sur l'assassinat des Députés français sic à Rastadt]* (Ormrod, [1799]); original orthography. See Catherine Hebert, "French Publications in Philadelphia in the Age of the French Revolution: A Bibliographical Essay," *Pennsylvania History*, vol. 58, no. 1 (January 1991), p. 52.

44. Records of Holy Trinity Roman Catholic Church, Philadelphia, Baptisms and Marriages, 1790–1806.

45. Ibid.

46. See note 10.

47. John Adams to A. Belen [sic], February 17, 1800, Founders Online, s.v. "John Adams," http://founders.archives.gov (accessed June 5, 2015).

48. Thomas Jefferson to August Belin, March 6, 1800, *The Papers of Thomas Jefferson*, vol. 31, *1 February 1799–31 May 1800*, p. 417, http://founders.archives.gov.

49. John Baptiste Dumoutet Jr. (q.v.) advertised that "he has on hand a quantity of thin rings so much in demand, with the likeness of George Washington"; *Constitutional Diary* (Philadelphia), January 17, 1800.

50. Miles, *Saint-Mémin and the Neoclassical Profile Portrait*, p. 156.

51. Illustrated in Robert D. Schwartz, "Stephen Girard's Silver," in *The Stephen Girard Collection: A Selective Catalog* (Philadelphia: Girard College, 1980), cat. 44.

52. *Relf's Philadelphia Gazette*, January 3, 19, 1804; *Aurora General Advertiser* (Philadelphia), February 23, 1804. A double-spouted pot with the initials "EW" belonged to Powell; Wakefield-Scearce Galleries, Shelbyville, KY, advertisement, *Antiques*, vol. 89, no. 3 (March 1966), p. 330.

53. "Stores Open," *Poulson's American Daily Advertiser*, October 1, 1805.

54. Philadelphia, 1789–80, Naturalization Records, Declaration of Intent, Eastern District, District Court of Pennsylvania, Ancestry.com.

55. Philadelphia Deed Book EF, vol. 31, p. 195.

56. The location was well south of his other residence at 12 South Third Street and outside the general neighborhood of other French inhabitants.

57. Philadelphia Deed Book IC, vol. 5, p. 348.

58. *Amerikanischer Beobachter* (Philadelphia), February 2, 1809; Philadelphia Deed Book IC-5-348.

59. Philadelphia Deed Books EF-24-184, -185 ,-186, -188; and IC-3-327.

60. Philadelphia Deed Book IC-12-532.

61. Philadelphia Deed Book IC-15-560.

62. *Poulson's American Daily Advertiser*, March 31, 1814.

63. Ibid.

64. Miscellaneous Accounts, 1677–1894, box 1, nonprinted bills, Winterthur Library, Downs Collection; Edward Shippen Burd Papers, 1799–1848, folder 4, HSP.

65. Daniel Dupuy, Receipt Book, vol. 2, typescript, Yale University Art Gallery.

66. Ibid.

67. Undated clipping of an advertisement by Hinda Kohn, New York, from *Antiques*, curatorial files, AA, PMA.

68. "A Duncan Mac-Intosh," in *Poésies choisies de Jean-Simon Chaudron*, pp. 21–26.

69. Deborah Dependahl Waters, "From Pure Coin: The Manufacture of American Silver Flatware, 1800–1860," *Winterthur Portfolio*, vol. 12 (1977), p. 21.

70. *Democratic Press*, September 26, 1811, p. 2.

71. Ibid., January 4, 1811, p. 3. The 1810 U.S. census noted that their silver manufactory employed some twenty-seven people.

72. The state banks financed the government during the War of 1812, but specie payments were suspended during the panic of 1814; Russell Weigley et al., *Philadelphia: A Three-Hundred Year History* (New York: Norton, 1982), p. 256.

73. Philadelphia Deed Books IC-15-188 (Chaudron to Joseph Chauveau); IC-12-532 (Chaudron to Anthelme Francis Fournier Rostain); IC-26-624 and IC-27-415 (Chaudron to John Laval); IC-17-689 and IC-17-691 (Lewis Martin to Chaudron).

74. By 1812 Anthony Rasch had moved to 118 Market Street (Philadelphia directory 1813, n.p.), and by 1816 to 94 High (Market) Street, previously Joseph Anthony Jr.'s (q.v.) old property (1817, p. 359).

75. The pitcher and both tureens are in the collection of the New-York Historical Society; Margaret K. Hofer et al., *Stories in Sterling: Four Centuries of Silver in New York*, exh. cat. (New York: New-York Historical Society, 2011), pp. 138–40, cat. 3.10 (Jones tureen); pp. 143–44, cat. 3.12 (Lawrence tureen and pitcher).

76. Philadelphia directory 1817, p. 67; 1818, n.p. Louis Belin died in Philadelphia in 1818; his executors were the merchant tailor Lewis Howard and the merchant John Lavalle, who were both located nearby on South Second and Pine streets. In Belin's will he was listed as "silversmith and chaser late of Paris, the son of Nicholas"; Philadelphia Will Book 6, p. 553. There are no records of him in Philadelphia before 1817. He was probably a relation of Auguste Belin (1774–1845), who came to the United States from Saint-Domingue and served as secretary of the L'Amenité lodge. He sent a copy of Chaudron's oration to Thomas Jefferson; see Jefferson to Auguste Belin, February 27, 1800, *The Papers of Thomas Jefferson*, vol. 31, p. 396, http://founders.archives.gov. "Augustus Belin" is listed on Spruce Street in the Philadelphia directories of 1806–10, 1813, 1814, 1816, 1817, and 1820–24.

77. On the tureens and pitcher, see note 75. Bridport brought a full library as well as "a variety of small plaster ornaments forming enrichments for panels, heads, Foliage, in number, 68 pieces." He ran a drawing academy at 6 South Eighth Street in 1817; *Poulson's American Daily Advertiser*, January 29, 1817. The inventory of his estate listed 188 volumes on design and manuals for the architect and decorator, including: Alexander Adam, *Roman Antiquities, or An Account of the Manners and Customs of the Roman*; Thomas Hope, *Household Furniture and Interior Decoration from Designs by Thomas Hope*; Michel-François Dandré-Bardon, *Traité de peinture, suivi d'un essai sur la sculpture*; Francesco De Sanctis, *Pitture de' vasi antichi possedute da sua eccellenza il sig. cav. Hamilton*; Charles Percier and Pierre-François-Léonard Fontaine, *Recueil de décoration intérieures comprenant tout ce qui rapporte à l'ameublement*; Henry Moses, *Collection of Antique Vases, Altars, Paterae, Tripods, Candelabra, Sarcophagi…* (7 vols.); and Nicolas Ponce, *Collection des tableaux et arabesques antiques trouvés à Rome dans les thermes de Titus*, among many others. Inventory of the Personal Estate of George Bridport, inventory no. 60, April 26, 1819, Philadelphia City Archives. These books may have been used by Philadelphia craftsmen generally and Belin, Chaudron, and Rasch more specifically.

78. Philadelphia Deed Books IC-27-415 and IC-27-418 (Simon Chaudron to John Laval et al.), November 13, 1813.

79. Philadelphia Deed Book IC-26-624, December 6, 1813.

80. *Poulson's American Daily Advertiser*, March 31, 1814.

81. *Grotjan's Philadelphia Public Sale Report*, April 11, 1814.

82. *Poulson's American Daily Advertiser*, March 31, 1814.

83. Ibid., August 8, 1815.

84. Harriet Manigault, *The Diary of Harriet Manigault, 1813–1816* (Philadelphia: Colonial Dames of America Chapter II, 1976), p. 62.

85. Document reproduced in Goldsborough 1975, p. 18.

86. Philadelphia directories 1818–22.

87. Demopolis was a colony established for Bonapartist refugees.

88. SMP Silver Salon Forums, smpub.com, posted December 10, 2006 (accessed May 4, 2015).

89. W. H. Britton, "French Refugee Chaudron's Silver Superb," *Antique Monthly*, June 1974, p. 19A.

90. See note 9.

91. 1850 U.S. Census.

92. Thomas Jefferson to Jean-Simon Chaudron, March 3, 1819, *The Papers of Thomas Jefferson*, http://founders.archives.gov (accessed June 5, 2015).

93. Breck Family Papers, 1679–1888, HSP. Kindly translated from the French by Katherine B. Heisinger, the J. Mahlon Buck Jr. Family Senior Curator of European Decorative Arts after 1700, Philadelphia Museum of Art.

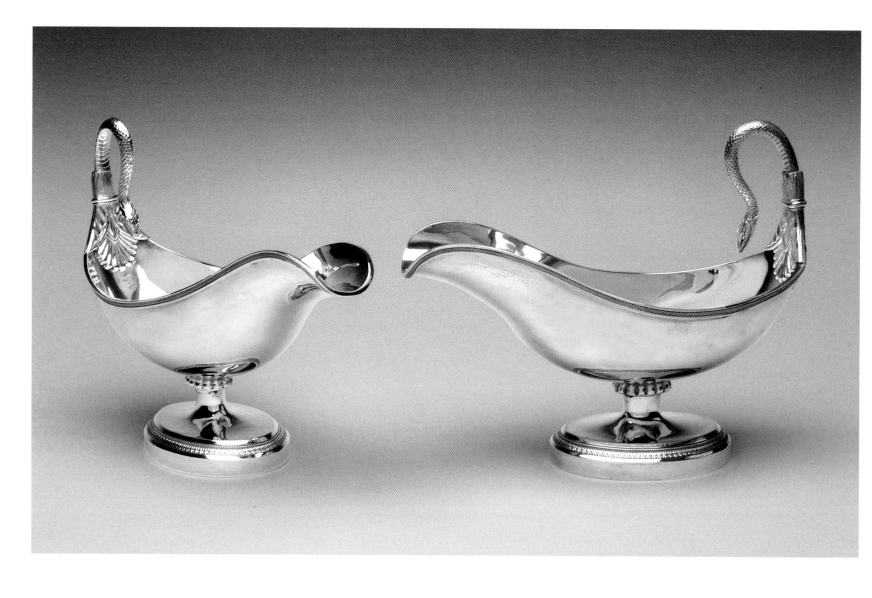

Cat. 133

Jean-Simon Chaudron
Pair of Sauceboats

1800–1809

MARK (on each): CHAUDRON (in banner, twice on underside; cat. 133-1)

1991-1-1

INSCRIPTION: N° 28 / 27 (scratched, on underside)
Height 9½ inches (24.1 cm), length 10⅝ inches (27 cm), width 4¼ inches (10.8 cm)
Weight 27 oz. 3 dwt.

1991-1-2

INSCRIPTION: N° 28 / 31 (scratched, on underside)
Height 9¾ inches (24.8 cm), length 10¼ inches (26 cm), width 4⅜ inches (11.1 cm)
Weight 31 oz. 1 dwt.

Purchased with the Richardson Fund and with funds from the Bequest of Mrs. James Alan Montgomery, 1991-1-1, -2

PROVENANCE: James Robinson, Inc., New York, 1951; Estate of Williamina Meyer de Schauensee.

EXHIBITED: *Henry Connelly and Ephraim Haines, Cabinet-makers: Philadelphia Sheraton Furniture*, Philadelphia Museum of Art, March 20–April 19, 1953, cat. 123; Garvan 1987, p. 59, fig. 37.

Chaudron clearly marked these sauceboats, but it is not certain that they were made by him or in his silver manufactory in Philadelphia. After the French Revolution the city was a popular destination for French royalty and craftsmen, and merchants in Philadelphia were importing regularly to serve this market. Chaudron was one of many who capitalized the word "FRENCH" in their advertisements.[1] Philadelphia merchants such as Chaudron imported in quantity and made huge profits if the merchant ships successfully managed hazards and lawlessness on the high seas, not to mention embargoes imposed by the English and the French in the period leading up to the War of 1812.

These sauceboats exhibit an elegant interpretation of the neo-Grec fashion as practiced by French craftsmen, some of whom came to Philadelphia from a European apprenticeship. This pair, distinctly in the French style and bearing French weight marks, may have been made in Chaudron's manufactory by such an immigrant craftsman.[2] However, the composition is extraordinarily similar to the design of a sauceboat made by an unidentified French silversmith around 1793 or 1794.[3] The handles on the Museum's sauceboats are almost identical to the handle on

Cat. 133-1

the French example, although they are slightly less articulated. The curvaceous form of the snake, the detailing of its scaly skin, and the sculptural, abstract anthemion designs on the boats at the base of the handles are alike. Another pair bearing Chaudron's mark (and originally owned by a Philadelphian who incidentally died in Paris) have the same features of shape and the same snake handle and socket with the same sculptural, anthemion design.[4] If the Museum's sauceboats were made in Philadelphia, there was surely a model, and perhaps even some molds for cast details, close at hand.[5]

The decorative, die-rolled running bands of classical motifs, applied around bases and top rims, appear in a wide variety of patterns and scales on silver marked by Chaudron, and different patterns were sometimes used on the same piece. These

sauceboats have a plain band around the bases, creating a slightly raised foot. The band on 1991-1-1, obviously a reused piece, has an incomplete die-rolled classical pattern on the reverse. There have been other repairs to the base of this piece. The base band on 1991-1-2 is smooth on both sides and may also be a repair, although Chaudron used plain bands on other silver.[6] The French examples seem to have had running designs on that foot band. The pedestals are in one unit joined to the body of the sauceboats with an encircling, slightly flared, tooth-like bead collar.

If these sauceboats were French imports, the fact that they have no other French marks probably means that they were made during the interim period in France after the Revolution when the wardens and assayers who had supervised the goldsmith business were absent and records were not kept.[7]

Edward C. Moore made at least one sauceboat in this suave style for the Tiffany & Co. store at 550 Broadway between about 1857 and 1870.[8] BBG

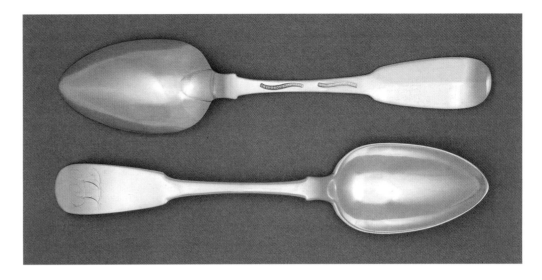

Cat. 134-1

1. "For Sale, By the Subscriber, No. 12 South Third Street, A large assortment of elegant Watches, Gold Chains and jewellery, Suitable for the Spanish and West India markets, Also a quantity of FRENCH Silver Plate"; *Federal Gazette and Philadelphia Daily Advertiser*, November 27, 1799.
2. The troy-ounce weight scratched on the underside of each sauceboat is preceded by "N° 28," possibly a shop inventory number. The same system of recording weight with an inventory number appears on pieces of Parisian silver in the Museum's collection. I am grateful to Donna Corbin, formerly the Louis C. Madeira IV Associate Curator of European Decorative Arts, Philadelphia Museum of Art, for consultation regarding these French weight marks.
3. Marked "C.P.V."; Faith Dennis, *Three Centuries of French Domestic Silver: Its Makers and Its Marks* (New York: Metropolitan Museum of Art), vol. 1, p. 220, cat. 329.
4. Sotheby's, New York, *Important Americana Including Silver, Prints, Folk Art, Furniture, and Property Formerly in the Estate of Ulysses S. Grant*, January 18–19, 2001, sale 7590, lot 280. This pair is believed to have belonged to James Logan Fisher (1783–1814), who happened to die in Paris, and his wife Ann Eliza George Fisher.
5. Lewis Belin, the sculptor and later silversmith, was in Philadelphia in 1817.
6. See cat. 136.
7. Dennis, *Three Centuries of French Domestic Silver*, vol. 2, p. 21.
8. Spencer Marks, Southampton, MA, advertisement, *Silver Magazine*, vol. 32, no. 3 (May/June 2000), p. 10.

Cat. 134

Chaudron & Rasch
Pair of Tablespoons

1809–12
MARKS (on each): CHAUDRON'S & RASCH (in banner); STER. AMERI.MAN. (in banner; all on back of handle; cat. 134-1)
INSCRIPTION (on each): LL (engraved script, on front of handle)
2010-145-4
Length 8⁹⁄₁₆ inches (21.8 cm)
Weight 2 oz. 3 dwt. ½ gr.
2010-145-5
Length 8⁹⁄₁₆ inches (21.7 cm)
Weight 1 oz. 19 dwt. 20 gr.
Gift of Robert T. Trump and Sandra S. Trump, 2010-145-4, -5

Sugar Tongs

1809–12
MARK: CHAUDRON'S & RASCH (in banner, inside one arm; cat. 134-1)
INSCRIPTION: L L (engraved script, on outside of bow)
Length 6⁵⁄₁₆ inches (16 cm), width 1½ inches (4.1 cm)
Weight 1 oz. 17 dwt.
Gift of Robert T. Trump and Sandra S. Trump, 2010-145-8

The American eagle was a popular motif on late eighteenth- and early nineteenth-century Philadelphia flatware, most frequently rendered as swaged decoration on the backs of spoons.[1] The die-stamped eagle applied to these sugar tongs was much less common. Eagles with or without the shield, arrows, and olive branch that were part of the U.S. coat of arms also appeared on American furniture as well as ceramics made in Europe and China for the American market. This use of the national emblem to embellish objects intended for domestic use (as opposed to official commissions, such as the 1817 porcelain state service ordered by President James Monroe) has been interpreted as patriotic fervor in the early days of the new republic, a point reinforced by Chaudron & Rasch's mark "STER[LING] AMERI-[CAN] MAN[UFACTURE]," which celebrated the objects' American origin.[2]

The same engraved initials "LL" on each indicate that these two spoons and sugar tongs originally were owned by the same unidentified person. DLB

1. Donald L. Fennimore, *Flights of Fancy: American Silver Bird-Decorated Spoons* (Winterthur, DE: Henry Francis du Pont Winterthur Museum, 2000), pp. 22–26; Hollan 2013, pp. 275–80.
2. Philip M. Isaacson, *The American Eagle* (Boston: New York Graphic Society, 1975); Susan Gray Detweiler, *American Presidential China: The Robert L. McNeil, Jr., Collection at the Philadelphia Museum of Art* (Philadelphia: the Museum, 2008), pp. 36–38.

Cat. 135

Chaudron & Rasch
Pair of Teaspoons

1809–12
MARKS (on each): CHAUDRON'S & RASCH (in banner);
STER.AMERI.MAN. (in banner; all on back of handle;
cat. 134–1)
INSCRIPTION (on each): P A H (engraved script,
on front of handle)
2010-145-6: Length 5¹⁵⁄₁₆ inches (15.1 cm)
Weight 12 dwt. 8 gr.
2010-145-7: Length 6 inches (15.2 cm)
Weight 11 dwt. 16 gr.
Gift of Robert T. Trump and Sandra S. Trump,
2010-145-6,-7

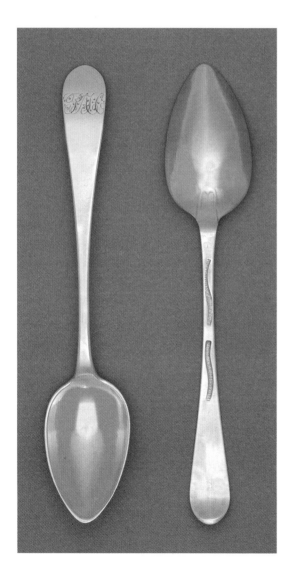

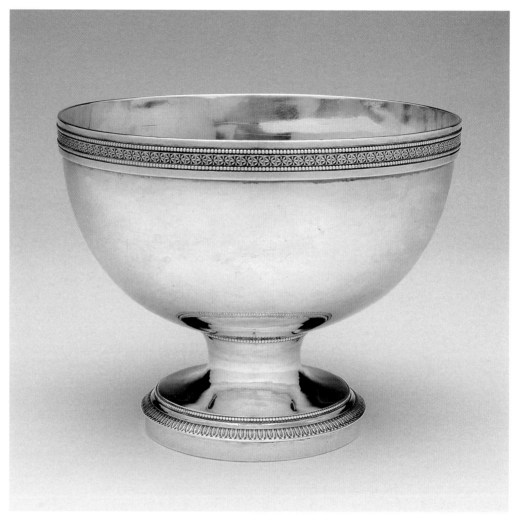

Cat. 136

Jean-Simon Chaudron
Bowl

1812–15
MARK: CHAUDRON (in banner, twice on underside of foot;
cat. 133–1)
Height 5 inches (12.7 cm), diam. 6⅜ inches (16.2 cm),
diam. foot 3⁹⁄₁₆ inches (9.1 cm)
Weight 19 oz. 3 dwt. 15 gr.
Gift of the McNeil Americana Collection, 2005-68-16
PROVENANCE: Purchased by the donor prior to 1970.

Distinguished for its simplicity and weight, this object
was probably made as a slop bowl for a tea service;
it is nearly identical to a slop bowl from a tea service
by Chaudron engraved with the Penn-Gaskell arms.[1]
The decoration on the Museum's bowl consists of
two applied decorative bands, a small band of bead,
a classical egg-and-dart design around the top of
the plain foot, and an abstract floral motif between
two bands of fine bead around the top edge. As the
bowl bears only Chaudron's mark, it was probably
made in his manufactory in Hamilton Village after his
partnership with Rasch. BBG

1. Christie's, New York, *Important American Furniture, Silver,
Folk Art and Decorative Arts*, January 20, 1989, sale 6742,
lot 291.

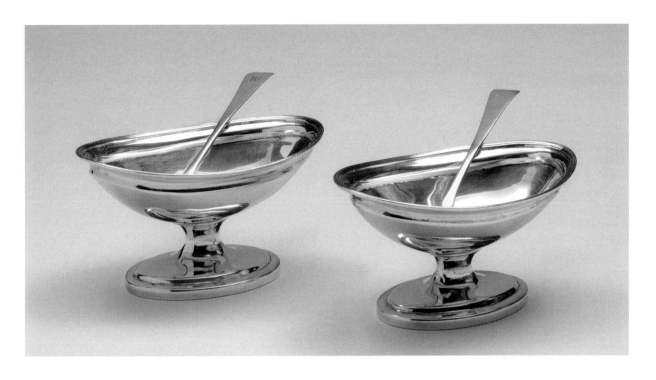

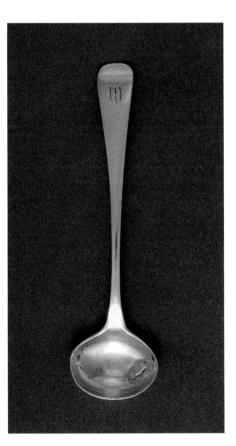

Cat. 137

Jean-Simon Chaudron
Pair of Salt Dishes and Spoons

1812–15

MARK (on each): CHAUDRON (in banner, once on under-side of pedestal, once on reverse of handle; cat. 133-1)
INSCRIPTION: W (engraved gothic script, at top of obverse of handle of each spoon)
Dishes: Height 2¼ inches (5.7 cm), length 4¹⁄₁₆ inches (10.3 cm), width 2½ inches (6.4 cm)
Weight 2 oz. 3 dwt.; 2 oz. 8 dwt. 10 gr.
Spoons: Length 4⅛ inches (10.5 cm)
Weight 5 dwt. 20 gr.; 5 dwt. 22 gr.
Gift of the McNeil Americana Collection,
2005-68-12–15

PROVENANCE: The history of ownership published when these salts were sold at auction in 1990 named the original owners as Warner Washington Jr. (1751–1829) and his wife, Sarah Warner Rootes, who were married in 1816 and lived at "Fairfield" in Clark County, Virginia.[1] Warner Washington was a first cousin of George Washington, and as Chaudron was an avid admirer of the first president, the Washington connection seems reasonable. The salts descended from their great-great-grandson Bowden Washington (1892–1931) to the consignor. Christie's, New York, *Important American Furniture, Silver, Folk Art and Decorative Arts*, October 19, 1990, sale 7146, lot 66.

Other salt dishes of the same design and with the same engraved lettering suggest that they were made in Chaudron's silver manufactory, operating on the west side of the Schuylkill River in what was known as Hamilton Village. His workmen made this form of salt dish more than once, and they engraved initials using gothic letters.[2] BBG

1. Warner Washington Jr. was the son of Colonel Warner Washington (1722–1790), son of George Washington's brother John Washington, who married Hannah Fairfax as his second wife and who appears in George Washington's diaries and letters as a family and social connection; George Washington, Washington Genealogy, s.v. "George Washington," May 2, 1792, founders.archives.gov.
2. Six salt dishes made for "B" and "JBP" in the collection of Winterthur are identical or similar in size and weight; Quimby and Johnson 1995, p. 345, cat. 328a–f.

S. & T. Child

| Philadelphia, 1848–1895

Samuel Teas Child (1814–1895), born October 6, 1814, and Thomas Teas Child (1820–1886), born August 15, 1820, were sons of the Philadelphia clockmaker John Child (1789–1876) and Rachel Teas (1790–1857), who were married in 1811.[1] The brothers apprenticed as clock- and watchmakers with their father and worked for him at 452 North Second Street following the end of their training.[2] Samuel married Sarah Lloyd (1819–1874) in 1840 and was recorded living at 248 St. John Street in 1843.[3] In the same year Thomas married his first wife, Elizabeth Kenderdine (1817–1844), and moved to Seventh Street above Parrish.[4] After Elizabeth's death in childbirth Thomas married his second wife, Anna Martin (1815–1898), in 1847.[5] John Child retired in 1848, and Samuel and Thomas took over his shop, renaming the business S. & T. Child.[6]

As a "plain Friend," John Child had disapproved of dealing in or wearing jewelry, but facing an overall decline in prices for clocks and watches, his sons expanded their retail stock to include jewelry and silver flatware.[7] In 1857 the firm's address was renumbered 824 North Second Street.[8] By 1862 Samuel's son Henry L. Child (born 1841) became the third generation working for the business; he was identified as "watchmaker" as early as the U.S. census of 1860, when he was nineteen years old. Thomas's son George C. Child (1851–1925), Henry's cousin, began working for the firm as a watchmaker in 1872.[9]

Beginning in 1867 S. & T. Child were described as "jewelers" in city directories. However, the firm continued to advertise watches as its primary focus: one 1884 advertisement claimed, "In Ladies' American Key Winders we have the largest assortment in the city."[10] Its inventory included watches made by other companies, including the Elgin National Watch Company of Illinois.[11] Samuel and Thomas Child both retired in 1882; Thomas died on August 22, 1886, and Samuel on October 16, 1895.[12] They were buried in adjacent lots in Friends' Fair Hill Burial Ground.[13] Henry and George Child continued the business as S. & T. Child for fourteen years. In 1884 they joined the Jewelers' Security Alliance, a national organization that funded the investigation and prosecution of thefts.[14] Henry had retired by 1896, when the firm was renamed George C. Child.[15] The following year George Child relocated to 1020 Chestnut Street in the city's "Jewelers' Row" neighborhood, and in 1900 he moved to 11 South Ninth Street.[16] The firm was renamed George C. Child and Son in 1912 when his son Stanley Gausler Child (born 1880) became a partner; at that time they were located at 20 South Tenth Street.[17] Stanley Child graduated from the University of Pennsylvania in 1901 with a degree in electrical engineering and subsequently worked for Baldwin Locomotive Works and taught at his alma mater as well as the Drexel Institute; it seems unlikely that he was trained as a watchmaker or had more than a supervisory role at the firm.[18] In 1922 the business moved to 5022 Morris Street in Germantown.[19] George Child died in 1925; his widow, Nina Gausler Child (born 1858), continued George C. Child and Son in Germantown until about 1940.[20] DLB

1. See the Shoemaker-Roberts-Wright-Erskine family tree, Ancestry.com (accessed April 14, 2014).

2. *Association of Centenary Firms and Corporations of the United States* (Philadelphia: Christopher Sower, 1916), pp. 149–50. This detailed account of the firm's history provided the basis for this biography. Presumably prepared by George or Stanley Child, it contains information not available elsewhere, although in several instances dates are incorrect.

3. Philadelphia directory 1843, p. 46.

4. Ibid. 1845, p. 59. Elizabeth K. Child's life dates are recorded on her gravestone; memorial no. 66069797, www.findagrave.com (accessed April 11, 2014). She died ten days after giving birth to an unnamed son, who also died; Register of Interments in Friends' Fair Hill Burial Ground, 1843–1917, p. 4, Ancestry.com.

5. Anna M. Child's life dates are recorded on her gravestone; memorial no. 66069804, www.findagrave.com (accessed April 11, 2014).

6. Philadelphia directory 1848, p. 58, where they were erroneously listed as "Childs S. T. & T. T., watchmrs., 652 N 2nd."

7. *Association of Centenary Firms and Corporations*, p. 150.

8. Philadelphia directory 1858, p. 109.

9. Gopsill's Philadelphia directory 1873, p. 317.

10. *The American* (Philadelphia), November 22, 1884, front cover.

11. Elgin Private Label Database, NAWCC Information Storage, www.nawcc-info.org (accessed June 3, 2015).

12. Register of the First Unitarian Society of Philadelphia, vol. 2, p. 160, Archives of First Unitarian Church of Philadelphia; Philadelphia Death Certficates Index, 1803–1915, Ancestry.com.

13. Memorials nos. 66069815 and 66069821, www.findagrave.com (accessed April 14, 2014).

14. "The Jewelers' Security Alliance," *Jewelers' Circular*, vol. 15 (June 1884), p. 138.

15. Gopsill's Philadelphia directory 1896, p. 340.

16. Ibid. 1897, p. 347; 1900, p. 395.

17. Boyd's Philadelphia directory 1912, p. 377.

18. *A Record of the Class of Nineteen Hundred, University of Pennsylvania* (Philadelphia: the Class, 1900), p. 53; *Catalogue of the University of Pennsylvania, 1907–1908* (Philadelphia: the University, 1908), p. 48; Selective Service Registration Cards, World War II, Records of the Selective Service System, NARA, Washington, DC, Ancestry.com.

19. "Drives Bandits Away," *Jewelers' Circular*, vol. 85 (October 18, 1922), p. 91.

20. Polk's Boyd's Philadelphia directory 1926, p. 395.

Cat. 138

S. & T. Child
Pair of Teaspoons

1848–65

MARK (on each): S & T.CHILD COIN (incuse, on back of handle; cat. 139-1)

INSCRIPTION (on each): Hart (engraved script, lengthwise on front of handle)

2008-132-4: Length 5¹⁵⁄₁₆ inches (15.1 cm)
Weight 12 dwt. 6 gr.

2008-132-5: Length 6 inches (15.2 cm)
Weight 12 dwt. 13 gr.

Gift of Mary Tatnall, 2008-132-4, -5

PROVENANCE: Based on the subsequent history of their ownership, this pair of spoons apparently belonged to Lydia Hart (1808–1869) of Philadelphia, or one of her relatives; she married Isaac Remington (1804–1862) in 1828. Their grandson William Penn Troth Jr. married Theodosia (Ashmead) Jones, who was the maternal grandmother of the donor's first husband.[1] DLB

1. Thomas Allen Glenn, *Some Colonial Mansions and Those Who Lived in Them, with Genealogies of the Various Families Mentioned* (Philadelphia: Henry T. Coates, 1900), pp. 391, 393; Richard and Agnes Townsend of the Bucklebury family tree, Ancestry.com (accessed May 26, 2015). See also cat. 58.

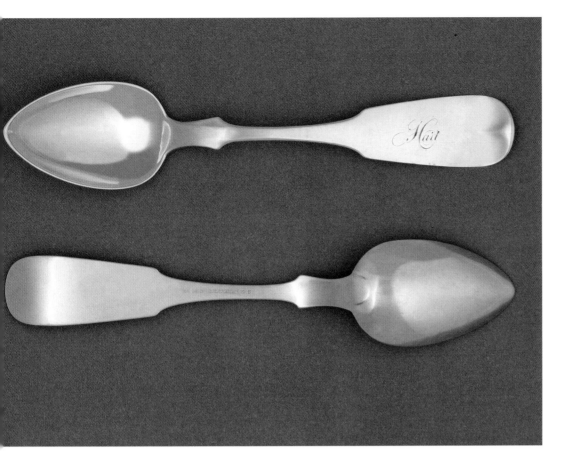

George K. Childs

Philadelphia, born 1801
Philadelphia, died 1867

Cat. 139

S. & T. Child

Teaspoon

1848–65

MARK: COIN S & T.CHILD (incuse, on back of handle; cat. 139-1)

INSCRIPTION: C S P (engraved script monogram, lengthwise on front of handle)

Length 5 13/16 inches (14.8 cm)

Weight 13 dwt. 11 gr.

Gift of Charlene D. Sussel, 2009-155-7

PROVENANCE: From the stock of the Philadelphia antiques dealer Eugene Sussel (1913–1989), the donor's husband.

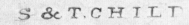

Cat. 139-1

George Killinger Childs was born on October 7, 1801, son of the mariner Captain Samuel Childs and Margaret Killinger Favell (Feble) Childs (1767–1853), daughter of George Killinger (c. 1730–1818), a cordwainer located at 75 Union Street in 1793, at 58 Lombard Street from 1798 until 1807, and at 13 Spafford Street by 1814. She was the widow of William Favell (Feble) (1768–1793).[1] Samuel and Margaret were married at Christ Church, Philadelphia, on September 29, 1800.[2] In 1806 they were listed at 58 Lombard Street, living with her father.[3] Samuel Childs was not listed after 1806 in the Philadelphia city directories, and it was probably he who died and was buried at Christ Church on November 7, 1806. Margaret Childs was listed in the directory in 1807 as widow resident at 62 Plum Street,[4] and in 1811 as "tutress" at 101 Christian Street. Subsequently, Margaret married William Long, a gold- and silversmith. He was listed in the Philadelphia directory in 1809 at 20 Cherry Street, in 1816 at 212 North Eighth Street, and in 1819 at 284 North Eighth Street. William Long died between 1822 and 1824, when Margaret was listed in the city directories as "Widow of Wm, 284 N. 8th Street." The U.S. censuses of 1830 and 1850 suggest that she had moved into her son's household. The *Philadelphia Inquirer* of April 13, 1853, carried a notice of Margaret's death: "On Monday morning, the 11th inst, Mrs. MARGARET LONG CHILDS, relict of the late Capt. Samuel Childs, aged 86 years. The relatives and friends of the family are particularly invited to attend her funeral, from the residence of her son, George K. Childs, No. 114 Spruce Street, at 3 o'clock on Thursday afternoon, the 14th inst., without further notice."

George Killinger Childs was named for Margaret's father, or perhaps Margaret's brother George Killinger Jr., who died in the yellow-fever epidemic of 1793. It is probable that George Childs apprenticed with his stepfather, William Long. If he followed a traditional path, he would have served as a journeyman in a Philadelphia shop before setting up on his own.[5] The Philadelphia directory of 1828 carried the first notice

of G. K. Childs as a silversmith, with his address as 32–34 Dock Street in the Dock Ward opposite Girard's Bank.[6] He was well-known by 1829 and an active member of the group known as the Working Men of Dock Ward. At a meeting held at the house of Charles Bard Reess, Enniskillen Castle Hotel, 97 South Fifth Street (fig. 58), he was one of five delegates elected to represent the ward in a city and county conference, for the nomination of a ticket in support of the Working Men.[7] The census of 1830 reveals that he then had an extensive household of fourteen persons, indicating a full and ongoing enterprise, probably the beginnings of his silver manufactory. There were seven males between the ages of fifteen and nineteen; two boys, one under five and one between ten and fourteen; two males between twenty and twenty-nine, one probably a journeyman, and one, George, himself. There was one female between the ages of twenty and twenty-nine, one between thirty and thirty-nine, and one, probably his mother, between fifty and fifty-nine.[8] These numbers may have included Edward P. Lescure and Nicholas Le Huray Jr. (q.q.v.), whose debts Childs assumed in 1839. In 1833 he and Le Huray were cited as "references" for applicants to a "Select Boarding School for Boys in Doylestown, Bucks County."[9] From 1833 until 1841 Childs's address was 8 Laurel Street. This was a spur lane that extended from 29 Spruce Street to Pear Street; Pear extended from 62 Dock Street to 83 South Third. From 1845 to his death in 1867, Childs's address was on Spruce Street.[10]

Childs carried on an active business in real estate and retail business between 1830 and 1839, which supplemented his silver manufacturing, while also participating in civic affairs. On April 26, 1830, Hugh Catherwood, distiller, George K. Childs, silversmith, and William Stapleton, carpenter, acting as trustees for the heirs of David McDonald, grocer, paid McDonald $1 and assumed the mortgage on ground and buildings on the southwest corner of Lombard and Seventh streets.[11] On November 20, 1833, Andrew Caldwell, house carpenter, and his wife Elizabeth sold to George K. Childs "of the City of Philadelphia, silversmith for $2,600 lawful money of the United states, a certain brick messuage and tenement and lot or piece of ground that had until 1803, belonged to the Presbyterian Church, situate on the West side of Second Street at the North West corner of said Second Street and Coats Street in the Northern liberties."[12] On January 23, 1834, the lawyer Silas H. Judah sold to G. K. Childs, silversmith, for $600, "various lots and pieces of ground" fronting 50 feet on Cherry Street.[13]

In 1837 Childs was elected a trustee of the Board of Delegates of the Fire Association of

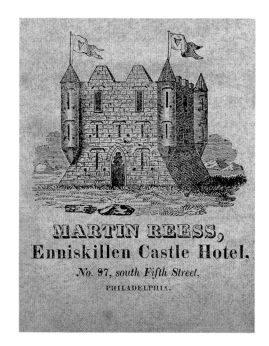

Fig. 58. Advertisement for Martin Reess, Enniskillen Castle Hotel, 97 South Fifth Street, from the Philadelphia directory of 1819 (p. 2.) Historical Society of Pennsylvania, Philadelphia

Philadelphia; Isaac Lloyd Jr. was president.[14] In 1839 Childs was elected by the Van Buren General Ward Committee to be on the ticket for the Philadelphia Common Council.[15]

The financial panic of 1837 resulted in several years of failures and bankruptcies among small businesses, especially tradesmen. On October 25, 1839, Childs and John Leadbeater, a Patent Lamp maker, were creditors of the estate of debtor George Jeffries, coachmaker, to pay his workmen and house servants and to pay the children and grandchildren of James Jeffries, deceased.[16] In October and November 1839 Childs was a leading creditor (more than fifty creditors were listed) in the bankruptcy proceedings of Nicholas Le Huray Jr., who had been hired by Childs and Joseph S. Randall, a clerk in the Western Bank (northwestern corner of Sixth and High Streets), to accomplish sales of stock, jewelry, and real estate for their "concern." Le Huray was to pay bills, give receipts, rent houses, collect rents, sell stock, and do everything just as if it were his own. He was to receive $10 per week, a house and store at 170 North Second Street, all the watch-repairing business, and all the profits from goods he chose to buy and sell on his own account.[17] Childs's testimony on May 12, 1843, noted: "He [Le Huray] sold them by retail except some few which he sold at auction—he collected the rents of the Real Estate—I don't know about his collecting debts, he might have collected some few old debts, there were not many—He is in debt to the assignees for monies thus received and not paid over to them, one hundred and thirty

six dollars."[18] Childs, Randall,, and Childs's counsel Oliver Hopkins, gave testimony on May 18, 1843: "Mr. LeHuray was a watchmaker, and when the pay ceased it was by his own offer. Mr. LeHuray received money as our agent. . . . Mr. Randall and Mr. LeHuray to handle the books, I was to attend to the 'out of door business.'"[19]

The 1840 census confirms that Childs had removed to the northern part of the city, in the South Mulberry Ward, and that his household was considerably smaller than it had been in 1830, with two males between the ages of twenty and twenty-nine (probably Le Hurray, who was at 172 North Second Street from 1841 until 1844), one male (himself) between thirty and thirty-nine, one female between twenty and twenty-nine, and one female (his mother) between seventy and seventy-nine. Three persons were "employed in manufacturing and trade." In August 1842 Childs, "of the Dock Ward," was elected chairman of the Democratic Conference of the City and County of Philadelphia.[20]

Also in 1842 Childs married Sarah Diehlman Burling (1808–1880), daughter of Abraham and Elizabeth (Beck) Burling from Burlington County, New Jersey.[21] They had a son, George Kettinger (Killinger) Childs Jr., born January 20, 1843, who became a carriage maker.[22] No other children have been recorded.[23] There is no entry in the 1843 city directory for G. K. Childs. In 1845 he had moved back to 114 Spruce Street, contiguous with his old Laurel Street residence. With the addition of buildings by 1857 his address had become 312 Spruce Street, where he lived for the rest of his life, and where his son and mother lived subsequently.

In 1844 he was captain of the Hook and Hose Fire Company in Philadelphia, which became embroiled in the anti-Catholic riots of that year. General George Cadwalader, one of the city commissioners and judges of the Court of Quarter Sessions, learned that "Mr. George K. Childs who was Captain for one portion of my posse, had 50 muskets then in his house: I directed him to arm fifty citizens as posse and ordered him to report immediately to General Patterson for duty."[24]

In 1845 Childs was elected a director of the Bank of Commerce. At the same time he was president of the Southern Insurance Trust Company, located at the southwest corner of Second and Spruce streets.[25] In 1848 he was appointed foreman of the Grand Jury of the Court of Quarter Sessions.[26] In 1849 he signed a petition presented at a town meeting on November 16 to effect a consolidation of the city of Philadelphia and surrounding districts.[27] The census of 1850 notes that his mother Margaret, age eighty-three, wife Sarah, forty-two, son George K., six, servant Hannah

Walker, twenty-one, and three silversmiths—Willard Barnes (eighteen), George Coats (nineteen), and Wincoum Shinn (seventeen)—were resident with him in Philadelphia's Pine Ward.

At midcareer George Childs was producing some examples of monumental presentation silver. On January 5, 1853, the *Philadelphia Inquirer* reported that "the employees in the establishment of Mr. Richard B. Jones of the Exchange Hotel on Dock Street, have just obtained a splendid silver tea sett [*sic*], which they are about to present to Mrs. Jones. It is intended as a testimonial of respect and good-will, and is honorable in the highest degree to all the parties concerned. It was manufactured at the establishment of Colonel George K. Childs, and we need scarcely add, is finished throughout in excellent taste. It is quite massive and heavy, yet each piece is richly chased, and tastefully and handsomely embellished." On December 12, 1854, Childs was appointed chief coiner of the mint in Philadelphia.[28] The *Inquirer* carried the following notice: "Mr. C is a practical man and is in every way qualified. He has been actively engaged in business in this city for years, is widely and deservedly popular and will no doubt discharge his new duties with efficiency and fidelity."[29]

The census of 1860 noted his location in Ward 5, Southern Division: George K. Childs, age fifty-eight; Sarah Childs, forty-five; George K. Childs, seventeen; and Mary Fisher, thirty-nine. At his retirement in 1861, at a meeting of the employees of the mint, Childs was presented with "a case containing a splendid M. J. TOBIAS full jeweled gold lever watch, with the appurtenances complete." It was inscribed on the back of the inside case: "Presented to G. K. Childs Esq. by the employees of the coining department United States Mint, as an evidence of their regard for him, both as an officer and gentleman, July 27, 1861."[30]

By 1863 George K. Childs was retired and listed as "gentleman." As president of the Good Intent Hose (Hook and Ladder Company no. 2, 602 Spruce Street), he made the formal announcement, on April 16, 1865, of the death of President Abraham Lincoln.[31] Although retired he was still listed from 1864 until 1867 together with his son as "silversmiths" at 312 Spruce Street. George K. Childs died on September 11, 1867, "after a lingering illness" of heart disease, "in the 66th year of his age."[32] He was interred at the Union Burial Ground Society Cemetery.[33] In the same section of the cemetery were buried Margaret L. Childs, Leo K. Childs, Sarah Childs, George K. Childs, and Elizabeth W. Childs.[34]

George K. Childs's obituary in the *Philadelphia Inquirer* summed up his life and role in Philadelphia:

Yesterday afternoon the funeral of George K. Childs, one of our oldest and most respected citizens, took place from his late residence, in Spruce Street above Third. Mr. Childs for many years has centered in himself the respect and esteem of a numerous circle of friends and gathered around him many ties of a public and private nature. A prominent mason and old fireman, he had the most undoubted and cordial esteem of all in those bodies who knew him. The respect in which he was held was fairly attested by the numerously attended funeral, which accompanied his remains to their long home. The Montgomery Lodge, No. 19 A.Y.M., the Good Intentioned Hose, the Hibernia Engine, and many other bodies were present in considerable numbers.[35]

The U.S. census of 1880 notes that Sarah Childs, age sixty-nine, was living with her son George K., carriage builder, and his wife Lotta W. Childs. Sarah died on August 28, 1880, at her residence of 312 Spruce Street. Her service was held at St. Peters Church on Third Street.[36] BBG

1. William Favell was a baker listed at 1 Chancery Lane. He died in a yellow-fever epidemic; Philadelphia directory 1793, p. 45; Matthew Carey, *A Short Account of Malignant Fever Lately Prevalent in Philadelphia ... and a List of the Dead* (Philadelphia: privately printed, 1794) p. 133.

2. 1850 U.S. Census; *Pennsylvania Archives*, 2nd ser. (Harrisburg, 1876), vol. 8, p. 46 (as Margaret Farill).

3. A Samuel Child (no "s") was listed as a cabinetmaker at 257 South Second Street in 1802–3, but not in 1804–5; Philadelphia directory 1802, p. 51; 1803, p. 51. A Samuel Childs, age five months, was buried at Christ Church on August 4, 1807; Philadelphia Death Certificates Index, 1803–1915, Ancestry.com. He was listed with others deceased as resident with a Mrs. Carlile; "Earliest Records of the Burials in Philadelphia from the Board of Health," *Publications of the Genealogical Society of Pennsylvania*, vol. 2, no. 1 (June 1900), p. 37. A Samuel Childs served in the Revolution and was a prisoner of the British in July 1781 at the barracks in Lancaster County. He was called "Captain" in the record of this family. He did not leave a will; www.myheritage.com/cemetery _records. The Killinger and Childs families were associated with Philadelphia's Gloria Dei and Christ churches, the Favells with the Catholic church of St. Michael's.

4. According to the Philadelphia directory of 1819, at that time Plum Street ran east to west from 230 South Second to South Sixth (p. xv).

5. His name mark, which is sometimes accompanied with "PHILA," both in serrated rectangles, is very like John Curry's (q.v.) mark. The latter's first listing was in 1825 as "Curry & Preston"; Philadelphia directory 1825, p. 39.

6. Built as the Bank of the United States, the building referred to was called "Girard's Bank" after 1811 when the charter of the Bank of the United States was not renewed. Dock Street ran from 138 South Front and 15 Spruce Street to 67 Third Street, and was the only street in Philadelphia that was not straight; it curved northwest from Front and Spruce to Third between Chestnut and Walnut. Dock Ward was located between Walnut and Spruce and between the Delaware River and Fourth Street; Philadelphia directory 1819, p. vi. The entrance to Dock Street began at Front Street. The Childs's house must have been close to this intersection, and thus his address was on Dock Street but given in the census as Front Street.

7. "Dock Ward.—Working Men," *Philadelphia Inquirer*, August 26, 1829.

8. These data suggest that George K. Childs may have been married, but to date no record of a marriage before 1842 has emerged.

9. *Philadelphia Inquirer*, April 16, 1833. The school referred to was probably Duncan Macgregor's classical school for boys, founded at some time between 1812 and 1815 and located a mile below Doylestown; W. W. H. Davis, *The History of Bucks County* (Doylestown, PA: Democrat Book and Job Office Print, 1876).

10. These addresses were all within a block or so of one another.

11. In trust for the benefit of Lafayette and Malcolm McDonald, minors. McDonald had purchased the property in 1823 in fee simple: "all that certain lot/ground and frame house thereon situate at the SW corner of Lombard and seventh Streets, together with the three storied brick house and one storied frame house and four two storied frame messuage fronting seventh Street and adjacent to the first mentioned house and lot with the yard and appurtenances"; Philadelphia Deed Book AM-1-555.

12. This property had been purchased by Caldwell from the First Presbyterian Church in the Northern Liberties about 1803; Philadelphia Deed Book AM-45-43.

13. Philadelphia Deed Book AM-45-719. Silas Judah does not appear in Philadelphia directories from 1800 to 1835. In the Philadelphia directory of 1820, a Harriet Judah, "a person of color," was located on Paper Alley (n.p.).

14. *Philadelphia Inquirer*, December 20, 1837.

15. *National Gazette* (Philadelphia), September 17, 1839.

16. Philadelphia Deed Book GS-10-163.

17. Bankruptcy proceedings of Nicholas Le Huray Jr., 1842–43, National Archives at Philadelphia, NARA.

18. Exhibit A, May 12, 1843, G. K. Childs and Joseph S. Randall vs. Le Huray, U.S. District Court, Philadelphia, National Archives at Philadelphia, NARA. John Leadbeater, $60; Charles Beradon, $10; Lewis Redner, $290; John R. Neff, $140; John M. Ford, $135; Beta Badger, $50; Joseph Ellis, $40; James Hickey, $125.

19. The federal Bankruptcy Act of 1841 was the first law to provide for voluntary as well as involuntary bankruptcy, and it covered all individual debtors, not just merchants and traders, as had been the case with the earlier act of 1800.

20. Local Affairs, *Public Ledger* (Philadelphia), August 30, 1842.

21. Death notice of Sarah Burling, *Philadelphia Inquirer*, September 1, 1880.

22. Jane Thompson Starr, *The Burling Books: Ancestors and Descendants of Edward and Grace Burling* (Baltimore: Gateway, 2001), vol. 2, p. 806.

23. Sarah's brother John named a son George K. Childs Burling in 1834; Pat Wardell, "Early Bergen County Families," p. 582, http:// njgsbc.org/indexes/bergen-county-families (accessed February 16, 2016).

24. "Official Testimony of Sheriff Morton McMichael and General Cadwalader from *The Olive Branch* ... With Documents Relating to the Late Disturbances in Philadelphia," in The Philadelphia Riots of 1844: Reporting Ethnic Violence, http://hsp.org (accessed April 2, 2015).

25. McElroy's Philadelphia directory 1845, p. 444. The company was incorporated in 1836.

26. Local Items, *Philadelphia Inquirer*, January 4, 1848.

27. Scharf and Westcott 1884, vol. 1, pp. 693–94.

28. He was the third to hold the appointment, following Henry Voigt (1793–1814), Adam Eckfeldt (1814–39), and Franklin Peale (1839–54); George G. Evans, ed., *Illustrated History of the United States Mint* (Philadelphia: printed by the editor, 1885), pp. 109–11.

29. "George K. Childs, Philadelphia," *Philadelphia Inquirer*, December 4, 1854.

30. "Meeting of the Employees of the United States Mint," *Philadelphia Inquirer*, July 29, 1861.

31. "Hall of the Good Intent Hose," *Philadelphia Inquirer*, April 17, 1865.

32. Obituary of George K. Childs, *Philadelphia Inquirer*, September 12, 1867.

33. www.myheritage.com/cemetery records.

34. Union Cemetery records, Pennsylvania and New Jersey Church and Town Records, 1708–1985, Ancestry.com.

35. "Funeral of George K. Childs," *Philadelphia Inquirer*, November 16, 1867.

36. Death notice of Sarah Childs, ibid., September 1, 1880.

Cat. 140

George K. Childs
Presentation Urn

1844–48

MARK: G.K.CHILDS (twice) / PHIL^A. (in serrated rectangles, on each corner of underside of base; cat. 140-1)

INSCRIPTION: THE DEFENCE OF THE LAWS IS THE HERO'S HIGHEST GLORY / Presented to / BRIGADIER GENERAL GEO. CADWALADER / by the Citizens of Philadelphia / as a testimonial of their admiration & gratitude for / the distinguished ability, intrepidity & prudence manifested / by him in Suppressing the riots of May & July 1844; and of / their profound respect for him as / A Citizen, a Soldier, & a man (engraved script in oval reserve, on front; cat. 140-2)

Height 30 inches (76.2 cm), width 15¼ inches (38.7 cm), depth 10½ inches (26.7 cm)

Weight 329 oz. 17 gr.

Gift of John C. Cadwalader Jr., 1998-157-1a,b

PROVENANCE: Descended in the donor's family.

PUBLISHED: Martha Gandy Fales, *Early American Silver*, rev. ed. ([S.l.]: Excalibur, 1970), fig. 35.

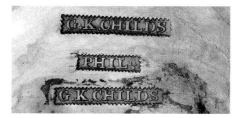

Cat. 140-1

The towering form of this covered urn, which is festooned with ornament, exhibits in scale and detail the flamboyance and sculptural effects characteristic of early Victorian design. Polished surfaces are set against frosted ones; swirling foliage shows texture; and the cast ornament, bird's-claw feet, and figure of a classical gladiator on the top enhance the three-dimensional aspect of the design.[1] On one side of the upper section, the inscription is enclosed in a "triumph" consisting of a classical wreath, furling flags with stars and stripes, cannon, and drums. On the opposite side is a relief showing a cannon, drum, winged eagle, and flag topped with a liberty cap, and in the center, the female figure of Liberty.

This impressive piece of silver was presented to General George Cadwalader (1806–1879) by the Irish Catholic citizens of Philadelphia to honor his role in leading a volunteer militia during the anti-foreign riots in the city in May and July 1844. Instigated by the Native American Party against the great numbers of Catholics who had emigrated and who worked for lesser wages, three days of violence and street fighting—with guns, cannons, swords, and stones— broke out, directed against the Catholics and their churches, two of which were burned; violence was also directed against the troops that rallied to protect them.[2] Some five hundred volunteer militia were called to restore order. General George Cadwalader and his volunteer company defended the churches and ground until companies of volunteers from fire companies, including some from outlying counties,

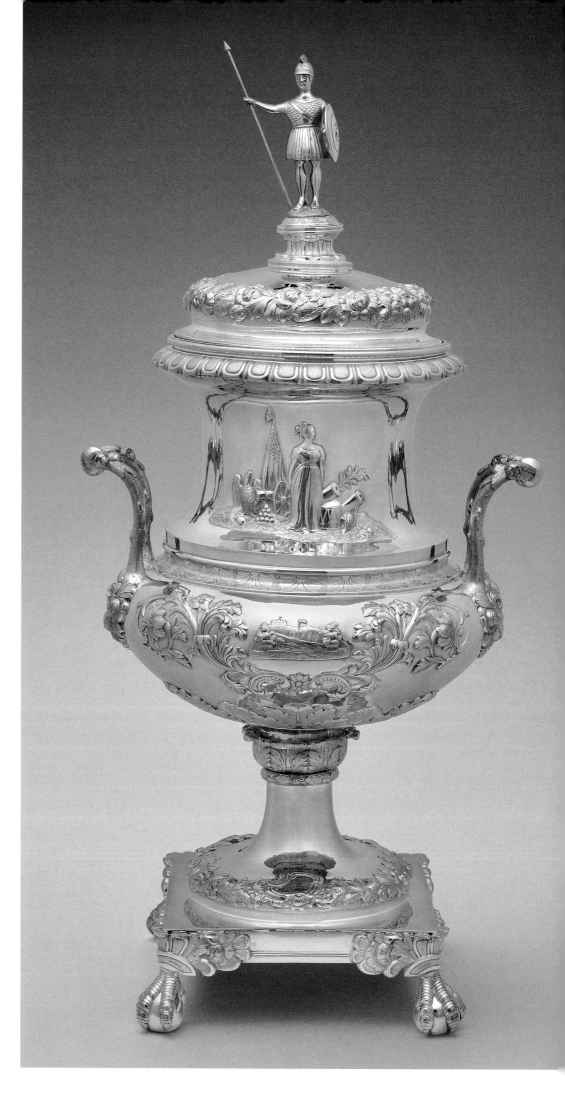

Fig. 59. *GE[N] Cadwalader at the Battle of the National Bridge*. Lithograph, image 8 x 12⅜ inches (20.3 x 31.3 cm), sheet: 13⅝ x 11⅞ inches (34.7 x 30.3 cm). Published by J. L. Magee. Medium Graphics Collection, Historical Society of Pennsylvania, Philadelphia

Cat. 140-2

arrived, and civil order was established. George K. Childs, an active fireman and captain of one section of Cadwalader's posse, participated in the action under General Patterson.[3] He was ordered to secure fifty muskets, which were stored at a firehouse, and to arm as many volunteers to quell the riots.

Surely the interactions between G. K. Childs and General Cadwalader secured this commission for the former, but perhaps it was instigated by Childs. It is curious that on the bowl of this urn, the reliefs on front and back (cats. 140-3, 140-4) show scenes of a fort on a hill or a castle, with flags hoisted, which seem to illustrate Cadwalader's actions in the Mexican War—raising the flag over the Chapultepec Palace in 1847 (fig. 59). A pair of soup tureens—also engraved with the phrase "The defense of the laws is the hero's highest glory"—were in fact inscribed and presented to Cadwalader for that action (see fig. 25).[4] As he did not return from the south to Philadelphia until 1848, this urn may have been designed to be presented en suite with the tureens.

A successful lawyer, businessman, sportsman, and military leader, Cadwalader distinguished

himself not only in the Mexican War but also with the Union forces in the Civil War.[5] Sidney George Fisher described him:

> Cadwalader is a remarkable person . . . and tho not capable of thought on abstract or general topics, & without knowledge or cultivation from books, has a fund of sound common sense which guides his judgment with great certainty in all practical things. . . . Hence his remarkable success in all that he undertakes. He has made a large fortune & lives in more luxury & style than any man in town, he has gained a distinguished reputation as a soldier, performed signal services to the city in the riots of 1844. . . . Withal he is a gentleman in his manners as he is in birth & breeding.[6]

Thomas Eakins painted a posthumous portrait of Cadwalader in 1880.[7] BBG

1. Patricia Wardle, *Victorian Silver and Silver-Plate* (New York: T. Nelson, 1963), p. 80.
2. St. Augustine's and St. Michael's Catholic Church and Rectory were burned; Nicholas B. Wainwright, ed., *A Philadelphia Perspective: The Diary of Sidney George Fisher* (Philadelphia: Historical Society of Pennsylvania, 1967), pp. 172–74, 225; John B. Perry, *A Full and Complete Account of the Late Awful Riots in Philadelphia* (Philadelphia: printed by the author and Henry Jordan, 1848).
3. "Official Testimony of Sheriff Morton McMichael and General Cadwalader from *The Olive Branch* . . . ," in The Philadelphia Riots of 1844: Reporting Ethnic Violence, http://hsp.org (accessed April 2, 2015); "The Riots," *Pennsylvania Freeman* (Philadelphia), July 18, 1844.
4. See PMA 1998-157-3a,b.
5. General George Cadwalader Papers, Series 7, Cadwalader Family Papers, c. 1700–1893, n.d., Military Papers—Mexican War, 1847–1849, HSP.
6. "The Diaries of Sidney George Fisher, 1844–1849," *PMHB*, vol. 86, no. 1 (January 1962), pp. 88–89.
7. Thomas Eakins, *Portrait of General George Cadwalader* (1880), Butler Institute of American Art, Youngstown, Ohio (1945-O-103). See Anthony Garvan and Carol Wojtowicz, *Catalogue of the Green Tree Collection* (Philadelphia: Mutual Assurance, 1977), p. 64. Cadwalader refused a life portrait.

Cat. 140-3

Cat. 140-4

Chunghi Choo

| Inchon, Korea, born 1938

Chunghi Choo (fig. 60) was born in 1938 in Inchon, Korea (now South Korea), to Young Bong Han and Kwang Hyun Choo and was one of three children. The Choo family descends from Zhu Zai, the third son of Zhu Zi, the great Chinese philosopher who at the end of the Song dynasty in China immigrated to Koryo, the former name for Korea. The artist's grandfather Myung Kee Choo was a successful businessman and philanthropist in Inchon. Both sides of Chunghi Choo's family embraced the arts, with a focus on classical music, the fine arts, and antique objects. She grew up in Seoul,

Fig. 60. Chunghi Choo, in an undated photograph

where the Choo family originated, surrounded by antique objects, and recalls a childhood wish to create beautiful things herself.[1]

After graduating from Ewha High School, Choo was encouraged by her art teacher to pursue an art major in college. She attended Ewha Woman's University in Seoul, studying painting with Park No Soo (1929–2013), an Abstract Expressionist landscape painter. Later she studied privately with the renowned painter Lee Sang-beom (1897–1972). Although painting gave her "great joy," Choo became curious in her senior year of college about making three-dimensional art.[2] Influenced by her childhood admiration of the antique ceramics and jewelry in her home, she began working

with metal. Encouraged by her family, she traveled to the United States, where she studied ceramics, enameling, and stone cutting at the Penland School of Crafts in North Carolina during the 1961 fall semester.[3] She transferred in the spring of 1962 to Cranbrook Academy of Art in Bloomfield Hills, Michigan, where she studied metalsmithing with Richard Thomas (1917–1988) and ceramics with Maija Grotell (1899–1973). Choo graduated from Cranbrook with an MFA in 1965.[4]

In the fall of 1965 Choo was hired to teach the general crafts course at the University of Northern Iowa in Cedar Falls, providing instruction in weaving, textile design, woodworking, and other media, including metalsmithing and jewelry making. In 1968 she was invited by the University of Iowa to teach metalsmithing and jewelry making. The textile designer Jack Lenor Larsen (born 1927) has supported Choo's work since 1969. She credits him for introducing her work to the art world, which gained Choo international recognition. In the summer of 1971 she attended Stanley Lechtzin's (born 1936; q.v.) electrochemistry and electroforming class at Tyler School of Art in Philadelphia,[5] which spurred her to pursue a grant to obtain and install an electroforming facility at the University of Iowa in 1973. According to Choo it exceeds 250 gallons in capacity and is known as the largest copper-plating tank in any art school in the United States.[6] This facility helped her to develop and refine the potential of electroforming, allowing "unlimited expression in forming metals, and lifted some of the technical limitations in metalworking that existed in the past." It is thus considered one of her significant contributions to the field.

Choo is the F. Wendell Miller Distinguished Professor of Art Emerita in the jewelry and metalsmithing department, School of Art and Art History, University of Iowa, Iowa City. She was awarded a National Endowment of the Arts Fellowship in metalwork and presented with the AMOCO Excellence in Teaching Award from the University of Iowa. Her work can be found in major museums around the world, including the Museum of Modern Art and the Metropolitan Museum of Art in New York, the Victoria and Albert Museum in London, and the Museum fur angewandte Kunst in Frankfurt.[7] ERA

1. An avid lover of classical music, Choo asserts that growing up in a home that valued listening to music and playing instruments stimulated her artistic sensibility and thereby heightened her abstract reasoning skills; Chunghi Choo, oral history interview, July 30, 2007– July 26, 2008, p. 10, Archives of American Art, Smithsonian Institution, Washington, DC; Chungi Choo, email message to the author, October 4, 2017.

2. Choo, oral history interview, p. 12.

3. Korea was then in the midst of political and economic unrest.

A revolution took place on May 16, 1961, the year Choo graduated from Ewha Woman's University. At the time arts education in Korea was not equipped for instruction in metalsmithing and jewelry; ibid.

4. Richard Thomas was an extremely influential, first-generation American studio metalsmith and professor, leaving a legacy of prominent students who passed along his lessons to future generation of artists and teachers in the United States and abroad; Chungi Choo, email message to the author, October 4, 2017.

5. Choo, oral history interview, p. 17.

6. Choo, email message to the author.

7. "Chunghi Choo," School of Art and Art History, University of Iowa, www.art.uiowa.edu (accessed June 3, 2015).

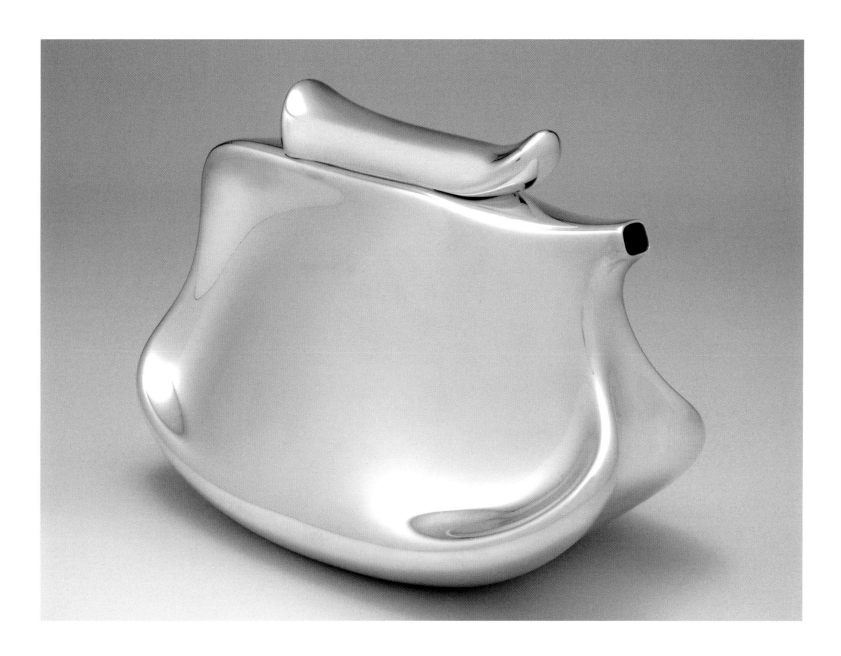

Cat. 141

Chunghi Choo
Decanter

1980
Silver electroplated on copper
MARK: Chunghi Choo / 33 / 35 (engraved, on underside;
cat. 141-1)
Height 7¾ inches (19.7 cm), width 8½ inches
(21.6 cm), depth 5 inches (12.7 cm)
Purchased with funds contributed by the Women's Com-
mittee and the Craft Show Committee of the Philadelphia
Museum of Art, 1992-109-1a,b

EXHIBITED: Rosanne Raab, *Benchmarkers: Women in Metal*
(Memphis, TN: National Ornamental Metal Museum,
1998), and Schick Art Gallery, Skidmore College, Saratoga
Springs, NY, April 16–June 15, 1999.

PUBLISHED: "National Endowment for the Arts Craftsmen's
Fellowships 1981," *American Craft*, vol. 41, no. 4 (August/
September 1981), p. 3; Robert A. Rorex, "Chunghi Choo:
Works in Metal and Silk," *Orientations*, October 1982,
p. 39, fig. 2; Suzanne Mack, New York, advertisement,
Silver Magazine, vol. 21, no. 1 (January/February 1988),
p. 6; Victoria Geibel, "The Silver Vessel," *Metropolis* (New

York), December 1988, pp. 78–79; Suzanne Ramljak and
Darrel Sewell, *Crafting a Legacy: Contemporary American
Crafts in the Philadelphia Museum of Art* (Philadelphia: the
Museum, 2002), p. 137, pl. 84.

Cat. 141-1

This decanter is electroformed from copper and
silver plated. It is number thirty-three of an edition
of thirty-five. The lid is removable.

Sensuous in form, the work embodies Choo's
integration of simplicity, harmony, and tranquility in
her work.[1] She studied traditional painting, the phi-
losophy of Asian art, and Chinese brush calligraphy
as an undergraduate at Ewha Woman's University in
Seoul. This foundation informs her approach to her
work as a metalsmith, as indicated in this decanter.
Speaking of her work in general, Choo has noted: "I

believe that the sweeping movements of the brush
in calligraphy have influenced my work and give it a
flowing energy"—a statement that provides an apt
description of this decanter's elegant form.[2] Choo
also conveys "her own love of the sumptuous and
luxurious" even in a simple form such as this one.[3]
Through her innovative use of electroforming, she
"can achieve fluid forms in metal that are unknown
in hand-forging."[4] This method also permits her to
make limited editions of particular designs, such as
this example. BBG/ERA

1. Robert Rorex, "The Energy of Qi," *Metalsmith*, vol. 11, no. 1
(Winter 1991), p. 26.
2. Quoted in ibid.
3. Robert Rorex, "Chunghi Choo: Works in Metal and Silk,"
Orientations, October 1982, p. 42.
4. Victoria Geibel, "The Silver Vessel," *Metropolis* (New York),
December 1988, p. 78.

Sharon Church

| Richland, Washington, born 1948

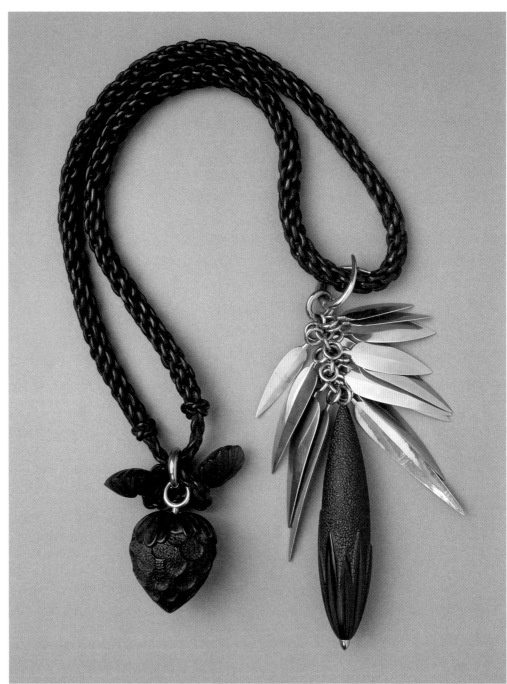

During her childhood the importance of art was impressed upon Sharon Church (fig. 61) by her parents and by visits to museums. Her family had a great reverence for silversmiths, and she specifically references a cherished silver bowl, given to the family at the time of her brother's birth, which was made by Joel Hewes (active 1910–50; q.v.), a silversmith from her father's hometown of Titusville, Pennsylvania.[1] Also among her earliest recollections is the influence of her mother, who briefly was an artist. Church earned her bachelor of science degree in 1970 at Skidmore College, Saratoga Springs, New York, studying under the jeweler Earl Pardon (1926–1991).[2] In 1973 she earned her master's degree in art from the School for American Craftsmen at Rochester Institute of Technology, where her instructors were the notable metalsmiths Hans Christensen (1924–1983) and Albert Paley (born 1944; q.v.).

Church was awarded a National Endowment for the Arts Fellowship in 1978 and the James Renwick Alliance Distinguished Educator Award in 2008. Her work is in many public collections, including the Museum of Arts and Design, New York, the Museum of Fine Arts, Boston, and the

Fig. 61. Sharon Church in her studio, Mount Airy, Pennsylvania, 2014. Photo: Jared Castaldi

Museum of Fine Arts, Houston, and is also found in private collections. Church's jewelry has been exhibited nationally and internationally, including the exhibitions *Ornament as Art: Avant-Garde Jewelry from the Helen Williams Drutt Collection*, Museum of Fine Arts, Houston, in 2007, and *Craft Today: Poetry of the Physical*, American Craft Museum, New York, in 1986. Formerly a professor of crafts at the College of Art and Design, University of the Arts, Philadelphia, where she taught beginning in 1979, Church retired from teaching in 2014. ERA

1. Sharon Church, telephone conversation with the author, March 2014.

2. Cindi Strauss, *Ornament as Art: Avant-Garde Jewelry from the Helen Williams Drutt Collection, The Museum of Fine Arts, Houston*, exh. cat. (Stuttgart: Arnoldsche Art Publishers, 2007), p. 469.

Cat. 142

Sharon Church
Pendant No. 2

1990
Goatskin, ebony, gold
MARK: 14K CHURCH © (incuse, on back of one petal; cat. 142-1)
Length 24¼ inches (61.6 cm)
Gift of Jane Korman, 2009-26-1

EXHIBITED: *On Longing: The Jewelry of Sharon Church and Mary Preston*, John Michael Kohler Arts Center, Sheboygan, WI, June–October 2003; *Wrought and Crafted: Jewelry and Metalwork, 1900–Present*, Philadelphia Museum of Art, May 8, 2009–February 7, 2010; *At the Center: Masters of American Craft*, Philadelphia Museum of Art, August 12, 2017–July 22, 2018.

Pendant No. 2 is an amalgam of Sharon Church's earlier necklaces, often ropelike and beaded constructions, and later works of hand-forged and hand-carved representations of natural plant forms.[1] Having developed her skill as a metalsmith under the tutelage of Earl Pardon (1926–1991), Hans Christensen (1924–1983), and Albert Paley (q.v.), Church is virtuosic in her skill as a jeweler.[2] Acutely aware of the body, she creates jewelry that is talismanic yet ornamental.[3] Referencing growth, renewal, and loss, Church carves forms that are inspired by nature, drawn from her own garden and from the Morris Arboretum of the University of Pennsylvania in Philadelphia.[4]

Pendant No. 2 was commissioned by Jane Korman, a collector in Philadelphia, and created during Church's sabbatical from the University of the Arts in Philadelphia in 1990. At that time she "launched into an exploration of how weight, movement, and gravity play a key role in jewelry as worn. . . . Walks led me to closely observe the nuts, pods, and seeds found in abundance in the woods and in my backyard. In *Pendant No. 2*, I was inspired by these forms and used them as models for weighted jewelry elements that would swing and sway in intimate response to the body's movement."[5]

The work is made from two organic materials—ebony and goatskin—and gold. Ebony is a very dense black wood, sourced from a living tree. Most artists who work with wood, including Church, consider it a living material, for it continually expands and contracts in its many shaped and worked forms. In itself the carved ebony element, although cut from its life source, has a pulse, so to speak. The goatskin, which came from a living animal, and the hand-hewn gold elements that have been pounded with the artist's hammer, further her exploration of "the paradox of death in life": each element in the piece has been infused with a life force or heartbeat.[6]

Church considers *Pendant No. 2* to be a turning point in her oeuvre.[7] The rare and welcomed opportunity of a private commission provided the artist with the ability and freedom to put aside production work and fully express herself artistically. ERA

1. Sharon Church to the author, February 15, 2009, curatorial files, AA, PMA.
2. Helen W. Drutt English and Peter Dormer, *Jewelry of Our Time: Art, Ornament, Obsession* (New York: Rizzoli, 1995), p. 118.
3. See note 1.
4. Marjorie Simon, "The Articulation of Desire: The Jewelry of Sharon Church," *Metalsmith*, vol. 19, no. 1 (Winter 1999), p. 22; Church to the author, February 15, 2009.
5. See note 1.
6. Simon, "The Articulation of Desire," p. 22.
7. Ibid.

Cat. 142-1

Clark & Biddle

| Philadelphia, 1865–71

Jedediah Preble Clark (1833–1895) was born in Portland, Maine, in 1833, son of the cabinetmaker John W. (1800–1845 or 1846) and Susan Preble Clark, who married in 1821.[1] He apparently was apprenticed about 1844 to George I. Johnson (1824–1857), a silversmith in Saco, Maine, who in 1849 married Jedediah's elder sister Isabella P. Clark (1824–1898).[2] Johnson was listed as "jeweler" in the Saco city directory; he died of consumption in Portland at age thirty-three.[3] The U.S. census of 1850 recorded the seventeen-year-old Clark as a "goldsmith" in Johnson's household. In 1858, the year following Johnson's death, Clark first appeared in the Philadelphia directory at 822 Chestnut Street as "jeweler"; the next year he was listed as "watchmaker."[4] In November 1859 he married Susan Parks (1831–1912) in Portland, with Philadelphia given as his residence.[5] He moved to New York City by 1861 and worked in Manhattan as a jeweler until his return to Philadelphia in 1865.[6]

Samuel Biddle (1844–1919) was born in Philadelphia on July 10, 1844, son of William Biddle (1806–1887), a merchant and an executive of the Mine Hill and Schuylkill Haven Railroad Company, and Elizabeth Cresson Garrett Biddle (1806–1881), daughter of the silversmith Philip Garrett (q.v.).[7] He was a direct descendant of William Biddle (1630–1712) who emigrated from England to New Jersey in 1681. In about 1857 Samuel Biddle was apprenticed to his maternal uncle, the silversmith Thomas Cresson Garrett (q.v.), who was married to Samuel's paternal aunt Frances Biddle (1803–1873). In the U.S. census of 1860, Samuel Biddle was living at 2141 Arch Street with his parents and his mother's cousin the currier William Garrett (1809–1891) and his family. Thomas Garrett retired at the time Biddle completed his apprenticeship in 1865, and Biddle took over his uncle's business at 712 Chestnut Street by forming a partnership with the jeweler and watchmaker Jedediah Clark.[8] In the same year Biddle married Katharine Townsend Harned (1845–1892) on August 3.[9]

Biddle, Clark, and their families were all recorded in the U.S. census of 1870 living in the same boardinghouse with the silversmith William H. Wilson (q.v.) at 922 Spruce Street. Even at that relatively early date in his career, Biddle had personal property valued at $35,000. As their advertisement in the city directory of 1868 made clear, Clark & Biddle were working silversmiths as well as retailers of imported watches and fancy goods: "[They] solicit inspection of their large and carefully selected stock, comprising watches, manufactured expressly for them, also those of the most celebrated European and American makers. Diamond, ruby, emerald, sapphire, opal, pearl, coral, and a general assortment of other jewelry, of the most fashionable styles which their facilities enable them to keep constantly replenished. Silver ware, in every variety manufactured on the premises. Plated ware, fine table cutlery, clocks and bronzes, of their own importation. Particular attention given to designing and executing articles for presentation."[10]

In addition to manufacturing silver "on the premises," Clark & Biddle sold objects from other Philadelphia silversmiths. The incuse mark on cat. 143 also appears on a salt spoon made by Peter L. Krider (q.v.).[11] Clark & Biddle moved their shop to 1124 Chestnut Street in 1869.[12] One year later the partnership's name was changed to Robbins, Clark & Biddle (see PMA 1988-25-15, a mustard spoon by the Gorham Manufacturing Company) when the jeweler Jeremiah Robbins joined the firm; he had been one of the partners in the reorganization of Bailey & Co. (q.v.) in 1850.[13] A trade card for Robbins, Clark & Biddle described them as "jewelers and silversmiths," and they continued to advertise imported goods such as "novelties in jewelry, to arrive per steamer Java . . . purchased in Europe under the depressing influences of the [Franco-Prussian] war at great bargains."[14] In 1873 the patent agent William A. Wiedersheim (1808–1881) became a fourth partner, presumably as an investor.[15]

Jedediah Clark left the partnership in 1875 and worked independently for a few years; in 1878 he was recorded as "watchmaker & diamond dealer," with his shop located on the second floor of 929 Chestnut Street. In May 1879, however, the silverplate manufacturers Mead & Robbins (q.v.) announced a "new department" of "diamonds, watches, jewelry, sterling silverware and fancy goods . . . under the supervision of J. P. Clark, formerly of the firm of Robbins, Clark & Biddle."[16] He was recorded as a jeweler in the U.S. census of 1880, and subsequent city directory listings gave only his home address at 914 Spruce Street.[17] In addition, Clark patented electric signals for

railroads in the 1880s with his former colleague Wiedersheim acting as his agent.[18] He died in Philadelphia on July 7, 1895.[19]

After 1875 the firm's name was changed to Robbins, Biddle & Company.[20] They remained at 1124 Chestnut Street, advertising as "importers and dealers in fine watches, jewelry, diamonds, silverware, clocks and fancy goods" until 1878, when they merged with Bailey & Co. to form Bailey, Banks & Biddle (q.v.).[21] After a long and financially successful career, Samuel Biddle retired in 1894 and subsequently became president of the German-American Trust Company in Philadelphia.[22] In 1899 he married his deceased wife's younger sister Elizabeth Harned (1851–1916).[23] In the U.S. census of 1910, they were recorded living at 1429 Arch Street with Biddle's two unmarried daughters and two African American servants. He died on March 4, 1919, and was buried with his second wife in the Friends Southwestern Burial Ground in Upper Darby, Pennsylvania.[24] DLB

1. Maine Marriage Records, 1705–1922, Maine State Archives, Augusta, Ancestry.com. John W. Clark has not been recorded in surveys of Maine cabinetmakers, probably because he worked for William Haskell's Furniture Manufactory at 233–35 Congress Street in Portland. Beginning in 1831 he was recorded as a cabinetmaker living on Chestnut Street; *The Portland Directory* (Portland, ME: Arthur Shirley, 1831), p. 13. His last listing was in 1844 (working at Haskell's), and his widow Susan Clark was recorded living on Chestnut Street in 1846; 1844, p. 16; 1846, p. 133.

2. Maine Marriage Records, 1705–1922. George Johnson's birth date was recorded as August 7, 1824; Maine Birth Records, 1621–1922, Maine State Archives, Augusta, Ancestry.com. Isabella (Clark) Johnson's birth and death dates were noted in her death record; Maine Death Records, 1617–1922, Maine State Archives, Augusta, Ancestry.com.

3. *The Business Directory of Saco and Biddeford, for the Year 1849* (Saco, ME: L. O. Cowan and A. A. Hanscom, 1849), p. 40; Maine Death Records, 1617–1922.

4. Philadelphia directory 1858, p. 112; 1859, p. 117.

5. Maine Marriage Records, 1705–1922. Susan P. Clark's death is recorded in Baptisms, Marriages, and Burials, 1893–1963, Episcopal Church of the Savior, Philadelphia, Historic Pennsylvania Church and Town Records, HSP, Ancestry.com.

6. Trow's New York City directory 1862, p. 159; 1864, p. 162.

7. Jordan 1911, vol. 1, pp. 180–81.

8. Philadelphia directory 1866, p. 143; Garret is listed in ibid. as "gentleman" (p. 267).

9. Jordan 1911, vol. 1, p. 181; Forman family tree, Ancestry.com (accessed June 5, 2015).

10. Gopsill's Philadelphia directory 1868–69, p. 366.

11. DAPC 78.3729.

12. Gopsill's Philadelphia directory 1870, p. 355.

13. Ibid. 1871, p. 1203; see also p. 80 in this volume.

14. The trade card is illustrated in Silversmiths and Related Craftsmen, s.v. "Samuel Biddle," Ancestry.com; *Daily Evening Telegraph* (Philadelphia), September 7, 1870.

15. Gopsill's Philadelphia directory 1873, p. 1107. Wiedersheim was recorded in the 1869 city directory as a partner in Wiedersheim & Company, "patent agents" at 400 Chestnut Street; 1869, p. 1554.

16. Ibid. 1878, p. 317; advertisement, *Philadelphia Inquirer*, May 23, 1879.

17. Gopsill's Philadelphia directory 1895, p. 335.

18. *Specifications and Drawings of Patents Relating to Electricity Issued by the United States from July 1, 1882, to July 1, 1883* (Washington, DC: Government Printing Office, 1884), vol. 25, n.p., patent nos. 265,756 and 265,757.

19. Philadelphia Death Certificates Index, 1803–1915, Ancestry.com.

20. Gopsill's Philadelphia directory 1876, p. 338.

21. See the trade card of Samuel Biddle illustrated in Silversmiths and Related Craftsmen (see note 14 above).

22. "Philadelphia," *Jewelers' Circular*, vol. 28 (May 2, 1894), p. 12; "Death Overtakes Founder of Bailey, Banks, & Biddle Company," *Philadelphia Inquirer*, March 7, 1919.

23. Jordan 1911, vol. 1, p. 181; memorial no. 67947899, www.findagrave.com (accessed June 3, 2015). Jordan erroneously recorded her birth year as 1850; see the Forman family tree, Ancestry.com (accessed April 21, 2014).

24. Memorial no. 67947914, www.findagrave.com (accessed June 3, 2015).

Cat. 143

Clark & Biddle
Teaspoon

1865–71
MARK: CLARK&BIDDLE (incuse, on back of handle; cat. 143-1)
INSCRIPTION: Annie (engraved script, lengthwise on front of handle)
Length 6 1/16 inches (15.4 cm)
Weight 13 dwt. 6 gr.
Gift of Charlene D. Sussel, 2009-155-8

PROVENANCE: From the stock of the Philadelphia antiques dealer Eugene Sussel (1913–1989), the donor's husband.

CLARK&BIDDLE

Cat. 143-1

The pattern engraved on this spoon's handle appears to be a variation on the *Josephine* pattern introduced by Gorham & Company (q.v.) in 1855.[1] DLB

1. Carpenter 1982, p. 293.

Cat. 144

Clark & Biddle
Card Receiver

1865–71
MARKS: 925 STERLING / 40; CLARK & BIDDLE (all incuse, on underside of base; cat. 144-1)
INSCRIPTIONS: R J K (engraved script monogram in roundel, at center of top; cat. 144-2); O 61 / [triangle] x x v (scratched, on underside of base)
Height 5 15/16 inches (15.1 cm), width 7 1/16 inches (17.9 cm), diam. 6 5/8 inches (16.8 cm)
Weight 10 oz. 15 dwt. 2 gr.
Gift of Beverly A. Wilson, 2010-206-3

CLARK& BIDDLE

Cat. 144-1

Visiting or calling cards became popular in late eighteenth-century Britain among the upper classes, and the custom spread quickly to the United States.[1] As objects of specialized function multiplied during the industrial revolution, card receivers (also known

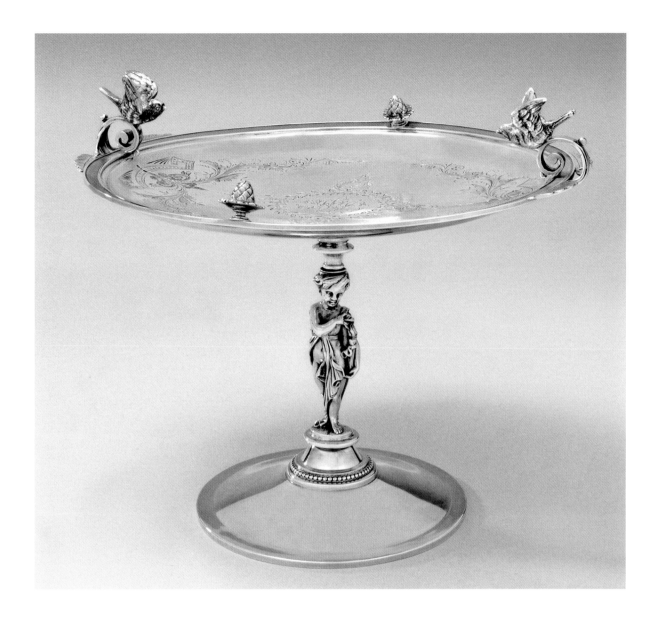

as card stands) also became popular as the appropriate receptacle for leaving cards in the front hall of a house. They usually were designed as a small footed tray or compote.[2]

Manufactured in a wide variety of designs in electroplate,[3] card receivers were a relatively uncommon form in sterling silver. The overall design of this example, particularly its central caryatid support of a child in classical drapery and birds perched on the rim, was derived from Renaissance models such as the Merkel centerpiece made around 1549 by Wenzel Jamnitzer of Nuremberg, Germany.[4] The top surface of this tray originally was gilded before it was engraved, so the bright-cut engraving created the effect of silver against gold. DLB

1. See PMA 1925-27-415, a card case by John Taylor and John Perry.
2. Kenneth L. Ames, "First Impressions," in *Death in the Dining Room and Other Tales of Victorian Culture* (Philadelphia: Temple University Press, 1992), pp. 35–37. In 1877 William Wilson & Son (q.v.) advertised "card stands"; *Philadelphia Inquirer*, December 6, 1877.
3. See PMA 1988-22-2 by the Middletown Plate Company.
4. J. F. Hayward, *Virtuoso Goldsmiths and the Triumph of Mannerism, 1540–1620* (London: Sotheby Parke Bernet, 1976), pls. 132 and 417.

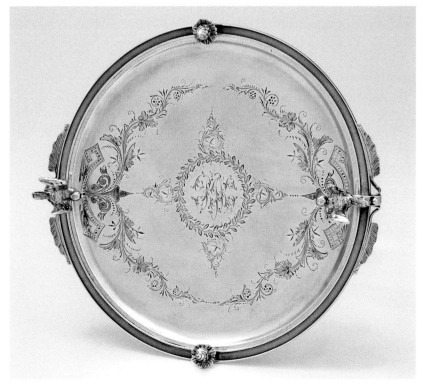

Cat. 144-2

John Cluett Jr.

Albany, New York, baptized 1728
Probably Albany, New York, died after 1787

Although relatively little is known of the silversmith John Cluett Jr.'s career, the Colonial Albany Social History Project has discovered much about his life, navigating the wide variety of spellings for his surname.[1] He apparently was the Johannes Knoet baptized in the Dutch Reformed Church of Albany on September 15, 1728, son of Johannes and Anna Knoet.[2] The same church issued a marriage license for Johannes Cloet of Albany and Sarah Van Arnhem of Rensselaerwyck on September 27, 1752.[3] Their son, also Johannes, was baptized on September 9 of the following year; the witnesses were Johannes and Anna Cloet, presumably the same individuals in the 1728 record.[4] The younger couple had ten more children over the next twenty-one years, all baptized in the Dutch Reformed Church.

Nothing is known of Cluett's training as a silversmith, although a possible financial connection with the Ten Eyck family (see below) suggests that he may have apprenticed with Jacob Ten Eyck (1705–1793), his younger brother Barent Ten Eyck (1714–1795), or possibly their father, Koenraet Ten Eyck (1678–1753). Cluett was first recorded as a silversmith in 1752, the year of his marriage. On June 18, 1752, "John Cluet Jr." billed the Albany merchant Robert Sanders for four silver spoons weighing 7 oz. 8 dwt. at a cost of £3 8s. 9d., with an additional 12s. for "fashioning of the same." Cluett receipted payment four days later; on the back of the bill is the notation, "Receipt of Van Sandford & Cloet."[5] The nature and duration of this partnership are unknown; his partner possibly was the Albany ship captain Cornelis Van Santvoort (born c. 1710). As "John Knout," Cluett was again identified as a silversmith in the list of Albany residents capable of quartering troops prepared by the British army in November 1756; his home had two fireplaces and one room "without Fire."[6]

Only about a dozen objects have been published with Cluett's barred "I C" mark, including a tankard made for Leendert and Catarina Gansevoort of Albany and a porringer.[7] Cluett marked a spoon with an engraved inscription dated 1757 identifying it as a New Year's gift for the same Leendert Gansevoort.[8] The following year Jacob Lansing of Albany advertised for a stolen silver tankard with "the Maker's Mark I.C.," possibly a work by Cluett.[9] In March 1764 he signed (as John Cluet Jun'.) the petition by Albany merchants to the Lords Commissioners of Trade and Plantations in London regarding trading regulations in the formerly French territories that had come under English control at the conclusion of the Seven Years' War.[10] Cluett's support of this petition suggests he may have been supplying silver "trinkets" to merchants involved in the Indian trade.

A list of freeholders in the city of Albany in 1763 included Johannes Cluet, and his property was included in the assessment rolls of the city's third ward.[11] Cluett held several civic posts, including firemaster, constable, and high constable.[12] His political allegiances shifted several times during the Revolutionary War. As John Cluet, he signed the Albany Sons of Liberty Constitution in 1766 and was one of two clerks appointed on May 29, 1775, to "Transcribe the Rough Minutes of this Board, and all such other Papers as shall be handed them" by the Albany Committee of Correspondence.[13] By June 1776, however, the committee's minutes recorded: "Staats M. Dyckman and John J. Cluet appeared before this Board and where [sic] charged with being notoriously disaffected to the Cause of America, and with drinking damnation to the Enemies of the King—The said Persons were offered the new association and refused to Sign the same, Ordered that they be sent back to Gaol."[14] The following day, however, Cluet returned and signed the Association, entering security "for his future good behavior."[15] On May 21, 1777, the committee received a letter from John J. Cluet, apparently again in jail under suspicion of being disloyal, and ordered him to appear, and "Mr. Cluet appeared and readily took the Oath [of Allegiance] above alluded to and was thereupon set to his former Liberty."[16] Cluett had another change of heart in November 1777 and sought the committee's permission to relocate to Canada or New York City, which was held by the British army throughout the war, but "the Committee took the same into Consideration and thereupon Resolve not to grant his request."[17] He would have been exempted from military service because of his age. A 1781 list of men eligible for a bounty of 500 acres as volunteers for service in the Second Regiment of the Albany County militia included a John Clute Jr., although this was more likely the silversmith's son baptized in 1753.[18]

On July 13, 1787, "John Cluett of Albany in the Colony of Renselaerwyk Silver-Smith" signed a bond for £400 from the Albany merchant Barent Ten Eyck (1722–1792), a nephew and cousin of the Ten Eyck silversmiths.[19] Cluett apparently was still active as a craftsman at that date, although no subsequent record of him has been found. DLB

1. Stefan Bielinski, "John Clute, Jr.," http://exhibitions.nysm.nyseds.gov//albany/bios/c/joclute1637.html (accessed July 12, 2017). Unless otherwise referenced, information on Cluett's life is taken from this source.

2. "Records of the Reformed Dutch Church of Albany, Part 3: 1725–1749," *Year Book of the Holland Society of New-York* (New York: the Secretary, 1906), p. 31.

3. "Records of the Reformed Dutch Church of Albany, Part 4: 1750–1764, ibid. 1907, p. 4.

4. Ibid. p. 36. The Johannes Cloet baptized on this occasion apparently is the same John J. Cluett who died on February 23, 1836, at the age of eighty-three; Albany Rural Cemetery Internment Cards, section 49, lot 12, Albany Rural Cemetery, Menands, NY; see also memorial no. 89280121, www.findagrave.com (accessed July 12, 2017).

5. Norman Rice referred to a 1944 article by Helen Burr Smith that cited this bill; Rice, *Albany Silver, 1652–1825* (Albany: Albany Institute of History and Art, 1964), p. 71. Smith had made handwritten and typewritten transcriptions of the bill that are preserved in the Silversmiths' Papers, Sanders folder, box S, c. 1675–1830, Manuscript Collection, New-York Historical Society. She recorded the original document as being in the Sanders Papers at the New-York Historical Society, but recent efforts to locate it there have been unsuccessful.

6. The original document is in the Loudoun Americana Collection, Henry E. Huntington Library, San Marino, California; transcribed in "Loudoun's Enquiry, November 1756," http://exhibitions.nysm.nysed.gov//albany/census1756.html#282 (accessed July 1, 2017).

7. Rice, *Albany Silver*, p. 34, fig. 54; Wees and Harvey 2013, p. 289. For a tankard with a cover marked by Cluett, possibly as a repair, see Spencer 2001, p. 106. Ensko (1948, p. 191) may have been the first source to identify this mark as Cluett's. This attribution was supported by John D. Kernan Jr. ("A New Albany Smith and Further Light on AC and IGL," *Antiques*, vol. 74, no. 2 [August 1958], p. 140), with the observation that the documented objects with this mark all had histories of ownership in Albany.

8. Detroit Institute of Arts (42.110), illus. in Rice, *Albany Silver*, p. 35, fig. 57.

9. Rita Susswein Gottesman, comp., *The Arts and Crafts in New York, 1726–1776* (New York: New-York Historical Society, 1938), p. 36.

10. John Romeyn Broadhead, *Documents Relative to the Colonial History of the State of New-York*, ed. E. B. O'Callaghan (Albany: Weed, Parsons, 1856), vol. 7, p. 615.

11. *Genealogy Trails*, http://genealogytrails.com/ny/albany/freeholders1763.html (accessed July 12, 2017).

12. He is recorded as "constable" in 1751; "The Albany City Council," http://exhibitions.nysm.nysed.gov/albany/org/cc.html (accessed July 12, 2017).

13. The original "Sons of Liberty Constitution" is known only through a photostat of the now-unlocated original; see http://exhibitions.nysm.nysed.gov/albany/solconst.html#doc (accessed July 12, 2017); and James Sullivan, ed., *Minutes of the Albany Committee of Correspondence, 1775–1778* (Albany: University of the State of New York, 1923), vol. 1, p. 55.

14. Sullivan, *Minutes of the Albany Committee of Correspondence*, p. 435. The "General Association" in support of the Patriot cause was voted by the Committee of Correspondence on February 17, 1776; see ibid., pp. 3–4. Staats (or States) Morris Dyckman (c. 1755–1806) was a diehard Loyalist who served on the British side during the Revolutionary War; see James Thomas Flexner, *States Dyckman: American Loyalist* (Boston: Little, Brown & Company, 1980).

15. Sullivan, *Minutes of the Albany Committee of Correspondence*, p. 438.

16. Ibid., p. 762.

17. Ibid., p. 860.

18. *New York in the Revolution as Colony and State* (Albany: J. B. Lyon, 1904), vol. 1, p. 223.

19. John Cluett, Bond to Barent Ten Eyck, MS 2958.1978, New-York Historical Society. This document was first noted by John D. Kernan Jr., "Further Notes on Albany Silversmiths," *Antiques*, vol. 80, no. 1 (July 1961), p. 61.

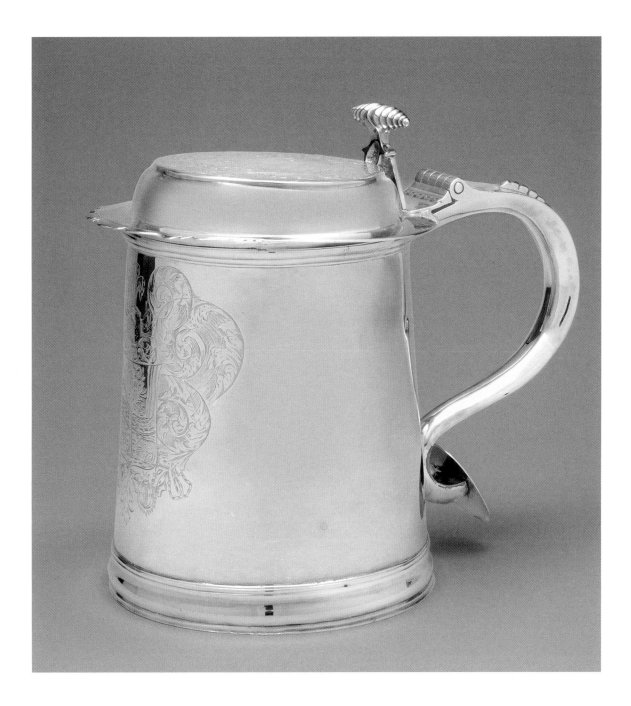

Cat. 145

John Cluett Jr.
Tankard

1750-60

MARK: I C (barred "I" in rectangle, once on either side of handle at rim, once on cover; cat. 145-1)

INSCRIPTIONS: E·V·R (engraved, shaded letters on disc, at end of handle); [coat of arms (DePeyster)] (on front opposite handle); 45 oz. (scratched, on underside)
Height 8⁵⁄₁₆ inches (21.1 cm), width 9¾ inches (24.8 cm), diam. 6¹⁄₁₆ inches (15.4 cm)
Weight 42 oz. 11 dwt.
Gift of Mrs. Courtlandt S. Gross and Mr. Antelo Devereux in memory of Alexander Van Rensselaer, 1977-4-1

PROVENANCE: Descended in the donors' family.

Cat. 145-1

The three marks on this tankard are clear, identical strikes. The tankard itself has had significant restoration. A pitcher spout had been inserted at the front and then removed. The modern engraving of the DePeyster arms, perhaps based on the original armorials, was added after the cutout for the spout was filled and the surface was buffed. The engraving on the cover and the handle terminal are likewise in a modern hand and may replicate earlier decoration. The bezel and flange of the cover, as well as the segmented molding applied to the handle, are replacements. Although Cluett made another tankard for Leendert and Catarina Gansevoort with a relatively plain base molding, the more usual, stamped ornamental band may have been removed from this tankard as part of its renovation.[1] The Gansevoort tankard also has a plain oval handle terminal.

This tankard bears the arms of the DePeyster family. Cornelia de Peyster (1774–1849), daughter of Pierre de Peyster (born 1707), married Jacob Rutsen Van Rensselaer (1767–1835).[2] The tankard was given in memory of Alexander Van Rensselaer II (1850–1933), who married Sarah Drexel (Fell; 1860–1929), daughter of Anthony J. Drexel of Philadelphia, in 1898. His father was the Reverend Cortlandt Van Rensselaer (1836–1882). The initials on the disc, "E V R," may have belonged to Alexander's sister, Elizabeth Van Cortlandt Van Rensselaer (1787–1868). The tankard descended to Antelo Devereux and his sister Alexandra Van Rensselaer Devereux (Wanamaker) Gross (Mrs. Courtlandt S. Gross).[3] BBG/DLB

1. Norman Rice, *Albany Silver, 1652–1825* (Albany: Albany Institute of History and Art, 1964), p. 34.
2. Kiliaen Van Rensselaer, *The Van Rensselaer Manor* (Baltimore, 1929), p. 71.
3. *Philadelphia Social Register*, 1924.

Abraham W. Coats (or Coates)

Location unrecorded, born c. 1799
Philadelphia, died 1857

Nothing definite is known about jeweler Abraham W. Coats prior to December 27, 1852, when he advertised a "new store" in Philadelphia selling "Jewelry, Silver, and Plated Ware, Dixon's fine and other Brittania [*sic*] unusually cheap; Diamond Rings and Pins," at 41 North Sixth Street.[1] He advertised until September 1853, when he announced the sale of "a large variety of new style Jewelry at cost, to close business . . . Store to Let, and Fixtures for sale."[2] However, between 1854 and 1856 he continued to be listed as a jeweler at the same address in city directories, which consistently spelled his surname "Coates," unlike his advertisements or the mark struck on cat. 146.[3] Coats died on April 7, 1857, at age fifty-eight.[4] He was buried at Laurel Hill Cemetery; his surname was spelled "Coates" on his gravestone although in his interment record it was spelled "Coats."[5]

An A. W. "Coats" between thirty and forty years old was recorded in the U.S. census of 1830, residing alone in the Chestnut Ward. This individual may be the A. W. "Coats" listed as a jeweler at 21 Franklin Place in the 1833 city directory.[6] According to Maurice Brix, the partnership of Coats & Boyd, jewelers, was listed in an 1831 directory.[7] Catherine Hollan has proposed that this Coats working in the 1830s is the same person as the Coats active in the 1850s, despite his twenty-year absence from Philadelphia records.[8] The Abraham Coats, age thirty to forty years, recorded in the 1840 census living in Northern Liberties was a currier and presumably not the jeweler. No Abraham Coats appeared in the 1850 census for Philadelphia. DLB

1. *Public Ledger and Daily Transcript* (Philadelphia), December 27, 1852.

2. Ibid., September 27, 1853.

3. McElroy's Philadelphia directory 1854, p. 92; 1855, p. 94; 1856, p. 109.

4. *Public Ledger and Daily Transcript*, April 8, 1857.

5. Interment permit no. 1100, April 8, 1857, Coates Family Lot Records, Laurel Hill Cemetery, Philadelphia.

6. Desilver's Philadelphia directory 1833, p. 39.

7. Brix 1920, p. 23; however, Coats was not listed in Desilver's 1831 directory, which recorded only Ezekiel Boyd as a jeweler (p. 21).

8. Hollan 2013, p. 41. Hollan, as well as Brix (1920, p. 23), also state that A. W. Coats was listed as a jeweler in an 1837 Philadelphia directory, but he does not appear in McElroy's 1837 directory.

Cat. 146
A. W. Coats (or Coates)
Tablespoon

1852–57
MARK: A.W. COATS.41.N.6TH ST. (incuse, on back of handle; cat. 146-1)
INSCRIPTION: A E H (engraved script monogram, lengthwise on front of handle)
Length 8⅝ inches (21.9 cm)
Weight 1 oz. 7 dwt. 14 gr.
Purchased with funds contributed by Peggy Cooke, 2009-114-7

PROVENANCE: Niederkorn Antique Silver, Philadelphia.

A.W. COATS.41.N.6TH ST.

Cat. 146-1

John Coburn

York, Maine, born 1724
Boston, died 1803

John Coburn was born in Maine on May 24, 1724.[1] Through his mother's family, the Storers, he was related to other families who produced important Boston silversmiths: John Coney, John Edwards (q.q.v.), Thomas Edwards, and Joseph Edwards Jr. Coburn probably served his apprenticeship in Boston with Samuel Edwards (1705–1762), his uncle by marriage. Coburn became a member of the Boston Artillery Company in 1751; he was a warden in Boston in 1772; and he took the census in 1776. He married twice, to Susanna Greenleaf (1722–1782) in 1750 and to Catherine Vance (c. 1739–1807) in 1784. He had no children.

The *Boston Newsletter* of November 2, 1750, announced his presence as a goldsmith located "at the head of the Town Dock." He owned property in Boston in 1755. In 1764 he was on Fish Street and in 1776 on King Street. He left Boston early in 1776 but was advertising his business on King Street again in August. He seems to have paid his fines to avoid military service during the Revolutionary War. In 1786 he purchased and moved to a residence on State Street, at which point he was listed as "gentleman" in the Boston city directory.

The accounting of known silver ware by John Coburn, which accompanies the biography by Deborah Federhen, shows the range of forms typical of an eighteenth-century urban shop.[2] There are four porringers listed with a suggested dating of 1750–60. BBG

1. This short summary is based on Deborah Federhen's exemplary work on this maker, in which she draws directly from historical primary documents; Kane 1998, pp. 293–306.

2. Ibid., pp. 298–305.

Cat. 147

John Coburn
Porringer

1750–60

MARK: I·C (in rectangle, once at center of inside of
bowl, once on reverse of handle; cat. 147–1)

INSCRIPTION: S R F / to / R A F (engraved script,
on front opposite handle)

Height 1 13/16 inches (4.6 cm), diam. 3 3/4 inches (9.5 cm),
length 6 1/16 inches (15.4 cm)

Weight 5 oz. 1 dwt. 3 gr.

Bequest of Lizette A. Fisher, 1944-40-1

PROVENANCE: Descended in the donor's family.

Cat. 147-1

The pierced pattern on the handle of this porrin-
ger appears to be from the same mold as another by
Coburn, although the curves here are not quite so
crisp.[1] There may have been some erasure of engrav-
ing on the top of the handle. The handle is slightly
cracked on the reverse. The loosely scribed, engraved
script on the front of the bowl of this porringer is in a
nineteenth-century hand and style similar to that on
other silver owned in the Fisher family of Philadelphia.

This porringer was surely purchased in Boston. It
originally was the property of a member of the Red-
wood family, possibly Sarah Redwood (1755–1847),
born in Newport, Rhode Island, in 1755. She married
Miers Fisher (1748–1819) of Philadelphia on February
17, 1774. The inscription probably refers to their daugh-
ter Sarah Redwood Fisher (1791–1827), who married
Samuel Longstreth; they too had a daughter Sarah.
The initials "RAF" belonged to Robert Andrews Fisher
and descended in the family to the donor.[2]

Sarah Redwood was the daughter of Quakers,
William Redwood (1726–1815) and Hannah Holmes

Redwood. Sometime before his death in 1815, Wil-
liam and family moved to Burlington, New Jersey. His
will noted that all of his estate in Rhode Island was
"to go to his daughter Sarah Redwood Fisher, wife
of Miers."[3] Miers Fisher was a prominent lawyer and
member of a large Quaker family. But come the British
occupation of Philadelphia in February 1776, he and
his brothers Samuel and Thomas were suspected of
Loyalist complicity, deemed too dangerous to remain
in the city, and imprisoned in Winchester, Virginia, for
eight months.[4] BBG

1. Buhler 1972, vol. 1, p. 311, cat. 266.
2. For other silver in the Museum's collection that descended
in this family, see the trays by Thomas Whartenby (2005-68-
96, 2005-68-97) and porringers and mugs by Samuel Wil-
liamson (2002-100-1, 2005-68-103–5).
3. Philadelphia Will Book 5, p. 445. An interesting connec-
tion exists here: William Redwood's will was witnessed by
Nathaniel Coleman (q.v.), a prominent Quaker silversmith in
Burlington, New Jersey.
4. *Minutes of the Supreme Executive Council of Pennsylvania*
. . . (Harrisburg, 1852), vol. 11, pp. 288, 296, 309, 460.

Howard & Cockshaw

| New York City, 1885–1912

Herbert Cockshaw

| New York City, 1912–14

Herbert Cockshaw Jr.

| New York City, 1914–c. 1960

The New York jewelry company founded by Herbert Cockshaw (1855–1928) and continued by his son, Herbert Cockshaw Jr. (1892–1981), was in business for seventy-five years. Marked examples of their work, including the miniature frame illustrated here (cat. 148), appear to be conservative in style and intended for a midlevel market, unlike the costly and stylistically more significant pieces made by Tiffany & Co. and Marcus & Co. (q.q.v).[1] The eight-pointed-star mark used successively by Howard & Cockshaw and Herbert Cockshaw Sr. and Jr., without any identifying letters or names, suggests that these successor firms operated as wholesale manufacturers and not as retail jewelers.

Herbert Cockshaw was born in Lewisham, London, on September 8, 1855, one of seven children of Samuel Cockshaw (1824–1884), a printer, and his wife Betsy (Bessie) Carter Cockshaw (1825–after 1906).[2] In 1859 the Cockshaw family immigrated to the United States and by 1870 were settled in Newark, New Jersey.[3] Newark was then a leading center of the American jewelry industry, and Herbert Cockshaw may have learned the trade in that city.

His first listing as a jeweler, in the 1876 Brooklyn directory, would have coincided with the completion of his training or apprenticeship.[4] He began his work as an independent craftsman with the firm of Cox & Sedgwick at 26 John Street in Manhattan.[5] On October 14, 1880, he became a naturalized U.S. citizen, witnessed by his fellow jeweler John Tasker Howard (1845–1921), who also worked at Cox & Sedgwick; Cockshaw registered to vote in that same year.[6] In 1890 he married Jane Hedges Sayre (1862–1947), daughter of Edward

Sayre (1835–1911), a coal merchant, and Martha Perry Hughes Sayre (1841–1925) of East Orange, New Jersey. Herbert and Jane Cockshaw had two children, Herbert junior and Dorothy (1891–1977).[7] The family lived at a number of different addresses in Brooklyn and Manhattan over the years.[8]

In 1885 Cockshaw and John T. Howard formed the partnership of Howard & Cockshaw, manufacturing jewelers.[9] Howard, whose older brothers had established the retail firm of Howard & Company in 1866 (see cat. 225), appears to have been more of a businessman, whereas Cockshaw clearly was a working jeweler. He was awarded at least two patents, one for a flexible bracelet in 1883, when he was working for Cox & Sedgwick, and the other for an improvement in chain links in 1914.[10] Howard & Cockshaw's factory was located at 857 Broadway on Union Square but moved in 1892 to 218–220 Fourth Avenue, where it remained until 1914.[11] In 1899 the New York State factory inspector reported that the company employed twelve men and five women.[12] The business was successful and respected: in 1898 Howard was elected a director of the New York Jewelers' Association, and Cockshaw was elected to the nominating committee.[13] During the firm's years of operation, it weathered a number of financial downturns. In response to the Panic of 1893, the company contributed $25 to the Jewelers' Relief Association of New York, and in 1906 it donated a pearl and ruby brooch as a prize to benefit victims of the San Francisco earthquake.[14]

The partnership was dissolved when Howard retired in 1912, and the company was renamed Herbert Cockshaw.[15] The firm moved to 29 West Thirty-Eighth Street in 1914, when Cockshaw retired. It was then taken over by Herbert Cockshaw Jr., who may have had some training as a jeweler, although his role in the company appears to have been largely that of manager and owner.[16] By 1919 Herbert Cockshaw Sr. had become president of the Mary Arden Corset Company at 524 Madison Avenue; in 1925 he moved to the Dakota apartment building at 1 West Seventy-Second Street, where he died on November 8, 1928.[17]

In the 1920s and 1930s the firm of Herbert Cockshaw Jr.—by 1922 located at 353 Fifth Avenue —was listed in New York business directories under "jewelry manufacturers and wholesale dealers."[18] The company subscribed to new standards for marking gold in 1938.[19] By 1942 it had moved to 15 West Forty-Seventh Street, in the heart of New York's "diamond district," where it remained until at least 1960.[20] Cockshaw retired to California in the early 1970s and died in Scottsdale, Arizona, on March 16, 1981.[21] DLB

1. Marked examples published online include a silver-gilt coin purse with amethysts, http://pinterest.com/pin/152770612330546218; and a silver and marcasite necklace, http://vintagesilverjewelry.net/silver/silver2.html (both accessed December 12, 2016).

2. England and Wales Civil Registration Indexes, General Register Office, London, Ancestry.com; Census Returns of England and Wales, 1851, National Archives of the UK (TNA), Public Record Office (PRO), Ancestry.com; 1900 U.S. Census.

3. 1870 U.S. Census.

4. Brooklyn city and business directory 1876, p. 158.

5. See the obituary "Death of H. Cockshaw," Jewelers' Circular, vol. 97 (November 15, 1928), p. 89. For the partnership of Stephen P. Cox and John W. Sedgwick, see Goulding's New York City directory 1877, vol. 3, pp. 286, 1288; advertisement, Jewelers' Circular, vol. 15 (August 1884), p. xi.

6. Committee of One Hundred on Democratic Re-organization, List of Registered Voters in the City of New York, for the Year 1880 (New York: M. B. Brown, 1881), p. xix-14-1; Selected U.S. Naturalization Records, NARA, Washington, DC, Ancestry.com.

7. Theodore M. Banta, Sayre Family: Lineage of Thomas Sayre, a Founder of Southampton (New York: [De Vinne], 1901), p. 660; death notice of "Sayre," New York Times, March 14, 1925; death notice of Jane H. Cockshaw, New York Times, July 1, 1947; death notice of Dorothy Cockshaw, New York Times, June 11, 1977; Thomas Arthur Ball Jr., Sons of the American Revolution membership application, September 13, 1965, National Society of the Sons of the American Revolution, Louisville, KY (SAR membership no. 93235).

8. As recorded in the Brooklyn and Manhattan directories, Herbert Cockshaw's residences were 264 Twelfth Street, Brooklyn (1876, p. 158); 431 West Fifty-Seventh Street, Manhattan (1880, p. 267); 162 Sixth Avenue, Brooklyn (1888, p. 341); East Orange, New Jersey (1889, p. 347); 58 Montgomery Place, Brooklyn (1891, p. 240); Hotel Marguerite, Brooklyn (1910, p. 262); 323 Garfield Place, Brooklyn (1911, p. 276); 880 Carroll Street, Brooklyn (1913, p. 480); 15 West Seventy-Fourth Street, Manhattan (by 1920, p. 472); 45 East Fifty-Fifth Street, Manhattan (1922, p. 508); and 1 East Seventy-Second Street, Manhattan (1925, p. 592).

9. "Death of H. Cockshaw" (see note 5); obituary, "Death of John T. Howard," Jewelers' Circular, vol. 83 (December 21, 1921), p. 75; Rainwater and Redfield 1998, pp. 159–60.

10. Patents no. 272,829 (February 20, 1883), and no. 1,102,645 (July 7, 1914), United States Patent and Trademark Office, Washington, DC, www.pat2pdf.org (accessed April 10, 2013); Trow's New York City directory 1885, p. 305.

11. Trow's New York City directory 1892–93, p. 249.

12. Fourteenth Annual Report of the Factory Inspector of the State of New York, for the Year Ending November 30, 1899 (Albany: James B. Lyon, 1900), p. 318.

13. "Annual Meeting of the New York Jewelers' Association," Jewelers' Circular, vol. 37, no. 10 (October 5, 1898), p. 19.

14. "Good Work of the Jewelers' Relief Fund Association," Jewelers' Circular, vol. 27 (January 31, 1894), p. 29; "Needs of the Poor Growing," New York Times, February 4, 1894; "Aid Funds Grow as Fast as Ever," New York Times, April 27, 1906.

15. "Death of H. Cockshaw" (see note 5); "Death of John T. Howard" (see note 9).

16. Herbert Cockshaw Jr. attended the Virginia Military Institute in Lexington and served in the U.S. Navy from 1917 to 1919; see Virginia Military Institute Archives, Lexington, www.vmi.edu/archiverosters (accessed April 10, 2013); The Bomb (Lexington: Virginia Military Institute, 1911), p. 49; Beneficiary Identification Records Locator Subsystem (BIRLS) Death File, U.S. Department of Veterans Affairs, Washington, DC, Ancestry.com.

17. 1920 U.S. Census; Polk's Trow's New York City directory 1922, pp. 205, 508; 1925, p. 592; Official Gazette of the United States Patent Office, vol. 273, no. 4 (April 1920), pp. xv, 772; death notice of Herbert Cockshaw, New York Times, November 9, 1928; "Death of H. Cockshaw (see note 5).

18. Polk's Trow's New York City directory 1922, p. 508; The Phillips' Business Directory of New York (New York: John F. White, 1926), p. 565; 1931, p. 508.

19. U.S. Department of Commerce, Marking Articles Made of Karat Gold, Commercial Standard CS67-38 (Washington, DC: U.S. Govern-

ment Printing Office, 1938), p. 8.

20. Manhattan New York City directory 1942, p. 197; 1959, p. 309; 1960–61, p. 313.

21. *Santa Barbara: Gaviota, Goleta, Montecito, Santa Barbara, and Summerland* ([Thousand Oaks, CA]: GTE California, 1972), p. 54; death notice of Dorothy Cockshaw (see note 7); Master File, Social Security Death Index, Social Security Administration, Washington, DC, Ancestry.com; memorial no. 26462365, gravestone of Herbert Cockshaw, Paradise Memorial Gardens, Scottsdale, AZ, www.findagrave.com (accessed December 12, 2106).

Cat. 148

Herbert Cockshaw Jr.

Miniature Frame

c. 1918
Silver gilt with turquoises
MARKS: STERLING [eight-pointed star] / 122 (all incuse, on reverse; cat. 148-1)
Height 2⅞ inches (7.3 cm), width 2¼ inches (5.7 cm)
Gross weight (frame) 2 oz. 10 dwt. 15 gr.
Gift of the Pennsylvania Society of Miniature Painters in memory of Emily Drayton Taylor, bequest of Berta Carew, 1959-91-21

PROVENANCE: Berta Carew; bequeathed in 1956 to the Pennsylvania Society of Miniature Painters; donated by the Society to the Museum in 1959.

Cat. 148-1

Small, relatively inexpensive silver frames such as this example were intended for photographs and sold in large numbers by retail jewelers in the early twentieth century. The miniature painter Berta Carew

(1878–1956) selected this frame for her watercolor-on-ivory portrait *My Mother (Laura Adelaide Colman)*, undoubtedly because the color of the turquoises matched the background hue of the painting. Carew apparently thought Cockshaw's frames complemented her work, as unmarked silver frames with the identical handle and scrolling-leaf pattern are found on other miniatures painted by her between about 1905 and 1930.[1] These frames and other objects made by the firm, such as a "skirt grip" advertised in 1895, were available in a wide variety of finishes: "plain silver, chased silver, silver gilt, plain gold, chased gold, jeweled, etc."[2] DLB

1. In the Museum's collection see the frames on *Self-Portrait in an Old Fashioned Dress* of c. 1905 (1959-91-16), another version of *My Mother (Portrait of Laura Adelaide Colman)* of 1919–20 (1959-91-22), and *Little Mary* of 1920–30 (1959-91-28). The miniatures are catalogued in *Paintings from Europe and the Americas in the Philadelphia Museum of Art: A Concise Catalogue* (Philadelphia: the Museum, 1994), pp. 482–84.
2. Advertisment, *Jewelers' Circular*, vol. 30 (June 12, 1895), p. 34.

Nathaniel Coleman

Cornwall, New York, born 1765
Burlington, New Jersey, died 1842

Nathaniel Coleman (fig. 62), known familiarly as "the Quaker silversmith of Burlington," was somewhat of an antiquarian and a historian who recorded and drew sketches of notable relics.[1] He was the son of Thomas (1732–1797) and Elizabeth Roe Coleman (1731/32–before 1798), first cousins, of Cornwall, Orange County, New York. Born on July 12, 1765, Nathaniel was named for his grandfather Nathaniel Roe (1701–1789).[2] He apprenticed, evidently very successfully, in Kingston, Ulster County, New York, with James Roe, a relative of his mother, who presented him with a "certificate" at the end of the seven years: "May 14, 1783 . . . he hath honestly and faithfully served me as an apprentice seven years to learn the trade (aforesaid): always behaved faithfull, industrious and honest, . . . did punctually observe his duty as an apprentice in his proper time industriously labored and workt [*sic*] at the trade aforesaid, and his demeanor in my family quiet, sober, peaceable and oblidging [*sic*], obedient in all and every part of his duty."[3]

His older brother Samuel, born December 8, 1761, was also a silversmith and eventually joined Nathaniel in Burlington, New Jersey. Samuel married four times, first to Deborah Brown in Cornwall, New York, about 1795. He then married Elizabeth Hampton (died 1836) in 1807 in Wrightstown, Bucks County, Pennsylvania; their three children were born in Trenton between 1808 and 1812.[4] His third wife was Sarah Uncles, whom he married in Burlington; they had one child, Elizabeth. The name of the fourth wife is unknown.[5]

Nathaniel Coleman was in Burlington by 1784 or 1885.[6] In 1791 he joined the Burlington Friends Meeting, and in October of that year he married a widow, Elizabeth Elton Lippincott, as announced in Philadelphia in the *Pennsylvania Mercury* on October 22.[7] Together they had two daughters, neither of whom survived him; his heirs were his wife's daughters from her first marriage to John Lippincott.

The Nathaniel Colemans purchased a house on High Street in Burlington in 1793 and lived there until they died.[8] The "Friendly Institution"

Fig. 62. Nathaniel Coleman. From a portrait owned by the Burlington County Historical Society, Burlington, New Jersey. Published in Carl M. Williams, *Silversmiths of New Jersey, 1700–1825: With Some Notice of Clockmakers Who Were Also Silversmiths* (Philadelphia: George S. MacManus, 1949), p. 28, fig. 8.

of Burlington, founded in the Colemans' house in 1797, was an organization dedicated to the community good, including relief of the poor.[9] Membership carried a pledge to secrecy by the donors as to who received the benefits. Nathaniel's workshop was on the second floor in the back, and a corner fireplace served as the furnace in the production of his silver. In the workshop were the desk and bookcase, serving as his tool case, that William Penn had sent to Pennsylvania as a furnishing for his own house at Pennsbury on the Delaware.[10] Coleman removed the mirrored doors and hung them as looking glasses in his parlor.[11] They were eventually inherited by Elizabeth Coleman's granddaughters, Mary L. Newbold and Elizabeth Nicholson.[12]

Although only bits and pieces of evidence have survived, it has been established that the Colemans were prominent Quakers at the heart of that community in Burlington and were also well-known among Philadelphia Quakers. In the *Pennsylvania Gazette* of September 9, 1801, Nathaniel Coleman in Burlington and John Thompson at 33 South Front Street in Philadelphia placed an advertisement for a "handsome three-story brick house" to be sold or let in the city of Burlington. Nathaniel served as a witness to the will of William Redwood the elder, formerly of Rhode Island but then of Burlington, when he died in 1815.[13] In

May 1818 Coleman had good credit when he borrowed from George Dillwyn, a fellow Quaker: "To cash sent him as per his note $100 £37 10s.—cr. 1818 8 mo.10 By cash [£]18 15s. / 8m. By ditto [£]18 15s."[14]

Nathaniel Coleman died in 1842 and was interred in the Friends Burial ground in Burlington.[15] He had made silver for his family use, and some pieces were identified in his will. A coffeepot, a cream pot, and a pair of salt dishes, which were specifically noted as weighing 40 ounces, were to go to his granddaughter Mary Newbold after the death of her mother. When Elizabeth died in 1845 she further divided the family silver by weight and value among the four children of her daughter, Beulah Lippincott Nicholson.

BBG

1. Coleman's biography was included in early publications; see especially Carl Williams, *Silversmiths of New Jersey, 1700–1825* (Philadelphia: G. S. MacManus, 1949), pp. 24–31). See also Pansylea Howard Wilburn, "Quaker Silversmith of Burlington, New Jersey: Nathaniel Coleman," *Silver Magazine*, vol. 33, no. 1 (January–February 2001), pp. 32–39. Wilburn includes a bibliography, anecdotes, and notes from a lecture given by the New Jersey historian Helen Burr Smith. What follows has been drawn from those publications unless otherwise noted.

2. Coleman and Roe marriage, 1753, Orange County, New York, http://genforum.genealogy.com (accessed February 20, 2014).

3. Text transcribed with no source citation in a letter from John H. Buck, curator, Department of Metalwork, Metropolitan Museum of Art, New York, to Edwin Atlee Barber, director, Philadelphia Museum of Art, November 12/13, 1908, series IIA, Correspondence: 1901–1911, Edwin Atlee Barber Records, Philadelphia Museum of Art, Library and Archives. For Coleman's certificate of commendation from Roe, see "Old American Silver," *Pennsylvania Museum Bulletin*, vol. 7, no. 26 (April 1909), p. 29.

4. The Benjamin Coleman suggested as a relative by Stephen G. C. Ensko and succeeding scholars was indeed related. He was the son of Nathaniel's brother Samuel, born July 4, 1812, in Trenton, New Jersey; Coleman and Roe marriage, 1753 (see note 2).

5. Ibid.

6. Curiously, on June 7, 1786, an advertisement in the *Pennsylvania Gazette* (Philadelphia) was placed by a Nathaniel Coleman: "The public are here informed that good boats are kept at Joseph Crawford's Ferry on the Monogahela [sic] River, about three miles above the old Fort, and 22 miles from Catfish, there are good roads for wagons on both sides of the river. Good attendance and the best of usage, at the lowest rate by June 5, 1786." From 1800 until 1866 there were Nathaniel and Nathan Colemans in Pennsylvania and New Jersey; Orange County, New York; and Brunswick, Virginia. Nathaniel, Samuel, and Joshua Coleman owned land in Irwin, Sandy Lake, and Cool Spring townships, New Jersey, and Nathaniel held public office as a constable in Burlington County from 1811 until 1820; 1811–20 U.S. Censuses.

7. Elizabeth Elton married John Lippincott on August 1, 1782; *Archives of the State of New Jersey*, 1st ser. (Trenton: John L. Murphy, 1909), vol. 22, p. 241, Ancestry.com.

8. The house remains on the site, although it has been altered and is now a jewelry store; "Nathaniel Coleman House," *Historic Burlington City, NJ* (blog), http://burlington1677.blogspot.com/2011/09/nathaniel-coleman-house.html (accessed December 7, 2016).

9. Amelia Mott Gummere, "The 'Friendly Institution' of Burlington New Jersey," *PMHB*, vol. 21, no. 3 (1897), pp. 347–60. The organization was still active as of December 2016.

10. The weathervane on the house bore the date 1722. It was taken down when the house was altered in 1865 and deposited in the

Historical Society of Pennsylvania, Philadelphia. Amelia Mott Gummere and John Woolman, "Friends in Burlington (cont.)," *PMHB*, vol. 8, no. 1 (May 1884), p. 4.

11. Williams (*Silversmiths of New Jersey*, frontis.) illustrates a watercolor showing one of the looking glasses in the Colemans' parlor; formerly John Collins Collection of Drawings, Burlington County Historical Society, Burlington, NJ.

12. Since 1830 a great deal has been written about this desk; John F. Watson, *Annals of Philadelphia: Being a Collection of Memoirs, Anecdotes, and Incidents of the City and Its Inhabitants…* (Philadelphia: E. L. Carey & A. Hart; New York: G. & C. H. Carvill, 1830), p. 732. The desk is now in the collection of and exhibited at the Library Company of Philadelphia.

13. Philadelphia Will Book 5, p. 445. Nathaniel Coleman is also listed, along with Elizabeth Coleman, as a witness for "Sarah Kerlin," Philadelphia Will Book 6, 1815, p. 28.

14. George Dillwyn, Account Book, 1793–1820, Cox-Parrish-Wharton Papers, 1700–1900, vol. 19, HSP.

15. Rowland J. Dutton, "Friends' Burial-Ground, Burlington, New Jersey," *PMHB*, vol. 24, no. 2 (1900), p. 153.

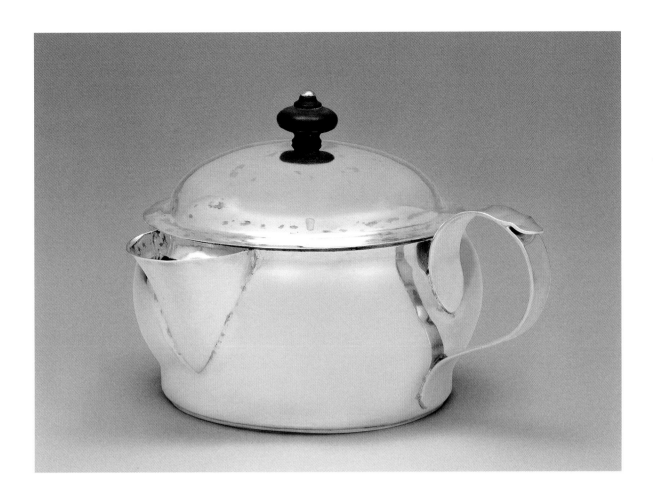

Cat. 149

Nathaniel Coleman

Saucepan

1819

MARK: N·COLEMAN (in rectangle, on underside;
cats. 149–1, 151–1)

INSCRIPTION: N C. to H. C. Newbold 12 Mo 22" 1819.
(engraved script in scribed lines encircling centering dot,
on underside; cat. 149–1)

Height 3^{9}/$_{16}$ inches (9.1 cm), width 5^{3}/$_{8}$ inches
(13.7 cm), diam. 4^{7}/$_{8}$ inches (12.4 cm)

Gross weight 6 oz. 1 dwt.

Purchased with the Joseph E. Temple Fund, 1909–129,a

PROVENANCE: The careful engraving on the underside of
this saucepan documents a gift from Nathaniel Coleman to
his daughter Hannah Coleman (1793–1822), who

married Joseph W. Newbold (1794–1822) on March 4,
1819, in Burlington, New Jersey.[1]

PUBLISHED: "Old American Silver," *Pennsylvania Museum
Bulletin*, vol. 7, no. 26 (April 1909), p. 29.

Although there are no insulators on the flat handle,
the lid of this saucepan has a turned wooden knob
and is removable, suggesting that this small vessel
was used to serve a hot gravy or sauce. There is a
strainer inside the spout. BBG

1. "Old American Silver," *Pennsylvania Museum Bulletin*,
vol. 7, no. 26 (April 1909), p. 29; life dates for Joseph New-
bold vary in the following two sources: Rash's Surname
Index, www.pennock.ws/surnames (accessed December
12, 2016); *The Coleman Family: Descendants of Thomas
Coleman, 1598–1867* (Philadelphia: Lippincott, 1867).

Cat. 149–1

Cat. 150

Nathaniel Coleman

Four Teaspoons

1820–30

MARK (on each): N·C (in rectangle with serrated left edge, twice on reverse of stem; cat. 150-1)
INSCRIPTIONS: (1932-45-9a,b,d) T (engraved script, at top of obverse of handles). (1932-45-9c) R J (engraved script, at top of obverse of handle)
Maximum length 5¼ inches (13.3 cm)
Weight 10 dwt. 9 gr. to 11 dwt.
Bequest of Lydia Thompson Morris, 1932-45-9a–d

PROVENANCE: Descended in the donor's family.

Cat. 150-1

The spoons have down-turned handles with only a hint of a midrib on the reverse. The tapering drop is blunt ended.

The initials "RJ" on one spoon belonged to Rebecca Chalkley James (born c. 1753), daughter of the Quakers Abel and Rebecca Chalkley James, who had married in 1747. The younger Rebecca married John Thompson in 1782. The initial "T" on the three other spoons noted Thompson ownership and may have been made to match the one engraved "RJ." The spoons descended to their daughter Rebecca Thompson (1811–1881), who married Isaac Paschall Morris (1803–1869) at the Orange Street Friends Meeting on November 17, 1841, and then to their daughter Lydia Thompson Morris, the donor.[1] BBG

1. Moon 1898–1909, vol. 2, p. 693. For another piece of silver in the Museum's collection that descended in this family, see the salver by Jeremiah Elfreth (cat. 232).

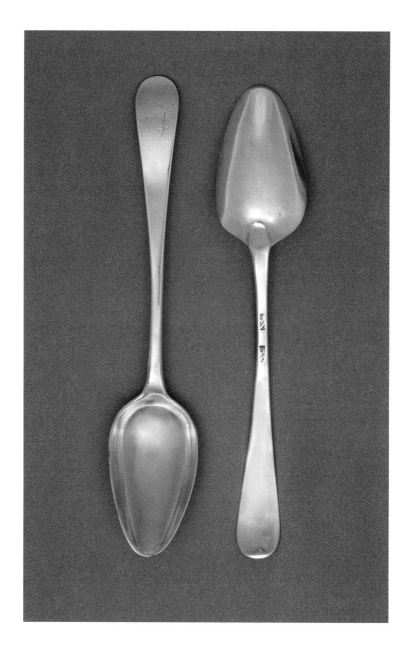

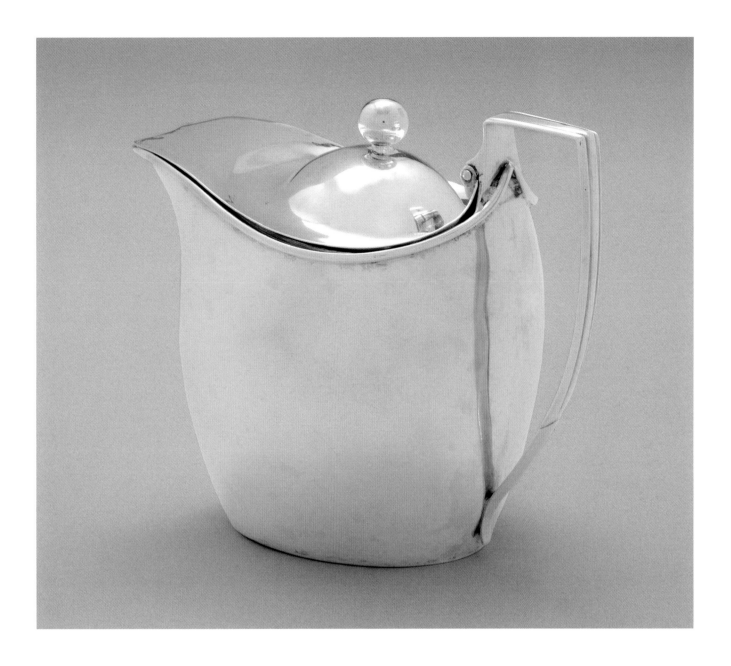

Cat. 151

Nathaniel Coleman

Syrup Jug

1832

MARK: N·COLEMAN (in rectangle, on underside; cats. 149-1, 151-1)

INSCRIPTION: Coleman / 7 MO 12 . . 1832 (engraved script, on underside; cat. 151-2)

Height 4¹/₁₆ inches (10.3 cm), width 4¾ inches (12.1 cm), depth 3⅛ inches (7.9 cm)

Weight 5 oz. 10 dwt. 4 gr.

Purchased with the Joseph E. Temple Fund, 1909–130

PROVENANCE: This jug was made for use by Nathaniel Coleman's own family. The dated inscription marked Coleman's sixty-seventh birthday.[1]

PUBLISHED: "Old American Silver," *Pennsylvania Museum Bulletin*, vol. 7, no. 26 (April 1909), p. 29.

Cat. 151-1

The lid fits tightly into the concave shape of the upper rim, securing the contents from bugs or bees. Syrup and honey were not cold stored, as were milk and cream, so the hinged lid was a necessity. BBG

1. Carl M. Williams, *Silversmiths of New Jersey, 1700–1825* (Philadelphia: G. S. MacManus, 1949), p. 25.

Cat. 151-2

Albert Coles & Co.

| Long Island, New York, born c. 1812
| New York City, died 1885

Albert Coles—his genealogy, work, partnerships, and business as a silversmith in New York—is the subject of a four-part study by D. Albert Soeffing.[1]

Albert Coles (c. 1812–1885) was born to Joseph and Sarah Shute Coles, probably about 1812, one of ten children.[2] The family can be identified with the earliest settlement of Massachusetts and, in the seventeenth century, on Long Island. Albert married twice, to the sisters Catherine Harris (died 1849) and Mary Elizabeth Harris, who survived him, as did three children. Various family members joined the business: two sons by his first wife, Albert L. Coles and Henry Hamilton Coles (died 1873); a George Coles from Pennsylvania; two nephews, Gilbert E. Coles and William L. Coles; and Robert A. Coles, J. L. Coles, and D. H. Coles. Some had apprenticed in the Coles manufactory.

The New York City directory first lists Albert Coles, silversmith, in 1835, and he operated alone until 1850, when he partnered with his nephew William L. Coles and the listing became Albert Coles & Co. In the early years they employed about fifteen men, but by 1860 they employed twenty-five. From 1868 to 1872 Albert Coles partnered with Elisha W. Manchester. Thereafter he was listed as sole owner and manufacturer. He advertised regularly. The location of his business, both the manufactory and retail shop, never changed, although his first address, 6 Little Green, became 4 Liberty Place in 1849. Thereafter, Coles's addresses were consistently at Liberty Place, a building owned by the Platt family of Long Island, who were later related to Coles through marriage. Liberty Place was also occupied by other silversmiths and jewelers.

In 1872 Albert Coles and his son Henry and family were living at 255 West Thirty-Ninth Street. Albert's will noted that he owned pew number 79 at the Church of the Incarnation at the corner of Thirty-Fifth Street and Madison Avenue. He produced high-quality objects, especially flatware, for which he won awards in 1843

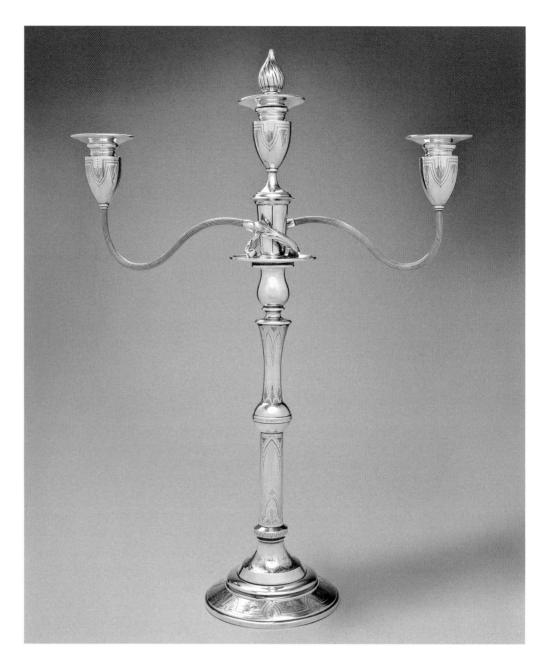

and 1847, and smalls such as matchboxes, filigree bouquet holders, nutmeg graters, thermometers, christening cups, and coffin plates.

In 1877 Coles retired and sold his business to Samuel Montgomery, who had been a worker at the factory. Coles's third pseudo-hallmark, identified by a male bust facing left, continued to be used by Morgan Morgans Jr.[3] BBG

1. D. Albert Soeffing presented new information, corrected the past record, and made deductions and suggestions where the record was incomplete. Soeffing, "Albert Coles, Silversmith of New York City," pt. 1, *Silver Magazine*, vol. 32, no. 4 (July–August 2000), pp. 34–37 (including a transcript of Cole's will); pt. 2, "The Marks," vol. 32, no. 5 (September–October 2000), pp. 36–41; pt. 3, vol. 32, no. 6 (November–December 2000), pp. 38–41; pt. 4, vol. 33, no. 1 (January–February 2001), pp. 28–31.

2. A death certificate suggested a birth date of 1815; ibid., pt. 1, p. 34. For a similar example of the difficulty of establishing birth dates based on official records, see the biography of James E. Caldwell (q.v.).

3. Soeffing named this bust "pig tail man"; ibid., pt. 2, p. 37.

Cat. 152
Albert Coles & Co.
Candelabrum

1860–70
MARK: [eagle] (in oval) / <u>A</u> / C (in lozenge) / [profile head facing right] (in oval, on underside; cat. 152-1)
Height 22¼ inches (56.5 cm), height stick 14¼ inches (36.2 cm), width 15 inches (38.1 cm), diam. base 5⅞ inches (14.9 cm)
Weight 33 oz. 8 dwt.
Gift of Mr. and Mrs. I. Wistar Morris III, 1988-89-4a–c

The pseudo-hallmark on this candelabrum was the second of three that Albert Coles used as his manufactory marks. In this case it is not accompanied by one of his incuse name stamps. If the object had been made by a neighboring shop, it would not bear the pseudo-hallmark, but rather an incuse name mark as retailer. Soeffing identifies this mark as the "funny face man" and suggests that

Benjamin Franklin may have been the model.[1] Hollowware, or large objects such as this candelabrum, bearing Coles's manufacturing marks are rare.[2]

The surfaces on this graceful candelabrum are chased with Persian motifs, including varying shapes of the palmetto leaf. There are multiple bands of stipple work outlining other motifs. The swirling arms of the candelabrum are fitted at the ends with cups and bobeches, and the cast flame-shape finial at the center can be removed and replaced with another candle. BBG Cat. 152-1

1. "The bug-eyed little portrait is probably Benjamin Franklin"; D. Albert Soeffing, "Albert Coles: Silversmith of New York City," pt. 2, "The Marks," *Silver Magazine*, vol. 32, no. 5 (September–October 2000), pp. 37–39. The "bug eyes" are possibly an attempt at spectacles.
2. "It is doubtful that Coles ever produced any large hollowware"; ibid., pt. 4, *Silver Magazine*, vol. 33, no. 1 (January–February 2001), p. 28.

Cats. 153, 154

Albert Coles & Co.

Tablespoon

c. 1864–70
MARKS: [eagle] (in oval) / A / C (in lozenge) / [profile head facing right] (in oval, on back of handle; cat. 153-1)
INSCRIPTION: A A R (engraved script monogram, lengthwise on front of handle)
Length 8¼ inches (21 cm)
Weight 1 oz. 18 dwt.
Gift of Stewart G. Rosenblum in memory of his aunt, Gertrude I. Gordon, 2011-15-3
PROVENANCE: Ruth T. Marsh, Bedford, New York, estate sale, April 23, 2010.

Fork

1870–77
MARKS: [eagle] (encircled) / A / C (in lozenge) / [profile head facing left] (encircled; cat. 154-1); A. COLES (incuse) (all on back of handle; cat. 154-2)
INSCRIPTION: TD (engraved script monogram, lengthwise on front of handle)
Length 6¾ inches (17.2 cm)
Weight 1 oz. 8 dwt. 14 gr.
Gift of D. Frederick Baker from the Baker/Pisano Collection, 2016-134-14

Cat. 154-2

The beading and female mask on this handle design were details inspired by motifs from English Renaissance architecture and metalwork, grafted onto a threaded oval pattern.[1] *Kenilworth*, the name of

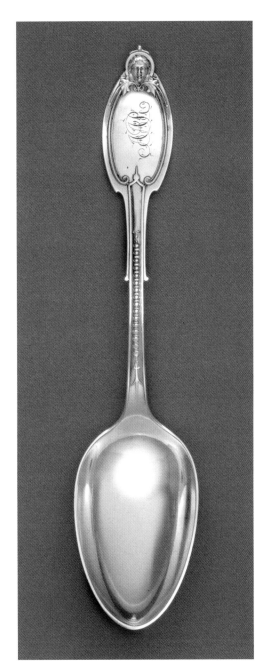

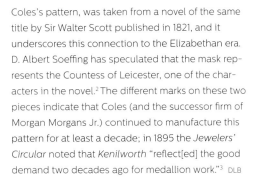

Cat. 153-1

Coles's pattern, was taken from a novel of the same title by Sir Walter Scott published in 1821, and it underscores this connection to the Elizabethan era. D. Albert Soeffing has speculated that the mask represents the Countess of Leicester, one of the characters in the novel.[2] The different marks on these two pieces indicate that Coles (and the successor firm of Morgan Morgans Jr.) continued to manufacture this pattern for at least a decade; in 1895 the *Jewelers' Circular* noted that *Kenilworth* "reflect[ed] the good demand two decades ago for medallion work."[3] DLB

1. See also the serving spoon by R. & W. Wilson (PMA 2000-130-22).
2. D. Albert Soeffing, *Silver Medallion Flatware* (New York: New Books, 1988), p. 32.
3. For dating these two marks, see D. Albert Soeffing, "Albert Coles, Silversmith of New York City," pt. 2, "The Marks," *Silver Magazine*, vol. 32, no. 5 (September–October 2000), pp. 39–40; "The Spoon Patterns of American Silversmiths, Part V," *Jewelers' Circular*, vol. 30 (May 8, 1895), p. 21.

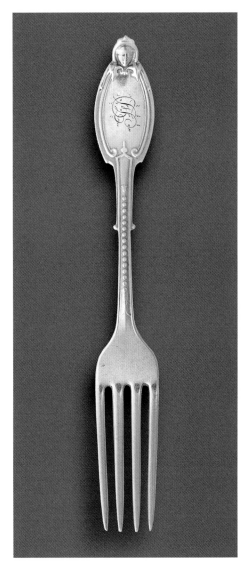

Cat. 154-1

Colette

| Oakland, California, born 1937

The artist uses the mononym Colette in the context of her artistic output. Born in 1937 as Colette Reay Burns in Oakland, California, she grew up in a musical and artistic home. Her grandmother was a concert pianist, and an uncle was a graduate of the California College of Art and Craft (CCAC; now the California College of the Arts).[1] According to the artist she attended too many high schools to mention and a junior college for a short time. She audited art classes at the University of California, Berkeley, and unofficially sat in on classes at CCAC. Colette's artistic career began in the early 1950s with fiber-based work, mainly wearable art. She began selling her work by renting a small shop behind Caffe Mediterraneum, a notable coffeehouse in Berkeley.[2] As politics heated up around the People's Park movement in the late 1960s, Colette and her family moved to Mendocino, California, and built a transparent dome as their dwelling in the woods.[3]

Heavily influenced by her surroundings, she began making textiles characterized by motifs from nature. Her large appliquéd wall hangings were first sold locally through the county library. The Julie Artisans Gallery (1973–2013) in New York also began exhibiting her wall hangings.[4] Eventually Colette began making elaborate cloaks, which became part of Art to Wear, the wearable fiber movement of the 1970s and early 1980s. Having finished the first cloak, she was in need of a special button for the clasp. Colette became aware of Mimi Sheiner's (born 1950) enameled metalwork through *Four County Artists*, a group exhibition at the Mendocino County Museum in Willits, in the fall of 1973, in which her fiber art was included.[5] Sheiner, who lived in a nearby commune, gave Colette two lessons in enameling. Colette then made two more cloaks, these with proper enameled clasps, and sold them through the Julie Artisans Gallery to the recording artists Elton John and Roberta Flack.

Colette, who considers herself an autodidact, began exploring cloisonné enameling and exhibited widely throughout the United States in jewelry exhibitions at major museums and in distinguished galleries.[6] Her enamels were acquired by both private and public collections, including the Oakland Museum of Art, the Museum of Fine Arts, Boston, the Museum of Arts and Design, New York, and the Royal Ontario Museum, Toronto. In 1978 the enamels she exhibited in the fourth international Biennial Festival of Enamel in Limoges, France, received the Prix d'honneur.[7] In the 1980s Colette's designs became more elaborate, and she hired Jennifer Banks, a recent graduate of CCAC, to create the intricate metalwork settings. Depending on Colette's projects, she has hired artists such as Kent Raible, David Boye, and Garry Knox Bennett to do various fabrications both large and small. Currently residing and working in Berkeley, Colette still does a small amount of enameling, but is now devoting most of her time to painting. ERA

1. Colette, email message to the author, April 7, 2014; State of California, California Birth Index, 1905–1995 (Sacramento: State of California Department of Health Services, Center for Health Statistics), Ancestry.com. Colette Burns married Robert S. Denton in 1964; State of California, California Marriage Index, 1960–1985 (Sacramento: California Department of Health Services, Center for Health Statistics), Ancestry.com.

2. Caffe Mediterraneum, known as The Med, was located at 2475 Telegraph Avenue, and considered the center of Berkeley's free speech and beat movements; www.berkeleyside.com/2014/07/02 /berkeleys-iconic-caffe-mediterraneum-is-up-for-sale; http:// caffemed.com (both accessed September 18, 2017).

3. Their small commune consisted of Colette's daughter Michele Lomax, partner Dennis Fischer (a woodworker), his sister Wendy Cragg (a quilt maker), and her partner Larry (a musician). Colette, email, April 7, 2014.

4. According to the artist's curriculum vitae, she had an exhibition at the Julie Artisans Gallery in New York in 1978; Colette, email message to the author, April 7, 2014.

5. Ann Sampson, "Local Women Displaying Art at County Museum," *Ukiah (CA) Daily Journal*, November 28, 1973; curricula vitae provided by the artist, 1996 and 2009.

6. Enamel Arts Foundation, The Collection, s.v. "Colette," www.enamelarts.org (accessed December 20, 2016).

7. Thomas Farber, "Colette: Beneath the Surface," Colette Studio, http://colette-studio.com (accessed December 20, 2016).

Cat. 155

Colette

Pendant No. 2, from the *Handpiece* series

1978
Gold with cloisonné enamel decoration, silver, amethyst
MARK: Colette (engraved script, on reverse at bottom edge; cat. 155-1)
Height 3 15/16 inches (10 cm), width 1 3/4 inches (4.5 cm), depth 5/16 inch (.8 cm)
Gross weight 2 oz. 9 dwt. 6 gr.
Gift of Mrs. Robert L. McNeil, Jr., 1995-75-1

EXHIBITED: Sign of the Swan Gallery, Philadelphia, 1979; *Wrought and Crafted: Jewelry and Metalwork, 1900 to the Present*, Philadelphia Museum of Art, May 8, 2009– February 2, 2010.

Cat. 155-1

Pendant No. 2 is an example of Colette's early cloisonné enamel jewelry, which showcased her ability to apply brilliant colors. The dense and colorful imagery was created on a silver base by using very thin, hand-rolled gold wire to encapsulate layers of fused glass. The composition, framed in the shape of a human hand, depicts a bird in flight over a night sky, hieroglyphics, human tears, lips, and sperm. An amethyst is set outside the frame and attached to the outer edge. The artist notes, "One can see the influence of ancient Egyptian culture. As a child I was totally immersed in all things of that culture."[1] Confined by the limits of this intensely compressed format, Colette employs a vocabulary of recurring symbols and personal iconography. She incorporates ideograms of jeopardy, loss, and love. Her work, she observes, is derived "from [her] desire to state in visual and palpable terms the paradoxes [we live with]: exaltation and sorrow; tension and relief; rationality and passion; the physical and the transcendent."[2] She began the *Handpiece* series in 1976 and concluded it around 1980.[3] ERA

1. Colette, email message to the author, November 19, 2009.
2. Artist's statement, n.d., curatorial files, AA, PMA.
3. Colette, email message to the author, January 3, 2015.

Simeon Coley

England, born c. 1725
Enfield, Middlesex, England, died 1798

Simeon Coley registered his first silver-smith's mark and gained his freedom in London as a small worker in 1761; he registered his second mark, also in London, in 1763.[1] The Coley family—Simeon, his wife Elizabeth (died 1778) and probably his young son Simon Coley Jr. (1752–1810), a daughter Hannah, his sister Elizabeth (died 1794), and his eldest son, William Coley (1745–1843)—arrived in New York sometime in the mid-1760s. They may have come expecting to benefit from the growing markets in America. Simeon belonged to the Moravian Church, which was well established in America; his immigration may have had a missionary purpose as well.

In New York Simeon and William worked together until September 11, 1766, when they parted company.[2] It is tempting to blame the breakup on a generational dispute exacerbated by the political ferment surrounding the Townshend Acts and the resulting non-importation agreements. Merchants in New York were slow to adopt the agreements and did not adhere rigorously to the boycott of English goods.[3] Simeon Coley seems to have treated the agreements casually or possibly disregarded the ban on importation, defying the authorities almost immediately. His advertisements regularly carried the increasingly offensive phrase "Lately Imported from London." He remained a silversmith in New York and joined in other partnerships.

By March 1767 Simeon had set up his own shop and advertised from his new location with a rather smug comment about the repeal of the Stamp Act and the continuing non-importation pledge by merchants: "In Commemoration of the Publick's fast friend, The Right Honourable WILLIAM Earl of Chatham, by whole noble Espousal of BRITISH LIBERTY, the fatal *Stamp-Act* was repealed the EIGHTEENTH of MARCH, 1766. / SIMEON COLEY / Gold-Smith, and Jeweller, from London, HAS made several very neat Fancy-Rings, to be worn on the above happy occasion, which may be had at his shop near the Merchant's Coffee-House. Said COLEY, makes all sorts of large and small Plate, Mourning Rings, &c. &c. / New-York, 16th march, 1767."[4] Coley continued to advertise in the *New-York Gazette and Weekly Mercury* as "goldsmith from London at his Shop near the Merchant's Coffee House by the Ferry stairs." From May 25 through June 1, 1767, and into October, his advertisements listed quantities of English imported items: cases of silver-handled knives, "Cutto's De Chase with Silk Morocco, and Calf Belts . . . Gilt Buckles, neat Plated bits and Sturups, with all sorts of Silver Work as usual. N.B. The best Lind violins, German Flutes, tipt and plain, Fifes, Tabors and Pipes, with books of Instruction."[5]

Although his advertisements abated, Coley must have continued his conspicuous importing, even though the non-importation agreements remained in force and were increasingly in the news and conversation. In July 1769 Coley was publicly denounced by the Committee of Merchants in New York:

The Conduct of Simeon Cooley [*sic*], in his daring Infractions of the Non-Importation Agreement; his insolent and futile Defence of those inglorious measures; with his avowed Resolution obstinately to persevere in counteracting the legal Efforts of a brave and free People in support of their inestimable Rights "alarmed and insenced [*sic*]" the Inhabitants of this City, who dreading the destructive Consequence that might have ensued from so dangerous an Example, determined, at a General Meeting held on Friday Evening last, to call the said Cooley to Account; and prevail on him, IF POSSIBLE, to desist from his vile Practices, and endeavour to bring him to such Concessions as should to them appear best calculated to atone for his repeated and unprecedented Offences. Two Gentlemen were appointed to inform him of the Sentiments of the Inhabitants, who required his immediate Attendance at their Place of Meeting, and to assure him that no injury should be offered to his Person; (to prevent which, every imaginable Precaution was taken) by Cooley, (influenced perhaps by some ill-disposed STUPID ADVISER) refused to attend the Place appointed, and alleged in Excuse for his Non-attendance, "that he did not think "it consistent with his personal Safety to meet them THERE," at the same Time he expressed a Willingness to make the Concessions required, from his Parlour Window. When the Inhabitants received this disagreeable Intelligence, they immediately proceeded towards his House; but Cooley, apprized of their coming, thought proper to decamp, accompanied by a Military Gentleman, (who covered his Retreat) sought for a Sanctuary within the Fort Walls, which could afford him but an indifferent Protection against the keen Reproaches of a guilty Conscience, the only Punishment he had to dread. Whilst the Inhabitants

were assembled in the Fields, M—r P—r ordered a File of Soldiers to guard his (Cooley's) House, who were accordingly drawn up before his Door, with their Musquets loaded, &c. Whether the Author of this unwarrantable Step, designed a compliment to the Magistracy and Inhabitants of this City, or to recommend himself to his Superiors by his officious and blundering Zeal, is unknown: but 'tis more than probable, that his precipitate Conduct was disapproved of by the latter, . . .

On Saturday Morning, Cooley consented to meet the Inhabitants; and Four in the Afternoon being the Time appointed, and the Merchant's Coffee-House the Place, they assembled in Expectation of this important Event; but the Majority thinking it a very unsuitable Place for the Purpose, required his Appearance in the Fields, where he attended, and publickly acknowledged his Crimes; implored the Pardon of his Fellow Citizens; engaged to store an Equivalent to the Goods he had sold, together with all those he had in Possession that were imported contrary to Agreement; and so to conduct for the future as not to render himself obnoxious to the Contempt and just Resentment of an injured People.[6]

This provoked a prompt response from Coley: "TO THE PUBLIC / As I am convinced that my refusing to store my Goods, was wrong; I do promise and consent, That they shall be deposited in the public Store with other Goods which were imported contrary to the *Non-importation Agreement;*—which I hope will appease the Minds of my injured Fellow Citizens, and convince them that I do not regard sacrificing my private Interest for the *Good of the Public.* / SIMEON COLEY / New-York 21st July 1769; Afternoon, 2 o'clock."[7]

On September 11, 1769, he announced in the *New-York Gazette and Weekly Mercury* that he "[b]egs to inform the Public, that he intends to leave this City this Month, with his family; —he humbly intreats [sic] all that stand indebted to him to settle their Accounts directly; —all those that have any Demands upon him are desired to call, and they shall be paid. Sept. 4 1769." Coley returned to England, and from 1790 until 1793, Coley & Son were working silversmiths at 35 Fetter Lane, London.[8]

Other New York connections developed that may have reinforced Simeon's Loyalist position. Gerard Gerrit Lydecker (1729–1794) married Simeon Coley's sister Elizabeth in New Jersey on August 6, 1770.[9] The Lydeckers had been landowners by patent in Long Island, New York, and in New Jersey in the seventeenth century. They moved from one place to the other and sold some of their property.[10] Gerard Lydecker joined the Dutch Church in 1752. He attended Princeton University and was ordained in the conservative

branch of the church. A Loyalist during the Revolutionary era, Lydecker was considered the most outspoken Tory of them all. He and his family returned to England in 1783.[11]

Coley's wife had died in 1778, and at the time he wrote his will in 1798, his son Simeon junior was an established goldsmith and jeweler on Fetter Lane, and his two daughters, Elizabeth Amelia and Elizabeth, born after his return to England, were under twenty-one and unmarried. William was not mentioned.[12] Simeon Coley left a considerable estate, valued in the hundreds of pounds, which he specified to be invested in "The Funds" for the benefit of his children and to continue on to their children. If the girls' lines died out lacking heirs, the remainder of the estate would revert to his son Simeon and his heirs. Simeon Coley died a gentleman of Enfield, Middlesex, England, on June 9, 1798.[13] BBG

1. Arthur G. Grimwade, *London Goldsmiths, 1697–1837: Their Marks and Lives* (London: Faber and Faber, 1976), pp. 468–69.

2. Advertisement, *New-York Gazette, or The Weekly Post-Boy*, September 11, 1766. The partnership mark is "C / W S" in an oval, which offers the possibility that William was the senior in the partnership. In 1801 William was at 191 Washington Street, and in 1804 at 64 Ann Street; Stephen Ensko, *American Silversmiths and Their Marks* (New York: privately printed, 1927) p. 81.

3. "New York Merchants Non-importation Agreement; October 31, 1765," The Avalon Project: Documents in Law, History and Diplomacy, http://avalon.law.yale.edu (accessed March 18, 2014).

4. *New-York Gazette and Weekly Mercury*, March 9–16, 1767.

5. Ibid., May 25–June 1, 1767.

6. Ibid., July 24, 1769.

7. Ibid., July 22, 1769; Library of Congress, Printed Ephemera Collection, portfolio 103, folder 25.

8. Ambrose Heal, *The London Goldsmiths, 1200–1800: A Record of the Names and Addresses of the Craftsmen, Their Shop Signs and Trade Cards* (1935; repr., Newton Abbot, England: David & Charles Reprints, 1972), p. 128.

9. Robert C. Lydecker, "Lydecker Descendants: Ryck Lydecker, 1650," typescript, Short Hills, NJ, 1987, p. 31. I am indebted to Mary Collins, librarian of the Holland Society of New York, for making this and other Lydecker documents available for study. New Jersey marriage records suggest another Coley family: "Garrit LYDECKKER (LYDEKKER) and John COLEY, both of Hackensack in the County of Bergen . . . [bound to] . . . William FRANKLIN, Governor . . . 500 pounds . . . 6 Aug 1770. . . . John COLEY . . . obtained license of marriage for Garrit LYDECKKER . . . and for Elizabeth COLEY of the county afores'd. . . . [w] blank"; Early New Jersey Marriages—Extracts, no. 242, http://files .usgwarchives.net (accessed June 4, 2015). John Coley obtained the marriage license for Garret Lydecker and for Elizabeth Coley; Index to Marriage Bonds and Marriage Records in the Office of the Secretary of State at Trenton, NJ, http://files.usgwarchives .net (accessed June 4, 2015).

10. A William Coley placed the following advertisement in the *New-York Gazette and Weekly Mercury* on July 24, 1769: "To be sold or Let . . . the farm whereon Mr. William Coley now lives, pleasantly situated for a gentleman's country seat, merchant or farmer, on the North side of Hempstead-Plains, on Long island." This was the area of Lydecker land, but whether this William Coley was the silversmith has not been investigated. For a description of the Lydecker land on Long Island, see Lydecker, "Lydecker Descendants," pp. 7–8.

11. Lydecker, "Lydecker Descendants," p. 30.

12. Their relationship has not been firmly established as father

and son. William may have been a nephew. He was too young to have been Simeon's brother.

13. Will of Simon [sic] Coley, Silversmith Gentleman of Enfield, Middlesex, National Archives of the United Kingdom, PROB 11/1307/260; photocopy, curatorial files, AA, PMA. The will was probated and verified June 7, 1798: "Appeared personally, William Allen of King's Road, Bedford Row in the County of Middlesex, coachmaker and John Jefferson of Fetter lane London, afterwards of Enfield in the County of Middlesex and late of Rosamond Street in the Parish of St. James Clerkenwell, City of Middlesex for several years before and to the time of his death."

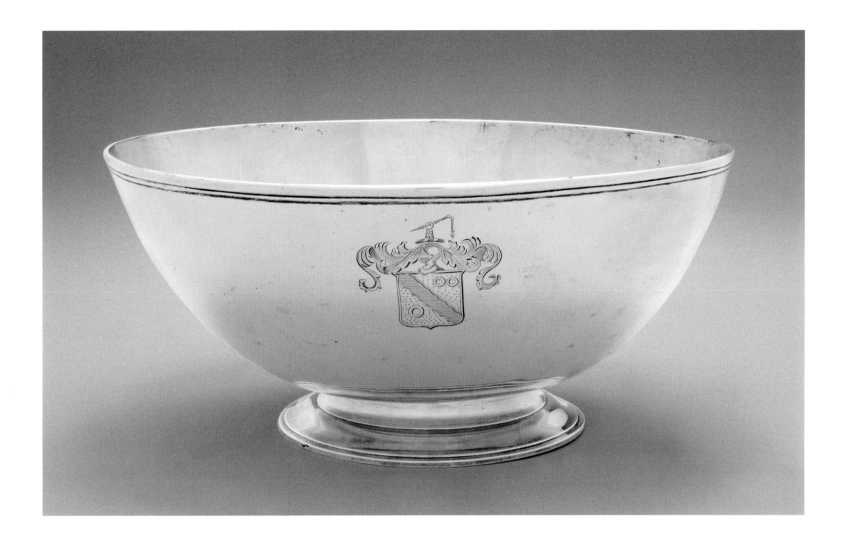

Cat. 156

Simeon Coley
Punch Bowl

1764–66

MARK: SC (in rectangle with chamfered corners) /
N-York (in rectangle, all on underside; cat. 156-1)
INSCRIPTION: [coat of arms and crest]
Height 4$^{15}/_{16}$ inches (12.6 cm), depth 10$^{7}/_{8}$ inches
(27.6 cm), diam. foot 5$^{1}/_{2}$ inches (14 cm)
Weight 43 oz. 10 dwt.
Gift of Susanne Strassburger Anderson, Valerie Anderson
Readman, and Veronica Anderson Macdonald from the
estate of Mae Bourne and Ralph Beaver Strassburger,
1994-20-77

PUBLISHED: Peter Thompson, *Rum Punch and Revolution*
(Philadelphia: University of Pennsylvania Press, 1999),
p. 4.

Cat. 156-1

Simeon Coley trained in London, and his mark on
the underside of this bowl is the one he registered at
Goldsmith's Hall, London, on April 7, 1763.[1] The ser-
ifs are clear on the "S" but not on the "C." The mark
as illustrated by Arthur Grimwade does not seem
to have chamfered or rounded corners, as this one
clearly does. Coley's advertisement in the *New-
York Gazette* for March 9–16, 1767, notes that "Said
COLEY, makes all sorts of large and small Plate."

This is an unusually large bowl, even for punch.[2]
The mercury gilding on the interior is consistent
with the period of the bowl. There is a centering dot
on the interior, which is not covered by the gild-
ing. The round foot is a heavy casting and has been
reattached with uneven soldering. The applied rim
molding has slightly split where the ends join. The
armorials are twentieth-century but may replicate
earlier engraving that was removed when the bowl's
exterior was buffed. The crest, "an arm in amour
grasping in the hand a broken spear, all proper," was
the ancient crest of the Ferguson family of London.[3]
The arms, *Or, a bend engrailed azure between three
annulets argent*, have not been identified. BBG

1. Arthur G. Grimwade, *London Goldsmiths, 1697–1837: Their
Marks and Lives* (London: Faber and Faber, 1976), p. 180,
cat. 2492. The first mark registered was "S·C" in a rectangle.
Although the strike is not perfect, the mark on this bowl has
no evidence of a pellet.
2. For another, smaller bowl by Coley, see Christie's, New
York, *Important American Furniture, Silver, Prints, Folk Art
and Decorative Arts*, January 21–22, 1994, sale 7820, lot 117.
The bowl is marked "S.Coley" and measures 3 1/2 inches
high and 8 7/8 inches in diameter.
3. James Fairbairn, *Fairbairn's Book of Crests of the Fam-
ilies of Great Britain and Ireland* (London: TC & EC Jack,
1951), vol. 1, p. 198, pl. 210, no. 9. The New York Public Library
has a collection of papers from the Ferguson family of New
York; Ferguson Family Papers, 1727–1943, Manuscripts and
Archives Division, New York Public Library.

John Coney

Boston, born 1655/56
Boston, died 1722

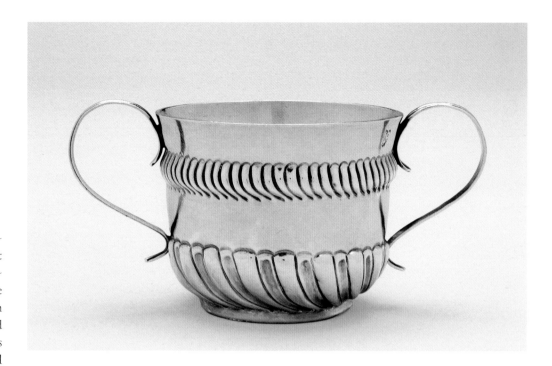

John Coney, an early and prolific silversmith in Boston, has been the subject of articles, monographs, and full biographies by eminent historians since American silver has been celebrated. Hermann Frederick Clarke's *John Coney: Silversmith* of 1932 and Patricia Kane's *Colonial Massachusetts Silversmiths and Jewelers* of 1998, should be consulted for a full appreciation of Coney's prominence as a craftsman.[1] The foremost silversmith in Boston during his active years, Coney ran a large silver workshop, which included numerous apprentices. His early designs were reminiscent of seventeenth-century English forms, especially his caudle cups, casters, chafing dishes, monteiths, and salvers. Coney supplied local and regional private patrons as well as fulfilling commissions for Harvard College and the Artillery Company. He also engraved the plates for bills of credit for the Province of Massachusetts. Extant records of his patrons reveal that many paid at time of purchase, in cash.

John Coney was born in Boston on January 5 in either 1655 or 1656. He apprenticed with Jeremiah Dummer (1645–1718). In 1677 he married Dummer's wife's cousin, Sarah Blakeman (1658–1694), with whom he had nine children. Coney belonged to the Old South Church but was a subscriber to the building fund of the King's Chapel of the Anglican Church in 1694. He married for the second time, also in 1694, Dummer's sister-in-law Mary Atwater Clark. They had six children and were members of the First Church. Coney owned city property that included a warehouse and wharf in 1704.

Coney died in Boston on August 20, 1722. He was survived by his widow Mary, who acted as executor to his will. His inventory, taken in October 1722, was long and complete, especially the list of tools, and included the note "Paul Rivoire's Time about Three Years and half as Indenture £30."[2] The total value of the estate was £3,714 2s. 11½d. BBG

1. A complete biography, together with a descriptive list of objects extant and patrons known, is included in Kane 1998; see also Hermann F. Clarke, *John Coney: Silversmith, 1655–1722* (Boston: Houghton Mifflin, 1932).

2. Paul (or Apollos) Rivoire was the father of Paul Revere Jr. (q.v.).

Cat. 157

John Coney
Caudle Cup

1690–1705

MARK: IC (over fleur-de-lis in heart shape, on underside and one side; cat. 157-1)

INSCRIPTION: I I [subsequently altered to] NR (conjoined) D P (all engraved, on underside); 2 oz. 10 dwt. (scratched, on underside)

Height 2⅜ inches (6 cm), diam. 3 inches (7.6 cm)
Weight 2 oz. 9 dwt. 2 gr.

On permanent deposit from The Dietrich American Foundation Collection to the Philadelphia Museum of Art, D-2007-38

PROVENANCE: Sotheby's, New York, *Important Americana*, January 30–February 1, 1986, sale 5429, lot 403; Mr. and Mrs. Eddy G. Nicholson, Portsmouth, NH; Christie's, New York, *Important American Furniture, Silver, Prints, Folk Art and Decorative Arts*, January 21–22, 1994, sale 7820, lot 114; (Jonathan Trace, Putnam Valley, NY).

EXHIBITED: *Early American Silver from the Collections of H. Richard Dietrich, Jr. and the Dietrich American Foundation*, Yellow Springs Antiques Show, Chester Springs, PA, October 21–22, 2000.

PUBLISHED: Lita Solis Cohen, "The Silver Market Gets a Boost," *Maine Antiques Digest*, March 1986, p. 6-B.

Cat. 157-1

Small two-handled cups like this one were an important form in use in England in the seventeenth century and were produced in New England at first settlement.[1] They were used for caudle, a thin gruel with wine and spices, which was served warm. This small caudle cup, one of a pair, has a lively surface presence created with two different bold, encircling bands of swirling spirals in repoussé detailed with chasing, which alternate with plain surfaces.[2] Coney used the same decorative technique on two small cups with globular bodies and, boldly, without the swirls on a grand covered cup presented in 1701 to Harvard University by William Stoughton, lieutenant governor of Massachusetts.[3] Another cup, almost identical in shape, size, and weight but with different initials, is in the collection of Historic Deerfield.[4]

The original initials on the underside were "II." The next set of initials, "NR" (conjoined), were created by adding the lobe and extending the foot of an "R" to the second "I." The third set, "IRDP," was created by erasing the diagonal in the "N" and adding the "DP." The scribed lines creating the letters "DP" in the final rendition are distinctly wider than the original letters "II." The head and foot serifs on the "D" and the "P" lack the distinctive slash of Coney's hand.[5] BBG

1. See Bigelow 1941, pp. 104–27.
2. See Sotheby's, New York, *Important Americana, Including Furniture, Folk Art and Folk Paintings, Prints, Silver and Chinese Export Porcelain*, January 30–31, February 1, 1986, sale 5429, lot 402.
3. Buhler 1972, vol. 1, cats. 39, 40.
4. Henry N. Flynt and Martha Gandy Fales, *The Heritage Foundation Collection of Silver, with Biographical Sketches of New England Silversmiths, 1625–1825* (Old Deerfield, MA: the Foundation, 1968), p. 84, fig. 57.
5. See Sotheby's, New York, *The Collection of Mr. and Mrs. Walter M. Jeffords: Early American Silver*, October 28–29, 2004, sale 8016, lot 690 (initials on a silver salver by Coney, c. 1710).

Cat. 158

John Coney
Tankard

c. 1715

MARK: IC (crowned) / ["coney"] (once next to handle attachment, once on underside; cat. 158–1)
INSCRIPTION: I I (engraved, on handle)
Height 8½ inches (21.6 cm), width 7 ³/₁₆ inches (18.2 cm), diam. 5¹/₁₆ inches (12.9 cm)
Weight 27 oz. 13 dwt. 8 gr.
On permanent deposit from The Dietrich American Foundation Collection to the Philadelphia Museum of Art, D-2007-28

PROVENANCE: This tankard bears the initials of the original owner, Colonel John Jones (1691–1773), whose initials "II" are engraved at the top of the handle. A cordwainer by profession, he was born in Boston but lived in Hopkinton, Massachusetts. He married Elizabeth Simpson (died 1724) as his first wife in 1713. In his will written in October 1772, the tankard was specifically noted to go to his son John Jones. It was inherited by the younger Jones's daughter Olive Jones Howe (Mrs. Priest), of Weymouth, and then went to her son Dr. Appleton Howe, to his daughter Harriet Howe Matson, to her cousin Appleton Howe Fitch, to his daughter Grace Allen Fitch Johnson, to her son Jerome Allen Johnson, to his son Martin Lewis Johnson, and to his son and his daughter-in-law Mrs. Lewis F. Johnson, who owned the tankard in 1935 when it was exhibited at the Museum of Fine Arts, Boston.[1]

EXHIBITED: Exhibition of Silversmithing by John Coney, 1655–1722, Museum of Fine Arts, Boston, Summer 1932; Fogg Art Museum, Harvard University, Cambridge, MA, 1956. On long-term loan to the William Penn Memorial Museum, Harrisburg, PA, 1974–78; Yale University Art Gallery, New Haven, 1978–81; Springfield Museum of Fine Arts, Springfield, MA, 1981–85; The Huntington Library, Art Collections, and Botanical Gardens, San Marino, CA, 1985–present.

PUBLISHED: W. W. Watts, "A Tankard by John Coney," Connoisseur, November 1924, pp. 171–72; Hermann F. Clarke, John Coney: Silversmith, 1655–1722 (Boston: Houghton Mifflin, 1932), p. 7; Kane 1998, p. 331.

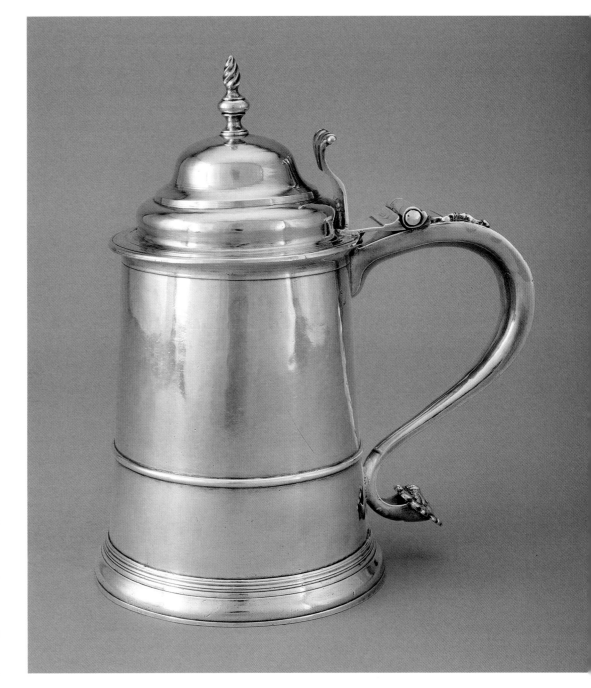

Cat. 158-1

This tankard is a typical example of the form as made in Boston before 1730, with a plain, flared body with base molding and a narrow molding at the top edge. Although the motif was used before 1730, the midband on this tankard was a later feature.[2] The silver lid is a different color from the body; its double, domed shape with flame finial was popular in the 1770s.[3] The thumb piece had been bent, causing it to slightly miss hitting its wear mark on the top of the handle.

In a conservation report from Winterthur in 1979, it was noted that the silver content of the tankard is consistent with eighteenth-century materials.[4] Thus, although this solid tankard has a history of repairs of the vulnerable working parts, perhaps some of the additions and/or replacements might have been accomplished as an updating of the style in about 1773, when the first owner died.[5] BBG

1. Family history from Mrs. Lewis Johnson, Cambridge, Massachusetts, 1954; curatorial files, AA, PMA.
2. Kane 1998, p. 331. A tankard with a midband was made by the Boston silversmith Joseph Kneeland (1698–1760) and presented to Harvard College in 1729; Bigelow 1941, p. 137, cat. 68. For an illustrated timeline of Massachusetts tankards, see Avery 1930, p. 299.
3. Avery 1930, p. 299. The finial is soldered through the lid.
4. Conservation Report, 1979, Winterthur Museum, Winterthur, DE, 1979.
5. Kathryn Buhler commented that both Benjamin Burt and Paul Revere Jr. (q.q.v.), as noted in his daybooks, made new lids for tankards; Buhler to H. Richard Dietrich, Jr., January 25, 1970, curatorial files, Dietrich American Foundation, PMA.

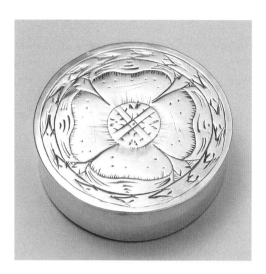

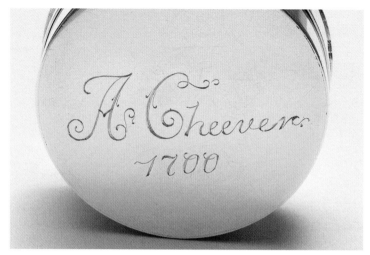

Cat. 159-1

Cat. 159

John Coney (attributed)
Patch Box

c. 1710–20
INSCRIPTION: A Cheever. / 1700 (engraved script,
on underside; cat. 159-1)
Height ½ inch (1.3 cm), diam. 1⁷⁄₁₆ inches (3.7 cm)
Weight 10 dwt. 17 gr.
Gift of Mrs. Hampton L. Carson, 1931-56-1a,b

This small box was used as a container for beauty
patches. It is not marked but has been rescued from
the unmarked objects in this volume by knowledge-
able colleagues.[1] The size, weight, and manufacture
are typical of early Boston work, and similar exam-
ples by prominent Boston silversmiths survive.[2]
Distinctions among them exist largely in the engrav-
er's interpretations of the Tudor-rose design on the
lids. The engraving on the lid of this box appears
to be very similar to that on a box marked by John
Coney.[3] Both have the flat Tudor rose, at the cen-
ter of which is a circle cut in quadrants by parallel
lines. Unevenly clustered straight lines radiate from

the edge of the circle. There is spare dotting near
the edges of the petals and sharp V-cuts between
the petals. The designs differ in that this box has a
running-arrow design around the edge. As noted
in Patricia Kane's biography of Coney, he did not
always mark his silver.[4]

The inscription "A Cheever. / 1700" is not in the
traditional style and may be later than the box. The
name may have belonged to either of two women
named Abigail Cheever born in Boston around that
time. One Abigail Cheever (1690–1778) married the
Boston silversmith John Burt, who was an appren-
tice of John Coney.[5] (That the box is unmarked but
so similar to the example marked by Coney suggests
that Burt may have made it during his apprentice-
ship.) The other Abigail Cheever (1694–1719), who
died unmarried, was the daughter of Richard and
Abigail Cheever (died 1732).[6] BBG

1. With thanks to Patricia E. Kane and David L. Barquist for
expertise and comparative examples.
2. See the patch boxes by Jeremiah Dummer (1645–1718)
in Alice H. R. Hauck et al., *American Silver, 1670–1830:
The Cornelius C. Moore Collection at Providence College*
(Providence: Rhode Island Bicentennial Foundation and

the College, 1980), pp. 52, 81–83, cat. 90; by John Dixwell
(1680–1725), Yale University Art Gallery (1980.22a,b); and by
William Cowell (1683–1736), Currier Museum of Art, Man-
chester, NH (1948.7). See also Sotheby's, New York, *The Cor-
nelius Moore Collection: Early American Silver*, January 31,
1986, sale 5430, lot 68.
3. The author has based this conclusion on the photograph
reproduced in an advertisement by Gebelein Silversmiths,
Boston, in *Antiques*, vol. 105, no. 1 (January 1974), p. 62.
4. From Coney's distant customer John Chester in Connecti-
cut: "I gave you my Coat of Arms to sett upon the Tankard
which you have omitted, & also omitted ye markings of all
but ye tankard, which will give me the trouble of bringing
y [sic] o Boston, to gett them done, or I must keep them as
they are, wch will bee against my mind." Kane 1998, p. 319.
5. Abigail Cheever Burt, daughter of Thomas and Sarah
Cheever, was married on June 3, 1714; Marriages Registered
in Boston (as Abigall Cheever), Town and City Clerks of Mas-
sachusetts, Massachusetts Vital and Town Records, Ancestry.
com. For a quotation from the Burt family Bible, see Buhler
1972, vol. 1, p. 145; for a full biography of Burt, see Kane 1998,
pp. 246–49.
6. Boston Index, Deaths, 1700–1800, Town and City Clerks
of Massachusetts, Massachusetts Vital and Town Records,
Ancestry.com.

Joseph Cooke

England, born 1750
Philadelphia, active 1784–96
Died after 1801

Joseph Cooke's advertisements in Philadelphia newspapers reveal a retailer of prodigious energy and ambition, one who never ceased proclaiming his prowess as a goldsmith, jeweler, and merchant able to provide everything in desirable furnishings for persons and homes.[1] Always on his toes looking for opportunity in the marketplace, he slanted his advertisements after 1790 to the newly elected members of the government of the United States who were settling in Philadelphia. He also solicited the French-speaking nobility arriving after 1789, as well as those from Cap-Français, Saint-Domingue, in 1791.

In his first appearance in Philadelphia, Joseph Cooke introduced himself and his business in the *Freeman's Journal, or The North-American Intelligencer* published on May 26, 1784: "A New Wholesale and Retail Manufactory and Commission-Store, Is now Opened in Second-street, between Market and Chestnut streets, By Cooke & Co. Jewellers and Silversmiths from London . . . a large and most elegant Assortment of every Article in their Line of Business, and have received from the last Vessels from Europe, a most brilliant and fashionable Supply of the under mentioned articles; which for Beauty, Elegance, Fashion, and Taste, do great Credit to the Manufacturers, and far excel any Thing of the Kind ever imported into this City." He ended on a pragmatic note: "A youth of reputable Parents, who can write a good hand, and is conversant in accounts, is wanted as an Apprentice." In August he was advertising the "Best French paste for shoe and stock buckles," and indicated that he sought for "employment as a clerk, a young man who speaks French."[2] Cooke stressed his expertise: "Ladies, Gentlemen, Captains of Ships, Merchants, Country Traders, and the Public, will find it much to their advantage to make trial, as it is a particular point with them to keep all their Goods of the best quality and sell for the smallest profit; which their long residence in England, and the number of workmen they employ, enables them to do."[3]

Cooke came to the United States from England.[4] Whether he had connections previous to his arrival in Philadelphia is not known; however, his first location in 1784 was in the Middle Ward in the center of the commercial city, on Second Street between Market and Chestnut streets.[5] Daniel Dupuy Sr. and Jr. and Richard Humphreys (q.q.v.) were close by. The U.S. census of 1790 placed him at number 40, several houses south of the Dupuys, on the west side of Second Street. In August 1784, already planning his grand scheme, Cooke advertised that he wished "to rent or purchase a convenient House or Lot, not less than twenty feet in front, anywhere between Market Street and Chestnut Street in Second Street, or in Market Street between Third and Front Streets."[6] In 1786 he was still in the Middle Ward, as Joseph Cooke and Co., renting a house from Thomas Howard. Cooke's business from this location was valued at £512, on which he paid tax of £1 5s. 1d.[7] In 1787, again at the same address, Joseph Cooke, silversmith, paid 5s. 9d. on £100 as an occupation tax and was renting the dwelling, now valued at £1,100, from John Howard.[8] In January 1788 Cooke announced that he carried on the business of goldsmith and jeweler in the same manner as done by "him and Co." heretofore, and "on his own account, and for the greater convenience has opened A Ware-House at the corner of Black Horse Alley in Second Street between Market and Chestnut Streets."[9]

This location put him less than a block from Samuel Folwell, who had his shop on Laetitia Court. Folwell advertised as a miniature painter, engraver, and hairworker,[10] and probably apprenticed in hairwork with Jeremiah Boone (q.v.). He presented himself as a specialist and resented the fact that silversmiths commissioned him to do their hairwork, paying him 7s. 6d. a day, and then sold his work in their shops for more. "This induced me," he advertised, "to inform the public where they might apply when they wished to have their work performed in the best and cheapest manner. Prior to my first advertisement, Mr. [Joseph] Anthony (one of the above gentlemen) gave me to understand that Mr. J[eremiah]. Boone intended to leave the City without any prospect of returning, and in consequence there of, invited me to continue here, as I should in all probability be the only person of this particular profession, although Mr. Boone may have since concluded to reside here longer." Folwell subsequently advertised that he was "the only real hair worker in Philadelphia." Joseph Anthony Jr. (q.v.), Jeremiah Boone, and Cooke strongly objected in a newspaper notice.[11] Cooke, in particular, could not bear the effects on pricing in his grand shop, and in long notices he protested vociferously about Folwell's ingratitude, charging that Folwell "indirectly denies the services which I have hitherto rendered him . . . but with respect to the ingenuity and talents of the person who has attacked me, it must be observed that when he entered my service, he was ignorant of the first and simplest principles of the art to which he alludes. . . . I beg leave to refer him to the fable of the Viper . . . he will there learn, not only the baseness of ingratitude, but likewise what I believe, will have greater weight with his pusillanimous mind, the punishment which generally accompanies it."[12]

The U.S. census of 1790 listed Joseph Cooke, silversmith, as "removed" with a household of two free white males over the age of sixteen, including heads of families, two free white males under sixteen, and four white females including heads of families, suggesting that Cooke was married and had a workman and probably apprentices living with him. His own notice in the *Federal Gazette and Philadelphia Daily Advertiser* on December 2, 1790, recorded that he was "removing to his house (No. 38)" on the south side of Market Street between Front and Second streets. Also listed in the 1790 census, on Market Street south of the Delaware River, was "Jos Cooke removed" (added by a different hand, with no house number or information), between the listings for Thomas Harrison, tailor, at number 36, and Jonas Philips, merchant, at number 31.

Cooke called this location the Federal Manufactory, perhaps because he desired to connect his venture with the newly elected U.S. government, which had just moved to Philadelphia.[13] He expanded his services to include a "Counting House and watch seals . . . elegantly engraved from the famous Lockington's London Cipher book, for the modest price of one dollar each," while noting "the very great honor already done him by some of the first characters of the United States in visiting his manufactory."[14] In 1790 President George Washington ordered "bottle holders" from Joseph Cooke, the first of several orders he made during the 1790s.[15] Later that year Cooke received a letter written on behalf of Washington: "It having been intimated to the President of the United States that you are about to have his arms fixed over your shop, with the addition of your being silver Smith to the President. He has therefore directed me to inform you that the carrying the foregoing intention into effect will be very disagreeable to him and he requests you would not do it."[16] By 1792 Cooke called his jewelry emporium "The Federal Manufactory and European Repository Wholesale and Retail Warehouse."[17] At the same time he was advertising for four or five apprentices for his "Manufacturing" business.

Cooke's grand enterprise, conceived in 1793 and completed in 1795, was from the outset

a conspicuous project. First he had to clear off the old buildings at Third and Market, which he owned. He devised the following scheme: "To be sold Cheap. All the old buildings that stand on the South east corner of Market and Third Streets which are to be taken away by the purchaser in ten days after the day of sale or forfeit the purchase money, and whatever remains on the premises after the said ten days are expired is also to be forfeited."[18]

At the height of his optimism, he advertised, "Wanted immediately, from twenty to thirty journeymen goldsmiths, spoon makers, small-workers, Lapidaries, Chape-makers, Buckle-makers, Plate-workers, or other mechanics useful to the branches of the goldsmith and jewellery manufactory."[19] However, at the end of that notice, he added, "A partner is likewise wanted who can advance £10,000." Cooke had followed the traditional mercantile path to prosperity by investing in city real estate.[20] The fact that in 1794 he began to sell off some of his investments to further his enterprise, too grand for Philadelphia as it turned out, was the result of his optimism and possibly a misunderstanding of Philadelphia's general conservatism.

Fig. 63. Enclosure, Joseph Cooke to George Washington, December 25, 1797. Library of Congress, Manuscript Division, George Washington Papers, 1741–1799, Series 4, General Correspondence, 1697–1799

On February 7, 1795, in the *Pennsylvania Packet*, he thanked his customers for their ten years of patronage and announced that he had removed from 38 Market Street to "the middle house of the new buildings completed by him, at the corner of South Third and Market Streets where he has opened for sale . . . that foreigners may not be at a loss on account of their language he employs a gentleman who transacts his business, and speaks the different languages for their accommodation." In that same notice he wrote: "N. B. The house he now occupies to be let or sold as he intends to remove to the corner store as soon as the workmen can complete it which is expected by the first of next month."[21] By September the whole enterprise was for sale.[22]

Cooke must have been desperate in early 1796 when—perhaps showing some sympathy for Robert Morris, whose own building became known as his "folly"—Cooke & Co. advertised that "every article will be sold wholesale and retail, on the lowest terms with the notes of Mr. Robert Morris and Mr. John Nicholson received in payment at their current value."[23] Cooke stopped advertising and disappears from Philadelphia records after November 1796. He was, however, far from discouraged, as in 1795 he had worked out an elaborate scheme to dispose of his building by a lottery in Washington, details of which appeared in Philadelphia's *Aurora General Advertiser* on December 17, 1795: "The subscriber confidently hopes, that, independent of the important pecuniary advantage which may be derived from adventuring in the purchase of Chances of insurance, the public will consider it as a proper opportunity to favor and patronize an individual, whose exertions have greatly contributed to embellish the City of Philadelphia . . . and it is presumed from the characters of integrity and respectability of the above men subscribers, that a doubt cannot remain . . . but every arrangement will be to insure an impartial, faithful and expert execution of the scheme above submitted . . . the subscriber hereby binds himself."

Under the heading "WE, the subscribers," appear the names of some seventy Philadelphians, among them John Aitken, William Ball, Edmund Milne, James Musgrave, Roland Parry, Joshua Dorsey (q.q.v.), Josiah H. Anthony, and Alexander Stedman,[24] followed by a paragraph that was probably written by Cooke himself: "Considering Joseph Cooke's exertions as having

greatly contributed to improve and embellish the city of Philadelphia; desirous to encourage in others a similar spirit, by which the lives of private individuals are rendered instruments of public utility, do earnestly recommend the following Scheme of GRAND CHANCES to be insured and founded on the LOTTERY SCHEME of the FEDERAL CITY, No. 2, to the favourable attention of our Fellow-Citizens and the Public in general: City of Washington. SCHEME OF THE LOTTERY No. II FOR THE IMPROVEMENT OF THE FEDERAL CITY." The scheme was for disposing "of the REAL ESTATE PROPERTY of JOSEPH COOKE, Founded on the FEDERAL LOTTERY. This property consists of his Three story Houses, corner of Market and Third Sts in the City of Philadelphia." Cooke seems to have proposed this plan in detail and signed it in January 1795. At the time he was occupying the corner house with his shop; a Mr. Beurier, an apothecary and chemist, was in the middle house; and a Mr. Andrews, the southernmost house. The chances included insurance on the buildings, the buildings themselves, and the jewelry and other goods in Cooke's manufactory.

Perhaps anticipating a grand success from his lottery, in April 1796 and still working in Philadelphia, Cooke advertised for two or three apprentices for his manufactory. However, after November 7, 1796, Joseph Cooke does not appear on the public scene in Philadelphia. He moved to Washington, endeavoring at first to continue his trade, but later attempting to find new employment for himself. On December 25, 1797, Cooke wrote a letter to President Washington describing his economic misfortunes and inquiring whether the president might have some employment for him or whether his wife might serve as a lady's maid to Mrs. Washington. He had probably given up his trade in silversmithing, as the jobs he suggested were "Stuart overseer Colector of reants or Any thing Else that you might think me Capible of wich I would Cheaerfulley Acpt." Enclosed with the letter were two advertisements, one from Cooke's Philadelphia ventures (fig. 63) and one from Washington. The notice listing his address in Washington, North F Street, Square 253, indicates his ability to supply silver but not to make any new wares.[25] BBG

1. To date no goldsmith's mark has been attributed to Joseph Cooke or his workshop.

2. *Pennsylvania Packet* (Philadelphia), June 5, 1784; *Freeman's Journal, or The North-American Intelligencer* (Philadelphia), August 11, 1784, and October 12, 1785.

3. *Pennsylvania Journal and Weekly Advertiser* (Philadelphia), August 11, 1784.

4. Newspaper advertisement enclosed with a letter, Joseph Cooke to George Washington, December 25, 1797, *The Papers of George Washington, Retirement Series*, vol. 1, *March–December 1797*,

ed. W. W. Abbot (Charlottesville: University of Virginia Press, 1998), pp. 531–32, http://founders.archives.gov.

5. Advertisement, *Pennsylvania Packet and General Advertiser* (Philadelphia), June 5, 1784.

6. *Pennsylvania Journal and Weekly Advertiser*, August 11, 1784.

7. Tax and Exoneration Lists, 1762–94.

8. Ibid.

9. *Pennsylvania Journal and Weekly Advertiser*, January 5, 1788. Black Horse Alley ran from east to west between Front and Second streets.

10. *Pennsylvania Packet and General Advertiser*, July 1, 1786.

11. See the biographies of Joseph Anthony Jr. and Jeremiah Boone (q.q.v.).

12. *Pennsylvania Packet*, March 31, 1788. Folwell remained in Philadelphia until late 1789 but relocated to Charleston, South Carolina, where the *City Gazette and General Advertiser* on May 18, 1791, carried the notice that "Samuel Folwell has removed from No. 29 Elliot Street to no 105 1/2 Church Street."

13. "A great variety of all sorts of Goldsmith's Jewellery, Silver, Plated and Cutlery wares etc. are now ready for Sale at the Federal Manufactory, No. 38 South Side of Market Street between Front and Second Streets, by Joseph Cooke, goldsmith and jeweler, late of Second Street"; *Federal Gazette and Philadelphia Daily Advertiser*, January 13, 1791.

14. *Dunlap's American Daily Advertiser*, March 2, 1791.

15. Bottle Rollers, 1790 (Mount Vernon, 2007.12.2). Washington also paid Cooke $25.14 on August 31, 1793, for "his accot of Goldsmith's work &c." and £3 5s. on December 21, 1795, "for sundr[ie]s"; Cooke to Washington, Presidential Household Accounts, 1793–97, http://founders.archive.gov.

16. Tobias Lear to Joseph Cook, December 21, 1790, George Washington Papers at the Library of Congress, 1741–1799, series 2, Letterbooks, memory.loc.gov.

17. *Dunlap's American Daily Advertiser* (Philadelphia), November 10, 1792.

18. *Federal Gazette and Philadelphia Daily Advertiser*, January 18, 1793.

19. *Dunlap and Claypoole's American Daily Advertiser* (Philadelphia), July 8, 1795.

20. "To be let or sold: An elegant three story brick house, No. 228 South Second Street opposite the New Market; To let, the house No. 57 South Second Street, the corner of Chestnut, lately occupied by Francis Brooks [the same house purchased in 1796 by John Dumoutet Sr. and Jr.; q.q.v.]; To let or sell the four story brick house next to benedict Dorssey, being part of the building which he is now completing at the corner of Third and market Streets. And as he intends to remove into said building as soon as completed, he will let or sell the lease of the house he now occupies; also several tracts of land which he will sell cheap." *Federal Gazette and Philadelphia Daily Advertiser*, January 21, 1794.

21. A revised notice was also published in ibid., March 16, 1795. The notice of February 7 was repeated in the *Aurora General Advertiser* (Philadelphia), May 12, 1795.

22. *Federal Gazette and Philadelphia Daily Advertiser*, September 24, 1795. A complete description of this building "from garret to cellar in the most elegant European stile [*sic*]" can be found in the August 22, 1795, issue of the same newspaper.

23. *Gazette of the United States* (Philadelphia), March 5, 1796; *Federal Gazette and Philadelphia Daily Advertiser*, March 5 and 18, and April 5, 1796; for illustrations of "Cooke's Folly" and Robert Morris's "Folly," see William Russell Birch, *Birch's Views of Philadelphia: A Reduced Facsimile of the City of Philadelphia—As It Appeared in the Year 1800* (1800; repro, Philadelphia: Free Library of Philadelphia, 1982), pls. 8, 14.

24. For Josiah H. Anthony, see the biography of Joseph Anthony Jr. (q.v.). For Alexander Stedman see the biography of Samuel Alexander (q.v.).

25. Cooke to Washington, December 25, 1797 (original orthography), *Papers of George Washington, Retirement Series*, vol. 1 (see note 4 above).

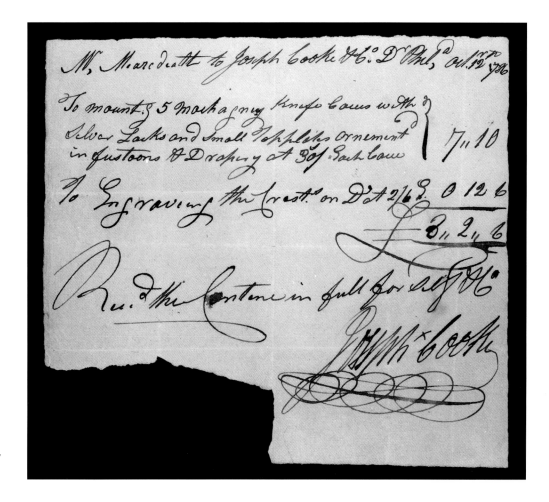

Cat. 160

Joseph Cooke
Receipted Bill

October 12, 1786

MARK: Joseph x Cooke (manuscript signature in ink)
INSCRIPTION: Mr, Mearedeath to Joseph Cooke & Co. Dr Phil[a], Oct.[r] 12th 1786 / To mount.g 5 Machagney Knife Cases with / Silver Locks and small Topplates ornement[d] / in fustoons & Drapery at 30[s] / Each Case [£] 7„ 10 / To Engraving the Crest.[s] on Do 2/6d / [£] 0 12 6 / £8„ 2„ 6 / Rec.[d] the Contens in full for self & Co / Joseph [x] Cooke.
Height 7¼ inches (18.4 cm), width 8⅛ inches (20.6 cm)
Gift of Mrs. Arthur J. Sussel in memory of her husband, 1959-65-3

Grand mahogany knife cases ornamented with silver mounts, such as that referenced in this receipt, became prominent on dining room sideboards in the Federal period. Elaborate table settings for seated dinners included knives in different sizes for meat, fish, and fruit. The display of knives in these cases was a conscious exhibition of status and style. Other examples were owned by George Washington, Robert Morris, Samuel Powel, and John Penn.[1]

"Mr. Mereadeath" may have been Samuel Meredith (1741–1817), a merchant and financier. In 1789 George Washington appointed him as the first treasurer of the United States under the Constitution. Alternately, the name may instead be that of Charles Meredith, who purchased from Daniel Dupuy Sr. or Jr. BBG

1. One pair of cases, from an original group of five that belonged to Governor John Penn and then Robert Morris, is illustrated in William Macpherson Hornor Jr., *Blue Book: Philadelphia Furniture; William Penn to George Washington* (Philadelphia, 1935), pl. 210. The pair owned by Samuel Powel is exhibited at the Powel House, 244 South Third Street, Philadelphia.

Daniel Cunningham

Ireland, born 1814
New York City, died 1855/56

S cant information has been found to document the career of the silversmith Daniel Cunningham. According to the U.S. census of 1850 and the New York State census of 1855, he was born in Ireland in 1814. He apparently emigrated to New York at the age of eleven and presumably trained with a local silversmith.[1] He first appeared in the New York City directory in 1838 as the partner of Philo Baker Gilbert (1816–1875) in Gilbert & Cunningham, silversmiths, at 8 Cortlandt Street.[2] The following year the firm moved to 106 Reade Street, and in 1841 it was renamed Gilbert, Cunningham, & Co. at 102 Reade Street.[3] The partnership had dissolved by 1842, when Cunningham was recorded at 49 Orchard Street and Gilbert formed a new partnership with James G. Everitt.[4] On May 16 in that same year, Cunningham signed the petition made by New York gold- and silversmiths to the Committee of Manufactures of the U.S. Senate advocating increasing the tariffs on imported precious metal goods.[5]

At some point in the early 1840s, Cunningham married. His wife Mary was a native New Yorker six years his junior. He lived and worked at 10 Varick Street in 1843, 221 Walker between 1844 and 1847, 29 Mott Street from 1850 to 1852, and 148 Mulberry Street from 1853 until his death.[6] He was not listed in the 1848 and 1849 city directories. He served as a member of the volunteer Independence Hose Company Number 3.[7] Cunningham died late in 1855 or early in 1856; Mary Cunningham was listed as his widow in the city directory of 1856–57 at 148 Mulberry Street. Daniel Cunningham apparently had been successful; in 1855 the family had two Irish-born servants in their household, and Mary was recorded in the U.S. census of 1860 with real estate valued at $10,000 and $2,000 in personal property. DLB

1. The 1855 New York State census recorded that he had been resident in New York City for thirty years.

2. Longworth's New York City direetory 1838–39, p. 271. Genealogical information on Philo Gilbert is taken from the Leif Larsson Släkttträd family tree, Ancestry.com; and www.findagrave.com

(both accessed January 8, 2016).

3. Longworth's New York City directory 1841–42, p. 298; the address change probably reflects a renumbering.

4. Ibid.,1842–43, pp. 86, 112, 131.

5. D. Albert Soeffing, "The New York City Gold and Silver Manufacturers' Petition of 1842," *Silver Magazine*, vol. 24, no. 3 (May–June 1991) p. 11. Cunningham's first name is incorrectly transcribed as "David."

6. Doggett's New York City directory 1850–51, p. 128; 1843–44, p. 89; 1844–45, p. 91; 1847–48, p. 109; Rode's New York City directory 1853–54, p. 165.

7. "Document No. 50, Report of the Chief Engineer of the Fire Department," in *Documents of the Board of Councilmen of the City of New York, from No. 45 to No. 75, Inclusive—From July to December, 1855* (New York: McSpedon & Baker, 1855), vol. 2, pt. 2, p. 66.

Cat. 161

Daniel Cunningham (attributed)
Six Forks

1840–55

MARKS (on each): [profile head facing right] [lion passant] (sideways); C (each in separate rounded rectangle on single die, on back of handle) (cat. 161-1)
INSCRIPTION (on each): Henriette. (engraved script, lengthwise on front of handle)
Length 7 11/16 inches (19.5 cm)
Weight 1 oz. 17 dwt. 16 gr.
Gift of Mrs. E. C. Eisenhart, 1995-69-19-24

PROVENANCE: This set of forks belonged to Henriette (or Henrietta) Wilhelmina Schubert (1857–1915) of Philadelphia, who in 1888 married Henry Bausch (1859–1909) of Rochester, New York, a vice-president of Bausch & Lomb Company.[1] The set descended to her grandson Edward Charles Eisenhart (1920–2001), who in 1974 married the donor, Sarah Mercur (née Albert) Black (1919–2009) as her second husband.[2]

The marks on these forks appear on flatware also marked by many retailers in and around New York City and from as far away as Montgomery, Alabama, and St. Louis, Missouri. Based on this evidence, John McGrew theorized that these marks were used by a New York manufacturer and attributed them to one of the series of partnerships that the flatware manufacturer Philo B. Gilbert formed between 1838 and 1841 with Daniel Cunningham and between 1843 and 1848 with Francis W. Cooper (1815–1898).[3] However, the capital "C" mark more likely would have been used by Cunningham or Cooper when they were working independently. In the absence of any silver or mark definitively ascribed to Cunningham, this mark can be attributed only tentatively to his shop. The mark could have been used by Francis Cooper, who was active as a silversmith in New York from 1841 to 1890, although on ecclesiastical hollowware Cooper employed an incuse mark with his full name.[4]

The pattern of the forks, known as *Plain Thread*, *Threaded*, or *Double Threaded*, enjoyed its greatest popularity in the second quarter of the nineteenth century; the set presumably was several decades old when Henriette Bausch acquired it by inheritance or purchase.[5] DLB

1. Berti Kolbow, Immigrant Entrepreneurship: German-American Business Biographies, 1720 to the Present, ed. William J. Hausman, vol. 2, s.v. "John Bausch," www.immigrant entrepreneurship.org. For more information on Henry and Henrietta Bausch, see the Murphy family tree, Ancestry.com (accessed January 8, 2016); obituary of Henry Bausch, *Cornell Alumni News*, vol. 11 (March 10, 1909), pp. 270–71.
2. Information on the Eisenhart family can be found in the Shields family tree, Ancestry.com (accessed January 8, 2016).
3. McGrew 2004, pp. 10–11.
4. Jennifer M. Swope, "Francis W. Cooper, Silversmith," *Antiques*, vol. 155, no. 2 (February 1999), pp. 290–97; Cooper's mark is illustrated on p. 293, fig. 4.
5. In the 1830s Thomas Fletcher (q.v.) used various names to refer to this pattern, including "double threaded" and "plain thread"; Fennimore and Wagner 2007, pp. 158, 189.

Cat. 161-1

John Curry

Location unknown, born 1798 or 1799
Philadelphia, died 1868

The first public notice of John Curry (1799–1868) as a silversmith was published in in the Philadelphia directory of 1825 as the partnership of "Curry & Preston, silver-smith manufactory b[ack] of 46 N 7th."[1] His partner was William R. Preston (1800?–1859), who likewise was not listed individually before that date.

Little is known about the early life of John Curry. One death certificate states that he was born in Nova Scotia, Canada, to which many Irish families had migrated between 1795 and 1812 to escape the factional warfare for religious liberties raging in Ireland.[2] Another says that he was born in the "U.S.," and the 1850 census says he was born in Pennsylvania.[3] He may have been the son of James Curry, an Irish Catholic who settled in the Northern Liberties and Kensington section of Philadelphia, as suggested by the Nova Scotia entry. This was Curry's location throughout his career, a location that became important later as historical animosities between religious factions broke out into riots in Philadelphia in 1831.[4] His business location at 76 Chestnut Street was engulfed in the clash, which was concentrated between Chestnut and Walnut streets on Fourth Street. The dissolution of Curry's partnership with William R. Preston in 1831 dates from this time.

On March 7, 1826, silversmith John Curry married Elizabeth Levy (c. 1803–1865), daughter of Joseph Levy, Esq. (1758–after 1850) and Maria Levy (1775/76–1823), at the Evangelical Lutheran Church of St. John, located on the north side of Race Street below Sixth Street. Joseph Levy was a prominent Jewish exchange merchant at 91 South Front Street, with his residence on Spruce Street in 1805. According to the city directories, he moved to 117 Chestnut Street in 1813; in 1816 he moved to 49 South Third; and from 1821 until 1824 he was at 36 South Third, less than a block from Curry's location.[5] According to the U.S. census of 1850, John and Elizabeth Curry had five children: John (born 1828); Elizabeth (1832–1854), who married William Henry Bird, son of James, in 1847;[6] Preston (born 1835), who later worked

with his father; Emma (born 1848); and Frances (born 1859). John junior, who worked briefly with his father, had been apprenticed on September 24, 1845, to serve two years, five months, ten days, to Lawrence M. Potts to learn the "Black & White-smithing" trade.[7]

The identification of William R. Preston with this partnership has been suggested by his record in the U.S. census of 1850, where he was listed as a silversmith born in Pennsylvania. His age was given as forty-one, and that of his wife Charlotte as forty-two. The dates and ages in the census are often not precise and in this case are contradicted by Quaker records. William R. Preston was a Quaker, not to be confused with a William Preston Sr. (died 1820) and Jr. (died 1819), Quaker boat builders in the Northern Liberties;[8] a William Preston (1770–1839) of Chester County; or a William Riley Preston (1790–1834) of Oneida, New York, who was active there in 1820. Philadelphia Quaker records differentiate between the boat builders and the silversmith by including the middle initial "R" in entries pertaining to the silversmith.[9] William Roberts Preston was born November 12, 1800, the third child of William (died 1807/1808) and Mary Roberts Preston. William was the son of Henry and Susanna Roberts Preston, daughter of Levi and Elizabeth Evans Roberts, who belonged to the Gwynedd Meeting. William and Mary R. Preston married in the North Meeting House (Northern District) in Philadelphia on April 12, 1795. Later they belonged to the Southern District Friends Meeting. After her husband's death Mary transferred back to the Northern District Meeting. On February 20, 1816, the Northern District Meeting recommended William Preston Jr. to the Southern Meeting, "where he was residing," probably as an apprentice. He does not appear again until 1839. Quakers held a "Preparation" Meeting on June 20, noting that William Preston had married contrary to the order of discipline with a person professing with another religious society. The Quaker Meeting sent Philip Garrett (q.v.) and Moses Brown "to treat with him." The U.S. census of 1850 records that Preston's wife was named Charlotte.

With whom Curry apprenticed is not yet known.[10] The Quaker affiliation of the Lownes and the Prestons offers the possibility that at least Preston apprenticed with Joseph Lownes (q.v.), as his move to the Southern District in 1816 would have been the right age for an apprenticeship to begin. Curry's name mark is most like those of Harvey Lewis and Edward Lownes (q.q.v.), especially the latter, in terms of the style of letters within a serrated rectangle. At least one set of Edward Lownes's marks—his name in a serrated rectangle,

PHILADELPHIA with arrowheads on either side of a dot, in a circle, and a florette—seems identical to one used by Curry & Preston.[11] John Curry and William R. Preston may have overlapped with Edward Lownes in apprenticeships with Joseph Lownes, and perhaps they continued as journeymen with Edward Lownes before establishing their own partnership. According to the Philadelphia city directories, from 1821 until 1825 Edward Lownes was located at 123 Chestnut Street.[12]

It would appear that Curry was the principal partner. His name was listed first, he was older, and perhaps his father-in-law was instrumental in setting him up. In 1828 and 1829 the partnership was listed at 103 Chestnut Street, while Edward Lownes was at 123 Chestnut; both locations were between Third and Fourth streets. In 1830 Curry & Preston (see fig. 64) moved further east and advertised its spoon and fork manufactory at 55 Chestnut Street, at the corner of Strawberry Street (Alley), which ran north to south between 58 High (Market) Street and 56 Chestnut Street, between Second and Third streets.[13] The U.S. census of 1830 in the Chestnut Ward noted that John Curry's combined silver business and household was made up of thirteen free persons: two males under the age of five, five males between fifteen and nineteen, one male between twenty and twenty-nine (probably Preston), one male between thirty and thirty-nine (Curry), one female under five, one female between fifteen and nineteen, one female between twenty and twenty-nine (Curry's wife Elizabeth), one female between fifty-five and ninety-nine (possibly Preston's mother Mary), and one free colored person. The numbers suggest that the Curry and Preston households were together at 72 Chestnut Street with additional apprentices.[14] The dissolution of the partnership the next year, described as by mutual consent, must have been amicable, as Curry named a boy Preston Curry.[15]

William Preston may have continued as a silversmith in another shop. The U.S. census of 1850 noted him as "silversmith." However, in 1833 he was acting as an administrator and assignee to collect debts owed to creditors from Henry H. Lindsay, who had a hat store at 54 Chestnut Street across from Curry's silver shop.[16] In 1834, from his office at 124 High Street, Preston acted as administrator to the estate of John C. McKnight, a merchant located at the southwest corner of High and Eighth streets.[17] Preston was located at 8 Commerce Street, with his home at 4 Bank Street, directly across Chestnut from Curry's location, suggesting that he may have joined, and then taken over as a broker, from Joseph Levy, who was retiring.[18] From 1837 to his death in 1859, Preston is listed in the city directory as "gentleman."

In 1839 or 1840 he moved to 116 Chestnut Street. From 1840 to 1857 he and his wife Charlotte were on Mulberry (Arch) Street above Third Street.[19] Toward the end of his life, the Prestons moved to 1228 Arch Street, where his widow continued.[20]

In June 1831 Curry confirmed that, although his partnership with Preston had ended, "the manufacturing of Silver plate, spoons and forks, will be carried on by JOHN CURRY, at the old stand, No. 72 Chestnut Street, opposite Bank Street."[21] Whether the confrontation and violence that would break out in July 1831 between the Irish Catholics and the Irish Protestants was more than coincidence, or whether it precipitated the dissolution of Curry and Preston's partnership, is not clear. It is sheer speculation, but perhaps a pacifist Quaker and a quixotic Irishman took different sides. The drama played out on their block. By 1833, with additional buildings in place, the address on Chestnut Street had become number 76. Curry's advertisement in 1834 noted that his "MANUFACTORY on Chestnut Street, no. 76" was at the "corner of Exchange Street," where the membership of the Merchant's Exchange included the politicians and financiers of Philadelphia. Curry occupied the space through 1840.

The marks of Curry and Preston often included notations stamped with values of European coins—the French five-franc piece and English crowns—and U.S. Standard, Spanish-American, Mexican, and other currencies, presumably to guarantee the materials used in their craft (see fig. 64).[22] Curry's advertisement in the *Philadelphia Inquirer* for June 17, 1834, noted, "Terms as low (for the quality) as can be purchased in the United States." Thus it may be that he was the "John Curre" who signed the petition in 1834 "asking for relief from the present pecuniary distress caused by the disordered state of the currency," and requesting the return of government deposits to the Bank of the United States.[23]

From 1832 to 1836 the bank crisis caused hardship to all craftsmen and merchants who preferred to deal in specie rather than in credit. A succession of silversmiths' advertisements during the years between 1830 and 1836 illustrated their manner of dealing with the uncertainty. For example, Curry's advertisement in 1835, with the "cut" of an ornate sugar bowl, carried the headline "STERLING SILVER"; in 1837 an advertisement with the same illustration noted a "Rare Opportunity / SELLING OFF AT REDUCED PRICES." Also in 1837 Curry moved his domicile to Germantown "below Mud lane," but his shop remained at 76 Chestnut Street.[24] On November 6, 1838, the Philadelphia *Public Ledger* commented on the "handsome workmanship" of the silver

ware of John Curry, Bailey and Kitchen, Samuel Kirk, Leonard and Wilson, Reed & Barton (q.q.v.), and James Thompson, and noted that "the silver trumpet by George K. Childs [q.v.] is a beautiful article." Curry continued to advertise his silver manufactory through 1839, and when the currency crisis had somewhat abated, he reused the illustration from 1837 with the headline "GOLD AND SILVERSMITH."[25]

Curry's style of hollowware was fashionable and showy, with full, round forms and ornament. Even plainer pieces were fitted with encircling bands of classical designs and elaborate cast handle sockets. He produced hollowware in company with the other nearby silver manufactories.

Fig. 64. Advertisement for Curry & Preston, *Pennsylvania Inquirer*, January 1, 1830

Decorative cast ornament, banding patterns, and other elements on John Curry's pieces are also found on products by Thomas Fletcher and Sidney Gardiner (q.v.), nearby on Chestnut above Fourth Street, and the spoon manufacturers Robert and William Wilson (q.v.), located at Fifth and Cherry streets.[26] A grand tea and coffee service, with a suave chased pattern of a garland of leaves with a centralized full-blown rose, may have been designed by Curry, who marked four of the pieces; Robert and William Wilson marked two.[27] It was surely a collaborative effort between the shops. Curry's advertisements always included references to spoons, forks, and general tableware, which must have been his "bread and butter." Extant receipts suggest that he produced large quantities. In November 1831 a Mr. Skerret paid $34.85 for six forks.[28] On November 25, 1837, a workman or apprentice by the name of Price signed a receipt to a Mrs. Stewart for her order of six silver tablespoons at $19.00,

twelve silver teaspoons at $14.50, one pair of sugar tongs at $4.25, and one butter knife at $3.00, with "[$]40.75. rec'd payment in full for John Curry / BWL Price."[29] Curry and his son Preston were still at work in 1863 when they made some teaspoons for Mary Harris, who married Wistar Morris and then resided in Germantown. The season for presents was beginning to be a focus of advertisements, and from October 1839 through December 24 of that year, Curry did not miss an issue of the *Philadelphia Inquirer*. In 1840 he continued his business at 76 Chestnut Street, near Third Street and opposite the Bank of the United States.[30] His establishment was continually located at the center of commerce, in the Chestnut Ward, which included the area between Front and Seventh streets, bounded on the north by High Street and on the south by Chestnut.

He had a full household in 1840, as illustrated by the census accounting, which included Peter L. Krider (q.v.), an apprentice from 1835 to 1841. There were three boys under the age of sixteen; one between twenty and thirty; Curry himself, forty-two; two girls under ten; his wife, thirty-seven; and one free colored female between twenty-four and thirty-six. In 1842 heavy tariffs and speculation caused financial collapse and depression throughout the crafts, and on June 13, 1842, John Curry, silversmith, filed a petition of bankruptcy.[31] Among the twenty-five creditors were his father-in-law, Joseph Levy, 36 Sansom Street, for $1,350; George K. Childs, 8 Laurel Street, for promissory notes, $700; James Marsh, Fifth Street below Cammac, for $405; Joseph Pancoast, MD, 300 Chestnut Street, for professional services, $20; John Birkey Dentistry, 99 South Fifth Street, $410; G. F. Fontanges, 508 Chestnut Street, rent of workshop, $25; and William R. Preston, corner of Thirteenth and Arch streets, for cash lent by him, $36. The total of Curry's cash debt was $4,689.78. The household furniture at his residence "on the Germantown Road at the intersection of old 4th street" was estimated at $120, the tools of his trade at $100.

Debts owed to Curry were also listed: Adam F. Levy of New York, $100; Robert Hemphill, Philadelphia, $3.50; estate of Michael Nesbit, deceased, $21; C. S. Richie, Philadelphia, $29; Harrison Locke, Legrane, Tennessee, $41.37; Martin Nangle, Philadelphia, $50; William Smith (insolvent), Philadelphia, $40; and the invoice of jewelry in the hands of Hurst as collateral security, $200. The total was estimated at $984.37.

He left his central business location and moved to the property his father-in-law, Joseph Levy, had purchased earlier in Kensington and that had been part of the original Fair Hill estate of the Norris and Lloyd families. Curry's address

in the 1843 McElroy's city directory became "GT road bel 5th" (Germantown Road below Fifth). In 1846 the address was recorded as "G T road bel Mud la." Mud Lane extended east from the Black Horse–Frankford Road to the Germantown Road. McElroy's directory continued to list him there as John Curry, silversmith, until 1853, when his residence was given a number, 487 Germantown Road.[32] From 1854 to 1860 John Curry, silversmith, and his son Preston Curry, silversmith, were listed in the city directory at 487 Germantown Road above Columbia Avenue.[33]

The U.S. census of 1850, taken on April 21, described his household as consisting of John Curry, silver plater, born about 1798, living in Kensington Ward 7, age fifty-two; his wife Elizabeth, forty-seven; son John, twenty-two (no occupation); Elizabeth, eighteen; Preston, fifteen (no occupation), who attended school within the year; Emma, thirteen, and Frances, eleven, who both attended school within the year; and Joseph Levy (born in Germany), gentleman, ninety-two. In spite of their apparent lack of occupation, according to the same census both boys were surely working in some capacity with their father. Silver marked on the underside with an incuse single letter, a "J" or a "P," along with their father's mark, probably identifies John and Preston.[34]

The manuscript version of the 1850 census includes a notation of $15,000, beside Joseph Levy's name at the bottom of the listing, probably his valuation as Curry had been insolvent. In 1861 the household moved to Germantown proper, at 1731 Germantown Avenue, and John Curry added another address, noted as "residence," also in Germantown, at 2006 Greene Street, where the extended family resided.[35]

Elizabeth Curry died on March 23, 1865, at the age of sixty-two. Relatives and friends were invited to attend her funeral from the residence of her son-in-law, Mr. Stephen Riezel, at 2006 Green Street.[36] John Curry died "suddenly" in his sixty-ninth year on February 6, 1868. Once more, relatives and friends of the family were invited to attend the funeral, from the same address, which was also listed on Curry's death certificate as his residence. He was buried in Woodlawn Cemetery.[37] BBG

1. Philadelphia directory 1825, p. 39. This location would have been between Arch and Race streets.

2. Philadelphia Death Certificates Index, 1803–1915, Ancestry.com.

3. One of the death certificates notes "abt 1799" as his birth year; Philadelphia Death Certificates Index, 1803–1915. His birth was in 1798 according to the 1850 U.S. Census. In 1859 there were nine John Currys listed in the Philadelphia directory.

4. See Francis W. Hoeber, "Drama in the Courtroom, Theater in the Streets: Philadelphia's Irish Riot of 1831," PMHB, vol. 125, no. 3 (July 2001), pp. 193–232; David A. Wilson, United Irishmen, United States: Immigrant Radicals in the Early Republic (Ithaca, NY: Cornell

University Press, 1998), p. 179. If John Curry was a member of the Curry family in the Northern Liberties and Kensington, he was probably Catholic. Not to be confused with John Curry, tailor, who was in the military supply business during the War of 1812.

5. Addresses in city directories and newspapers do not always agree. Newspaper advertisements were probably most accurate, because placed by the principal. House numbers changed with the addition of buildings on a block. In 1816 Curry advertised at 49 South Third Street; Poulson's American Daily Advertiser (Philadelphia), May 7, 1816.

6. See the biography of Joseph Bird Jr. (q.v.).

7. Philadelphia Apprentice Records, Martin Lutz Docket, 1845–1850, p. 8.

8. Philadelphia Will Book 7, pt. A, pp. 197, p. 67.

9. Friends Historical Library.

10. "They [Curry and Preston] had both been brought up to all the different branches of silver smithing"; Hollan 2013, p. 45.

11. For Edward Lownes's mark, see Hollan 2013, p. 124.

12. The U.S. census records his wife Charlotte; Harriet Nixon, listed as mulatto, age nineteen; and Sally Chilo, listed as black, age fifty. There are no other Prestons recorded as silversmiths in sources consulted.

13. Philadelphia directory 1830, p. 44; Philadelphia Inquirer, November 18, 1829. Strawberry Street is clearly delineated on the 1797 Plan of the City of Philadelphia. Other silversmiths, including Samuel Alexander and Jeremiah Boone (q.q.v.), were also located on Strawberry Street; 1790 U.S. Census. The Philadelphia directory of 1794 listed a William Preston, bricklayer, at 40 Strawberry Street (p. 123).

14. This was not a singular arrangement; see the biography of George K. Childs (q.v.).

15. 1850 U.S. Census.

16. Philadelphia Inquirer, March 25, 1833.

17. Ibid., February 27, 1834.

18. Ibid., February 27, 1834. Bank Street intersected Chestnut directly across from Curry's manufactory; McElroy's Philadelphia directory 1837, p. 177; 1797 Plan of of the City of Philadelphia.

19. In 1854 Mulberry Street officially became Arch Street.

20. McElroy's Philadelphia directory 1839–59; changes to the address occurred in 1839, p. 203; 1840, p. 203; 1841, p. 217; 1843, p. 225; 1854, p. 426. 372 Mulberry becomes 372 Arch, as the name of the street had been officially changed; 1858, p. 347; 1860, p. 796. There were several contemporary William Prestons at various addresses, but this William seems always to have used the middle initial "R" in his full name. A William R. Preston was an apothecary in Portsmouth, New Hampshire, in 1839; Portsmouth Journal of Literature and Politics, March 17, 1838.

21. Philadelphia Inquirer, June 10, 1831. Bank Street was William Preston's address in 1837; McElroy's Philadelphia directory 1837, p. 177.

22. Hollan 2013, p. 233. If these marks could be dated and confirmed by ownership, perhaps the "Preston" identity could be confirmed or denied.

23. A "John Curre" was one of 268 watchmakers, silversmiths, and jewelers who in 1834 signed this petition dealing with the insecurity of the currency. It is not an alphabetical list, and some of the signatories are listed without specific occupation; however, this name appears amid twenty or more like craftsmen. William R. Preston does not appear in the list with the craftsmen. H.R. doc. no. 206, 23rd Cong., 1st sess. (1834).

24. Philadelphia Inquirer, September 11, 1835; October 5, 1837; May 14, 1839.

25. Fennimore and Wagner 2007, p. 55.

26. Robert and William Wilson advertised their "Silver Plate, Spoon, and Fork Manufactory" immediately under John Curry's advertisement, both with illustrative cuts, in the Philadelphia Inquirer, September 11, 1835.

27. Christie's, New York, Important American Furniture, Silver, Prints, Folk Art and Decorative Arts, January 17–18, 1992, sale 7398, lot 136.

28. John Curry to Mr. Skerrett, receipt, November 18, 1831, Williams-Skerrett Family Papers, 1817–1950, HSP.

29. John Curry to Mrs. Stewart, receipt, November 25, 1837,

nonprinted bills, Downs Collection, Winterthur Library. There are many additional receipts, discovered by colleagues; for examples see Fennimore and Wagner 2007.

30. McElroy's 1841 Philadelphia directory lists Curry at that address for that one year (p. 58).

31. Public Ledger (Philadelphia), June 14, 1842. Records of the U.S. District Court for the Eastern District of Pennsylvania, file no. 591, NARA, Philadelphia.

32. McElroy's Philadelphia directory 1843, p. 61; 1846, p. 77; 1853, p. 90.

33. Philadelphia directory 1854, p. 114. In 1857 there were nine John Currys listed in the city directory (p. 145).

34. Hollan (2013, p. 46) suggests these may be journeymen's marks.

35. Philadelphia directory 1861, p. 209.

36. Philadelphia Inquirer, March 27, 1865.

37. Not to be confused with John Curry, cordwainer, who died in 1869. For John Curry, silversmith, see the death notice in the Public Ledger, February 10, 1868. For both John Currys, see Philadelphia Death Certificates Index, 1803–1915.

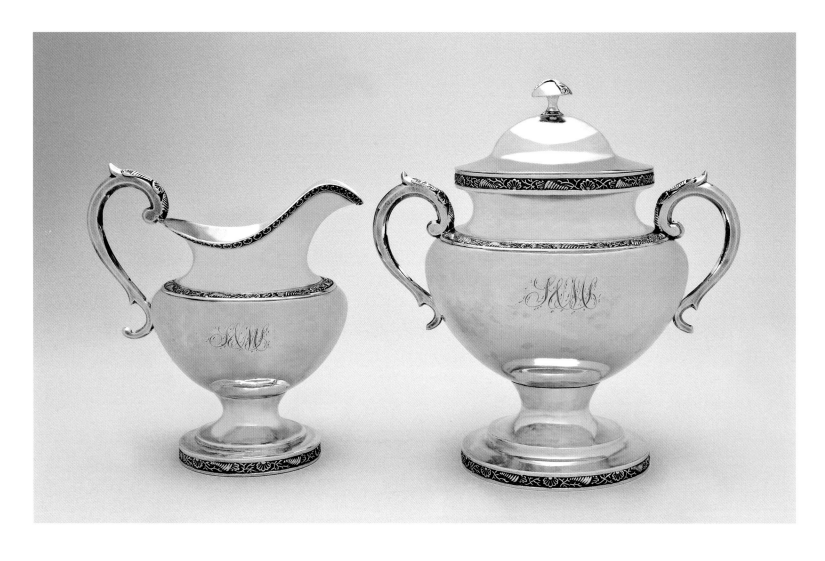

Cat. 162

John Curry
Sugar Bowl and Cream Pot

1833–43

MARKS (on each): J.CURRY. (in serrated rectangle, twice, on underside); PHILADELPHIA ← • → (in circle, on underside) (cat. 162-1)

INSCRIPTION (on each): S & M S (engraved script)

Sugar Bowl: Height 8¼ inches (21 cm), width 7⅝ inches (19.4 cm), depth 5 inches (12.7 cm)
Weight 16 oz. 19 dwt. 8 gr.

Cream Pot: Height 6¼ inches (15.9 cm), width 5⅞ inches (14.9 cm.), depth 3¾ inches (9.5 cm)
Weight 8 oz. 13 dwt. 18 gr.

Gift of Mrs. Edward C. Eisenhart, 1995-69-14a,b, -15

PROVENANCE: According to the donor, this set originally belonged to Samuel Stanhope Smith Stryker (1797–1875) and Mary Scudder Stryker (1802–1866), who married in New Jersey in 1825. Mary Scudder Stryker was the daughter of John Scudder and Mary Holme Keen Scudder (1766–1839) of Hunterdon County, New Jersey, who married in 1791.[1]

The Philadelphia circle mark was also used by the partnership of John Curry and William Preston, active from 1825 until 1831.[2]

There is a distinctive patterned banding in a chased design of shells, coral, and cornucopia running around the bases and shoulders of the cream pot and the sugar bowl, and around the upper rim of the sugar bowl. The banding on the base of the cream pot appears faintly on the inside. The cornucopia motif is repeated on the top of the cast handles and on the mushroom-shaped knop on the sugar bowl. BBG

1. Gregory B. Keen, "The Descendants of Jöran Kyn, the Founder of the Upland (continued)," *PMHB*, vol. 4, no. 3 (1880), pp. 357–58.
2. For an interesting discussion of regional stamped marks, e.g., "PHILADELPHIA" in a circle, their significance undetermined to date, see "When Coin Evolved to Sterling," Silver Salon Forums, posted December 21, 2004, http://www.smpub.com/ubb/Forum19/HTML/000494.html (accessed December 7, 2016).

Cat. 162-1

Cat. 163

John Curry

Pair of Tablespoons

1840–50
MARKS (on each): J.CURRY · (in serrated rectangle) [eagle]
(in rounded square, all on reverse of handle; cat. 163-1)
INSCRIPTION (on each): J M E (engraved script, at top of
obverse of handle)
Length 8⅞ inches (22.5 cm)
Weight 1 oz. 16 dwt.; 1 oz. 17 dwt. 10 gr.
Gift of Sewell C. Biggs, 2000-130-1, -2

PROVENANCE: The initials "JME" belonged to Joseph
Morgan Eldridge of New Jersey, Philadelphia, and Mary-
land. He was the son of Joseph Eldridge and Ann Morgan
Coxe of Cape May, New Jersey, members of a Baptist
and Episcopalian family. His sister Anne married Samuel
Elkington Wills in 1851, and the spoons descended in
their family to the donor.[1]

Cat. 163-1

These spoons were made from very thin-guage
metal. BBG

1. For other silver in the Museum's collection that descended
in this family, see 2000-130-25; teaspoons and dessert
spoons by Haydock & Fidler (2000-130-4–15, 16–21); a
tablespoon by Nicholas Le Huray Jr. (2000-130-3); a serving
spoon and teaspoons by Robert and William Wilson (2000-
130-22, 2000-130-26-35); and salt spoons with an unidenti-
fied mark (2000-130-23,24).

Cat. 164

John Curry

Pair of Teaspoons

1850–60
MARK (on each): J. CURRY (in rectangle, on reverse of
handle; cat. 164-1)
INSCRIPTION (on each): M H (engraved script, on front of
handle)
Length 5¹³⁄₁₆ inches (14.8 cm)
Weight 11 dwt. 3 gr.; 11 dwt. 18 gr.
Gift of Mrs. W. Logan MacCoy, 1957-93-17,18

PROVENANCE: Descended in the donor's family.

Cat. 164-1

This Curry mark does not have a serrated top edge or
a pellet after the maker's name, as appears on other
objects attributed to Curry.[1] The spoons have a single

drop and a short midrib. The handle is turned back
at the top in a late eighteenth-century style. The
spoons apparently were made to match a set of
tablespoons that Joseph Lownes (PMA 1957-93-20-
31) made for Mary Hollingsworth Morris (1776–1820)
about 1800. The engraved letters in the monogram
on Curry's teaspoons are styled identically to those
on Lownes's tablespoons but are by a different
hand.

Considering Curry's known working dates, family
history suggests that these spoons were made for
Mary Harris (1836–1924), who married Wistar Morris
(1815–1891) in 1863. The Morrises had only one child,
Mary Hollingsworth Morris (1864–1891), who in 1883
married the Reverend Charles Wood (1851–1939) and
was the mother of the donor.[2] BBG

1. See cat. 163.
2. Moon 1898–1909, vol. 2, pp. 554, 557; Robert C. Moon,
Descendants of Samuel Morris, 1734–1812 (Philadelphia:
printed by the author, 1959), pp. 1, 4, 12, 29. For other silver
that descended in this family, see cat. 93.

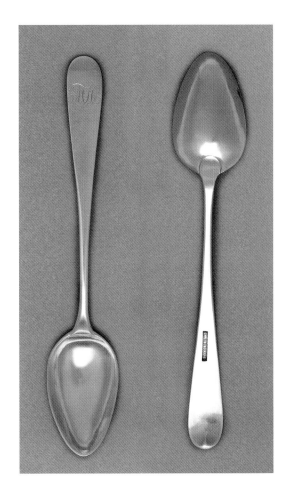

Virginia Wireman Cute (later Curtin)

Virginia, born 1908
Philadelphia, died 1985

Virginia Wireman Cute (fig. 65) was the daughter of Henry Wireman and the illustrator Katherine Richardson Wireman (1878–1966), a descendant of the Richardson family of Philadelphia silversmiths. Although Virginia was born in (and perhaps named for) the state of Virginia, she returned to Philadelphia in 1913, and that city became her lifelong home.[1] She attended the Springside School in Chestnut Hill in 1927.[2] In addition to being an accomplished silversmith and teacher of metalwork, she had a career as an occupational therapist, during which she also taught metalwork. She collected silver, especially pieces marked and made by her ancestors Francis Richardson Sr. and Joseph Richardson Sr. and Jr. (q.q.v.).

Wireman's first work experience in occupational therapy was from 1934 until 1937; from 1941 until 1948 she was an instructor in the Philadelphia School of Occupational Therapy. She served in various capacities from 1953 until 1970 at the University of Pennsylvania, as instructor, assistant director, acting chairman, and in 1970

Fig. 65. Virginia Wireman Cute, in an undated photograph

associate professor in the department of occupational therapy.

Wireman began studying silversmithing in 1930 with Douglas Gilchrist (1878–1943) at the Philadelphia Museum School of Industrial Art, and with Adda Husted-Andersen (1898–1990), a Danish silversmith. She taught at the Springside School from 1939 to 1941. Wireman earned a BFA from Moore College of Art & Design, Philadelphia, in 1942. She married James Francis Cute (1906–1963) in 1943, and they lived near her mother in Germantown. Gilchrist died that same year, and Cute began teaching his classes at the renamed Philadelphia School of Industrial Art. Until 1953 she served as director of the silver and jewelry program at the school, which became the Philadelphia Museum School of Art in 1948 and later the Philadelphia College of Art (now University of the Arts). Richard H. Reinhardt (q.v.), who would chair the silver and jewelry program at the Philadelphia College of Art after Cute, was one of her pupils.[3] Cute received her MFA from the University of Pennsylvania in 1961.

Beginning in 1947 Cute attended the influential Handy & Harman workshops for metalsmithing teachers organized by Margret Craver. The first year was taught by the British silversmith William E. Bennett (1906–1967), and the sessions in 1948, 1949, and 1951 were taught by Baron Herman Erik Fleming (1894–1954), the court silversmith in Sweden.[4] In 1949 she was invited to study with Bennett at the Sheffield College of Arts and Crafts in England. Cute's contact with British silversmiths and their teaching enriched the craft movement developing in Philadelphia and raised the status of women in the metalsmithing world. She was the first American woman to have work hallmarked by the Worshipful Company of Goldsmiths, and in May 1949 two of Cute's pieces (including cat. 165) were registered under the date letter "F" at Sheffield, England. Her silver was exhibited in a number of regional shows and in 1949 at the exhibition *Form in Handwrought Silver* at the Metropolitan Museum of Art, New York (cat. 165).[5]

Cute lectured and published on the history, collecting, and care of antique American silver.[6] She also served on numerous committees related to her professional work at the University of Pennsylvania.[7] In 1952 she was selected as one of Pennsylvania's Distinguished Daughters and was cited by Governor John Fine for her pioneering work in art education.[8] Her civic involvement was equally extensive. Cute was a member of various organizations, including the Peale Club, the Pennsylvania Society of Colonial Dames, the Germantown Historical Society, the International House

Art Committee, and the American Craftsmen's Council.[9] She was an enthusiastic and generous donor to the Philadelphia Museum of Art. Among her gifts were two pieces made by her ancestors: a mote spoon by Joseph Richardson Sr. (1974-190-1) and a caddy spoon by Joseph Richardson Jr. (1974-190-2).

In February 2002 two pieces of Cute's silver were exhibited at the Museum of Fine Arts, Boston, in the exhibition *Margret Craver and Her Contemporaries*.[10] JZ

1. In different sources she is listed by variations of her three surnames, Wireman, Cute, and Curtin. Following the death of her first husband, she married Judge Thomas J. Curtin (1899–1984) in 1965 and lived in Chestnut Hill. Henrietta Wireman Shuttlesworth, *Sunshine and Shadows: A Biography of Katharine Richardson Wireman* (Riverton, NJ: Richardson, 2000), p. 53. Many details cited in the present brief biography of Cute are drawn from Jeannine Falino, "Metalsmithing at Midcentury," in *Sculptural Concerns*, exh. cat. (Cincinnati: Contemporary Arts Center, 1993), p. 15; and Falino and Ward 2008, s.v. "Virginia Wireman Cute."

2. "Virginia Wireman Curtin '27," *Springside Bulletin*, vol. 41, no. 1 (November 1985); curriculum vitae, created by Curtin and kindly provided by her nephew, David Remington; curatorial files, AA, PMA.

3. Falino and Ward 2008, p. 417.

4. W. Scott Braznell, "The Early Career of Ronald Hayes Pearson and the Post World War II Revival of American Silversmithing and Jewelrymaking," *Winterthur Portfolio*, vol. 34, no. 4 (Winter 1999), pp. 188–90.

5. Photocopy of the exhibition brochure; curatorial files, AA, PMA.

6. Bea Garvan, communication with the author. Garvan knew Cute personally.

7. At the University of Pennsylvania she served as chairman, committee of resident operations, 1965–69; associate chairman, lecture committee, *The University Hospital Antique Show*, 1970; and a member of the selection committee for the Dean of Allied Medical Professions. In addition, she served as vice president of the Faculty Club board of managers, Moore College of Art & Design.

8. Curriculum vitae of Virginia Wireman Cute Curtin.

9. Faculty vitae, Moore College of Art & Design, Philadelphia; curatorial files, AA, PMA.

10. One of the pieces was a bowl in the collection of the Museum of Fine Arts, Boston (1999.736); see Falino and Ward 2008, cat. 337.

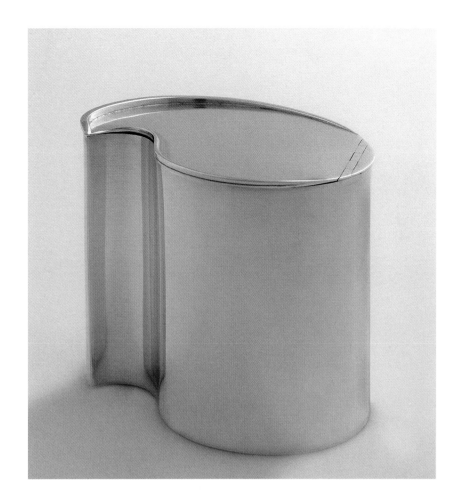

Cat. 165

Virginia Wireman Cute (later Curtin)
Cigarette Box

1949
MARKS: A&C (in four-sided polygon) [crown] [lion passant guardant] F (in seven-sided polygons; all on underside); [lion passant guardant] (in seven-sided polygon, on underside of lid; cat. 165-1)
Height 3 inches (7.6 cm), width 3½ inches (8.9 cm)
Weight 9 oz. 15 dwt. 15 gr.
Gift of the artist, 1970-202-1

EXHIBITED: *Form in Handwrought Silver*, December 13, 1949–January 29, 1950, Metropolitan Museum of Art, New York, no. 63; *Affects/Effects: Past Faculty of PCA*, November 19–December 21, 1982, Philadelphia College of Art.

PUBLISHED: Virginia Wireman Cute, "Contemporary American Silver," *Craft Horizons*, vol. 12 (March–April 1952), p. 30; "The Eighth Annual Antiques Show and Sale of the University of Pennsylvania Hospital," *Apollo*, vol. 89 (April 1969), fig. 2, p. xcviii.

Cat. 165-1

This small box is one of the two by Virginia Wireman Cute that she made in England and were struck with the hallmarks of the Sheffield Assay Office, a distinction not previously awarded to an American woman. Seemingly simple, the sinuous, essentially oval, shape of the box is subtly reinforced by the fit of the lid. The edge of the lid is thicker at one end, where it is hinged to the box. At the other end, where the oval is interrupted by a concave contour, the lid thins out along the matching curve, leaving a space between the top of the box and the lid, which creates a line of shadow that enhances the shape. BBG

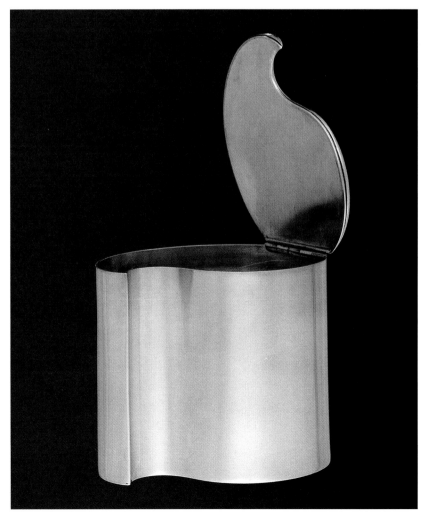

Cat. 166

I C

Quebec, Canada (?)

Goblet

c. 1740 (?)
Mark: IC (over pellet, in shield, four times on one side
of cup near rim; cat. 166–1)
Height 5¾ inches (14.6 cm), diam. rim 4⅛ inches
(10.5 cm), diam. base 4 inches (10.2 cm)
Weight 10 oz. 3 dwt.
Gift of Susanne Strassburger Anderson, Valerie Anderson
Readman, and Veronica Anderson Macdonald from the
estate of Mae Bourne and Ralph Beaver Strassburger,
1994-20-69

Cat. 166-1

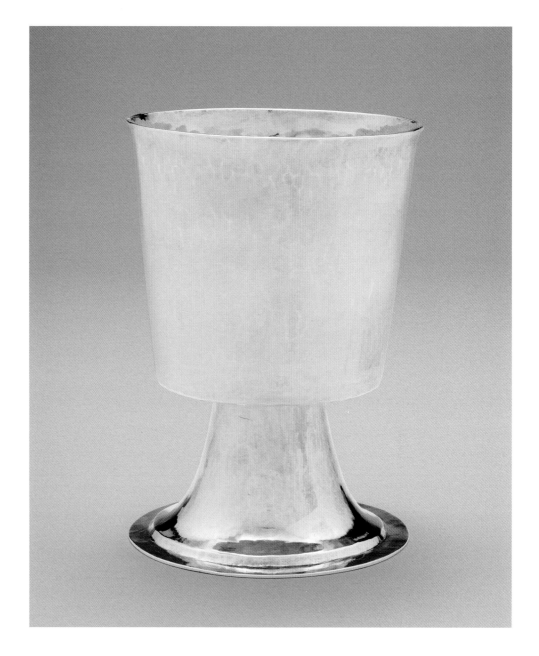

The provincial character of this cup and its maker's mark suggest the Canadian attribution, while the very plain and somewhat abrupt connection between the cup and the pedestal suggests a provincial version of a late seventeenth-century design. The tapered shape of the cup and the funnel-shaped pedestal with a wide flaring foot recall early Communion vessels, but this piece is small for that use, and there are no inscriptions to identify its purpose. It may have been a wine goblet.[1] The cup itself has a flat bottom, and in comparison with an otherwise similar Communion cup with paten, made in London about 1667 or 1668, the stem is stubby without any articulation.[2] There is no raising dot visible on the underside of the cup, which was secured as a separate piece, although a seam is not obvious. The surfaces are hammered. There is little wear on the bottom rim, and there is no discoloration on the inside surface of the foot and pedestal. The solder line on the outside, joining the cup and the pedestal, is crude.

This cup had been attributed to John Coney (q.v.), but it is unlike any other known examples of

his work, and the shield-shaped mark is unlike any currently recognized as his.[3] The width of the dies as struck and measured under magnification, from one top corner of the shield to the other, vary between 5 mm and 6 mm. The pellets are diamond shaped. The surfaces of the letters in the mark are smooth. The ground of the die is rusticated and rough. A straight-sided dram cup made in St. John, New Brunswick, by William Brothers (active c. 1783–85) has the same hammered surface texture and similarly placed marks near the top rim.[4] The mark on this cup or chalice is similar to one used by Jean Cotton (1698–after 1744), a silversmith in Quebec, Canada: "IC" over a diamond-shaped pellet with the addition of a crown above the initials.[5] By 1715 Cotton was working with his brother Michel (c. 1690–after 1747) in Quebec, where they were commissioned in 1738 to make a chalice and paten for the Church of Notre Dame de Quebec. The shape of one of Jean Cotton's marks suggests the shield shape seen on this cup. The thin, sharp ends of the tops and bottoms of the "I" are similar, and the motif of the pellet, slightly

askew, is also similar. If it could be established that a crown above the initials has been erased or was never applied, this chalice or cup might confidently be attributed to Jean Cotton. BBG

1. See Robert Lloyd, Inc., New York, advertisement, *Antiques*, vol. 173, no. 2 (February 2008), p. 45.
2. Francis J. Puig et al., *English and American Silver in the Collection of the Minneapolis Institute of Arts* (Minneapolis: the Institute, 1989), cat. 9, p. 16.
3. Kane 1998, cat. 316. The cup and the mark are too eccentric to have been an attempt at faking a Coney piece.
4. He was the brother of the Philadelphia silversmith Michael Brothers (q.v.); Donald C. Mackay, *Silversmiths and Related Craftsmen of the Atlantic Provinces* (Halifax, Nova Scotia: Petheric, 1973), cat. 5.
5. Robert Derome, *Les orfèvres de Nouvelle-France: Inventaire descriptif des sources* (Ottawa: Galerie nationale du Canada, 1974), p. 32.

D

John David Sr.

| Philadelphia, born 1736
| Philadelphia, died 1794

John David Jr.

| Philadelphia, born 1772
| Philadelphia, died 1809

John David Sr., the son of Peter David (q.v.) and Jeanne (Jane) Dupuy David, was baptized at Christ Church in Philadelphia on October 4, 1736, at the age of nine days.[1] His father was an active silversmith in Philadelphia by 1735 with a residence and shop, first on Front Street, and by 1750 with an additional residence on Second Street.

John David Sr. surely apprenticed with his father and probably began his training before the age of eleven. Judging by his mature work, John was well taught and had innate skills in method and design. He was nineteen when his father died in October 1755. In his will Peter David addressed John as "silversmith."[2] Son John, with Peter's second wife, Margaret, served as executors. Peter's extensive estate was appraised by Philip Syng Jr. and Joseph Richardson Sr. (q.q.v.). The executors advertised in the *Pennsylvania Gazette* on March 18, 1756, for a sale to take place on the 22nd: "to be sold by public Vendue at the house of the late Peter David dec'd, in Second Street, sundry sorts of household goods and furniture, and some silversmith's tools and plate work." Although John may have inherited some of the tools, Margaret continued to offer silversmith's tools in her sales of Peter's effects after she moved out of the Davids' residence. On October 14, 1756, she placed almost the same advertisement in the same newspaper, for "sundry sorts of household goods and silversmith's tools . . . to be sold by public vendue at the house of Margaret David, in Church Alley on Thursday, the 21st instant." This suggests that Peter may have been in her debt when he died. Later records do not suggest that Margaret remained connected to the David family.[3] Margaret David died in 1795. There was no reference to her David stepchildren in her will probated December 3, 1795.[4]

Exactly where John David was working between 1755 and 1763, when he placed his first advertisement, is not certain, perhaps on his own on Front Street, or with Philip Syng, who was one block north on Front Street. His purchases at the sale of the estate of silversmith Philip Hulbeart (q.v.) in 1763, which was managed by Philip Syng and Joseph Richardson Sr., suggest that he was setting up shop. On February 26, 1763, David's account in that sale included twelve black melting pots for 9s., two strings of jet beads and one key spring for 4s., and one set of pennyweights and grains for 2s.; in March, six nest crucibles for 7s. 6d.; and in May, a dozen stone jacket buttons for £1 5s., which he returned.[5] John David placed his earliest advertisements in the *Pennsylvania Gazette* on January 13 and February 24, 1763, announcing that he had moved from Front Street to Chestnut Street, "at the Coffee Pot" next door to the Second Street corner (see fig. 67).[6] It was the same location his father had advertised in 1751.[7] The Stretch family clock shop was across Second Street on the southwest corner of Second and Chestnut and had been known for years as "Stretch's Corner." Silversmiths John Bayly, Daniel Dupuy, and William Hollingshead (q.q.v.) were within a block, as were their patrons the Pembertons, Norrises, and Willings, among other merchants and civic leaders.[8]

Just two years later, on March 28, 1765, John David advertised in the *Pennsylvania Gazette* that he had removed from Chestnut to Second Street, next door to the widow Anthony (see fig. 66) and nearly opposite James Pemberton in the Walnut Ward.[9] This location had also been his father's when the house had belonged to Captain Stephen Anthony (no relation to the silversmith Joseph Anthony [q.v.]), an Elder in the Baptist Church.[10] By the time of David's tenure, Stephen Anthony's widow, Joanna, was living "next door" in a small addition she had made to the house.[11] Joanna Anthony became a person of note in her own right, even notorious in the city for having spoken up in 1764 for womens' votes in general matters of the Baptist church, and thus she was worthy of citation by a craftsman as a "location."[12]

In July 1766 John David's name appeared in the records of the Philadelphia Guardians of the Poor for a bond of indemnity: "John David, goldsmith, and William Huston, clockmaker, on account of a daughter of Ann Crispin named Esther, whereof the said David is the R[eputed] father."[13] On November 29, 1766, John David married Deborah Williams (1736–1788) at Christ Church.[14] Their son John junior was born in 1772, and their daughter Deborah Mary about 1779.[15] In 1767 and 1775 John David Sr. was on the lists to serve on a traverse jury.[16] In the first part of 1769, he was paying ground rent of £14 to Anthony Morris for his property on Front Street, and £4 property tax for owning a negro.[17] Later that year John David moved his residence to the Second Street property in the Walnut Ward, again where his father had been, next door to the "widow Anthony," and paid her £26 per year for his lease. In turn, Joanna Anthony was paying £15 3s. ground rent to George Gray for the Second Street property, thus making a profit of about £11. At the same time Joanna Anthony took over (or took back) the Davids' Front Street lease from John Morris, paying a ground rent of £1 10s.[18] In December of that year John David and his wife took on Mary Collins as an apprentice to "sew, knit, read the Bible, write a legible hand and housewifery with freedom dues, for six years and ten months."[19]

Fig. 66. The home of Captain Steven Anthony on Second Street in Philadelphia. From John F. Watson, *Annals of Philadelphia, and Pennsylvania, in the Olden Time . . .* (Philadelphia: Lippincott, 1870), vol. 2, opposite p. 618

John David's tax in 1770 located him precisely, on "Front Street near the drawbridge in the house where James White deceased formerly lived. N.B. a shop and cellar to be let."[20] In 1774 David paid £75 to the estate of James White, which included the lease taken by Peter David from John Langdale in the Mulberry Ward for his livestock.[21]

John David's name does not spring forth in the news, advertisements for his business are spare, and he did not enter the political or civic scene until the Revolution. In 1772 he was located at "the fourth door from the drawbridge" and advertising for an apprentice.[22] On October 7, 1772, David placed an advertisement in the *Pennsylvania Gazette* for "smalls," fine jewelry, seals, bells and whistles, and so forth, "with a quantity of large and small silver work." In 1773 he took in William Williams, who advertised as a "Native of this city, house carpenter, returned from London, and located at Mr. John David's, Goldsmith near the drawbridge."[23] Williams appears later, in 1782 in the Dock Ward, as "William Williams and for John David's est . . . £900"; the large amount, probably a ground rent, was the result of postwar inflation. In 1774 John David and William Young (q.q.v.), who advertised as a goldsmith in 1768, were noted as next door to Thomas Shields (q.v.), and taxed as having an "estate" in the Dock Ward. David paid £4 for owning a negro, and "10 doll £2 10s." on his "estate."[24] In the same tax list of 1774 for the Dock Ward, the silversmiths Giles Lewis and John Murdock (q.v.) were listed immediately after John David, as single with no property and no tax, indicating that they were employed in David's shop. On January 11, 1777, David advertised in the *Pennsylvania Evening Post* that his "free negro" was to be sold at the "vendue" of Jacob Keene.

The interruptions of trade on land and sea seemed not to affect John David as much as they did others whose advertisements featured imports. David's advertisements seem more modest and feature his own production and trades with his contemporaries. Some craftsmen served their military duties and returned to their shops during the years of the Revolution. From 1775 to 1777 David had a regular account with neighbor Thomas Shields, from whom he purchased small items, including shoe chapes, gold ear wires, a pair of "gold joint earrings," swivels and plated spurs, a twin set of gold rings, and a steel-topped thimble.[25] David's account was always paid up and in cash. That he remained at his address on Front Street when Revolutionary activity and the British occupation took over city commerce is evidenced by his advertisement in the *Pennsylvania Evening Post* on October 17, 1776: "Was stolen last night, out of the dwelling house of the subscriber, living in Front-street, near the Drawbridge, a PIECE of DOWLAS, containing about thirty yards, marked with red letters DS, ornamented with a green leaf round the letters. . . . FOUR DOLLARS reward."[26] In preparation for the defense of Philadelphia, each city ward was required to produce "a return of males from 16 to 50 residing in the Ward." In the Dock Ward on December 23, 1776, William Morris, constable, produced his list beginning at the South Street wharf: John David, Joseph Lownes (q.v.), Samuel Richards (q.v.), and Thomas Shields were listed.[27] In November 1777 John David subscribed to an agreement to accept the "continental, resolve, and commonwealth" paper currency, along with other silversmiths including William Ball, John Bayly, John LeTelier Sr., the three Richardsons (q.q.v.), Samuel Jeffrey, and William Pinchon.[28] In 1777 "a Tax of Five Shillings in the pound and Thirty Shillings per head (besides their Estates) [was] laid on the Estates of the Inhabitants and on single men of the City and County of Philadelphia in pursuance of a Supplement to the Act entitled An Act for emitting the sum of two hundred thousand pounds in Bills of Credit, for the defence of this State, and providing a fund for finding the sum by a Tax on all estates, real and personal, and on all Taxables within same."[29] Also at this time, during the years 1777 and 1778, an oath of allegiance was required from all persons, public and professional. John David "goldsmith" was assessed in the Dock Ward for his occupation at £10 and noted as "double"—that is, he had not taken the oath—with a tax of £2 10s. Thomas Shields was assessed £155 and noted "allowed" with a tax of £38 16s.; since he was serving he was noted as "Captain" in the list. David took the Oath of Allegiance to the state of Pennsylvania on August 13, 1778.[30]

In the General Return of the Second Battalion of the Pennsylvania Militia in 1779, John David and Joseph Lownes were both listed in Captain William McCullough's company as privates fifth class but were also noted as "paid," the former on September 15 and the latter on October 11; they had subscribed to a common practice and paid for a substitute to serve. In the sixth class of the same battalion, a Thomas Shields was noted as serving in Chester County, and in the seventh class John Germon (q.v.) was noted as "paid September 1779."[31]

The rampant inflation and problems with currency at the end of the Revolutionary War were clearly apparent in the 1780 tax assessments. For John David's property, located in the north part of the Dock Ward, with tax set at 4 s. per £100 for two months, his value was estimated at £97,200 and he was taxed at £174 8s., with an additional amount for James Byrnes's estate, valued at £40,000 and taxed at £80. The second Effective Supply Tax in 1780, set at 7s. per £100, valued David's estate in the Dock Ward at £4,300, with a tax of £80 12s. 6d.; he was also taxed for James White's estate, valued at £6,000, at £112 10s. In addition, John David had £625 cash, for which he was taxed £7 16s. 3d. In 1781 his estate was valued at £769 with a tax of £7 13s. 10d.; he was further taxed for James Byrnes's estate, valued at £1,000, for £10[32]; and for "his own house," valued at £1,000, for £10. In 1783 John David's estate was valued at £626, with a tax of £3 15s. 8d., and he was taxed for Mark Wilcock's estate, valued at £1000, at £6 10d. On February 24, 1780, John David, goldsmith, expanded his enterprise by buying two pieces of property on the Delaware River waterfront, just a few doors below his original location, perhaps to better serve his clientele from the state of Delaware; the river was the most efficient means of transit. For £500 in gold and silver coin, he purchased from James Ham, mathematical instrument maker, and Joyce, his wife, a house and ground between Front and Penn streets and between Spruce and Pine, subject to a yearly rent of £2 7s. sterling, to be paid to the assigns of George Fitzwater. The property was bounded on the east by Penn Street and on the west by Front.[33] On March 8, 1780, John David, goldsmith, purchased from William McCullough, mariner, and Hannah, his wife, for £1,300 in gold and silver coin, "a house and lot on the West side of Front Street, in the Eastward side of Dock Street between Walnut and the Drawbridge."[34] It was bounded on the north by ground belonging to John Reynolds, on the east by Front Street, on the south by a house and lot belonging to Griffith Jones, "now in the occupation of Thomas Shields," and on the west by Dock Street. McCullough had purchased the property from Moses and Elizabeth Cox in October 1778. This complex would become the Davids' permanent location. In 1785, when numbers were assigned, the property became 124 South Front Street, with Shields at number 126. A deed between John David and Thomas Shields drawn up on July 7, 1790, described in vivid detail the problems encountered with houses closely built with party walls: "Whereas Thomas Shields is seized of a messuage and lot of ground on the West side of Front Street, in his deed mentioned to be in breadth 25 feet, depth 121 feet on South side, and on North side 123 feet. Agreed by and between Mark Wilcox, Thomas Shields, John David and others that a regulation [requested in 1785 and passed in 1790] of their respective lots, be considered: Thomas Shield's breadth 19 feet 11 inches, John David's breadth 20 feet six inches." Further details regarding rights and remuneration were subsequently recorded on July 12, 1792.[35]

The 1783 Federal Supply Tax for the northern Dock Ward listed John David with one horse, one cow, and three negroes. In 1783 and 1784 everyone was taxed for a "conveyance"; John David had one chair, taxed at £1 10s. In 1785 Shields and David were listed together, with the former valued at £912, taxed £4 16s. 5d., and the latter at £949, taxed at £5 6d. In 1786 David's estate was assessed as follows: house and lot at £800, two negroes at £80, one horse at £8, one chair at £20, 60 ounces of plate at £24, and his occupation at £30, for a total value of £962; his tax was £2 16s. 11d. David's neighbor Thomas Shields paid the same £30 occupation tax.[36]

From 1784 to 1794 John David and his neighboring silversmiths Lownes and Shields continued to be listed in the muster rolls of various battalions of the Pennsylvania Militia, which was kept active after the Revolution. In 1784 and 1785 they were listed in the Fifth Company of the Sixth Battalion, and in 1786 and 1787 in the Fourth Company of the First Battalion. In 1794 Liberty Browne (q.v.) and John David (probably junior, as the elder had died in 1794) were listed in the Second Company of the Third Regiment.[37]

On July 10, 1786, John David paid 7s. for one person toward the rent of pew number 56 at Christ Church, which he shared with his relatives the Dupuys.[38] On July 30, 1788, John David's wife Deborah died. In the *Pennsylvania Gazette* of August 6, 1788, she was described as "the amiable consort of Mr. John David, of this city," and it was reported that "her remains were interred in Christ Church Burial Ground, attended by a great number of respectable citizens. During a lingering disorder, she exhibited a truly Christian fortitude." On November 26, 1788, John David was included in the list of donors to the Pennsylvania Hospital with a contribution of £10 25s. 6d.

The U.S. census of 1790 noted John David's household at 124 South Front Street, west side, as consisting of three males over sixteen and none under, three females, one other free person, and two slaves. George Drewry (q.v.) may have been living and/or working with the Davids at this time. The Philadelphia directory of 1793 listed Drewry, "goldsmith," immediately after John David and without an occupation, which usually indicated dependency and/or residency. In January 1791 David was one of a committee, with Joseph Lownes and Thomas Shields, appointed to receive applications for the relief of the unemployed in the Dock Ward.[39]

In 1793, while on a visit to his daughter Deborah, John David was taken ill while in Newport, Delaware, where he wrote his will on October 4. She had married Thomas Latimer (1765–1833), a prominent Federalist who had been a delegate to

the Convention that ratified the Federal Constitution.[40] John David returned to Philadelphia, where he died of yellow fever on January 3, 1794.[41] The stock left in his shop was valued at £703 6s. 9d.[42]

The silver that John David Sr. made is handsome, the forms are generous, and the early engraving is elegant, whoever did it.[43] His work, especially the grand coffeepots, are very like those made by Philip Syng Jr. and William Hollingshead. David senior's advertisement that appeared in the *Pennsylvania Gazette* on February 24, 1763 (see fig. 67), featured a coffeepot detailed with a stylish double-reverse cypher. The image with its short announcement, inserted at the bottom of a solid page of text, had visual impact. On March 28, 1765, he advertised again, using the same illustration.

In the early 1770s David made some handsome silver for notable patrons: a tall coffeepot and a cann with the Dickinson arms for John Dickinson; an elaborate cruet stand engraved with the Chew arms for Benjamin Chew; another cruet stand, with the initials "CR"; and a spoon with a coat of arms, advertised in November 1773 as stolen.[44] Also in 1773 John Penn, with funds from the estate of Harriet Sims, commissioned David to make a flagon, a chalice with cover, and a paten for St. Peter's Church in Lewes, Delaware.[45] David also made tablespoons for Margaret Rankin of Newcastle County, Delaware, valued at 30s.[46] His silver work after the Revolution was as distinctive and fine in the new neoclassical vocabulary as it had been in the earlier style. His sugar bowls, to which he added pierced galleries, retained their curvy shapes, bead bands, and staccato punching. In 1782 he had an active account with Levi Hollingsworth (1739–1824), another mill owner in Delaware near the Latimers' mills. David made military hardware, including a ball pommel for a plain small sword marked with his "ID" die.[47] Some pieces also made their way to Bermuda.[48] The wood handles on his tea and coffeepots were made by the cabinetmaker Daniel Trotter and Trotter's carver John Watson, as noted in Trotter's account book.[49]

In January 1794, after his father's death, John David Jr. advertised that "he carries on the GOLD and SILVER-SMITH business at the late dwelling house of his father, Front Street, No. 124, near the Draw-bridge, and requests the continuance of the favors of his father's former friends, in particular, and of the public in general."[50] Just how much work David junior accomplished in the years after his father died might be determined by identifying the engraved initials of owners. The small mark "ID" in an oval probably was used by both silversmiths. The "JD" in an oval may have belonged to David junior, working with his father until 1796 or doing journeyman's work for Thomas Shields; the

cream pots by the Davids and by Shields are similar. In September 1794 a patent for land in Northumberland County was issued to John David Jr. (in 1803 the property was noted as having fees overdue).[51] On May 6, 1796, he advertised in *Claypoole's American Daily Advertiser* that he had lost on April 26 "my Note of Hand for two hundred and fifty eight dols payable in sixty days from this date, in favor of Robert C. Latimer . . . return it to me at No. 124, South Front street. . . . As it was not indorsed [*sic*], it can be of no use to any person but the owner."

A month later, on June 2, 1796, the same paper carried the notice "Married, on Thursday Evening, by the Rev. Mr. Meeder, Mr. JOHN DAVID, to Miss SUSAN BARTOW."[52] She was the fourteenth child of Thomas Bartow Jr. (1737–1793) and Sarah Benezet Bartow (1746–1818). Her marriage and those of two of her sisters took place at the Moravian Church in Philadelphia.[53] Susan's sister Mary (born 1770) married George Peters on April 9, 1795, and Sarah (1773–1817) married William Geddes Latimer (1771–1810) of Newport, Delaware, on November 4, 1794, that marriage creating another connection between the David and Latimer families. The Latimers were living in Philadelphia's Dock Ward in 1800. John and Susan David remained at 124 South Front Street until 1798. In June 1798 newspapers posted notices of merchandise that had been left unclaimed for nine months at the custom house, including "one small box of plated Ware" consigned to John David.[54]

On July 18, 1798, in an advertised sale, John David, goldsmith, and "Susannah" his wife sold to the goldsmith Joseph Lownes, who was then living at 130 South Front Street, for $3,150 in gold and silver "money of Pennsylvania," their house and shop, "all that certain messuage and lot of ground thereto belonging."[55]

In the U.S. census of 1800, John David and his wife, their ages given as being between sixteen and twenty-five, were listed in Southwark. They are not found in the city directory after 1800. John David Jr. died in August 19, 1809.[56] His widow probably moved to Northampton County to live in the Moravian community. Her sister Elizabeth (1769–1799) had married Johann Christian Reich at the Moravian Church in Bethlehem, Pennsylvania, on February 25, 1792.[57] Susannah David died in 1843 and was buried in the Moravian Cemetery in Bethlehem, Pennsylvania.[58] BBG

1. "Records of Christ Church, Philadelphia: Baptisms, 1709–1760," *PMHB*, vol. 15, no. 3 (1891), p. 357. Not to be confused with the contemporary Welshmen John David of Gwynedd Township and John David of Whitpain Township; John David of Great Valley, Chester County (Philadelphia Will Book C, 1712, no. 237, p. 296); nor John David of Upper and Lower Merion Township (as recorded in deed books and lists of landowners).

2. Philadelphia Administration Book G, no. 21, p. 39.

3. From 1767 to 1779 she was taxed in the North Ward. In 1774 she was collecting ground rents from nineteen persons for a total of £104 5s. 6d. Tax and Exoneration Lists, 1762–1794.

4. The Parham children, John Parham and Maria Bennett, and grandchildren Paul Beck Jr. and Richard and Samuel Parham, children of her deceased son William Parham, were the heirs. Philadelphia Will Book X, pt. 1, 1795, p. 373.

5. Account of Goods Sold of Phil [sic] Hulbeart, pp. 6, 8, 12, Downs Collection, Winterthur Library, coll. 602, no. 58x31.3.

6. Other distinctive advertisements with special illustrative "cuts," including a wild pig, a saddle, and a sickle, advertising other craftsmen, appeared in the same eye-catching location in other issues of the *Pennsylvania Gazette.* John David's advertisements were the only pictorial silversmiths' advertisements in the publication in 1763 and 1764.

7. *Pennsylvania Gazette,* August 8, 1751.

8. The possibility of a partnership or similar arrangement between David and Dupuy emerges in every relevant publication and seems reasonable, although no facts have emerged to confirm or refute the speculation. The name David does not appear in Daniel Dupuy's receipt book, either in early entries or later entries by Daniel Dupuy Jr., nor in the Herbert Dupuy Papers of 1770–1814, the Meredith Papers of 1760–1888, nor in the two receipt books of Charles Meredith of 1753–72 and 1773–91, in the Coates and Reynell Papers of 1702–1843; all at the HSP.

9. Joanna Anthony (died 1809) was the widow of Captain Stephen Anthony (1697–1763). Both were Baptists in Philadelphia. *Pennsylvania Gazette,* August 20, 1761; memorial no. 155006065, www.findagrave.com (accessed November 28, 2016). The house was known for being the location of the meetings of the Assembly of Pennsylvania in 1728–29. The fact that David's advertisement referred to her location suggests that she was better known than he. See also "Fragments from Old Philadelphia Graveyards," *Pennsylvania Genealogical Magazine,* vol. 11, no. 1 (1930), p. 31.

10. Captain Anthony was well-known in the city by 1720. His location was noted as no. 8 in *The South East Prospect of the City of Philadelphia,* painted by Peter Cooper about 1718 (Library Company of Philadelphia).

11. Philadelphia Deed Book D-29-21. Johanna Anthony sold to Jas. Stuart on February 19, 1787, a "messuage & tenement & lot of ground situate on the North side of the dwelling house of Stephen Anthony deceased (being the second from the corner of Gray's Alley (Northward) and of and in a yearly ground rent of l6.10sh payable by John Moore for a lot of ground in Front Street (the same being bequested in dowry during my natural life or marriage by the said Stephen Anthony in lieu & full of my dower or two thirds of his estate."

12. Jon Butler, Grant Wacker, and Randall Balmer, *Religion in American Life: A Short History* (Oxford: Oxford University Press, 2011), p. 127.

13. There was a bond of friendship and trust between John David and the clockmakers James and William Huston. In his will of 1791 James Huston bequeathed a house and ground that adjoined the north end of his dwelling house, "said lot situate, lying and bordering on Second St. extending backward to Strawberry Alley . . . [to] my trustee friends John Wood watchmaker and John David silversmith . . . use proceeds from rent for maintenance and support of his grandchildren, the children of his son William deceased—sell when youngest reaches maturity and divide." Will of James Huston, Philadelphia Will Book W, written 1793, probated 1794, no. 46, p. 88.

14. *Pennsylvania Archives,* 2nd ser. (1895), vol. 8, p. 65. She died in July 1787, at age fifty-two, and was interred in Christ Church ground; *Pennsylvania Gazette,* July 30, 1787.

15. Petition of Deborah Mary David for a guardian: "under the testament and last Will of her father John David [she] is entitled to considerable real and personal estate in the County of Philadelphia and that she is by reason of a tender age incapable of managing the said estate . . . whereas the said Deborah who is above the age of fourteen years prays the Court to appoint some person to manage and take care of the said Petitioner. May 7, 1794"; John David, Philadelphia Orphans Court Records, 1719–1880, no. 17, p. 54, HSP. Thomas Cuthbert was appointed. He was also a witness to John David's will; Philadelphia Will Book W, 1794, no. 402, p. 665.

16. Courts of Oyer and Terminer, ser. 126, Supreme Court, Record Group 33, Pennsylvania State Archives, Harrisburg, Ancestry.com.

17. Tax and Exoneration Lists, 1762–1794.

18. Ibid.

19. Memorandum Book, Philadelphia Guardians of the Poor, Indentures, 1751–97.

20. *Pennsylvania Chronicle* (Philadelphia), April 9, 1770, Brix files, Yale University Art Gallery.

21. James Byrnes, tavern keeper in the Mulberry Ward, was managing James White's estate; Tax and Exoneration Lists, 1762–1794.

22. *Pennsylvania Gazette,* October 28, 1772. Also in 1772 James Byrnes, tavern keeper in the Mulberry Ward, had £75 from John David on account for the estate of James White, deceased; Tax and Exoneration Lists, 1762–94.

23. *Pennsylvania Gazette,* January 4 and 13, 1773; Prime 1929, p. 297.

24. Seventeenth Eighteen Penny Provincial Tax (1774) on the Inhabitants of the City and County of Philadelphia, Pa., HSP.

25. Thomas Shields, Daybook, Downs Collection, Winterthur Library.

26. Dowlas was a fairly coarsely woven linen. Textiles were expensive at this time, and the description suggests that it may have been a family piece.

27. *Pennsylvania Archives,* 6th ser. (1906), vol. 1, p. 472.

28. *Pennsylvania Ledger, or The Weekly Advertiser* (Philadelphia), November 12, 1777, Brix Files, Yale University Art Gallery.

29. Tax and Exoneration Lists, 1762–94.

30. Thompson Westcott, *Names of Persons Who Took the Oath of Allegiance to the State of Pennsylvania Between the Years 1777–1789, with a History of the "Test Laws" of Pennsylvania* (Philadelphia: John Campbell, 1865), p. 40.

31. The Thomas Shields in this list might have been one of the same name resident in Chester County; *Pennsylvania Archives,* 6th ser. (1906), vol. 1, pt. 1, p. 133.

32. Tax and Exoneration Lists, 1762–94.

33. Philadelphia Deed Book I-17-330.

34. Philadelphia Deed Book I-17-375. As noted above, John David had served in the militia under William McCullough.

35. Thomas Shields to John David, Philadelphia Deed Book 39.

36. Tax and Exoneration Lists, 1762–94.

37. *Pennsylvania Archives,* 6th ser. (1907), vol. 3, pp. 970, 980, 1167, and 1177; "Muster and Pay Rolls, Pennsylvania Militia, 1790–1800," in ibid., vol. 5, p. 510.

38. Christ Church Pew Rent Book, no. 238, September 1786, Christ Church Archives, courtesy of Carol W. Smith, archivist; John David's location at the time was noted as "Front near the Drawbridge." Elsewhere, John David is listed as vestryman both at Christ Church and at St. Peters, and as occupying pew no. 16 at both churches; "List of Vestrymen of Christ Church, Philadelphia," *PMHB,* vol. 19, no. 4 (1895), p. 520; C. P. B. Jefferys, "The Provincial and Revolutionary History of St. Peter's Church, Philadelphia, 1753–1783 (continued)," *PMHB,* vol. 68, no. 4 (1924), p. 364.

39. *General Advertiser, and Political, Commercial, Agricultural and Literary Journal* (Philadelphia), January 7, 1791.

40. Thomas was the son of John David's friend George Latimer (1750–1825), also a member of Philadelphia's Christ Church, a land speculator and flour merchant who owned the Latimer Mills at Newport on the Christiana River; John H. Munroe, "The Philadelawareans: A Study in the Relations between Philadelphia and Delaware in the Late Eighteenth century," *PMHB,* vol. 69, no. 2 (April 1945), pp. 128–49. See also William Henry Egle, "The Federal Constitution of 1787," *PMHB,* vol. 11, no. 2 (July 1887), pp. 219–20.

41. "Short Account of Malignant Fever in Philadelphia—List of Dead (1793), Philadelphia County, Pa.," transcribed and submitted by Marjorie B. Winter, 2005, www.usgwarchives.net (accessed November 28, 2016).

42. Philadelphia Will Book W, no. 402, 1794, n.p.; Philadelphia Administration folder 402.

43. For other coffeepots by David, see cat. 173. The Dickinson coffeepot is illustrated in "Restoring a Maryland Mansion," *Antiques,* vol. 65, no. 5 (May 1954), p. 408; Hammerslough 1958–73, supp., vol. 3, pp. 74–75; Sotheby's, New York, *Fine Americana,* January 23, 1992, sale 6269, lot 164; Sotheby's, New York, *Highly Important Americana from the Collection of Stanley Paul Sax,* January 16–17, 1998, sale 7087, lot 87. For a tankard see cat. 171. Stephen Reeves, goldsmith, used the same engraver as did John David Sr. In 1767 Reeves's tax, also in Walnut Ward, was listed at £38; Philadelphia Tax Book 1767, Rare Book Collection, Van Pelt Library, University of Pennsylvania.

44. The cruet stand with the initials "CR" (probably for Caesar Rodney) is illustrated in Quimby and Johnson 1995, pp. 348–49, cat. 334. "A TABLE SPOON . . . with a dragon's head in a ducal coronet engraved on the handle"; *Pennsylvania Packet* (Philadelphia), February 22, 1773.

45. Jones 1913, pp. 242–43; Quimby and Johnson 1995, p. 349, cat. 335. For other silver made by John David for "TSC," see also cats. 171 and 180.

46. *Pennsylvania Packet, or The General Advertiser* (Lancaster), April 8, 1776.

47. Daniel D. Hartzler, *Silver Mounted Swords: The Lattimer Family Collection, Featuring Silver Hilts through the Golden Age* (State College, PA: Josten's Printing, 2000), p. 90.

48. See Bryden Bordley Hyde, *Bermuda's Antique Furniture and Silver* (Hamilton: Bermuda National Trust, 1971), cat. 453.

49. Anne Castrodale Golovin, "Daniel Trotter: Eighteenth-Century Philadelphia Cabinetmaker," *Winterthur Portfolio,* vol. 6 (1970), p. 163.

50. *Dunlap and Claypoole's American Daily Advertiser* (Philadelphia), January 7, 1794.

51. *Aurora General Advertiser* (Philadelphia), December 2, 1803.

52. The records of the Moravian Church, Philadelphia, state the date as January 27, 1796. She was born February 10, 1775. John and Susannah David had no children. She died September 25, 1843; "Bartow Genealogy," *PMHB,* vol. 14, no. 2 (1890), p. 214; Samuel Small and Anne H. Creson, *Genealogical Records of George Small . . .* (Philadelphia: Lippincott, 1905), p. 181.

53. *Pennsylvania Archives,* 2nd ser. (1896), vol. 9, p. 149.

54. "Notice of the Collector's Office at the Custom House," *Gazette of the United States* (Philadelphia), June 13, 1798.

55. Philadelphia Deed Book D-72-290. Joseph Lownes advertised in *Dunlap and Claypoole's Daily Advertiser* on February 9, 1799, that he had removed to 124 South Front Street.

56. His will was written July 31, 1809, and probated August 26, 1809.

57. *Pennsylvania Archives,* 2nd ser. (1896), vol. 9, p. 109.

58. Memorial no. 68994751 (Susanna [sic] Bartow David), www.findagrave.com (accessed July 24, 2015).

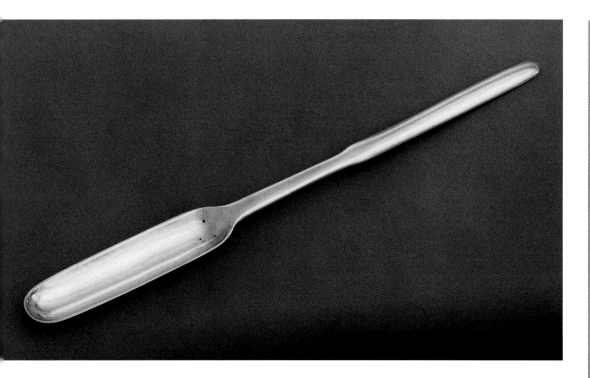

Cat. 167

John David Sr.
Marrow Scoop

1760–70
MARK: ID (in rectangle with chamfered corners, twice on one side; cat. 167-1)
Length 8⁷⁄₁₆ inches (21.4 cm)
Weight 18 dwt. 16½ gr.
Alan Dewees Wood Collection, 1969-224-178

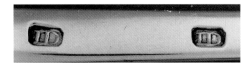

Cat. 167-1

The conjoined letters in the very small mark on this scoop are exactly like the last two letters of John David Sr.'s full name marks (see cats. 170-1, 173-1).[1]

This is an especially clean strike of this mark, which appears to have been a rectangle with chamfered corners rather than an oval. Another double marrow scoop with the mark described as "ID in an oval" is probably the same mark.[2]

Marrow scoops were in use in the early seventeenth century and continued to be popular as long as bone marrow continued to be a dining delicacy, until the end of the Victorian era. They were made by specialists in great numbers and in a variety of forms.[3] BBG

1. Belden 1980, p. 130; Ensko 1948, p. 192. The mark closest in form to this one is on a buckle in the collection of the Yale University Art Gallery; Buhler and Hood 1970, vol. 2, p. 278, cat. 905.
2. See Hammerslough 1958–73, vol. 1, p. 85. This mark is also like one recorded in 1735 by Jeremiah Davis, an English small-silver worker.
3. G. Bernard Hughes, *Small Antique Silverware* (New York: Bramhall House, 1957), p. 199.

Cat. 168-1

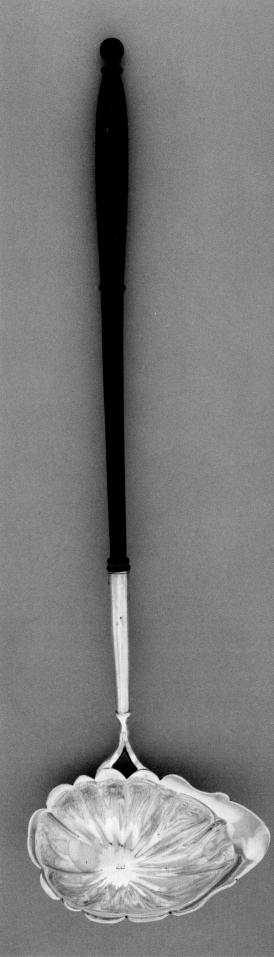

Cat. 168

Cat. 168

John David Sr.
Ladle

1760–80

MARK: ID (in rectangle with chamfered corners, at center of obverse of bowl; cat. 167-1)
INSCRIPTION: BEY (engraved script, on side opposite pouring lip; cat. 168-1)
Length 14⅝ inches (37.1 cm), width bowl 4⅛ inches (10.4 cm)
Gross weight 3 oz. 10 dwt.
Gift of Henry C. Brengle, 1922-86-18

PROVENANCE: Purchased from Cornelius Hartman Kuhn (1854–1948) of Philadelphia.

EXHIBITED: Paul L. Grigaut, *The French in America, 1520–1880*, exh. cat. (Detroit: Detroit Institute of Arts, 1951), p. 144, cat. 383; Philadelphia 1956, cat. 50.

This is an elegant, fluted punch ladle. The mark is in a vulnerable position at the center of the inside of the bowl, and the impression is worn. The letters seem to be John David Sr.'s small mark, the initials with conjoined serifs.

The style of the engraved initials "BEY" on the front of this ladle is fluid, the letters simply drawn in single lines with apostrophe-like droplets flicking off. This "hand" also engraved for Bancroft Woodcock (q.v.) and appears on other silver marked by John David Sr.[1] Four coasters made by Robert Hennell in London in about 1785 bear the same initials engraved in the same style.[2] BBG

1. See the sugar bowls by John David Sr. (cat. 174) and by Bancroft Woodcock (PMA 1923-28-1a,b).
2. See the pair of coasters by Robert Hennell (PMA 1922-86-28a,b).

Cat. 169

John David Sr.
Skewer

1770–80

MARK: ID (in oval, on reverse; cat. 169-1)
INSCRIPTION: NON DEGENER (engraved motto over Wyvern's head erased proper, on one side at top of handle; cat. 169-2)
Length 9¹⁄₁₆ inches (23 cm)
Weight 1 oz. 17 dwt. 19½ gr.
Alan Dewees Wood Collection, 1969-224-113

Cat. 169-1

The mark "ID" with serifs conjoined in a small oval on this skewer also appears on another, slightly longer skewer with the same engraved crest and motto, in the collection of the Winterthur Museum.[1] A third, similar skewer has a different crest with the same mark and is also attributed to John David Sr.[2]

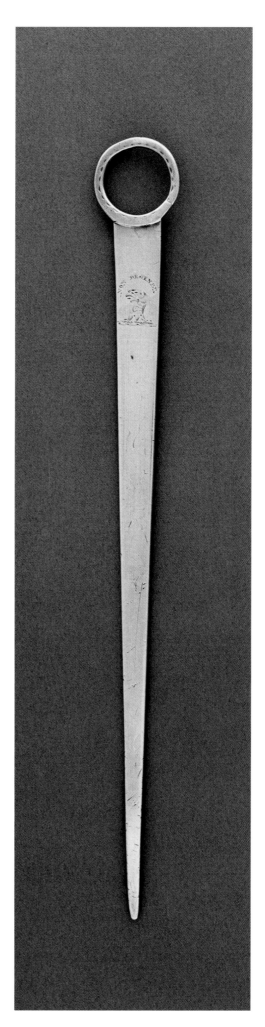

An engraved crest was a common decoration on skewers.[3] The motto "Non Degener" (literally, "not degenerate") was accomplished with a burin, and the crest, a Wyvern's head erased proper, is recorded as belonging to the Scottish Wedderburn family.

Skewers were made in sets. The earliest use for a skewer was to secure meat turning on a spit.[4] Later, as serving became more refined, skewers were used to aid in carving or "spearing" meat at table. By the nineteenth century skewers became handy letter openers.[5] BBG

1. According to Martha Fales, the crest and motto on the example at Winterthur were added at a later date; Fales, *American Silver in the Henry Francis Dupont Winterthur Museum* (Winterthur, DE: Winterthur Museum, 1958), cat. 94. The engraving on this skewer is uneven and was accomplished with a burin. The two examples are similar and possibly by the same hand, but not so alike to suggest that they were engraved from a pattern.
2. Hammerslough 1958–73, vol. 1, illus. p. 85. The crest (a sheaf of wheat or cummin over a rhinoceros) may be that of the Scottish Comyn family; see A. C. Fox-Davies, *A Complete Guide to Heraldry* (New York: Bonanza, 1978), p. 278, fig. 497, pp. 217, 219. That crest is not illustrated or described in Eugene Zieber, *Heraldry in America* (1895; repr., New York: Greenwich House, 1984), or in John Matthews, *American Armoury and Blue Book* (London: privately printed, 1907). A clear impression of this mark is illustrated in Woodhouse 1921, pl. I; see also p. 11, cat. 24 (tablespoon with inscription "MC to Elizabeth"). There does not seem to be an English or Scottish maker with this "ID" mark; information kindly provided by Donna Corbin, formerly the Louis C. Madeira IV Associate Curator of Decorative Arts, Philadelphia Museum of Art.
3. G. Bernard Hughes, *Small Antique Silverware* (New York: Bramhall House, 1957), p. 204.
4. Henry J. Kauffman. *The Colonial Silversmith: His Techniques and His Products* (New York: Galahad, 1969), p. 163.
5. See the skewer or letter opener by Bailey & Co. (cat. 32). The ring at the top is similar, although the shape of the blade has changed.

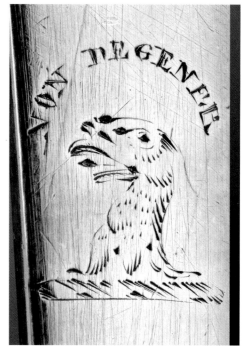

Cat. 169-2

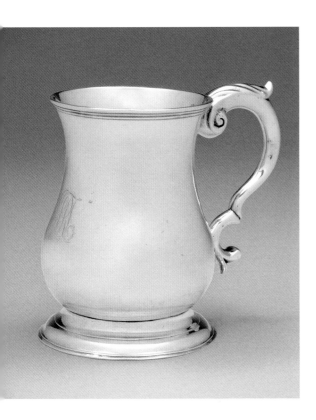

Cat. 170

John David Sr.

Cann

1770–90

MARK: I·DAVID (in rectangle, on underside; cat. 170-1)
INSCRIPTIONS: S R T (engraved script, on front opposite
handle); T (lightly scratched, on underside)
Height 3⅞ inches (9.8 cm), width 4½ inches (11.4 cm),
diam. top 2⅝ inches (6.7 cm), diam. foot 3 inches
(7.6 cm)
Weight 7 oz. 6 dwt. 10 gr.
Gift of the McNeil Americana Collection, 2005-69-4

Cat. 170-1

This is an almost clear strike of John David Sr.'s name
mark. It is the same mark that he used on the chalice
he made for St. Peter's Church at Lewes, Delaware,
engraved June 10, 1773.[1] The mark, the robust shape,
and the stepped, molded foot of this cann are char-
acteristic of hollowware by John David Sr. The initials
are similar to the engraved "BFG" on a tea service
by William Hollingshead that was made about 1783
(PMA 1956-84-27,28a,b, -30a,b). BBG

1. Jones 1913, pp. 242–43; Quimby and Johnson 1995, p. 349,
cat. 335. Cruet stands attributed to John David Sr. made for
the Ringglod and Chew families also bear this mark; David
B. Warren, Michael K. Brown, Elizabeth Ann Coleman, and
Emily Ballew Neff. *American Decorative Arts and Paintings
in the Bayou Bend Collection* (Princeton: Princeton Univer-
sity Press for the Museum of Fine Arts, Houston, 1998), illus.
p. 311.

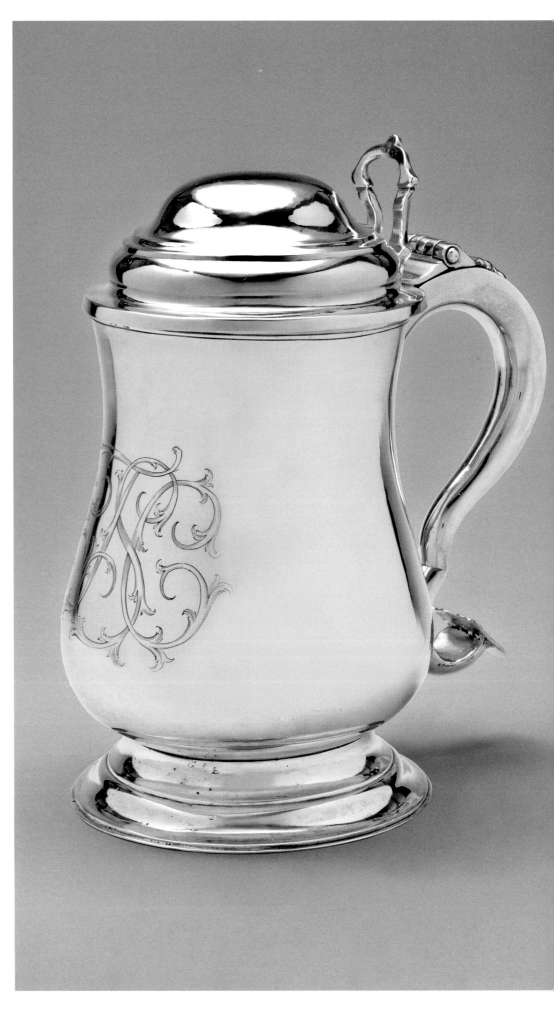

Cat. 171

John David Sr.

Tankard

1770–80

MARK: I·DAVID (in rectangle, twice, on each side of centering dot on underside; cat. 170-1)

INSCRIPTION: T S C (engraved script, on front opposite handle; cat 171-1)

Height 8½ inches (21.6 cm), width 7 inches (17.8 cm), diam. base 4⅞ inches (12.4 cm)

Weight 33 oz. 13 dwt. 10 gr.

On permanent deposit from The Dietrich American Foundation Collection to the Philadelphia Museum of Art, D-2007-6

PROVENANCE: Elinor Gordon, Villanova, PA.

EXHIBITED: On long-term loan to the Diplomatic Reception Rooms, U.S. Department of State, Washington, DC, 1968–80 (Buhler 1973, p. 69, cat. 148); Atwater Kent Museum, Philadelphia, 1980–85; Huntington Library, Art Collections, and Botanical Gardens, San Marino, CA, 1985–96; *Early American Silver from the Collections of H. Richard Dietrich, Jr. and the Dietrich American Foundation*, Yellow Springs Antiques Show, Chester Springs, PA, October 21–22, 2000.

Cat. 171-1

This handsome tankard bearing the initials "TSC" may have been made en suite with a pair of sauceboats by John David Sr. in the Winterthur collection bearing the same initials by the same engraver using Sympson's *New Book of Cyphers* (London,

1726).[1] This engraver also accomplished the initials on a pair of canns by silversmith Bancroft Woodcock (q.v.) of Wilmington, Delaware, for Sarah and Ann Drinker of Philadelphia. The sauceboats are thought to have been owned by Thomas (died 1788) and Sarah Lowen Cooch of Delaware. His inventory dated 1788 notes value but not maker or marks, engraving, or weights: "a pair of sauce boats, tankard, 2 pair salt cellars."[2] A tankard, two "butter boats," and salts engraved "C / T·S" are among the items noted on a list of family silver that descended in the extended family of Clement Biddle (see cat. 180). Both documents, the Cooch Inventory and the Biddle family list, lack the information needed for perfect identification with these surviving silver objects. BBG

1. Quimby and Johnson 1995, p. 349, cat. 355a,b.
2. The inventory was kindly provided by Ann Wagner, Curator of Collections, Winterthur Museum. Thomas Cooch's son Thomas junior had predeceased him, and he left his whole estate to his grandchildren; Newcastle, Delaware, Will Book M, pp. 78, 353.

Cat. 172

John David Sr.

Salt Dish

1760–70

MARK: I DAVID (in rectangle, twice on underside, one mark double struck; cat. 173-1)

INSCRIPTION: G / M C (engraved, on underside)

Height 1½ inches (3.8 cm), diam. 2⅝ inches (6.7 cm)

Weight 2 oz. 5 dwt. 4½ gr.

Gift of Mr. and Mrs. Walter M. Jeffords, 1960-52-2

EXHIBITED: Philadelphia 1956, cat. 56.

This salt dish has a deeper body and less articulation of the shells joining the legs to the body than on the pair marked by John David Jr. (cat. 180). The engraved initials, with the "M" shaded and the "G" and "C" with vertical serifs, are in a midcentury style of lettering. BBG

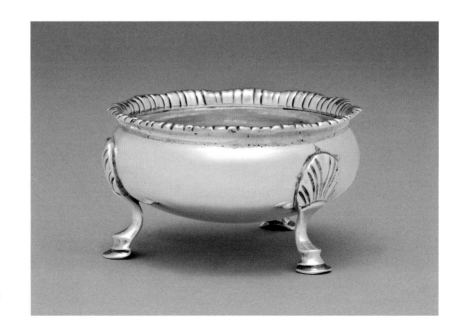

Cat. 173

John David Sr.
Coffeepot

1765–70

MARKS: I DAVID (in rectangle, twice on underside;
cat. 173-1) / oz 38-5 (scratched, on underside)
INSCRIPTION: S M D (engraved script. on one side)
Height 13½ inches (34.3 cm), width 9⁷⁄₁₆ inches
(23.9 cm), diam. 5¼ inches (13.3 cm)
Gross weight 38 oz. 3 dwt. 18 gr.
Purchased with funds contributed by Mr. and Mrs. Percival
E. Foerderer and with the Thomas Skelton Harrison Fund,
1956-49-4

PROVENANCE: The initials "SMD" belonged to Colonel
Sharpe (1739–1799) and Margaret Robinson Delany
(1745–1813), who married at Trinity Church, Oxford
Township (now Philadelphia), on September 7, 1763.[1]
The Museum purchased the coffeepot from David Stock-
well, Wilmington, DE.

EXHIBITED: Philadelphia 1956, cat. 45; *American Silver
and Art Treasures: An Exhibition Sponsored by the
English-Speaking Union and Held at Christie's Great
Rooms*, London, 1960, p. 55, cat. 165.

PUBLISHED: Louis C. Madeira IV, "The Quest for Philadelphia
Silver," *Philadelphia Museum of Art Bulletin*, vol. 53,
no. 255 (Autumn 1957), p. 10, fig. 3.

Cat. 173-1

John David Sr.'s first advertisement in the *Penn-
sylvania Gazette*, on February 24, 1763, featured a
coffee-pot form complete with a double-reverse
cypher (fig. 67). David's coffeepots are tall, in a
reverse-pear shape, with high, raised lids and ped-
estals that are enhanced by bands of bold gadroon-
ing or bead. Surviving coffeepots by John David Sr.
are handsome and consistent in size, weight, and
detail, and he must have been known for his exper-
tise in their production. Notable patrons owned
David's coffeepots.[2] The maker's mark on this pot
is crisp and seems to be the same as on the chal-
ice that David made for St. Peter's Church at Lewes,
Delaware, which was engraved with the date
June 10, 1773.[3]

Sharpe Delany was the eldest child of Daniel
and Rachel Sharpe Delany. His wife, Margaret Rob-
inson, was his first cousin, the daughter of Rachel
Delany's elder sister, Sarah, and her second hus-
band, Thomas Robinson. Sharpe Delany served in
the Third Battalion of the Pennsylvania Militia from
1776 to 1779 under his close friend General Anthony
Wayne (1745–1796). Delany contributed £5,000 to
supply the Army of the Revolution.[4] In 1789 he was
appointed by George Washington as the first Collec-
tor of the Port of Philadelphia, where his work has
led to his being considered the founder of the U.S.
Coast Guard. He turned down an appointment to
the Council of Safety, whose task was to seize and

Fig. 67. Advertisement for John David in the *Pennsylvania
Gazette*, February 24, 1763. Historical Society of Pennsylva-
nia, Philadelphia

manage the estates forefeited by Loyalists. He was
elected to the Pennsylvania General Assembly in
1780.[5] The coffeepot with a stand were listed in his
estate inventory at a value of $30.[6]

Sharpe and Margaret Delany's daughter Sarah
Delany (1767–1814) married Major James Moore
(1757–1813) at Christ Church in Philadelphia on
October 17, 1787.[7] John David had made a similar cof-
feepot for James Moore's parents, William (c. 1735–
1793) and Rachel Wright Moore.[8] James Moore also
served under Anthony Wayne in 1775, as captain of
the Seventh Company, Fourth Battalion. The Delany
and Moore families lived in style: Sarah Delany was
a celebrated "belle," and George Washington dined
with them. They traveled in fine carriages and served
as marshalls in the great parade of July 4, 1788.[9]

The engraved, foliate, script initials on the Delaney
coffeepot seem to be by the same hand as on a
drum-shaped teapot John David made for Dr. Enoch
(1751–1802) and Frances Gordon Edwards, who mar-
ried at Christ Church in 1779.[10] BBG

1. Sharpe Delaney was known variously as Doctor (he was a
druggist) and Colonel (for his leadership and service in the
Revolutionary War); "Naval History Blog, Founders of the
U.S. Coast Guard," www.navalhistory.org (accessed June 4,
2015); Henry Simpson, *Lives of Eminent Philadelphians Now
Deceased* (Philadelphia: W. Brotherhead, 1859), p. 308; Will
of Margaret Delany, May 22, 1813, Philadelphia Will Book 4,
no. 354.
2. See the coffeepot for John Dickinson, Dickinson Man-
sion, Dover, Delaware, illus. in Martha Gandy Fales, *Early
American Silver for the Cautious Collector* (New York: Funk &
Wagnalls, 1970), p. 91; coffeepot for William Moore, in Ham-
merslough 1958–73, vol. 3, p. 65; and coffeepot, Sotheby's,
New York, *Fine Americana*, January 23, 1992, sale no. 6269,
lot 164.
3. Jones 1913, pp. 242–43; Quimby and Johnson 1995, p.
349, cat. 335.
4. "Orderly Book of Captain Sharp [sic] Delany, Third Bat-
talion Pennsylvania Militia, July 16–25, 1776," *PMHB*, vol. 32,
no. 3 (1908), pp. 302–6. Delany was executor of Wayne's
will, February 15, 1797; Philadelphia Will Book X, p. 545.
5. Oswald Seidenstricker, "Frederick Augustus Conrad
Muhlenberg, Speaker of the House of Representatives, in the
First Congress, 1789," *PMHB*, vol. 13, no. 2 (July 1889), p. 194.
6. Philadelphia Administration Book K, no. 206, p. 5.
7. *Pennsylvania Archives*, 2nd ser. (1896), vol. 8, p. 78; Emily
Steelman Fisher, "Colonel James Moore (Born 1757); Moore
and Towles Bible Records," *National Genealogical Society
Quarterly*, vol. 7, no. 1 (April 1918), pp. 9–12.
8. Hammerslough 1958–73, vol. 3, p. 65. William and Rachel
Wright Moore married at Christ Church, Philadelphia, on
August 16, 1758; *Pennsylvania Archives*, 2nd ser. (1896),
vol. 8, p. 191. In another generation Rebecca Wright Morris
(1816–1894) married Charles Delany in 1859; Moon 1898–
1909, vol. 2, p. 639.
9. W. S. Long, "Judge James Moore and Major James Moore,
of Chester County, Pennsylvania (concluded)," *PMHB*, vol. 12,
pp. 465–74.
10. Philip Johnston, *Catalogue of American Silver: The Cleve-
land Museum of Art* (Cleveland: the Museum, 1994), illus. p. 41.

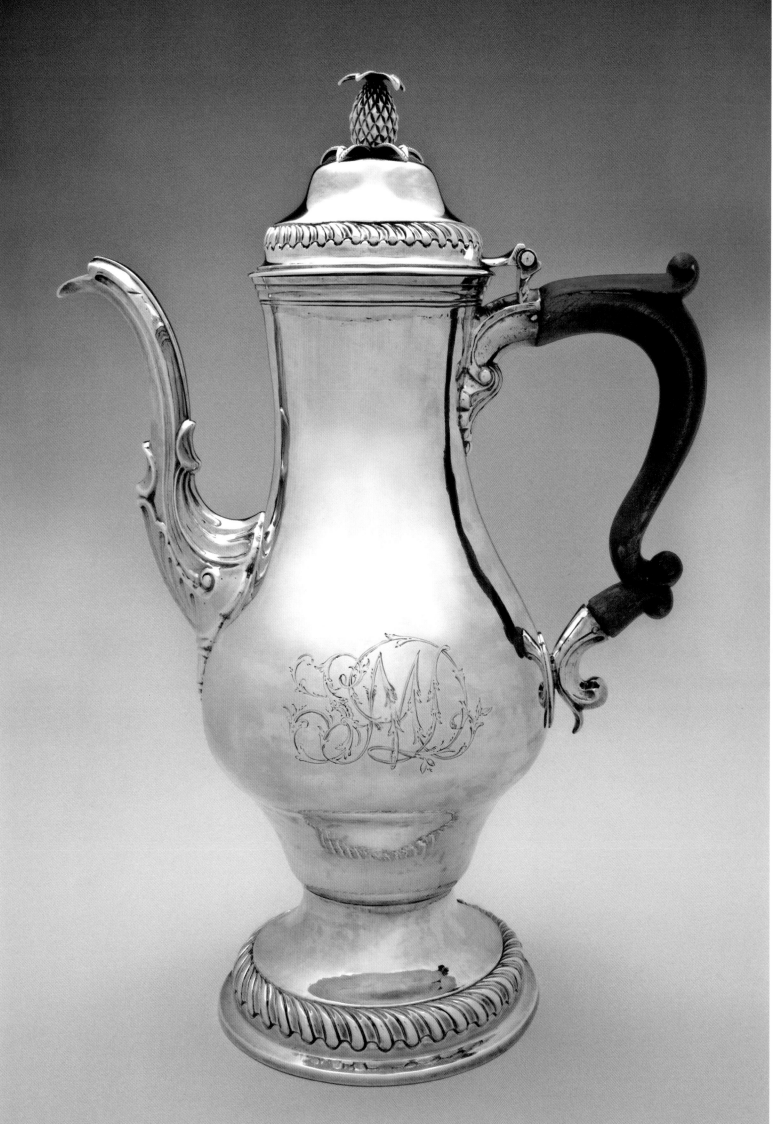

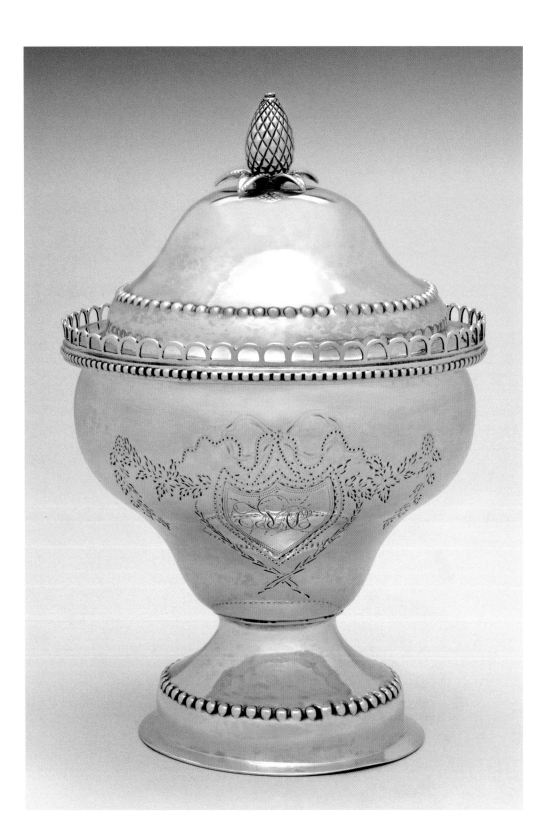

Cat. 174
John David Sr.
Sugar Bowl

1780–90

MARK: I DAVID (in rectangle, on underside; cat. 173–1)
INSCRIPTIONS: N A S (engraved script in bright–cut shield
with ribbons and floral swags, on one side); / M / I I
(engraved, on one edge of underside of foot);
12 oz = 2 (scratched, on underside)
Height 7 inches (17.8 cm.), diam. 4¾ inches (12.1 cm),
diam. foot 3¼ inches (8.3 cm)
Weight 11 oz. 14 dwt. 15 gr.
Gift of the McNeil Americana Collection, 2005–68–17a,b

PROVENANCE: Sotheby Parke Bernet, New York, *English,
Continental and American Silver,* July 15, 1980, sale
4409, lot 279.[1]

The flat flange around the raised and slightly dished
base of this sugar bowl was a distinctive feature of
silver from the Davids' shop. The deep repoussé
pearl work encircling the lid and base as well as the
flattened edge of the base were also characteristic
of their work.

The shape recalls a mid–eighteenth–century style,
while the pierced gallery and the pineapple finial
were design features of the 1780s. This combination
was not unusual. The matching teapot was drum
shaped, with the same engraved initials and flutter-
ing ribbons and garlands.[2] The shield surrounding
the initials and the decorative garlands were accom-
plished with a small punch and a sharp–edged
tool. It is most like the engraving on a punch ladle
and coasters engraved for Benjamin and Elizabeth
Delany Young.[3] The initials "MII" on the bottom of
the edge of the foot have been partially covered by
an encircling band added around the edge of the
base. BBG

1. At auction the sugar bowl was accompanied by a drum-
shaped teapot with matching details of engraving, pierced
gallery, bead bands, and pineapple finial (lot 278).
2. See note 1.
3. For the ladle by David, see cat. 168; for the coasters by
Robert Hennell, see PMA 1922-86-28a,b.

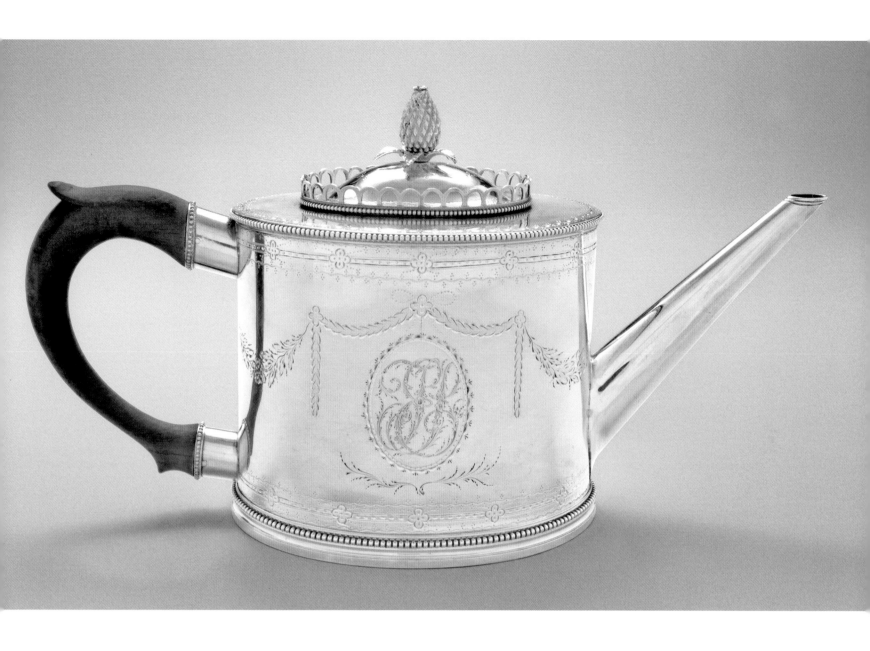

Cat. 175

John David Sr.

Teapot

1785–90

MARK: I DAVID (in rectangle, twice on underside; cat. 173-1)

INSCRIPTION: T E S (foliate script in bright-cut oval, on one side; cat. 175-1)

Height 6¼ inches (15.9 cm), width 11⅛ inches (28.3 cm), diam. 4¼ inches (10.8 cm)

Gross weight 18 oz. 7 dwt.

Gift of the McNeil Americana Collection, 2005-68-18a,b

PROVENANCE: Sotheby's, New York, *Important American Furniture, Folk Art, Silver, Chinese Export Porcelain and Rugs*, January 31, 1985, sale 5282, lot 67.

This is an especially handsome and heavy teapot with emphasis on decorative bands of bead and a raised gallery on the lid. There are three dots on

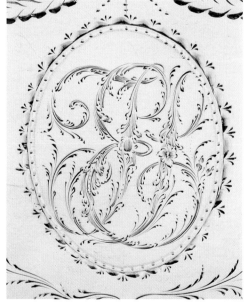

Cat. 175-1

the bottom for scribing and cutting the oval shape. The design in the Federal style is as smooth and restrained as the Davids' coffeepots were robust and curvy in an earlier style. Decorative bands of fine bead encircle the base, top edge, and edge of the lid, which has a pierced gallery. The pineapple finial, missing its top leaves, is secured with the threaded bolt and shaped nut found on the finials of other pots made in the Davids' shop (see cat. 174).

The engraving is particularly fine, and elaborate. The same engraver worked on the tea and coffee service John David Sr. made for George Corbin (cat. 177). There are encircling bands around the top and bottom edges of the pot, and garlands and swags around the midsection. The leafy, shaded engraved initials "TES" are enclosed in a bright-cut oval, which is suspended from the decorative swag.

BBG

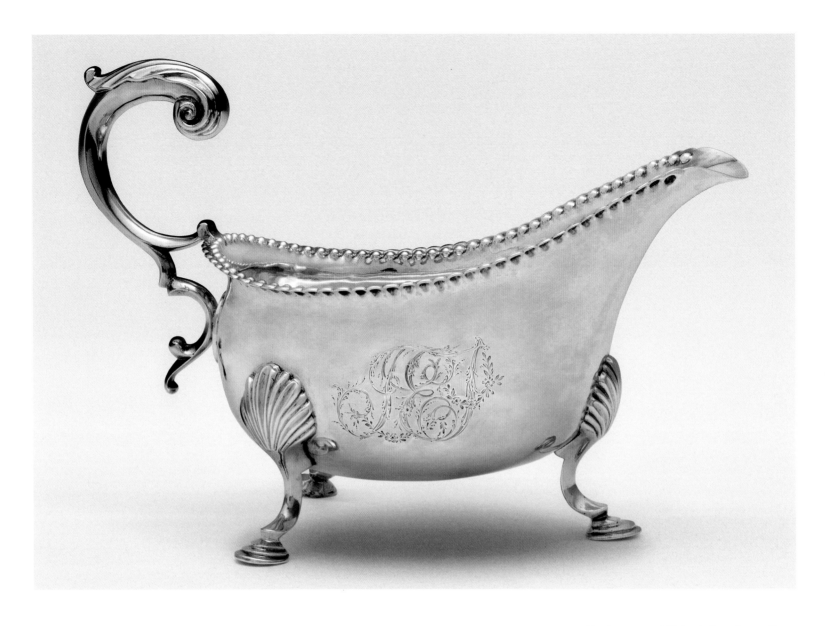

Cat. 176

John David Sr. or Jr.
Sauceboat

1790–92

MARK: I DAVID (in rectangle, on underside, cat. 173-1)
INSCRIPTION: J E T (engraved and embellished script with
bright-cut flower garlands, on one side; cat. 176-1)
Height 4¾ inches (12.1 cm), width 3⁷⁄₁₆ inches (8.7 cm),
length 7¹⁄₁₆ inches (17.9 cm)
Weight 8 oz. 19 dwt. 15 gr.
Gift of Walter M. Jeffords, 1956-84-2

PROVENANCE: This sauceboat originally belonged to John
(died 1804) and Elizabeth Bond Travis (c. 1768–1821),
who married on March 27, 1791, at Christ Church,
Philadelphia.[1]

This is one of a pair of sauceboats marked by John
David Sr. but possibly made by John David Jr.[2] There
are three compass points on the bottom to set the
oval shape. The tight shell forms at the top of the
legs are convex and rounded, similar to those on the
Davids' salt dishes (cat. 180).[3] The repoussé pearl
work around the top is deep and bold, creating a
decorative edge that is almost identical to the edge

of a sauceboat by Abraham Dubois Sr. or Jr. (q.v.),
and on some cream pots by Joseph Anthony Jr.
(q.v.).[4] The letters of the initials "JET" and the inter-
twining foliate garlands are elegantly engraved.

John Travis was a prominent merchant and was
listed in the Philadelphia directory as a "gentleman
merchant" at 317 Market Street until 1800, when he

moved his business to 237 South Front Street. After
his death in 1804, his widow moved to 178 Chest-
nut Street, where she remained until 1814. In 1819 she
moved up Chestnut just below Thirteenth Street. On
July 29, 1843, their daughter Ann Bond Travis (1793–
1851) became the third wife of Lord David Erskine
(1777–1855). They lived in London.[5] David Erskine's

Cat. 176-1

second wife was Frances Cadwalader (1781–1843), daughter of General John Cadwalader (1742–1786). The mate to this sauceboat descended in the Cadwalader family. BBG

1. *Pennsylvania Archives*, 2nd ser. (895), vol. 8, p. 258.
2. The mate to this sauceboat was exhibited in Philadelphia 1956, cat. 57. It remains in the family collection. There is a teapot marked "I DAVID" and a sugar bowl marked "JD" in an oval, both of which are engraved with the same initials in the same style as those on this sauceboat; Quimby and Johnson 1995, p. 351, cat. 337. The sugar bowl also bears the family initials "AWC." The designs of the teapot and the sugar bowl match in their urn-shaped bodies, but the designs of the galleries are different. Both pieces have the David-style pineapple finial with two sets of leaves. John junior probably made the sugar bowl as it bears his mark, "JD" in an oval. He was about nineteen at the time.
3. They are also like the shells on the legs of the cream pot by the silversmith and engraver Thomas Sparrow (PMA 2005-68-122). A sauceboat by William Faris of Annapolis, in the same full-bodied shape, has an almost identical handle, with similar shell knees and flat, disc feet; Mark B. Letzer and Jean B. Russo, eds., *The Diary of William Faris* (Baltimore: Maryland Historical Society, 2003), p. 43, fig. 22. These similarities in design suggest connections between the Davids in Philadelphia and William Faris and Thomas Sparrow in Annapolis.
4. Illustrated by Firestone and Parson, Boston, www.firestoneandparson.com/showitem.php?sect=2&subcat=30 (accessed 2005).
5. Family history prepared by T. L. N. Cadwalader, manuscript, 1994; curatorial files, AA, PMA.

Cat. 177

John David Sr.
John David Jr.
Tea and Coffee Service

1785–90

MARKS: I DAVID (in rectangle, once on base of coffeepot, four times in corners of underside of base of teapot, twice on underside of base of sugar bowl, four times on underside of base of slop bowl; cat. 173-1); JD (in an oval, four times on underside of base of cream pot; cat. 180-1)
INSCRIPTIONS: G C (engraved script in circle centered in shield, on each); 1691 (scratched, on one corner of underside of base of sugar bowl)

Coffeepot: Height 15 inches (38.1 cm), width foot 4 inches (10.2 cm)
Gross weight 44 oz. 19 dwt. 14 gr.
Teapot: Height 10¼ inches (26 cm), width foot 3⅛ inches (7.9 cm)
Gross weight 33 oz. 13 dwt. 14 gr.
Sugar bowl: Height 9½ inches (24.1 cm), width foot 2¾ inches (7 cm)
Weight 12 oz. 8 dwt. 14 gr.
Cream pot: Height 6⅝ inches (16.8 cm), width foot 2⅛ inches (5.4 cm)
Weight 12 oz. 2 dwt. 10 gr.
Slop bowl: Height 4⅞ inches (12.4 cm), width foot 3¾ inches (9.5 cm)
Weight 12 oz. 2 dwt. 10 gr.
On permanent deposit from The Dietrich American Foundation Collection to the Philadelphia Museum of Art, D-2007-17-21

PROVENANCE: The identification of the initials "GC" with George Corbin (1744–1793) of Corbin Hall, Virginia, was provided by the descendant who consigned the service to auction in 1969; Sotheby Parke Bernet, New York, *Fine American and English Silver*, March 25, 1969, sale 2825, lot 65; (Elinor Gordon, Villanova, PA).

EXHIBITED: On long-term loan to the Diplomatic Reception Rooms, U.S. Department of State, Washington, DC, 1969–78 (Buhler 1973, p. 70, fig. 19); Springfield Museum of Art, Springfield, MA, 1978–85; Huntington Library, Art Collections, and Botanical Gardens, San Marino, CA, 1985–2017 (*Virginia Steele Scott Gallery Guide* [Pasadena, CA: Huntington Library, Art Collections and Botanical Gardens, n.d.], p. 4).

This handsome service was obviously made as a unit; the same engraver's hand is evident throughout in the bright-cut engraving of the monograms set in a decorative circle design, which in turn is enclosed in a shield-shaped outline of beribboned festoons.[1] The original pineapple finials have a double row of spiky leaves. The cream pot lacks the band of bead between the base and the body that all the other pieces have and is the only piece with the mark "JD" in an oval, and thus it is attributed to John David Jr.

Corbin Hall became the name of a property located in the northeast section of Virginia's Eastern Shore that was purchased about 1745 by Colonel Convention Corbin (1711–1778) and his second wife, Barbara Drummond Corbin (died 1756), and that included at least one residence where they

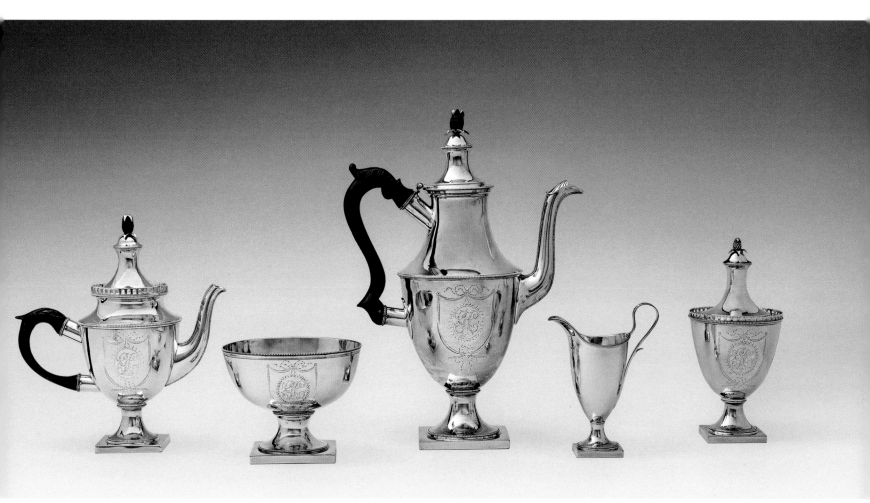

lived.[2] Their son, Colonel, later General, George Corbin (1744–1793), married Elizabeth Revell Horsey in 1772. He served on the Committee of Correspondence in 1774 and as the county lieutenant in 1775 in Accomack County, Virginia.[3] He resigned in 1783 "because of bodily infirmities." In November 1787 he served in the Virginia House of Delegates sitting in Richmond, where he debated the resolutions of Congress regarding establishment of a new federal government.[4]

His grand brick mansion house, 60 feet, 8 inches in length and 38 feet, 3 inches in width, was built on the family property. Known as Corbin Hall, it had the date 1787 set into the brickwork in two places. A description of the house suggests that versatile local craftsmen familiar with fine brickwork produced a smooth, new (Federal-style) house for their patron, who must have been familiar with Federal-style buildings from his stints in Alexandria, Delaware, or Philadelphia.[5] The interiors, however, were finished with elaborate woodwork in the earlier rococo style that was possibly more familiar to local joiners and carpenters.

In his will written in 1797, George Corbin left all his estate to his daughter Agnes Drummond (Mrs. John Shepherd) Ker "provided she have a son . . . [and] call such a son George Corbin, to which son I will my Chincoteague plantation Island, and swamp land."

This complete tea and coffee service, which bears only the initials "GC." may have been presented to Colonel George Corbin in recognition of his civic and military service, or perhaps he commissioned it to furnish his new house. BBG

1. The same engraver was working for John David Sr. when he made the teapot for "TES" (cat. 175).
2. Sotheby Parke Bernet, New York, *Fine American and English Silver*, March 25, 1969, sale 2825, lot 65; Miles Files 16.3, s.v. "Col. George Corbin," Eastern Shore Public Library, Accomack, VA, http://espl.evergreenva.org/eg/opac/home (accessed November 2, 2016); National Register of Historic Places Inventory-Nomination Form, 1940, Historic Buildings Survey, depository, Library of Congress, Washington, DC.
3. Susie Wilkins Walker and Nora Miller Turman, *Accomack County, Virginia, Soldiers and Sailors in America's War for Independence: April 1775 to December 1783* (s.l., 1975); James Bright Corbin, The Corbin Family of Northampton, Accomack County, Virginia; Ancestry.com.
4. "He closed an elegant and judicious speech with proposing several resolutions, the principal of which was to this effect: That a convention should be called, according to the recommendations of Congress." *Massachusetts Gazette* (Boston), November 11, 1787.
5. National Register of Historic Places Inventory-Nomination Form (see note 2 above).

Cat. 178

John David Sr.
John David Jr.
Sugar Bowl and Cream Pot

1792
MARKS: I DAVID (in rectangle, once in each corner on underside of base of sugar bowl; cat. 173-1); J D (in small oval, once in each corner of underside of base of cream pot; cat. 180-1)
INSCRIPTION (on each): N S S (engraved script in oval with garlands and ribbons, on one side)
Sugar Bowl: Height 10⅛ inches (25.7 cm), diam. top 4⁵⁄₁₆ inches (11 cm)
Weight 14 oz. 6 dwt. 20 gr.
Cream Pot: Height 6⅝ inches (16.8 cm), width 5 inches (12.7 cm)
Weight 5 oz. 13 dwt.
Gift of Mrs. William Snowden Stansfield, 1932-44-1a,b, 1932-44-2

PROVENANCE: The initials "NSS" belonged to the Reverend Nathaniel Randolph Snowden (1770–1851) and his wife, Sarah Gustine (1775–1856), who married on May 21, 1792; by descent in the family to Miss Louise Snowden and then to the donor, Mary Thompson Snowden Stansfield.[1]

EXHIBITED: Paul L. Grigaut, *The French in America, 1520–1880*, exh. cat. (Detroit: Detroit Institute of Arts 1951), p. 144; cat. 385; Philadelphia 1956, cats. 59, 63; *La France et Philadelphia*, The Athenaeum of Philadelphia, January 11–16, 1962; Philadelphia 1969, p. 55, cat. 12 (sugar bowl).

PUBLISHED: Mrs. Alfred C. Prime, *Three Centuries of Historic Silver* (Philadelphia: Pennsylvania Society of Colonial Dames of America, 1938), p. 140, pl. 18.[2]

John David Jr.'s mark "JD" in an oval on this cream pot is the same as that on the salt dishes in cat. 180. The mark of John David Sr. is clearly struck on the sugar bowl and is the same as that he used on another sugar bowl in reverse-pear shape (cat. 174). The cream pot was originally fitted with a lid, as indicated by remnants of a hinge. Although clearly a set, with both pieces made at the same time—the bases match and the same running bead appears at the top of the stems and top edges of the vessels—the engraved designs are slightly different. The cream pot has an added element of paired fronds under the roundel enclosing the initials. The engraving technique on the sugar bowl is lighter and sharper than on the cream pot and is like the engraving with garlands on a coffeepot marked with John David Sr.'s full name mark ("I DAVID") and on a sugar bowl and cream pot engraved for "MW."[3] The different handling

of the engraving could be attributed to father and son or to different engravers. For similar handling of a set, see a full tea and coffee service (cat. 177), also by both Davids, senior and junior, and engraved "GC" for George Corbin.

Nathaniel Snowden was born in Philadelphia, the fourth son of Isaac and Mary Coxe Snowden. His father was president of the board of Princeton College and donated the land upon which Nassau Hall was built.[4] Nathaniel graduated from Princeton in December 1787 and gave his final oration on the subject of "Negative Good."[5] In 1790 he received his doctorate of divinity from Dickinson College. He and his four brothers were a fourth generation of Presbyterian ministers. Nathaniel Snowden was the first pastor of the Fourth Market Square Presbyterian Church, Harrisburg, in 1793. He served primarily in Harrisburg but simultaneously at Williamsport and Chester. Sarah Snowden was the daughter of Lemuel and Susanna Smith Gustine of Carlisle, Pennsylvania. Nathaniel and Sarah Snowden had six children: four sons were physicians, one was a lawyer, and one was a Speaker of the Pennsylvania House of Representatives.[6] He died at the residence of his son Charles in 1850; Sarah died in 1854. BBG

1. Also descending in the same family is an unmarked gold card case (PMA 1932-44-7).
2. Noted as in the collection of Miss Louise Snowden.
3. Both are attributed to John David Sr. and were surely made before his death in 1794; Philadelphia 1956, cat. 46. For the sugar bowl and cream pot marked "I DAVID" and "ID," see Sotheby's, New York, *Fine Americana*, January 28–31, 1993, sale 6392, lot 114.
4. Major General George R. Snowden, "A Century of Pastors," in *Centennial Memorial, English Presbyterian Congregation, Harrisburg, Pa.*, ed. George Black Stewart (Harrisburg: Harrisburg Publishing Company, 1894), pp. 355–57.
5. *Independent Gazeteer* (Philadelphia), January 5, 1787.
6. Snowden, "A Century of Pastors."

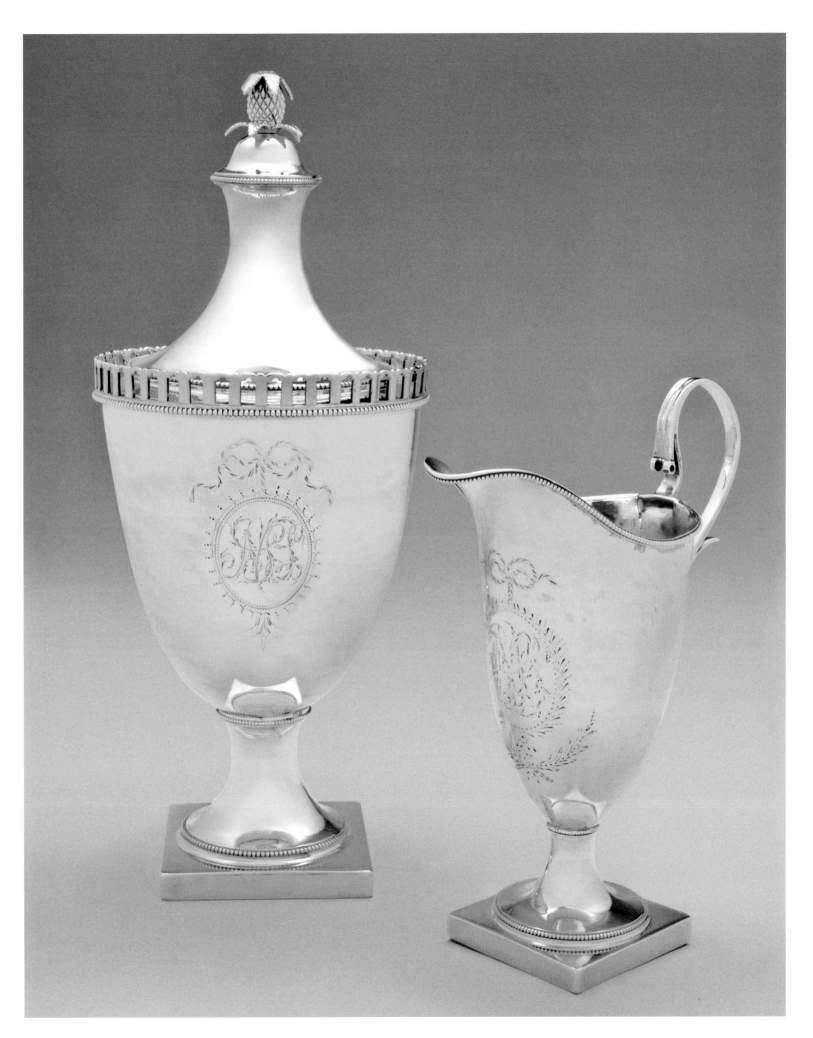

Cat. 179

John David Jr.
Cream Pot

1794–1800

MARK: J D (in oval, on underside of body; cat. 180-1)

INSCRIPTION: R L (engraved foliate script, on front opposite handle)

Height 4⅞ inches (12.4 cm), width 3¹⁵⁄₁₆ inches (10 cm)

Weight 4 oz. 5 dwt. 17 gr.

Gift of Mrs. Hampton L. Carson, 1919-52

EXHIBITED: Philadelphia 1956, cat. 64.

PUBLISHED: Thorn 1949, p. 105.

The small "JD" mark on this cream pot is the same one as on a pair of salt dishes (cat. 180). The design and line engraving of the initials, although too worn to be clear, is weak and is like the line-engraved "GE" on two salts by Richard Humphreys (q.v.) for George Emlen.[1] The reverse-pear shape of the body of this cream pot is unusual, a little awkward but not unique.[2] The flat, round foot shows signs of repair. The foot and the handle are very like those on a cream pot by Thomas Shields (PMA 1991-143-4). BBG

1. For Humphrey's salts for "GE," see Hammerslough 1958–73, supp., vol. 3, p. 57.
2. A sugar bowl by Joseph Richardson is similar; W. L. Harris, "Some Significant Silver," *Antiques*, vol. 9, no. 3 (March 1926), p. 160.

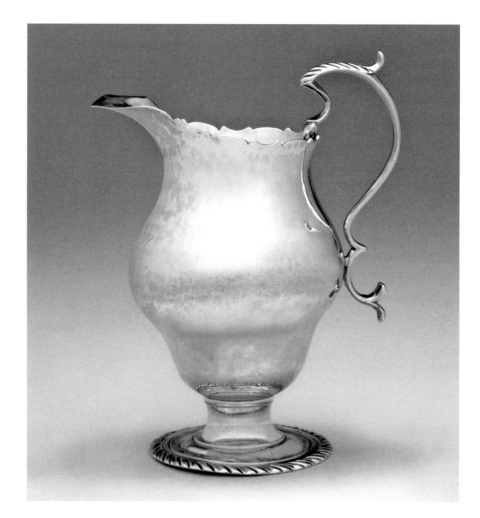

Cat. 180

John David Jr.
Pair of Salt Dishes

1796–98

MARK (on each): J D (in oval, three times on underside; cat. 180-1)

INSCRIPTION (each): C / T·S (engraved, on one side)

Height 1¹¹⁄₁₆ inches (4.2 cm), diam. 2¹⁵⁄₁₆ inches (7.4 cm)

1920-37-4a: Weight 2 oz. 14 dwt. 19 gr.

1920-37-4b: Weight 2 oz. 14 dwt. 6 gr.

Purchased with the Joseph E. Temple Fund, 1920-37-4a,b

PROVENANCE: Catherine Meredith Biddle and Sarah Caldwell Biddle.

EXHIBITED: Philadelphia 1956, cat. 67.

Cat. 180-1

A receipt in the Brix Collection at the Yale University Gallery lists an assemblage of "silver plate and plated ware"(fig. 68). The receipt, dated January 1815 and written by "DM," probably David Meredith (1787–1822), lists the silver from an extended family that was left for safekeeping in the care of William T. Meredith (1772–1844), then president of the Schuylkill Bank. The objects that can be identified belonged to descendants of Colonel Clement Biddle (1740–1814) and his second wife, Rebekah Cornell Biddle (died 1831), who married in Philadelphia on August 18, 1774.[1] His death in 1814 was probably the reason for the storage of the silver. Their son James Cornell Biddle Sr. (1795–1838) married Sarah Caldwell Keppele (born c. 1800), on March 9, 1825.[2] Their grandson James Cornell Biddle Jr. (1835–1898) married Gertrude Gouverneur Meredith. The last private owners of these salts, Catherine Meredith Biddle (born 1865) and her sister Sarah Caldwell Biddle (born 1866), were named for their maternal grandmothers.[3] They lived at 1326 Spruce Street. A sauce boat by John David Sr., without engraved initials, was loaned to the Philadelphia Museum in 1921 by the wife of George Biddle (1885–1973), great-grandson of Clement Biddle, and was probably one of the two "butter boats" on the 1815 receipt.[4]

These salts by John David Jr., engraved with the initials "C/T·S" on one side, were added to two earlier pairs by London silversmith Henry Corry (PMA 1920-37-3,3a), and Richard Humphreys (PMA 1920-37-5,5a). The initials "C/T·S" are engraved on the undersides of the Corry and Humphreys salts. Those salts differ from David junior's as they have engraved

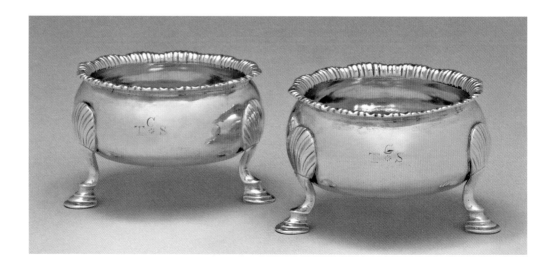

Wayne's executor and organized the sales of property and furnishings in Delaware and Philadelphia. The proceeds were divided between his children, son Isaac and daughter Margaretta W. Attlee. The initials added to the Wayne salts suggests that they may have been purchased by Thomas Collins (1774–1814) of Delaware, who would marry Sarah Read (died 1804) in Philadelphia on September 28, 1796, about two months after Wayne's death. There were three sales at Waynesborough, from 1801 to 1803, and "salt sellers" were purchased from the 1803 sale for £1 by a T. Pennington.[8]

Clement Biddle was closely associated with both Wayne and Delaney, during and after the Revolutionary War.

1. Meredith Family Papers, 1756–1964, Series 2, David Meredith 1787–1822, HSP.
2. Moon 1898–1909, vol. 1, pp. 251, 252; vol. 2, pp. 425, 589, 590.
3. The sisters presented the portraits by Thomas Sully of Mrs. William T. Meredith (Gertrude Gouverneur Ogden) (born 1777) and Gouverneur Morris (1732–1816) to the Historical Society of Pennsylvania in 1916; Nicholas B. Wainwright, *Paintings and Miniatures at the Historical Society of Pennsylvania* (Philadelphia: the Society, 1974), pp. 174, 178.
4. Woodhouse 1921, p. 11, cat. 27. The sauce boat by John

David Sr. was not noted as having initials on the receipt, and the sauceboat loaned did not have initials. It had elegant splayed feet like the sauceboats by John David Sr. for Thomas and Sarah Cooch but a different contour of the "boat"; Quimby and Johnson 1995, p. 346, cat. 335. With thanks to Morgan Little, registrar, Philadelphia Museum of Art, for pertinent records.
5. Eugene Zieber, *Heraldry in America* (New York: Greenwich House, 1984), p. 87, fig. 266. A strainer by John David Jr. bearing the initials "C/T·S," by a different engraver, descended in the Delaware family of Thomas (died 1788) and Sarah Cooch (died 1784), both of whom died long before Anthony Wayne; Christie's, New York, *Important American Furniture, Silver, Prints, Folk Art and Decorative Arts*, January 17–18, 1992, sale 7398, lot 158. See also cat. 171.
6. John A. Munroe, "The Philadelawareans," *PMHB*, vol. 68, p. 137. Among Wayne's estate papers is a receipt dated 1793/94 for the purchase of a lady's gold watch. Information thanks to Lynn Anderson of the Furnishings Committee at Historic Waynesborough.
7. As quoted in Wayne's will, courtesy of Lynn Anderson, Historic Waynesborough.
8. Information from documents kindly supplied by Lynn Anderson, Historic Waynesborough.

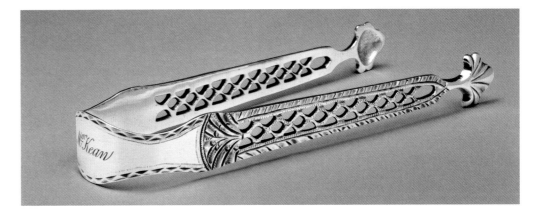

on one side of each a stag's head erased proper, the crest of the Wayne family.[5]

The salts by David junior are most like Henry Corry's, quite plain with convex shell knees and hoof feet. The pair by Humphreys have fluted shell knees, a rolled "ankle," and radiating shell feet, features found on a sauceboat by John David Sr. as noted on the 1815 receipt. All three pairs of salts are round with a "ruffled" top edge.

The early salts probably belonged to General Anthony Wayne (1745–1796), who led a stylish life when not serving in the army. Adding the crest would have made them "his," which probably meant more to him than a perfect match. Wayne owned a farm in Chester County called "Waynesborough," where his family lived and where his wife Mary Penrose Wayne died in 1792. However, he spent much of his time in Philadelphia in a handsome three-story brick house on the east side of Second Street between Market and Walnut, where he lived between serving in the military and holding official appointments. In 1794–95, after the death of his wife, Wayne furnished a house in Newcastle, Delaware, in anticipation of his second marriage, to Mary Vining, "sister of a Congressman, acquaintance of noblemen, beloved of a dashing soldier."[6] The crested salts may have been purchased by him for either domicile. Wayne died unexpectedly on military duty in western Pennsylvania in July 1796. At the time, he was deeply in debt. Wayne's "dear friend Sharpe Delaney [sic]"[7] was

Cat. 181

John David Jr.

Sugar Tongs

1790–95
MARK: J D (in oval, at top of inside of one arm; cat. 180-1)
INSCRIPTION: McKean (engraved script, at top of handle)
Length 5¾ inches (14.6 cm), width ¹³⁄₁₆ inch (2.1 cm)
Weight 1 oz. 13 dwt. 12 gr.
Gift of Fenton L. B. Brown, 1991-143-3

These are spring-action tongs with elaborate pierced arms decorated with bright-cut engraving and chasing. The edges of the cuts creating the design are rough. A similar design was marked by McFee and Reeder (q.v.).[1] The flaring, fan-shaped decoration at the top of the arms is repeated in the shaping of the nippers.

These tongs probably belonged to Thomas McKean (1734–1817), a signer of the Declaration of Independence and governor of Delaware in 1777.

He married twice, first to Mary Borden and second to Sarah Armitage in 1774. McKean resigned as governor of Delaware to become chief justice of Pennsylvania and finally governor of Pennsylvania from 1799 to 1808. His will devised land to his living children, his grandchildren, and the children of his deceased children.[2]

The surname inscription rather than the traditional marking with initials suggests that it was added later, possibly by his daughter Sarah McKean (1777–1841), who married Don Carlos Martinez de Yrujo, or by one of his six other daughters. The date of 1763, marking the marriage date of Thomas McKean and his first wife, was added to a ladle by Joseph Anthony Jr. (q.v.) that bears the more familiar script initials "T McK."[3] BBG

1. See the sugar tongs by McFee and Reeder (PMA 1924-27-2).
2. Will of Thomas McKean, written 1814, probated June 1817; Philadelphia Will Book 6C, p. 467.
3. Philadelphia 1956, cat. 10.

Peter David

New York City, born 1707
Philadelphia, died 1755

Peter David, of Huguenot ancestry, was born in New York City in 1707.[1] His paternal grandparents, Hester (Esther) Vincent David and the vintner John David I (died after 1712), were French refugees who fled from France to England after the Edict of Nantes. They were naturalized by royal letters patent in Westminster, London, on March 8, 1682, as was Dr. Jean Dupuy and his son Jean, a "minor" (1679–1744).[2] The David and Dupuy families would later become intertwined by marriages, New York property exchanges, and trade.

The David family first settled in the Huguenot community in Kingston, Ulster County, New York.[3] By 1694 John David I and wife Hester and family had moved from upstate New York to New York City.[4] Their eldest child, John (Jean) David II (before 1687–before 1724), was probably born in England, as both John Davids, I and II, were made freemen and freeholders in the East Ward of New York City in 1701.[5]

John David II married Louise Strang (died before 1722) as his second wife. Their son Jean was baptized on December 25, 1702, in New York at the French Church,[6] and Peter was baptized April 23, 1707, in the city's Dutch Church. Peter David's apprenticeship document was registered for Peter Quintard and dated October 3, 1724, and noted him as fifteen years of age and an orphan, meaning that his father, but not necessarily his mother, was deceased. The document also notes that his term of seven years had commenced in June 1722, with the consent of John David (his father) and John Dupuy, surgeon. It was signed in 1724 by Peter David, Jean [sic] David, and J. Dupuy; the "Jean" in this case was Peter's older brother, and "J. Dupuy" was his uncle, the doctor.[7] Peter Quintard (1699–1762), silversmith in New York, was also a French émigré who came to New York, from Bristol, England. In 1735 he advertised in the *New York Gazette* as a "Goldsmith living near the New Dutch Church in the City of New York."[8] Peter David's apprenticeship was due to end in 1729. He was granted his freedom in 1731, but he may have continued to work for Quintard until 1734 or 1735,

when Quintard was planning a move to Norwalk, Connecticut.[9]

In 1735 Peter David married his cousin Jeanne (later Jane) Dupuy (1716–1752), daughter of Dr. John and Anne David Dupuy, probably in New York.[10] Very soon after the marriage they must have moved to Philadelphia, as that year he was purchasing supplies from metalsmith Stephen Paschall (born 1709). In 1735 "Mr. Davis Silversmith" was entered in Paschall's accounts for merchandise: "Gold Dr. to cash for a Dubloon @ £5 12s., a Map of Penselvania [sic] £0 1s. 6d., Silver Dr. to John Breitnall £10 sterling in English shill £16 13s. 4d., 4 oz. 3/8 spanish silver @ £1 19s. 4d., a dollar £0. 5s. 0d."[11] Family tradition suggests that Peter David may have brought his nephew Daniel Dupuy (q.v.) with him as apprentice. Beyond this conjecture, no record has emerged to suggest that the Dupuys and Davids had business asociations, although their family relationships continued with settlements and sales of inherited property.[12] On October 4, 1736, Peter and Jane's son John (John David Sr. [q.v.]) was baptized in Philadelphia at Christ Church; their daughter Anne was baptized at Christ Church on January 17, 1740, but died in July 1743.[13]

On May 18 and 25, 1738, Peter David advertised in the *American Weekly Mercury*, "Lately Imported from London, A Choice parcel of iron-mongers Ware, to be sold at very reasonable rates by Peter David, Gold-smith, at his house in Front Street." In August 1738, in the same paper, the London jeweler Charles Webb advertised that he was "to be spoke for at Mr. Peter David's in Front Street." Peter David repeated his advertisement for ironmongery, nails, tools, brass locks, and so forth, again in the *American Weekly Mercury*, from April to October 4, 1739.[14] The location was at the center of sea trade, and hardware was important for the shipbuilding trades. He was called upon to witness the wills of mariners including Lawrence Bray in 1745, and George Bringham and John Spellman in 1747.[15]

Peter David's exchanges with Joseph Richardson Sr. (q.v.) in 1739 are an indication that he was active in the silver trade as well.[16] Advertisements for lost silver by David began appearing in the *Pennsylvania Gazette* by 1741.[17] He marked a heavy, tulip-shaped tankard perhaps made for, but documented as owned by, the silversmith and watchmaker William Faris (1728–1804), who apprenticed in Philadelphia about 1740.[18] It is large with a bold interpretation of the curvaceous shape featured in Philadelphia and shows an accomplished hand by a silversmith trained in the straight-sided, flat-topped style of New York tankards.

Peter David leased a property in 1739 on Second Street, which must have become his residence.[19] He leased the "ground floor" to the merchant Joseph Redmond, who was there in August 1750 and in June 1751, when Redmond advertised "At his Store at the Dwelling House of Mr. *Peter David*, Silver Smith in *Second Street* . . . wrought and plain Plate, entirely new, Watches and Seals in gold, Silver, and Pinchbeck . . . Diamond Rings, Pocket Twees [etuis], Stone and new fashion'd Buckles . . . choice collection of Paintings, done by some of the most eminent hands, and set in a gilt Frame . . . Tea Chests . . . sugar Boxes."[20] Peter's son John continued his father's lease, and Redmond seems to have retained his part of the Second Street address after Peter David's death. On July 26, 1760, Redmond placed an advertisement in the *Pennsylvania Journal and Weekly Advertiser*: "Lately imported in the Ship Swift, Captain Le Groe, and to be sold wholesale or retail by Joseph Redmond at his store at the late dwelling house of Mr. Peter David on Second Street."[21] This lease would continue in the tenure of his son John David.

On January 14, 1746, Peter David purchased on ground rent of £18 per year, from John Langdale, tanner, 17 1/6 acres of ground in the Northern Liberties. It adjoined land owned by Philip Syng (q.v.) and the Coates family's brickyard. This was probably the property, described in the tax of 1754, where he kept his livestock.[22] Peter David was working on Front Street in 1747.[23]

Peter David continued to live on Second Street, but in 1751 he advertised another location, at the southeast corner of Chestnut and Second, where he advertised in the *Pennsylvania Gazette* on August 8, 1751: "All persons that have any demands on Lawrence Hebert [Herbert], Engraver, are desir'd to bring in their accounts to the dwelling-house of Mr. Peter David, in Second-Street, Philadelphia." He was thus settled in the Chestnut Ward along with fellow silversmiths Philip Syng and Francis Richardson Jr. (q.v.). His wife Jane died soon thereafter, on October 1, 1752.[24] Unfortunately, no deeds have been discovered that would establish whether he purchased or leased the various properties where he resided and worked.

On July 28, 1753, at Gloria Dei Church, Peter David married, by license, Margaret Swanson Parham, widow and an inn holder, a traditional role for widows.[25] Peter and Margaret had one daughter, Jane, who was born in 1754 and died at the age of three.[26] Margaret was the land-wealthy widow of Sir John Parham (died 1750).[27] After he died Margaret mortgaged to John Stamper a portion of her property, which was later sold to Joseph Wharton, who had paid her ground rents between 1753 and 1760.

In 1754 Peter David was subject to the Philadelphia tax of 2 pence on the pound of income, and 6s. per head. His income/occupation was valued at £20, and his tax was 3s. 4d. Listed with him was John Dawson, who was noted as "poor" and paid a head tax of 6s. David's property was taxed at £11 8s. 4d., and included one servant, taxed at £1 10s. (probably Dawson), along with five horses, sixteen cows, and twenty-five sheep, taxed at £9 18s. 4d.[28] Margaret's heirs were her children. Her wealth does not seem to have transferred to Peter's heirs.

Peter David must have still been active when he died in 1755. His son John was noted as "silversmith" in Peter's will. The administration of his estate was issued as follows: "Know all men by these present that we Margaret David wid & Relict of Peter David late of Philadelphia Silversmith decd. David . . . [Margaret] . . . of Philada aforesaid Innholder and John David of ye same place Silversmith are held and firmly bound."[29]

The inventory taken by Philip Syng and Joseph Richardson Sr. on October 24, 1755, revealed that the house was a typical four-room plan, with a first-floor parlor and kitchen, second and third floors, and bedrooms.[30] Among the personal items "Upstairs" were three sets of bed Curtains, two coats, two pairs of britches, two wigs, six silk gowns, two linen gowns, six "glass pictures," two canvas and two silk bed quilts, and three rugs. The total value of the inventory was £250 14s. The first unit of material listed was "Work in a Glass case," which was located in the parlor on a mahogany tea table, enlivened no doubt by a parrot in a cage standing nearby. The case contained: 64 ounces of wrought silver valued at £33 12s., three whistles and corals at £5, eleven pairs of shoe buckles at £6 10s., thirteen pairs of knee buckles at £3 5s., three pairs of "plain" shoe buckles at £1 15s., six silver seals with cornelian stones at £1 10s., one stone girdle buckle and nine bone stay hooks at £1, and three pairs of stone buttons at 15s., for a total value of £53 7s.

The inventory of Peter David's parlor furnishings included, among other items, a large sconce looking glass with the highest value, at £4, sixteen "pictures," mahogany and walnut furniture (a desk, chests, chairs, a tea table, a cradle, and a corner cupboard), full sets of pewter and china, brass candlesticks, beds and bedding, a silk quilt, and two wigs. The list of "Working Tools" seems complete:

18 Beak Irons £13.10.0 / 2 Forgeing Anvils @ 4.12.6 / 1 Planishing Test & 3 spoon Tests(?) @ 4.4.2 / 1 Bench vise @ 1.0.0 / 64 Hammers @ 5.0.0 / 3 Skilletts and Three Ingots @ 2.17.6 / 4 pr Tongs 8 sh–1 pr Stock Shears 10sh @ 0.18.0

/ 11 Bottom Stakes @ 2.0.0 / 16 Stakes and Crutches @ 0.15.0 / 18 Spoon Punches etc. @ 1.0.0 / 1 Drawing Swage Brass @ 1.0.0 / 2 Turning benches @ 0.12.0 / 4 Swages, 4 hammers & 2 stakes @ 0.12.0 / 1 Thimble Stamp @ 1.15.0 / Cutting punches, dapping do & sundrys @ 1.0.0 / 2 Brass Stamps 12/ & 2 Boiling Pans 5/ @ 0.17.0 / Sundry Hand vices, plyars, files etc. @ 1.0.0 / 3 old Brass Stamps Saw and Brace @ 1.0.0 / 4 Pair of Scales amd weights @ 2.10.0 / Button Punches, Collar Dies @ 2.0.0 / Bellows, Lead, Coke and Lamp @ 1.0.0 / 5 Pr Brss Flasks @ 3.0.0 / Drawing Iron, bench wheel & Lathe Bench, Vise, Iron Flasks & Polishing Lathes @ 3.0.0 / 1 Lb Borax @ 1.0.0 / 6 Bellow Stakes @ 1.12.0 / 17 Button Punches @ 1.14 / 13 lb Binding Wires Large and Small @ 1.13 / 1 Gross 1/2 of Shoe & Knee Buckle Chapes @ 5.10.0 / 6 sheets of Sand paper @ 0.1 / 17 Sheets of Red and White foil @ 0.10 / 5 Doz large and Small files @ 0.13 / 1 Dozen Gravers @ 2.6 / 1 Screw Plate @ 6 / 2 Pair Nippers @ 6.6 / 2 pair Compasses @ 7.0 / 2 Foot Rule @ 6.0 / 1 Scale & Box @ 15.0 / 6 Pr Plyars @ 9.0 / 1 Doz. Rowals @ 2.6 / 1 Set Chasing Punches @ 17.0 / 2 Pair Clams @ 4.0 / 1 1/2 Doz. Pencls @ 5.0.0 / 2 Spring Saws @ 12.0 / 2 Hand Vises @ 7.0 / 3 Spring Hammers @ 1.0 / 2 hand vises @ 7.0 / 1 Agit Mortar & Pestil @ 15.0 / 4 Watches @ 14.0.0. Total for tools, £20.2.6. March 22, 1756.

On October 7, 1756, Margaret David was living on Church Alley and advertising in the *Pennsylvania Gazette* "sundry sorts of household goods and silversmith tools belonging to the estate of Peter David late of this City goldsmith." Presumably Peter's son John had his own complement of tools in 1755.

In 1767 "Margaret David old widow" was taxed on her income, largely from the ground rents from Joseph Wharton's commercial buildings on South Wharf. In 1772 she was assessed in the North Ward £99 5s., and in 1774 £104 5s. 6d.[31] She died in 1795, and her will was probated on December 3 that year.[32] BBG

1. See Philadelphia 1976, pp. 44–45; Dupuy 1910, pp. 14, 16, 19, 20, 26. For clarity and corrections, see Gary E. Young, "Dr. John Dupuy's wife NOT a Chardavoine," at Genforum, https://genforum.genealogy.com/dupuy/messages/655.html (accessed September 10, 2013).

2. See the biographies of Daniel Dupuy Sr. and Jr. (q.q.v.).

3. On the Huguenot community in Kingston, see the biography of Abraham Dubois Sr. (q.v.).

4. Their second child, Anne David (1687–1769), was baptized at the First Reformed Protestant Dutch Church in Kingston. Another child, Daniel, after whom Daniel Dupuy (q.v.) was named, was also baptized there. About 1702 Anne David married Dr. John Dupuy (1679–1744), son of Dr. John Dupuy, in New York City, and they lived briefly in Jamaica (1709–1711), where she had Vincent relatives. Their daughter Hester Dupuy, named after the wife of John David I, was born there. The Dupuys returned to New York about 1712 and purchased a house in 1714, from John David I or II (the deed does not specify); New York Common Council, *Minutes of the Common Council of the City of New York, 1675–1776* (New York: Dodd, Mead, 1905), vol. 2, p. 173.

5. John David I, a merchant, owned property in the city that

Dr. John Dupuy would purchase from him in 1714, and that became known by the Davids and Dupuys as "the old family homestead." It was sold to silversmith Myer Myers (q.v.) in 1765.

6. MSS notes, "New York Silversmiths," Francis H. Bigelow Papers, Department of American Art, Yale University Art Gallery; Dupuy 1910, pp. 14, 16, 19, 20, 26; "Baptisms of New York," in *Collections of the Huguenot Society of America* (New York: the Society, 1886), pp. 92, 137.

7. "Registered for Mr. Peter Quintard the 3rd day of October Anno Dom 1724/Indenture of Peter David an infant of about fifteen years of age and an orfen [orphan] by and with the consent of John David and John Dupuy, cherurgien [surgeon], to Peter Quintard, Goldsmith from June 12, 1722 for seven years." *Records of Indentures of Apprentices, 1718–1727* (New York: New-York Historical Society, 1909), p. 166.

8. As quoted in Avery 1930, p. 114.

9. Waters, McKinsey, and Ward 2000, p. 175.

10. In Philadelphia records she was often called "Jane." Charles R. Hildeburn, contributor, "Records of Christ Church, Philadelphia. Baptisms, 1709–1760 (continued)," *PMHB*, vol. 15, no. 3 (1891), p. 357.

11. Stephen Paschall, Record of purchase by Peter Davis, Stephen Paschall, Account Book, Stephen and Thomas Paschall Records, 1694–1866, HSP. In records likely to have been gathered phonetically, he was called "Peter Davis."

12. "A GOOD Plantation in the County of orange [New York], containing 1250 Acres of Land . . . dwelling house, orchard, creek, well timbr'd . . . signed by Mrs. Ann Dupuy in new York, Daniel Dupuy and Peter David, Gold-smiths in Philadelphia." *New York Gazette*, March 7, 1748; see also the biography of Daniel Dupuy Sr. and Jr. (q.q.v.).

13. Hildeburn, "Records of Christ Church, Baptisms," p. 357; "July 12, 1743 Ann David, the daughter of Peter, " cited in Charles R. Hildeburn, contributor, "Records of Christ Church, Burials, 1709–1760 (continued)," *PMHB*, vol. 2 (1878), p. 461n4.

14. Richard Pitts (q.v.) was also living at this time on Front Street and advertising the sale of leather chairs, pickled cod by the barrel, and other merchandise; *American Weekly Mercury*, February 12–19, 1739.

15. Philadelphia Will Books G (1745), p. 205; H (1747), pp. 256, 164.

16. Joseph Richardson, Ledger, 1734–40, Joseph Richardson Papers, 1733–1831, HSP.

17. "Stolen. Four silver spoons, 'MG' and 'B / I L,' silversmith's mark PD"; *Pennsylvania Gazette* (Philadelphia), August 27, 1741. "Lost–silver tablespoon, maker Peter David. With a shell on the bottom of the bowl, at the end of the handle"; ibid., November 2, 1752.

18. Illustrated in Mark B. Letzer and Jean B. Russo, *The Diary of William Faris* (Baltimore: Maryland Historical Society, 2003), pp. 43, 77. There is no evidence to date that Faris apprenticed with Peter David.

19. Peter David does not appear in deed records as a grantee for this property and thus may have held it on a ground-rent lease.

20. *Pennsylvania Journal and Weekly Advertiser* (Philadelphia), August 2, 1750. A similar advertisement appeared in the *Pennsylvania Gazette* (Philadelphia), June 6, 1751.

21. As Peter David died in 1755, this notice suggests that Redmond may have purchased the David property, where he had his store.

22. William and Rachel Coates had transferred the land to Langdale on May 9, 1745. Philadelphia Deed Book I-12-94; William Savery, "List of Taxables of Chestnut, Middle, and South Wards, Philadelphia, 1754," *PMHB*, vol. 14, no. 4 (1890), pp. 414–20.

23. "Notes and Queries: Some Residents of Philadelphia in 1747," *PMHB*, vol. 14, no. 2 (July 1890), p. 215.

24. Hildeburn, "Records of Christ Church, Burials," p. 461.

25. The Swansons were early Swedish settlers who were bought out of their Southwark property by William Penn but accumulated and continued to own extensive lands in Wicaoa, "on the east side of Front Street down the River Delaware for 60 feet, continuing into the River Delaware so far as to erect buildings, wharfs and quays." "Peter David & ux goldsmith & Margaret, to Joseph Trotter, Cutler," recorded September 30, 1755, Philadelphia Deed Book H, no. 6, p. 530. In September 1755 Peter and Margaret David transferred this piece of her Swanson family property, a

portion of their total holdings, to Joseph Trotter, a cutler, who from 1742 to 1754 also had a house on Second Street. Ibid.; *Pennsylvania Gazette*, April 10, 1755; Hannah B. Roach, "Taxables of Chestnut, middle & South Wards," *Pennsylvania Genealogical Magazine*, vol. 21 (1958–60), p. 73.

26. Peter David stood as godfather for Sarah Cox at Gloria Dei Church in January 1753. Peter and Margaret's daughter was christened at Gloria Dei but was buried at Christ Church. Baptisms and Marriages, Gloria Dei Church, 1750–1789, vol. 1, pp. 14, 272, HSP.

27. Park McFarland Jr., 1750–1863, *Marriage Records of Gloria Dei Church, "Old Swedes," Philadelphia* (Philadelphia: McFarland & Sons 1879), p. 10.

28. William Savery, "List of Taxables of Chestnut, Middle, and South Wards, Philadelphia, 1754," *PMHB*, vol. 14, no. 4 (1890), p. 415; Roach, "Taxables of Chestnut, Middle & South Wards," p. 73.

29. This preamble suggests that Margaret held an innholder's license, acquired before she married Peter David.

30. A photostat is in the Brix files, Yale University Art Gallery. The present location of the original is unknown.

31. Philadelphia tax lists, HSP.

32. Will of Margaret David, widow, signed May 31, 1794, probated December 3, 1795, Philadelphia Will Book X , no. 236, p. 373.

Cat. 182

Peter David
Serving Spoon

1735–40
MARK: P·DAVID (in rectangle, three times on reverse of handle; cat. 182-1)
INSCRIPTION: I / I·E (engraved over the Marshall crest, on reverse of handle)
Length 13 7/8 inches (35.2 cm), width 2 11/16 inches (6.8 cm)
Weight 6 oz. 2 dwt. 17 gr.
Gift of Walter M. Jeffords, 1956-84-3
EXHIBITED: Philadelphia 1956, cat. 71; Lindsey et al. 1999, p. 197, cat. 274.

Cat. 182-1

This grand serving spoon is heavy and well balanced.

The initials "I / IE" are deeply engraved over the partially buffed out or very worn crest of the Marshall family.[1] The spoon was probably owned originally by the Revolutionary patriot and diarist Christopher Marshall (1709–1797), a prosperous chemist at the sign of the Golden Ball in Philadelphia. He supported the American cause in the Revolutionary War and served on the Committee of Safety in 1776. For these activities he was read out of Quaker Meeting.[2] The initials suggest that this spoon, as did a tankard by Johannis Nys (PMA 2005-69-23), came into the ownership of John and Elizabeth Jones, possibly during the Revolution when the Marshall estates were ravaged in 1777 by the British troops. In that case the spoon may have been inherited by their granddaughter Elizabeth Flower, who married Christopher Marshall Jr., also in 1777. BBG

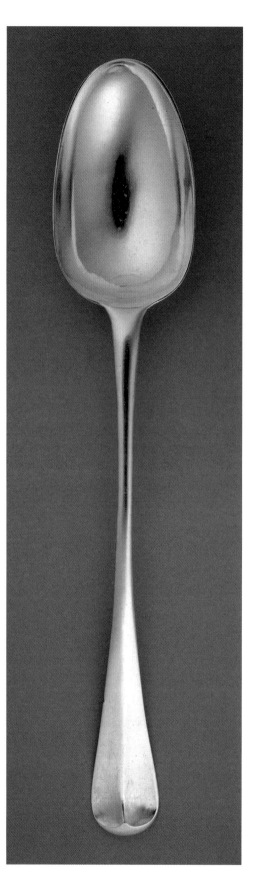

1. Several members of the Marshall family owned silver bearing the crest but made by craftsmen active later than the silversmith Peter David. A caster by Philip Syng (PMA 1959-2-8) belonged to Christopher (born 1740) and Patience Parrish Marshall. For the vandalism of the Marshall properties, see Christopher Marshall Papers, 1744–c. 1971, HSP.
2. Christopher Marshall is most famous for his diary, or "Remembancer," whose original manuscript is at the HSP. DAB, s.v., "Christopher Marshall."

Cat. 183

Peter David
Shoe Buckle

1740–55
MARK: P·D (in rectangle, on inside of one end; cat. 183-1)
Length 3 5/8 inches (9.2 cm), width 1 7/8 inches (4.8 cm), depth 1 1/4 inches (3.2 cm)
Gross weight 1 oz. 6 dwt.
Gift of Mrs. Paul Nemir Jr. in memory of Mrs. Thomas Leiper Black, 1992-107-2

Cat. 183-1

This buckle was accessioned as one of a pair; the other is marked by John Strangeways Hutton (PMA 1992-107-1). The two are almost identical in their design. The buckles are of the same period style, but the decorative tooling on the inner edges is different. Peter David's has a zigzag chased border; Hutton's has a band of semicircular shapes. The Hutton buckle has the initials "LB" engraved on the reverse.[1] Both have heart-shaped chapes, which were imported in great numbers into Philadelphia from the factories at Birmingham, England.[2]

Peter David and John Strangeways Hutton both began fashioning silver in New York. Hutton was fifty-one when he moved to Philadelphia in 1735, and Peter David first appears in Philadelphia records about the same date. They surely knew each other, but these buckles were probably not a pair.[3] The chape design was likely available at most silversmiths' shops, and Hutton worked in the shop of Joseph Richardson Sr. (q.v.), where buckles were an element of daily business. BBG

1. Buckles were sometimes marked this way if commissioned rather than purchased from imported stock. Richard Humphreys's buckles (see PMA 1921-34-146,a) are marked on the reverse with "RH" and the numerals XXVII.

2. The metal manufactories at Birmingham made and exported steel chapes, and whitesmiths and silversmiths made and repaired them in America. The daybook and account book of Ziba Blakeslee describe in detail the versatility of a bucklemaker who, in the 1790s, made and mended "chapes and tongues," sold imported buckles and silver, made corner pieces for Bibles, engraved, and cast bells for clocks; Ziba Blakeslee, Account Books, 1768–1834, Downs Collection, Winterthur Museum. Joseph Richardson Jr. (q.v.) entered in his daybook on May 21, 1796: "To puting chapes in a pair shoe buckles for his son. £0 2s. 6d.," and again in May 1797 for Jonathan Evans: "To putting chapes in Shoebuckles £0 2s. 0d."; Joseph Richardson Papers, 1733–1831, HSP. Peter David did some business with Richardson; see the biography of Peter David in Philadelphia 1976, pp. 44–45. Another, unmarked pair (PMA 1929-168-5a,b) has the same heart-shaped chape, but it was not the usual design. See Edward Wenham, "Buckles," Antiques, vol. 56, no. 5 (November 1949), pp. 368–69; Avery 1930, pp. cxliv–cxlvii; and Ruth Frost, "The Toy Trades," Birmingham Museum and Art Gallery, Department of Local History Information Sheet, no. 12 (1981).

3. It was usually the chape rather than the silver frame that broke; Edith Monroe Moe, The Beauty of the Silversmith's Craft: Handbook of a Silver Collection (Louisville, KY: J. B. Speed Memorial Museum, 1981), pp. 86–87. Plate 35 in ibid. shows a pair of buckles with different chapes, one of which has the heart-shaped "fork." But it would also have been unusual practice for a set to have been made or marked by different workers in the same shop.

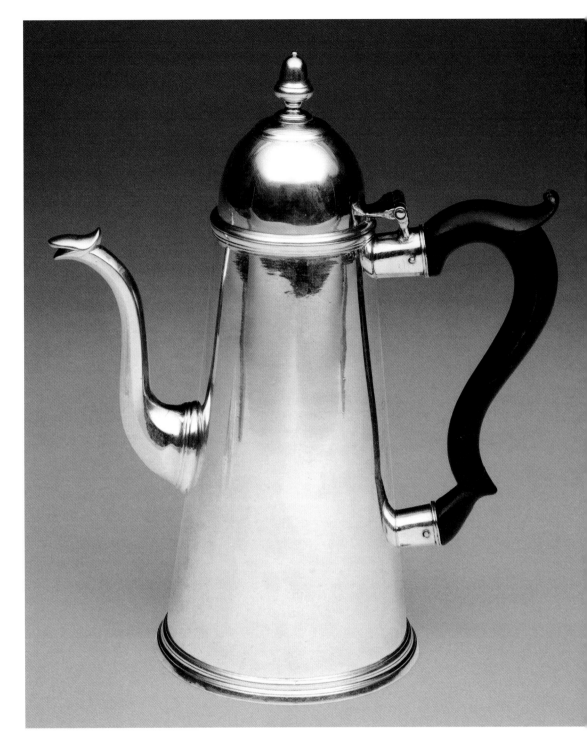

Cat. 184

Peter David

Coffeepot

1750

MARK: PD (in rectangle with convex right end, twice on each side of upper handle socket; cat. 184-1)

INSCRIPTION: 17 S·L 72 / E F / 38 oz (engraved script, on underside)

Height 10¾ inches (27.3 cm), width 9⅛ inches (23.2 cm), diam. 4¹³⁄₁₆ inches (12.2 cm)

Gross weight 37 oz. 18 dwt. 10 gr.

Gift of Mr. and Mrs. Henry Cadwalader, 1991-81-1

PROVENANCE: This coffeepot probably was made for William Logan (1718–1776) and his wife Hannah Emlen Logan, who married in 1750. The inscriptions on the underside of the pot refer to their daughter Sarah Logan (1751–1795) and the date of her marriage, on March 17, 1772, to Thomas Fisher (1741–1810). "EF" were the initials of either Esther Fisher (1788–1849), who died unmarried, or her sister-in-law Elizabeth Powell Francis (born 1777), who in 1806 married Joshua Fisher (died 1806). Their son Joshua Francis Fisher (1807–1839) married Elizabeth Izard Middleton (1815–1890). The Middletons' daughter Mary Helen Fisher (1844–1937) married John Cadwalader (1843–1925).[1] The pot descended in the family to the donors.

EXHIBITED: Woodhouse 1921, p. 12, cat. 31; Philadelphia 1956, cat. 68; Philadelphia 1969, p. 55, cat. 14; Philadelphia 1976, cat. 33, p. 45; Lindsey et al. 1999, p. 189, cat. 210.

The design of this coffeepot was rare in early American silver, and to date it is the only example of the

Cat. 184-1

form known to have been made in Philadelphia. There was English precedent: the Hamilton family owned one (PMA 1921-27-2) made by the English silversmith Samuel Margas in London, bearing the date mark for 1722 and their engraved arms. There is an earlier Boston coffeepot of this form by Jacob Hurd (q.v.) at Winterthur.[2] The shape of the body, seamed up the back under the handle, the raised, dome-shaped lid with cast finial, and the curved, faceted spout are features used by New York silversmiths. It was sometimes referred to as a "lighthouse" shape.

Charles Le Roux (q.v.) of New York made one for Thomas Moore II and another for Ralph Asheton of Philadelphia.[3] Peter David had apprenticed in New York with Peter Quintard, who in turn had apprenticed with Charles Le Roux, and thus the influence was to hand. The coffeepot originally had a matching stand, which descended in a separate line of the family and is now in a private collection.[4] BBG

1. Biographical/Historical Note, Logan Family Papers, HSP; www2.hsp.org/collections/manuscripts/l/Logan0379.html.
2. Quimby and Johnson 1995, pp. 122–24, cat. 79
3. For the coffeepot by Charles Le Roux (PMA 1980-90-1), see Lindsey et al. 1999, p. 183, fig. 213. See also Le Roux's coffeepot at the Metropolitan Museum of Art, in Wees and Harvey 2013, pp. 198–99, cat. 72.
4. See Lindsey et al. 1999, p. 176, fig. 207.

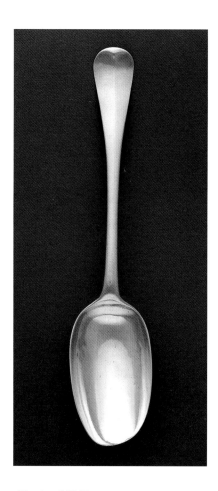

Cat. 185

Peter David

Tablespoon

1754–55

MARK: P·DAVID (in rectangle, twice on back of shaft; cat. 182–1)

INSCRIPTIONS: S·M (engraved, on reverse at top of handle); J M (engraved script, on reverse below "S·M")

Length 8⅛ inches (20.6 cm)

Weight 1 oz. 14 dwt. 8 gr.

Gift of Mrs. W. Logan MacCoy, 1957-93-19

PROVENANCE: The initials "SM" belonged to Samuel Morris (1734–1812), distinguished for being the first patriot mayor of Philadelphia. In his will dated 1810, he left "one silver pint can, and all his other plate, and all the rest of the Kitchen furniture, valued at 1000 dollars," to his daughter Catherine Wistar Morris (1772–1859), who died unmarried.¹ She left this spoon to her younger brother Israel Wistar Morris (1778–1870), to whom the initials "IM" belonged. The spoon descended in the family to the donor.

This spoon shows considerable wear on the tip of the bowl, and the engraving is worn.

Addressed as "Captain" throughout his life for his role as captain of the First Philadelphia City Troop of Light Cavalry, Samuel Morris was also governor of the State in Schuylkill Fishing Club, a member of the Revolutionary War Council of Safety and the Navy Board, a member of the Pennsylvania Assembly, and president of the Gloucester Fox Hunting Club. He married Rebecca Wistar on December 11, 1755, at Christ Church, Philadelphia. BBG

1. Moon 1898–1909, vol. 1, pp. 320–56.

Davis & Galt

Philadelphia, 1888–1914

Previous partnerships
Hamilton & Davis, 1875–80
J. H. Davis & Company, 1880–84

Junius Harrison Davis was born in Virginia in 1841, the son of Hector and Eveline Davis.¹ His widowed mother had moved with her children to Philadelphia by 1860,² when Junius was recorded in the U.S. census as "app[renticed] to silversmith," whose identity is unknown. Davis's apprenticeship must have ended shortly thereafter.

"Julius" Davis was recorded in the 1861 Philadelphia directory as an independent silversmith at his mother's residence at 1207 Ellsworth Street, where he remained until about 1869. In 1860–61, he married Lucy Ruhl (c. 1845–1893), with whom he had at least eight children.³ Three of his sons took up silversmithing and presumably trained in his shop. Hector (1861–1882) was recorded as a silversmith in both the U.S. census of 1880 and his burial record, and his younger brother Junius H. Davis Jr. (1867–1889) was listed as a silver chaser in the 1888 city directory and his burial record.⁵ Their longer-lived brother Jasper N. Davis (1866–1929) was recorded in city directories variously as an engraver, a chaser, and a silversmith and presumably worked for his father, although in later U.S. census records he appeared as a machinist in a department store.⁶ In 1872–73 Junius Davis moved his family to 2055 Kater Street, and in 1876 he and his wife were confirmed at Holy Trinity Memorial Chapel at Twenty-Second and Spruce streets.⁷ The family moved in 1878–79 to 2347 Catherine Street, and in 1880–81 to 2233 St. Alban's Place and joined the Episcopal Church of the Holy Apostles at Twenty-First and Christian streets.⁸

After working independently for fifteen years, in 1875 Davis embarked on a series of partnerships that presumably provided the manpower and capital to expand the scale of his business. He formed the partnership of Hamilton & Davis with the silversmith Matthew F. Hamilton (q.v.) at 101 South Eighth Street; in 1877 they relocated their shop to 732 Sansom Street, at the center of Philadelphia's "Jewelers' Row."⁹ The buildings at 732 and 730 Sansom were twin, four-story, brick row houses converted to commercial use. The partnership was dissolved in 1880, when Davis formed

J. H. Davis & Company at the same address, in partnership with John H. Scott Jr., who was also identified in directories as a conveyancer, or real estate lawyer, and presumably was only an investor in the business.¹⁰ Davis's second partnership apparently had ended in 1884, and he worked independently at 732 Sansom Street for four years.¹¹

In July 1888 Davis formed the partnership of Davis & Galt with Charles Ernest Galt (1852–1900), adopting the mark of a fleur-de-lys that they would trademark with the U.S. Patent Office in 1893.¹² Galt was the grandson of James Galt (1779–1847), a silversmith in Alexandria, Virginia, and the eldest son of Matthew W. Galt (1821–1898), co-owner of M. W. Galt & Brother, the leading jewelers in Washington, D.C. In the U.S. census of 1880, Charles Galt was living with his parents and had the profession of "Dealer in W[atches] & Jewelry" at his father's store.¹³ Davis & Galt supplied silver to M. W. Galt & Brother, and it seems likely that the partnership signified a financial investment by the Galt family in Davis's business.¹⁴ The firm was located at 730 Sansom Street, next door to Davis's previous address, which perhaps represented an expansion into the adjoining row house. The firm manufactured silver on a significant scale, using drop presses and other machinery (see cat. 186). In 1891 Davis received a patent for an improved method of die-rolling ornamental handles for scissors.¹⁵

The financial Panic of 1893 adversely affected many luxury-goods manufacturers, and in August of that year Davis & Galt put their workforce on half-time, although they returned to full-time hours by October.¹⁶ In that same year Davis experienced a personal tragedy when his wife Lucy died at the age of forty-seven on October 4; he moved to 4018 Spruce Street.¹⁷ On May 19, 1894, the partnership of Davis & Galt was dissolved "by mutual consent, the said Junius H. Davis retiring from the said firm."¹⁸ Beginning with the 1895 city directory, Davis was listed without a profession, and he moved to 340 North Forty-Second Street.¹⁹ The U.S. census of 1900 recorded Junius Davis as retired, and in that year he was still living on North Forty-Second Street with his sons Jasper and George and daughters Laura and Evelina.²⁰ Davis died on March 22, 1904, and was buried in Mount Moriah Cemetery in Philadelphia.²¹

The firm of Davis & Galt continued to operate under that name at 730 Sansom Street, with Galt listed as the sole proprietor until his death in 1900.²² The following year William Linker (born 1863) was the individual associated with the firm.²³ It is not known when he began working for the company; he was first recorded in city directories in 1883 as a salesman and, beginning in 1891, as a

silversmith.[24] He may have trained with Davis. The first documented connection between Linker and Davis & Galt came in 1896, when Linker returned from a successful business trip for the company.[25] In the U.S. census of 1900, Linker was listed as "Man-iger Silberware [sic]," and it was not until 1912 that he was identified in the city directory specifically as Davis & Galt's president and treasurer, although he may have held these positions earlier.[26] The firm went out of business in 1914.[27] DLB

1. 1900 U.S. Census. In many sources, including some city directories and the 1880 U.S. Census, Davis's given name was incorrectly recorded as "Julius."

2. McElroy's Philadelphia directory 1860, p. 214.

3. 1880 U.S. Census; Smith and Selover family tree, Ancestry.com (accessed September 30, 2015). I am grateful to Ann Glasscock for this reference.

4. McElroy's Philadelphia directory 1861, p. 219; Gopsill's Philadelphia directory 1869, p. 423.

5. Philadelphia Death Certificates Index, 1803–1915, Ancestry.com; Gopsill's Philadelphia directory 1888, p. 440.

6. Pennsylvania Veterans Burial Card no. 3819, Pennsylvania Historical and Museum Commission, Bureau of Archives and History, Harrisburg; Gopsill's Philadelphia directory 1895, p. 439; Philadelphia directory 1897, p. 466; Philadelphia directory 1901, p. 592; 1910 U.S. Census; 1920 U.S. Census. A fourth son, George Washington Davis (born 1876), was recorded as a clerk in the 1900 U.S. Census and apparently never worked as a craftsman.

7. Gopsill's Philadelphia directory 1873, p. 393; Records of the Parish of Cranmer Chapel in the City of Philadelphia, 1858–1892, Church of the Holy Trinity, Philadelphia.

8. Gopsill's Philadelphia directory 1879, p. 413; 1881, p. 418.

9. Ibid. 1876, p. 338; ibid. 1878, p. 664.

10. Ibid. 1881, pp. 418, 1462.

11. Ibid. 1885, p. 446.

12. Trademark no. 22,275; "The Latest Patents," Jewelers' Circular, vol. 25 (January 11, 1893), p. 46.

13. 1880 U.S. Census; Galt's life dates are recorded on his grave-stone, memorial no. 55241153, www.findagrave.com (accessed June 9, 2015).

14. A black coffeepot decorated in an allover repoussé pattern bears the marks of both Davis & Galt and M. W. Galt & Brother (offered at Neal Auction Company, New Orleans, August 4, 2001, lot 312).

15. U.S. Patent 453,548, June 2, 1891, U.S. Patent Office, Washing-ton, DC.

16. "Philadelphia," Jewelers' Circular, vol. 27 (August 23, 1893), p. 33; "Philadelphia," Jewelers' Circular, vol. 27 (October 18, 1893), p. 35.

17. Baptisms, Marriages, and Burials, 1882–1896, Church of the Holy Apostles and the Mediator, Philadelphia; "Philadelphia," Jewelers' Circular, vol. 27 (October 11, 1893), p. 33; Gopsill's Philadelphia directory 1894, p. 469.

18. "Partnership Notices," Philadelphia Inquirer, June 2, 1894; "Philadelphia," Jewelers' Circular, vol. 28 (May 30, 1894), p. 30.

19. Gopsill's Philadelphia directory 1895, p. 436; 1896, p. 459.

20. 1900 U.S. Census; Philadelphia directory 1901, pp. 592–93.

21. Burials, 1896–1944, Church of the Holy Apostles and the Mediator, Philadelphia.

22. Gopsill's Philadelphia directory 1900, p. 527.

23. Ibid. 1901, p. 588.

24. Ibid. 1883, p. 957; 1891, p. 1104.

25. "Philadelphia," Jewelers' Circular, vol. 32 (March 4, 1896), p. 25.

26. 1900 U.S. Census; Philadelphia directory 1912, p. 1158.

27. Boyd's Philadelphia directory, 1914, pp. 352, 685, 2028. The firm was not listed in the city directory of 1915 or thereafter. William Linker was recorded as a partner in William Linker & Company, contractors; ibid. 1915, pp. 667, 2004.

Cat. 186

Davis & Galt
Dessert Spoon

1888–1914
Retailed by J. E. Caldwell & Co. (q.v.)
MARKS: [fleur-de-lys] (in shield); STERLING J.E. CALD-WELL &Co. (incuse; all on back of handle; cat. 186-1)
Length 6⅝ inches (16.8 cm)
Weight 1 oz. 12 dwt. 15 gr.
Gift of Charlene D. Sussel, 2009-155-33

PROVENANCE: From the stock of the Philadelphia antiques dealer Eugene Sussel (1913–1989), the donor's husband.

The floral repoussé pattern on this spoon is similar to those made popular by silversmiths in Baltimore, beginning in 1828 with *Repoussé* made by Samuel Kirk and *Rose* made by the Stieff Company (q.q.v.) in

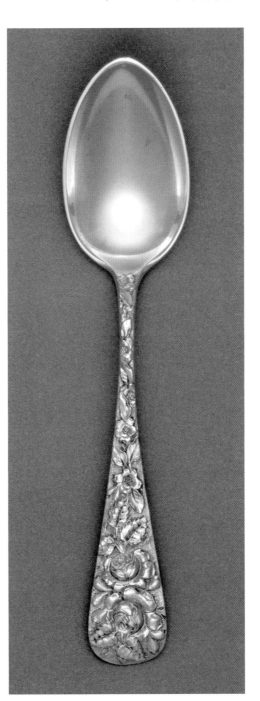

1892 (PMA 2010-206-26–28). The die-struck dec-oration has been enhanced significantly by hand chasing and deep undercutting of some flowers, creating a heavily textured quality characteristic of late nineteenth-century repoussé patterns. In 1888 Junius Davis patented a design for a similarly ornate handle with a diagonal line of flowers in high relief.[1]

Like many pieces of flatware marked by Davis & Galt, this spoon was also marked for the Philadel-phia jeweler J. E. Caldwell & Co. (q.v.). A significant part of Davis & Galt's production was intended for retail jewelers across the country, and it is possible that the firm operated exclusively as a wholesale manufacturer. Flatware made by Davis & Galt was marked for retailers including Shreve & Company of San Francisco (see PMA 2010-206-46), and Shreve, Crump & Low (cat. 191) and Bigelow, Kennard & Company (cat. 227), both of Boston.[2] DLB

1. U.S. Patent D18,459, July 17, 1888, U.S. Patent Office, Wash-ington, DC. I am grateful to Spencer Gordon for the informa-tion on this patent.
2. A berry spoon marked for Shreve & Company was offered by the dealers Cottage and Castle, www.ebay.com/itm/ws/eBayISAPI.dll?ViewItem&item=360692165723&item=360692165723&lgeo=1&vectorid=229466 (accessed July 11, 2013); a pea spoon marked for Bigelow, Kennard & Company was offered by the dealer Spencer Marks, www.spencermarks.com/html/d69.html (accessed July 11, 2013); and a set of soup spoons marked for Shreve, Crump & Low sold at auction at Skinner, Marlborough, Massachusetts, *Discovery*, March 14, 2012, sale 2587M, lot 51.

Cat. 186-1

William Gaetano deMatteo

Acciaroli, Salerno, Italy, born 1895
Charlotte, North Carolina, died 1981

Gaetano deMatteo was born in the village of Acciaroli, Salerno, Italy, on March 17, 1895, the son of Luciano deMatteo, a fisherman.[1] His father immigrated to the United States in 1898 and brought Gaetano to New York City in 1905, when he acquired William as a first name. He became a naturalized citizen of the United States at the age of sixteen in 1911.[2] He continued to use the name Gaetano on some occasions, such as his draft registration in 1917 and his listing in the 1922–23 New York City directory.[3] In 1918, at the age of twenty-three, he married Elizabeth (last name unknown; 1899–1983), who had been born in Connecticut of immigrant parents from Germany and Austria-Hungary.[4] They had two children, Margaret (born 1920) and William L. (1923–1988).

DeMatteo completed school through the eighth grade,[5] and in 1909 he took a job sweeping floors at a factory operated by Reed & Barton (q.v.) in New York. He soon became an apprentice and subsequently an employee. By June 1917 he was working for the New Art Plating Company on Sixth Avenue.[6] At the time of the U.S. census of 1920, deMatteo was employed as a silversmith in an unspecified factory and was living at 510 East Seventy-Seventh Street.[7] The following year he opened his own shop in New York, which he operated for five years. The location of this shop was not recorded in New York City directories; in the New York directory for 1922–23, deMatteo's name was listed without a profession at his residence on Seventy-Seventh Street.[8]

In 1926 deMatteo built a new home and shop at 53 Harcourt Avenue in Bergenfield, New Jersey, where he worked for forty years until his retirement (fig. 69). He took private commissions and made hollowware and flatware for Manhattan retailers such as Cartier, Tiffany & Co. (q.v.), S. J. Shrubsole, and S. Wyler. Between about 1940 and 1951 he created several hundred different designs for Frederik Lunning's New York branch of Georg Jensen (see cat. 187). DeMatteo primarily worked alone, although he hired short-term assistants when needed. Beginning in the late 1930s, he trained his son William as a silversmith, and the two worked together until William entered the navy in World War II.

DeMatteo retired in 1967 and thereafter occasionally worked with his son, who served as the master silversmith at Colonial Williamsburg from 1953 until his retirement in 1979.[9] William G. and Elizabeth deMatteo moved to Pompano Beach, Florida, in 1968 and subsequently to Beaufort, South Carolina. He died in Charlotte, North Carolina, on June 8, 1981.[10] His grandson Chip deMatteo (born 1949), a third-generation silversmith, owns Hand and Hammer Silversmiths in Woodbridge, Virginia, manufacturers of silver jewelry and Christmas ornaments.[11] DLB

1. Unless otherwise noted, information for deMatteo comes from Schiffer and Drucker 2008, pp. 12–14.

2. 1920 U.S. Census.

3. World War I Selective Service System Draft Registration Cards, 1917–18, NARA, Ancestry.com; Polk's Trow's New York City directory 1922–23, p. 589.

4. 1920 U.S. Census.

5. 1940 U.S. Census.

6. World War I Selective Service System Draft Registration Cards, 1917–18 (see note 3).

7. 1920 U.S. Census.

8. Polk's Trow's New York City directory 1922–23, p. 589. According to Schiffer and Drucker (2008, p. 12), "Little is known about this period."

9. Schiffer and Drucker 2008, p. 186.

10. North Carolina, Death Indexes, 1908–2004, Ancestry.com.

11. Schiffer and Drucker 2008, p. 186; see also the company website, www.hand-hammer.com (accessed June 9, 2015).

Fig. 69. William G. deMatteo raising a silver bowl, c. 1950. Courtesy of Hand & Hammer Silversmiths, Woodbridge, VA

Cat. 187

William Gaetano deMatteo
Pitcher

1940–67
Ivory handle
MARKS: HAND MADE (in rectangle) / STERLING (incuse) / D (in conforming surround, at center of spoked wheel; all on underside; cat. 187-1)
Height 9⅜ inches (23.9 cm), width 8⁷⁄₁₆ inches (21.4 cm), diam. 6½ inches (16.5 cm), diam. base 4⁷⁄₁₆ inches (11.3 cm)
Gross weight 34 oz. 8 dwt. 14 gr.
Purchased with the Richardson Fund, 2006-140-1
PROVENANCE: Robert Mehlman, New York City.

Cat. 187-1

Following the outbreak of World War II, it became difficult for Georg Jensen, the Copenhagen firm, to supply its New York distributor, Georg Jensen Handmade Silver, established by Frederik Lunning in 1924. Lunning responded to this shortfall by commissioning silver from two New Jersey silversmiths, Alphonse LaPaglia (1907–1953) in Summit and William deMatteo in Bergenfield. DeMatteo estimated that, between 1940 and 1951, when Lunning discontinued the sale of American-made objects, he had produced several thousand iterations of more than a hundred different designs in the Jensen manner, as well as others inspired by eighteenth-century American objects, all of which Lunning offered at his store.[1] DeMatteo continued to make his Jensen-influenced objects after he ceased working for Lunning, and the absence of a "Georg Jensen, Inc. USA" mark on this pitcher suggests that it may date from that later period.

The ivory handle, beading, and openwork band of naturalistic ornament demonstrate deMatteo's absorption of the Jensen idiom, which by the 1940s had already exerted a profound influence

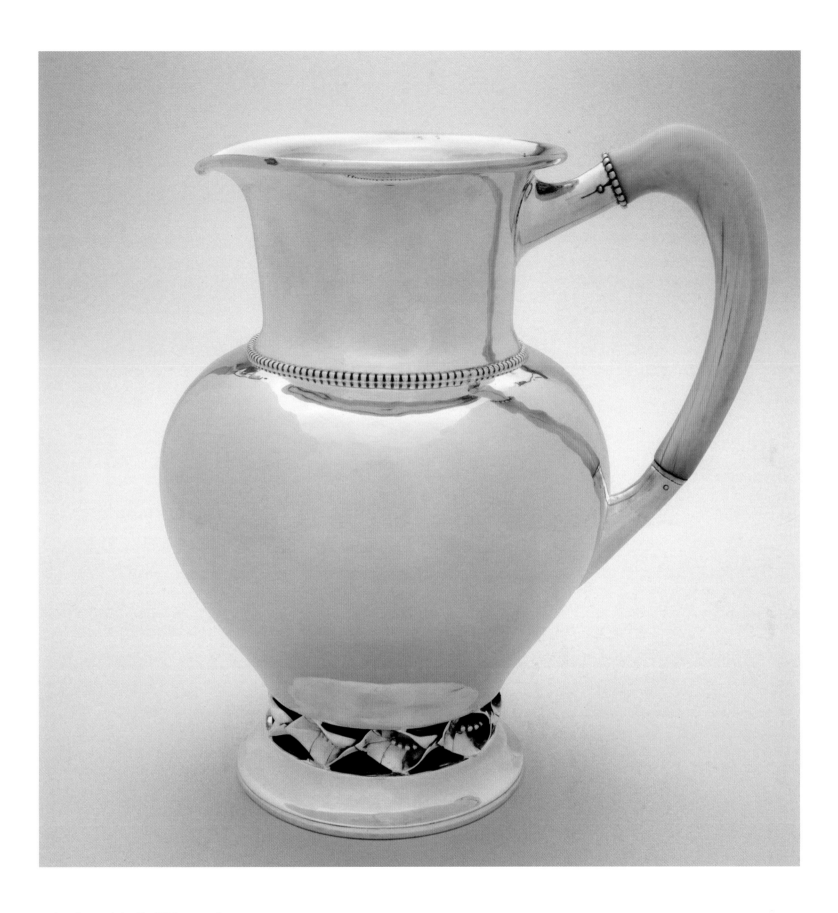

on American metalsmiths.[2] At the same time deMatteo maintained that his Jensen-inspired objects were original designs rather than copies.[3] The classic, inverted baluster form of the pitcher is more geometric than are the organic shapes favored by Jensen, and calla lilies were not a Danish motif. The pitcher's design seems akin to deMatteo's early work in the Colonial

Revival style, and it is not clear to what extent his Jensen-style work was a practical response to Lunning's patronage. Despite its shimmering, hammered surface and deMatteo's mark proclaiming hand workmanship, the body of the pitcher was not raised in the traditional manner but fabricated in two sections from seamed sheet metal; the bottom disk is soldered in place. His record cards indicate

that he made the pitcher with or without the "lily wreath," both versions at the same price of $110.[4]

DLB

1. Schiffer and Drucker 2008, pp. 8–10, 43–49.
2. See the vase by Peer Smed (PMA 2001-7-1).
3. Schiffer and Drucker 2008, pp. 14, 150, 152.
4. Ibid., p. 24.

William Waldo Dodge Jr.

Washington, D.C., born 1895
Asheville, North Carolina, died 1971

Trained as an architect at the Massachusetts Institute of Technology, William Waldo Dodge Jr. served in World War I and was critically injured, first with shrapnel and later with chlorine gas.[1] To recuperate he was sent to Oteen, North Carolina, where he learned silversmithing skills from Margaret Wheeler Robinson (1890–1987), a trained occupational therapist who became his wife in 1920.[2] When he relapsed in 1923, he was sent to the Gaylord Farm Sanitarium in Wallingford, Connecticut, where the medical staff noted in their annual report that "they were fortunate in being able to interest Mrs. W. W. Dodge, Jr., of Meriden in coming to us at a nominal salary" to set up a program in silver work; "Mr. Dodge . . . was one of our U.S. Service patients and gave great assistance to the work; in fact providing us with many of the designs we are now making. The success which we have attained is in fact chiefly due to the interest and effort of Mr. and Mrs. Dodge."[3] The silver line became known as Gaylord Silvercraft.

In 1924 William and Margaret Dodge relocated in Asheville, North Carolina, and opened a silver shop in a cottage on Charlotte Street. At the same time he established his architectural practice and developed as a painter of regional landscapes.

William Dodge worked in the Arts and Crafts style, which continued in the United States long after the fashion for it had waned in England. His silver line sold well and in 1927–28, through a creative financial arrangement with the developers of the subdivision project at the Biltmore estate, Dodge built his silver workshop and showroom at 365 Vanderbilt Road, in the newly created town of Biltmore Forest (fig. 70). The shop included an architectural drafting room, which absorbed more and more of his time and skills. He employed at least three assistants in the silver shop, Johnny Green, Ray Yeomans, and Dick Shuford.[4] The shop became known for its production of most forms of domestic silver, with varied and distinctive textural surfaces. Dodge advertised through his own printed catalogues and in national magazines,

and he made consignment arrangements east and west. The shop managed to stay active through the Depression of 1929–33. A large slice of his business during this period was with residents of Biltmore Forest for domestic silver, and with their local organizations for trophies. The tourist traffic through the Biltmore and Asheville area further contributed to the survival of the shop.

World War II effectively ended the William Dodge silver shop. In 1942 his workmen were drafted, and his raw materials were increasingly difficult to obtain. Dodge turned to his architectural skills, joining with four others working on military contracts. He retired in 1958 to his farm near Asheville. BBG

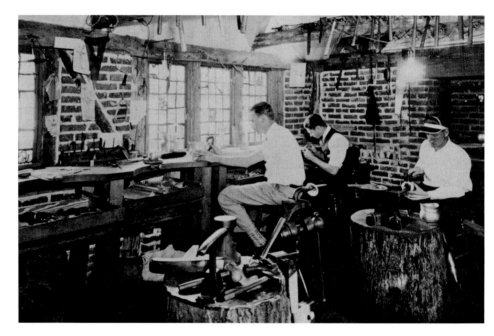

Fig. 70. William Waldo Dodge (left), in his Asheville workshop, 1928, with his assistants Dick Shuford (center) and Ray Yeoman (right). From Bruce Johnson, "William Waldo Dodge: The Asheville Craftsman," *Silver Magazine*, vol. 26, no. 9 (July–August 1994), p. 32.

1. There is a rich bibliography for William W. Dodge, from which this short summary has been drawn: Stephen C. Worsley, "William Waldo Dodge, Jr. Silversmith," *Carolina Comments: North Carolina Office of Archives and History*, vol. 37, no. 5 (November 1989); Bruce E. Johnson, "William Waldo Dodge, Jr.: A Southern Architect, Artist, and Artisan," in *Southern Arts and Crafts, 1890–1940*, ed. James C. Jordan III and Jane Ellen Starnes (Charlotte, NC: Mint Museum of Art, 1996), pp. 24–30; Rainwater and Redfield 1998, p. 94; W. Scott Braznell, "Silversmithing as a Treatment for Tuberculosis: William Waldo Dodge, Jr. and the Beginnings of Gaylord Silvercraft," *Connecticut Historical Society Bulletin*, vol. 57, nos. 3–4 ([Summer/Fall 1992] 1996), pp. 175–86.

2. District of Columbia, Marriages, 1830–1921 (Salt Lake City: FamilySearch, 2013), Ancestry.com.

3. They consulted with and were advised by Thomas Singleton and Samuel Wilkes of the R. Wallace & Sons Mfg. Co. of Wallingford, who actually visited and offered technical advice; the International Silver Company of Meriden, Connecticut (Mrs. Dodge was a friend of the firm's president, George Wilcox); and Mr. Frank W. Purdy of the Gorham Manufacturing Company (q.v.); "Sixteenth Annual Report 1920," Gaylord Farm Sanatorium, Wallingford, CT, 1920, pp. 20–21; and "Nineteenth Annual Report 1923," 1923, pp. 33–35.

4. David Schulman, *Biltmore Forest: Our History, Our Lives* (Biltmore, NC: 1998), p. 17.

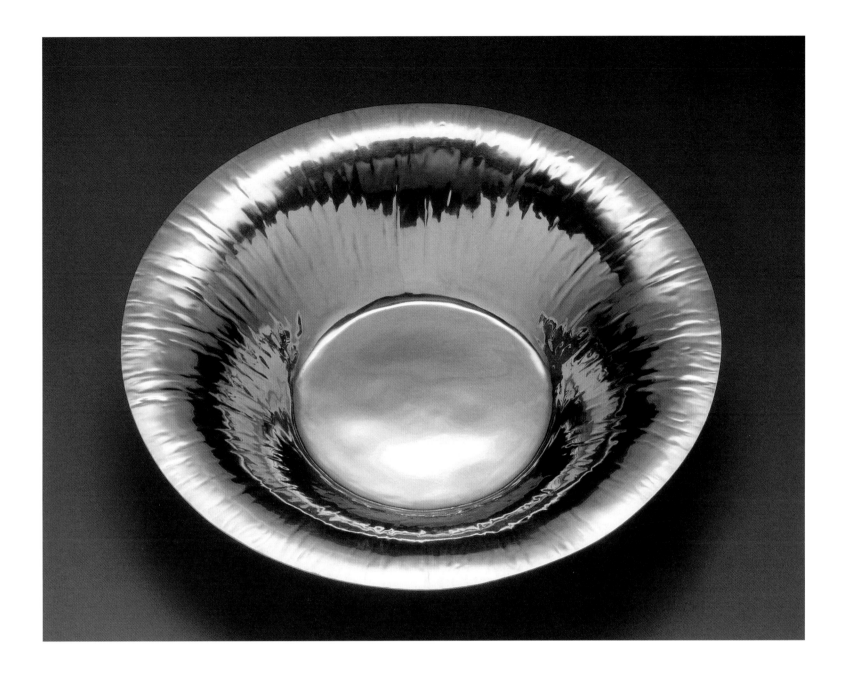

Cat. 188

William Waldo Dodge Jr.

Bowl

1932

MARKS: DODGE (in rectangle) / STERLING (in rectangle with rounded ends) / [eagle in circle] [crosslet and four raised dots in shield] / BY HAND (in rectangle with rounded ends) / 8 (in square) A (in heart) 1 (in soft triangle) 3 (in square; all on underside; cat. 188–1)

Height 2 inches (5.1 cm), diam. 10 inches (25.4 cm), diam. bottom 4½ inches (11.4 cm)

Weight 20 oz. 2 dwt.

Purchased with funds contributed by the Levitties Family Trust, 1997-66-1

PROVENANCE: Margaret B. Caldwell, New York.

A reading of the marks indicates that the bowl was made in August 1932 by Johnny Green and the first to be marked that month. This piece has the bowl shape and surface texture for which the Dodge shop was well known.[1] BBG

1. For a similar bowl, see Gebelein Silversmiths, Boston, advertisement, *Silver Magazine*, vol. 24, no. 2 (March/April 1991), p. 2.

Cat. 188-1

Dominick & Haff

| New York, 1872–1928

Dominick & Haff, the partnership between Henry Blanchard Dominick (1848–1928) and Leroy Barbour Haff (1841–1893), evolved out of the company Gale, Dominick & Haff (1870–72); the firm became Dominick & Haff in 1872, and after fifty-six years of production was purchased by Reed & Barton (q.v.) in 1928.[1]

Henry Blanchard Dominick was born in New York City. He identified himself as a descendant of a French Huguenot, George Dominick, who served as a captain of the New York City Militia in September 1775.[2] Henry Dominick started in the silver business with William Gale & Son, the New York firm run by William Gale (q.q.v.), when he was fifteen years old, around 1863.[3] Leroy Barber Haff (fig. 71) was born in Peru, New York, in 1841 and was associated with the retail department of William Gale beginning in 1867 as a bookkeeper.[4] From 1870 to 1872 the new firm was listed as Gale, Dominick & Haff, after which the Gale

Fig. 71. Leroy B. Haff, from "The Death of Leroy B. Haff," *Jewelers' Circular*, vol. 27 (September 27, 1893), p. 13. New York Public Library, Astor, Lenox and Tilden Foundations. Art & Architecture Collection, Miriam and Ira D. Wallach Division of Arts, Prints and Photographs

firm was absorbed by Dominick & Haff; the trade marks of the firms were very similar. In 1872 Haff's name in the New York city directory was followed by the annotation "silverware" and his location as 451 Broome Street; Henry B. Dominick was listed at the same address as "smith."[5]

The 1875 city directory listed "Dominick & Haff, silver, 451 Broome Street," and Dominick himself at the same address, with the indication "silver." In 1876 the personal listings in the same directory for both Dominick and Haff were annotated "silver," as was the listing for Dominick & Haff, now at 1 Bond Street.[6] On October 31, 1877, Dominick married Mary Sampson (1850–1947) in New York.[7] That same year, the Waltham Building, where the firm was located, burned to the ground and the concern moved a few blocks down to 9 Bond Street. In its early period the firm made small sterling-silver novelties, pins, bracelets, buckles, and so forth, and fancy goods. After the fire in 1877 Dominick & Haff developed a full line of silverware that included elaborately decorated hollowware and flatware in current styles.[8] In 1883 the partners moved again, to 5 Bond Street, with Dominick listed as "jeweler" and Dominick & Haff still listed as "silver."[9]

In the U.S. census of 1880, Leroy Haff was noted as a resident in Englewood, New Jersey, where he lived with his uncle and aunt Mr. and Mrs. Ralph Barbour and was listed as a "manufacturer of silverware." Ralph Barbour was listed as a bookkeeper, the position that Leroy had held when he first joined the William Gale firm in 1867; perhaps Ralph had moved to Englewood from the family home in Peru, New York, in order to join the profession of his nephew.[10] Haff died on September 18, 1893, in the Adirondacks, where he had gone to visit for the benefit of his poor health. His obituary noted that he had been widely admired and respected, but that his death was most keenly felt by Mr. Dominick because, "between himself and the deceased, there existed for the past twenty-five years, the closest relations, both in business and in private life."[11] Less than a year later George Dominick's younger brother Alexander, who had also been associated with Dominick & Haff, died.[12]

After Haff's death the firm continued to be known as Dominick & Haff. The firm purchased the flatware dies of Adams & Shaw (q.v.), which had earlier purchased the dies of John R. Wendt & Co. (q.v.). Dominick & Haff was also associated with the firm that the silversmith Samuel McChesney had founded in Newark, New Jersey, in 1921. Following McChesney's death in 1926, Dominick & Haff purchased the firm, and Samuel McChesney's brother William McChesney

became president after the merger. In 1928 Reed & Barton purchased the firm of Dominick & Haff.[13]

BBG

1. Rainwater and Redfield 1998, pp. 95, 118.

2. *New York Times*, December 24, 1928; *Year Book of the Sons of the Revolution in the State of New York* (New York: Society of the Sons of the Revolution in the State of New York, 1909), p. 409.

3. *New York Times*, December 24, 1928.

4. "The Death of Leroy B. Haff," *Jewelers' Circular*, vol. 27 (September 27, 1893), p. 13. Dorothy Rainwater describes the succession of partnerships that created Dominick & Haff: Gale & North; to Gale, North & Dominick; to Gale, Dominick & Haff; to Dominick & Haff in 1872. Rainwater, *Encyclopedia of American Silver Manufacturers*, rev. ed. (New York: Crown, 1975), p. 48

5. Trow's New York City directory 1872, p. 462.

6. Ibid. 1875, p. 298; 1876, p. 330.

7. Index to New York City Marriages, 1866–1937, Ancestry.com.

8. Rainwater and Redfield 1998, p. 95.

9. Trow's New York City directory 1884, p. 414.

10. Adaline Wheelock Sterling, *The Book of Englewood* (Englewood, NJ: Committee on the History of Englewood, 1922), p. 90.

11. "Death of Leroy B. Haff."

12. *New York Times*, June 10, 1894.

13. Rainwater and Redfield 1998, pp. 48–49.

Cat. 189
Dominick & Haff
Comb

1877

MARKS: D&H (in rectangle with rounded ends) [circle] 1877 (in horizontal lozenge) (all incuse; cat. 189-1); 53 (incuse); STERLING (incuse; all on reverse)

INSCRIPTION: Elvira from Luther (engraved script, on reverse)

Height 5¾ inches (14.6 cm), width 3½ inches (8.9 cm)

Weight 1 oz. 11 dwt. 5 gr.

Gift of Mrs. William D. Frishmuth, 1902-345

Cat. 189-1

This hair comb was the kind of novelty product that Dominick & Haff was known for before the great fire that consumed the firm's premises and stock. Stylish additions to the Victorian costume, hair combs were usually made of tortoiseshell with the flaring tops ornamented with applied cast, chased, and pierced silver work. Solid silver combs, such as this example, were usually made for special occasions and were popular during the Victorian era.[1] This comb seems to have been made with one piece of silver and shaped over a form to achieve the arc of the teeth, which are curved to fit the head.

The engraved names, Elvira and Luther, suggest a marriage, as does the style and arrangement of the chased Japonesque motifs on the flaring top. The names are not identified. The donor, Mrs. William Frishmuth (Sarah Sagehorn Frishmuth) (1842–1926), was a passionate collector of antique musical instruments, American decorative arts, tools, textiles, and artifacts.[2] BBG

1. Diana Cramer, "Providence Shell Works," *Silver Magazine*, vol. 34, no. 5 (September–October 1991), p. 43.
2. For another silver comb donated by Mrs. Frishmuth, see PMA 1902-346 (unmarked). Mrs. Frishmuth's portrait, *Antiquated Music (Portrait of Sarah Sagehorn Frishmuth)*, was painted in 1900 by Thomas Eakins (PMA 1929-184-7).

Cat. 190
Dominick & Haff
Vase

1880–90
Copper appliqués
MARK: STERLING / 925 (in rectangle with rounded ends) [circle] [horizontal lozenge] (see cat. 192-1) / 16 (all incuse, on underside)
INSCRIPTIONS: J S G (engraved and shaded script, on underside below mark); SH-15 (scratched with outline of heart, on underside); 8502 6/1 cahc/C Em (scratched, on underside)
Height 5¾ inches (14.6 cm), diam. bottom 2⅞ inches (7.3 cm)
Gross weight 11 oz.
Purchased with the Richardson Fund, 1984-111-1

PROVENANCE: Slavid & Applegate Antiques, Dayville, CT.

The hammered surface of this small vase, which includes appliqué panels of copper with designs of butterflies and leaves, is characteristic of the best silver work by Dominick & Haff.[1] The date numerals in the mark are illegible from wear. BBG

1. Venable 1994, p. 318.

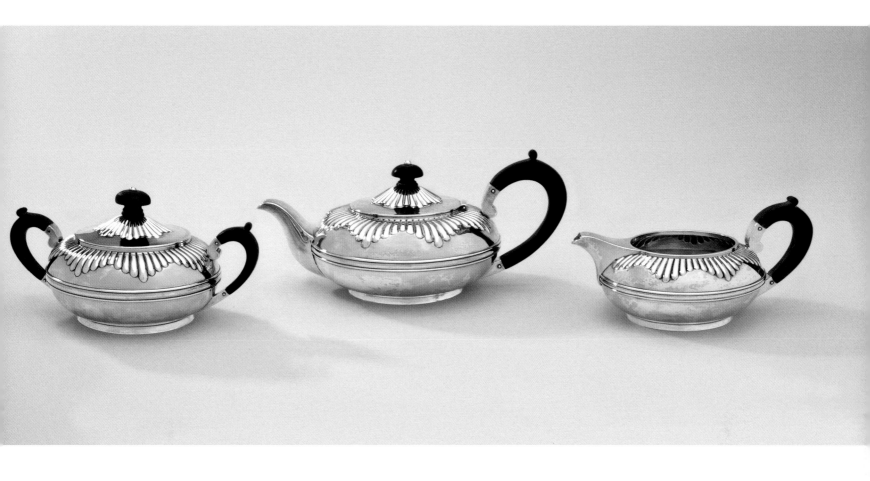

Cat. 191

Dominick & Haff
Pitcher

1881

Retailed by Shreve, Crump & Low, Boston (1869–present)

MARKS: 925 (in rectangle with rounded ends) [circle] 1881 (in horizontal lozenge; all incuse; see cat. 192-1); STER-LING (incuse, on underside at edge); SHREVE CRUMP & LOW (in arced shape, double struck)/ 86 (all incuse, on underside)

INSCRIPTION: L W E O / 1 m 10 / 3051 / 46 (all scratched, on underside)

Height 7⅞ inches (20 cm), width 7¹¹⁄₁₆ inches (19.5 cm), depth 5⁵⁄₁₆ inches (13.5 cm)

Weight 26 oz. 10 dwt. 10 gr.

Purchased with the Richardson Fund, 1984-112-1

PROVENANCE: Slavid & Applegate Antiques, Dayville, CT.

After the fire of 1877 the firm of Dominick & Haff branched out to produce a full line of silver hollow-ware and flatware. The chased and repoussé floral motifs on this pitcher, budding lilies entwined with hibiscus flowers against stylized cloud motifs in the Japanese style, are set against a hammered surface. The handle is hollow. BBG

Cat. 192

Dominick & Haff
Tea Service

1883

Retailed by J. E. Caldwell & Co. (q.v.)

Teapot

MARKS (on each): 925 (in rectangle with rounded ends) [circle] 1883 (in horizontal lozenge; cat. 192-1); J.E. CALDWELL & Cº.); 212 ; STERLING (all incuse, on underside);

INSCRIPTION: 8057 / 74508 (scratched, on underside)

Height 3¾ inches (9.5 cm), depth 5⅜ inches (13.7 cm), width 8½ inches (21.6 cm)

Gross weight 11 oz. 19 dwt. 12 gr.

Sugar bowl

INSCRIPTION: 8058 8/12 axdo; 74508 cv'on (scratched, on underside)

Height 3⅜ inches (8.6 cm), depth 4⅜ inches (11.1 cm), width 6⅜ inches (16.2 cm)

Gross weight 8 oz. 11 dwt.

Cream pot

INSCRIPTION: 8059⁵⁄₁₆; 74508 cu[] u (scratched on underside)

Height 3 inches (7.6 cm), depth 4 inches (10.2 cm), width 5⅞ inches (14.9 cm)

Gross weight 5 oz. 14 dwt. 12 gr.

Bequest of Elizabeth Wheatly Bendiner, 1991-79-5-7

Cat. 192-1

This tea service is small in size but of monumental design and was intended as an individual service.[1] Each unit stands on a short, slightly flaring foot ring. The roundness of the design is strengthened and enhanced by the molded midrib and the flaring, convex fluting in repoussé, which encircles the tops and shoulders of each piece. The pouring spouts and the handle sockets are curved but have a flat profile, an element forecasting the designs of the 1900s. The ebony finials are secured with a screw and inside nut. The ebony handles are held at the bottom in the scrolled sockets.[2] BBG

1. The body is pierced where the spout joins, confirming its design for tea rather than after-dinner coffee. Another tea and coffee service, also retailed by J. E. Caldwell, shows the same convex fluting and was advertised as "in the Georgian Taste"; Larry Freeman, *Victorian Silver* (Watkins Glen, NY: Century House, 1967), p. 110.

2. For other silver in the Museum's collection that descended in this family, see the serving spoon by Walter Archdall (1991-79-8); slop bowl by Thomas Shields (1991-79-3); canns by Philip Syng Jr. (1991-79-2) and Jacobus van der Spiegel (1991-79-1); a thimble and case by the Unger Brothers (1991-79-10a,b); and unmarked mote spoon (PMA 1991-79-9).

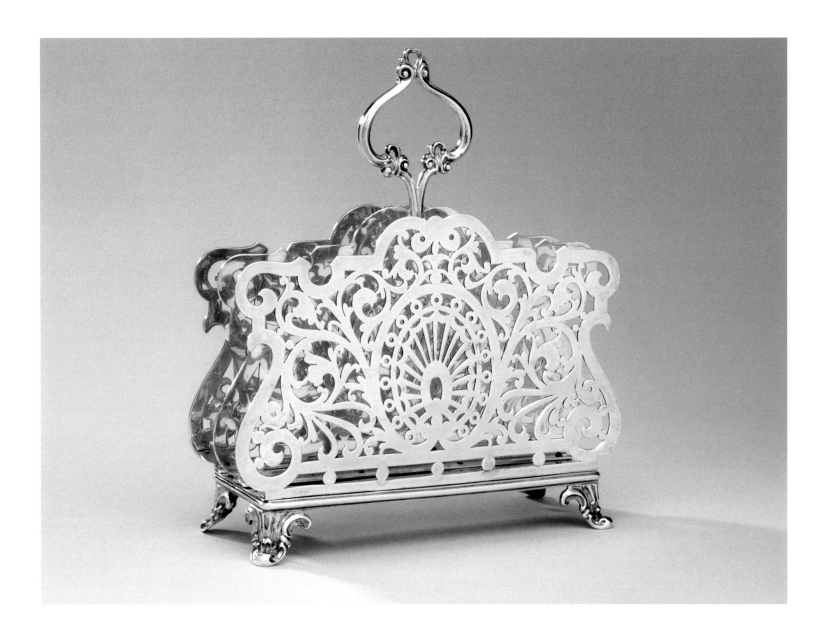

Cat. 193

Dominick & Haff

Letter Rack

1892
MARKS: 10 STERLING B / 925 (in rectangle with rounded ends) [circle] 1892 (in lozenge) (all incuse, at three cardinal points on underside; cat. 193-1)
INSCRIPTION: 3816 (scratched, on underside)
Height 7⁵⁄₁₆ inches (18.6 cm), width 6⁵⁄₈ (16.8 cm), depth 2³⁄₁₆ inches (5.6 cm)
Weight 16 oz. 7 dwt. 2 gr.
Gift of Beverly A. Wilson, 2010-206-61

Cat. 193-1

Letter racks, and the closely related form of toast racks, first appeared in Great Britain during the last quarter of the eighteenth century.[1] Their production was made economical by the use of wire and die-stamped elements, but the die-stamped, openwork design on this later example mimicked patterns from saw-pierced objects of the mid-eighteenth century, a technique that would have rendered this modest piece prohibitively expensive. Such Rococo Revival designs were popular at the end of the nineteenth century; a similar letter rack of cast and gilded iron was made by the Bradley and Hubbard Company of Meriden, Connecticut, at some time between 1885 and 1900.[2] DLB

1. Michael Clayton, *The Collector's Dictionary of the Silver and Gold of Great Britain and North America* (Feltham, England: Hamlyn Publishing Group, 1971), pp. 174, 317.
2. LosFabulous, www.etsy.com/listing/90606005/bradley -hubbard-letter-rack-victorian (accessed June 18, 2014).

Cat. 194

Dominick & Haff

Child's Porringer and Spoon

c. 1919
Retailed by J. E. Caldwell & Co. (q.v.)
Porringer
MARKS: STERLING; 71; J.E.CALDWELL & CO. (in arc) / 925 / STERLING / 1000 / PHILADELPHIA (in arc, all incuse, on underside)
INSCRIPTIONS: K / H / K (engraved, on front of handle); KATHERINE H. KIRK / APRIL 23, 1919 / FROM / M.W.F. HOWE (engraved, on underside); H47714 (scratched, on underside)[1]
Height 1¾ inches (4.5 cm), length 7¹⁄₁₆ inches (17.9 cm), diam. 4⅝ inches (11.8 cm)
Weight 4 oz. 16 dwt.
Spoon
MARKS: M; [rectangle with rounded ends, circle, lozenge]; STERLING; J.E.CALDWELL & CO (all incuse, on back of handle; cat. 194-1)
INSCRIPTIONS: K / H / K (engraved, on front of handle); N (scratched, on back of handle)
Length 6⅛ inches (15.6 cm)
Weight 1 oz.

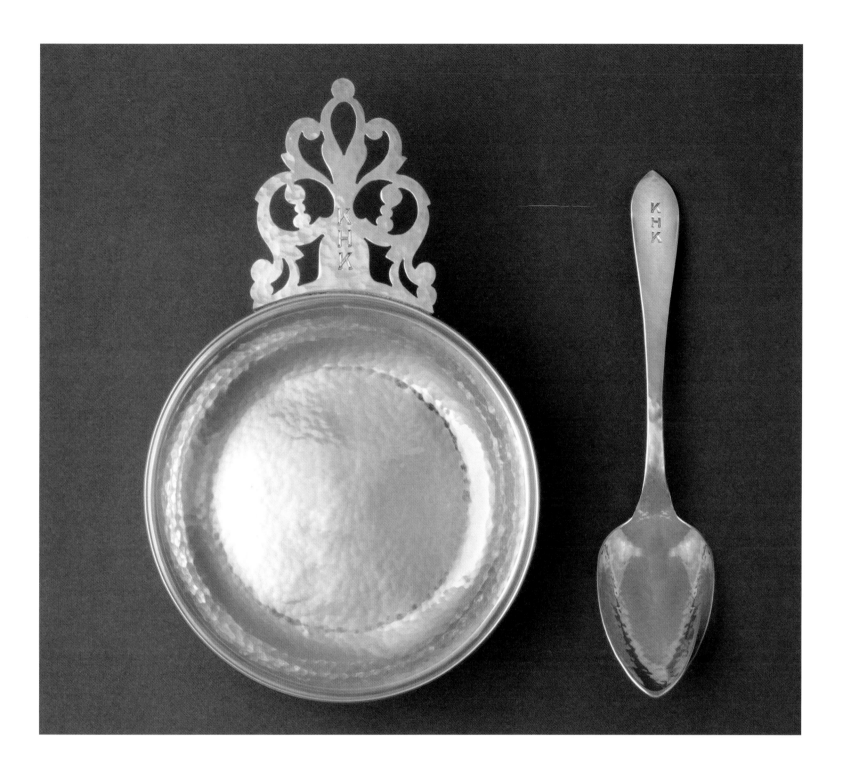

Bequest of Margaret McCready Kirk, 1998-81-10a,b

PROVENANCE: Mary Wilson Fell Howe (1848–1924) of Philadelphia gave this child's set as a christening gift to Katherine Hart Kirk (1919–1920),[2] the daughter of her late husband's business associate Louis Eyre Kirk (1882–1934) and his wife Susanna Cox McCready (1887–1976). Following Katherine's death, shortly after her first birthday, the porringer and spoon were given to her older sister, Margaret McCready Kirk (1915–1997), who eventually bequeathed the set to the Museum.

Cat. 194-1

Children's eating sets with bowls in the form of eighteenth-century porringers became popular during the heyday of the Colonial Revival in the early twentieth century. Appropriately, the spoon in this set was made in a variant of Dominick & Haff's *1776* pattern. As with most silver objects produced by large manufacturers, the hammered surfaces of this child's set were purely decorative finishes applied to pieces on which no hammers had been used for the fabrication. The bowl was spun on a lathe and its handle was sawn from sheet metal. The hammered surfaces of the porringer and spoon are so similar that it seems likely they were made by Dominick & Haff as a set, although the porringer is not marked by its manufacturer. DLB/JCP

1. The engraved date is four days before the recipient's actual birth date and presumably represents an error.
2. Miranda S. Roberts, comp., *Genealogy of the Descendants of John Kirk*, ed. Gilbert Cope (Doylestown, PA: Intelligencer, 1912–13), p. 278; Pennsylvania, Death Certificates, 1906–1963, Ancestry.com. Louis Kirk worked in Philadelphia for the coal mining and shipping enterprise A. Pardee & Company and subsequently served as secretary and treasurer of the Ogden Mine Railroad Company in New Jersey, for which Mary Howe's husband Herbert Marshall Howe (1844–1916) had served as president; *Herringshaw's American Blue Book of Biography* (Chicago: American Publishers' Association, 1915), p. 656; Philadelphia city directory 1918, p. 1000.

Joshua Dorsey

Probably Maryland, born 1770
Philadelphia, active 1795–1804

The Dorsey family was among the founders of Anne Arundel and Howard counties in Maryland in the seventeenth century, and their descendants intermarried, with first names used repeatedly in succeeding generations and for siblings.[1] Leonard and John Dorsey were in Philadelphia by 1779.[2] Greenberry, Leonard, Benedict, and John Dorsey were men of property and are listed in Philadelphia directories into the nineteenth century. In 1783 Leonard (died 1795), a well-to-do storekeeper in Mulberry Ward, owned his dwelling, valued at £1,650, as well as a "riding chair"; paid his occupation tax on £300; and owned 63 ounces of plate.[3] John, leasing his residence from Thomas Coats, also in Mulberry, paid an occupation tax on £300 and owned 14 ounces of plate.[4] By 1785, as sugar refiners and grocers, the Dorseys were located at 22, 57, and 59 North Third and at 3 and 5 South Third streets, in the North, Mulberry, and Chestnut wards.

In the family's exhaustive genealogical records, the silversmith Joshua Dorsey of Philadelphia is not immediately identifiable.[5] If his father was the Nicholas (1741–1796) who married Ruth Todd (1741–1816), as has been published, Joshua must have been born in Maryland.[6] Nicholas does not appear as resident in the Philadelphia directory or in court, census, or tax records. If the published birth date of May 11, 1770, is correct, the silversmith may have been the Joshua Dorsey who served in Private Strong's Company, 1st U.S. Regiment, between 1785 and 1790.[7]

In 1791 the Dorseys listed in the city directory were in commodities, sugar, and groceries. In 1792 an advertisement placed by John Dorsey, grocer, at his usual location, 22 North Third Street, suggests that he had expanded from groceries into a retail business: he noted that he had "just received from London, Sheffield and Birmingham, by the latest Arrivals, a General Assortment of Fine Steel, Cutlery, Plated, Japanned and Hardware."[8] In September 1792 he supplied General Philemon Dickinson with, among other things, four pairs of candlesticks and branches and two waiters and a cake basket for a Mrs. McCall, with a total bill of £52 3s.[9] In 1793 John was listed only as a "silver and plated ware merchant" at 22 North Third Street. In 1794 two John Dorseys were listed at 22 North Third Street, one as a "silver and plated ware" dealer, the other as a "sugar refiner." After 1795–96 John Dorsey's listing became simply "sugar refiner" at his North Third Street address.[10]

Joshua was probably in the Philadelphia household of the above John Dorsey, surely a relative, and working with him, although it is also possible that John was giving Joshua a start in business. The first record of Joshua Dorsey in Philadelphia was on December 17, 1795, as a subscriber to the lottery proposed by Joseph Cooke (q.v.).[11] Information for the Philadelphia directories was collected in the fall for publication the following year. Joshua missed the deadline for 1795, and he is first listed in the supplement of the 1796 directory as "dealer in plated wares" at 44 High (Market) Street. Joshua Dorsey established his shop in property that he rented from Solomon White near the corner of Second Street in the commercial center of the city. It had a high value of $3,000, on which Joshua paid $12.00 tax or rent.[12]

On October 24, 1796, the *Pennsylvania Gazette* carried his notice: "Goldsmith, Jeweler and Hair Worker, and now opening for sale, a large assortment of Household Plated Ware."[13] To list himself as such, Joshua Dorsey must have apprenticed, even if for less than the usual seven years. The Philadelphia directories in 1799 and 1800 list him at two addresses, 44 High Street as dealer and 33 South Second Street as silversmith. In 1800 he used the term "silversmith" at both addresses. From 1793 to 1796, exactly the years that Joshua might have apprenticed, Christian Wiltberger (q.v.) was at 33 South Second Street,[14] barely a block from John Dorsey. When Wiltberger and Samuel Alexander (q.v.) dissolved their short-lived partnership in 1797, Wiltberger remained at their premises at 13 North Second Street, and Alexander moved to Wiltberger's former address, 33 South Second Street.[15] In 1801–2 Samuel Alexander and Anthony Simmons (q.v.) moved into Joshua Dorsey's old place at 44 High Street.[16] There was some interplay among these independent silversmiths, although Joshua Dorsey's occupancies do not seem to overlap with those of the others. Wiltberger and Dorsey supplied different pieces for a tea service, with two of the pieces marked by Dorsey.[17]

Details of Joshua Dorsey's family life are not at all clear. He was moving farther from the center of the city, which suggests that his business was failing.[18] In 1800 he was listed at 44 High and 53 South Second streets in the city directory, placing him in the Chestnut Ward, whereas the U.S. census located him in the Lower Delaware Ward.[19] At that time he had a household of eight: one boy and two girls under ten, one male between the ages of sixteen and twenty-five, two males between the ages of twenty-six and forty-four (himself and another), one female between the ages of twenty-six and forty-four (perhaps his wife), and one other free person. By 1802 Dorsey had moved to 113 North Second Street in the Lower Delaware Ward.[20] As no records of his marriage or death have surfaced, it has not been possible to identify him with any of the women named Dorsey and listed as widows after 1804.[21] An incomplete entry for "Garrow and Dorsey, jewelers and dry goods store" (lacking initials and address) in the 1800 city directory suggests that he may have turned back to his old trade as a dealer.[22] The city directory of 1804 noted that Joshua Dorsey had moved farther north to 14 Green Street, where he was listed as "goldsmith &c,"[23] his last entry in that capacity.

Advertisements in Baltimore papers for a Joshua Dorsey, auctioneer, began in 1801, very close to the time of the silversmith's move to the Lower Delaware Ward in Philadelphia.[24] On September 13, 1813, "An Act For the Relief of Joshua Dorsey" was passed by both houses of the U.S. Congress and signed by Henry Clay, Elbridge Gerry, and James Madison.[25] In Philadelphia a J. Dorsey appeared in the *Democratic Press* on August 28, 1810, as an active real estate auctioneer. Another advertisement in the same edition of that paper, placed by "J Dorsey," offered for a sale at the Merchant's Coffee House "GROCERIES / pipes brandy / spermaceti candles / After which a quantity of Gold and Silver watches, Plate, an elegant Coach, Madrass hdkfs, Furniture, etc . . . within doors." In 1811 a John Dorsey had become an active auctioneer in Philadelphia at 61 and 63 South Front Street.[26] BBG

1. For example: Ann Dorsey, daughter of Joshua and Ann Ridgely Dorsey, married John, son of Caleb Dorsey. Her brother Nicholas Dorsey could have been the father of the silversmith Joshua Dorsey of Philadelphia; J. D. Warfield, *The Founders of Anne Arundel and Howard Counties, Maryland: A Genealogical and Biographical Review from Wills, Deeds, and Church Records* (1905; repr., Baltimore: Regional Publishing, 1967), pp. 151, 345–47, 352–53, 379. See also note 6 below.

2. Tax and Exoneration Lists, 1762–94.

3. Ibid.

4. "John Dorsey no. 22 N 3rd St," *Philadelphia Gazette and Universal Daily Advertiser*, September 10, 1795. In 1796 John was a manager of the Humane Society; Philadelphia directory 1796, p. 27.

5. The 1790 U.S. Census notes a Joshua Dorsey as head of family (age sixteen and over) and one white female (over sixteen) in Montgomery County, Maryland. Joshua Dorsey, lawyer, of Frederick, Maryland, was the son of Captain Philemon Dorsey and married Janet Kennedy (died 1801), daughter of George Kennedy of Philadelphia, who owned considerable property including a brick store and wharves in the Dock Ward in 1798; 1798 U.S. Direct Tax; "Joshua Dorsey to John Fries," Philadelphia Deed Book EF-6-448 [1801]; Richard Henry Spencer, ed., *Genealogical and Memorial Encyclopedia of the State of Maryland: A Record of the Achievements of Her People in the Making of a Commonwealth*

and the Founding of a Nation (New York: American Historical Society: New York, 1919), vol. 2, pp. 613–14.

6. Silversmiths and Related Craftsmen, s.v. "Joshua Dorsey," http://freepages.genealogy.rootsweb.ancestry.com (accessed June 9, 2015); Maryland Births and Christenings, 1600–1995, index (Salt Lake: FamilySearch, 2009, 2010), Ancestry.com.

7. Virgil D. White, *Index to Volunteer Soldiers, 1784–1811* (Waynesboro, TN: National Historical Publication Company, 1987), p. 183. In that case he may not have apprenticed as a young person in the usual manner but begun as a retailer and added silversmith's skills as opportunity arose.

8. *Dunlap's American Daily Advertiser* (Philadelphia), January 21, 1792.

9. John Dorsey to General Philemon Dickinson, receipt, Cadwalader Family Papers, 1623–1962, Series 2, box 20, folder 4, HSP.

10. Philadelphia directory 1793, p. 37; 1794, p. 41; 1795, p. 38; 1796, p. 50. A William Council, hatter, occupied 44 High Street in 1795; 1795, p. 9.

11. *Aurora General Advertiser* (Philadelphia), December 17, 1795.

12. 1798 U.S. Direct Tax.

13. Philadelphia directory 1799, pp. 44–45; 1800, p. 42.

14. Ibid. 1796, p. 201.

15. Ibid. 1797, pp. 15, 197. Wiltberger had moved to 13 North Second Street by 1799; ibid. 1799, p. 152.

16. Ibid. 1802, p. 221.

17. Teapot marked "I•DORSEY" and sugar urn marked "I•D"; Buhler 1973, p. 71, cats. 154–55.

18. The uncertainty of currency due to the closing of the Bank of the United States, as well as trade embargoes, caused general financial hardship before the War of 1812.

19. Philadelphia directory 1800, p. 42.

20. Ibid., p. 74; 1803, p. 74.

21. "Dorsey Mrs. 10 Stall's Court," ibid. 1805, n.p.; "Dorsey Elizabeth widow 65 New," ibid. 1808, n.p.; "Dorsey E. gentlewoman 65 New St," and "Dorsey Elizabeth widow 3 Stall's court," ibid. 1809, n.p.; "Dorsey E. gentlewoman 65 New St," ibid. 1810, p. 84; "Dorsey E. gentlewoman 65 New St" and "Dorsey Mary tailoress back 67 Queen," ibid. 1811, p. 90; "Dorsey E. gentlewoman 65 New St," ibid. 1813, n.p.; "Dorsey E. gentlewoman 65 New St" and "Dorsey Mary tayloress 111 Swanson," ibid. 1814, n.p. There are no listings for 1816 or 1817. "Dorsey—widow 7 Bird's Alley (S.)," ibid. 1818, n.p.; "Dorsey Elizabeth widow 210 north Fourth," ibid. 1819, n.p.; "Dorsey Mary widow 7 n Ninth," ibid. 1820, n.p.; "Dorsey Mary widow 7 n Ninth," ibid. 1821, n.p.; "Dorsey Mary widow 7 n Ninth," ibid. 1822, n.p.; "Dorsey Mary widow 5 n Ninth," ibid. 1823, n.p.; "Dorsey Mary widow 5 n Ninth," ibid. 1824, n.p.

22. No address is given with this listing, there is no initial for "Dorsey," and "Garrow" does not appear again; ibid. 1800, p. 52.

23. Ibid. 1804, p. 70. Green Street ran between North Front Street and the Old York Road. In 1836 a Henry Dorsey entered into an agreement related to renting a house on Green Street, the property of William Bell; William Bell Papers, 1797–1842, Society Small Collection, box 2, folder 12, HSP. In the Philadelphia directory for 1804, a Samuel Dorsey, silversmith, was listed as being at 171 Mulberry Street (p. 40), but he does not appear again in the city directories. A Simon Dorsey, goldsmith, at Christian Street above Seventh, was listed once in the city directory of 1820 (n.p.).

24. These advertisements began in the *Federal Gazette and Philadelphia Daily Advertiser* on January 19, 1801, and ran almost weekly throughout that year. This fellow was almost immediately in debt and was jailed along with many others in 1813; *Baltimore Patriot and Evening Advertiser*, December 13, 1813. In August 1813, "Mr. McKim reported a bill to discharge Joshua Dorsey from confinement—It was read three times successively and passed the house"; "Congressional Register," *Democratic Press* (Philadelphia), August 3, 1813. The Baltimore directory of 1810 (p. 63) shows no listings for Joshua Dorsey. Thus Philadelphia's Joshua did not pursue the silversmith trade there but may have been the auctioneer described above.

25. Published in several newspapers around the country, including the *New Hampshire Patriot and State Gazette* (Concord), September 21, 1813.

26. Philadelphia directory 1811, p. 90.

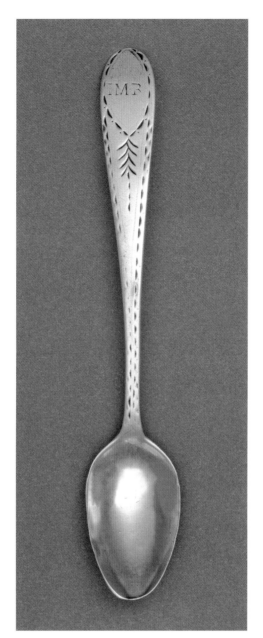

Cat. 195

Joshua Dorsey
Teaspoon

1795–1804
MARK: I•DORSEY (in rectangle, on reverse
of handle; cat. 195-1)
INSCRIPTION: I•M•B (engraved in oval, at top
of obverse of handle)
Length 5¾ inches (14.6 cm)
Weight 10 dwt. 22 gr.
Gift of the McNeil Americana Collection, 2005-68-21

This spoon has especially thin edges and a plain
drop. The bright-cut engraving is imprecise. BBG

Cat. 195-1

George Christopher Dowig

| Born c. 1724[1]
| Baltimore, died 1807

George Christopher Dowig's name, with all its possible variations of spelling (Dalwig, Derwag, Derwent, Dornig, Dorage), does not appear on the lists of those who took the Oath of Allegiance administered to foreign-born males over the age of sixteen entering the port of Philadelphia between 1750 and 1775.[2] The first sure date for his being in the city is a marriage notice: "George Chirs[8] Dewig [sic] married Marg[t] Halliday" at St. Paul's Church, Philadelphia, on April 20, 1764.[3] Nothing further has turned up about Margaret, as Halliday or Dowig, neither where she was born or died nor whether there were children. Jacob Hall Pleasants and Howard Sill have stated that Dowig had no children.[4] However, in his will George Dowig wrote, in addition to the bequests to his stepson John Hasselback: "I give and bequeath to my granddaughter Polly Rutter [sic] and Betsy Rush, the house and lott [sic] where I now live in old town Bridge Street."[5] Pleasants and Sill state that he left this property to Hasselback, but the will states that he left to him "the house I formally lived in." However, the Baltimore directories of 1802 and 1807 (the year George Dowig died) listed a Charles Dowig, gentleman, at 50 Pitt Street and a John Dowig, gentleman, also on Pitt Street in 1808.[6]

In 1765 Dowig occupied property that belonged to Daniel Benezet (1724–1797), a prosperous merchant and member of the Merchant's Committee in 1770, who had immigrated to Philadelphia in 1731 and became a Quaker.[7] Benezet was known for doing good works, one of which was housing newly arrived, indentured, German men at his house on the north side of Mulberry (Arch) Street.[8] In 1752 Benezet's store had been on Front Street at the corner of Morris's Alley, where he sold general merchandise and "very cheap silver watches."[9] In 1754 Benezet "moved his store from Front Street to Arch Street between Front and Second Street near the Sign of the George," while retaining ownership of his property on

Front Street.[10] The Arch Street property, which included more than one building, was at the heart of the commercial activity in the early city. In 1773, when Benezet insured it with the Philadelphia Contributionship, the house was valued at £350, the staircase at £50, the kitchen at £100, and the store at £300. The second property was on the east side of Second Street near Mulberry (Arch) and included two houses adjacent to each other. That was the property where George Dowig was first located in 1765.[11]

Evidence that Dowig was ready for business appeared in the unusually long advertisement, describing his skills and stock, that he placed in the *Pennsylvania Gazette* on August 1 and 8, 1765:

> George Christopher Dowig, jeweler and goldsmith at the house of Daniel Benezet between Arch and Race Streets [on Second Street] sells all sorts of jewelry . . . viz. Wedding, Mourning and other Gold Rings, particularly a sort of Rings out of which Water springs, most curious Wedding-rings of an entire new Invention. . . . He likewise mends all sorts of Jewelers, and Gold and Silversmiths Work, as well of stones, gold and silver, so as to make it appear like new . . . likewise china and glass. . . . NB. As he is willing to take an Apprentice on reasonable terms, Parents or Guardians who have a mind to put out a lad to this Business may apply to him at his above said dwelling house.

An advertisement in the *Pennsylvania Gazette* on September 20, 1764, regarding a "large, plain cream pot" marked "GD" that was stolen from Robert Knox of Southwark, indicates that Dowig must have been active in his craft by 1765 in order to afford to occupy such a central location. Depending on his age and the date of his arrival, Dowig surely entered the silversmith's trade as an indentured person, possibly with basic skills in his craft.[12] A case may be made for his having served as a journeyman in the shop of Philip Syng Jr. (q.v.) by comparing a handsome, fully rococo-style coffeepot made and marked by Dowig about 1765[13] to one made by Syng for David and Mary Potts about 1767.[14] The comparison offers similarities of design and detail beyond generic style: both pots have the same grand, curvaceous shape, a double domed lid, and exuberant details on the cast spout, and are of similar weights (40 and 44 ounces, respectively). Especially noteworthy is the precise, alternating pattern of the gadroon on the feet on a sugar bowl by Dowig; see cat. 196. Dowig's finial seems to have been cast from the same mold as the one on Syng's coffeepot for Joseph Galloway (PMA 1966-20-1). The engraved initials on Dowig's pot were previously published as "AAR" on one side with, on the opposite side, "JMR" with crest. The crest can be identified with

the Robinson family.[15] The initials "AAR" may have belonged to Alexander and Ann Jameson Robinson, who married in Philadelphia at the First Presbyterian Church on April 23, 1765.[16] The crest and initials "JMR," which appear to be later additions, may have belonged to James and Mary Davis Robinson, who married in Philadelphia at the Second Presbyterian Church on January 22, 1772.[17]

Judging by the rarity of his surviving silver, Dowig was not a prolific silversmith. He never seemed settled, but what he made was well constructed with appropriate scale and detail, evidence of a strong apprenticeship.[18] He worked with equal facility in the rococo style of his Philadelphia period (before 1765–80), as demonstrated by the coffeepot discussed above and the sugar bowl with a reverse pear shape (cat. 196). Although the neoclassical style was beginning to appear in Philadelphia in 1780, the urn-shaped sugar bowl and cream pot (cat. 197) for Mary Schlessman was probably made by Dowig in Baltimore since the date of her marriage, 1791, coincides with the dates by which there is evidence of his residence there.

On October 25, 1765, some of the merchants of Philadelphia organized and passed a non-importation agreement in response to the stamp tax issued by the English Parliament. The merchants, including Daniel Benezet, having resolved not to import goods from Great Britain, signed the agreement in November.[19] George Dowig, was not, however, listed among the signatories.[20] Commerce was interrupted and factions were developing that would lead to the Revolutionary War.

On July 5, 1770, Dowig placed a long advertisement in the *Pennsylvania Gazette*: "On Friday, the 13th of July will be sold at the City Vendue Store in Front Street all the jewelry and silverware belonging to George Dowig, jeweler and goldsmith: garnet earrings set in gold, chrystal ditto . . . likewise a silversmith's flatting-mill, all his jewelry and silversmith tools, a negroe man, by trade a silversmith, a variety of unset stones . . . also all his household and kitchen furniture. . . . All persons indebted to said Dowig are requested to make immediate payment as he intends to leave the Province soon." Then, on July 12, he announced that the sale was to be postponed until further notice, perhaps because, as was reported in the same issue, the non-importation agreement was reaffirmed in Maryland.[21] Dowig's moves back and forth between Philadelphia and Baltimore suggest that he vacillated between support for the ban on importing and support for the patriot cause.

At some time between the announced sales in July 1770 and May 4, 1772, when he advertised in the *Pennsylvania Packet, or Daily Advertiser*—"Horse taken by mistake"—Dowig had moved from

Benezet's property on Second Street to Benezet's old location in 1752, on Front Street.[22] In 1772 Dowig also took on an apprentice, Henry Demler, "to be taught the art and mystery of a jeweler and goldsmith, all necessaries except clothing, for five years."[23] On March 13, 1772, Dowig was assessed as "Jeweler/dwelling house" with the tax set at £20 19s.[24]

Although he did not move to Baltimore immediately, Dowig did sign the "Articles for the Government of the Evangelical Lutheran Congregation in Baltimore" on August 5, 1773. His name, however, was not on the first list of founders in 1769.[25]

The *Pennsylvania Journal and Weekly Advertiser* of May 11, 1774, contained the advertisement of John Norman, engraver, that he was renting an apartment at Mr. Dowig's, goldsmith, in Front Street near the Coffee House. This was in the High Street Ward, where in 1774 Dowig was noted as "jeweler" and assessed for £40 for his dwelling, taxed at £24, and for one negro, taxed at £4.[26]

With the exception of entries in the daybook of Thomas Shields (q.v.), who had family and business connections in Baltimore as well as Philadelphia, there is little in the written record about Dowig's daily production. He was trading with Shields for some time before 1775, as noted in one of the latter's entries: "1775, August, George Dowig Cr. By 1 set hair pins had some time ago, £0 15s."[27] The next entry in September notes that Shields's accounts were "Dr. to cash in full [£]10 11s."[28]

On April 24, 1775, the news from Boston that the British under General Gage had fired on the Massachusetts Militia galvanized the Committee of Safety in Philadelphia, and enlistment began promptly. Thus, in the fall of 1775, having settled his account with Shields, Dowig enlisted as a private in Captain Richard Peters's Company of the Philadelphia Militia, one of the first raised in the city. William Haverstick was the second sergeant.[29] The length of service agreed upon by the mostly volunteer army varied from two months to a year or more. By February 1776 Dowig must have finished his agreed-upon-term of service, as he was again trading with Thomas Shields: "George Dowheg [*sic*] Dr to 4 salt spoons, neat £1 1s. 3d. . . . to cash on account, gold buttons £1 6s." In March Dowig made a pair of "sett" shoebuckles at £1, and in same month, he was debtor for one silver-mounted sword and money totaling £8 16s. 6d. In April Dowig was credited "by discount made by way of work £8 19s. 3d."[30]

In 1777 Dowig was called up again, to the Fourth Battalion of the Philadelphia Militia, Captain Adam Foulk's Company, but he was "excused at Appeal" and went back to work at his shop.[31] He witnessed the marriage by proclamation of

Niclaus Paulus and Margareta Mullerin on August 28, 1777, at St. Michael's and Zion Church in Philadelphia.[32] Contemplating another move to Baltimore, he placed the following advertisement in the *Pennsylvania Gazette and Daily Advertiser* on October 17, 1778: "To be sold by public Vendue . . . at the house of George Dowig, Goldsmith, in Front Street near the corner of Market street . . . two elegant looking glasses, two stoves, brass andirons with shovel and tongs, brass candlesticks, pewter plates, a parcel of dry goods, some patterns of broadcloth, woolen and cotton caps, Hungary lace, an elegant chintz bed coverlid, some plate and jewellery, and several other articles to tedious to mention." If those were his possessions, he was doing well.

Dowig's advertisements placed in the *Pennsylvania Evening Post* of October 23 and November 11, 1778, and in the *Pennsylvania Packet* of October 27, 1778, reveal that Haverstick was now working with, and probably resident with Dowig: "Sixteen Dollars reward. Stole last Friday night the 23d inst. out of a silversmith's case, at the subscriber's house in Front-street near Market-street, half a dozen of new SILVER TABLE SPOONS stamped W H, and the handles turned back." Both men were of German heritage, but whether Haverstick was previously an apprentice or a journeyman with Dowig, or whether they met when serving in the same Pennsylvania militia, is not yet known. In 1779 Dowig's record for Tax and Exoneration in the High Street Ward recorded his value at £72, taxed at £18, and listed with him "William Haverstick phd [per head]," with tax of £1 10s., suggesting that Haverstick was an employee; a "Jacob Frank," silversmith, was also listed with Dowig, valued at £7 and taxed at £1 15s.[33] Dowig's assessment in 1779 was £6,500, taxed at £97 10s., with Haverstick valued at £1,000 and taxed at £15, and Jacob Frank valued at £500 and taxed at £7 10s.[34]

In January 1780 Dowig, along with most of the German community in Philadelphia, signed "A Bill to Incorporate the German Society at Philadelphia contributing for the relief of Distressed Germans in the State of Pennsylvania."[35] No advertisements or other personal facts about Dowig or his business in Philadelphia have surfaced for 1780 except for a tax assessment in November revealing that William Haverstick, goldsmith in the High Street Ward, was paying a tax of £96 for George Dowig's estate, valued at £32,000, and Jacob Frank was listed as an independent goldsmith, assessed at £6,200 and taxed at £18 12s. Haverstick took over the Dowig shop, and Dowig moved to Baltimore.[36] In 1781 Dowig was still paying his Effective Supply Tax (23s. per £100) of £9 4s. on £800 on the Front Street property, as well as his head tax of 11s. on

£50.[37] In 1781 Haverstick was no longer listed in the Philadelphia tax record at the Front Street location, but by 1783 he was back at the Second Street site between Arch and Race.[38] Frank was in the Front Street property and paying £9 4s. tax on Dowig's estate (property), while Dowig himself paid a head tax of 11s. 6d. on £50.[39]

In 1782 or 1783 George Dowig married the wealthy, twice-widowed Catherine (?) Hasselbach Aikenhead in Baltimore.[40] He set up shop again, in Baltimore's main commercial area on Market Street and, in 1784, advertised for the owner of a gold repeating watch to apply to him at his location on Market.[41] Probably not needing further financial means, he announced his retirement in 1789, "having fully determined upon quitting the Business of a Silversmith" and that "he would dispose of his remaining stock in Trade by Lottery, which will positively be the last."[42] The U.S. census of 1790 shows four people in his household, he and his wife, one male under sixteen, and one slave. In 1790 Dowig was still importing jewelry and selling silversmith tools and was probably also filling small commissions.[43] On May 13, 1793, the silversmith William Ball (q.v.) of Baltimore announced in the *Baltimore Daily Repository* that he had moved into George Dowig's shop on Market Street at the Sign of the Golden Ball. In 1799 that location was noted as 62 Baltimore Street.[44]

Dowig had finally retired.[45] In 1799 he was living on the north side of Pitt Street, Old Town, described in the city directory as "that part of Waping farthest from the City and from George Street to the lower end of the Point." The directories of 1801 and 1804 list George Dowig, gentleman, at 54 Pitt Street, on the south side from Jones Falls. Listed next to him, with no address and thus probably in residence, was Joseph Jackson, silversmith.[46]

Catherine Dowig owned considerable property in Baltimore, inherited from her two previous husbands. At some point Dowig and his wife leased or purchased a property on the west side of Smith's Alley from a Francis Coates.[47] Another land transaction took place in 1791 between George and Catherine Dowig and an Edward Murray.[48] Dowig wrote his will in April 1804, beginning it with the words "for some time in declining state of health." In 1806 he contributed to the building fund of the Zion Evangelical Lutheran Church. He left a house on Market Street, on the north side of Baltimore, to his wife. The house on Bridge Street, where he was living when he wrote his will, he left to a Hasselbach stepson.[49] On March 17, 1807, Catherine Dowig died at the age of eighty-one. George Dowig died on April 12, 1807.[50] BBG

1. Goldsborough 1975, p. 44.

2. See *Pennsylvania Archives*, 2nd ser. (1890), vol. 17.

3. Ibid., 2nd ser. (1896), vol. 2, p. 468.

4. Pleasants and Sill 1930, p. 118.

5. Will of George Dowig, Ancestry.com (accessed November 2, 2017); written April 14, 1804, probated April 25, 1807 (Pleasants and Sill 1930, p. 118).

6. These two, Charles and John, do not appear in the city directories before or after these dates. For confirmation of facts I thank Francis O'Neill at the Maryland Historical Society, Baltimore. A John Dowig applied for 400 acres in Washington County, Pennsylvania, on September 13, 1784. His application was "Ret'd 5 [illegible] Janr'y 1796"; Land Warrants, Pennsylvania State Archives, Harrisburg, Ancestry.com.

7. Edward I. Clark, *A Record of the Inscriptions on the Tablets and Grave-Stones in the Burial-Grounds of Christ Church, Philadelphia* (Philadelphia: Collins, 1864), p. 517.

8. In 1754 Drs. Thomas Bond and Thomas Graeme told Benezet to move any of the sick out of town. The long list of males who arrived in Philadelphia from Hamburg and Rotterdam in the early eighteenth century covers many years; at the bottom of each list were the names of those who were sick. Thomas Graeme and Thomas Bond, "Colonial Health Report," *PMHB*, vol. 36, no. 4 (1912), pp. 476–77.

9. *Pennsylvania Gazette* (Philadelphia), January 28, 1752.

10. Ibid., June 13, 1754.

11. Benezet insured his properties on May 31, 1773; insurance surveys S01681–S011684, Philadelphia Contributionship for the Insurance of Houses from Loss by Fire, www.philadelphia buildings.org/contributionship (accessed May 6, 2015).

12. The Dowig name does not appear in Philadelphia or Delaware records earlier than 1764.

13. See Northeast Auctions, Portsmouth, NJ, *Monahan Collection*, August 4 and 5, 2001, no. 743.

14. See the coffeepot for the Potts by Philip Syng Jr. (PMA 2005-68-88).

15. John Matthews, *Matthews' American Armoury and Blue Book* (London: Privately printed, 1907), addendum, p. 66.

16. *Pennsylvania Archives*, 2nd ser. (1896), vol. 2, p. 211.

17. Ibid., p. 212. There were other James Robinsons in marriage lists.

18. A pair of candlesticks that Dowig marked, and identical to a pair by John Lynch in Baltimore, are grand; Christie's, New York, *Highly Important Americana*, January 16, 1998, sale 8840, lot 72. The Lynch pair is at Winterthur Museum; Quimby and Johnson 1995, p. 394.

19. Scharf and Westcott 1884, vol. 1, pp. 272–73.

20. Ibid. John Bayly, John Leacock, Joseph Richardson Sr., and Philip Syng Jr. (q.q.v.), signed.

21. "A Letter from the Merchant's Committee of New York," ibid., July 12, 1770.

22. "Whoever has made the above mistake is requested to apply to George Dowig, goldsmith in Front Street, in order that each owner may get his horse again."

23. "Records of Individuals Bound Out as Apprentices and Servants in Philadelphia, 1771–1773," *Pennsylvania German Society* (Reading, PA), vol. 16 (1905), p. 82.

24. Fifteenth Eighteen Penny Provincial Tax, March 13, 1772, for the City and County of Philadelphia.

25. Julius Hofmann, *A History of Zion Church of the City of Baltimore, 1755–1897* (Baltimore: C. W. Schneidereith, 1905), pp. 23, 31, 43.

26. Tax and Exoneration Lists, 1762–94.

27. Shields's family connections and investments in land in Maryland may have influenced Dowig's eventual move to Baltimore; Pleasants and Sill 1930, p. 181.

28. Thomas Shields, Daybook, 1775–1791, pp. 2, 33, Downs Collection, Winterthur Library.

29. "Muster Roll of Captain Richard Peter's Company of Philadelphia Militia," *PMHB*, vol. 23, no. 3 (1899), pp. 394–95.

30. Thomas Shields, Daybook, 1775–1791, pp. 40, 42, 47.

31. There seemed to be no penalty for an excuse. A payment of £6 was required for a person to serve as a substitute; *Pennsylvania*

Archives, 6th ser. (1906), vol. 1, p. 292.

32. Marriages, St. Michael's and Zion Church, p. 6, HSP.

33. Maurice Brix, *List of Philadelphia Silversmiths and Allied Artificers from 1680 to 1850* (Philadelphia: privately printed, 1920, p. 39) lists Jacob Frank as a goldsmith included in the Philadelphia directory from 1785 to 1794.

34. Tax and Exoneration Lists, 1762–94. These amounts probably reflect the inflation and shortage of currency during the Revolutionary period.

35. *Pennsylvania Packet, or The General Advertiser* (Philadelphia), January 15, 1780.

36. *Pennsylvania Archives*, 3rd ser. (1897), vol. 15, p. 313.

37. Ibid., p. 590. I have found no record that Dowig purchased the properties from Benezet.

38. *Pennsylvania Packet and General Advertiser* (Philadelphia), October 30, 1783. This was shortly after Daniel Benezet moved to Chestnut Street.

39. *Pennsylvania Archives*, 3rd ser. (1897), vol. 15, p. 590.

40. She was born Catherine Steiz (1726–1807) in Germantown and must have moved to Baltimore with her husband Nicholas Hasselback, who enrolled as a private with Maryland troops on July 20, 1776; *Muster Rolls and Other Records of Maryland Troops in the American Revolution, 1775–1783* (Maryland Historical Society, 1900), vol. 18, p. 50. Nicholas Hasselback emigrated to Philadelphia in 1749, worked as a printer in the Koch paper mill in the Northern Liberties, and moved to Baltimore in 1773. Nicholas and Catherine had a daughter Catherine H. (1755–1820), who married John Hillen and had four children. Nicholas died at sea in 1769. Catherine married secondly George Aikenhead, a Scottish merchant who died about 1781. Lawrence C. Wroth, *A History of Printing in Colonial Maryland, 1686–1776* (Baltimore: Typothetae, 1922), p. 112.

41. *Pennsylvania Gazette*, October 6, 1784.

42. *Maryland Gazette, or The Baltimore Advertiser*, July 7, 1789.

43. For example, the sugar bowl and cream pot for Mary (Maria) Schlessman (see cat. 197).

44. Baltimore directory 1799, p. 5.

45. Pleasants and Sill 1930, p. 89 (as George Dorage).

46. Baltimore directory 1804, pp. 72, 114. See the biography for William Ball (q.v.).

47. Pattie Causey, "Grantee's Index 1801," Baltimore City, bk. 65, fol. 407, www.mdgenweb.org/baltimorecity/grantors%20index /Grantee1801.htm (accessed January 4, 2013).

48. Chancery Papers, record 25, p. 311, Baltimore City Lots 1, 71–73, Baltimore County Land Survey, Subdivision, and Condominium Plats, MSA S1553, http://plato.mdarchives.state.md.us (accessed May 16, 2014).

49. He bequeathed the property he had acquired through his marriage back to his wife and then to his son John Hasselbach. In an "N.B." at the end of the will, he specified that furniture and silver plate be divided between the wives of John Hillen and John Hasselbach after the demise of his wife Catherine. He also bequeathed £400 "to be put out on good security with lawful interest and from that interest should be bought firewood for ten poor distressed families to have equal share every year forever." Will of George Dowig, Ancestry.com.

50. *Baltimore Advertiser*, March 18, 1807. "1807, April 12 Died in Baltimore, PUBLIC NOTICE is HEREBY Given—John Hillen Administrator to personal estate of George Dowig deceased . . . all claims by November 6 next or forfeit claim"; ibid., June 12, 1807.

Cat. 196

George Christopher Dowig
Sugar Bowl

1765–73

MARK: GD (in rectangle with rounded ends, three times on underside; cat. 196-1)

INSCRIPTION: S / M·C (engraved, on flaring rim of lid)

Height 7 inches (17.8 cm), diam. 4¹¹⁄₁₆ inches (11.9 cm)

Weight 11 oz. 4 dwt. 14 gr.

The Henry M. Phillips Collection, F1902-2-44a,b

EXHIBITED: Philadelphia 1956, cat. 75; Goldsborough 1983, p. 107, cat. 79.

PUBLISHED: Harold D. Eberlein and Abbot McClure, *The Practical Book of Early American Arts and Crafts* (Philadelphia: Lippincott, 1916), p. 154.

The curvaceous shape of the body and the lid with a bold gadroon on the base and rim are typical of the Philadelphia style at midcentury, especially in the work of Philip Syng Jr. (q.v.). This sugar bowl was surely made before Dowig moved to Baltimore. The top leaves on the pineapple knop are missing. Dowig made a pair of salt dishes in a similar style for an "MS."[1] BBG

1. A pair of salts by Dowig from his Philadelphia period and also engraved "MS" descended in the Rhoads and Fisher families; Buhler 1972, p. 606, cat. 517.

Cat. 196-1

Cat. 197

George Christopher Dowig
Sugar Bowl and Cream Pot

1785–87

Sugar bowl

MARK: GD (in rectangle with rounded ends, twice on underside; cat. 196-1)

INSCRIPTION: M S (engraved script, on front)

Height 10⅜ inches (26.4 cm), width 4¾ inches (12.1 cm)

Weight 16 oz. 6 dwt. 19 gr.

Cream pot

MARK: GD (in rectangle with rounded ends, twice, on two corners of base; cat. 196-1)

INSCRIPTION: MS (engraved script, under pouring lip)

Height 7⅛ inches (18.1 cm), width (lip to handle) 4⅞ inches (12.4 cm)

Weight 7 oz. 12 dwt. 10 gr.

Gift of Mr. and Mrs. Theophilus B. Stork in memory of Emma Baker Stork, 1942-47-1a,b, −2

PROVENANCE: This sugar bowl and cream pot originally belonged to Mary (Maria) Schlessman (1767–1850), daughter of Henry (1733–1795) and Anna Katharina Schlessman (1742–1799).[1] At the time they were given to the Museum, the donors recounted that these pieces were given to Mary Schlessman when she married John [Johann] Remagius Becker (Baker) (1763–1829) in Philadelphia on December 10, 1791.[2] The silver descended in his family.

EXHIBITED: Philadelphia 1956, cats. 74, 76; Goldsborough 1983, p. 107, cat. 80.

The engraving on these two objects is especially interesting and unusual.[3] Although the pattern of leafy swags, ribbons, and bows was ubiquitous in the late eighteenth century in Philadelphia and Baltimore, the hand that accomplished this example was skilled and sure. The design is lively and the cuts deep. The result is a colorful rendition of fluttering ribbons supporting an oval, which is created with fine bright-cut engraving. The initials "MS" are shaded and interlocked with looping tails. Engraving on other silver by Dowig on other pieces is more linear.[4]

The sugar bowl and cream pot may have been purchased from Dowig's stock or at his auction in 1788, or are evidence of his continuing silver work into the early 1790s.[5] Other silver owned by Mary Schlessman included six teaspoons by Richard Humphreys (q.v.), and a pair of tongs by John Myers (q.v.) that also descended in the Baker family to the donors.[6] BBG

1. Will of Henry Schlessman, March 19, 1802, Philadelphia County Wills, 1682–1819 (HSP), Ancestry.com.
2. *Pennsylvania Archives*, 2nd ser. (1895), vol. 9, p. 421. Mary and John Baker's son Charles Henry Baker (1793–1872) and his wife Elizabeth had a daughter, Emma Baker (1815–1917), who married the Reverend Theophilus Stork (1814–1879) on August 31, 1848, in Philadelphia.
3. This engraver's hand does not appear in the books investigated to date that illustrate Baltimore silver.
4. Another sugar bowl with the same shape and detail has a similar engraved pattern, but without the drama; Charlton Hall Galleries, West Columbia, SC, *Ancient Artifacts to Americana II*, March 25, 2012, sale 262, lot 654, www.charltonhallauctions.com (accessed May 22, 2014).
5. Death certificates, 1906–1963, Series 11.90, Records of the Pennsylvania Department of Health, Record Group 11, Pennsylvania Historical and Museum Commission, Harrisburg, Ancestry.com; John G. Morris, *The Stork Family in the Lutheran Church* (Philadelphia: Lutheran Publication Society, 1886), pp. 29, 85.
6. See the teaspoons by Richard Humphreys (PMA 1942-47-4–9) and the tongs by John Meyers (PMA 1942-47-3).

Joseph Draper

Trowbridge, England, born 1801
Cincinnati, died 1864

A memorial biography of Draper published in 1881 is the primary source for information on his early life.[1] Born near Trowbridge, England, Joseph Draper came to the United States at the age of nine with his father, who died on a return voyage to England to retrieve his wife and other children. Draper settled in Wilmington, Delaware, and apprenticed with an unidentified silversmith described as "an old citizen." It is also possible Draper trained or worked with Henry J. Pepper (q.v.), who was only twelve years his senior but who in 1826 offered the testimonial: "From a thorough knowledge (for more than 12 years) of . . . J. DRAPER, I can confidently recommend him to the patronage of the public," indicating that he had known Draper since he was about thirteen years old.[2]

Draper established himself as an independent craftsman in Wilmington when he acquired Pepper's shop at 2 West Third Street in March 1826, one month after Pepper had offered it for sale. Draper advertised that he manufactured "Silver Spectacles, Silver Table and Tea Spoons, and all kinds of Gold and Silver Ware,"[3] which suggests that he primarily made spoons and jewelry and produced little if any hollowware; none with a history of ownership in Delaware is known to survive. Draper also countermarked copper cent coins, presumably as a form of advertising.[4] His workshop included the fifteen-year-old Theodore McMurphy, who apprenticed himself to Draper in 1829.[5] On November 6, 1829, Draper married Martha S. Inskip of Christiana Hundred, New Castle County.[6] The U.S. census of 1830 recorded Draper as head of a household that, in addition to his wife, included two white males between the ages of fifteen and twenty, presumably McMurphy and another apprentice, and one white female also between fifteen and twenty, probably a servant or relative.

Draper continued working in Wilmington until January 1832, when he advertised his intention to "leave the state," and sold his shop to the silversmith Emmor Jeffries (1804–1892).[7] By 1834 Draper had established himself in Cincinnati, where he became a prominent silver manufacturer and jeweler. In the years just before his retirement in 1856, his annual production was valued at $3,000.[8] He died on November 15, 1864, and was buried two days later in Spring Grove Cemetery in Cincinnati.[9] DLB

1. *Proceedings of the Memorial Association, Eulogies at Music Hall, and Biographical Sketches of Many Distinguished Citizens of Cincinnati* (Cincinnati: A. E. Jones, 1881), pp. 142–44. Dehan (2014, p. 98) notes that, in some previous sources, Draper has been confused with a younger silversmith of the same name, working in Kentucky about 1850.

2. *American Watchman* (Wilmington), March 23, 1826.

3. Ibid.

4. Gregory G. Brunk, *Merchant and Privately Countermarked Coins: Advertising on the World's Smallest Billboards* (Rockford, IL: World Exonumia Press, 2003), p. 155.

5. Apprenticeship indenture, October 20, 1829, New Castle County Court of General Quarter Sessions Records, Delaware Public Archives, Dover.

6. New Castle County, Delaware, Marriages 1645–1899, http://genealogytrails.com/del/newcastle/newcastlemarriages-D.html.

7. *Delaware Journal* (Wilmington), January 13, 1832.

8. Dehan 2014, pp. 97–99.

9. Decedent card file, Spring Grove Cemetery, Cincinnati, www.springgrove.org/stats/14121.tif.pdf.

Cat. 198

Joseph Draper
Eight Teaspoons

1826–32

MARK (on each): J.DRAPER (in rectangle with chamfered corners, on back of handle; cat. 198-1)
INSCRIPTION: J R (engraved script, on front of handle)
Length 5⅞ inches (14.9 cm)
Weight 9 dwt. 5 gr.
Gift of Karl Lohmann Jr., Carolyn Faucett, and Elizabeth Pusey Lohmann-Faucett in honor of Jane Richardson England-Lohmann, 2015-55-1-8

PROVENANCE: These spoons descended to the donors through a maternal great-great-grandmother, Jane Richardson Pusey (1849–1919) of Wilmington, Delaware. The engraved initials suggest that the spoons originally belonged to her unmarried aunt and namesake, Jane Richardson (1805–1839), also of Wilmington.[1]

The history of ownership indicates that these spoons were made before Draper's departure from Wilmington in 1832. An earlier date in his career is also indicated by their style, with rounded-end, downturned handles. The set originally was larger; a ninth spoon is owned by the Delaware Historical Society in Wilmington. DLB

1. Information on the Richardson family was provided by the donors and can be referenced in the Paxon family tree and the Betty Meyer family tree, Ancestry.com (accessed January 8, 2016).

Cat. 198-1

George Drewry

Philadelphia?, born c. 1740
Philadelphia?, died after 1795

One of two public notices placed by George Drewry, goldsmith, in Philadelphia appeared in the *Pennsylvania Gazette* in the spring of 1763 to advertise that he had "just opened Shop in Walnut-street, four doors below Second Street."[1] If he followed the traditional path through apprenticeship, he was born in the early 1740s, probably in Philadelphia. In February 1763, just before his opening advertisement, he had purchased twenty-two pairs of chapes and tongues (buckle equipment) and seventeen pairs of knee buckles for £1 9s. 4d. from the estate of the deceased silversmith Philip Hulbeart (q.v.).[2] Then, in June 1763, he moved from his first location down the block toward the Delaware River to the corner of Front and Walnut streets, "next door to Captain Archibald Gardiner."[3] Members of his family were Presbyterians, but he is not listed in church records.[4]

Little is known about George Drewry, but bits of biographical information about him have emerged in tangential family accounts, in some of which the name is spelled Drury. In 1754, when the Philadelphia merchant George Spafford signed his will, he listed his nephews William and George "Drury."[5] When William Drewry signed his own will in Philadelphia some thirty years later, on November 20, 1783, he mentioned his wife Mary, his brother George, and two sons, Spafford Drewry of Charleston, South Carolina, a merchant who was then in the city of Philadelphia, and Edmund Drewry, a lawyer: "To my wife Mary one third part of all my personal estate whatever . . . I do give and devise and bequeath the same unto my brother George Drewry the sum of Ten pounds, and all the rest to my two sons Edmund Wooley Drewry and Spafford Drewry equally divided." His executors were his wife Mary and his "esteemed friend, Captain George Goodwin."[6] Mary Drury was listed in the U.S. census of 1790 as a shopkeeper with two females, including the head of household, at 269 South Second Street and, in the Philadelphia directory, as a widow and shopkeeper at the same address until 1797.

William Drewry, George Drewry's brother, was a ship chandler. He had married Sarah Wooley on September 27, 1767, as his first wife.[7] William was listed in the Tax and Exoneration records with considerable value. In 1774 he owned his house, had a servant and two negroes, and was valued at £92 14s.[8] The assessment of damage done to his property in Southwark by the British in 1777 and 1778 was £1,525.[9] In 1780 his estate value, in the inflated currency after the Revolutionary War, was £35,600, and he was paying ground rent to Edward Shippen. Following his death in 1784, the payments were continued by his second wife, Mary.[10] He had owned three frame houses in Southwark, which were still in his estate in 1787.[11] A Captain William Drewry served in the militia in 1782, but there is no record of a George Drewry having served.[12]

George Drewry may have been living with John David Sr. (q.v.) in 1790, when the U.S. census recorded three males over sixteen and one other free person in the household. The 1793 Pennsylvania Septennial Census listed "George Drury, Goldsmith," as a resident in the Dock Ward in Southwark.[13] This was also his location in 1763. The manuscript census tally of residents in this ward lists, in the following order, Joseph Lownes (q.v.) at 130 South Front Street; Samuel Dilworth, ironmonger, at number 128; Thomas Shields (q.v.), goldsmith and Sallows Shewell, merchant, both at 126 South Front; John David [Sr.], goldsmith, at number 124; "George Drury, Goldsmith," with no number; and John Purdon, shopkeeper, at number 122. This is an indication that George Drewry was probably boarding and working with the John Davids at least until John senior died in 1794, and he may have continued there with John junior (q.v.), who was at that address until 1800.[14]

Spafford Drewry, son of William and nephew of George, signed his will in Philadelphia on October 8, 1795: "I will and bequeath unto my Uncle George Drewry if he be living at any time to receive it in his own hands, the sum of Five Hundred Pounds lawful money of Pennsylvania and unto my apprentice John Dayton, one thousand pounds."[15] Other bequests in the will were to cousins and the Presbyterian Church, suggesting that Spafford was unmarried.[16] George Drewry was admitted to the almshouse on August 13, 1796: "George Drewry, an old man, a silversmith with the Fever and Ague, sent in by John Johnson." He was discharged on September 15, 1796.[17]

With the two exceptions of the Septennial census and the almshouse record, George Drewry is not recorded in manuscript sources explored to date. The Philadelphia directory of 1793 lists "Drewry goldsmith" without an address, following John David. The few known facts suggest that he was in and around Philadelphia as a young person, probably apprenticed there, and was resident until at least 1795, when Spafford Drewry wrote his will. He is not documented as having owned property. He does not appear in tax records in the period between the 1770s and the 1790s, even for the per-head occupation tax. Spafford's unusually large bequest to his Uncle George suggests that he may have been a dependent or was in some way incapacitated. Silver marked by Drewry is rare, but it and the engraving hand on his marked silver are similar to objects made in the shop run by the John Davids, senior and junior.[18]

This biographical sketch of George Drewry perhaps represents how little we know about the lives and services of skilled journeymen working in large shops in Philadelphia before 1800.[19] BBG

1. *Pennsylvania Gazette* (Philadelphia), March 17 and April 14, 1763.

2. Account of Goods Sold of Phil Hulberts [Hulbeart], p. 4, Downs Collection, Winterthur Library.

3. *Pennsylvania Gazette*, June 9, 1763. In 1791 an Archibald Gardener (died 1796, of yellow fever) was listed as a tallow chandler at 108 North Front Street. An Alexander Gardener, a mariner (perhaps a captain), was located further south, at 97 Swanson Street.

4. His brother William (Drury) married, as his second wife, a widow, Mary Pierce, in 1777 at the Second Presbyterian Church, Philadelphia; *Pennsylvania Archives*, 2nd ser. (1896), vol. 9, p. 584.

5. Will of George Spafford, Philadelphia Will Book K, p. 191.

6. Will of William Drewry, Philadelphia Will Book Q, p. 432.

7. *Pennsylvania Archives*, 2nd ser. (1896), vol. 2, p. 75.

8. Tax and Exoneration Lists, 1762–94.

9. "Assessment of Damages Done by the British Troops during the Occupation of Philadelphia, 1777–1778," *PMHB*, vol. 25, no. 4 (1901), p. 555.

10. Tax and Exoneration Lists, 1762–94.

11. Ibid.

12. Revolutionary War Rolls, 1775–1783, War Department Collection of Revolutionary War Records, Record Group 93, NARA, Washington, DC, Ancestry.com.

13. Names were given without specific addresses in this census. Dock Ward comprised the area east and west between Walnut and Spruce streets, and north and south between Fourth and Front.

14. Philadelphia directory 1793, p. 32. By 1801 Joseph Lownes had moved into 124 South Front.

15. Will of Spafford Drewry, Philadelphia Will Book Y, pt. 2, 1802, no. 9, p. 638.

16. The will of Spafford's brother Edmund designated bequests to cousins, made no mention of Uncle George, and was unsigned but probated with witnesses on August 10, 1795. In 1796 he, too, probably died of yellow fever; will of Edmund Drury, Philadelphia Will Book X, 1795, pt. 1, p. 311.

17. Guardians of the Poor, Daily Occurrences, September 1795–October 1795, Philadelphia City Archives.

18. Sugar urn, c. 1780, advertised at S. J. Shrubsole, www.shrubsole.com/americansilver/web/pages/03 41.htm (page no longer active).

19. The only listing for a George Drewry in the 1820 U.S. census was in Smith, Tennessee, with a household of nine persons.

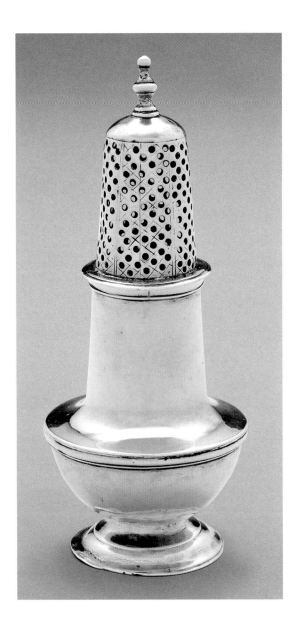

Cat. 199

George Drewry

Caster

1763–70

MARK: G D (in conjoined circles, on underside; cat. 199-1)
Height 5½ inches (14 cm), diam. 2¼ inches (5.7 cm),
diam. base 1⅝ inches (4.1 cm)
Weight 3 oz. 14 dwt. 10 gr.
Gift of the McNeil Americana Collection,
2005-68-127a,b

PROVENANCE: Sotheby Parke Bernet, New York, *American
Heritage Society Auction of Americana*, November
16–18, 1978, sale 4180, lot 398; (Elinor Gordon,
Villanova, PA).

The seams have split at the edge of the bezel and
on the body at midsection. The foot has been dam-
aged, reworked, and reduced in size. BBG

Cat. 199-1

Abraham Dubois Sr.

Harlingen, New Jersey, born 1751
Philadelphia, died 1807

Abraham Dubois Jr.

Philadelphia, born 1780
Clark's Ferry, Pennsylvania, died 1825

The Dubois family had ancient roots in Europe. Its members were Huguenots, forced to leave Switzerland, Germany, and France in the 1690s to escape religious persecution. They are recorded in the Netherlands and England, where some remained, and members of the family are listed in records of the London goldsmiths company.[1] In the seventeenth century members of the Dubois family, along with other Huguenot families, including the Davids (q.v.), settled in the area around New Paltz, New York.[2]

Louis Dubois (born 1626), the first patentee in New Paltz, and his wife Catherine LeBlancon Dubois emigrated from Mannheim, Germany, to Kingston, New York, in 1658. Their eldest son, Abraham (1657–1731), was baptized in the Old Dutch Church there, on January 3, 1658,[3] and he married Margaret Deyo on March 6, 1681, in Kingston.[4] They had two sons, Abraham Dubois (the elder silversmith's grandfather; 1685–1758) and Joel (1703–1734), and five daughters: Sarah (born 1682), Leah (born 1687), Mary (born 1689), Katherine (born 1693), and Rachel, who married a cousin, Isaac Dubois.[5] The daughters and their families settled on a land grant of a thousand acres in the Conestoga-Lancaster region of Pennsylvania, which had been purchased by their father Abraham Dubois.[6]

Land had been a focus of the Dubois family from the time they first settled in New York in the seventeenth century. It was a source of the Dubois family's early wealth, and their property soon extended into New Jersey and Pennsylvania. In an indenture and deed of 1724, recorded in Philadelphia in 1772, Abraham Dubois, the elder silversmith's grandfather, purchased half of a large parcel (1,285 acres) of land "situate and lying in the County of Philadelphia, Province of Pennsylvania, for £360 current money of New York" from Philip

Dubois of New Paltz. The other half was retained by Solomon Dubois.[7] In 1732 Abraham Dubois of Somerset County, New Jersey, deeded the "messuage and plantation or tract of land formerly part of the reputed manor of Gilbert on the Schuylkill River adjacent to land of Joseph Richardson [Sr.; q.v.] situate in the County of Philadelphia" for 5s. to Rachel Dubois, widow of his son Isaac Dubois, the silversmith's uncle.[8] The family interest in real estate was carried on by Abraham Dubois Sr., silversmith, and became a central focus in his life. Traditionally land was a secure and conservative repository for mercantile and trade profits. However, by the time Abraham senior had accumulated enough capital to invest, inflation and speculation were rampant, and wars interrupted trade.

The silversmith's grandfather Abraham moved from New Paltz to property in Somerset County on the Raritan River in New Jersey. He married Marie La Siliere, probably in New Paltz before he moved. Their son Abraham (1725–1792), the elder silversmith's father, is recorded as having married Jane Van Dyke in 1747.[9] They had six children: Margaret (born 1749), Abraham, our elder silversmith (1751–1807), Nicholas (1753–1825), Dominicus (Minna) Dubois (1756–1824), Mary (born 1758), and Catherine (born 1760).[10] Jane Van Dyke Dubois died in 1763, and Abraham married, as his second wife, Jannetje Nevius Monfort (died 1809), widow, in 1770.[11] The Dubois descendants used the same given names in succeeding generations.[12] Fortunately, the life dates for Abraham Dubois Sr., Philadelphia silversmith, can be established from the record of his death in Philadelphia in 1807.[13]

There are two large collections of Abraham Dubois Sr.'s papers. The business correspondence and legal papers, including estate accounts archived at the Historical Society of Pennsylvania in Philadelphia, record the uncertainties of life and commerce in the United States during the trying period between the Revolution and the War of 1812. The other collection, at the Hagley Museum and Library in Wilmington, Delaware, contains a letter book and business and family correspondence.[14]

Dubois senior emerged out of a Philadelphia apprenticeship or arrived in the city just as revolutionary activity was heating up. After the Townshend Acts were repealed in 1770, Philadelphia merchants returned to the sea trade, and Philadelphia again became an active trading port. Although Dubois was probably not yet financially independent enough to establish foreign contacts for silver imports, he began very quickly to establish his credit for shipping and commerce. Surviving documents suggest that he and his son

Abraham junior were taking orders for their silverware until Abraham senior died in 1807. References to Dubois's silver business are few in the two extant manuscript collections. From Philadelphia on January 10, 1804, Abraham senior wrote to John LeTelier Jr. (q.v.) of Delaware:

> The purport of this is to remind you of the small ac't so long standing between ($16 for the lathe) which you several times promise should be settled and which I then offered to take in work and requested you to make me a couple of large size creampots, but wo'd now prefer the money as I am about to deliver the business, yet if it is much more convenient to you, I will take the work, and beg you'll be so good as to make me the two creampots. Let them be of the urn kind, a large size with strong handles both to weigh above 5 oz 10 dwt each and forward them to me by the first good conveyance. . . . at present your place of residence is unknown to me tho I suppose it to be no great distance from Newcastle.

Abraham senior followed up in April of that year: "Understanding that you had removed to Washington City . . . your small account of $16 for the turning lathe I sold you so long since . . . pay the amount to my friend Mr. Henry Foxall at the Columbia Foundry in Georgetown."[15]

Having traveled in 1805, presumably on a selling trip, Dubois senior wrote to Messrs R. & H. Farnum in Boston on his return:

> Arrived at Phila after tolerable passage via New Haven & New York. No one there (yellow fever). In looking over your order we are at a loss to know how the two sugar dishes are to be made which you have put down without foot etc. from which I suppose they are to be made without a cover also and nearly the shape of the oval bottom tea pots but no mention of handles. You will therefore have the goodness to inform my son in time more particularly how they are to be made, and in the meantime the other articles may be going on, the fluted sett mentioned to you are still unsold which with a part of the rest, I am directed to say will probably be forwarded to you by the first of next month and should you in the interim have a call for a sett or any piece of plate of the urn fashion, it may be forwarded by the first conveyance.[16]

Hollowware marked by Dubois senior and junior is not plentiful, and father and son appear to have used the same maker's marks. The silver made by Dubois senior in a mid-eighteenth-century style suggests that he may have apprenticed with one of the older silversmiths in Philadelphia, perhaps John David Sr., also of Huguenot heritage and from New Paltz; Thomas Shields, with whom he did business right after his apprenticeship; or William Hollingshead (q.q.v.), who had family

connections in New Jersey and was also a member of the Second Presbyterian Church.

Exactly where Dubois was living when first setting up his business is not known. He was at work in Philadelphia by 1774 when he "Rec'd from Catherine Wistar, the just sum of £6 13 sh for a soop ladle & silver tablespoons."[17] He does not appear as a single male with the per-head designation in earlier Philadelphia tax records. He took the required oath of allegiance in Philadelphia in 1775.[18] Dubois was entered as account number 7 in Thomas Shields's daybook on September 3, 1775, but the two may have been doing business before then as the entries refer to earlier accounts. On the credit side Dubois supplied Shields with a variety of small, specialized items, including watches, gold ciphers, hairwork in a locket, cash, cuttoe handles, silver swivels, plats, a dove and branch for lockets, watch glasses, "cyphers" and a "dove" of hair, and a hair urn.[19] On the debit side Dubois was always just a little behind at the end of the month: an entry for November 1, 1775, records "Abraham Deboys Dr. to a Balance unpd in a watch 2d hand." In October 1775 he was debited for two small sword blades (for which he may have made the above cuttoe handles). On November 30 he was debited for "Dr. to a Box Shoe Chapes"; December 2 for "Dr. to six doz shoe chapes"; and December 9 for "12 Cuo handles £4 10s." and "Dr. To 1 silver Corals & Bells is Neat £2, To 1 Dz pair best Shoe Chapes £0 16s., To 9 pair Plaited Shoebuckles @ 2/10 £5 6s."[20] These entries suggest he was doing piece work, possibly as a journeyman for Shields. The shape of the perky cream pot (cat. 203) with repoussé garlands is very like pots made by John David Jr.[21] A rotund sauce boat with the initials "AB" and a quart wine cann for "RES" by Dubois are typical of hollowware made in Philadelphia shops just before and after the Revolution.[22]

On May 2, 1776, Dubois married Elizabeth Cheeseman, daughter of Samuel, cordwainer, and Sarah Cheeseman.[23] The Reverend James Sproat performed the ceremony at the Second Presbyterian Church in Philadelphia.[24] Two days after his marriage Dubois was entered in Shields's day book again when he was debited for "a pr silver tea tongs, and on the 7th, 1 nest sand crucibles." He is not listed in the accounts after July 6, 1776, when he began his term of service in the Revolutionary War. Dubois joined the militia as one of the officers and men "Belonging to the City and Liberty," in service December 24, 1776, along with William Haverstick and Charles Willson Peale.[25] In February 1777, having completed his six-month term of military service, Dubois was back at work when he again was debited £10 2s. in Shields's accounts for "2 nests sand crucibles."[26] On May

20, 1777, he placed what may have been his first advertisement, in the *Pennsylvania Evening Post*, noting that he had for sale an assortment of beaver and castor hats of the very best quality, gold and silver watches, gold lockets, and different kinds of silver work and jewelry, at his house on Second Street, four doors below Arch. This property was on the east side of Second Street between Market and Mulberry (Arch) and belonged to his wife's mother, Sarah Cheeseman. It became the principal residence and business location of the Dubois family.[27] It was subject to an unusual ground-rent payment to Anthony Morris, brewer: "£3 lawful silver of Pennsylvania or eight ounces, and three fourths of an ounce of silver plate current in the province of Pennsylvania, due on the 25th of March and 28th of September by equal portions yearly forever."[28] Dubois's advertisement refers to "his house," and the Effective Supply Tax of 1782 notes that in Dubois's valuation he was credited for £30 ground rent, the same amount stated for the property in later tax records.[29] His payment of ground rent at this time may have been an accommodation in place of rent as it was not until October 7, 1784, that Sarah Cheeseman deeded the property to her son-in-law Dubois, recorded as goldsmith, for £1,200 in gold and silver coins of Pennsylvania.[30] The 1787 tax noted that Sarah Cheeseman had moved into another structure on the property. As described in the survey for reinsurance on February 2, 1817, the property had a frontage of 15 feet, 3/4 inch on Second Street and extended back 100 feet. In addition to the original brick house, Dubois had added a piazza 8 feet by 9 feet, and a nursery and kitchen 10 feet by 32 feet. Samuel Cheeseman had purchased the property from Septimus Robinson in 1753.[31] In the U.S. Direct Tax of 1798, it was valued at £3,800 with a tax of £19 3s. On May 4, 1784, probably to finance his purchase of the house and shop from his mother-in-law, "Abraham Dubois, goldsmith and Elizabeth (wife) sold to Jan Yost Sluyter, merchant for £450 in specie gold and silver, a large piece of undeveloped ground, width E&W 100 feet, length N&S 104 feet on the North side of Mulberry Street in a lane between Broad Street and Thirteenth Street."[32]

The Dubois shop and house were at the heart of the "traffic" in Philadelphia in 1777 when on September 26, "about 11 o'clock A.M. Lord Cornwallis with his division of the British and Auxiliary Troops amount'g to about 3000, marched into this city."[33] When the British occupied Philadelphia, Dubois and his family, like many others, moved out of the city to Germantown. Upon his return Dubois served as an assessor for the High Street Ward for damage done by the British occupiers. His own account for damages was £175.[34] The 1779

Head Tax showed Dubois's occupation valued at £30, and his mother-in-law, Sarah Cheeseman, in her separate quarters, at £1. The records of the Effective Supply Tax in November 1780 reveal the inflation after the war. Abraham Dubois, goldsmith, had a valuation of £81,800 and tax of £245 8s.[35] Even with postwar inflation this was a large capital amount for Dubois, probably estimated as a goldsmith and a merchant. For comparison, in the same Effective Supply Tax other contemporary goldsmiths were valued as follows: William Ball at £196,400, Daniel Van Voorhis at £39,000, and William Hollingshead (q.q.v.) at £56.[36]

Dubois took on some civic roles after the war. He endorsed passes for travelers who wanted to leave Pennsylvania for New York.[37] In 1780 he signed a "Petition to prevent Slavers being fitted out at the Port of Philadelphia."[38] He collected pew rent for the Presbyterian Church in 1782.[39] His son Samuel was born in 1778; Abraham junior was born on July 12, 1780, and baptized in the Second Presbyterian Church on September 8, 1780.[40] Abraham junior would have reached his majority in 1801 and was probably trained by his father, but a silversmith's mark has not been specifically assigned to him. No notice of a marriage for Abraham junior has turned up. His first appearance is in the Philadelphia directory of 1803: "Dubois Abraham Sr. and Jr., goldsmiths at No. 65 North 2nd Street."

Perhaps it was at first to supplement his silver business, but by 1780 Dubois was actively trading by sea to the West Indies. He invested heavily in the enterprise, and the flourishing West Indies trade was profitable for him. If a ship made a clear passage, without being raided by pirates or suffering confiscation by foreign inspectors—French or British, depending on the year—large profits ensued.[41] Dubois began his trade with agents on Saint Vincent and Saint-Domingue (now Haiti) at Cap-Français.[42] Charles McAllister was his factor in Philadelphia and traveled abroad on the ships carrying Dubois's cargo to negotiate sales in the West Indies and London.[43] Dubois's manifests show him shipping produce and goods from Pennsylvania and importing coffee and sugar through the 1780s.[44] In August of 1785 there was a commercial panic with a shortage of specie and credit, and the first bankruptcy law was instituted. Eighty-four Philadelphia merchants filed for bankruptcy, and sixty-eight actually went under. Individuals who were sued for a debt and unable to raise the money were bankrupt unless a special condition or gradual payoff was agreed upon. Land was especially difficult to convert.[45] In 1785 Dubois joined Levi Hollingsworth, Thomas McKean, Joseph Wharton, and other merchants

who were having financial difficulties, to urge the Pennsylvania State Congress that "the penal laws formerly used should be reformed by the Legislature as soon as may be, and punishments in some cases made less sanguinary, and in general more proportionate to the crimes."[46] They objected to debtors being jailed, which made it impossible for them to work to get out of debt.

Dubois's successes are not recorded, but fluctuations in the valuation of his estate and the subsequent taxes provide a rough estimate of his business. In the U.S. Direct Tax of 1781, his estate was valued at £914 less the ground rent at £50.[47] For the 1782 Effective Supply Tax, his estate was valued at £797 with credit for £30, the ground rent to Morris.[48] In 1782 his dwelling was valued at £700; 30 ounces of plate, £12; his occupation, £75; and credit for ground rent, £30. In 1783 the value of his dwelling was £575; 30 ounces of plate, £12; one negro, £30; one cow, £3; his occupation, £100; and credit for ground rent, £30.[49]

Dubois seems to have returned to his silver work in the late 1780s, perhaps as his son Abraham junior was of apprenticeship age. On June 1, 1786, Mrs. Mary Meredith purchased from him a silver sugar dish for £9 10s.[50] He made a tea service for Vice President Aaron Burr about 1790, and a handsome, complete tea and coffee service in the new Federal style for Edward and Mary Ireland of Baltimore.[51] But the dearth of Dubois's advertisements suggests that the import-export business, concentrated in commodities, was paramount. The silver and jewelry business was carried on with commissions forwarded by traveling agents, some of whom were family, including brother Minna and grandson Abraham in North Carolina, and brother Nicholas in Baltimore. However, their correspondence was largely concerned with regional conditions for sales or land management.[52]

Sarah Cheeseman, widow and Dubois's mother-in-law, was listed in tax records and directories separately on part of her original property until her death in 1786.[53] The Reverend John Woodhall of New Jersey, who married her daughter Sarah, was the executor of the widow's will, written in September and probated in December 1786. Abraham Dubois, William Hollingshead, and John Redman were witnesses. The will was curious in its omission of any mention of Elizabeth or her Dubois children.[54] As Dubois's business was on the brink of insolvency at this time, she may have been protecting what estate she had from what probably appeared then as Abraham's imminent bankruptcy. In 1786 he was listed within the bankruptcy proceeding of merchant dealer Joseph Parker; it is not clear whether Dubois was

officially identified as a bankrupt who would have had to forfeit all his property, or as a debtor who was cited but had enough credit or property to pay off debt over time.[55] In 1788 Dubois seems to have recouped and was actively trading again. In the 1788 valuation for the Property Tax, Dubois, silversmith, was assessed at £637, of which £525 was for his dwelling, £50 for a negro, £12 for 30 ounces of plate, and £50 for his occupation.[56]

Other children followed the birth of Abraham junior: Nicholas (born 1783), Jane (born 1788), Mary (born 1789), Edmund C. (born 1793), and James S. (born 1795).[57] The Dubois family moved household for short periods. The U.S. census of 1790 noted "Abraham Dubois, goldsmith" on the east side of Water Street with twelve inhabitants, including three males under sixteen, three males over sixteen, five females, and one slave. However, the city directories do not record this move and continued to list Dubois at 65 North Second Street. The 1800 census recorded the Dubois family in the High Street Ward, with two males under ten, one male sixteen to twenty-five, one male forty-five and over, two females ten to fifteen, one female over forty-five, and two other free persons, for a total of nine persons in the household. For one short year the Dubois shop was listed in the Philadelphia directory of 1803 under "Removals" as "Dubois & Co. goldsmiths" at 34 South Third Street.

Throughout the 1790s Dubois senior invested heavily in unclaimed western land, with an application for patents to 200 acres in Tuscarora Township, Bedford County, Pennsylvania. He ran his business with agents. Samuel Roberts was supposed to attend to the taxes on land in Sunbury, Bucks County, Pennsylvania, but neglected to forward the papers. Dubois wrote to John Young of Baltimore about his lands in Kentucky and Virginia; to George Sibbald, asking that he "handle my Georgia lands purchased in 1794"; to John Taylor about land held near Poughkeepsie, New York; and to his brother Minna, expressing his disappointment that the turnpike would not go through his land.[58] He continued with options and purchases in Union and Susquehanna counties, Pennsylvania, and was in full swing when he purchased twenty-nine land patents in Luzerne County.[59]

In June 1792 he purchased shares in a 280-acre tract on the Susquehanna River in Susquehanna County as a subscriber to the Azilum (Asylum) Company, formed by French émigrés and promoted by John Nicholson and Robert Morris as the site for a settlement that might serve as a possible refuge for beleaguered French royalty.[60] The company likely appealed to Dubois from the outset. It was a project of the French community in Philadelphia, to which he probably felt connected,

but it turned out to be a financial misstep for everyone involved; the project was in trouble from the beginning. The company had not paid its land taxes by 1799, and shareholders were distressed at a proposal to resell their shares. They printed an indenture, with Dubois's name on the letterhead, to "keep all the Articles of Association in the first part."[61] The fact that the company was a scheme promoted by Morris and Nicholson to profit from land on which they held options escaped the notice of Dubois and others. Only John Nicholson purchased a greater number of shares than Dubois. After the bankruptcy of Morris and Nicholson, the Azilum Company was reorganized by a group of Philadelphia merchants in 1801. Abraham Dubois retained his shares, which his brother Minna eventually acquired.[62]

Financial chaos reemerged in Pennsylvania in December 1796 and January 1797, and several of Dubois's properties involved lawsuits. A notice in the *United States Gazette* (Philadelphia) on December 29, 1796, stated: "Those gentlemen who hold any of the under mentioned Notes or Draughts (whether due or not) are requested to meet at the City-Tavern on Wednesday next at 6 o'clock in the evening; at which time arrangement will be proposed which it is expected will be satisfactory to the holders. . . . Abraham Dubois's note to Edward Fox . . . Edward Fox's note to Abraham Dubois, James Greenleaf's draughts on Abraham Dubois." But Dubois continued to acquire property. In 1797 he purchased from John Hall, Esq., and his wife a three-story brick house and ground on the north side of Mulberry Street between Sixth and Seventh streets for $3,000, and in 1798 sold it to George Heberton for $2,100. In both deeds Dubois was noted as "merchant."[63]

The timing of his sales and purchases of property suggests that he bought and sold city properties to reinvest and to pay the costs of undeveloped western land. He purchased, or possibly inherited from family, a large piece of undeveloped ground just beyond the commercial center of Philadelphia, with an east–west width of 100 feet and a north–south length of 104 feet, on the north side of Mulberry Street in a lane between Broad and Thirteenth streets. On May 4, 1784, he and his wife Elizabeth sold it to Jan Yost Sluyter, merchant, for £450 in specie gold and silver.[64] In 1796 John Baker, sheriff, awarded Dubois damages for a debt unpaid, with the option of purchasing at the sheriff's sale a "one story frame messuage and lot (12 feet 8 inches by 8 feet five inches) situate in Strawberry Alley" for £210.[65] At the time Jeremiah Boone (q.v.) was occupying this property. In 1801 Dubois sold it for $300 to John Darragh, an innkeeper of Newcastle, Delaware, to clear a debt of his own.[66]

On November 27, 1797, John Hall, Esq., and his wife Eliza Ann sold to Abraham Dubois, "merchant," a house and lot 16 by 20 feet on the north side of Mulberry Street in the square between Sixth and Seventh streets, for $3,000 gold and silver money. Hall had purchased the property in 1794 from James and Esther Smith, and in July 1798, within a few days of the death of his wife Elizabeth, Abraham Dubois, again noted as merchant, sold it to George Heberton, merchant, at a loss, for $2,100.[67] Long a widower, Dubois remarried on October 9, 1801, to Mary L. Heberton (1767–1826), sister of his great friend George Heberton. Their children were George H. (born 1805) and Elizabeth (born 1807, just before her father died); both were included in his will.[68]

In January 1806 Charles Willson Peale, writing to Thomas Jefferson, mentioned that he had commissioned "an Ingenious Silver-Smith Mr. Abraham DeBois [Sr.]" to do the silver work on the polygraph that Peale was making for Jefferson.[69] In April 1806 Peale wrote again:

I must repeat what I had mentioned in a former letter that Mr. DeBoise had not made some of his work so neat as I could wish, the hinges in particular ought to have been better, but having finished them I could not think of giving him the trouble and expense of making others. . . . Before you wrote informing that the locks &c should be silver, we had finished one or two of the catches in which the inner parts were made of brass, but all that could be seen was of solid silver . . . however when I had your more particular directions, nothing was afterwards made but of silver except pins & screws.[70]

Abraham Dubois Sr. died October 23, 1807, at the age of fifty-six years and seven months, and was interred at the Second Presbyterian Church yard.[71] Given the month, October, he may have died of yellow fever, as his young daughter Elizabeth had died just four days earlier. His will was written August 28, 1804, and probated November 7, 1807. A codicil of October 21, 1807, read: "Two children born George H. Dubois, and Elizabeth, to share equally."[72] The executors were his wife Mary, his old friend and brother-in-law George Heberton, and his sons, Abraham and Nicholas: "All my silversmith's tools to Abraham . . . as to the residue of my property or estate . . . sell, or convey, or divide into eight equal parts for my wife and six children and grandson Abraham DuBois (son of Samuel). Educate the children on interest of the estate so shares won't be diluted when they come of age. A good proportion of my estate will be in lands."[73] The estate account listed the following debts: "taxes on land, advances to heirs, University of Pennsylvania for tuition for Edmund,

funeral expenses, moving furniture to Vine Street, George Holt for bleeding and cupping AD dec'd, Duties on Coffee per Benj. Hetty $142.00, Isaac Catherall for attendance on AD dec'd. Credit to account: J. Eberts for 3 mo rent of house No. 65 N. Second Street $126.00, returns of silver per brig *Hetty* $404.50, Jacob Britten for sundry articles of jewelry $30.87, cash for loan he made."[74]

After the death of Abraham Dubois Sr., the Second Street property or parts of it were leased. Abraham junior moved briefly to 71 North Fifth Street.[75] Abraham senior's widow, Mary, moved to 167 Vine Street. After 1807 Dubois junior was not listed in the directories or advertisements as a goldsmith, and he was probably living with his siblings and stepmother. From 1809 through 1812 her directory listing reads "Dubois, widow of Abraham, late goldsmith, 137 Vine." In 1813 she was at 71 North Fifth Street. In 1814 "Abraham Dubois" (widow and/or junior) was there, and in 1816 "Dubois, Abraham" was listed at 65 North Second and 71 North Fifth. From 1819 to her death in 1826, Mary Dubois, widow of Abraham senior, was at 65 North Second Street.

Other members of the family had settled in Baltimore. George Heberton, Mary Heberton Dubois, Abraham junior, and their attorney, Charles Meredith, were occupied from 1817 to 1824 in settling Dubois senior's estate. When Dubois junior died in 1826, his estate was valued at less than $100 and there were unpaid taxes due on the North Second Street property. His executor was Minna Dubois's son George Heberton, who settled Abraham Dubois Junior's final accounts August 21, 1828.[76]

In 1804 Dubois senior wrote to William Cochran in Baltimore summarizing his sense of despair: "this sale of land for bread has proved very unfortunate."[77] His letters to his children were thoughtful and parental. To Nicholas in Baltimore, he wrote on February 1, 1804: "I must recommend you to economy and attention to business . . . remember what an old friend Gray used to say, that it was better to mourn over your goods than after them."[78] On July 11, 1807, he wrote again to Nicholas, who was then in Lumberville, North Carolina, and dealing with land titles: "Haven't heard from you but will cover George Simpson's Draft on the bank of Charleston for $200—and tell me where I am to direct to you in the future. Since the above date our Rupture with the British has in some measure subsided, as you will observe by the papers, yet many here are of the opinion that a War will be the consequence. . . . I was never more at a loss to know what to set about. . . . your affectionate parent."[79]

His letter of January 29, 1807, to Jane read:

I was mortified at being under the necessity of telling him [Charles Egerton] that it was out of my power to make you any advance at present a thing generally expected on such an occasion . . . for tho I am out of business I am not yet quite out of debt, nor have I yet been able to do anything for your brothers who are all endeavoring to do for themselves (except what I had to answer for our poor dear unfortunate son) so you'll observe there will be no partiality shown in that respect; but be assure my dear child, that you have the same share in my affection as if I had thousands to give you at this time. . . . I hope my dear you'll be happy in your intended connection. . . . I hope you'll not be disappointed, but consider seriously before it is too late remember what you are about to do is not for a day or a week but for life. . . . your truly affectionate Father.[80]

At the very end of his life, between July 31 and December 31, 1806, Abraham Dubois Sr. bought several books from Robert Aitkin that perhaps reflect a contemplative state of mind in light of his circumstances: a copy of *The Gospel Its Own Witness*, a copy of *The Complaint, or Night-Thoughts on Life, Death, and Immortality* (poems by Edward Young), a book of lyric poems, and three gilt volumes of "Witsius divinity The Economy of Covenants between God and Man."[81] BBG

1. Isaac Dubois, goldsmith, Savoy, 1703; Joseph Dubois, jeweler, Newcastle Court, Butcher's Row, near Temple Bar, 1731. See Ambrose Heal, *The London Goldsmiths, 1200–1800: A Record of the Names and Addresses of the Craftsmen, Their Shop Signs and Trade Cards* (1935; repr., Newton Abbot, England: David & Charles Reprints, 1972), p. 144.

2. Albert F. Koehler, "The Huguenots, or The Early French in New Jersey," typescript (Huguenot Society of N.J., Bloomfield, NJ, 1955), p. 18, Paul Robeson Library, Rutgers University–Camden.

3. Louis had two more sons, Jacob (born 1661) and Solomon (born 1670), both of whom shared in the estate.

4. He died in Kingston, Ulster County, but was buried in the Walloon Cemetery, Lancaster, Pennsylvania; Ancestral File, FamilySearch.org.

5. Abraham was administrator of (and Daniel Dubois a witness to) Joel's will, June 21, 1734; Joel Dubois (1703–1734) was a yeoman in Philadelphia County in 1730 when he was administrator of the estate of Noah Dubois; "Philadelphia Administrations," *Pennsylvania Genealogical Magazine*, vol. 4 (1909–11), p. 256; Ralph Lefevre, *History of New Paltz, New York and Its Old Families from 1678 to 1820* (1903; repr., Bowie, MD: Heritage, 2003), pp. 289–90; New Jersey Births and Christenings, 1660–1931, index (Salt Lake City: FamilySearch, 2009, 2010), Ancestry.com.

6. This Abraham was the son of Louis and Catherine Dubois; Lefevre, *History of New Paltz*, p. 289.

7. Deed of Partition, 1718, recorded in Philadelphia Deed Book I-10-483-485.

8. Philadelphia Deed Book I-12-207, recorded January 15, 1774. For petitions regarding ownership of this tract, see *Pennsylvania Gazette* (Philadelphia), April 4, 1771.

9. Dubois folio Bible (Rutgers University Library), published in *Genealogies of New Jersey Families, from the Genealogical Magazine of New Jersey*, comp. Louis P. de Boer (Baltimore: Genealogical Publishing, 1996), pp. 714–15.

10. New Jersey Births and Christenings, 1660–1931 (see note 5). Abraham and Dominicus were baptized in Harlingen, Somerset County, New Jersey. Minna traveled as a marketing agent for

Abraham's trading business; he also owned land and lived in Hillsborough Township, New Jersey, in 1785. He married Elizabeth Scudder (died 1848). They had a son Abraham (born c. 1790) who married Juliet (?) and succeeded his father in ownership of his silversmith uncle's property at Great Bend, Susquehanna County, acquired originally as part of the Azilum Company scheme (discussed below); *Encyclopedia of Biography*, s.v. "Dubois Family"; U.S. Census 1820, 1840, 1850.

11. See note 9.

12. The silversmith has been confused with Abraham Dubois (1738–1811) and Charles Dubois, both of Pittsgrove, New Jersey, and both of whom are supposed to have married Elizabeth Preston on December 1, 1761, according to family trees at Rootsweb.com and www.cavaro.com/Genealogy/surname-file /Preston (accessed May 6, 2015). He has also been confused with Abraham DePeyster Dubois (1794–1856), Fishkill, New York. An Abraham Dubois (born 1754), son of Jonathan Dubois, belonged to the Reformed Dutch Church in Bucks County, Pennsylvania, was prominent in the county, and served in the Revolution; Familysearch.com; *Pennsylvania Gazette*, March 14, 1781.

13. "1807 Almshouse. Abraham Dubois age 56 years, October 23, buried Second Presbyterian Burial ground"; "Earliest Records of the Burials in Philadelphia from the Board of Health," *Pennsylvania Genealogical Magazine*, vol. 2 (1900), p. 40.

14. Abraham Dubois Papers, 1792–1809, HSP. A letter book (1803–16), family letters, and real estate and mercantile contacts for Abraham Dubois are at the Hagley Library, Wilmington, DE, MSS no. 416.

15. Dubois to John LeTelier Jr., Abraham Dubois, Letter Book, Hagley Museum and Library.

16. Dubois to R. & H. Farnham, Boston, October 1805, ibid..

17. Caspar Wistar, Receipt Book, HSP.

18. The oath was administered by Andrew Allen, attorney general; Courts of Oyer and Terminer, Series 126, Supreme Court, Record Group 33, Pennsylvania State Archives, Harrisburg, Ancestry.com.

19. Thomas Shields, Day Book, 1775–1791, Downs Collection, Winterthur Library.

20. Ibid.

21. Spencer 2001, p. 168.

22. The sauce boat was offered by Firestone and Parson, Boston, in 2005; for the cann see Kathryn C. Buhler, *American Silver: From the Colonial Period through the Early Republic in the Worcester Art Museum* (Worcester, MA: the Museum, 1979), p. 87.

23. Samuel Cheeseman died in 1770; Philadelphia Will Book O, p. 553. Sarah Cheeseman died in 1786, Philadelphia Will Book T, p. 463.

24. *Pennsylvania Archives*, 2nd ser. (1896), vol. 2, p. 76.

25. *Pennsylvania Archives*, 6th ser. (1906), vol. 1, pp. 473–74. Not to be confused with "Abram" Dubois who served in Bucks County in 1778; *Pennsylvania Archives*, 5th ser. (1906), vol. 5, p. 305.

26. See note 19.

27. Samuel Cheeseman, High Street Ward, cordwainer, Philadelphia Will Book O, p. 553, September 21, 1770; Sarah Cheeseman, widow, Philadelphia Will Book T, p. 463, December 29, 1786, witnesses, William Hollingshead (q.v.) and Abraham Dubois Sr.

28. Philadelphia Deed Book D-18-309.

29. In the tax of 1787, "5/11 in every hundred Pounds," Dubois's estate in High Street Ward was valued at £607 "& for Deborah Morris GR. £30"; Tax and Exoneration Lists, 1762–1794.

30. Philadelphia Deed Book D-18-309, recorded April 16, 1787. Sarah Cheeseman had died in 1786. Abraham Dubois and William Hollingshead (q.v.), witnessed her will. Will Book T, p. 463.

31. Philadelphia Contributionship for the Insurance of Homes from Loss by Fire, policy no. 211, Meredith Papers, box 44, folder 15, HSP. In 1787 Sarah Cheeseman was living next to the Dubois family on property that had also belonged to Septimus Robinson. A piazza was at that time defined as "a room linking a dwelling with the back building proper and housing the staircase"; Anthony N. B. Garvan et al., *The Architectural Surveys, 1784–1794* (Philadelphia: Mutual Assurance Co., 1976), vol. 1, p. 321.

32. Philadelphia Deed Book D-9-485. For the early allocation of open land above Tenth Street, see A. P. Folie and R. Scot, *Plan of*

the City and Suburbs of Philadelphia (1794).

33. Robert Morton, September 26, 1777, in John Rhodehamel, *The American Revolution: Writings from the War of Independence* (New York: Library of America, 2001), p. 362.

34. William Hollingshead claimed £166 18s. 9d. and Thomas Shields claimed "£577 50.0" [*sic*]. The losses of a major merchant such as Levi Hollingsworth were £1,665 2s. while those of the cabinetmaker Benjamin Randolph were estimated at £2,811 10s.; "Assessment of Damages Done by the British Troops during the Occupation of Philadelphia, 1777–1778," *PMHB*, vol. 25, no. 3 (1901), pp. 324–25.

35. Tax and Exoneration Lists, 1762–94.

36. The Effective Supply tax of 1780 was 6s. per £100; *Pennsylvania Archives*, 3rd ser. (1897), vol. 15, pp. 309, 310.

37. "Applications and Passes, 1776–1790, Pennsylvania's Revolutionary Governments," *The Pennsylvania Genealogical Magazine*, vol. 45, no. 1 (Spring/Summer 2007), pp. 183, 185: "Samuel Mylon & family . . . requests passes to New York, Uncle in Amsterdam, Dutch background, endorsed by Abraham Dubois, John Wood, John Murdock, Daniel van Voorhis, Tom Milne March 1, 1780. . . . rejected"; Dubois endorsed Susanna Morgan for a pass to New York on May 13, 1782.

38. "Petition to prevent Slavers being fitted out at the Port of Philadelphia," *PMHB*, vol. 15, no. 3 (1891), pp. 372–73.

39. Joseph Carson, Receipt Books, 1775–91 (May 20 and December 11, 1782; May 26, 1783), HSP.

40. Second Presbyterian Church (Philadelphia) records, Baptisms, marriages, burials, 1745–1833, pt.1, pp. 53, 54.

41. In 1794 at least one of his shipments was captured by pirates, as reported to Dubois by his factor, Charles McAllister; Dubois Papers, folder 2, HSP. The Dubois Papers at the HSP are especially rich in information about his trade.

42. Dubois Papers, folder 3, HSP.

43. January 16, 1804, Abraham Dubois, Letter Book, 1803–16, Hagley Museum and Library.

44. "Schooner *Lively*, Davis, from Cap Frncois [*sic*] / Abraham Dubois / 39 hhds, 155 bags coffee 12 barrels sugar, 76 hhds"; *Finlay's American Naval and Commercial Register* (Philadelphia), May 17, 1796.

45. Thomas M. Doerflinger, *A Vigorous Spirit of Enterprise: Merchants and Economic Development in Revolutionary Philadelphia* (Chapel Hill: published for the Institute of Early American History and Culture, Williamsburg, VA, by the University of North Carolina Press, 1986), p. 142.

46. *Pennsylvania Mercury* (Pottstown), September 16, 1785. See also *Pennsylvania Gazette*, July 20, 1785.

47. *Pennsylvania Archives*, 3rd ser. (1897), vol. 15, p. 593.

48. "Supply, and State Tax Lists of the City and County of Philadelphia: For the Years 1781, 1782, and 1783," in ibid., vol. 16, p. 407.

49. Tax and Exoneration Lists, 1762–94.

50. Charles Meredith, Receipt Book, 1773–1791, HSP.

51. For the tea service, see Buhler and Hood 1970, vol. 2, pp. 217–18, cat. 888; the tea and coffee service was offered by the Bernard Levy Gallery, New York, in 2017.

52. The Dubois files at the Hagley Museum and Library list 105 correspondents.

53. See note 27.

54. Philadelphia Will Book T, p. 463. The children of Abraham and Elizabeth were Samuel (1778–1801), Abraham junior (1780–1825), Nicholas (1783–1819), Jane (born 1788), Mary (1789–1807), Edmund Cheeseman (born 1793), and James Sproat (born 1795).

55. *Guide to the Microfilm of the Records Pennsylvania's Revolutionary Governments, 1775–1790* (Harrisburg: Pennsylvania Historical and Museum Comission, 1978), p. 277.

56. Tax and Exoneration Lists, 1762–94.

57. See note 40.

58. Dubois Papers, folder 5, HSP; Dubois Papers, no. 416, Hagley Museum and Library. See also John Beverly Riggs, *A Guide to the Manuscripts in the Eleutherian Mills Historical Library: Accessions through the Year 1965* (Greenville, DE: the Library, 1970), pp. 728–30.

59. *Poulson's American Daily Advertiser* (Philadelphia), July 2, 1803.

60. Elsie Murray, "French Experiments in Pioneering in Northern Pennsylvania," *PMHB*, vol. 68, no. 2 (April 1944), pp. 175–88.

61. The officers of the Azilum Company were Robert Morris, president, and John Nicholson, Omer Talon, and Louis de Noailles. Morris and Nicholson were land poor. The company could not pay tax and was preparing to get out from under the obligation by reselling the shares to raise the funds; Asylum Company Papers, box 2, folder 24, HSP.

62. Asylum Company, Minutes, 1794 (1802–1804), HSP. Dubois and others retained their devalued shares in the 280 acres. Eventually, his brother Minna took possession of the shares, but in 1821 Minna and his son had to sue in the U.S. Circuit Court to establish ownership. Minna's son Abraham (born c. 1790) and his family were recorded as living there, on the shores of the Susquehanna River, in the 1850 U.S. Census. Following the bankruptcy, William Crammond, Archibald McCall, and Louis de Noailles were interested shareholders.

63. Philadelphia Deed Book D-73-117,118.

64. Philadelphia Deed Book D-9-485. For the sparse allocation of open land above Tenth Street, see A. P. Folie and R. Scot, *Plan of the City and Suburbs of Philadelphia* (1794).

65. Philadelphia Deed Book EF-10-496.

66. Ibid.

67. Philadelphia Deed Book D-73-128, recorded July 22, 1798. The recorded date suggests that Dubois was unable to cover the purchase in July, which must have been within a day or two of Elizabeth's death, with the result that he was forced to sell at a loss. George Heberton was listed as a merchant at 15 South Second Street from 1793 to 1806.

68. Philadelphia Will Book T, p. 463.

69. Lillian Miller, ed., *The Selected Papers of Charles Willson Peale and His Family*, vol. 2, *The Artist as Museum Keeper, 1791–1810* (New Haven, CT: Yale University Press, 1988), pt. 2, p. 921 (January 12, 1806).

70. Ibid., p. 953 (April 5, 1806).

71. See note 13.

72. Philadelphia Will Book 2A, no. 111, p. 189. George H. and Elizabeth were born after August 1804.

73. At his death Dubois owned property in Union County; 280 acres in Susquehanna County; forty-eight tracts in Luzerne County; other property in Pennsylvania, New York, and Georgia; 113,000 acres in North Carolina; 10,000 acres in Harrison County, Virginia; and various properties in the city of Philadelphia. For a list of Dubois's correspondents in these states, and more, see "Accessions Received through the Year 1965," pp. 728–30, Hagley Museum and Library.

74. Meredith Family Papers, box 44, Dubois Estate, HSP. In 1811 the lands, tenements, and hereditaments of Dubois's Cumberland County estate were seized; for his debts, see *Trenton Federalist*, June 6, 1811. After Mary M. Dubois died in 1826, the remainder of the estate was turned over to the lawyer Charles Meredith; it was still being settled in 1844.

75. Leased to Mrs. Wurts and son, c. 1807–9; to Rufus Petcher, 1809–10; to Timothy Matlack, 1810; and to John Owen, 1822; Meredith Family Papers, box 44, Dubois Estate, HSP.

76. Philadelphia Administration Book N, no. 192, p. 160.

77. Abraham Dubois, Letter Book, Hagley Museum and Library.

78. Ibid.

79. Ibid.

80. Ibid. Jane Dubois married Charles Calvert Egerton in Baltimore on February 5, 1807; *True American* (Bedford, PA) and *Poulson's American Daily Advertiser* (Philadelphia), February 16, 1807.

81. Robert Aitkin, Account Book, HSP. With thanks to Jim Gergat for bringing this manuscript to my attention and James Green, Library Company of Philadelphia, for the full titles. See Andrew Fuller, *The Gospel Its Own Witness, or The Holy Nature, and Divine Harmony of the Christian Religion Contrasted with the Immorality and Absurdity of Deism* (London: Clipstone, 1802); *The Complaint, or Night-Thoughts on Life, Death, and Immortality* (London: printed for R. Dodsley, 1742); Herman Witsius, *The Oeconomy of the Covenants, between God and Man, Comprehending a Complete Body of Divinity* (New York: printed by Thomas Kirk, 1804).

Cat. 200

Abraham Dubois Sr.
Cream Pot

1779–85

MARK: AD (in oval, three times on underside around centering dot; cat. 200-1)

Height 5⅞ inches (14.9 cm), width 4⅞ inches (12.4 cm), diam. foot 2½ inches (6.4 cm)

Weight 5 oz. 13 dwt. 18 gr.

Gift of the McNeil Americana Collection, 2005-68-22

PROVENANCE: This cream pot apparently descended in the family of Sarah Lukens Keene (1784–1866) of Bristol, Pennsylvania, who bequeathed her family home and its furnishings to the Episcopal Church as the Keene Home for Aged Gentlewomen. The Home closed in 1962, and the furnishings were sold at auction in the following year, when the cream pot was purchased by the donor (Samuel T. Freeman & Co., Philadelphia, *Early American Furniture . . . from the Estate of the Late Sarah L. Keene "The Keene Home,"* September 23–25, 1963, lot 266).

The shape of this plain cream pot was typical of the form as made by Dubois, as is the toothlike squared bead that he used around the foot. The handle with a sweep and twist was a design generally attributed to makers in New York.[1] It seems somewhat short when compared with other handles by Dubois. Given the maker's New York connections, the handle may be original. If a replacement, it was carefully applied. BBG

1. See the cream pot by John Hutton (PMA 1982-24-2); see also the cream pot by Elias Pelletreau, in Buhler and Hood 1970, p. 110, cat. 671.

Cat. 200-1

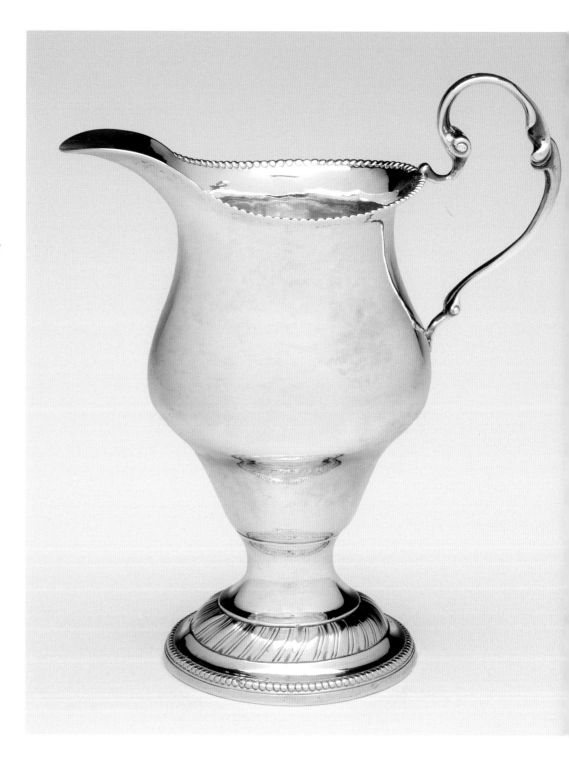

Cat. 201

Abraham Dubois Sr.

Brooch

1780–1800
Gold
MARK: AD (in oval, twice on reverse; cat. 200-1)
INSCRIPTION: M T (engraved script, on obverse)
Length 1 inch (2.5 cm), width $^{11}/_{16}$ inch (1.8 cm)
Weight 2 dwt. 15 gr.
Gift of Mrs. Henry W. Breyer Sr., 1964-28-1

PROVENANCE: Parke-Bernet Galleries, Inc., New York, *Arts and Crafts of Pennsylvania and Other Notable Americana: The Collection of the Late Arthur J. Sussel, Philadelphia*, October 23–25, 1958, no. 442; the donor presumably acquired the brooch at this sale.

This small, oval brooch is fitted on the reverse with a pin that pivots between two posts at one end and is secured when its sharp point slips into a narrow bracket. BBG

Cat. 202

Abraham Dubois Sr.

Four Tablespoons

1780–90
MARK (on each): AD (in oval, twice on back of handle; cat. 200-1)
INSCRIPTION: M " P (engraved, at top of obverse of handle)
Length 5$^{1}/_{16}$ inches (12.9 cm),
Weight 6 dwt. 2 gr. to 6 dwt. 12 gr.
Purchased with the Director's Discretionary Fund, 1967-213-1–4

PROVENANCE: Edith Newlin Fell (1879–1967), Philadelphia and Bucks County, PA; Samuel T. Freeman & Co., *Important 18th Century Pennsylvania Furniture: The Estate of the Late Edith Newlin Fell*, October 20, 1967, lot 21.

On the reverse of the bowl of each spoon there is the raised design of a long-necked bird with a crest (cat. 202-1). Facing left but twisting right, the bird holds an olive branch in its beak. The design is very similar to a pattern used by Christian Wiltberger (q.v.).[1] The dimensions of these spoons are consistent, and the variations in weight are probably related to wear at the tips of the bowls. BBG

1. Donald L. Fennimore, *Flights of Fancy: American Silver Bird-Decorated Spoons* (Winterthur, DE: Winterthur Museum, 2000), p. 8, fig. 8; Hollan 2013, p. 272. For other bird-back spoons in the Museum's collection, see the examples by Richard Humphreys (1976-103-6–8; 1990-55-27), Lewis and Smith (1991-97-1), Joseph junior and Nathaniel Richardson (1981-65-4), and Christian Wiltberger (1996-8-1–5).

Cat. 202-1

Cat. 203

Abraham Dubois Sr.
Cream Pot

1780–90

MARK: AD (in oval, on underside; cats. 203-1, 204-1)

INSCRIPTION: J M Y (engraved script, on front under pouring lip below repoussé garland; cat. 203-2)

Height 5¼ inches (13.3 cm), width 5³⁄₁₆ inches (13.2 cm)
Weight 5 oz. 5 dwt. 1½ gr.

Purchased with the Joseph E. Temple Fund, 1921-56-2

PROVENANCE: Willoughby Farr, Edgewater, NJ.

EXHIBITED: Pennsylvania Building, New York World's Fair, April 30, 1939–October 31, 1940; Philadelphia 1956, cat. 79.

PUBLISHED: S. W. W., "Two Interesting Pieces of Early Philadelphia Silversmithing," *Pennsylvania Museum Bulletin*, no. 70 (February 1922), pp. 20–21; Prime 1929, p. 60; Edward Wenham, "The Silversmiths of Early Philadelphia," *The Antiquarian*, September 1929, p. 49; Avery 1930, p. 329, pl. LVII; Thorn 1949, p. 105; McGoey 2016, p. 92.

Cat. 203-1

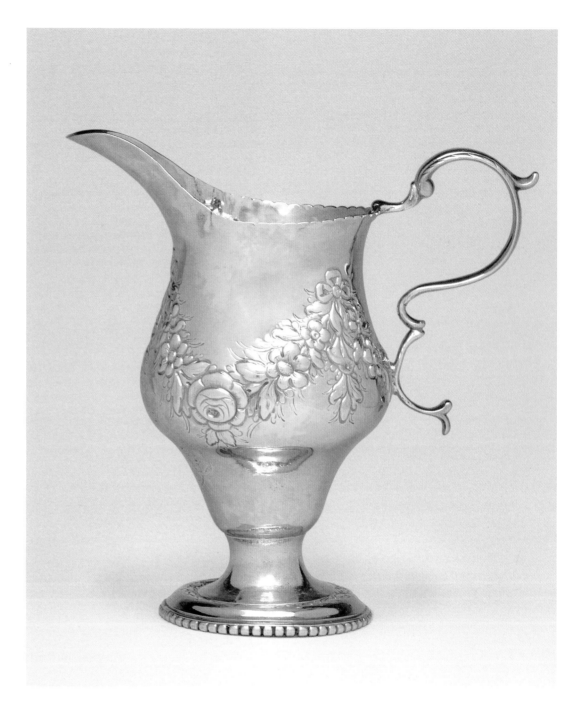

There are at least two other cream pots by Dubois that feature this high-waisted, reverse-pear shape and long, flaring pouring spout.[1] One of the pots has a similar but more stylized garland of repoussé work. The engraved initials, although miniaturized, are by the same hand, or at least derived from the same engraver's manual, and are similar to those on objects by Joseph Anthony (q.v.).[2]

A drum-shaped, Federal-style teapot marked "A·Dubois" in a rectangle—the mark usually attributed to Dubois junior—bears the same fine "JMY" initials by the same engraver's hand.[3] With the exception of the similar toothlike bead around the bases of each piece and the foliate initials, the rococo cream pot and the Federal teapot illustrate the practice of combining styles, which was not unusual in Philadelphia between 1790 and 1810.[4] The "AD" mark on this cream pot is also found together with the "A·Dubois" mark on another drum-shaped teapot (cat. 204), suggesting that their usage was contemporaneous. BBG

Cat. 203-2

1. See James Graham & Sons, New York, advertisement, *Antiques*, October 1961, p. 300; and curatorial files, AA, PMA.
2. See the coffeepot (cat. 12) and slop bowl (cat. 16) by Joseph Anthony.
3. W. L. Harris, "Some Significant Silver," *Antiques*, vol. 9, no. 3 (March 1926), p. 162, fig. 13. The initials "JMY" may have belonged to John Young (1762–1840), a distinguished judge, and Maria Barclay Young, who married at Swedes' Church in Philadelphia on November 12, 1794; *Pennsylvania Archives*, 2nd ser. (1896), vol. 8, p. 573.
4. For another example, see the tea service by William Hollingshead (PMA 1956-84-28a,b,29a,b,30a,b).

Cat. 204

Abraham Dubois Sr. or Jr.
Two Teapots

1790–1800

2008-29-1a,b
MARK: AD (in oval, four times on underside; cats. 203-1,
204-1); A·Dubois (in rectangle, on underside;
cat. 204-1)
INSCRIPTION: oz dwt /16 " 10 (scratched, on underside)
Height 6¾ inches (17.2 cm), width 9⅞ inches (25.1 cm),
diam. 4½ inches (11.4 cm)
Gross weight 16 oz. 20 dwt.

2008-29-2a,b
MARKS: A·Dubois (in rectangle, twice on underside;
cat. 204-1)
INSCRIPTION: oz dwt / 19 " 6 (scratched, on underside)
Height 7³⁄₁₆ inches (18.3 cm), width 10⅜ inches (26.4 cm),
diam. 4¾ inches (12.1 cm)
Gross weight 19 oz. 6 dwt. 13 gr.
Gift of the Estate of Allison Virginia Smith, 2008-29-1a,b;
2008-29-2a,b

PROVENANCE: These teapots descended in the family of the
donor, Allison Smith (1917–2007), with no specific his-
tory. Among the most likely candidates for their original
owners were her father's maternal great-great-grandpar-
ents, Israel (1770–1811) and Mary Lewis Bringhurst
(1771–1846), who were married on September 27,
1792. Bringhurst was living in Philadelphia at the time of
the U.S. census of 1790, and after their marriage the cou-
ple lived in Upper Providence Township, Montgomery
County.[1]

Cat. 204-1

Late eighteenth-century tea services sometimes
included separate teapots for green and black tea, or
for tea and hot water; a large tea and coffee service
by Joseph Richardson Jr. (q.v.) included two teapots
that were slightly different in size.[2] The minor differ-
ences in the dimensions and finishing of Dubois's
otherwise identical examples would have facilitated
the distinction between their contents when in use.
The pineapple finials are different castings, scaled
to each pot's dimensions, and the applied galleries
around the covers are also treated differently, with
an incised band below the gallery on the smaller
one. This smaller teapot is identical in almost every
detail and dimension to another example by Dubois
in the Metropolitan Museum of Art.[3] The cylindrical
shape would have been easy to fabricate by seam-
ing sheet metal, but Dubois and several of his con-
temporaries preferred the traditional method of
raising this form.[4] DLB

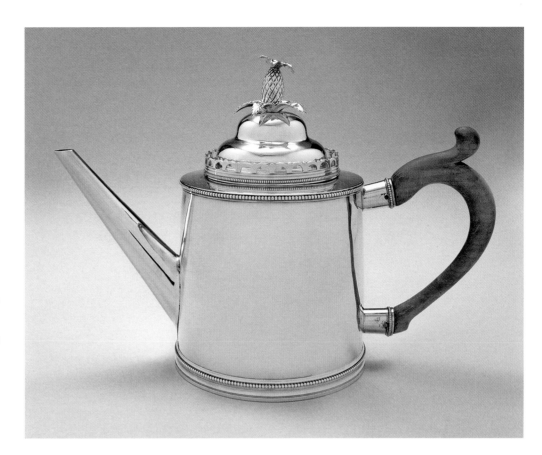

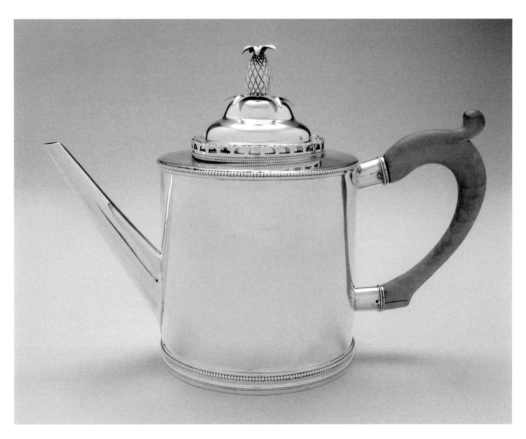

1. Genealogical information from the Joseph Leedom Lewis
family tree and the Harkness family tree, both Ancestry.com
(accessed July 15, 2014); U.S. Census 1790, 1800, 1810.
2. Quimby and Johnson 1995, cat. 446a–s.
3. Wees and Harvey 2013, p. 294 (35.73). This teapot is
engraved with the monogram "AMT," but the history of its
ownership is unknown.

4. See the teapots by Joseph junior and Nathaniel
Richardson (PMA 1964-115-1a,b) and Daniel Van Voorhis
(PMA 2002-18-1).

Cat. 205

Abraham Dubois Sr. or Jr.

Soup Ladle

1800–10
MARK: A·Dubois (on reverse; cat. 204-1)
INSCRIPTION: C / A·C (engraved in bright–cut oval, on front)
Length 14¾ inches (37.5 cm), diam. bowl 4¹⁄₁₆ inches
(10. 3 cm)
Weight 5 oz. 12 dwt. 1 gr.
Gift of Lucien Phillips, 1957-64-1

The large round bowl and the long handle made
this ladle especially suited for the service of stews
and soups from grand tureens. BBG

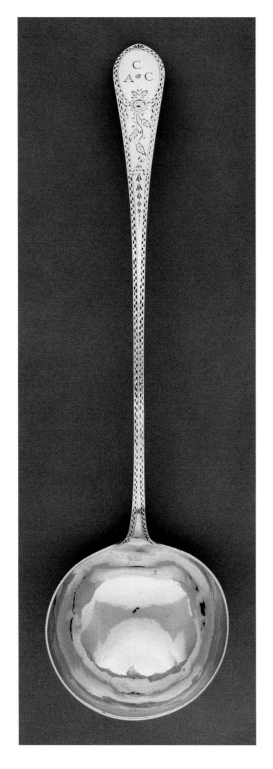

Cat. 206

Abraham Dubois Sr. or Jr.

Cream Pot

1800–5
MARK: A Dubois (in rectangle, on underside; cat. 206-1)
INSCRIPTION: H G (engraved script, on one side)
Height 5⅝ inches (14.3 cm), width 5⅜ inches (13.7 cm),
diam. bottom 3 inches (7.6 cm)
Weight 5 oz. 2 gr.
Purchased with Museum funds, 1950-12-2
PROVENANCE: Albany Institute of History and Art,
Albany, NY.

Cat. 206-1

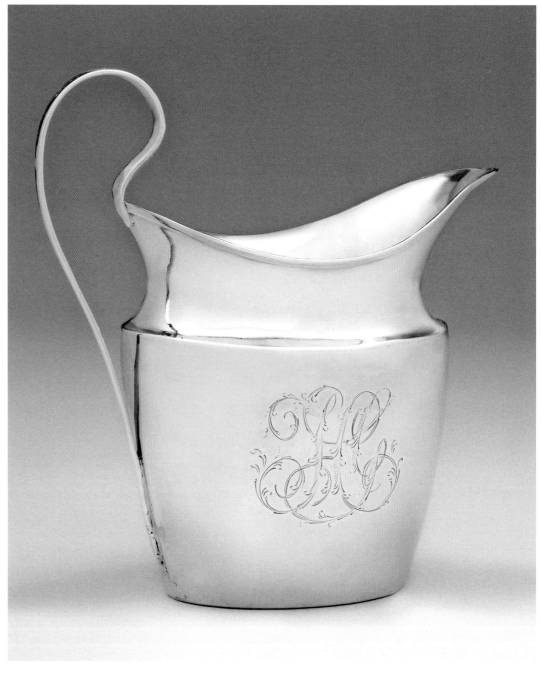

Cream pots were most often made in Philadel-
phia in the urn shape. The style of this example was
described by Dubois after a trip to New England in
October 1805, when he wrote to the Messers R. & H.
Farnham in Boston: "In looking over your order we
are at a loss to know how the two sugar dishes are
to be made which you have put down without foot
etc. from which I suppose they are to be made with-
out a cover also and nearly the shape of the oval
bottom tea pots but no mention of handles. You
will therefore have the goodness to inform my son
in time more particularly how they are to be made."[1]
Joseph Anthony (q.v.) also used this accomplished
engraver.[2] BBG

1. Abraham Dubois, letter book, 1803–16, Hagley Museum
and Library, Wilmington.
2. See the coffeepot (cat. 12) and slop bowl (cat. 16) by
Joseph Anthony.

Joseph Dubois

Freehold, New Jersey, born 1767
New York City, died 1798

Joseph Dubois was born in Freehold, New Jersey, and baptized in the Dutch Reformed Church on August 9, 1767.[1] He was the eldest child of the Reverend Benjamin Dubois (1739–1827), the church's minister, and Femmentje (also Phemertje or Phoebe) Denise (1743–1839), who were married in 1765. Joseph's career as a silversmith benefited from his kinship to a network of fellow craftsmen. Abraham Dubois Sr. (q.v.) was his third cousin, and Daniel Van Voorhis (q.v.) was the second cousin of his mother's brother-in-law John Schanck (1751–1834).[2] In 1784 Dubois's first cousin Garret Schanck (q.v.) was apprenticed to Van Voorhis in New York, and it is possible that Dubois also apprenticed with him, perhaps when Van Voorhis was working in Princeton in 1782–84 and continuing after his move to New York City.

Dubois presumably had completed his training by October 1789, when he married Elizabeth Duryea (1765–1795)[3] and opened his first shop at 17 Great Dock Street in New York. He and Elizabeth had one son, Benjamin Isaac Dubois, who lived to adulthood. Dubois worked at three different addresses in New York during his nine-year career. In 1793 he moved to 87 Pearl Street, and in the following year moved to 81 John Street, where he remained until his death. It seems likely that he trained his younger brother, Teunis Denise Dubois (1773–1843), who in February 1794 joined Joseph's shop as a journeyman, receiving room and board in addition to his weekly wages. The brothers formed a partnership in June 1795 that lasted until the spring of 1797, when Teunis established his own shop nearby at 90 John Street. Elizabeth Dubois and Garret Schanck both died in 1795, probably during the yellow-fever epidemic. Joseph Dubois appraised the inventory of Schanck's estate, and in 1796 married Schanck's widow, Sarah Van Dyke Schanck (1769–1867).[4] During a second yellow-fever epidemic in New York, Joseph Dubois died and was buried on August 27, 1798.[5] The administration of his estate was granted on November 23, 1798, to his widow and Alexander Campbell and Abraham Lebagh; in addition to these three, the bond was posted by William Hillyer of New York City and Matthias Van Dyke of Kings County, New York (both of whom had done the same for Garret Schanck's estate).[6] DLB

1. Biographical information for Joseph and Teunis Dubois is taken from Christine Wallace Laidlaw, "Silver by the Dozen: The Wholesale Business of Teunis D. DuBois," *Winterthur Portfolio*, vol. 23, no. 1 (Spring 1988), pp. 25–26, 32–33; Paul von Khrum, *Silversmiths of New York City, 1684–1850* (New York: printed by the author, 1978), p. 41; Waters, McKinsey, and Ward 2000, vol. 2, pp. 309–10, 391, 419–20; and Sarah B. Heald, "'With Elegance and Dispatch': Monmouth County Silversmiths, 1775–1864," *Silver Magazine*, vol. 20, no. 1 (January–February 1987), p. 12.

2. Joseph Dubois and Abraham Dubois Sr. were great-great-grandsons of Louis Dubois (1626–1697); Joseph was descended from Louis's son Jacob (baptized 1661). Ralph Lefevre, *History of New Paltz, New York and Its Old Families from 1678 to 1820*, 2nd ed. (Albany: Fort Orange Press, 1909), pp. 128–30.

3. Biographical information for Elizabeth Duryea is taken from the Mulhern family tree, Ancestry.com (accessed June 24, 2013).

4. Biographical information for Sarah Van Dyke Schanck is taken from the Hartrampf-Fischer family tree, Ancestry.com (accessed June 24, 2013); and Kenneth Scott and James A. Owre, *Genealogical Data from Inventories of New York Estates, 1666–1825* (New York: New York Genealogical and Biographical Society, 1970), p. 129.

5. *Records of Burials in the Dutch Church, New York* (New York: South Reformed Church, 1899), p. 161.

6. Kenneth Scott, *Genealogical Data from New York Administration Bonds, 1753–1799: Collections of the New York Genealogical and Biographical Society, vol. 10* (New York: the Society, 1969), pp. 45, 120.

Cat. 207
Joseph Dubois
Four Tablespoons

1789–98

MARKS (on each): J·D (in rectangle with chamfered corners) / [eagle's head facing right in oval] (all on back of handle; cat. 207-1)

INSCRIPTION (on each): U B C (engraved monogram script, lengthwise in reserve, on front of handle)

2012-96-2, 2012-96-4: Length 8 11/16 inches (22 cm)
Weight 1 oz. 18 dwt. 5 gr.

2012-96-3: Length 8 9/16 inches (21.8 cm)
Weight 1 oz. 17 dwt.

2012-96-5: Length 8 3/8 inches (21.3 cm)
Weight 1 oz. 16 dwt. 18 gr.

Gift of the McNeil Americana Collection, 2012-96-2–5

PROVENANCE: Sotheby Parke Bernet, New York, *Fine American and English Silver*, March 25, 1969, sale 2825, lot 84.[1]

During his nine-year career, Joseph Dubois produced objects for other silversmiths as well as for his own shop. The eagle's-head mark on this set of spoons appears on silver with one of his marks (as here), with the mark of his partnership with Teunis, and with the mark of William Garret Forbes (1751–1840), who presumably purchased such pieces from Dubois to retail.[2] Hollowware made by Dubois is less

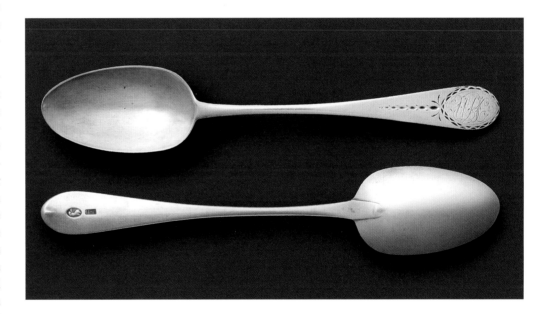

Cat. 207-1

common than flatware; among the surviving examples is an alms basin presented by Leonard Bleecker in 1792 to the Dutch Reformed Church in New York.[3] DLB

1. The spoons were listed by the auction house as by John David Jr. (q.v.).
2. Christine Wallace Laidlaw, "Silver by the Dozen: The Wholesale Business of Teunis D. DuBois," *Winterthur Portfolio*, vol. 23, no. 1 (Spring 1988), pp. 26–32.
3. Jones 1913, p. 330. Another example is a neoclassical sugar urn at the Museum of the City of New York; Waters, McKinsey, and Ward 2000, vol. 2, cat. 152.

Duhme & Co.

| Cincinnati, Ohio, 1842–1910

The city of Cincinnati was founded about 1788 and became a center for commerce between the East and the new settlements west of the Mississippi. By the 1850s it was America's fastest growing city.[1] Herman G. Duhme (1819–1888; fig. 72) was born in Osnabruck, Hanover, Germany, and emigrated with his family and others to the United States in 1834. They settled first in Springfield, Ohio.[2]

In 1838 Duhme moved to Cincinnati, where he had jobs in dry goods and jewelry. In 1843 he and his brother John (died 1853) partnered in developing a jewelry business, Duhme & Co., which at first was largely occupied with importing watches. Their business grew along with the expansion of the city. The company suffered reverses in the depression of 1857, but by 1869 the firm employed more than a hundred workmen, many from Europe, and initiated the use of machinery and steam power in the manufacture of sterling silver. The firm was most prominent in America, however, for its hand

processes; Duhme & Co. was distinguished for making solid silver objects in elaborate Classical Revival, Rococo Revival, and Japanesque styles. In 1879 the company opened a large store at Fourth and Walnut streets in Cincinnati, exhibiting the firm's silver in glass vitrines that lined the walls.

Herman Duhme died in 1888.[3] In 1896 jewelry was reintroduced as an important line for Duhme & Co., and it became largely a retail firm. The company eschewed the use of the rolling and stamping machines introduced by the Gorham Manufacturing Company (q.v.) in 1853, and in the end the handcrafted products could not carry the firm financially. When the company was forced into bankruptcy in 1897, family members purchased assets. Two sons, Frank and Herman, carried on the business from 1899 to 1904 as Duhme Jewelry Company. The business closed in 1910.[4] BBG

1. For detailed accounts of the firm of Duhme (which operated under several variations of the name), see Dehan 2014, pp. 100–149; and James R. Hillard, et al., "Duhme & Company of Cincinnati," pt. 1, *Silver Magazine*, vol. 29, no. 5 (September/October 1997), pp. 18–23, and pt. 2, *Silver Magazine*, vol. 29, no. 6 (November/December 1997), pp. 52–54.

2. Dehan 2014, p. 100; and Elizabeth D. Beckman, "Duhme & Company Cincinnati Silversmiths," *Silver Magazine*, vol. 21, no. 2 (March/April 1988), pp. 33–35.

3. Rainwater and Redfield 1998, p. 50.

4. Ibid., p. 142.

Fig. 72. Engraved image of Herman G. Duhme, from Armin Tenner, *Cincinnati Sonst und Jetzt: Eine geschichte Cincinnati's und seiner verdienstvollen bürger deutscher zunge…* (Cincinnati: Druck van Mecklenborg & Rosenthal, 1878), opposite p. 41. New York Public Library, Astor, Lenox and Tilden Foundations, Milstein Division of United States History, Local History & Genealogy

Cat. 208
Duhme & Co.
Dessert Spoon

1870–85
MARK: DUHME& CO (incuse, on back of handle; cat. 209–1)
INSCRIPTION: From D. & A.J. / to J. & E.H. (engraved script, on back of handle)
Length 7³⁄₁₆ inches (18.3 cm)
Weight 1 oz. 4 dwt. 10 gr.
Gift of D. Frederick Baker from the Baker/Pisano Collection, 2016-134-13

As Amy Dehan has noted, Duhme & Co. began manufacturing flatware in the late 1860s, featuring exaggerated "fiddle" handles with twist sections, embellished with engraving.[1] The only medallion pattern the firm offered in a full range of flatware forms featured the head of Mercury.[2] The dies used for striking different sizes of the applied medallions varied greatly in quality; the medallion found on smaller pieces like this spoon lacked the detail and finesse of the larger medallions on ladles. DLB

1. Dehan 2014, pp. 102–6.
2. Illus. in "Duhme & Company, Cincinnati, Silversmiths," *Silver Magazine*, vol. 21, no. 2 (March-April), p. 36.

Cat. 209
Duhme & Co.
Serving Spoon

1870–85
MARK: DUHME& CO (incuse, on back of handle; cat. 209-1)
Length 9½ inches (24.1 cm)
Weight 2 oz. 4 dwt. 15 gr.
Gift of Beverly A. Wilson, 2010-206-50

Hunting subjects became extremely popular for dining room furnishings and tableware by the middle of the nineteenth century, and stags appeared on a wide variety of silver hollowware and flatware. Describing this taste as "alimentary imperialism," Kenneth Ames observed that hunting motifs celebrated both humans' domination of the earth's resources and their civilizing role in transforming so-called raw nature into prepared food. The traditional identification of hunting as an aristocratic pastime further enhanced its popularity.[1] The terminal of this handle is another variation of the complex *Fiddle* patterns made by Duhme & Co. DLB

1. Kenneth L. Ames, "Death in the Dining Room," in *Death in the Dining Room and Other Tales of Victorian Culture* (Philadelphia: Temple University Press, 1992), pp. 71–81.

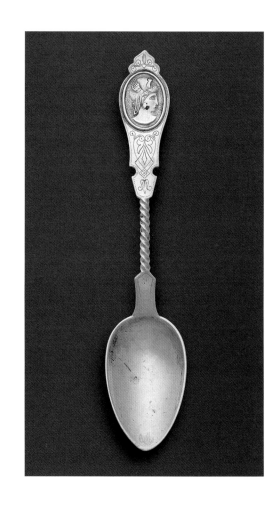

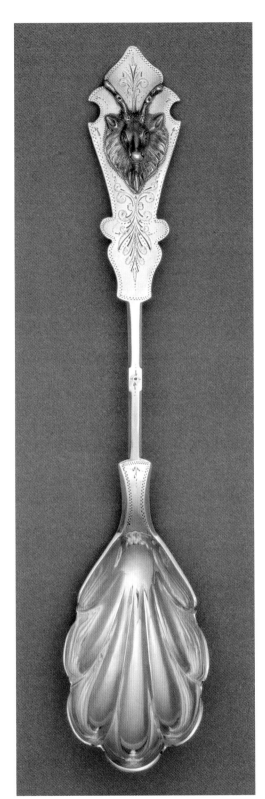

Cat. 210

Duhme & Co.
Standing Cup

1870–90

MARK: DUHME& CO (incuse, on underside of foot;
cat. 209-1)

INSCRIPTION: E B L (engraved script in circular reserve,
on front)

Height 9 inches (22.9 cm), diam. top 4¼ inches (10.8 cm),
diam. base 4 inches (10.2 cm)

Weight 10 oz. 3 dwt. 3 gr.

Gift of Elizabeth L. McAdams, 1994-89-2

PROVENANCE: The cup descended to the donor, Elizabeth
Lish McAdams (1917–1997), from her family.

This tall ceremonial form in coin silver was machine spun.[1] It shows little wear and may have been one of a pair of cups presented to a bride and groom for wedding toasts. The donor stated that she let her friends use it as a "loving cup" at weddings.[2] The interior of the cup is gilt. BBG

1. Although Duhme & Company advertised that the firm did not do rolling and stamping, many of its small hollowware items were spun.
2. Elizabeth L. McAdams to Anne d'Harnoncourt, July 9, 1995, curatorial files, AA, PMA.

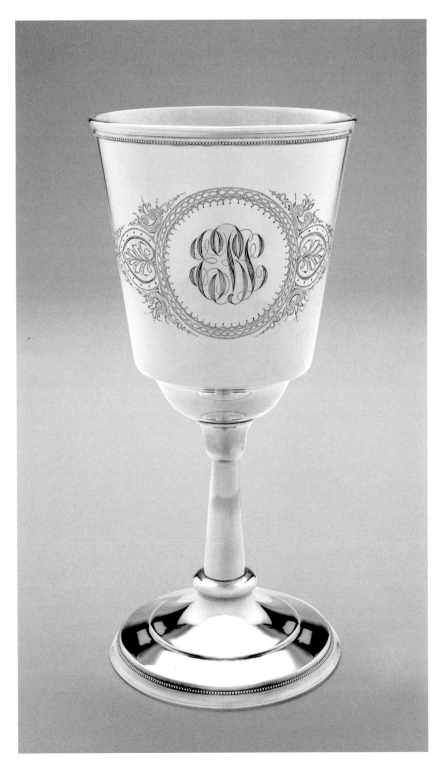

John B. Dumoutet Sr.

Bourges, France, born c. 1759?
Unknown, died after 1820

John B. Dumoutet Jr.

Bourges, France, born 1761
Philadelphia, died 1813

There were two John B. Dumoutets in Philadelphia in 1798 when they declared their intent to become citizens of the United States, and both were goldsmiths and jewelers. The indication of senior or junior in documents, directory listings, and newspaper advertisements also makes clear that there were two of the same name, and that they came not from the West Indies with so many of the French escaping from the riots in Saint-Domingue, but directly from France.

Among the copious materials collected in the mid-twentieth century by genealogist Francis James Dallett, who was interested in émigré French families and the founding of the French Benevolent Society in Philadelphia, is a copy of a letter he wrote to Bourges, France, seeking information about the Dumoutets and suggesting that the Dumoutets were brothers.[1] Dallett's notes also include his transcription of relevant information he likely found in immigration records: "John Baptiste Dumoutet age 32, native of Bourges in Berry, France, goldsmith and jeweler, came to Philadelphia 3 April 1792 to carry on business, and since here. . . . Jean Dumoutet l'aine [elder] age 39, native of Bourges in Berry in France, goldsmith and jeweler, came to Philadelphia August 21, 1798 to carry on business. Intends to be a citizen." Both records were dated December 15, 1798.[2] The 1798 date on the Dumoutets' documents in Philadelphia is significant. The Alien and Sedition Acts passed in 1798 required a residence in the United States of fourteen years, with five years' residence in a state, to be eligible to make a declaration of intention. This resulted in an exodus of French émigrés living in eastern cities, especially Philadelphia, which had become the location of choice of French refugees from the Saint-Domingue riots of 1790 and the French Revolution.[3] In 1802 the law reverted to a 1795 statute that required simply a

five-year residency for eligibility. On December 22, 1807, "John B. Dumoutet" stated in the Supreme Court of Pennsylvania, in his Petition of Naturalization, that "he was residing . . . in the United States between January 29, 1795 and June 18, 1798 and has resided sixteen years now last past within the United States and all that time within the State of Pennsylvania."[4]

The Philadelphia Dumoutets were likely members of the eighteenth-century family of merchant-goldsmiths in Bourges, in the district of Cher, France, where there were two of the name, designated as I and II. Jean-Baptiste Dumoutet I (born 1742), who entered his apprenticeship with master goldsmith Pierre Desbans (1726–1793) at the age of twenty in 1762, was declared maître in 1771. Jean-Baptiste Dumoutet II (born 1761), nephew and godson of Dumoutet I, entered an apprenticeship with his uncle in 1775, at the age of fourteen, and due to the relationship the elder reduced his usual fee in half. Dumoutet I was in France in 1793 after the revolution, succeeding Desbans in caring for and documenting the silver and gold vessels that belonged to the church at Bourges.[5] The first mention of Dumoutet I in Philadelphia was in 1798, in the immigration notice. He may have arrived at the behest of Dumoutet II, who by 1796 had found a ready market for French jewelry and products in Philadelphia.

If the designation as "elder" in Dallett's notes, and Dumoutet I in French records, became "senior" in Philadelphia, and Dumoutet II was the "junior," the two men were indeed the French goldsmiths. The first names of Dumoutet I and II were published in Philadelphia directories and newspapers, and recorded in deeds as "Jean Baptiste," "John," and "J. B." After Dumoutet senior's arrival in 1798, their names were noted as senior and junior, and the elder established himself at a different address on South Second Street. In a will written in Philadelphia on May 23, 1813, "John Baptiste Dumoutet" (with no designation as to junior or senior) wrote that he was a native of Cher, France, but had been "residing for sometime past in the City of Philadelphia." The bequests to his children and wife included in the will identify him as Dumoutet junior.[6] No will has turned up in Philadelphia for another J. B. Dumoutet, nor is Dumoutet senior mentioned in the will of 1813.[7] If Dumoutet junior arrived in 1791/92 having completed an apprenticeship in Bourges as a goldsmith, he would have found immediate employment as a journeyman in Philadelphia with one of the French shops already established. His prompt entry into the real estate market suggests that he came with some financial assets as well as the mind of an investor, a combination

that in Philadelphia was likely to bring security and success.

Possibly responding to an advertisement in *Dunlap's American Daily Advertiser* of March 31, 1792, for "a valuable piece of land in Frankfort . . . also a convenient Messuage and lot in Elm Street," Dumoutet junior purchased 71 Elm (North) Street on December 27, 1792, from the auctioneer William Shannon and his wife Jane for £550 in gold and silver coin.[8] The U.S. Direct Tax records of October 1, 1798, for Oxford Township note that John Baptiste Dumoutet had purchased from Joseph J. Miller's estate a 15-by-30-foot, two-story stone house with two perches of land on Adams Road, valued at $1,000, and another piece of adjoining land of the same value.[9] In 1799, 1800, 1802, and 1812, Dumoutet junior purchased from owners' and sheriffs' sales several other contiguous parcels of a property in Frankford, Oxford Township, in Northeast Philadelphia, possibly parts of the "valuable" property in the advertisement of March 31, 1792. Located on or near the main road between Philadelphia, Bristol, and New York, the property had belonged to Rebecca Mifflin and was being subdivided and developed. It was known for the handsome estates of the midcentury merchants Edward Stiles at Port Royal (c. 1761) and Abel James at Chalkley Hall (1750–70).

Oxford Township was developing quickly and becoming investment property. Frankford became an industrial center for textiles and mills.[10] Dumoutet junior purchased one piece of land on the southeast side of Main Street for $600 from Peter Neff and his wife Rebecca in 1799, to which he had added two houses and barns by 1813.[11] In 1800 he purchased at a sheriff's sale from John Travis for $2,750 two stone houses and land on Paul Street as well as the contiguous lots on the south side of Adams Road.[12] In April 1802 he purchased from John Anan and his wife Elizabeth for $300 a lot of one acre with a frame building on the northeast side of Adams Road.[13] In October 1802 he purchased for $200 "silver money" a piece of ground composed of two contiguous lots, again on the northeast side of Adams Road.[14] These deeds were all recorded on July 24, 1804. Dumoutet's last purchase was on May 20, 1812, from the merchant John R. Neff for $600: property on the southeast side of Main Street in Frankford, continuing 300 feet to Paul Street and bounded by his other properties.[15] He also owned a piece of ground in Southwark on German Street between Second and Third streets, as well as property in Northumberland County.[16]

Dumoutet junior's first location in Philadelphia, 71 Elm Street, was a brick house and a lot of ground on the north side of Elm Street, which ran east-west one block between Second and

Third streets between Vine and Sassafras (Race). The property had frontage of 18 feet, 5 inches on Elm and 75 feet in length north and south, and it was "subject to a ground rent of five Spanish pistoles and one half of a pistole of fine gold or value thereof in lawful money of Pennsylvania payable to John Pemberton and heirs."[17] Dumoutet must have occupied Elm Street promptly, as he is listed in the 1793 directory: "John Baptiste Dumoutet gs[goldsmith] 71 Elm Street." This address was in a French neighborhood just north of Market Street. In 1794 "Georgean & Philip," French goldsmiths and jewelers, were at number 74 on the south side of Elm Street. In 1797, when Dumoutet's corner property was identified as 75 North Third Street, F. Poincignon, goldsmith, was at 55 North Third Street.

On February 17, 1793, John Baptiste and Elizabeth Therese Dumoutet's daughter Joanna was baptized at Holy Trinity Church, which had been formed in 1784 to serve a Catholic congregation, largely German at that date. The baptismal sponsors were Etienne Dumoutet and Joanna Sophia Coulon ("single").[18] No further information about this marriage, Etienne Dumoutet, Joanna Coulon, or the child Joanna has turned up. A poignant note in the Philadelphia directory of 1795 immediately following the entries for Elm Street reads: "34 persons died in this Street of the epidemic in 1793." Might members of the Dumoutet household have been among those thirty-four victims of the rampant yellow fever? It was all around them. On November 22, 1793, J. B. Dumoutet junior served as witness to the will of Joseph Bret, who died of yellow fever.[19]

There seem to have been two other children from the marriage of John Baptiste and Elizabeth Dumoutet: Mary Dinah, born 1795, who is not listed in John Baptiste's will and must have died before him, and Amelia Mary Anna, born in 1797, after the Dumoutets' move to 57 South Second Street.[20] The family may have moved for health reasons or, more likely, because he was expanding his business; South Second Street was a center of the silver and jewelry trade in the 1790s.[21] Dumoutet retained the Elm Street property as investment, and it was specified in his will as a bequest to his daughter Jane for the same purpose.[22]

On August 9, 1796, Dumoutet junior placed an advertisement in Philadelphia's *Federal Gazette and Daily Advertiser*: "Those who are desirous to have their likenesses taken in miniature . . . address the artist at Mr. Dumoutet's jeweler at No. 57 South Second Street." The artist may have been David Boudon (1748–1816), an itinerant miniature painter from Geneva, Switzerland, who was in Charleston in 1794, and again in Philadelphia in 1797. On December 3, 1804, he advertised his services in the

Raleigh Register, stating that he could be reached through the shop of J. B. Dumoutet.[23] An oval, gold-framed miniature portrait in watercolor on ivory, identified as that of J. B. Dumoutet (Jr.) and dated about 1805, was probably done in Charleston, where Dumoutet junior had opened a shop in 1802.[24] The miniature is unattributed but similar to some signed by Boudon.[25]

On December 6, 1796, Dumoutet junior advertised in the Philadelphia *Courier Français* for a runaway mulatto, Auguste Gatereau. In 1796 Dumoutet took on Marie Louis Mercier from Paris for two years and seventeen days.[26] And then, in 1797, the yellow fever came again. Cornelius William Stafford, editor of the 1798 Philadelphia directory added a page at the back of his publication entitled "A Few Observations on the Yellow Fever," and recorded as follows: "In July 1797, the yellow fever again made its appearance in Philadelphia, and providentially for the city, it subsided so early as the October following. . . . The melancholy scene which presented itself in the year 1793, induced many on the confirmation of its being again in existence, to quit the city." Dumoutet junior "quit the city" in 1797, presumably with family and apprentice. In the August 17, 1797, issue of Trenton's *New Jersey Gazette*, Dumoutet announced that he had opened for business in Trenton as a goldsmith, jeweler, and hairworker and was then resident at the house of a Mr. Morris, tailor, "where he intends to stay during the epidemic in Philadelphia."[27] As suggested by Stafford, the yellow-fever episode in 1797 was considerably shorter than the previous one, and on December 9 Dumoutet was back in Philadelphia at 57 South Second Street, when he published a public apology, under the heading "Atonement," to the parents of his apprentice Samuel Fletcher, whom he had charged with stealing and running away.[28] On December 18, 1797, he took Peter Robinson, age eight, for thirteen years to learn the trade of gold- and silversmith.[29]

Dumoutet I (senior) arrived in 1798, settled at 193 South Second Street, and was listed promptly in the directory of 1799. He would have been about fifty-six years of age when he arrived. His arrival may have encouraged if not facilitated Dumoutet junior's acquisition of 55 South Second Street, next door to his property at number 57.[30] Dumoutet junior was established there by December 1, 1798, when he and J. B. Lemaire, silversmith on Carter's Alley, advertised in French and English in the *Aurora General Advertiser* the sale of the estate of a neighbor, deceased jeweler Claudius Edmé Chat, who had lived on Carter's Alley and probably died in the 1798 yellow-fever epidemic.[31] Dumoutet junior promptly advertised himself as

a hairworker and jewelry manufactory at his new address.[32] His wife Elizabeth may have died in the epidemic of 1798. No further records about her have emerged, but when daughters Mary Dinah and Amelia Mary Anna were baptized together at St. Joseph's Catholic Church on April 7, 1799, Mary Dinah's sponsors were John Baptiste Dumoutet and Elizabeth Kendall (noted as not Catholic); her godparents were Francis Bourgeras and Mary Dinah Chamberlain. Amelia Mary Anna's sponsors were John B. Dumoutet senior and, again, Elizabeth Kendall; her godparents were John Dumoutet and Mary Ann Gerfaux.[33] In the records of St. Joseph's kept by the Reverend Mr. Carr, J. B. Dumoutet married Elizabeth Kendall (not Catholic) on July 20, 1800; the witnesses were Robert Keating and Mary O'Brien.[34] Jane Dumoutet (1800–1850) and Emma J. (no dates found) were children of this second marriage. A record of baptisms has not turned up.

As jewelers and hairworkers, the two Dumoutets advertised almost the same merchandise and offered the same skills. The *Aurora General Advertiser* of November 27, 1799, carried one of the first advertisements of John Dumoutet Sr., goldsmith and jeweler: "JEWELERY OF ALL KINDS, Fash.d under his immediate inspection. . . . He works HAIR in the most elegant manner. . . . He has everything in his line of the best French fashions, executed by himself." Another advertisement in the same publication ran from November through December 1799 and noted that "John Dumoutet Senr. GOLDSMITH & JEWELLER was located at No. 193 South Second Street." Presumably the same shop and workmen served both Dumoutets. On November 7, 1800, Dumoutet junior was importing and advertised that he had "just received per the *Kensington*, from London, a quantity of fashionable goods."[35]

Both households were accounted for in the U.S. census of 1800. Dumoutet junior was at 55/57 South Second Street in the Walnut Ward, with a household of seventeen persons: seven males ages ten to fifteen, one male twenty-six to forty-four, four females under ten, three females sixteen to twenty-five, one female twenty-six to forty-four, and one other free person, probably Ann O'Brien, who was listed in Dumoutet junior's will for four hundred dollars as "a legacy not owed for service."[36] At 193 South Second Street in the New Market Ward, Dumoutet senior had a household of seven persons, one male under ten years of age, three males ten to fifteen, one male twenty-six to forty-four, one female sixteen to twenty-five, and one other free person.

This was a moment for heroes in Philadelphia. The president and congress were located

in the city until 1800, and there was competition for identification with George Washington in all media. On February 27, 1800, Dumoutet junior advertised in the *Philadelphia Gazette and Universal Daily Advertiser*: "John B. Dumoutet having discovered that there are a quantity of RINGS etc. with false likenesses of the late GENERAL WASHINGTON informs his customers and the Public, that he is the only person in Philadelphia that is in possession of the plate, WITH A TRUE LIKENESS OF GENERAL WASHINGTON IN UNIFORM DRESS. AS HAS BEEN ALLOWED BY THE BEST ARTISTS."[37] He may have been referring to the engraving of Washington by James Akin from Charleston, who arrived in Philadelphia about 1798, and who engraved a trade card for Dumoutet illustrating an elaborate pictorial "triumph" featuring the bust of Washington in uniform with all the accompanying symbols of liberty and freedom (fig. 73). Printed on white silk, these engravings may have been used by Dumoutet to line his jewelry boxes. He also had a plain, oval trade card.[38] Jean-Simon Chaudron (q.v.) in Philadelphia and John Cook & Co. in New York were two competitors.[39]

The Dumoutets had connections with fellow members of the Catholic congregations as well as the city's arts community. During his life Dumoutet junior (as John Baptiste) contributed to the Catholic churches. On June 12, 1796, he subscribed $25 to the building fund of St. Augustine's. Dumoutet was also a pew holder at St. Augustine's from June 7, 1801, until sometime in 1808, as was "Mrs. Dumoutet," from 1814 to 1820.[40] The family also attended St. Mary's Catholic Church, where John Dumoutet Jr. was buried on July 20, 1813.[41] Italian artist and drawing master Peter Ancora (1780–1844), who was in Philadelphia in 1805, named his children after the Dumoutets.[42] Dumoutet junior subscribed to Matthew Carey's *The School of Wisdom, or American Monitor* in 1800. His daughter Jane was elected a member of the Musical Fund Society.[43] In 1804 he signed a prospectus for the reorganization of the French Benevolent Society in Philadelphia.[44] On August 2, 1800, Dumoutet senior advertised in *Claypoole's American Daily Advertiser* for a runaway apprentice, the mulatto Peter Dumortier, age nineteen.

The *Philadelphia Gazette and Daily Advertiser* on August 28 and August 29, 1800, respectively, published the following notice: "Died after a long and tedious illness Mrs. Barbara Dumoutet, wife of John Dumoutet Sr. Jeweler." Given the date, it may have been yellow fever again. Dumoutet senior moved from 193 South Second Street in 1802, possibly as a result of losing his wife. He was listed once thereafter, in the 1803 directory, as

Fig. 73. Trade card of J. B. Dumoutet Jr. on white silk, c. 1800. James Akin, engraver. New-York Historical Society, Bella C. Landauer Collection of Business and Advertising Ephemera. Photo: © New-York Historical Society

"John Dumoutet, goldsmith, 28 Kunckle Street," in the Northern Liberties. After this he does not appear in Philadelphia directories, and the suffix senior no longer appears in family business advertisements.[45]

Among the prominent Philadelphians whom Dumoutet junior or senior supplied with "Filagree and fine pearl necklaces, Lockets, enamelled with Diamond, Topaz and fine pearls, Gold and silver Thread, Ditto Spangles,"[46] was the merchant Stephen Girard, who purchased nine feet of gold chain costing $51.50 and a locket and latch at $2.00.[47] By 1802 Dumoutet junior had opened a shop in Charleston, and his first advertisement placed there noted that he had moved his shop from Meetinghouse Street to 120 Broad Street. He listed the above "trinkets" while adding discreetly at the bottom of the list—after "Ladies and Gentlemen's Pocket Books"—"A Quantity of Silver ornaments for Indians," which he had advertised in Philadelphia on November 7, 1800, as "one thousand ounces of sterling silver Indian Ornaments."[48] The Dumoutets traveled between the two cities by boat. Elizabeth Dumoutet carried on the family business after her husband died, and on December 6, 1822, the Charleston *City Gazette and Commercial Daily Advertiser* noted: "Arrived yesterday the Ship Governor Hawkins, from Philadelphia . . . Mrs. Dumoutet, her order . . . Passengers, Mrs. Dumoutet and two children."

Dumoutet junior identified himself in Philadelphia and Charleston as a goldsmith, jeweler, and specialist in hairwork; Dumoutet senior

apparently never worked as a goldsmith in the United States. Whether Dumoutet junior himself produced any silver is not clear. He marked hollowware and flatware with his surname in rectangles and wavy rectangles.[49] His marked silver is rare, and perhaps silver was available only by special order. A silver-mounted etui (a small, ornamental case) is engraved around the top edge "J B Dumoutet No. 55 South 2nd St. Phila. also 120 South Broad St. Charleston S.C.," and the date of 1803 is engraved on the underside. It is inscribed but not marked.[50] Dumoutet is known to have retailed the work of other Philadelphia silversmiths. In the March 1803 accounts of Samuel Williamson (q.v.), John B. Dumoutet [junior] is charged with quantities of silver, probably for the Charleston shop: a slop bowl, ladles, ten sets of teaspoons, and two tumblers for a total of $116.66. In June 1804, Williamson supplied him with a plain coffeepot with handle and "pineapple" for $59.84, and on June 30, 1804, another plain teapot and a sugar dish.[51] A teapot with Williamson's mark overstruck with Dumoutet's surname mark documents this relationship (fig. 74; see also cat. 211).

A tea service with fluted bodies much more elaborate than any Dumoutet silver known to date may have been made by Dumoutet junior's close neighbor James Musgrave (q.v.), who was at 44 South Second Street from 1805 to 1810. It bears several marks of interest: "I•DUMOUTET" in a plain rectangle, "I•D" in a small rectangle, and four pseudo-hallmarks.[52] The plain rectangular mark seems to have been used before Dumoutet junior expanded his business to Charleston, but the pseudo-hallmarks are like those on silver marked by his associate in business, silversmith William Miller (q.v.). This service may have been made at least partially by Musgrave and retailed by the Dumoutet-Miller association in Philadelphia. On silver thought to be from his Charleston period, Dumoutet used the surname mark without the initials mark. Miller's mark was often used with an eagle stamp, the same one used by other Philadelphia silversmiths, including Joseph Bird and Samuel Hildeburn (q.q.v.). On March 31, 1808, Dumoutet gave a receipt to a Mr. Ashurst, a Philadelphia merchant who purchased a caster and candlesticks.[53] Dumoutet junior noted in a Charleston advertisement that he would supply the most fashionable goods from London and Paris, and likewise from his manufactory in Philadelphia.[54] Dumoutet senior may have moved from Kunckle Street into his nephew's buildings at 55–57 South Second Street and participated in the manufactory, but the possibility remains that Dumoutet senior moved to Charleston when

Dumoutet junior opened his shop there. With the exception of military accoutrements, after the government moved south in 1800, general business in Philadelphia was stagnant—before the War of 1812 due to embargos, and following the war due to a flood of imported goods. Dumoutet junior's Charleston shop carried military paraphernalia, which were in demand during the war period, but there are no advertisements to suggest that the Philadelphia branch did the same.

It is also possible that Dumoutet senior assumed another role in the business encouraged by William Y. Birch, a neighbor on South Second Street, who was Dumoutet junior's appointed trustee for management of his estate. Birch invested in the rapidly growing patent medicine business in Philadelphia. In 1807 T. W. Dyott occupied the Dumoutets' property at 57 South Second Street for the firm's patent medicine warehouse, before the company became established on North Third Street. Dyott's advertisement in the *Aurora General Advertiser* of December 30, 1807, read: "PREPARED AND SOLD, Wholesale and for exportation, with full directions for using it by T.W. DYOTT, at his Medical Warehouse, No. 57, South Second Street, Philadelphia, second door from Chestnut Street, also by appointment, at J. B. Dumoutet's, No. 120, Broad Street, Charleston, South Carolina where also may be had, THE IMPERIAL WASH, for taking out stains." The Dumoutets must have made an arrangement with Dyott and supplemented their jewelry business with the commerce in patent medicine. Dumoutet senior may have given up working as an active goldsmith/jeweler to become the Dumoutets' traveling agent. In 1810 the Charleston shop had expanded the merchandise it advertised in the *Charleston Courier* to include not only jewelry but also millinery, umbrellas, and patent medicines, with an adjacent "Military store."[55] On August 1, 1810, Dyott listed in Philadelphia's *Tickler* its agents for "Dr. Robertson's" cures, including J. B. Dumoutet at 120 Broad Street in Charleston as well as others in Boston, Pittsburgh, Raleigh, Newport, and Goshen, New York.

These contacts were profitable for the Dumoutets as well. In 1804 J. B. Dumoutet, with no indication as to senior but a "jeweler from Philadelphia," was in Raleigh.[56] On March 17, 1812, Dumoutet junior was in New Hampshire, as noted in Portsmouth's *New Hampshire Gazette*: "John Dumoutet Jr., jeweler and hairworker, informs the public in general that he manufactures and repairs all kind of jewelry and hair work, with neatness and punctuality. Any orders left at Mr. Hardy's store in Market Street will be received with gratitude." After Dumoutet junior died in 1813, a notice

in *Poulson's American Daily Advertiser* (Philadelphia) on May 24, 1819, recorded that "on Saturday sailed the fine packet ship Dido, with the following passengers, Messrs Dumoutet and Pituare."[57] This must have been Dumoutet senior, and in the *New Hampshire Gazette* of July 6, 1819, there was notice of a letter at the post office for John B. Dumoutet. Nothing further has emerged in the record about Dumoutet senior.

John B. Dumoutet Jr. died on July 20, 1813. His will—probably dictated, as the text is handsome and the signatures are sketchy—was written May 23, 1813, signed by him on May 25, and probated July 28.[58] It included specific instructions:

in consideration of my said wife's bringing up my children to their respective ages of twenty one or marriage, no interest to be charged on the amount of the said stock to the time Amelia arrives age twenty one and my wife to receive the profits of my stock in trade. . . . I order all my stock in trade both in Charleston and in the City of Philadelphia to be fairly valued, appraised and inventoried . . . by discreet and honest persons . . . and I order that the said stock shall be kept and detained by my Executors named . . . for the purpose of carrying on business until my daughter Amelia arrives at the age of twenty one. . . when she is 21 divide the stock according to the inventory: 1/5 to Jane Dumoutet, 1/5 to Emma Dumoutet, 1/5 to Amelia Dumoutet, my daughters and the remaining two fifths to my wife Elizabeth.

He then described the real estate to be distributed to each, with William Y. Birch acting as administrator to manage their properties.[59] His stock in the Farmers and Mechanics Bank and United States Loan, as well as bonds, mortgages, and other securities, were to be managed by Birch for the benefit of Dumoutet's wife. He left all his "household furniture, linnens [*sic*] and woolens, both at Philadelphia and in Charleston," to his wife.

Thus, Elizabeth Dumoutet, and later with Jane, continued the Philadelphia and Charleston businesses after her husband died. Elizabeth retained her listing in the Philadelphia directories, as "widow" at 55/57 South Second Street. She was in Philadelphia to sign her husband's will as an executor in May 1813 and for probate in July 1813; silversmith William Miller may have been then attending the Charleston shop. In 1823 she announced in an advertisement in the *Charleston Courier* the closing of the Charleston store and sale of the stock.[60] In Philadelphia in 1824 she was located at 254 Spruce Street. William Miller, who lived close by at 49 South Second Street, had a hand in running the South Second Street "factory." One of his silver marks is similar to Dumoutet's,

but the capital letters are incuse in the wavy banner. Miller was listed in the 1825 directory at 55 South Second Street. He may have had some interest in the property, but major interest was still held in the family when, in 1848, Emma Dumoutet McCauley, wife of John McCauley, "gentleman," transferred her interest to Amelia Priestman, her daughter by her first husband, William Priestman.[61] Real estate held by Dumoutet junior's heirs was finally being settled by the court in 1851, and in 1855 by his heirs Emma McCauley, Francis Blackburn, and Amelia Priestman.[62]

Elizabeth Dumoutet's will and administration included in detail her estate appraisal and inventory, all of which was bequeathed to daughters Jane Dumoutet and Emma Priestman. It included the contents of two parlors, a dining room, and bedrooms valued at $683.12, and a full-page listing of "silver and plated ware," which included two silver ragout spoons ($7.00), a lot of jewelry ($20.00), and one set of spangles, bullion, and gilt and plated laces ($30.00). The total value was $1,012.85.[63]

Jane Dumoutet never married. She was listed as "gentlewoman" at 102 North Eleventh Street from 1837 to 1850, after which there are no Dumoutets listed in the Philadelphia directories. She died September 12, 1850, age fifty, and was buried in the Old Cathedral Cemetery in Philadelphia, probably by Emma, as the tombstone reads: "My SISTER Jane Dumoutet." Her only heir was her sister Emma McCauley.[64] Jane's estate was well managed by William Birch and subsequently probably by herself. Until her death, she carried insurance on the first Dumoutet property she had inherited from her father.[65] The record of her estate, inventory, and accounts taken in 1850 totaled $3,670.45 and included complete furnishings of two parlors with pier mirrors, chandeliers, candelabras, mantel ornaments, a music stand, ten mahogany chairs, a furnished dining room, another dining room and sitting room on the second floor, a three-story back building, and some silver and garnets. She had stock in the Union Canal, Bank of Pennsylvania, and Lehigh Coal and Navigation Company and owned several pieces of real estate out on lease.[66] The property at 55 South Second Street continued to be identified with the Dumoutets after their tenure and was notorious as an eccentric bit of architecture. As described in Casper Souder Jr.'s nineteenth-century scrapbook titled "History of Chestnut Street":

The Southeast corner of 2nd and Chestnut Sts. years ago was familiarly known as "Dumoutet's corner." The old building still stands, but is in a very crazy and shackling condition. The secret of so poor a structure

having so long an existence can perhaps be explained by the fact that the building stands two feet over the line of 2nd Street and when it is torn down its successor will be compelled to fall back to the legal line of the street. Two feet in a shallow lot at Second and Chestnut streets is a matter that is not to be despised, and accordingly the old building has been allowed to stand. The house is of three stories of brick, with a fourth story of wood; the whole plastered up to represent what it is not, to wit; a substantial stone building. As unroofing the house would compel the owner to demolish the walls . . . when it wanted repairing the plan has been to put a new roof over the old.[67] BBG

1. Francis James Dallett to Bourges, District of Cher, regarding "Jean Dumoutet et autre Jean Baptiste Dumoutet, frères"; Francis James Dallet Papers, 1853–1997, Series 1, box 6, folder 8, HSP. There was no answer to the request included in the folder labeled "Dumoutet." The French Benevolent Society was founded in 1793 to give financial and moral assistance to French émigrés and was incorporated in 1805.

2. The original document Dallett transcribed has not been identified. Dallett's notes offer only the page numbers 31 and 32, respectively, as references; Dallett Papers, Series 1, box 6, folder 8. William Filby, ed., *Philadelphia Naturalization Records* (Detroit: Gale Research, 1982), Ancestry.com; Register of Members [of the French Benevolent Society], 1793–1843, Dallett Papers, Series 3, box 18, folder 1. There is a discrepancy between Dumoutet senior's age (thirty-nine) in the 1798 record as transcribed by Dallett and his birth date of 1742 in Nicole Verlet-Reaubourg, *Les orfèvres du resort de la Monnaie de Bourges* (Geneva: Droz, 1977). Dumoutet senior would have been fifty-six years old in 1798.

3. Catherine Hebert, "The French Element in Pennsylvania in the 1790s: The Francophone Immigrants' Impact," *PMHB*, vol. 108, no. 4 (October 1984), pp. 451–69.

4. Dumoutet's testimony was vouched for by Benjamin Nones of Philadelphia; Dallet Papers, Series 1, box 6, folder 8. This was the only Dumoutet noted as fulfilling the requirements.

5. Verlet-Reaubourg, *Les orfèvres du resort de la Monnaie de Bourges*, pp. 5, 7, 8, 105, 113–14.

6. Philadelphia Will Book 5, no. 82, pp. 23–25.

7. There was a "J. B. Dumoutet" in Canada in 1769; Inventory, April 11, 1769, Fonds Cour Supérieure, Greffes de notaires, Bibliothèque et Archives nationales du Québec, Montréal, Ancestry.com. His relationship to the Philadelphia silversmiths was not investigated.

8. Philadelphia Deed Book D-36-425.

9. 1798 U.S. Direct Tax, Oxford Township, October 1, 1798. As he used his full name, John Baptiste, this was probably Dumoutet junior. No deed for the property was located.

10. Diane Sadler, "Historical Northeast Philadelphia: Stories and Memories, 1994; Frankford," http://nephillyhistory.com/hnep1994/frankford.htm (accessed October 18, 2017).

11. Philadelphia Deed Book EF-16-374.

12. Philadelphia Deed Book EF-16-375.

13. Philadelphia Deed Book EF-16-377.

14. Philadelphia Deed Book EF-16-379.

15. Philadelphia Deed Book IC-18-706; see also Philadelphia Mortgage Book 19, p. 54, for resolution of the mortgage in the Court of Common Pleas, November 18, 1868.

16. Philadelphia Will Book 5, no. 82, p. 25.

17. Wm. Shannon to John B. Dumoutet, recorded January 3, 1793; Philadelphia Deed Book, D-36-425. The Philadelphia directory of 1795 identified this property as 75 North Third Street. Dumoutet junior retained this property, and it was inherited by his daughter Jane, who occupied it for a period and then leased it. The property was in her estate in 1850 when the insurance policy was canceled; Philadelphia Contributionship Insurance of Homes from Loss by Fire, policy no. 507993-001A, www

.philadelphiabuildings.org/contributionship.

18. Dallett Papers, Series 1, box 1, folders 3, 8, 22.

19. Philadelphia Will Book W, no. 389, written November 22, 1793, probated November 27, 1793.

20. *Records of the American Catholic Historical Society of Philadelphia* (Philadelphia: the Society, 1902), vol. 17, p. 332.

21. Among the silversmiths were Samuel Alexander, Jeremiah Boone, Daniel Dupuy Sr. and Jr., Anthony Simmons, and Christian Wiltberger (q.q.v.).

22. Philadelphia Will Book 5, no. 82, p. 25.

23. Cited in Nancy E. Richards, "A Most Perfect Resemblance at Moderate Prices: The Miniatures of David Boudon," *Winterthur Portfolio*, vol. 9 (1974), p. 82.

24. Tennessee Portrait Project, Cheekwood Museum of Art, Nashville, http://tnportraits.org/dumoutet-i-b.htm (accessed October 18, 2017).

25. Richards, "A Most Perfect Resemblance at Moderate Prices," pp. 74–101. See also p. 142, fig. 40.

26. Indentures, 1791–1822, Philadelphia City Archives.

27. Margaret White, *The Decorative Arts of Early New Jersey* (Princeton, NJ: Van Nostrand, 1964), p. 87.

28. *Claypoole's American Daily Advertiser* (Philadelphia), December 9, 1797.

29. Indentures, 1791–1822, Philadelphia City Archives.

30. From 1791 to 1793 John Aitken, joiner, occupied 55 South Second Street before he moved to Chestnut Street. A deed for the Dumoutet acquisition was not located.

31. *Aurora General Advertiser* (Philadelphia), December 1, 1798. The notice announced the sale would be held December 26 at 71 South Second Street, between Chestnut and Walnut. William Shannon, who had sold Dumoutet his first house, was one of the auctioneers; ibid., January 8, 1799.

32. Helen Sheumaker: *Love Entwined; The Curious History of Hairwork in America* (Philadelphia: University of Pennsylvania Press, 2007), p. 4.

33. *Records of the American Catholic Historical Society of Philadelphia*, vol. 17, p. 332.

34. "Marriage Registers at St. Joseph's Church, Philadelphia," in *Records of the American Catholic Historical Society of Philadelphia*, vol. 20, no. 1 (March 1886), p. 27.

35. *Federal Gazette and Philadelphia Daily Advertiser*, November 7, 1800.

36. The 1850 U.S. census recorded Ann O'Brien, age sixty, as resident with Jane Dumoutet.

37. Ellen G. Miles, *St. Memin and the Neoclassical Profile Portrait in America* (Washington, DC: National Portrait Gallery, 1994), p. 103. For Saint-Memin's small oval portrait of Washington in uniform, see ibid., p. 101, fig. 5.18; and Davida T. Deutsch, "Washington Memorial Prints," *Antiques*, vol. 111, no. 2 (February 1977), p. 331.

38. A copy is in the curatorial files, AA, PMA.

39. Rita Susswein Gottesman, comp., *The Arts and Crafts in New York, 1726–1776* (New York: New-York Historical Society, 1938), vol. 3, p. 95, no. 180.

40. Louis de Noailles (the former Vicomte de Noailles) subscribed $20 and George Washington, $50; *Records of the American Catholic Historical Society of Philadelphia*, vol. 1 (1887), pp. 352, 354, 356.

41. Philadelphia Death Certificates Index, 1803–1915, Ancestry.com.

42. John Dumoutet Ancora (born 1811), Emma A. Dumoutet Ancora (born 1813), and Mary Jane Ancora (born 1815). Peter Ancora's family belonged to St. Mary's Catholic Church. A further relationship to the Dumoutets was not explored.

43. Dallet Papers, Series 1, box 6, folder 8.

44. Ibid.

45. See, for example, *Aurora General Advertiser*, August 2, 1800.

46. *City Gazette and The Daily Advertiser* (Charleston, SC), January 18, 1802.

47. John Baptiste Dumoutet to Mr. Stephen Girard, receipt, December 5, 1803, Dallet Papers, Series 1, box 6, folder 8.

48. *Charleston City Gazette and Daily Advertiser*, January 18, 1802; Quimby and Johnson 1995, p. 354.

49. E. Milby Burton, *South Carolina Silversmiths, 1690–1860*, Contributions from the Charleston Museum, no. 10 (Charleston: the Museum, 1942), p. 32.

50. Christie's, New York, *Important American Furniture, Folk Art, Silver and Prints*, January 20–21, 2005, sale 1474, lot 139.

51. Samuel Williamson, Daybook, 1803–1810, Downs Collection, Winterthur Library.

52. Gebelein Silversmiths, Boston, advertisement, *Antiques*. vol. 112, no. 1 (July 1977), p. 44.

53. Ashurst Family Papers, Series 1, receipts and bills, folder 2, Downs Collection, Winterthur.

54. *City Gazette and The Daily Advertiser*, June 21, 1802.

55. Minnie Coffin Dick, "Some South Carolina Silversmiths and Their Work," *Antiques*, vol. 59, no. 5 (May 1951), pp. 380–82.

56. Belden 1980, p. 145.

57. The *Dido* sailed between New York, Charleston, and Liverpool.

58. Philadelphia Will Book 5, no. 82, p. 23.

59. To his daughter Emma, Dumoutet left his properties in Frankford on Main Street, as income in trust, and on the northeast side of Adams Road; to daughter Amelia, his properties in Frankford on Paul Street and on the south side of Adams Road; and to daughter Jane, his properties in Southwark and Northumberland County.

60. E. Milby Burton and Warren Ripley, *South Carolina Silversmiths, 1690–1860*, Contributions from the Charleston Museum, no. 10, 3rd. rev. ed. (Charleston: the Museum, 1991), p. 32.

61. Grantor Elizabeth Cunningham, trustee for Emma McCauley, wife of John, for property valued at $9,500, late of J. B. Dumoutet deceased; Philadelphia Deed Book AWM-84-407.

62. Laws of the General Assembly of the Comonwealth of Pennsylvania, 1851, pp. 8, 9; John B. Dumoutet, Philadelphia Administration Book Q, no. 419, p. 367.

63. Philadelphia Will Book 11, no. 130, p. 264, transcription in curatorial files, AA, PMA.

64. Emma Dumoutet married William Priestman (died 1830) at St. Augustine's Church on June 17, 1815, and secondly John McCauley on May 10, 1832; *The Intellectual Regale, or Ladies' Tea Tray*, June 24, 1815; *National Gazette* (Philadelphia), May 12, 1832.

65. Philadelphia Contributionship for the Insurance of Houses from Loss by Fire, Jane Dumoutet, 71 New Street, 1850, canceled policy no. S07993-001A.

66. Philadelphia Administration Book Q, no. 360, p. 47, transcription in curatorial files, AA, PMA

67. The scrapbook, now in the collection of the Library Company of Philadelphia, collects newspaper articles dated April 18, 1858–October 9, 1859, along with sketches, images, and other material on the history of Chestnut Street.

Cat. 211

John B. Dumoutet Jr.

Sugar Bowl

1796–1800
MARK: DUMOUTET (on base opposite initials; cat. 211-1)
INSCRIPTION: R W (engraved script, on one side)
Height 10½ inches (26.7 cm), diam. 4¾ inches (12.1 cm)
Weight 14 oz. 7 dwt. 10 gr.
Gift of Charlene Sussel, 2006-94-2a,b

PROVENANCE: From the stock of the Philadelphia antiques dealer Eugene Sussel (1913–1989), the donor's husband.

Cat. 211-1

This sugar bowl matches a teapot (fig. 74) made for the same client by the Philadelphia silversmith Samuel Williamson (q.v.), whose mark was overstruck by Dumoutet junior as the retailer, and it is possible that the sugar bowl was also made in Williamson's shop. The unidentified initials "RW" engraved on both pieces show the same engraver's sure, light touch. The generous round shape of this handsome sugar bowl is in the best Philadelphia style. There are rows of encircling bands of bead over the joins between units of the piece. The urn-shaped finial is peened.

 Dumoutet's plain rectangle mark on this sugar bowl puts its manufacture in the late 1790s, just before he opened his branch in Charleston, South Carolina. BBG

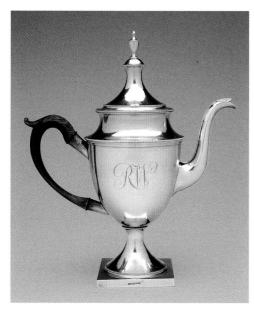

Fig. 74. Samuel Williamson (1772–1843). Teapot, 1796–1800. Silver, height 12⅜ inches (31.4 cm), width 10½ inches (26.7 cm), diam. 4¹⁵⁄₁₆ inches (12.5 cm). Philadelphia Museum of Art. Gift of the McNeil Americana Collection, 2005-68-123a,b

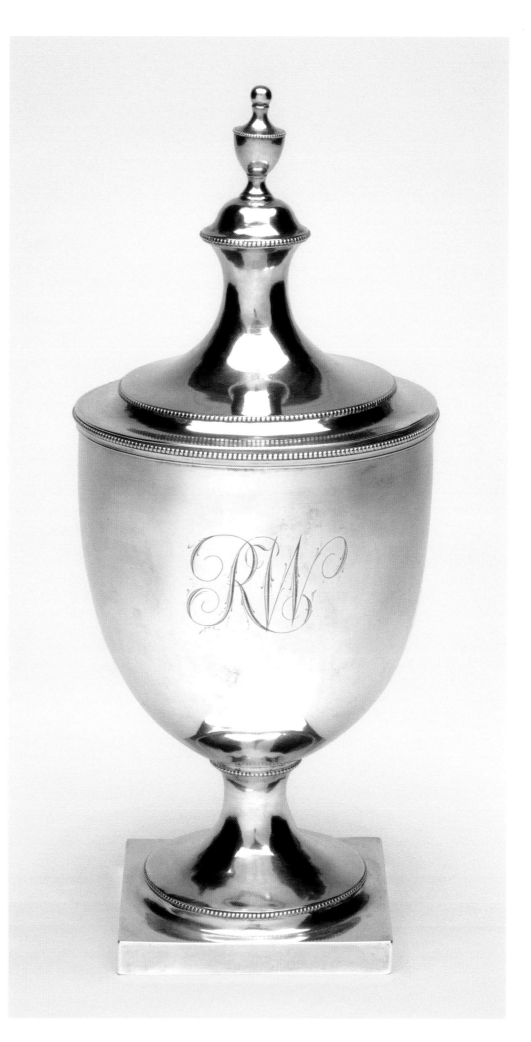

Cary Dunn

Newport, Rhode Island, born 1732
Queens County, New York, died 1809

Carew Cary Dunn was the seventh of the eleven children of Samuel (1699–1739/40) and Ann Clarke Dunn.[1] He was born June 11, 1732, at Newport, Rhode Island, where he probably apprenticed.[2] He was married in Newport to Ann Atkinson on November 1, 1754, by the Reverend Nicholas Eyres.[3] Before June 10, 1759, when their son Cary Dunn Jr. was baptized at the First Presbyterian Church in New York City, Dunn senior had set up his silversmith's shop at 23 Crown Street, near the Dutch Church. He was admitted "freeman," as a goldsmith, in New York on October 29, 1765. In 1767 he described his location as "opposite to Mr. Browns printing-office, in New Dutch Church Street."[4] In 1774 Dunn advertised that he had a list of 124 persons from Scotland, "men, women and children, with and without trades," for employment; interested parties were to contact "Mr. Cary Dunn Gold and Silversmith . . . who has in his custody, a true list of their names, ages, and places of residence."[5]

Dunn worked on Crown Street in the North Ward until the beginning of the Revolutionary War.[6] A war claim for pension dated June 7, 1832, placed by Cary Dunn Jr., notes that "Cary Dunn in the State of New York was a Major in the Continental Line commanded by General George Clinton, for two years and a few months."[7] He probably served between 1775 and 1777 under General Clinton at the battles of Fort Montgomery and Clinton on the palisades bordering the Hudson River. The Americans believed they could hold the northern section of the New York settlement and the forts on the highlands, but the British prevailed and occupied all of New York in 1776–77. Cary Dunn probably served with Clinton until 1777, as in that year he moved his household to Morristown, New Jersey, where they remained until the end of the war.[8] In 1782–83 the family moved to Newark, New Jersey. In 1784 he advertised that he was moving back to New York "after seven years out," and he settled at his former location of 23 Crown Street, between the Fly Market and the New-Dutch Church.[9] His son Cary Dunn joined in partnership

with him as Cary Dunn & Son from 1786 to 1792, at which time the shop sold hardware and jewelry as well as silversmith's wares.[10]

Cary Dunn became a member of the Gold and Silversmith's Society in 1786, which put him in touch with other members.[11] In 1789 Cary Dunn was appointed an inspector of fireplaces for the North Ward, regulations for which included the requirement that "every stove erected in carpenters and joiners shops, and other places where similar hazardous trades are carried on to be placed on a platform of brick or clay and enclosed with a curb."[12] Evidence that he was well-known can be found in the advertisements of other craftsmen and merchants, such as Samuel Hill, who noted that his shop at "No 32, Smith Street, Corner of Maiden Lane" was opposite "Mr. Cary Dunn's."[13] The miniature painter Philip Parisian, located on Queen Street, advertised that "a specimen of his performance is to be seen at Mr. Cary Dunn's, Silversmith, No. 31 corner of Maiden-lane and William street."[14] John Ferrers advertised a house for sale "opposite the office of Cary Dunn, Esq. near the corner of William-Street."[15] In 1796 Dunn served as a witness to the will of Samuel Johnson, a fellow silversmith.[16]

He was elected vice president of the Democratic Society in 1796.[17] In the U.S. census of 1790, Dunn's household was listed in New York's North Ward as consisting of five members, one male under the age of sixteen, two males age sixteen and over, and two females. Cary Dunn Sr. moved to Jamaica, Long Island, before January 1798, when he advertised his New York City location for sale.[18]

In the U.S. census of 1800, Cary Dunn Jr. was listed as being alone in New York's Second Ward. In 1809 he was appointed the first judge of the Court of Common Pleas for the County of Queens.[19] The census of 1810 noted that his household numbered eight persons.

Cary Dunn Sr., silversmith, died in 1809, probably in Queens County, Long Island.[20] BBG

1. Hofer and Bach 2011, p. 190.

2. David L. Barquist suggests that, because Dunn paid for his freedom in New York, he probably did not serve his apprenticeship there; Barquist, *Myer Myers: Jewish Silversmith in Colonial New York*, exh. cat (New Haven, CT: Yale University Art Gallery, 2001), p. 58.

3. Marston Watson, *Royal Families: Americans of Royal and Noble Ancestry*, vol. 2, *Reverend Francis Marbury and Five Generations of His Descendants . . .* (Baltimore: Genealogical Publishing Company, 2004), p. 123.

4. *New-York Journal*, July 30, 1767.

5. *Rivington's New York Gazetteer*, January 20, 1774.

6. Edward F. De Lancey, *The Burghers of New Amsterdam and the Freemen of New York, 1675–1866*, Collections of the New-York Historical Society, [vol. 18] (1885), p. 211; Kenneth Scott, *Rivington's New York Newspaper: Excerpts from a Loyalist Press, 1773–1783* (New York: New-York Historical Society, 1973), p. 80; Waters, McKinsey, and Ward 2000, vol. 1, pp. 130–31.

7. New York, Revolutionary War Pension and Bounty-Land Warrant Application Files, 1800–1900, no. 1246, Records of the Department of Veterans Affairs, Record Group 15, NARA, Washington, DC, Ancestry.com. In 1775 George Clinton (1739–1812) was appointed brigadier general of the Ulster and Orange County Militia, where he commanded the forts in the Hudson Highlands. Extremely popular, Clinton went on to be governor of New York and vice president under both Thomas Jefferson and James Madison; Mark O. Hatfield et al., *Vice Presidents of the United States, 1789–1993* (Washington, DC: U.S. Govt. Printing Office, 1997), pp. 49–60.

8. Waters, McKinsey, and Ward 2000, vol. 1, p. 130.

9. *New-York Packet*, January 5, 1784.

10. Waters, McKinsey, and Ward 2000, vol. 1, p. 130; Belden 1980, p. 146.

11. "Gold and Silver Smith's Society, meets on Wednesdays, at the house of Walter Heyer. Myer Myers, Chairman, Members,—Samuel Johnson, William Gilbert, Esq [q.v.]; [number missing], Broadway, Otto De Perrizang, William Forbes, 88, Broadway, John Burger, 207, Queen-street[,] Daniel Chene, Cary Dunn, Benjamin Halsted, 13, Maiden-lane[,] Ephraim Brasher, 1, Cherry-street"; *New York Directory* (1786; New York: F. B. Patterson, 1874), p. 69; see also Hofer and Bach 2011, p. 190.

12. *New York Daily Gazette*, November 25, 1789.

13. *Daily Advertiser* (New York), June 19, 1790.

14. *New York Daily Gazette*, March 29, 1790.

15. *The Argus and Greenleaf's New Daily Advertiser* (New York), February 24, 1796.

16. New York County Surrogate's Court, *Abstracts of Wills on File in the Surrogate's Office, City of New York*, vol. 15 (February 15, 1796–January 14, 1801) (New York: New-York Historical Society, 1907), bk. 42, p. 1.

17. Belden 1980, p. 45.

18. *New York Daily Gazette*, January 2, 1798.

19. Edgar A. Werner, *Civil List and Constitutional History of the Colony and State of New York* (Albany: Weed, Parsons, 1889), p. 492.

20. *The Observer* (New York), May 21, 1809; Hofer and Bach 2011, p. 190n1.

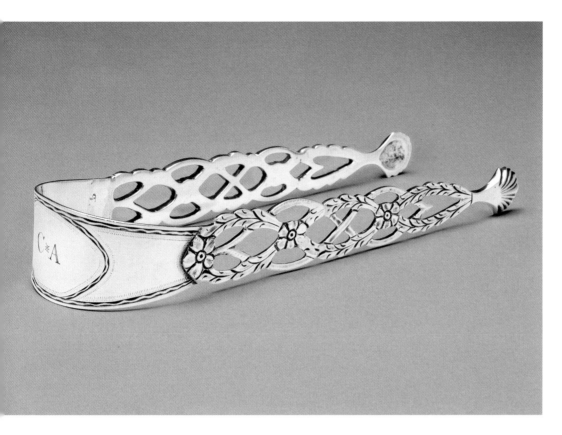

Daniel Dupuy Sr.

New York City, born 1719
Philadelphia, died 1807

Daniel Dupuy Jr.

Philadelphia, born 1753
Philadelphia, died 1826

Cat. 212

Cary Dunn
Sugar Tongs

1770–75
MARK: C·DUNN (in rectangle, at top of one arm; cat. 212-1)
INSCRIPTION: C·A (engraved, at top of handle); B (engraved, inside bow opposite mark)
Length 6⅜ inches (16.2 cm), width top ⅞ inch (2.3 cm)
Weight 2 oz. 2 dwt. 10 gr.
Gift in memory of Eugene Sussel by his wife Charlene Sussel, 1991-98-21

PROVENANCE: From the stock of the Philadelphia antiques dealer Eugene Sussel (1913–1989), the donor's husband.

EXHIBITED: R. T. Haines Halsey, *Catalogue of an Exhibition of Silver Used in New York, New Jersey and the South* (New York: Metropolitan Museum of Art, 1911), pt. 3, p. 22, cat. 43.

Cat. 212-1

The pierced arms of these tongs were cast and decorated with chasing. The style was characteristic of pre-Revolutionary work but could also have been made by Dunn upon his return to New York after the war. They were soldered to the curved "spring" section at the top. BBG

The lives of Daniel Dupuy Sr. (fig. 75), goldsmith, and his sons John (1747–1838), watchmaker, and Daniel junior (see fig. 77), silversmith, spanned the better part of the eighteenth century and extended into the second quarter of the nineteenth. Their important location on South Second Street was still owned by a descendant in 1910.[1]

The Dupuys were direct descendants of Jean DuPuy, Lord of Ville Francine, who, driven by religious persecution, moved from France to England with his son Jean (1679–1744), then a minor, where the latter was naturalized by Royal Letters Patent in Westminster on March 8, 1682. At the same time John David I, his wife Esther (Hester) Vincent David, and their son John David II, all French Huguenots, were also naturalized. There were close connections between these families, first in France and then by marriage in England and America.[2]

Fig. 75. Portrait of Daniel Dupuy Sr. From Charles Meredith DuPuy, with Herbert DuPuy, *A Genealogical History of the Dupuy Family* (Philadelphia: printed for private circulation by J. B. Lippincott, 1910), opposite p. 26.

Trained in surgery in London, Jean (John) Dupuy, the minor, was dispatched to Port Royal, Jamaica, in about 1709 to serve and practice medicine at the English military post there. He had married Anne David (1687–1769), daughter of the above-mentioned John David I and his wife Esther, probably before going to Jamaica.[3] The doctor completed his tour of duty in 1712, sold his house in Jamaica for £500 on March 11, 1713, and moved to New York.[4] The Dupuys were a wealthy family, owning plate and property.[5] Soon after his arrival in New York in 1714, Dr. John Dupuy purchased a house on King Street on a large lot bounded at one end by Wall Street and adjoining the property of the pirate Captain William Kidd. Before 1712 that property had belonged to John David I, who had moved from Kingston, New York, about 1694, and attained his freedom in 1701 in New York City as a vintner and merchant.[6] The property was known in the Dupuy family as "the old homestead" when it was sold in 1765 by Dr. John Dupuy's widow, Anne David Dupuy. John David Jr. and Daniel Dupuy Jr. joined in the conveyance of the property.[7] Daniel Dupuy Sr. was born there on April 30, 1719. He was named after his uncle Daniel David (born 1694) and was baptized in the French Church in New York on May 10, 1719.[8] Dr. John Dupuy had become an elder in that church, resigning in 1728 when he became an active and contributing member of Trinity Church on Broadway, where he was buried in June 1744.[9]

Family tradition had it that Daniel Dupuy began his apprenticeship in New York with his brother-in-law Peter David (q.v.), who had married Daniel's older sister Jane (Jeanne) Dupuy, and that Daniel moved to Philadelphia with the Davids about 1735.[10] In 1740 or 1741, with his apprenticeship probably completed, Daniel Dupuy in Philadelphia began to make entries in a small, two-volume receipt book, which suggests that the family tradition was correct.[11] The entries give no hint that he continued to work for Peter David; they suggest that from the outset he was independent, with possibly one recorded exception, a venture to Guadaloupe with his contemporaries William Ball, John Leacock, Edmund Milne, and Joseph Richardson Sr. (q.q.v.). It was not profitable.[12] The Dupuys invested in real estate and their silver work. Although the Dupuys and their David cousins John senior and junior (q.q.v.) must have retained close family connections—in 1786 they shared pew number 56 at Christ Church—there does not seem to be any clear evidence of a business partnership among these family members.[13]

The earliest entry transcribed in Daniel Dupuy's receipt book is December 9, 1741: "Rec'd of Mr. Daniel Dupuy, The Sum of Three pounds Twelve Shillings in full for Six Red leather Chairs / Pitts."[14] The entry suggests that Dupuy was furnishing a dwelling when he purchased the chairs from the silversmith Richard Pitts (q.v.). Nine days later, on December 18, 1741, Jeremiah Warder signed a receipt to Dupuy: "By discount for one pair Buckles, £1 6s. 6d., & in cash £4 13s., rec'd In full of all Accts & Demands." The next entry is a transcribed receipt dated March 20, 1742, which was signed by Peter Stretch (1670–1746), clockmaker: "£4 10s. for one quarter's rent."[15] The Warders, Jeremiah and John, and Peter Stretch, were Quakers, handling leases and sales of parcels of city real estate that had been granted to the Friends Meeting by William Penn. It seems reasonable to assume that these credits to Dupuy note his quarterly payment on a lease for a property on the west side of Second Street between High (Market) and Chestnut, which he eventually purchased from the Friends in 1753.[16] The terms of the lease were £22 10s. per year, with installments due quarterly.

Daniel Dupuy maintained his ties with family in New York, and he traveled from Philadelphia to New York to do business with his brother, also a Dr. John Dupuy, and to visit his mother.[17] His father died in New York in 1744 and left a bequest to Daniel of £60, to be paid six months after his death.[18] Following specific instructions in Dr. John Dupuy's will to sell his "Orange County" property, "Mr. Daniel Dupuy, goldsmith in Philadelphia," and "Doctor Dupuy in New York" placed a notice in the *Pennsylvania Gazette* of January 27, 1745, advertising the sale of "a plantation of 1250 acres, with house, orchard and creek, in Orange County, New Jersey."[19] This is the first public notice found to date that mentions Dupuy as "goldsmith" although he must have been practicing his craft by 1742. The next, on June 22, 1749, regarding the sale of property belonging to Daniel's wife, again in the *Pennsylvania Gazette*, offers the first notice of his location beyond the above surmise about his lease, "Enquire of Daniel Dupuy, goldsmith in Second Street."

On September 6, 1746, Daniel Dupuy married Eleanor Cox Dylander (1719–1805), daughter of the early landowners Peter (1688–1749/50) and Margaret Mattson Cox, widow of the Reverend John Dylander (1709–1741), a Swedish minister from Stockholm who had been the rector of the Gloria Dei Church in the Southern District of Philadelphia.[20] This was the church of Eleanor Dupuy's forebears, the Mattsons and Coxes, seventeenth-century Swedish owners of property south of the city of Philadelphia. It was also the church of Margaret Parham David, Peter David's second wife, whom he married in 1753, coincidentally the same year that Daniel Dupuy finally purchased the Second Street property. Daniel Dupuy Sr. was a vestryman at Gloria Dei, as was his son John later, and the family continued to participate at that church.[21] Daniel Dupuy Sr. and his family eventually became full members of Philadelphia's Christ Church, paying a pew rent of £2 5s. in May

Fig. 76. View of Clover Hill, Gray's Ferry, Philadelphia. From Dupuy, *A Genealogical History of the Dupuy Family*, opposite p. 30

1757, and Daniel senior was buried there.[22] Daniel Dupuy Sr. signed articles of agreement on June 24, 1760, to raise funds for the establishment of the Episcopal Church of St. Paul, where he served as a vestryman from 1764 to 1767, and again in 1771.[23]

In 1745, before her marriage to Dupuy, Eleanor Cox Dylander inherited two pieces of property from her parents that were part of a 300-acre land grant made to her grandparents in 1676 by Sir Edmund Andros representing the Duke of York. The properties were located south of the city, in the Districts of Passyunk and Moyamensing on the east side of the Schuylkill River at Gray's Ferry.[24] One piece was a tract of twelve acres, which later became known as Clover Hill. Eleanor was born there in 1719, Charles Meredith Dupuy was born there in 1823, and according to family records both Daniel Dupuy Sr. and Jr. died there.[25] The property

remained in the Dupuy family until 1850 (fig. 76). The other property had a house with one acre, valued by the assessor in 1798 at $650, also just east of the Schuylkill River, where in 1802 Daniel Dupuy Jr., then managing the family investments, advertised that he had: "BUILDING STONE for sale. They are perched up, on the subscribers place, on the east side of Schuylkill about a half mile from Gray's ferry, and a short distance below the United States Laboratory. Also a quantity of Timothy and Clover Hay for sale."[26] Dupuy Sr. paid the taxes due on these properties from 1779 to 1786 while leasing them to the farmers John Ferick in 1779, John Sikes in 1780, and George Smith from 1782 to 1786. The latter leased property noted as ten acres and a dwelling, possibly Clover Hill.[27] In 1749 Dupuy began to advertise the Passyunk properties: "A Tract of land, in Passyunk township two miles from Philadelphia, leading to George Gray's ferry, about twenty yards from the road, pleasantly situate [sic] for a country seat; there is a fine young orchard, with several sorts of fruit trees, a new log house, a good well, with extraordinary good water, an oven and a new fence. The lot contains seven acres and a quarter, three and a half whereof clear'd and grubb'd, the rest with good timber."[28] In the *Pennsylvania Gazette* of February 23, 1769, John placed an advertisement that stated "for further particulars, Enquire of Daniel Dupuy, goldsmith . . . for a good commodious BRICK HOUSE . . . located on the Passyunk Road about half a mile from the City; it is commonly known by the name of the Horse and Dray Tavern."[29]

Rebecca Cox Weiss, Eleanor Dupuy's sister, had also inherited a family property about three miles from the city, "at the angle of the ferry road below the arsenal" and adjoining some Dupuy land.[30] She married Dr. Jacob Weiss (Wise) who had the reputation of being the first man to bring Lehigh coal to Philadelphia for experiment: "he, bringing what he had in his saddlebags, was laughed out of his hopes therein on its being tried for ignition in his cousin Dupuy's silversmith's furnace."[31] The coal did not ignite.

The Dupuys had two sons, John (1747–1838) and Daniel junior (1753–1826), both of whom were baptized at Gloria Dei Church. They had four daughters: Jane (1749–1816), who married William Coates, a tanner in the Northern Liberties,[32] and Eleanor, Margaret, and Ann, all of whom died as infants.[33] Both sons apprenticed as silversmiths, but John turned to watchmaking. He may have shown an early aptitude for the mechanics of watches, or perhaps his specialty offered an opportunity to expand the family enterprise.[34]

Francis Dupuy (1721–1750), Daniel's brother and a doctor in New York, was unmarried and had

volunteered to sail as ship's surgeon on the privateer *David* in 1744 in the war against the French. He was lost at sea in the West Indies in 1745. Francis left his estate to his widowed mother, Anne David Dupuy, who soon thereafter moved from New York to Philadelphia to live with Daniel and his family on South Second Street.[35] At that time, John Hallowell, cordwainer, was occupying the southern half of Dupuy's joined buildings, and the Friends were rebuilding their Great Meeting House at the corner of Market and Second streets. Thus, when Israel Pemberton, acting for the Overseers of the Free Public School, offered Dupuy the opportunity to buy the property they were leasing to him, Dupuy made the purchase on September 7, 1753, for £150.[36]

Promptly, on January 1, 1754, Daniel Dupuy insured his property.[37] The survey noted that the brick dwellings were two stories high with a one-story, four-inch partition wall. The upper stories were lath and plaster. John Hallowell, cordwainer, was noted in the survey as occupying the southernmost building. Twenty years later, in 1772, Dupuy made some repairs, and on May 5, 1772, he was billed £1 9s. by John Parrish for the repair of four sets of cellar steps, the repair of a furnace, and three bushels of lime. He was credited "By his bill for Sundrys."[38]

Thirty-two years later, on September 6, 1785, about the time that Daniel senior was retiring from active silver work, the Dupuys had their property resurveyed. This survey is in the names of Daniel and John Dupuy and offers a description of the buildings with additions since 1754, and as occupied by the Dupuys during their most productive years: "Two adjoining Tenements (house & piazza) belonging to Daniel Dupuy [senior or junior was not specified] situate on the West side of 2nd Street between High and Chestnut Streets in one of which Tenements he dwells—Both together—20 ft front, 36 ft deep 3 storys [sic] high, outside party walls, 9 inches partition between them with walls one story from thence up a frame & plastered, plastered partitions, garret plastered. Two storys mostly old & very plain, 3rd story & Roof new outside (& two storys within of northernmost house, painted). Two wooden buildings back of the house. £300 @ 40 for £100 additional."[39] The house and piazza were surveyed for fire insurance again on March 2, 1811, in the names of John and Daniel Dupuy.[40] In 1804 house numbers were assigned and the property became 4 South Second Street. With the growth of the city, in 1812 number 4 became number 16 when "Daniel Dupuy, silversmith, and John Dupuy, junior, storekeeper" were resident.[41]

By 1768 John had just reached his majority, and Daniel junior must have been apprenticing in

his father's shop. There was likely a need for additional work space to accommodate an apprentice, an increasing family, and probably some household staff, and thus the proprietary tax for 1769 noted that Daniel senior had three servants and leased another property, one of two houses on South Second Street owned by Dr. Thomas Bond Sr. (1712–1784).[42] Thomas Bond's own house was on the east side of Second Street, between Chestnut and Walnut in the Walnut Ward.[43] Bond's lot and house "where Daniel Dupuy dwells" was located on the west side of Second between Market and Chestnut in the Middle Ward, and was bounded on the north by Dupuy's own property.[44] In 1774 the Head and Estate Tax noted that Dr. Bond's estate value included "£60 from Daniel Dupuy."[45] It was identified in Dr. Bond's valuation as income not ground rent, and it did not appear as an abatement for ground rent in Dupuy's tax record.[46] The £60 was probably an annual lease, as no grantor or grantee deed regarding this property appears in Daniel Dupuy's name.

It would appear from the few records of this family of silversmiths that Daniel senior and his sons were cautious in their dealings and kept careful records. On October 25, 1784, a letter from Joseph junior and Nathaniel Richardson to Masterman & Sons in London illustrates the Dupuys' approach to business: "We called on Daniel Dupuy as you requested and found he was not willing to be at the expense nor run the risque of remitting to you the money at par which considering all circumstances we thought best to accept, you will therefore please to charge us with £24/18/2 sterling which we received of him."[47]

Early on, by 1755, Daniel senior was active in the civic life of Philadelphia and gained a reputation for industry, honesty, and devout practice. On May 29, 1755, he signed the act to establish a hospital, contributing £10, and he continued making contributions into the 1780s.[48] In 1769 he served on the petit jury of the Court of Oyer and Terminer, and from 1771 to 1773 on the traverse jury.[49] He served as a tax collector in April 1770 for the Paving Tax, and in June 1771 for the Watch and Lamp Tax.[50] For the years 1772 to 1774, he was elected to an important civic role as assessor for the Middle Ward, where he lived, which entailed valuing estates, including his own, and making judgments about credits and debits while taking into consideration "exoneration," that is, the personal circumstances of his neighbors.[51]

From the outset Daniel Dupuy Sr., and later Daniel junior and John, recorded in the receipt books various transactions, such as the continual expense of purchasing their raw material.[52] In 1746 Daniel senior purchased a silver tankard weighing

29 ounces 5 pennyweight from John Clare. In 1748 he paid John Leacock Jr. (q.v.) £18 8d. for 45 ounces of silver at 8s. per ounce, and paid £3 2s. to Joseph Applin for half a dozen tablespoons. In 1760[53] Dupuy had an account with William Ball (q.v.), purchasing a dozen knee chapes for 13s. in 1760, and purchased from Owen Jones sixteen woman's silver thimbles, one card of locket buttons, and eleven carnelian seals for £9 19s.[54] In 1763 Dupuy purchased buckle chapes, gold lockets, gold buttons, rottenstone, and tea tongs from the sale of the deceased silversmith Philip Hulbeart (q.v.).[55] In 1771 he paid Sacher Wood £15 11s. 2d. for an old silver tankard weighing 35 ounces 5 pennyweight, at 8s. per ounce. Dupuy valued a pair of "stone earrings," a "stone stud," and a "stone ring" belonging to Catherine Malcomb, who presented them in 1772 with a voucher of value to Joseph Wharton as part payment of her rent due.[56] In 1773 Dupuy sold and mended knee and shoe buckles for William Logan, and paid Richard Humphreys (q.v.) £252 for forty-two pairs of silver shoe buckles. In 1782 he purchased from the city auction a silver tankard of 52 ounces 12 pennyweight at 12s. 2d. per ounce. In 1784 he received from D. (Morris) Smith Major £10 16s. for 27 ounces of silver articles: six tablespoons, six teaspoons, one soup ladle, one punch ladle, and a pair of spring tongs. In 1788 Dupuy paid Deborah Logan £9 17s. 6d. for a silver waiter of 25 ounces 10 pennyweight, at 7s. 9d. per ounce.

A few advertisements suggest imports as well as the Dupuys' own production, with offerings of "neat garnet broaches . . . cream jugs, plain, chased and fluted, very neat . . . sprig hair pins . . . paste crosses . . . plated cutteau de chase with white and green handles . . . [and] silver frames for spectacles."[57] Their advertisements for items stolen also offer a hint about current fashion and in three instances verify that Daniel Dupuy Sr. did indeed use a "DD" initial mark: "stolen/lost from child's neck . . . a large gold locket 'SB' in a cipher, maker 'DD' on the inside"; "stolen, 2 small spoons 'MI,' maker 'DD'"; "stopt by Daniel Dupuy, William Ghiselin, and Philip Syng [q.q.v.], two large silver spoons, broke in pieces (some of the pieces wanting), tea spoons the names of the owners being broken off, makers marks PS and DD."[58]

The three Dupuys were noted as taking on Joseph Evans on April 27, 1772, as an apprentice for the silversmith's trade, "large work excepted."[59] And on September 22, 1773, they advertised in the *Pennsylvania Gazette* for an apprentice and journeyman.

Besides their successful silver enterprise, the Dupuys were active participants in real estate, both buying and leasing. It was an important facet of the Philadelphia economy and contributed to

the Dupuys' financial independence. An advertisement placed by the Dupuys in the *Pennsylvania Gazette* on September 22, 1773, presented a detailed listing of their mixed stock of silver and jewelry imports and their own products, silver and watchmaking. The text is prominently centered under an elaborate rendition of the Penn arms, with their location, "In Second Street, four doors below the Friend's Meeting." Their names appear in all capital letters, with Daniel Dupuy at the top and John Dupuy below, but the largest type was reserved for "A HOUSE next door, nearer the market, to be lett. Enquire as above." John did occasionally advertise on his own: "Extraordinary good WATCHES, To be SOLD, by JOHN DUPEY [sic], Clock and Watch Maker in Second Street, the fourth door from the Friends Meeting House . . . he has on hand a few Gold and Silver Hat Bands, Buttons and loops, with Buckles to suit the same."

In his earliest Tax and Exoneration record for the Middle Ward, that for 1762, Dupuy's Second Street property was valued at £160, his occupation tax as a goldsmith at £150, and his estate at £425. In 1769 he had income from the leases on the Passyunk (Gray's Ferry) properties, less the £22 10s. ground rent to the Free Public School, for a total estate value of £56 18s.; John and Daniel junior were listed with him as "per head" with no tax.[60] In the 1772 Head and Estate Tax, Daniel senior showed three negroes valued at £31 and income from the Passyunk leases at £79 4s., less ground rent of £23 14s. "for the old property from the Free Public School," with the total estate valued at £55 14s. John was listed, untaxed, with Daniel senior.[61]

Daniel Dupuy Sr. does not appear on the list of Philadelphians who signed the non-importation agreements,[62] and he does not seem to have entered the political scene during the unrest among Philadelphia merchants leading up to the Revolutionary War. But when the city was threatened with occupation by British troops in the winter and early spring of 1777, importing was not popular and commissions were infrequent. At the same time, John Adams pronounced that a smallpox epidemic was developing in the city, exacerbated by the daily arrival of crowds of refugees and soldiers retreating from the battles of Trenton and Princeton, and many had succumbed to the disease.[63] These factors surely contributed to the Dupuys' move on May 7, 1777, to the town of Reading in Berks County.[64] On that day a notice placed by John Dupuy in English and German appeared in the *Wöchentliche Philadelphische Staatsbote*, a Philadelphia newspaper that circulated outside the city for the predominantly German population.

It advertised the family move, listing their wares and skills, including the repair of clocks. Dupuy bought a house in Reading "on the North side of High Street about a square below the inn, The Fountain, in which Christopher Matheria formerly lived; Where he practices the gold and silversmith's work in all its branches." A year later, in June 1778, the Dupuys were still in Reading but the property was being advertised for sale.[65]

The militia law that had been passed in March 1777 required that before July of that year all male citizens over the age of eighteen were to take an oath in front of a magistrate, renouncing George III and giving allegiance to the free and independent State of Pennsylvania.[66] This was an important topic at the time, and one that did serve to reveal the political inclinations of the citizenry, especially the Loyalists. Whether it was their conservative mercantile policies amid the general confusion and uncertainties of the era, or the move of household to Reading, the Dupuys postponed taking the oath. Thus, the Tax and Exoneration records of 1777 note that Daniel Dupuy Sr., Daniel junior, and John "refused to qualify" ("non juror"), meaning they had not yet taken the oath. As a penalty, besides the restrictions placed on doing business or having any role in public service, the per-head tax was doubled. Daniel senior was assessed £84 8s. 6d. on his estate of £30,700, and his sons at £30 per head. Daniel Dupuy Sr. finally took the oath on July 23, 1777, and as the deadline had been extended, his entry "refused to qualify" in the tax ledger was crossed out. Whether he took the oath in Berks County or Philadelphia is not recorded.

After the British left Philadelphia for New York on June 18, 1778, the Dupuys returned to Philadelphia. Daniel junior noted in his receipt book in October of that year a payment for £10 to a John Curry for building a "Forge and Furnace and finding 2 hods mort[ar], to 3 bushels of lime other jobs / £1 9s." As the British had destroyed property throughout the city during their occupation, this was probably payment for refitting their Second Street workshop. On September 2, 1779, Cadwalader Dickinson, tax collector, collected £57 8s. from Dupuy and signed in the Dupuys' receipt book for his 1778 Continental Tax as well as for the £6 head tax for Daniel junior and John.[67] Also in 1779 Dupuy senior acquired from his contemporary Hugh McCullough a long-term lease on a property on Front Street in the North Ward, safely out of the crowded city center, a property that the family retained and used.[68]

In 1780, when the Dupuys were called up for militia service, Daniel senior took advantage of the custom of paying for substitutes to serve. On June

12, 1780, Captain George Taylor signed a receipt in the Dupuys' receipt book: "the sum of £112 10s., in full for procuring a substitute; also for John and Daniel Dupuy junior, agreeable to law, their sum being £45, the total being £157 10s." When called up again for military service in 1781, John did enlist as a private in the First Regiment of Foot under the command of Major David Reese.[69] His regiment was sent to Boston by Robert Morris on a secret mission to guard and escort back to Philadelphia, in fourteen wagons hauled by fifty-six oxen, a load of gold bullion valued at 2,500,224 livres, which had been shipped by the French to support the American cause.[70]

Soon after peace was established, and in spite of remaining economic difficulties, a shortage of currencies, and inflation, the Dupuys were in Philadelphia and back in business. Daniel senior was living in the northernmost building on Second Street; Daniel junior and John were working in the annexed southern building.[71] In August 1782 they advertised again for a journeyman and an apprentice, and Daniel senior continued to invest in real estate.[72] In 1782 he purchased a house and lot in the Southern District from John Hutton, shipbuilder, and his wife Elizabeth, who were then living there, for £600 gold and silver of Pennsylvania.[73] It was on the south side of Almond Street, bounded on the south by Cox Alley. Dupuy promptly insured it with the Philadelphia Contributionship for £400, then leased it back to the Huttons.[74] On July 12, 1783, Daniel Dupuy Jr. advertised the property in the *Pennsylvania Packet* as "now in the tenure of Mr. John Hutton . . . To be sold or exchanged for a House and Lot in the upper part of the city." It was described as "a commodious house 18 feet front and 28 feet deep, with two good rooms on a floor, a piazza of 16 feet, in which the stair-case is placed; adjoining is a very good two story brick kitchen . . . the house is insured; the whole is clear of ground rent or any other incumbrance."

In the assessment record of 1783 for the Middle Ward, Daniel Dupuy, silversmith, was assessed £700 for his Second Street property, £16 for 40 ounces of plate, £150 for his occupation, and 13s. each for Daniel and John. Daniel senior owned all of the Dupuy family real estate and paid the taxes, including the per-head tax for his sons. The names of John and Daniel junior do not appear on ownership documents or with estate valuations until Daniel junior is listed in the record as paying his per-head tax of 3od.[75]

In 1784 Daniel Dupuy Sr. purchased a small, three-story house (19 feet by 30 feet) with a separate kitchen (21 feet by 10 feet) on the southeast corner of Elm and Vine streets, in the Upper Delaware Ward. It had been built about 1773 and

Fig. 77. Silhouettes of Daniel Dupuy Jr. and his wife, Mary Meredith Dupuy. From Dupuy, *A Genealogical History of the Dupuy Family*, opposite p. 36

belonged to John Linnington when Dupuy bought it.[76] On September 6, 1785, his insurance on the purchase was recorded, and at the same time, he renewed the insurance on his old Second Street property.[77] In 1789 Daniel junior leased the property to William Sansom.

In April 1784 their former neighbor and family doctor Thomas Bond died. On May 4, Dr. Thomas Bond Jr., the son and executor of his father's estate, signed a receipt to Daniel Dupuy Jr., recorded in the receipt book, for "the sum of thirty Shillings for medicine & attendance of his father's family & this rect. is in full of all accts. due to the estate of Dr. Thos. Bond."[78] On June 10, 1784, Daniel Dupuy Jr. purchased a quantity of silver from Sarah Bond, the doctor's second wife and widow, who signed in the receipt book: "Received of Danl Dupuy Jur. The sum of Forty Four Pounds Fourteen shillings & in full for one hundred and eleven ounces and Fifteen pennyweight of Silverplate consisting of the following Articles 1 coffee pot, 1 large bowl, 4 tumblers, 1 sauce boat, 1 salt Cellar & 1 pr tongs, 3 tablespoons & 2 shell ladles / Sarah Bond."[79]

On June 5, 1788, Daniel Dupuy Jr. married Mary Meredith (1757–1832) at Christ Church. She was the daughter of Charles Meredith, a prominent merchant (fig. 77).[80] They had two children, John Dupuy (1789–1865) and Charles Meredith Dupuy (1792–1875). Shortly after Daniel's marriage, Daniel senior and his wife Eleanor, with

John as their "caretaker," had moved to the house at 15 North Front Street in the Northern Liberties, leased some years before from Hugh McCullough. Daniel Dupuy Sr. was taxed there, in the Northern District, in 1789 for one negro at £30 and with an occupation tax of £50; John was taxed "per hd 15 sh." In 1800 Daniel Dupuy, "gentleman," and John Dupuy, watchmaker, were listed in the South Mulberry Ward.[81]

By the middle of the eighteenth century, the occupation tax for an independent silversmith was at least £150, a value that Daniel senior had carried throughout his career. However, by 1785 his occupation value was reduced to £50, his Second Street house was valued at £600, and he had 40 ounces of plate valued at £16, one chair ("the carriage red and the body green") at £15, and one negro at £50.[82] The substantial reduction in his occupation value suggests that Daniel senior had given up his silver work and retired. However, the Dupuy real estate interests continued, and some may have been conducted by Daniel senior. In 1788 the Dupuys were leasing a "dwelling" from William Smith, a druggist in the Mulberry Ward, and the U.S. Direct Tax of 1798 notes that a Daniel Dupuy was leasing 197 North Second Street to a Thomas Gilpin.[83] On May 7, 1793, Daniel Dupuy advertised in *Dunlap's American Daily Advertiser* a three-story house, to be leased or sold, on Third Street between Race and Vine, at that time rented to Mrs. Sarah Rhoads. It had front and back parlors, a two-story kitchen,

a paved yard, and an alley navigable by a carriage. Daniel Dupuy advertised in *Poulson's American Daily Advertiser* on November 26, 1819, noting his current residence at 160 Race Street and a "House to let in North Front-street, No. 15, near Market-street. This house may be used for a store, or may accommodate a family, as there are four chambers and garrets, a double cellar, and a vault for wood." It was the house previously occupied, in 1789, by his parents and John.

In the U.S. census of 1790, Daniel Dupuy Jr. was listed as head of a family resident on the west side of South Second Street at number 4: two males age sixteen and over, including Daniel junior, one male under the age of sixteen, and two females. The entry reflects recognition by the census taker that Daniel junior was the active silversmith; the Septennial Census of 1800 for the Middle Ward, which included South Second Street, also listed "Daniel Dupuy, silversmith," without the suffix "Jr." Moreover, after 1784 notes in the receipt books and other documents were signed by John or Daniel junior, and newspaper advertisements were placed by Daniel junior.

Daniel junior took over the day-to-day family business, and his name began to appear in records without the suffix "junior" and with his occupation taxed at £150. A Daniel without "Jun" was listed under "Goldsmiths" in the Philadelphia *New Trade Directory* for 1800.[84] In 1799 Daniel junior replaced Edward Shoemaker for the term of a year as a Guardian of the Poor.[85]

Signatures in the Dupuy receipt books show John and Daniel junior active in their professions and record some silver work. In 1811 Daniel regularly employed Samuel Williamson's (q.v.) engraver William Carr. Between 1811 and 1814 he purchased dozens of thimbles from John Owen. He paid Jean-Simon Chaudron (q.v.) $14 "on account." From Harvey Lewis (q.v.) in March 1812 Daniel bought two half-pint canns for $29.70, and in April a sugar bowl for $30.33. In October 1812 he paid Claude Amable Brasier (q.v.) $2.67. In April 1813 Robert Gethen provided him with a receipt that reads: "Received April 5, 1813 from Daniel Dupuy seventeen dollars ninety seven cents in full for making and silver for 1/2 doz. Table spoons. $17.97 For John Gethen [q.v.] spoons 13 oz. 9 1/2 dwt."

In 1810 Daniel, with a household of eight persons, occupied the house at 159 North Third Street in the Upper Delaware Ward that his father had purchased in 1784.[86] In 1813 he purchased a property on the south side of Sassafras Street, 16 by 85 feet, bounded on the west by William Naugh's house and lot, on the north by Sassafras (Race), on the east by Michael Hillegas's ground, and on the south by a lot that was at some time in the tenure of John Houk Lerein (?), with "free use and privilege" of a five-foot alley leading from the southwest corner of the lot granted into Sterling Alley.[87] In November 1814 Daniel Dupuy, "silversmith," and Nathaniel Richardson (q.v.), "gentleman," solved a party-wall problem on their contiguous lots on the north side of Sassafras between Delaware Fourth and Fifth streets.[88] Dupuy ended up paying Richardson $50.

On March 15, 1805, *Poulson's* carried this notice: "Departed this life, on Thursday the fourteenth instant, Mrs. Eleanore Dupuy, at the advanced age of eighty six years. She lived and died a sincere Christian, and has left an aged partner to deplore her loss." Daniel senior paid Eastburn and Lesley $22.66 for his wife's coffin and Joseph Dolby $11.86 for her burial, which included the ground, ministers, clerks, bell, grave, and invitations.[89]

On May 8, 1805, Daniel senior, "Philadelphia goldsmith," deeded to his sons John and Daniel junior the original property he had acquired in 1753. To John "gentleman," the messuage and lot "on the West side of 2nd street bounded with property formerly of Dr. Thomas Bond, West with ground belonging to Overseers of the Public School, by Indenture bearing the date 27th day of September 1753, granted to the said Daniel Dupuy the elder in fee under a ground rent of twenty-two pounds ten shillings lawful money of Pennsylvania per annum payable to the Overseers of the public school." Daniel senior also deeded to Daniel junior the northernmost and contiguous messuage and lot "for one dollar, in his actual possession now being."[90] In 1806 Daniel senior, "gentleman," and John Dupuy, "watchmaker," were still listed in the Pennsylvania Septennial Census on Sassafras Street in the South Mulberry Ward.

Daniel Dupuy Sr., "goldsmith and silversmith," died at his residence of "Clover Hill near Gray's Ferry," on August 30, 1807, at the age of eighty-eight and was buried on September 1 in Christ Church grounds.[91] The *True American* of September 1, 1807, noted: "Daniel Dupuy, Senr. In the eighty-ninth year of his age; long a respectable inhabitant of this city . . . funeral from his late residence in Race Street between Third and Fourth Streets." His death was also noted on September 3, 1807, in the *New-York Gazette and General Advertiser* and on September 7, 1807, in the *Essex Register* of Salem, Massachusetts.

Daniel Dupuy Sr. had written his will on September 6, 1793, and it was probated September 7, 1807. He left to his wife Eleanor "the free use of the tenement where he dwells and the annual income. At her death to son John." To Daniel junior he left other Second Street properties that were rented out. He still owned land in Passyunk Township,

which he left to his daughter Jane Coates, wife of William, tanner, in the Northern Liberties.[92]

"Uncle" John Dupuy never married. He worked with his father and brother and on his own at 4 South Second Street until he moved temporarily to care for his aged parents. In 1810 John paid a Dr. Duffield $75 for "medicines & attendance to dear Father & Mother, from 1793. He (Meredith) also discharges me (Dupuy) from any demand, the cash was paid from sundry Silver plate sold. Paid January 24, 1810 & the plate was left to me."[93] After his parents died, he trained his nephew John in the watchmaking business; both were listed as "storekeeper" in the city directories. In 1812–13, they were working in the southernmost house on the South Second Street property. John altered his house and expanded his retail shop, adding the double-bow windows described by John Evans in the insurance survey of 1811.

In 1820 John Dupuy, watchmaker, had a working household of six people at 4 South Second Street. John died on October 29, 1838, at the age of ninety-one and left his half of the joined buildings to his nephew John, son of his brother Daniel, subject to a life estate thereon for himself. In 1833 Daniel transferred title to his half of the house on Second Street to his son John.[94]

Daniel junior and his wife Mary occupied the adjoining northernmost house, where he continued active silver work. On December 5, 1815, he paid John Marley "for a new shaft to a chair," and paid Philip Halzel in jewelry and silver for eight fancy chairs.[95] In his will Daniel junior had left his house to his wife for her lifetime and then to John, and at her death in 1833 John became the owner of both properties. Daniel Dupuy Jr. died at his property south of the city in Clover Hill on July 31, 1826, and was buried in Christ Church burial ground.

The Dupuys made some handsome silver within the design vocabulary favored in Philadelphia during their long careers, including the grand sauceboats with quite extraordinary handles made for "GEJ."[96] Tea services and their components may have been a specialty of their shop. Doctor Benjamin Rush was presented with a tidy sugar urn by his students in 1790 (cat. 218). Their silver was usually engraved skillfully, as seen in a fluted, oval-shaped tea caddy with particularly elaborate engraving of running bands, swags, and floral sprays, possibly by William Carr, whom Dupuy paid for work in 1811.[97]

Throughout the research on this family of craftsmen, it became clear that they managed their family and their work carefully, with much attention to their investment properties. A note written by Daniel Dupuy Sr. to John Nicholson in October 1794 suggests Dupuy's persistence in his attention

to business: "I bege you to have house build & 20ty acres of my land grub up; I shall deposite in your hands a sum sufficient to defray this expense."[98] This property was an investment in western land promoted by Nicholson and Robert Morris in the 1790s, far from the silversmith's bench.

Early inheritances from the Dupuys in New York and the Coxes in Philadelphia must have facilitated the Philadelphia Dupuys' early real estate activity, providing some protection from the economic upheavals caused by the wars, currency shortages, credit problems, and yellow fever that affected so many craftsmen. The central location from which they operated for two generations and their sober advertisements, if truly representative of their enterprise, reveal a low-key, sturdy independence that allowed them to avoid the risk of diversifying their commerce into a more general mercantile trade. Ever protective and with a sure hand in business, Daniel senior controlled the day-to-day family enterprise. Probably inspired by his son John's reaching his majority, on June 10, 1768, he wrote a treatise addressed to all of his sons that they found later among his papers. It read in part:

It is my belief you desire to be happy here and hereafter. You know there are a thousand difficulties that attend this pursuit, some of them perhaps you for see [sic], but there are multitudes which you could never think of. Never trust, therefore, to your own understanding in the things of this world where you can have the advice of a wise and faithful friend. . . . To direct your carriage towards God, converse particularly with the Book of Psalms. . . . To behave aright among men acquaint yourself with the book of Proverbs. . . . As a trader keep that Golden sentence of your Savior ever before you, "Whatsoever you would that men should do unto you, do you also unto them." . . . Farewell.[99]

1. During his father's active life, Daniel Dupuy Jr. used the abbreviation "JR" following his name. In the late 1780s and by 1793, when his father was failing, Daniel himself, and the person making the record, sometimes dropped the suffix.

2. John David II (died before 1722) of New York, was the father of Peter David and grandfather of John David Sr., both silversmiths (q.qv.). Further back, the family originated in Italy, descending from the Del Poggios in Lucca. For a family history, see DuPuy 1910.

3. For an important correction to the published Dupuy genealogy, namely, that Dr. John Dupuy's wife was not Anne Chardavoine, as stated in ibid. (p. 19), but rather Anne David (1721–1750), daughter of John and Esther Vincent David, see Gary E. Young, "Dr. John Dupuy's Wife Not a Chardavoine," posted February 17, 2010, www.genealogy.com/forum/surnames/topics/dupuy/655.

4. DuPuy 1910, pp. 10–11.

5. Dr. John Dupuy's will, written in 1741 and probated in 1745, included: "my large silver tankard 29 oz. 14 pw . . . which was brought to me from Jamaica," a silver porringer, four negroes, a house "with appurtenances, furniture, a house & ground next, the corner of King Street in William Street, rented, . . . my great garden in William Street [two lots, each 25 feet by 157 feet]," a

little garden near the French Church, and a house, land, and a farm in Orange County. The tankard was listed in Daniel Dupuy Sr.'s will in 1807, but not thereafter. Ibid., p. 15.

6. See the biography of Peter David in this volume.

7. This property was sold by Anne David Dupuy to the New York goldsmith Myer Myers (q.v.) for £1,000. DuPuy 1910, p. 16; David L. Barquist, Myer Myers: Jewish Silversmith in Colonial New York (New Haven, CT: Yale University Press, 2001), p. 32.

8. Francis H. Bigelow Papers, Yale University Art Gallery, New Haven. Daniel had two brothers, John and Francis, and two sisters, Hester and Jane (Jeanne).

9. DuPuy 1910, p. 13.

10. Peter David was purchasing gold, silver, and medicines from Stephen Paschall in Philadelphia in 1735; Stephen Paschall, Account Book, 1735–1736, Stephen and Thomas Paschall Records, 1694–1866, HSP.

11. Maurice Brix selected and transcribed records from the Dupuys' receipt books dated November 1, 1740–March 16, 1805, and October 4, 1811–July 6, 1829. The present location of the books is unknown. Copies of the Brix transcriptions were provided courtesy of the Department of American Art, Yale University Art Gallery (hereafter Dupuy, Receipt Books).

12. Fales 1974, p. 40.

13. Daniel senior's cousin John David Sr. was noted as "one person" and shared the pew, for which he paid 7s. The Dupuys' location was noted as "2nd bel[ow] Market." Christ Church Pew Rent book, no. 238, May 17, 1757, signed by Jacob Harvey; Christ Church Archives, courtesy of Carol W. Smith, archivist. I have been unable to verify the conjecture in Ensko (1948, p. 45) that the Dupuys and the Davids joined in a partnership.

14. Dupuy, Receipt Books. The first entry transcribed is dated 1741. Pitts was also offering for sale a house and lot in Sassafras (Race) Street that had belonged to his father-in-law, John Yeldhall; Pennsylvania Gazette (Philadelphia), May 28 and June 4, 1741.

15. Dupuy, Receipt Books, December 18, 1741 (Jeremiah Warder); March 25, 1742 (Peter Stretch).

16. Philadelphia Deed Book EF-25-640-644, September 7 and 25, 1753. It was part of a lot granted by charter to the Free Public School in September 1705 by William Penn. Members of the board were John Armitt, William Callender, Edward Catherall, Joshua Crosby, William Logan, Anthony Mazur Jr., Samuel Borton (?) Moore, Anthony Morris, Isaac Norris, Israel Pemberton, Israel Pemberton Jr., Samuel Powell, John Reynell, Benjamin Shoemaker, and John Smith. Israel Pemberton facilitated the sale to Dupuy, whose payments of ground rent to the Friends' Free Public School are recorded in his tax accounts for the Middle Ward; Tax and Exoneration Lists, 1762–1794.

17. Herbert DuPuy (1910, pp. 14–15) stated that the receipt books contained entries recording Daniel senior's travel expenses to and from New York.

18. Dr. John Dupuy's will was signed in 1741 and probated in 1745; ibid., p. 14.

19. Another sale notice about this property directed inquiries to "Mrs. Anne Dupuy in New York or Mr. Daniel Dupuy, goldsmith, in Philadelphia"; New York Weekly Post-Boy, March 31, 1746.

20. John Dylander (1709–1741), the fifth rector of Gloria Dei Church, married Eleanor Cox, daughter of Peter, in September 1741 but died in November of that year; DuPuy 1910, p. 28. Jeremiah Elfreth (q.v.) was a witness to the will of Peter Cox; Philadelphia Will Book J, p. 82, written October 9, 1748, recorded October 22, 1748, probated January 27, 1750.

21. DuPuy 1910, p. 39; Reverend Charles Meredith Dupuy (1792–1875), Daniel Jr.'s grandson, was assistant minister there from 1822 to 1828.

22. Edward L. Clark, A Record of the Inscriptions on the Tablets and Grave-stones in the Burial-Grounds of Christ Church, Philadelphia (Philadelphia: Collins, 1864), p. 568; DuPuy 1910, p. 32.

23. Norris Stanley Barratt, Outline of the History of Old St. Paul's Church, Philadelphia, Pennsylvania . . . (Philadelphia: Colonial Society of Pennsylvania, 1917), pp. 34, 272.

24. The Cox properties are identified on the 1777 Plan of the City and Environs of Philadelphia by Nicholas Scull and George Heap, and as owned by Dupuy on the 1802 Plan of the City and Environs by P. C.

Varle; see Russell F. Weigley, ed., Philadelphia: A 300 Year History (New York: Norton, 1982), illus. pp. 206–7.

25. DuPuy 1910, p. 44.

26. 1798 U.S. Direct Tax; Poulson's American Daily Advertiser (Philadelphia), January 26, 1802.

27. In the 1798 Direct Tax, a Dupuy property (Clover Hill?) was noted as having ten or twelve acres adjoining some of George Gray's land, valued at $1,200, with a house 16 feet by 32 feet, valued at $731.25 with tax of $19; Proprietary, Supply, and State Tax Lists, City and County of Philadelphia, Ancestry.com.

28. Pennsylvania Gazette, June 22–July 13, 1749.

29. A "tavern" does not appear in other Dupuy records. However, the property seems to be the same one advertised in 1749.

30. Dupuy, Receipt Books, January 10, 1760.

31. John F. Watson, Annals of Philadelphia, and Pennsylvania, in the Olden Time . . . (Philadelphia: Lippincott, 1870), vol. 2, p. 480.

32. For William Coates, see page 191.

33. See note 22 for the children's burials.

34. Odran Dupuy, a "watchfinisher" from London, was located on Arch Street "next door to the bell" on January 28 and February 4, 1735, when he advertised in the Pennsylvania Gazette that he, besides having "a true method of bringing a watch to go nearly exact," would open a school to teach the French language, and his wife would instruct young ladies in needlework. A relationship to the silversmiths has not been established.

35. The will was not probated until 1750. Anne David Dupuy died in 1769 and was buried at Christ Church, Philadelphia. DuPuy 1910, p. 19.

36. Philadelphia Deed Book EF-25-640-644, September 7 and 25, 1753. The property was described in the deed as follows: "two contiguous messuages and a lot of ground thereto belonging, in breadth North and South 20 feet, in length 72 feet, bounded on the east with Delaware 2nd Street, extending in depth to Strawberry Alley, South with Thomas Bond's messuage and lot, West with ground belonging to Overseers of the Public school, North with a messuage and lot in tenure and occupation of George Morrison, being part of a certain High Street and 2nd Street lot of ground wherein William Penn by his petition did grant under the hands of his deputies and great seal bearing the date of September 1705, a piece of ground on Second Street [extending] to Strawberry Alley for £22.10 ground rents due 25th March, 24th June, 29th September, 25th December, forever; if in arrears to be sold." The deed was finally recorded on January 8, 1807, when the property was inherited by Daniel junior and John Dupuy. In the records for the 1754 tax for regulating and repairing the streets, Dupuy and John Hallowell were listed in the Middle Ward as taxables at 2d. on the pound. William Savery, "List of Taxables of Chestnut, Middle, and South Wards, Philadelphia, 1754," PMHB, vol. 14, no. 4 (1890), pp. 414–20; Hannah Benner Roach, "Notes on John Hallowell, Daniel Dupuy, George Morrison and George Warner, Residents in the Middle Ward, Philadelphia in 1754," Pennsylvania Genealogical Magazine, vol. 21, no. 4 (1960), pp. 328–34.

37. Survey for policy no. S00191, January 1, 1754, written for Daniel Dupuy Sr. for the Second Street houses, Philadelphia Contributionship for the Insurance of Homes from Loss by Fire, www.philadelphiabuildings.org/contributionship. The Reverend Charles Meredith Dupuy, Daniel junior's grandson, recollected: "For a long period he [Daniel junior] had tenanted, as had his father before him, the property now No. 16 South Second Street, but then owned by the Society of Friends. Desiring to give expression to their appreciation of Mr. Dupuy's character, the Society invited him to purchase the property, fixed a very reasonable price for it, and asked him to name payments to suit his convenience. Since the owners were so generous in their expression of confidence in Dupuy, he reciprocated by accepting their offer, and thus became possessed of the property at the cost of a few hundred dollars, leaving to be paid an annual ground rent of thirty dollars." DuPuy 1910, pp. 36–37.

38. John Parrish, Account Book, no. 1, p. 4, Cox-Parrish-Wharton Papers, HSP.

39. This policy and survey (S00191-001A), dated September 6, 1785, renewed the insurance policy of 1754 (0191); Gunning Bedford, resurvey, 1811, policy no. S00191-002A, Philadelphia Contributionship. Improvements had been made to the northernmost building, including the addition of a story. Wood

structures commanded a higher premium. A piazza was described as a room linking a dwelling with the back building proper and housing a staircase. It was not a veranda or porch. Anthony N. B. Garvan et al., *The Architectural Surveys, 1784–1794*. Philadelphia: Mutual Assurance Co., 1976), vol. 1, p. 321.

40. Resurvey, 1811, policy no. S00191-002A, Philadelphia Contributionship. The property was described as follows: "20 feet x 37 feet, three stories high, 14 & 9 inch walls, two rooms in the lower story & short passage, the front a dry goods shop with two circular Bulk windows with 30 lights glass 11 by 18 inches. back a parlor with plain mantle to the fireplace—2nd story in two rooms with base only rounds, finished very plain, the floors old and much worn, winding stairs from the 2nd story into the garret—the third story with 4 rooms, very plain, and garret in 4 rooms—4 dormer windows in the roof square top and trap door—plain e[a]ve front and back wooden gutter & tin pipe front, and all wo[o]d back—Piazza 8 feet by 12, two stories high with one flight of open newel stairs, plain nosings, turned banisters & cherry rail, skirted up the wall newly built—roof of the house twenty years old—a wooden kitchen back with doors of communication—ash hole in the cellar."

41. Philadelphia directory 1813.

42. *Pennsylvania Archives*, 3rd ser. (1897), vol. 14, p. 154; Daniel junior paid £55 14s. in the Middle Ward. Gunning Bedford surveyed two houses for Dr. Thomas Bond Sr. in April 1769, and both buildings together were insured for £850; survey nos. S01302 and S01303, Philadelphia Contributionship.

43. Survey no. S01303, Philadelphia Contributionship. Located on Second Street between Chestnut and Walnut, the house was extant as of July 31, 2017, as the Thomas Bond House Bed and Breakfast; www.thomasbondhousebandb/history.php.

44. Daniel Dupuy's property was described by Gunning Bedford in the insurance survey of 1769 as "Fifteen feet front, thirty three feet deep, 3 storys high, 9 inch walls except one gable end which is 4 inches—2 rooms on a floor—plastered partitions, board newel stairs—finished very plain and mostly old—outside and one story within painted—shingling old. Back building 34 by 10 feet, 2 story high—9 inch walls except about half the 2nd story which is wood and occupied as a goldsmith's work shop. £300 house. £50 Back Building @ 32/6 pct." Daniel Dupuy was noted as "tenant" in survey no. S01302, Philadelphia Contributionship, www.philadelphiabuildings.org/contributionship. Bond's house that Dupuy leased was located between High and Chestnut streets with frontage on the west side of Second Street, and insured for £850. Second Street was the dividing line between the Chestnut Ward (considered the east side) and Middle Ward (the west side) in 1785. In 1800 Fourth Street became the dividing line between those two wards. Tax records were listed by ward.

45. Thomas Bond, in Tax and Exoneration Lists, 1762–1794.

46. Daniel Dupuy, in ibid.

47. Fales 1974, p. 303.

48. *Pennsylvania Gazette*, May 29, 1755; Dupuy, Receipt Books, April 1780, for two years "interest of his contribution" paid to Hugh Roberts, treasurer.

49. Traverse Jury, "Courts of Oyer and Terminer: Juries and Appointments, Philadelphia County," *Pennsylvania Genealogy Magazine*, vol. 46, no. 1 (Spring/Summer 2009), pp. 88, 90, 94.

50. Caspar Wistar, Receipt Book, 1747–1786, HSP.

51. *Pennsylvania Packet, or The General Advertiser* (Lancaster), October 5, 1772; October 4, 1773; October 10, 1774. For a consideration of the role of assessors and their discretion in estimating estate values, see Karen Wolf, "Assessing Gender: Taxation and the Evaluation of Economic Viability in Late Colonial Philadelphia," *PMHB*, vol. 21, no. 3 (July 1997), pp. 201–35.

52. The entries that follow are from Dupuy, Receipt Books, unless otherwise identified.

53. William Ball, Account Book, Ball Families Papers, 1676–1879, HSP.

54. Owen Jones, Daybook, 1759–1761, D-35, HSP.

55. The purchase totaled £16 6s. 4d.; Account of Goods of Philip Hulbeart, Downs Collection, Winterthur, coll. 602 58x531.3.

56. Joseph Wharton estate, Miscellaneous receipts, Small Collection, 1769–1975, box 41, folder 17, HSP.

57. *Pennsylvania Packet, or The General Advertiser*, April 18, 1774.

58. These advertisements, which include notes about marks, confirm Daniel senior's use of the "DD" initial stamp; *Pennsylvania Gazette*, June 14, 1750, and February 12, 1756; *Pennsylvania Journal and Weekly Advertiser* (Philadelphia), June 23, 1781.

59. Joseph Evans, apprenticeship contract, dated April 27, 1772; cited by John Gibson, *Record of Indentures of Individuals Bound Out as Apprentices, Servants, etc. . . .*, Pennsylvania German Society, vol. 16 (Lancaster, PA: the Society, 1907), pp. 78–79.

60. Tax and Exoneration Lists, 1762–1794, Southwark Ward: taxed for three negroes; for £43 of James Cochran and £40 of Catherine Pursell in the Midddle Ward; and for £14 of John Farrick and £15 of Peter Young in Passyunk. Dupuy's tax was £55 14s., £79 4s. less the £23 10s. ground rent of the Free Public School. John was listed with no tax, although he paid the 1798 U.S. Direct Tax on his Passyunk properties.

61. Tax and Exoneration Lists, 1762–1794.

62. Scharf and Westcott 1884, vol. 1, pp. 272–73.

63. "John Adams, writing in July 1777, said there had been two thousand interments in Potter's Field (probably now known as Washington Square), and that the disease destroyed ten soldiers where the enemy slew one"; ibid., vol. 1, p. 340.

64. Richard Humphreys (q.v.) was another silversmith who moved out of Philadelphia to Reading; notice of sale, *Pennsylvania Packet, or The General Advertiser*, June 10, 1778.

65. Ibid., June 10, 1778: "A HOUSE and LOT in the town of Reading: The lot is situated on the north side of the main street, containing in front 60 feet and in depth 22 feet: the house is well built of stone, 30 feet by 27, two rooms on the first floor, and a large convenient kitchen; on the second are three rooms. There is on the said lot a very good stone stable large enough for four horses, and a loft that will contain two tons of hay; likewise a well built shop of hewn logs 18 feet square, lately built, and would answer for a dwelling house; a pump before the door, and an oven in the yard; the whole in good order, and wants no repair. For further particulars apply to the subscriber, who lives on the premises. DANIEL DUPUY." The tax was to be 2s. 6d. per £100. In 1781 Daniel senior's value was £692, the tax was £7 19s. 1 1/2d., and his sons were taxed at £3 per head. In 1782, with the tax set at 10s. 4d. per £100. Daniel senior was valued at £767 (which included his occupation value at £150), his tax was £3 19s. 4d., and his sons were taxed at £1 per head. Tax and Exoneration Lists, 1762–94.

66. William Siebert, "The Loyalists of Pennsylvania," *Ohio State University Bulletin*, no. 24 (April 1920), pp. 56, 96, 101.

67. On April 1, 1778, the period for taking the oath was extended to June 1, 1778. *Pennsylvania Archives*, 2nd ser. (1896), vol. 3, p. 28. For the year 1778 Daniel senior was taxed £57 8s. and £6 "for his two sons for their Head Tax for the same year / £69 8s."

68. "Daniel Dupuy for Hugh McCullough's Est. £400, Tax £6"; Tax and Exoneration Lists, 1762–94. "Died, at Philadelphia, Daniel Dupuy, aged 89—and Hugh McCulloch, about the same age"; *New York Gazette and General Advertiser*, September 3, 1807. Daniel Dupuy junior still owned the house on Front Street in 1817; *Poulson's American Daily Advertiser*, July 14, 1817.

69. DuPuy 1910, p. 34.

70. "Extracts from the Diary of Jacob Hiltzheimer, of Philadelphia, 1768–1798 (continued)," *PMHB*, vol. 16, no. 2 (July 1892), p. 160.

71. Roach, "Notes on John Hallowell, Daniel Dupuy, George Morrison and George Warner," pp. 328–29.

72. *Pennsylvania Packet, or The General Advertiser* (Philadelphia), August 20, 1782.

73. Philadelphia Deed Book D-13-508, October 19–23, 1782. The insurance survey (no. S01157) was a continuation of one issued in 1767 to Captain Richard Taylor; Philadelphia Contributionship. In 1783 John Hutton Jr.'s occupation tax was £150 (shipbuilders and silversmiths were among those who carried the highest occupation tax). John Hutton Jr., shipwright, was the son of the silversmith John Strangeways Hutton (q.v.). The Huttons leased the house behind the Dupuys. The shipwright's wife Elizabeth was listed in the Philadelphia directory in 1793 as a widow at 40 Almond Street.

74. In the assessment of John Hutton's estate record for 1783 in Southwark: "John Hutton/for House & Lot . . . £160, Occupation £150, [total] £310 . . . and for Daniel Dupuy's Est £425"; Tax and Exoneration Lists, 1762–1794.

75. For the year 1779 Daniel senior was valued at £6,600, his abatement was £3,000, his tax was £54, and his sons John and Daniel were taxed per head at £15. For the year 1780, with a tax rate of £2 per £100, Daniel senior was valued at £5,200, his tax was £104, and the abatement allowed for Friends Meeting ground rent was £450. Daniel junior was taxed per head at £30 and John per head at £25. For the supply tax in 1781, with a tax rate of £1 3s. per £100, Daniel senior was valued at £692 and his tax was £7 19s., with both John and Daniel junior taxed per head at £3. For the year 1782, with a tax rate of 10s. 4d. per £100, Daniel Dupuy was valued at £767, his tax was £3 19s. 2d., and Daniel junior and John were taxed per head at £1. In 1782 the dwelling of Daniel Dupuy, "goldsmith," was valued at £600, 40 ounces of plate at £17, and his occupation at £150, and Daniel and John Dupuy (as "Inmates") were taxed per head at £4. In 1783 Daniel senior, noted as "silversmith," was taxed as follows: dwelling and lot at £700, 40 ounces of plate at £16, and occupation at £150, with Daniel and John taxed per head at £13 each. In 1785 Daniel senior paid £22 10s. ground rent to Friends Meeting, and his estate value tax was £225, with John and Daniel junior taxed at £30 per head.

76. Survey no. S01676, May 3, 1773 (for John Linnington), Philadelphia Contributionship: house valued at £400, kitchen at £50. The house and kitchen were described in part: "Two rooms & an entry below. Both rooms finisht with Breast sirbace skirting & single cornice Round. Entry finisht with sirbace skirting & single cornice, wainscot Partition & sliders between the front Room & Entry. Two Rooms in 2nd Story, front Dᵒ finisht with Breast and sirbace skirting & single cornice Round. Back room finisht with Breast sirbace & skirting. Third story Plain Board newel stairs Plaistered partitions. Garret—Plaistered Modillion Eves Front & plain Frontispiece. Kitchen 21 feet by 10 feet Including an Inclosed Piazzo [*sic*] & small plain stair case / Bord Newell. Two-story-high, 9-inch walls The whole New & painted Inside and outside." The property became 159 Third Street in the Upper Delaware Ward.

In 1789 William Sansom was the tenant, but the property was being advertised for rent with "two neat parlours and upper rooms, a convenient two story kitchen and a cellar under the whole. It is [in] good repair. A commodious yard with an alley on the back. For particulars apply to Daniel Dupuy, jun." *Pennsylvania Packet* (Philadelphia), September 19, 1789. In 1793 Mrs. Sarah Rhoads was the tenant; *Dunlap's American Daily Advertiser* (Philadelphia), May 7, 1793. It was advertised again in *Poulson's American Daily Advertiser* on June 5, 1807, just after Daniel senior's death on June 4, 1807, "to lett on the East side of Third Street between Race Street and Vine." Reverend Charles Meredith Dupuy had it resurveyed in 1842 for an addition to the main building of a room 18 feet by 5 feet, "throwing the whole lower story into one room—a grocery store therein"; policy no. S01676 continued, Philadelphia Contributionship.

77. See note 37 for the insurance on the Second Street property.

78. Dupuy, Receipt Books. The phrase "full of all accounts" suggests that the Dupuys had paid off any debt.

79. Ibid. Sarah Bond died later that year, in October; Philadelphia Will Book Q, p. 43.

80. *Pennsylvania Archives*, 2nd ser. (1896), vol. 8, p. 78. Daniel Dupuy Sr.'s sister Jane married William Coates at Christ Church on May 11, 1775 (ibid.).

81. Philadelphia directory 1800; 1800 U.S. Census, South Mulberry Ward.

82. The chair was purchased by Daniel junior from George Chaplin on May 13, 1784, for £2 10s.; Dupuy, Receipt Books.

83. Tax and Exoneration, 1762–1794; 1798 U.S. Direct Tax. The property he leased to William Smith, druggist, in 1788–89 was valued at £500. Another property, a dwelling valued at £120, was leased to Solomon Lyons, baker; and a third dwelling, valued at £300, was leased in 1789 to Abraham Weaver, cordwainer. All three properties were in the Mulberry Ward. See the 1798 U.S. Direct Tax. Also noted was another property, at 197 North Second Street, which Dupuy rented to Thomas Gilpin, and for which Dupuy paid a tax of $5.58 on a value of $1,395.

84. *New Trade Directory* 1800, p. 61.

85. *Claypoole's American Daily Advertiser* (Philadelphia), March 15, 1799.

86. Philadelphia directory 1810.

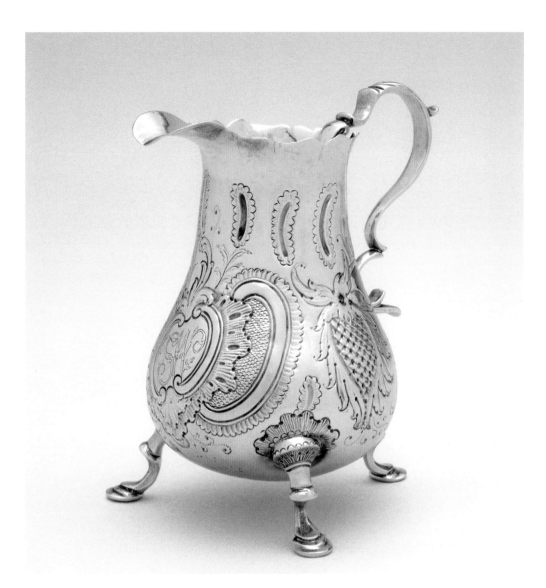

87. Daniel Dupuy Sr. had purchased this property, 160 Race Street (Philadelphia Deed Book D-12-175), from Abel James and his wife Rebecca in 1783 for £805 "in gold and silver." On May 17, 1784, Daniel senior paid Nicholas Forsbery £12 11d. "for painting and glazing his house in Race Street the house being measured by Mr. Nevil & Moulder"; Dupuy, Receipt Books. In 1819 Daniel Dupuy Jr. was located at this property.

88. Philadelphia Deed Book MR-2-591, November 22, 1814. The properties at issue were located on the north side of Sassafras Street between Fourth and Fifth streets. Daniel Dupuy's lot was the westernmost, with 16 feet of frontage and and a depth of 80 feet.

89. Dupuy, Receipt Books.

90. "Daniel Dupuy the elder, goldsmith, to Daniel Dupuy, his son the younger, goldsmith, for natural love and affection"; May 8, 1805, recorded December 1, 1806, Philadelphia Deed Books EF-25-424, EF-25-426.

91. Barratt, *Outline of the History of Old St. Paul's Church*, p. 272.

92. Dupuy estate, Philadelphia Will Book 2, no. 85, p. 153; Philadelphia Deed Book AM-54-308, April 1, 1833.

93. Dupuy, Receipt Books.

94. Thus John junior became the owner of both houses on this property, which was still in the family in 1850.

95. Dupuy, Receipt Books.

96. For the sauce boats, see Christie's, New York, *Important American Furniture, Silver, Prints, Folk Art and Decorative Arts*, January 26–27, 1995, sale 8076, lot 393.

97. Spencer 2001, illus. p. 170.

98. John Nicholson Papers, Dallett Series II, box 6, folder 12, HSP. The 1798 U.S. Direct Tax listed rental properties owned by the Dupuys, one of which was at 197 North Second Street and leased to Thomas Gilpin, inspector of lumber. Besides city property, Dupuy senior, following the custom of investing in vacant land, took out two land warrants: one on July 1, 1784, for 400 acres in Berks County, and the other in February 1794 for 400 acres in Luzerne County; *Index of Early Pennsylvania Land Warrants, 1733–1987*, from the Pennsylvania State Archives (Stevens, PA: Ken McCrea, 2010), Ancestry.com.

99. For the full text, see DuPuy 1910, pp. 31–32

Cat. 213
Daniel Dupuy Sr.
Cream Pot

1760–70

MARK: DD (in rectangle, three times on underside; cat. 213–1)

INSCRIPTION: S W (engraved script enclosed in rococo cartouche, on front opposite handle; cat. 213–2)
Height 4¼ inches (10.8 cm), width including legs 3¼ inches (8.3 cm), width top 3¾ inches (9.5 cm)
Weight 3 oz. 3 dwt.
Gift of the McNeil Americana Collection, 2005-68-23

PROVENANCE: Sotheby Parke Bernet Galleries, New York, *The American Heritage Society Auction of Americana*, November 16–18, 1978, sale 4180, lot 405; (Elinor Gordon, Villanova, PA).

Cat. 213-2

Cat. 213-1

There is some question about the date of the elaborate and unusual chased decoration (cat. 213–2), and the style of the initials is unlike others on silver by Dupuy. The pot itself, the legs, and the stepped hoof feet are surely the work of the elder Dupuy. BBG

Cat. 214

Daniel Dupuy Sr.

Clasp for a Necklace or Bracelet

1770–85

Gold

MARK: DD (in rectangle, on reverse; cat. 214-1)

INSCRIPTION: L.E.R (engraved on reverse; cat. 214-1)

Length 1 1/16 inches (2.7 cm), width 5/8 inch (1.6 cm)

Weight 2 dwt. 20 gr.

Gift in memory of Elizabeth DuPuy Graham Hirst, 1968-202-1

PROVENANCE: Purchased from the Philadelphia antiques dealer Leon F. Stark (1902–1981).

PUBLISHED: Carol Eaton Soltis, *The Art of the Peales in the Philadelphia Museum of Art: Adaptations and Innovations* (Philadelphia: the Museum, 2017), p. 146, fig. 3.14.

The clasp has three pierced flanges at each end where strings of beads, probably coral, were secured. BBG

Cat. 214-1

Cat. 215

Daniel Dupuy Sr.

Two Pairs of Sleeve Buttons

1770–85

Gold

MARK: DD (in rectangle, on reverse of one button of each pair; cat. 215-1)

INSCRIPTION: E D (engraved script in oval frame, on each button)

1962-95-1a, 1962-95-2a: Length 11/16 inch (1.8 cm), width 7/16 inch (1.2 cm)

Weight 1 dwt. 9 gr.

1962-95-1b, 1962-95-2b: Length 5/8 inch (1.6 cm), width 7/16 inch (1.2 cm)

Weight 1 dwt. 8 gr.

Gift of Mrs. M. Basil B. Rolfe, 1962-95-1a,b, 1962-95-2a,b

PROVENANCE: The initials "ED" belonged to Eleanor Cox Dupuy (1719–1805), Daniel Dupuy Sr.'s wife. The buttons descended to their grandson John Dupuy (1789–1865), and to his great-granddaughter Leslie Isabel Wright Rolfe (1903–1966), the donor.

One pair of these handsome oval buttons is slightly longer than the other. Each pair is joined with a substantial gold wire that passes through round loops on the reverse of each button. The engraved initials and the band of zigzag chasing around the edge of the oval buttons are deep and detailed. When worn, the initials on the buttons would read right side up. The oval shape is generally considered to be a mid-eighteenth-century style and became especially popular in the 1780s.[1] BBG

1. I. Noel Hume, "Sleeve Buttons: Diminutive Relics of the Seventeenth and Eighteenth Centuries," *Antiques*, vol. 79, no. 4 (April 1961), pp. 380–83.

Cat. 215-1

Cat. 216

Daniel Dupuy Sr. or Jr.
Pitcher

1780–90

MARK: DD (double struck in rounded rectangle, under the upper rim to left of handle; cat. 218-2)

INSCRIPTIONS: J E M (engraved script, on front below ouring lip; cat. 216-1); 35≡2, 40745≡3029 JEM (scratched, on underside)

Height 13 inches (33 cm), width 8⁵⁄₁₆ inches (21.1 cm), depth 5⅝ inches (14.3 cm)

Weight 34 oz. 13 dwt. 18 gr.

Gift of Walter M. Jeffords, 1956-84-4

EXHIBITED: Philadelphia 1956, cat. 88; Philadelphia 1969, p. 55, cat. 17.

Pitchers of this size were used variously to serve lemonade, beer, and water. This pitcher seems to have been designed in three units. The foot, stem and urn-shaped body are like the sugar-bowl form and seem too small to support the tall, upper unit and generous flare of the pouring lip. The engraved initials are fine. The initials and numbers scratched on the underside suggest a commission, with the initials provided for the engraver.

Daniel Dupuy Sr. probably made the handsome coffer-shaped tea caddy that seems to bear the same mark as well as the same inscription as on this pitcher.[1] However, a different engraver, working in a slightly earlier style, produced the "JEM" initials on the caddy. Where the engraving on the otherwise plain surface of the pitcher is feathery and free, the tight and precise bright cut-work bandings and the neat initials enclosed in a vertical oval on the caddy suggest the elder Dupuy as maker.

Tiny scratched numbers appear often on silver owned by the Morris family of Philadelphia. The initials "JEM" may have belonged to James (1753–1795) and Elizabeth Dawes Morris (1746–1826),[2] who married in 1772 at Gwynedd Monthly Meeting. BBG

1. Philadelphia 1956, cat. 92 (lent by Mrs. John Emerson Marble). The initials are period, an indication that they were not added by the lender, whose initials are the same; Spencer 2001, pp. vii, 170.

2. Dawesfield was built about 1736 by Abraham Dawes, whose father had bought the land in 1731 from Anthony Morris, James Morris's grandfather; Moon 1898–1909, vol. 2, pp. 492–95. The house still exists in private ownership.

Cat. 216-1

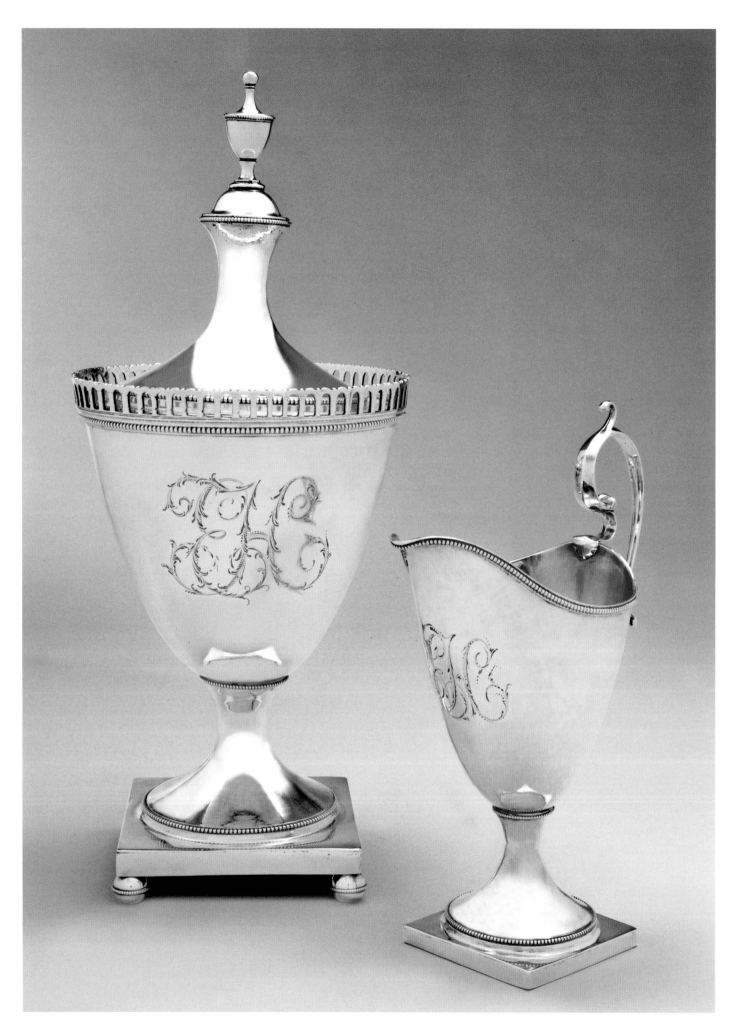

Cat. 217

Daniel Dupuy Sr. or Jr.

Sugar Bowl and Cream Pot

1780–90

MARKS: DD (in rounded rectangle, on two corners of under-side of base of sugar bowl; cat. 218-2). DD (in rectangle, on two corners on underside of base of cream pot; cat. 217-1)

INSCRIPTIONS: E H (engraved script, on front of each); 8019 (scratched script, in one corner of base of each and inside lid of sugar bowl); oz / 19 (scratched in one corner on underside of base of sugar bowl); oz / 5 " 2 (scratched, in one corner on underside of base of cream pot)

Sugar Bowl: Height 11 inches (27.9 cm), diam. 4¾ inches (12.1 cm)
Weight 18 oz. 11 dwt. 18 gr.
Cream Pot: Height 6⅞ inches (17.5 cm), width 4¾ inches (12.1 cm)
Weight 5 oz. 5 gr.

Gift of Elsie DuPuy Graham Hirst in memory of her son, Thomas Graham Hirst, 1960-107-1a,b, -2

PROVENANCE: Although the donor was a direct descendant of Daniel Dupuy (see cat. 223), these objects are not known to have belonged to a member of the Dupuy family. In 1956 they were lent to the Museum by the antiques dealer David H. Stockwell of Wilmington, Delaware, from whom Elsie Hirst may have acquired them.

EXHIBITED: Philadelphia 1956, cats. 86, 90; Philadelphia 1976, pp. 161–62, cat. 131; Garvan 1987, sugar bowl: p. 76, fig. 45; cream pot: p. 89, pl. 23; *Oh Sugar! Philadelphia's Sweet Story: The Magical Transformation from Cane to Candy*, Independence Seaport Museum, Philadelphia, August 16, 2013–February 3, 2014.

PUBLISHED: Diana Cramer, "Philadelphia Museum of Art, American Wing," *Silver Magazine*, vol. 22, no. 3 (May–June 1989), p. 28; Beatrice B. Garvan, "Metalwork in Pennsylvania," *International Fine Art and Antique Dealers Show: The Seventh Regiment Armory, New York City, October 15–21, 1993* (New York: International Fine Art and Antique Dealers Show Ltd., 1993), p. 24, fig. 7.

Cat. 217-1

This sugar bowl is an elegant example of the galler-ied form made by Philadelphia silversmiths. The ball feet are attached to silver rods that are fitted into the corner of the base. Although unusual, the sol-der appears original. The exaggerated spirelike lid, similar to that for the sugar bowl for Benjamin Rush, adds to the vertical design and seems to be a feature of the Dupuys' work.

The engraving is especially well placed and in scale with the shape. The lettering is in the same florid rococo vocabulary and probably by the same hand as that on a neoclassical-shaped coffeepot by Abraham Dubois Sr. or Jr.[1] The number "8019," possi-bly an order or inventory number, is scratched on the bases of both pieces and on the inside of the lid of the sugar bowl.[2] The swinging loops and fillips of the handle design are especially elegant, but the cream pot shows less finesse in the design. It lacks the ball

feet (there is no evidence that there ever were any), and the engraved initials are less accomplished than those on the sugar bowl. BBG

1. Philadelphia 1956, cat. 78.
2. This suggests that they were made as a pair. Scratched numbers appear on Dupuy silver and on some family-owned units. They may refer to estates or to silversmith's accounts.

Cat. 218

Daniel Dupuy Jr.

Urn

1790

MARK: DD (in rounded rectangle; cat. 218-2), once in each corner of underside of base

INSCRIPTIONS: R (engraved gothic script encircled with floral garlands, centered on front); Presented to Dr. Benjamin Rush, June 1790 by his grateful Students (engraved, gothic script, encircling lid; cat. 218-1)

Height 8¾ inches (22.2 cm), width base 2⅞ inches (7.3 cm), depth base 2⅞ inches (7.3 cm), diam. 4⅛ inches (10.5 cm)
Weight 14 oz. 4 dwt.

Gift of Dr. Robert C. Abrams in memory of his parents, Dr. and Mrs. Michael A. Abrams, 1996-76-1a,b

PROVENANCE: The engraved inscription records this urn as presented in 1790 to Benjamin Rush (1745–1813).[1] The urn's subsequent history is unknown until its acquisition by the donor's father, Dr. Michael Albert Abrams (1885–1960) of Baltimore.

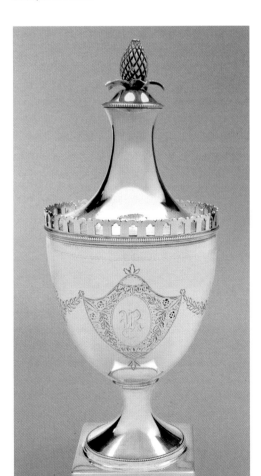

PUBLISHED: "'Lost' Silver Urn of Benjamin Rush Found," *American Antiques*, vol. 4, no. 10 (October 1976), p. 33.

The sugar bowl becomes an urn when elegantly inscribed as a presentation piece. The lid bearing the inscription is especially tall and fits loosely. It may have replaced a more usual sugar-bowl lid to suit its presentation purpose.

The calligraphy of the capital initial "R" and the letters in the inscriptions are engraved in an artistic version of a gothic style. This inscription was added after the surface of the urn and its cover had been buffed by machine, although it may replicate earlier wording that had been removed by polishing.

Advising his students, Benjamin Rush declared that "you will profit more by asking them [eminent physicians and surgeons] questions in a few hours, than by attending hospital practice for years."[2] Per-haps it was because Daniel Dupuy Sr. was an original contributor to the founding of the Pennsylvania Hos-pital that the doctor's students went to the Dupuys for this urn to honor him. BBG

1. For a summary of the life of Benjamin Rush, see William Henry Egle, "The Federal Constitution of 1787 (concluded)," *PMHB*, vol. 11, no. 3 (October 1887), pp. 262–63.
2. Quoted in Whitfield J. Bell Jr., "Philadelphia Medical Students in Europe, 1750–1800," *PMHB*, vol. 67, no. 1 (January 1943), p. 18.

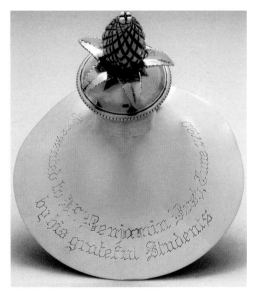

Cat. 218-1

Cat. 218-2

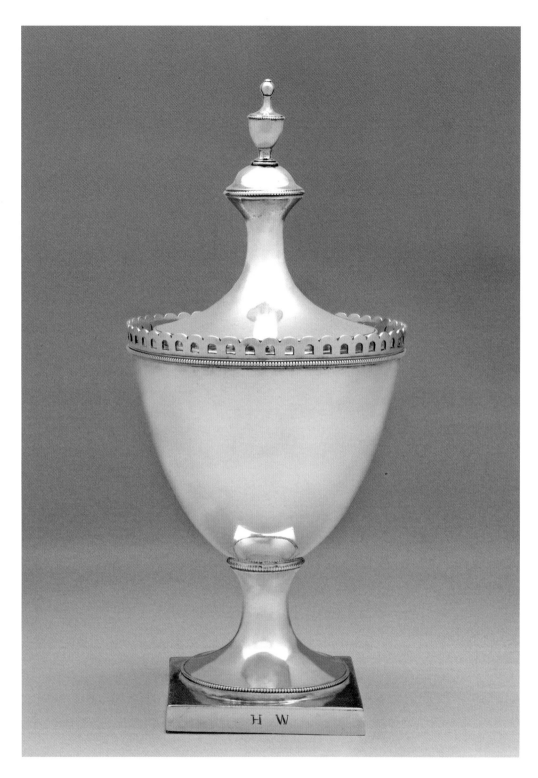

Cat. 220

Daniel Dupuy Jr.
Sugar Bowl and Cream Pot

1795–1800

MARKS: DD (in rounded rectangle, on one edge of base of sugar bowl; cat. 218–2); DD (in rectangle with left end rounded, on two corners on underside of base of cream pot; cat. 217–1)

INSCRIPTIONS: RH (engraved, on one side of base of cream pot); E.R.A. (stipple engraved, on one side of base of each); oz D / 15 ″ 8 (scratched, on underside of sugar bowl)

Sugar Bowl: Height 9 11/16 inches (24.6 cm), width 4 3/8 inches (11.1 cm)
Weight 13 oz. 15 dwt. 16 gr.
Cream Pot: Height 6 3/4 inches (17.2 cm), width 4 3/4 inches (12.1 cm)
Weight 4 oz. 8 dwt. 3 gr.
Gift of Miss Emily R. Ashbridge, 1937–28–2a,b

PROVENANCE: The initials "RH" belonged to Rebecca Hunter (1776–1852), daughter of Edward Hunter (1747–1817) and Hannah Maris Hunter (1755–1803), Lutherans, who lived in West Chester, Pennsylvania. She married Peter Pechin (1771–1858), on February 26, 1795, and they lived in Radnor. He was buried from the Merion Baptist Meeting. Their daughter Rebecca Emily Pechin (1814–1891) married Joshua Ashbridge (1806–1881) on March 9, 1848. Their daughter, the donor Emily R. Ashbridge (1852–1940), died unmarried.[1]

EXHIBITED: Philadelphia 1956, cats. 85, 89.

PUBLISHED: Graham Hood, *American Silver: A History of Style, 1650–1900* (New York: Praeger, 1971), p. 182, fig. 199.

The different marks on this cream pot and sugar bowl are the same as those on the cream pot and sugar bowl in cat. 217, further evidence that Daniel junior continued to use marks employed by his father.[2] The basic shapes and the decorative details on sugar bowls by the Dupuys and some by Samuel Williamson (q.v.) are very alike in shape, proportion, and detail. This cream pot and sugar bowl are en suite with two teapots and a slop bowl by Samuel

Cat. 219

Daniel Dupuy Jr.
Sugar Bowl

1790–95

MARK: DD (in rectangle, in corner on underside of base; cat. 217–1)

INSCRIPTIONS: H W (engraved, on one edge of base); oz. dw / 15 15 (scratched, on one corner on underside of base)

Height 10 inches (25.4 cm), base each side 3 1/8 inches (7.9 cm), diam. 4 1/2 inches (11.4 cm)
Weight 15 oz. 12 dwt. 17 gr.

Gift of Mr. and Mrs. J. Welles Henderson in memory of his mother, Anne Dreisbach Henderson, 1992–1–1a,b

This sugar bowl is a typical Philadelphia type, with plain surfaces that sweep from concave to convex and are detailed by fine, encircling bands of beading.[1] A distinguishing characteristic of the Dupuys' designs is the repetition of the urn shape in the finial. The scratched weight on the underside is in the same hand and style as those on a pitcher by the same maker (cat. 216), and the mark is the same as that on the cream pot inscribed "ERA," which dates to between 1795 and 1800 (cat. 220). BBG

1. The body of this sugar bowl appears to have been buffed.

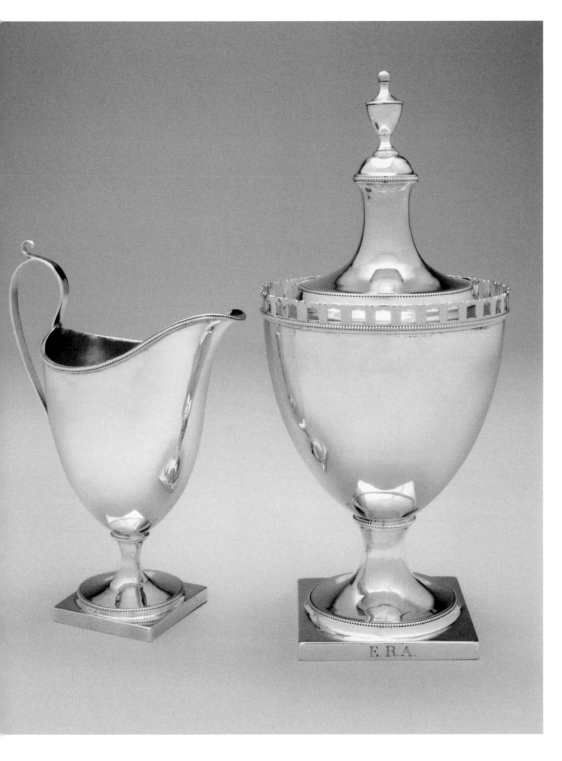

Cat. 221

Daniel Dupuy Jr.

Tablespoon

1790–1800

MARK: D.Dupuy (script in conforming rectangle, on reverse; cat. 221-1)

INSCRIPTION: W+S (engraved, on obverse at top of handle)

Length 9 inches (22.9 cm)

Weight 1 oz. 14½ dwt. 8 gr.

Gift of Mrs. George B. Walton in memory of Henry S. McNeil, 1986-99-1

Cat. 221-1

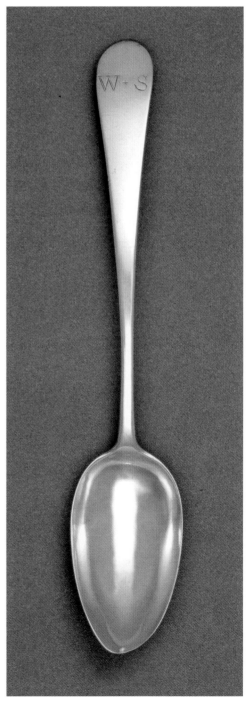

Williamson (PMA 1937-28-1Aa,b,c) and sugar tongs by Joseph Richardson Jr. (PMA 1937-28-3), surely an assembled set, perhaps purchased at different times, although neither the sugar bowl nor the Williamson pieces bear the engraved initials "RH" that appear on the cream pot. The sugar tongs by Richardson are, however, engraved "RH" and were part of the set. In terms of relative heights and details, the pieces by Dupuy and Williamson seem to fit well together. A comparison of the cut work of the galleries on this sugar bowl and the slop bowl by Samuel Williamson reveal different hands at work. The two teapots, also in the set, are similar but clearly not the same design, lacking the galleries. BBG

1. W. T. Ashbridge, *The Ashbridge Book: Relating to Past and Present Ashbridge Families in America* (Toronto: Copp, Clark, 1912), p. 138.

2. Belden 1980, pp. 12–13, 146–47.

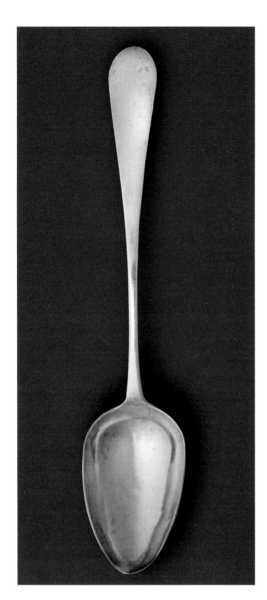

Cat. 223
Daniel Dupuy Jr.
Marrow Scoop

1775–90
MARK: D·DUPUY (in rectangle, on reverse; cat. 222-1)
Length 9¼ inches (23.5 cm)
Weight 1 oz. 15 dwt. 19½ gr.
Gift of Mrs. Elsie DuPuy Graham Hirst in memory of her
son, Thomas Graham Hirst, 1961-101-1

PROVENANCE: The donor, born Elizabeth "Elsie" Graham
(1869–1965), was a great-granddaughter of Daniel
Dupuy Jr. through his son John Dupuy (1789–1865),
although there is no documentation that this scoop
descended in the family.[1]

See the entry for a marrow scoop by John David Sr.
(cat. 167). BBG

1. DuPuy 1910, pp. 56, 64–65.

Cat. 222
Daniel Dupuy Jr.
Tablespoon

c. 1800
MARK: D·DUPUY (in rectangle, on back of handle;
cat. 222-1)
Length 9³⁄₁₆ inches (23.3 cm)
Weight 1 oz. 16 dwt. 10 gr.
Gift of the McNeil Americana Collection, 2012-96-1

Both this spoon and cat. 221 have a plain rounded
drop where the bowl meets the stem. BBG

Cat. 222-1

William B. Durgin Company

| Concord, New Hampshire, 1853–1905

Figs. 78, 79. William Butler Durgin (left) and George Francis Durgin (right), from *Genealogical and Family History of the State of New Hampshire . . .* (1908; West Jordan, UT: Stemmons, 1990), vol. 2, pp. 159, 161. New York Public Library, Astor, Lenox and Tilden Foundations, Milstein Division of United States History, Local History & Genealogy

A native of New Hampshire, William Butler Durgin (1833–1905; fig. 78) apprenticed with the silversmith Newell Harding in Boston.[1] Durgin then returned to Concord and, in 1853, bought out his competition and set up business producing spoons and tableware. Throughout his career he retained his contacts in Boston, both with retailers and as a source of skilled workmen. By 1860 his company was producing a variety of flatware patterns (see fig. 80).[2]

George Francis Durgin (1855–1905; fig. 79) joined his father William in 1880. They incorporated the firm in 1898. To accommodate their growing business, which by then employed three hundred workmen, the Durgins built a new manufacturing facility in Concord in 1904. However, both father and son died the following year, and the firm was purchased by the Gorham Manufacturing Company (q.v.). As a division of Gorham, the Durgin Company continued to manufacture under its own mark until 1931, when Gorham moved the business to Providence, Rhode Island. BBG

1. Biographical data gleaned from Dorothy T. Rainwater, *Encyclopedia of American Silver Manufacturers*, rev. ed. (New York: Crown, 1975), p. 51; Venable 1994, p. 318.

2. For a discussion of Durgin's flatware patterns and business, see William P. Hood, Charles S. Curb, and John R. Olson, "Flatware by the William B. Durgin Company," *Silver Magazine*, vol. 34, no. 3 (May–June 2002), pp. 20–29; vol. 34, no. 4 (July–August 2002), pp. 22–32.

Fig. 80. Billhead of William B. Durgin, Concord, New Hampshire, 1886. Courtesy of the Winterthur Library, Wintherthur, Delaware. Joseph Downs Collection of Manuscripts and Printed Ephemera, 06x34.639a

Cat. 224

William B. Durgin Company
Napkin Ring

1875–90
MARKS: STERLING SILVER (in arc, incuse) / 925/1000 (incuse) / [flying dove within laurel wreath surmounted by "D," all in oval] / 70 (incuse; all on interior; cat. 224-1)
INSCRIPTION: H.E.W. (engraved script, on exterior)
Height 1 9/16 inches (4 cm); diam. 1 3/4 inches (4.5 cm)
Weight 1 oz. 5 dwt. 16 gr.
Gift of Beverly A. Wilson, 2010-206-56

The decoration on this napkin ring, executed in bright-cut and roulette engraving, was inspired by Anglo-American interpretations of contemporary Japanese designs. However, the motif of an owl and crescent moon was more common in Europe and America than in Japan. DLB

Cat. 224-1

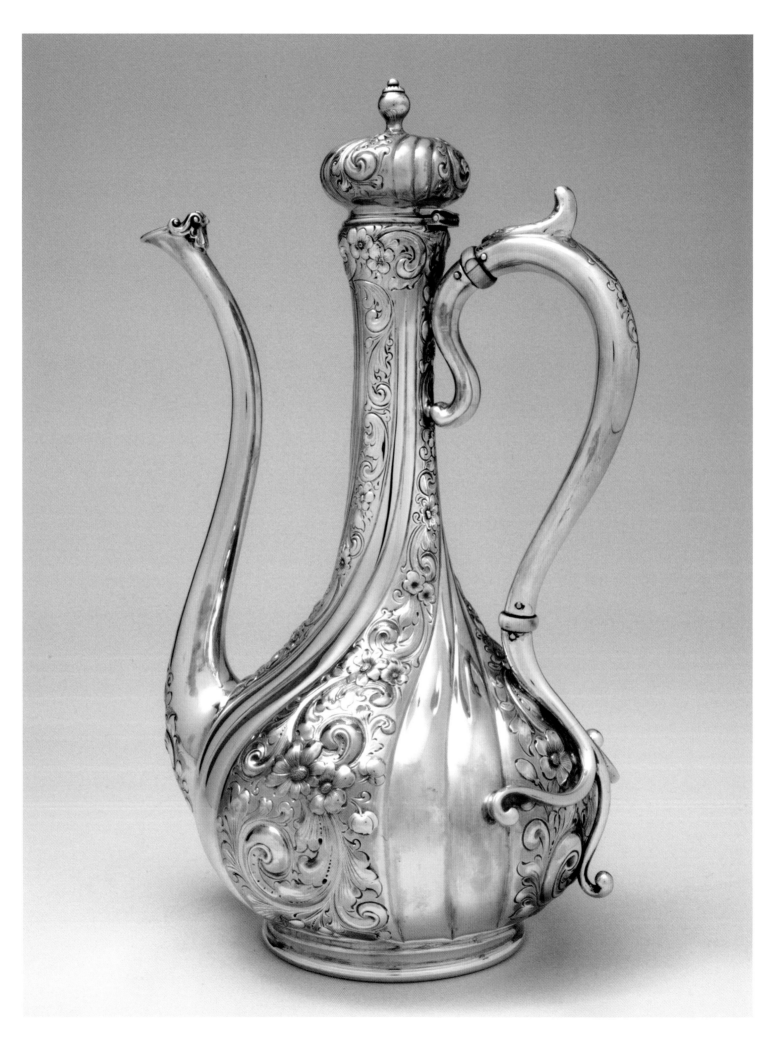

Cat. 225

William B. Durgin Company
Coffeepot

1890
Retailed by Howard & Company, 1866–1922
New York City
MARKS: HOWARD & CO. STERLING / 135 NEW YORK 1890
(all incuse, on underside at four cardinal points)
Height 10⅜ inches (26.4 cm), width 6¹¹⁄₁₆ inches (17 cm),
depth 5³⁄₁₆ inches (13.2 cm)
Weight 19 oz. 12 dwt. 5 gr.
Gift of Beverly A. Wilson, 2010-206-36

Although this striking coffeepot was marked only by
the retailer Howard & Company, its maker can be
identified by an almost identical example marked
by Durgin,[1] which has only minor differences in the
chased decoration. The sinuous, swirling lines were
inspired by European Art Nouveau by way of fash-
ionable Middle Eastern prototypes. The body and
cover were spun before they were chased, making
the coffeepot less expensive and lighter in weight
than more elaborate versions, such as that made by
Gorham in the *Martelé* line (PMA 1976-160-1). DLB

1. Christie's, New York, *Important American Furniture, Silver,
Folk Art and Decorative Arts*, June 23, 1993, sale 7710, lot 22.

Cat. 226

William B. Durgin Company
Pair of Ice Cream Spoons

1897–98
Retailed by Bailey, Banks & Biddle Co. (q.v.)
MARKS: D (relief script, on front of handle near bowl;
cat. 226-1); STERLING (incuse, on front of handle);
B. B. & B. CO. (incuse, on one side of handle)
INSCRIPTION: F G P (engraved shaded script, on front of
handle)
Length 5¾ inches (14.6 cm)
Weight 18 dwt. 17 gr.
The Henry P. McIlhenny Collection in memory of Frances
P. McIlhenny, 1986-26-66, -67

PROVENANCE: The initials "FGP" belonged to Frances
Galbraith Plumer (1869–1943), who married John D.
McIlhenny (1866–1925) in Pittsburgh in 1898.[1] They
were the parents of the donor.

These spoons are lavishly decorated in the *Marechal
Niel* pattern, named after a deep-yellow rose. The
reverse side of the bowl is encrusted with raised
forms of roses and foliage. BBG

1. Joseph J. Rishel, *The Henry P. McIlhenny Collection: An
Illustrated History* (Philadelphia: Philadelphia Museum of
Art, 1987), pp. 6–8.

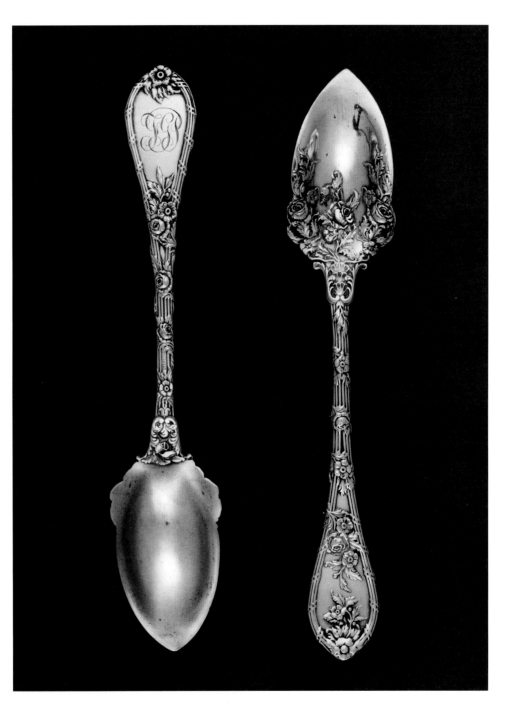

Cat. 226-1

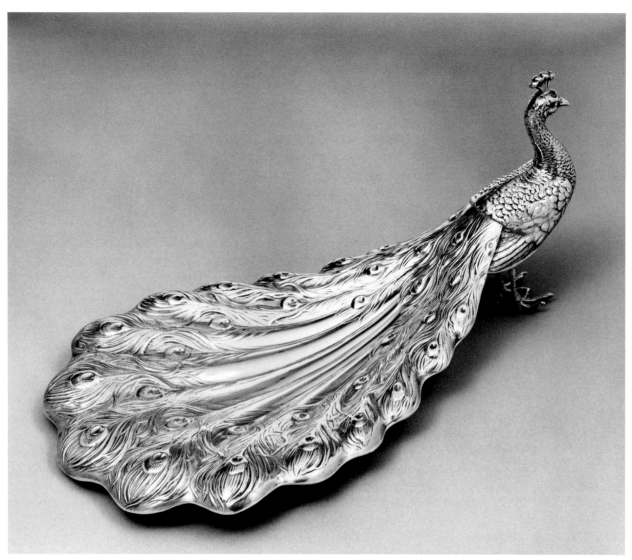

Cat. 227

William B. Durgin Company

Division of Gorham Manufacturing Company (q.v.)

Pair of Bon Bon Dishes

1905–22

Retailed by Bigelow, Kennard & Company, Boston (1863–1922)

MARKS (on each): GORHAM / D (script, in oval outline) / STERLING / 3 / MADE FOR / BIGELOW,KENNARD & CO. (all incuse, on underside; cat. 227-1)

1944-93-5a

INSCRIPTION: 2448 I F/30/40 (scratched script, on underside)

Height 3¹³⁄₁₆ inches (8.1 cm), length 9⁷⁄₁₆ inches (23.9 cm), depth 5⅜ inches (13.7 cm)

Weight 8 oz. 1 dwt.

1944-93-5b

INSCRIPTION: 2450 I F / 250 / 70 (scratched script, on underside)

Height 3⁹⁄₁₆ inches (9.1 cm), width 9⁷⁄₁₆ inches (23.9 cm), depth 5⅜ inches (13.7 cm)

Weight 7 oz. 17 dwt.

Gift of Evelyn Eyre Willing in memory of Mary Eyre Howell and Evelyn Virginia Willing, 1944-93-5a,b

PROVENANCE: Although the donor collected antique silver,[1]

these dishes presumably were acquired new by her parents, George Willing Jr. (1877–1934) and Evelyn Virginia (Howell) Willing (1877–1941), perhaps as gifts when they married in Philadelphia in 1910.[2]

In a trade catalogue published by Gorham around 1910, these bon bon dishes were shown in two sizes, the smaller (model D2; 6¾ inches in length) and the larger (model D3), seen here.[3] With die-stamped tails and bodies, and superficial chasing, these objects required less silver as well as less finishing work and could be marketed at a relatively low price. The Durgin Company used the same components to create a vase in the form of three addorsed peacocks.[4]

DLB

1. See the slop bowl by Samuel Kirk & Son (PMA 1944-93-17).
2. Genealogical information about George and Evelyn Willing is found in: Parish Register of St. Luke's Church, Germantown, 1867–1878, pp. 170–71; death certificate of George Willing, Records of Pennsylvania Department of Health, Pennsylvania Historical and Museum Commission, Harrisburg, Ancestry.com (accessed July 8, 2015); "Gloucester County, New Jersey History & Genealogy: Candor Hall—John Ladd Family Genealogy," www.nj.searchroots.com /Gloucesterco/ladd.htm (accessed July 8, 2015); Interment Book 4, p. 2238, Laurel Hill Cemetery, Philadelphia;

1910 U.S. Census.
3. *Silverware of Moderate Cost* (New York: Gorham, n.d.), p. 2.
4. Sotheby's, New York, *Important Americana*, June 17, 1997, sale 7010, lot 3.

Cat. 228

William B. Durgin Company

Division of Gorham Manufacturing Company (q.v.)

Coffeepot

Designed c. 1920

Retailed by Shreve, Crump & Low, Boston (founded 1796)

White metal handle with woven fiber cover, ivory finial

MARKS: D (script, encircled in crowned cartouche) / STERLING / 940C / 1¼Pt. / SHREVE,CRUMP & LOW CO (all incuse, last line double struck, on underside; cat. 228-1)

INSCRIPTION: 12 N O = E V / M O (scratched, on underside)

Height 7⅝ inches (19.4 cm), width 6¾ inches (17.2 cm), diam. 3¹⁄₁₆ inches (7.8 cm)

Gross weight 13 oz. 13 dwt. 9 gr.

Purchased with funds contributed by the Levitties Family, 2000-124-1

PROVENANCE: Ellen Bennett, Alpharetta, GA.

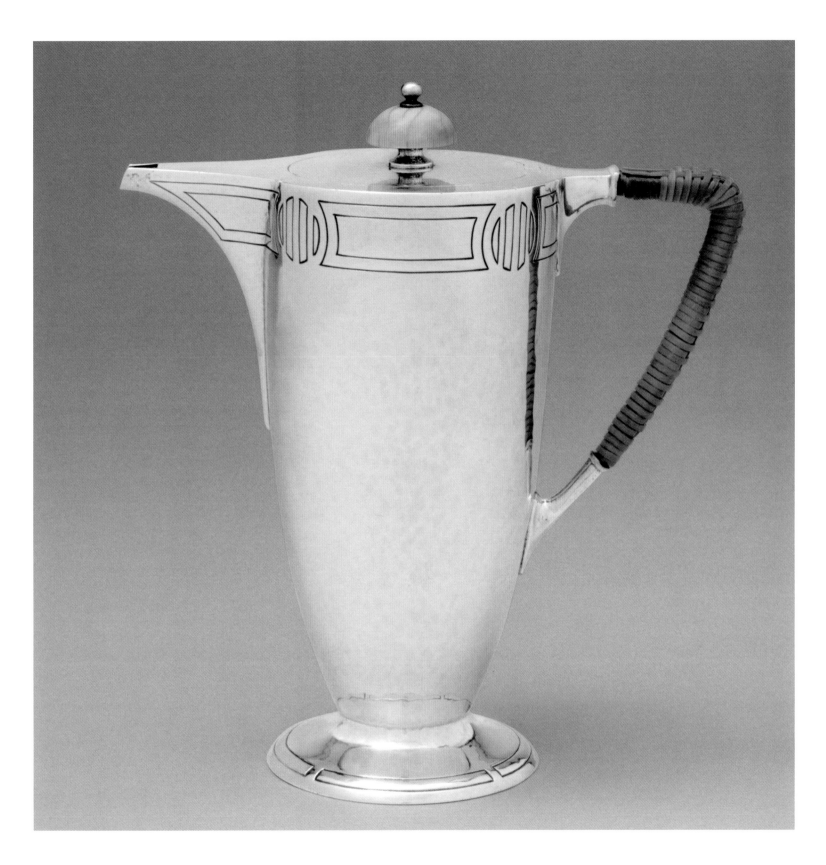

The Durgin division of Gorham introduced this coffeepot in 1920 as part of a service that included a cream pot, sugar bowl, and tray.[1] The service required fourteen hours of chasing, including the hammered surface intended to suggest that the bodies were raised when in reality they were spun. The sleek silhouette of the coffeepot, with a flat top and sides tapering sharply to a narrow foot, is in a simplified, modernist idiom and presages later versions of the form, including one designed in 1928 by Johan Rohde for Georg Jensen and another from the early 1930s made by Bloch-Eschwège of Paris.[2] DLB

1. Price List, 1931–33, and W. A. Foy, "Flatware and Hollowware Estimates and Regular Prices Quoted to Customers, also new goods data under Stock 'S,'" pp. 1–2, sect. 12, Durgin Records, The Gorham Manufacturing Company Archives, John Hay Library, Brown University, Providence, RI.
2. Dedo von Kerssenbrock-Krosigk and Claudia Kanowski, *Modern Art of Metalwork* (Berlin: Bröhan-Museum, 2001), cats. 262 and 50, respectively.

Cat. 228-1

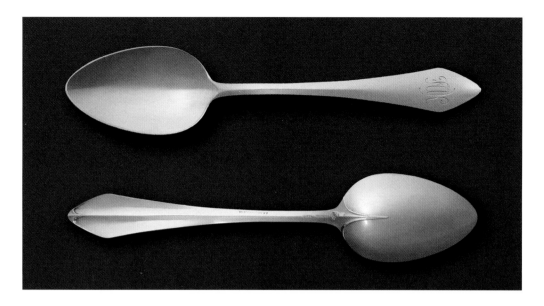

Cat. 230

William B. Durgin Company

Division of Gorham Manufacturing Company (q.v.)

Tea Caddy

1930

MARKS: GORHAM / D (script, in oval) / STERLING / 10 / GORHAM INC.; [elephant statant] / 2 (all incuse except "D," on underside; cat. 230-1)

INSCRIPTIONS: M L O S (engraved script, on front); Z 16628B - 1 (scratched, on underside)

Height 4¼ inches (10.8 cm), width 4¹⁵⁄₁₆ inches (12.5 cm), depth 3¹³⁄₁₆ inches (9.7 cm)

Weight 12 oz. 14 dwt. 17 gr.

Gift of Beverly A. Wilson, 2010-206-37a,b

Based on neoclassical prototypes (see cat. 120), the sleek contours of this oval tea caddy also accorded with the modernist aesthetic of 1930. The engraved monogram, in a late eighteenth- or early nineteenth-century style, was obscured subsequently with crude chased decoration, presumably when the caddy changed ownership. DLB

Cat. 229

William B. Durgin Company

Division of Gorham Manufacturing Company (q.v.)

Four Tablespoons

Frederick R. Roberts Jr. (1867–1936), designer

Designed 1914

Retailed by J. E. Caldwell & Co. (q.v.)

MARKS: M (lengthwise) D (gothic capital in oval, lengthwise) STERLING PAT'D J.E. CALDWELL & CO. (all incuse except "D," on back of handle; cat. 229-1)

INSCRIPTION: F a K (engraved script, on front of handle; cat. 229-2)

Length 8⅝ inches (22 cm)

Weight 1 oz. 19 gr. to 2 oz. 10 gr.

Gift of Harvey S. Shipley Miller, 2012-90-1-4

Among the most popular patterns made by Durgin, *Chatham* was available plain, as here, or hammered, as well as with chased or engraved ornament in six different designs. Frederick Roberts, the designer, filed an application for a patent on the design for the pattern on September 11, 1914; the patent was granted on December 1, 1914.[1] The lowercase central letter in the engraved monogram on these spoons is unusual.

Frederick Roberts was born in Providence and presumably trained as a silversmith with his father, an immigrant silversmith from England.[2] The Rhode Island State Census of 1885 recorded the younger Roberts, at the age of seventeen, as an engraver.[3] He moved to Concord, New Hampshire, in 1887 or 1888 and began working as a designer for the Durgin Company, for which he created several flatware patterns as well as designs for hollowware and souvenir spoons.[4] DLB

Cat. 229-1

Cat. 229-2

1. *Official Gazette of the United States Patent Office* (Washington, DC: Government Printing Office, 1915), vol. 209, p. 310.

2. Death record, New Hampshire, Death and Disinterment Records, 1754–1947, New England Historical Genealogical Society, citing New Hampshire Bureau of Vital Records, Concord, Ancestry.com.

3. Rhode Island State Census, 1885, Providence, New England Historic Genealogical Society, Boston, Ancestry.com.

4. *The Concord Directory* (Boston: W. A. Greenough, 1889), p. 227; Roberts was not recorded in the 1887 Concord directory. For his flatware designs, see Silversmith Directory, "Patterns," s.v. "Frederick Roberts," sterlingflatwarefashions.com (accessed June 29, 2015); for hollowware, see *Official Gazette of the United States Patent Office*, vol. 209, p. 658; for souvenir spoons, see an example in the Mary Baker Eddy Library, Boston, www.marybakereddylibrary.org/research/souvenirspoons (accessed June 27, 2014).

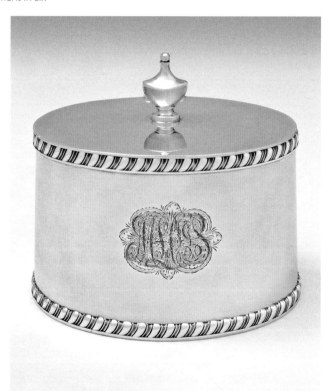

Cat. 230-1

E

Jeremiah Elfreth Jr.

| Philadelphia, born 1723
| Philadelphia, died 1765

Jeremiah Elfreth was at the head of three generations of the Elfreth family in Philadelphia: Jeremiah senior (1692–1772), a blacksmith; Jeremiah junior, the silversmith; and Jeremiah III, a cabinetmaker. Jeremiah junior was the son of the blacksmith and his first wife, Sarah Oldman Elfreth (1698–1728). Jeremiah III was the son of Jeremiah junior, the silversmith, and his wife Hannah Trotter Elfreth (1729–1791).[1]

The Elfreths were a Quaker family, and Jeremiah senior was a central figure in the Society of Friends in Philadelphia and active in civic government. In 1737 he was elected an assessor of the Province of Pennsylvania and, in 1739, when Anthony Morris was mayor, elected assessor for the City of Philadelphia.[2] As assessor he served with the silversmiths Philip Syng Jr. and Henry Pratt (q.q.v.) in 1743 and, in 1745, when James Hamilton was mayor, with Thomas Howard and Francis Richardson.[3] In 1755 Jeremiah senior served on the Committee of the Friends. A property owner, he had land and buildings in various parts of the city. He was among the owners of prime land at the south end of the city, at the Blue Anchor Tavern, which was the access point to the wharves and shipping, and other property at the ships' landing at the entrance to Dock Creek.[4] In 1739 Syng sold him a lot on what was then generally called Gilbert's Alley and would later come to be known as Elfreth's Alley, where he built a two-story house with garret.[5] He owned considerable property in the North Ward in 1769; his own dwelling, plus money lent and incoming ground rents, put his estimated worth at £126 10s.[6] He married five times, and his second wife was Letitia Swift Richardson, widow of Francis Richardson Sr. (q.v.). They married in 1731 and, as a result, he became the stepfather of Joseph Richardson Sr. (q.v.), from whom he bought a tankard in 1734.[7]

With each of his five marriages broadening his familial connections,[8] he had plenty of opportunity to place Jeremiah junior in an advantageous apprenticeship. Although no document regarding an apprenticeship with Joseph Richardson Sr. has been found, it would have been entirely customary for such an arrangement between the families.[9] There are entries in Richardson's accounts noting payments to "Jerey" for specifics: "a Salver £0 7s. 16d., to hard Sawder [solder] £0 5s. 18d., to Silver £0 17s. 12d.," and for "silver" in 1743.[10]

Notices about Jeremiah Elfreth Jr. are as rare as his silver and reveal little about his life or work.[11] He was one of the twenty-six original founders of the Union Library in 1746–47 and was listed in their membership roster as "goldsmith." The silversmith William Ball (q.v.) was another founding member,[12] and Elfreth's purchases from Ball, which probably were continuous, are recorded in the latter's surviving journal book of 1760–61.[13]

In October 1749 a Jeremiah Elfreth (whether senior or junior was not specified) and Thomas Say took an inventory and appraised the estate of the silversmith Charles Pickney, which was valued at £26 4d., indicating that this was probably a basic journeyman's "kit."[14] In September 1750 Jeremiah (again, unspecified) witnessed the will of the widow Mary Hill, whose sister was Elizabeth Trotter.[15] On October 25, 1750, an Elfreth (unspecified yet again, but probably Jeremiah Elfreth Sr.) placed an advertisement in the Pennsylvania Gazette: "Lent or Lost, a drab colored Kersey Great Coat, bring to the subscriber, 5 shillings reward."

On August 27, 1752, Jeremiah junior married Hannah Trotter, a Quaker friend of the family, at the Friends' Meeting.[16] Her father, Joseph Trotter, a cutler, was well known to Jeremiah senior and, like him, a property owner with considerable wealth.[17] In the records for the 1756 Head and Estate Tax, Jeremiah Elfreth Sr. and Jr., both freeholders, were resident in the northern part of the city, in Mulberry Ward. Jeremiah senior's value was £72, Jeremiah junior's £24.[18] In 1760 Jeremiah junior purchased his house and shop from Charles Stow Jr. The property was on the east side of North Second Street near Arch, in the Mulberry Ward, and he remained there until he died in 1765.[19] In 1763 Jeremiah junior was elected to the membership of the Fort St. David's Fishing Club, a gentlemen's club.[20] In 1764 he took in the son of Robert Willis, a Quaker from Plainfield, New Jersey.[21]

Jeremiah Elfreth Jr. died in 1765, and the silversmith John Browne (q.v.) appraised Elfreth's shop and took an inventory (unlocated).[22] Browne's wife Mary was the daughter of Benjamin Trotter, a chairmaker, and Hannah Elfreth, Jeremiah's widow, witnessed Trotter's will in 1768.[23] Hannah had moved to Southwark before 1769 and, in the tax records for that year, it was noted that she was living next door to her father, Joseph Trotter, but paying ground rent to Joseph Morris.[24] Jeremiah Elfreth Sr., who was by then living on Second Street, the second door above Elfreth's Alley, died in 1772 at the age of eighty.[25] To his grandsons, Jeremiah III and Josiah, he left his house and shop, on the east side of Second Street and north side of Gilbert's Alley, and to his daughter-in-law Hannah, he left the rents of those properties.[26]

When Hannah Elfreth died in 1791, she was living in the Elfreth Alley property with her sons.[27] Her inventory of plate was taken there on October 3: one tankard, two canns, two cream pots, one pepper box, one punch strainer, and sundry other pieces of plate, valued at eight shillings an ounce, the total quantity amounting to 96 ounces, 3 pennyweight and valued at £38 13s. 2d.[28] BBG

1. Jacob R. Elfreth, "Elfreth Necrology," *Publications of the Genealogical Society of Pennsylvania*, vol. 2, no. 2 (1902), pp. 172–73; Carl M. Williams, "An Unrecorded Goldsmith," *Antiques*, vol. 51, no. 1 (January 1947), pp. 40–42; burial record of Jeremiah Elfreth Jun., February 11, 1765, Friends Historical Library.

2. Scharf and Westcott 1884, vol. 3, p. 1736; *Pennsylvania Gazette* (Philadelphia), September 29, 1737.

3. *Pennsylvania Gazette*, October 6, 1743, and October 3, 1745. Francis Richardson presumably was the silversmith Francis Richardson Jr. (q.v.).

4. The land had been reserved by the Penn Proprietorship for common use as a landing point for ships unloading stone, sand, and lumber and for protection from ice in the winter freeze. However, Elfreth and other owners had ignored the injunction, and in 1753 the city council ordered that Jeremiah senior and other owners not block or build on access to the port there, as it was the only water access to the town: "And it is further ordered that Jeremiah Elfreth and all other persons concerned, pretending to have any Title or Right to the said Vacancy or Landing-place, shall desist and forbear building and incumbering the same." *Pennsylvania Gazette*, February 20, 1753; see also John F. Watson, *Annals of Philadelphia: Being a Collection of Memoirs, Anecdotes, and Incidents of the City and Its Inhabitants...* (Philadelphia: E. L. Carey & A. Hart; New York: G. & C. & H. Carville, 1830), pp. 283–84.

5. It was surveyed in 1762 as 124 and 126 Elfreth's Alley. Information about the history of Elfreth's Alley before the Elfreths owned property there was generously provided by Dierdre Kelleher, a doctoral student in archaeology at Temple University whose research activities focused on the alley; curatorial files, AA, PMA.

6. Tax and Exoneration Lists, 1762–94.

7. Fales 1974, pp. 33, 64. The tankard weighed 34 ounces 15 pennyweight and cost £16 10s. 1d.; Harrold E. Gillingham, "The Cost of Old Silver," *PMHB*, vol. 54, no. 1 (1930), p. 44.

8. Jeremiah Elfreth is mentioned numerous times in the Philadelphia Quaker meeting records, many of which are housed in the Swarthmore College and Haverford College libraries.

9. Fales (1974, p. 64) points out that a number of Elfreth's pieces have details, such as salver borders, identical to Richardson's and were possibly cast from the same molds.

10. Joseph Richardson, Commonplace Book, Downs Collection, Winterthur; Fales 1974, p. 64.

11. He made a porringer for John and Mary Warder in 1759; Sotheby's, New York, *The Collection of Mr. and Mrs. Walter M. Jeffords: Early American Silver*, October 28–29, 2004, sale 8016, no. 645. A splendid, fat cream pot, with a mask at the top of the cabriole legs and with splayed shell feet, was offered at Conestoga Auction Company (Mannheim, PA), *Spring Americana Auction*, March 1, 2008, no. 1093.

12. This library was later absorbed by the Library Company; E. V. Lamberton, "Colonial Libraries of Pennsylvania," *PMHB*, vol. 42, no. 3 (1918), p. 195.

13. William Ball, Journal Book, Ball Families Papers, 1676–1879, HSP, p. 57.

14. There are earlier records of a Jeremiah Elfreth witnessing wills. As Jeremiah senior outlived his son, I have assumed, unless

the generation is specified, that the reference is to the elder. "To a hatt, 1 pr old butes & shuse, to 1 Grate Coat, To father bead, boulster & 2 pillows, To 1 quilt & 2 blanckets, To 3 sheats & 2 pillowcases, To 1 pine Chest, 1 small pine Table & Small Cobberd, To 1 pr Saddle Bags; 1 pr Bollases, & 1 Cane, To 9 Books & 1 Map with a frame. . . . To the Amount of the Appraisement of the Plate & his working Tooles [no amount specified]"; Inventory and Appraisement of the Goods and Chattels of Charles Pickney, Brix Files, Department of American Art, Yale University Art Gallery.

15. Philadelphia Will Book J, p. 326.

16. Friends Historical Library. Hannah's will (1791) identified Daniel Trotter, cabinetmaker, as a cousin; Philadelphia Will Book W, p. 71; Elfreth, "Elfreth Necrology," pp. 172–73.

17. In 1769 his house in Southwark was valued at £50; Tax and Exoneration Lists, 1762–94.

18. Ibid. The tax was "for regulating and continuing the Nightly Watch, and enlightening the Streets, lanes and Alleys of the City of Philadelphia, and for raising Money on the Inhabitants and estates of the said City for defraying the necessary Expenses thereof"; Hannah Benner Roach, *Taxables in the City of Philadelphia, 1756* (Philadelphia: Genealogical Society of Pennsylvania, 1990), p. 3.

19. Williams, "An Unrecorded Goldsmith," p. 40.

20. As described in Watson, *Annals of Philadelphia*, p. 374: "A society of gentlemen of Philadelphia, many years ago [said to be 100 years], had a house at the falls of Schuylkill, called Fort St. David, where they used to meet at fishing seasons, by public advertisement, beginning with the first of May, and continuing every other Friday during the season. Much good living was enjoyed there. The building, a kind of summer pavilion, stood on the descent of the hill, leading to the Falls bridge; a sketch of it, such as it was, is preserved in the Dickinson family, being on an elegant silver box, presented to John Dickinson in 1768, for his celebrated 'Farmer's Letters.' In the house and along its walls, were hung up a great variety of curious Indian articles, and sometimes the president of the day was dressed in the entire garb of an Indian Chief. The same association still exists, but have transferred their place of meeting . . . the former attractions at the Falls, as a celebrated fishing place, having been ruined by river obstructions, &c. They now call their association the 'State in Schuylkill, &c.'"

21. As recorded in the Quaker meeting records: "the son of friend Robert Willis, now living under the care of Jeremiah Elfreth in this City."

22. Monthly Meeting of Friends of Philadelphia, Pa., Minutes, 1759–1772, Ancestry.com.

23. Will of Benjamin Trotter, Philadelphia Will Book O, p. 220. There did not appear to be any documents or inventory in his administration folder in the Philadelphia City Archives (examined in 2012).

24. Tax and Exoneration Lists, 1762–94.

25. Hannah B. Roach, *Colonial Philadelphians* (Philadelphia: Genealogical Society of Pennsylvania, 2007), pp. 173–92.

26. Philadelphia Will Book P, no. 231, p. 340.

27. For images of the house about 1910, see "Jeremiah Elfreth House, 126 Elfreth's Alley, Philadelphia, Philadelphia County, PA," Historic American Buildings Survey, Library of Congress, www.loc.gov/pictures/collection/hh/item/pa1210 (accessed April 6, 2015).

28. Williams, "An Unrecorded Goldsmith," p. 41.

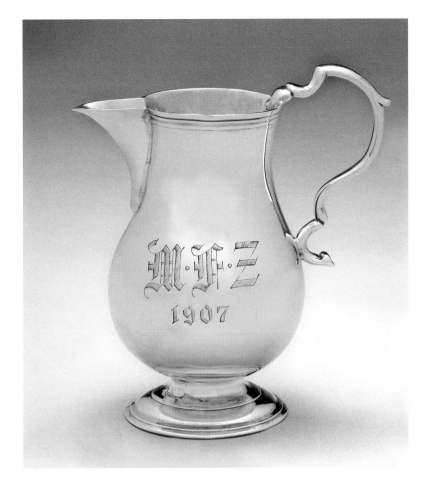

Cat. 231
Jeremiah Elfreth Jr.
Cream Pot

1750–55

MARK: J·E (in rectangle with chamfered corners, twice, on underside; cat. 233–2)

INSCRIPTIONS: W Z (engraved, on underside of foot); Z / I·M (engraved, at top of handle); Z / 1800 (engraved, shaded gothic letters, on one side); M·F·Z / 1907 (engraved, shaded gothic letters, on opposite side); Rudolph (scratched, on underside)

Height 3⅞ inches (9.9 cm), width 3¹¹⁄₁₆ inches (9.3 cm)

Weight 4 oz. 4 dwt.

Gift of Walter M. Jeffords, 1958-115-3

EXHIBITED: The Pennsylvania Building, New York World's Fair, April 30, 1939–October 31, 1940; Philadelphia 1956, cat. 93.

The features of this cream pot are unusual. The very rounded body is typical of the earliest rococo style as practiced in Philadelphia, but a flaring pedestal with a narrow stem, more like the base of a coffeepot, has replaced the usual three legs. The cast handle appears original. There has been repair at the rim of the pitcher where the handle joins. The spout is continuous with the upper rim and tapers to an elegant small "drop."

The initials "WZ" belonged to William Ziegler, a house carpenter who was listed in the Philadelphia directory from 1801 to 1805 at a shop at 90 Green Street. His residence was at 321 North Second Street. The initials "Z / IM" belonged to William Ziegler's son Jacob, also a house carpenter, who in 1793 was located at 33 St. John's Street. The notations "Z/1800" and "MFZ/1907" belonged to Frederick Ziegler, an engraver located at 1919 North Warnock, who did the commemorative, gothic engraving on the sides of the pot. BBG

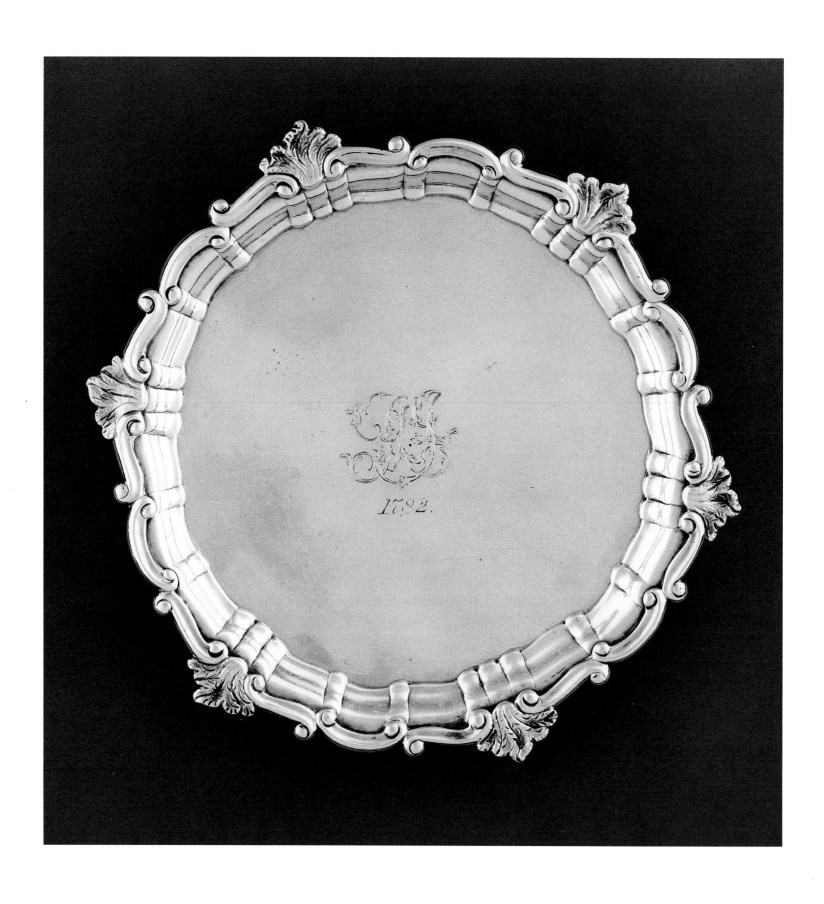

Cat. 232
Jeremiah Elfreth Jr.
Salver

1747–50

MARK: J·E (in rectangle with chamfered corners, on under-side; cat. 233-2)

INSCRIPTIONS: R J (engraved script, on center of obverse) / 1782 (engraved script, on obverse under initials); Phebe P. Thompson / 1860 / Lydia Thompson Morris / 1891 (engraved script, on reverse) / P Thompson (scratched, on reverse); oz dwt / 8 3 (scratched, on reverse)
Height 1 1/16 inches (2.7 cm), diam. 7 1/8 inches (18.1 cm)
Weight 7 oz. 19 dwt. 20 gr.
Bequest of Lydia Thompson Morris, 1932-45-5

PROVENANCE: The initials "RJ" belonged to Rebecca Chalkley James, daughter of the Quaker preacher and merchant Thomas Chalkley (1675–1741) and Martha Betterton Chalkley. Rebecca married Abel James (1724–1790) at the Philadelphia Friends Meeting on April 9, 1747.[1] Their grand-daughter Rebecca James inherited the salver. Her marriage to John Thompson in 1782 is noted in the engraved date.[2] On the reverse of the salver are the names and dates by acquisition of subsequent owners. It descended to Phebe Poultney Thompson (born 1815) in 1860, and then to the donor, Lydia Thompson Morris (1849–1932), daughter of Isaac Paschall Morris (1803–1869) and Rebecca Thompson Morris (1811–1881).[3]

EXHIBITED: Philadelphia 1956, cat. 98; Buhler 1956, cat. 277, no. 120; *Masterpieces of American Silver*, Virginia Museum of Fine Arts, Richmond, January 15–February 14, 1960; Philadelphia 1969, p. 55, cat. 18; Lindsey et al. 1999, cat. 241, p. 193.

PUBLISHED: Carl M. Williams, "An Unrecorded Goldsmith," *Antiques*, vol. 51, no. 1 (January 1947), p. 42, fig. 5.

The design of this salver is similar to but not identical with designs by Joseph Richardson Sr. (q.v.), under whom Elfreth is believed to have apprenticed. Richardson was making the leaf form from 1750 to 1760, but Elfreth's leaf forms, which flare beyond the scrolled rim, are freer and more naturalistic than Richardson's. In the reticulation of the sides of the knees on the three short legs of this salver there is an especially nice detail that is repeated on the hoof feet. Martha Fales notes that salvers by Elfreth are so similar to Richardson's that details such as the borders may have been cast from the same molds.[4] BBG

1. U.S., Quaker Meeting Records, 1681–1935, Ancestry.com. See also the teaspoon by John Strangeways Hutton (PMA 1932-45-10). A cann (PMA 1925-27-342) marked by Joseph junior and Nathaniel Richardson bears the same initials but by a different engraver, as does a sauceboat by William Hollingshead (q.v.), inscribed "Phoebe [sic] P. Thompson / 1860" (private collection; DAPC 65.2671).
2. The date is in a different hand and was probably added at the time of inheritance.
3. For other silver that descended in this family, see cat. 150.
4. Fales 1974, p. 64.

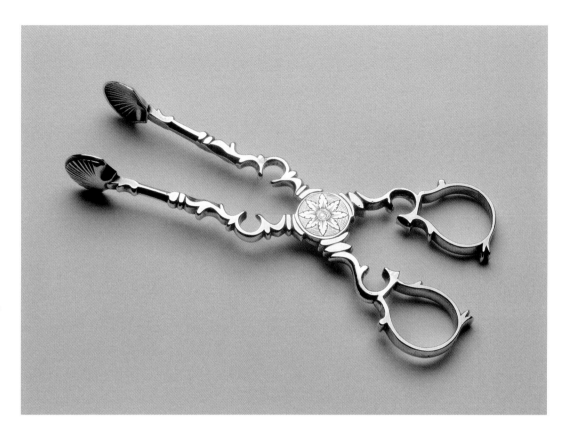

Cat. 233
Jeremiah Elfreth Jr.
Sugar Tongs

1750–60

MARK: J·E (in rectangle with chamfered corners, on inside of each shell tip; cat. 233-2)
INSCRIPTION: E S (engraved script, one letter at top of each finger loop; cat. 233-1)
Length 5 inches (12.7 cm), width handles closed 1 5/8 inches (4.1 cm)
Weight 1 oz. 7 dwt. 14 gr.
On permanent deposit from The Dietrich American Foundation Collection to the Philadelphia Museum of Art, D-2007-70

PROVENANCE: Walter M. Jeffords (1882–1960), Glen Riddle, Pennsylvania; Mr. and Mrs. Walter M. Jeffords Jr., New York; Sotheby's, New York, *The Collection of Mr. and Mrs Walter M. Jeffords, Early American Silver*, vol. 3, October 29, 2004, sale 8016, lot 646; (Jonathan Trace, Rifton, NY).

EXHIBITED: Philadelphia 1956, cat. 95; on long-term loan to the Columbia Museum of Art, SC, 2009–16.

Cat. 233-1

These scissor-action tongs are small, sturdy, and handsome. The profiles of the arms have especially pretty scrolls ending in a reticulated shell design. The finger loops are generous. The round hinge cover is engraved on both sides with a daisylike flower where the pin is decoratively engraved at the center. BBG

Cat. 233-2

Joseph S. Elliott

England, born 1822–1823
Pottsville, Pennsylvania, died 1864

According to his draft registration in July 1863, Joseph Elliott was born in England and was forty years old.[1] It is not certain when he moved to Pennsylvania or with whom he trained as a watchmaker. He may have been the Joseph Stewart Elliott who immigrated to Philadelphia from England in 1836 and, on November of that year, declared his intention, in the Philadelphia Court of Common Pleas, to become a U.S. citizen.[2] He was first securely recorded in Pottsville in 1847 as the assistant secretary for the newly founded Lily of the Valley Lodge of the International Order of Odd Fellows.[3] By 1848 Elliott had formed a partnership with William Brady (born 1823 or 1824) as the retail jewelers Brady & Elliott at a shop on Centre Street.[4] Given their closeness in age, it is possible the partners had met as apprentices. They used a relief mark with their surnames in conjunction with the same "POTTSVILLE" mark found on a sugar spoon (cat. 234); a printed watch paper for the partnership also survives.[5]

The 1850 U.S. census recorded Elliott as unmarried and boarding at the Exchange Hotel in Pottsville's Northwest Ward. Within a couple of years he had married Jane Loeser (c. 1827–1866), the daughter of Charles Loeser, a cashier at the Miner's Bank in Pottsville.[6] At some point in the 1850s, Elliott's partnership with Brady dissolved, and Brady moved to Harrisburg, where he was recorded in the U.S. census of 1860. Elliott remained in Pottsville and continued to operate as a watchmaker and retail jeweler on Centre Street.

Fig. 81. Watch paper of Joseph S. Elliott. Courtesy of the American Antiquarian Society

His watch paper (fig. 81), engraved by Martin Leans (born 1817) of Philadelphia, advertised "Fine Watches, Jewelry & Silver Ware." In addition to the relief mark on the Museum's spoon, he may have used the incuse surname mark found on an otherwise undocumented dessert spoon with a double-swelled and tipped handle.[7]

The 1860 U.S. census recorded Elliott in the South Ward of Pottsville as the head of a household that included wife Jane, twin daughters Sarah and Emily, age eight years, son Charles John, six, an Irish-born servant, and Ann McDonald, fifteen, whose relationship to the family is unknown. He did not own real estate, but his personal estate was valued at $4,000. In 1852 Elliott was one of the members of Trinity Episcopal Church who signed a petition seeking the appointment of a new rector, and his children were baptized there on July 27, 1852, and November 28, 1854.[8] In the later 1850s and early 1860s, he was active in the Pennsylvania Sons of Temperance, serving as a patriarch of the Pottsville chapter.[9] He may have been a Mason, as his watch paper includes an image of the Masonic square and compass, although there is no record of his membership at any lodge in Pennsylvania.[10] Elliott died in Pottsville on March 3, 1864, and was buried three days later in Mount Laurel Cemetery. His wife Jane died on December 30, 1866, and the 1870 U.S. census recorded their three children living in the household of their maternal aunt Elizabeth (Loeser) Patterson and her husband Frederick.[11] DLB

1. Consolidated Lists of Civil War Draft Registrations, 1863–1865, Pennsylvania, 10th Congressional District, NM-65, entry 172, ARC ID: 4213514, Records of the Provost Marshal General's Bureau (Civil War), Record Group 110, NARA, Washington, DC, at Ancestry.com.

2. P. William Filby and Mary K. Meyer, *Passenger and Immigration Lists Index* (Detroit: Gale, 1981), vol. 1, p. 551; P. William Filby, ed., *Philadelphia Naturalization Records* (Detroit: Gale, 1982), p. 171.

3. Eli Bowen, ed., *The Coal Regions of Pennsylvania* ... (Pottsville, PA: E. N. Carvalho, 1848), p. 66; *History of Schuylkill County, Pennsylvania* ... (New York: W. W. Munsell, 1881), p. 279.

4. Bowen, *Coal Regions of Pennsylvania*, advertisements, p. 4. In the 1850 U.S. census Brady was recorded as a jeweler in Pottsville.

5. For the mark, see Silversmith Directory, s.v. "Brady & Elliott," www.SterlingFlatwareFashions.com (accessed April 25, 2013); for the watch paper (undated), see Watch Papers Collection, AmericanAntiquarian.org (accessed October 26, 2017).

6. 1850 and 1860 U.S. Census.

7. DAPC 97.2014.

8. Baptism, Communicant, and Burial Register, 1832–1863, Trinity Episcopal Church, Pottsville, PA, pp. 206, 244, 270–71; Historic Pennsylvania Church and Town Records, HSP, Ancestry.com.

9. *Journal of Proceedings of the Grand Division of Sons of Temperance of the State of Pennsylvania* (Philadelphia: Barnard & Jones, 1859), p. 5; ibid. (Philadelphia: William W. Axe , 1861), p. 5.

10. I am grateful to Glenys A. Waldman, librarian of the Masonic Library and Museum of Pennsylvania, for searching for Elliott in their records.

11. Baptism, Confirmation, Marriage, and Burial Register, 1863–1872, Trinity Episcopal Church, Pottsville, PA, pp. 246, 250; Historic Pennsylvania Church and Town Records, HSP, Ancestry.com.

Cat. 234

Joseph S. Elliott
Sugar Spoon

1850–60
MARKS: J.S.ELLIOTT. (in rectangle) POTTSVILLE (in rectangle; all on back of handle; cat. 234-1)
Length 7 1/16 inches (17.9 cm)
Weight 19 dwt. 18 gr.
Gift of Charlene D. Sussel, 2009-155-9

PROVENANCE: From the stock of the Philadelphia antiques dealer Eugene Sussel (1913–1989), the donor's husband.

Cat. 234-1

Joseph Elliott presumably marked this sugar spoon as its retailer; it probably was made by a Philadelphia silversmith such as Samuel Hopper, who marked an almost identical example (PMA 1986-99-2). The distribution of Philadelphia-made goods to inland regions of Pennsylvania was facilitated greatly by the expansion of the railroad in the early 1830s, a development underscored by the central image of a train on Elliott's watch paper (see fig. 81). Elliott's use of a town mark suggests that his clientele extended beyond Pottsville itself to rural areas of Schuylkill County, where his name would be less recognized.
DLB

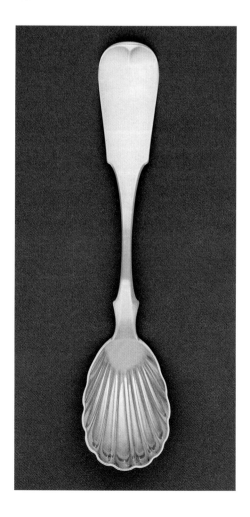

Eoff and Phyfe

New York City, Partnerships 1844–49, 1852–55

Edgar Mortimer Eoff was born in New York City on March 8, 1806, to Garret Eoff (1779–1845), a silversmith, and his wife Catherine E. Bain (Bean) Eoff (1785–1860).[1] Edgar probably worked with his father at 58 Bedford Street before he married Rachel Ann Hoppler (1821–1897) around 1842 and moved nearby to Hammersley Street. They had six children, only one of whom, Charles Walton Eoff (1855–1928), survived him.[2]

A William M. Phyfe is listed in Boston records as marrying Elizabeth W. Foster on December 16, 1833, and Rachel Crooker, also in Boston, on August 7, 1838.[3] The William M. Phyfe of Eoff and Phyfe was at work as a silversmith at 43 Bank Street in New York City by 1842.[4]

The New York partnership of Eoff and Phyfe has been published as active from 1844 to 1849 and again from 1852 to 1855.[5] In 1845 the silversmiths lived near each other, Eoff at 81 Hamersley Street and Phyfe at number 60, and were listed as working together at 5 Dey Street.[6] In 1849 Phyfe abandoned the partnership and joined the Gold Rush to California, and Eoff moved his business to 83 Duane Street in New York and his home to Jersey City, New Jersey.[7] In 1851 or 1852 Phyfe returned, and the partnership was resumed until 1855.[8] In the New York City directory of 1857, Phyfe was listed as "smith" at 358 Hudson Street.[9] He was not in the 1865 directory. By 1857 Eoff had partnered with George Shepard at 83 Duane Street, and the two remained in business together until about 1861.[10] Eoff had property in Hudson, New Jersey, by 1860, the year he died in West Hoboken.[11] He was buried in Green-Wood Cemetery, Brooklyn, as were several of his children and his siblings.[12]

BBG

1. An earlier Garret Eoff married Sarah Heyer, antecedent of the silversmith William Heyer (q.v.), in 1788; William Nelson, ed., *Documents Relating to the Colonial History of the State of New Jersey*, vol. 22, *Marriage Records, 1665–1800* (Paterson, NJ: The Press Printing and Publishing, 1900), p. 127. An Edgar M. Eoff married a Rachel Anne Hoppler and had three children who lived to adulthood: Catharine Matilda Eoff Alpaugh (1843–1873), Edgar Gerrit Eoff (1844–1878), and Charles Walton Eoff (1855–1928); "New Jersey Births and Christenings, 1660–1931," index (Salt Lake

City: FamilySearch, 2009, 2010), Ancestry.com; memorial no. 11836768 (Edgar M. Eoff), www.findagrave.com (accessed April 18, 2015).

2. Doggett's New York City directory 1842–43, p. 122; 1860 U.S. Census; memorial no. 23405441 (Charles Walton Eoff), www.findagrave.com (accessed April 7, 2015).

3. Town and City Clerks of Massachusetts, "Massachusetts Vital and Town Records, Boston," Ancestry.com.

4. Doggett's New York City directory 1842–43, p. 258.

5. "Silversmiths and Related Craftsmen," Partnerships, s.v. "Edgar Mortimer Eoff," Ancestry.com.

6. Doggett's New York City directory 1845–46, p. 122; Waters, McKinsey, and Ward 2000, vol. 2, p. 317; Doggett's New York City directory 1842, p. 380. Dey Street ran from 193 Broadway west to the North (Hudson) River.

7. Stephen Ensko, *American Silversmiths and Their Marks* (New York: privately printed, 1927), p. 85; obituary of Edgar Mortimer Eoff, *New York Times*, March 21, 1897.

8. See note 5.

9. Trow's New York City directory 1857, p. 657.

10. Ibid., p. 259.

11. 1860 U.S. Census; *New York Times*, March 21, 1897.

12. Memorial no. 11836768 (Edgar M. Eoff), see note 1 above.

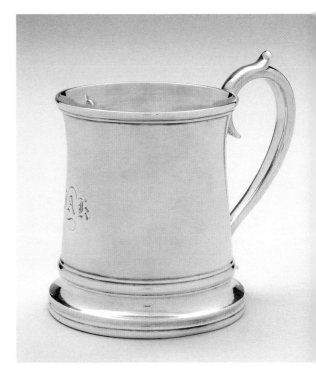

Cat. 235
Eoff and Phyfe
Cup

1844–49
Retailed by Gelston & Co., New York (1837–49)
MARKS: E & P (in a rectangle, on underside; cat. 235-1) / GELSTON.& Cº. (in rectangle, on edge of underside under handle; cat. 235-2)
INSCRIPTIONS: J A K (engraved gothic letters, on front opposite handle); HRNS / VRNS (scratched, on underside)
Height 3⅝ inches (9.2 cm), width 4⅛ inches (10.5 cm), diam. 3¹/₁₆ inches (7.8 cm)
Weight 4 oz. 4 dwt. 15 gr.
Gift of an anonymous donor, 1994-184-2

This small cup is reminiscent of the straight-sided mug shapes of the eighteenth century. It is seamed under the cast handle. The base moldings form a slightly raised foot. A mug with the same maker's and retailer's marks is in the collection of the Museum of the City of New York.[1]

The principals in Gelston & Co., jewelers, silversmiths, and retailers, were George Sears Gelston (1805–1890) and Henry Gelston (born 1803), the latter being the active partner in the early 1840s. The Gelstons' shop was at 1 Astor House, on Broadway.[2] George was the son of William and Siena Sayre Warner Gelston. He married Maria A. Meinell (born New York, 1812), in 1841 in South Oyster Bay, New York.[3] In 1839–40 he was at 18 Vesey Street.[4] In the U.S. census of 1850 he was recorded in New Utrecht, Kings County, New York, and listed among owners, agents, or managers of farms. In 1865 he was at Fort Hamilton and was taxed for a gold watch and a piano.[5] In 1875 he was listed as a "retired jeweler."[6] He died March 6, 1890, in Brooklyn. His estate was valued at $100,000.[7] BBG

1. Waters, McKinsey, and Ward 2000, vol. 2, p. 317, cat. 159.
2. Doggett's New York City directory 1842; Belden 1980, pp. 185–86.
3. *New York Post*, July 24, 1841. "George Gelston . . . Retired Jeweler, married the daughter of Meinell, the Leather Dealer of the Swamp"; Moses Yale Beach, *Wealth and Biography of the Wealthy Citizens of New York City*, 6th ed. (New York: Sun Office, 1845), p. 13.
4. Longworth's New York City directory 1839, p. 276
5. Records of the Internal Revenue Service, Record Group 58, NARA, Washington, DC, Ancestry.com.
6. 1875 New York State Census, New York State Archives, Albany, Ancestry.com.
7. Beach, *Wealth and Biography of the Wealthy Citizens of New York City*, p. 13.

Cat. 235-1

Cat. 235-2

Henry Erwin

Wilmington, Delaware, born 1794
Burlington, New Jersey, died 1845

Henry Erwin was four years old when his parents, Samuel (1753–1798) and Lydia Stowe Erwin (1752–1798) of Wilmington, Delaware, died in the yellow fever epidemic of 1798.[1] The youngest of their six children, Henry was born in Wilmington.[2] He would have been apprenticed in about 1805, and it seems probable that his apprenticeship overlapped with that of Edward Lownes in the active shop run by Joseph Lownes (q.v.) at 124 South Front Street in Philadelphia. Erwin's and Edward Lownes's marks, first initial and surname in a serrated rectangle, are very similar, and their first entry at the same location in the Philadelphia directory of 1816 indicates that they were both at the same location, suggesting a working relationship.[3] Neither was listed separately in that directory, and the fact that Joseph was listed with them suggests that he may have set his apprentices up in business, with his nephew Edward as the primary partner. Joseph Lownes was also listed, in the same directory, at his shop at 124 South Front Street with Josiah Lownes. In 1817 and 1818 Henry Erwin was the only occupant of 191 South Second Street.[4] In 1819 he had moved to 26 South Third Street, probably with another jeweler or silversmith.[5] He was not listed in the U.S. census of 1820.

Henry Erwin married Rebecca Ashton Albania Warner (born 1800) on June 23, 1823, and moved to 33 North Third Street, which became his primary address for ten years.[6] They had two children there: Joseph Warner Erwin (1824–1890) and Lydia Warner Erwin (1827–1864).[7] In 1828 Henry listed himself as a jeweler, and in 1829 his residence was at 301 Mulberry (Arch) Street.[8]

On November 3, 1830, Henry Erwin, at 33 North Third Street near the City Hotel, announced in the *Philadelphia Inquirer* a "Pawnbrokers sale of unredeemed pledges," consisting of a "large and extensive variety of watches, jewelry, plate, fancy goods and clothing by order of a licensed pawnbroker, consisting of gold and silver watches . . . pencil cases . . . umbrellas, pistols, and flutes." The sale went on in the evening to hardware and cutlery, and on "Friday evening a Book Sale—By

Catalogue . . . a share in the Philadelphia Library etc." At the same time Erwin began to speculate in real estate and advertised for rent, "a neat three story brick house, with communicating doors and marble mantels, situate on North 8th Street above Arch."[9] Then on March 9, he advertised the sale of "the household furnishings of a family declining housekeeping" at the third door above Arch on the west side of Eighth Street.[10]

By this date he was fully invested in the auction business and was paying "Auction Duties." In March he paid $148.52, which placed him at the bottom of the list of auctioneers with accountable proceeds; at the top was Gill Ford & Co., paying $4,865.03. In June Erwin paid $315.44; at the top of the list was R. F. Allen, who paid $10,578.02.[11] In 1834 he and Edward Lownes were but two of many silversmiths and hundreds of craftsmen who signed a "memorial" petition to the U.S. Congress for relief from economic distress and a restoration of deposits to the Bank of the United States.[12] In 1839 Henry Erwin returned to his craft and advertised as a watchmaker at 167 Chestnut Street with his residence at 301 Arch (Mulberry) Street.[13] The U.S. census of 1840 listed the Erwin household in the South Mulberry Ward as consisting of seven persons: he and his wife, between the ages of forty and forty-nine, two boys, between the ages of fifteen and nineteen, one girl, between the ages of ten and fourteen, and two free colored females; one person was noted as employed in commerce. During this period Erwin seems to have speculated in property, particularly a house and lot on the west side of Tenth Street, which in April 1841 was offered for sale.[14] This property was bounded by other lots also owned by Erwin.

In 1843 and 1844 Henry Erwin advertised as a real estate broker, selling property and lending money toward development. He was working from his home at 301 Mulberry (Arch) Street, "the first door above Eighth Street."[15] On August 17, 1843, he placed an announcement in the *North American*: "To Builders—To Let on Ground rent, a lot on the South east corner of Schuylkill 5th and Filbert Streets. A sum of money will be loaned on each lot to a responsible person who will improve the lot. Apply to Henry Erwin, Real Estate Office, No. 301 Arch Street." In the same issue he also placed the following notice: "A small sum of money to loan on Mortgage. $350 to $400 will be loaned on Mortgage on a Property in the City, safe for the amount. Apply to Henry Erwin, 301 Arch Street." On October 21 he advertised the sale of a farm in Solebury Township, Bucks County; in November, various rents; and, on November 28, "a valuable lot of ground on Arch Street West of Broad, for sale or exchange."[16] On April 6, 1844, again in the *North*

American, he advertised "$500 to Loan in good City or County Security."

At some point he moved to Burlington, New Jersey, probably residing with his son John, who had married Caroline A. Borden. The *Philadelphia Inquirer* and the *National Gazette* of June 12, 1845, both carried a notice of Erwin's death and interment: "on the 10th inst, at his residence in Burlington, New Jersey, Henry Erwin late of Philadelphia age fifty one. His funeral will proceed by boat to Wilmington, Delaware at 9 AM from the Chestnut Street Wharf." He was buried at the First Presbyterian Church in Wilmington in the Borden family section. BBG

1. Samuel Erwin was buried on August 29 and his wife on October 11, 1798, at the First Presbyterian Church, Wilmington, New Castle, Delaware; List of Names and Monuments on Tombstones in Graveyard of First Presbyterian Church of Wilmington (1904), First Presbyterian Church (Wilmington) Records, Pennsylvania Genealogical Society, Philadelphia, Ancestry.com.

2. Not to be confused with Henry Erwin, MD, who died in 1852 (Philadelphia Will Book 29, no. 43, p. 98); or Henry Erwin (born 1845), son of John (born 1795), a farmer in Burlington, New Jersey (1850 U.S. Census).

3. Philadelphia directory 1816, n.p. The partnership of Lownes & Erwin was published in the past as having been Joseph Lownes & Henry Erwin; Ensko 1948, p. 87. A handsome tea and coffee service bearing the marks of Edward Lownes and Henry Erwin is illustrated in Elizabeth and Stuart P. Feld, "Classical Decorative Arts of Philadelphia," *Antiques and Fine Art*, vol. 7 (Spring 2007), illus. p. 190.

4. Joseph and Josiah H. Lownes were at 124 South Front Street, and/or 18 Dock Street; Edward Lownes was at 10 1/2 South Third Street; Philadelphia directory 1817, pp. 160, 280.

5. Ibid. 1819, n.p.

6. Pennsylvania and New Jersey, Church and Town Records, 1708–1985, Ancestry.com; Philadelphia directory 1823, n.p. Rebecca was the daughter of Joseph C. Warner and Sarah Powell and granddaughter of the silversmith Joseph Warner (1742–1800) of Wilmington; Familysearch.org (accessed April 8, 2015).

7. Joseph married Caroline Ann Borden in 1850; National Society, Daughters of the American Revolution, *Lineage Book of the Charter Members of the National Society of the Daughters of the American Revolution*, vol. 20 (1897), Ancestry.com. Lydia married Edward J. Maginnis in 1853; William R. Merchant family tree, Ancestry.com.

8. Philadelphia directory 1828, p. 25; 1829, p. 58.

9. *Philadelphia Inquirer*, March 9, 1831.

10. Ibid.

11. Ibid., March 24, 1831; *National Gazette* (Philadelphia), June 23, 1831.

12. Executive Documents, 23rd Congress, 1st session, 1833–34, document no. 86, p. 48.

13. McElroy's Philadelphia directory 1839, p. 15.

14. *North American* (Philadelphia), April 12, and 19, 1841.

15. McElroy's Philadelphia directory 1844, p. 93.

16. He also published real estate listings in the *North American* on October 20 and November 7, 8, 16, and 17, 1843; and December 7, 12, and 30, 1843.

Cat. 236

Henry Erwin

Teaspoon, Tablespoon, Dessert Spoon, and Fork

1817–30

MARK (on each): H.ERWIN (in rectangle with rounded ends, on reverse of stem; cat. 236-1)

INSCRIPTION (on each): B (engraved script, on back of handle)

Teaspoon: Length 6½ inches (16.5 cm)
Weight 1 oz. 1 dwt. 12 gr.

Tablespoon: Length 7¼ inches (18.4 cm)
Weight 1 oz. 19 dwt. 14 gr.

Dessert spoon: Length 8⅞ inches (22.5 cm)
Weight 3 oz. 6 dwt. 1 gr.

Fork: Length 8¼ inches (21 cm)
Weight 3 oz. 4 dwt. 5 gr.

Gift of Dorothy Burr Thompson, 1991-35-4–7

PROVENANCE: The donor, Dorothy Burr Thompson (1900–2001), recalled that the "B" engraved on these pieces was for her maternal great-grandparents, John Remigius Baker II (1818–1892) and Anna Robeson Lea (1825–1887) of Philadelphia, who were married in 1847. Given the year of their marriage and the flatware's earlier date of manufacture, the silver probably was owned originally by Baker's parents, Charles Henry Baker (1793–1872) and Elizabeth Boller (1799–1891), also of Philadelphia, who were married in 1814.[1]

Cat. 236-1

The pattern on this flatware is *Shell and Thread*, which was popular and produced by most silver manufacturers by 1830. There is a convex shell at the top of the obverse of the handles, with its negative, concave version on the reverse of the handles.[2]

The engraved script letter "B" on this tableware is by a less accomplished hand than the initial on the sugar tongs (PMA 1991-35-8) made by Henry Pepper for the Baker family. BBG/DLB

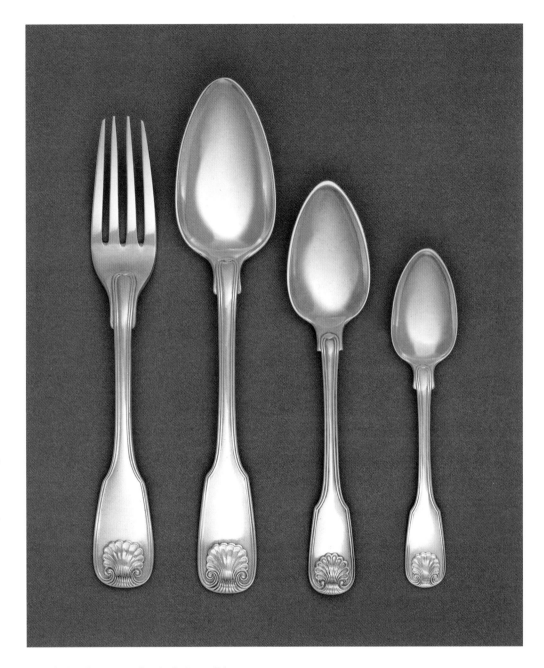

1. Dorothy Burr Thompson to Beatrice B. Garvan, February 26, 1991, curatorial files, AA, PMA. Information on the Baker family is taken from the Hulick family tree, Ancestry.com (accessed November 9, 2017).
2. The donor owned matching pieces of flatware in this pattern that were marked by Robert and William Wilson with the "B" engraved on the obverse of the handles.

F

William Faber & Sons

| Philadelphia, 1865–97

William Faber (1800–1868) probably was born in Port-au-Prince, then in the French colony of Saint-Domingue, where his father, Jacob Faber, was manager of the American Hotel.[1] During the turmoil of the Haitian Revolution, Jacob and his wife Sarah returned to their native state of Maryland and settled in Baltimore. On September 24, 1817, William "Fabers," age seventeen, was apprenticed to the Baltimore silversmith Andrew Ellicott Warner Sr. (1786–1870).[2] Faber had established himself as an independent silversmith in Baltimore by 1823–24.[3] On June 26, 1825, he married Mary Ann G. Meredith (1802–1829) in Baltimore, where their one son, William Thomas Faber (1826–1878), was presumably born.

William "Fabers" first appeared in Philadelphia in the 1828 city directory as a silversmith located at 9 Mulberry Alley.[4] Following Mary Ann's death in Philadelphia on October 19, 1829,[5] he married Sarah Noble (1810–1886) of New Jersey and, beginning in 1834, had four more children. Faber relocated his shop to 1 Pennsylvania Avenue in 1830 and moved again to 124 North Fifth Street in 1836.[6] In that same year he formed a one-year partnership with Joseph Eves Hover,[7] who was recorded as a silversmith between 1839 and 1841. In 1841 Hover, who died in about 1885, began a longer and very successful career as an ink manufacturer.[8] During this period Faber countermarked an 1846 cent coin as a means of advertising.[9] After almost two decades at 124 North Fifth Street, Faber moved to 214 North Fifth in 1857, and as early as 1858 the city directories identified his specialty as flatware ("Spoons & Forks," "Silver Knives &c.").[10] The U.S. censuses of 1850 and 1860 indicate that Faber realized some financial success, employing domestic servants and owning real estate valued at $3,000 in 1850; ten years later his real estate was valued at $5,000 and his personal property at $2,000. In May 1863 he was assessed an ad valorem tax of $15 for annual income over $600.[11]

In 1865 Faber formed the partnership of William Faber & Sons with his sons William T. Faber and Charles H. Faber (1837–1893), both of whom,

presumably, he had trained. The firm was located at 11 Haviland Place (west of Eighth between Race and Vine streets) and continued to specialize in flatware.[12] William T. Faber had been listed as a silversmith at 53 Lewis Street beginning in 1854; subsequently he worked at 959 Warnock Street before forming the partnership with his father.[13] In 1858 Charles Faber was working as a silversmith with his father at 214 North Fifth Street, as was his brother Edmund A. Faber (1834–1903), who was listed in the directory as a "clerk," although he had appeared in the U.S. census of 1850, at age sixteen, as a silversmith.[14] Another son who became a silversmith, Jacob H. Faber (1842–1881), also apparently worked for the firm but, like Edmund, was never listed as a partner or owner. Jacob was listed in the 1875 city directory as a silversmith with his residence at 1503 North Tenth Street, the address of his widowed mother.[15]

Following William Faber's death on November 19, 1868, his sons relocated the business to 618 Chestnut Street, in the new "Jewelers' Row" neighborhood, where they continued to operate under the company's existing name.[16] A trade card with this address described the company as "manufacturers of sterling silverware" (fig. 82). The firm apparently also retailed silver, as its mark appeared on flatware made by the Gorham Manufacturing and Whiting companies (q.q.v.).[17] Louise Belden mistakenly stated that the firm operated a branch in New Orleans. A jeweler named William Faber was recorded in the New Orleans directories of 1879 and 1881, although he did not use the company name "William Faber & Sons," and both William Faber and his namesake son had died by 1879.[18]

After William T. Faber's death in 1878, Charles was listed as the company's sole owner and proprietor.[19] Following Charles's death fifteen years later, the firm moved to 738 Sansom Street, and his widow, Emily Walsh Barker Faber (1844–1917), became the owner.[20] In 1895–96 their sons William B. Faber (born 1870) and Frank O. Faber (born 1877 and, at age eighteen, living with his widowed mother) were listed as the owners, but in 1897 Emily reappeared as the owner with Solomon L. Kahn, who had previously been listed in directories as a salesman.[21] The firm apparently went out of business in that year, as no further listings for it appeared in city directories. William B. Faber subsequently worked as a silversmith at 733 Sansom Street until at least 1915; his brother Frank was recorded in directories as a "clerk," although it is unclear from these listings whether he was associated with his brother's business.[22] DLB

Fig. 82. Trade card of William Faber & Sons, c. 1880. Private collection

1. Unless otherwise noted, biographical information, including life dates, for members of the Faber family came from three principal sources that sometimes contradict one another: William Faber family tree, Ancestry.com (accessed March 28, 2013); a letter from William T. Faber's great-granddaughter, Virginia C. Baum, March 13, 1978 (curatorial files, AA, PMA); and telephone conversations and email messages between Robert Faber and the author, April 10, 2012, and December 21, 2017.

2. Goldsborough 1983, p. 251.

3. Ibid.

4. Desilver's Philadelphia directory 1828, p. 26.

5. Death notice of Mary Ann Faber, *Pennsylvania Inquirer* (Philadelphia), October 22, 1829.

6. Desilver's Philadelphia directory 1831, p. 66; 1837, p. 67.

7. The firm is listed in ibid. 1837, p. 67, as "Faber & Hovers [*sic*]"; unlike Faber, Hover is not listed independently. Brix (1920, p. 52) incorrectly recorded this individual as Joseph E. Hoover, as did Hollan (2013, p. 66).

8. For information on J. E. Hover Ink Company, see www.bottlebooks.com/inkcompanyhistory/Hover_ink.htm; www.hairraisingstories.com/Products/HOVER_HD.html (accessed October 26, 2017).

9. Gregory G. Brunk, *Merchant and Privately Countermarked Coins: Advertising on the World's Smallest Billboards* (Rockford, IL: World Exonumia, 2003), p. 161.

10. McElroy's Philadelphia directory 1858, pp. 201, 845.

11. Records of the Internal Revenue Service, Record Group 58, NARA, Washington, DC, Ancestry.com.

12. McElroy's Philadelphia directory 1866, p. 232.

13. Ibid. 1854, p. 157; 1858, p. 201.

14. Ibid. 1858, p. 201, where Edmund was listed incorrectly as "Edwin."

15. Gopsill's Philadelphia directory 1875, p. 496.

16. Death notice for William Faber, *Philadelphia Inquirer*, November 21, 1868; Gopsill's Philadelphia directory 1870, pp. 496, 530.

17. The mark "W. FABER & SONS" on the Museum's spoon also appears on a tablespoon marked by Whiting in the *Alhambra* pattern (DAPC 81.3371) and by Gorham in the *Cottage* pattern (DAPC 81.3379); see also the mustard spoon (PMA 1988-25-15) by Gorham.

18. Belden 1980, p. 161; *Soards' New Orleans City Directory for 1879* (New Orleans: L. Soards, 1879), p. 268; 1881, p. 286.

19. Gopsill's Philadelphia directory 1879, p. 519.

20. Ibid. 1894, p. 606.

21. Ibid. 1895, p. 568; 1896, p. 591; 1897, p. 604.

22. Ibid. 1898, p. 662; 1916, p. 578. Hollan (2013, p. 67) illustrates an incuse mark, "WM. B. FABER," that, presumably, he used after 1897.

Cat. 237
William Faber & Sons
Fork

c. 1870
MARK: COIN W. FABER & SONS (incuse, on back
of handle; cat. 237-1)
INSCRIPTIONS: T F W (engraved script, on front
of handle); 1870 (engraved, on back of handle)
Length 7³⁄₁₆ inches (18.3 cm)
Weight 1 oz. 7 dwt. 6 gr.
Gift of Charlene D. Sussel, 2009-155-10

PROVENANCE: From the stock of the Philadelphia antiques
dealer Eugene Sussel (1913–1989), the donor's husband.

W. FABER & SONS

Cat. 237-1

The firm William Faber & Sons produced flatware in
a wide range of styles, including downturned, fid-
dle, tipt, neo-grec, and engraved. The angular sil-
houette of the handle of the fork and the bright-cut
engraving were characteristic of American patterns
in the years following the Civil War, and the use of
coin-standard silver and the engraved date further
suggest a date of manufacture around 1870. DLB

Robert Farrell

| Fort Atkinson, Wisconsin, 1960

Robert Farrell (fig. 83) was raised in
a clapboard house built in 1904 by
his great-grandfather John Huppert,
filled with antiques and family trea-
sures.¹ At a young age the artist learned from his
mother, June Winter Farrell, "the importance of
objects as part of rituals or as embodiments of
those who had passed." She also strongly influ-
enced him to "do things with his hands," whether
it was reupholstering or refinishing furniture, or
altering objects around their home. In addition,
she instilled in him a reverence for antiques, espe-
cially heirloom silver serving pieces; their status
of being "passed down" left an indelible mark
upon the artist. As a child he was also drawn to
building structures and the miniature world. He
had a penchant for dioramas and often played
with Lincoln Logs, blocks, Legos, and tents and
forts built from blankets and ropes. At the age of
eight his family moved to Venice, Florida, but held
onto their ancestral home in Wisconsin.

By the time he attended junior high school,
Farrell was aware that three-dimensional objects
held his interest. He attended the University of
Wisconsin at Whitewater, with a double major
in English and studio art, earning a BA in 1987. His
childhood fascination with antiques came into
focus through a newfound love of art history, along
with the metal, clay, and stone functional artifacts
left behind by ancient civiliza-
tions. While in college he was
initially drawn to functional,
wheel-thrown ceramic vessels,
as their practical use "justified"
their existence. Farrell took
Linda Threadgill's (born 1947)
class in metals, but while he
"loved the material, and loved
her work," he struggled with the
medium itself, finding it "techni-
cally challenging" and soldering
"a nightmare." His coursework
in ceramics challenged him to

create only hand-built, nonfunctional work, and
in defiance Farrell abruptly turned his attention
to metalwork. Like all beginners, he primarily
explored hollowware and fabricated forms, which
drew influence from Threadgill's tutelage and style.

At Tyler School of Art of Temple University
in Philadelphia, Farrell pursued his MFA, focus-
ing on metal and jewelry. Studying under Stan-
ley Lechtzin, Vicki Sedman (q.q.v.), and Daniella
Kerner, he explored jewelry forms that were "the-
atrical and impractical" in nature—what Far-
rell calls "extravagances of hollow fabrication."
While in school he submitted a design to *Silver:
New Forms and Expressions*, a competition orga-
nized by Fortunoff's and Rosanne Raab.² Teapots
were the theme, and his design was selected to
be showcased in the window of Fortunoff's flag-
ship retail store at 681 Fifth Avenue in New York.
Farrell applied to the following year's compe-
tition, which focused on spoons, and his design
was again chosen for exhibition. Still a graduate
student, in 1989 he was accepted to participate in
the prestigious Philadelphia Museum of Art Craft
Show. These early experiences of fanciful explora-
tion of hollowware forms, success in competition,
and introduction to juried retail shows were for-
mative for the artist, and set him on the path of a
successful thirty-year career.

Spending the academic year in Florida and
summers in Wisconsin, Farrell has continued
his lifelong pattern of translocation to this day.
A keen observer of the altering landscape—rural,
suburban, and urban—between his two homes,
and with a propensity for architecture and struc-
tures of all sorts and sizes, Farrell has witnessed
the distinct changes and decay of the buildings
he encounters on his biannual migrations.³ These
observations have led to a new body of sculptural
work that is informed by the rapidly fading archi-
tectural landscape of his youth. Farrell's career

Fig. 83. Robert Farrell at work.
Courtesy of the artist

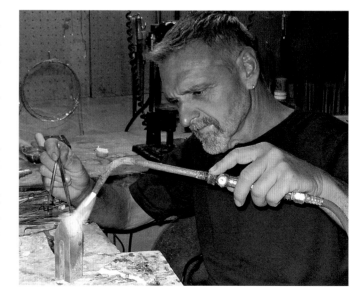

has focused mainly on jewelry, hollowware, flatware, and sculpture and can be found in the collections of the Mint Museum of Art, Charlotte, North Carolina; Museum of Arts and Design, New York; Renwick Gallery, Smithsonian American Art Museum, Washington, D.C.; and Victoria and Albert Museum, London. ERA

1. Information for this biography was gleaned from the artist's curriculum vitae and two artist's statements dated April 17, 2015 (curatorial files, AA, PMA); a telephone conversation with the artist, September 8, 2017; and email message with the artist, September 14, 2017.

2. Rosanne Raab, director of Rosanne Raab Associates (1983–present), a New York–based consulting firm specializing in the arts of craft and design, created the format and administered three annual invitational exhibitions (1989–91) designed to show silver holloware and flatware by master metalsmiths and winners of a juried competition at Fortunoff's. These exhibitions then traveled to U.S. universities and museums each year.

3. Farrell has commented that the source of inspiration for his work is imagery "from a lifetime of driving around the United States going to art shows and observing what I've seen along the way."

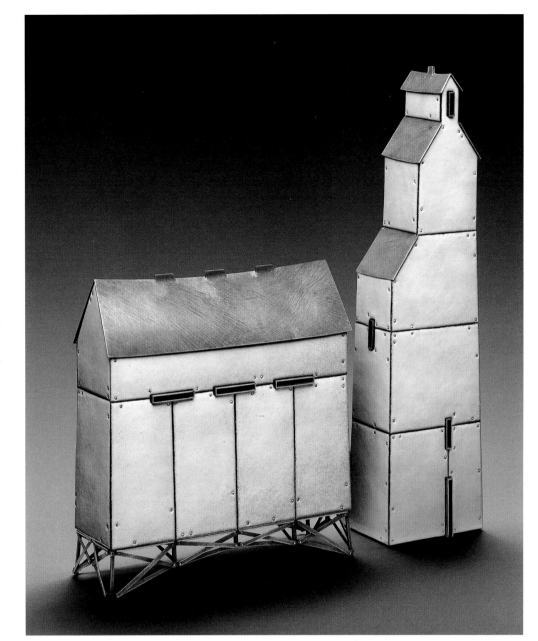

Cat. 238

Robert Farrell

Winter

2015

Sterling silver, copper, nickel silver, glass enamel
MARKS: ROBERT FARRELL 2015 / STERLING, COPPER. NICKEL, ENAMEL (incised, on bottom of shed; cat. 238-1); ROBERT FARRELL 2015 / SILVER, COPPER, NICKEL, ENAMEL (incised, on bottom of grain elevator; cat. 238-1)
Shed: Height 9¾ inches (24.8 cm), width 9¼ inches (23.5 cm), depth 3¼ inches (8.3 cm)
Grain Elevator: Height 15¾ inches (40 cm), width 4 inches (10.2 cm), depth 2¾ inches (7 cm)

Purchased with funds contributed by Robert and Frances Coulborn Kohler, Boo Stroud, and The Women's Committee and the Craft Show Committee of the Philadelphia Museum of Art, 2015-58-1a,b

Cat. 238-1

Winter is Robert Farrell's most sophisticated sculpture to date, the result of a major shift in his output that occurred around 2005. Abandoning the constraints of functionality and a taught reverence for the material, he began drawing upon his emotions to make a new body of work that connects to his soul. In doing so, he mined his childhood memory of a small Wisconsin town laden with abandoned and decaying rural structures. For Farrell they have punctuated the landscape for decades, as if sentinels bearing witness to "progress" that surrounds them. According to Farrell, their decay is symbolic of change. *Winter*, a contemporary reliquary for emotions and memories, grows out of an inherited respect for the importance of ritual objects. This was imparted to Farrell while growing up in his ancestral home, surrounded by antiques imbued with the memory of deceased loved ones. A container for his memories, longings, regrets, and hopes—all sacred—*Winter* is not a direct representation of actual structures but rather is suggestive or vague, as are most memories. It invites spectators to bring their own recollections into view. *Winter* serves as repository for our collective memories of bygone structures, transporting us to a rapidly disappearing landscape. It is recollection that evokes a simpler and slower time, as we mourn the loss of structures built by our own hands and former connections to the land.

The donors Robert and Frances Coulborn Kohler are longtime supporters of the Philadelphia Museum of Arts Craft Show and the many artists who exhibit there annually. The Kohlers wanted to make a purchase from the 2014 Craft Show on behalf of the Museum and chose Robert Farrell as their worthy recipient, an artist they have watched grow over many years. The curator agreed to commission Farrell to create a one-of-a-kind sculpture for the Museum's collection of contemporary craft. *Winter* was the remarkable end result, one that especially resonated with Robert Kohler, born in Sheboygan, Wisconsin. ERA

John Ferguson

Location unrecoded, born 1777
Philadelphia, died 1810

Fig. 84. Engraved silver medal attributed to John Ferguson and made for the American Company of Booksellers as second-place prize in 1804. Library Company of Philadelphia, no. 861

Scant information survives to document John Ferguson's brief life and career. Much of what is known comes from the records of Christ Church, located in close proximity to his homes in Elfreth's Alley and North Front Street. His gravestone recorded his birth date as April 22, 1777, and he may be the same John Ferguson, born in Ireland, who immigrated to Philadelphia in 1798 and, on February 13 of that year at the State Supreme Court of Pennsylvania, declared his intention to become a U.S. citizen.[1] Ferguson married Mary Anderson of Philadelphia at Christ Church on January 1, 1803, and had four children.[2]

He first appeared as a watchmaker in Philadelphia's High Street Ward in the Pennsylvania Septennial Census of 1800. In the 1801 city directory he was listed as a partner in the firm of "Moore and Fergerson [sic; q.v.], gold and silver smiths" at 42 North Front Street. Equally little is known about his partner, Charles Moore, who was also recorded in 1800 as a watchmaker in the High Street Ward.[3] Beginning in 1803 Ferguson's residence was at 17 Elfreth's Alley.[4] The partnership lasted until 1805, when Moore moved to 18 North Front Street, and Ferguson continued to work as a silversmith at their old address.[5] By 1807 he had moved to 45 South Second Street.[6] Ferguson's final listing in city directories was in 1810 as a silversmith at 42 North Front Street, although his obituary listed his residence as "in Pewter platter alley near Second Street."[7]

In 1804 Ferguson received a commission from the American Company of Booksellers for the gold medal, worth fifty dollars, that had been awarded by the booksellers to the printer Robert Carr of Philadelphia. As reported subsequently:

The medal was, accordingly, ordered; and, John Ferguson, jeweller, was applied to, by the president [Mathew Carey], to execute it; and the following was the inscription:— "Presented by the American Company of Booksellers, to Robert Carr, for excellence in printing Johnson's edition of the bible, in four volumes, 8 vo." It was presented to Mathew Carey, the founder, the father, and president of the institution; and payment of the bill, from month to month, was demanded.—At last, forsooth, it was discovered that no money was in the treasury; and, Mathew Carey, generously, out of his own pocket, gave five dollars, for the artist to murder the medal in the crucible, and, with it, the merit which properly ought to be to the handsomest bible maker. . . . We will ask . . . if this was fair conduct? — For, Ferguson paid five dollars for the engraving.[8]

Although Ferguson apparently melted down this gold medal, the engraved silver medal that was awarded as the second-place prize in 1804 survived (fig. 84) and may also be Ferguson's work.

John Ferguson, "silversmith," died on May 9, 1810, "after a short but painful illness, which he bore with Christian fortitude," and was interred in Christ Church's burial ground.[9] DLB

1. Memorial no. 11323236, www.findagrave.com (accessed June 12, 2015); P. William Filby and Mary K. Meyer, *Passenger and Immigration Lists Index* (Detroit: Gale, 1981), vol. 1, p. 597; P. William Filby, ed., *Philadelphia Naturalization Records: An Index to Records of Aliens' Declarations of Intention and/or Oaths of Allegiance, 1789–1880 . . .* (Detroit: Gale Research, 1982), p. 185.

2. "Marriages," *Philadelphia Repository and Weekly Register*, January 8, 1803; Marriage Register, 1800–1900, p. 4621, Christ Church, Philadelphia, http://christchurchphila.pastperfectonline.com (accessed June 12, 2015).

3. Septennial Census 1800. Moore was not listed in Philadelphia city directories after 1809.

4. Philadelphia directory 1803, p. 87.

5. Ibid. 1806, n.p.

6. Ibid. 1807, n.p.

7. Ibid. 1810, p. 98; obituary of John Ferguson, *Poulson's American Daily Advertiser*, May 11, 1810.

8. *Spirit of the Press* (Philadelphia), June 1, 1808. I am very grateful to Catherine Hollan for this reference and to James Green for information on Matthew Carey and the American Association of Booksellers.

9. Obituary of John Ferguson. *Poulson's American Daily Advertiser*, May 11, 1810; Burial Register, 1785–1900, p. 3679, Christ Church, Philadelphia (see note 2 above).

Cat. 239

John Ferguson
Teaspoon

1805–10
MARK: I·FERGUSON (in rectangle, on back of handle; cat. 239-1)
INSCRIPTION: A " N (engraved, on front of handle)
Length 5 3/16 inches (13.2 cm)
Weight 5 dwt. 5 gr.
Gift of Charlene D. Sussel, 2009-155-12

PROVENANCE: From the stock of the Philadelphia antiques dealer Eugene Sussel (1913–1989), the donor's husband.

Cat. 239-1

John Ferguson's mark has been recorded only on pieces of flatware, many with the downturned, pointed-end handles seen on this example.[1] In contrast, the mark of the partnership between Charles Moore and John Ferguson appears on Neoclassical hollowware forms, including a fluted cream pot and an urn-shaped teapot and sugar bowls.[2] DLB

1. See also DAPC 74.113, 75.4586, and 85.2103. Ferguson's mark does appear on a pair of tablespoons with feather-edge decoration, www.davidpownallwillis.com /items/377917/item377917store.html (accessed June 11, 2015), and a teaspoon with a downturned "fiddle" handle (DAPC 81.3122).
2. Cream pot, Metropolitan Museum of Art, New York (33.120.303; as by "WH" in Avery 1920, p. 177, fig. 136); teapot, Northeast Auctions, Portsmouth, NH, *26th Annual Summer Americana Auction*, August 3–5, 2012, lot 1170; sugar bowl, Yale University Art Gallery (1995.75.5a,b); sugar bowl, Northeast Auctions, Portsmouth, NH, *Mother's Day Weekend Auction*, May 10–11, 2014, lot 651.

James B. Fidler

Philadelphia, born 1822
Philadelphia, died 1861

James B. Fidler was born in New Jersey on May 3, 1822; he died in Philadelphia at age thirty-eight on April 12, 1861, and was buried in Pemberton, Burlington County, New Jersey. On the following day both the *Philadelphia Inquirer* and the *Public Ledger* published the notice of the funeral "from his late residence in Poplar Street, below Broad, and to proceed to Pemberton [N.J.] by the 8 o'clock line from Walnut Street Wharf."

Fidler was in Philadelphia at least by 1846, since the U.S. census of 1850 records that his daughter Adalaide, age four, was born in Pennsylvania. In 1849 Fidler and James E. Caldwell (q.v.), were among petitioners for David Paul Brown, Esq., to "discuss before them . . . the effects of the use of the lash on sailors and others."[1] It may have been Caldwell, a merchant born in New York, who introduced Fidler to William M. Youmans, a jeweler from New York. Youmans and Fidler were listed together in the U.S. census of 1850 in the Walnut Ward, but not in the Philadelphia city directories of 1849 or 1851. In 1854 Youmans was resident with Fidler for a year, at 12 South Second Street, as a "clerk."[2]

James had married Hope Eliza Burr (c. 1827–1901) in New Jersey in about 1845.[3] According to the census of 1850 (when James was the only Fidler listed in the city directory),[4] he and Hope were living with her family in a "boarding house" in Philadelphia's North Mulberry Ward. The census lists James B. Fidler, jeweler, age twenty-seven; Hope Eliza Burr Fidler, twenty-three; their two children, Adalaide, four, and Frank, two; and a John A. Fidler, twenty. There were fifteen others listed as resident with them, including six members of the Burr family, also from New Jersey: Hope Burr, fifty-three, was listed first; then Benjamin (c. 1792–1866); Benjamin junior, twenty-one, a tailor; and three younger Burrs noted as born in Pennsylvania. There were also three single men in the household: Samuel P. Welsh, a clerk, and George Smith, both twenty-three; and Lewis Atkinson, a tailor, nineteen. Noted after Hope Burr's name was "Boarding House," and after Benjamin Burr

(Sr.), "insane," which may have been the reason Hope Burr was listed before her husband as head of household.[5] This address in North Mulberry Ward turned out to be where James B. Fidler was first publicly listed as a jeweler: "Fidler, James B., jeweller, 281 Sassafras."[6] In 1851 the Burrs moved from Sassafras Street to 811 Race Street, and the Fidlers moved to 12 South Second Street, which was to be their permanent address.[7]

From 1854 to 1856 Fidler was also listed in the business section of the city directory under "Jewelers."[8] James Fidler's partnership with Eden Haydock (q.v.) was listed in 1856 and 1857, with both men at Fidler's address, 12 South Second Street.[9] John A. Fidler, bookkeeper, was listed at the same address. The 1856 city directory noted that it was "Published annually about the beginning of the Year," and thus the partnership may have been set up in 1855. As Haydock's name appears first, he was, presumably, the primary partner. At this time the partnership added the mark "STANDARD" on silver to indicate the 925/1000 silver content.[10]

In 1859 Fidler's listing as "jeweler" included a home address, 1329 Thompson Street, which was just off Poplar Street. The census of 1860 listed James B. Fidler, age thirty-eight; Hope E., thirty; Frank B., eleven; George B., nine; Howard, seven; Kate, five; and Alice, three. James Fidler died the next year, and his widow Hope was living with Eliza Fidler, "gentlewoman," at 1002 Race Street. From 1867 until her death, Hope Fidler resided at her family's house with her brother Benjamin Burr Jr. and in 1880 with her son Howard James Fidler (1852–1897), a railroad worker, and daughter Kate, who was twenty-six that year.[11] BBG

1. *Philadelphia Inquirer*, May 12, 1849.

2. McElroy's Philadelphia directory 1854, p. 584 (as Youmans and Fidler). In McElroy's directory of 1856 (p. 715), "Wm. M. Youmans," watchmaker and jeweler, was listed at 282 North Second Street.

3. Dillard (Profico) family tree, Ancestry.com.

4. McElroy's Philadelphia directory 1850, p. 130. However, a Jacob Fiedler appeared as "morocco dr."

5. In 1841 Burr & Brothers were tailors at 150 Chestnut Street. They were not listed in city directories by 1848. Presumably Benjamin Burr Jr. apprenticed with them while living with his father, Benjamin, "merchant," at 281 Sassafras (Race) Street. The Burrs were listed there from 1847 to 1850. Benjamin Burr is listed in McElroy's 1850 Philadelphia directory (p. 54) as resident at 281 Sassafras Street, with no occupation noted.

6. Ibid., p. 150: "James B. Fidler, watches & jewelry, 12 S. 2nd."

7. Between 1851 and 1852 Fidler must have been moving, as he is not listed again until 1853; ibid. 1853, p. 128.

8. Ibid. 1854, p. 36.

9. Their partnership has been published as existing from 1854 to 1856. It is not listed under "watchmakers, jewelers" or, in the alphabetical list of residents, as individuals at the same address in the city directories of 1854 or 1855. In 1856 "Haydock & Fidler" is listed in the back of McElroy's directory under "watchmakers & jewelers." Haydock is not listed separately there, but Fidler is (p. 784), and in the regular alphabetical listings, each is listed separately, as is the firm (pp. 197, 274).

10. Many jewelers at this time began to add the mark "STANDARD" in order to assure their customers of the high-quality silver being used.

11. 1880 U.S. Census.

Cat. 240

James B. Fidler
Mustard Spoon

c. 1854
MARK: J.B.FIDLER (incuse, on reverse of handle; cat. 240-1)
INSCRIPTION: C B (engraved script, on obverse of handle)
Length 5½ inches (14 cm)
Weight 6 dwt. 10 gr.
Gift of Sewell C. Biggs, 2000-130-25

PROVENANCE: The initials "CB" belonged to Caroline Beekman (1832–1900) of Somerset County, New Jersey, who married Sewell C. Biggs (1823–1911) in 1854.[1] She was the donor's paternal grandmother.

This light, graceful spoon has the same characteristics as the dessert spoons and teaspoons that bear the same engraved initials.[2] BBG

1. Membership application of John Franklin Biggs, Delaware Society of the Sons of the American Revolution, August 23, 1927, Ancestry.com.
2. For other silver in the Museum's collection that descended in this family, see the tablespoons by John Curry (cat. 163); teaspoons and dessert spoons by Haydock and Fidler (2000-130-4–15, -16–21).

J.B.FIDLER

Cat. 240-1

Harvey Filley & Sons

| Philadelphia, 1864–90

Harvey Filley Sr. (1794–1877) was born in Bloomfield, Connecticut, the son of Oliver Filley Sr. (1757–1796) and Tabitha Barber (1757–1842). He was apprenticed to his older brother, Oliver Filley Jr. (1784–1846), who had established a successful business making, decorating, and selling tin-plated sheet-iron utensils. Beginning in the autumn of 1815, Harvey worked as both a craftsman and peddler for the Lansingburgh, New York, branch of the family enterprise, under the supervision of his cousin and brother-in-law, Augustus Filley (1789–1845).[1]

In 1818 Harvey senior moved to Philadelphia to establish another branch of the tinware business, which continued for the following three decades. First located at the corner of High (Market) and Thirteenth streets, the shop was moved to 376 High Street in 1824, to 434 High Street in 1836, and to 436 High Street in 1844.[2] Harvey's role was primarily supervisory, and, in 1822, he wrote to Oliver, saying "I keep 5 workmen in my shop" and asking whether his brother could send decorators down from Connecticut.[3] Edward A. Filley (1818–1901), the eldest son of Augustus Filley and Harvey's second cousin, worked in the Philadelphia branch between about 1844 and 1848.[4] In 1826 Harvey Filley married Laura Marshall, and they had two sons, William H., who died in infancy, and Harvey junior (1830–1858). Following Laura's death in 1830, Filley married Chloe Ca[l]dwell (1810–1887) in 1831, and they had three children: Caroline (1832–1856), Otis Cadwell (1836–1898), and James Alden (1838–1927).[5]

By 1850, after his older brother Oliver had died, Harvey senior, faced with a decreasing demand for tin-plated objects, converted at least part of his factory to the electroplating of silver. In the 1850 city directory he was listed as a "tinplate worker" at 436 High Street but also as a partner in Filley, Mead & Cadwell, silver platers, at the same address.[6] His partners were Jay Cadwell (1820/21–1874), from Hartford, who left the partnership after one year, and John O. Mead (q.v.).[7] Filley and Mead continued the partnership until 1854, with Mead presumably providing the expertise for silver plating.

Beginning with the 1854 city directory, Filley was listed independently and exclusively as a silver plater, although he may have continued to do some tin plating.[8] In 1857 he moved his factory to 1222 Market Street. That year his business, together with those of John Mead and Meyer & Warne (q.v. Hatting, Meyer & Warne), was named, in a survey of the city's manufacturers, as the leading silver platers in Philadelphia.[9] The 1859 *Ladies Philadelphia Shopping Guide* described the same three establishments as presenting "the most beautiful display[s] of this [silver plated] ware."[10] Filley offered goods wholesale as well as retail: in 1856 Thomas Murray (c. 1811–1892), a watchmaker and jeweler in Fredericksburg, Virginia, was indebted to Filley in the amount of $14.93, presumably for electroplated wares.[11] Electroplating made Filley wealthy: in the U.S. census of 1850, his real estate was valued at $35,000 and, in the 1860 census, at $9,000 with his personal property valued at $65,000 and his wife Chloe's personal property valued separately at $10,000.[12] By 1870 his real and personal property were each valued at $100,000.[13]

In the 1860 city directory Filley's sons James and Otis were listed as clerks with the company and joined their father as partners in 1864, with the name changing to Harvey Filley & Sons.[14] The 1870 city directory was the first to include Britannia ware among the company's products, and the firm was listed under this category in the city business directory in 1876,[15] although it continued electroplating silver. The company's printed letterhead on a document dated 1874 listed its products as "Britannia, Nickel Silver, and Fine Silver Plated Ware, also, Solid Silver," with no mention of tin plating.[16] Some of the "solid silver" offered was, apparently, manufactured by other makers in Philadelphia: H. Filley & Sons marked two coin-standard salt spoons that were also marked with the chevron-and-horse-head device of James Watts (q.v.), who presumably supplied them.[17]

Harvey Filley Sr. died on August 21, 1877, and was buried in the family vault at the Church of the Epiphany at Fifteenth and Chestnut streets.[18] James and Otis Filley continued to live with their widowed mother at 1507 Arch Street and operated the company as Harvey Filley & Sons at 1222 Market Street until 1884, when they moved the firm to 1223 Leiper Street in the city's Frankford neighborhood.[19] By 1887 they were listed as "jewelers" in the city directory and had opened a store at 15 South Thirteenth Street, with the factory still on Leiper.[20] The following year James's son William H. Filley (1865–1916) became a partner in the company.[21]

In the early 1880s Philadelphia was home to the first aluminum manufacturer in the United States, founded by William H. Frishmuth, and the Filleys became interested in the potential of plating with aluminum.[22] On March 25, 1890, Harvey Filley & Sons was incorporated, with $100,000 in capital, under the name Harvey Filley Aluminum Plating Company, "manufacturing and dealing in brittania silver and plated wares and of electro-plating the same with aluminum and metals under patented process."[23] In May of the same year, it was reported that the Filleys had been successful in developing an aluminum plating process: "The company . . . is endeavoring to introduce this new plating as a substitute for silver, and with some show of success. . . . Burnishing is indispensable to bring out the luster of the metal, as is the case also with silver. This is a costly operation, and this makes it impossible to compete with nickel-plating for a host of cheap articles."[24] Another contemporary source noted that the Filleys electroplated aluminum onto sheet iron, "thus making a substitute for tin-plate of greater durability and which will not rust."[25] This indicates that the firm had never abandoned its original specialty of tin-plating sheet iron, as does the unnamed "tinplate" company listed in the 1895 city directory with James and William Filley as its officers.[26] The final directory listing for the Harvey Filley Aluminum Plating Company was in this same year. A "Harvey Filley Plating Company," with James A. Filley as its manager, appeared sporadically in subsequent directories until 1907.[27] This company advertised "Gas Fixtures, Brass Beds, metal tables polished, refinished in all colors," and its final advertisements also appeared in 1907, suggesting that this was the last year the firm was in business.[28] DLB

1. Biographical information on the Filley family is taken from Shirley Spaulding DeVoe, *The Tinsmiths of Connecticut* (Middletown, CT: Wesleyan University Press for the Connecticut Historical Society, 1968), and Gina Martin and Lois Tucker, *American Painted Tinware: A Guide to Its Identification* (Cooperstown, NY: Historical Society of Early American Decoration, n.d.), vol. 3, pp. 1–2, 33–35, 69–72.

2. Philadelphia directory 1819, n.p.; 1825, p. 51. The last "move" may represent a renumbering of the buildings on the street.

3. Martin and Tucker, *American Painted Tinware*, p. 71.

4. McElroy's Philadelphia directory 1845, p. 113; 1848, p. 111.

5. Life dates for Filley and his family are recorded on their gravestone at West Laurel Hill Cemetery, Philadelphia; memorial no. 91486095, www.findagrave.com (accessed June 15, 2015). Chloe Filley's maiden name was recorded inconsistently as "Cadwell" and "Caldwell." William Filley's death date is recorded in his Philadelphia burial record; Philadelphia Death Certificates Index, 1803–1915, Ancestry.com. The dates of the deaths of James Alden Filley and his son William H. Filley are recorded in Record of Interments, 1866–1989, section A, lot 72, Lot Books, Mount Peace Cemetery, Philadelphia.

6. McElroy's Philadelphia directory 1850, p. 130.

7. *Biographical Annals of Lancaster County, Pennsylvania* (Chicago: J H Beers, 1903), pp. 923–24. Cadwell's gravestone records his age

as fifty-three at the time of his death; memorial no. 34345698, www.findagrave.com (accessed June 12, 2015). Cadwell may have been the brother of Filley's second wife; the U.S. census consistently recorded Chloe Filley's birthplace as Connecticut.

8. McElroy's Philadelphia directory 1854, p. 164.

9. Edwin T. Freedley, *Philadelphia and its Manufactures: A Hand-Book Exhibiting the Development, Variety, and Statistics of the Manufacturing Industry of Philadelphia in 1857* (Philadelphia: Edward Young, 1859), pp. 349–51.

10. McElroy's Philadelphia directory 1858, p. 209; *Ladies Philadelphia Shopping Guide and Housekeeper's Companion for 1859* (Philadelphia: S. E. Cohen, 1859), p. 64.

11. Hollan 2010, p. 558.

12. In the 1860 census Chloe's name was recorded incorrectly as "Clara."

13. 1870 U.S. Census.

14. McElroy's Philadelphia directory 1865, p. 229.

15. Isaac Costa, comp., *Gopsill's Philadelphia Business Directory for 1876* (Philadelphia: James Gopsill, 1876), p. 124.

16. Connecticut Historical Society, Hartford, illus. in DeVoe, *Tinsmiths of Connecticut*, p. 18.

17. DAPC (76.2415).

18. Philadelphia Death Certificate Index, 1803–1915; burial no. 621, Records of Confirmations, Marriages, Baptisms, and Burials, Church of the Epiphany, Philadelphia; Episcopal Church of the Redemption, Philadelphia. The Church of the Epiphany was demolished in 1902 and replaced by Wanamaker's department store; the remains in the Filley family vault were reinterred in West Laurel Hill Cemetery.

19. Gopsill's Philadelphia directory 1885, p. 586.

20. Ibid. 1887, p. 559.

21. Ibid. 1888, p. 581.

22. Sarah Nichols, *Aluminum by Design* (New York: Abrams, 2000), pp. 59–61.

23. *Laws of the General Assembly of the Commonwealth of Pennsylvania, Passed at the Session of 1891* (Harrisburg: Edwin K. Meyers, 1891), p. 247.

24. "Electro-Plating with Aluminum," *Manufacturer and Builder*, vol. 22 (May 1890), p. 102.

25. Joseph W. Richards, *Aluminum: Its History, Occurrence, Properties, Metallurgy and Applications, Including its Alloys*, 3rd ed. (Philadelphia: Henry Carey Baird, 1896), p. 310.

26. Gopsill's Philadelphia directory 1895, p. 591.

27. Ibid. 1899, p. 718; 1907, p. 597.

28. See *Philadelphia Inquirer*, May 5, 1907.

Cat. 241

Harvey Filley & Sons
Mustard Spoon

1864–90
Silver electroplated on white metal
MARK: H FILLEY & SONS 3 (incuse, on back of handle; cats. 241-1, -2)
Length 5⁷⁄₁₆ inches (13.8 cm)
Gift of Charlene D. Sussel, 2009-155-11

PROVENANCE: From the stock of the Philadelphia antiques dealer Eugene Sussel (1913–1989), the donor's husband.

This spoon is in the popular *Oval Thread* pattern, which Harvey Filley had used for a pair of silver salt spoons made between 1854 and 1864.[1] The incuse "3" may refer to three layers of electroplate that would make the plating less susceptible to wear; the identical numeral appears on electroplated spoons made by Filley & Mead between 1852 and 1854 as well as on pieces made by Harvey Filley working independently.[2] DLB

Cats. 241-1, 241-2

1. Noel D. Turner, *American Silver Flatware, 1837–1910* (South Brunswick, NJ: A. S. Barnes, 1972), p. 85. The salt spoons were offered for sale by John R. Snedden Ltd., Centre Hill, PA, www.johnrsneddenltd.com/silver/filley_salts2.html (accessed August 15, 2013).
2. A teaspoon made by Filley & Mead is in the collection of the Missouri Historical Society, St. Louis (72.82.39); a dessert spoon made by Harvey Filley is in a private collection (DAPC 75.4925).

Finberg Manufacturing Company

| Attleboro, Massachusetts, 1906–c. 1990

Leizer Fienberg, the company's founder, was born August 5, 1870, in the town of Mikhalishki, then in the Russian empire and now in Lithuania.[1] He was the son of Shabshel Fienberg, the town's rabbi, and Ettel Brudny.[2] Leizer immigrated to the United States in the late 1880s and became a naturalized U.S. citizen (as "Joseph Finberg") in Bristol County, Massachusetts, in 1891.[3] On June 28, 1896, Finberg married his first wife, Sarah Jane "Sadie" Brooks (1873–1925), a native of Charlottetown, Prince Edward Island, Canada. Despite his Jewish faith, they were married in the Second Congregational Church in Attleboro, Massachusetts.[4]

Finberg first appeared in the 1890–91 Attleboro city directory as "Joseph Fienberg, jeweler," although it is not known where or even whether he had been trained in that profession.[5] His subsequent career suggests that he was more of an entrepreneur than a working craftsman. He gave up being a jeweler after 1893 and had opened Attleboro Press, a printing company, by 1896.[6] The venture lasted only two years, and by 1898 he had established Joseph Finberg & Company, producing perfumes and cosmetics at 140 Park Street in Attleboro. His profession was given as "Mfg. of Perfume Extract" in the U.S. census of 1900.[7]

Finberg apparently returned to jewelry manufacturing in 1900, when he purchased the Curtin Jewelry Company of Attleboro.[8] By 1904 he had formed a partnership with William H. Heald (born 1857) as Finberg & Heald, jewelry manufacturer, at 140 Park Street.[9] Heald was the manager of the Union Braiding Works, a tack manufacturer in Sandwich, Massachusetts, and apparently had a majority financial interest in the Attleboro partnership; according to Dorothy Rainwater, Union Braiding Works had purchased Finberg's company.[10] The name was changed to Finberg Manufacturing Company in 1906, and the following year a "large addition" was made to the plant on Park Street.[11]

Like other companies in Attleboro such as R. Blackinton & Company and Whiting and Davis

(q.q.v.), Finberg specialized in mass-produced gold, silver, gold-filled, and silver-plated jewelry. The firm was assigned a design patent for a bracelet in 1910 and for a ring in 1916.[12] Intended for middle-class consumers, some of these products were retailed by mail order.[13] Finberg's production capacity must have been considerable; large-scale, oil-powered engines were used in the factory.[14] The company had significant capital assets of $100,000 when it was incorporated in 1923; by 1929 these had increased to $140,000 and there were fifty employees.[15] Finberg maintained a representative in New York City between 1922 and 1932.[16]

By the late 1920s Joseph Finberg had become a wealthy businessman and philanthropist, sitting on the boards of the local hospital and two local banks. He married his second wife, Jessie Kalter (1890–1942), in 1928.[17] The company continued manufacturing at the Park Street address through the Depression. In 1938 William E. Lingard, who previously had been the company's office manager, was named secretary, with Finberg as president and treasurer.[18] Finberg died at his summer home in Touisset, Rhode Island, on August 15, 1945, and was buried at Lincoln Park Cemetery in Warwick, Rhode Island.[19] His estate was estimated at $100,000, and among the bequests in his will were gifts to nineteen employees of Finberg Manufacturing Company, eleven of whom had worked for the company for more than fifteen years.[20]

After Finberg's death, Lingard became president and treasurer and James E. Essex, previously the shop foreman, became secretary; in 1956 Essex became vice president and Minnie Lingard became corporate clerk.[21] Under their management the Finberg Manufacturing Company continued to operate at the Park Street address until at least 1963, when George T. West joined the board as treasurer and James Brink was named corporate clerk.[22] According to Rainwater, West had assumed ownership of the company in 1961. It was still in business in 1988 and apparently continued operations until about 1990.[23] DLB

1. This birth date is recorded on Finberg's gravestone; "Anne Brooks' Ancestry," www.annebrooks.ca (accessed June 12, 2015); and in his naturalization record, Index to New England Naturalization Petitions, 1791–1906, NARA, Washington, DC; and in Index to New England Naturalization Petitions, 1791–1906, M1299, Ancestry.com. His membership card in the Ezekiel Bates Lodge gives August 3, 1870; Massachusetts Grand Lodge of Masons Membership Cards, 1733–1990, New England Historic Genealogical Society, Boston, Ancestry.com. His obituary on August 15, 1945, noted that he had just celebrated his seventy-fifth birthday (quoted in "Anne Brooks' Ancestry"), making his birth year 1870. This combination of sources suggests that the birth year of 1871 provided in the 1900 U.S. census and the "Anne Brooks' Ancestry" website is incorrect.

2. Ester De Paz, "Biography of Leizer Joseph Finberg," 2006, transcribed on "Anne Brooks' Ancestry."

3. Index to New England Naturalization Petitions, 1791–1906 (see

note 1). A 1913 ship passenger list records the date of his naturalization as 1893; Passenger and Crew Lists of Vessels Arriving at New York, New York, 1897–1957, T715, Records of the Immigration and Naturalization Service, NARA, Washington, DC, Ancestry.com.

4. Massachusetts Vital Records, 1840–1911, New England Historic Genealogical Society, Boston, Ancestry.com. For Sarah Brooks's death date see the Attleboro directory 1927, p. 211.

5. Attleboro directory 1890–91, p. 65.

6. Finberg's marriage record of June 28, 1896, gives "Printer" as his profession; see also ibid. 1897, pp. 68–69.

7. Ibid. 1899, p. 71.

8. The Annual Statistics of Manufactures, 1900, Public Document no. 36 (Boston: Wright & Potter, 1901), p. 28.

9. Attleboro directory 1905, pp. 101, 114, 174, 201. See also Biographical Sketches of Representative Citizens of the Commonwealth of Massachusetts (Boston: Graves & Steinbarger, 1901), pp. 379–80.

10. Rainwater and Redfield 1988, p. 89.

11. Attleboro directory 1907, p. 103; "Mill News: Enlargements and Improvements," Textile World Record, vol. 33, no. 2 (May 1907), p. 161.

12. Annual Report of the Commissioner of Patents for the Year 1910 (Washington, DC: Government Printing Office, 1911), p. 593; Official Gazette of the United States Patent Office, vol. 223 (Washington, DC: Government Printing Office, 1916), p. 481.

13. "The Finberg Manufacturing Company: A Legacy of Fine Enameled Cases," via "Collecting Vintage Compacts," blog, http://collectingvintagecompacts.blogspot.com/2011/05 /finberg-manufacturing-company-legacy-of.html (accessed June 13, 2014).

14. Oil and Gas Journal, vol. 15, no. 35 (February 1, 1917), p. 31.

15. Attleboro directory 1939–40, p. 161; Orra L. Stone, History of Massachusetts Industries: Their Inception, Growth and Success (Chicago: S. J. Clarke, 1930), vol. 1, p. 262.

16. Polk's Trow's New York City directory 1922–23, p. 698; Phillips' Business Directory of New York City (New York: The Phillips' Business Directory of N.Y., 1932), p. 482. Finberg Manufacturing Company was not listed in the 1921 or 1933 directories.

17. Attleboro directory 1929–30, p. 215. The date of Jessie Finberg's death was recorded in Polk's Attleboro directory 1942, p. 99.

18. Attleboro directory 1937–38, p. 208; 1939–40, p. 161.

19. Polk's Attleboro directory 1946, p. 104; "Funeral for Joseph Finberg," Attleboro (MA) Sun, August 20, 1945; see also his obituary, quoted in "Anne Brooks' Ancestry (see note 1 above).

20. "Public Bequests in Attleboro Will," Lewiston (ME) Daily Sun, August 24, 1945.

21. Polk's Attleboro directory 1942, p. 97; 1946, p. 104.

22. Ibid. 1963, p. 174.

23. Rainwater and Redfield 1988, p. 89; see also "The Finberg Manufacturing Company: A Legacy of Fine Enameled Cases" (see note 13 above). The company is no longer in business in Attleboro. An obituary for William Sanderson (1920–2003) stated that "he worked for forty-five years for the former Finberg Manufacturing Company of Attleboro," a period that would have lasted from about 1945 until his retirement in 1990; Rhode Island Obituary and Death Notice Collection, www.genealogybuff.com (accessed June 12, 2105).

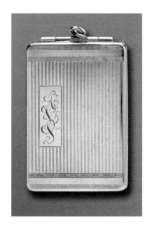

Cat. 242

Finberg Manufacturing Company Locket

1915–20

MARKS: FMCO STERLING (incuse, twice, on underside of each removable frame mat; cat. 242-1)
INSCRIPTION: A / L / S (engraved vertical script monogram, on outside of cover)
Height 1 ⅞ inches (4.8 cm), width 1 ¼ inches (3.2 cm)
Weight 13 dwt.
Gift of Mrs. Edwin H. Weil, 1958-65-16

PROVENANCE: The donor was this locket's original owner, Amalia Lorraine (Schloss) Weil (1897–1985), daughter of Solomon and Rea (Bergenstein) Schloss of Ligonier, Indiana.[1] In 1921 she married Edwin Hugo Weil (born 1890) of Philadelphia and subsequently lived in Cheltenham Township and Philadelphia.[2] Amalia Schloss probably acquired this locket, and other jewelry engraved with the initials of her maiden name, shortly before her marriage.[3]

Cat. 242-1

Made from die-stamped components with minimal hand work, this locket is characteristic of the relatively inexpensive jewelry produced by manufacturers in Attleboro and North Attleboro, Massachusetts.
DLB

1. Judith Saul Stix, "The Schloss Family in Indiana" (typescript), p. 6, Leo Beck Institute, New York City. This source incorrectly records her birth year as 1987. Social Security records give her birth date as November 26, 1897; Social Security Death Index, 1935–Current, Social Security Administration, Washington, DC, Ancestry.com (accessed July 1, 2015).
2. Marriage Records, Marion County Clerk's Office, Indianapolis, Ancestry.com (accessed July 1, 2015); Marion County, IN, Index to Marriage Records, 1920–1925, original record located: County Clerk's Office Indiana, bk. 117, p. 119, Ancestry.com.
3. In the Museum's collection see the purse by R. Blackinton & Co. (cat. 82); bracelet by J. M. Fisher (cat. 243); change purse by the Webster Company (1958-65-14); and vanity case and bag (1958-65-15 and 1958-65-8, respectively) by an unknown maker or makers.

J. M. Fisher & Co.

| Attleboro, Massachusetts, 1879–1987

In 1879 Charles R. Harris provided the capital and John Melatiah Fisher (1850–1920) the expertise in the formation of a jewelry manufacturing company, "Harris & Fisher," in Attleboro, Bristol County, Massachusetts.[1] They started out in a small brick building known as the Bailey Carriage Shop on Railroad Street in Attleboro. In 1880 they moved to a larger brick building on Union Street. Harris retired in 1885; other investors joined with Fisher, and the firm became J. M. Fisher & Co. in 1886.

John Melatiah Fisher (1850–1920; fig. 85) was the son of Samuel E. and Cordelia D. Fisher of Fisherville, Massachusetts.[2] At the age of twelve John was employed making sabers with his brother for a local firm. Still young, he apprenticed with, and then worked as a journeyman for the East Attleboro, Massachusetts, jewelry firm of Hayward and Briggs.[3] He married Hannah Slade Horton from nearby Rehoboth on June 10, 1877, and established a dry goods business, a five-and-ten-cents store, which he continued after they moved to Attleboro and established the jewelry business with Charles Harris.[4]

By 1894 the jewelry company had a national reputation, employed some fifty workers, specializing in charms for necklaces and bracelets, cufflinks, stickpins, and other novelties. Their annual output of charms in 1894 was reported to be forty thousand to fifty thousand dozens.[5] In 1897 the *Jewelers' Circular* reported that "Fred W. Lincoln severed his connection with C. J. Wetherill & Co. last week. He has taken a position of considerable responsibility with J. M. Fisher & Co. Ernest J. Quarastrom has also joined the force of J. M. Fisher and rumor has it that Mr. Fisher intends to take two new partners into the firm."[6] In 1909 the company was organized as a corporation under the laws of Rhode Island, but their manufacturing was carried out in Attleboro, Bristol County, Massachusetts. In 1914 they applied to register their trademark "JMF Co," which was granted in 1917. It was renewed until 1954, and expired July 20, 1998.[7] In 1987 Lestage Manufacturing Co., another jewelry manufacturer in Attleboro, established in

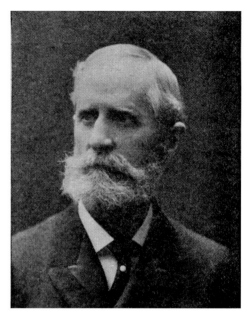

Fig. 85. John M. Fisher, from his obituary, *Jewelers' Circular*, vol. 80 (July 28, 1920), p. 91

1863, purchased the Fisher Company and the name became Fisher-Lestage.

John M. Fisher held leading positions in the civic life of Attleboro as a member of the Chamber of Commerce, and as a director of the Attleboro Trust Company. He was a major donor to and leader of the Methodist Church and the La Salette Seminary. He was a director of the Manufacturing Jewelers' Board of Trade in 1891–92, and in 1900, as the culmination of his life-long interest in temperance as a member of the Womens' Christian Temperance Union, he was nominated for governor of Massachusetts on the Prohibition Party ticket.[8]
BBG

1. Orra L. Stone, *History of Massachusetts Industries: Their Inception, Growth, and Success* (Boston: S. J. Clarke, 1930), pp. 245–62.
2. Compact Manufacturers, https://tri-stateantiques.com; obituary of John M. Fisher, *Jewelers' Circular*, vol. 80 (July 28, 1920), p. 91. Much of the genealogical information included here was drawn from these sources.
3. Charles E. Hayward (East Attleboro, Massachusetts, born 1824) apprenticed and served as journeyman for Tift and Whiting until starting his own firm, Thompson, Hayward & Co. in 1851. From 1855 to 1883 Hayward partnered with Jonathan A. Briggs (1797–1883), and the name became Hayward & Briggs. Duane Hamilton Hurd, comp., *History of Bristol County, Massachusetts: With Biographical Sketches of Many of Its Pioneers and Prominent Men* (Philadelphia: J. W. Lewis, 1883), pt. 2, p. 598; *Wilson's New York City Copartnership Directory*, vol. 28 (March 1979); *Jeweler's Circular*, vol. 34 (March 24, 1897), p. 23.
4. Stone, *History of Massachusetts Industries*, pp. 245–62.
5. Ibid.
6. *Jewelers' Circular*, vol. 34 (March 17, 1897), p. 22.
7. Application of J. M. Fisher Company by Lewis S. Chilson, treasurer, registered October 16, 1917, U.S. Patent and Trademark Office.
8. Obituary of John M. Fisher (see note 2 above).

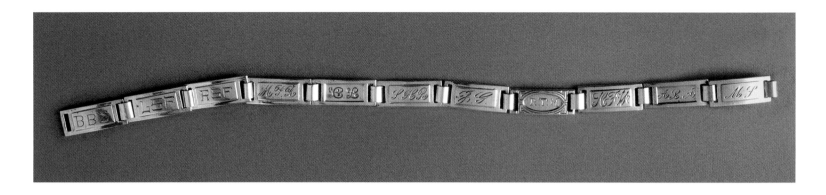

Cat. 243

J. M. Fisher & Co. (1879–1987)

Eisenstadt Jewelry Company (1853–1971)

Friendship Bracelet

1914–30
MARKS: STERLING / JMFCO (in horizontal diamond) / PAT. APLD FOR (all raised letters, on reverse of eight links); BOBOLINK / STERLING / PAT. APLD. FOR (all raised letters, on reverse of one link; cat. 243-1); STERLING E (inside mason's square) / PAT.APLD.FOR (all raised letters, on reverse of one link); catch with hook is unmarked

INSCRIPTIONS: BBΣ LSF RSF (block capitals); MPR CL SHR JG HFW ALA MS (script capitals); R.T.M (block capitals enclosed in frame; all engraved, one set of initials on each link; cat. 243-2)
Length 7¼ inches (18.4 cm), width each link ¼ inch (.7 cm)
Weight 6 dwt. 15 gr.
Gift of Mrs. Edwin H. Weil, 1958-65-17

PROVENANCE: See cat. 242.

Known as the BOB-O-LINK bracelet, each link of this friendship bracelet was engraved from handwritten initials. The center link is engraved with the initials "R T M" enclosed in an oval frame, suggesting that they were the initials of the original owner.

The inventive design of a flexible "friendship" bracelet was achieved by linking the segments with a ribbon threaded through the slots at the end of each small panel; thus the panels were interchangeable.[1]

The Eisenstadt Manufacturing Company registered their trademark in 1915.

Two of the links in this bracelet are marked by the Eisenstadt Jewelry Company. Michael Gabriel Eisenstadt (died 1863) founded the Eisenstadt Jewelry Company at Twelfth and Olive streets in St. Louis, Missouri, in 1853, and family members were involved with the company into the twentieth century.[2] It was one of seven such firms in St. Louis, and at first occupied palatial grand quarters in the Star Building. In 1856 the company moved to 71 North Fourth Street, and in 1860 to 703–705 South Fourth, each time to secure more space. The business was incorporated in 1883, and the name became the M. Eisenstadt Jewelry Company. In 1893 a number of employees established the factory. The firm was reorganized and in 1919 became the Eisenstadt Manufacturing Company. "BOB O LINK," a line of bracelets and parts thereof, belt buckles, and finger rings was registered as a trademark of the company in 1915.[3]

The links of this bracelet by the J. M. Fisher Company, although exhibiting a similar idea and purpose, differ from the Eisenstadt links in that they are secured to each other with hooks directly one to the other, and thus are less interchangeable. In 1917 the Eisenstadt Company brought suit against the Fisher Company for infringement of their patent and unfair competition: "Complainant extensively advertised friendship links, which could be interchanged by friends, and being strung upon narrow ribbon

become a bracelet to be worn on the wrist. The links were not patented, but were designated as 'bob-o-links' and being advertised as such in connection with the friendship idea were selling for many times their intrinsic value. Defendant began the manufacture of similar links."[4] Eisenstadt's suit was denied as it was interpreted that their patent was a "utility patent," which did not apply to an idea but to the method of joining the links. Clearly, in this example, the J. M. Fisher Company adapted some of the Eisenstadt Company's links to their design. The bracelet became a staple of the J. M. Fisher jewelry firm. BBG

1. Edwardian Sterling Friendship Bracelet, illus., House of Francheska, www.house-of-francheska.co.uk/vintage francheskadesigns135.htm (accessed January 9, 2018).
2. The information in this paragraph is gleaned from J. W. Leonard, *The Industries of Saint Louis: Her Relations as a Center of Trade, Manufacturing Establishments and Business Houses* (St. Louis: J. M. Elstner, 1887), p. 234; "St. Louis as a Jewelry Mart," *Jewelers' Circular*, vol. 78 (February 1919), p. 409.
3. Trademark Electronic System (TESS), s.v. "Bob O Link" (accessed 2017).
4. U.S. Patent and Trademark Office, U.S. serial no. 71086315, http://tsdr.uspto.gov (accessed June 12, 2015). The interpretation of this case from the Circuit Court of Appeals, First Circuit, No. 1260, February 27, 1917, was generously supplied by Frances Lippincott, JD.

Cat. 243-1

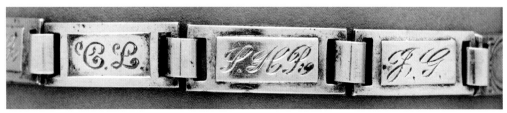

Cat. 243-2

Thomas Fletcher

| Alstead, New Hampshire, born 1787
| Delanco, New Jersey, died 1866

Fletcher & Gardiner

| Boston, 1808–1811
| Philadelphia, 1811–1827

Fletcher & Bennett

| Philadelphia, 1835–1837

The partnership of the merchant and entrepreneur Thomas Fletcher (1787–1886; fig. 86) and the silversmith Sidney Gardiner (1787–1827) produced many of the most important examples of American silver in the Classical Revival style. Fletcher's surviving correspondence offers exceptional documentation for their career and provided the foundation for a major exhibition and catalogue by Donald Fennimore and Ann Wagner in 2007.[1] The Museum's collection of Fletcher & Gardiner's work ranges from their earliest years in Philadelphia (cat. 244) to the last decade of Fletcher's activity (cats. 253, 256). It encompasses the full range of their production, from flatware (cat. 255) and jewelry (cat. 250) to tea and coffee services (cats. 248, 251) and presentation pieces (cats. 249, 252).

The son of a farmer, Thomas Fletcher was born in Alstead, New Hampshire, and around 1803 was apprenticed to Joseph Dyer, a stationery and fancy-goods merchant in Boston. Sidney Gardiner was born in Mattituck, Long Island, son of the physician Dr. John Gardiner, and was also apprenticed in Boston. Fennimore and Wagner have speculated that Gardiner was trained by the silversmith Samuel Stafford Greene (born 1782), who was a relative. In January 1808 Dyer sold his business to John McFarlane, a merchant, who established a store at the same location, only to liquidate the enterprise in October of the same year.

Demonstrating the business acumen that would characterize his career, Fletcher seized the opportunity to acquire his former master's stock and clientele. He negotiated for financial help from Dr. Gardiner, who observed in a letter to Fletcher, "You are a stranger to me, but my sons has [sic] given you an Excellent Character, & such a one as I could wish them to be connected with."[2] Forming a partnership with Sidney Gardiner, who oversaw silver manufacturing, Fletcher agreed to take Sidney's younger brother Baldwin (q.v.) as an apprentice in the "selling shop"; Fletcher's younger brother Charles Fosdick Fletcher also worked for the firm as a clerk.[3] The partners offered for sale a wide range of goods typical of retail jewelers, including silver-plated and Britannia tablewares, watches, clocks, spectacles, razors, swords, military insignia, thimbles, and combs in addition to jewelry and silver hollowware and flatware. They advertised that "their principal attention will be directed to the manufacturing of GOLD and SILVER WORK of every description, and particularly elastic HAIR WORK, for Bracelets, Necklaces, Ear Rings, and Watch Chains."[4] By 1810 Fletcher

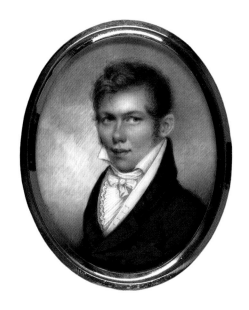

Fig. 86. Henry Williams (American, 1787–1830), *Thomas Fletcher*, 1810. Watercolor on ivory, 2 15/16 × 2 1/4 inches (7.5 × 5.7 cm). Yale University Art Gallery, Mabel Brady Garvan Collection, 1936.301

and Gardiner had prospered sufficiently that they moved to a larger shop at 59 Cornhill Street in the heart of Boston's fashionable retail neighborhood.

Their success in Boston was short-lived, partly the effect of accumulated debt and partly that of what Fletcher characterized in May 1811 as "the most cordial *hatred* & opposition from every member of the craft."[5] After briefly forming a partnership with John McFarlane, Fletcher and Gardiner decided to relocate their business to a more hospitable city. Although they considered New York, they moved in November 1811 to Philadelphia and advertised the opening of their shop at 24 South Second Street on December 19. They offered a similar range of goods as in Boston, as well as

"carrying on extensively the Manufactory of Silver Plate and Jewellery, of every kind."[6] Within a year the shop was so busy that they advertised "SILVERSMITHS WANTED IMMEDIATELY, two or three Journeymen Silversmiths, they must be good workmen and of steady habits."[7] In the 1813 city directory Fletcher was listed as a jeweler and "Gardner" as a goldsmith.

Before moving to Philadelphia Sidney Gardiner married Mary Holland Veron (1788–1875) in Boston in 1811. She was the daughter of the French émigré Étienne Veron and presumably was related to Elizabeth Veron, who ran a boarding house at 59 Cornhill Street, where Fletcher & Gardiner's shop was located. The Veron family provided additional bonds between the partners, as Baldwin Gardiner married Mary's younger sister Louise-Leroy Veron (1796–1849) in 1815, and three years later Thomas Fletcher married Mary and Louise's youngest sister, Melina de Grasse Veron (1797–1849).[8] Two of Étienne Veron's sons were apparently employed by Fletcher & Gardiner in Philadelphia: in 1812, Fletcher signed a Seaman's Protection Certificate on behalf of Lewis (1793–1853),[9] and in March 1818 Timothy Veron (1799–1869) signed a receipt to Edward Shippen Burd for payment for a pair of butter boats.[10]

In September 1812, a group of Philadelphia citizens commissioned Fletcher & Gardiner to make a monumental urn for presentation to Isaac Hull, a hero of the War of 1812, a commission that was the single most significant event in the partners' career. Completed by December 1813, the urn was the largest and most complex piece of silver produced up to that date in the United States and gave its makers a nationwide reputation. Fletcher wrote to his father in December 1813, "We have had Thousands to view it, and it is allowed to be the most elegant piece of workmanship in this Country."[11]

Over the next two decades the partners maintained this reputation for producing silver of the highest quality. Regarding a "set of plate," the jeweler R. & A. Campbell in Baltimore wrote: "We are much pleased with the Work but are sorry to say that it is too good. The price is rather higher than we are able to obtain at present."[12] When Fletcher exhibited the spectacular silver tea service made at his shop for Nicholas Biddle in 1838, the New York diarist Philip Hone commented that "Fletcher & Co., are the artists who made the [DeWitt] Clinton vases. Nobody in this 'world' of ours hereabouts can compete with them in their kind of work."[13]

Not surprisingly, their work was avidly sought after in Philadelphia and beyond. Commissions for equally monumental commemorative objects became a staple of the firm's production (see cat. 249). In 1822 Fletcher & Gardiner was

commissioned to make badges for the Order of Our Lady of Guadalupe, which had been recently established by Emperor Augustín de Iturbide of Mexico. The firm also produced large quantities of table silver for local customers. Writing to her cousin Titian Ramsay Peale in November 1819, Sarah Miriam Peale informed him that "Dr. [James] Rush is Married at last to Miss [Phoebe Ann] Ridgeway frequently called the Chesnut [sic] St Steam boat. Fletcher and Gardiner have been making 5000. Dols. worth of plate for her."[14]

Fletcher had the reputation of being an outstanding entrepreneur; his friend Jacob Gates wrote, "Your strict attention to business will cause you to rise superior to every obstacle."[15] He was constantly strategizing ways to increase profits and expand business, and these plans usually involved keeping the enterprise within the partners' extended families. In 1816 he recommended establishing the partnership between Baldwin Gardiner and Lewis Veron as retail jewelers; a similar enterprise was the 1819 partnership of Fletcher's brothers Charles and George (1796–1876), which likewise sold jewelry and fancy goods. Both Charles Fletcher and another brother, Henry (1789–1866), became salesmen for Fletcher & Gardiner, with Henry eventually establishing a successful store in Louisville, Kentucky. Thomas Fletcher took every opportunity to extend the enterprise's market beyond the Philadelphia area. William Pelham, a shopkeeper in Zanesville, Ohio, wrote to Sidney Gardiner in 1815: "In his letter to me Mr. F. mentions that you will probably have many articles which I might find it advantageous to deal in. I should think you will not have many such, as your assortments will be calculated for the refined taste of an opulent city, whereas my objects of trade must be necessarily limited to articles of necessity suitable to the first stages of civilized life."[16]

Sidney Gardiner was the craftsman who supervised workmen in the shop as well as the showroom. Charles Fletcher reported to his brother in July 1815: "Mr G. is using the greatest exertions to prepare for the goods he has hired of Richard Peters Esq[r] . . . & has moved the Partition back & run it Strait across—but has preserved the angles on our side & made deep shelves in them—the pillars are to be taken away & cases to be made where the looking glasses were[,] the mirrors taken out of the Frames & placed in the back of the circular case."[17] Although clearly an exceptional metalsmith, Gardiner apparently lacked some of his partner's entrepreneurial acumen. Gates wrote contemptuously to Fletcher, "G[ardiner] did not appear, taking certain transactions & circumstances into consideration, capable of conducting an extensive business."[18]

Nonetheless Gardiner did envision the profits to be made in the newly independent nation of Mexico, noting "From what I have seen & heard since being in this Empire—a Manufacty at the Capital would yeald proffits beyond calculation."[19] In 1823 he made the first of three trips to Mexico, seeking markets for a wide range of fancy goods in addition to silver.

Fletcher apparently was not routinely involved with production in the shop. In 1823 Gardiner wrote to him from Mexico: "How do you get along with the Manufactory. I am affraid you will get quite out of paicence [sic] with the charge of workmen."[20] Although he may not have been a craftsman, Fletcher was a talented designer, creating several of the firm's most important commissions. In a handbill published when the pair of monumental vases made by Fletcher & Gardiner was presented to Governor DeWitt Clinton of New York in 1825,[21] Fletcher took credit for their design. His work acquired a national reputation for its quality. Writing to the governor of Virginia in 1821 about a commission for a presentation sword, General Winfield Scott observed about the firm, "I have seen several [swords] of their make, ordered by public bodies, executed with superior taste & workmanship. They make the best cast steel blades, & have a great variety of antique models, from which to compose the ornaments of their work."[22] Fletcher's familiarity with antique models was enriched greatly by the year-long trip he made to Great Britain and France in 1815–16 (see cat. 249).

Another goal of Fletcher's trip to England was to resupply the shop with silver-plated and fancy goods that had been unavailable during the War of 1812. Many of these were in patterns previously unseen in the United States, and in December 1815 Gardiner informed Fletcher: "No other, Store in the united States looks so well as ours does at this time, the people flock arround [sic] our windows & in the Store as if they never had seen any thing of the kind."[23] The firm stocked fancy goods and jewelry throughout its years of operation. In July 1841 Ball, Tompkins & Black (q.v. Ball, Black & Company) wrote to Fletcher, "The diamond which you carried on with you and the price we had not definitely fixed upon we will sell for $205 cash N York funds."[24] He loaned Edward Shippen Burd fifteen "Greenough's Patent Lamps" and "1 pr Candelabras Br[onze]d & Gilt" in April 1842.[25]

Fletcher had an abiding interest in technological innovation and attempted to keep the firm abreast of the latest developments available for silver manufacturers. On his trip to England in 1815, he purchased "a pair of 10 inch rollers with frame" for producing sheet metal, as well as "two small mills" for making patterned borders, the dies commissioned from a Sheffield die sinker.[26] Fennimore and Wagner have identified borders made in Fletcher & Gardiner's shop that were purchased and used by other Philadelphia silversmiths, including Bailey & Kitchen, Conrad Bard, George K. Childs, Harvey Lewis, Edward Lownes, John McMullin, and William Seal (q.q.v.).[27] He also used dies for creating flatware, as evidenced from correspondence (see cat. 255) regarding an order in 1831 for a set of forks. At some point in the late 1810s or early 1820s, Fletcher & Gardiner acquired a steam engine to power the shop's machinery, such as drop presses for producing flatware and ornamental elements. Fletcher acknowledged its limitations in a letter to Baldwin Gardiner in 1831, "I have had about as much [business] as we could attend to with the power we have, your steam is on the high pressure principle, —ours on the low."[28] Fletcher's interest in technological advances and manufacturing naturally led him to be the founding vice president of the Franklin Institute in 1823, and the firm submitted examples of its silver to the Institute's annual exhibition four times between 1825 and 1838.

As with many silversmiths, Fletcher & Gardiner's business fluctuated with economic and political events, both personal and national. During the economic boom that followed the War of 1812, its business prospered, and the shop had sixteen apprentices in 1815. In the 1820 Census of Manufactures, the firm is listed as employing seven men, two women burnishers, and nine apprentices, and producing gold and silver worth $100,000.[29] As Fennimore and Wagner point out, the workforce of nine paid employees enabled the partners to reduce or augment the number of craftsmen in response to demand, rather than relying on the traditional but costly apprentice system. In 1820 an ill-fated investment in a wood-screw manufactory forced the partners to sell their entire retail stock at auction to pay off their creditors, but they soon recovered. In 1827, at a peak of activity, Sidney Gardiner died at age forty of yellow fever at Veracruz, Mexico. Thomas Fletcher continued the business under his own name, although he continued to stamp objects with a Fletcher & Gardiner mark until at least 1830 (see cat. 248), and the firm was listed as Fletcher & Gardiner in Philadelphia tax records until 1836.[30]

Fletcher faced another crisis in the mid-1830s, when a scarcity of silver and hard currency resulted from President Andrew Jackson's economic policies. In March 1834 both Fletcher and his nephew Calvin W. Bennett Jr. (1808–1851) signed a petition protesting the monetary policy;

Bennett was appointed to the committee that drafted the resolutions, and Fletcher to the committe charged with delivering the petitions to Congress and the Pennsylvania legislature.[31] That same year he described his workshop as "almost deserted," noting that two journeymen silversmiths, Conrad Bard and George Jacobs (active 1834–46), one jeweler, William H. Sharpe (c. 1807–1870), and three apprentices "comprise the principal if not all the inmates of that once busy hive."[32]

In the years after Gardiner's death, two of Fletcher's nephews, sons of his sister Hannah (Fletcher) Bennett (1776–1838), worked with him. Jacob Bennett (1804–1871) may have apprenticed with Fletcher, and a communion service presented by Sarah Redman to Christ Church, Philadelphia, was marked by both Fletcher and Bennett.[33] Although Jacob Bennett had established himself independently as a jeweler by 1828, he was still doing work for Fletcher ten years later, when he was entrusted with making the presentation tea service for Nicholas Biddle at a cost of $23,000.[34] Bennett's brother Calvin was working in Fletcher's retail store by 1829; he receipted payment for a silver tea service, tablespoons, and plates in April 1831.[35] When Fletcher and Calvin Bennett formed a two-year partnership beginning in 1835, Fletcher noted that he "has been with me several years and had the principal charge of the retail business."[36] In 1836 Fletcher was compelled to sell the building at 130 Chestnut Street, moving his home, shop, and factory to 194 Chestnut. The following year, he moved once again, to 188 Chestnut. His partnership with Bennett supposedly ended that same year, although both men continued to work at the same address. In February 1840 a newspaper advertisement, presumably placed by Fletcher, announced a silver pitcher on display "at the Store of Messers. FLETCHER & BENNET [sic]."[37]

In the last years of operation, Fletcher still attracted prominent clients and put on exhibitions of his work, such as the Nicholas Biddle service in 1838 and the "splendid silver pitcher" made for presentation to the dentist C. J. Houpt in 1840.[38] In January 1841 he supplied Baldwin Gardiner with a tea service and also retailed silver sent from New York by Gale, Wood & Hughes (q.v.).[39] At the same time he opened a Temperance Hotel in the building that housed his shop, which suggests that revenues from the silversmithing business were declining. He closed his firm in May 1842, and the tools and remaining shop stock were sold at auction to satisfy creditors. For a few years thereafter Fletcher may have continued a small retail business, as he was listed as a jeweler and silversmith in city directories as late as 1851.[40] By 1850, however, his hotel had also failed, and in that year Fletcher began working as prothonotary of the U.S. District Court in Philadelphia. He died in 1866 at his son's house in Delanco, New Jersey. DLB

1. Unless otherwise noted, information on Fletcher and Gardiner's lives and careers was taken from Fennimore and Wagner 2007.

2. John Gardiner to Thomas Fletcher, September 28, 1808, private collection. Fletcher's response of October 18 is quoted at length in Fennimore and Wagner 2007, p. 37.

3. Fennimore and Wagner 2007, p. 37. Charles F. Fletcher died in Philadelphia and was buried in Ivy Hill Cemetery; Baptisms, Marriages, and Burials Register, 1865–1887, p. 118, Grace Episcopal Church, Philadelphia.

4. Boston Gazette, November 8, 1808.

5. Thomas Fletcher to unidentified recipient, May 7, 1811, Thomas Fletcher Letters, HSP, as cited in Fennimore and Wagner 2007, p. 38.

6. Aurora General Advertiser (Philadelphia), December 19, 1811.

7. Ibid., December 7, 1812.

8. Life dates for Veron family members come from the Terry family tree, Ancestry.com (accessed October 10, 2014).

9. Proofs of Citizenship Used to Apply for Seamen's Certificates for the Port of Philadelphia, 1792–1876, NARA, Washington, DC, Ancestry.com.

10. Entry for March 12, 1818, Receipt Book, 1813–23, Edward Shippen Burd Papers, HSP. Timothy Veron's life dates are recorded in Philadelphia Death Certificates Index, 1803–1915, Ancestry.com.

11. Thomas Fletcher to Timothy Fletcher, December 19, 1813, Fletcher Papers, box 1, Athenaeum of Philadelphia. For the significance of the Hull Urn to Fletcher & Gardiner's career, see Fennimore and Wagner 2007, pp. 40–42.

12. R. & A. Campbell to Thomas Fletcher, July 20, 1823, Fletcher Letters, 1806–1855, HSP.

13. Bayard Tucker, ed., The Diary of Philip Hone, 1828–1851 (New York: Dodd, Mead, 1889), vol. 2, pp. 288–89.

14. Sarah Miriam Peale to Titian Ramsay Peale, November 7, 1819, in The Selected Papers of Charles Willson Peale and His Family, ed. Lillian B. Miller (New Haven, CT: Yale University Press for the National Portrait Gallery, Smithsonian Institution, 1988), vol. 3, p. 778.

15. Jacob Gates to Thomas Fletcher, February 18, 1812, Thomas Fletcher Papers, box 13, Athenaeum of Philadelphia.

16. William Pelham to Sidney Gardiner, April 23, 1815, Thomas Fletcher Correspondence, 1812–1841, HSP.

17. Charles Fletcher to Thomas Fletcher, July 2, 1815, Fletcher Papers, box 1, Athenaeum of Philadelphia.

18. Jacob Gates to Thomas Fletcher, November 11, 1815, Fletcher Letters, HSP.

19. Sidney Gardiner to Thomas Fletcher, January 9, 1823, Fletcher Letters, HSP (original orthography).

20. Ibid.

21. Reproduced in Fennimore and Wagner 2007, Appendix 3, p. 272.

22. Winfield Scott to T. M. Randolph, July 9, 1821, quoted in Jay P. Altmayer, American Presentation Swords (Mobile, AL: Rankin, 1958), p. 18.

23. Sidney Gardiner to Thomas Fletcher, December 15, 1815, Fletcher Papers, box 1, Athenaeum of Philadelphia.

24. Ball, Tompkins & Black to Fletcher, July 1, 1841, Fletcher Letters, HSP.

25. Thomas Fletcher, invoice to Edward Shippen Burd, April 22, 1842, Edward Shippen Burd Papers, folder 14, HSP.

26. Fennimore and Wagner 2007, p. 46.

27. Ibid., p. 76.

28. Thomas Fletcher to Baldwin Gardiner, July 20, 1831, as cited in Fennimore and Wagner 2007, p. 49.

29. Deborah Dependahl Waters, "'The Workmanship of an American Artist': Philadelphia's Precious Metals Trades and Craftsmen, 1788–1832" (PhD diss., University of Delaware, 1981), pp. 129–30.

30. Fennimore and Wagner 2007, pp. 198–99, cat. 60; see also p. 267, figs. 6a,b.

31. H.R. doc. no. 206, 23rd Cong., 1st sess. (1834).

32. Thomas Fletcher to Levi Fletcher, May 6, 1834, as cited in Fennimore and Wagner 2007, p. 55. The jeweler William Sharpe died in Philadelphia at age sixty-three on October 12, 1870, and was buried at St. Peter's Church (Philadelphia Death Certificates Index, 1803–1915, Ancestry.com). For George Jacobs, see Hollan 2013, p. 104.

33. Fennimore and Wagner 2007, p. 267. Bennett's life dates appear on his gravestone in Woodlands Cemetery, Philadelphia (memorial no. 66755936, www.findagrave.com, accessed October 26, 2017); his obituary appeared in The Press (Philadelphia), September 13, 1871.

34. Desilver's Philadelphia directory 1828, p. 6; advertisement for Jacob Bennett & Son in Philadelphia, Its Founding and Development, 1683–1908, comp. William W. Matos (Philadelphia: Executive Committee, Founders Week Celebration, 1908), p. 488.

35. Hollan 2013, p. 17; invoice to William Meredith, Esq., April 16, 1831, photostat copy, Brix Files, Department of American Art, Yale University Art Gallery. According to the family grave marker in Evergreen Cemetery, Leominster, Massachusetts, Bennett died on August 5, 1851; memorial no. 62632898, www.findagrave.com (accessed June 12, 2015).

36. Thomas Fletcher to Richard Singleton, June 12, 1835, as cited in Fennimore and Wagner 2007, p. 55.

37. Public Ledger (Philadelphia), February 20, 1840.

38. Ibid.

39. Baldwin Gardiner to Thomas Fletcher, January 29, 1841; and Gale, Wood & Hughes to Thomas Fletcher, January 26, 1841; Fletcher Correspondence, HSP.

40. McElroy's Philadelphia directory 1851, p. 136.

Cat. 244

Fletcher & Gardiner

Plate

1811–20
MARKS: F.&G. (in rectangle) / PHILADᴬ (in rectangle; all on underside of rim; cat. 244–1)
INSCRIPTIONS: L (engraved gothic letter, in center of front); 16 / -- 1695 / 214 (scratched script, on underside)
Diam. 9⅞ inches (25.1 cm)
Weight 15 oz. 19 dwt. 17 gr.
Gift of Walter M. Jeffords, 1958-125-9

Cat. 244-1

The "F&G" mark on this plate was the earliest used by the partnership; it was struck on communion cups they made in Boston for churches in that city and Plymouth, Massachusetts.[1] They continued to use the same mark after their relocation to Philadelphia, together with the "PHILADᴬ" mark. Plates like this example were a stock production of the firm. A pair of nearly identical plates with the same marks was supplied from Philadelphia to William Wetmore (1749–1830) of Boston, presumably a client from before their relocation.[2] In 1830 Fletcher & Gardiner charged William Meredith $40 for "2 Silver plates 32 oz," each approximately the same weight as the present example.[3] BBG/DLB

1. Fennimore and Wagner 2007, p. 113, cat. 2; p. 266.
2. Ibid., cat. 6.
3. Invoice to William Meredith, Esq., April 16, 1831, photostat, Brix Files, Department of American Art, Yale University Art Gallery.

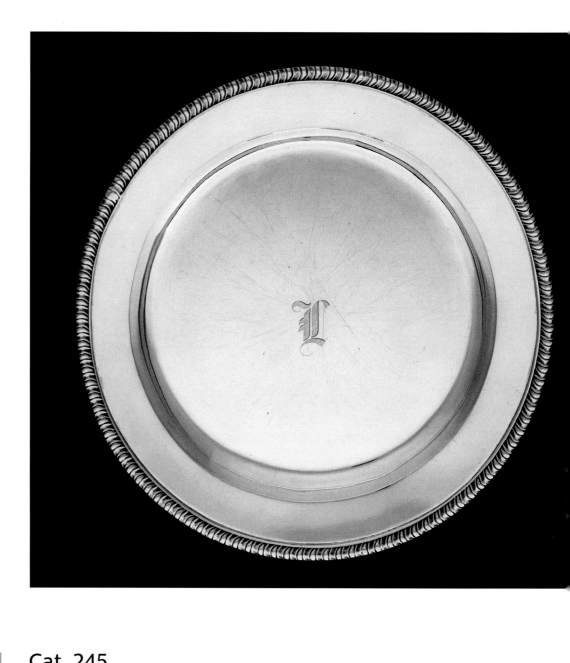

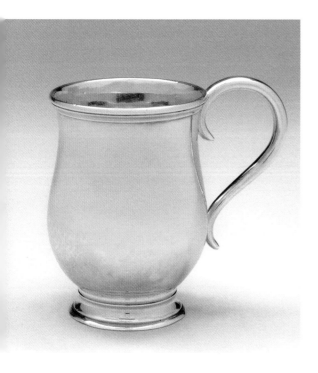

Cat. 245

Fletcher & Gardiner

Cann

1815–25
MARKS: FLETCHER & GARDINER. (in circle) / PHILᴬ (in rectangle; all on underside; cat. 246–1)
INSCRIPTION: oz / 6 - 5 (scratched script, on underside)
Height 3⁹⁄₁₆ inches (9.1 cm), width 2½ inches (6.4 cm), depth 3¹³⁄₁₆ inches (9.7 cm)
Weight 4 oz. 10 dwt. 8 gr.
Gift of John G. Carruth, 1922-86-24

PROVENANCE: Cornelius Hartman Kuhn (1859–1948), who inherited silver from various Philadelphia forebears (see cat. 22).

PUBLISHED: S. Y. S. [Sara Yorke Stevenson], *Exhibition of Old American and English Silver* (Philadelphia: Pennsylvania Museum, 1917), p. 45, cat. 230; Katharine Morrison McClinton, *Collecting American Nineteenth-Century Silver* (New York: Scribner, 1968), p. 23.

This diminutive, half-pint cann is a late example of a form that was going out of fashion in the early nineteenth century, although Fletcher continued to make canns into the 1830s.[1] The discrepancy between the scratch weight of 6 oz. 5 dwt. and the present weight suggests that the foot, which is inexpertly attached, is a replacement. BBG/DLB

1. Sotheby's, New York, *The Collection of Mr. and Mrs. Walter M. Jeffords: Early American Silver*, October 28, 2004, sale 8016, lot 620.

Cat. 246

Fletcher & Gardiner
Tea and Coffee Service

c. 1825

MARKS (on each): FLETCHER & GARDINER. (in circle); PHIL^A (in rectangle; all on underside; cat. 246-1)

INSCRIPTIONS: Wm D. Lewis (engraved, on lower edge of bases of sugar bowl and cream pot); 33 " 12 (scratched, on underside of sugar bowl); 15 " 2 (scratched, on underside of cream pot); 7391 (scratched, on underside of coffeepot); 1927 (scratched, on underside of larger teapot); 1927 4843 6779 (scratched, on underside of smaller teapot)

Coffeepot: Height 9 9/16 inches (24.3 cm), width 12 1/2 inches (31.8 cm), depth 7 1/4 inches (18.4 cm)
Gross weight 50 oz. 2 dwt.

Teapot (1974-40-2): Height 8 3/4 inches (22.2 cm), width 11 1/16 inches (28.1 cm), depth 6 3/16 inches (15.7 cm)
Gross weight 36 oz. 12 dwt. 15 gr.

Teapot (1974-40-3): Height 8 15/16 inches (22.7 cm), width 10 3/4 inches (27.3 cm), depth 6 3/16 inches (15.6 cm)
Gross weight 35 oz. 2 dwt. 4 gr.

Sugar Bowl: Height 9 inches (22.9 cm), width 7 1/4 inches (18.4 cm), diam. 6 1/8 inches (15.6 cm)
Weight 33 oz. 6 dwt. 20 gr.

Cream Pot: Height 6 1/16 inches (15.4 cm), width 4 7/16 inches (11.3 cm), depth 6 7/8 inches (17.5 cm)
Weight 14 oz. 18 dwt.

Slop Bowl: Height 5 13/16 inches (14.8 cm), diam. 7 inches (17.8 cm)
Weight 31 oz. 10 dwt. 12 gr.
Gift of Mrs. Crawford C. Madeira and her three nephews, Harry R. Neilson Jr., Rev. Albert P. Neilson, and Benjamin R. Neilson, 1972-40-1–6

PROVENANCE: This service originally was made for William David Lewis (1792–1881) and Sarah Claypoole (1801–1879), who were married in Philadelphia on June 25, 1825.[1] The service descended from their daughter, Sarah Claypoole Lewis (1829–1919), who married Thomas Neilson (1826–1910) in 1849, to her granddaughter and namesake, Sarah Claypoole (Neilson) Madeira (1897–1992), who, together with children of her brother, Henry Rosengarten Neilson Sr. (1893–1949), donated the service to the Museum.[2]

This service represented Fletcher & Gardiner's standard design for tea and coffee forms. The same casting patterns used for its handles and handle sockets were used about five years later on both the Norris and Craig-Biddle services (cats. 248 and 251, respectively). However, its grapevine decoration was rendered by die-rolled borders, rather than the die-stamped grapevines applied to the Craig-Biddle service, a simpler design element that presumably also made the Lewis service more affordable. BBG/DLB

1. James Grant Wilson and John Fiske, eds. *Appleton's Cyclopaedia of American Biography* (New York: D. Appleton, 1888), vol. 3, p. 707; *DAB*, s.v. "William David Lewis."
2. Genealogical information on the Neilson family comes from the Knutrud family tree, Ancestry.com (accessed October 22, 2014).

Cat. 246-1

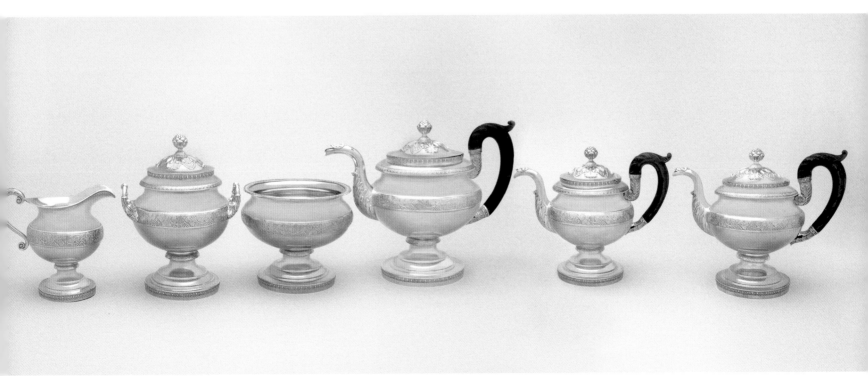

Cat. 247

Fletcher & Gardiner
Tray

1815–25
MARKS: FLETCHER & GARDINER. (in rectangle) / PHILAD^A
(in rectangle; all on underside; cat. 247-1)
Height 2 inches (5.1 cm), width 31¾ inches (80.7 cm),
depth 20¼ inches (51.4 cm)
Weight 174 oz. 12 dwt. 17 gr.
125th Anniversary Acquisition. Gift of Cordelia Biddle
Dietrich and Jesse Zanger, Mr. and Mrs. H. Richard Dietrich
III, and Christian Braun Dietrich in memory of Livingston L.
Biddle Jr. and in honor of Cordelia Frances Biddle,
2008-3-1

PROVENANCE: James H. Halpin (1903–1992), New York
City; Christie's, New York, *Important American Silver: The
Collection of James H. Halpin*, January 22, 1993, sale
7624, lot 72; purchased by H. Richard Dietrich, Jr., for use
with the tea and coffee service (cat. 251); by gift to his
children, the donors.

Silver trays of this size were rare in early American
silver, due to the significant amount of metal—over
174 troy ounces in this instance—as well as the skill
required for their manufacture, but they became
more common with increased mechanization and
the discovery of silver in the western United States.[1]
As with other large trays made by the partnership,
the applied, reeded border and handles were filled
with silver solder to provide additional strength.[2] DLB

1. See the tea tray by George B. Sharp (PMA 1977-86-1).
2. See Fennimore and Wagner 2007, p. 164, cat. 37; p. 204,
cat. 63.

Cat. 247-1

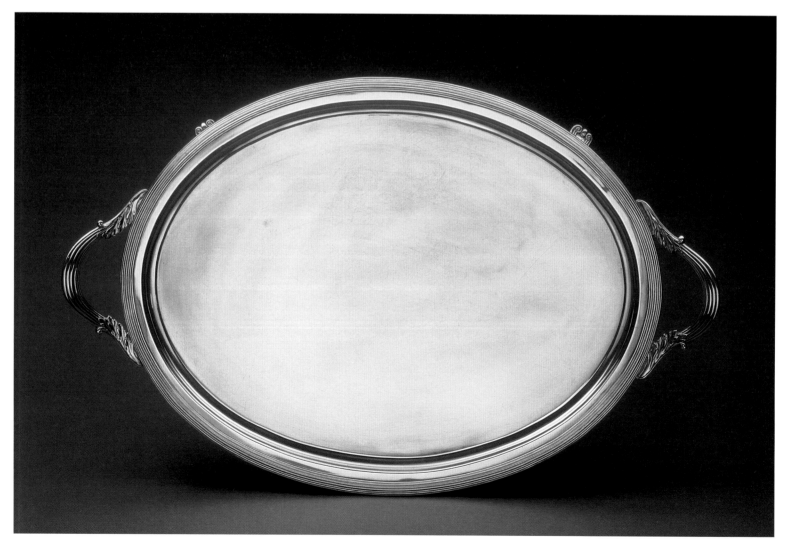

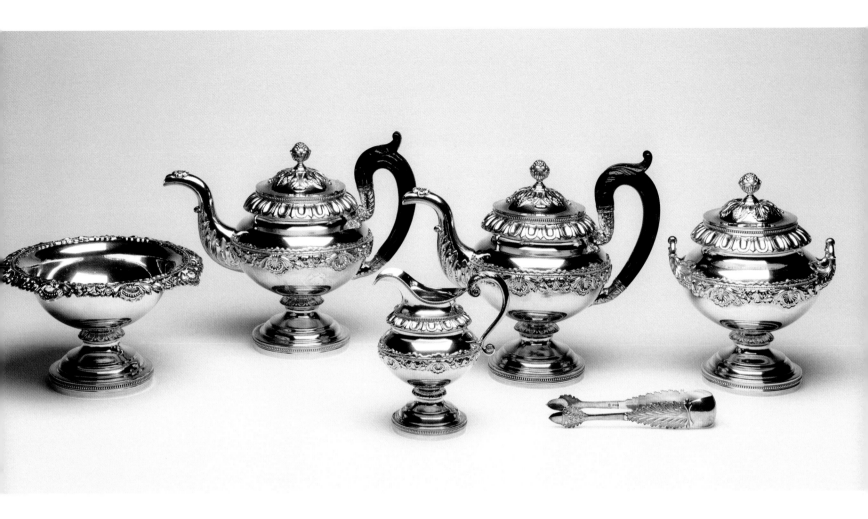

Cat. 248

Fletcher & Gardiner
Tea Service

c. 1825–30

MARKS (on each, except tongs): FLETCHER & GARDINER. (in circle) / PHIL^A (in rectangle; all on underside; cat. 246-1); (on tongs) [spread eagle] (in square with chamfered corners), F & G (in rectangle with chamfered corners), P (in square with chamfered corners, all inside one arm; cat. 248-1); [spread eagle] (in square with chamfered corners), F & G (in rectangle with chamfered corners, inside other arm)

INSCRIPTIONS: (on each teapot) 36 – ; (on sugar bowl, twice) 36 12"; (on slop bowl) 25, 5; (on cream pot) 13 10 (all scratched, on underside of bases)

Teapot (1933-65-1a): Height 11 inches (27.9 cm), width 11 3/8 inches (28.9 cm), depth 5 3/4 inches (14.6 cm) Gross weight 40 oz. 6 gr.

Teapot (1933-65-1b): Height 9 5/8 inches (24.5 cm), width 11 11/16 inches (29.7 cm), depth 6 11/16 inches (17 cm) Gross weight 40 oz. 10 gr.

Sugar Bowl: Height 9 inches (22.9 cm), width 7 3/8 inches (18.7 cm), depth 6 9/16 inches (16.7 cm) Weight 36 oz. 7 dwt. 5 gr.

Slop Bowl: Height 5 1/2 inches (14 cm), diam. 9 1/2 inches (24.1 cm) Weight 25 oz. 1 dwt.

Cream Pot: Height 6 5/16 inches (16 cm), width 5 5/8 inches (14.3 cm); diam. 4 3/16 inches (10.6 cm) Weight 13 oz. 6 dwt. 13 gr.

Sugar Tongs: Length 7 inches (17.8 cm), width 1 3/4 inches (4.3 cm) Weight 3 oz. 2 dwt.

Bequest of Clara Norris, 1933-65-1a–f

PROVENANCE: This service originally belonged to Dr. Isaac Norris (1802–1890) and Mary Pepper Norris (1806–1862) of Philadelphia, who were married on May 18, 1830. It descended to their granddaughter Clara Norris (1864–1933), the donor.

EXHIBITED: Garvan 1987 (not published).

PUBLISHED: Thorn 1949, p. 131; Fennimore and Wagner 2007, p. 169, cat. 41.

Cat. 248-1

In contrast to the tea service made about five years earlier for William and Sarah (Claypoole) Lewis (cat. 246), these vessels are more elaborate, with sculptural ornament characteristic of the later Classical Revival style, such as the repoussé-chased egg-and-dart moldings on the shoulders and the die-stamped shell and foliage bands around the midsections. The bold acanthus-leaf grips and oak-leaf and acorn terminals on the sugar tongs are particularly striking. Some of the same decorative elements were employed for the service made

for the Craig-Biddle family (cat. 251), including the chased foliage on the covers and the die-stamped egg-and-dart moldings at the juncture of the base and body. The Norris service teapots retain their original carved wood handles.

The precise date of manufacture is uncertain. Although most of the pieces in this service were struck with the Fletcher & Gardiner partnership mark, the history of ownership indicates it was purchased about three years after Gardiner's death. As noted above, it shares decorative elements with the Craig-Biddle service marked by Fletcher and probably dating to the early 1830s. However, an almost identical service belonged to Isaac Norris's sister Deborah Norris (1800–1844), who married William Brown in Philadelphia in 1823,[1] and some of the same castings also appear on Fletcher & Gardiner's service for William and Sarah Lewis of circa 1825 (cat. 246). BBG/DLB

1. Jordan 1911, vol. 1, p. 90. This service is owned by a descendant.

Cat. 249

Thomas Fletcher
The Maxwell Vase

1829

Retailed by Baldwin Gardiner (q.v.)

MARKS: B·GARDINER / NEW·YORK (in serrated arcs, on underside of vase and on top and underside of base; cat. 249-1)

INSCRIPTIONS: Presented to Hugh Maxwell Esqr. by the Merchants of the City of New York in testimony of / their high opinion of the ABILITY, FIRMNESS, INDUSTRY, PERSEVERANCE & PUBLIC-SPIRIT, / exhibited by him in the discharge of his duties as District Attorney. A.D. 1829. (engraved script, on one side of base); I give to the President of the Law Institute of the City of New York and to his successors in office my silver / vase given as a mark of regard for professional services as District Attorney by the Merchants of the City of / New York while acting as such under the appointment of Governors Tompkins and Clinton I also / give to the said Institute the portraits of Kent and Emmett, my honored friends (engraved script, on another side of base); EXTRACT FROM THE LAST / WILL AND TESTAMENT / OF / Hugh Maxwell. / WHO DIED / March 31st 1873 (engraved script, on corner of base)

Height 24¾ inches (62.9 cm), width 20½ inches (52.1 cm), depth 17¾ inches (45.1 cm)

Weight 352 oz. 14 dwt. 16 gr.

Height bowl 14⅜ inches (36.5 cm), diam. rim 16⅛ inches (41 cm), diam. foot 6⅞ inches (17.3 cm)

Height base 10½ inches (26.7 cm), width 17¾ inches (45.1 cm)

Purchased with funds from the bequest of Lynford Lardner Starr, 2010-5-1a,b

PROVENANCE: Hugh Maxwell (1787–1873); by bequest to to the New York Law Institute, 1873; Sotheby's, New York, *Important Americana*, January 22–23, 2010, sale 8608, lot 425.

EXHIBITED: On long-term loan to the New-York Historical Society, 1959–2009; Wendy A. Cooper, *Classical Taste in America, 1800–1840*, exh. cat (Baltimore: Baltimore Museum of Art, 1993), cat. 99; *The New-York Historical Society Bicentennial: Celebrating Two Centuries of Collecting*, Winter Antiques Show, New York, January 20–30, 2005; Fennimore and Wagner 2007, pp. 182–83, cat. 51.

PUBLISHED: *Antiques*, vol. 86, no. 3 (September 1964), p. 284; Katharine Morrison McClinton, *Collecting American Nineteenth-Century Silver* (New York: Scribner, 1968), p. 133; Graham Hood, *American Silver: A History of Style* (New York: Praeger, 1971), p. 200, fig. 222; Voorsanger and Howat 2000, p. 360; Margaret K. Hofer, "The New-York Historical Society Bicentennial: Celebrating Two Centuries of Collecting," *Catalogue of Antiques and Fine*

Cat. 249-1

Art, vol. 5, no. 5 (January 2005), p. 233, fig. 5; Hofer and Bach 2011, p. 152, fig. 3.16a; *Philadelphia Museum of Art Handbook* (Philadelphia: the Museum, 2014), p. 280.

Following the Panic of 1825 in Great Britain, unstable international financial markets caused several public companies in New York to fail. Hugh Maxwell, the district attorney, led a controversial prosecution of these companies' directors, whom he suspected of financial mismanagement and indicted on charges of fraud and conspiracy. Some of these directors were found innocent of all charges, and in July 1828 supporters of Henry Eckford (1775–1832), a director of the Life and Fire Insurance Company, celebrated his exoneration by presenting him with a silver vase ordered through the jeweler Baldwin Gardiner.[1] Apparently in response, Maxwell's supporters raised funds to commission this vase for the district attorney, also ordered from Gardiner.

Since its presentation to Maxwell in 1829, this monumental vase has been connected with Gardiner, who had arrived in New York only one year before receiving the commission. Thomas Fletcher's role as its maker was not identified until almost 140 years later, when Donald Fennimore discovered a letter from Gardiner to Fletcher and dated August 29, 1828:

I have been applied to, to make a <u>Splendid Vase</u> & a <u>pair of Pitchers</u>, intended to be presented by the Citizens of New York, to Mr Maxwell (the District Atty.) as a token of their respect, and approbation of his course of prosecuting the late conspiracy cases, so called. —The Price to be paid for <u>the Vase & Pitchers</u>, from $800 to $1000. —These are the particulars.

If you are disposed to make them, and in such a way as will answer my just expectations of profit, I shall be glad to have you undertake it then, —and I am ready to say I shall be satisfied <u>with a very small profit</u>; the more so to enable you to bestow the greater pains in <u>their elegant execution</u>, —for I shall look as much to the <u>honour of [the] thing</u>, as to the profit. —Of course, I shall expect to have my name stamped upon the bottoms. —In order, however, to let you see that I am frank and open on this point, I told Mr. Crary [John S. Crary] that I would apply to you, by name, to make them; —and have told him that within a Week, I would show him <u>your drawings</u> for such as is proposed to make. —Mr. Crary told me that he had "the Say" in the Business and that I should make them. —

None of the Silversmiths here know that I have the order, as several of them w.d drop the hammer for me, if they knew I sent to Philad.—and as soon as I am ready for such a course on their part, I shall be very glad to have them.[2]

The pitchers that Gardiner mentioned as part of this commission apparently were never executed, perhaps because it was decided to put all the available funds into the production of the vase. Contemporary accounts were ecstatic in their descriptions

of Maxwell's vase and made no mention of additional objects. On October 3, 1829, the *Niles Weekly Register* reported: "A silver vase, weighing 730 [*sic*] ounces, and said to be a most splendid article, not surpassed in design and finish in this country, was, on Tuesday last week, presented to Hugh Maxwell, esq. by a committee of merchants."[3]

Gardiner's decision to have his brother-in-law execute this commission in secret may have been undiplomatic but was hardly surprising, as by 1828 Fletcher had established himself as the leading American purveyor of large-scale presentation silver. The Maxwell Vase represents the culmination of a sequence of monumental objects made by Fletcher & Gardiner's shop in the decades after the War of 1812, beginning with the Isaac Hull vase in 1813 and including the DeWitt Clinton vases in 1824.

Even allowing for nineteenth-century hyperbole, the description of the Maxwell Vase as "not surpassed in design and finish in this country" was apt; the vase represents one of the most spectacular statements of the Classical Revival style in American silver. Fletcher based his design on contemporary London models; as Fennimore has observed, Fletcher's visit to Britain in 1815 marked a significant stylistic shift in his work from French to English influence.[4] Fletcher modeled the vase itself on the so-called Warwick Vase, a colossal marble vase made from fragments excavated in 1770 from the ruins of Hadrian's Villa at Tivoli and sold to the Earl of Warwick.[5] From the 1810s into the 1830s, it was a popular model for wine coolers and presentation pieces made by English silversmiths.[6] On his trip to London in June 1815, Fletcher commented on some of these made by Paul Storr at the shop of the royal goldsmiths, Rundell, Bridge, and Rundell: "Here I saw elegant silver chased work—the first I have met with . . . I was shewn cases filled with Goods of the most costly kind—a fine vase, copied from one in the possession of the Earl of Warwick at Warwick Castle which was dug from the ruins of Herculaneum [*sic*] is very beautifully made—it is oval, about 2/3ds the size of that made for Hull—the handles are Grape Stalks & a vine runs all round covered with leaves & clusters of Grapes—below are heads of Bacchus &c.—finely chased."[7]

The triangular base of the Maxwell Vase, with its sphinx supports (cat. 249-2), was also derived from precedents in English silver. At the shop of Rundell, Bridge, and Rundell, Fletcher may have seen a drawing or model for the triangular centerpiece with three sitting female sphinxes in pharaonic headdresses that the architect Charles Heathcoate Tatham (1772–1842) had designed for them in 1806/7 (fig. 87). Sphinx supports had become a popular motif in European decorative arts by the beginning of the nineteenth century; as early as 1769 or 1770, James Wyatt designed a triangular stand for a coffeepot made by Boulton & Fothergill with three sitting female sphinxes inspired by Greek models.[8] Recumbent sphinxes in pharaonic headdresses were based on the archaeological publications that

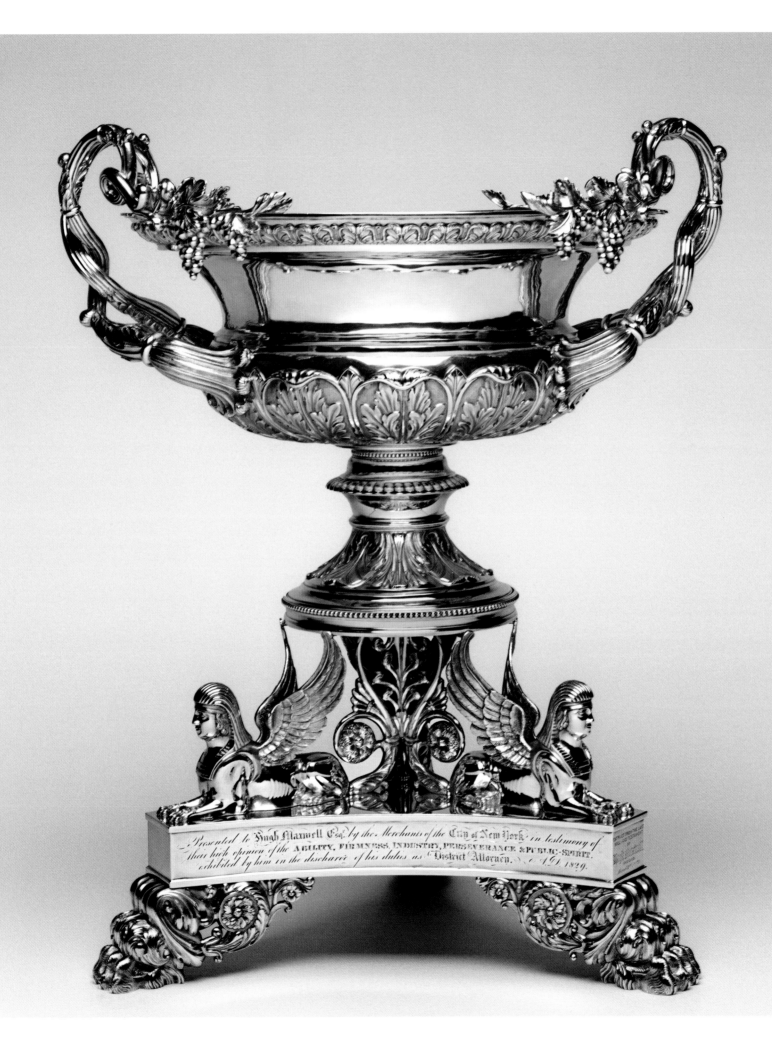

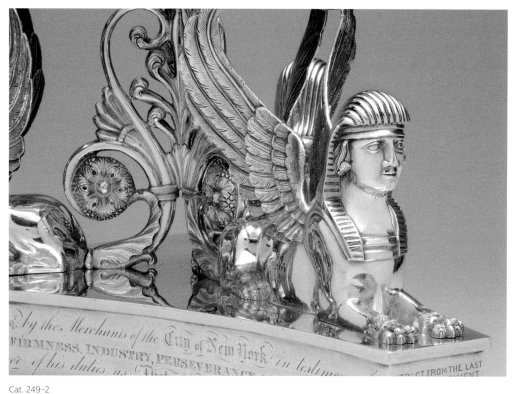

Cat. 249-2

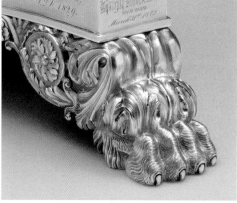

Cat. 249-3

The sculptural quality of both the paw feet and the sphinxes was without parallel in American silver of this period, and the monumental scale, superb quality of execution, and sophisticated design of the Maxwell Vase anticipated silver objects made, on a similarly grand scale, in the second half of the nineteenth century.[13] DLB

1. Hofer and Bach 2011, cat. 3.16. Hugh Maxwell's portrait is in the collection of the New-York Historical Society; *Catalogue of American Portraits in the New-York Historical Society*, vol. 2 (New York: New-York Historical Society; New Haven, CT: Yale University Press, 1974), cat. 1389.
2. Baldwin Gardiner to Thomas Fletcher, August 29, 1828, Thomas Fletcher Papers, box 3, Athenaeum of Philadelphia.
3. *Niles' Weekly Register* (Baltimore), 4th ser., vol. 1, no. 6 (October 3, 1829), p. 90.
4. Donald L. Fennimore, "Thomas Fletcher and Sidney Gardiner: The Stylistic Development of Their Domestic Silver," *Antiques*, vol. 102, no. 4 (October 1972), pp. 642–46.
5. Richard Marks and Brian J. R. Blench, *The Warwick Vase* (Glasgow: The Burrell Collection, Glasgow Museums and Art Galleries, 1979), pp. 6–8, 20–22.
6. Christopher Hartop, *Royal Goldsmiths: The Art of Rundell & Bridge, 1797–1843* (Cambridge: John Adamson, 2005), p. 117.
7. Thomas Fletcher, Account, Memorandum, and Letter Book, p. 144, Fletcher Papers, box 11, Athenaeum of Philadelphia.
8. Shena Mason, ed., *Matthew Boulton: Selling What All the World Desires* (Birmingham, UK: Birmingham City Council, 2009), pp. 192–93, cat. 207.
9. David Watkin, "The Lure of Egypt," in Hartop, *Royal Goldsmiths*, pp. 56–59.
10. Jean-Marcel Humbert, Michael Pantazzi, and Christiane Ziegler, *Egyptomania: Egypt in Western Art, 1730–1930* (Ottawa: National Gallery of Canada, 1994), pp. 301–2, cat. 179.
11. Christie's, New York, *Important English, Continental and American Silver and Gold*, May 17, 2011, sale 2447, lot 159.
12. Buhler and Hood 1970, vol. 2, cat. 926; Barbara McLean Ward and Gerald W. R. Ward, eds., *Silver in American Life: Selections from the Mabel Brady Garvan and Other Collections at Yale University*, exh. cat. (New Haven: Yale University Art Gallery, 1979), pp. 168–69.
13. See the yachting prize cup by the Gorham Manufacturing Company (PMA 1982-128-1).

followed Napoleon's Egyptian campaign of 1798. A pair of wine coolers made in London in 1805–6 by Digby Scott and Benjamin Smith II featured female sphinxes of this type.[9] Fletcher's model for the winged male sphinxes with pharaonic headdresses on the Maxwell Vase was most likely the work of Paul Storr. Four smaller sphinxes of this type on a plinth with incurved sides formed the base for the silver-gilt tureens made by Storr in 1802–3 as part of the prince regent's "Grand Service."[10] Fletcher's design for the Maxwell Vase resembles a centerpiece made by Storr in 1820–21 with three winged male sphinxes, their tails morphing into openwork

foliate scrolls, atop a base with incurved sides supported by animal-paw feet.[11] In 1828 such sculptural figures were all but unprecedented in American silver. One of the only other instances of sphinx supports appeared on an inkwell made between 1815 and 1825 by Harvey Lewis (q.v.) with female sphinx monopodiae wearing Indian feather headdresses, copied from an early nineteenth-century English porcelain prototype.[12]

Two years after Sidney Gardiner's death, the ability of the shop to execute a work of this scale and quality was undiminished. Although not a working silversmith, Fletcher was adept at designing objects in the Classical Revival style (see p. 408). In this instance, he created an impressive composition to suit what Baldwin Gardiner had termed "the honor of the thing." Although based on English models, certain details had a particularly local quality, most notably the hairy paw feet with openwork acanthus leaves (cat. 249-3) that are strikingly similar to carved feet on contemporary Philadelphia case furniture.

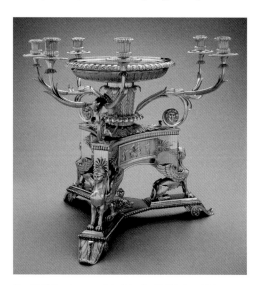

Fig. 87. Philip Cornman (English, died 1822). Candelabrum centerpiece, 1806/7. Made for Rundell, Bridge & Rundell (English, 1797–1843), designed by Charles Heathcote Tatham (English, 1772–1842). Silver gilt, height 18¼ inches (46.4 cm), width 23 inches (58.4 cm). Museum of Fine Arts, Boston. Museum purchase with funds donated anonymously, 2007.349. Photo © 2018 Museum of Fine Arts, Boston

Cat. 250

Attributed to Thomas Fletcher
Locket Frame

1820–40
Rose gold over copper, glass
MARK: THOMAS [FLETCHER] / 130 Chesn[ut Street] /
FIRST DOOR ABOVE FOUR[TH STREET] / Informs his
friends, an[d (?)] . . . / FLET[CHER] . . . / (fragment of
printed trade card inserted behind verso side of miniature;
cat. 250-1)
Height 2⅞ inches (7.3 cm), width 1⅞ inches (4.8 cm),
depth ⅝ inch (1.6 cm)
Gift of the McNeil Americana Collection, 2008-112-22

PROVENANCE: Edward Grosvenor Paine (1911–1994),
New Orleans; Sotheby Parke Bernet, New York, *Notable
Americana*, May 10, 1974, sale no. 3638, lot 113 (as
John Wesley Jarvis, *Charles H. Atherton*).

PUBLISHED: Carol Eaton Soltis, *The Art of the Peales in the
Philadelphia Museum of Art: Adaptations and Innova-
tions* (Philadelphia: the Museum, 2017), pp. 120–21,
pl. 3.36.

This miniature of Philadelphia attorney Humphrey
Atherton (1788–1845) was painted by Raphaelle
Peale about 1819.[1] Backing a lock of hair in its frame
is a portion of an unrecorded trade card for Thomas
Fletcher (cat. 250-1), printed some time after Sidney
Gardiner's death in 1827 and before Fletcher's move
to 188 Chestnut Street in 1836. The discrepancy of
dates between miniature and card may indicate
that Atherton had Fletcher repair an existing locket
or provide a replacement frame for the miniature,
using a trade card as new backing. Although no other
documentation survives identifying Fletcher as the
locket's maker, he and Atherton had a long acquain-
tance. In 1815 and 1816 Atherton's law office was
located on an upper floor of 130 Chesnut, the site
of Fletcher & Gardiner's shop and manufactory.[2] His
receipt book recorded quarterly rent payments to
the partners, and he also wrote to Fletcher in Europe
in 1815 concerning a mutual friend.[3] Fletcher's sub-
sequent shop at 188 Chestnut was next door to a
building at 190 Chestnut owned by Atherton.[4]

From the first year of his partnership with Gar-
diner, Fletcher had advertised that the firm manu-
factured gold jewelry, and it remained a principal
product of the shop. The frame on Atherton's min-
iature, made of gold-plated copper, has an unusual
bail, composed of two interwoven wires with a ball
finial that may indicate that the locket was made in
Fletcher's shop rather than imported from England.[5]
Fletcher signed a very different gold miniature frame
made in 1825 for presentation to the Marquis de
Lafayette.[6] Fletcher's brother Charles criticized his
reliance on jewelry in 1829, when he discharged

specialist spoon makers and retained the jewelry
makers (see cat. 255). In 1834 Fletcher was billed
$5.50 for four dozen "Best" morocco leather spec-
tacle cases, supplied by McAllister & Company (q.v.),
presumably for gold or silver frames made in house.[7]
At the same time, Fletcher retailed gold jewelry that
he imported from England or commissioned from
other American craftsmen. In 1833 Taylor & Bald-
win (q.v., Taylor & Hinsdale) of Newark, New Jer-
sey, responded to an order from Fletcher: "We shall
be hapy [*sic*] to make the chains you request & are
delighted to hear that there is any one on the whole
earth that wants better Jewellery than we have been
compelled to make for the depraved markett [*sic*] of
late years."[8] DLB

Cat. 250-1

1. Carol Eaton Soltis, *The Art of the Peales in the Philadel-
phia Museum of Art: Adaptations and Innovations* (Phila-
delphia, the Museum, 2017), pp. 120–21.
2. Philadelphia directory 1816.
3. Humphrey Atherton, receipt book, 1815–22, pp. 6, 11, 14,
22, 29, 45, Humphrey Atherton Papers, box 10, HSP; Hum-
phrey Atherton to Thomas Fletcher, August 29, 1815, Thomas
Fletcher Letters, 1806–55, HSP.
4. Philadelphia directories recorded Atherton's law office
at 194 Chestnut Street between 1820 and 1822, and at 190
Chestnut between 1823 and 1833, possibly a renumbering of
his earlier address. He apparently retained ownership of the
building when he moved his office after 1833.
5. Observation made by Katherine G. Eirk in a letter to Robert
L. McNeil, Jr., September 12, 1995, curatorial files, AA, PMA.
6. Fennimore and Wagner 2007, p. 174, cat. 44.
7. Receipt, McAllister & Company, July 14, 1834, Fletcher Cor-
respondence, 1812–41, HSP.
8. Taylor & Baldwin to Thomas Fletcher, July 1, 1833, Fletcher
Letters, HSP.

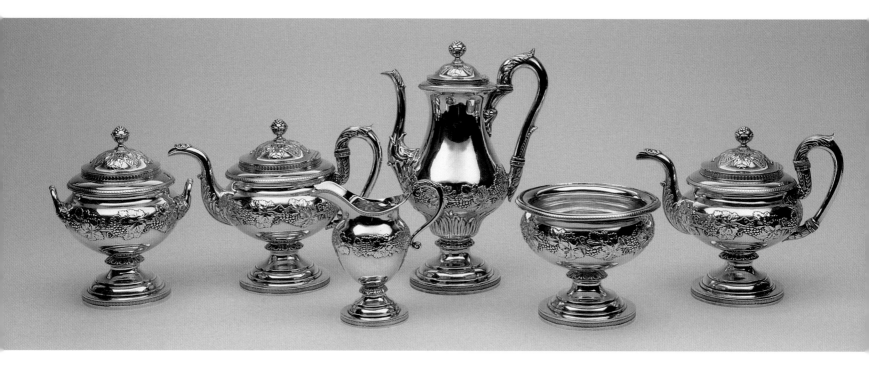

Cat. 251

Thomas Fletcher
Tea and Coffee Service

1830–40

MARKS (on each): · T.FLETCHER · / PHILAD. (in oval; all on underside; cat. 251-1)

INSCRIPTIONS: [Craig coat of arms: Ermine on fess Sable three crescents Argent], [crest: chevalier on horseback in full charge grasping broken lance in bend Proper], VIVA DEO UT VIVAS (Live for God and you shall have life) (engraved, on coffeepot and cream pot; cat. 251-2);[1] 10923 / 9235 (scratched script, on underside of smaller teapot); 9383 (scratched script, on underside of sugar bowl)

Coffeepot: Height 12¹¹⁄₁₆ inches (32.3 cm), width 9⁵⁄₁₆ inches (23.6 cm), diam. foot 5 inches (12.7 cm) Gross weight 53 oz. 4 dwt.

Teapot (2008-2-2): Height 8¾ inches (22.2 cm), width 11½ inches (29.2 cm), diam. foot 4¹⁵⁄₁₆ inches (12.5 cm) Gross weight 41 oz. 13 dwt.

Teapot (2008-2-3): Height 8¾ inches (22.2 cm), width 10¹¹⁄₁₆ inches (27.2 cm), diam. foot 4¹⁵⁄₁₆ inches (12.5 cm) Gross weight 41 oz. 7 dwt.

Sugar Bowl: Height 9 inches (22.9 cm), width 7⁵⁄₁₆ inches (18.6 cm), diam. foot 4⅝ inches (11.8 cm) Weight 32 oz. 14 dwt.

Cream Pot: Height 6⅞ inches (17.5 cm), width 6¹¹⁄₁₆ inches (17 cm), diam. foot 3⁷⁄₁₆ inches (8.7 cm) Weight 13 oz. 1 dwt.

Slop Bowl: Height 6 inches (15.2 cm), width 7³⁄₁₆ inches (18.3 cm), diam. foot 4¹⁵⁄₁₆ inches (12.5 cm) Weight 26 oz. 1 dwt.

125th Anniversary Acquisition. Gift of Cordelia Biddle Dietrich and Jesse Zanger, Mr. and Mrs. H. Richard Dietrich III, and Christian Braun Dietrich in memory of Livingston L. Biddle Jr. and in honor of Cordelia Frances Biddle, 2008-2-1–6

PROVENANCE: In 1968 the dealer Horace W. Gordon of Villanova, Pennsylvania, acting on behalf of H. Richard Dietrich, Jr., purchased this service from Katharine Jennings (Legendre) Biddle (1892–1973). Katharine Biddle's husband, Charles John Biddle (1890–1972), had

inherited the estate Andalusia in 1923, and Biddle family tradition held that this service belonged to Jane Margaret Craig (1793–1856), who married Nicholas Biddle (1786–1844), the financier, in 1811 and lived at Andalusia. The Craig family coat of arms supposedly were engraved on two pieces to ensure that the service would not be confiscated from Nicholas Biddle to satisfy creditors of the United States Bank.

However, the coat of arms and the service's date of manufacture suggest that more likely original owners were Jane Biddle's younger brother, John Charles Craig Jr. (1802–1837) and Jane Josephine Sarmiento (1816–1884), first cousins who were married on April 29, 1833. In 1838 Nicholas and Jane Biddle were presented with another tea service made by Fletcher, which would have been unnecessary if they had acquired one recently. The provenance is complicated by the fact that, after John Craig's death, Jane (Sarmiento) Craig married Nicholas and Jane Biddle's son Edward Biddle Sr. (1815–1872), who was her late husband's nephew and her own second cousin. If Edward and Jane Biddle in fact owned the service, possession passed, at some point, to his brother Charles John Biddle (1819–1873) or his descendants, possibly in 1857 when Edward and Jane Biddle sold many of their household goods prior to a seven-year sojourn in Europe.

In 2001 H. Richard Dietrich, Jr., gave the service and the tray he purchased to use with it (cat. 247) to his children to present to the Museum in honor of their mother and their maternal grandfather, Livingston Ludlow Biddle Jr. (1918–2002).

EXHIBITED: On long-term loan to the Diplomatic Reception Rooms, U.S. Department of State, Washington, DC, 1969–80 (Buhler 1973, p. 71); Alice O. Beamesderfer, *Gifts in Honor of the 125th Anniversary of the Philadelphia Museum of Art* (Philadelphia: the Museum, 2002), p. 60; Fennimore and Wagner 2007, pp. 178–79, cat. 49.

PUBLISHED: Donald L. Fennimore, "Thomas Fletcher and Sidney Gardiner: The Stylistic Development of Their Domestic Silver," *Antiques*, vol. 102, no. 4 (October 1972), p. 648, fig. 12 (coffeepot).

This elegant service is enhanced with die-stamped grapevine ornament that closely resembles the effect of repoussé chasing. Thomas Fletcher used this classical motif on many objects (see cats. 246, 248, 252) and in his correspondence referred to a tea service "with large grape leaves on the body."[2] On the Craig-Biddle service this decoration may have had additional significance as a reference to the renowned grape houses that Nicholas Biddle established at his country house, Andalusia, in the mid-1830s.[3]

Donald Fennimore rightly observed the close similarity of the coffeepot, with its double-bellied shape, rococo spout and upper handle socket, and the chased decoration of cattails below the applied grapevine, to mid-eighteenth century examples.[4] Although a design drawing survives from Fletcher's shop for a similar coffeepot,[5] the Craig-Biddle

Cat. 251-1

Cat. 251-2

example is exceptional among known coffeepots marked by Fletcher and his contemporaries. One possible explanation is that Fletcher salvaged a damaged, eighteenth-century family heirloom, creating a base, cover, and handle similar to those on the other pieces in this service. The coffeepot has suffered significant damage and underwent extensive repairs, which may have included relocating the spout and handle sockets at points 45 degrees from their original positions. When in the coffeepot's history these repairs took place is uncertain. The Craig coat of arms was engraved over an area where the surface has been damaged, suggesting that it was not contemporaneous with the coffeepot's original manufacture. BBG/DLB

1. The cream pot lacks the crest, and the engraving on it is less expertly rendered and placed off center.
2. Thomas Fletcher to John B. Jones, September 25, 1829, as cited in Fennimore and Wagner 2007, p. 179.
3. Nicholas B. Wainwright, "Andalusia, Country Seat of the Craig Family and of Nicholas Biddle and His Descendants," *PMHB*, vol. 101 (January 1977), pp. 31–32, 41–42.
4. Donald L. Fennimore, "Thomas Fletcher and Sidney Gardiner: The Stylistic Development of Their Domestic Silver," *Antiques*, vol. 102, no. 4 (October 1972), p. 646.
5. Fennimore and Wagner 2007, p. 105, drawing no. 31.

Cat. 252

Thomas Fletcher
Presentation Vase

1833
MARK: · T.FLETCHER · / PHILAD. (in oval, on underside of vase; cat. 251-1)
INSCRIPTION: Presented / by the Stockholders of the / SCHUYLKILL NAVIGATION COMPANY / - to - / THOMAS FIRTH ESQ. / under a resolution of the 7. of January 1833. (engraved script, on front of vase); In testimony / of their sense of his long continued, faithful and disinterested / services as a MANAGER in conducting / their concerns, under circumstances often of great discouragement, / and bringing them at length to an / eminently prosperous condition (engraved script, on back of vase)
Height 20⅛ inches (51.1 cm), width 13³⁄₁₆ inches (33.5 cm), depth 8¾ inches (22.2 cm)
Weight 150 oz. 15 dwt. 2 gr.
Purchased with the Richardson Fund, the John D. McIlhenny Fund, and the American Art Revolving Fund, 1985-89-1

PROVENANCE: Thomas Firth (1776–1861); antiques dealer Joseph Sorger (1919–2008), Philadelphia, before 1970.

EXHIBITED: Berry B. Tracy et al., *19th Century America: Furniture and Other Decorative Arts* (New York: Metropolitan Museum of Art, 1970), cat. 51; Philadelphia 1976, cat. 247; Fennimore and Wagner 2007, pp. 214–15, cat. 70.

The Schuylkill Navigation Company was chartered in 1815 to construct a system of locks, canals, aqueducts, tunnels, dams, and slack water pools that would make the Schuylkill River navigable from Philadelphia to Port Carbon in Pennsylvania's anthracite coal region. Following the system's completion in 1825, coal was shipped to developing industrial

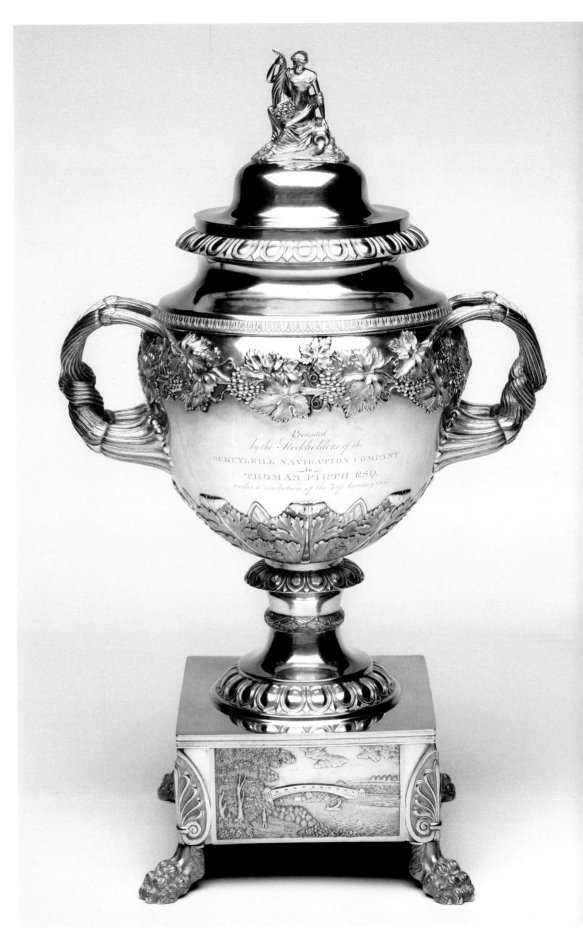

centers such as Reading, Pottstown, Phoenixville, and Philadelphia, which in turn supplied manufactured goods to the booming mining towns.[1] Two of the relief panels bolted to the base of the vase depict company projects, the Flat Rock Dam at Manayunk and the Hay Creek Aqueduct at Birdsboro. A third panel probably depicts the valley where the town of Schuylkill Haven was located; it

Fig. 88. *Upper Ferry Bridge, West View*, 1829. George Lehman, published by C. G. Childs & R. H. Hobson, Philadelphia. Hand-colored aquatint, image: 6¾ x 8⅝ inches (17.1 x 21.9 cm), plate: 7¾ x 9⅞ inches (19.7 x 25.1 cm), sheet: 9⁹⁄₁₆ x 12¹⁄₁₆ inches (23.7 x 30.6 cm). Philadelphia Museum of Art, Gift of the McNeil Americana Collection, 2012-172-21

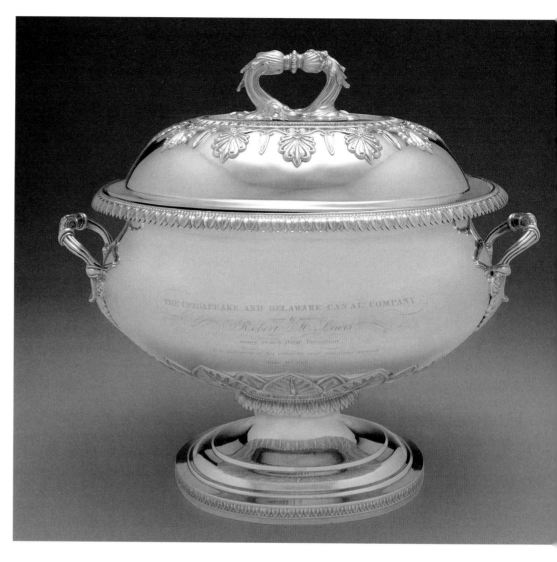

served as a principal depot for shipping coal on the canal.[2] Although not a company project, the Upper Ferry Bridge built at Fairmount in Philadelphia in 1813 was considered an engineering marvel as the nation's longest single-span wood bridge; the image of the bridge on the front of the plinth was copied from an aquatint made in 1829 by George Lehman (fig. 88).

For this commission, Fletcher reused a design he had created three years earlier for a vase presented by the Schuylkill Navigation Company to Cadwalader Evans.[3] His design was replete with classical imagery: the form was based on Roman cinerary urns, embellished with grapevine handles copied from the Warwick Vase (see cat. 249) and surmounted by a female personification of the Schuylkill River, holding a cornucopia of wealth generated by the river's traffic.

Like Evans's vase, the five vases made for this commission in 1833 each cost $500. Donald Fennimore and Ann Wagner have observed that this presentation of identical testimonials celebrated corporate unity over individuality.[4] This one of the five to be presented to outgoing officers of the Schuylkill Navigation Company was given to Thomas Firth (1776–1861).[5] Firth apparently never married, and the subsequent ownership of the vase before the later twentieth century is unknown. BBG/DLB

1. See Harry L. Rinker, *The Schuylkill Navigation: A Photographic History* (Berkeley Heights, NJ: Canal Captain's Press, 1991).
2. The late Edwin Wolf II suggested this identification for the landscape scene, noting its similarity to an image of the valley at Schuylkill Haven in the subsequent publication by Eli Bowen, *The Pictorial Sketch-Book of Pennsylvania* (Philadelphia: Willis P. Hazard, 1852), p. 100; notation on photocopy, curatorial files, AA, PMA.
3. Fennimore and Wagner 2007, pp. 194–95, cat. 58; p. 214.
4. Ibid., pp. 194–95, 214.
5. Ibid., p. 214. The other recipients were Manuel Eyre, Joshua Lippincott, Lindzey Nicholson, and Dr. Jonas Preston. Of the five vases, only Firth's and Lippincott's presently are known to have survived.

Cat. 253

Thomas Fletcher

Tureen

1836

MARKS: · T.FLETCHER · / PHILAD. (in oval, on underside; cat. 251-1); 1 (incuse, on rim of tureen and flange of cover)
INSCRIPTION: THE CHESAPEAKE AND DELAWARE CANAL COMPANY. / to / Robert M. Lewis / many years their President. / As a testimony of his efficient and assiduous services. / June 6th 1836. (engraved script)
Height 12⅞ inches (32.7 cm), width 14⅛ inches (35.9 cm), depth 9¾ inches (24.8 cm)
Weight 101 oz. 12 dwt. 13 gr.
Gift of Edward F. Beale, Mrs. Alfred W. Putnam, and Mrs. Evan Randolph in memory of their parents, Mr. and Mrs. Leonard T. Beale, 1972-38-1a,b

PROVENANCE: This tureen is one of a pair presented in 1836 to Robert Morton Lewis (1786–1855), president of the Chesapeake and Delaware Canal Company. Lewis married Martha Rutter Stocker (1789–1868) on February 23, 1815; her younger sister, Anna Maria Stocker (1798–1879), married Lewis's first cousin Lawrence Lewis (1787–1855). Martha Lewis apparently gave or bequeathed the pair of tureens either to her sister or to her sister's two youngest sons; it is also possible that Robert and Martha Lewis's unmarried daughter Margaretta (1819–1886) inherited them and gave or bequeathed

them to her cousins. The tureen descended through Francis R. Lewis (1833–1883) to his granddaughter Anna McClelland (Lewis) Beale (1884–1969), the donors' mother.[1] Its mate, marked with the incuse numeral 2, descended through Robert M. Lewis (1828–1899) to his great-granddaughter Louise W. (Lewis) Page (1922–1976).[2]

The die-stamped anthemion-and-feather ornament on the cover of this tureen appeared on a variety of objects made in Fletcher's shop after about 1835, including a basket and a tea service in the Rococo Revival style.[3] Mid-eighteenth-century models also inspired the pyriform body, which is unlike the hemispherical tureens made earlier by Fletcher & Gardiner. A tureen of this shape and with similar applied decoration appears in a design drawing from Fletcher's shop.[4] The cast handle of the cover is removable, permitting the top to be used separately as a serving dish.

For other silver commissioned from Fletcher by canal companies, see cat. 252. BBG/DLB

1. Genealogical information on the Lewis family is taken from Anne Hollingsworth Wharton, *Genealogy of the Wharton Family of Philadelphia, 1664 to 1880* (Philadelphia: n.p., 1880), p. 23; John W. Jordan, *Colonial Families of Philadelphia* (New York: Lewis, 1911), vol. 2, pp. 1065–66; the Lewis

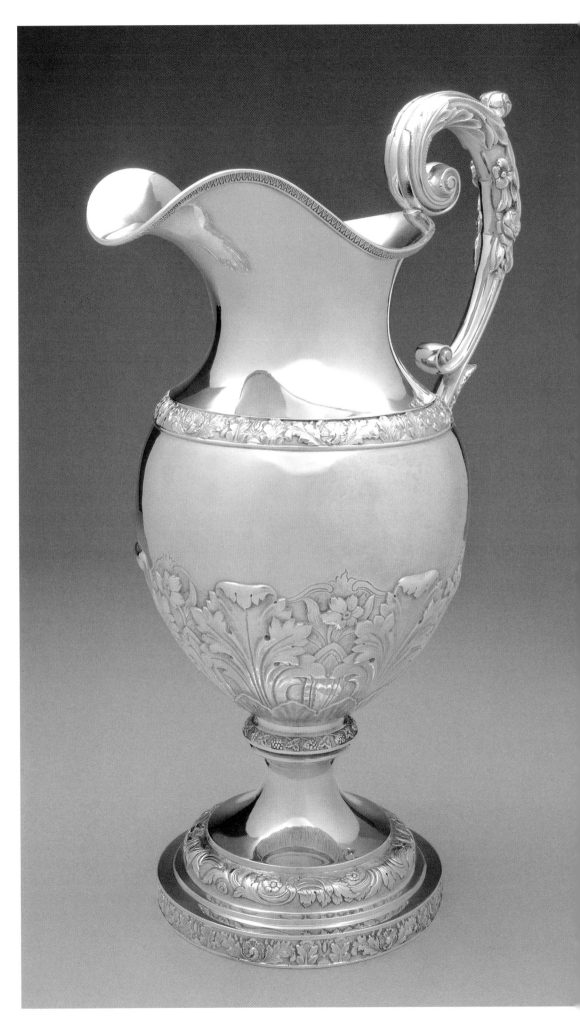

family gravestone, St. Peter's Church, Philadelphia, memorial no. 80387255, www.findagrave.com (accessed June 12, 2015); and the Brown-Bowles family tree, Ancestry.com (accessed October 21, 2014). Anna McClelland Lewis married Leonard T. Beale (1881–1966) in 1911; Marriage License Index, 1885–1951, Clerk of the Orphans Court, Philadelphia.
2. Fennimore and Wagner 2007, p. 236–37, cat. 83; Louise Page or her heirs sold the second tureen to its present owner.
3. Ibid., pp. 244–47, cats. 87, 88.
4. Ibid., p. 102, drawing no. 26.

Cat. 254

Thomas Fletcher

Ewer

1830–40
MARKS: · T.FLETCHER · / PHILAD. (in oval, on underside of base¹; cat. 251-1)
Height 16¾ inches (42.6 cm), width 11¹/₁₆ inches (28.1 cm), diam. 7⅛ inches (18.1 cm), diam. base 6¼ inches (15.9 cm)
Weight 74 oz. 1 dwt.
Gift of the McNeil Americana Collection, 2005-68-25

PROVENANCE: In the twentieth century this ewer was owned by the collector James R. Herbert Boone (1899–1983) of Baltimore. It may have been inherited by Boone or his wife, Muriel Harmar Wurts-Dundas (1903–1970), who was a descendant of several prominent Philadelphia families. Sotheby's, New York, *Property from the Estate of James R. Herbert Boone*, September 16–17, 1988, sale 5747, lot 645.

A surviving design drawing from Fletcher's shop depicts a ewer very similar to this example, with bands of die-rolled ornament on the shoulders and top and underside of the base.¹ The Museum's ewer is further embellished with repoussé ornament on the body and foot, and naturalistic flowers and shells that evoked eighteenth-century models appear in the repoussé work, cast handle, and some of the bands. This large and impressive object probably was made as a presentation piece; an engraved inscription has been removed from the front. DLB

1. Fennimore and Wagner 2007, p. 99, drawing no. 21.

Cat. 255

Thomas Fletcher
Ladle

1830–40

MARKS: [profile head facing left, encircled]
T (in shield with diagonally striped ground)
F (in shield with diagonally striped ground)
[eagle] (encircled) P (in shield with diago-
nally striped ground; all on back of handle;
cat. 255-1)

INSCRIPTION: [crest of demi griffin segreant,
engraved, on back of handle]
Length 13½ inches (34.3 cm), width bowl
4⅝ inches (11.8 cm)
Weight 11 oz. 18 dwt. 20 gr.
Gift of Charlene Sussel, 2006-94-11

PROVENANCE: From the stock of the Phila-
delphia antiques dealer Eugene Sussel (1913–1989),
the donor's husband.

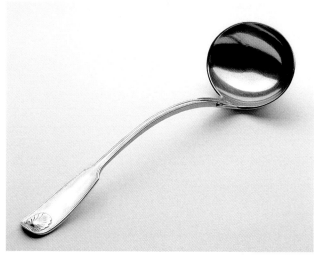

Cat. 255-1

As for most silversmiths, flatware comprised a major
part of both Fletcher & Gardiner's and Thomas
Fletcher's production. Fletcher employed spe-
cialist craftsmen to manufacture flatware using
drop presses he had acquired (see p. 408). In 1829
Charles Fletcher wrote to his brother, "I was very
sorry to learn that you had discharged your spoon
makers, I should have much rather heard that you
had given up the manufacture of Jewellery & turned
your whole force to plate & spoons."[1]

The pattern on this ladle was known as *Thread
and Shell* and was extremely popular during the sec-
ond quarter of the nineteenth century. Responding
to an order in 1831 for forks in the *King* pattern, he
wrote, "If you mean the pattern which Whartenby
[Thomas, q.v.] makes, I have not the dies, if the dou-
ble thread & shell, I have them."[2] In August 1833
Benjamin Gratz (1792–1884), a Philadelphian who
had settled in Lexington, Kentucky, sent an order
to Fletcher for tablespoons, teaspoons, and a soup
ladle, accompanied by a drawing of a *Thread and
Shell*–pattern spoon.[3] BBG/DLB

1. Charles Fletcher to Thomas Fletcher, Baltimore, January 18,
1829, Thomas Fletcher Correspondence, 1812–41, HSP.
2. Thomas Fletcher to Robert and Andrew Campbell, July 23,
1831, as cited in Fennimore and Wagner 2007, p. 234.
3. D. Albert Soeffing, "An Interesting Letter to Thomas
Fletcher, Philadelphia Silversmith, from Benjamin Gratz,"
Silver Magazine, vol. 34, no. 2 (March/April 2002), pp. 14–15.

Cat. 256

Thomas Fletcher
Tea- or Coffeepot

1835–42

MARKS: P (in rectangle with chamfered corners, twice);
[spread eagle] (in square with chamfered corners);
[profile head facing right] (in rectangle with chamfered corners;
all on underside; cat. 256-1)
Height 9⅝ inches (24.5 cm), width 11⁹⁄₁₆ inches (29.4 cm),
depth 6⅝ inches (16.8 cm)
Gross weight 31 oz. 11 dwt. 3 gr.
Bequest of Clara Norris, 1933-65-2

PROVENANCE: According to the donor, this coffeepot

descended in the family with the tea service owned by her
grandparents, Isaac and Mary Norris (see cat. 248).

This coffeepot bears little similarity to the Norris
family's tea service and presumably was purchased
from Fletcher at a later date. The double-bellied
body and die-rolled borders are in the Rococo
Revival style, and the cast silver handle with ivory
insulators is also characteristic of the 1830s. Late in
his career Fletcher's shop made silver with forms and
ornament inspired by mid-eighteenth-century mod-
els, an example being the dinner service made for
Nicholas Biddle in 1836–37.[1] DLB

1. Fennimore and Wagner 2007, p. 235, cat. 82; pp. 244–47,
cats. 87, 88.

Cat. 256-1

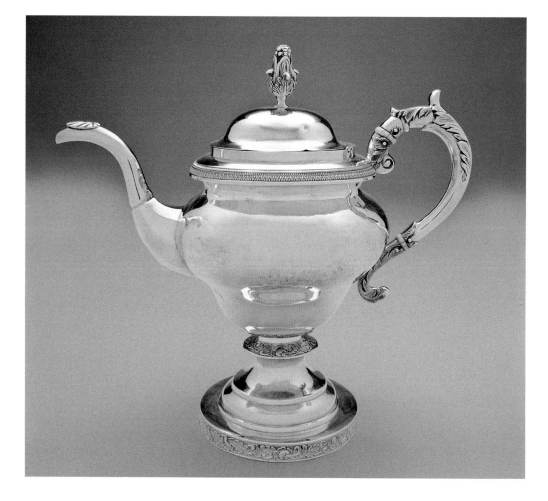

John Wolfe Forbes

New York City, born 1781
New York City, died 1864

John Wolfe Forbes had what he described as a "regular apprenticeship,"[1] probably under his father, William G. Forbes (1751–1840), as did his brother Colin Van Gelder Forbes (1776–1859).[2] John started working in 1802 at age twenty in his own shop at 415 Pearl Street in New York.[3] This was in the First Ward, where his father also worked, at 90 Broadway. The following year, in 1803, John married Eliza Clark, also from New York, on August 14.[4] By 1810 their household numbered six persons, one male between the ages of twenty-six and forty-four (John) and two males under ten, one female between twenty-six and forty-four (Eliza), one female between sixteen and twenty-five, and one female under ten.[5]

In 1805 John W. Forbes advertised for sale, at reduced prices, "silver work and jewellery . . . elegant glass cases for counters, lined with black velvet and looking glass . . . silversmith's scales and weights," as well as the lease on a three-story brick house at 421 Pearl Street, at the corner of Rose Street, with "a large work-shop with two forges and a furnace." In the advertisement he calls the building "one of the first stands for business in this city."[6]

In 1813 he was listed as a silversmith at 95 Maiden Lane, and in 1817 he moved to a building owned by his father at 90 Broadway.[7] John and his brother Colin formed a partnership at that location sometime in 1819, but it was dissolved on November 23 of the same year.[8] The silver made during their partnership was marked "C. & I.W. FORBES" in a rectangle with pseudo-hallmarks of a star and two anchors. In 1820 John's household numbered eight, and Colin's numbered eleven. In each household "a person engaged in manufacturing" was listed.[9]

After the dissolution of the partnership, John W. Forbes's advertisements became more elaborate, embellished with an illustration of a female figure holding scales next to a column from which an unfurled banner read "90 Broad Way," in front of a harbor bustling with ships.[10] In December 1820 he advertised on one occasion

for "an able & experienced Miner to work in the Mount Pleasant Silver Mine," and on another for an "apprentice to the Silver Smith business, a lad . . . of respectable connections."[11]

John Forbes moved again, in 1825, to 114 William Street, and found occasion to relocate his silversmith business several times until 1831, when he was listed at 55 Provost Street.[12] From at least 1835 to 1839, he was listed as a U.S. Measurer at 22 Northmore.[13]

The U.S. census of 1850 listed John W. Forbes in the Fifth Ward, at the age of sixty-eight; Elizabeth, sixty-five; their daughter Elizabeth C., forty; and Bridget Harrison, twenty-one. In 1860, at the age of seventy-nine, he was still at the same address, with Elizabeth, seventy-three; Eliza C., fifty; and their son Malcom, thirty. Also residing there was another family: Edgar Ruckel, twenty-one; Matilda Ruckel, sixteen; Eliza Ruckel, fourteen; and Maria Jones, twenty-five.

Elizabeth Clark Forbes died on December 25, 1862, at the age of seventy-eight. John W. Forbes died December 28, 1864, at eighty-three. Both were buried in the Green-Wood Cemetery in Brooklyn.[14] The executors of John's estate were Malcom Forbes, Eliza C. Forbes, and Mary Ann Browning. The Internal Revenue Service charged the estate at the rate of 1 percent, for a total of $97.50.[15]

John W. Forbes may have been the most prolific of the Forbes silversmiths. Catalogues, advertisements, exhibitions, and sales invariably illustrate his silver with few repeats. Connoisseurs have commented on his skill and the quality of his silver.[16] He supplied the English and Dutch gentry of New York with domestic and presentation silver, which featured familiar elements of style, old and current.[17] BBG

1. *New-York Daily Advertiser*, December 16, 1819.

2. Colin married Eliza Bullock on June 14, 1798.

3. Ensko 1927, p. 87.

4. Marriage Records of the Reformed Protestant Dutch Church of New York City, Holland Society of New York, Ancestry.com (as Elizabeth Clark). Eliza was born in New York on February 20, 1784; U.S., Find A Grave Index, 1600s–Current, Ancestry.com.

5. 1810 U.S. Census.

6. *New York Gazette and General Advertiser*, January 22, 1805. His uncle Abraham was listed at 9 and 11 Rose Street between 1796 and 1802; "Collector's Notes," ed. Edith Gaines, *Antiques*, vol. 103, no. 3 (March 1973), p. 561. John W. Forbes advertised the sale of 9 Rose Street in 1816; *Columbian* (New York), February 24, 1816.

7. Longworth's New York City directory 1813, p. 110.

8. *New-York Daily Advertiser*, February 12, 1820.

9. 1820 U.S. Census.

10. *The American* (New York), September 15, 1820.

11. *New-York Daily Advertiser*, December 4 and 29, 1820.

12. Rachael B. Crawford, "The Forbes Family of Silversmiths," *Antiques*. 107, no. 4 (April 1975), pp. 730–35.

13. Longworth's New York City directory, 1835, p. 290; 1839, p. 259.

14. U.S., Find A Grave Index (see note 4 above).

15. Records of the Internal Revenue Service, Record Group 58, NARA, Washington, DC, Ancestry.com.

16. For example, the sixty-five-inch-long plateau in the collection of the Metropolitan Museum of Art, New York (1993.167) and a large silver tray made for James Lenox (New-York Historical Society, 1950.258).

17. Voorsanger and Howat 2000, pp. 36–64.

Cat. 257
John Wolfe Forbes
Knitting-Needle Shield

1802–40
Marks: I.W.F (in rectangle), [anchor] (in oval), [profile head facing right] (in oval), [six-pointed star] (encircled; all on reverse; cat. 257-1)
Inscription: A H (engraved script, in hexagonal reserve on front)
Length 2⅝ inches (6.6 cm), width 15/16 inch (2.4 cm)
Weight 5 dwt. 10 gr.
Gift of Miss Sarah A. Swain in memory of Mrs. Sara S. Swain, 1909-144a,b

This tiny object, carefully marked in full by the silversmith, hardly represents the oeuvre of one of New York's most productive artisans. It is an especially delicate piece of work, finely drawn with silver wire set into a fine frame. One end of a fine steel knitting needle would fit into a socket on the reverse. The fabric to which the shield is fastened may have been knitted with such a needle, size 1 or smaller. BBG

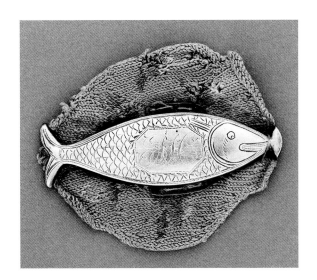

Cat. 257-1

William Forbes

New York City, born 1799
Rahway, New Jersey, died 1888

The son of the silversmith Colin Van Gelder Forbes (1776–1858) and his wife Elizabeth Bullock (1776–1856), who had married in June 1798, William Forbes was the third generation of his family to work in New York City as a silversmith.[1] His paternal grandfather, William Garret Forbes (1751–1840), his great-uncle, Abraham Gerritze Forbes (1764–1833), and his paternal uncle John Wolfe Forbes (q.v.) all were silversmiths.[2]

William was born on March 11, 1799, and baptized on April 14 in the Reformed Dutch Church of New York. Presumably he trained with his father, and in 1825 they formed the partnership of Colin V. G. Forbes & Son, located at 2 Greene Street, New York, until 1833, and at 49 and 53 Vandam Street between 1833 and 1838.[3] The partnership produced several impressive presentation pieces, including a hot-water urn given to John De Grauw in 1835.[4] They also supplied silver to the retail jeweler Marquand & Company. On October 16, 1826, William Forbes married Jane McLachlan (1807–1878) of Albany, the daughter of John (dates unknown) and Ann (c. 1778–1866) McLachlan.[5] William and Jane Forbes were listed in the U.S. census of 1830 as living in the Fifth Ward of New York with their daughter Anne Elizabeth (1827–1878); they had at least nine more children.[6] Not surprisingly, Forbes became involved with causes and organizations that promoted American manufactures. In New York's 1834 mayoral election, he supported the Whig candidate Guilian Verplanck, who favored high tariffs on imported goods, and in 1842 he and his father were among the precious-metal craftsmen who signed a petition supporting a 10 percent increase in the tariff on silver imported into the United States.[7] Forbes joined the American Institute of the City of New York for the Encouragement of Science and Invention in 1847.[8]

After his father retired from silversmithing in 1838, Forbes continued working at 53 Vandam Street. In 1844 he moved his residence to 247 Spring Street (renumbered 277 Spring Street in 1848).[9] His shop at the rear was where he worked for the next twenty years. Most of the silver made by Forbes

during this period was also struck with marks for Marquand & Company's successor firms: first Ball, Tompkins & Black and later Ball, Black & Company (q.v.). Forbes must have been a principal supplier of hollowware to these retailers, although unlike John R. Wendt (q.v.) he worked in his own shop. The large quantity and high quality of surviving objects suggest that he employed a sizable workforce with specialist craftsmen such as chasers. Between 1849 and 1854, the silversmith William Bogert (1811–1881), who was Forbes's second cousin, worked in his shop and was living in his household from 1849 to 1851.[10] In the U.S. census of 1850, Forbes was listed as also having two apprentice or journeymen silversmiths living with him: his eighteen-year-old son Thomas Jefferson (known as Jefferson) and William Lockart, aged nineteen, an immigrant from Scotland. It is possible that his immediate neighbor in 1850, a silversmith named William Bryant, worked for him; additionally, Bryant's fifteen-year-old son Joseph was recorded in the same census as a silversmith.[11]

William Forbes continued operating his shop at the rear of 277 Spring Street until 1863, when he retired after four decades of activity.[12] Three years earlier, he had moved his residence and extended family to Rahway, New Jersey.[13] His son Colin Van Gelder enrolled for the draft in Union County in June 1863, and his mother-in-law, Ann McLachlan, died there in March 1866.[14] The U.S. census of 1870 recorded him in Rahway as a farmer with real estate valued at $7,000 and a personal estate of $6,500. His household comprised his wife, his widowed daughter Anne Elizabeth Scott, and his unmarried children Colin (who would be married one year later) and Catherine. Jane Forbes died in Rahway on February 27, 1878, and Forbes signed the administrators' bond for her intestate estate on May 4.[15] Ann Scott died one month after her mother on March 27, 1878. In her will, dated 1873, she named her father sole executor and divided her estate equally among her six surviving siblings.[16]

Forbes's son Jefferson was the fourth generation of his family in the profession. Both the New York State census of 1855 and the U.S. census of 1860 recorded him as a silversmith; in 1855 he was still living (and presumably working) with his father in the Eighth Ward, whereas by 1860 he had moved into the household of the huckster William French. He does not appear in subsequent census records, and the only directory listings for a Jefferson Forbes, a clerk, appeared in 1870 and 1872.[17] This paucity of records suggests that he was employed in another craftsman's shop or factory, most likely by his father, and it is possible that father and son ceased working as silversmiths at the same time. William Forbes wrote his will

in 1881, dividing his estate equally among his five surviving children. He added two codicils, in 1883 and 1885, that provided for his daughter Catherine, "for her services in the care of my household," and funds for the maintenance of the family burial plot, centered on a towering granite obelisk, at Green-Wood Cemetery in Brooklyn.[18] Forbes died in Rahway on October 10, 1888, and was buried three days later, alongside his wife and several of his children, in Green-Wood.[19] DLB

1. Samuel S. Purple, ed., *Records of the Reformed Dutch Church in New Amsterdam and New York*, vol. 1, *Marriages from 11 December, 1639, to 26 August, 1801* (New York: New-York Genealogical and Biographical Society, 1890), p. 275; Tobias Alexander Wright, ed., *Records of the Reformed Dutch Church in New Amsterdam and New York*, vol. 3, *Baptisms from 1 January, 1731, to 29 December, 1800* (New York: New-York Genealogical and Biographical Society, 1902), p. 478. Obituaries for Colin and Elizabeth Forbes appeared in the *New York Times* on January 20, 1858, and July 22, 1856, respectively.

2. Biographical information on the Forbes family is found in Waters, McKinsey, and Ward 2000, vol. 2, pp. 318–27.

3. Longworth's New York City directory 1826, p. 198; 1833, p. 263; 1837, p. 247.

4. David B. Warren, Katherine S. Howe, and Michael K. Brown, *Marks of Achievement: Four Centuries of American Presentation Silver*, exh. cat. (Houston: Museum of Fine Arts, 1987), cat. 156, which incorrectly lists John Wolfe Forbes as one of the partners.

5. *New-York Evening Post*, October 19, 1826.

6. Their children were Agnes (born c. 1831), Thomas Jefferson (known as Jefferson, 1832–1875), Catherine Van Gelder (1834–1908), John M. (c. 1837–c. 1880), William A. (1839–1905), Colin Van Gelder (c. 1841–1912), Isabella (born c. 1844), Augustus Henry (born and died 1848), and Robert McLeod (born and died 1849). Names and dates for Forbes family members are taken from U.S. census records and grave markers in their family plot in Green-Wood Cemetery, Brooklyn, section 97, lot 5290, recorded at www.findagrave.com.

7. Waters, McKinsey, and Ward 2000, vol. 2, p. 318; D. Albert Soeffing, "The New York City Gold and Silver Manufacturers' Petition of 1842," *Silver*, vol. 24, no. 3 (May–June 1991), pp. 10–11.

8. Waters, McKinsey, and Ward 2000, vol. 2, p. 318.

9. Longworth's New York City directory 1838, p. 252; Doggett's New York City directory 1844, p. 128; 1848, p. 153.

10. Doggett's New York City directory 1849, p. 56; Trow's New York City directory 1854, p. 78; D. Albert Soeffing, "William Bogert and His Family," *Antiques*, vol. 150, no. 1 (July 1996), pp. 102–4.

11. Bryant and his son do not appear independently in New York City directories and were not recorded in New York in the 1855 New York State census or 1860 U.S. census.

12. Trow's New York directory 1863, p. 296.

13. Ibid. 1860, p. 295.

14. Consolidated Enrollment Lists, 1863–65, New Jersey, vol. 3, n.p., Records of the Provost Marshal General's Bureau, NARA, Washington, DC; *New-York Evening Post*, March 19, 1866.

15. Administrators and Guardians Bonds, Union County Surrogate's Court, Elizabeth, NJ, vol. C–D, 1871–1887, p. 352.

16. Unrecorded Estate Papers, no. 2539, Union County Surrogate's Court, Elizabeth. Forbes's refusal to pay one of the bequests from his daughter's estate resulted in litigation that was resolved in his favor in June 1880.

17. Trow's New York directory 1870, p. 401; 1872, p. 399.

18. Wills, Union County Surrogate's Court, Elizabeth, vol. J–K, 1888–1892, pp. 1–6.

19. *New York Times*, October 11, 1888; Burial records, Green-Wood Cemetery, Brooklyn, NY, www.green-wood.com/burial_results/index.php (accessed June 1, 2017).

Cat. 258

William Forbes
Kettle on Stand

1839–51
Retailed by Ball, Tompkins & Black (q.v. Ball, Black & Company)
MARKS: BALL.TOMPKINS & BLACK (in arc) / SUCCESSORS TO (in rectangle) / [spread eagle] (in oval) MARQUAND & CO (in arc) [spread eagle] (in oval) / NEW-YORK (in rectangle) / W.F (in rectangle; all on underside of kettle; cat. 258-1); stand is unmarked
Height 17⁵/₁₆ inches (43.9 cm)
Gross weight 81 oz. 15 dwt. 4 gr.
Kettle: Height 12¹⁵/₁₆ inches (32.9 cm), width 11¼ inches (28.6 cm), depth 7⁵/₈ inches (19.4 cm)
Gross weight 53 oz. 13 dwt. 17 gr.
Stand: Height 4¹¹/₁₆ inches (11.9 cm), diam. 7⁷/₁₆ inches (18.9 cm), depth 7⁷/₁₆ inches (18.9 cm)
Weight 28 oz. 1 dwt. 11 gr.
Purchased with the Richardson Fund, funds contributed in memory of Sophie E. Pennebaker, the Center for American Art Acquisition Fund, and with funds contributed by the Levitties Family, 2011-99-1a,b

PROVENANCE: Ruth M. Sherlip (1919–2009), New York City;[1] Doyle New York, *American Furniture and Decorative Arts, Including Fine Furniture and Decorations*, November 18, 2010, sale 10AM02, lot 183; Robert Mehlman, New York City.

PUBLISHED: *Philadelphia Museum of Art Handbook* (Philadelphia: the Museum, 2014), p. 289.

Cat. 258-1

Silver kettles for serving hot water with tea were uncommon in America before the second half of the nineteenth century, primarily because they usually required more metal than a standard three-piece tea service does. Not surprisingly, given their cost, the few eighteenth-century American examples that have survived are significant stylistic statements, most notably the lavishly ornamented rococo kettle on stand by Joseph Richardson Sr. (q.v.).[2] Forbes's kettle on stand is an equally exceptional example of the American Gothic Revival style, embellished with motifs taken from medieval architecture and metalwork. The polygonal body resembles those of fourteenth-century silver ewers.[3] Pointed and trefoil arches were flat-chased on the sides.[4] A large trefoil arch formed the handle, its hinges mounted on quatrefoil roundels. The foliate finial is similar to those found on buildings and on fourteenth- and fifteenth-century silver cups and censers.[5] The polygonal shape and flared ends of the stand recall the center column of the early

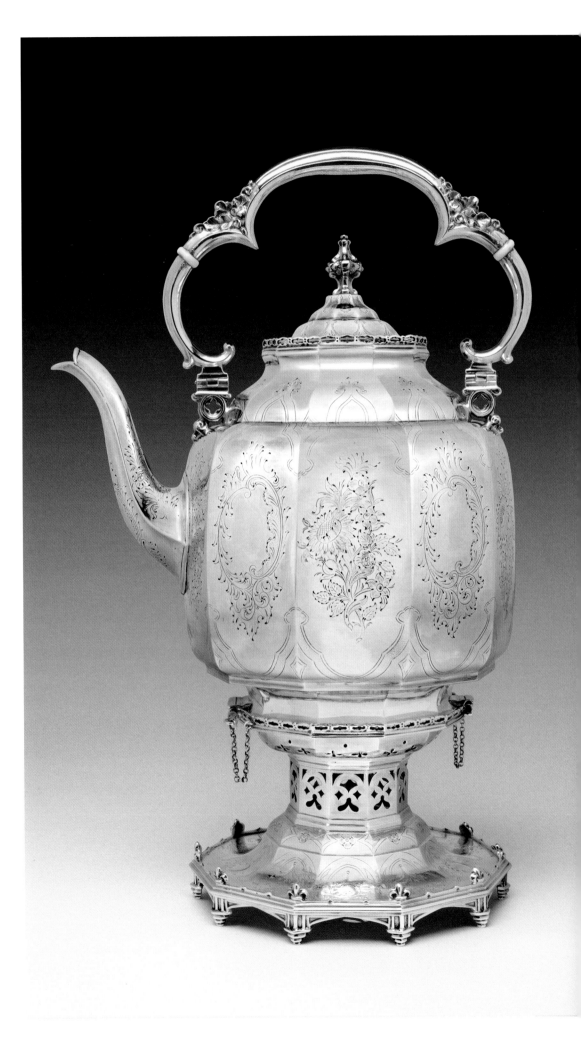

fourteenth-century chapter house at Wells Cathedral in England, as well as the bases of numerous late fourteenth- and early fifteenth-century Perpendicular-style baptismal fonts.[6] The feet of the stand were inspired by the collar braces and pendants of hammerbeam roofs, such as the late fifteenth-century example at Eltham Palace, Greenwich; a similar motif appears on the baptismal font in Saint John the Baptist Church, Badingham, Suffolk.[7]

This relationship to English Gothic architecture suggests that Forbes took inspiration from an English source, and his kettle on stand is strikingly similar to one made by Elkington, Mason & Company of Birmingham that was exhibited at the London Crystal Palace in 1851 (fig. 89). Forbes presumably was familiar with this design, which probably predated the Great Exhibition, particularly given the date range of his kettle. Forbes modified the Elkington model by elongating the body, eliminating the band of horizontal ornament, and giving the handle a trefoil rather than ogival arch shape. Despite its eclectic combination of details, Forbes's kettle on stand has a unified character. The curved profile and dramatic trefoil handle of the kettle and the flared shape of the stand add a lively, graceful quality to the overall design. The stand has a precious, reliquary-like quality, perhaps because of its miniaturized architectural details. Its saw-pierced openings are reminiscent of window tracery and, when the now missing lamp was lit, would have cast gothic-inflected shadows on the table, enhancing any association with a distant past that the original owners might have prized.

American domestic silver hollowware in the Gothic Revival style is exceptionally rare, perhaps because the style is associated in the United States with churches and country houses, rather than with urban residences or public buildings. Fewer than a dozen other examples have been recorded, most marked by makers or retailers in New York and Boston between 1835 and 1855; among them is a child's mug also made by Forbes for Ball, Tompkins & Black.[8] All these objects are octagonal in section and feature pointed arches as a primary ornamental motif. Some of these objects, including Forbes's kettle and mug and flatware such as William Gale and Son's *Gothic* pattern (PMA 2009-15-1), melded the gothic style with naturalistic, rococo motifs. The sides of the kettle are, for instance, chased with rococo-style cartouches and bouquets of flowers. Americans took up the Gothic Revival style as a picturesque alternative to classicism, as did the British: the eighteenth-century "gothick" designs of Batty Langley or Horace Walpole were an aspect of rococo anti-classicism.[9] DLB

Fig. 89. Silver tea service in the Gothic Revival style by Elkington, Mason & Co., Birmingham, from *Art Journal Illustrated Catalogue: The Industry of All Nations* (London, 1851), p. 193.

ewer made c. 1350 in Paris. This piece was acquired by the South Kensington Museum (now the Victoria and Albert Museum in London), but not until 1864, at least a decade after Forbes's kettle on stand was made; see R. W. Lightbown, *Secular Goldsmiths' Work in Medieval France: A History*, Reports of the Research Committee of the Society of Antiquaries of London 36 (London: Society of Antiquaries, 1978), pls. 26–27.

5. Charles Oman, *English Church Plate, 597–1830* (London: Oxford, 1957), frontispiece; Lightbown, *Secular Goldsmiths' Work in Medieval France*, pl. 56.

6. For the Wells Chapter House, see Nikolaus Pevsner, *North Somerset and Bristol* (Harmondsworth, UK: Penguin, 1958), p. 299. Octagonal and decagonal baptismal fonts with flared elements are illustrated in E. Tyrrell-Green, *Baptismal Fonts, Classified and Illustrated* (London: Society for Promoting Christian Knowledge, 1928), pp. 99–111.

7. Michael Turner, *Eltham Palace*, rev. ed. (London: English Heritage, 2012), p. 14; Ann Eljenholm Nichols, *Seeable Signs: The Iconography of the Seven Sacraments, 1350–1544* (Woodbridge, UK: Boydell, 1994), pl. 81.

8. Susan B. Matheson and Derek D. Churchill, *Modern Gothic: The Revival of Medieval Art*, exh. cat. (New Haven, CT: Yale University Art Gallery, 2000), cat. 38. Other pieces of hollowware include a crenellated teapot made 1835–49 by John Chandler Moore for the retailers John and James Cox, for which see Katherine S. Howe and David B. Warren, *The Gothic Revival Style in America, 1830–1870*, exh. cat. (Houston: Museum of Fine Arts, 1976), cat. 145, and now in the Museum of Fine Arts, Boston (2010.484); two pitchers with matching goblets made in 1845 by Zalmon Bostwick following the design of Charles Meigh's stoneware "Minster" pitcher of 1842, for which see Voorsanger and Howat 2000, cat. 298, and Donald C. Peirce, *Art and Enterprise: American Decorative Art, 1825–1917, The Virginia Carroll Crawford Collection*, exh. cat. (Atlanta: High Museum of Art, 1999), cat. 28; a covered pitcher made in 1844 by Low, Ball & Company of Boston, for which see *Lyndhurst Corporation: Fine American Furniture and Silver of the Nineteenth Century* (New York: Lyndhurst, 1982), p. 9; and a cruet frame marked by the Boston firm Harris, Stanwood & Company, in partnership 1844–48, for which see Elizabeth Feld, Stuart Feld, and David B. Warren, *In Pointed Style: The Gothic Revival in America, 1800–1860*, exh. cat. (New York: Hirschl and Adler Galleries, 2006), cat. 23.

9. Terence Davis, *The Gothic Taste* (Rutherford, NJ: Fairleigh Dickinson University Press, 1975); Megan Aldrich, *Gothic Revival* (London: Phaidon, 1994).

1. Ruth M. Sherlip, a native of New York City, lived in Greenwich Village; obituary, *New York Times*, February 17, 2010.

2. Buhler and Hood 1970, vol. 2, cat. 843. A kettle made c. 1710–20 in New York City by Cornelius Kierstede is published in Wees and Harvey 2013, cat. 64.

3. John Cherry, *Medieval Goldsmiths*, 2nd ed. (1992; repr. London: British Museum Press, 2011), figs. 39, 61.

4. Flat-chased trefoil arches have a precedent in medieval silver, appearing on a silver-gilt mounted rock-crystal

Cat. 259

William Forbes
Pitcher

1855–60
Retailed by Ball, Black & Company (q.v.)
MARKS: BALL, BLACK & Cᵒ (in arc) / NEW-YORK (in rectangle) / [eagle] (in oval), W.F. (in rectangle); [five-pointed star] (encircled; all on underside; cat. 259-1)
INSCRIPTION: L F C (engraved script monogram in reserve, on front)
Height 12 inches (30.5 cm), width 10 inches (25.4 cm), depth 7½ inches (19.1 cm)
Weight 40 oz. 2 dwt. 5 gr.
Gift of Dr. and Mrs. Orville Horwitz, 2001-195-1

This is a grand, full-bodied water pitcher. The surfaces are covered with a chased and repoussé design of swirling vines carrying flowers of mixed forms with ivylike foliage. The overall surface is enlivened with staccato points of chasing. The handle is formed to resemble the vine's thick stem, with realistic details of pruned branches. The forms of the repoussé flowers with different foliage and no vines, as well as the molded pouring lip, are similar to those on a pitcher by Forbes in the Museum of the City of New York.[1] BBG

1. Waters, McKinsey, and Ward 2000, vol. 2, cat. 168, p. 327.

Cat. 259-1

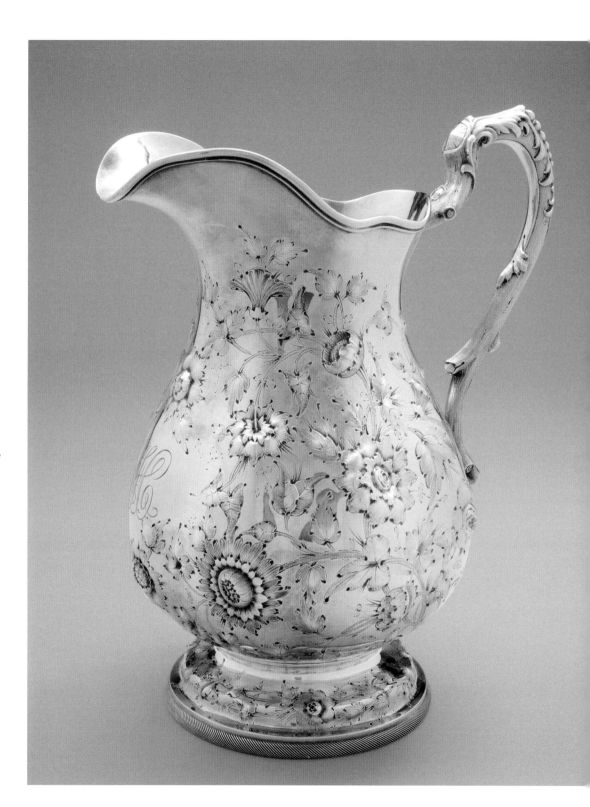

Steve Ford

| Lafayette, Indiana, born 1964

David Forlano

| Charleston, South Carolina, born 1964
| Partnership, 1988–

Figs. 90, 91. Steve Ford (top) and David Forlano (bottom). Photos: Jared Castaldi

Steve Ford (fig. 90) was born in 1964 in Lafayette, Indiana, and studied painting at Washington University in St. Louis. David Forlano (fig. 91) was born in 1964 in Charleston, South Carolina, and was a student at Tyler School of Art, Temple University, Philadelphia.[1] They met in 1985 while studying for a semester in Italy through Tyler School of Art in Rome. While abroad these two artists began a series of discussions about methods and approaches to painting. Finding their conversations artistically stimulating, they decided to work as a team and began trading half-finished drawings and paintings in order to learn from each another and to fuse their individual ideas. Ford subsequently transferred to Tyler for his senior year, and both artists graduated with BFAs in painting in 1986. "Swapping" became an essential element in their work,[2] and their collaboration remains vibrant today. Ford and Forlano began making jewelry together in 1988, choosing polymer clay, at that time a new material just being explored, and introducing metal around 2000.[3] Maryanne Petrus-Gilbert (born 1970), a Philadelphia-based metalsmith, fabricates the metalwork for their jewelry.[4]

The two men worked side by side in their North Philadelphia studio until 2006, when Forlano moved to Santa Fe, New Mexico. They continue their partnership by shipping work back and forth between the two cities. Forlano's strength lies in his ability to "push color, pattern and surface in new directions," while Ford experiments with "three-dimensional structures and how things fit together mechanically."[5] Having exhibited for many years in the Philadelphia Museum of Art Craft Show, Smithsonian Craft Show, and American Craft Show Baltimore, their work can be found adorning many admiring collectors. The best of their work is found in several important public collections, including the Museum of Fine Arts, Boston; the Museum of Arts and Design, New York; the Newark Museum, New Jersey; and DesignMUSEO, Helsinki.[6] ERA

1. Marjorie Simon, "Ford + Forlano: Serendipitous Structure," *Metalsmith*, vol. 23, no. 1 (Winter 2003), p. 30.

2. Ibid.

3. Ibid., p. 25.

4. Artists' statement, curatorial files, AA, PMA. Maryanne Petrus-Gilbert graduated from Tyler School of Art with a BFA in jewelry and metals; Petrus-Gilbert, telephone conversation with the author, July 1, 2014.

5. Artists' statement, undated, curatorial files, AA, PMA.

6. Curriculum vitae, www.fordforlano.com (accessed April 7, 2014).

Cat. 260

Steve Ford and David Forlano
Pillow Collar Necklace

2009
Sterling silver, 22 karat gold, polymer clay (PVC), rosewood
MARKS: ford / forlano (in rectangle); 2009; 22K; .925; yann (all incuse, on disk soldered to reverse of one bead; cat. 260-1)
Length 20½ inches (52.1 cm), width 1½ inches (3.8 cm), depth ½ inch (1.3 cm)
Weight silver 36 oz.
Purchased with funds contributed by The Women's Committee and the Craft Show Committee of the Philadelphia Museum of Art in memory of Anne d'Harnoncourt, 2008-121-1

EXHIBITED: *Wrought and Crafted: Jewelry and Metalwork, 1900 to the Present*, Philadelphia Museum of Art, May 8, 2009–February 2, 2010; *First Look: Collecting for the Philadelphia Museum of Art*, July 13–September 8, 2013.

PUBLISHED: "Chance Meeting in Rome Evolves into Ford/Forlano Jewelry," via *Tyler School of Art* (blog), http://tyler.temple.edu/blog (accessed May 20, 2015); "Changes, Honors, Farewells," *American Craft Magazine*, posted July 7, 2009, http://craftcouncil.org/magazine (accessed May 20, 2015); "Ford/Forlano Weigh In," *Polymer Clay Daily*, http://polymerclaydaily.com (accessed May 20, 2015).

Pillow Collar Necklace is made up of one hundred beads—the face of each is polymer clay mounted on a silver "button"— with fifty-one on the neutral-colored side and forty-nine on the colorful side,[1] and clasped by a series of hook-and-eye catches.[2] The idea of a commission by the Museum for a tour-de-force neckpiece was first broached during a

Cat. 260-1

Fig. 92. Ford/Forlano. *Drawing of Pillow Collar Necklace*, 2008. Opaque watercolor and sparkly highlights and graphite, with inkjet-printed collage elements, on cream wove paper, sheet: 22⅜ x 22⅝ inches (56.8 x 57.5 cm). Purchased with funds contributed by The Women's Committee and the Craft Show Committee of the Philadelphia Museum of Art in memory of Anne d'Harnoncourt, 2008-121-2.

curatorial studio visit with Steve Ford and David Forlano in 2007. A year later they presented a concept for this necklace. The presentation in June 2008 coincided with the untimely death of Anne d'Harnoncourt, the director of the Philadelphia Museum of Art, which proposed that the necklace be commissioned in her memory.[3] The drawing (fig. 92) presented with the artist's final proposal was accompanied by this statement: "The red area represents one whole side of the necklace which will be colorful but unified, probably with one dominant color, but a wide range of clay and printed metal patterns. The other side of the necklace will be more neutral; that is, all black and white with subtle color bits. We think of it as a combination of something classical, restrained, and dignified on the one side and something rich, exuberant, adventurous on the other—like Anne herself."[4]

Using nature as an inspiration, Ford and Forlano look to seed clusters, shell formations, and flower buds as well as their carefully composed, organized parts.[5] Seeds, shells, and plant forms are made up of numerous, seemingly identical but unique units. Whereas it is evident that *Pillow Collar Necklace* is composed of singular beads of varied textures and colors, it is the structure of the necklace—also informed by nature—that provides the foundation for this masterful object. A collection of unique elements, the necklace is composed of what the artists call "conceptual fragments." However, it is their arrangement as a whole composition that allows the narrative to come into focus and be complete. Having visited the Museum's 2008 exhibition *Calder Jewelry*, Ford and Forlano infused the necklace with the movement and spirit of Calder's wearable sculptures.[6] The realized work is a powerful statement of the artists' skill and their devotion to d'Harnoncourt. Ford and Forlano consider *Pillow Collar Necklace* the most complex object that they have made to

date and comment that "the commission remains our greatest honor."[7] It is a seminal work of art and illustrates their creativity and skill in polymer clay and metal.[8] ERA

1. Maryanne Petrus-Gilbert (born 1970), a Philadelphia-based metalsmith, executed the silver work for this necklace.

2. Steve Ford and David Forlano, email message to the author, February 23, 2009, curatorial files, AA, PMA.

3. Anne d'Harnoncourt was an ardent supporter of Ford/Forlano and owned five of their necklaces and several brooches. Inspired by her support of their work, the Museum saw fit to commission jewelry from them in her memory. Two weeks later, the Philadelphia Museum of Art's Women's Committee expressed interest in having its funds be directed toward a specific purchase from the 2008 Philadelphia Museum of Art Craft Show to honor her memory. When informed about the impending commission, the committee underwrote the purchase of the neckpiece. Curatorial files, AA, PMA.

4. Ford and Forlano, email message to the author, September 23, 2008.

5. Artists' statement, undated, curatorial files, AA, PMA.

6. *Calder Jewelry* was on exhibit at the Philadelphia Museum of Art, July–October 2008.

7. Ford and Forlano, email messages to the author, February 23, 2009, and July 1, 2014.

8. It should also be noted that this necklace was designed in the twentieth year of their collaboration.

August Conrad Frank

Stuttgart, Germany, born 1866
Philadelphia, died 1946

August Frank established his engraving and die-sinking business, August C. Frank & Co., in Philadelphia shortly after his arrival from Germany in 1892.[1] From 1897 to 1907 he listed himself in the Philadelphia city directory as an engraver or a die sinker, or both, at 1018 Chestnut Street. From 1904 to at least 1930, his business was listed at 732 Sansom Street.[2] Frank produced medals in a style that came to be known to some in the minting world as the "Philadelphia Style." After his death in 1946 his sons continued the business until 1972, when they sold it to the Medallic Art Company.[3]

Frank was not on the staff of the U.S. Mint, but exchanges of design and methods were common between private engravers and die sinkers and U.S. Mint personnel. These two groups were, however, distinctly separate in their areas of production. There was a private market for awards and prizes, and engravers and die sinkers, as well as silversmiths such as Conrad Bard and Peter L. Krider (q.q.v.), designed and produced such pieces. Krider and Frank are known to have collaborated on some private commissions, as they did in 1897 for a medal commissioned by the Society of the Cincinnati commemorating the unveiling of the Washington Monument in Philadelphia.[4] BBG

1. 1900 U.S. Census; Burials, Grace Episcopal Church, Mt. Airy and Philadelphia, Historic Pennsylvania Church and Town Records, HSP, Ancestry.com.

2. His residence was listed in 1897 at 833 North Twelfth Street, in 1899 at 825 Cambria Street, and then from 1914 on at 950 North Franklin Street; Gopsill's Philadelphia directory 1897, p. 671; 1898, p. 766; 1899, p. 766; 1900, p. 764; 1901, p. 264; 1904, p. 856; 1914, p. 444; and 1930, p. 529.

3. D. Wayne Johnson, "Philadelphia Engravers Among America's Unpublished School of Art," http://medalblog.wordpress.com (accessed June 12, 2015).

4. Society of Cincinnati Commemorative Medal, New York Historical Society (X.482), marked "PETER L. KRIDER CO. PHILA." and "AUG. C. FRANK, PHILA."

Cat. 261

August Conrad Frank
Medal

1899
Silver electroplated on bronze[1]
MARK: AUG. C. FRANK.PHILADELPHIA (on plinth under seated figure of Benjamin Franklin)
INSCRIPTION: NATIONAL EXPORT EXPOSITION (struck around edge on obverse) / AWARDED / BY THE / NATIONAL / EXPORT EXPOSITION / TO / ON RECOMMENDATION OF THE / FRANKLIN INSTITUTE / PHILADELPHIA / 1899 (struck on reverse); SARA Y. STEVENSON *Director* / SOUVENIR (engraved at center of reverse)
Diam. 2 inches (5 cm)
Gift of the estate of Mrs. Sara Yorke Stevenson, 1922-64-12

This medal is an example of those produced in Philadelphia at the end of the nineteenth century by independent engravers and die sinkers, as distinguished from the personnel of the U.S. Mint:

> The typical style of Philadelphia School of Art medalists was most evident with a *single device*.[2] Their medallic work lacked subsidiary devices; no lesser design elements supported the main device. No attributes accompanied the main device. . . . No seals or logos were associated with the issuing organization and none appeared on the same side as the device. The obverse design was a bare minimum occupied by a single device only accompanied by only the necessary lettering, almost always as legend around the periphery of the medal's edge. The technology to produce these medals was to engrave a *device punch*, sink this in a fresh diestock, then add the lettering a single letter at a time with *letter punches*. . . . [I]t was a simple style and its execution was devoid of all unnecessary elements.[3]

The Franklin Institute was established in April 1824 in order to promote domestic manufactures and subsequently inaugurated a series of lectures, founded a library, and encouraged inventions.[4] The National Export Exposition for the Advancement of American Manufactures and Extension of the Export Trade, which took place in Philadelphia in 1899, between the 1876 Centennial Exposition and the 1926 Sesquicentennial Exposition, was the first world's fair devoted to commerce. Known as the National Export Exposition, it was organized by the Franklin Institute and the Commercial Museum, which was founded in 1897,[5] and held in a group of impressive permanent and temporary buildings located at the west end of the South Street Bridge in Philadelphia.

Sara Yorke Stevenson (1847–1921) was the daughter of Thomas and Sarah Yorke. She was born and educated in Paris and spent five years (1862–67) in Mexico. She met Cornelius Stevenson in Philadelphia, and they were married June 30, 1870. She was a founder of the museum at the University of Philadelphia and served as president of its board of managers. She also founded the Egyptian Department of the Penn Museum, published articles on Egyptian archaeology, and was elected a member of the American Philosophical Society. In 1894 she was the first woman to be awarded an honorary degree, the doctor of science, by the University of Pennsylvania. In 1917 she organized an exhibition drawn from Philadelphia family collections, *Old American and English Silver*, for the Pennsylvania Museum (now the Philadelphia Museum of Art) at Memorial Hall in Fairmount Park. She was a charter member and president of the Acorn Club for twenty-five years. In 1920 she was made a Chevalier of the Legion of Honor by the Republic of France for her war-relief work in World War I. She was described as a person "of keen wit, wide acquaintance, and rich experience, which enabled her to wield extensive influence."[6] BBG

1. *The Metal Worker*, vol. 54 (July–December 1900), p. 58.
2. In this case, the isolated figure of a seated Franklin.
3. D. Wayne Johnson, "Philadelphia Engravers among America's Unpublished School of Art" (original emphases), http://medalblog.wordpress.com (accessed June 12, 2105).
4. Scharff and Westcott 1884, vol. 3, pp. 2234–35.
5. P. A. B. Widener, *National Export Exposition for the Advancement of American Manufactures and the Extension of the Export Trade* (Philadelphia: Department of Publicity and Promotion, National Export Exposition, 1899), pp. 3–4, 24.
6. Melanie S. Gustafson, "Women and Municipal Reform," *The Historical Society of Pennsylvania: Pennsylvania Legacies*, vol. 11, no. 2 (November 2011), pp. 12–17; Notable Women Scientists, s.v. "Sara Yorke Stevenson," *Biography in Context*, http://infotrac.galegroup.com (accessed November 3, 2014).

The Franklin Mint

Wawa and Exton, Pennsylvania,
founded 1964

n 1964 Joseph M. Segel of Philadelphia founded General Numismatics Corporation in Wawa, Pennsylvania. The firm specialized in making commemorative medals in platinum, gold, silver, and bronze that were sold by subscription in limited editions. The company promoted its products as combining aesthetic quality with intrinsic value. Segel recruited Gilroy Roberts (1905–1992), chief engraver of the U.S. Mint, as artistic director. The firm's name was changed to the Franklin Mint when it became a publicly traded company in 1965.[1]

During the 1970s the Franklin Mint became the nation's largest manufacturer of precious-metal commemorative medals and also struck currency for a few foreign governments, including Jamaica and Tunisia.[2] Its annual sales rose from $392,000 in 1965 to $45.8 million in 1970. Roberts retired in 1971, and Segel retired as chairman of Franklin Mint Corporation in 1973. After the Hunt Brothers manipulated the price of silver in late 1979 and early 1980, the Franklin Mint dramatically reduced its production of precious-metal objects. Warner Communications acquired the company in 1980, and subsequently its ownership has changed several times. In the 1990s, at the peak of demand for collectibles, the company operated retail stores in several states and had sales of about $610 million in 1993. By 2001 sales had fallen to one-tenth of that figure, to about $6.5 million. The company closed its retail stores and laid off two hundred employees in 2004. Now based in Exton, Pennsylvania, the firm currently markets jewelry, dolls, memorabilia, and other collectibles in addition to coins and medals.[3] DLB

1. *A Tour of the Franklin Mint* (Franklin Center, PA: Franklin Mint, n.d.); Joseph M. Segel—Biography, www.josephsegel.info/ (accessed June 12, 2015); Ed Dinger, *International Directory of Company Histories*, vol. 69, s.v. "The Franklin Mint."

2. Virginia Culver and Chester I. Krause, *Guidebook of Franklin Mint Issues* (Iola, WI: Krause, 1974), pp. 9–13.

3. D. William J. McDonald, *Direct Marketing: An Integrated Approach* (New York: Irwin McGraw-Hill, 1998), pp. 483–88; Dana Mattioli, "Sequential Brands Buys the Franklin Mint Brand," *Wall Street Journal*, November 3, 2013; Joseph N. DiStefano, "Franklin Mint Revives," *Philadelphia Inquirer*, April 9, 2008. The range of products is listed on the company's website: http://secure.franklinmint.com (accessed June 12, 2015).

Cat. 262

The Franklin Mint
Thomas Eakins Medal

1972
Designed by Leonard Baskin
(1922–2000)
MARKS: fm (conjoined, struck on reverse below inscription); STERLING C (encircled) fm (conjoined, in rounded square) 72 (in rounded square) 0454 (all incuse, on outside edge; cat. 262-1)
INSCRIPTIONS: · EAKINS · / BASKIN·F· (struck on obverse); TO / COMMEMO-RATE / THE · RESTORATION / OF · THE · HOUSE · AND/ STUDIO · OF / THOMAS · EAKINS / ·1972· (struck on reverse)
Diam. 2½ inches (6.3 cm)
Weight 6 oz. 17 dwt. 7 gr.
Gift of Seymour Adelman, 1973-74-1

Leading American artists designed many of the medals struck at the Franklin Mint during the 1970s. The Museum commissioned the printmaker and sculptor Leonard Baskin in 1972 to design this medal commemorating the restoration of Thomas Eakins's house at 1729 Mount Vernon Street in Philadelphia. Baskin greatly admired Eakins, writing that "his life-long persevering despite neglect and official stupidity is testament of the puissance of his probity. . . . He is the archetypal American realist, giving nutriment to generations of artists dedicated to the realist vision,"[1] and over the course of his career, Baskin produced at least sixteen different images of Eakins's face and head. Baskin owned a photograph of Eakins taken around 1900 that became the point of departure for an etching made in 1964 that served as the basis for the medal (fig. 93).[2] The Museum also owns Baskin's

Cat. 262-1

plaster model for the medal's obverse.[3]

Eakins's house was purchased by the medal's donor, Seymour Adelman, and given to the city of Philadelphia in 1968 with the provision that its programs be administered by the Museum. After considering its potential as a historic house, Evan H. Turner, the Museum director, proposed that the building would better serve its Spring Garden neighborhood as a community center. Between 1972 and 1977 it served as the headquarters of the Museum's Department of Urban Outreach, which brought art and art programs to inner-city neighborhoods.[4] The Eakins house presently serves as the headquarters of Philadelphia's Mural Arts Program. DLB

Fig. 93. Leonard Baskin (American, 1922–2000). *Thomas Eakins*, 1964. Etching, plate: 17¾ x 13¼ inches (45.1 x 33.7 cm), sheet: 29⅜ x 20⅝ inches (74.6 x 52.4 cm). Gift of Marc and Mi-Young Mostovoy in memory of Ira and Floretta Mostovoy, 2014-49-27

1. Leonard Baskin, *Laus Pictorum: Portraits of Nineteenth-Century Artists Invented and Engraved by Leonard Baskin* (New York: A. Lublin, 1969), n.p.
2. Baskin's photograph is illustrated in Gordon Hendricks, *The Life and Work of Thomas Eakins* (New York: Grossman, 1974), p. 263, fig. 288. For the etching, see Alan Fern and Judith O'Sullivan, *The Complete Prints of Leonard Baskin* (Boston: Little, Brown, 1984), cat. 465.
3. Gift of the artist (PMA 1972-236-1).
4. Barbara Y. Newsom and Adele Z. Silver, eds., *The Art Museum as Educator* (Berkeley: University of California Press, 1978), pp. 144–46.

Elsa Freund

Mincy, Missouri, born 1912
Little Rock, Arkansas, died 2001

Fig. 94. Elsa Freund in her studio, n.d. From *Elsa Freund: Modern Pioneer*, exh. cat. (St. Petersburg, FL: Florida Craftsmen, 1993).

Elsa Freund (fig. 94) was born Elsie Marie Bates in 1912, the youngest of the three daughters of Ralph C. and Clara Irma Gardner Bates of Mincy, Missouri.[1] Her childhood was spent on an isolated private game park, where her father was the superintendent.[2] The family's lifestyle was simple, requiring the girls to fill their days through their own imagination and invention. Many families in the first half of the twentieth century repurposed discarded and found objects, turning them into something useful or, in the case of Elsa Freund, into an arrangement of forms. The Clemons family, owners of the game park, exposed the Bates sisters to music and brought gifts of books, paper, and art supplies. At the age of five, Elsa declared that she was going to be an artist. When Elsa and her sisters were older, the family moved to Presbyterian Hill in Hollister, Missouri, so they could attend high school. The Raymonds, frequent visitors to Presbyterian Hill, invited the Bates girls to live with them in Girard, Kansas, so that they could attend high school. Elsa's artistic endeavors were greatly inspired by Mrs. Raymond, who created a studio in her house, permitted her to be part of a local art circle, and lent her money to take an art course by correspondence from the Federal Schools of Minneapolis. At the age of sixteen Elsa attended two weeks of a six-week summer class in Springfield, Missouri, with Adrian Dornbush (1900–1970), a Midwestern regional painter. After graduating in 1929 from high school in Girard, she taught elementary school for one year. She then attended the Kansas City Art Institute for two years, taking courses in drawing from plaster casts, commercial art, anatomy, illustration, and painting with Ross Braught (1898–1983).

Upon returning home to Hollister, Elsa was employed as a receptionist for a recreational boating company that ran trips on the White and Buffalo rivers. It was at this time that she first began to make jewelry, and displayed her own artwork in the reception room. Naming the space the Hillgirl's Craft Shop, she sold bracelets, necklaces, and belts made from pods, nuts, peach seeds, and shells. Through a Work Projects Administration grant to document the life of people in the Ozarks, Louis Freund (1905–1999) paid a visit to the shop in 1936. They married in 1939 in Eureka Springs, Arkansas, at their newly renovated home, Hatchet Hall, the former home of the prohibitionist Carry Nation.[3] In 1940 Elsa took weaving classes through an adult education program at a local high school, which enabled her to teach weaving and design at Hendrix College in Conway, Arkansas. There her access to the college's collection of Asian art inspired her to think more seriously about jewelry. In 1941 the Freunds began their Summer Art School of the Ozarks at Hatchet Hall; Elsa also started to dabble in ceramics and watercolors at this time. After the war the Freunds used Louis's G.I. Bill grant to attend classes at the Colorado Springs Art Center and the Wichita Art Association, where Elsa studied ceramics and glaze theory. The couple moved to DeLand, Florida, to hold positions as artists-in-residence at Stetson University in 1949. Over the next eighteen years in DeLand, they were active in craft communities throughout the state and formed the Florida Craftsmen Association in 1951.[4]

Elsa's experiments with clay in the early 1940s led to more serious jewelry making a few years later. She began to incorporate glass by fusing it during the firing process. Named "Elsaramics" by Louis, then shortened to "Elsa," these glass-fused ceramic "stones" were fired in an enameling kiln. At some point she took a jewelry class with George H. Gaines (1919–2002), assistant professor of arts at Stetson University, to learn soldering and other techniques.[5] In 1950 she took a leave of absence from the university, where she was teaching crafts and design, to focus on her jewelry.[6] By 1953 Freund had developed a line of work that she sold in the shop of Jane Hershey, on St. Armand's Key in Sarasota, as well as other small Florida boutiques.[7] Hershey was a friend and advocate from the Freunds' summer art school. Around 1957 America House in New York City[8] began exhibiting and selling her jewelry, which was subsequently advertised in the *New Yorker* and the *New York Times Sunday Magazine*. Over the years she produced both her commercial line and the showcase works that were exhibited in competitions at art museums and centers.[9] In 1964 she discontinued her line but continued to make exceptional examples of jewelry until 1983, when she was forced to limit her work due to a diagnosis of Graves's disease and loss of the sight in one eye.[10]

Retrospectives for both Elsa and Louis Freund took place at the Arkansas Art Center in Little Rock in 1991. Elsa's jewelry can be found in prominent collections, including those of the Mint Museum, Charlotte, North Carolina; Cooper-Hewitt, Smithsonian Institution, New York; Museum of Fine Arts, Boston; Los Angeles County Museum of Art; Victoria and Albert Museum, London; and Schmuckmuseum, Pforzheim, Germany.[11] ERA

1. The primary source for this biography was Anne Allman, "Biography of Elsie Marie Bates-Freund," typescript, Louis and Elsie Freund Papers, 1945–1994, Special Collections, College of the Ozarks, Point Lookout, MO.

2. Her father was of Irish and Cherokee descent. Freund's Native American heritage was an important source of pride, and she was known to describe herself as "close to nature"; Alan DuBois, *Elsa Freund: American Studio Jeweler* (Little Rock: Arkansas Arts Center Decorative Arts Museum, 1991), p. 7.

3. The Freunds stumbled upon the dilapidated home of Carry Nation while on a sketching expedition with friends in Eureka Springs in 1937. This historic site was about to be torn down and sold for scrap. The Freunds put down $250 to purchase it, and later named their home Hatchet Hall. Elsie stayed in Eureka Springs to repair the house, while Louis went to work at Hendrix College in Conway, Arkansas, having received a second artist-in-residence grant sponsored by the Carnegie Corporation for the Association of American Colleges; Allman, "Biography of Elsie Marie Bates-Freund," p. 5.

4. Ibid., pp. 4–12.

5. DuBois, *Elsa Freund*, p. 12; obituary of George H. Gaines, *Atlanta Journal-Constitution*, September 17, 2002.

6. Freund used two signatures: "Elsa" for jewelry and "Elsie" for paintings; DuBois, *Elsa Freund*, pp. 9–10.

7. The shop Hershey owned was called The Sea Chantey. Elsa sold more than ten thousand works through this outlet; Allman, "Biography of Elsie Marie Bates-Freund," p. 13.

8. America House opened at 7 East 54th Street in New York in 1940 as a cooperative shop selling American-made crafts; Emily Zaiden, "Untold Stories: The American Craft Council and Aileen Osborn Webb," *Craft in America*, www.craftinamerica.org/artists_metal/story_585.php (accessed May 1, 2014).

9. DuBois, *Elsa Freund*, pp. 10–11.

10. Allman, "Biography of Elsie Marie Bates-Freund," p. 14.

11. Elsa Freund, curriculum vitae, curatorial files, Corning Museum of Art, New York.

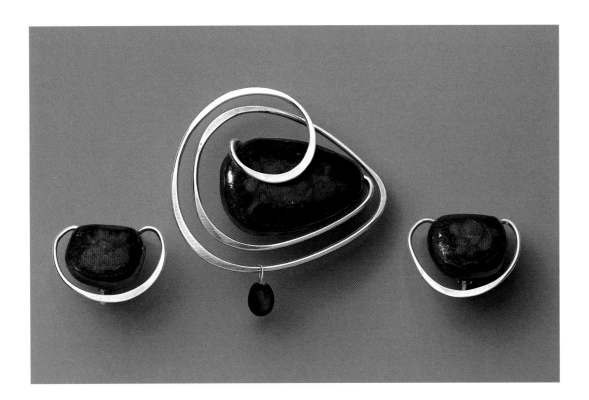

Cat. 263

Elsa Freund
Brooch and Earrings

1953
Silver, earthenware with fused-glass glaze
MARK: Elsa (stamped, on reverse of brooch)
Brooch: Length 2½ inches (6.4 cm), width 2 inches
(5.1 cm)
Gross weight 14 dwt. 13 gr.
Earrings: Length 1½ (3.8 cm), width ¾ inch (1.9 cm)
Gross weight (combined) 7 dwt. 22½ gr.
Gift of Mrs. Libby West, 1991-109-1a–c

EXHIBITED: *Precious Possessions: The American Craft Collection*, Philadelphia Museum of Art, November 3, 2007–October 26, 2008.

PUBLISHED: Suzanne Ramljak and Darrel Sewell, *Crafting a Legacy: Contemporary American Crafts in the Philadelphia Museum of Art* (Philadelphia: the Museum, 2002), p. 181, cat. 256.

This composition of swirling metal surrounding a natural-shaped bauble is the signature of jewelry by Elsa Freund. Made as a matching set of earrings and brooch, each piece has a fused glass-and-clay element or "stone" with a deep scarlet splash of color at the center. The silver frame of the brooch, which Elsa refers to as "movements," (see figs. 95, 96), is composed of flattened silver wire, encircles the stone twice, and terminates in a lively spiral in the middle. A smaller stone, attached as a pendant, dangles from the outer wire. The same silver-wire framing device brackets the earring on three sides of the "stone."

Having become familiar with ceramics and glazing techniques, Freund spent three years to develop her designs and the use of glass as glaze.[1] Like many midcentury American studio jewelers, Freund combined unconventional, nonprecious materials in

instinctive and fresh designs. She collected broken glass from ordinary household vases, drinking glasses, bottles, and old automobile taillights for the colors they would provide when fused on the surface of her "gems." Rather than formally mounting her fused-glass ceramic "stones," she bound them with odds and ends such as raffia, copper, brass wire, and aluminum clothesline. "Certainly it's the artist's aim to create beauty. But, I haven't the least desire to design settings for precious stones, like diamonds, which already have value in themselves. I want to take materials which have little or no value, and give them worth by making them beautiful."[2] In

1953, following this exploratory period, fashionable shops in Key West, Palm Beach, Sarasota, and Fort Lauderdale, Florida, began selling her jewelry. At this time, on the advice of one of the dealers, who commented that "copper and aluminum will remind people of kitchenware," she also began incorporating the use of silver wire,[3] which had the effect of simplifying and purifying the form of her jewelry. This brooch and earrings, made in 1953 and showcasing her brilliant colored gems encircled in elegant silver curves, are superb examples from this period of Freund's career. ERA

1. Nancy Ukai Russell, "Modern Jewelry Pioneer: Elsa Freund," *Ornament*, vol. 15, no. 1 (Autumn 1991), p. 52.
2. *DeLand (FL) Sun News*, September 16, 1962.
3. Russell, "Modern Jewelry Pioneer," p. 85.

Figs. 95, 96. Two of Elsa Freund's preparatory drawings for jewelry. Department of American Art, Philadelphia Museum of Art

John Fries

Salem County, New Jersey, born c. 1805
Philadelphia, died 1874

An active clock-and watchmaker in Philadelphia from 1829 to his death in 1874, John Fries was one of many of the same occupation who handled a variety of "smalls," and who were located in the northern section of the city on Second Street, between Race and Vine, and on New and Story streets, between Second and Third, along the edges of the Upper Delaware Ward.[1] Similarly, their advertisements were clustered along the edges or margins of the city's newspapers. Fries's advertisements, in the *Philadelphia Inquirer* and the *Public Ledger*, stood out as he often used capital letters and a cut of a pocket watch showing the details of a chain and lapel button; later he would vary the notices by emphasizing one or another of his wares: "Cheap for Cash or Exchange. Watches, also silver spoons, spectacles, thimbles, scissor hooks, sugar tongs, silver combs, etc."[2]

Working backward from a combination of Philadelphia directory listings, available census records, and the notice of his death in 1874, it may be ascertained that John Fries, watchmaker, was born in Salem County, New Jersey, in about 1805, to one of the large, extended families of Frieses located there.[3] He may have apprenticed in Philadelphia, possibly with the watchmaker John Dupuy or, more likely, with Nicholas Le Huray Sr., with whom he worked for most of his career. To date no document has surfaced noting any formal transactions between Dupuy and LeHuray or apprenticeship documents regarding John Fries. However, shortly after LeHuray arrived in Philadelphia, he was located at Dupuy's property at 4 South Second Street.[4]

If he did apprentice with LeHuray, Fries probably began about 1819 at the age of fourteen and may have been a resident apprentice in the LeHuray household, which was not an unusual arrangement. On July 2, 1827, when he was twenty-two, John Fries married Julia LeHuray, daughter of Elizabeth and Nicholas LeHuray Sr. and sister of Nicholas LeHuray Jr. (q.v.), also a watchmaker.[5] Julia Fries, who was twenty years old when she married, died on July 21, 1828, leaving an infant daughter, also named Julia.[6]

John Fries is not listed in the 1828 or 1829 city directories. However, in the *Pennsylvania Inquirer* of December 4, 1829, he placed a prominent advertisement, probably his first: "The subscriber informs his friends and the public that he has just received a large assortment of first rate watches of every description . . . call at No. 86 North Third Street / John Fries / Successor to Abraham Stein." Whether the term "successor" indicated that he had previously worked with Stein, or whether he invested in the latter's stock and took over his shop is not clear.[7] From at least 1795 through 1828, Abraham Stein's shop had been located at 86 North Third Street. It is possible that Fries worked, however briefly, for Stein, but he is not listed at that address again.[8]

In 1830 John Fries married as his second wife Anna Louisa Reese (1817–after 1899), who was born in Philadelphia.[9] The Philadelphia city directory of 1830 carried Fries's first listing as a clock and watchmaker, noting him at the 86 North Third Street address. The U.S. census of that year noted a total of twelve persons in Fries's household.[10]

In 1816 Nicholas LeHuray Sr. had purchased property on Second Street at the corner of Elm (New) Street. At some time later, the LeHuray family moved to this property—160 North Second Street in the Upper Delaware Ward—and it became their permanent location.[11] In 1831, probably because of the close family connection and for the sake of his infant daughter, John Fries moved there to reside and work with Nicholas senior.[12] The following year, in March, Nicholas LeHuray Sr. and Elizabeth his wife, "late of the City of Philadelphia, now of the State of Delaware, clock and watch maker, sold to John Fries, jeweler . . . all the tenements and lot of ground on the east side of Delaware Second Street and on . . . the North side of Elm Street" for $8,100.[13] In 1837 John and Phineas Fries (perhaps his brother) were working together at number 160; Nicholas LeHuray Jr. was next door at 170 North Second Street, and after he died in 1846, his son Theodore continued at 172 North Second Street.[14]

Fries's watch paper (fig. 97) features a border of flowers and leaves, motifs that he would use later on his silver.[15] On October 15, 1840, Fries advertised in the *Public Ledger* (where he was placing notices daily until 1842) that he had in stock the newest "Patent and Vibratory Watches." In December 1840 on the day before Christmas, his shop was robbed:

> A colored man who gave his name James Anderson, was brought before Alderman Christian, on Tuesday evening, charged with stealing five watches from the watch and jewelry store of Mr. John Fries, No. 160

Fig. 97. Watchpaper of John Fries, undated. Courtesy of the Winterthur Library, DE. Joseph Downs Collection of Manuscripts and Printed Ephemera, Scrapbook, doc. 499

north second Street. It appeared that the defendant dashed his hand through one of the windows in Mr. Fries' store, and snatching the five watches which were hanging up there, instantly decamped with them. The alarm being given he was pursued and taken in north Fifth Street near Race. The defendant during the chase had contrived to dispose of three of the watches, a handsome gold lever and two silver ones. The other two were found near the door of Mr. Fries' store.[16]

Needing space for his growing family[17] and the development of what would become his silver spoon factory, John Fries purchased two more units of the property at the corner of Second and New streets that Nicholas LeHuray Sr. had bought into in 1816. In 1844 he bought one-sixth shares of the property belonging to Sara Zane (a single woman) and Gustavus A. Thompson (a merchant of Annapolis) on May 9 and May 10, respectively.[18] Later that year or in 1845, he opened his "SILVER SPOON MANUFACTURY" ([sic] and always listed in capital letters), at 160 North Second Street, advertising it as the location "where Silver Spoons can be bought very cheap and handsomely lettered gratis—Highest price given for Old Silver and Spanish Dollars."[19] The spoons were plain with pointed wings at the bottom of the handles, pointed bowls, and wide fiddle-shaped handles turned up with a hint of a midrib. He made one style with added decoration, which he described in an advertisement of March 30, 1847: "SILVER TABLE, TEASPOON AND SPECTACLE MANUFACTORY—The subscriber having improved in the facility of the manufacture of SILVER SPOONS is prepared to supply his customers at a cheaper rate than they have ever been sold before, with a wreath to surround the name,

the handsomest pattern ever made, or plain. Also more than four hundred Watches for sale from $3.50 to $70."[20] Other watchmakers and silversmiths used their mark on spoons, including ones with flowered handles, produced in this factory.[21]

A notice in the *Public Ledger* on August 4, 1848, suggests that John Fries had a specially designed trade card:

> Charged with passing a False Token, Horatio Squire Captain of a canal boat, was committed by Alderman Gaw last evening, on a charge preferred by a colored man who had been employed by him in unloading his cargo of lumber, of having passed upon him for a dollar note, a card in the shape of a bank note issued by Mr. Fries the watchmaker. The complainant not being able to read was not aware of the fraud till sometime afterwards.

The U.S. census of 1850 (where he was given as John Fells) listed, in addition to Fries's own family, an apprentice John Newborn, age fifteen; Susan Gilley (born 1795); Julia Bowman, fourteen, born in Delaware; Ann Andrews, twenty-one, born in Ireland; and Pane Shannon, twenty-two, born in Scotland. In 1853, on August 2, in the *Public Ledger*, Fries advertised: "two journeymen spoon makers wanted, corner Second & New Streets." In 1855 he was still at 160 North Second Street, listed in the city directory under silversmiths but not under watchmakers, although he also appeared under "Watches, Jewelry and Silver Ware."[22] His residence was then at the northwest corner of Fifth and Westmoreland streets, in the Twenty-Fifth Ward; he had an income of $619.86, paid an income tax of $18, and owned a one-horse carriage for which he was taxed a dollar on its value of $75.[23]

By 1864 he was living with his daughter Julia Roberts at 836 North Sixth Street.[24] In 1869 he partnered for one year with his son Walter S. Fries at 822 Spring Garden, where they were listed as jewelers.[25] During the following year, 1870, John Fries advertised his shop at 826 Spring Garden Street, announcing that he employed experienced workmen and that his watches "were warranted not to vary a minute in a month."[26] In the 1870 census it was noted that John Fries, jeweler, age sixty-five, was "born abt 1805"; his name and that of his wife, Anna, were followed by those of six members of the Roberts family, probably his daughter Julia's family (one was another Julia, age six), and two domestic servants born in Ireland.

Fries died on March 14, 1874. The death certificate confirmed his birth date as (again) "abt" 1805.[27] Notices in the *Philadelphia Inquirer* on March 16 and March 20, respectively, gave his age as sixty-five and sixty-nine (Anna was fifty-five), and

reported that he died suddenly on Saturday afternoon, at 826 Spring Garden Street, the body taken to his late residence, 836 North Sixth Street. He had written his will on January 15, 1874, and a codicil on February 13, 1874. The executors were Julia E. Roberts and Anna Fries, 836 North Sixth Street. In his will Fries instructed:

> Firstly, pay all my debts. To my beloved wife Anna Fries all my household furniture, all beds and bedding . . . no real estate to be sold while my wife or either of my four children, Emma, Clara, Julia and Walter, is living . . . and the interest of the two mortgages, one of $4000 and one of $1000 I own . . . the house on 22nd Street near Norris to be appraised to pay the interest on the mortgages held by Samuel Bettle on my premises at North West corner of Second Street & New Streets and I order and direct that when said mortgage on 22nd Street is paid off it must be by my executor or the Orphan's Court appropriated to pay off the mortgage on the NW corner of second and new Street.
>
> It is my wish that my family should live on in harmony as they are now and have been for so long and each one to try to excel the other in making each happy. . . . It is for that purpose I leave to my wife and my daughter Julia, all the rest of my property they paying the taxes, repairs, water rents and interest on the mortgage. But should the household get broken up by my wife Anna Fries or my daughter Julia E. Roberts break up home by getting married then I bequeath to my wife Anna Fries one half of my net income of my real estate in lieu of dower as common law during the full term of her natural life . . . she paying out of her income to her niece Anna Field $10 per week as long as she lives. And the net income of the other half I give to my daughter Julia E. Roberts while she remains single. If she gets married, then this half of the net income I give to my four children Clara, Emma, Julia and Walter. If Anna Field outlives my wife, I will that a legacy of ten dollars and fifty cents per week be paid to her out of my estate during the full term of her natural life.[28] BBG

1. For example: John M. Harper, 3 Bank Alley near the Exchange; Henry Ormsby (q.v.), 366 North Second Street above Green; Baily's, 216 Market near Decatur; S. Zepps, 79 North Second Street; Isaac Reed, 176 North Second Street, corner of Vine; J. Ladomus, at the "old stand," 413 Market above Eleventh Street; Lewis Ladomus (q.v.), 103 Chestnut Street, east wing of Franklin House; S. M. Jones, northeast corner of Third and New streets; Stauffer & Harley, 96 North Second Street.

2. *Philadelphia Inquirer and Public Ledger* (Philadelphia), both December 11, 1835.

3. Septennial Census Returns 1779–1863. The name "Fries" was spelled phonetically in many records as Freaze, Frist, or Frize; William H. Frist and Shirley Wilson, *Good People Beget Good People: A Genealogy of the Frist Family* (Lanham, MD: Rowman & Littlefield, 2003), pp. 4–5. He was not related to John Fries (1744–1824), merchant; the John Fries of the 1798 Rebellion (who died in 1818); or another (possibly a mistake) John Fries, noted as watchmaker, age fifty in 1863. A Jacob Fries (born 1716) from

the province of Friesland, Netherlands, was the founder of Friesburg, Salem County, New Jersey.

4. See the biography of John Dupuy in this volume.

5. *The Souvenir* (Philadelphia), August 1, 1827, p. 39.

6. Pennsylvania and New Jersey Church and Town Records, Ancestry.com.

7. Abraham Stein (1765–1835) advertised "Gold and Silver Watches" at 86 North Third Street from the 1790s until at least 1811; *Poulson's American Daily Advertiser*, November 4, 1811. He was noted in the 1810 U.S. census as a "dealer in watches" at 86 North Third Street with a household of three, he and his wife, both age forty-five or over, and another female, sixteen to twenty-five. In the 1820 U.S. census Stein's household included an additional female age sixteen to twenty-five, but no younger males, which does not suggest that Fries apprenticed or was resident with Stein. Stein does not appear in the Philadelphia directories after 1828.

8. Desilver's Philadelphia directory 1796, p. 40 (Stein); 1828, p. 78 (Stein); 1830, p. 67 (Fries).

9. The U.S. censuses of 1850 and 1870 recorded her birth as 1815. In the 1880 census Anna L. Fries was "widowed and boarding on Frankford Ave." On March 10, 1899, she was "received in by examination" at the Presbyterian Church in Frankford; "Bible Records," *Pennsylvania Genealogical Publications*, vol. 10 (1927–29), pp. 170–72. Desilver's city directory listed a John L. Reese, storekeeper, at 133 North Second Street in 1828 (p. 67) and 1830 (p. 159).

10. One male under a year, one male age ten to fourteen, two males fifteen to nineteen, one male twenty to twenty-nine, one male thirty to thirty-nine, one female under five, one female five to nine, two females ten to fourteen, one female fifteen to nineteen, and one female thirty to thirty-nine.

11. Philadelphia Deed Book MR-8-525, recorded July 1816. Elm (New) Street extended from 160 North Second Street to 153 North Third. Elm Street is identified on A. P. Folie and R. Scot, *Plan of the City and Suburbs of Philadelphia* (1794).

12. Desilver's Philadelphia directory 1831, p. 74.

13. Philadelphia Deed Book AM-24-194.

14. According to city directories and the U.S. Census, from 1839 to 1850 Phineas Fries (1814–1897), also born in New Jersey, worked at 311 1/2 North Second Street and in 1855 at 353 North Second Street, which may have been the same location. From 1869 to 1885 he and his son Edgar, jewelers, were at 541 North Second Street.

15. Dorothea E. Spear, "American Watch Papers in the Collection of the American Antiquarian Society, " in *Proceedings of the American Antiquarian Society* (Worcester, MA: the Society, 1951), pp. 297, 303, 326.

16. *North American and Daily Advertiser* (Philadelphia), December 24, 1840. In 1858 another robbery was attempted but was foiled by an ingenious alarm that went off in each of four contiguous houses if one were forced open; *Philadelphia Inquirer*, April 17, 1858.

17. Emma R. (born c. 1832), Clara (born 1840), Walter (born 1845), Anna (1837–1841); 1850 U.S. Census (as John Fells). All were noted as born in New Jersey, which to date I cannot verify; baptisms would be more likely.

18. This deed read: "lying and being on the West side of Second Street. . . . bounded East by Second Street, South by New Street, West by a ten foot wide alley leading from New Street to Vine Street, and North by a lot of ground granted to John Henry Krauss"; Philadelphia Deed Books RLL-20-110 and RLL-70-468.

19. *Public Ledger*, April 26, 1845.

20. Ibid., March 30, 1847.

21. Among those using their mark on spoons were Lewis Ladomus and Osmon Reed.

22. McElroy's Philadelphia directory 1855, pp. 696, 706.

23. Records of the Internal Revenue Service, Record Group 58, NARA, Washington, DC, Ancestry.com.

24. McElroy's Philadelphia directory 1855, p. 696. By this time residences and workplaces were usually separate. Walter Fries lived on North Eleventh Street at the corner of Oxford Street; see note 23 above. Julia, who had married William Roberts, seems to have been closely connected to her father throughout his life.

25. Gopsill's Philadelphia directory of 1869 also carried a listing for Fries P. & Son (Phineas and Edgar), watchmakers, 529 North Second Street; p. 574.

26. *Public Ledger*, November 17, 1870.

27. Philadelphia Death Certificates Index, 1803–1915, Ancestry.com.

28. Will of John Fries, Philadelphia Will Book 81, no. 221, p. 14.

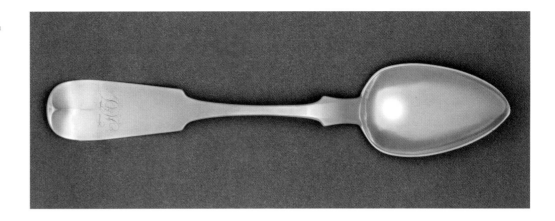

Cat. 264

John Fries

Tablespoon and Four Teaspoons

1845–58

MARK (on each): J. FRIES (in serrated rectangle, on reverse of handle; cat. 264-1)

INSCRIPTION: H A T (engraved script, on obverse of handle)

Tablespoon: Length 9⅛ inches (23.2 cm)

Weight 1 oz. 12 dwt. 2 gr.

Teaspoons: Length 5¾ inches (14.6 cm)

Weight: 11 dwt. 2 gr. to 9 dwt. 9 gr.

Gift of Patricia A. Steffan in memory of Mr. and Mrs. Thomas Hollingsworth Andrews III, 1996-81-43; 1996-81-44–47

PROVENANCE: The initials "HAT" belonged to Hannah Ann Thomas (1834–1912), daughter of Samuel Thomas of Torresdale, Philadelphia County. In 1858 she married Thomas Lancaster Leedom (1828–1901) of Newtown, Bucks County, who was founder of the Leedom Carpet Company.[1] The spoons descended in the family of the donor.[2]

These spoons have no drop on the reverse of the bowl, and the handles are thin. The handle is slightly turned up with a partial midrib. They were surely made in Fries's Silver Spoon Manufactory. BBG

1. Carolyn Lee Mackie Applebee, "Descendants of Thomas Lancaster Leedom," Ancestry.com (accessed June 12, 2015).
2. Curatorial files, AA, PMA. For other silver in the Museum's

Cat. 264-1

collection that was owned by this family, see the dessert spoons by Bailey & Co. (cat. 30); dinner forks by Conrad Bard (cat. 62); dessert spoon by Thomas J. Megear (1996-81-17); ladle by Joseph Shoemaker (1996-81-4); miniature flatware by John Tanguy (1996-81-18–34); flatware by Robert and William Wilson (1996-81-50–64); tablespoons by Christian Wiltberger (1996-81-39–42); and pap dish by Thomas Wriggins (1996-81-3).

Cat. 265

WF

Saucepan

1850–75

MARKS: WF (in oval, on underside and on handle socket); [lion passant (?) in shaped surround, on underside] (cat. 265-1)

INSCRIPTION: M E H (engraved script monogram, on front opposite handle)

Height 3¹¹⁄₁₆ inches (9.4 cm), diam. 4¾ inches (12.1 cm), width 9½ inches (24.1 cm)

Gross weight 12 oz. 11 dwt.

Gift of Evelyn Eyre Willing in memory of Mary Eyre Howell and Evelyn Virginia Willing, 1944-93-9

PROVENANCE: Mary Eyre (Savage) Howell (1845–1925) of Philadelphia, by descent to her granddaughter, the donor.[1]

At the time of its donation to the Museum, this saucepan was attributed to the New York City silversmith William Garret Forbes (1751–1840). However, the "WF" mark struck twice on this object is not among those associated with Forbes or his grandson William Forbes (q.v.). Another mark on the underside is so abraded that it is difficult to identify with certainty, but it may be a lion passant, which raises the possibility that the piece was made in England. Unlike eighteenth- or early nineteenth-century examples of the form, this saucepan is made from heavy-gauge metal, with no centering punch or defined molding around the rim. Its somewhat squat

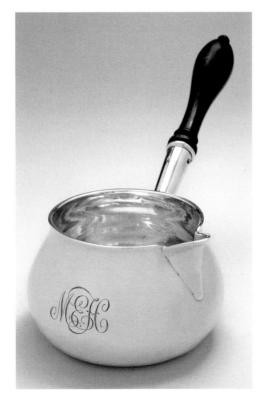

Cat. 265-1

proportions further suggest that it was made later in the nineteenth century. The surface was heavily buffed at some point prior to the addition of Mary Eyre Howell's monogram. Information provided to the Museum in 1944 indicated that Howell collected old silver and often had pieces engraved with her initials.[2] BBG/DLB

1. Mary Eyre Savage, daughter of William Lyttleton Savage of Philadelphia, married Joshua Ladd Howell on April 15, 1875; Pennsylvania, Death Certificates, 1906–44, Series 11.90, Records of the Pennsylvania Department of Health, Record Group 11, Pennsylvania Historical and Museum Commission, Harrisburg, Ancestry.com. She was a regular contributor to the Pennsylvania Prison Society from about 1895 to about 1901; "Treasurer's Report, Donations Received," *Journal of Prison Discipline and Philanthropy*, vol. 40 (1901), p. 64.
2. The donor, Evelyn Eyre Willing, gave the piece in memory of her mother, Evelyn Virginia Willing, and her grandmother, Mary Eyre Savage Howell, whose initials are engraved; obituary of George Willing, *New York Times*, July 27, 1834. For other silver in the Museum that was owned by this family, see the miniature teaspoons by Thomas Bruff (cat. 102); porringer by Samuel Casey (cat. 128); bon bon dishes by the William B. Durgin Company (cat. 227); ewer (1944-93-18) and plates (1944-93-19, 1944-93-20, 1944-93-31a–l) by Samuel Kirk and Henry Child Kirk; porringer by John Le Roux (1944-93-2); salver by John McMullin (1944-93-16); unmarked nutmeg grater (1944-93-13); and cream pot by the Stieff Company (1944-93-23).

Concordance

of Museum Accession Numbers and Catalogue Numbers

Numbers preceded by "D" are on permanent deposit from The Dietrich American Foundation at the Philadelphia Museum of Art, and numbers preceded by "F" are on permanent deposit from Fairmount Park, Philadelphia.

1902-345	cat. 189
1909-129,a	cat. 149
1909-130	cat. 151
1909-144a,b	cat. 257
1912–217	cat. 67
1913-32	cat. 103
1917-134	cat. 90
1919-52	cat. 179
1920-37-4a,b	cat. 180
1921-56-2	cat. 203
1922-64-12	cat. 261
1922-86-1	cat. 22
1922-86-18	cat. 168
1922-86-24	cat. 245
1926-64-1	cat. 49
1928-4-1a,b	cat. 69
1928-25-1a–c	cat. 14
1929-140-1	cat. 68
1931-56-1a,b	cat. 159
1932-44-1a,b	cat. 178
1932-44-2	cat. 178
1932-45-5	cat. 232
1932-45-9a–d	cat. 150
1933-65-1a–f	cat. 248
1933-65-2	cat. 256
1937-28-2a,b	cat. 220
1940-16-707	cat. 92
1942-47-1a,b, –2	cat. 197
1944-40-1	cat. 147
1944-93-3	cat. 128
1944-93-4a–f	cat. 102
1944-93-5a,b	cat. 227
1944-93-9	cat. 265
1945-55-4	cat. 21
1950-12-2	cat. 206
1950-12-3	cat. 3
1950-53-1	cat. 15
1956-49-4	cat. 173
1956-69-1	cat. 85
1956-84-1	cat. 26
1956-84-2	cat. 176
1956-84-3	cat. 182
1956-84-4	cat. 216
1957-64-1	cat. 205
1957-93-3–16	cat. 93
1957-93-17,18	cat. 164
1957-93-19	cat. 185
1958-65-13	cat. 82
1958-65-16	cat. 242
1958-65-17	cat. 243
1958-115-3	cat. 231
1958-115-4a–c	cat. 51
1958-125-9	cat. 244
1959-65-3	cat. 160
1959-91-21	cat. 148
1960-52-2	cat. 172
1960-53-1	cat. 88
1960-107-1a,b, –2	cat. 217
1961-1-1–4	cat. 124
1961-101-1	cat. 223
1961-105-1	cat. 34
1962-95-1a,b	cat. 215
1962-95-2a,b	cat. 215
1964-28-1	cat. 201
1965-165-7	cat. 80
1967-213-1–4	cat. 202
1968-202-1	cat. 214
1968-243-1, –2	cat. 84
1969-200-2	cat. 54
1969-224-113	cat. 169
1969-224-119	cat. 32
1969-224-178	cat. 167
1970-202-1	cat. 165
1972-38-1a,b	cat. 253
1972-40-1–6	cat. 246
1972-51-1	cat. 124
1973-74-1	cat. 262
1974-147-1	cat. 126
1976-105-1–6	cat. 101
1976-165-1	cat. 9
1976-249-1, –2	cat. 76
1977-4-1	cat. 145
1981-71-1	cat. 116
1984-111-1	cat. 190
1984-112-1	cat. 191
1984-120-1	cat. 108
1985-89-1	cat. 252
1986-26-66, –67	cat. 226
1986-99-1	cat. 221
1986-101-1, -2	cat. 63
1987-43-1	cat. 120
1988-25-9	cat. 60
1988-25-13, –14	cat. 47
1988-25-22, –23	cat. 59
1988-25-24	cat. 61
1988-34-1	cat. 25
1988-36-1	cat. 37
1988-67-1	cat. 50
1988-89-3	cat. 64
1988-89-4a–c	cat. 152
1989-19-1	cat. 100
1990-55-38, –39	cat. 41
1990-55-40	cat. 42
1991-1-1, –2	cat. 133
1991-35-4–7	cat. 236
1991-79-5–7	cat. 192
1991-81-1	cat. 184
1991-98-1	cat. 38
1991-98-2	cat. 132
1991-98-7, –8	cat. 36
1991-98-21	cat. 212
1991-98-25	cat. 91
1991-98-27	cat. 117
1991-98-30	cat. 44
1991-109-1a–c	cat. 263
1991-143-3	cat. 181
1991-143-11	cat. 55
1991-143-12	cat. 104
1991-158-10	cat. 125
1992-1-1a,b	cat. 219
1992-107-2	cat. 183
1992-109-1a,b	cat. 141
1994-8-2	cat. 114
1994-14-5	cat. 48
1994-20-69	cat. 166
1994-20-77	cat. 156
1994-56-1	cat. 72
1994-89-2	cat. 210
1994-184-2	cat. 235
1995-69-14a,b, –15	cat. 162
1995-69-19–24	cat. 161
1995-75-1	cat. 155
1996-76-1a,b	cat. 218
1996-81-5–16	cat. 62
1996-81-43	cat. 264
1996-81-44–47	cat. 264
1996-81-48, –49	cat. 30
1997-66-1	cat. 188
1998-81-10a,b	cat. 194
1998-157-1a,b	cat. 140
1998-164-2	cat. 111
1999-8-39a,b	cat. 70
2000-124-1	cat. 228
2000-130-1, –2	cat. 163
2000-130-25	cat. 240
2001-99-1–10	cat. 81
2001-106-1–4	cat. 97
2001-190-2	cat. 113
2001-195-1	cat. 259
2002-169-1a,b	cat. 53
2005-40-3a,b	cat. 56
2005-40-4, –5	cat. 95
2005-50-1, –2	cat. 95
2005-68-1	cat. 4
2005-68-2	cat. 18
2005-68-3, –4	cat. 13
2005-68-5	cat. 16
2005-68-6	cat. 66
2005-68-7	cat. 86
2005-68-8	cat. 87
2005-68-9	cat. 98
2005-68-10	cat. 99
2005-68-11a,b	cat. 123
2005-68-12–15	cat. 137
2005-68-16	cat. 136
2005-68-17a,b	cat. 174
2005-68-18a,b	cat. 175
2005-68-21	cat. 195
2005-68-22	cat. 200
2005-68-23	cat. 213
2005-68-25	cat. 254
2005-68-116a,b	cat. 7
2005-68-121	cat. 57
2005-68-127a,b	cat. 199
2005-69-2	cat. 23
2005-69-3	cat. 121
2005-69-4	cat. 170
2005-69-58	cat. 77
2005-87-2a,b	cat. 119
2005-87-6	cat. 118
2006-94-1a,b	cat. 78
2006-94-2a,b	cat. 211
2006-94-4	cat. 40
2006-94-6	cat. 46
2006-94-10	cat. 43
2006-94-11	cat. 255
2006-140-1	cat. 187
2007-19-1	cat. 24
2007-32-1a,b	cat. 130
2007-64-2	cat. 28
2008-2-1–6	cat. 251
2008-3-1	cat. 247
2008-29-1a,b	cat. 204
2008-29-2a,b	cat. 204
2008-112-22	cat. 250
2008-121-1	cat. 260
2008-132-1	cat. 58
2008-132-4, –5	cat. 138
2008-133-1	cat. 94
2009-26-1	cat. 142
2009-84-1–4a,b	cat. 45
2009-114-7	cat. 146
2009-155-1	cat. 6
2009-155-3	cat. 106
2009-155-4	cat. 107
2009-155-5	cat. 112
2009-155-6	cat. 127
2009-155-7	cat. 139
2009-155-8	cat. 143
2009-155-9	cat. 234
2009-155-10	cat. 237
2009-155-11	cat. 241
2009-155-12	cat. 239
2009-155-32	cat. 52
2009-155-33	cat. 186
2010-5-1a,b	cat. 249
2010-145-4, –5	cat. 134
2010-145-6, –7	cat. 135
2010-145-8	cat. 134
2010-206-2a,b	cat. 29
2010-206-3	cat. 144
2010-206-8, –9	cat. 115
2010-206-23	cat. 11
2010-206-30a–c	cat. 31
2010-206-36	cat. 225
2010-206-37a,b	cat. 230
2010-206-48, –49	cat. 5
2010-206-50	cat. 209
2010-206-56	cat. 224
2010-206-59	cat. 79
2010-206-61	cat. 193
2010-206-65, –66	cat. 131
2011-14-2	cat. 35
2011-15-3	cat. 153
2011-94-1	cat. 109
2011-94-3	cat. 110
2011-99-1a,b	cat. 258
2012-90-1–4	cat. 229
2012-96-1	cat. 222
2012-96-2–5	cat. 207
2013-59-1a,b	cat. 39
2013-119-2	cat. 105
2013-122-1a,b	cat. 33
2013-124-1, –2	cat. 2
2014-10-2	cat. 74
2014-10-3	cat. 75
2014-156-1a,b	cat. 89
2015-53-1–6	cat. 17
2015-55-1–8	cat. 198
2015-58-1a,b	cat. 238
2015-117-1a,b–3	cat. 73
2016-66-1	cat. 65
2016-131-4	cat. 129
2016-134-13	cat. 208
2016-134-14	cat. 154
2016-200-1	cat. 71
2017-5-1	cat. 8
2017-11-1	cat. 122
D-2007-2, –3	cat. 19
D-2007-4 -5	cat. 20
D-2007-6	cat. 171
D-2007-8	cat. 27
D-2007-12	cat. 12
D-2007-17–21	cat. 177
D-2007-28	cat. 158
D-2007-33	cat. 83
D-2007-38	cat. 157
D-2007-42, –43	cat. 96
D-2007-70	cat. 233
F1902-2-44a,b	cat. 196
Promised Gift of Beverly A. Wilson	cats. 1, 10

References

Abbreviations

DAB
Dictionary of American Biography. 22 vols. New York: Scribner's Sons, 1928–58

DAPC
Decorative Arts Photographic Collection, Winterthur Library, DE

Downs Collection, Winterthur Library
The Joseph Downs Collection of Manuscripts and Printed Ephemera, Winterthur Library, Winterthur Museum, DE

HSP
Historical Society of Pennsylvania, Philadelphia

NARA
National Archives and Records Administration

PMHB
The Pennsylvania Magazine of History and Biography. 1877–

Frequently Cited Sources

Archival Sources

Brix Files, Yale University Art Gallery
Maurice Brix Files, Department of American Art, Yale University Art Gallery, New Haven, CT.

Friends Historical Library
Friends Historical Library, Swarthmore College, Swarthmore, PA; and Quaker and Special Collections Library, Haverford College, Haverford, PA. Ancestry.com.

H.R. doc. no. 206. 23rd Cong., 1st sess. (1834)
U.S. Congress. House. 23rd Congress, 1st Session. *Pennsylvania Memorial of silversmiths, &c. of Philadelphia, in favor of restoring the public deposites. March 24, 1834. read, and laid upon the table.* (H.Doc 206). Washington, DC: Gales and Seaton, 1834. (*Serial Set 257.*)

Philadelphia Administration Book
Philadelphia Almshouse Records
Philadelphia Apprentice Records
Philadelphia City Death Certificates
Philadelphia Deed Books
Philadelphia Mortgage Book
Philadelphia Orphans' Court Records

Philadelphia Records of Indentures and Marriages, 1800-1808
Philadelphia Registrations of Deaths
Philadelphia Will Books
All on file at the Philadelphia City Archives.

Septennial Census
Pennsylvania, Septennial Census Returns, 1779–1863. Box 1026, microfilm, 14 rolls. Records of the House of Representatives. Records of the General Assembly, Record Group 7. Pennsylvania Historical and Museum Commission, Harrisburg.

Tax and Exoneration Lists, 1762–94
Tax and Exoneration Lists, 1762–1794. Series No. 4.61; Records of the Office of the Comptroller General, RG-4. Pennsylvania Historical and Museum Commission, Harrisburg. Ancestry.com.

U.S. Direct Tax of 1798
United States Direct Tax of 1798: Tax Lists for the State of Pennsylvania. M372, microfilm, 24 rolls. Records of the Internal Revenue Service, 1791–2006, Record Group 58. National Archives and Records Administration, Washington, DC. Ancestry.com.

City Directories

Attleboro, Massachusetts
Published variously as *Attleboro Directory* and *Attleboro, North Attleboro and Plainville, Directory,* 1800s–c. 1939/40; and *Polk's Attleboro (Bristol County, Mass.) City Directory,* c. 1941–present.

Baltimore
The Baltimore Directory. Baltimore: [various publishers], 1802– .
E. M. Cross & Co.'s Baltimore City Business Directory. Baltimore, 1864–?
Matchett's Baltimore Directory. Baltimore, 1819–56.
The New Baltimore Directory and Annual Register for 1800 and 1801. Baltimore, 1800.
Polk's Baltimore (Anne Arundel, Baltimore and Howard Counties) City Directory. Baltimore, 1887–?
Polk's Baltimore (Maryland) City Business Directory. Baltimore, 1800s–?
Sheriff & Taylor's Baltimore City Directory for 1885. Baltimore, 1884–1880s.
Woods's Baltimore City Directory. Baltimore, 1860–86.

Boston
The Boston Directory. Boston: [various publishers], 1789–1981.

Brooklyn, New York
The Brooklyn City Directory. Brooklyn: [various publishers], 1800s–1900s.

Cincinnati
Williams' Cincinnati Directory. Cincinnati, 1849/50–53, 1855–1941.

Newark, New Jersey
Holbrook's Newark City Directory. Newark, NJ, 1800s–?

New York City
Doggett's New-York City Directory. New York, 1842–54.
Goulding's New York City Directory. New York, 1875–76.
Longworth's American Almanac, New-York Register, and City Directory. New York, 1796–1842/43.
Manhattan New York City Telephone Directory. New York, 1935–.
Polk's (Trow's) New York City (Boroughs of Manhattan and Bronx) Directory. New York, 1900s.
R. L. Polk & Co.'s Trow's General Directory of New York City: Embracing the Boroughs of Manhattan and the Bronx. New York, ?–1918.
Rode's New York City Directory. New York, 1800s–1853.
Trow's New York City Directory. New York, 1853–1900.

Philadelphia
Boyd's Philadelphia Directory. Philadelphia, 1907–.
Desilver's Philadelphia Directory, and Strangers' Guide. Philadelphia,1828–37.
Gopsill's Philadelphia City Directory. Philadelphia, 1867/68–1907.
Macpherson's Directory, for the City and Suburbs of Philadelphia. Philadelphia, 1785.
McElroy's Philadelphia Directory. Philadelphia, 1837–67.
The Philadelphia Directory. Philadelphia: [various publishers], 1785, 1791–1824.
Polk's Boyd's Philadelphia Directory. Philadelphia, 1925–1935/36
Stephen's Philadelphia Directory. Philadelphia, 1796.
White, Francis. *The Philadelphia Directory.* Philadelphia, 1785–91.

Providence
Polk's Providence (Providence, R.I.) City Directory. Boston, 1900s–?

The Providence Directory and Rhode Island Business Directory. Providence: Sampson & Murdock Company, 1824–?

Utica, New York
Utica City Directory. Utica, NY: C. N. Gaffney, 1828–90.

Books and Articles

Almquist 1996
Almquist, Barbara A. "A Touch of Class: Silver in Social Settings." In *The 1996 Philadelphia Antique Show.* Philadelphia, 1996.

Avery 1930
Avery, C. Louise. *Early American Silver.* New York: The Century Company, 1930.

Bailey 1892
Ancestry of Joseph Trowbridge Bailey [2] *of Philadelphia and Catherine Goddard Weaver* [2] *of Newport, Rhode Island.* Philadelpia: privately printed, 1892.

Ball 1993
Ball, A. William. *William Ball, Philadelphia Silversmith, and Some Notes about the Baltimore Silversmith Wm. Ball.* [PA]: privately printed, 1993.

Belden 1980
Belden, Louise Conway. *Marks of American Silversmiths in the Ineson-Bissell Collection.* Charlottesville: University Press of Virginia, 1980.

Bezdek 1994
Bezdek, Richard H. *American Swords and Sword Makers.* Vol. 1. Boulder, CO: Paladin, 1994.

Bigelow 1941
Bigelow, Francis Hill. *Historic Silver of the Colonies and Its Makers.* Rev. ed. New York: Macmillian, 1941.

Browne and Spencer 1987
Browne, Olive, and Sue Spencer. *Liberty Browne Reunion.* S.l., 1987? On file at the Historical Society of Pennsylvania, Philadelphia.

Brix 1920
Brix, Maurice. *Philadelphia Silversmiths, 1682–1850.* Philadelphia: privately printed, 1920.

Buhler 1956
Buhler, Kathryn C. *Colonial Silversmiths: Masters and Apprentices.* Exhibition catalogue. Boston: Museum of Fine Arts, 1956.

Buhler 1972
Buhler, Kathryn C. *American Silver, 1655–1825, in the Museum of Fine Arts, Boston.* 2 vols. Boston: Museum of Fine Arts, 1972.

Buhler 1973
Buhler, Kathryn C. *Silver Supplement to the Guidebook to the Diplomatic Reception Rooms: Early American Silver and Gold, English Silver, Paul Storr, English Silver Gilt, French Bronze Doré.* Washington, DC: Department of State, 1973.

Buhler and Hood 1970
Buhler, Kathryn C., and Graham Hood. *American Silver: Garvan and Other Collections in the Yale University Art Gallery.* 2 vols. New Haven, CT: Yale University Press for the Yale University Art Gallery, 1970.

Carpenter 1982
Carpenter, Charles H., Jr. *Gorham Silver, 1831–1981.* New York: Dodd, Mead, 1982.

Corlette 1973
Corlette, Susanne. *A Royal Province: New Jersey, 1738–1776.* Exhibition catalogue. Trenton: New Jersey State Museum, 1973.

Dehan 2014
Dehan, Amy Miller. *Cincinnati Silver, 1788–1940.* Exhibition catalogue. Cincinnati: Cincinnati Art Museum, 2014.

Dietz et al. 1997
Dietz, Ulysses, Jenna Weissman Joselit, Kevin J. Smead, and Janet Zapata. *The Glitter and the Gold: Fashioning America's Jewelry.* Exhibition catalogue. Newark, NJ: Newark Museum, 1997.

Dupuy 1910
DuPuy, Charles Meredith, with Herbert DuPuy. *A Genealogical History of the Dupuy Family.* Philadelphia: printed for private circulation by J. B. Lippincott, 1910.

Earl 1967
Earl, John L., III. "Talleyrand in Philadelphia, 1794–1796." *Pennsylvania Magazine of History and Biography,* vol. 91, no. 3 (July 1967), pp. 282–98.

Ensko 1927
Ensko, Stephen. *American Silversmiths and Their Marks.* New York: privately printed, 1927.

Ensko 1948
Ensko, Stephen G. C. *American Silversmiths and Their Marks III.* New York: Robert Ensko, 1948.

Fales 1970
Fales, Martha Gandy. *Early American Silver.* Rev. ed. [S.l.]: Excalibur, 1970.

Fales 1974
Fales, Martha Gandy. *Joseph Richardson and Family: Philadelphia Silversmiths.* Wesleyan, CT: Wesleyan University Press for the Historical Society of Pennsylvania, 1974.

Falino and Ward 2008
Falino, Jeannine, and Gerald W. R. Ward, eds. *Silver of the Americas, 1600–2000: American Silver in the Museum of Fine Arts, Boston.* Boston: Museum of Fine Arts, 2008.

Fennimore 2014
Fennimore, Donald L. "George Armitage: Silver Plater in Early Philadelphia." *Silver Magazine,* vol. 46, no. 5 (September–October 2014), pp. 20–21.

Fennimore and Wagner 2007
Fennimore, Donald L., and Ann K. Wagner. *Fletcher and Gardiner: Silversmiths to the Nation, 1808–1842.* Exhibition catalogue. Woodbridge, UK: Antique Collectors' Club, 2007.

Garde 1993
Garde, H. F. "Peter Bentzon—en vestindisk guldsmed" [Peter Bentzon—a West Indian goldsmith]. *Personalhistorisk Tidsskrift,* vol. 1 (1993), pp. 68–77.

Garvan 1987
Garvan, Beatrice B. *Federal Philadelphia, 1785–1825: The Athens of the Western World.* Exhibition catalogue. Philadelphia: Philadelphia Museum of Art, 1987.

Goldsborough 1975
Goldsborough, Jennifer Faulds. *Eighteenth and Nineteenth Century Maryland Silver in the Collection of the Baltimore Museum of Art.* Baltimore: Baltimore Museum of Art, 1975.

Goldsborough 1983
Goldsborough, Jennifer Faulds. *Silver in Maryland.* Exhibition catalogue. Baltimore: Museum and Library of Maryland History, Maryland Historical Society, 1983.

Green 1965
Green, Joseph Hugh. *Jewelers to Philadelphia and the World: 125 Years on Chestnut Street.* Newcomen Society in North America: New York, 1965.

Greenwood 1887
G[reenwood], I. H. "Notes, Queries, and Replies: Washington's War-Sword." *Magazine of American History* (New York), vol. 17, no. 4 (1887), pp. 351–52.

Hammerslough 1958–73
Hammerslough, Philip H. *American Silver Collected by Philip H. Hammerslough.* 4 vols. Hartford, CT: privately printed, 1958–73.

Hartzler 2000
Hartzler, Daniel D. *Silver Mounted Swords: The Lattimer Family Collection, Featuring Silver Hilts through the Golden Age.* State College, PA: Josten's Printing, 2000.

Hindes 1967
Hindes, Ruthanna. "Delaware Silversmiths, 1700–1850." *Delaware History,* vol. 12 (October 1967), 247–308.

Hill and Hill 1982
Hill, J. Bennett, and Margaret Howe Hill. "William Fisher: Early Philadelphia Quaker and His Eighteenth Century Descendants. . . ." In *Genealogies of Pennsylvania Families from the Pennsylvania Genealogical Magazine,* vol. 1, *Arnold–Hertzel,* pp. 552–88. Baltimore: Genealogical Publishing, 1982.

Hofer and Bach 2011
Hofer, Margaret K., and Debra Schmidt Bach. *Stories in Sterling: Four Centuries of Silver in New York.* New York: New-York Historical Society, 2011.

Hollan 2010
Hollan, Catherine B. *Virginia Silversmiths, Jewelers, Watch- and Clockmakers, 1607–1860: Their Lives and Marks.* McLean, VA: Hollan Press, 2010.

Hollan 2013
Hollan, Catherine B. *Philadelphia*

Silversmiths and Related Artisans to 1861. McLean, VA: Hollan Press, 2013.

Jones 1913
Jones, E. Alfred. *The Old Silver of American Churches*. Letchworth, UK: National Society of the Colonial Dames of America, 1913.

Jordan 1911
Jordan, John W., ed. *Colonial and Revolutionary Families of Pennsylvania*. 3 vols. New York: Lewis Publishing Company, 1911.

Kane 1998
Kane, Patricia E., ed. *Colonial Massachusetts Silversmiths and Jewelers: A Biographical Dictionary Based on the Notes of Francis Hill Bigelow and John Marshall Phillips*. New Haven, CT: Yale University Art Gallery, 1998.

Kauffman and Bowers 1974
Kauffman, Henry J., and Quentin H. Bowers. *Early American Andirons and Other Fireplace Accessories*. New York: Thomas Nelson, 1974.

Lindsey et al. 1999
Lindsey, Jack L., et al. *Worldly Goods: The Arts of Early Pennsylvania, 1680–1758*. Exhibition catalogue. Philadelphia: Philadelphia Museum of Art, 1999.

McGoey 2016
McGoey, Elizabeth, ed. *American Silver in the Art Institute of Chicago*. Chicago: Art Institute of Chicago, 2016.

McGrew 2004
McGrew, John R. *Manufacturers' Marks on American Coin Silver*. Hanover, PA: Argyros, 2004.

Marter 1983
Marter, Joan. "Sculpture and Painting." In *Design in America: The Cranbrook Vision, 1925–1950*, edited by Robert Judson Clark and Andrea P. A. Belloli, pp. 237–62. Exhibition catalogue. New York: Abrams, in association with the Detroit Institute of Arts and the Metropolitan Museum of Art, 1983.

Moon 1898–1909
Moon, Robert C. *The Morris Family of Philadelphia, Descendants of Anthony Morris*. 5 vols. Philadelphia: privately printed, 1898–1909.

New Trade Directory 1800
New Trade Directory for Philadelphia, anno 1800 Philadelphia: printed for the author by Way & Groff, 1799.

Pennsylvania Archives
Pennsylvania Archives. 1st ser., vols. 1–12; 2nd ser., vols. 1–19; 3rd ser., vols. 1–30; 4th ser., vols. 1–12; 5th ser., vols. 1–8; 6th ser., vols. 1–15; 7th ser., vols. 1–5; 8th ser., vols. 1–8; 9th ser., vols. 1–10. S.l.: Secretary of the Commonwealth and State Library under the direction of the Superintendent of Public Instruction, 1852–1935.

Peterson 1954
Peterson, Harold L. *The American Sword, 1775–1945: A Survey of the Swords Worn by the Uniformed Forces of the United States from the Revolution to the Close of World War II*. New Hope, PA: Robert Halter, The River House, 1954.

Philadelphia 1956
Philadelphia Silver, 1682–1800. Philadelphia Museum of Art, April 14–September 9, 1956. Exhibition catalogue published under the same title in *Philadelphia Museum Bulletin*, vol. 51, no. 249 (Spring 1956), n.p.

Philadelphia 1969
The University Hospital Antique Show. Philadelphia, April 22–26, 1969. Exhibition catalogue.

Philadelphia 1976
Philadelphia Museum of Art. *Philadelphia: Three Centuries of American Art*. April 11, 1976–October 10, 1976. Exhibition catalogue. Philadelphia: Philadelphia Museum of Art, 1976.

Plan of the City of Philadelphia 1797
Plan of the City of Philadelphia and Its Environs (Showing the Improved Parts). John Hill, 1797. Library of Congress, Washington, DC. https://lccn.loc.gov/2007625050.

Pleasants and Sill 1930
Pleasants, J. Hall, and Howard Sill. *Maryland Silversmiths, 1715–1830: With Illustrations of Their Silver and Their Marks and with a Facsimile of "The Design Book of William Faris."* Baltimore: Lord Baltimore Press, 1930.

Prime 1929
Prime, Alfred C. *The Arts and Crafts in Philadelphia, Maryland, and South Carolina, 1721–1785: Gleanings from Newspapers*. [Topsfield, MA]: Walpole Society, 1929.

Prime 1938
Prime, Mrs. Alfred C. *Three Centuries of Historic Silver: Loan Exhibitions under the Auspices of the Pennsylvania Society of the Colonial Dames of America*. Exhibition catalogue. Philadelphia: the Pennsylvania Society of the Colonial Dames of America, 1938.

Quimby and Johnson 1995
Quimby, Ian M. G., and Dianne Johnson. *American Silver at Winterthur*. Winterthur, DE: Henry Francis du Pont Winterthur Museum, 1995.

Rainwater and Redfield 1998
Rainwater, Dorothy T., and Judy Redfield. *Encyclopedia of American Silver Manufacturers*. 4th ed. Atglen, PA: Schiffer, 1998.

Rower and Rower 2007
Rower, Alexander S. C., and Holton Rower, eds. *Calder Jewelry*. Exhibition catalogue. New York: Calder Foundation; West Palm Beach, FL: Norton Museum of Art; New Haven, CT: Yale University Press, 2007.

Scharf and Westcott 1884
Scharf, J. Thomas, and Thompson Westcott. *History of Philadelphia, 1609–1884*. 3 vols. Philadelphia: L. H. Everts, 1884.

Schiffer and Drucker 2008
Schiffer, Nancy N., and Janet Drucker, *Jensen Silver: The American Designs*. Atglen, PA: Schiffer, 2008.

Selim 2015
Selim, Shelley. *Bent, Cast and Forged: The Jewelry of Harry Bertoia*. Exhibition catalogue. Bloomfield Hills, MI: Cranbrook Art Museum, 2015.

"Shaw" 1914
"Thomas Shaw." In *A History of Morris County, New Jersey: Embracing Upwards of Two Centuries, 1710–1913*. Edited by Henry C. Pitney Jr. 2 vols. New York: Lewis Historical Publishing Company, 1914.

Soeffing 1995
Soeffing, D. Albert. "Some Bailey & Co. Marks and Their Significance."

Silver Magazine, vol. 27, no. 6 (November–December 1995), pp. 12–15.

Spencer 2001
Spencer, Hope Judkins. *American Silver, 1700–1850: The Mrs. John Emerson Marble Collection at the Huntington Library, Art Collections and Botanical Gardens*. Santa Barbara, CA: Fithian, 2001.

Spraker 1922
Spraker, Hazel Atterbury. *The Boone Family: A Genealogical History of the Descendants of George and Mary Boone Who Came to America in 1717*. Rutland, VT: Tuttle, 1922.

Thorn 1949
Thorn, C. Jordan. *Handbook of American Silver and Pewter Marks*. New York: Tudor Publishing, 1949.

Venable 1994
Venable, Charles L. *Silver in America, 1840–1940: A Century of Splendor*. Exhibition catalogue. Dallas: Dallas Museum of Art, 1994.

Voorsanger and Howat 2000
Voorsanger, Catherine Hoover, and John K. Howat, eds. *Art and the Empire City: New York, 1825–1861*. Exhibition catalogue. New York: Metropolitan Museum of Art; New Haven, CT: Yale University Press, 2000.

Waters, McKinsey, and Ward 2000
Waters, Deborah Dependahl, Kristan H. McKinsey, and Gerald W. R. Ward. *Elegant Plate: Three Centuries of Precious Metals in New York City*. 2 vols. New York: Museum of the City of New York, 2000.

Wees and Harvey 2013
Wees, Beth Carver, and Medill Higgins Harvey. *Early American Silver in the Metropolitan Museum of Art*. New York: Metropolitan Museum of Art, 2013.

Wolfe 1980
Wolfe, Richard J. *Early American Music Engraving and Printing: A History of Music Publishing in America from 1787 to 1825 with Commentary on Earlier and Later Practices*. Urbana: University of Illinois Press, 1980.

Woodhouse 1921
Woodhouse, Samuel, Jr. "Special Silver Catalogue." *The Pennsylvania Museum Bulletin*, vol. 17, no. 68 (June 1921). Exhibition catalogue.

Life and marriage dates are provided for owners because of potential confusion between people with similar names, but not for makers or retailers.

Page numbers in italics indicate illustrations.

Pineda, Antonio, 240
Pitts, Richard, 319n14, 366, 371n14
Plumer, Frances Galbraith (1869–1943), 383
Portsmouth family, 234
Poulat, Matilde, 239
Powel, Samuel (1704–1759), and Mary Morris
	Powel (1713–1759), 174
Pratt, Henry, 176n2, 388
Preston, William R., 291–93, 294
Price, Isaac (1768–1798), and Mary Fentham Price
	(born c. 1770), 62
Pyne, Benjamin, 3
	teakettle stand, *xiv*

Rasch, Anthony, 51, 52, 250, 251n74, 251n77
Rawle, Margaret (1760–1881), 230
Reed, Osmon, 221, 436n21
	presentation ewer, *8, 9*
Reed & Barton, 292, 324, 328
Reinhardt, Richard H., 296
Revere, Paul, Jr., 150, 208, 284n2, 285n5
Richards, Samuel, Jr., *5*, 54n66, 66, 155, 158, 159,
	301
Richards & Williamson, 159
Richardson, Francis, Jr., 119, 318, 388, 388n3,
	388n9
Richardson, Francis, Sr., 61, 296, 388
Richardson, Joseph, and Nathaniel, 54n69,
	67n3, 228, 229, 230, 230n20, 367,
	391n1
Richardson, Joseph, Jr., 13, 48, 54n69, 67n3, 198,
	230nn24–25, 296, 301, 321n2, 353,
	379
Richardson, Joseph, Sr., 1, 13, 70, 140, 171n5, 174,
	184, 186, 228, 230nn24–35, 296, 300,
	301, 318, 319, 320, 338n20, 345, 366,
	388, 388n9, 391, 425
	buckle, *12*
	cann, *3, 3*
Richardson, Nathaniel, 54n69, 229, 370
Robbins, Clark & Biddle, 83, 265–66
Robbins, Jeremiah, 265
Roberts, Frederick R.
	tablespoon (designed), cat. 229
Rogers and Brother, 19
Rulon, John West (1799–1872), 94
Rundell, Bridge & Rundell
	candelabrum centerpiece (retailed), 414, *416*
Rush, Benjamin (1745–1813), 370, 377
Ryerss, Anne Waln (1813–1886), 224

Sands, Joseph (1772–1825), 59, 65–66, 66n13
Schanck, Garret, 355
Schlessman, Mary (Maria; 1767–1850), 336, 340
Schubert, Henriette (or Henrietta) Wilhelmina
	(1857–1915), 290
Scott, John Morin (1789–1858), 224–25
Seal, William, 158, 183n19, 198, 201n62, 201nn50–
	51, 249–50, 408
Sedman, Vickie, 398
Sharp, George B., 78, 81–82, 84, 86, 94, 98, 226
Shields, Thomas, 8, 15n21, 48, 97, 135, 137, 141, 142,
	191, 192, 194, 301–2, 316, 337, 338n27,
	343, 345, 349n34
	cup, *123*, 194, 195, 195n1
Shinn family, 145

Shreve, Crump & Low, 323
	coffeepot (retailed), cat. 228
	pitcher (retailed), cat. 191
Simmons, Anthony, 4, 8, 25, 31–34, 36n40,
	36n43, 36n57, 46, 52n5, 171n14, 207,
	251n38, 334, 362n21
Skoogfors, Olaf, 13
	necklace with pendant, *13*
Snowden, Nathaniel Randolph (1770–1851), and
	Sarah Gustine Snowden (1775–1856),
	314
Solon, Marc-Louis-Emmanuel
	vase (*Folie* [*Jester*]), 86
Sommer, Anna E. (1893–1987), 164
Southack, Cyprian (1662–1745), and Elizabeth
	Foy Southack (born 1672), 39
Spratling, William, 239, 240
Stevenson, William Yorke (1878–1922), 106
Stieff Company, 29, 43, 323, 437n2
Stone, Arthur, 243
Story, Hannah (1858–1910), 105
Stryker, Samuel Stanhope Smith (1797–1875),
	and Mary Scudder Stryker (1802–
	1866), 294
Swan, Robert, 26n31
Syng, Philip, Jr., 5, 12, 45, 53n23, 119, 120n24, 134,
	138, 140, 184, 186, 187n9, 198, 235, 300,
	302, 318, 319, 320n1, 336, 338n20,
	339, 368, 388
Syng, Philip, Sr., 119, 184

Tanguy, John, 148, 182
Taylor, George W., 30
Taylor, William, 24, 25n3, 25n10
Taylor & Hinsdale, 189, 417
Taylor & Lawrie, 78, 81, 82, 86, 87n16, 90
	pitcher, 89, *89*
	tureen, 78, *79*
Thibault, Frederick, 182
Thomas, Martha Archer (1820–1855), 131
Tiffany & Co., 19–20, 21, 42, 86, 90, 98, 162, 178,
	253, 272, 324
	tureen with liner (retailed), cat. 1
Tifft & Whiting, 405n3
Tonkin, Mary (1748–1822), 135, 138–39
Travis, John (died 1804), and Elizabeth Bond
	Travis (c. 1768–1821), 312

Van der Spiegel, Jacobus, 167
Van Renssalaer, Alice Cogswell (1846–1878), 227
Van Rensselaer, Elizabeth Van Cortlandt
	(1787–1868), 269
Van Voorhis, Daniel, 76, 179, 346, 349n37, 355
Venturi, Robert
	tray, *13*, 15n39
Vergereau, Peter, 173
Vernon, John, 41

Ward, Jehu, 206n5
Ward, John, 206n5
Washington, Warner, Jr. (1751–1829), and Sarah
	Warner Rootes Washington, 255,
	255n1
Watson, James, 155
Watson and Hildeburn, 157
Watts, James, 211, 211n18, 402

Weil, Amalia Lorraine (Schloss; 1897–1985), 405
Wendt, John R., 84, 113, 424
Wendt, John R., & Co., 19, 328
Whartenby, Thomas, 422
Whitall, John Mickle (born 1800), 131–32, 132n5
White, William (died 1778), 144, 144n1
Whiting and Davis Company, 404
Whiting Manufacturing Company, 19, 84, 162,
	397, 404
Willett, Marinus (1740–1830), 180
Williamson, Samuel, 5, 32, 33, 34, 36n50, 66, 69,
	158, 159nn6–7, 159, 182, 183, 198, 213,
	251n31, 360, 370, 378–79
	teapot, 363, *363*
Willing, George Jr. (1877–1934), and Evelyn Vir-
	ginia (Howell) Willing (1877–1941), 384
Wilson, Robert, 158
Wilson, Robert and William, 6, 30, 156, 292,
	293n26, 395n2
Wilson, William, & Son, 267n2
Wilson, William H., 265
Wiltberger, Christian, 8, 25, 27, 31, 32–33, 34,
	36n26, 36n35, 36n37, 36n60, 37,
	73, 160n1, 171n14, 197, 200n19, 229,
	230n28, 230nn35–36, 249–50, 334,
	335n15, 351, 362n21
Winslow, Edward, 39
Woodcock, Bancroft, 119, 120n30, 212, 214, 305,
	307
Wood & Hughes, 409
Woods, Richard M., & Company, 84
Wyckoff, Catherine van Dorn (born 1707), 168

Young, William, 119, 120n30, 186, 301

Ziegler, William (active 1801–05), 389
Zirnkilton, Franz, 165n1

Index of Forms

This publication was generously supported by a bequest from Robert L. McNeil, Jr., with additional funding from the Center for American Art at the Philadelphia Museum of Art, the Institute of Museum and Library Services, The Henry Luce Foundation, and The Women's Committee of the Philadelphia Museum of Art.

Produced by the Publishing Department
Philadelphia Museum of Art
Katie Reilly, The William T. Ranney Director of Publishing
2525 Pennsylvania Avenue
Philadelphia, PA 19130-2440 USA
www.philamuseum.org

Published in association with
Yale University Press
302 Temple Street
P.O. Box 209040
New Haven, CT 06520-9040 USA
www.yalebooks.com/art

Edited by Mary Cason
Production by Richard Bonk
Photography by Lynn Rosenthal, Will Brown, Graydon Wood, Timothy Tiebout, and Joseph Hu
Design by Steven Schoenfelder, New York
Separations by Professional Graphics, Inc., Rockford, IL
Printed in Spain by Brizzolis, Madrid
Bound in Spain by Encuadernación Ramos, Madrid

Text and compilation © 2018 Philadelphia Museum of Art

Cover: Jean-Simon Chaudron. Pair of Sauceboats, 1800–1809 (cat. 133). Pages ii–iii: Fletcher & Gardiner, Tea Service, c. 1825–30 (cat. 248). Page iv: John David Sr., Teapot, 1785–90 (cat. 175). Page vi: William Forbes, Kettle on Stand, 1839–51 (cat. 258). Pages xii–xiii: *Plan of the City of Philadelphia and Its Environs*, 1802. Drawn by Pierre Charles Varlé, engraved by Robert Scot. Ink on laid paper, plate: 18³⁄₁₆ x 25¼ inches (46.2 x 64.0 cm), image: 17³⁄₈ x 24³⁄₈ inches (44.8 x 62.0 cm). Winterthur Museum, Delaware. Museum purchase, 1960.385.1. Courtesy of the Winterthur Museum. Page xiv: Benjamin Pyne, Teakettle Stand; Peter Archambo, Teakettle, Cream Jug, and Sugar Box; and John Farnell, Tea Caddies. Philadelphia Museum of Art. Gift of Mrs. Widener Dixon and George D. Widener (1959-151-9–12, 1975-49-1, -2).

ISBN 978-0-300-22940-0

Library of Congress Cataloging-in-Publication Data

Names: Philadelphia Museum of Art, author. | Garvan, Beatrice B., author. |
 Barquist, David L., author. | Agro, Elisabeth R.
Title: American Silver in the Philadelphia Museum of Art / Beatrice B. Garvan
 and David L. Barquist ; with contributions by Elisabeth R. Agro.
Description: Philadelphia, PA : Philadelphia Museum of Art, [2018] | Includes
 bibliographical references. Contents: Volume 1, Makers A–F
Identifiers: LCCN 2018020329 | ISBN 9780300229400 (hardback)
Subjects: LCSH: Silverwork--United States--Catalogs. |
 Silverwork--Pennsylvania--Philadelphia--Catalogs. | Philadelphia Museum of
 Art--Catalogs. | BISAC: ANTIQUES & COLLECTIBLES / Silver, Gold & Other
 Metals. | DESIGN / Decorative Arts. | ART / Collections, Catalogs,
 Exhibitions / Permanent Collections.
Classification: LCC NK7112 .P49 2018 | DDC 739.2/30973--dc23 LC
record available at https://lccn.loc.gov/2018020329